Tapestry in the Baroque

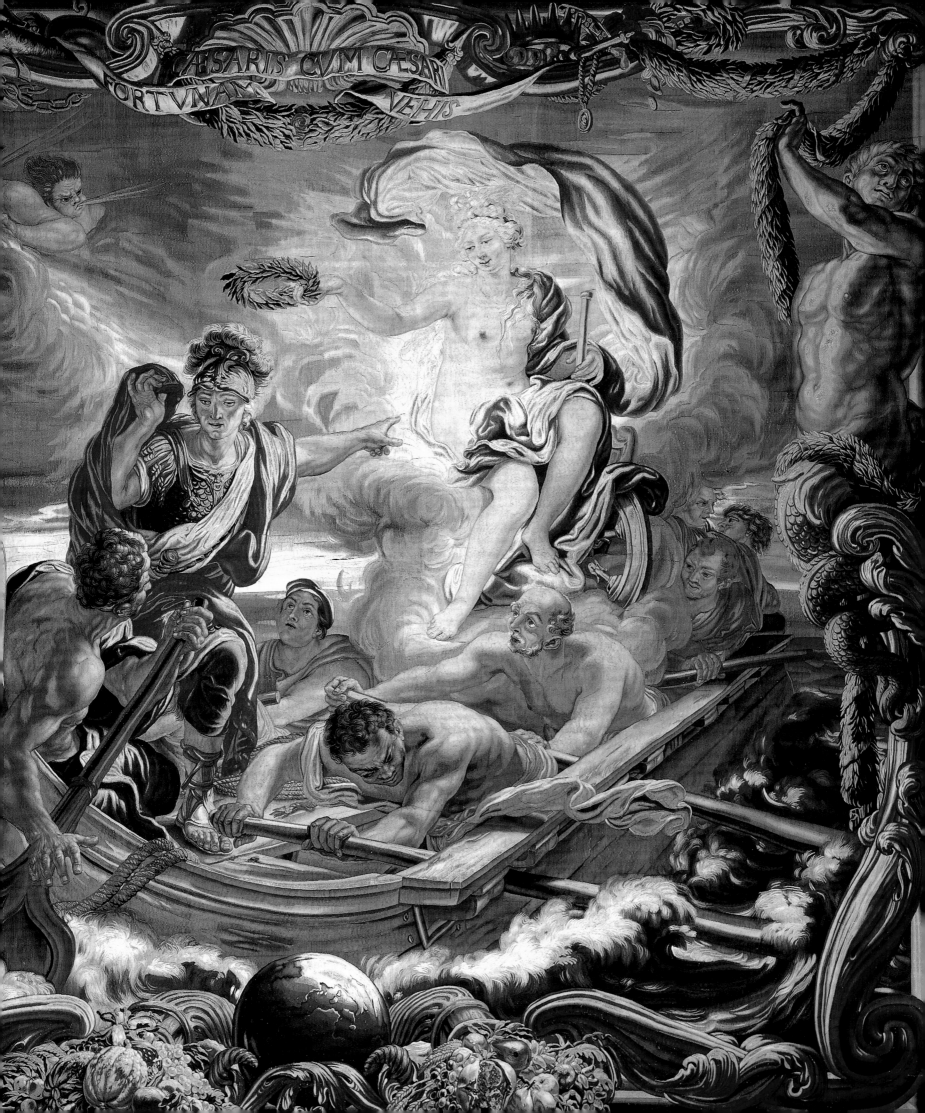

Tapestry in the Baroque
Threads of Splendor

Thomas P. Campbell, editor

Essays by Pascal-François Bertrand, Charissa Bremer-David, Koenraad Brosens, Thomas P. Campbell, Guy Delmarcel, Isabelle Denis, James G. Harper, Wendy Hefford, and Lucia Meoni

Catalogue entries by Jeri Bapasola, Charissa Bremer-David, Koenraad Brosens, Elizabeth Cleland, Isabelle Denis, Nello Forti Grazzini, James G. Harper, Ebeltje Hartkamp-Jonxis, Wendy Hefford, Concha Herrero Carretero, Katie Heyning, Florian Knothe, Lucia Meoni, Katja Schmitz-von Ledebur, Hillie Smit, and Jean Vittet

Photography by Bruce White

THE METROPOLITAN MUSEUM OF ART, NEW YORK
YALE UNIVERSITY PRESS, NEW HAVEN AND LONDON

This catalogue is published in conjunction with the exhibition "Tapestry in the Baroque: Threads of Splendor," on view at The Metropolitan Museum of Art, New York, October 17, 2007–January 6, 2008; and at the Palacio Real, Madrid, March 6–June 1, 2008.

The exhibition is made possible by the Hochberg Foundation Trust and the Gail and Parker Gilbert Fund.

Corporate support is provided by Fortis.

The exhibition is also made possible in part by the National Endowment for the Arts, the Society of Friends of Belgium in America, and the Flemish Government.

The catalogue is made possible by The Andrew W. Mellon Foundation, the Samuel I. Newhouse Foundation, Inc., and the Doris Duke Fund for Publications.

The exhibition was organized by The Metropolitan Museum of Art, New York, with the generous participation of the Patrimonio Nacional, Madrid.

It is supported by an indemnity from the Federal Council on the Arts and the Humanities.

Published by The Metropolitan Museum of Art, New York
John P. O'Neill, Publisher and Editor in Chief
Gwen Roginsky, General Manager of Publications
Margaret Rennolds Chace, Managing Editor
Margaret Aspinwall, Senior Editor
Bruce Campbell, Designer
Sally Van Devanter, Production Manager
Robert Weisberg, Assistant Managing Editor
Kathryn Ansite, Desktop Publishing Specialist

New color photographs of tapestries by Bruce White, Caldwell, New Jersey. Unless otherwise specified, all other photographs were supplied by the owners of the works of art, who hold the copyright to the photographs, and they are reproduced with permission. For additional credits, see p. 563.

Translations: From Dutch, "Tapestry in the Spanish Netherlands, 1625–60" by Guy Delmarcel, translated by Diane Webb; cat. nos. 53, 58 by Hillie Smit, translated by Nicholas Devons. From French, "Tapestry Production at the Gobelins during the Reign of Louis XIV, 1661–1715" by Pascal-François Bertrand, translated by Mark Polizzotti; "The Parisian Workshops, 1590–1650" and cat. nos. 12–14 by Isabelle Denis, and cat. nos. 15, 41–47 by Jean Vittet, translated by Jane Marie Todd. From German, cat. nos. 25–28 by Katja Schmitz-von Ledebur, translated by Russell Stockman. From Italian, "Tapestry Production in Florence: The Medici Tapestry Works, 1587–1747" and cat. nos. 31–34 by Lucia Meoni, translated by Ann Aspinwall. From Spanish, cat. nos. 6, 10–11, 19–24 by Concha Herrero Carretero, translated by Suzanne Stratton.

Type set in Bembo and Medici Script
Separations by Professional Graphics Inc., Rockford, Illinois
Printed by Brizzolis Arte en Gráficas, Madrid
Bound by Encuadernación Ramos, S.A., Madrid
Printing and binding coordinated by Ediciones El Viso, S.A., Madrid

Front jacket/cover illustration: Detail of cat. no. 40, *The Battle of the Granicus* from a set of the *Story of Alexander*. Tapestry design by Charles Le Brun, 1664–65; cartoon by Louis Licherie, 1665; woven at the Manufacture Royale des Gobelins in the workshop of Jean Jans the Younger, Paris, 1680–87. Wool, silk, and gilt-metal-wrapped thread, 485 x 845 cm. Kunstkammer, Kunsthistorisches Museum, Vienna (T V 2)

Endpapers: Details of cat. no. 30, *Table Carpet*. Tapestry design based partly on prints attributed to Jan Snellinck the Elder and on a print after Michiel Coxcie, woven in the northern Netherlands, 1652. Wool, silk, and some metal-wrapped thread, 202 x 281 cm. Rijksmuseum, Amsterdam (BK-16395)

Frontispiece: Detail of cat. no. 54, *Caesar Crowned by Fame* from a set of the *Story of Caesar*. Design and cartoon by an unidentified artist tentatively identified here as Charles Poerson, ca. 1650–67, woven in the workshop of Jean or Hieronymus Le Clerc, Brussels, ca. 1660–80. Wool and silk, 374 x 407 cm. Kunstkammer, Kunsthistorisches Museum, Vienna (T CV2 2)

Cataloging-in-Publication Data is available from the Library of Congress.
ISBN 978-1-58839-229-9 (hc: The Metropolitan Museum of Art)
ISBN 978-1-58839-230-5 (pbk: The Metropolitan Museum of Art)
ISBN 978-0-300-12407-1 (hc: Yale University Press)

Contents

Sponsors' Forewords VI

Director's Foreword VII

Preface and Acknowledgments VIII

Lenders to the Exhibition X

Introduction: The Golden Age of Netherlandish Tapestry Weaving, by Thomas P. Campbell 3

The Disruption and Diaspora of the Netherlandish Tapestry Industry, 1570–1600, by Thomas P. Campbell 17
CATALOGUE NUMBERS 1–6 28

The Development of New Centers of Production and the Recovery of the Netherlandish Tapestry Industry, 1600–1620, by Thomas P. Campbell 61
CATALOGUE NUMBERS 7–11 76

Stately Splendor, Woven Frescoes, Luxury Furnishings: Tapestry in Context, 1600–1660, by Thomas P. Campbell 107

The Parisian Workshops, 1590–1650, by Isabelle Denis 123
CATALOGUE NUMBERS 12–15 140

The Mortlake Manufactory, 1619–49, by Wendy Hefford 171
CATALOGUE NUMBERS 16–18 184

Tapestry in the Spanish Netherlands, 1625–60, by Guy Delmarcel 203
CATALOGUE NUMBERS 19–30 218

Tapestry Production in Florence: The Medici Tapestry Works, 1587–1747, by Lucia Meoni 263
CATALOGUE NUMBERS 31–34 276

Tapestry Production in Seventeenth-Century Rome: The Barberini Manufactory, by James G. Harper 293
CATALOGUE NUMBERS 35–38 304

Collectors and Connoisseurs: The Status and Perception of Tapestry, 1600–1660, by Thomas P. Campbell 325

Tapestry Production at the Gobelins during the Reign of Louis XIV, 1661–1715, by Pascal-François Bertrand 341
CATALOGUE NUMBERS 39–49 356

Manufacture Royale de Tapisseries de Beauvais, 1664–1715, by Charissa Bremer-David 407
CATALOGUE NUMBERS 50–52 420

Flemish Production, 1660–1715, by Koenraad Brosens 441
CATALOGUE NUMBERS 53–58 454

Continuity and Change in Tapestry Use and Design, 1680–1720, by Thomas P. Campbell 491

Bibliography 509

Index 543

Photograph Credits 563

Sponsors' Forewords

FORTIS is proud to support The Metropolitan Museum of Art as a sponsor of "Tapestry in the Baroque: Threads of Splendor." This magnificent presentation of seventeenth-century European tapestries illustrates the importance of this prestigious artistic medium in the great secular and religious courts of Europe.

Fortis is a global financial services firm engaged in merchant and private banking, retail banking, asset management, and insurance in fifty countries around the globe. Fortis is based in Belgium and the Netherlands, and it chose to sponsor this exhibition to celebrate an artistic tradition that shares its roots in this part of Europe. Fortis is honored to participate in this celebration of the spectacular achievements that resulted from the collaboration of artists and weavers both in the Low Countries and in other European centers, where master craftsmen from the Low Countries also played a crucial role in helping to establish and staff new manufactories.

With loans from royal, ducal, and papal collections in more than fifteen European countries, this unique exhibition contains forty-five rare tapestries made in Brussels, Paris, London, Florence, Rome, and Munich between 1590 and 1720. The international character and scope of the exhibition is an appropriate reflection of Fortis's own commitment to its growing international presence, and a fitting parallel to the part that Fortis now plays in international banking and insurance.

Waldo Abbot
CEO, Fortis Americas

THE MINISTRY OF CULTURE OF THE GOVERNMENT OF FLANDERS is pleased to support The Metropolitan Museum of Art in gathering forty-five rare Baroque tapestries made between 1590 and 1720 in New York in the significant exhibition "Tapestry in the Baroque: Threads of Splendor."

Over the centuries, tapestry has been an important component of production and trade in Flanders, and the supreme excellence of the tapestries made in Flemish workshops exemplifies the importance of the Low Countries in this industry. Flemish cultural heritage comprises not only such tangible elements as the extraordinary tapestries themselves, but also intangible traditions like the remarkable designs for tapestries created by such Flemish masters as Peter Paul Rubens and Jacob Jordaens, as well as the supremely skillful weaving techniques that produced them. We are proud to share our Flemish heritage with the rest of the world and to provide a Flemish cultural presence in New York through this partnership with The Metropolitan Museum of Art.

While the tapestries circulated through purchase and gift to noble collections throughout Europe, Flemish weavers were also migrating to work in princely courts from Denmark in the north and Britain in the west to Florence and Rome in the south. The travel of cultural goods and skills still plays an important role in our increasingly mobile contemporary world. Lately there is heightened international attention being given to the circulation of museum collections, and the Flemish Community is involved in the European Union project on collection mobility. The Flemish Ministry of Culture is therefore proud to note that the tapestries in this exhibition come from collections in more than fifteen countries.

We would like to thank the staff of the Metropolitan Museum for their hard work, and we are also gratified that Flemish tapestry scholars have been involved in the preparation of this exhibition and its catalogue.

Bert Anciaux
Flemish Minister of Culture

Director's Foreword

For a modern audience, conditioned to think of figurative art in seventeenth-century Europe largely in terms of painting and sculpture, it is something of a surprise to encounter evidence of the size and scale of the tapestry industry at this period, and the enormous sums that contemporary patrons spent on these woven frescoes. But that was indeed the case. Tapestry was a traditional art form, associated with the lifestyle of courts and churches ever since the early Middle Ages. And, despite the growing interest in old master and contemporary painters that began to develop among the cognoscenti during the sixteenth and seventeenth centuries, the tapestry medium continued to exercise its fascination for the grander and more visionary patrons. Some of the most artistically enlightened rulers, such as the Medici dukes of Florence, poured fresh resources into existing workshops during this period; others sought to establish new ones. Grandest of all was the Manufacture Royale des Tapisseries de la Couronne established in 1662 for Louis XIV of France, one of the most ambitious exercises in art patronage ever undertaken by a European ruler. For those who could not afford such extravagance, the workshops of Paris, Brussels, and many other centers provided alternative sources, and competition was fierce for both old master designs and the best new weavings. Another factor that can come as a surprise to a modern audience is the extent to which many of the greatest artists of the day were engaged in supplying tapestry designs. Indeed, in the context of their own careers and work, the large tapestry designs these artists provided were often among their most important creations.

There are many reasons why the modern art history establishment has neglected tapestry, not the least of which is the difficulty of exhibiting them and the space this requires. The Metropolitan Museum is one of the few institutions with the resources to undertake such a task. This is the second large tapestry exhibition that the Metropolitan has mounted in recent years, following on from our pioneering 2002 exhibition "Tapestry in the Renaissance: Art and Magnificence." As with that exhibition, almost every tapestry in "Tapestry in the Baroque: Threads of Splendor" comes from a crown or papal collection. These tapestries hung on the walls of the palaces in which the fate of European history was decided; in many cases, they commemorate significant parts of that history. It is no exaggeration to say that this exhibition comprises one of the most spectacular demonstrations of Baroque tapestry since the time when monarchs such as Charles I of England, Philip IV of Spain, and Louis XIV of France held audience in the grand palaces of the day. It will be an unparalleled experience for a modern audience.

As in 2002, this exhibition has required the goodwill and collaboration of sister institutions and owners around the world. I would particularly like to extend special thanks to our colleagues at the Patrimonio Nacional with whom we are organizing the Madrid venue of this exhibition (March 6–June 1, 2008), especially Yago Pico de Coaña de Valicourt, President of the Spanish Patrimonio Nacional, and his predecessor and long-time friend of the Metropolitan Museum, the Duke of San Carlos, who arranged this collaboration with Mahrukh Tarapor, Associate Director for Exhibitions at the Metropolitan. I also extend my deepest thanks to the institutional and private owners of the tapestries for the exceptional loans that we have received from their collections.

The exhibition and this accompanying publication were conceived by Thomas Campbell, Curator, Department of European Sculpture and Decorative Arts, and Supervising Curator, Antonio Ratti Textile Center. As with the catalogue for the 2002 exhibition, this book both documents the exhibition and provides a significant contribution to a field in which there have been few survey publications. To this end, we are extremely grateful to the team of international experts who accepted our invitation to contribute essays and entries for this catalogue. The value of the book is additionally enhanced by the new color photography by Bruce White, which provides an opportunity to appreciate these tapestries in the best possible light.

The Metropolitan Museum of Art is grateful to the Hochberg Foundation Trust and the Gail and Parker Gilbert Fund for their crucial support of the exhibition. We also offer our deepest thanks to Fortis, the National Endowment for the Arts, the Society of Friends of Belgium in America, and the Flemish Government for making possible this presentation through their generous support. The Federal Council on the Arts and the Humanities continues to have our sincerest appreciation for its on-going assistance through the Federal Indemnity Program. We are also indebted to The Andrew W. Mellon Foundation, the Samuel I. Newhouse Foundation, Inc., and the Doris Duke Fund for Publications for making important volumes such as this one available.

Philippe de Montebello
Director
The Metropolitan Museum of Art

Preface and Acknowledgments

In the spring of 2002 The Metropolitan Museum of Art mounted a groundbreaking exhibition, "Tapestry in the Renaissance: Art and Magnificence," which celebrated European tapestry production between 1480 and 1570. The present exhibition has been conceived as a sequel, and considers developments up to about 1720. The 2002 show focused primarily on Brussels, from whence high-quality tapestries were exported all over Europe. It took 1570 as a cutoff point because about this time religious strife and civil war ravaged the Flemish tapestry industry, leading to the migration of many of the weavers and designers and, eventually, the emergence of new centers of production in other countries. The present exhibition traces the parallel development of those new centers, along with the recovery of Brussels, in the course of the seventeenth century.

In order to better represent the production of these diverse workshops, it was logical to follow the model of the earlier exhibition and include individual tapestries from a range of design series, rather than presenting a small number of sets in entirety. Even so, the resulting synthesis provides only a fractional view of the range of Baroque tapestry, and it should be noted that this exhibit focuses unashamedly on high-quality, artistic production, rather than on European tapestry per se. It is to be hoped that the current exhibition may encourage future monographic exhibitions on particular workshops, designers, and tapestry series.

From the earliest conception of this exhibition, I have received support and encouragement from Philippe de Montebello, Director of The Metropolitan Museum of Art, Mahrukh Tarapor, Associate Director for Exhibitions, and Ian Wardropper, Iris and B. Gerald Cantor Chairman of the Department of European Sculpture and Decorative Arts. Pledges of international support were received at an early stage from the Duke of San Carlos, then president of the Patrimonio Nacional, Madrid, Wilfried Seipel of the Kunsthistorisches Museum, Vienna, and Arnauld Brejon de Lavergnée of the Mobilier National, Paris. The subsequent decision to have a second venue at the Palacio Real in Madrid was conceived by Mahrukh Tarapor and the Duke of San Carlos and implemented under the jurisdiction of the latter's successor, Yago Pico de Coaña de Valicourt. The arrangements for the Madrid venue were developed in the early stages by Rosario Diez del Corral Garnica and Carmen Cabeza Gil-Casares of the Patrimonio Nacional, working in conjunction with Linda Sylling and Martha Deese of the Metropolitan Museum. Following Rosario's return to the academic world, full responsibility for the Madrid arrangements was assumed by Carmen, in conjunction with Isabel Morán Suárez and Concha Herrero Carretero.

In the course of early research for the content of this exhibition I received help from many colleagues, particularly: Ebeltje Hartkamp-Jonxis (Rijksmuseum, Amsterdam), Guy Delmarcel (Antwerp), Lucia Meoni (Palazzo Pitti, Florence), Concha Herrero Carretero (Patrimonio Nacional, Madrid), Jean Vittet (Mobilier National, Paris), Katja Schmitz-von Ledebur and our dear late friend and colleague Rotraud Bauer (Kunsthistorisches Museum, Vienna). In its final form the New York venue of the exhibition incorporates loans from twenty-five institutions located in ten countries, entailing the support and assistance of scores of people. I would especially like to thank the following, listed in order of the location of the institutions with which their assistance was related: Ronald de Leeuw, Ebeltje Hartkamp-Jonxis, J. P. Sigmond (Rijksmuseum, Amsterdam); Duncan Robinson, David Scrase (Fitzwilliam Museum, Cambridge); James Cuno, Adrienne Jeske, Martha Wolff (Art Institute of Chicago); Cristina Acidini, Caterina Chiarelli, Giovanna Giusti, Lucia Meoni, Antonio Paolucci (Galleria degli Uffizi and Palazzo Pitti, Florence); Eric Rochat, Giselle Eberhard Cotton (Fondation Toms Pauli, Lausanne); John Barnes and the staffs of Historic Royal Palaces and the Textile Conservation Studio (Hampton Court Palace); Hugh Roberts (Royal Collection Trust, London); Mark Jones, Clare Browne, Linda Parry, Sue Pritchard (Victoria and Albert Museum, London); William M. Griswold, Charissa Bremer-David (J. Paul Getty Museum, Los Angeles); Peter Morrin, Ruth Cloudman, Charles C. Pittenger (Speed Art Museum, Louisville); Miguel Zugaza, Alejandro Vergara (Museo Nacional del Prado, Madrid); Yago Pico de Coaña de Valicourt, Carmen Cabeza Gil-Casares, Concha Herrero Carretero, Juan Carlos de la Mata (Patrimonio Nacional, Madrid); Valentijn Byvanck (Zeeuws Museum, Middleburg); William M. Griswold, Robert Jacobsen, Tanya Morrison, Lotus Stack (Minneapolis Institute of Arts); Renate Eikelmann, André Brutillot (Bayerisches Nationalmuseum, Munich); Johannes Erichsen, Sabine Heym, Christine Jungworth (Neues Schloss Schleissheim, Munich); George Goldner, Carmen Bambach, Kit Basquin, David del Gaizo, Catherine Jenkins, Nadine Orenstein, Perrin Stein, Elizabeth Zanis (Drawings and Prints, The Metropolitan Museum of Art, New York); Christian Noyer, Régine Pierre-Chollet (Banque de France, Paris); Arnauld Brejon de Lavergnée,

Bernard Schotter, Jean Vittet (Mobilier National, Paris); Henri Loyrette, Marc Bascou, Emmanuel Coquery, Carel van Tuyll van Serooskerken, Françoise Viatte (Musée du Louvre, Paris); Anne d'Harnoncourt, Alice Beamesderfer, Jack Hinton, Sara Reiter, Dean Walker (deceased) (Philadelphia Museum of Art); Lorenza Mochi Onori, Anna Lo Bianco (Palazzo Barberini, Rome); Jean-Pierre Mazery, Robert Shafer (Knights of Malta, Rome); Mikhail Piotrovsky, Alexi Lariono, Tatiana Volchkova (State Hermitage Museum, Saint Petersburg); Solfrid Söderlind, Karen Blomberg, Torsten Gunnarsson, Lars Holst, Lillie Johansson, Anette Kjaerholm Larsen, Cilla Robach, Susanne von Plrnker-Tind (Nationalmuseum, Stockholm); Lars Ljungström, Agneta Lundström, Ursula Sjöberg (Royal Collections, Stockholm); Lucio Mule Stagno, Antoinette Caruana, Pierre Bonello, Keith Sciberras (Heritage Malta, Valletta); Francesco Buranelli, Arnold Nesselrath, Anna Maria De Strobel (Vatican Museums, Vatican City); Wilfried Seipel, Karl Schütz, Helmut Trnek, Katja Schmitz-von Ledebur (Kunsthistorisches Museum, Vienna); Janet Pinn, Sarah Montgomery, Sandra Richards (Warwick Castle); His Grace the Duke of Marlborough, Jeri Bapasola, John Forster, Caroline McCormack (Blenheim Palace, Woodstock).

Other friends and colleagues have opened doors, assisted in facilitating loans, and helped in various additional ways, especially Mrs. Laurence Adam-Quinchon, Andrea Bayer, Daniel Berger, Brenda Boozer, Birgitt Borkopp, Keith Christiansen, Paulette Cole, David and Simon Franses, Jean-Jacques Gautier, John O'Keefe, Lucy McGrath, Yvan Maes, Florence and Jacopo Patrizi, Doralynn Pines, Emily Rafferty, Carl B. Strehlke, and Anne van Devanter Townsend. Nancy Bialler, Stefan Kist, and Otto Naumann kindly assisted with the preparation of the Federal Indemnity application.

The funding of an exhibition like this is obviously an immense challenge. Hilary and Steven Hochberg were supportive from an early stage of development, as were Gail and Parker Gilbert. Ambassador Dominique Struye de Swielande and Ambassador Alan Blinken and Melinda Blinken were deeply engaged in obtaining support from the Belgian community, and Françoise Maertens and Bart Hendrickx were indispensable in their efforts to secure funding from the Flemish Government. Consul General Renilde Loeckx-Drozdiak in New York and members of the Society of Friends of Belgium in America, most especially SUEZ and KBC, have also been committed to generating awareness of this project. I would also like to thank Fortis and, in particular, Waldo Abbot, Chief Executive Officer, for their corporate sponsorship and endorsement of the Museum's exhibition program. At a crucial point in loan negotiations, Eric and Nancy Garen made a generous gift to facilitate the conservation of the tapestry *Night* from the Bayerisches Nationalmuseum, Munich.

An ambitious international loan exhibition like this could not take place without the aid of numerous colleagues at the Metropolitan Museum. Linda Sylling managed the operations and budget with efficiency and dry humor despite the countless challenges and uncertainties that hampered plans along the way. Nina Maruca and the staff of the Office of the Registrar managed the international transport and insurance arrangements with calm and aplomb. Michael Langley designed the installation with deftness and patience, while graphics were developed with characteristic flair by Sophia Geronimus and the labels were edited punctiliously by Pamela Barr. Reconfiguration and preparation of the galleries was supervised by Taylor Miller and the Department of Buildings workshops. The installation was coordinated by Florica Zaharia and Cristina Carr and the staff of the Department of Textile Conservation. Physical installation of the tapestries was undertaken by the staff of Textile Conservation in conjunction with Denny Stone, Bedel Tiscareño, Juan Stacey, and Jeff Elliot, European Sculpture and Decorative Arts, and the Rigging Shop under the direction of Crayton Sohan.

During early stages of researching the scope and content of the exhibition, I was ably assisted at different stages by Jacqueline Coutré, Catherine Jenkins, and Christina Stacy. For the last year I was fortunate to have the unflagging assistance of Sarah Thein, who juggled a multitude of tasks with infinite energy and attention to detail. Many other Museum colleagues assisted in the preparation of the exhibition in one way or another: Jennie Choi (Collections Management); Elyse Topalian, Mary Jane Crook, Mary Flanagan, Jennifer Oetting, and Sarah Wilson (Communications); Nina Diefenbach, Chris Begley, Andrea Kann, Allison Sawczyn, and Thea Hashagan (Development); Martha Deese and Emily Vanderpool (Office of the Director); Kent Lydecker, Rika Burnham, Merantine Hens, Joseph Loh, Nicole Leist, and Vivian Wick (Education); Elizabeth Berszinn, Flaminia Gennari Santori, Cybèle Gontar, Roger Haapala, Wolfram Koeppe, Erin Pick, Melissa Smith, and Charlotte Vignon (European Sculpture and Decorative Arts); Harold Holzer (External Affairs); Rebecca Murray and Beth Vrabel (Office of the General Counsel); Julie Zeftel and Deanna Cross (The Image Library); Marjorie Shelley (Paper Conservation); Barbara Bridgers, Josephine Freeman, Einar Brendalen, Mark Morosse, Nancy Rutledge, Thomas Ling (The Photograph Studio); the staff of the Antonio Ratti Textile Center; Kenneth Soehner, Mindell Dubansky, Robyn Fleming, Nancy Mandel, and staff of the Watson Library; and Lasley Steever (Website). The Audio Guide was coordinated by Mara Gerstein and written by Amy Heibel.

As anyone reading these words will see, the catalogue accompanying this exhibition is lavish, conceived to serve beyond the exhibition as a comprehensive introduction to a subject that has been neglected by the English-speaking art world. For this, I would like to thank Philippe de Montebello and Editor in Chief John P. O'Neill, both of whom fully embraced the concept of this book. It was their joint decision to commission Bruce White to make new photography of almost all of the tapestries included in the exhibi-

tion, a major contribution in a field that has usually not been well served by photographic representation. From the first, the catalogue was conceived as a multiple-author work, drawing on the expertise of the foremost tapestry scholars and curators of this period, to round out the many facets of this large and complex subject. I would like to express warmest thanks to my fellow writers, colleagues, and friends: Jeri Bapasola, Pascal François-Bertrand, Charissa Bremer-David, Koenraad Brosens, Elizabeth Cleland, Guy Delmarcel, Isabelle Denis, Nello Forti Grazzini, James G. Harper, Ebeltje Hartkamp-Jonxis, Wendy Hefford, Concha Herrero Carretero, Katie Heyning, Florian Knothe, Lucia Meoni, Katja Schmitz-von Ledebur, Hillie Smit, and Jean Vittet. There cannot be many subjects in art history more challenging for editors than that of tapestry, made as it was with contributions by artists, cartoonists, and weavers—many of whom moved with perverse regularity from one country to another, changing their names as they went—and in multiple weavings, often with crucial design or qualitative distinctions. The task of coordinating and copyediting this enormous body of complicated

material was undertaken by my esteemed colleague Margaret Aspinwall, who managed the project with authoritative calm and skill. One of the greatest challenges was establishing a degree of conformity among texts that ranged widely in style. In this, we relied on the gifted assistance of Elizabeth Cleland, who made significant, albeit invisible, contributions to the catalogue well beyond her own entries. Editing was also done by Cynthia Clark and Fronia W. Simpson. Bibliographic details were ruthlessly checked by Jayne Kuchna. The index was prepared by Kate Mertes. The wonderful design of the book reflects the accomplished eye of Bruce Campbell. Production was managed with cheerful professionalism by Sally Van Devanter. Color correction, an extremely challenging task with big tapestries, was undertaken with patience and expertise by Gwen Roginksy and Chris Zichello. My heartfelt thanks to all.

Finally, I would like to thank my wife, Phoebe Campbell, and children, Charles and Honor, who have been thoroughly supportive throughout the long gestation of this project.

Thomas P. Campbell

Lenders to the Exhibition

Amsterdam, Rijksmuseum, 7, 30, 53, 58

Cambridge, Syndics of the Fitzwilliam Museum, 19

Chicago, The Art Institute of Chicago, 22

Florence, Deposito Arazzi della Soprintendenza Speciale per Il Polo Museale Fiorentino, Galleria degli Uffizi, 33

Florence, Deposito Arazzi della Soprintendenza Speciale per Il Polo Museale Fiorentino, Palazzo Pitti, 34, 39, 49

Fontainebleau, Musée National du Château de Fontainebleau, 41

Lausanne, Fondation Toms Pauli, 37

Los Angeles, The J. Paul Getty Museum, 52

Louisville, Speed Art Museum, 23

Madrid, Museo Nacional del Prado, 20

Madrid, Patrimonio Nacional, Palacio Real, 6, 10, 11

Madrid, Patrimonio Nacional, Monasterio de las Descalzas Reales, 21, 24

Middelburg, Zeeuws Museum, 5

Minneapolis, Minneapolis Institute of Arts, 12

Munich, Bayerisches Nationalmuseum, 8

Munich, Bayerische Verwaltung der Staatlichen Schlösser, Gärten und Seen, Neues Schloss Schleissheim, 57

London, Victoria and Albert Museum, 18

New York, The Metropolitan Museum of Art, 2, 51

Paris, Mobilier National, 15, 16, 43, 44

Paris, Musée du Louvre, 45, 46, 47, 50

Philadelphia, Philadelphia Museum of Art, 35

Rome, Galleria Nazionale d'Arte Antica, Palazzo Barberini, 36

Rome, Sovereign Order of Malta, 9

Saint Petersburg, The State Hermitage Museum, 3, 42

Stockholm, Nationalmuseum, 1

Stockholm, The Royal Collections, 17, 29

Valletta, Heritage Malta, 48

Vatican City, Vatican Museums, 31, 32, 38

Vienna, Kunsthistorisches Museum, 13, 14, 25–28, 40, 54

Warwick, Warwick Castle, 4

Woodstock, The Trustees of the Marlborough Chattels Settlement, Blenheim Palace, 56

Tapestry in the Baroque

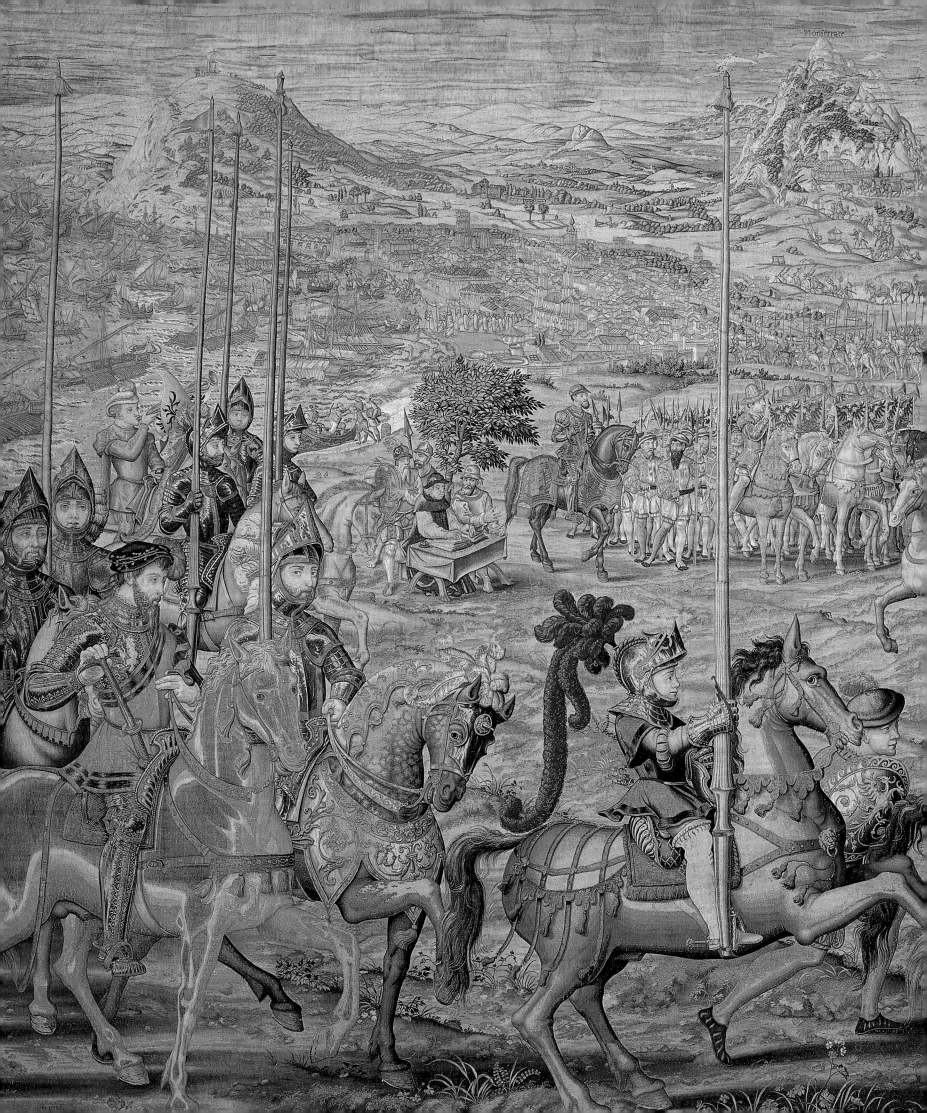

Introduction: The Golden Age of Netherlandish Tapestry Weaving

THOMAS P. CAMPBELL

The scale of the Netherlandish tapestry industry during the second third of the sixteenth century, not to mention the artistic and technical quality of its weavings, has never been surpassed. At its center lay Brussels, which, because it dominated high-quality production from the late fifteenth century, had attracted an unprecedented volume of lucrative commissions from patrons all over Europe. Writing a description of the Netherlands in 1567, the Florentine ambassador Ludovico Guicciardini stated that the Brussels tapestry trade was the most profitable one of the city; indeed, he claimed, Brussels tapestries made from silk, silver, and gold were universally admired.[1] Goods of more quotidian quality were made in other Flemish towns, foremost among which were Tournai, Oudenaarde, and Enghien.[2]

The size and sophistication of this industry were results of developments that stretched back over the previous two centuries. Workshops making small, relatively simple figurative tapestries had probably existed throughout early medieval Europe, much as they continued to exist along the Rhine and in the cantons of Switzerland well into the sixteenth century. But from the early fourteenth century, a more sizable industry grew in a number of towns in the southern Netherlands. Several factors were responsible, among them the availability of skilled weavers and dyers associated with the cloth trade, the existence of local guilds that supported this nascent activity, and the commissions of local patrons, especially the dukes of Burgundy. By the mid-fifteenth century, numerous tapestry workshops were established in the Low Countries in such towns as Arras, Tournai, Lille, and Brussels, capable of producing a steady volume of tapestries in a range of qualities.[3]

This was no cottage industry. Tapestries were made on looms that consisted of two large parallel rollers arranged vertically (for a high-warp loom) or horizontally (for a low-warp loom), separated by a space of five or six feet (figs. 2–4). To begin a tapestry, the weaver stretches plain woolen threads, known as warps, between the rollers. The weaver then passes bobbins, carrying the colored weft thread, in and out of the warps by hand, thus creating a web that is regularly tamped down with a comblike instrument so that the warps are totally covered.[4] Generally speaking, a skilled weaver can produce approximately one square yard of medium-quality tapestry per month, a rate that declines in proportion to the fineness of the weave and the complexity of the design that is to be reproduced. Thus, a medieval tapestry measuring four by eight yards, or thirty-two square yards, would have engaged four weavers sitting side by side at a large loom for anywhere from eight to sixteen months, depending on the tapestry's quality. If that tapestry was one of a set, then similar numbers of weavers would be required to make each of the other pieces. The weaving of tapestries, therefore, was labor-intensive, and during the second third of the fifteenth century, an enormous number of artisans entered the trade via a rigorous apprentice system to meet an ever-expanding European market. As the decades passed, town guilds passed ever more stringent regulations governing local production, at once to ensure the proficiency of guild members and the quality of what they made, and to protect those guild members from competition.

The growth of the labor force weaving the tapestries was matched by parallel trends in the necessary support industries. Although proficient medieval weavers were capable of inventing decorative details, the main outlines of the composition were copied from a full-scale design known as the cartoon, which was painted in watercolor on linen (paper cartoons came into widespread use for tapestries only in the early sixteenth century). As the tapestry industry developed during the fifteenth century and designs became more and more complex, artisans had to follow the carefully drawn cartoons ever more carefully. While some designs were produced on an ad hoc basis by artists associated with a court, the majority of tapestries woven in centers such as Arras and Tournai appear to have been

Fig. 1. Detail of fig. 15, *The Review of the Troops at Barcelona* from a set of the *Conquest of Tunis*

3

made from cartoons painted in workshops that specialized in such work, which probably accounts for the familial likeness of different groups of medieval tapestries.[5] Similar specialization in the dyeing industry meant that the tapestry workshops could count on a steady supply of well-dyed wools and silks. And, finally, underpinning all of this, a network of relationships developed between the tapestry workshops and rich entrepreneurs who provided advances for the costs of labor and materials and, in some cases, commissioned new cartoons from local artists on a speculative basis.[6] While a significant part of the highest-quality production was negotiated between patrons and merchants, the vast majority of the lower- and medium-quality products from the many workshops throughout the Netherlands were sold via annual fairs in port towns like Bruges and Bergen op Zoom. By about 1500 Antwerp had become the most important center of distribution.[7]

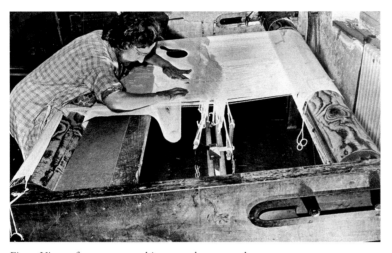

Fig. 2. View of a weaver working on a low-warp loom

Fig. 3. Tapestry sample demonstrating hatchings and other effects

Fig. 4. View of a tapestry web with warp and weft

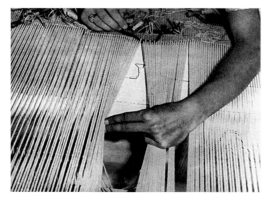

The commercial market for these Netherlandish tapestries expanded hugely in the fifteenth century. At a practical level, they provided a form of insulation and decoration that could be easily transported. In addition, the process of tapestry weaving, where every stitch is placed by hand, enabled figurative images to be created on a scale, complexity, and richness that were unattainable in any other medium. Some of the finest medieval tapestries measure as much as five by ten yards and sets could include ten or more pieces. Most of the weaving was relatively coarse, intended for decorative purposes, but wealthy patrons could commission designs whose subjects depicted celebratory or propagandistic themes. Enriched with silk and gilt-metal-wrapped thread, such woven frescoes were a central component of the ostentatious magnificence that powerful secular and religious rulers put on display to broadcast their wealth and might.[8] It should be noted that quite apart from any iconographic message they conveyed, large sets of tapestries finely woven in precious materials were a very literal display of wealth. Tapestries made with wool and silk cost four times as much as those made with wool alone, whereas those enriched with gilt-metal-wrapped thread cost between twenty and fifty times as much. Tapestries woven with gilt-metal-wrapped thread were the exclusive preserve of the very richest members of society and could cost hundreds of times more than the paintings and frescoes that modern historians often use today as a measure of the artistic interests of those patrons.

While the style of medieval tapestry design reflected the broad developments of contemporary painting, it differed from painting because of the scale and the nature of the medium. Created as large-scale wall decorations, medieval tapestries were frequently hung around corners and with sections of the design obscured by furnishings and architectural features. Because of this mode of display, during the first three-quarters of the fifteenth century, designs were developed in which the narrative was distributed over the entire surface of the tapestry. In addition, because it is much more cumbersome to represent three-dimensional form in tapestry than in painting, medieval tapestry design emphasized line and pattern rather than volumetric illusion. Where a painter can simply blend colors to depict the passage from shadow to highlight, a weaver can only suggest such nuances by creating many small interlocking triangles of different colors (known as hatchings or hachures), a slow and laborious process.

The linear intricacy of medieval tapestries was often matched by iconographic complexity. Tapestries provided vast

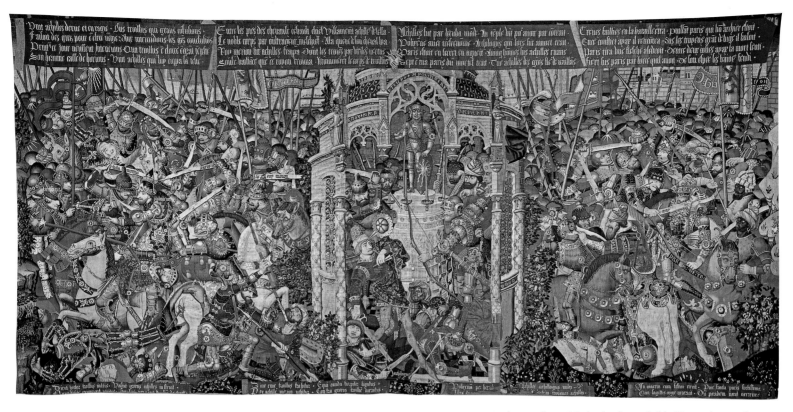

Fig. 5. *The Death of Troilus, Achilles, and Paris* from a set of the *Story of the Trojan War*. Tapestry woven in the southern Netherlands, probably Tournai, ca. 1480–90. Wool and silk, 481 x 942 cm. Museo Catedralico, Zamora

surfaces that were ideally suited to the portrayal of elaborate narratives, and over the fifteenth century cartoonists crammed more and more into their designs. Eventually, visual coherence was sacrificed in favor of a self-conscious confusion of interlocking narrative incidents that required careful scrutiny by the observer. Since wall hangings were often the main figurative decoration in the palace audience chambers of the day, such a presentation had its merits, providing the viewer with a time-consuming exploratory experience. From a practical point of view, these designs limited the amount of effort that weavers had to commit to the reproduction of complex spatial effects. This style, which reached a peak in the late 1460s, is typified by the *Story of the Trojan War* tapestries (fig. 5), of which the first documented set was made for Charles the Bold, duke of Burgundy, in the early 1470s.[9] Thereafter, Pasquier Grenier, the rich Tournai merchant who owned the cartoons for this series, sold duplicate sets to many of the leading rulers of the day including Federigo da Montefeltro, duke of Urbino (1476), Henry VII, king of England (1488), the French court (before 1494), and Matthias Corvinus, king of Hungary (before 1490). The reproduction of this design for so many patrons demonstrates that tapestry provided a common visual medium at the leading European courts, long before the dissemination of prints.

During the last quarter of the fifteenth century, high-quality Netherlandish tapestry production was increasingly dominated by the workshops in Brussels. This was the result of three factors: the decline of the erstwhile high-quality industries in Arras and Tournai because of local political and economic circumstances; the emergence of Brussels as the principal seat of the Burgundian court in the Netherlands, which cemented its importance as a center of artistic and commercial activity; and the monopoly that the Brussels artists' Guild of Saint Luke secured in 1476 over the fabrication of new figurative tapestry cartoons, ensuring the artistic quality of designs used thereafter. During the next twenty years or so, until the end of the century, Brussels weavers refined and perfected the techniques with which they could reproduce the painterly effects of an artist's cartoon, using finer grades of warp and weft and a broader range of colors of dyed silks and wools. Yet, despite the stimulus of the artistic developments taking place in Italy, the Brussels workshops continued to produce tapestry designs of a complex if somewhat *retardataire* decorative and narrative character during the early years of the sixteenth century. Passages of illusionism were often set within areas of two-dimensional pattern, particularly bejeweled architectural frames and gowns with rich folds, for the simple reason that it was still very time-consuming to

Fig. 6. *The Conversion of Saul* from a set of the *Acts of the Apostles*. Tapestry design by Raphael and workshop, woven in the workshop of Pieter van Aelst, Brussels, ca. 1517–19. Wool, silk, and gilt-metal-wrapped thread, 484 x 540 cm. Vatican Museums, Vatican City (3872)

produce the illusion of space and volume in tapestry (fig. 154).[10]

This practical but conservative tendency was challenged by a set of ten tapestries traditionally known as the *Acts of the Apostles* (1516–21). Commissioned in 1515 by Pope Leo X for the Sistine Chapel, they were woven in Brussels from cartoons designed and painted by one of the most famous artists in Rome, Raphael (1483–1520).[11] The *Acts* embodied an iconographic program that was partly intended to celebrate Leo as Christ's representative on earth. Recognizing the illusionistic potential of the tapestry medium, and intrigued by the visual conundrum of woven paintings, Raphael devised the scheme as a vast woven fresco incorporating lifesize figures acting in fully realized illusionistic settings, with narrative and decorative detail limited to a judicious minimum (fig. 6). During the following decade, other papal tapestry commissions from designs by Raphael's protégés, notably Giulio Romano (ca. 1499–1546), Giovanni da Udine (1487–1564), Giovanni Francesco Penni (ca. 1496–after 1528), and Tommaso Vincidor (fl. 1517–36), were also undertaken in Brussels.[12] The illusionistic effects that these Italian designs required were no easier to achieve than in the past, but their artistry and innovative style evidently captured the imagination of northern painters, encouraging them to bring a new vision to their own tapestry designs. Indeed, through their influence on northern artists, these Raphael school designs fundamentally altered the subsequent development of Netherlandish tapestry.

The first Netherlandish painter whose tapestry designs reflect an informed response to the aesthetics of the Italian Renaissance was the Brussels master and court painter to Margaret of Austria, Bernaert van Orley (1488 or 1491/92–1542). Under the influence of the Italian cartoons he saw in Brussels between 1516 and 1530, and also the work of the German artist Albrecht Dürer (1471–1528), Van Orley devised a new approach to the composition of large-scale tapestry designs. This new formula can be traced in his major designs of these years: a series of *Passion* designs created between 1520 and 1525 (fig. 7); the *Battle of Pavia* set (fig. 8) commissioned in about 1527 by the States-General of the Netherlands as a gift for Charles V, to whom it was presented in 1531; the *Hunts of Maximilian* (fig. 9) designed and woven for the Habsburg court between 1530 and

Fig. 7. *The Crucifixion* from a set of the *Passion* (known as the *Alba Passion*). Tapestry design by Bernaert van Orley, probably woven in the workshop of Pieter de Pannemaker, Brussels, ca. 1525–28. Wool, silk, and gilt-metal-wrapped thread, 364 x 354 cm. National Gallery of Art, Washington, D.C., Widener Collection, 1942 (1942.9.448)

1533; and the *Story of Jacob* designed about 1532 for Willem de Kempeneer (fl. 1530–48), one of the leading tapestry merchants of the day.[13] In these works, Van Orley combined elements taken from the Italian cartoons—most significantly, the visualization of each scene as a realistic depiction of a moment of physical or emotional drama embodied by lifesize figures acting in clearly defined perspectival settings—with elements taken from the Netherlandish tapestry tradition—notably, subsidiary narrative scenes in the background and complex anecdotal, decorative, and landscape detail. It should be stressed that the secondary scenes and decorative detailing were not *retardataire* holdovers of outworn conventions but thoughtful responses to the aesthetic properties and technical challenges of the tapestry medium. The large, dramatic figures in the foreground provided a bold focus that read clearly from a distance, while the subsidiary scenes and decorative details rewarded closer inspection. A practical reason argued for the retention of elaborate pattern and detail: it is difficult to weave designs that incorporate large, bare spaces that must be defined by subtle modulations of a single color. Pattern and detail served to break up such surfaces, delighting the eye, rather than inviting it to find fault with the weaver's ability to create a seamless tonal transition.

Fig. 8. *The Surrender of King Francis I*, by Bernaert van Orley, ca. 1527. Modello for a tapestry in the *Battle of Pavia*. Ink and wash on paper, 39.5 x 75.4 cm. Département des Arts Graphiques, Musée du Louvre, Paris (20.166)

Fig. 9. *Departure for the Hunt (Month of March)* from a set of the *Hunts of Maximilian*. Tapestry design by Bernaert van Orley, woven in the Dermoyen workshop, Brussels, ca. 1531–33. Wool, silk, and gilt-metal-wrapped thread, 440 x 750 cm. Musée du Louvre, Paris (OA 7314)

If Van Orley borrowed and adapted the stylistic lessons of Raphael's artistic vision, he also seems to have benefited from the example of the latter's workshop practice. Raphael evidently developed the main compositions of his tapestry designs through careful preparatory drawings, and he also painted significant sections of the *Acts of the Apostles* cartoons himself. Nonetheless, he delegated substantial portions of the cartoon painting to his assistants, as he did the design and execution of certain aspects of the landscape, fauna, and border designs. Van Orley must have heard about Raphael's workshop at first hand from Vincidor, who was dispatched to Brussels in 1520 to execute cartoons and supervise the weaving of various papal tapestries.[14] During the 1520s Van Orley seems to have adopted this practice, assigning the elaboration of his designs into full-scale cartoons to artists who specialized in depicting landscapes, animals, and decorative borders. This process ensured that the whole surface of the tapestry design was visually engaging and that sequences of large tapestry cartoons could be completed in a timely manner, something that a single artist could never have managed alone.

Van Orley's artistic and administrative innovations were quickly taken up by his pupils and followers, foremost among whom was Pieter Coecke van Aelst (1502–1550), who traveled to Italy in the 1520s and settled in Antwerp in 1527. Like Van Orley, Coecke absorbed the lesson of the Raphael workshop cartoons, but he developed a more mannered and dynamic style of composition, using high viewpoints, atmospheric effects, and animated figures, as illustrated by such sets as the *Story of Saint Paul* (fig. 10) and the *Seven Deadly Sins*, conceived about 1530 and 1533–34, respectively. Sometime about 1540, Coecke established a cartoon workshop in Antwerp, and his later designs, such as those for the *Story of the Creation* and the *Story of Vertumnus and Pomona* (fig. 11) are less frenetic, with a greater emphasis on the friezelike arrangement of carefully drawn foreground figures, depicted against landscapes, rich in decorative and narrative detail.[15]

New Italian designs continued to arrive in Brussels during the 1530s. For example, in the 1520s, Giovanni Francesco Penni and Giulio Romano collaborated on an extensive set of tapestries of the *Deeds and Feats of Scipio* of which the editio princeps was

Fig. 10. *The Conversion of Saul* by Pieter Coecke van Aelst, ca. 1529–30. Modello for the tapestry in the *Story of Saint Paul*. Brown wash and white heightening on paper, 25.8 x 41.5 cm. Victoria and Albert Museum, London (Dyce 190)

Fig. 11. *Vertumnus as a Haymaker* from the *Story of Vertumnus and Pomona*. Tapestry design by Pieter Coecke van Aelst, woven in the workshop of Willem de Pannemaker, Brussels, ca. 1545–50. Wool, silk, and gilt-metal-wrapped thread, 430 x 648 cm. Patrimonio Nacional, Palacio Real de Madrid (TA-17/1)

Fig. 12. *The Battle of Zama* from a set of the *Deeds of Scipio*. Tapestry design by Giulio Romano, probably woven in the workshop of Balthazar van Vlierden, Brussels, ca. 1544. Wool and silk, 480 x 902 cm. Patrimonio Nacional, Madrid (TA-26/5)

Fig. 13. *The Creation and Fall of Man* from a set of the *Story of the First Parents*. Tapestry design by Michiel Coxcie and collaborators, woven in Brussels, ca. 1545–50. Wool, silk, and gilt-metal-wrapped thread, 463 x 854 cm. Zamek Królewski na Wawelu, Kraków

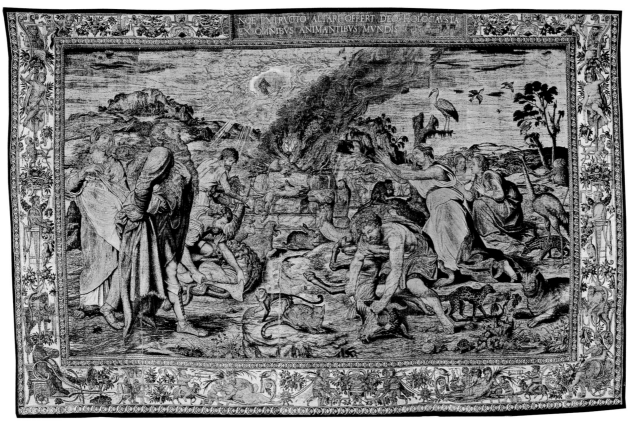

Fig. 14. *Noah's Sacrifice* from a set of the *Story of Noah*. Tapestry design by Michiel Coxcie and collaborators, woven in Brussels, ca. 1545–50. Wool, silk, and gilt-metal-wrapped thread, 462 x 711 cm. Zamek Królewski na Wawelu, Kraków

eventually woven for Francis I between 1532 and 1535. This edition was burned—to extract its gold content—after the French Revolution, but the appearance of the set can be reconstructed from preparatory drawings and from later sets made for other patrons (fig. 12).[16] During the 1530s Giulio produced other designs for Ferrante Gonzaga, duke of Urbino, some of which were woven in Brussels. Meanwhile, Perino del Vaga (1501–1547) was providing innovative designs for Andrea Doria, admiral of the imperial fleet and ruler of Genoa, which were also made in Brussels.[17]

A further Romanist influence was introduced to Flemish tapestry design following Van Orley's death in 1542, when his role as the official tapestry designer in Brussels was taken over by Michiel Coxcie (1499–1592), who had lived in Rome during the 1530s. In series such as the *Story of the First Parents* (fig. 13) and the *Story of Noah* (fig. 14) designed for the Polish king in the late 1540s, Coxcie followed Van Orley's compositional formula in placing large, dramatic figures in the foreground and subsidiary scenes in the background, but his figures are imbued with a grander style and better understanding of physiognomy, which reflected Coxcie's admiration, and sometimes outright

plagiarism, of the art of Michelangelo, Raphael, and Giulio Romano.[18] Like Van Orley and Coecke, Coxcie evidently employed a number of assistants, who may subsequently have worked independently. Thus, his style characterizes many Brussels tapestries of the 1540s, 1550s, and 1560s that are evidently made from cartoons by a number of different hands.[19]

The workshops of Van Orley, Coecke, and Coxcie brought to tapestry design an inventiveness and productivity that coincided with a period of unprecedented investment in high-quality tapestries by the leading rulers of the day. Fueled by the spirit of rivalry between their courts, and consciously employing tapestry as a medium of magnificence and propaganda, Henry VIII, king of England, Francis I, king of France, and Charles V, king of Spain and Holy Roman Emperor, invested vast sums of money in the finest tapestries that had ever been produced.[20] These commissions ensured that enormous amounts of money flowed into the hands of the leading tapestry merchants and manufactory owners, which in turn encouraged and facilitated ever more ambitious projects and the participation of cartoonists and weavers who were increasingly experienced and specialized in their skills. Surviving examples, such as the *Story of*

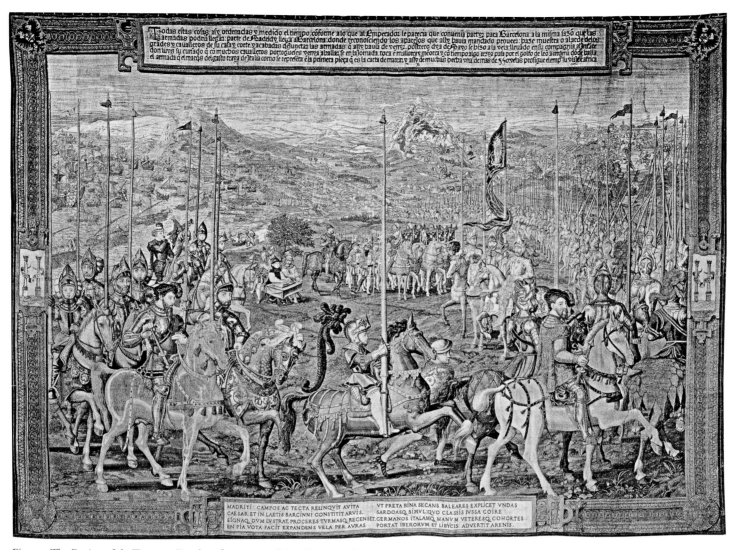

Fig. 15. *The Review of the Troops at Barcelona* from a set of the *Conquest of Tunis*. Tapestry cartoon by Jan Cornelisz Vermeyen and Pieter Coecke van Aelst, woven in the workshop of Willem de Pannemaker, Brussels, 1546–54. Wool, silk, and gilt-metal-wrapped thread, 521 x 712 cm. Patrimonio Nacional, Madrid (TA-13/2)

Abraham set woven for Henry VIII in the early 1540s from designs by the Coecke workshop (Hampton Court Palace; fig. 152), the *Conquest of Tunis* set commissioned by Charles V and made between 1548 and 1554 from designs by Jan Cornelisz Vermeyen (ca. 1500–ca. 1559) and Pieter Coecke (figs. 1, 15), or the Old Testament sets woven for the Polish king Sigismund II Augustus in the early 1550s from designs by Michiel Coxcie (figs. 13, 14), embody a scale of conception, excellence of design, technical execution, and material quality that are superior to anything produced in any later period, with the exception of the most lavish tapestries made for Louis XIV in Paris in the third quarter of the seventeenth century.[21] Grand sets like these were the exclusive preserve of the very richest patrons of the day, but they provided an example that was emulated to a lesser degree by patrons all over Europe, not only in the north but also in Italy, where tapestry remained a central

feature of the art and magnificence of the papal and ducal kingdoms.

Although Brussels continued to dominate large-scale, high-quality production throughout the first two-thirds of the sixteenth century, and other Netherlandish centers continued to export large quantities of lower-grade tapestries, a number of smaller enterprises were set up elsewhere in Europe. Documentation indicates that a considerable amount of independent weaving took place in France during the sixteenth century. In the early 1540s Francis I established a short-lived manufactory at Fontainebleau, whose only identifiable product is a set that reproduces, in perfect trompe l'oeil, the famous stucco and fresco gallery designed by Rosso Fiorentino (1494–1540) and Francesco Primaticcio (1504/5–1570) in the palace there (fig. 16).[22] From a commercial point of view, the most successful French workshops were those in Paris, which managed

to maintain an independent existence, supplying tapestries to the French Crown and nobility. Few works have survived, but the tapestries made for Diane de Poitiers sometime about 1550 demonstrate the quality and aesthetic of the finest Paris products. It should be emphasized, however, that such tapestries were less finely woven and in a more limited palette than those being made at the time in Brussels.[23]

The continuing taste for tapestry among Italian patrons spurred new enterprises there. Of particular note are the workshops established by Ercole II d'Este in Ferrara in 1536, where designs by Dosso Dossi (ca. 1486–1541/42) and Giulio Romano, among others, were produced.[24] In 1539 a workshop was established in Mantua by Federigo Gonzaga, which used designs by Giulio Romano.[25] A number of the weavers involved in these workshops subsequently relocated to Florence when Cosimo I de' Medici established two workshops in 1545 staffed with émigré weavers from the Low Countries. During the next fifteen years these enjoyed a period of dazzling and innovative achievement, working from designs by artists like Francesco Salviati (1510–1563), Agnolo Bronzino (1503–1572; fig. 17), and Bacchiacca (1494–1557).[26]

However, such projects were extremely expensive, and no individual patron had the funding to maintain long-term production at the level of quality that was available through the network of tapestry workshops and entrepreneurial merchants in the Netherlands. Many of the richest financiers lived in Antwerp, where they played a key role, acting as middlemen between patrons and workshops, commissioning new designs as speculative ventures, and providing advances to the workshops for necessary materials and labor. And it was through Antwerp that the vast majority of the Netherlandish tapestries were shipped to patrons all over Europe.[27] Tensions inevitably grew between those involved in the tapestry trade in Brussels and in Antwerp. Authorities in Antwerp encouraged artists, cartoonists, and weavers to resettle in that city beginning in the 1540s, and the Brussels guild of weavers vehemently objected to the way in which the Antwerp authorities delayed promulgating the 1544 imperial regulations regarding the tapestry trade. Nonetheless, links between the tapestry communities in the two towns were extremely close. The Antwerp Pand, a purpose-built tapestry market constructed in the 1550s, provided a place where cartoons and raw materials could be bought and

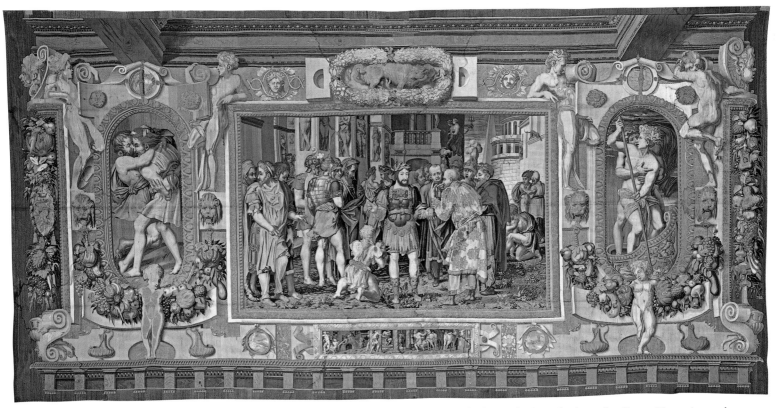

Fig. 16. *The Unity of the State* from a set known as the *Gallery of François I.* Tapestry design by Claude Baudouin and others after Rosso Fiorentino and Francesco Primaticcio, ca. 1539, woven at Fontainebleau, between 1540 and 1547. Wool, silk, and gilt-metal-wrapped thread, 330 x 620 cm. Kunsthistorisches Museum, Vienna (KK T CV 6)

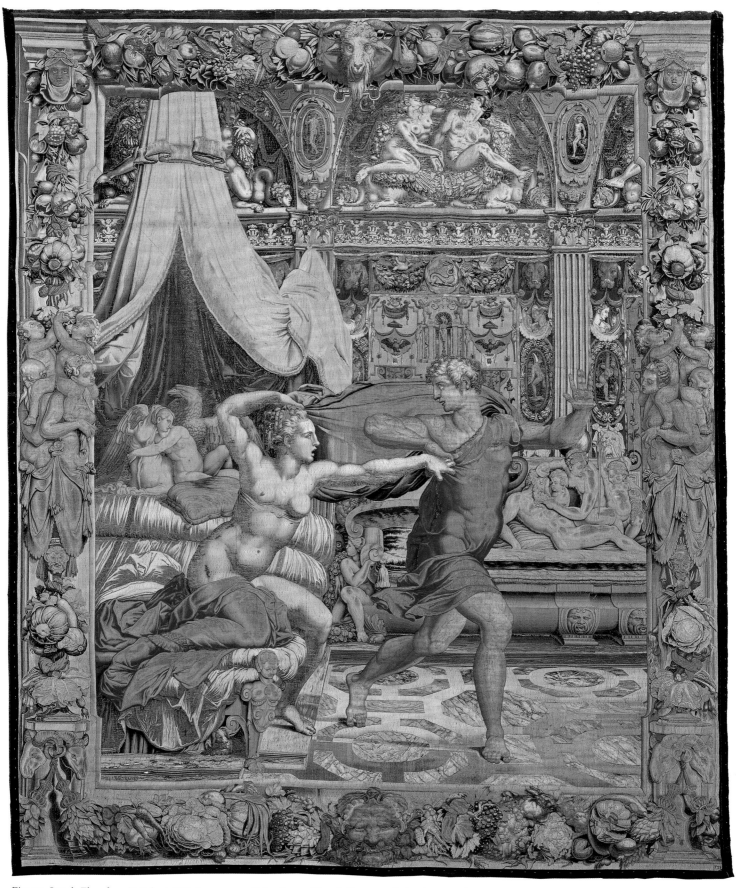

Fig. 17. *Joseph Flees from Potiphar's Wife* from a set of the *Story of Joseph*. Tapestry design by Agnolo Bronzino and collaborators, woven in the workshop of Nicolas Karcher, Florence, ca. 1548–49. Wool, silk, and gilt-metal-wrapped thread, 570 x 457 cm. Palazzo Vecchio, Florence

where sales and commissions could be negotiated. Most of the high-quality goods traded there came from the workshops in Brussels.

This, then, was the complex and symbiotic system of merchants, weavers, artists, dyers, carters, and shippers that enabled the Netherlandish tapestry industry to produce such large volumes of high- and medium-quality weavings during the first two-thirds of the sixteenth century. And it was this intertwined and flexible structure that was severely undermined during the last third of the century by Philip II's determination to enforce the Counter-Reformation in the Low Countries. A goal rooted in religious conviction had the effect of dispersing Flemish weavers of the Protestant faith throughout Europe, weakening the Netherlandish tapestry industry and creating the circumstances in which competitive industries were able to develop in other European centers in the late sixteenth and early seventeenth centuries.

1. Guicciardini 1567, p. 58.
2. The present summary is based on the much more detailed discussion of the development of the Brussels tapestry industry by T. Campbell in New York 2002, passim. For discussion of weaving in other Flemish centers at this period, and further bibliography, see Delmarcel 1999a, pp. 164–207.
3. T. Campbell in New York 2002, pp. 29–36.
4. For discussion of how tapestries are made, see T. Campbell in New York 2002, pp. 5–6.
5. Ibid., pp. 41–49.
6. Ibid., pp. 32–35.
7. Ibid., pp. 37–38.
8. Ibid., pp. 14–27.
9. Ibid., pp. 33–34, 45, 55–64.
10. Ibid., pp. 133–38, et infra.
11. Ibid., pp. 186–218.
12. Ibid., pp. 224–61.
13. Ibid., pp. 286–339.
14. Ibid., pp. 229–37.
15. Ibid., pp. 378–90, 406–28.
16. Ibid., pp. 341–48, 364–70.
17. Ibid., pp. 349–63, 371–77.
18. Ibid., pp. 394–402, 441–47, 452–57.
19. Ibid., pp. 399–402.
20. Ibid., pp. 262–72.
21. Ibid., pp. 383–85, 416–23 (for the *Abraham* set); 397–99, 441–51 (for the *Old Testament* sets); 385–91, 428–33 (for the *Tunis* set).
22. Ibid., pp. 465–68, 470–76.
23. Ibid., pp. 462–65, 477–81.
24. Ibid., pp. 483.
25. Ibid., pp. 48–93, 506–13.
26. Ibid., pp. 493–505, 514–28.
27. Ibid., pp. 280–82.

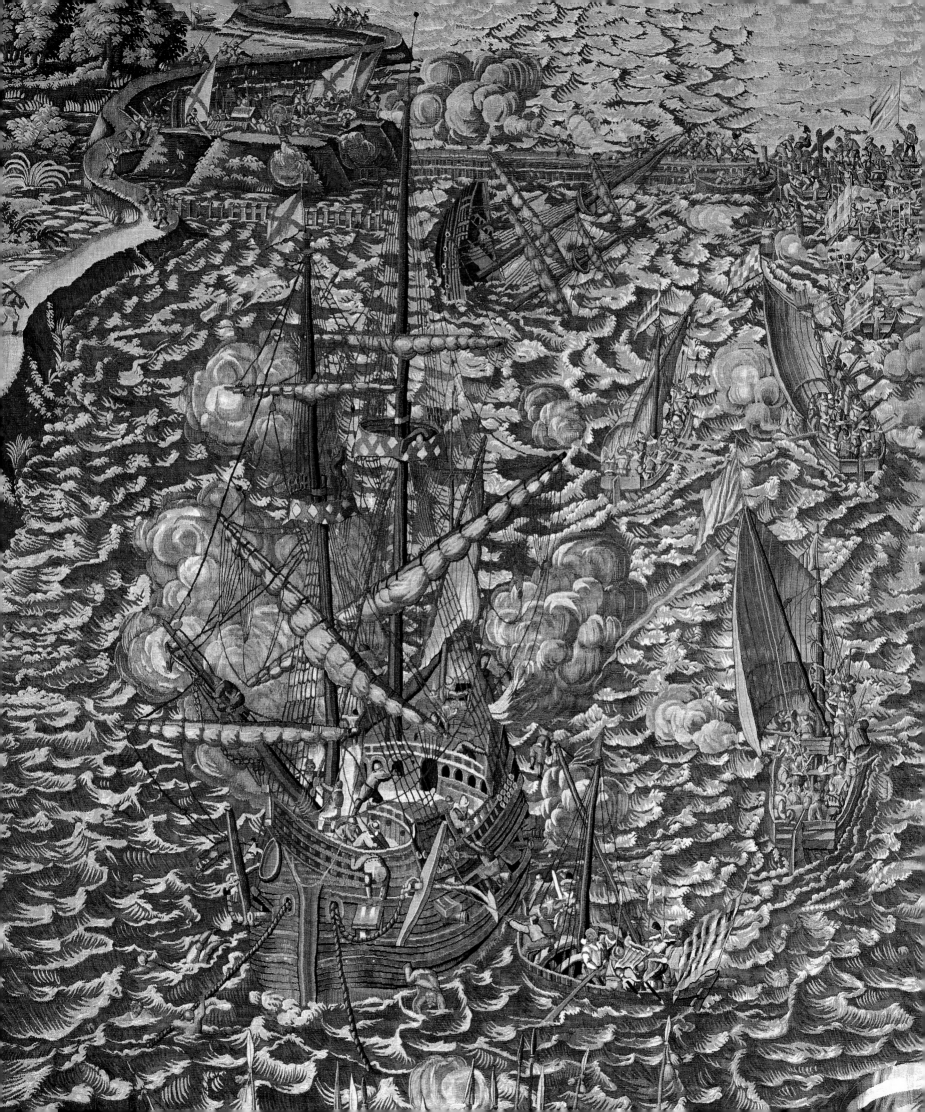

Disruption and Diaspora: Tapestry Weaving in Northern Europe, 1570–1600

THOMAS P. CAMPBELL

The fragmentation of the tapestry industry in the southern Netherlands during the last third of the sixteenth century and the subsequent growth of rival centers in other European towns during the same period were results of the religious strife and civil wars that roiled the Low Countries during the 1570s and 1580s. Persecution of reformers had cast its shadow over the tapestry industry as early as 1527, when various leading Brussels merchants and weavers, including Pieter de Pannemaker (fl. 1517–32), court tapissier to Margaret of Austria, were fined for attending sermons preached by the Lutheran Claes van der Elst. Bernaert van Orley, court artist to Margaret of Austria and the leading Flemish tapestry designer of the day, was also among those charged.[1] The punishments imposed on that occasion were commuted or reduced, and for the most part, Van Orley and his colleagues continued their trades relatively unaffected by these events.[2] Nonetheless, persecution of reformers encouraged a steady trickle of weavers to migrate to foreign countries during the 1530s, 1540s, and 1550s. Jan Rost (fl. 1535–64), a master weaver from Brussels, was persecuted for heresy in 1534, and this must have been a factor in his moving to Italy in 1536. There he was to be a key figure in the tapestry manufactory established in Florence in 1545 by Cosimo I de' Medici.

Other weaver-entrepeneurs who left the southern Netherlands in this initial phase of emigration set up workshops in the Germanic states, thereby belatedly bringing the Renaissance pictorial tradition to Germanic tapestry production. The workshops established during the late 1540s and 1550s by Seger Bombeck (fl. 1545–59) in Torgau, Leipzig, and later Dresden and by Peter Heyman (fl. 1547–66) in Stettin are especially noteworthy for both the quality and the Reformation iconography of their designs (fig. 19).[3] During the second quarter of the century, however, the impact of persecution and migration on the high-quality Netherlandish tapestry industry

Fig. 18 (opposite). Detail of cat. no. 5, *Siege of Zierikzee* from a set of the *Zeeland Tapestries*

Fig. 19. *The Croy-Teppich*. Tapestry woven in the workshop of Peter Heyman, Stettin, 1554. Wool and silk, 446 x 690 cm. Ernst Moritz Arndt Universität, Greifswald, Germany

Fig. 20. *David with Goliath's Head* from a set of the *Story of David*. Tapestry design by Nicolaas van Orley, woven in the workshop of Jacob de Carmes, Stuttgart, 1571–73. Wool and silk, 450 x 637 cm. Kunsthistorisches Museum, Vienna (KK T LXIX 4)

was relatively slight. This can be explained in part because many of the key weavers and merchants in Antwerp enjoyed a privileged position. Although Antwerp was especially fertile ground for the Reformation movement, thanks to the number of foreigners resident there and the constant traffic passing through it, the fact remained that the Habsburg regime depended on financing from the Antwerp merchant community. This meant that religious persecution was less stringent and the Inquisition was less rigorous there than in other centers. Indeed, after 1520 the city enjoyed certain privileges that shielded merchants from Protestant regions from persecution for their faith.[4] This tolerance must have been among the factors that encouraged large numbers of Brussels weavers to relocate to Antwerp during the second third of the century.[5]

The Counter-Reformation and the Flemish Tapestry Industry
This situation changed following Philip II's accession as king of Spain in 1556. His attempt during the early 1560s to turn the

Netherlands into a Spanish dependency governed by Spanish ministers generated considerable discontent among the leading members of the Council of State that were only briefly allayed when Cardinal Granvelle left the Netherlands in 1564. Philip's determination to enforce the decrees of the Council of Trent resulted in renewed opposition, culminating in the embassy of Lamoral, count of Egmont, to Spain in January 1565 to discuss the state of affairs. Philip received Egmont warmly, but the rigors of the Inquisition continued unabated in the Netherlands, giving rise to widespread unrest during 1566 and 1567, the so-called Wonderyear, when Antwerp became a Calvinist stronghold. In response, Philip dispatched Fernando Álvarez de Toledo, the duke of Alba, to the Netherlands in 1567 at the head of an army of ten thousand soldiers. Alba was granted unlimited powers to root out heretics, and on his arrival he established a tribunal, the Council of Troubles, to try those who had been involved in the disturbances. Egmont and Philip de Montmorency, count of Hoorn, popular leaders of the

Protestants, were arrested in September 1567, imprisoned, and executed in June 1568. They were followed to their deaths by more than one thousand of their fellow citizens.

Inevitably, these developments had a devastating impact on the labor-intensive tapestry industry because many weavers and tapestry merchants were sympathetic to, or active participants in, the Reformation movement. Some chose to emigrate to Protestant regions at the earliest hints of impending persecution. For example, in 1562, at the invitation of Frederick III, the elector of the Palatinate, more than fifty-eight weavers and their families relocated to Frankenthal, where they were housed in a former Augustinian abbey.[6] They included weavers from Brussels, Oudenaarde, and Tournai. Two years later, another group of weavers were asked to move to Stuttgart by Prince Christoph of Württemberg. A workshop was established there under the direction of Jacob de Carmes (fl. 1564–73), originally of Oudenaarde, and more recently living in Cologne. Cartoons were provided by Nicolaas van Orley (fl. 1566–74)—a nephew of Bernaert van Orley—who moved to Stuttgart from Brussels in 1566. Over the next four years Nicolaas supplied the Stuttgart workshops with several series of Old Testament subjects, of

which examples survive in Vienna (fig. 20). Subsequently he worked in Strasbourg and Cologne before he also settled within the community of Netherlandish weavers in Frankenthal sometime before 1574.[7]

England was another attractive haven for émigré Protestants, following the accession of Queen Elizabeth I in 1558 and the reversal of Queen Mary's policies to reintroduce Catholicism as the national faith. During the 1560s a number of Flemish weavers traveled there, and while most settled in London, some played a part in the new tapestry workshops established about 1560 in Barcheston and Weston (Warwickshire) by William Sheldon (d. 1570), a local landowner. Indeed, it has been suggested that the master weaver at this workshop, Richard Hickes (ca. 1524–1621), was actually of Flemish origin, and that his surname was an English rendering for Van den Hecke, a common name among Flemish weavers.[8] In his will, Sheldon boasted that Hickes introduced the art of tapestry weaving to England. Although this was an overstatement, there being earlier evidence of small-scale tapestry workshops in London, the claim reflects the impact at this time in England of émigré weavers from the Low Countries and the sense of new initiative that

Fig. 21. *Creso Is Taken Prisoner* from a set of the *Story of Cyrus*. Tapestry design by Michiel Coxcie and collaborators, ca. 1560, woven in the Brussels workshop of Jan van Tieghem. Wool, silk, and gilt-metal-wrapped thread, 410 x 700 cm. Patrimonio Nacional, Palacio Real de Aranjuez (A365-12357)

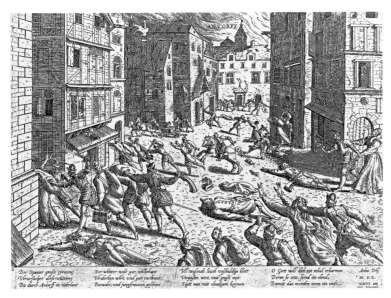

Fig. 22. *The Sack of Antwerp* from *Events in the History of the Netherlands, France, Germany, and England between 1535 and 1608*, by Frans Hogenberg. Engraving, 20.8 x 27.3 cm. The Metropolitan Museum of Art, New York, The Elisha Whittelsey Collection, The Elisha Whittelsey Fund, 1959 (59.570.200[26])

they brought to native production. During the early 1560s other such weavers are recorded in Sandwich and Stamford.[9]

Those Protestants who had not left the southern Netherlands before Alba's arrival were given considerable incentive to do so thereafter. In Brussels, even figures with close ties to the Spanish Crown were not exempt from religious persecution. Willem de Pannemaker (fl. 1535–70), the leading tapestry merchant of the day, who had supplied the *Conquest of Tunis* tapestries to Charles V along with many other royal commissions, and who also had commercial dealings with both Granvelle and Alba, nonetheless came under Alba's suspicions in 1568. Happily for Pannemaker, the accusation of heresy was not proved, and he appears to have successfully reingratiated himself with the duke, who commissioned various tapestries from him, including a custom-made set depicting the duke's military victories.[10] It is somewhat ironic that Alba took advantage of his residence in Brussels to order tapestries there, even as he was instituting policies that were tearing the industry apart.

Another leading Brussels merchant, Jan van Tieghem (fl. 1540–73), was not so lucky. Van Tieghem's mark appears on many of the finest tapestries of the period, including a set of the *Acts of the Apostles* after Raphael made for Cardinal Ercole Gonzaga about 1550 and a richly woven *Story of Cyrus* made for Philip II shortly before 1560 (fig. 21).[11] Despite his work for such eminent clients, Van Tieghem was expelled from the Netherlands by Alba's council in 1568. He subsequently established workshops in Cologne and Wesel, where he wove tapes-

tries for Landgraf Wilhelm von Hessen-Cassel including, between 1570 and 1573, a set of the *Story of Cyrus*, now lost, that must have been made from cartoons that Van Tieghem brought with him from Brussels.[12] Van Tieghem seems to have been successful in reestablishing his workshop and finding new clients. But others were less fortunate. For example, information regarding the Oudenaarde community reveals the large numbers of tapestry weavers who were active Protestants there, the torture and execution of some of the more prominent figures, and the many who fled.[13]

Civil War and Further Emigration

The situation only deteriorated in the following years. Alba's merciless actions encouraged the resistance and organization in the northern Netherlands of anti-Catholic forces, who defeated the Spanish fleet and gained power in North Holland and Mons. Other towns declared their support for the rebels, and the States-General, assembled in Dordrecht, declared themselves against Alba's government and rallied under the banner of William I, Prince of Orange. Alba's army proceeded to reclaim the provinces, with the exception of Zeeland and Holland, but was repulsed in its attempts to take Alkmaar. Philip recalled Alba, enfeebled in health, to Spain in December 1573, but the vicissitudes of war were to continue. Some had direct and devastating impact on the tapestry industry. Direst of all was the sack of Antwerp in November 1576 by the poorly paid and mutinous Spanish troops.

The events were swift and brutal. On November 4, five thousand soldiers from garrisons in Maastricht, Aalst, and Lierre descended on the town, which they pillaged over the following week (fig. 22). Six thousand citizens were massacred, eight hundred houses were burned, and horrendous abuse was inflicted on the citizens of the town. One group of troops made straight for the Antwerp Pand, the center of distribution for much of the Netherlandish tapestry industry. They were led by Francisco de Ontoneda, a Spanish merchant from Bruges, who was well acquainted with the trade. Over the succeeding days, they looted hundreds of tapestries from the booths of the principal tapestry merchants, carrying them to the nearby residence of a certain widow Aranda, who was Ontoneda's mother-in-law. Adding insult to injury, the soldiers forced various tapestry workers to organize, pack, and, in some cases, value the tapestries. During the next month, the majority of these goods were shipped out of Antwerp, traveling via Lierre and Maastricht to Paris and Spain, although some remained in the hands of the soldiers who had assisted in the looting.[14] Antwerp was regained by

William of Orange in 1577, and over the next two years many of the merchants who had suffered at the hands of the Spanish troops tried to track down and reclaim their stolen goods. The activity of the weaver-entrepreneur Frans Spierincx, later known as François Spiering (1549/51–1630), is particularly well documented in this respect. In pursuit of the large volume of goods that had been looted from his premises, he traveled to Maastricht and Paris.[15] Although he and some of his colleagues succeeded in reclaiming a portion of their property, others were totally ruined.

Further impoverishment and misery were inflicted on many of the traditional Netherlandish weaving centers over the next five years. William of Orange enjoyed temporary success against the Catholic forces in the southern Netherlands during 1577 and 1578, but his advances were reversed during the late 1570s and early 1580s by the military campaign of the new Spanish regent, Alessandro Farnese, duke of Parma (r. 1578–92). Brussels, Tournai, Bruges, and Ghent were all reoccupied by the Spanish forces. Oudenaarde fell in 1582 after a three-month siege, while Antwerp, which fought off the French forces of the duke of Anjou in 1583, was taken by the Spanish in August 1585 after a

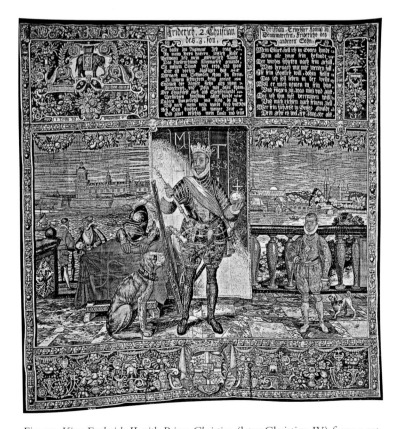

Fig. 23. *King Frederick II with Prince Christian* (later Christian IV) from a set of the *Genealogy of the Danish Kings*. Tapestry design by Hans Knieper, woven in the workshop of Hans Knieper, Helsingør, ca. 1581–85. Wool and silk, 394 x 367 cm. Kronborg Castle, Helsingør

long and bitter blockade that brought the population close to starvation. According to Parma's peace terms, Protestant citizens were given four years in which to leave the city, a further blow to both the weavers and the merchants on whom the success of the Antwerp tapestry trade had depended.

The Continuing Diaspora of Flemish Weavers

The cumulative effect on the tapestry industry of these relentless events was profound. The steady migration of merchants and weavers turned into a flood during the 1570s and 1580s. Some émigré weavers followed their compatriots to Protestant cities in Germany.[16] For example, the leading Brussels weaver-entrepreneur, Joost van Artsdael I (fl. 1559–89), also known as Van Herzeele, moved his workshop first to Antwerp in 1580 and then about 1586 to Hamburg. There his son Joost II (fl. 1589–1621) continued the enterprise well into the second decade of the seventeenth century, producing sets featuring classical heroes such as the *Story of Octavian* and the *Story of Scipio* for local patrons like Graf Ernst von Schaumburg (examples survive at the Kunsthistorisches Museum, Vienna).[17] Others went to London, where they assimilated with the existing "Dutch" community. An official register of alien residents in London made in 1593 records the names of more than fifty Flemish weavers. Recent research suggests that at least a portion of the tapestries generically known as Sheldon, after William Sheldon, may actually have been made in London by émigré weavers at this time.[18]

Much of what these émigré workshops produced was, of necessity, of fairly low quality and small dimension, reflecting the difficulty of obtaining new designs and good-quality materials and ensuring sufficient numbers of skilled weavers to make large sets. But where there was sufficient money, a high level of quality might still be achieved. For example, some of the most interesting tapestries woven by émigré Flemish workers during the 1560s and 1570s were made in rival workshops established in Sweden and Denmark. As early as 1553, Erik IV of Sweden had established a court workshop under the direction of Nils Eskilson (fl. 1550–69), a Swedish weaver who had trained in the Low Countries, and a Fleming called Paul de Bucher (d. 1565). Staffed with Flemish weavers, the workshop's most important product was a set of the *Genealogy of the Swedish Kings* after designs by the Antwerp artist Domenicus Verwilt (fl. 1544–66).[19] This work came to an untimely end in 1565 when de Bucher and several of his fellow weavers died of the plague. Of the five panels completed for this set, only two fragments survive (Royal Palace, Stockholm). Composed in a style that

Fig. 24. *The Story of Cephalus and Procris* from a set of the *Story of Diana*. Tapestry design by Karel van Mander I, ca. 1590–92, woven in the workshop of François Spiering, Delft, ca. 1595. Wool and silk, 350 x 535 cm. Rijksmuseum, Amsterdam (BK-1954-69-B)

reflects the influence of Michiel Coxcie, both weaving and materials are of high quality.

A decade later, in 1577, the Swedish example spurred the Danish king Frederick II, to establish a workshop at Kronborg Castle in Helsingør, under the direction of the Antwerp artist Hans Knieper (fl. 1577–87).[20] The first sets made by the Helsingør workshop, which employed about twenty-five Flemish weavers, featured Old Testament subjects, but in 1581 Frederick commissioned a large set of the *Genealogy of the Danish Kings* for the great ballroom at Kronborg. The set eventually totaled forty pieces, delivered in the space of about five years, of which fourteen survive today (fig. 23). The decorations were completed by an elaborate throne canopy (cat. no. 1), lavishly woven with silver and gold thread. The quality of weaving and materials in the canopy recall those of the finest Brussels examples, demonstrating that with sufficient funding and good-quality materials, the traditional skills of the Flemish weavers could still achieve the highest results.

The Helsingør workshop, like so many émigré enterprises of this period, was short-lived and seems to have closed around the time of Frederick II's death. Maintaining a tapestry workshop was expensive, and few patrons were able or willing to sustain the high costs over time. Similarly, few merchant tapissiers now had the resources to establish long-lasting commercial enterprises without substantial external help. In this respect, some of the workshops set up in the northern provinces, such as Middelburg, Gouda, and Delft, fared better because of the subsidies they received from the town authorities who, recognizing that tapestry workshops would boost the local economy, encouraged Flemish weavers to resettle in their precincts with offers of funding and work spaces in property seized from convents.[21]

The Spiering Manufactory in Delft
The most remarkable of these new workshops was established in Delft by the Antwerp entrepreneur François Spiering. A

Mennonite, Spiering seems to have relocated to Delft sometime before 1582, but he may then have lived for a time in Cologne. However, he was back in Delft by 1591, when he received a commission from the States-General for an unidentified set of tapestries, and he was certainly engaged in the production of other tapestries by 1592. In December of that year he contracted with the town authorities to set up a sizable workshop in the former convent of Saint Agnes.[22] The neighboring cloister was torn down to make way for housing for the weavers. Here, he began to weave tapestries from designs by the versatile and prolific Mannerist artist Karel van Mander the Elder (1548–1606), another Mennonite. Van Mander had spent three years in Rome (1574–77) before traveling home via the Viennese court of Rudolf II, where he worked briefly with Bartholomeus Spranger (1546–1627). Following his return to the Low Countries, and after barely escaping death at the hands of marauding Walloon soldiers in his native town of Meulebeke, Van Mander settled in Haarlem. There he befriended Hendrick Goltzius (1558–1617) and Cornelisz van Haarlem (1562–1638), and together these artists—whom Van Mander himself described as an "Academy"—propagated Spranger's Mannerist style in their paintings and designs.

Spiering's workshop immediately benefited from purchases and commissions by leading figures at the English court and the States-General. As early as 1593, Sir Walter Raleigh acquired from Spiering a twelve-piece set of the *Story of Diana*, woven from Van Mander designs. A partial set of the *Diana* design, possibly from the English royal collection, survives today at Knole House, while other panels are at the Rijksmuseum, Amsterdam (fig. 24).[23] Also at Knole is a scene of the *Story of Amadis of Gaule*, a series that was also conceived by Van Mander in the early 1590s and was to enjoy considerable popularity (see cat. nos. 2, 3).

The most significant of the commissions that Spiering undertook for a member of the English nobility was that placed in 1592 by Lord Charles Howard of Effingham, the Lord Admiral, for a set of tapestries depicting the recent and crushing defeat in 1588 of the Spanish Armada.[24] The cartoons were painted by Hendrick Cornelisz Vroom (1566–1640) on the basis of detailed contemporary accounts and are among the earliest known seascapes by this artist, who subsequently enjoyed great success in the genre. The borders included medallions with portraits of the commanders of the English fleet, so the set must have required discussion and collaboration with many members of the English nobility. Reminiscent of the great battle tapestries woven for the Burgundian and Habsburg rulers in earlier periods, this ambitious set was delivered in 1595 at the enormous price of 1,582 pounds. According to contemporary gossip, Queen Elizabeth I was disappointed that Howard did not present the set to her in 1602, but it was eventually purchased from Howard by James I in 1612 and thus entered the royal collection. In 1651 it was hung in the House of Lords, where it

Fig. 25. *Sir Francis Drake Takes de Valdez's Galleon, and the Bear and Mary Rose Pursue the Enemy.* Engraving after a Delft tapestry from a set of the *Story of the Spanish Armada*, in John Pine's *The Tapestry Hangings of the House of Lords . . .* (London, 1739). The Metropolitan Museum of Art, New York, The Elisha Whittelsey Collection, The Elisha Whittelsey Fund, 1963 (63.608.1).

remained for the next 183 years, until it was destroyed by fire in 1834. Fortunately, the appearance of the tapestries is recorded by engravings made in 1739 (fig. 25).[25]

While the *Armada* commission was the most ambitious that the Spiering manufactory undertook, it was evidently just one of many for the English nobility. Few of the tapestries survive, because their high silk content has made them especially vulnerable to the ravages of time, but one rare example is provided by an exquisite set at Warwick Castle that is dated 1602 and depicts elaborate Mannerist gardens with fountains carved with mythological gods (cat. no. 4).

If English courtiers were keen customers of the Spiering workshop, they were not alone.[26] As early as 1591 Spiering was weaving tapestries for the States-General, and in 1594 the States of Zeeland commissioned a set from him depicting the sea battles between the Dutch and Spanish forces that had taken place between 1572 and 1576, also from designs by Vroom. In the event, Spiering only wove the first piece of the set. The rest, along with a heraldic tapestry featuring William of Orange after a design by Van Mander, were woven between 1598 and 1604 in a workshop in Middelburg established by Jan de Maeght (ca. 1530–1598) and his son Hendrick (d. 1603), formerly of Brussels (cat. no. 5).[27]

A vivid impression of the contemporary esteem for the material and artistic quality of Spiering's tapestries is provided by Arend van Buchell, a humanist and art collector from Utrecht, who visited the Spiering workshop in 1598 and recorded the event in his diary:

> The same day, we went to visit François Spiering, who is suffering from consumption, I fear to the detriment of art. He showed us all sorts of tapestries, made with excellent workmanship, worth a king's ransom, on which exotic creatures can be seen, excellently depicted with unprecedented artistry; forms and representations of animals and various figures could also be made out, so accurately woven that it was not far from excellent painting and in lively colours far bypassed anything in the art of painting. He is apt to sell a square ell for 26 guilders or more, depending on the excellence of the work. . . . This Spiering used many designs and examples by Karel van Mander, living in Haarlem, an excellent painter whose wit, he claimed, was so inventive that his designs could be borrowed from by masters of any type of art: painters, sculptors, glassmakers, embroiderers or needleworkers, architects, goldsmiths, weavers.[28]

The Character of Netherlandish Tapestry in the 1580s and 1590s
The economic and religious turmoil in the southern Netherlands during the third quarter of the sixteenth century seriously disrupted the conditions that had supported large-scale, high-quality production for so long. But for every weaver who left Brussels, Enghien, Oudenaarde, and Bruges, others remained, and if patrons from Protestant Europe were now obtaining their tapestries from new émigré workshops, those from Catholic Europe continued to use the traditional sources. Some clients from Protestant countries even found their way around the battle lines to do the same, and the duke of Parma granted a number of passports to allow merchants and clients to cross from one side to the other, such as the one he issued in 1588 to an agent of Lord Cobham to travel to Oudenaarde and Brussels from Oostende to purchase tapestries.[29]

Generally speaking, far fewer sets were custom-designed during the 1570s and 1580s than in previous decades. A rare exception is the so-called Valois set; these tapestries depict members of the Valois dynasty in the foreground and representations of the grandest French court festivals held during the 1560s in the background (fig. 26). Recent research suggests that Catherine de' Medici commissioned this set as an affirmation of the goals and ideals of the Valois court during the early 1570s, a time of extreme political upheaval.[30] The details of the festivals appear to be based on drawings made by Antoine Caron (1521–1599), presumably when the festivals took place, and it is possible that the portraits are also by Caron. The stiff foreground figures, the minute detailing of the distant scenes, and the filigree of grotesque ornament in the borders contrast with the more robust, grandiose Brussels designs of the 1550s and 1560s by Michiel Coxcie and Peter de Kempeneer (ca. 1503–1580). As such, they anticipate a tendency toward smaller figures and a profusion of stylized decorative details that became increasingly marked in tapestry design in the 1570s and 1580s.

With its complex dynastic iconography, the Valois commission was a rarity in Brussels production at this time. The vast majority of tapestries made in the southern Netherlands during the 1570s and 1580s appear to have been woven as speculative ventures. Despite the difficult circumstances, large numbers of tapestries continued to be made in the southern Netherlands. This is a simple reflection of the sheer number of people involved in the industry and the fact that they needed to stay in business in the face of circumstances, however dire. But it is also true that tapestries made in this period are of lesser quality than those of the previous era. The large, well-modeled figures and

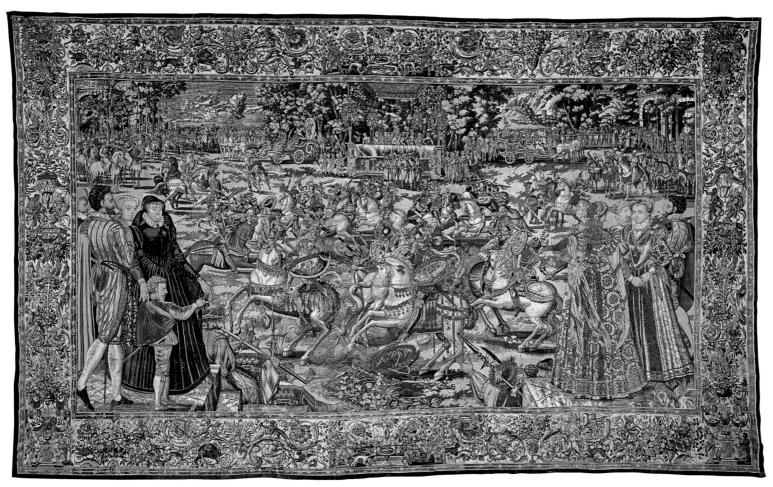

Fig. 26. *Tournament of Breton and Irish Knights at Bayonne* from a set known as the *Valois Tapestries*. Tapestry after designs by Antoine Caron, woven in Brussels, ca. 1575. Wool, silk, and gilt-metal-wrapped thread, 391 x 611 cm. Galleria degli Uffizi, Florence

beautifully delineated physiognomies of the greatest sixteenth-century Brussels tapestries became a thing of the past, because they required levels of artistic skill, technical ability, and material quality—and thus funding—that were no longer readily available.

Making a virtue of necessity, many of the tapestry cartoons created in the last two decades of the sixteenth century, both in the traditional centers of production and in the new workshops, featured small figures in elaborate but somewhat stylized gardens and landscapes. The character of such work is exemplified by a set of *Landscapes* with the arms of the Venetian Contarini family in the border (fig. 27), which have the marks of Brussels and the workshop of Joost van Herzeele.[31] (In this case, the significance of the Brussels mark is uncertain, as Van Herzeele continued to use it after he moved to Antwerp, leading to an official complaint by his peers in 1584.)[32] Conceived in terms of line, pattern, and decorative colors rather than illusionistic verisimilitude, designs like these did not require the

exacting and expensive reproduction of volumetric full-scale figures or tonal atmospheric effects that had characterized high-quality Brussels tapestries made during the second third of the century. The figures and settings are all rendered in relatively two-dimensional terms, the illusion of depth depending largely on the comparative scale of the figures and the overlapping arrangements of trees and architecture between foreground and distance. The vast majority of tapestries produced in this style were decorative landscapes with hunting or pastoral scenes, often with architectural elements copied from contemporary engravings. Yet because groups of small figures could be easily incorporated in different parts of the composition, narrative subjects, both secular and religious, were readily represented. Generally speaking, the majority of such narrative subjects depicted mythological or Old Testament subjects, which were marketable on both sides of the religious divide. New Testament subjects were less common, but at least one new *Life of Christ* series was woven in the Brussels workshop of Maarten

Reymbouts (fl. 1576–1618) during this period. Cesare Speciano, archbishop of Cremona, donated a set to his cathedral sometime after his appointment in 1591 (fig. 28).[33] The narrative components of the *Life of Christ* are arranged against a ground covered with leaf and plant motifs, recalling the two-dimensional millefleurs compositions of the fifteenth century.

Some of the finest examples of this small-figure genre were the mythological and romance subjects designed during the 1590s by Karel van Mander for the Spiering manufactory. Van Mander's designs feature elongated, graceful figures in fantastic, masquelike costumes in a world of elaborate gardens and sylvan glades. To that extent they reflect the Mannerist style that he developed under the influence of Spranger. However, these elements are transmuted by their translation into tapestry cartoons, where the moody atmospherics of Van Mander's oil paintings are replaced by evenly lit scenes in which the strong colors of the figures and landscapes in the foreground, woven in a mixture of wool and silk, segue to distant landscapes that are delineated almost entirely in subtly dyed silk yarns. Additional visual richness derives from the elaboration of the borders, the rich patterns of the costumes and horror vacui of the settings, which are crammed with flora and fauna, often of disproportionate size. The cumulative effect of these components is that the figures seem to exist in an enchanted world in which the line between represented object and symbol is blurred. Considering the volume of work that Van Mander produced, it seems probable that after establishing the overall composition and character of the figures in the modelli (cat. no. 4), he entrusted the execution of the actual cartoons to artists who specialized in this particular style, albeit following Van Mander's sketches. Certainly, the elaboration of the decorative elements, as evidenced by the extant tapestries, indicates a careful attention to surface pattern and a thoughtful response to the requirements of tapestry design and the circumstances of production that prevailed in the Low Countries at this time.[34] Documentation reflects the presence of a number of specialized tapestry cartoonists in Delft in 1613, such as Franchoys Verhulst and Hans Verlinden, and we can conjecture that it was artists like these who were translating Van Mander's designs into full-scale cartoons.[35]

Fig. 27. *A Woodland Park with Palace and Pavilions* from a set of *Landscapes*. Tapestry woven in Brussels (?), before 1589. Wool and silk, 233 x 403 cm. Victoria and Albert Museum, London (129-1869)

Fig. 28. *Jesus and His Disciples on the Banks of Lake Genazareth* from a set of the *Life of Christ*. Tapestry design by an unidentified artist, woven in the workshop of Maarten Reymbouts, Brussels, ca. 1590. Wool and silk, 288 x 242 cm. Cremona Cathedral

Where Van Mander and his collaborators had developed a decorative, narrative formula that was well suited to the depiction of mythological scenes and romances, contemporary efforts to create sets with heroic or contemporary subject mat-

ter were rare and less successful. For example, when the Antwerp magistrates decided in 1597 to commission a set of tapestries to present to Duke Albert of Austria—who had been appointed in 1595 governor of the Spanish Netherlands—the modelli were prepared by Otto van Veen, called Vaenius (1556–1629), one of the leading painters of the day, and the cartoons were painted by Jan Snellinck the Elder (ca. 1549–1638).[36] The set was completed in time to be presented to Albert and his new wife, Isabella Clara Eugenia, daughter of Philip II, on the occasion of their Joyous Entry to Antwerp in 1599 (see cat. no. 6). The set depicted Albert's victories in the civil war of the previous years, a Catholic response to the *Armada* and *Dutch Sea Battles* sets then being woven in Delft and Middelburg, and a modern counterpart to the victories celebrated in great tapestries in the Habsburg collection, such as the *Battle of Pavia* that had been presented to Charles V by the States-General in 1531, and the *Conquest of Tunis*, woven for Charles V in the late 1540s. But in contrast to these earlier sets, Vaenius's designs are awkward in conception and execution, lacking the grandeur or scale of their forebears. The figures seem crowded into the landscapes, the transition between foreground, middle ground, and distance is often confused, and there are jarring mistakes of proportion and perspective. All these factors reflect the inexperience of Vaenius and Snellinck in preparing tapestry designs and cartoons. It was perhaps for exactly this reason that during the late 1590s and early 1600s, the Brussels workshops made increasing use of simplified copies of the large-figure designs of the mid-sixteenth century, a topic that will be discussed in "New Centers of Production and the Recovery of the Netherlandish Tapestry Industry, 1600–1620."

1. For Van Orley, see T. Campbell in New York 2002, pp. 287–303.
2. Decavele 1979–83.
3. Göbel 1933–34, vol. 2, pp. 43–56, 137–38; D. Heinz 1963, pp. 295–301, 304; Bauer 2002.
4. Marnef 1996, pp. 14–22 (with bibliography).
5. Ibid., pp. 69–72.
6. Göbel 1933–34, vol. 2, pp. 8–15; E. Duverger 1995; Bauer 2002, pp. 83–84.
7. Göbel 1933–34, vol. 2, pp. 8, 11, 12; E. Duverger 1995, pp. 87–88; Bauer 2002, pp. 71–82.
8. Hefford 2002, pp. 45–46.
9. Thomson 1930, pp. 263–64.
10. Steppe 1981, p. 131; Horn 1989, pp. 130, 136; Delmarcel 1999a, p. 136.
11. T. Campbell in New York 2002, p. 201, and T. Campbell and Karafel in New York 2002, pp. 214–18, no. 24, for the Gonzaga *Acts of the Apostles;* Junquera de Vega and Herrero Carretero 1986, pp. 279–89, for the *Cyrus* set.
12. Göbel 1923, p. 327; Schneebalg-Perelman 1972, pp. 428–34; Bauer 2002, pp. 70–71.
13. Göbel 1923, pp. 469–70; Vanwelden 1999, pp. 59–66.
14. Donnet 1894.
15. Ibid., pp. 449, 454, 459–62.
16. For a full discussion of this emigration, see the essays in Delmarcel 2002b.
17. Göbel 1933–34, vol. 2, pp. 113–17; Bauer 2002, pp. 67–68.
18. Hefford 2002, pp. 43–48. Hillary Turner is currently undertaking a comprehensive review of the tapestries traditionally attributed to Sheldon.

19. Böttiger 1895–98, vol. 1, pp. 50–56, vol. 4, pp. 18–34; Woldbye 2002, pp. 104–5.
20. Woldbye 2002, pp. 91–104.
21. Hartkamp-Jonxis 2002b, pp. 16–17.
22. Van Ysselsteyn 1936, vol. 1, pp. 68–70; Van Zijl 1981, p. 203.
23. Hartkamp-Jonxis in Hartkamp-Jonxis and Smit 2004, pp. 203–15, no. 52a–c.
24. Van Ysselsteyn 1936, vol. 1, pp. 72–78, vol. 2, no. 165.
25. Pine 1739; Rogers 1988; Brassat 1992, pp. 175–76.
26. Göbel 1923, pp. 539–43; Hartkamp-Jonxis in Amsterdam 1993, pp. 316–17, 420–23 nos. 78–80 (with bibliography); Hartkamp-Jonxis in New York–London 2001, pp. 512–14, 514–19 nos. 137–39; Hartkamp-Jonxis 2002b, p. 26.
27. For the *Dutch Sea Battles* tapestries, see cat. no. 5; also Hartkamp-Jonxis in Amsterdam 1993, pp. 421–22, no. 79.
28. Van Buchell 1907, pp. 460–61; translation by Elizabeth Cleland.
29. Wauters 1878, pp. 183–84.
30. Bertrand 2006–7.
31. Wingfield Digby 1980, p. 59; Patricia Fortini Brown in London 2006, pp. 55, 353 no. 27, pl. 3.4. For examples, see Göbel 1923, fig. 152; E. Duverger 1969; and Delmarcel 1999a, pp. 172–74.
32. Delmarcel 1999a, p. 177.
33. Bandera 1987b; Cremona 1987, pp. 126–31; Van Tichelen 1987, p. 54.
34. Hartkamp-Jonxis in New York–London 2001, pp. 514–19, nos. 137–39.
35. Hartkamp-Jonxis in Amsterdam 1993, p. 317.
36. Göbel 1923, pp. 334, 423; Van Tichelen 1987.

1.
Throne Baldachin

Made up of eight separate tapestry components
Design by Hans Knieper
Woven under the directorship of Hans Knieper,
Helsingør (Denmark), 1585–86
Wool, silk, and silver and gilt-metal wrapped thread
Backcloth 275 x 353 cm (9 ft.¼ in. x 11 ft. 7 in.),
canopy 403 x 275 cm (13 ft. 2⅜ in. x 9 ft.¼ in.), inner
and outer central valances for canopy 36 x 275 cm
(1 ft. 2⅛ in. x 9 ft.¼ in.), inner and outer side valances
for canopy 36 x 403 cm (1 ft. 2⅛ in. x 13 ft. 2⅜ in.)
8 warps per cm
Date (1586) on both vertical borders of backcloth
Nationalmuseum, Stockholm (Indep 2 LRK 28861,
28862), on long-term loan from the Livrustkammaren,
Stockholm

PROVENANCE: 1581, commissioned as part of a
wider project by Frederick II, king of Denmark and
Norway; 1585–86, woven in Hans Knieper's work-
shop in Helsingør, Denmark; 1586–1658, Helsingør
Castle; 1658–59, removed by Swedish troops; Swedish
state collection.

REFERENCES: Looström 1885; Böttinger 1895–98,
vol. 2, pp. 46–48; Göbel 1933–34, vol. 2, pp. 227–30;
Krarup and Lassen 1946–47; Mackeprang and Müller-
Christensen 1950, pp. 43–48, 104–5; Lassen 1973;
Lindblom 1979, p. 109; Mellbye-Hansen and Johansen
1997, pp. 29–30, 106; Woldbye 2002, pp. 101–3;
Reindel 2006.

*S*uch is the quality of this throne bal-
dachin that, were it not for the survival
of its contract, one would think it had been
made in one of the major Flemish weaving
centers. However, substantial archival docu-
mentation reveals that it was woven not in
Brussels or Antwerp but in Helsingør, in
Denmark. The canopy is both the crowning
achievement and the swan song of the short-
lived workshop set up by Frederick II, king of
Denmark and Norway.

The Weaving Workshop at Helsingør, 1577–ca. 1588

The tapestry baldachin was initially commis-
sioned in December 1581, as part of a wider
project, with a second, more detailed contract
drawn up in July 1585.[1] The date woven into
both vertical borders of the backcloth, 1586,
means that the baldachin was probably com-
pleted only a year later. The weaving workshop
in which it was created was not small; at one
point as many as twenty journeymen were
employed. The excellence of the craftsman-
ship and the speed with which the baldachin
was apparently woven attest to a singularly
skillful, efficient, and well-run shop. Most
unusually, however, an unforeseen string of
events meant that this workshop, officially at
least, was not under the supervision of a mas-
ter weaver but instead was directed by its
primary cartoon painter.

Nine years earlier, in 1577, King Frederick
had dispatched an agent, Thomas Tenniker, to
Flanders.[2] Tenniker's mission had been to
enlist an artist to undertake painting projects
and a core group of craftsmen to run a tapes-
try weaving workshop, both to be located at
Kronborg Castle in Helsingør. Frederick had
started transforming the early fifteenth-
century fortress into a Renaissance palace
three years earlier. With the structural rebuild-
ing directed by the Flemings Antonis van
Obberghen and Hans Floris by now well
under way, it was time to concentrate on the
ornamental embellishment of the palace.[3]
Rather than importing finished objects from
the artistic centers of northern Europe, the

king opted to bring the artists themselves to
Denmark: from Nijmegen in the northern
Netherlands came the Rome-trained sculptor
Johann Gregor van der Schardt (ca. 1530–after
1581); for his painter and weavers, Frederick
looked to Brabant.[4] Tenniker returned with a
painter, Hans Knieper (fl. 1577–87), referred
to in his contract with the Danish king as
"Johannes de Antwerpia." It has tentatively
been suggested that this Knieper may have been
the same "Jean de Knibbere" who had been
banished from Brussels thirty-five years earlier
for the murder of fellow craftsman Frans de
Smet.[5] Traveling with Knieper to Denmark
was the master weaver Anthonius de Corte,
also called de Goech, later joined by eight
journeymen weavers. Royal account books
reveal that all the craftsmen were enrolled into
royal service and provided with board and
lodging.

Anthonius de Corte's contract, dating from
July 19, 1577, names him director of the
weavers; he had clearly traveled to Denmark
prepared for this role, bringing with him from
Flanders the raw materials of wool, silk, and
warp yarns, for which he was subsequently
compensated the substantial sum of 260
Danish talers. However, he apparently had little
opportunity to put these materials to use,
since he died less than eight months after his
appointment to the post, in March 1578.

As a result, Hans Knieper, who in 1577 had
signed a contract to work as Frederick II's
court artist and cartoon painter earning a
yearly stipend of one hundred Danish talers,
was officially promoted in April 1578 to the
directorship of the weaving workshop, with
an additional allowance of one hundred talers.
In practice, Knieper's connection with the
tapestry weavers must already have been
established. From the beginning, his role as
head cartoon painter had been recognized: he
had brought paints and paper for cartoons
with him from Flanders, for which he was
later reimbursed, and his initial contract had
included a bonus of three talers to be paid
to him for every square ell of tapestries com-
pleted. He had also, it seems, taken on

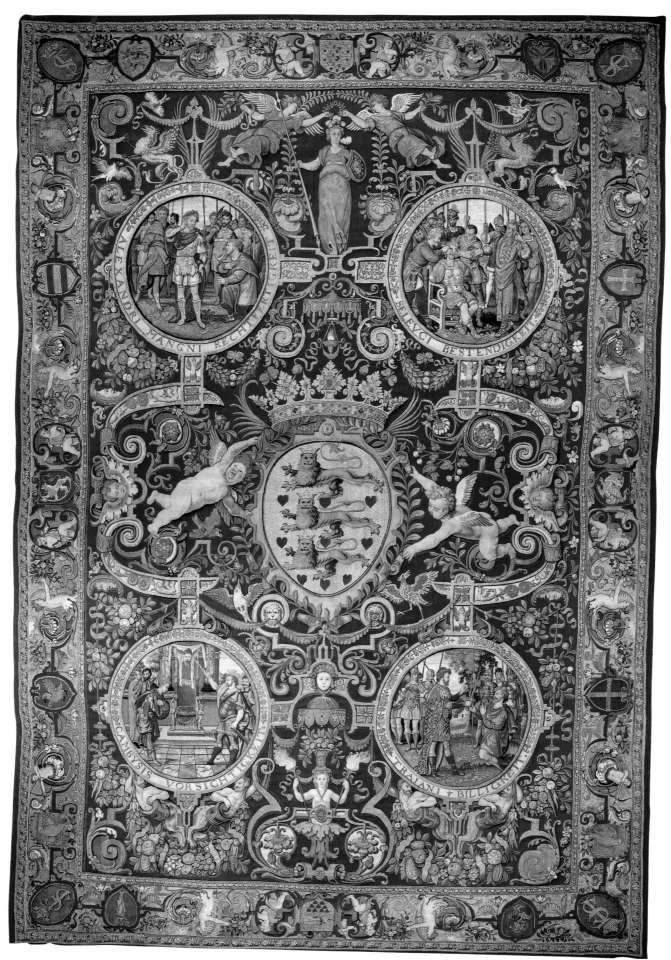

1, canopy

Detail of cat. no. 1

De Corte's duties before the official recognition of this in April, signing delivery receipts for imported weaving silks.[6]

Knieper clearly played an active role as director of the weavers, undertaking journeys to the Netherlands to supervise purchase of more silks and wools, in addition to expanding his workforce. One visit resulted in the arrival in Denmark of seven journeymen, accompanied by five women and a youth, perhaps as an apprentice; a little over a year later, a further twenty workers, including four women, children, and another youth arrived at Helsingør. Knieper also remained remarkably active as an artist beyond the confines of the tapestry workshop, painting a full-length portrait of King Frederick, the altarpiece of the chapel, three decorative room schemes including a cycle of Gideon for the king's chamber, and, beyond Kronborg, contributing the landscape sections to wall paintings in the Uranienborg observatory for the court astronomer, Tycho Brahe. In 1580 Knieper added to his duties, and his salary, by taking on the role of custodian of the royal textile collection.[7]

There is certainly no reason to suppose that Knieper had any weaving skills himself, and in all probability, at least one of the weavers he brought from Flanders would have

Detail of cat. no. 1

assumed the unofficial role of master weaver within the workshop. One weaver, Franz Paulli, although paid a relatively high wage for his role as *Tapetmager* (Tapestry Maker), had left the Kronborg workshop by December 1585, so he could have played at the most only a partial role in the creation of the baldachin.[8] Significantly, though, he cannot have traveled far, since "Frantz Paulier" was among the eight weavers who in 1586 received a special bonus in acknowledgment of their services to King Frederick.[9] Another of those named in this group is Jacob de Korte, who may have been a relative of Kronborg's first master weaver, Anthonius de Corte. Göbel has sug-

gested that the weaver Christof Keluneicz from Oudenaarde might also have worked at Kronborg, since the Oudenaarde records note that he immigrated to Denmark in 1585 and, after six years there, moved to Frankenthal.[10]

The weaving workshop at Kronborg created a significant number of tapestries for King Frederick during the nine years of Knieper's directorship. A twelve-piece *Story of David* set and a single tapestry of the *Chaste Susanna* were delivered in mid-May 1579, with a further five tapestries completing the *Susanna* series and a single *Daniel* finished at the end of August of the same year, and a second *Daniel* tapestry delivered at the end of

December 1579. The apparent hiatus in activity between these *Old Testament* tapestries and the *Genealogy of the Danish Kings* commissioned in December 1581 has prompted speculation that the workshop may have been closed in these intervening years.[11] However, a note in the 1581 contract for the *Genealogy* and the baldachin specifically stresses that, to expedite completion of the series, the weaving workshop must not undertake work for any other clients. Compensation for this exclusivity was included in the price Frederick named in the contract. It seems reasonable to suggest, therefore, that the weaving workshop in Helsingør remained active between 1579

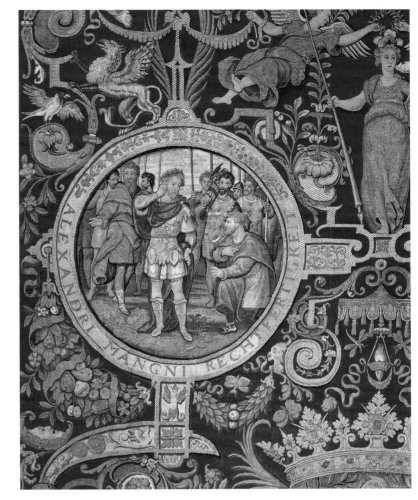

Details of cat. no. 1

and 1581, working on nonroyal commissions. Certainly the exquisite standard of workmanship of the baldachin suggests an established and well-honed team of weavers. There is no indication if all the Flemings whom Frederick II employed beginning in 1577 remained in Denmark or, instead, traveled back and forth between Scandinavia and the Netherlands. The presence of their wives and children suggests an element of settling down; certainly, Knieper himself met and married a Danish woman, Marine Johansen, who was a very wealthy widow when he died in November 1587.[12]

Although three months into his reign in 1588 King Christian IV contracted Heribrecht Leymeyers, possibly of the Brussels Leyniers weaving family, to become the new director of the Helsingør workshop, he lacked his father's enthusiasm for locally woven tapestries. Within a decade, Christian commissioned major tapestry series from the likes of the

Delft-based François Spiering and the Antwerp agent Adam Baseler.[13]

The Baldachin and Ceremonial Hall of Kronborg Castle

After the successful delivery of the twenty *Old Testament* tapestries, Frederick II's next task for the tapestry workshop was the weaving of the *Genealogy of the Danish Kings,* an ambitious series featuring lifesize, fulllength portraits of 111 Danish monarchs, beginning with King Knud and culminating in a double portrait of Frederick II and his heir, Christian (fig. 23). Even with some hangings, by necessity, incorporating groups of kings, the complete series nevertheless included forty tapestries (fourteen of which survive), together with three hunting scenes.[14] Designed specifically for the proportions of the Great Hall, the tapestries covered all available wall space, even the sloping walls on either side of the twenty-three window

bays.[15] The throne baldachin culminated the dynastic cycle. This was an inspirational moment of proto-Baroque theater on the part of Frederick and his advisers: in a room encircled by more than one hundred previous rulers represented in tapestry, the centerpiece would be the actual ruler himself, living, breathing, and framed against a tapestry surround.

Frederick II's baldachin was intended to hang above the royal table at which he and his wife, Queen Sophie, would sit. The use of textile baldachins as royal awnings already had a long and established history by this date.[16] Tapestry examples could be splendid, incorporating extensive figurative details with sumptuous colors and glittering metalwrapped threads. It is quite plausible that Knieper and his Netherlandish weavers would have been aware of the particularly impressive baldachin that had been woven in Brussels for Charles III, duke of Lorraine, twenty-five

years earlier.[17] The cartoons for that work were created by Knieper's contemporary and fellow Antwerp artist Hans Vredeman de Vries (1527–ca. 1606); his name is even proudly included in a small cartouche in Greek letters, ϕΡΕΕΔΜΑΝ ϕΡΙΕΣΕ. Michiel Coxcie (1499–1592) is believed to have contributed the figures in the central design. Both baldachins are of comparable construction, with eight separate tapestry components forming a backcloth or dossal, canopy, and double-sided valances or lambrequins. The Brussels-made baldachin and the Helsingør example are the same width. The older baldachin is the taller of the two, but its canopy is considerably shallower. Frederick II's canopy, in contrast, stretches out so far that it is actually longer than the backcloth is tall. Although Charles of Lorraine's baldachin is exquisitely well made, Frederick II's is almost as finely woven, with a comparably tight warp count.

The sumptuousness of the Helsingør-woven baldachin could rival that of any contemporary piece. The weaving contains so much gilt- and silver-metal-wrapped thread that it shimmers; the effect during candlelit court festivities and banquets in the ceremonial hall must have been breathtaking. This was certainly Frederick II's aim. Although the need for a baldachin had already been noted in the original 1581 contract for the *Genealogy*, its weaving was left until last. Perhaps in response to the now-delivered *Genealogy* tapestries, the king had a second, more detailed contract dealing specifically with the baldachin drawn up. This second contract is concerned, above all, with the richness of the baldachin. Frederick specifies that it should be woven with "gold, silver and good silk," later reiterating that "what is yellow in the designs be [woven] in gold; what is white, in silver; what is red, in red silk."[18] As far as possible, the rest should be woven in silk and those areas that were not in silk should be in the finest Flemish wool. It would be Knieper's responsibility to supply all these raw materials, but he would be handsomely rewarded: whereas Frederick had paid nine thousand talers for the forty-three *Genealogy* and *Hunting* tapestries, he provided two thousand talers (the equivalent of twenty years' worth of Knieper's salary) for the baldachin alone.

Iconography of the Throne Baldachin

Neither of the contracts makes any reference to what should be depicted on the baldachin. Unlike the *Genealogy* series, which had quite specific directions, Knieper was left a free hand with the designs of the backcloth, canopy, and valances, although he was required to show his plans to the king for approval before weaving. Knieper harmonized the baldachin with the existing tapestries surrounding it by repeating the 1:2:1 three horizontal-banded composition that distinguished all forty of the *Genealogy* tapestries. The entablature three-quarters of the way up the baldachin's backcloth is level with the frames of the text blocks above each of the kings' tapestry portraits. However, where the dominant palette of the *Genealogy* series is green and blue, the baldachin's red and gold serve not only to distinguish it from the rest but also observe the heraldic colors of the Oldenburg dynasty.

In the center, the allegorical figure of Justice, sword and scales in hand, is flanked by the coats of arms of Frederick II and of his wife, Sophie of Mecklenburg-Schwerin. Knieper has wittily represented a canopy within this canopy, above Justice's head, its valance decorated with the device of an elephant repeated four times, alluding to Frederick II's chivalric Order of the Elephant. To the left of the royal armorials stands Temperance; to the right, Fortitude. The entablature above Justice is inscribed in gold lettering with Frederick II's motto MEIN HOFFNUNG ZU GOTT ALLEIN (My hope toward God alone); his second motto, TREU IST WILD-PRET (Loyalty is a precious thing), appears above Temperance, while Queen Sophie's motto, GOTT VERLÄSST DIE SEINE NICHT (God does not forsake his own) is inscribed above Fortitude. Decorative grotesques above the entablature surround a golden Pegasus and his mirror image, six putti, and fruit swags; beneath them, the lowest quarter of the backcloth is dedicated to the glory of the waterbound Danish realm. Two river gods face each other; between them are the bounties of the sea, with a triumvirate of ewers representing Denmark's three main sea channels: the Sound (Øresund), the Great Belt (Storebælt), and the Small Belt (Lillebælt).[19]

The dominant themes spill into the borders, with a further allusion to the king and queen in the crowned FS monogram at the corners (although this has also been interpreted as Fredericus Secundus rather than Frederick and Sophie).[20] At the center of the vertical borders, two further Virtues are identified as Mercy and Prudence; the centers of the horizontal borders repeat the emblems of the Order of the Elephant.

When the baldachin was in use, with King Frederick and Queen Sophie seated beneath it, their subjects facing them would enjoy the full effect of the crowned armorials above their monarchs' heads, with Virtues flanking them almost as handmaidens, and, above them, the musical fanfare of the putti's minstrels' gallery. King Frederick and Queen Sophie, seated beneath the baldachin, would be in the best position to enjoy the canopy's iconographic message. The canopy would probably originally have been positioned with its top, or head, end directly above the monarchs so that, should they look up, the figurative designs would be oriented toward them rather than toward their subjects facing the baldachin.[21]

The unusual length of the canopy provides freedom to develop distinctive subject matter. Whereas Charles of Lorraine's canopy is decorated with a trompe l'oeil dome, Knieper had the room to create a comparable illusion of soaring heights, with flying putti, seen from below, struggling to support the crowned arms of Denmark, but also space around them for a full array of grotesques and four figurative medallions. At the head of the canopy stands Pallas Athena, crowned with laurels by two angels. Below her, the medallions display detailed scenes representing historical examples of good governance.

The splendid golden borders of each medallion include an inscription identifying the scene's protagonist and moral: ALEXANDRI MANGNI RECHFERTIGKEIT (Alexander the Great Justice); SELEUCI BESTENDIGKEIT (Seleucus [sic] Resolution); TRAIANI BILLIGKEIT (Trajan Fairness), and CAMBYSIS VORSICHTIGKEIT (Cambyses Prudence). Alexander the Great, in the top left medallion, stands with his hand covering one ear while a figure kneels before him. This illustrates an episode in which Alexander heard both sides of an argument without bias, literally offering one ear to each plaintiff, before reaching judgment. In the

medallion to the right, the inscription refers not to Seleucus, the Macedonian king, but rather to Zaleucus, a seventh-century B.C. lawmaker in Locri.[22] According to Valerius Maximus, Zaleucus made blindness the penalty for adultery: when it was discovered that Zaleucus's son was guilty of the crime, rather than retract the law, Zaleucus decided that the fine should be paid with only one of his son's eyes, and that he himself would sacrifice one of his. The medallion depicts a bearded man pointing to a bloody eye socket and gesturing to a seated youth, over whom two men lean in the process of extracting his right eye. In the lower right medallion, the Roman emperor Trajan is represented, sword raised to execute a soldier who, according to legend, had accidentally killed a child. Although en route to war, Trajan heeded the mother's pleas to punish the perpetrator then and there rather than postpone justice. In the fourth medallion, the Persian emperor Cambyses points toward a throne with, as canopy, the flayed skin of a man. This alludes to the story of the judge Sisamnes, who committed perjury and whom, as punishment, Cambyses ordered flayed alive. As a reminder of the dangers of duplicity, his skin was suspended over the judicial throne on which his successor, his son Otanes, would sit.

It is likely that Knieper's source for most of these exempla was a popular printed text, the *Regentenbuch* (Sovereigns' book), written by the sixteenth-century chancellor Georg Lauterbeck.[23] The text would certainly have been known to Frederick II since its third edition, of 1572, included the official account of the coronation of Frederick's parents, King Christian III and Queen Dorothea.[24] Even without the *Regentenbuch*, Knieper would probably have been familiar with the legends and their iconography. Versions of the Zaleucus, Cambyses, and Trajan exempla were already listed under "Iudices" in an alphabetical iconographic source book called the *Tabula Exemplorum* (ca. 1275) and were included in the popular fifteenth-century Middle Dutch printed book *Das Scaecspel*. Formally comparable miniature scenes of both the Zaleucus

and Cambyses legends were also widely published in Hans Sebald Beham's printed frontispiece to *Der gerichlich Prozess*.[25] Knieper would also, doubtless, have heard about, if not seen, the versions of these legends in particularly well-known and admired civic painted decorative projects, from Rogier van der Weyden's *Judgment of Trajan* in Brussels (probably completed by 1441), to Gerard David's *Judgment of Cambyses* for the aldermen's chamber of Bruges (1498), and Hans Holbein the Younger's wall paintings in the town hall in Basel, which included the *Judgment of Zaleucus* (1521–22).[26]

The weavers succeeded in representing these designs with incredible skill, from the background landscape of the Trajan episode to the veined marble floor beneath Cambyses' feet. In all, suits of armor glitter with gilt-metal-wrapped thread, which also abounds in the surrounding grotesques and shimmers in the golden grounds of the canopy's borders and valances.

The grotesques that decorate the whole of the baldachin correspond with those made popular by such artists as Hans Vredeman de Vries and Frans Floris—so much so that it has been suggested that Knieper brought models of their designs with him from Antwerp.[27] The intriguing suggestion that Frans Floris's son may have been employed at Kronborg as an architect and sculptor suggests an alternative source that may have been available to Knieper.[28]

The iconographic program of Frederick II's baldachin succeeded in combining its principal armorial function with an allegorical message of just governance and antique precedent. Its rich decoration of grotesques and elegantly elongated figures match the cutting-edge designs of both Flanders and Fontainebleau. In its scale, exquisite workmanship, and splendid red-and-gold color scheme, it succeeded in fulfilling all Frederick II's expectations. The baldachin represents the best of the work of immigrant Flemish weavers and amply illustrates the success of Frederick's scheme to set up a local Danish workshop.

ELIZABETH CLELAND

1. First published in *Nye danske Magazin* 2 (1806), pp. 99–100, reprinted (with omissions) in Göbel 1933–34, vol. 2, p. 315, nn. 8, 9. See also Mackeprang and Müller-Christensen 1950, pp. 79–80.
2. Göbel 1933–34, vol. 2, p. 226.
3. See Honnens de Lichtenberg 1984.
4. See Honnens de Lichtenberg 1981.
5. See Mackeprang and Müller-Christensen 1950, p. 96, n. 1, citing Wauters 1878, p. 453.
6. Göbel 1933–34, vol. 2, p. 226.
7. Woldbye 2002, p. 94.
8. Göbel 1933–34, vol. 2, p. 228.
9. Mackeprang and Müller-Christensen 1950, pp. 8, 104; Woldbye 2002, p. 94.
10. Göbel 1933–34, vol. 2, p. 227, citing Göbel 1923, vol. 1, p. 608, n. 11.
11. Woldbye 2002, p. 94.
12. Göbel 1933–34, vol. 2, p. 228.
13. Ibid., pp. 230–37.
14. Known from royal inventory of 1718 (see Mackeprang and Müller-Christensen 1950, pp. 80–81). Fourteen of the *Genealogy* and one of the *Hunt* scenes remain in the Nationalmuseet in Copenhagen.
15. The ceremonial hall was greatly damaged by fire in 1629 and subsequently rebuilt. Reconstructions are suggested by Mackeprang and Müller-Christensen 1950, p. 7, and Langberg 1985, p. 40.
16. See Mellbye-Hansen and Johansen 1997.
17. See T. Campbell and Bauer in New York 2002, pp. 452–57, no. 54.
18. "[S]oll von Goldt, Silber und gutter Seiden sein . . . wie obgedacht entworffen . . . gelb ist, von Gold, was weize, von Silber, was Rothe, von rother Seiden"; see Mackeprang and Müller-Christensen 1950, pp. 79–80.
19. Ibid., p. 44.
20. "Fredericus Secundus" is proposed by Krarup and Lassen 1946–47, p. 111.
21. This arrangement, which is the opposite of the current orientation of the canopy on display in the National Museum Stockholm, was also recently suggested by Katia Johansen (written communication, 2006).
22. Krarup and Lassen (1946–47, p. 112) mistakenly identify the protagonist as Seleucus of Babylon; Reindel (2006, pp. 21–23) discusses the potential source for a Seleucus rather than Zaleucus exemplum.
23. First suggested by Mackeprang and Müller-Christensen 1950, p. 44. For the *Regentenbuch*, see Philipp 1996.
24. See Arenfeldt 2005.
25. See Van der Velden 1995a.
26. For Brussels, see Cetto 1966 and Cleland 2007. For Bruges, see Van der Velden 1995b.
27. Mackeprang and Müller-Christensen 1950, p. 49; Woldbye 2002, p. 104.
28. Honnens de Lichtenberg 1981.

2.
The Liberation of Oriane

From a six- or seven-piece set of the *Story of Amadis of Gaule*
Design attributed to Karel van Mander the Elder, ca. 1590–95
Woven by François Spiering, Delft, ca. 1590–95
Wool and silk
348 x 396 cm (11 ft. 5 in. x 13 ft.)
8.25 warps per cm
Brussels mark at left end of bottom selvage, weaver's mark at bottom of right selvage
The Metropolitan Museum of Art, New York, Walter and Leonore Annenberg and The Annenberg Foundation Fund, 2006 (2006.36)

PROVENANCE: Ca. 1852, collection of Robert Windsor Clive (1824–1856), St. Fagans, Glamorgan; collection of the Windsor Clive family, Earls of Plymouth, St. Fagans, Glamorgan, December 13, 1991, sold, Sotheby's, London, no. 7; 1992, S. Franses, London; 2006, purchased by The Metropolitan Museum of Art.

REFERENCES: Sale cat., Sotheby's, London, December, 13, 1991, no. 7; Desprechins de Gaesebeke 1996a, p. 254; Desprechins de Gaesebeke 1996b, pp. 82, 84–87; Hartkamp-Jonxis in New York–London 2001, pp. 516–19, no. 138; Hartkamp-Jonxis 2002b, pp. 35–36; Hartkamp-Jonxis in Hartkamp-Jonxis and Smit 2004, p. 181; Forti Grazzini 2005, pp. 26, 28; T. Campbell 2006.

CONDITION: Good. Overall fading and spot repairs.

3.
Oriane Passing the Magical Love Tests in the Magician's Enchanted Garden

Modello for the tapestry in the *Story of Amadis of Gaule*
Attributed to Karel van Mander the Elder, ca. 1590–95
Brown ink and brown wash over pencil on paper
27.2 x 49.6 cm (10¾ in. x 19½ in.)
The State Hermitage Museum, Saint Petersburg (15092)

PROVENANCE: Collection of Ivan I. Betskoy, Saint Petersburg; 1767, Academy of Fine Arts, Saint Petersburg; 1924, acquired by the Hermitage.

REFERENCES: Gerszi 1985; Hans Buijs in Amsterdam 1993, pp. 370–71, no. 29; Desprechins de

Gaesebeke 1996a, p. 253; Desprechins de Gaesebeke 1996b, p. 82; Alexei Larionov in New York 1998, pp. 90–91, no. 44; Plomp in New York–London 2001, pp. 476–77, no. 118; Forti Grazzini 2005, pp. 23–31.

The group of tapestries illustrating the knight-errant tale of Amadis of Gaule testifies to the inventiveness of François Spiering's newly established weaving workshop in Delft. Despite his relatively insecure position, having recently arrived from the physical and pecuniary dangers of Antwerp and now at the helm of a fresh workshop in a center that had not much of a tradition in weaving, Spiering chose to weave a narrative that had apparently never before been depicted in tapestry, and so had no exempla to fall back on. Yet this was not a misguided gamble. With Karel van Mander the Elder providing the designs, Spiering was assured of thoughtful and decorative solutions. The collaboration seems to have been successful. Soon after, Spiering commanded the attention of the most notable patrons of the period and became one of the most sought-after Flemish weavers working in the northern Netherlands.

Description and Iconography
Although obscure now, the story of Amadis of Gaule enjoyed great popularity during the sixteenth century. Based on a medieval Iberian chivalric legend, which had been spread by the vocal, troubadour tradition, the earliest-known published version appeared in 1508 in Castilian, under the authorship of Garci Rodriguez de Montalvo.[1] By 1540 Nicolas d'Herberay des Essarts had published a French translation; in 1546, a version in Flemish was available. Italian, English, and German adaptations followed. In the space of eighty-six years, the initial four books, or sets of chapters, had been expanded and embellished to twenty-one books. The core story follows the fortunes of Amadis, the illegitimate child of King Périon of Gaul and Princess Élisène, who falls in love with Princess Oriane, the daughter of King Lisuart

of England and his Danish queen, Brisène. Initially believing himself to be a simple page and unaware of his noble birth, the lovelorn Amadis leaves Oriane's service for a life as a knight errant, searching for feats to test his courage and clues to reveal his parentage.

The tapestry the *Liberation of Oriane* illustrates an episode from the first book, during which Oriane had been abducted by the evil wizard Arcalaus. In the foreground, Amadis declares his love for Oriane, whom he has just freed from the clutches of Arcalaus. To the left stands Oriane's handmaiden, steadying Amadis's horse; to the right Amadis's companion in arms, Gandalin, watches the reunion. In the background, the events leading up to Oriane's liberation are recounted: at the top left, Amadis and Gandalin, pursuing the abductors, discover the body of a knight slain by the villains. While Gandalin stays to bury the unfortunate victim, Amadis claims his steed and carries on the pursuit. In the central plane of the tapestry, he reappears, sword raised, charging toward Arcalaus and his henchmen, in the feat of bravery that will end with the abductors dead and Oriane liberated. The border is decorated with playful putti and mermaids supporting swags of fruit. At the lower left corner, Paris and Helen of Troy are identified, as is their pendant at the right, another famous mythological pair of lovers, Mercury and Herse.

The drawing *Oriane Passing the Magical Love Tests in the Magician's Enchanted Garden* illustrates a considerably later episode in the story, from the fourth book. Amadis's true parentage by now long known, the two lovers have taken refuge from Oriane's hostile father on the Isle Ferme. On the island, Amadis, Oriane, and their friends find themselves in the domain that had once belonged to the magician Apolidon and his beautiful lover, Grimanèse. Apolidon's garden and palace remain enchanted. Only the love of the noblest knight and fairest lady will be able to pass a series of magical tests to break the spell. In the foreground of the drawing, Amadis leads a procession of courtly figures from left

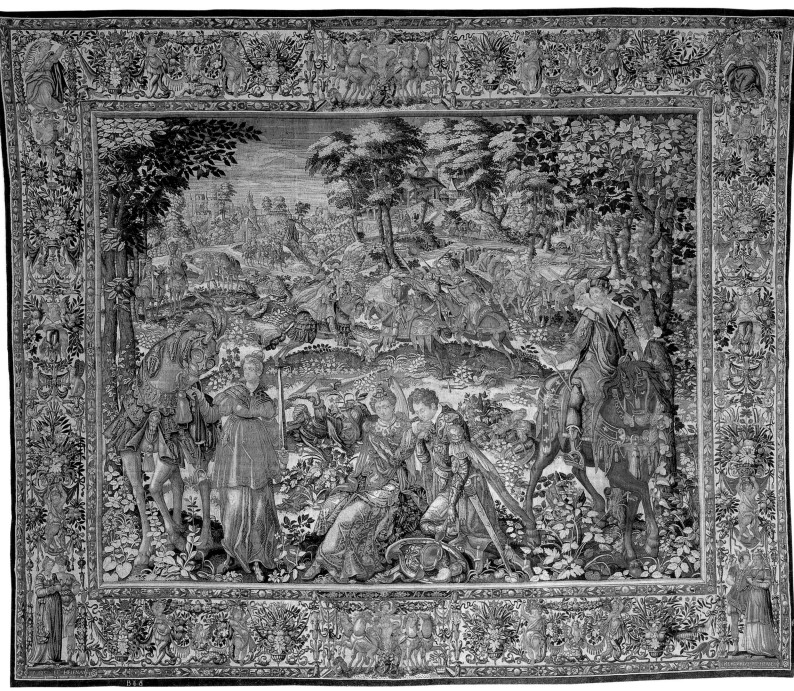

to right gesturing toward Oriane, who glances behind her just as she is about to pass under a magical archway; when true lovers pass beneath it, a sweet melody will sound and petals will fall from the cornucopia held by the statue above. The petals have already appeared at Oriane's approach. Successive elements of the narrative have been sketchily alluded to in the background. The figure raising an arm toward a fountain in the center of the garden, for example, is Oriane, whose beauty and true love are again recognized when the fountain statue of Venus comes to life and hands her the apple from Paris. To the left, a woman extends her arm toward the doorway of a palace. In this final episode of Apolidon's tests, Oriane succeeds in opening the enchanted entrance to his home. Other young couples in their party have likewise tried the tests, but each is revealed to be wanting in the sincerity of their love or the depth of their beauty. The powerful spells repel women from the doorway to Apolidon's palace with such force that they collapse. In the left foreground, one is helped to her feet.

Two tapestries are known that repeat the composition, in reverse, of the drawing: one is in Knole House; the other in the Art Museum of Princeton University (fig. 29).[2] The foreground figures of the *Liberation of Oriane* are replicated in a curtailed version now in the Museo Poldi Pezzoli in Milan.[3] A pendant tapestry in Milan illustrates a further episode from the story; it has been identified as *Amadis Bidding Farewell to Oriane*, as he departs once more on his quest. The *Presentation of the Enchanted Lance*, when Amadis and his companion Gandalin meet a sorceress named Urgande, is represented in a tapestry in a private collection in London.[4] In a further tapestry (private collection, Rome) Amadis duels with the Knights of Léonorette.[5] Two additional, unpublished *Amadis of Gaule* tapestries were reputedly in a collection in Epinay: *Amadis Dueling with King Abies of Ireland* and *Oriane with the Magic Jewels of Macadon*.[6]

In the intervening centuries, the story of Amadis of Gaule has become increasingly obscure. Already by 1705 the clerk drawing up the inventory of Knole was unable to identify the subject matter of the *Amadis* tapestry hanging there, describing it simply as "A garden scene."[7] Since then, tentative identi-

fications of the various *Amadis* tapestries have ranged from scenes from Lodovico Ariosto's *Orlando furioso*, to Torquato Tasso's *Gerusalemme liberata*, to the legend of the goddess Diana.[8] It was only in the mid-1990s that the Belgian scholar Anne Desprechins de Gaesebeke recognized the subjects as the adventures of Amadis of Gaule.[9] Spiering's late sixteenth-century audience would have been much more familiar with the narrative. In addition to the numerous printed translations and sequels, episodes were reenacted at the marriage of Philip II of Spain and Elizabeth of Valois in 1559, while the Dutch stadtholder William the Silent suggested that it would make better reading for his seventeen-year-old wife than the Scriptures.[10] Other than Spiering's tapestries, however, no woven or large-scale painted depictions of the story are known until the late seventeenth century.

Designer

Illustrating the final episode of the story, the designer of catalogue number 3 has succeeded in including all the major scenes, from the petaled archway to the living statues, fountains, and enchanted doorway, while simultaneously alluding to Oriane as the only lady to radiantly triumph. Yet the composition remains spacious and uncluttered. The same courtly elegance that distinguishes the written text permeates the scene. The sharp chiaroscuro of the sun-dappled foreground figures and the light-filled garden capture the air of benign enchantment of Apolidon's domain with a few well-placed lines. A sense of the splendidly rich costumes is provided with a few diagonal lines on Oriane's skirt and, above all, by the elegant and mannered silhouettes. Despite its air of spontaneity, the composition is tightly held together by the rhythm of the foreground frieze of figures and the wide arc of the parterre behind. Within the arrangement, the eye is drawn to particular groups, from the minuetlike pairing of Oriane and Amadis at the musical archway on the right to the group clustered around one of the hapless ladies ejected from Apolidon's doorway.

The drawing has been attributed on stylistic grounds to Karel van Mander the Elder.[11] Further evidence is provided by the inclusion of his KVM monogram atop the left-hand

column in one of the woven versions.[12] Indeed, the posthumous biography of Van Mander that was added to the second edition of his *Schilder-boek* (1618) refers to "drawings from his hand...for the excellent tapestry-weaver, Spierincx of Delft, designs for the tapestries of entire rooms."[13] As mentioned above, when the Dutch humanist Arend van Buchell visited Spiering's workshop in 1598, the "designs and examples by Karel van Mander" particularly drew his attention.[14] According to Spiering's comments to Van Buchell, Van Mander designed for many types of craftsmen in a variety of media, from sculptors to glassmakers and goldsmiths.

Catalogue number 3 is a preparatory drawing for the full-scale, colored cartoon that was subsequently copied at least twice (Princeton, fig. 29; and Knole). Although the two tapestries are not identical—one striking difference is the omission of Van Mander's monogram in the tapestry at Knole—they nevertheless seem to have been woven after the same cartoon. Catalogue number 3 could have been either a preparatory sketch, in which Van Mander was still developing his ideas of how the finished cartoon should appear, or the actual design, or modello, that was used by the cartoon painter.

The primary difference between the drawing and the two tapestries is the reverse orientation of the final composition. This was probably caused by weaving on a horizontal, or low-warp, loom, for which the weavers worked facing what would become the reverse of the finished tapestry. Since they were copying the cartoon in front of them, positioned so as to be visible beneath the warp threads, once the tapestry was finished, taken off the loom, and turned to display the front, the front would be the mirror image of the cartoon. Both tapestries are far more detailed than the drawing: clothing, foliage, architectural decorations, and background landscape have been embellished, sometimes almost beyond recognition. Traditionally, these are just the areas that would be developed in the large cartoon stage and left relatively sparse in the modello. The marks placed regularly along the edges of the drawing might have been intended as a guide for an overlying grid, which could have been used for copying the design, enlarged section by section, and

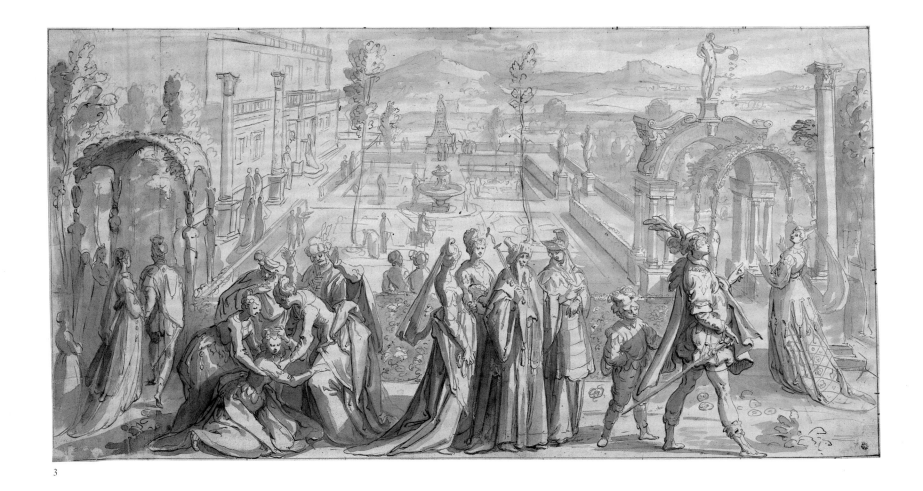

3

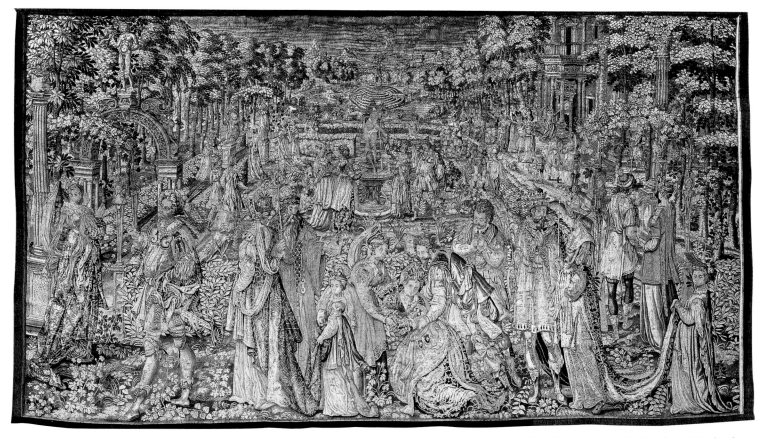

Fig. 29. *Oriane Passing the Magical Love Tests in the Magician's Enchanted Garden* from a set of the *Story of Amadis of Gaule*. Tapestry design by Karel van Mander the Elder, woven by François Spiering, Delft, ca. 1590–1600. Wool and silk, 249 x 432 cm. The Art Museum, Princeton University, Gift of Hugh Trumbull Adams, Class of 1935 (Y1954-76)

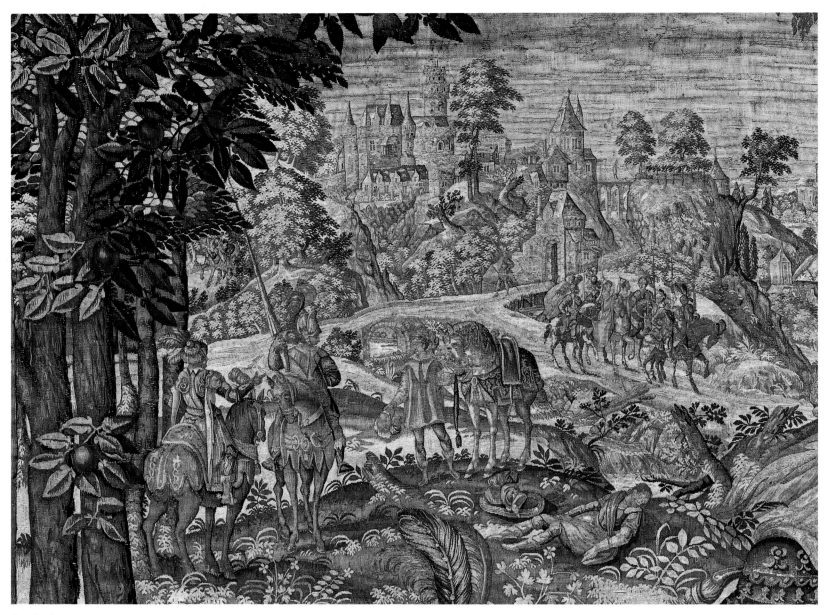

Detail of cat. no. 2

transferring it onto the paper or cloth support of the large cartoon.

If catalogue number 3 was indeed the modello, however, the cartoon painter took some liberties with the distribution of the foreground figures: the fainting group has shifted toward the center, and some secondary figures have been excluded and new ones added. The cartoon painter was as talented as the draftsman of the modello: details developed at cartoon stage include the splendid manipulation of color, contrasting bright costumes with the greens and blues of the surrounding foliage and distant landscape. To prompt recognition of particular protagonists as they reappear in each episode, certain features are judiciously repeated: Amadis's golden

curls, for example, and the singular costumes and headdresses of Oriane and her handmaiden. The cartoon painter also had access to distinctive decorative textile patterns, which reappear in other tapestries woven by Spiering.[15]

The identity of the artist who enlarged Van Mander's modelli into full-scale cartoons is unknown, but it may have been Van Mander himself, albeit with assistance from others. Evidence that he was experienced in this process comes from the fact that his son, Karel van Mander the Younger, was also a highly proficient, specialist cartoon painter.[16] Stylistically, the details absent from the modelli and added during the painting of the cartoons, such as the exotic headdresses, costumes, and

drapery, are typical of Van Mander's style, visible, for example, in the drawing *Head of a Woman* (Teyler Foundation, Haarlem).[17] As Edith Standen and Nello Forti Grazzini have observed, the tapestries' landscapes repeat the distant vistas punctuated by coppices and follies in Van Mander's paintings, such as the *Continence of Scipio* (Rijksmuseum, Amsterdam) and *Saint John the Baptist Preaching in a Landscape* (Niedesächsisches Landesmuseum, Hannover).[18] If catalogue number 3 is indeed the finished modello on which the cartoon was based, it appears that it was the cartoon painter who was responsible for the detail of the heraldic lion atop the column on the far left, in the Princeton version bearing Van Mander's own KVM monogram;

40

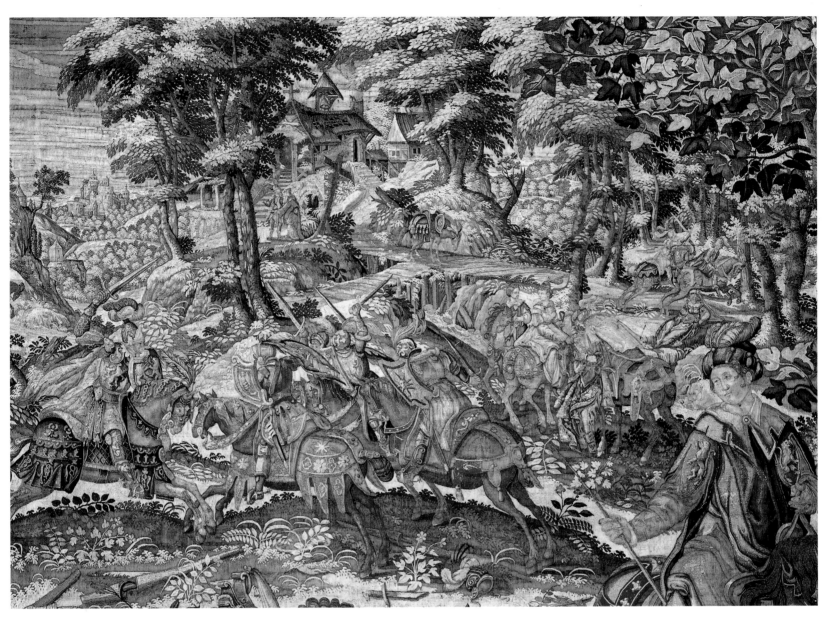

Detail of cat. no. 2

the most likely person who would include it was Van Mander himself.

Van Mander certainly played a considerable part in the creation of tapestries produced by Spiering's workshop. The designs of other surviving sets, such as the *Story of Diana* (also called *Scenes from Ovid's Metamorphoses*; fig. 24) have been attributed to his hand.[19] He also recommended to Spiering which artists would be specifically suited to particular projects, for example, when the weaver needed a marine painter to provide designs for the *Defeat of the Spanish Armada*, made for Lord Charles Howard of Effingham in 1592.[20] He collaborated with other artists in the creation of designs, perhaps in a supervisory capacity, since he was paid considerably more than

they.[21] His activities with Spiering were significant enough to be the first achievements listed after panel paintings in his biography in the *Schilder-boek*, before designs for other textiles, glass, prints, and his many written works.

Weaver

On the lower right corner of the edge, or guard, of the *Liberation of Oriane* is the weaver's mark that identifies this as the work of François Spiering. Toward the lower left corner appears the double B sign flanking a shield. Since the imperial edict of 1528, this had been the official mark of tapestries produced within the city of Brussels. However, since Spiering had never run a weaving work-

shop in Brussels, this tapestry cannot have been woven there. Spiering was born in Antwerp in 1551 and went on to own a tapestry workshop there. Around the close of the sixteenth and early in the seventeenth centuries, weavers of Brussels had occasion to lodge at least three separate complaints that their counterparts in Antwerp were using the mark of Brussels manufacture on tapestries that had actually been woven elsewhere.[22] Nor was this behavior limited to the southern Netherlands: in 1631 a Flemish weaver-entrepreneur who had emigrated to Schoonhoven in the northern Netherlands defended his use of the BB sign as an indication that his work was "Bon Bon" ("good, good" or "well, well").[23] In these cases, the use

41

of the double B was doubtless fraudulent, intended to pass off works as products of the highly sought-after Brussels workshops. But it is also conceivable that it was intended as a universal mark of good quality, made to match the exacting standards of the Brussels weavers' guild. As Marthe Crick-Kuntziger had already observed in 1936, in the case of François Spiering, there may have been extenuating circumstances to permit his use of the double B on works not made in Brussels. Spiering appears to have had close links with the town: his establishment in Antwerp was called In 't Schild van Brussel (At the Arms of Brussels), and he may have been related to the documented Spierinck family of Brussels.[24]

In December 1592 François Spiering permanently moved from Antwerp to Delft, which was duly noted in the records of the Antwerp guild of tapestry makers.[25] It is possible that Spiering began the transferal much earlier: he had already married a woman from Delft in 1582.[26] By 1591 he had finished tapestries in his workshop to show to prospective clients.[27] Spiering used an HD symbol, for "Holland Delft," sometimes in addition to the BB mark, on his later tapestries woven in Delft. The absence of the HD mark on catalogue number 2 and the other *Amadis of Gaule* tapestries from the same edition (the *Presentation of the Lance* and the *Knights of Léonorette*) might suggest that these were woven in Antwerp before Spiering's move.[28] The association between François Spiering and Karel van Mander only began, however, after both had moved to the northern Netherlands. Further, stylistic evidence suggests an early to mid-1590s date for catalogue number 2: this work, the *Presentation of the Enchanted Lance*, and the *Knights of Léonorette* all share the same design of borders with grotesques and pairs of mythological lovers that are present in the lower corners of

Spiering's eight surviving tapestries representing the *Story of Diana* (fig. 24). The designs of this group of tapestries have also been attributed to Karel van Mander the Elder and are so stylistically similar to the *Story of Amadis* that the tapestries have often been confused as pieces of a single series. The first documented reference to the *Diana* series is the set that Spiering sold to Sir Walter Raleigh in 1593.[29]

Spiering might have conceived and produced the *Amadis* series as a speculative sale, perhaps with the iconographic advice of Karel van Mander, as Forti Grazzini has posited.[30] Alternatively, in light of William the Silent's penchant for the story of Amadis of Gaule, Ebeltje Hartkamp-Jonxis has suggested that the set of which catalogue number 2 is part might have been commissioned by a member of his family, perhaps on the occasion of a royal wedding such as that of Louise Juliana and Frederick IV, the Elector Palatine, in 1593.[31] Other potential princely patrons include Henry IV, king of France, to whom Spiering sent six tapestries in 1600, perhaps to mark the French king's marriage to his second wife, Marie de' Medici.[32] Certainly, six *Amadis of Gaule* tapestries were in France by 1681, perhaps with a royal provenance: listed in the *chambre de la Reine* at a dwelling in Grigny, they were part of an inherited collection being dispersed among heirs.[33]

The *Amadis of Gaule* series must have been considered a success: Spiering reused the cartoons at least once. The three *Amadis* tapestries in Milan and at Knole have slightly different borders; in place of the mythological lovers are representations of the Four Seasons. This second edition bears Spiering's full name (FRANCISCUS SPIRINGIUS FECIT), the date 1602, and both the BB and HD marks. Like the set of catalogue number 2, it is woven without gold and silver metal-wrapped threads.

The absence of expensive gilt-metal-wrapped thread from these sets is typical of

Spiering's output. Working without any consistent patron or financier, he was obliged to keep his expenses as low as possible, as he had discovered to his cost: an early six-piece commission from the Delft workshop was transferred to rival Flemish weavers, Jan and Laurens de Maeght in Middelburg, after the delivery of the first piece, apparently because Spiering's prices were deemed too high (cat. no. 5).[34] The *Amadis* and contemporary *Diana* tapestries suggest a carefully run workshop, in which reused borders saved on artists' fees and the duplication of various scenes reveals that Spiering retained and reused his cartoons. The stylistic closeness of the two sets, including repeated costumes, comparable color schemes, and shared figure sizes and horizon lines, might have been intentional: Spiering could combine and sell odd pieces as if they constituted complete tapestry sets; the tapestries of *Diana and Acteon*, the *Pride of Niobe*, and *Oriane Passing the Magical Love Tests in the Magician's Enchanted Garden* at Knole, for example, have been hung and long treated as if a matching group. Spiering's economies succeeded: when, in 1606, Karel van Mander the Younger tried to undercut Spiering's prices, he found that he could not.[35]

The visual appeal of catalogue number 2 lies in part with Karel van Mander the Elder's design, with its mass of detail and the dispersal of the narrative action, which meanders gracefully through the tapestry. Whereas larger-scale figures would demand blocks of color and correspondingly time-consuming fine and faultless weaving, the kaleidoscopic palettes and patterns of the *Amadis* tapestries allowed the weavers to work at a brisker pace. Nevertheless, the skill of the weaving of catalogue number 2 is not in question; the depth and development of the figures within the landscape and its far-ranging vista, rendered mainly in glossy silk, are splendid.

ELIZABETH CLELAND

1. O'Connor 1970; Desprechins de Gaesebeke 1996a and 1996b.
2. For Knole, see Erkelens 1962c, p. 84; T. Campbell 1997, p. 149, pl. 34; Forti Grazzini 2005, pp. 22–31. For Princeton, see Standen 1988, pp. 9–11; Fort Grazzini 2005, pp. 23–31.
3. Forti Grazzini 2005.
4. Hartkamp-Jonxis in New York–London 2001, pp. 516–19, no. 139.
5. Crick-Kuntziger 1936, p. 170; Forti Grazzini 2005, pp. 21–22, 30.
6. Hans Buijs, unpublished communication, cited by Hartkamp-Jonxis in New York–London 2001, p. 516, and Forti Grazzini 2005, p. 28.
7. Published by Phillips 1930, app. IV, p. 449, panel III. Hans Buijs in Amsterdam 1993, p. 370, reserves judgment on the subject matter, also calling it a garden scene.
8. As *Orlando furioso*: Van Ysselsteyn 1937, p. 172; Amsterdam 1955, no. 279; Viale-Ferrero 1984, p. 19, nos. 4, 5. As *Gerusalemme liberata*: Delft 1962, pp. 32–33, no. 68. As *Diana*: Standen 1988, pp. 9–11.
9. Despechins de Gaesebeke 1996a and 1996b.
10. See Hartkamp-Jonxis in New York–London 2001, p. 517.
11. Gerszi 1985.
12. Standen 1988, pp. 9–11.
13. "[V]an zyne teeckeninghe…voor de treffelijcke Tapijtsier Spierincx tot Delft heele kameren met Tapytseryen"; Van Mander 1618, fol. S2v.
14. "[N]otatis et exemplis Karoli Vermandre"; Van Buchell 1907, p. 461.
15. The textile of Oriane's costume is reused in the *Story of Diana/Scenes from Ovid's Metamorphoses* for Diana in *Cephalus and Procris* and for Jupiter as Diana in *Jupiter and Callisto* (both Rijksmuseum, Amsterdam); Standen 1988, p. 11.
16. Van Mander 1618, fol. S3r; Van Zijl 1981, pp. 206–7.
17. Amsterdam 1955, no. 212.
18. Standen 1988, p. 11; Forti Grazzini 2005, p. 43.
19. See Erkelens 1962c, p. 77; Standen 1988, pp. 9–11; Hartkamp-Jonxis in Hartkamp-Jonxis and Smit 2004, pp. 203–14, no. 52a–c.
20. See Eisler 1921, p. 197; Hartkamp-Jonxis 1993, pp. 215–16.
21. See Göbel 1923, pp. 558–59.
22. Crick-Kuntziger 1936, pp. 168–69.
23. Van Ysselsteyn 1936, vol. 2, no. 469; Crick-Kuntziger 1936, p. 172; Hartkamp-Jonxis 2002b, p. 34.
24. Wauters 1878, p. 184; Crick-Kuntziger 1936, p. 170.
25. Göbel 1923, pp. 450–51, 603 n. 12.
26. Hoek 1959.
27. Erkelens 1962c, p. 66.
28. Guy Delmarcel attributed cat. no. 2 to Antwerp in sale cat., Sotheby's, London, December, 13, 1991, no. 7.
29. Van Ysselsteyn 1936, vol. 1, pp. 70, 75, vol. 2, nos. 104, 165.
30. Forti Grazzini 2005, p. 50.
31. Hartkamp-Jonxis in New York–London 2001, p. 517; Hartkamp-Jonxis 2002b, p. 36; Hartkamp-Jonxis in Hartkamp-Jonxis and Smit 2004, p. 181.
32. Göbel 1923, p. 542.
33. "Extrait de l'inventaire des meubles estant en la maison de Grigny, à partager entre M. Quentin de Richebourg et Mme de Caumartin de Boissy (31.1.1681)"; in "Tentures de tapisseries" 1892, p. 128.
34. Erkelens 1962c, p. 68.
35. Van Zijl 1981, p. 207.
34. Erkelens 1962c, p. 68.
35. Van Zijl 1981, p. 207.

4.
Garden with Diana Fountain

From a five-piece set of *Garden Scenes with Mythological Fountains*
Design attributed to Karel van Mander the Elder, ca. 1604
Woven by François Spiering, Delft, 1604
Wool and silk
350 x 375 cm (11 ft. 5¾ in. x 12 ft. 5⅝ in.)
FRANCISCUS SPIRINGIUS FECIT ANNO 1604, center of inside register of lower border
Warwick Castle, Warwick

PROVENANCE: 1604, woven in the workshop of François Spiering in Delft; by 1826, listed in the State Bedroom, Warwick Castle, England.

REFERENCES: *Complete Guides to Warwick* 1826, p. 39; Malan 1900, p. 358; Crick-Kuntziger 1936, pp. 170–71; Van Ysselsteyn 1936, vol. 1, pp. 258–59, 271, vol. 2, p. 497; Wingfield Digby 1980, p. 60; Hartkamp-Jonxis in Hartkamp-Jonxis and Smit 2004, pp. 187–88; Forti Grazzini 2005, p. 36.

This tapestry is one of a set of five, signed and dated by François Spiering at the beginning of the seventeenth century, representing Mannerist garden landscapes. Their skillful design, spatial complexity, and diverting details reinvigorate subject matter that had been woven in rival Flemish centers for the past thirty years. Displaying an exquisite degree of technical excellence, catalogue number 4 illustrates the decorative success and appeal of the small-figure genre.

Description and Iconography

A clearing on a wooded hillside opens to reveal a splendid Mannerist garden. The domain is bordered by a narrow moat, glimpsed in the tapestry's foreground, fed by fountains spouting from the garden statuary and filled to surfeit with bulrushes, irises, and other water and bankside plants. Ducks swim at the right, while a whiskered mammal to the left wrestles with an eel. The unfettered nature in the foreground is set in sharp contrast to the delightful artifice of the garden behind. An ornate parapet, colorfully decorated with gilt arabesque ironwork and relief carvings of mermaids, sea monsters, and other nautical creatures, encloses the garden, within which paths lead between symmetrically positioned flower beds, potted trees, and bushes. Most eye-catching is the gilt statuary of the fountain at the right, and its pair glimpsed behind, apparently illustrating the episode in Ovid's *Metamorphoses* when Diana, chaste goddess of the hunt, punishes Acteon for spying on her bathing by transforming him into a stag. Crowned with the moon, she blows her hunting horn, while hounds seem to scramble for space on the plinth below her. Elsewhere, bridges and vine-covered trellises lead into a labyrinth, itself moated by waterways. Statues of male and female nudes, embodiments of abundance who proffer fruit-filled cornucopias, border the maze. Diminutive figures are glimpsed throughout: courtly couples relax beside balustrades and

Detail of cat. no. 4

The scene is set within a frame of arabesques of golden vines, punctuated by medallions representing urns of flowers. Catalogue number 4 is one of a set of five tapestries, all in Warwick Castle, each illustrating a Mannerist garden. Seen from correspondingly elevated viewpoints, they are unified by elaborate fountain statuary illustrating an episode from Ovid's *Metamorphoses*.[1]

It has been suggested that this set of tapestries illustrates actual seventeenth-century gardens, such as those surrounding the royal palace in Brussels or, although chronologically implausible, the arrangements at Versailles.[2] The royal gardens at the Coudenberg in Brussels did include a labyrinth, vines, trellises, and canopies, and, by 1600, ornamental waterworks and fountains.[3] Garden design manuals of the period also recommended sculptural decorations illustrating episodes from classical mythology.[4] However, the Warwick *Gardens* tapestries are not based on actual domains. Instead, the scenes in the tapestries, like the planting schemes at Brussels and elsewhere, are all emulations of an ideal. Catalogue number 4 can be located within an established convention: tapestries featuring enclosed courtly domains, planted in the ornate Mannerist style and set within fantastic landscapes were already being woven in Brussels, Enghien, Oudenaarde, and Antwerp from the 1560s on.[5] This type of tapestry has sometimes been interpreted as an allegory for the state of mankind, as microcosmos, within the world, the macrocosmos.[6] Although such a symbolic allusion may have been explored by the tapestries' original audience, their primary function was almost certainly decorative. The abundant foliage, flora, fauna, and engaging details of courtly and country figures echo the subject matter of fifteenth- and sixteenth-century verdure, or millefleurs, tapestries. These garden tapestries could offer the adaptability, the scale, and the appeal of verdures, of appropriate size and subject for use in wealthy domestic interiors. As such, they can be viewed as the stylistic development of the medieval millefleurs tradition.

Designer

Sixteenth-century *Garden* tapestry sets linked by hunting scenes, distinct topography, wild

on benches; musicians gather beneath the central pavilion of the maze; busy gardeners tend vines and wrestle with great urns of shrubbery. A lowered drawbridge leads from the garden into a splendid castle to the right. Opposite, in a homely echo of the courtly dalliances within the garden, peasants stroll,

fish, and collect water in the village glimpsed at the leftmost edge. A vista opens up beyond the domain. Wooded hilltops meet a stormy sky: turrets and battlements of far-off castles dot gently rolling hills, while picturesquely gabled cottages and church steeples nestle in the valleys.

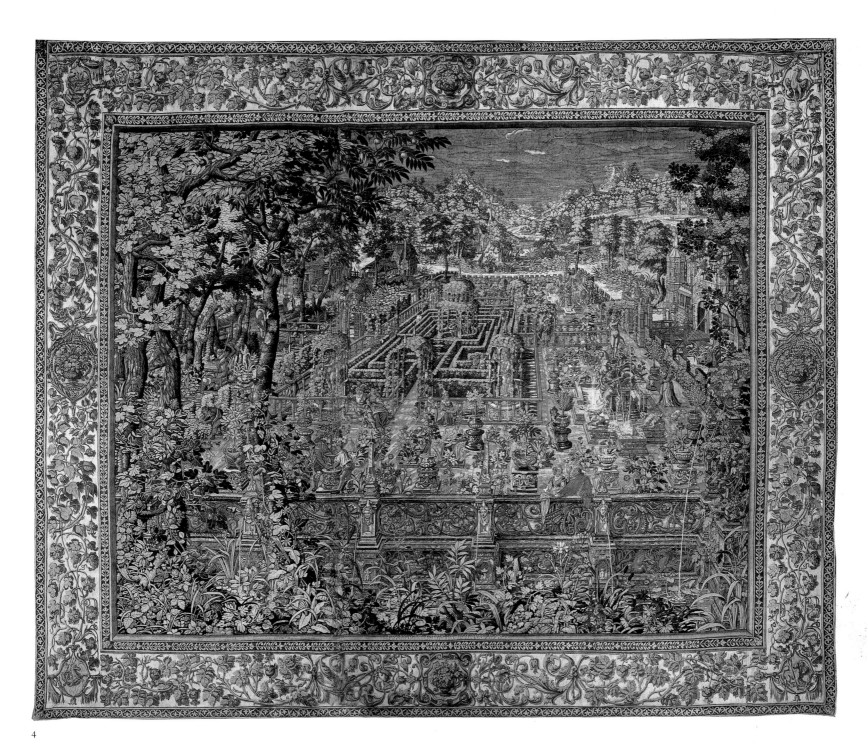

4

beasts, or courtly figures were not unusual. The choice to execute a set designed around the theme of ornate fountains representing different scenes from Ovid's *Metamorphoses* was unusual, however, and suggests that François Spiering gave some thought to the creation of this set and to the choice of designer of its cartoons.

The recent suggestion that Spiering was reweaving old cartoons used by the Enghien-based weaver Filips van der Cammen is untenable.[7] Not only is the iconography more ambitious than its earlier Flemish counter-parts, but the detail of the design is also considerably subtler and more inventive. The designer of the cartoon of catalogue number 4 has introduced a clever conceit to the genre: whereas earlier *Garden* tapestries, like those woven by Van der Cammen, Frans Geubels, and Joost van Herzeele, contrive to represent their formal gardens symmetrically, viewed head-on, in the Warwick set the gardens are seen at oblique angles. For example, the ideal, formalized view would actually be from the palace to the right. Instead, we look down on the scene, as if approaching the garden from the left, for an effect of spontaneity. The skill of the designer is also perceptible in the representation of the artworks within the garden. Portraying the labyrinth statues nude but gilding their crowns and cornucopia make the statues seem alive. Their pedestals and gazebos mark them as sculpture, yet the verisimilitude of their poses and their shared scale with the actual figures in the garden introduce a note of enchantment. It is not immediately clear

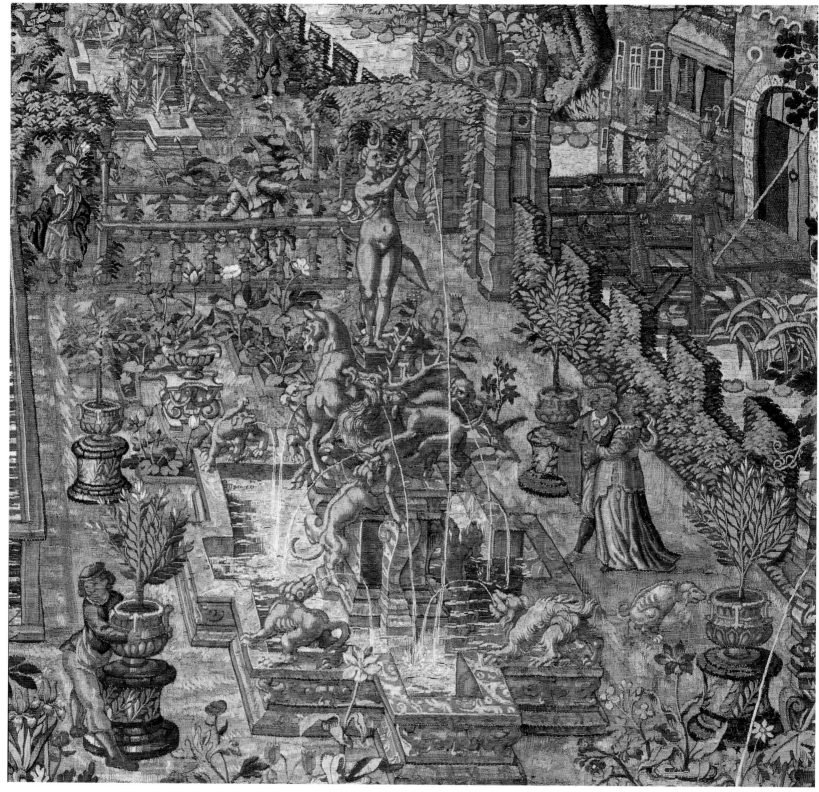

Detail of cat. no. 4

where the representation of reality ends and the representation of artistry begins. This is achieved above all with the Diana and Acteon fountain. Whereas the buildings, fountains, and statuary of other *Garden* tapestries tend to be based on staid and formal representa-tions from contemporary architectural manu-als, including the printed works of Hans Vredeman de Vries, the fountains here are quite unlike anything that had actually been built (predicting Luigi Vanvitelli's *Diana and Acteon* fountain at Caserta by more than 150 years).[8] The baying hounds scramble around the struggling stag with a spontaneity at odds with their carved-stone state. The designer reinforces this sense of heightened reality with the representation of an actual dog beside the fountain.

Spiering may have decided to commission designs for the *Garden Scenes with Mythological Fountains* from the artist with whom he had collaborated so well in the past and whose designs Arend van Buchell had admired in Spiering's workshop in 1598: Karel van Mander the Elder.[9] Van Mander the Elder was an artist fully capable of the spatial sophistication and inventiveness seen in this tapestry. The design of the *Garden* tapestries may have been one of his last commissions for Spiering: the tapestries were woven two years before Van Mander's death in 1606. This example shares the lively color, attention to detail, fantastical costumes, and enchanted quality of Van Mander's securely attributed designs for Spiering, the *Story of Amadis of Gaule* (cat. nos. 2, 3). The box hedges, terraces, labyrinth, gazebos, fountains, and meandering couples of catalogue number 4 find their counterparts in his evocation of the garden of Apolidon (cat. no. 3). The mannered elegance of the figures in catalogue number 4 also recalls Spiering's *Story of Diana* tapestries (fig. 24), attributed to Van Mander the Elder: the gilt Diana of the fountain echoes the pose of both a nymph in *Cephalus and Procris* (Rijksmuseum) and a horn-blowing hunter in the *Story of Meleager and Atalanta* (ex-Coty collection).[10]

Whether it was Karel van Mander the Elder or an artist within his circle, the designer of catalogue number 4 took an iconographic type, familiar from tapestries woven in great numbers in the leading Flemish workshops, and breathed new life into the formula. The designs of the frame, arabesquelike vines against a pale background rather than the colorful and detailed fruit, flora, and allegorical figures favored by the Flemish weavers, created an effective foil against the busy scenes. These borders also locate the tapestries firmly within modern, seventeenth-century design; as G. T. Van Ysselsteyn noted, they predict the borders that the Gouda-based weaver Tobias Schaep would use for his *Scenes of the Passion* tapestries, woven between 1634 and 1647.[11]

Weaver

The weaver's name and the date are inscribed along the lower horizontal border: FRANCISCUS SPIRINGIUS FECIT ANNO 1604. The lettering, in Roman capitals, is shaded to create the illusion of a carved inscription. While the weaver's mark used on François Spiering's earlier tapestries (for example, cat. no. 2) would have been recognizable only to professionals in his field, this inscription ensured that patrons, clients, subsequent owners, and all others who looked closely at the tapestry would learn the name of the craftsman responsible for its creation. His name, sometimes joined by his mark, appears on other tapestries in the Warwick *Garden Scenes with Mythological Fountains* set.[12] By the turn of the seventeenth century, Spiering's was the most successful tapestry weaving workshop in the northern Netherlands. This was due to a combination of excellent quality designs, skillful weavers, and shrewd business sense.

Although catalogue number 4 and the other *Garden Scenes with Mythological Fountains* seem rich and sumptuous, with gold-colored vines in their borders and the goldlike statuary represented in the gardens, no gilt or silver metal-wrapped threads were used. The nature of the designs, with small components set within detailed landscapes (the small-figure genre), also meant that they were easier to weave and thus more commercially viable. This effort to keep weaving costs low might indicate that Spiering produced the set on speculation rather than as a commission. The choice to weave garden scenes was astute: the success of the genre with Spiering's Flemish counterparts proved its popularity and international appeal. For example, there was a steady demand for garden tapestries in Italy with patrons such as the Contarini turning to the Antwerp- and Brussels-based Van Herzeele (see fig. 27), while Antonio Barberini owned a set produced in Geubels's Brussels workshop.[13]

While the Italians purchased from the Catholic southern Netherlands, Spiering could target the Protestant north. There was a proven taste in Britain for *Garden* tapestries; examples woven in Geubels's workshop were in London at the time, while the recently established Sheldon tapestry works in Warwickshire was producing high-quality armorial tapestries, decorated with medallions of garden scenes.[14] The 1604 weaving of the *Garden Scenes with Mythological Fountains* took place during a period of considerable success for Spiering with the English market: in 1592,

Lord Charles Howard of Effingham had commissioned the *Defeat of the Armada* series; a year later, Sir Walter Raleigh bought a *Story of Diana* set; in 1601 Henry Brook, Lord Cobham had obtained a six-piece *Story of Cleopatra* set from Spiering, which was already in the British royal collection by this date (confiscated by King James in 1603). Subsequently, Spiering would sell tapestries of the *Deeds of Scipio* to Thomas Howard, first Earl of Suffolk, by 1610; in 1613 the States-General would purchase a six-piece *Story of Diana* and a ten-piece *Deeds of Scipio* to present to King James's daughter Elizabeth on the occasion of her marriage; seven years later, they would gift an *Orlando Furioso* set woven by Spiering to Sir James Hay, Earl of Carlisle.[15] The circumstances in which the *Garden Scenes with Mythological Fountains* arrived at Warwick are unknown. Following the death of Ambrose Dudley, third Earl of Warwick, in 1589, Warwick Castle became the seat of the Greville family. It is possible that Fulke Greville, first Baron Brooke (1554–1628), or his heirs obtained the *Garden Scenes with Mythological Fountains* tapestries, perhaps as a gift from Spiering's circle of patrons, such as the Howard family, or as a royal perquisite. The bed and furniture of the State Bedroom, in which the tapestries have hung since at least the early nineteenth century, reputedly belonged to Queen Anne (1665–1714) and were presented to Francis Greville (1719–1773) by King George III (1736–1820).[16]

By choosing Ovid's *Metamorphoses* as the unifying link between the *Garden Scenes with Mythological Fountains*, Spiering not only introduced a thought-provoking variation to the genre of Mannerist garden tapestries. He also returned to the iconography that had proved so successful for him in the preceding decade, in which his *Story of Diana*, or *Scenes from Ovid's Metamorphoses*, was rewoven on numerous occasions. After Karel van Mander the Elder's death, Spiering reused this theme, in a second cycle of *Diana* cartoons, attributed to Karel van Mander the Younger. Incorporating the decorative gardens with his signature *Metamorphoses* subject matter, Spiering will have had little difficulty finding a purchaser for his *Garden Scenes with Mythological Fountains*. While the choice to weave these *Garden* tapestries

with small figures, in wool and silk alone, might indicate a measure of economy, no concessions have been made in the exquisite artistry of their design and weaving, rendering them among the best surviving examples of this genre.

ELIZABETH CLELAND

1. Observation made by Tom Campbell.
2. Brussels was suggested by the Countess of Warwick in Malan 1900, p. 358; Versailles in *Complete Guides to Warwick* 1826, p. 39.

3. See *Oxford Companion to Gardens* 1986, p. 77.
4. See Washington 1977.
5. See Göbel 1923, pp. 173–76; Crick-Kuntziger 1944, pp. 24–26; E. Duverger 1969, pp. 173–84; Delmarcel 1980, pp. 50–53; Oudenaarde 1999, pp. 142, 146; Wingfield Digby 1980, pp. 59–61 nos. 52–59, pls. 74–80.
6. Knowlton 1956, p. 144.
7. Hartkamp-Jonxis in Hartkamp-Jonxis and Smit 2004, p. 188.
8. See Göbel 1923, p. 176; Knowlton 1956, pp. 142–43; Standen 1974, p. 227; Wells-Cole 1983; Delmarcel 1999a, pp. 172–73.
9. Van Buchell 1907, pp. 460–61.

10. See Hartkamp-Jonxis in Hartkamp-Jonxis and Smit 2004, pp. 203–14, no. 52a–c; Van Ysselsteyn 1937.
11. Van Ysselsteyn 1936, vol. 1, p. 271. For Schaep, see Hartkamp-Jonxis 2002b, pp. 17, 22, 24.
12. See Crick-Kuntziger 1936, pp. 170–71.
13. For the Contarini, see Wingfield Digby 1980, p. 59 nos. 52–56, pls. 74–77B; London 2006, p. 353 nos. 26, 27, pl. 3.4. For the Barberini, see Ehret 1977.
14. For Geubels, see Kendrick 1927; for Sheldon, see Clark 1983.
15. Van Ysselsteyn 1936, vol. 1, p. 77, vol. 2, nos. 165, 222, 224–27, 229, 233–35, 326–32.
16. *Complete Guides to Warwick* 1826, p. 39.

5.
Siege of Zierikzee

From a six-piece set known as the *Zeeland Tapestries*
Design by Hendrick Cornelisz Vroom, autumn 1599
Cartoon executed by Hubrecht Leyniers
Woven in the workshop of Hendrick de Maeght, Middelburg, 1599–1600
Wool and silk
394.5 x 386 cm (12 ft. 11¼ in. x 12 ft. 8 in.)
7–8 warps per cm
Zeeuws Museum, Middelburg (BR72-010)

PROVENANCE: Between 1593 and 1602, set commissioned by the States of Zeeland, this piece in the summer of 1599; until 1679, set periodically displayed in the Prinsenlogement of Middelburg Abbey; from 1679, set hung in the assembly room of the States of Zeeland; 1811, French occupiers, expecting a visit from Napoleon, took the tapestries down, and the set was rehung a few years later; 1852, four tapestries, including the *Siege of Zierikzee*, taken down to make room for a public balcony; 1859, three tapestries, including this piece, sent to the Ministry of Internal Affairs in The Hague; 1867, these three tapestries exhibited at the Exposition Universelle, Paris; 1895, transferred to the Rijksmuseum, Amsterdam; 1904, returned to Middelburg and hung with the rest of the set in the new assembly hall of the States of Zeeland; shortly before World War II, set taken down; May 1940, transferred to a shelter in Limburg; after the war, set sent to the Rijksmuseum, Amsterdam, then returned to Middelburg one by one, this piece in 1960; since 1972, set exhibited in the Zeeuws Museum.

REFERENCES: Van der Graft 1869, pp. 180–83; De Waard 1897; Van Swigchem and Ploos van Amstel 1991, pp, 107–15; Heyning 2007.

CONDITION: Set cleaned and, where necessary, repaired yearly between 1604 and 1679. Incense and balm were used as preservatives. After 1679 there is no mention of regular cleaning. The set was washed again in 1784–85, when the assembly hall was redecorated and the tapestries were fitted into new wall paneling. Some parts were painted in by the Middelburg painter Johannes Piepers in watercolor. In 1901 the whole set was washed and restored in the atelier Guinet-Wallet in Neuilly-sur-Seine, France. This piece was extensively restored between 1966 and 1976 in the Werkplaats tot Herstel van Antiek Textiel in Haarlem. The colors had faded and the silk had decayed, although due to its position in the assembly hall there was considerably less deterioration than in other pieces of the set. Part of the border on the right-hand side was missing. Missing pieces from the top border that had been replaced by painted cloth were rewoven. On the lower border a section that had been cut out to incorporate a door was replaced.

*A*s an eyewitness account of the struggle against the Spaniards between 1572 and 1576 based on oral testimony of people who had actively participated in the battles, the Zeeland series is the most important extant set of northern Netherlandish tapestries recording contemporary events. The theme of the six-piece series is the fight for possession of the strategic Scheldt River delta, the waterways between Antwerp and the island of Walcheren that were the key to the Dutch revolt. The fight was won by the Zeeland rebels and resulted in the rise of the sovereign and independent States of Zeeland. The tapestries were ordered twenty years later to commemorate the struggle for freedom and were used as a visual display of power by this young state, which, together with six other provinces, formed the Dutch Republic. The series is unique as a historical record of carefully selected naval battles that were meant to show how perseverance and suffering led to victory and glory.

On April 6, 1572, the Zeeland town of Flushing on the island of Walcheren was the first city in the Netherlands voluntarily to join the revolt against the duke of Alba, the Spanish governor-general of the Netherlands. The Dutch revolt, which had started in response to high taxation and religious oppression, resulted in a war against the Spanish crown that lasted until 1648.[1] The anti-Spanish forces, which had rallied under the banner of William of Orange, gained considerable power between April 1572 and November 1576, when a temporary truce (the Pacification of Ghent) was signed. These first vital and important years were later frequently commemorated in tapestry, stained-glass windows, paintings, and silver. The Zeeland tapestries depict key moments during the first years of the revolt when the fighting still took place within the borders of the rebellious provinces. After 1576 no enemy troops set foot on Zeeland soil. At no other time were historical events in the Netherlands depicted in tapestries on this scale.

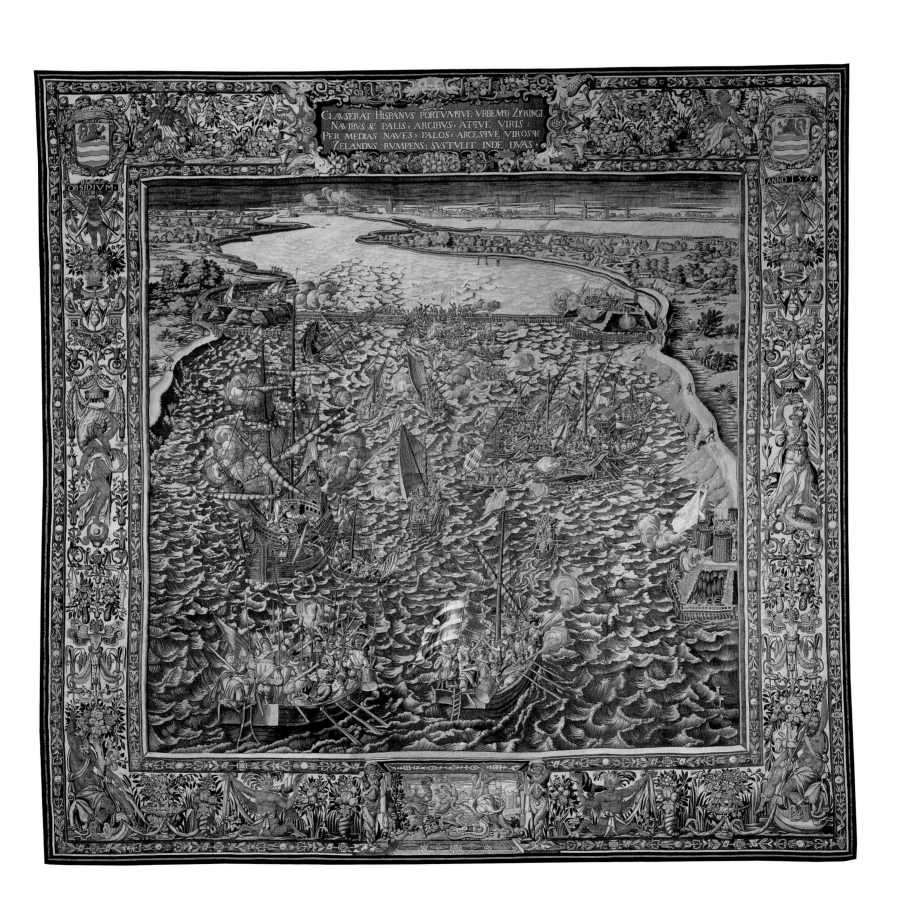

CLAVSERAT HISPANVS PORTVMQVE VRBEMQ; ZYRINGI
NAVIBVS & PALIS, ARCIBVS, ATQVE VIRIS :
PER MEDIAS NAVES, PALOS, ARCESQVE VIROSQ;
ZELANDVS RVMPENS; SVSTVLIT INDE DVAS.

OBSIDIVM.

ANNO 1575

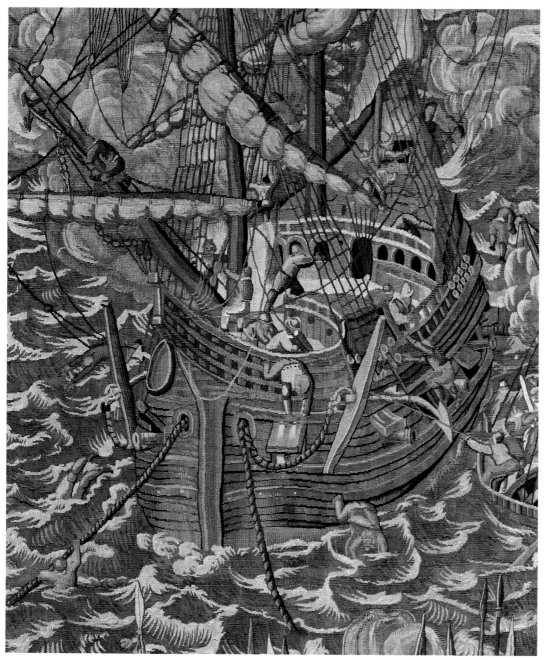

Detail of cat. no. 5

Description

Fifth in the sequence of six tapestries, the *Siege of Zierikzee* depicts an attempt by troops from Zeeland and Holland to relieve the town of Zierikzee on the island of Schouwen, which had been under siege by the Spaniards since November 1575. Because the people of Zierikzee had breached the dikes as soon as they learned the enemy was approaching, the land around the town was flooded. The Spanish troops could not attack and besieged the town for eight months. To block the harbor of Zierikzee and to prevent ships sailing

through the Dijkwater—the waterway that separated the islands of Schouwen and Duiveland and served as an entrance to the harbor of Zierikzee—the Spaniards decided to barricade this passage with poles and iron chains. When their first attempts were frustrated by weather conditions (time and again a combination of wind and water washed away the poles) the Spanish commander, Colonel Cristobal de Mondragon, decided to build a sturdy palisade of wooden poles right across the Dijkwater. On either side of this palisade fortifications were erected. The tapes-

try shows a synthesis of the principal events between April 11 and 13, 1576, when the Dutch attacked the Spaniards simultaneously from the north and the south. Although the siege of Zierikzee is extensively covered by the late sixteenth-century Dutch historians Pieter Bor and Emanuel van Meteren, the events of April are scarcely mentioned. However, the depicted events are documented in letters Colonel Mondragon wrote to the Spanish king.[2]

The tapestry focuses on the attack from the north. The background is formed by a detailed skyline of the city of Zierikzee with its gates, churches, and town hall seen from the northeast. On the left the drawbridge of the gate that connects the walled city with the fortified harbor (Havenpoort) is open. At the far right a second gate, the Nobelpoort, is depicted. The smoke in the distance marks the place of the simultaneous attack by fifty Zeeland ships from the river Scheldt in the south. The city is surrounded by water, and the Spanish encampment on the high ground along the dikes on both sides of the Dijkwater is clearly visible. The middle of the tapestry is dominated by Mondragon's palisade with fortifications on both sides. The white flags with the red Burgundian cross identify the Spanish troops. The foreground of the tapestry is occupied by two of the twenty-five Dutch boats that entered the Dijkwater from the north on April 11. Fire from the cannons behind wicker-clad emplacements in a small Spanish fortification at the lower right seems not to do much harm. Two companies of heavily armed Zeeland men are shown setting forth into battle. The different types of armor can be clearly seen. Most men bear pikes, swords, and rapiers, and some also carry a harquebus (firearm). One of the soldiers wears a shoulder belt with ammunition. Banners in the colors of the Prince of Orange—orange, white, and blue—identify the rebel troops.

Under cover of darkness at ten o'clock in the evening, the Dutch attacked the two Spanish galleys that were anchored near the palisade. On the right-hand side of the tapestry, the rebels, bearing a large banner with the arms of Zeeland (a lion struggling to emerge from the water), have surrounded the Spaniards and are boarding the galleys of

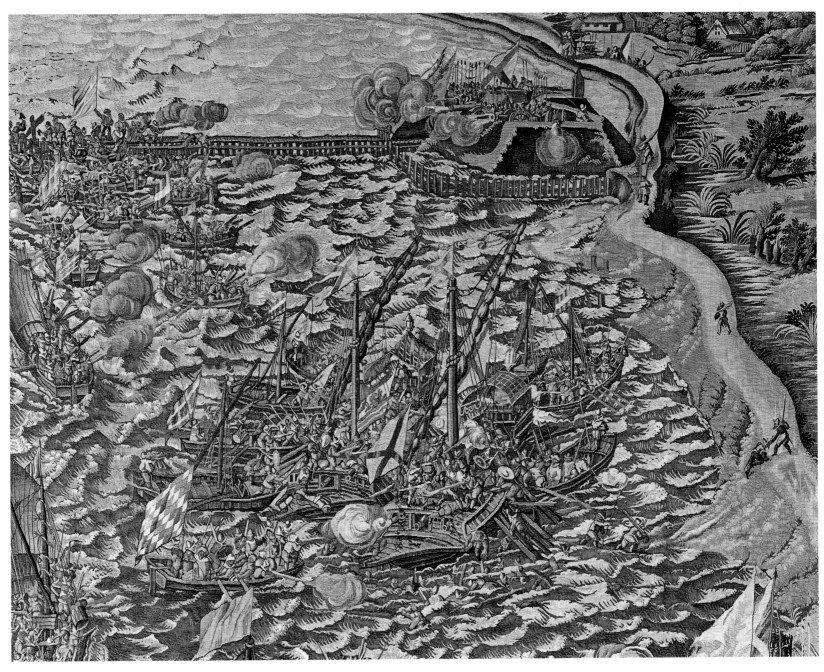

Detail of cat. no. 5

Admiral Sancho d'Avila and his vice admiral, the former Middelburg burgomaster Adriaen Jacob Joosz. Hand-to-hand fighting is breaking out everywhere. Spanish soldiers are desperately leaping overboard and some are seeking refuge onshore. On the left a second event is depicted. The crew of a small Zeeland ship is flinging a grappling iron into a Spanish *assabre* (small cargo ship). The crew is preparing to leap aboard as soon as they have drawn alongside. A shot has set the stern of the *assabre* afire and some of the Spaniards are already abandoning ship. The fighting went

on for hours, and the *assabre* was eventually sunk. At low tide the Dutch were forced to withdraw, taking the two Spanish galleys with them.

In the middle of the tapestry the events that took place in the early hours of the next day are depicted. The wreck of the sunken *assabre* on the left represents the later moment when the rebels attempted to break through the palisade for the second time. A number of Dutch vessels can be seen approaching the palisade while returning fire from the Spanish artillery on both sides of the water. In spite of

ferocious enemy fire, a small group has succeeded in reaching the palisade, and various people are attacking it with axes. In the middle a flag bearer is triumphantly waving his banner. Nonetheless, the attempt failed, as did the third attack the next day. In spite of various other efforts to relieve the city during the spring of 1576, the Spanish troops eventually captured the town on June 29. However, within days mutiny broke out among the underpaid Spanish soldiers, who decided to make their way to Antwerp while looting and plundering the countryside. Four months

after he had triumphantly entered the town, Colonel Mondragon was forced to abandon Zierikzee.

Border

The *Siege of Zierikzee* has retained its original border. The border of the first tapestry in the series, the *Battle of Bergen op Zoom*, which was woven by the Delft weaver François Spiering, served as a model for the others. All scenes are identified by an inscription in a cartouche in the center of the upper border. On the *Siege of Zierikzee* the text reads: CLAVSERAT HISPANVS PORTVMQVE VRBEMQVE ZYRINGI NAVIBVS & PALIS, ARCIBVS, ATQVE VIRIS: PER MEDIAS NAVES, PALOS, ARCESQVE, ZELANDVS RVMPENS; SVSTVLIT INDE DVAS (The Spaniards had sealed off the port and town of Zierikzee with ships, stakes, fortifications, and men. Breaking through those ships, stakes, fortifications, and men, the men of Zeeland captured two). The coat of arms of Zeeland can be seen in the upper corners. Under the left escutcheon the word OBSIDIUM (siege) is woven, under the right escutcheon, ANNO 1575.

In the center of the lower border a cartouche shows one of the twelve Labors of Hercules: Hercules and the Defeat of the Hydra of Lerna. The struggle between the many-headed Hydra and Hercules refers to a fight with an enemy who is judged invincible but who comes out worse in the end, as was the case in the struggle between the Spanish troops and the people of Zeeland. C. A. Van Swigchem suggested a print by Hendrick Goltzius as a model for this scene, but the resemblance is not convincing.[3] The decorative elements in the border are related to the central field in a general way. The allegorical figures of Fortune and Victory on the left and right symbolize the struggle for freedom. The areas in between are occupied by fantastical figures, sea monsters, water plants, flowerpots, fruit, and candelabra motifs.

Patron

In July 1591 the States of Zeeland discussed commissioning a tapestry depicting the important battle of Bergen op Zoom, which had taken place on January 29, 1574. The auditor-general Jacob Valcke was charged with the execution of this project. Valcke immediately approached the Delft weaver François Spiering, but the negotiations were difficult and took almost two years. The official commission was finally approved in April 1593. When the tapestry was completed in 1595, the Gecommitteerde Raden (Council of Deputies) decided to commission four more tapestries to form a chamber. These pieces were commissioned from the Middelburg workshop of Jan and Hendrick de Maeght. The last tapestry, meant as a chimneypiece, was commissioned in 1602 and was also woven in Middelburg. The accounts for the tapestries, which are preserved in the archives of the States of Zeeland, show the series was completed in 1604. The total cost amounted to 1,154 Flemish pounds, the equivalent of 7,000 Dutch guilders at the time.

The set visualizes the fight for the river Scheldt, which resulted in the rise of the independent state of Zeeland. The choice of subjects was influenced by the desire to show different aspects of this struggle. The hardship and suffering endured by the people of Zeeland in their struggle to retain the strategically important waters around the island of Walcheren are the main theme of the *Siege of Veere*. The *Battle of Rammekens* refers to the enormous booty that was won that day and that helped to finance the war. The *Battle of Lillo* portrays how ingenuity could help win a fight. The *Battle of Bergen op Zoom* commemorates the glorious victory in January 1574, when the Zeeland navy took definite control of the waters in the province. The *Siege of Zierikzee* symbolizes the stubborn perseverance necessary to defeat a supposedly invincible enemy. The last tapestry of the series shows the Zeeland coat of arms surrounded by the escutcheons of the six towns that governed the province since 1576 and the portrait of William of Orange. It symbolizes the new independent States of Zeeland that—with the help of God—was created by these events. As a form of visual propaganda the set reinforced the legitimate rule of the young state. When hung in the great hall in the Prinsenlogement, the series would immediately bring to mind the memorable acts that led to the creation of this state and the deliverance from the tyranny of Spain.

Designer

Documents preserved in the Zeeland archives state explicitly that the *Siege of Zierikzee* was designed by the Haarlem painter Hendrick Cornelisz Vroom (1566–1640).[4] Vroom received this assignment in September 1599 and sent his finished drawing to Hendrick de Maeght the following November, together with a letter stating he would rather concentrate on painting in the future. It would indeed be his last design for the series. Between 1596 and 1599 he had been involved in the tapestries showing the battle of Rammekens, the battle of Lillo, the siege of Veere, and the siege of Zierikzee. The commission for the design of the last tapestry in the series was given to the Haarlem painter Karel van Mander. Although no contemporary documentation has been found, most experts agree Vroom also designed the *Battle of Bergen op Zoom*.[5] Van Mander records in his life of Hendrik Vroom in *Het Schilder-boeck* (1604) how he referred Spiering to Vroom in 1592, when Charles Howard, Lord Admiral of the English navy, commissioned a set of ten tapestries of the naval battle between the English fleet and the Spanish Armada in 1588.[6] Van Mander had decided drawing ships was not his forte and recommended Vroom to undertake this work in his stead. As Jacob Valcke was at that moment already negotiating with Spiering about the production of the first of the Zeeland tapestries and Spiering explicitly states in a letter dated December 1592 he would like to start on the Zeeland project because he now had "extraordinary expertise" at his disposal, it seems logical to conclude Vroom must also have been involved in the design of the first tapestry of this set.

From the preserved documents we know Vroom visited Zierikzee in the fall of 1599. On October 21 he was paid 13 pounds, 5 shillings Flemish for an initial drawing and the cost of his trip. Just as he did when making the designs for the other Zeeland tapestries, Vroom wished to see the location in person to get the topographic details right. He even made an effort to render the situation as it had been in 1576 and so did not include the recent changes to the skyline of the city that resulted from the building of a new harbor. A contemporary print of the siege of Zierikzee by Frans

Hogenberg might have been helpful, although it shows the town from the south instead of the north.[7] Information about the events between April 11 and 13 must have been provided by people who had been present at the time of the attack, since in 1599 there were no publications available on which Vroom could have based his drawings. The documents in the Zeeland archives refer to various reconnaissance trips undertaken by the weavers and designer in company of members of the Zeeland admiralty. Payments for food and drink during consultations are also mentioned. Prominent members of the States of Zeeland and the Zeeland admiralty in the 1590s who had been closely involved in the struggles between 1574 and 1576 must have provided Vroom with the necessary information.

It has been suggested that Vroom's composition was influenced by the *Conquest of Tunis* series, woven by Willem de Pannemaker for Charles V between 1549 and 1554.[8] There are significant differences, however. In all his designs for the Zeeland tapestries, Vroom eliminated the foreground scenes with large heroic figures that characterize the *Tunis* set. Ebeltje Hartkamp-Jonxis has drawn attention to the cartographic inventions of Cornelis Anthonisz, which were available in the form of woodcuts and could well have inspired Vroom's bird's-eye view of the naval actions.[9] The full-scale cartoons for the *Siege of Zierikzee* were made by the Dordrecht painter Hubrecht Leyniers, who also made the cartoons for the other tapestries of this set. Although all preparatory drawings and cartoons were handed over to the representative of the States of Zeeland in

1604, up to now none of Hendrick Vroom's designs have been identified.

The States of Zeeland were satisfied with Vroom's work. Twice they expressed their appreciation with a gift. In the fall of 1599, while working on the design for the *Siege of Zierikzee*, Vroom received a tapestry blanket as a token of their esteem. Vroom's work on the Zeeland tapestries also led to commissions from high-ranking Zeeland politicians.[10]

Workshop

Although the first tapestry in the series was woven in the workshop of François Spiering in Delft, the next five pieces were commissioned from the Middelburg workshop of the De Maeght family. The persecution of reformers in the southern Netherlands resulted in a steady stream of weavers migrating to the north after the fall of Antwerp in 1585. One of them was Jan de Maeght (ca. 1530–1598), a Brussels weaver who first worked in Delft but set up a workshop in Middelburg in 1593. We find his name in the accounts of the States of Zeeland a number of times. Not only was he paid for the production of two tapestries from the Zeeland series (*Battle of Rammekens* and *Battle of Lillo*), but the States also rented tapestries from this weaver in 1596–97 and paid him 180 Flemish pounds for unspecified pieces in 1598.[11] After his death his son Hendrick (d. 1603) continued the workshop. He was responsible for the weaving of the remaining tapestries from the Zeeland series. Only the *Battle of Rammekens* is signed by Jan de Maeght; the other pieces bear no marks.

The weaving of the *Siege of Zierikzee* must have begun early in 1600. The exact moment of completion is not known. As the hanging system was adapted in the reception room of the Prinsenlogement that summer to ensure the windows could be opened when all the tapestries were hung, it was probably finished by the end of that year.[12] It was certainly completed in September 1604, when the final payments for the series were made. The cost of the *Siege of Zierikzee* amounted to 98 pounds, 5 shillings Flemish, basing the cost of the weaving on 3 Flemish pounds per ell (one ell is approximately 68.58 cm).[13] The only other known work by the workshop of the De Maeght family is the *Last Fight of the Revenge*, a tapestry made for Thomas Howard, first Earl of Suffolk, in 1598 depicting a naval battle between seven English vessels and the Spanish treasure fleet in 1591.[14]

KATIE HEYNING

1. For an overview, see Parker 1977.
2. Gachard 1848–1936, vol. 4, pp. 562ff.
3. Van Swigchem and Ploos van Amstel 1991, pp. 115.
4. Zeeuws Archief (hereafter ZA), Middelburg, Rekenkamer C, inv. 6858. Many are published in Van Ysselsteyn 1936, vol. 2, pp. 61–73. For Vroom, see Russell 1983.
5. Hartkamp-Jonxis in Hartkamp-Jonxis and Smit 2004, p. 185.
6. This set was destroyed by fire in 1834.
7. Kinds 1999, vol. 1, p. 127.
8. Horn 1989, p. 294.
9. Hartkamp-Jonxis in Hartkamp-Jonxis and Smit 2004, p. 185.
10. Russell 1983, p. 142.
11. ZA, Rekenkamer C, inv. 240 fol. 407, inv. 260 fol. 336.
12. ZA, Rekenkamer C, inv. 6335.
13. ZA, Rekenkamer C, inv. 6858.
14. Russell in Greenwich–Ulster 1988, p. 279, no. 16.23; Van den Donk 1994.

6.

Surprise Attack on Calais

First panel of a seven-piece set of the *Battles of the Archduke Albert*
Design by Otto van Veen, 1597; cartoons painted by Jan Snellinck the Elder, 1597–99
Woven in the workshop of Maarten Reymbouts II, Brussels, 1597–99
Silk, wool, and silver and gilt-metal wrapped thread
355 x 603 cm (11 ft. 7 ¾ in. x 19 ft. 9 ½ in.)
9–10 warps per cm
Weaver's mark of Maarten Reymbouts II at bottom of right selvage
Patrimonio Nacional, Palacio Real, Madrid
(TA-46/1 10005712)

PROVENANCE: 1597, the magistrate of the City of Antwerp commissioned the set from Otto van Veen (designs), Jan Snellinck the Elder (cartoons), and Maarten Reymbouts II (weaving); 1599, set presented to Archdukes Albert and Isabella on the occasion of their Joyous Entry into Antwerp as the new governors of the Spanish Netherlands; either given by Archduke Albert to Philip III, before 1621, or sent to Madrid at Philip IV's request after the death of Archduchess Isabella in 1633; 1666, listed in the inventory of the royal tapestry collection of Philip IV in the Alcázar, Madrid; 1700, listed in the testamentary inventory of Charles II; 1702, restored in the Alcázar under the direction of the head of the Oficio de la Real Tapicería; 1746, listed in the testamentary inventory of Philip V; 1750, restored in the Real Fábrica de Tapices, Madrid, under the direction of Francisco Vandergoten; 1788, listed in the testamentary inventory of Charles III; 1834, listed in the testamentary inventory of Ferdinand VII; 1878, exhibited at the Exposition Universelle, Paris;[1] 1880, set listed as number 46 in the first historical register of the tapestries in the Palacio Real de Madrid;[2] 1919, four pieces (*Assault on Calais, Retreat of the Ardres Garrison, Assault on Hulst*, and *Capture of Hulst*) sent to the apartment of the princess of Asturias in the Palacio Real, while the remaining three (*Surprise Attack on Calais, Battle in the Trenches of Hulst*, and *Assault on Ardres*) decorated the Real Armería; 1945, the four panels in the Palacio Real sent to the Despacho Oficial (office) of Francisco Franco in the Palacio Real de El Pardo, where they remain; the three panels from the Real Armería are now in the Palacio Real de Madrid.

REFERENCES: Bochius 1602, pp. 312–13; Wauters 1878, p. 296; Van den Branden 1883, pp. 406–8; Haberditzl 1907–9, p. 204; Kervyn de Lettenhove 1909, pp. 62–64, 79; Geudens 1911, pp. 136–38; Hunter 1912, p. 377; Tormo Monzó and Sánchez Cantón 1919, pp. 117–19; Calvert 1921, pls. 176–80; Göbel 1923, pp. 208, 423; Villalobar 1925, p. 46; De Maeyer 1955b; D. Heinz 1963, p. 226; Junquera de Vega and Díaz Gallegos 1986, pp. 19–26, 306; Herrero

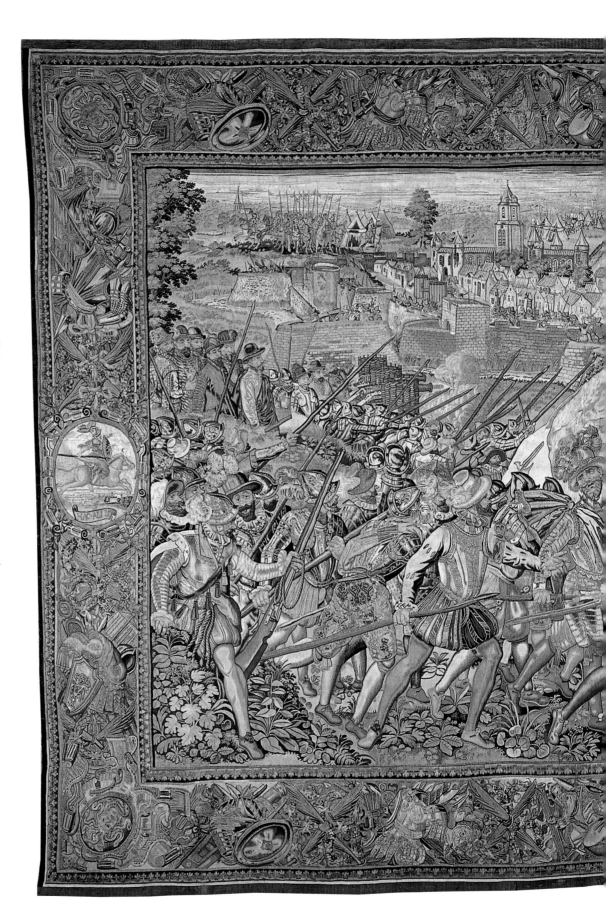

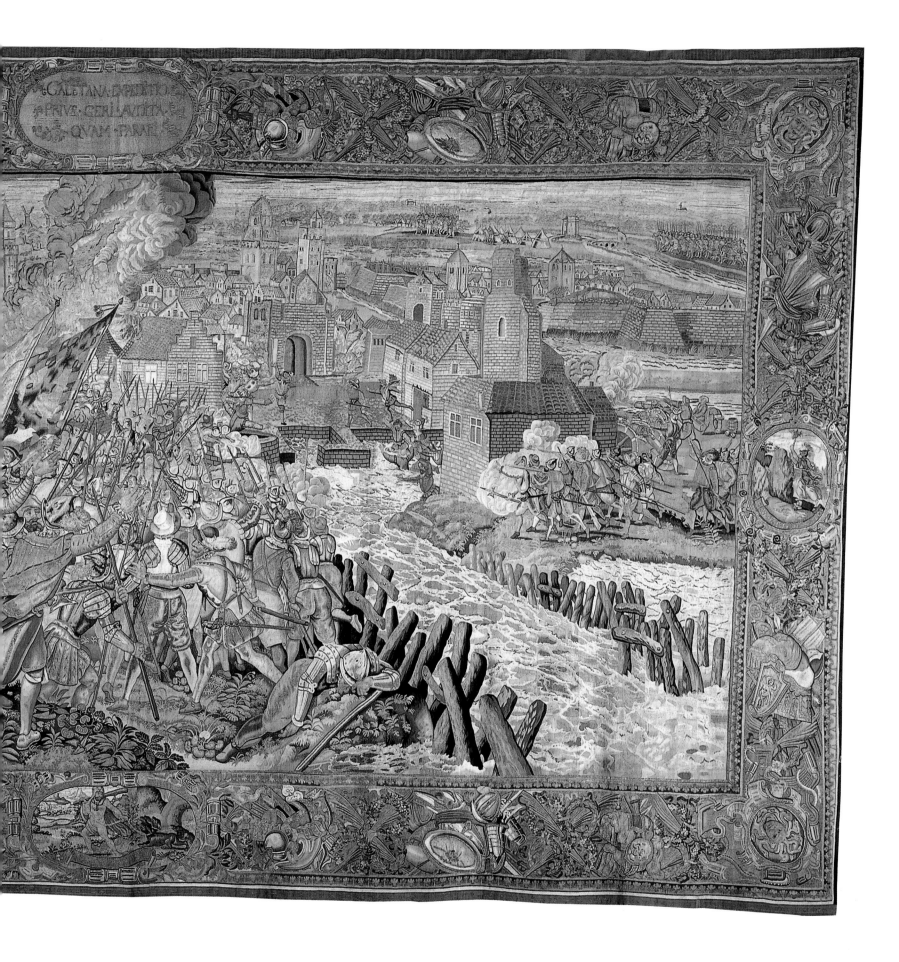

Detail of cat. no. 6

Carretero 1992–93, vol. 1, pt. 2, pp. 454–55; Herrero Carretero 1994; Herrero Carretero in Amsterdam 1998, pp. 83–84, no. 49; Delmarcel 1999a, pp. 222, 369; Herrero Carretero 1999, pp. 104, 105.

E mulating the ambitious propaganda schemes of some of the greatest Brussels tapestry sets made for Charles V during the second third of the sixteenth century—such as the *Battle of Pavia* and the *Conquest of Tunis*— the seven-piece set from which this panel derives celebrated the military achievements

of Archduke Albert, governor general of the Spanish Netherlands. The set was presented to Albert in 1599 on the occasion of his Joyous Entry into Antwerp with his new bride, Infanta Isabella Clara Eugenia (1566–1633), daughter of King Philip II of Spain. The Joyous Entry is described and illustrated in *Historica narratio profectionis et inaugurationis Serenissimorum Belgii Principum Alberti et Isabellae, Austriae Archiducum* (Antwerp, 1602), by Joannes Bochius, secretary of that city.[3] After his account of the decorations and spectacle of the entry, Bochius went on to describe how the city presented Archduke

Albert with a set of seven tapestries illustrating his military achievements.[4] Bochius included transcriptions of the inscriptions decorating the tapestries. These correspond, with some minor differences, to those on the seven tapestries of the *Battles of the Archduke Albert* now in the Spanish royal collection. In 1955 Belgian historian Marcel de Maeyer published references from the civic account books in Antwerp city archives that reveal the chronology of the city magistrate's commission of the tapestries, from the designs by Otto van Veen (1556–1629) and cartoons painted by Jan Snellinck the Elder (ca. 1549–1638) to the

weaving in the workshop of Maarten Reymbouts II (fl. 1576–1618).[5] In addition, De Maeyer drew attention to an anonymous eyewitness account of the presentation of the tapestries to the archduke and archduchess. On Wednesday, December 15, 1599, after a few days' delayed preparations, "It also happened in the Tapestry Pand where their Majesties were the other day, being Wednesday, that, in the evening around five o'clock, the magistrate's representatives, with the said pensionary Schotti as spokesman, presented to them the said gifts, being seven pieces of tapestry of gold and silk, representing the victories of the said lord Archduke, at Calais, Ardres and Hulst."[6]

Subject and Description

The siege of Calais was Archduke Albert's first military campaign soon after he became governor of the Low Countries for the Spanish monarchy in 1595. This seaport, strategically located at the narrowest point (the Pas de Calais, or Straits of Dover) of the English Channel, had been under French control since 1558. The town surrendered to Albert's troops, after a surprise attack, on April 17, 1596, and eight days later the castle was taken. This victory is represented in the first two panels of the tapestry series, which commemorated the triumphs of Albert over King Henry IV of France in Picardy: the *Surprise Attack on Calais* (the largest of the set) and the *Assault on Calais*.[7] The next two panels represent the Archduke's attack on Ardres, a town near Calais, and that town's capitulation on May 23, 1596.[8] The other three panels of the set are dedicated to Albert's victory against the Dutch Republic with aspects of the battle for the stronghold of Hulst, a fortress in the province of Zeeland, which took place in August 1596.[9]

The surviving record of payment to Van Veen in the Antwerp city archives for his designs for the tapestries specifically mentioned that he was also to provide "representations of particular faces from life."[10] In the *Surprise Attack on Calais*, it is not certain who the central figure, with the red sash and blue-plumed red hat among the soldiers in the foreground, is meant to represent. This figure, urging the Spanish troops toward the edge of the canal, might be Archduke Albert himself; his generic appearance corresponds with surviving portraits of the archduke painted by Otto

van Veen.[11] Alternatively, this figure's active role in the midst of the battle might be more appropriate for Don Luis de Velasco, count of Salazar, who was ordered by Archduke Albert to direct the three companies of Spanish infantry that assaulted Calais. If this were so, the archduke might be identified as the observing commander, also in red, baton in hand, standing to the left of the scene and overseeing the actions of the troops.

The main body of infantry—standard bearers, lancers, and musketeers—is shown in the foreground at the port next to the palings constructed to delimit the canal, which was opened and closed like a moat to flood the perimeter of the fortress. On the right are a large tower next to the arch leading into the stronghold and another tower called the Old Fortress. In the distance are the walls and houses of the town, with fortified towers and church spires poking up through the smoke caused by the charge that opened a breach in the wall on April 15, 1596. The cavalry is represented in the far distance to the left and right of the city, facing the road leading from Gravelines and near Nullet Bridge.

The borders of all seven tapestries in the set are crowded with war trophies interspersed with victory palms, maces, and clubs. In the corners are medallions with Medusa heads. Each tapestry bears a cartouche in the center of its upper border with a description in Latin of the scene below. The cartouche at the top of the *Surprise Attack on Calais* reads, in gold letters on a blue ground, CALETANA EXPEDITIO / PRIUS GERI AUDITAT / QUAM PARARI (The campaign against Calais is ordered to be carried out earlier than planned).[12] The cartouches in the side and lower borders contain emblems, battle scenes, and mythological allusions as commentaries to Albert's deeds in the main scene. In the lower border of catalogue number 6, Hercules, heroic paragon and personification of princely virtues, undertakes his twelfth labor, the capture of Cerberus, the three-headed dog guarding the entrance to Hades. Beneath is a phylactery with the inscription NON IANITOR ORGI TERRVIT (The guardian of the Underworld does not frighten him).[13] The cartouche in the left border shows a horseman, whom Bochius identified as Pallas riding Pegasus, above the inscription HAC ALITE (Swift like this). In the right border, a woman

bearing a fiery torch, described by Bochius as a Virtue, appears above the legend HAUD FATO SED FACTO (Not said but done, or No sooner said than done). Reymbouts's monogram is woven into the right-hand selvage.

The Artists

Archduke Albert's military achievements at Calais, Ardres, and Hulst provided ample iconographic fodder for the ephemeral artworks created to welcome him by southern Netherlandish towns and were frequently alluded to in one form or another at numerous Joyous Entries, including those at Mechelen, Leuven, and Ghent, either in valedictory speeches or as inscriptions crowning temporary triumphal arches.[14] The Antwerp magistrate chose to celebrate the archduke's victories in the more permanent and considerably more sumptuous medium of tapestry, to be ceremoniously presented to the archduke and the infanta during their visit to the town. The plans to create the tapestry set are first recorded in the city archives in the payment to Otto van Veen on November 3, 1597, of 650 guilders for the "design of the cartoons of the tapestries . . . which will be presented to His Highness by the town."[15]

The artist whom the magistrates chose to provide the designs was well-suited to the task. A fervent Catholic and supporter of the Spanish Crown, Otto van Veen was born in Leiden and studied in Rome during 1575–80, where he Latinized his name as Octavius Vaenius.[16] After having worked as artist-engineer of the royal armies and painter to the court in Brussels for Alessandro Farnese, duke of Parma and governor of the Spanish Netherlands, Van Veen moved to Antwerp after Farnese's death in 1592. In 1593 he was named a master in the Guild of Saint Luke. Aided by a large workshop that employed many pupils, including Rubens between 1594 and 1600, Van Veen undertook numerous commissions for altarpieces for the guild and confraternity chapels in Antwerp Cathedral. He simultaneously built up a reputation as a painter of contemporary battle scenes and portraits.[17] In addition to the *Battles of the Archduke Albert*, in 1597 he was also commissioned by the magistrate of Antwerp to design the triumphal arches to decorate the route of the Joyous Entry of Archdukes Albert and Isabella.[18]

Detail of cat. no. 6

Van Veen's designs were painted as full-size cartoons by Jan Snellinck the Elder. References to two payments to Snellinck survive in the account books in the city archives: in December 1597, Snellinck received 659 guilders "for the painting of cartoons of certain tapestries"; in March 1599, he received the final payment of 159 guilders for the painting of further cartoons, 129½ ells at 6 guilders the ell, "to be used for the tapestries for His Highness."[19] Although little is known about Snellinck, Karel van Mander referred to him in his account of the life of Otto van Veen in *Het Schilder-boeck.*[20] Van Mander recounted that Snellinck, born in Mechelen, was "amazingly ingenious in histories and in

making battle scenes" and had "received commissions for these from lords or princes and has painted various Netherlandish battles and events in which he depicts canon smoke very truthfully with the soldiers enveloped by it and hazily visible."[21]

Unfortunately, none of the preparatory drawings or cartoons are known to have survived. The cartoons were offered to Archduke Albert along with the tapestries. They were kept in the palace in Brussels and are included, described by subject matter, in surviving inventories of the painting collection drawn up between 1633 and 1650, in 1659, and between 1665 and 1670.[22] Three of the cartoons were destroyed and the other four very

badly damaged during the fire at the palace in February 1731; all further trace of the four that survived the fire has been lost.

Weaver

The magistrate of Antwerp had already drawn up a contract with a master weaver to produce the seven-piece set before Van Veen had been paid for his designs. On October 23, 1597, Maarten Reymbouts II (also known as Reynbouts) had agreed to undertake the weaving of the tapestries within his workshop in Brussels. In November 1597 he received 4,000 guilders; two years later, in November 1599, he received a further 1,588 pounds, 14 shillings for the production and delivery of

the seven tapestries, woven with gold, toward a total payment of 11,750 pounds.[23] In addition, Reymbouts was paid 428 pounds, 2 shillings for his expenses toward the cartoons for these tapestries. Since Snellinck had already been paid by the town, De Maeyer suggested that this might have been payment for separate cartoons for the borders that Reymbouts could have supplied, or for amendments Reymbouts might have found necessary to have done to Snellinck's finished cartoons.[24] Reymbouts's monogram is woven into the borders of five panels in the set.

Since Snellinck only received his final payment in early 1599, it is likely that Reymbouts's workshop was weaving simultaneously to Snellinck's production of the cartoons, with the Antwerp painter passing on each cartoon to the Brussels weavers as soon as it was finished, before embarking on the painting of the next cartoon. In ensuing years, Reymbouts, as well as Willem Tons, Jan Raes, and Catherine van den Eynde, furnished tapestries for the court of the archduke. According to payments made to him by accountant Christophe Godin between 1609 and 1615, Reymbouts delivered to the archduke six panels of the *Triumphs of Petrarch*, three of the *Galleries of Pomona*, and eight of the *Story of the Trojan War*.[25]

History of the Set

The first record of the seven-piece set of the *Battles of the Archduke Albert* in the Spanish royal collection is in the "Inventario y tasación de las Tapisería de Su Majestad el Señor Rey Don Felipe IV" of 1666, in which the set is valued at 6,700 reals of billon.[26] Having arrived in Madrid either as a gift from Archduke Albert to Philip III (r. 1598–1621) before 1621, or claimed by Philip IV from the estate of Archduchess Isabella after her death in 1633,[27] the tapestries remained in the Spanish royal collection and can be found, with valuations, in subsequent royal inventories.[28] The *Battles of the Archduke Albert* were clearly among the tapestries most highly prized by the kings themselves: during the reign of Philip IV this set decorated the

Cámara del Rey in the Alcázar of Madrid; Charles II took them with him on trips to Aragón and Burgos, and Philip V, at the beginning of his reign, had them installed in the lower apartments of the Alcázar "where His Majesty could see them."[29]

CONCHA HERRERO CARRETERO

1. Vaillant 1884, p. 68.
2. Juan Crooke y Navarrot, conde de Valencia de Don Juan, and Paulino Saviron y Esteban, "Inventario y registro histórico de las Tapicerías de la Corona existentes en el Real Palacio de Madrid en el año de 1880," Archivo del Servicio de Tesoro Artístico e Inventarios del Patrimonio Nacional, Madrid.
3. Bochius 1602, pp. 171–310.
4. Ibid., pp. 312–13.
5. De Maeyer 1955b, nos. 1–5.
6. "Desgelycx is gebeurt inden Tapisserierspandt, alwaer hunne Hoocheden hun gevonden hebben 't sanderdaegs, wesende woonsdage, hebbende dye vanden Magistraet, 'tsavonds ontrent den vijffven, door monde vanden voors. pensionaris Schotti, gepresenteert henne voors. gifte, geweest synde seven stucken tapisserye van gout ende syde, inhoudende de victorien vanden voors. heere Eertshertoch, soo te Cales, Ardres als Hulst"; De Maeyer 1955b, no. 6. The English translation is by Elizabeth Cleland.
7. *Assault on Calais*, 348 by 463 cm, Patrimonio Nacional, Palacio de El Pardo (TA-46/2 10072268).
8. *Nocturnal Assault on Ardres*, 356 by 397 cm, Patrimonio Nacional, Palacio Real de Madrid (TA-46/3 10005714); *Retreat to France of the Ardres Garrison*, 362 by 325 cm, Patrimonio Nacional, Palacio de El Pardo, Madrid (TA-46/4 10072269).
9. *Battle in the Trenches of Hulst*, 350 by 398 cm, Patrimonio Nacional, Palacio Real de Madrid (TA-46/5 10005713); *Assault on Hulst*, 349 by 394 cm, Patrimonio Nacional, Palacio de El Pardo, Madrid (TA-46/6 10072267); *Capture of Hulst*, 357 by 529 cm, Patrimonio Nacional, Palacio de El Pardo, Madrid (TA-46/7 10072270).
10. "[S]tellen van sekere troniën nae het leven"; Antwerp City Archives, Collegiaal Actenboek, 1597–1599, fol. 48v; published in Van den Branden 1883, pp. 406–7, and De Maeyer 1955b, no. 1.
11. For example, in the Musées Royaux des Beaux-Arts de Belgique, Brussels, inv. 319 and 3291; the former is illustrated in Miedema's commentary in Van Mander 1604/1994–99, vol. 6, fig. 42.
12. Bochius 1602, p. 312 wrote AUDITA. The English translation is by Elizabeth Cleland.
13. Bochius's transcription uses the more forceful NEC (Not even the guardian of the underworld frightens him).
14. For references to the battles during Joyous Entries, see Bochius 1602, pp. 147–48 (Leuven), 169 (Mechelen), 336 (Ghent).
15. "[P]rojecteren van den patroon van de tapisserye … daermede Syn Hoocheyt van der stadts wegen sal worden beschoncken"; Antwerp City Archives, Collegiaal Actenboek, 1597–1599, fol. 48v; published in Van den Branden 1883, pp. 406–7, and De Maeyer 1955b, no. 1.
16. See Van Mander 1604, fols. 295r–v; Larsen 1985, pp. 58–60; Cologne–Antwerp–Vienna 1992, pp. 320–21; and Miedema's commentaries in Van Mander 1604/1994–99,

vol. 6, pp. 53–58 (with bibliography).
17. De Maeyer 1955b, p. 108; Miedema in Van Mander 1604/1994–99, vol. 6, p. 57.
18. Haberditzl 1907–9, p. 204. For the iconography of the Antwerp Joyous Entry, see Thøfner 1999.
19. "[V]an het schilderen van den patroon van sekere tapisserye"; Antwerp City Archives, Collegiaal Actenboek, 1597–1599, fol. 69v, published in De Maeyer 1955b, no. 3. "[D]ienende totte tapisserye van Syne Hoocheyt"; Antwerp City Archives, Collegiaal Actenboek, 1597–1599, fol. 209, published in De Maeyer 1955b, no. 4.
20. Van Mander 1604, fol. 295r.
21. "[W]onder fraey van historien en te maken bataillien"; "van den Heeren oft Princen daer toe … ghebruyckt gheweest en heeft gheschildert verscheyden Nederlandtsche Slaghen en gheschiednissen seer eyghentlijck die roocken des geschuts met t'krijghvolck daer in bewolckt oft bedommelt uytbeeldende"; ibid.
22. De Maeyer 1955b, p. 107.
23. Antwerp City Archives, Collegiaal Actenboek, 1597–1599, fol. 48v, published in De Maeyer 1955b, no. 2; Antwerp City Archives, Privilegiekamer, Account book of the Joyous Entry kept by Thomas Anraet, pt. 2, 3c., fol. 6, published in De Maeyer 1955b, no. 5.
24. De Maeyer 1955b, p. 108.
25. Archives Départementals du Nord, Lille, inv. B2836, 2848, 2866, 2872. These references were kindly provided to me by Professor Werner Thomas of the Katholieke Universiteit Leuven. Partly published in Tormo Monzó and Sánchez Cantón 1919, p. 118, and Saintenoy 1932–35, vol. 3, pp. 40–44.
26. "Otra tapicería de oro, plata, seda y lana, de siete paños de las *Batallas y sitios de los triunfos del Archiduque Alberto*, de cinco anas de caída, que el primero, número uno, corre de largo ocho anas y dos tercias y cinco de caída, tiene cuarenta y tres anas y una tercia. Número dos corre siete anas y media, tiene treinta y tres anas y media. Número tres corre cinco anas tres cuartas, tiene veinte y ocho anas y tres cuartas. Número cuatro corre cuatro anas y tres cuartas, tiene siete anas y tres cuartas. Número cinco corre seis anas y media, tiene treinta y dos anas y media. Número seis corre cinco anas y media, tiene veinte y siete anas y media. Número siete y último de esta tapicería, corre cinco anas y tres cuartas, tiene veinte y ocho anas y tres cuartas, y todos siete paños doscientas veinte y dos anas y una sesma, forrados en la misma forma [en bocací negro, con sus cinchas largas para atar], que a trescientos reales de vellón cada ana monta sesenta y seis mil seiscientos reales de vellón"; Archivo General de Palacio, Madrid, Oficios, file 919, fols. 12–13.
27. Kervyn de Lettenhove (1909, p. 79), Tormo Monzó and Sánchez Cantón (1919, p. 119), De Maeyer (1955b, pp. 106–7), and Junquera de Vega and Díaz Gallegos (1986, p. 19) proposed that the archduke gifted them to Philip III; Herrero Carretero (1999, p. 105) suggested that they were among Isabella's tapestries that were claimed by Philip IV after her death. For Philip IV's use of Isabella's tapestries, see J. Brown and Elliott 2003, p. 108.
28. The inventories are in the Archivo General de Palacio, Madrid, registries 240–42, 247 (1747–48), 259 (1788, pt. 3, fol. 227v), 4807 (1834, pt. 1, fol. 202v); see also Fernández Bayton 1975, p. 250.
29. "[P]ara que su Majestad la viese hacer." For the Spanish royal tapestry collection under Philip IV, Charles II, and Philip V, see Herrero Carretero 1999, pp. 105–9.

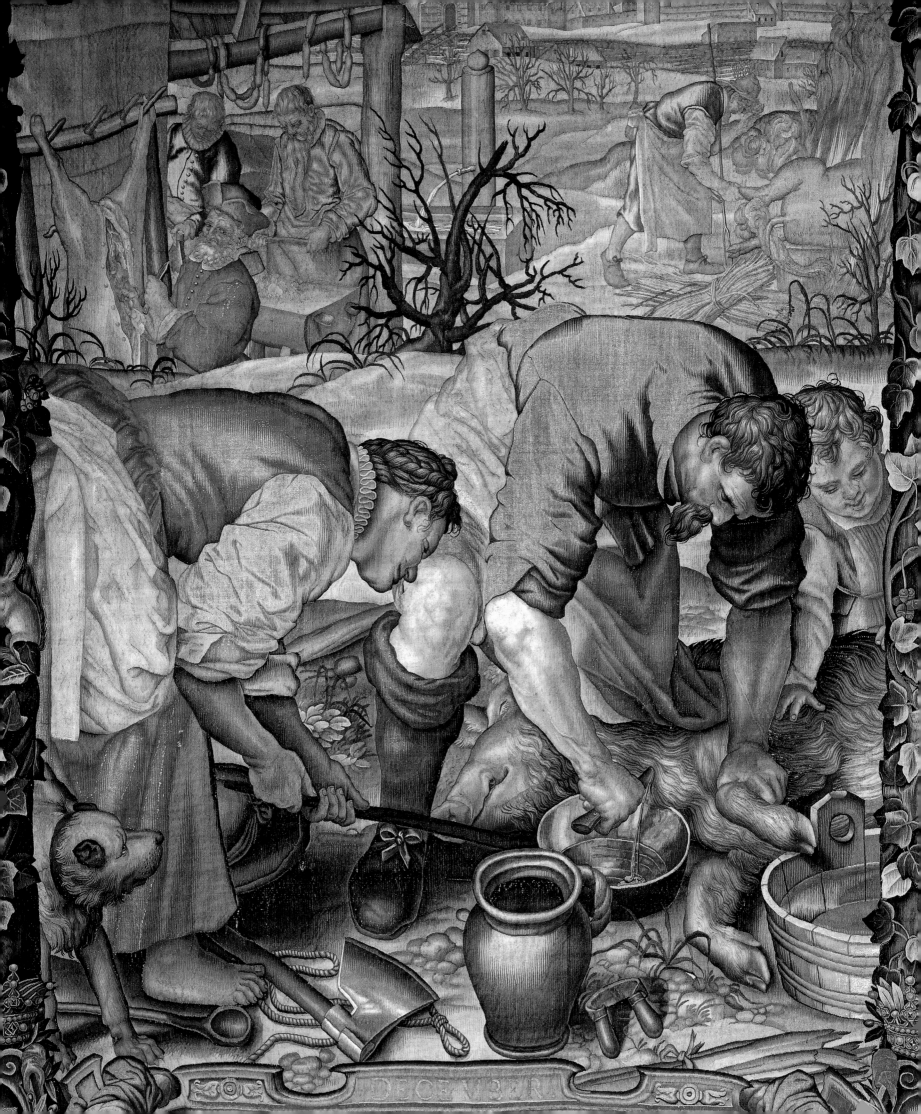

DECEMBER

New Centers of Production and the Recovery of the Netherlandish Tapestry Industry, 1600–1620

THOMAS P. CAMPBELL

The events that had devastated the economy of the southern Netherlands during the last quarter of the sixteenth century gradually relented around 1600. In accordance with the terms of the 1598 Treaty of Vervins with France, Philip had ceded the Spanish Netherlands to his daughter Isabella and her husband, Archduke Albert of Austria. Although Albert brought new vigor to the conflict with the United Provinces, the war had now reached something of an impasse. On July 2, 1600, the States-General defeated the Spanish army at the Battle of Nieuwpoort, but they failed to take Dunkirk, their objective. Thereafter, Duke Albert mounted the siege of Oostend, the fortified port from which the Dutch were launching attacks on the Spanish fleet. While the siege was to last for three years and was to be infamous for its bloodiness, it had the merit of localizing the conflict, providing something of a respite to the rest of the Low Countries. The geopolitical pressure on the Netherlands was further reduced with the death of Queen Elizabeth I in 1603 and the Treaty of London between England and Spain was signed at Somerset House in August 1604.

The reduction in hostilities between the southern Netherlands and its neighbors between 1598 and 1604 created the conditions that allowed the tapestry industry to recover. But after three decades of civil war the industry was in an enfeebled state, depleted by the migration of skilled weavers and artists to new centers and the disruption of the long-standing relationships between rich financiers and tapestry entrepreneurs that had facilitated the great products of the sixteenth century. The effective monopoly that the southern Netherlands had hitherto enjoyed over high-quality and large-volume production was destroyed, and the industry was now vulnerable to competition as never before. During the following years, the more prescient and richer European rulers sought to capitalize on this situation.

Competition from Paris

The example of competition was set by the French king, Henry IV. As early as 1583, when still king of Navarre, Henry had considered establishing a workshop of Calvinist weavers in the Béarn.[1] This project was never realized, but after his accession to the French Crown in 1594 he took steps to invigorate workshops already existing in Paris, such as that of Maurice Dubout (d. 1611), as part of his efforts to revive the national economy after the religious wars that had recently ravaged the country.[2] In 1600 he actively encouraged Flemish weavers to resettle in France, and in January 1601 two master weavers—Marc de Comans (1563–1644) of Antwerp and his brother-in-law Frans van der Plancken (1573–1627) of Oudenaarde, later known as François de La Planche—agreed to settle in Paris and to establish a manufactory. At the same time, Henry introduced legislation to ban the importation of foreign tapestries, giving the existing French workshops an enormous trade advantage.[3] The ambitious scale of Henry's vision is reflected by the royal charter issued to Comans and de La Planche in 1607, when it was agreed that they would maintain sixty looms in Paris at the Hôtel des Gobelins in the Faubourg Saint Marcel and twenty more in Amiens. An important part of Henry's intentions related to the training of native workers. According to the contract, the Flemings were to take twenty-five apprentice weavers in the first year and twenty in each subsequent year, thus developing a sizable native workforce. In return, the king granted that no comparably sized manufactory could be established in France for fifteen years, and the Flemings received promises of subsidies and exemptions from duty on various goods, including the right to brew and sell their own beer. Comans and de la Planche were also ennobled.[4]

As with all of the new manufactories created in this period, the first challenge was to find appropriate cartoons and, as was

Fig. 31. *The Reception of the Greek Embassy* from a set of the *Story of Otto von Wittelsbach.* Tapestry design and cartoon by Peter Candid, woven in the workshop of Hans van der Biest, Munich, 1612–14. Wool, silk, and gilt-metal-wrapped thread, 407 x 628 cm. Residenz Museum, Munich (W2)

also frequently the case, the first recourse was to designs created in the previous century. In this instance, the workshops utilized cartoons based on a series of pen and wash drawings of the *Story of Artemisia* that had been created by Antoine Caron (fig. 74) to illustrate a text written for Catherine de' Medici in the 1560s by the apothecary Nicolas Houel. In celebrating Artemisia's extravagant mourning for her husband, Mausolus, and her efforts to educate her son, Lygdamus, the sequence provided a flattering comparison for Catherine and her second son, Charles IX, after the death of, respectively, her husband, Henry II (d. 1559), and her eldest son, Francis II (d. 1560). The whole scheme was created with an eye to possible use as a series of tapestry designs, but perhaps because of political circumstances, it was never elaborated as such for Catherine. When the scheme was revived in the early 1600s, the cartoons were prepared by several Paris artists, including Henri Lerambert and Laurent Guyot. During the early 1600s, Lerambert, Guyot, Toussaint Dubreuil, and others created new cartoon series. Some, such as the *Story of Diana* (cat. no. 13) and the pastoral *Gombaut*

and Macée (fig. 63), were based in whole or part on mid-sixteenth-century designs; others, such as the *Story of Coriolanus,* the *Story of Pastor Fido,* and the *Story of Astrée,* were new conceptions (see Isabelle Denis, "The Parisian Workshops, 1590–1650"). Henry IV was an enthusiastic patron of the new workshops and encouraged others to follow his example. When Maffeo Barberini, later Pope Urban VIII, commissioned tapestries in Paris on behalf of Cardinal Alessandro Peretti Montalto in 1607, Henry IV visited the workshop and enjoined the workers to satisfy the cardinal as quickly as possible, without neglecting his own commissions, of course, because it was important that the king's artisans should have the reputation in Italy of doing good work.[5]

Weaving in Munich

The unprecedented scale of Henry IV's initiative in Paris provided an example that other European rulers were quick to follow. In 1604 the elector of Bavaria, Duke Maximilian I (r. 1597–1651), established a workshop in Munich under the

Fig. 32. *December* from a set of the *Months, Seasons, and Times of the Day*. Tapestry design by Peter Candid, woven in the workshop of Hans van der Biest, Munich, 1612–13. Wool, silk, and gilt-metal-wrapped thread, 406 x 519 cm. Residenz Museum, Munich (W29)

direction of a master weaver from Enghien, Hans van der Biest (fl. 1604–before 1618).[6] Whereas the Paris workshops were established to compete with the Flemish industry, Maximilian's ambitions were more modest and, as an ally of the archdukes, he negotiated permission for the migration of the Flemish weavers he required. The idea of establishing a workshop in Munich was not new. Maximilian's grandfather Albrecht V had tried to persuade a group of Antwerp weavers to relocate to that city in the early 1560s, but without success. An additional factor in Maximilian's thinking may have been an awareness of the achievements of the Medici workshops, because the Bavarian court artist, Pieter de Witte (ca. 1548–1628), called Pietro Candido or, north of the Alps, Peter Candid, had trained in the workshop of Giorgio Vasari, having moved to Florence at the age of ten with his father, who was a weaver from Bruges. Candid must therefore have been familiar with the tapestry designs that Vasari, along with Jan van der Straet (known as Joannes Stradanus and, in Italy, Giovanni Stradano; 1523–1605), and Alessandro Allori (1535–1607), provided for the Medici

palaces during the 1570s and early 1580s. In 1586, at the behest of Maximilian's father, Wilhelm V, Candid moved from Florence to the Bavarian court, where he was charged with a wide range of design tasks. When the Munich tapestry workshop was founded, designs for that became his main focus, and between 1604 and 1615 he provided modelli and cartoons for a number of decorative, genre, and historical series destined for the ducal palace. These included a set of the *Months, Seasons, and Times of the Day* (figs. 30, 32; cat. no. 8) and another of the *Story of Otto von Wittelsbach* (figs. 31, 33), the founder of the Bavarian dynasty. Candid's compositions look back to those of the great sixteenth-century designers like Bernaert van Orley and Michiel Coxcie, featuring friezelike arrangements of beautifully drawn, large, dramatic figures in the foreground, with subsidiary narrative scenes filling the middle ground and distance. The visual interest of the compositions is ensured by the rich costumes, detail of the landscapes, and elaborate decorative borders. Several of the borders were conceived as illusionistic frames, a development of the strapwork and figurative borders created by Stradanus and

Fig. 33. Detail of fig. 31, *The Reception of the Greek Embassy* from a set of the *Story of Otto von Wittelsbach*

tapestry designer at the end of his life, presumably because he was so occupied with literary work, including *Het Schilder-boeck*, his famous biography of antique and contemporary artists, inspired by Vasari's *Vitae*. But his son, Karel II (1579–1623), succeeded to his role as chief artist to the manufactory. Reflecting both the taste of the time and the increasing ambition of contemporary workshops, the series that Karel II conceived between 1605 and 1615, such as the *Story of Orlando Furioso* and the *Story of Scipio* (cat. no. 7), feature much larger figures than his father's designs, but they were still conceived with a shimmering profusion of surface patterning. Many of these tapestries were woven with a high proportion of silk, often dyed in the subtlest colors, to articulate the soft tonality of distant landscapes and the glitter of foreground details. This silk has rarely survived in good condition or color, an unfortunate impediment to appreciation of these tapestries today.

During the early 1600s Spiering tapestries were much in vogue at the Protestant courts as diplomatic gifts. For example, in 1609, on the occasion of the formal entry to Breda of Philips Willem, eldest son of William of Orange, the town authorities presented him with a set of Spiering tapestries depicting scenes from *Orlando Furioso*; the same year, another set was presented to Pierre Jeannin, the French minister of finance who had played an important part in the negotiation of the twelve-year

Allori in their Florentine tapestry designs, which often overlapped the main field. Candid's trompe l'oeil frames anticipate by almost fifteen years innovations that Peter Paul Rubens (1577–1640) was to introduce to Brussels tapestry design in the late 1620s. The quality of Candid's designs is matched by that of the weaving and materials. Indeed, the tapestries produced in Munich by Van der Biest's workshop, which employed approximately twenty weavers at its peak, are equal, if not superior, to anything produced in Brussels or Paris at this period. Van der Biest returned in 1615 to Enghien, where he continued to weave tapestries for Maximilian I.

Continuing Production in Delft

While the workshops in Paris and Munich reflected new initiatives undertaken at the expense of the traditional centers of production in the southern Netherlands, other émigré workshops that had been established earlier continued to prosper. The manufactory of François Spiering in Delft was especially successful, enjoying patronage from a wide range of Protestant courts. Karel van Mander I (1548–1606) was less active as a

Fig. 34. *The Triumph of David* from a pair of the *Story of David*. Tapestry cartoon by David Vinckboons, woven in the workshop of François Spiering, Delft, ca. 1610–20. Wool and silk, 211 x 767 cm. Private collection, London

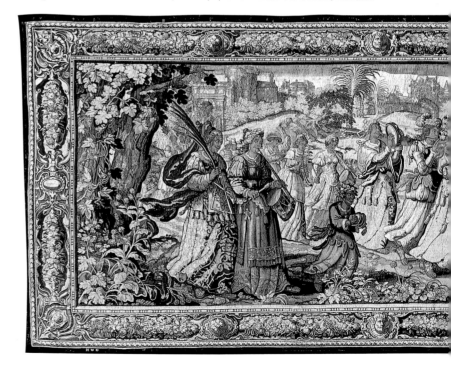

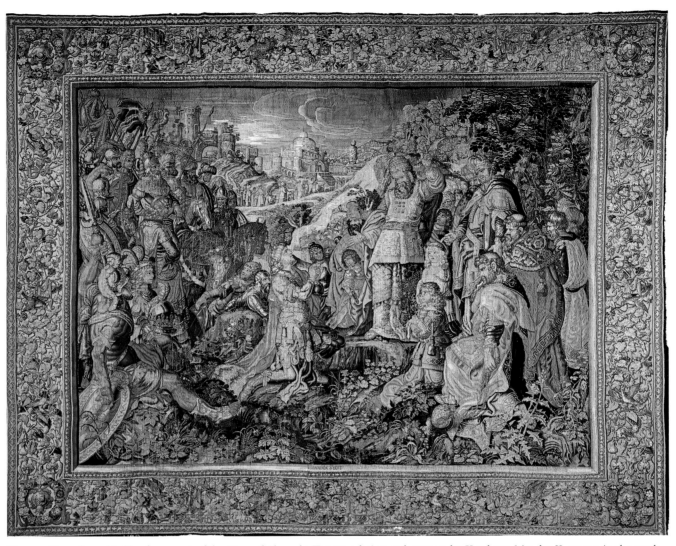

Fig. 35. *Alexander and Jaddua* from a set of the *Story of Alexander*. Tapestry design and cartoon by Karel van Mander II, woven in the work-shop of Karel van Mander II, Delft, ca. 1617/19. Wool and silk, 436 x 520 cm. Rijksmuseum, Amsterdam (BK-1961-52)

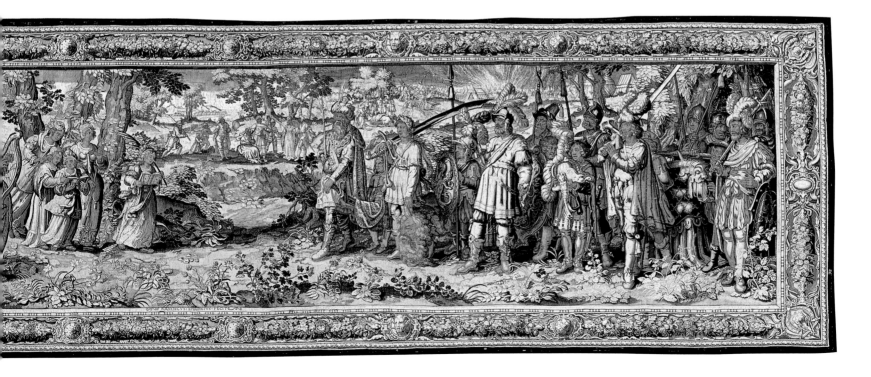

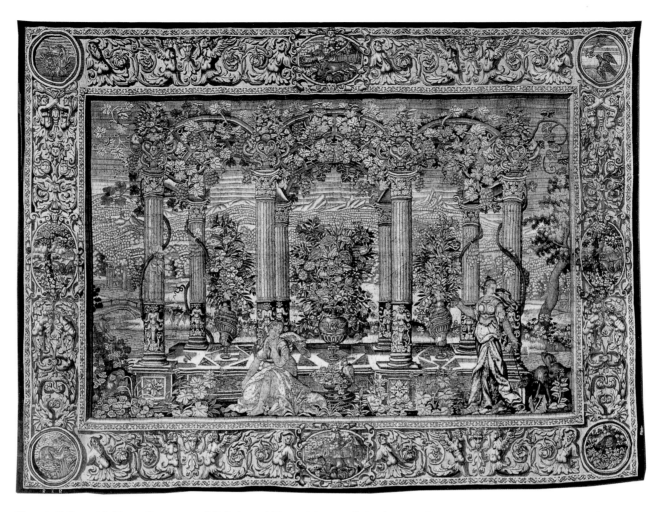

Fig. 36. *Gallery with Figures* from a set of *Galleries and Flowers.* Tapestry design by an unknown artist, woven in an unidentified Brussels workshop, ca. 1600–1610. Wool and silk, 343 x 452 cm. Museum of Fine Arts, Boston, Gift of Caroline Louise Williams French (05.4)

truce between the Catholic and Protestant Netherlands in 1609; in 1610 the States-General took over the cost of a set of *Scipio* tapestries that the English Lord Chamberlain Thomas Howard, Earl of Suffolk, had commissioned (cat. no. 7); in 1613 the States-General presented Spiering sets of the *Story of Scipio* and the *Story of Diana* to Elizabeth Stuart (eldest daughter of James I) on the occasion of her marriage to the Elector Palatine Frederick V; and in 1614 the States-General gave Hali Pasha, Turkish admiral, a set of Spiering *Landscapes.*[7]

The relationship between the Spiering manufactory and the younger Karel van Mander came to an abrupt end in 1615. Furious at the exploitative terms under which he claimed Spiering had forced him to work, and perhaps taking advantage of his knowledge of a large impending order from Christian IV, king of Denmark, Van Mander set up his own workshop in the former convent of Saint Anna, also in Delft, in partnership with the painter Huybert Jacobsz Grimani (1562–ca. 1631), and with funding from Nicolaas Snouckaert van Schauburg (1568–1635).

The first major commission was that received in 1616 from Christian IV for a twenty-six-piece set of the *Danish Wars against the Swedes*, which was to hang in Frederiksborg Castle. Completed four years later, it hung for many years in the ballroom of the castle until it was destroyed by fire in 1859.[8] Van Mander also produced a set of the *Story of Alexander* that was delivered to the Danish king before 1621.[9] During the same years his workshop also produced a design series featuring Scipio.[10] It is unclear whether the *Alexander* (fig. 35) and *Scipio* designs used at the Van Mander workshop had been originally commissioned by the Spiering workshop and then taken by Van Mander when he left. Spiering certainly instituted a lawsuit against his former collaborator, demanding the completion of cartoons of these subjects. Despite the patronage of the Danish court, the Van Mander enterprise was soon in financial difficulties, and in 1621 he had to yield control of the firm to Snouckaert van Schauburg. In 1622 Snouckaert agreed to amalgamate his business with the Spiering enterprise.[11]

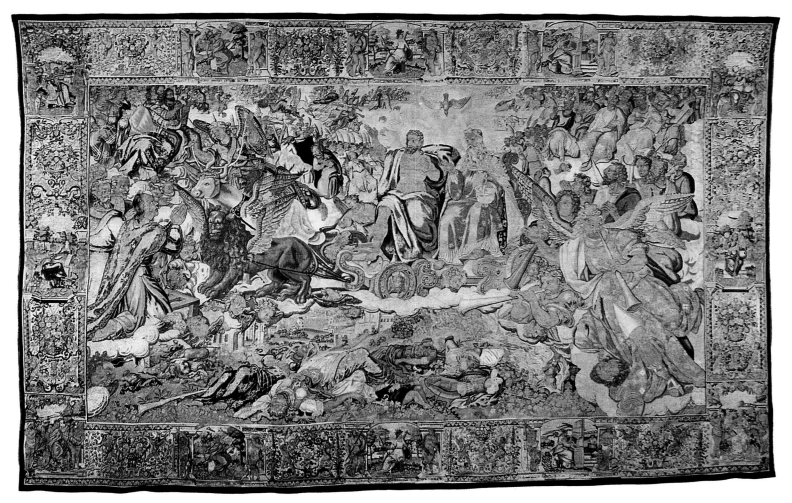

Fig. 37. *The Triumph of Divinity* from a set of the *Triumphs of Petrarch*. Tapestry design by an unknown artist, woven in the workshop of Maarten Reymbouts, Brussels, ca. 1610. Wool and silk, 340 x 530 cm. Location unknown

Van Mander died the following year, in 1623, while still working on the designs for a *Cleopatra* series; it was completed by other artists after his death.[12]

Despite competition from Van Mander, the Spiering manufactory continued to prosper, obtaining designs from other Dutch artists, such as David Vinckboons (1576–1633), who was responsible for the design of two unusually wide panels of the *Story of David* that must have been commissioned for a specific setting, possibly a Dutch town hall or courthouse (fig. 34).[13] Having lost the attention of the Danish court, François Spiering renewed his links with the Swedish court, sending his younger son Pieter to be his agent there. When François retired in 1620, the workshop had a staff of forty weavers. Direction was assumed by his son Aerts, and it was under Aerts that many sets of tapestry wall hangings, horse caparisons, and bedcovers (cat. no. 29) were supplied to King Gustav II Adolph, many of which were subsequently taken to Rome in 1654 by his daughter, Queen Christina, following her abdication.[14]

Revival of the Brussels Tapestry Industry

The rise of a sizable tapestry industry in Paris and the evident success of the workshops in the northern Netherlands spurred a belated attempt by the authorities in the Spanish Netherlands to defend and retrench their own industry in the face of these economic threats. In 1606 the leading tapestry merchants of Brussels, along with several town authorities, petitioned the archdukes Albert and Isabella to protect the reputation and quality of Brussels tapestries and to reinstate the measures that had been introduced in 1544 by Charles V. Among other things, these forbade workshops in other towns to use the BB (Brussels-Brabant) mark on their tapestries or to mix tapestries from different towns in one set. In response, the archdukes ratified an edict issued by Philip II that had itself validated the 1544 edict. In addition, they banned the export of the raw materials required for tapestry making, exempted weavers in Brussels from having to serve in the town guard, and reduced the levy on beer for the weavers. Financial aid was also provided to some of the

Fig. 38. *Noah's Sacrifice* from a set of the *Story of Noah*. Tapestry from a second-generation cartoon by an unidentified artist after Michiel Coxcie's designs, woven in the workshop of Maarten Reymbouts, Brussels, ca. 1600. Wool and silk, 337 x 376 cm. Patrimonio Nacional, Palacio de la Almudaina, Palma de Mallorca (A357-12025)

principal dye merchants, evidently an attempt to ensure the quality of the raw materials on which the tapestry workshops depended.[15] Similar steps were taken in other towns. In Oudenaarde, the local magistrates introduced legislation in 1604 to guarantee the quality of the dyes of the wools and silks used in locally produced tapestries.[16] Then, in 1606, the Oudenaarde authorities introduced legislation that forbade local weavers to move to other centers. The goods of any transgressor were to be confiscated and a fine of one hundred florins imposed on the parents or tutors who allowed him to leave.[17]

In conjunction with these legislative efforts, the archdukes seem to have embarked on a veritable shopping spree, distributing purchases and commissions among the leading Brussels merchants in a way that suggests a concerted effort on the part of the archdukes to aid the workshops. In 1603 they had commissioned a single set of *Grotesques* from the workshop of Jakob Tseraerts, the court tapissier, after designs by Denys van Alsloot, their court artist,[18] but after 1605 they purchased many more sets. From Gerard Bernaerts they bought two sets of *Galleries and Flowers* in 1605 and 1609;[19] from Catherine van den Eynde, widow of Jacques Geubels I (who died in 1605), they acquired a *Story of Joshua* (1605), a *Story of the Trojan War*, and a *Story of Cleopatra* (1607);[20] from Willem Tons, a set of the *Story of Constantine* (1607);[21] and from Maarten Reymbouts, a set of the

Triumphs of Petrarch (1609).[22] Although none of these survives in the Spanish royal collection, an idea of their appearance can be gleaned from pieces that are preserved elsewhere. The *Joshua* and *Trojan War* sets were likely adapted versions of sixteenth-century designs, albeit with modern borders,[23] while the *Galleries and Flowers* tapestries were probably a new series akin to examples in Boston (fig. 36) and elsewhere.[24] Stylized pergolas and flowerpots were very popular in the first half of the seventeenth century, providing a modern counterpart to the ever-popular millefleurs and verdure tapestries of earlier periods. It was a decorative formula that was relatively simple and inexpensive for the Brussels weavers to produce—compared, that is, with designs incorporating large figures or complex narratives. The *Petrarch* series was also a new design, albeit a very traditional tapestry subject, and must have been woven from the same cartoons as various tapestries of this theme with the Reymbouts mark, now dispersed among private collections (fig. 37).[25] The scenes are filled with a profusion of figures, set within decorative borders, but the quality of design is marred by discordances of scale and weaknesses of drawing. The visual coherence of the main scenes is also undermined by the complexity of the subsidiary scenes in the borders. Such weaknesses are typical of many of the new designs that came into use in the very early seventeenth century in Brussels.

Quite apart from the measures that the Brussels authorities were taking during the early 1600s to stimulate local tapestry production, the industry also reaped enormous rewards from the gradual cooling of hostilities with the United Provinces, ratified in the truce of 1609, which lasted for the next twelve years. Members of the English nobility—particularly those who were benefiting from the recent accession of James I—were quick to take advantage of the new opportunities to purchase tapestries from merchants in Antwerp and Brussels. Many of these efforts were directed through the English ambassador to the court of the archdukes, Sir Thomas Edmonds and, from 1609, William Trumbull. For example, as early as 1605–6, Trumbull, then working in Edmonds's embassy, coordinated the delivery to England of sample tapestries and designs for Robert Cecil, Earl of Salisbury, and Thomas Howard, Earl of Suffolk, respectively James I's secretary of state and Lord Chamberlain. The subjects included the *Triumphs of Petrarch*, the *Story of Hannibal*, the *Story of Jacob*, the *Story of Julius Caesar*, the *Labors of Hercules*, and the *Story of the Acts of the Apostles*.[26] Several of these designs can be identified with series woven by the Maarten Reymbouts workshop during the early 1600s, such as the *Triumphs*, already

Fig. 39. *Samson Betrayed by Delilah* from a set of the *Story of Samson*. Tapestry cartoon by an unidentified 16th-century Flemish artist, with borders by an unidentified 17th-century artist, woven in the workshop of Jan Raes, Brussels, ca. 1625. Wool and silk, 396.2 x 670.6 cm. Philadelphia Museum of Art, Gift of Clifford Lewis Jr. (1946-8-1)

discussed in the context of purchases by the archdukes. Three years later, in 1609, Edmonds was involved in bailing out the Countess of Shrewsbury's "tapestry man" after he got into trouble trying to recruit Flemish weavers to set up a workshop in England. Trumbull succeeded Edmonds as ambassador to the archdukes in 1609 and continued to act as a middleman for English nobles who wanted tapestries. In 1612 we find him writing to Viscount Lisle about his efforts to find good tapestries of the very specific dimensions that had been provided to him and his hopes of buying some "excellent olde" tapestries from the estate of the duke of Aerschot.[27] The following year, Lord Darcy also wanted tapestries from this estate.[28] And in 1613 Sir Thomas Wake and Grey Brydges, fifth Baron Chandos, were commissioning tapestries through him.[29] There was evidently a very considerable market for tapestries in Britain during the 1610s, a factor that must have informed the subsequent creation of the Mortlake tapestry works in 1619 (see Wendy Hefford, "The Mortlake Manufactory, 1619–49").

The Market for Old Master Designs

The examples given above of designs acquired by the archdukes and English noblemen during the early 1600s typify the relative clumsiness of the artists and cartoonists from whom the Brussels workshops were obtaining new cartoons. It was perhaps for this reason that at this time both the Brussels workshops and the patrons who were using them seem to have turned increasingly to the old master designs of the mid-sixteenth century. This was, of course, nothing new. The workshops in Brussels and other centers had utilized copies of a number of "old master" series during the 1580s and 1590s. The character of these copies is exemplified by a panel of the *Story of Noah* with the mark of Maarten Reymbouts, one of the leading Brussels workshops, that survives in the Spanish royal collection (fig. 38). The composition and figures are based on those of the series created by Michiel Coxcie in the late 1540s (fig. 14), but the scale of the figures is greatly reduced, and the realistic landscape of Coxcie's design has been replaced by stylized plant forms. The borders,

Fig. 40. *The Conversion of Saul* from a set of the *Acts of the Apostles*. Tapestry from a second-generation cartoon, by an unidentified Flemish artist, ca. 1615, based on the 16th-century original by Raphael, woven in the workshop of Jan Raes, Brussels, ca. 1620. Wool and silk, 525 x 602 cm. The Royal Collection, Hampton Court Palace

scenes symbolizing the four elements, are a simplified version of the borders that Philip II had commissioned for a set of the *Story of Noah* that had been woven for him in Brussels between 1563 and 1566.[30] Essentially, the grandiose Romanist vision of Coxcie's composition has been reduced to a much more decorative formula.

From about 1610, however, documentary and visual evidence indicates a more discriminating approach to these earlier designs and a new character in the reproductions themselves. In some cases, original sixteenth-century cartoons were utilized. In other cases, new copies of the old designs were made, in which the figures were copied to scale. The fact that the tapestry entrepreneurs were prepared to take on these designs shows that the workshops could call on increasing numbers of skilled weavers who were capable of reproducing the large, challenging figures in the cartoons. While this practice had the advantage of providing the workshops with impressive designs without the cost of making new ones, another factor in the continuing use and popularity of these designs must have been the desire, on the part of patrons, to buy copies of these old masters. For the aspirant, the acquisition of such sets was an easy way to adopt a veneer of the taste and manners of the grand courts of the

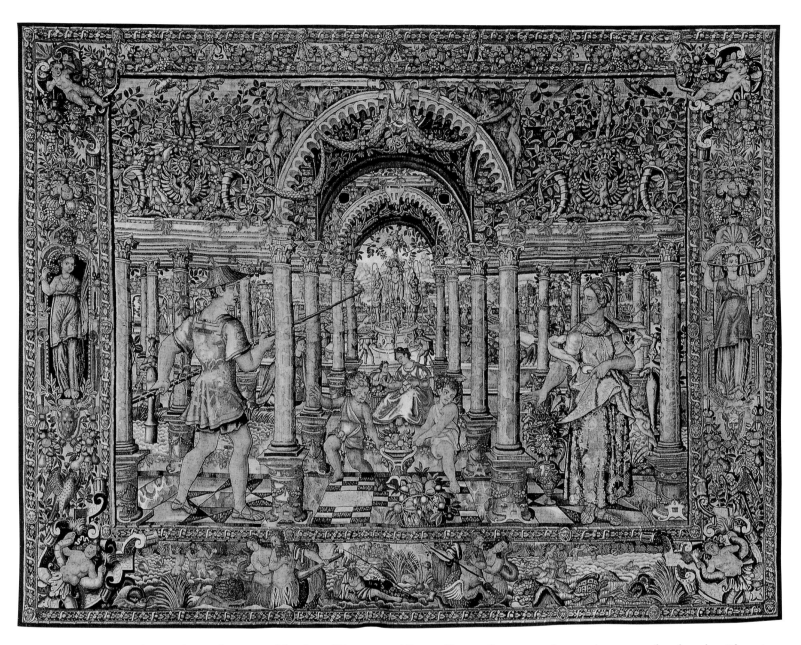

Fig. 41. *Vertumnus Disguised as a Fisherman* from a set of the *Story of Vertumnus and Pomona*. Tapestry from a second-generation cartoon, based on the 16th-century original by Pieter Coecke van Aelst, possibly woven by Maarten Reymbouts, Brussels, ca. 1610. Wool and silk, 410 x 521 cm. Museum of Fine Arts, Boston, Gift of Mrs. Ernest B. Dane (48.402)

previous century. For the more cultivated, it was a means to obtain the work of some of the great artists of the past.

One notable example of the reuse of a mid-sixteenth-century design can be seen in the commission placed in 1610 by Cardinal Scipione Borghese, nephew of Pope Paul V and secretary of state for the Vatican, for a set of tapestries of the *Story of Samson*. The cartoons had been commissioned by Henry II of France, but they were abandoned without being colored when the king died in 1559.[31] The cartoons remained in Brussels until the early seventeenth century, when they were brought to the attention of Guido Bentivoglio, the papal nuncio in Flanders,

who was acting as Borghese's agent. The identity of the artist is unknown: Bentivoglio attributed the cartoons to a Mechelen master called Giles who was said to have traveled in Italy. The large-scale figures and extended landscapes, as evidenced by seventeenth-century weavings of this design, were close in style to the designs of Michiel Coxcie, the Mechelen artist who had in fact resided in Italy in the 1530s.[32] In a letter of 1610, Bentivoglio wrote to Borghese, "The design is very beautiful, as I have said, and provides a glimpse of great inventiveness, and it is full of very large figures that move with extraordinary majesty."[33] Borghese eventually commissioned a sixteen-piece

set of this design, and Bentivoglio's correspondence with him reveals many interesting details about the state of the Brussels industry at this time.[34] The merchant with whom he contracted for the set, identifiable as Jan Raes II, was said to employ one hundred and fifty weavers, of whom about sixty subsequently worked on this commission, which seems to have been well advanced within twelve months, when the correspondence lapses. Borghese's set is now lost, although it has been plausibly suggested that three panels, formerly on the art market, may have formed part of it. The borders of this group are consistent in style with what we would expect for borders conceived for Henry II in the late 1550s.[35] Subsequent seventeenth-century weavings of this design utilized a more architectural border, evidently created for this purpose after the first set made for Borghese (fig. 39).

Another fascinating example of the reuse of an old master design by another discriminating Italian patron is provided by the *Landscapes with Animals* set woven for Cardinal Alessandro Montalto between 1611 and 1614 by the workshops of Jan Raes II and Catherine van den Eynde (cat. no. 9). This was based on cartoons designed about 1550 by an unidentified artist in the circle of Pieter Coecke van Aelst, possibly Jean Tons II or Willem Tons, renowned landscape cartoonists of the mid-sixteenth century, and depicts wild animals in exotic woodland settings, in a Christological allegory of the human condition. The borders must have been designed in the early seventeenth century. The collaborative manufacture of this set by the Raes and Van den Eynde workshops typifies a practice that became increasingly common in Brussels in the first decade of the seventeenth century, as it allowed workshops to complete commissions in a timely fashion and to spread the costs and risks of production.

Some patrons were evidently even more eclectic in their taste. One of the most intriguing copies of this period is that of a fifteenth-century *Story of the Trojan War* series (fig. 5) that had enjoyed great popularity during the last quarter of the fifteenth century. This was redone in the early 1610s by the Geubels and Raes workshops. Part of a set of this design was sold from the collection of the dukes of Berwick and Alba in 1877, and at least one piece remains in the Alba collection.[36] The reproduction of the medieval *Trojan War* set, however, seems to have been relatively unusual. For the most part, the market seems to have been for the grand designs of Raphael and Giulio Romano or their Flemish imitators, Pieter Coecke van Aelst and Michiel Coxcie. Indeed, during the early 1610s, the Brussels workshops appear to have equipped themselves with new copies of many of the greatest designs by these masters. In contrast to the copies

that had been made in the late 1590s and early 1600s, in which the scale of the figures was generally reduced in proportion to the composition as a whole and subsumed within decorative foliage, the copies of the 1610s were bolder in conception, with larger, more three-dimensional figures set in simplified renderings of the original landscapes. Another marked tendency toward a heavier style is reflected by the border designs, which take on a more architectural and florid character.

Grandest of all the old master copies that were used in the mid-1610s was a new set of cartoons based on Raphael's *Acts of the Apostles* designs with an ornate strapwork border. The earliest documented weaving of this "new" series is that which Jan Raes II and Frans Sweerts II supplied to the merchant Antonio Bono in September 1614. Jan Raes II supplied a second set of the *Acts of the Apostles*, this time of fifteen pieces, to the Infanta Isabella, in 1620, which Isabella gave to the Carmelite church in Brussels. It is unclear whether this is the set that now survives in the Spanish royal collection.[37] Another set, also produced by the Raes and Van den Eynde workshops, was sold from the collection of the dukes of Berwick and Alba in 1877. Purchased by Baron d'Erlanger, it was presented by him to the English Crown in 1905 (fig. 40).[38] The exact model for the seventeenth-century cartoons is unknown, because the originals were in Genoa and Florence by this date. Given the fact that Rubens was subsequently instrumental in helping Prince Charles of England to purchase the seven cartoons then in Genoa, and his claim in 1616 that he had had extensive dealings with the Brussels tapestry merchants, it is tempting to think that he may have played a part in the conception of these later copies. Equally, the architectural and landscape elements that are substituted for some of the more challenging aspects that were featured in Raphael's original designs suggest that he was not directly involved in the execution of the cartoons. While the rendering of detail and setting in these seventeenth-century versions is coarse when seen in comparison to the exquisite sixteenth century weavings of these groundbreaking designs (fig. 6), the handling of figures and musculature nonetheless reflects the continuing recovery of the Brussels workshops and the renewed ambitions of their entrepreneurial directors.

The *Acts of the Apostles* were not the only Raphael school designs to be revived. In the same year that Raes and Sweerts sold the *Acts* set to Antonio Bono, Sweerts also supplied sets of the *Story of Scipio and Hannibal* and the *Story of Saint Paul* to comte de Vaudémont, prince of Lorraine.[39] The former was presumably woven after the famous Giulio Romano designs, conceived in the 1520s (see fig. 12). The *Saint Paul* set was likely

a copy after the Pieter Coecke series (fig. 10), conceived in the late 1520s under the influence of Raphael's *Acts*. Both of these revived designs were popular in the first half of the seventeenth century.[40]

The increasing number of designs, old and new, being utilized by the Brussels workshops during the early 1610s reflects the renewed strength and prosperity of the industry. Further evidence of this recovery is provided by the legislative steps that were taken in 1613 in response to a petition from the nine leading tapestry merchants of the town: Maarten Reymbouts, Jan Mattens, Jan Raes II, Catherine van den Eynde, Cornelis Tserraerts, Nicasius Aerts, Peter de Goddere, Frans Tons, and Gerard Bernaerts. Claiming to be speaking on behalf of all masters and journeymen in the city, these merchants pointed to the long-standing excellence and primacy of the Brussels workshops: "Seeing that this noble art is useful and indispensable for all lords, princes and potentates of the world, and that the tapestries made in this city since living memory have, in the opinion of impartial judges and lovers of art, always had and maintained their value above all others."[41] The merchants pointed out that among the nine of them they employed more than six hundred weavers and that some of them had invested more than 30,000 florins in the purchase of new tapestry cartoons in the previous six years—a figure that presumably covered many of the new "old master" cartoons just discussed. In response, the town authorities followed the example of the grants made in Paris to Comans and La Planche, privileging these merchants with the right to brew beer and exempting them from paying tax on certain quantities of imported German and French wines. Similar considerations were also extended to the leading dyers who supplied the colored wools and silks to the tapestry workshops. In the following years, further steps were introduced to ensure the quality of Brussels tapestries, including the injunction that workshops should once again submit to elected guild officials all completed tapestries for examination before they were sold.

During this same period, the archdukes continued to buy steadily from the Brussels workshops. These purchases included sets of the *Story of Diana* and the *Story of Noah*, woven in partnership by Catherine van den Eynde and Jan Raes II in 1613; a set of *Landscapes with Poetic Figures* from Gerard Bernaerts in 1614;[42] and, from Maarten Reymbouts, two sets of *Galleries with Vertumnus and Pomona* (1611 and 1614) and a set of the *Story of the Trojan War* (1615). Again, most of these sets appear to have been woven from cartoons that were copied from mid-sixteenth-century designs. For example, *Vertumnus and Pomona* tapestries from the Reymbouts workshop that survive in Brussels (Musée du Cinquantenaire) and Boston (fig. 41) were made from cartoons that were evidently created in the early 1600s after copies of the very fine series of this subject designed in the mid-sixteenth century by Pieter Coecke and his workshop (fig. 11).

The Spanish Crown must also have made various purchases from the Brussels workshops. The royal collection now includes a number of sets that carry the marks of the leading Brussels workshops of the day, whose style suggests a date of production between 1610 and 1620. For example, a set of the *Story of Alexander*, based on cartoons of about 1560 from the circle of Michiel Coxcie, carries the marks of the Geubels–Van den Eynde and Raes workshops.[43] Similarly, two separate sets of the *Story of Scipio*, both based on the famous designs by Giulio Romano, survive in the Spanish royal collection, one with the marks of the Maarten Reymbouts workshop, the other with the mark of the Mattens workshop.[44]

Rubens and the Decius Mus Series

As has been demonstrated, the Brussels tapestry industry had recovered a considerable degree of vitality by the mid-1610s, even if it was to a large degree dependent on copies of old master designs. The quest for new designs must have been pressing, and it was presumably this need that precipitated a commission to the Antwerp artist Peter Paul Rubens to create a new set of cartoons for the *Story of Decius Mus*, the first of four major tapestry series that he designed. The patron has not been identified, but according to Rubens's own testimony, the series was conceived for some gentlemen from Genoa. The earliest reference to the series is a contract of 1616 for the production of two sets of this design between, on one hand, Franco Cattaneo, a Genoese merchant resident in Antwerp, and, on the other, Jan Raes II, the Brussels tapestry merchant, and Frans Sweerts the Younger, the Antwerp tapestry merchant. According to the contract, Rubens was still working on the cartoons. The contract contains the unusual stipulation that he was to examine the finished product and evaluate the work.

Rubens already enjoyed considerable success as a painter by the time he received this commission, having been appointed court painter to the archdukes following his return from Genoa in 1609. He was also no stranger to the tapestry trade. His maternal grandfather, Hendick Pypelinckx, and his maternal uncle Dionysus were tapestry merchants in Antwerp, and Otto Vaenius, under whom he had trained, had provided the designs for the *Battles of the Archduke Albert* (cat. no. 6). Rubens was

clearly inspired by the monumental, friezelike compositions of the *Acts of the Apostles*, which he knew from an early reweaving of the design made for Cardinal Gonzaga then in Mantua, and from the original cartoons, seven of which were in Genoa.[45] Indeed, as mentioned above, in 1623 he may have played a role in the acquisition of these cartoons by Charles, Prince of Wales. But if Rubens was inspired by the heroic figures and rhetorical gestures of the Raphael designs, the extent to which he was interested in, or sensitive to, the tapestry medium per se is uncertain.

Rather than preparing the modelli in ink and wash and the cartoons in watercolor on paper, the traditional media, Rubens painted the modelli in oil on board and the cartoons in oil on canvas. The latter, in which Anthony van Dyck may also have played a part, survive today in the collection of the prince of Liechtenstein (fig. 45). The canvases have not been divided into vertical strips, as would normally be required for weaving on the low-warp loom—the predominant mode of production in Brussels at this time. It therefore seems that the weavers must have used paper copies for the actual weaving of the tapestries. The cartoons are conceived with all the verve and movement of Rubens's painterly style of this period, with rich glazes, passages of dazzling color, and strong contrasts of light and shade. The cartoons suggest that the painter, like Raphael a century before him, was challenging the weavers to raise the medium to new heights of painterly expression. According to a letter Rubens wrote in May 1618 to Sir Dudley Carleton, the English ambassador in The Hague, he had extensive commercial dealings with the Brussels tapestry workshops, which must have given him an insight to the challenges and opportunities of the medium. The contractual stipulation that Rubens himself would inspect the finished work may also provide evidence that this commission was something of an experiment.

Certainly, the success of the designs, and indeed of all Rubens's subsequent tapestry designs, depends on the skill of the weavers who interpreted them in woven form. In the best weavings, the large muscular forms are exquisitely defined, and the sparse settings in which they are placed are carefully executed with convincing aerial perspective, a testimony to the revival of traditional weaving skills in the Brussels workshops. Unfortunately, however, the majority of the surviving examples dating from the second third of the seventeenth century are lesser-quality weavings. In them, the figures are clumsily executed, lacking the subtlety requisite to make the ample forms visually engaging; the settings look bare and uninteresting; shortcomings of proportion or anatomy that were barely detectable in the rich painterly compositions become glaringly obvious; and the surface

of the tapestries lacks the richness of design and enlivening patterns that characterized the great examples of the sixteenth century and, indeed, of later seventeenth-century productions, both in Brussels and elsewhere (see Isabelle Denis, "The Parisian Workshops, 1590–1650," and Pascal-François Bertrand, "Tapestry Production at the Gobelins during the Reign of Louis XIV, 1661–1715").

Rubens himself was proud of the designs. With his characteristic lack of modesty, he described them to Sir Dudley as "cartoni molto superbi" (very splendid cartoons). The extent to which his compatriots shared this judgment is uncertain, but Rubens seems not to have designed another tapestry series until the early 1620s, and that commission was for Louis XIII, king of France, executed in Paris. Indeed, not until the mid-1620s did Rubens receive another commission for a tapestry series to be made in Brussels. Yet, if these circumstances suggest that the *Decius* designs were considered difficult by the Brussels weavers and merchants, they nonetheless enjoyed considerable commercial success during the 1620s and 1630s—perhaps in part because of Rubens's international fame—and many duplicate sets were made. Whatever their faults, they introduced a new sense of drama and movement into tapestry design that was to be highly influential in Brussels and elsewhere during the 1630s and 1640s.

Continuing Migration and New Competition

The economic circumstances of the tapestry industry in the southern Netherlands greatly improved in the second decade of the seventeenth century, particularly in Brussels but also in other traditional centers such as Antwerp, Bruges, and Oudenaarde. Nonetheless, the lure of foreign patrons and exclusive commercial arrangements continued to attract Flemish weavers, and a number of small workshops were established elsewhere in Europe in the 1610s. These ranged from projects undertaken by weaver-entrepreneurs acting independently to more substantial enterprises begun by local princes and potentates. Henri II, duc de Lorraine, attempted to establish a workshop in Nancy, attracting various weavers there in 1613. But the workshop was never large, and only four or five sets were produced before the duke died in 1624; the workshop seems to have closed shortly afterward. The only extant product is a set of the *Story of Saint Paul*, now in Vienna (Kunsthistorisches Museum), which is copied from the sixteenth-century series by Pieter Coecke van Aelst.[46]

Of much greater significance was the initiative taken by the English Crown in 1619. With support from James I, his son, Charles, Prince of Wales, and their favorite the Marquis of

Buckingham, Sir Francis Crane, then secretary and friend to the Prince of Wales, was licensed to establish a tapestry workshop at Mortlake on the outskirts of London. Approximately fifty Flemish weavers and their families were persuaded to emigrate in great secrecy, and during the next twenty years the English Crown and leading courtiers lavished considerable expenditure on this workshop. Following the contemporary example of the Brussels workshops, the first tapestries woven at Mortlake were copied from sets acquired during the 1540s by Henry VIII. This reverence for old master designs culminated with the purchase in 1623 of seven of the original Raphael *Acts of the Apostles* cartoons from Genoa. New border designs for the first set (cat. no. 16) were commissioned from an artist called Frans Kleyn (fl. 1611–58), a native of Rostock, who had worked at the court of Christian IV in Copenhagen, before entering the service of the Prince of Wales in 1623–24. In 1626 Francis Clein, as he came to be known in England, was appointed official designer at the Mortlake tapestry

works, and for the next fifteen years, he produced a number of sets that reflect the influence of contemporary Continental artists like Gerrit van Honthorst and Rubens, such as the *Story of Hero and Leander* (cat. no. 17) and the so-called *Horses* (cat. no. 18). The Mortlake workshop and its products are discussed in greater length below (see Wendy Hefford, "The Mortlake Manufactory, 1619–49").

Finally, mention should be made of the workshop established in 1622 in Spain by Frans Tons, a leading Brussels weaver who emigrated after running into financial difficulties in his hometown. He was evidently inspired by previous generations of émigrés, for the petition he presented to the Spanish king in 1621 requested the same privileges that the French king granted to "those who had introduced this art to the kingdom of France," clearly referring to Henry IV's grants to Comans and de la Planche. Tons established a workshop in Patrana, which operated with only moderate success until his death in 1633.[47]

1. Guiffrey 1923, pp. 1–2.
2. For more detailed discussion of Henry IV's initiatives, see Isabelle Denis, "The Parisian Workshops, 1590–1650," below.
3. Guiffrey 1923, pp. 1–2, 31–32.
4. Ibid., pp. 2–6, 32–35.
5. Lefébure 1995, pp. 152, 163.
6. For this and what follows, see Volk-Knüttel 1976a, passim; Bauer 2002, pp. 63–66.
7. Hartkamp-Jonxis in Amsterdam 1993, pp. 316–17, 420–21 no. 78; Hartkamp-Jonxis and Smit 2004, pp. 428–29.
8. Van Zijl 1981, p. 207; Woldbye in Cophenhagen and other cities 1988, p. 115.
9. Hartkamp-Jonxis in Hartkamp-Jonxis and Smit 2004, pp. 222–26, no. 55.
10. Hartkamp-Jonxis in Amsterdam 1993, pp. 424–25, no. 82.
11. Hartkamp-Jonxis 2002b, pp. 18, 29; Hartkamp-Jonxis and Smit 2004, p. 425.
12. Hartkamp-Jonxis in Hartkamp-Jonxis and Smit 2004, p. 180.
13. Amsterdam 1993, pp. 425–26; Hartkamp-Jonxis 2002b, pp. 22–24.
14. Hartkamp-Jonxis in Amsterdam 1993, pp. 317, 426 no. 84.
15. Wauters 1878, pp. 220–21.
16. Göbel 1923, p. 470.
17. Wauters 1878, p. 193.
18. Göbel 1923, p. 328.
19. Ibid., p. 370.
20. Ibid., p. 363–64.
21. Ibid., p. 369.
22. Ibid., pp. 332–33.
23. For an early 17th-century weaving of a 16th-century Joshua design, carrying the marks of the Geubels–Van den Eynde and Raes workshops, see Göbel 1928, fig. 277 (for the tapestry), and T. Campbell 1994, pp. 22–26 (for the identification of the subject). For *Trojan War* tapestries with the Geubels–Van den Eynde and Raes marks, see Ragusa in Turin 1984, inv. 1043–1046.
24. Cavallo 1967, pp. 118–19; Delmarcel 1999a, pp. 132–33, 139–40.
25. For examples, see D. Boccara 1971, p. 77; sale cat., Sotheby's, New York, January 9–10, 1990, no. 336; sale cat., Christie's, London, May 2, 1997, no. 217.
26. Documentation relating to this commission is to be found in the National

Archives, Kew, Historical Manuscripts Commission (hereafter HMC), Report on the MSS of Lord de L'Isle and Dudley, vol. 3, 1936, pp. 265–68, 285, 290; HMC, Report on the MSS of the Marquess of Devonshire, vol. 2, 1936, pp. 2–3, 434; HMC, Report on the MSS of the Marquess of Salisbury, vol. 18, 1940, pp. 447–48.
27. HMC, Report on the MSS of Lord de L'Isle and Dudley, vol. 5, 1942, pp. 65–66.
28. HMC, Report on the MSS of the Marquess of Devonshire, vol. 4, 1940, pp. 160, 165, 169.
29. Ibid., pp. 212, 282, 497, 501.
30. Junquera de Vega and Díaz Gallegos 1986, p. 176. Another panel from this *Old Testament* series showing the Tower of Babel is now at the Isabella Stewart Gardner Museum, Boston; see Cavallo 1986, pp. 80–83, no. 16.
31. Cremona 1987, passim.
32. Bandera 1987a, pp. 84–92; T. Campbell in New York 2002, p. 401.
33. "'E bellissimo, com'ho detto, il disegno e vi scorge grand'inventione, et è pieno di grandissime figure, che muovono staordinaria maestà"; Hoogewerff 1921 (2nd ed., p. 131).
34. Delmarcel 1987, pp. 51–52.
35. Forti Grazzini, cited in Bandera 1987a, pp. 80, 84.
36. Göbel 1923, p. 365.
37. Ibid., p. 364; Junquera de Vega and Díaz Gallegos 1986, pp. 62–74.
38. Göbel 1923, p. 364; Marillier 1962, pp. 29–30.
39. Göbel 1923, p. 329.
40. T. Campbell in New York 2002, pp. 380–81; for the set by Giulio Romano, see T. Campbell in New York 2002, pp. 341–49.
41. Delmarcel 1999a, pp. 211, 214.
42. Göbel 1923, p. 370.
43. The 17th-century *Alexander* tapestries are intermixed with a finer 16th-century weaving. See Junquera de Vega and Herrero Carretero 1986, pp. 248–62.
44. Ibid., pp. 185–205.
45. T. Campbell in New York 2002, pp. 201–2 (for the whereabouts of the cartoons); T. Campbell and Karafel in New York 2002, pp. 214–18, no. 24 (for the Mantua set).
46. Göbel 1928, pp. 359–60; Antoine 1965, pp. 15–16.
47. Delmarcel 1999a, pp. 210–11; Delmarcel 2002a, pp. 9, 12, 13.

7.
Scipio and the Envoys from Carthage

From an eight-piece set of the *Deeds of Scipio*
Design attributed to Karel van Mander II, between 1607 and 1609
Cartoon executed by Coquel and probably also Karel van Mander II
Woven in the workshop of François Spiering, Delft, 1609
Wool and silk
414 x 404 cm (13 ft. 7 in. x 13 ft. 3⅛ in.)
7–8 warps per cm
Weaver's mark in lower part of right selvage; weaver's signature and date in center of lower inner border
Rijksmuseum, Amsterdam (BK-1972-77)

PROVENANCE: 1607, commissioned by Thomas Howard, first Earl of Suffolk; 1611–26, Thomas Howard, probably at Audley End House, Essex; 1626–70, the tapestry remained at Audley End when the property was purchased by Charles II; 1692– probably 1701, tapestry still at Audley End, as possession of the crown; 1972, with Robert Courtoy, Brussels; 1972, purchased from Robert Courtoy by the Rijksmuseum.

REFERENCES: Van der Graft 1869, pp. 74–76 (the set); Göbel 1923, p. 540 (the set); Van Ysselsteyn 1936, vol. 1, pp. 77–78, vol. 2, nos. 193, 194, 196, 202, 203 (the set); *Bulletin van het Rijksmuseum* 20, no. 4 (1972), p. 182, fig. 7; *Nederlandse Rijksmusea in 1972* (The Hague, 1974), pp. 52 fig. 30, 53; Drury 1980, pp. 4, 29; Erkelens 1981; Hartkamp-Jonxis in Amsterdam 1993, pp. 423–24, no. 81; D. Heinz 1995, p. 105, Hartkamp-Jonxis in Hartkamp-Jonxis and Smit 2004, pp. 215–18, no. 53.

CONDITION: Some fading, particularly in the landscape and the sky. Brightly colored later reweaving or retouching (?) in some pink areas, particularly in the coat of the man in the foreground. Local discoloration in the border. Blue selvage missing along the bottom.

The story of Scipio was well known from the set of twenty-two tapestries of the *Deeds and Triumphs of Scipio* that was designed by Giulio Romano with Giovanni Francesco Penni and woven in Brussels between 1532 and 1535 for King Francis I of France. The modelli for the *Deeds* seem to have been executed by Penni, in part after sketches by Giulio, and Giulio conceived those for the *Triumphs*.[1] That design series received such acclaim and fame that it was rewoven several times in the sixteenth and early seventeenth centuries. These reweavings were neither of the entire series nor wholly faithful to the original design, resulting from a number of different generations of cartoons based on copies of the original designs. The two parts of the Penni–Giulio series can be distinguished as the *Deeds*, which stress not only the military successes of Publius Cornelius Scipio (236–183 B.C.), but also his virtue, and the *Triumphs*, which glorify that great military leader from classical Rome.

Instead of following this well-known precedent, the designer of the set of eight *Deeds of Scipio* that includes the present tapestry, *Scipio and the Envoys from Carthage*, created his new designs in the idiom of the northern Baroque style, rendering his figures larger than life and interacting with theatrical pathos. The rhetorical grandeur of the figures is tempered, however, by the decorative patterning that covers every available surface of garments, setting, and borders. The set was woven in 1609 in the workshop François Spiering (1549/51–1630) set up in Delft after his flight from Antwerp following the troubles of the 1570s and early 1580s. Spiering may have started his Delft workshop in the early 1580s, for in 1582 he married the daughter of a Delft aristocrat. The first documented commission for a set of tapestries from his Delft workshop dates from 1591.[2] His business seems to have been firmly established by the end of 1592, for at that time the Delft city council procured for him at no charge the former convent of Saint Agnes and agreed to pay all the costs for restoring the buildings.[3]

From about 1606 to 1615, Karel van Mander II (1579–1623), who probably designed this *Deeds of Scipio* series, worked with Spiering, initially painting cartoons, later designing tapestries as well.

Description and Iconography

The subject of the tapestry derives from the end of Book 30 of Livy's *Ab urbe condita*, describing the final days of the Second Punic War (218–201 B.C.), which was brought to an end by Publius Cornelius Scipio in the Battle of Zama. After his triumphal entry into Rome, Scipio was called Scipio Africanus.

In the tapestry Scipio is seated on a chair ornamented *all'antica*, placed in a wooded landscape. Two of the military advisers with him carry fasces, symbol of the Roman Republic. Scipio directs his gaze toward the chief emissary of Carthage, who kneels before him holding an olive branch as a sign of his wish for peace. His despair is indicated by the fact that the second ambassador, also holding an olive branch, is supporting him. Behind these two, four other Carthaginians make submissive gestures toward Scipio, who is gesticulating to the small company. According to Livy (*Ab urbe condita* 30.37), Scipio is reproaching them for their unfaithfulness to him and admonishing them to believe in the gods and in the holiness of oaths, for surely they gained wisdom from so many defeats. Scipio went on to set conditions for peace, conditions that caused him to be regarded as a paragon of virtue. The Carthaginians were free to live according to their own laws, while keeping the cities and the land they had owned before the war, terms that Petrarch, in his epic poem *Africa* about the Second Punic War, described more fully. In the background of the tapestry, the soldiers who are pulling their horses into a walk may refer to another gesture of goodwill made by Scipio to the ambassadors: if they would accept his peace terms, including the condition that they would not go to war without permission from Rome, Roman soldiers would cease plundering Carthage

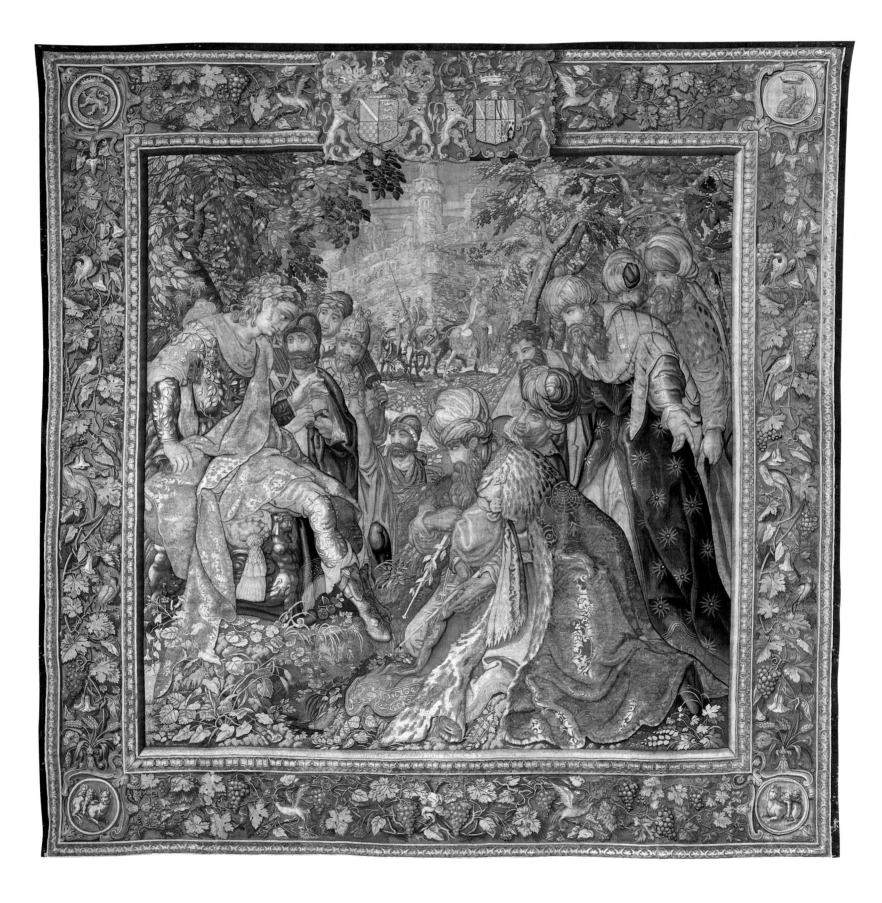

Detail of cat. no. 7

that very day. Behind the mounted soldiers, the citadel of Carthage rises.

In the center of the upper border are the coats of arms of Suffolk and Knevet, both surmounted by an earl's coronet and the arms of Suffolk surrounded by the Garter. These identify the commissioner of the tapestry, Thomas Howard, first Earl of Suffolk (1561–1626), and his wife, Catherine Knevet (also spelled Knyvet[t], ca. 1564–1633).[4] The medallions in the upper corners contain the badges of Suffolk and Knevet; in those in lower corners Romulus and Remus—the legendary founders of Rome—are represented, together with the she-wolf that was alleged to have nursed the twins.

Designer and Cartoonist

The name of Karel van Mander II does not occur in documents pertaining to the order for the tapestry set and its delivery to Thomas Howard, but that is hardly surprising since it was not customary in seventeenth-century Holland for official papers to mention the name of a tapestry designer who was employed in the weaver's workshop.

Van Mander was trained as a draftsman by his father, Karel van Mander I (1548–1606), well-known painter, artists' biographer, and poet who, originating from Meulebeke near Courtrai, had settled with his family in Haarlem in 1581. The elder Van Mander designed tapestries for Spiering in the 1590s,

in a late Mannerist style. He may well have organized an apprenticeship with Spiering for his son, which turned into a job. Van Mander II left the Spiering workshop in 1615 in a great row, which continued with legal procedures until after his death in 1623. In 1617, two years after Van Mander set up his own studio, Spiering filed a lawsuit at the Court of Holland in The Hague against his former employee, prohibiting Van Mander from taking orders for tapestries until he had finished the patterns for a number of tapestries that he had been working on in Spiering's shop, among which were those for the "histories of Scipio."[5] (In the event, the court recognized the validity of Spiering's suit but did not impose any sanctions on Van Mander.) Since King Gustav II Adolph of Sweden (r. 1611–32) ordered from Spiering a set of thirteen *Scipio* tapestries that was delivered in 1619, one may assume that Van Mander had not completed the five designs additional to the Howard set of eight before he left the Spiering shop.

That Van Mander designed at least the eight panels of the *Scipio* tapestries in the Howard set is an attribution based on the fact that between 1617 and 1619 he designed and wove in his own workshop a set of the *Story of Alexander*, proudly and provocatively signed in the same manner Spiering was accustomed to use, which is stylistically very close to the Howard *Scipio* series.[6] Whether Van Mander also drew the border for Howard's *Scipio* set is uncertain, since borders were often woven after designs in stock. The rather conspicuous border of the present tapestry, with its undulating vine tendrils, bunches of grapes, and birds casting pronounced shadows on the background, is very similar to the one on the *Alexander and Jaddua* tapestries in the Rijksmuseum, Amsterdam, which was unquestionably woven in the workshop established by Van Mander (whose signature it displays). Thus, whether Van Mander designed the borders of the *Scipio* and *Orlando Furioso* series woven at the Spiering workshop, he certainly took copies or re-created them for his own use when he established his own workshop.[7]

We know that a man by the name of Coquel worked as a cartoon painter on the *Scipio* set for Howard because at the August 5, 1610, meeting of the States-General, the Dutch parliament, his payment of 515 guilders "voor

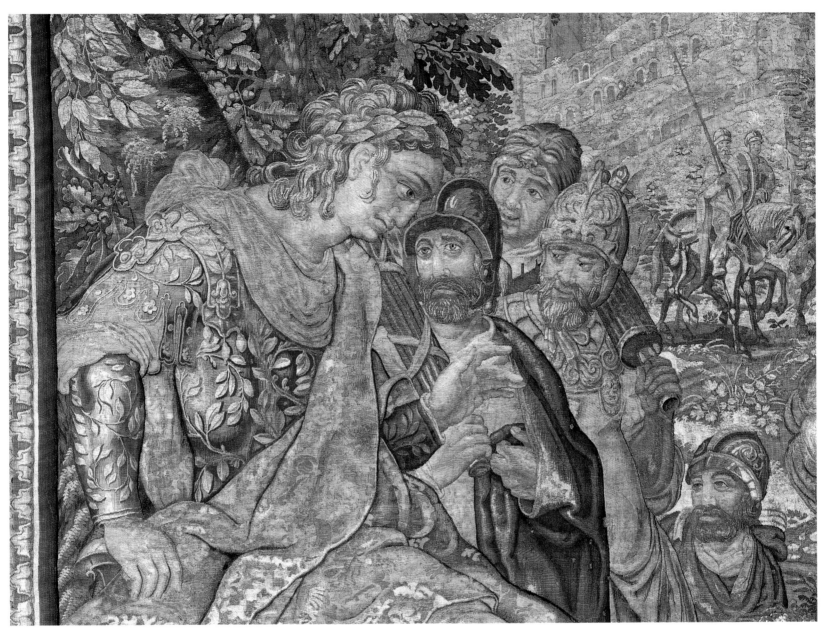

Detail of cat. no. 7

de schilderie" (for painting) was provided.[8]
This has given rise to the supposition that he
designed the tapestries. The payment, however,
implies that Coquel was an independent
draftsman, not an employee of the Spiering
shop. It may well be that Coquel and Van
Mander worked together on the cartoons.

Patron and Payment
Spiering wove the series of the *Deeds of Scipio*
at least three times. The first weaving we
know of is the 1609 edition for Thomas
Howard, first Earl of Suffolk, for which various
documents are preserved and of which two
tapestries are known, identified by the coats
of arms in the upper borders. In addition to

Scipio and the Envoys from Carthage, there is the
Clemency of Scipio, now in the Musées Royaux
d'Art et d'Histoire, Brussels, whose subject
concerns Scipio's pardoning and releasing a
captured cousin of the Carthaginian com-
mander Masinissa.[9] No tapestries can be
identified from the second documented
weaving of 1613. The documents pertaining
to that edition speak of a set of eight or ten
tapestries, which the States-General presented
to Elizabeth Stuart (1596–1662), daughter of
King James I of England, who married
Frederick V (1596–1632), Elector Palatine, in
London on February 14, 1613. The Dutch
Stadholder, Prince Maurits of the Netherlands,
Frederick's uncle, met the newlyweds in May

of that year in Flushing, where they landed on
their way from London to Germany. While
Frederick continued on his journey, Elizabeth
stayed for a while as guest at the court in The
Hague, and it was during this sojourn that the
Scipio tapestries were presented to her.[10] The
third known weaving was the thirteen-piece
set of the *Deeds and Triumphs of Scipio* that was
delivered to Swedish king Gustav Adolph in
1619. It was one of several tapestry series the
king ordered for his wedding to Maria
Eleonora of Brandenburg (1599–1655), which
took place in the autumn of 1620. Dutch doc-
uments from 1619, 1620, and 1621 refer to
passports for François Spiering's son Pieter to
accompany tapestries woven in his father's

workshop to Sweden and to the exemption of taxes, once the Swedish king had signed to pay for his order. Subjects of the tapestries are not mentioned.[11] From Swedish sources, however, it is evident that the large consignment—thirty-six tapestries—included a *Scipio* set.[12] A single tapestry from that set has been preserved—one of the *Triumphs*, in which Scipio is depicted riding in a triumphal chariot.[13] Since four of the six extant Spiering *Deeds of Scipio* tapestries do not have coats of arms or any other visual reference to the person for whom they were woven,[14] those four could have belonged to the set made for Elizabeth Stuart, to that made for King Gustav Adolph, or to yet another set for which no documents have come to light.

Thomas Howard, son of the fourth Duke of Norfolk and Margaret Audley, was created Earl of Suffolk in 1603, when James I came to the throne.[15] He was later credited with the discovery of the Gunpowder Plot, and he served from 1614 as Lord High Treasurer of England until he was convicted of embezzlement in 1618.[16] Through his mother, Howard had come into possession of Audley End House, south of Cambridge, a mansion that he rebuilt as a truly palatial residence, from 1603 onward. The king is supposed to have visited the house in January 1614.[17] During Howard's trial it was supposed that his wife, Catherine Knevet, whom he had married about 1583, had abetted him in defrauding the treasury and the king, among others in using the king's money for the building activities at Audley End. There were several sets of tapestries in the house, some of which can probably be identified in an inventory taken in October 1671, at the time the tapestries were acquired by Charles II. (The house had been purchased by the crown in 1668.)[18]

Documents concerning the weaving of the *Scipio* tapestries for Howard indicate that he personally ordered the set. Minutes of the States-General meeting of June 11, 1607, state that permission was granted to François Spiering to export eight tapestries to England without paying export duties because the "chamberlain to the king of Great Britain"—Thomas Howard—had them woven "for the room of his majesty."[19] This may refer to a room in Audley End House, either in the old mansion or one that Howard envisaged he

would have built in the new house. Three years later, on June 26, 1610, the order was discussed once more in the States-General. The minutes inform us of a letter from Noël de Caron, seigneur of Schoonewal, the Dutch agent of the States-General in England, to the advocate of the province of Holland, Johan van Oldebarnevelt, which had been forwarded to the States-General. Caron asked to "effectuate the presents for England" which the "great chamberlain" had ordered.[20] The subject of the tapestries is again not mentioned, but in the minutes of August 1, 1610, it is. Those minutes relate that Messrs. Syms and Joachimi had spoken with Spiering about the price and inspected "eight pieces of Scipio," and that the tapestries would be bought by the States-General for "the great chamberlain of England."[21] In the minutes for August 5, we read that the Messrs. Syms and Joachimi had come to an agreement with Spiering on the price for the tapestries for Howard, which were to be delivered to Caron.[22] The minutes of March 21, 1611, inform us of Spiering's sale of the eight pieces to the Dutch government, which presented them to "the great chamberlain of Great Britain," as "stated in a letter from ambassador Caron."[23] Spiering received 7,500 guilders for the *Scipio* set.[24]

Howard's fraudulent conduct regarding the English treasury and the king could indicate that he was manipulating the States-General into turning his personal order of tapestries into a gift. There is another instance of the States-General taking over a Spiering commission for a gift, however, for in 1610, they purchased a tapestry initially ordered by "the lord high treasurer"—Robert Cecil, first Earl of Salisbury—again on advice of their agent in England, Noël de Caron.[25] In fact, the States-General apparently considered Spiering tapestries as appropriate gifts for the ambassadors of foreign rulers. In 1610 they made these a present to Pierre Jeannin, president of the parliament of Dijon and minister of finance of the king of France;[26] and in 1614 the tapestries they ordered to give to Hali Pasha,[27] admiral of Turkey, were to be delivered in 1616, as Spiering always was late in executing orders.[28] As we have seen, this was also the case with the *Scipio* tapestries for Thomas Howard, the first contacts dating from 1607, the delivery taking place in 1611.

Howard's *Scipio* tapestries appear to have remained in the possession of the Howard family at Audley End until 1668. In that year, the house was acquired by King Charles II, and in October 1671 the tapestries and other furnishing of the house were also purchased by the crown for 2,000 pounds. The inventory of hangings and wardrobe stuff made at that time lists five pieces of *Hannibal and Scipio* with a total surface area of 380 ells.[29] The tapestries were still at Audley End in 1692, when seven pieces of this subject were listed among the tapestries belonging to the crown at Audley End in a document in the Lord Chamberlain's papers.[30] The tapestries may have remained at Audley End until 1701, when, according to tradition, William III disfurnished the house, sending the tapestries to the new palace of Het Loo. The subsequent provenance of the set is unknown before the appearance of the two extant pieces in more recent times.

EBELTJE HARTKAMP-JONXIS

1. For a lucid survey of the genesis of the *Scipio* tapestries designed by Giulio Romano and Penni, see T. Campbell in New York 2002, pp. 341–49, and T. Campbell and Karafel in New York 2002, pp. 364–70, nos. 41–43.
2. See Hartkamp-Jonxis and Smit 2004, p. 428.
3. For the document, see Van der Graft 1869, pp. 69–70, and Van Ysselsteyn 1936, vol. 2, no. 97.
4. For the heraldic description of the arms, see Hartkamp-Jonxis in Hartkamp-Jonxis and Smit 2004, p. 215.
5. For the document, see Van Ysselsteyn 1936, vol. 2, no. 298.
6. Hartkamp-Jonxis in Hartkamp-Jonxis and Smit 2004, pp. 224–25.
7. See ibid., p. 218. Almost identical borders as the one around the present tapestry run around a series of tapestries with scenes from Ariosto's *Orlando furioso*, woven by Spiering various times between 1609 and 1620. See Hartkamp-Jonxis and Smit 2004, fig. 83.
8. Van der Graft 1869, p. 76.
9. For an illustration, see Delmarcel 1999a, p. 211.
10. For the wedding and for Elizabeth's stay in the Netherlands, see Amberg 2003, p. 37. For documents relating to the gift to Elizabeth, Electress Palatine, see Van Ysselsteyn 1936, vol. 2, nos. 222, 224–27, 229, 233, 235. Eight *Scipio* tapestries are mentioned in no. 222, and ten in no. 225.
11. See Van Ysselsteyn 1936, vol. 2, nos. 315, 338, 341, 347.
12. See Böttiger 1895–98, vol. 2, pp. 7–8.
13. *Scipio in a Triumphal Chariot Drawn by Horses*, Palazzo Communale, Cagliari. For an illustration, see Nordenfalk 1966, fig. 7.
14. See Mulder-Erkelens 1981, pp. 36, 46 nos. 2–4 (these three illus.), 6; and Hartkamp-Jonxis and Smit 2004, fig. 81, illustrating Mulder-Erkelens 1981, no. 6, and proposing as its subject *Scipio Extorting the Oath from Young Romans* (Fürstliches Schloss Thurn und Taxis, Regensburg, Germany).
15. He should not be confused with his namesake Thomas Howard, twenty-first Earl of Arundel (1585–1646), one of the four noblemen who escorted the newly wed Elizabeth Stuart in 1613 from London to Holland and from there to Heidelberg (see note 10).
16. *Suffolk Collection* 1975, no. 8.

17. Tipping 1926, pp. 918, 922.
18. Samuel Pepys, when visiting the house on October 8, 1667, wrote in his diary that there was "not one good suit of hangings in all the house," in his rather negative comments on Audley End and its contents; Pepys 1921–24, vol. 7, pp. 138–39. For the inventory, see Drury 1980, p. 29.
19. Van Ysselsteyn 1936, vol. 2, no. 171.
20. Ibid., no. 193.
21. Ibid., no. 194.

22. Ibid., no. 196.
23. Ibid., nos. 202, 203.
24. He initially asked 7,650 guilders, then dropped his price to 7,000, but in the end he received payments for 7,000 and 500 guilders for the eight tapestries; Van Ysselsteyn 1936, vol. 2, nos. 194, 196, 202, 203.
25. Ibid., no. 193.
26. Ibid., no. 199.
27. The Dutch representative for the Levantine trade, living in

Istanbul at that time, wrote that the two most important men for the trade were the grand vizir and "the captain pasja." The latter can be identified as a pasha from Tunis who had become admiral of Turkey. His name varies in the documents from "a certain Ali" to Hallil Bassa, Hali Pascha, and Hali Pasha; see Heeringa 1910, vol. 1, p. 342.
28. Van Ysselsteyn 1936, vol. 2, nos. 252, 254, 255, 282, 285.
29. Drury 1980, pp. 4, 29.
30. National Archives, Kew, LC5/43, fol. 103.

8.

Night

From an eighteen-piece set of the *Months, Seasons, and Times of the Day*
Design by Pieter de Witte, called Peter Candid, ca. 1612
Woven in the workshop of Hans van der Biest, Munich, 1614
Wool, silk, and silver and gilt-metal wrapped thread
402 x 276 cm (13 ft. 2¼ in. x 9 ft. ⅝ in.)
8–9 warps per cm
Weaver's mark at left end of bottom selvage; Munich manufactory mark at center of bottom selvage
Bayerisches Nationalmuseum, Munich (T3902)

PROVENANCE: Ca. 1612, commissioned by Maximilian I, duke of Bavaria, as part of a series of the *Months, Seasons, and Times of the Day*; 1616, woven in Hans van der Biest's workshop in Munich; remained in the ducal tapestry collection until that became part of the holding of the Bayerisches Nationalmuseum, opened in 1855; on display in the Residenz.

REFERENCES: Müntz 1885, p. 293; Rée 1885, pp. 200, 201, 208, 211, 212; Steinbart 1928, pp. 152–53, 154; Göbel 1933–34, vol. 1, pp. 212–13; D. Heinz 1963, pp. 290, 293; Volk-Knüttel 1976a, pp. 24, 42, 64, 68, 143 no. 53, 178 no. 117; Volk-Knüttel 1976b, p. 1222; Munich 1978, pp. 69–70, illus.; Volk-Knüttel in Munich 1980, vol. 2, p. 208; Bauer 2002, p. 65.

CONDITION: The piece has been washed and conserved for this exhibition.

*N*ight, the final piece of the *Months, Seasons, and Times of the Day* series, was one of the last tapestries produced in Hans van der Biest's Munich-based workshop. As such, it represents a culminating achievement of the visiting Flemish weavers. Although plagued by internal disputes and intermittently challenged by the tapestry weavers' guild in Brussels, this modest-size workshop benefited from cartoons of extremely high quality provided by the court artist Peter Candid and from an unusually close collaboration between Candid and the master weaver Hans van der Biest to create tapestries of startlingly vibrant colors, dynamic figures, and engaging details. The tapestries produced in the short-lived workshop adorned one of the most splendid palaces in Central Europe, the Munich Residenz. Peter Candid succeeded in matching the traditions of monumental figures and richly composed settings developed by Bernaert van Orley and Michiel Coxcie, and the tapestries, in their dramatic lighting, visual dynamism, and the circumstances of their production, predict the initiatives of Rubens and Jordaens in the following twenty years.

Design and Iconography

Night depicts a male figure wearing a crown of poppy seed pods, asleep at the mouth of a cave. A woman embodying Dreams raises her arm, and flames smolder at her hand and head. An owl, illuminated by the flame of an oil lamp, sits on a ledge above the sleeper. Ivy, ilex, and other lush vegetation surround the cave and twine around tree trunks that flank the scene like columns and serve as the side borders of the tapestry; small nocturnal animals are visible among the leaves. The arms of Bavaria, suspended between the trees, crown the scene. In the bottom corners appears the ME monogram of Duke Maximilian of Bavaria (r. 1597–1651) and his consort, Elisabeth Renata of Lorraine; this device appeared in different media throughout the Residenz.

The twelve *Months* tapestries in the eighteen-piece set are each divided into two scenes, separated by a central tree trunk (fig. 32). The four panels of the *Seasons* and the two of *Times of the Day*, each half the width of the *Months*, were designed to be hung in pairs to create the same effect; thus *Night* (cat. no. 8) is the pendant of *Day*. The inscription on the tapestry places Night in context within the Months and the Seasons: CUM LUCE ALTERNAT NOX; VER SIT, SIVE SIT AESTAS. / SIVE SIT AUTUMNUS, SIVE SIT ACRIS HIEMS (Night alternates with the light [of day]; be it spring or be it summer / whether it be autumn or bitter winter). *Day* celebrates sunshine and regeneration and depicts an energetic laborer set in a landscape with a rainbow in the sky,[1] while *Night* emphasizes the dark with the scene barely illuminated by

a crescent moon and stars, the lamp, and, above all, the dramatic, supernaturally bright flames of the figure of Dreams. The chiaroscuro effect washes the sleeper's body in the warm light of Dream's fire but leaves his face in obscurity; sharp shadows are cast around his limbs while the edges of the scene are barely distinct in the darkness.

A visitor to Peter Candid's studio witnessed that he was still working on the designs of *Day* and *Night* in October 1612. A pen and ink drawing of *Night*, attributed to Candid,[2] reveals that he initially intended a far more threatening atmosphere for the tapestry. In the drawing, the contrast with *Day* is not limited to light and darkness but engages with Night as Day's negative and sinister counterpart. The drawn, shrouded figure of Dreams is considerably more disturbing: scowling and older, she strongly recalls the representation of Penance in Botticelli's *Calumny of Apelles*, which Candid may well have seen in Florence in Fabbio Segni's collection.[3] The sleeper's brow is furrowed as he lies, vulnerable in his dreams. The glaring, beaky owl and spluttering, smoking lamp appear considerably more malign than their woven counterparts. It may have been Candid who chose to soften this malevolent atmosphere; alternatively, it is possible that Maximilian or his representative felt that the design was inappropriately unsettling.

The drawing records how Candid thought about design, considering such practical aspects as the representation of the NOX inscription in reverse, as it would appear on the cartoon to be woven in mirror image. The drawing also reveals him concentrating on the figures, articulating the space in terms of their presence, with very little attention paid to the surrounding cave. Ultimately, the foliage would form an integral component of the finished composition, allowing the represented space to spill out into border, with an illusionism that predicts such trompe l'oeil settings as Rubens's *Triumph of the Eucharist*.

Peter Candid at the Court of Maximilian I
In December 1594, Wilhelm V, duke of Bavaria, invited his twenty-one-year-old son Maximilian to share his reign as coregent. Three years later, faced with bankruptcy and unnerved by the turmoil of contemporary politics, Wilhelm abdicated,[4] and Maximilian

took over the court in Munich, engaging with both the positive and the negative aspects of his father's legacy. Aside from daunting political and monetary debts, Wilhelm also handed over to his son a court full of talented artists, architects, and sculptors who were engaged in diverse schemes of decorative renovation and renewal at the various ducal properties.[5] Directing the projects was Friedrich, or Federigo, Sustris (ca. 1540–1599), born in the Veneto, the son of a Dutch immigrant artist. The projects that Wilhelm V had started included a new sculpture hall, or Antiquarium, at the Munich Residenz, decorated with ornate stuccowork and a ceiling of allegorical paintings in the Mannerist style. Wilhelm planned an elaborate grottoed arcade, called the Grottenhof, along the side of the court gardens. Sustris, who had initially traveled to Bavaria to decorate the Augsburg home of the banker Hans Fugger, had an ideal background to direct the works, having trained in Rome and Florence and worked alongside Giorgio Vasari on the interior redecorations of the Palazzo Vecchio. Working from Sustris's drawn designs, skilled plasterers and painters gave shape to Wilhelm's projects.[6]

Maximilian I proved to excel at the political and administrative tasks that had overwhelmed his father, and he soon replenished the bankrupt Bavarian coffers. He became solvent enough to employ a permanent body of state militia rather than having to depend on expensive and unreliable mercenaries, as most of his contemporaries continued to do. On the political front, Maximilian became a dynamic proponent of the Counter-Reformation cause: in 1609 he hosted the founding meeting of the new Catholic League, created as a riposte to the Union of Protestant Princes, and was named its first director.

With increasing funds at his disposal, Duke Maximilian completed the projects started by his father and undertook new and even more ambitious schemes. Conscious of the need to create an elegant court that would suitably reflect his role as head of the Bavarian state, Maximilian embarked on an elaborate remodeling of the Munich Residenz, including ceremonial halls, a new court chapel, a parterre garden with three pavilions, a new chamber chapel so sumptuous that it became known as

the Schöne or Reiche Kapelle, and culminating in the addition of a splendid new wing, grandly called the imperial court building, or Kaiserhofbau.[7] Maximilian recalled to court his father's favorite sculptor, Hans Krumper, commissioning from him ornate Baroque portals, stucco friezes, garden ornaments, and reliquaries.[8] Along with these building and restoration projects, Maximilian nurtured a reputation as a collector of older German art, with a particular taste for paintings attributed to Albrecht Dürer.[9]

The duke furnished his new rooms with tapestries. Perhaps inspired by his father's tentative purchases in this area,[10] in April 1603 Maximilian made use of Fugger's agents in Antwerp to commission and purchase three sets of tapestries, the *Deeds of Hercules*, the *Story of Cyrus*, and *Landscapes with Foliage and Hunting*.[11] The next month, at Maximilian's request, Fugger's agent in Venice purchased seven pieces from a set of the *Story of Hannibal* from the Fondaco dei Tedeschi, as well as a series of gilt-leather hangings. The same year, Maximilian obtained a twelve-piece set of Netherlandish tapestries of the *Story of Gideon* from the estate of Giovanni Battista Guidobon Calvachino, baron of Liechtenberg.[12] The *Hercules* tapestries from Antwerp were hung in the hall through which visitors passed just before they arrived at the ducal apartments. Although this room was part of the older Residenz building, Maximilian had transformed it into a splendid space, raising its coffered ceiling, incorporating a clerestory of quatrefoil-shaped windows, and adding a painted cycle celebrating the deeds of his Wittelsbach ancestors, below which were hung these glorious mythological tapestries. Becoming known as the Hercules Hall, the room impressed visitors and was recorded in a 1614 woodcut.[13]

Maximilian's specific instructions and the scheduling goals he relayed to the Antwerp weavers indicate his active engagement with the project and a sense of frustration at the geographical and temporal obstacles involved. The ultimate solution to this dilemma was his engagement in 1604 of a Netherlandish tapestry weaver, Hans van der Biest, to assemble and direct a local weaving workshop, enabling tapestries to be created in Munich for the Residenz. Besides Italian artists such as

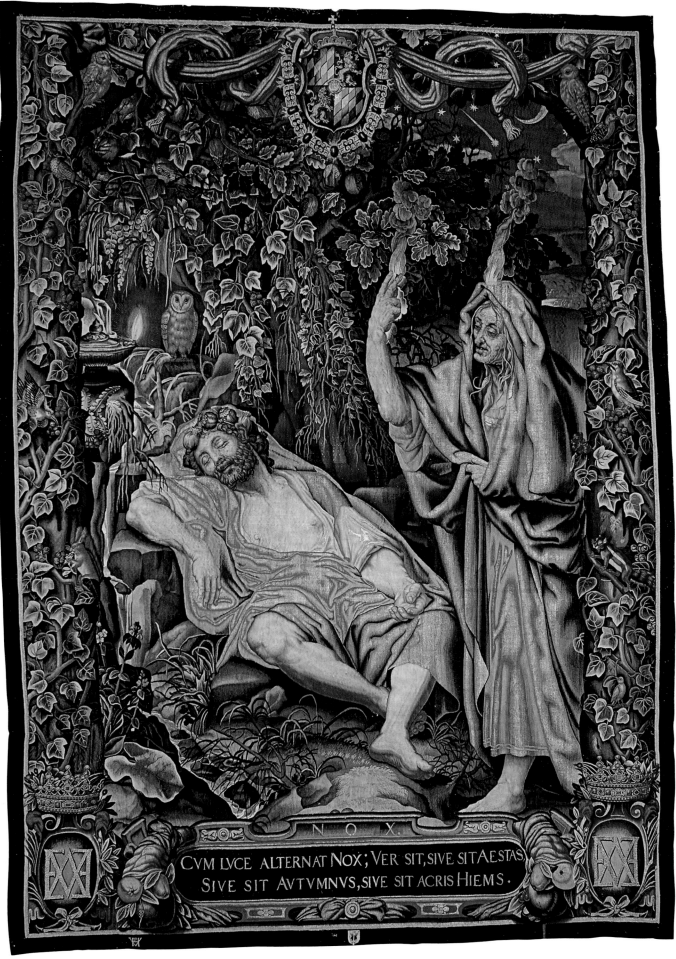

NOX

CVM LVCE ALTERNAT NOX; VER SIT, SIVE SITAESTAS
SIVE SIT AVTVMNVS, SIVE SIT ACRIS HIEMS.

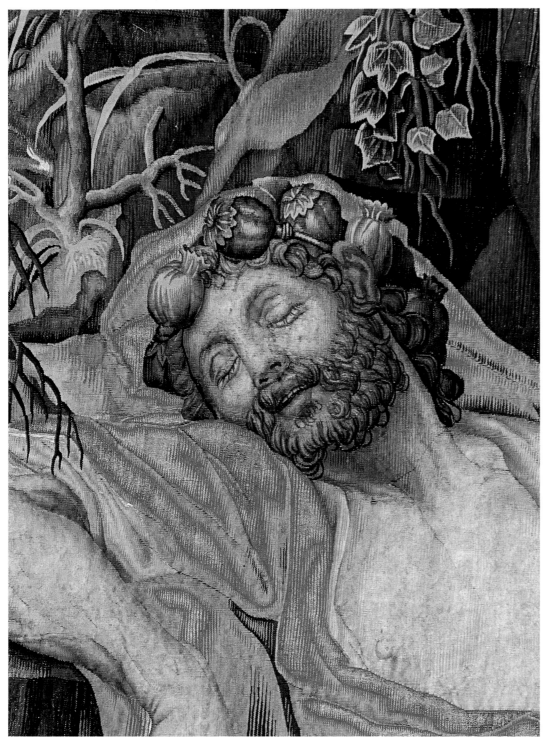

Detail of cat. no. 8

Antonio Ponzano and Alessandro Paduano, one of the painters employed at the Residenz who had worked on the ceiling of the Grottenhof, among other projects, was the Fleming Pieter de Witte (ca. 1548–1628).[14] Born in Bruges, he was still a child when his family moved south of the Alps. His father, Pieter de Witte the Elder, was a tapestry weaver who eventually took up employment as a specialist for detailed work at the Medici-

sponsored weaving workshops in Florence.[15] Pieter de Witte the Younger, whose name was Italianized to Pietro Candido, or Peter Candid, was trained by Vasari and assisted with the redecoration of the Palazzo Vecchio, in addition to various altarpiece commissions in Volterra.[16] He had arrived in Munich in 1586, invited by Wilhelm V following a recommendation from Giambologna. It is possible that, as Brigitte Volk-Knüttel has suggested,

Maximilian's decision to set up his own weaving workshop was in part influenced by the knowledge that in Peter Candid he had at his disposal an artist fully trained at and capable of cartoon painting. It is perhaps even more likely, however, that Maximilian was, as so often in artistic matters, influenced by a short-lived project of his father's to set up a court tapestry weaver.[17] Maximilian's court artist Friedrich Sustris had experience both at designing tapestries and at painting cartoons from his time in Florence and would have seemed to have been Maximilian's natural choice as tapestry designer for the Munich workshop. It was probably Sustris, already busy with the other Residenz design projects, who recognized Candid's potential and proposed him as tapestry designer.

Over the course of a decade, Candid provided designs for three tapestry series woven in Munich: a set of twelve *Grotesques*, the eleven-piece *Story of Otto von Wittelsbach* (figs. 31, 33, of which ten pieces survive; Maximilian later commissioned replicas of all eleven from the Paris-based weavers Marc de Comans and François de La Planche), and eighteen tapestries of the *Months, Seasons, and Times of the Day* (*December*, figs. 30, 32; *Night*, cat. no. 8). He also prepared the preliminary designs, although not the cartoons, for a series of twelve tapestries representing biblical and mythological figures to be hung in the imperial hall (or Kaisersaal) of the Residenz, woven under the direction of the same master weaver, Hans van der Biest, but in his Enghien workshop. Candid had a developed understanding of the language of tapestry design, having trained with Vasari who, in turn, had provided the Medici-supported weaver Jan Rost with some modelli.[18] According to Karel van Mander, who met Candid when they were both working in Italy, Candid himself had made "various tapestry designs and other things for the Duke of Florence."[19] Although the cartoons for the Munich-woven tapestries have not survived, it is highly likely that Candid painted these himself, as Sustris had done in Florence, rather than delegating them to assistants. The cartoons were certainly of a high enough artistic quality to have been preserved and perhaps kept on display.[20] One hundred years later, they were sufficiently

well preserved to be of use as models to the engraver Carl Gustav Amling.[21]

Candid took an active involvement in the weaving of his designs: contemporary accounts refer to his visits to the workshop in order to discuss how details of technique and palette could achieve the best results.[22] The artist may have had a nuanced understanding of weaving that he gleaned from his father. Candid's association with the tapestry weavers was close enough for him to stand proxy for the duke at the marriage of Van der Biests's daughter to his primary journeyman weaver, Hans van den Bosschen, and two years later, Candid's wife, Aemilia, was named godmother to their child, Aemilia Elisabetha van den Bosschen.[23]

Maximilian's choice of tapestry subject matter followed a methodical plan. With the delivery of the final Kaisersaal set in 1618, he had four distinct genres of tapestry: decorative, genealogical, landscape and allegory, and biblical and mythological. Contemporary accounts reveal that the tapestries were displayed with calculated care during noteworthy court visits. During the festivities of the nuptials of Maximilian's sister Magdalena to Duke Wolfgang Wilhelm of Neuburg, for example, the bridegroom's apartment was hung with the *Otto of Wittelsbach* set, celebrating the significance of the dynasty into which he was marrying, and in his mother's rooms were displayed the less politically charged landscapes of the *Months*. In the summer, tapestries were installed for the duke's enjoyment in arcades beside the gardens: a courtier from Augsburg described "nine vaulted *stantias,* painted with various figures by Peter Candid, furnished partly with beautiful stoves, partly with mantels on which stand antique busts and images, as also on the cornice (from which tapestries hang).... These are thus the duke's Sommer Zimmer, in which he has cross-ventilation"; other visitors referred to "two very long corridors, some hundred feet long, where in the summertime, tapestries of gold and silver, with beautiful figures, hang from the walls."[24] The splendor of the court, in which tapestries played such a role, did not go unnoticed: in 1644 the Italian musician and composer Baldassare Pistornini described its effect of a "sumptuous palace, an imperial rather than a ducal residence."[25]

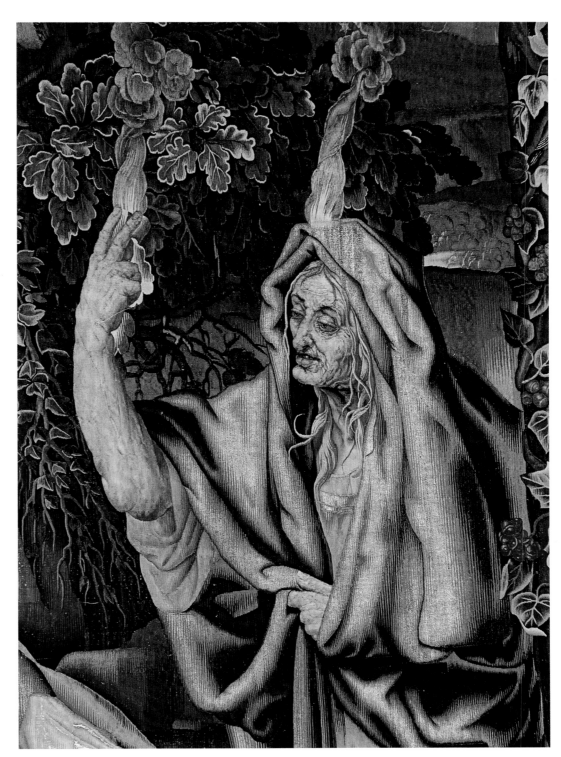

Detail of cat. no. 8

Van der Biest and the Munich Tapestry Workshop

The bottom selvage of catalogue number 8 contains the shield of the Munich manufactory and the mark of Hans van der Biest. The tapestry was formally delivered to the court in March 1614 by the journeymen weavers Hans Rosier, Franciscus Stalrauber, and Henrik van Bieurde.[26] Rosier and Stalrauber had been in the Munich workshop for just over six years;

Van Bieurde had worked there only since April of the previous year. All had been weaving under the direction of master weaver Hans van der Biest (fl. 1604–before 1618), contracted by Maximilian's chief steward Kaspar Fraisslich in March 1604 to set up and run a tapestry-weaving workshop in Munich.[27] Van der Biest, who came from Enghien, had initially trained as a cobbler but had been a weaver for thirty years and a master weaver

85

for the last twenty. Maximilian had arranged for him to receive a generous annual stipend as well as living expenses and money to finance his move, with his family, from Hainault to Bavaria. The duke supplied additional funds for Van der Biest to return to the southern Netherlands to purchase raw materials and to oversee the hiring of journeymen to work under his direction.

Even though Van der Biest came from Enghien, all his journeymen were recruited in Brussels. Heinrich Göbel suggested that younger sons of a number of significant weaving families spent time in the Munich workshop, including members of the Van den Dries and Van Tieghem households. Wilhelm Spiringkh, one of the journeymen, was conceivably related to François Spiering. Such was the caliber of the craftsmen being recruited that the Brussels magistrate, at the bidding of the tapestry weavers' guild, hindered the departure of weavers on at least three occasions. Twice the weavers were temporarily incarcerated and threatened with permanent exile and confiscation of all their possessions, necessitating an appeal from Maximilian to Archduke Albert for intervention. Van der Biest's establishment, set up to supply Maximilian's need for furnishings for the Residenz rather than as a commercial manufactory, nonetheless shared many characteristics with a traditional workshop, including apprentices, usually sons of local craftsmen, and auxiliary helpers. The workshop saw a varied and continuous stream of weavers: Brigitte Volk-Knüttel listed the forty-one names recorded in the Bavarian archives. At its peak, about twenty weaver journeymen were employed under Van der Biest and his assistant weaving director (and future son-in-law), Hans van den Bosschen. Six looms were working simultaneously by the time the team embarked on the *Months, Seasons, and Times of the Day* set. Archival records reveal consider-

able friction within the workshop, from brawls and insubordination among the journeymen to accusations of fraud and duplicity that were brought before Maximilian. Those charges were leveled against Van der Biest by two Francophone weavers, Hermann Labbé and Marx Delibet, the latter of whom, as Volk-Knüttel has shown, was probably from Lorraine and had worked for Maximilian on modest projects for six years before Van der Biest's arrival.[28]

Most of the wool and silk and the paper for cartoons used by Van der Biest was obtained from the Netherlands. The gilt and silver metal-wrapped threads were either bought directly from Italy or purchased from a Munich-based merchant, Franz Füll.[29] Over the course of ten years, Füll was paid 15,000 guilders for the gold and silver woven into the tapestries; that sum was equivalent to a senior journeyman weaver's wage for fifty years. Absence of local merchants used to catering to tapestry weavers required that the Munich weavers dye most of the yarns they needed themselves. Van der Biest took with him to Munich a "dye book," in which he had transcribed dyeing recipes collected from various weaving colleagues.[30] His apparently unorthodox dyeing methods were criticized by the French journeymen Delibet and Labbé, who also complained to the duke about the extent of Van de Biest's knowledge of weaving, complaints that are refuted by the quality of workmanship and depth of color of his surviving works, including catalogue number 8. The well-documented inquiry that followed these accusations seemed not to cause Van der Biest any loss of favor with the duke, for he continued to receive bonuses and tapestry projects, which were completed to an extremely high standard. Even after the Munich workshop closed, Maximilian supported Van der Biest with a final commission, the Kaisersaal tapestries. Van der Biest set up

shop in his native Enghien together with his Brussels-trained son-in-law Hans van den Bosschen, and there they completed the remaining commissions for the duke.

ELIZABETH CLELAND

1. For the use of the rainbow in *Day*, see Graziani 1972, p. 251.
2. Staatliche Graphische Sammlung, Munich, inv. 33179. Published in Volk-Knüttel 1976a, p. 178, no. 117; Munich 1978, pp. 69–70, no. 81.
3. Paris–Florence 2004, pp. 244–49, no. 40.
4. Munich 1980, vol. 1, pp. 185–268; Klingensmith 1993, p. 27; Tracy 2006, pp. 147–69.
5. Steinbart 1928; D. Diemer and P. Diemer 1995; Lietzmann 1998.
6. Steinbart 1928, passim; see also Munich 2005, pp. 147–87, nos. C1–C22; Princeton–Washington–Pittsburgh 1982, pp. 120–21, no. 4. For Sustris in Florence, see Meoni 1998, pp. 68–69, nos. 42–44.
7. Leuchtmann 1980; Stierhof 1980; Kaufmann 1995.
8. D. Diemer 1980.
9. Goldberg 1980.
10. For Wilhelm V's purchase of a *Hercules* set from the Antwerp weaver Michiel de Bos in 1565, see Buchanan 1994, and also Hager 1959–60.
11. Volk-Knüttel 1976a, pp. 10–11.
12. Göbel 1933–34, vol. 1, p. 201.
13. Volk-Knüttel 1967, pp. 187–94.
14. Steinbart 1937. See also Rée 1885; Antal 1951, p. 31; Volk-Knüttel 1976a, pp. 43–54; Marubbi 2003.
15. Meoni 1998, pp. 71–72.
16. Burresi and Piancastelli Politi Nencini 1994.
17. Göbel 1933–34, vol. 1, pp. 200–201; Volk-Knüttel 1981.
18. Meoni 1998, pp. 68–71; Wingfield Digby 1980, pp. 70–71, no. 67, pl. 96.
19. "[O]ock voor den Hertogh van Florencen verscheyden Tapijt-patroonen en ander dinghen"; Van Mander 1604, fol. 291v.
20. Volk-Knüttel 1976a, pp. 82, 86.
21. Ibid., pp. 82–83.
22. Göbel 1933–34, vol. 1, p. 206; Volk-Knüttel 1976a, no. 24.
23. Volk-Knüttel 1976a, p. 24.
24. Philipp Hainhofer in 1611, cited in Klingensmith 1993, p. 30; Gottfried Ehrenreich Berlichius in 1652, published in Trautmann 1887, p. 509. Volk-Knüttel (1976a, p. 86) argues that these refer not to tapestries but to cartoons.
25. Baldassare Pistorini, "Descrittione compendiosa del palagio sede de Serenissime di Baviera," Bayerische Staatsbibliothek, Munich, MS BstB, HsAbt, cod. it. 1409.1644; Longo-Endres 2006. See also Longo-Endres 2005.
26. Göbel 1933–34, vol. 1, p. 213; Volk-Knüttel 1976a, p. 143.
27. See Mayer 1892; Frankenburger 1913; Göbel 1933–34, vol. 1, pp. 202–13; Volk-Knüttel 1976a; Brassat 1992, pp. 177–79 no. 16, 197–98 no. 37.
28. Volk-Knüttel 1976a, p. 12.
29. Ibid., p. 31.
30. Ibid., no. 10.

9.
Leopard over a Pond

From an eleven-piece set of *Landscapes with Animals*
Cartoon by an unidentified Flemish painter, possibly
Pieter Coecke van Aelst the Younger or Jean Tons II,
ca. 1550–60
Woven in the workshop of Catherine van den Eynde,
working in partnership with Jan Raes II, Brussels,
1611–14
Silk
467 x 587 cm (15 ft. 3⅞ in. x 19 ft. 3⅛ in.)
10 warps per cm
Workshop mark of Catherine van den Eynde in
lower part of right selvage
Property of the Sovereign Order of Malta, Palazzo
Savelli Orsini, Rome

PROVENANCE: December 17, 1611, contract between
Guido Bentivoglio, archbishop of Rodi and papal
nuncio in Flanders, representing Cardinal Alessandro
Peretti Montalto, and Jan Raes II for making the set is
signed in Brussels;[1] 1614, set sent to Cardinal Montalto
in Rome and hung in the church of San Lorenzo in
Damaso for the Feast of San Lorenzo, July 19, 1614;[2]
1614–23, displayed in one of Cardinal Montalto's
Roman seats, perhaps his apartment as vice-chancellor
of the Church in the Palazzo della Cancelleria or in
his principal residence, the Palazzo Termini; 1623,
Cardinal Montalto's estate inherited by his brother
Prince Michele Peretti Montalto; 1631, Prince
Michele's estate inherited by his son Cardinal
Francesco Peretti Montalto; 1655, inventory of
Cardinal Francesco's estate lists the *Landscapes with
Animals* (their last mention as a complete set),[3] and
the estate went to Paolo Savelli; at Savelli's death, his
goods were dispersed; two panels of the *Landscapes
with Animals*, the *Leopard* and the *Ostriches*, are said to
have passed through the Chigi, Torlonia, and Sforza
Cesarini collections in Rome,[4] and became the prop-
erty of Countess Valeria Rossi di Montelera (1905–
1994); 1994, she bequeathed the *Leopard* and the
Ostriches, together with her apartment in the Palazzo
Savelli Orsini, to the Sovereign Order of Malta.[5]

REFERENCES: Hoogewerff 1925, pp. 140, 144–48,
nos. III–V; "Fastes romains" 1971, pp. 42 fig. 1, 43 fig. 4;
Waźbiński 1994, vol. 2, pp. 362, 632; Benzi and
Vincenti Montanaro 1997, p. 74; Forti Grazzini 2003,
p. 82; Forti Grazzini 2004, pp. 22–24, 30–32, 43;
Bertrand 2005, pp. 76, 230; Forti Grazzini 2007.

CONDITION: Very good, with no traces of
restoration.

A leopard stands on an ivy-covered tree
trunk that hangs out over a pond. The
tree is rooted on a small island covered with
dense foliage. The feline, with its anthropo-
morphic features and a much inflated upper
body, was probably not drawn from life, but its
body and posture nonetheless communicate a
sense of force and agility. From a branch far-
ther up the trunk, a wary parrot keeps an eye
on the leopard, which is also being watched
from within the trees by a goat that is casting
a malevolent look in its direction. Among the
tree roots and the water plants around the
island are two frightened ducks, a kingfisher, a
snail, and a frog. Two herons stand on the
bank of the pond at the left. The leopard,
looking forward over the surface of the pond,
demonstrates no interest in these animals.

The foreground of the tapestry, completely
occupied by water, displays marvelous effects
of light and reflection that were rarely repre-
sented in tapestries. The most notable is the
one just beneath the leopard, a reflection of
itself distorted by the rippling water. The
background shows the pond's far banks lined
with trees. The natural setting is European,
although a date palm on the island suggests an
African milieu, apt for a leopard.

The border of the tapestry, edged inside
and out by an ornate pattern of cream-colored
leaves on a deep mustard ground, consists of
simulated carvings of gilt foliate scrolls with
artichokes and pomegranate branches on a
red background. At the center of each side
border is an ornamental arrangement of oak-
leaf motifs. Medallions in the upper corners
contain the head of the god Bacchus covered
with grape-laden vines. In each lower corner
is the head of a ferocious lion with a menac-
ingly open mouth. The blue selvage all around
the tapestry is original, and the workshop
mark is woven into the lower right side.

Weaver
The workshop mark in the right selvage was
used by Brussels weaver Jacques Geubels I
until his death in 1605, and then by his
widow, Catherine van den Eynde (she was

privileged in 1613), who directed the work-
shop until her death, sometime between 1620
and 1629.[6] As her husband had, Van den
Eynde frequently worked in partnership with
other Brussels workshops, and the most fruit-
ful and durable association was with the one
directed by Jan Raes II (ca. 1570–1643), the
most important in Brussels during the first
third of the seventeenth century.[7] In addition
to *Landscapes with Animals*, Raes's and Van den
Eynde's marks alternate, for example, on a set
of the *Acts of the Apostles* after Raphael and
on two sets of *Decius Mus* after Rubens (all,
Patrimonio Nacional, Madrid).[8] That the
Leopard over a Pond was woven between 1611,
when the contract for the set's weaving was
signed, and 1614, when it was sent to Rome,
means its Geubels–Van den Eynde mark
refers to Catherine van den Eynde, and since
Jan Raes II's mark and signature are on the
Ostriches, another panel of the set, it is evident
that these two workshops wove the set in
partnership.

Source of the Design, Subject, and Iconography
The two earliest extant sets of *Landscapes with
Animals* were woven in Brussels about
1550–60: the so-called *Unicorn* set of nine
pieces in the Palazzo Borromeo at Isola Bella
(Stresa),[9] and the *Landscapes with Animals* set in
the Wawel Royal Castle, Kraków, now con-
sisting of forty-four pieces but originally
larger.[10] The wild animals in wooded land-
scapes depicted in these tapestries include
some from Europe (such as wolves, lynx,
stags), some from other continents (such as
lions, leopards, elephants, rhinoceroses,
ostriches), and some fantastic animals (uni-
corns, dragons); there are no human figures in
the compositions. The subjects and iconogra-
phy of the tapestries grew out of contemporary
interests in newly discovered or explored
lands in America, Africa, and Asia; in zoologi-
cal sciences that caught on in Europe toward
the middle of the sixteenth century, which
gave rise to illustrated books devoted to ani-
mals (by Conrad Gessner, Pierre Belon, and

Ippolito Salviani);[11] as well as in princely menageries of exotic animals and collections of natural marvels in *Wunderkammern*.[12] The tapestries also demonstrate a revival of interest in ancient texts on animals and their characteristics (by Pliny the Elder, Aelianus, and Solinus) and in the literature of late antiquity and the Middle Ages in which animals and their habits were interpreted as religious allegories (beginning with the Latin translation of the Greek *Physiologus* of the second century and the treatises of the church fathers, and continuing in medieval bestiaries, encyclopedias, and *summae*). The presence of religious allegory in a depiction of the natural world may explain why zoological tapestries were often made for important prelates.

In the Borromeo *Unicorn* set, probably made for Charles de Guise, cardinal of Lorraine (1524–1574), in which dramatic animal combats are represented, recognition of the religious symbolism is assured by inscriptions that refer to the Life and Passion of Christ and the Fall and Redemption of Man.[13] The principal aims of the *Landscapes* in Kraków, made for Sigismund II Augustus (1520–1572), king of Poland, seem to have been curiosity about the exotic in nature and the pleasure of observing it. Other similar series were designed and woven during the third quarter of the sixteenth century in Brussels and also in Oudenaarde and Enghien.[14] At the beginning of the seventeenth century, the demand for Flemish zoological tapestries was still high. Brussels weavers continued to use the cartoons painted in the previous century as models for a second wave of zoological sets, such as the one woven in Pastrana by Frans Tons, a Brussels weaver who emigrated to Spain,[15] and the ones made in Brussels by Jan Raes II and Catherine van den Eynde.

Flemish Renaissance zoological tapestries frequently included leopards. They are in four of the Borromeo *Unicorn* set, for example, and in five *Landscapes* in Kraków.[16] This wide figurative presence was a consequence of the role of leopards in ancient and medieval writings on animals, in which the feline is mentioned by its Latin name, *panthera*. An extensive description of the animal's habits and their Christian allegorical explanations may be found in the eleventh-century Latin *Physiologus*.[17] There the name of the animal is explained as meaning "he who takes everything," and it is related, though mistakenly (referring to Hosea 5:14), that the awaited Messiah is mentioned in the Bible as the "panther for Effraim." The leopard was thus interpreted as a symbol of Christ for its name; for its supposed benevolence toward nearly all animals except the dragon; for its pleasing appearance; for its compelling roar and the pleasing fragrance of its breath, intended as metaphors of the sweet Commandments of God and words of Christ; and for its supposed habit of sleeping for three days after eating, likened to the Death and Resurrection of Christ.[18] This notion is implied in tapestries in which leopards are depicted fighting with animals that carry demonic symbolism, such as the monkeys and the unicorn in the Borromeo hangings, and the dragon and the wolf in the Kraków tapestries. In *Leopard over a Pond*, the peaceable attitude of the protagonist toward the animals around it could have such allegorical connotations.

Other elements of the scene, however, refer more explicitly to a different Christian legend involving a wild feline. One such element is the goat, with its menacing expression, that observes the leopard. The goat was traditionally a symbol of the soul condemned to eternal damnation (Matthew 25:32–33) and of luxury, and a representative of the Devil. Another is the leopard's reflection on the pond, which alludes to the Christian allegory of felines being deceived by their reflection. Originally referring to tigers, this was recounted through the Middle Ages. Saint Ambrose (*Hexaemeron* 6.4), following Pliny the Elder (*Naturalis historia* 8.25), was among the first Christian writers to tell the legend of a hunter capturing a tiger cub for a pet. When he is followed by the tiger's mother, the hunter leaves a glass sphere, and the mother tiger, seeing its reflection reduced on the sphere, believes it has recovered its young and leaves the hunter free to escape with his prey. In later retellings (the Latin *Physiologus*, and by Hugo da San Vittore, Bartholomeus Anglicus, Vincent de Beauvais, and others), round mirrors replaced the glass spheres, but the story assumed an allegorical character: the pet was explained as the soul that the sinner (the tiger) has lost and will recover, but the

effort is in vain since the sinner is deceived by the mirrors of earthly temptations. A rhymed version of the allegory, written at the beginning of the fourteenth century by Cecco d'Ascoli (*L'acerba* 43), describes the deceived tiger as "simil di pantiera" (resembling a leopard).[19]

A small zoological scene, in which a great feline observes its face in a mirror, that is sometimes in the borders of Brussels tapestries in the third quarter of the sixteenth century is explained by these texts and is connected to the Latin motto *Decipior umbra* (I am deceived by the reflection). Mercedes Viale Ferrero listed these representations as always referring to tigers,[20] but sometimes their coats have the round spots of a leopard. Possibly those are inaccurate renderings or maybe they derive from the concept that not only tigers are deceived by their reflection. In a circular frame in the lower border of the Borromeo *Lioness*, the Latin motto refers to a lioness, and moreover, the animal is observing its reflection not in a mirror but in the water of a pond from its position on the bank.[21] This scene is the most apt iconographical comparison to the tapestry presented here: like our leopard, and in the same pose, the lioness is apparently not following the hunter with the lion cub but instead embodies the soul deceived by worldly temptations.[22] The symbolism of our leopard is reinforced by its unsure position on the tree trunk and by the presence of the menacing goat—the Devil spying on his intended victim.

The many cartoons that Jan Raes II owned and reproduced in his tapestries included designs of very important high Renaissance series. The cartoons for the *Landscapes with Animals* series from which Montalto's set and others (see below) were woven were mostly painted about 1550. Three panels of the series, the *Ostriches*, the *Leopard Biting a Lion*, and the *Lioness in a Pond,* are reweavings with different borders of pieces in the Borromeo *Unicorn* set of 1550–60.[23] Raes did include at least one subject that was painted anew: the *Unicorn Fighting Leopards*, known by a tapestry made with a reweaving of Montalto's *Landscapes*,[24] is not a replica of the Borromeo tapestry but shows a different and less naturalistic image, noticeable particularly in the small animals

9

in the background, which recalls zoological paintings by Jan Breugel the Elder and fits well with a chronology soon after 1600.

Although we have no information about a mid-sixteenth-century Brussels tapestry of the *Leopard over a Pond*, there is no doubt that the present tapestry was copied from a mid-sixteenth-century cartoon: the naturalistic rendering of animals and plants and the superb quality and expressiveness of the image reproduced on the tapestry made for Montalto are in the same vein as those we admire in the Borromeo and Kraków sets of about 1550–60. Indeed, there is a direct link between the iconography of our feline looking at its reflection and that in the roundel in the lower

border of the Borromeo *Lioness* panel. In addition, both the pose and the physical structure of our leopard are derived from the *Leopard* woodcut in the first volume (1551) of Conrad Gessner's *Historia animalium.*[25]

The skillful Flemish painter who was responsible for the cartoons for *Animals in a Wood* of about 1550–60 is not known, but a drawing by him, *Animals in a Wood* (British Museum, London), which seems to be preparatory for a lost tapestry, is inscribed with the date 1549 and *P v Aelst fe* (*Pieter van Aelst fecit*; fig. 42). Though not autograph, this inscription led Georges Marlier to assume that the painter worked in the circle of Pieter Coecke van Aelst (1502–1550) in Antwerp,

possibly his son Pieter Coecke the Younger, by whom no work survives.[26] Other scholars link that drawing and related zoological tapestry designs to the names of two painters in the Tons family, active in Brussels:[27] Jean Tons II (ca. 1500–1569/70), who was probably the painter Tons mentioned by André Félibien and Henri Sauval as the specialist of landscapes and animals who collaborated with Bernaert van Orley for the cartoons of the *Hunts of Maximilian* tapestries (Musée du Louvre, Paris);[28] or Willem Tons, documented as a cartoonist in 1577–79[29] and whose cartoons, according to Karel van Mander, represented "all kinds of trees and herbs, animals, birds, eagles, and suchlike, very subtly and well executed from life."[30]

Seventeenth-Century Series

The first owner of the *Landscapes with Animals* to which *Leopard over a Pond* belonged was Cardinal Alessandro Damasceni Peretti Montalto (1571–1623), for whom the set was ordered in Brussels in 1611 by papal nuncio Guido Bentivoglio and who received it in time to hang it in the church of San Lorenzo in Damaso in Rome for the feast of San Lorenzo on July 19, 1614 (see note 2). The set was listed as number 903 among numerous sets of tapestries in the 1655 inventory of the estate of his nephew Cardinal Francesco Peretti Montalto: "Tapestries numbering 11, of silk in *capicciola* [a kind of silk], done with Woods, different Animals, that is, elephants, lions, panthers, tigers, unicorn, dragons, with yellow friezes all around with leaves and pomegranates, with great roses in the middle [of each side], heads of Bacchus in the upper corners and heads of lions in the lower corners, they are 7 ells high, about 76 ells long, which is, for all of them, 532 [square] ells, I say 532 ells used."[31]

A friend of Cardinal Alessandro who evidently saw the *Landscapes* in Rome, Cardinal Scipione Borghese, received an answer to his inquiry about the tapestries from Ascanio Gesualdi, archbishop of Bari and papal nuncio in Flanders, sent from Brussels on January 14, 1617.[32] Gesualdi told Borghese that "Raes has the drawings or cartoons of the tapestries, which were woven entirely in silk for Cardinal Montalto and consisted of twelve pieces with landscapes and with large animals, as Your Lordship may see in the enclosed list of all the pieces for which there are cartoons here."[33] Raes could produce another set of the same high quality for the same price paid by Montalto: 28 florins per square ell. This was a very high price, explained by the extremely fine weaving made entirely with silk thread.[34] The cartoons were 7 ells high and 728 square ells, but the tapestries might be "cut or reduced in size according to the walls of the rooms where they will have to stay." Montalto had evidently done this, for his set measured 507 square ells. Gesualdi cautioned Borghese not to make the same mistake as another client of the weaver, Don Pietro de Toledo, chaplain of the archdukes of the southern Netherlands, did: his set of the *Landscapes* did not come out well because the hangings, at

only 5½ ells high and 370 square ells, lacked the foliage on the upper parts of the cartoons. Gesualdi's list enumerated subjects and widths of the twelve cartoons: (1) Elephant, 10 ells; (2) Leopard looking at its reflection ("dove il Liopardo si specchia"), 9½ ells; (3) Rhinoceros, 9½ ells; (4) Lion in the water, 8 ells; (5) Battle of the Leopard with the Unicorn, 9 ells; (6) Ostrich, 10 ells; (7) Elephant goes to drink with the Unicorn, 9 ells; (8) Battle of the Leopard with the Lion, 7 ells; (9) Dragon eats the eggs, 7 ells; (10) Battle of the Elephant with the Dragon, 11 ells; (11) Leopard and monkeys, 8 ells; (12) Dragon flies up to the tree, 6 ells.[35]

From the 1655 inventory, we know that Montalto selected eleven of the twelve subjects offered. *Leopard over a Pond* reproduces the second subject on Gesualdi's list, and according to the cartoon's dimensions (7 by 9½ ells is equivalent to 490 by 655 cm), the tapestry is reduced in height by about 20 centimeters and in width by about 80 centimeters. This left the upper foliage well visible and did not eliminate any important figurative elements. These *Landscapes* tapestries are very finely woven of silk weft on silk warp in a wide range of vibrant colors. In addition to *Leopard over a Pond*, the extant panels from Montalto's set, all with elegant borders of the same design,[36] are *Ostriches* (subject 6 on Gesualdi's list),[37] *Rhinoceros* (subject 3; fig. 43),[38] *Leopard Biting a Lion* (subject 8),[39] and *Stag*.[40] The main figure of this last tapestry is a powerful stag standing on the bank of a stream, and while the subject is not listed as such in Gesualdi's memorandum, this narrow panel shows a portion of a wider cartoon, probably the *Elephant Going to Drink with the Unicorn*, subject number 7 on Gesualdi's list.

There is a panel in the Borromeo set that corresponds with Gesualdi's subject number 11, "Leopard and monkeys,"[41] but no example woven in the seventeenth century by Raes is known. *Rhinoceros* is not a copy but, surely, a derivation from the 1549 modello for a zoological tapestry, mentioned above, conserved in the British Museum, maybe preparatory for a lost tapestry originally included in the *Landscapes with Animals* made in Brussels about 1550–60 for Sigmund II Augustus of Poland.[42] The Montalto *Stag*, as noted, is in mid-sixteenth-century style, as may be

confirmed by a similar stag in one of the *Landscapes* in Kraków.[43] In addition, the same stag and surrounding scenery on the Raes–Van den Eynde tapestries were represented in a reduced-size Brussels tapestry *Landscape with Castle and Animals* with Frans Geubels's mark (ca. 1560–85; Detroit Institute of Arts).[44]

During the second and third decades of the seventeenth century, the *Landscapes with Animals* series was woven in tapestries of lesser quality and with different borders, by Raes alone and in partnership with other weavers.[45] An isolated *Lioness in a Pond*[46] shows Gesualdi's subject 4; its border, which simulates a wood frame with animal and human grotesque masks in the corners and in the middle of each side, is the same as on three *Illustrious Men* tapestries, with workshop marks of Catherine van den Eynde.[47] Borders on an unsigned *Leopard Biting a Lion*[48] and a *Unicorn Fighting with Leopards*[49] with a Jan Raes II workshop mark—these are subjects 8 and 5, respectively—have masks in the corners, fruit and carved seashells in the middle of the sides, and two dolphins flanking a seashell containing a lion's head in the middle of the lower side; they are like those framing the *Decius Mus* sets in the Patrimonio Nacional marked by Raes and Van den Eynde or by Van den Eynde alone.[50] An isolated *Stag* in the Palacio de los marqueses de Viana, Córdoba,[51] with the coat of arms of the dukes of Arenberg above the scene, Raes and Van den Eynde workshop marks plus a third mark, AE, as well as Raes's signature, has the same border of foliate scrolls with precious stones that is on the *Acts of the Apostles*, signed by Raes and Van den Eynde, in the Patrimonio Nacional.[52]

Patron

The exceptional quality of the set of *Landscapes with Animals* to which *Leopard over a Pond* belonged and their high cost are not surprising considering the personality of their first owner. Alessandro Montalto, nephew of Pope Sixtus V (r. 1585–90), was made a cardinal in 1585 and named vice chancellor of the Church in 1589. He was a member of one of the most powerful and wealthy families in Rome, an illustrious patron of the arts and a friend of some of the most refined Roman collectors of his age: Cardinal Francesco Maria del Monte,

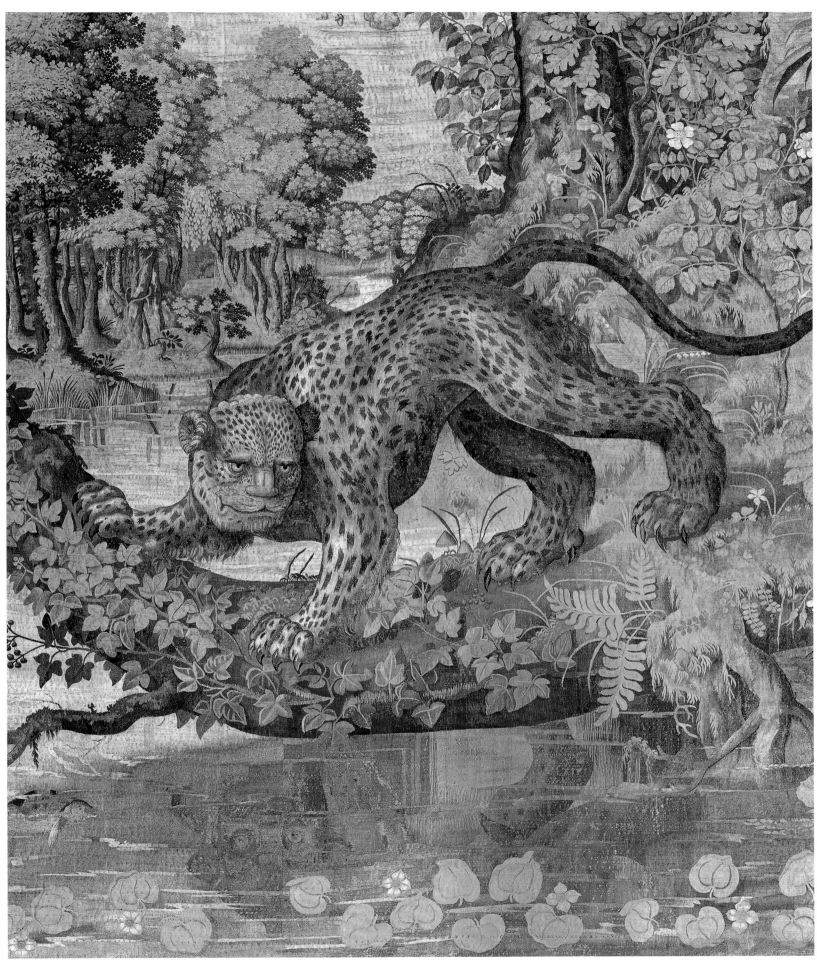

Detail of cat. no. 9

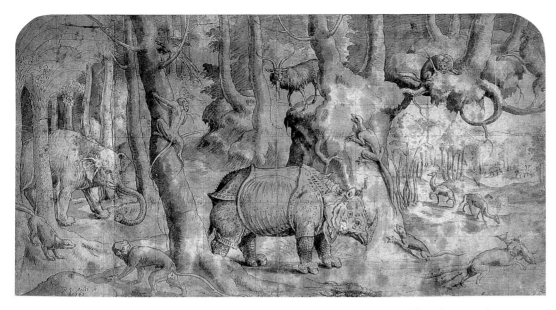

Fig. 42. *Animals in a Wood,* attributed to Pieter Coecke van Aelst, ca. 1549. Brown ink and gray wash on paper, 28.4 x 52.5 cm. The British Museum, London (1900-6-13.1)

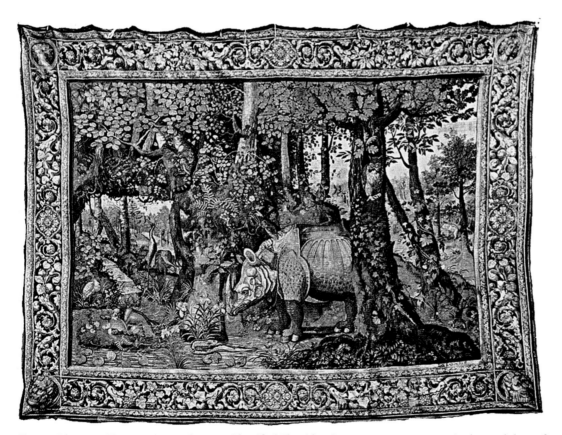

Fig. 43. *Rhinoceros.* Tapestry cartoon by an unidentified Flemish painter, ca. 1550–60, woven in the workshop of Catharine van den Eynde in partnership with Jan Raes II, Brussels, 1611–14. Location unknown

marchese Vincenzo Giustiniani, and Cardinal Scipione Borghese.[53] His physical appearance is recorded in a drawing by Peter Paul Rubens (Kupferstichkabinett, Berlin), whom he introduced into Rome in 1601, and in a

sculpted portrait by Gian Lorenzo Bernini (1621–22; Kunsthalle, Hamburg).[54] He was a protector of music and musicians,[55] and he commissioned works from the most renowned painters on the Roman scene: Paul

Bril, Cavalier d'Arpino, Antonio Tempesta, Antonio Carracci, Giovanni Lanfranco, Domenichino, Francesco Albani, Guido Reni;[56] Domenichino and Lanfranco executed frescoes in the choir and dome of the Roman church of Sant'Andrea della Valle, whose completion by Carlo Maderno and decoration were financed by Cardinal Montalto.[57] He commissioned statues, frescoes, and furniture for his two villas near Rome—Villa Lante in Bagnaia and Villa Grazioli in Frascati, although his principal patronage was devoted to embellishing the majestic estate (no longer extant) on Rome's Esquiline Hill that he inherited in 1606 from Sixtus V. This included the Palazzo Termini, which housed most of his artworks, an enormous park in which stood the Villa Felice.[58] He installed dozens of ancient and modern statues in the park, including Bernini's *Neptune and Triton* (now, Victoria and Albert Museum, London),[59] and among these statues were leopards, tigers, and rhinoceroses, signaling Montalto's interest in the marvels of nature and in the religious symbolism connected with these animals.[60]

Cardinal Montalto assembled his collection of tapestries in just a few years. It was the largest new such collection formed in Rome at the beginning of the seventeenth century, until the Barberini family began their systematic collecting. Montalto ordered new sets from Paris, Brussels, and Florence, and he also bought secondhand tapestries. His acquisitions and opinions (as evidenced by letters or demonstrated by his reactions to the different sets bought or made for him) reveal a preference for tapestries woven from sixteenth-century High Renaissance designs of historic or symbolic subjects.[61] Three such pieces survive from his first acquisition: the first enlarged edition of the *Story of Artemisia* from cartoons by Toussaint Dubreuil and Henri Lerambert, whose weaving in Paris, by Maurice Dubout in 1606–7, was at first supervised by papal nuncio Maffeo Barberini (future Pope Urban VIII).[62] Montalto was disappointed by these tapestries, probably because of their flat Mannerist style. Next he purchased in Paris a Brussels-woven fourteen-piece set of the *Story of Alexander,* then in 1612 in France, a Brussels-woven *Scipio* set from cartoons by Giulio Romano was procured for

him by the marchese Vincenzo Giustiniani.[63] In 1609–10 Jan Raes II wove a *Story of Noah* for him from the cartoons copied from those painted after Michiel Coxcie for the set woven in 1563 for Philip II of Spain,[64] and in 1614 Raes sent him the *Landscapes with Animals*. In the meantime the Medici manufactory in Florence, directed by Guasparri Papini, made for Montalto a six-piece *Story of Phaeton* (1609–12), woven with gold from cartoons by Alessandro Allori; two portieres with the cardinal's coat of arms between allegorical figures (1612); and a four-piece set of *Fishing (Summer)* from cartoons by Allori with new borders designed by Michelangelo Cinganelli.[65] Montalto did not like the *Fishing* tapestries, which he finally paid for in 1617 after many appeals from Florence, and he tried immediately, but in vain, to sell them to the court of Mantua.[66]

The sets of *Scipio, Landscapes with Animals, Noah, Alexander,* and the portieres are listed in the 1655 inventory of Cardinal Montalto's nephew.[67] As for the others, possibly Montalto himself sold the *Story of Artemisia* before his death in 1623. *Phaeton* and *Fishing* might have been sold by his brother and heir, Prince Michele Peretti, to Don Ruiz Gomez de Silva de Mendoza y de la Cerda, duque de Pastrana, who was in Rome in 1623–26 as Spanish ambassador to the papal court, and taken back to Spain among other tapestries, for the list of those include "fine tapestry of wool and silk with rich *matices* woven in Florence of a story of fishermen which is four panels [*Fishing*]... tapestry of wool and silk of the fables of Jupiter and Phaeton that has six panels... woven in Florence [*Phaeton*]."[68]

NELLO FORTI GRAZZINI

1. Hoogewerff 1925, p. 147, no. IV.
2. An "Avviso" of July 19, 1614, mentions the tapestries hanging in the church as "un paramento di due stanze di razzi nuovi, non già messi in mostra, di verdura boscareccia con Animali ritrati dal naturale" (a tapestry of two rooms of new weavings, not yet displayed, of wooded vegetation with Animals drawn from nature); Biblioteca Apostolica Vaticana, lat. 1082, fol. 410v, quoted in Waźbiński 1994, vol. 2, pp. 362, 632.
3. Bertrand 2005, p. 230; Forti Grazzini 2007.
4. John Edward Critien of the Sovereign Order of Malta, letter to Nello Forti Grazzini, October 21, 1998.
5. Photographs of the two tapestries hanging in a living room of the Palazzo Savelli Orsini were published in "Fastes romains" 1971, pp. 42 fig. 1, 43 fig. 4; Benzi and Vincenti Montanaro 1997, p. 74.
6. On Catherine van den Eynde, see E. Duverger 1981–84; Delmarcel 1999a, p. 365; see also De Poorter 1979–80.

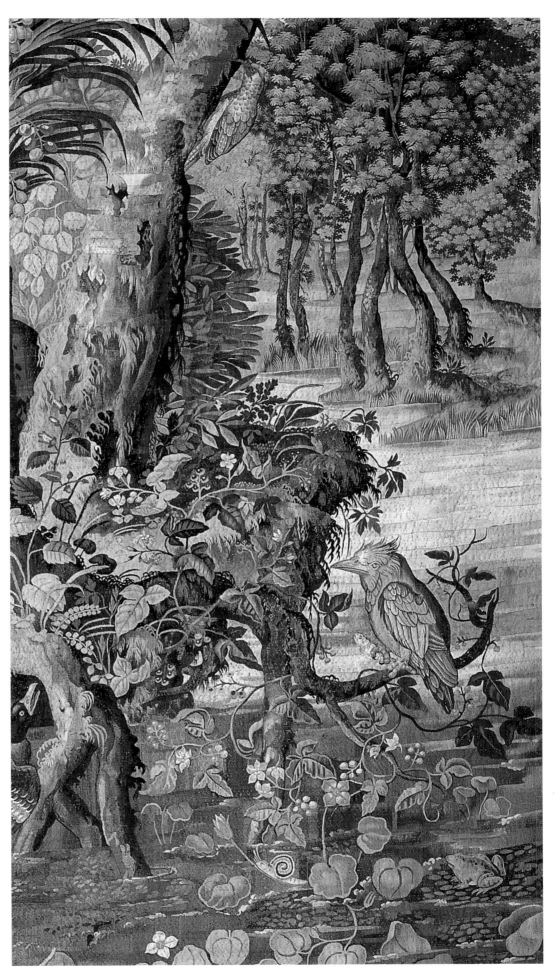

Detail of cat. no. 9

7. On Raes and his association with the Geubels and Van den Eynde atelier, see Delmarcel 1987; Delmarcel 1999a, p. 368.

8. Patrimonio Nacional series 48, 52, 53; Junquera de Vega and Diaz Gallegos 1986, pp. 62–74 (*Acts*), pp. 89–103 (*Decius Mus*). Similarly, the tapestries of a set of the *Story of the Trojan War* (Galleria Sabauda, Turin) are woven with the alternating marks of Raes and Van den Eynde and of Nicasius Aerts and Jacques Geubels II; Viale Ferrero 1981; Ragusa 1988, pp. 46–50.

9. Roethlisberger 1967; Viale Ferrero 1973; Michel 1999, p. 457; Natale 2000, pp. 61–70.

10. Hennel-Bernasikowa 1972; Hennel-Bernasikowa 1998, pp. 86–103.

11. Conrad Gessner, *Historia animalium*, 5 vols. (Zürich, 1551–87); Pierre Belon, *Histoire de la nature des oyseaux* (Paris, 1555); Ippolito Salviani, *Aquatilium animalium historiae* (Rome, 1554–57). See Mezzalira 2001, pp. 51–66.

12. On the menagerie founded by Duke Philip the Good of Burgundy in Brussels, of which there is information from 1446 and which was still in existence in the 16th century, see Saintenoy 1932–35, vol. 1, pp. 72–76; the presence of a leopard there, however, is not documented. A leopard captured with a ship of the pirate Barbarossa and presented to Emperor Charles V in Naples (1535) was sent by him as gift to the duke of Florence (ibid., p. 75). A useful synthesis on the naturalistic and scientific representation of animals in 16th-century Flanders, before Jan Brueghel the Elder, can be found in Kolb 2005, pp. 6–45, although she does not mention tapestries.

13. Viale Ferrero 1973.

14. Forti Grazzini 2003, pp. 81–82; Forti Grazzini 2007.

15. Asselberghs, Delmarcel, and Garcia Calvo 1985, pp. 107–9, figs. 7, 8, 10.

16. In the Borromeo set, there is a leopard in the background of *Lioness in the Pond*, in *Leopard Biting a Lion*, in *Snake and Leopard*, and in *Unicorn Fighting against Leopards and Lions*; see Roethlisberger 1967, figs. 6, 8, 7, 1. And in the Kraków set, leopards appear in *Combat between a Dragon and a Leopard*, in the background of *Wild Boar and Lion*, in *Combat between a Leopard and a Wolf*, in *Leopard*, and in *Leopards with Pheasant and Monkeys*; see Hennel-Bernasikowa 1972, pp. 193, 197, 214–16, 252, and Roethlisberger 1967, fig. 34.

17. *Physiologus*, version BIs, XXIV (*De panthera*); Morini 1996, pp. 54–61.

18. *Physiologus*, as in note 17; Morini 1996, pp. 54–61.

19. Morini 1996, pp. 608–9.

20. Viale Ferrero 1973, pp. 129–30.

21. Roethlisberger 1967, figs. 5, 14; Viale Ferrero 1973, fig. 10.

22. During the Middle Ages, leopards were sometimes said to be born from lionesses. See Isidoro, *Etymologiae* 12.2.1; Cecco d'Ascoli, *L'acerba* 40: "Di lionessa liopardo nasce..." (leopards issue from lionesses).

23. See their reproductions in Roethlisberger 1967, figs. 2, 8, 6.

24. In 1995, property of De Wit–Blondeel, Mechelen and Antwerp; 340 by 362 cm; Vianden 1995, pp. 48–49, no. 13.

25. Kolb 2005, fig. 30.

26. Marlier 1966, pp. 111–12, fig. 293.

27. Balis et al. 1993, pp. 72–74.

28. Félibien 1685–88, vol. 1, p. 552; Sauval 1724, vol. 3, p. 10; J. Duverger 1968a and J. Duverger 1968b.

29. Schrickx 1974, p. 52.

30. "[M]et allerley boomen, cruyden, dieren, doghelen, arenden, en berghlijcke, seer aerdigh en wel ghehandelt nae t'leven"; Van Mander 1604/1994–99, vol. 1, pp. 178–179.

31. "903. Arazzi numero 11 di seta in capicciola fatti con Boscaglie, Animali diversi cioè elefanti, lioni, pantere, tigri, alicorno, draghi, con fregi gialli intorno a fogliami e granati, con rose grandi in mezzo, a' cantoni di sopra teste di Bacco et a quelli di sotto teste di leoni, sono alti ale 7, larghi ale in giro n° 76 e fanno fra tutti ale 532 dico ale 532 usati"; Archivio di Stato, Rome, Archivio Notarile Urbano, sezione V, protocollo 4, fol. 69, notary Simonelli, Inventory of the Goods of Cardinal Francesco Peretti Montalto, May 3–July 30, 1655, MS, fol. 955, as quoted in Bertrand 2005, p. 230.

32. Archivio Vaticano, Archivio Borghese, II, vol. 137, fols. 3–4, 7; Hoogewerff 1925, pp. 144–46, 147–48, nos. III, V.

33. "Il Raes tiene li disegni o patroni della tappezzeria, che fu lavorata di tutta seta per il Cardinal Montalto, che consistono in dodici pezzi a paesi, et con animali grandi, come ne vedrà V. S. Illma. la nota quì inclusa d'ogni pezzo, come son quà li patroni"; Hoogewerff 1925, p. 145. Though Gesualdi seems to write of twelve tapestries made for Montalto, his woven set comprised eleven pieces; the number of *Landscapes with Animals* cartoons in Brussels was twelve.

34. In 1629–30, the Cathedral of Cremona paid 11 florins per square ell for its *Story of Samson* tapestries made by Raes, but those were woven with silk and wool, on seven to nine—rather than ten—warp threads per centimeter; Voltini 1987, pp. 62–66.

35. Hoogewerff 1925, pp. 147–48, no. V.

36. The borders were inspired by Renaissance borders with foliated scrolls of Italian design, such as those on the *Deeds and Triumphs of Scipio* in the Spanish Patrimonio Nacional (series 26; Junquera de Vega and Herrero Carretero 1986, pp. 176–84) and on the *Story of Moses* at Châteaudun (C. M. Brown and Delmarcel 1996, pp. 194–205), both from cartoons or designs by Giulio Romano and his circle. Borders of the same design as those on Montalto's *Landscapes* were used on a *Fall of Troy* auctioned by Christie's, London, December 8, 1988, no. 226 (a reweaving of one of the *Story of the Trojan War* set in Turin, which tapestries have the Raes and Van den Eynde workshop marks; Viale Ferrero 1981; Ragusa 1988, pp. 46–50), and on *Scipio Sending His Soldiers into Battle* (?), a tapestry once in the Jahnsson collection, Stockholm (Böttiger 1928, pp. 44–46, no. 35, fig. 34).

37. *Ostriches*, 470 by 592 cm, Brussels and Raes workshop marks in the selvage and Raes's name in the lower center, property of the Sovereign Order of Malta, Palazzo Savelli Orsini, Rome; Forti Grazzini 2004, pp. 24, 43; Forti Grazzini 2007.

38. *Rhinoceros*, 475 by 505 cm, Van den Eynde workshop mark in selvage and Raes's name in the lower center, whereabouts unknown. Roethlisberger (1967, p. 109, fig. 11) mentions that the tapestry was on the art market in Paris or Brussels in 1920–30. It was auctioned at Franco Semenzato and Co., San Nicolò di Monticella, Conegliano (Treviso), September 22–24, 1978, no. 1171; Forti Grazzini 2004, pp. 21, 41; Forti Grazzini 2007.

39. *Leopard Biting a Lion*, whereabouts unknown, cut into two pieces and said to have been auctioned in Paris or Brussels about 1920–30; Roethlisberger 1967, p. 109.

40. *Stag*, 473 by 340 cm, Brussels and Van den Eynde workshop marks in selvage, Galerie Rabel, Republic of San Marino; Forti Grazzini 2004; Forti Grazzini 2007.

41. *Snake and Leopard*; see Roethlisberger 1967, fig. 7.

42. Hennel-Bernasikowa 1998, p. 17.

43. *Unicorn and Stag*; ibid., pp. 94–95, no. XXV.

44. E. Duverger 1969, pp. 175–78, fig. 20; Forti Grazzini 2004, pp. 20, 22, 39.

45. These tapestries are listed in Forti Grazzini 2004, pp. 24ff.; Forti Grazzini 2007.

46. In 1996 it was property of a dealer in Florence; 344 by 451 cm; sale cat., Sotheby's, Zürich, December 10, 1996, no. 230.

47. The tapestries were once in the collection of Count Thure-Gabriel Bielke at Sturefors Castle, Sweden; Böttiger 1928, pp. 47–50, nos. 36–38, figs. 35–37.

48. In 1964–65, property of G. Neerman, Florence; 350 by 300 cm; reproduced in Forti Grazzini 2004, p. 41, from a photo owned by Federico Zeri at Mentana (now in the Fondazione Federico Zeri, Bologna).

49. In 1995, property of De Wit–Blondeel, Mechelen and Antwerp; 340 by 362 cm; Vianden 1995, pp. 48–49, no. 13.

50. Patrimonio Nacional, series 52, 53; Junquera de Vega and Díaz Gallegos 1986, pp. 89–103.

51. The panel measures 350 by 284 cm; Lara Arrebola 1982, pp. 62–74.

52. Patrimonio Nacional, series 48; Junquera de Vega and Díaz Gallegos 1986, pp. 62–74.

53. Cardella 1793, pp. 224–28; Moroni 1851, pp. 90–91.

54. For the drawing by Rubens, see Jaffé 1977, p. 75, fig. 288; on the portrait by Bernini, see I. Lavin 1985.

55. Hill 1997.

56. Schleier 1968; Schleier 1972; Schleier 1981; Pierguidi 2001.

57. Costamagna 2001.

58. Cavazzini 1993; Benocci 1995–96.

59. Marder 2004.

60. Benocci 1995–96, p. 122.

61. Forti Grazzini 2007.

62. F. Boyer 1930; Denis 1992; Adelson 1994, pp. 175, 183; Bertrand 2005, pp. 103–7.

63. Bertrand 2005, p. 86.

64. Baschet 1861–62, pp. 409–10; Hoogewerff 1921, pp. 143–44. Montalto's *Noah* set became the property of Pope Alexander VII in 1657; Bertrand 2005, p. 169, n. 30.

65. Meoni 1998, pp. 111, 342–44, 517, 518 (*Phaeton*), pp. 112, 518 (portieres), pp. 324–41 (*Fishing*). The *Story of Phaeton* was exhibited in Rome in 1612; Orbaan 1920, pp. 203–4. The only extant weaving of *Fishing* (private collection, Paris) is not from Montalto's set; Forti Grazzini 2002, pp. 156–59, figs. 11, 12.

66. Meoni 1998, pp. 108, 520; C. M. Brown and Delmarcel 1996, p. 132.

67. Bertrand 2005, pp. 230–31.

68. "[T]apiçeria de lana y seda fina con matices ricos labrados en *florencia* de ystoria de *pescadores* que son quatro paños [*Fishing*]...tapiçeria de lana y seda de *las fabulas de Jupiter y Faeton* que tiene seis paños...labrados en *florencia* [*Phaeton*]." This inventory is published in Asselberghs, Delmarcel, and Garcia Calvo 1985, pp. 99, 119 no. 8. Three months after his return to Spain, the duque de Pastrana died in Madrid in December 1626. According to J. Brown and Elliott (2003, p. 108), the *Phaeton* set in the Patrimonio Nacional (series 55; Junquera de Vega and Díaz Gallegos 1986, pp. 110–16) was purchased for King Philip IV by the conde de Castrillo in 1634 from the conde de Ricla, cousin of Don Gaspar de Guzmán y Pimentel, conde-duque de Olivares, first minister of the king. Might it have been the set brought from Rome by the duque de Pastrana? The possibility exists, considering that Pastrana was a collateral relative of Olivares, and also of Ricla, who might have been given the *Phaeton* tapestries by Pastrana either before or soon after Pastrana's death. A few years earlier, ca. 1622–23, the duque de Pastrana had gifted his Guzman collateral with a set of heraldic tapestries with the Guzman arms woven in the workshop that the Brussels weaver Frans Tons opened in Pastrana under the duke's protection; Asselberghs, Delmarcel, and Garcia Calvo 1985, pp. 103–7, figs. 3, 5.

10.

Decius Mus Consults the Oracle

Third panel of an eight-piece set of the *Story of Decius Mus*
Modello and cartoon by Peter Paul Rubens, 1616–17
Woven in the workshop of Jan Raes II, Brussels, between 1620 and 1629
Silk, wool, and silver and gilt-metal wrapped thread
408 x 490 cm (13 ft. 4⅝ in. x 16 ft. ⅞ in.)
9–10 warps per cm
Signature of Jan Raes II and Brussels-Brabant mark in lower selvage; monogram of Jan Raes II in right selvage
Patrimonio Nacional, Palacio Real, Madrid
(TA-52/3 10005846)

11.

The Battle of Veseris and the Death of Decius Mus

Sixth panel of an eight-piece set of the *Story of Decius Mus*
Modello and cartoon by Peter Paul Rubens, 1616–17
Woven in the workshop of Jan Raes II in collaboration with Jacques Geubels II, Brussels, between 1620 and 1629
Silk, wool, and silver and gilt-metal wrapped thread
400 x 580 cm (13 ft. 1½ in. x 19 ft. ⅜ in.)
8–9 warps per cm
Signature of Jan Raes II and Brussels-Brabant mark in lower selvage; signature of Jaques Geubels II in upper selvage; monogram of Jan Raes II in right selvage
Patrimonio Nacional, Embassy of Spain in Washington, D.C. (TA-52/6 10076094)

PROVENANCE: Probably acquired as part of the decoration for the Palacio del Buen Retiro during the reign of Philip IV; 1700, listed in the testamentary inventory of Charles II;[1] before 1734, transferred to the Madrid Alcázar, where they were damaged by smoke but not destroyed in the fire; 1746, listed in the testamentary inventory of Philip V;[2] 1747, cleaned and repaired in Madrid;[3] 1788, listed in the testamentary inventory of Charles III;[4] 1834, listed in the testamentary inventory of Ferdinand VII;[5] 1880, recorded in the first historical register of the royal collection;[6] 1960, dispersed to the Embassy of Spain in Washington, D.C.

REFERENCES: Wauters 1878, pp. 300–302; Rooses 1886–92, vol. 3, pp. 195–207, nos. 707–14; Rooses and Ruelens 1887–1909, vol. 2, p. 171; Göbel 1923, vol. 1, pp. 206–8, 356–57, 423–26; J. Duverger 1976–78;

Blažková 1978; Held 1980, pp. 19–30; Baumstark in New York 1985, pp. 338–55, passim; Junquera de Vega and Díaz Gallegos 1986, pp. 89–97; Herrero Carretero 1992–93, vol. 1, pt. 2, pp. 349–58; McGrath 1997, vol. 1, pp. 74–81, vol. 2, pp. 124–25, 140–45; Delmarcel 1997b; Delmarcel 1999a, p. 368; Herrero Carretero 1999, pp. 106–7; Tauss 2000.

CONDITION: Both tapestries are somewhat faded but in relatively good condition. The *Battle of Veseris and the Death of Decius Mus* has recently undergone conservation in 2000–2001 to repair damage caused at an unknown date along a fold line running across the sky just above the heads of the uppermost figures.

This pair of tapestries, of which one is displayed in the New York exhibition and one in the Madrid venue, depict the key events in the life of Decius Mus, a Roman consul whose deeds are recounted in the *Ab urbe condita*, an expansive history of Rome written by Livy (59 B.C.–A.D. 17). According to this text, the Roman consuls Publius Decius Mus and Titus Manlius Torquatus, who were leading the war against the Latins (inhabitants of Latium), had the same dream just before their decisive battle at Veseris in 340 B.C. Both leaders were visited by an apparition who declared that the army that lost its commander would be victorious. The consuls related their dreams to their troops and decided that the only way to avoid defeat would be for one of the generals to sacrifice himself. After consulting with the oracle, Decius volunteered before the high priest Marcus Valerius to sacrifice himself for the fatherland, and he sent his lictors, who had witnessed the decision, to inform Manlius. Bravely committing himself to his fate, Decius Mus threw himself into battle and died, thus securing the victory of the Roman army.

The series was designed by Peter Paul Rubens (1577–1640) sometime around 1616 for an unidentified Genoese patron. It was Rubens's first documented essay in tapestry design and the first of the ambitious pictorial cycles that he would undertake in his career.

The pride he took in this work is reflected by his description of the cartoons as "molto superbi" in a letter of May 1618 to the English collector Sir Dudley Carleton.[7] Eschewing the decorative, heavily patterned style of much contemporary tapestry, Rubens drew inspiration from Raphael's *Acts of the Apostles* tapestry designs and, in the case of the *Death of Decius Mus*, from Leonardo da Vinci's famous failed fresco the *Battle of Anghiari* in the Palazzo della Signoria (later called the Palazzo Vecchio), Florence. The series was additionally unusual because Rubens conceived the compositions as paintings rather than in the traditional medium of watercolor on paper. Both the modelli, of which five survive, and the full-scale cartoons, of which eight survive, were executed in oil on canvas.[8] This presented the Brussels weavers with a range of colors and painterly effects that were difficult to capture in wool and silk. Nonetheless, the designs were of immense significance, introducing a new spirit of drama and movement to contemporary tapestry design. This particular weaving ("Decio de Oro") is one of only two seventeenth-century sets of tapestry in the Spanish royal collection that include gilt-metal-wrapped thread, a reflection of the very high cost of such materials[9] (the other such set is the *Battles of the Archduke Albert*, cat. no. 6). The origin of the set is unknown, but on the basis of its location at the Palacio del Buen Retiro at the end of the seventeenth century and the efforts made by Philip IV (r. 1621–65) to acquire high-quality tapestries for this location during the 1630s and 1640s, it seems probable that it was aquired by Philip for that location. A second set of the same design series, but woven just in wool and silk ("Decio en Lana"), was also recorded at Buen Retiro in 1700 and survives today in the Patrimonio Nacional.[10]

Decius Consults the Oracle

The scene takes place in front of the tent of the high priest Marcus Valerius, who gestures

toward the entrails of the bull that Decius has just sacrificed. Examining the entrails and observing the birds flying in the sky (*aves spicere*, root of the word "auspices") enabled the oracle to make his prediction about the future. The gestured dialogue between the protagonists—the poses of their arms and hands, characteristic of Rubens's visual rhetoric—signal to the viewer the divine verdict. Decius wears the purple *toga praetexta* of consuls. Here and in other scenes, his armor is based on that of the Roman statue of Mars Ultor that was venerated in the Temple of Mars Ultor in the Forum of Augustus in Rome (now in the Capitoline Museum). While the moral and spiritual authority of Decius Mus and Marcus Valerius are suggested by their monumental and statuesque poses, their heads and faces are rendered with intense realism. A lictor behind Decius leans on the fasces, insignia of a consul, which is shown here upside down, symbolizing the bad tidings being delivered by the high priest.

The composition is clearly indebted to Raphael's tapestry design of the *Sacrifice at Lystra* in the *Acts of the Apostles* series, although Rubens enhanced the emotional intensity of the moment by simplifying the architectural setting of Raphael's scene so that there is little distraction from the gestures and expressions of the principal figures. Several of the figures and objects echo those in Raphael's composition, albeit enhanced by Rubens's knowledge of other antique depictions of sacrifices: the altar decorated with sphinxes, the piper (*tibicen*), the audience (*camilli*), the junior priests (*popae*), and the servants who burned the sacrifices (*victimarii*).[11] Rubens's close study of the ancient world is reflected by his careful visualization of select details, including a subtle correction to Raphael's representation of the pagan rite of sacrifice: where the bull in Raphael's scene is still wearing the red band (*infula*) that adorned the head of a sacrificial victim, in Rubens's scene the band has been removed, as it would have been at this point.[12]

The development of Rubens's design was effectively established by the time he painted the modello, suggesting that it was likely preceded by preparatory sketches, now lost.[13] The principal change between the modello and the full-scale oil cartoon is that in the modello, the priest's robe is a rich orange and yellow tone,

whereas in the cartoon—and the tapestry—it has been embellished with vegetal motifs in blue and yellow in imitation of the Italian and Flemish brocades in vogue in the seventeenth century. This change was probably made to give the priest's figure greater definition against the tent in front of which he stands. The fact that it was made in the oil cartoon suggests that it was made with Rubens's involvement, in contrast to analogous and less fortunate changes that were made to the robe of Christ in Raphael's *Charge to Peter*, which were probably introduced by the weavers themselves.[14]

The Battle of Veseris and the Death of Decius Mus

This tapestry depicts the climactic moment in the *Decius Mus* series. In the center of the composition, the hero is falling backward off his rearing white horse, his fingers still gripping its flowing mane; a Latin soldier's lance has mortally pierced him through the neck. Here, Rubens introduced a variant on Livy's text, according to which Decius died as a result of being shot through with an arrow. The lance, Rubens undoubtedly knew, was the weapon consecrated to Mars, god of war.[15] Here, it provides the central, dramatic accent of the scene. Even as Decius Mus falls, another Latin warrior is raising his sword high to bring it down on the doomed hero. The foreground of the scene is a confused mass of fallen soldiers and horses. Beyond the central composition, the Roman army can be seen chasing the fleeing Latin army.

Rubens's skill in depicting horses was founded on his study of drawings by Leonardo da Vinci. According to Roger de Piles, Rubens himself stated, in a now lost treatise, that he had studied Leonardo's notebooks in Arezzo and that he was profoundly impressed by the master's notes and drawings on this subject.[16] In this instance, his debt to Leonardo is even more explicit because the principal figures of the composition reflect his knowledge of Leonardo's *Battle of Anghiari* cartoon. The cartoon itself had deteriorated almost as soon as it was undertaken, but Rubens must have known Leonardo's studies and later copies. A drawing by Rubens of this

composition is in the Louvre.[17] Rubens followed Leonardo's ideas not only along general lines, but also in certain specific groups of figures. For example, two combatants in the center left foreground are close to a similar pair in Vasari's description of Leonardo's lost fresco: "on the ground, between the legs of the horses, there are two figures in foreshortening that are fighting together, and the one on the ground has over him a soldier . . . [and], struggling with his arms and legs, is doing what he can to escape death."[18]

The design of the tapestry, and presumably of the working cartoon from which it was woven, departs in a number of interesting ways from the earlier modello at the Prado (fig. 44). In this initial composition, Rubens included an apparition of a winged figure extending the laurel branch and palm of victory over the victorious Roman army.[19] As previous scholars have noted, this visionary apparition invites associations between Decius's sacrifice and that of the Christian martyrs.[20] Perhaps in an effort to enhance the drama and clarity of the composition in the tapestry medium for which it was intended, this ethereal figure was excluded from the final design, as embodied in the Liechtenstein oil cartoon (fig. 45). Instead, the principal figures were enlarged to fill out the central area of the tapestry. A change that can be remarked between the oil cartoon and the tapestry is that the foreground figure, luminously pallid in the cartoon, is clothed in a Roman cuirass and shirt in the tapestry. This change was probably determined by the fact that reproducing the subtle modulations of flesh tones was the most challenging task for the weavers and would have required considerable time and effort in a part of the composition that was relatively incidental to the main focus. Nonetheless, the fact that the costume is convincingly antique in style does suggest that this change, presumably made during the execution of the working cartoon from which the tapestry was actually woven, was made either by Rubens or from a sketch that he provided.

The Borders

The borders of the tapestries in both of the *Decius Mus* sets in the Spanish royal

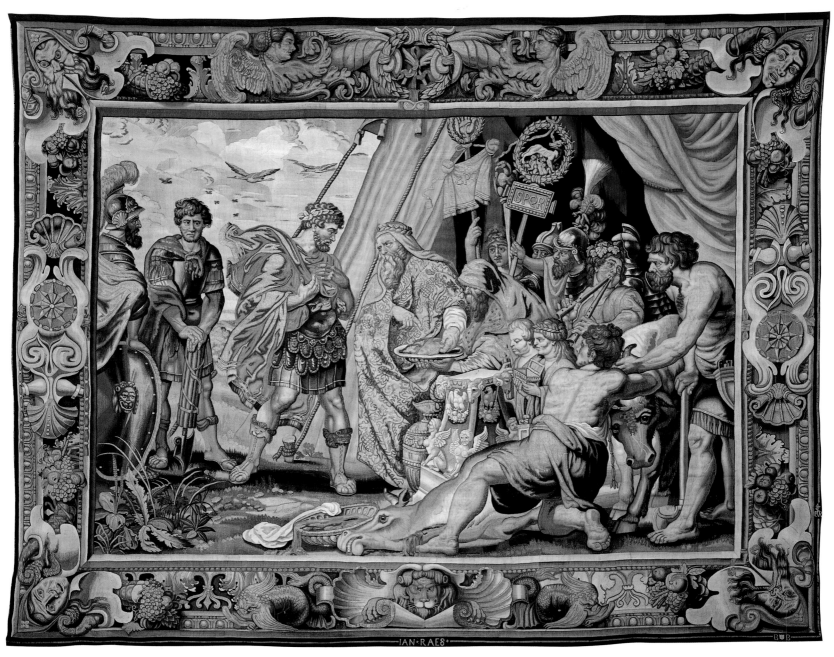

10

collection is composed of an egg-and-dart frame around sculptured volutes and scallop shells interspersed with harpies in the upper border, dolphins in the lower border, and roses or stars in the center of the side borders; these are all intertwined with cornucopias overflowing with fruit. Insignias of victory in battle—crowns of laurel, palm branches, and lion skins—appear in the top and bottom borders. Although no sketch by Rubens is known for the borders of the *Decius Mus* series, those that appear on the Spanish royal collection sets also appear on several other early weavings of the designs, which suggests

that these borders may have been created for this series and subsequently associated with it. It is unknown whether Rubens was involved in the border design, or whether an artist who specialized in the creation of these framing elements conceived it. Similar motifs appear in the borders of the *Story of Constantine* series that Rubens created for the Paris workshops a few years later, particularly the harpies in the top border and the faces in the corner escutcheons. In the case of the *Constantine* series, the border design is attributed to Laurent Guyot. It is therefore possible that Rubens provided preliminary

sketches for some of the motifs in the borders of both series, and that the designs for those borders were worked up by artists who specialized in the creation of these framing elements.

The Origin of the Decius Mus Series
The origin of the *Decius Mus* series is documented by a contract signed on November 9, 1616, between, on one hand, the Genoese merchant Franco Cattaneo, and on the other, Jan Raes II and Frans Sweerts, both described as tapestry merchants resident in Antwerp.[21] Raes and Sweerts agreed to deliver two sets

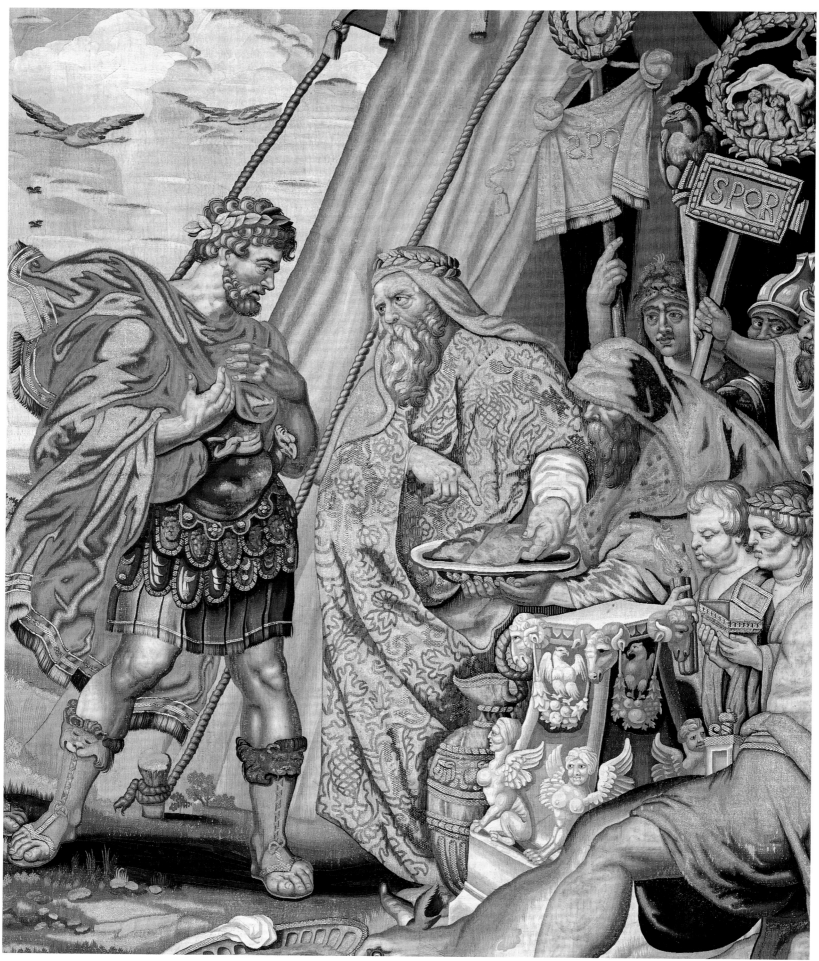

Detail of cat. no. 10

of tapestries of the *Story of Decius Mus* to Cattaneo within a year, provided that Rubens delivered the cartoons in a timely fashion. The contract stipulated the number and the dimensions of the pieces in each set—seven pieces and two overdoors in one, seven pieces and one overdoor in the other. The varying dimensions of the pieces in the two sets indicate that they were intended as an all-surrounding decor in two specific locations. The price agreed upon was 22 florins per ell, with the proviso that Rubens was to examine the final product to determine whether this should be increased to 23 florins. Progress on the tapestries must have proceeded rapidly because in late 1617 the papal nuncio Morra, archbishop of Otranto, referred to the *Decius Mus* series in letters to Cardinal Scipione Borghese, praising the design as "molto bello" and stating that it greatly pleased him.[22] Six months later, Rubens himself referred to the *Decius Mus* series in the course of correspondence with Sir Dudley Carleton about the deal they were then negotiating whereby Carleton would give Rubens his collection of antique sculptures in return for a selection of Rubens's paintings and a set of tapestries. In a letter of May 12, 1618, Rubens stated "and I, too, at the request of certain Genoese gentlemen, have made some very grand cartoons for tapestries which at present are being executed."[23] Two weeks later, in a letter of May 26, 1618, he referred more specifically to the series, saying that he would have to write to Brussels to obtain the exact dimensions "of my cartoon of the story of Decius Mus the Roman consul who sacrificed himself for the victory of the Roman people."[24] The patron for whom one or both of these sets was intended is unknown. Max Rooses, the historian who first discovered and published much of the relevant documentation, suggested that it may have been the marchese Nicolò Pallavicini, who was godfather of Rubens's second son, but this is by no means certain.[25] The fate and current location of the two sets made for the Genoese patrons are unknown. Four panels woven with gold entered the Liechtenstein collection in the late nineteenth century, and it is possible that these are to be identified with one of the two first weavings of the design.[26]

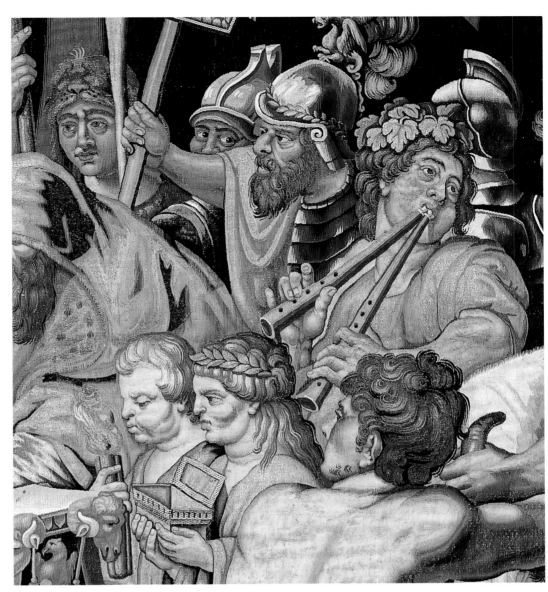

Detail of cat. no. 10

In conceiving the main scenes of the *Decius Mus* series, Rubens followed the events described in the *Ab urbe condita* (8.6.9–8.10.10) of Livy. The subject of the series was unusual, and no previous tapestry designs depicting Decius Mus are recorded. Frans Sweerts, one of the signatories to the contract with Cattaneo, had studied in Heidelberg under the humanist Janus Gruterus (1560–1627), author of a critical study of Livy, and may therefore have been influential in selecting the subject for the series.[27] Equally, Rubens's profound immersion in classical literature and history must have played a decisive part in the selection. As scholars have noted, earlier depictions of Decius Mus are rare, occurring in the context of visual cycles illustrating model heroes.[28] Rubens's treatment of the subject is no

exception, as evidenced by his statement to Carleton that it was the story of "the Roman consul who sacrificed himself for the victory of the Roman people" (see note 24). Indeed, the series is, in essence, an extended illustration of this exemplary deed, departing from Livy's text in a number of ways—particularly in the subordination of Titus Manlius until the scene of the funeral obsequies of Decius Mus—in order to focus the narrative on the hero's stoic acceptance of his fate and his selfless sacrifice for his country.[29] It seems, then, that in his first tapestry series, Rubens was giving visual form to the principal tenets of Neostoical philosophy expounded by his mentor the philologist and master of Neostoicism Justus Lipsius (1547–1606), in his influential *De constancia . . . in publicis malis*, published in 1584.

Designs and Modelli

No oil sketches are known for this series, but five modelli survive, executed in oil on panel, including those for the two tapestries presented here, *Decius Mus Consults the Oracle* (Sammlung Oskar Reinhart "Am Römerholz," Winterthur, Switzerland) and the *Battle of Veseris and the Death of Decius Mus* (fig. 44).[30] In addition, a preliminary drawing for one of the figures in the *Death of Decius Mus* also survives (Victoria and Albert Museum, London).[31] Eight cartoons, executed in oil on canvas, survive in the collection of the princes of Liechtenstein in Vienna, of which six represent narrative subjects: *Decius Mus Relates His Dream to His Officers*, *Decius Mus Consults the Oracle*, *Marcus Valerius Consecrates Decius*, *Decius Mus Dismisses the Lictors*, the *Battle of Veseris and the Death of Decius Mus* (fig. 45), and the *Funeral Obsequies of Decius Mus*. A seventh cartoon represents figures of Virtus Romana and Honor, and an eighth, a war trophy.[32] One or both of these may correspond to the overdoors described in the 1616 contract (as Julius Held noted, the two figures in the *Virtus Romana and Honor* panel were probably intended for two separate overdoors in one of the first weavings—like the example with Virtus Romana now in the Liechtenstein collection—in which case the *War Trophy* could have been intended for the single overdoor in the second set).[33] No cartoon has survived for the seventh narrative panel included in the first two sets, but its likely identity is provided by a scene that is included in a number of the extant early weavings, including the two sets in the Spanish royal collection and others in the Swedish royal collection and Hluboká Castle.[34] This has been identified as *Titus Manlius Presenting the Roman Senators with Plunder* (resulting from the victory at Veseris).[35] Finally, another scene that seems to have been added to the *Decius* series at an early date, and which is also included in the gold-woven Spanish set, has been identified as *Mars Appears before Rhea Silvia*, the parents of Romulus and Remus. It has been suggested that this may originally have been intended as the first panel in a set about the founders of Rome. A painting of this subject survives in the Liechtenstein collection, along with the other cartoons, but its relationship to those cartoons is ambiguous because it is smaller in

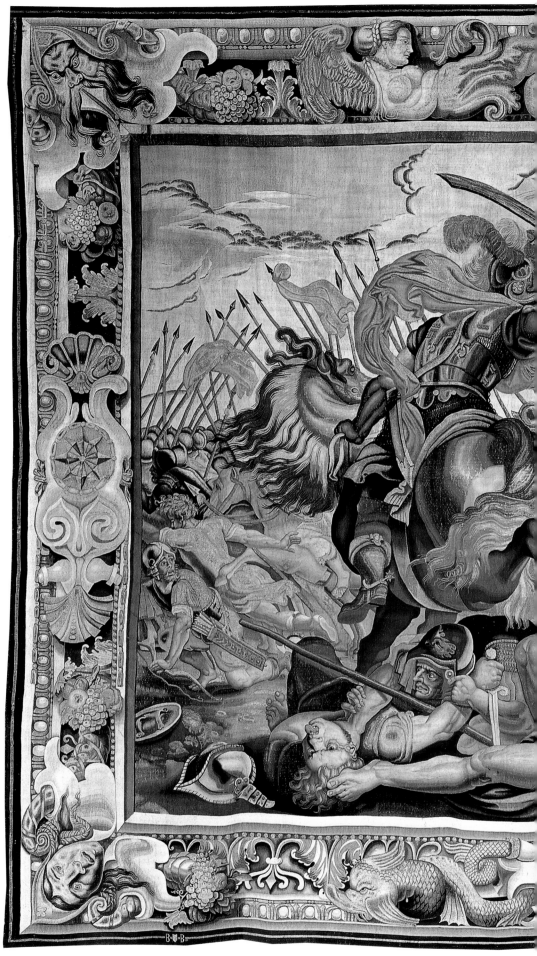

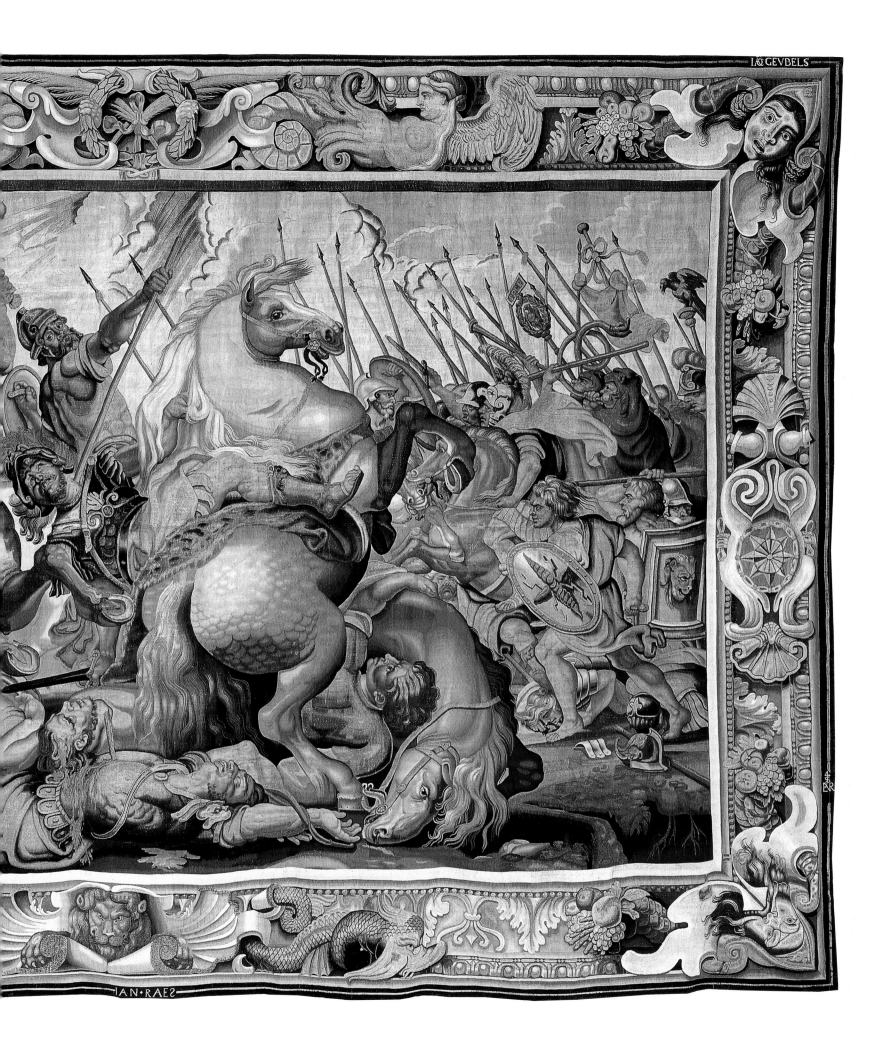

IAC GEVBELS

IAN·RAES

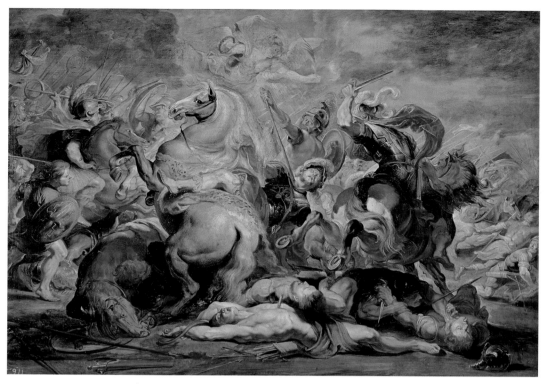

Fig. 44. *The Battle of Veseris and the Death of Decius Mus.* Modello for the tapestry in the *Story of Decius Mus,* by Peter Paul Rubens, 1616–17. Oil on wood, 88 x 138 cm. Museo del Prado, Madrid

scale. Equally, there can be no doubt that it was intended as a tapestry design because the attributes are shown backward, anticipating the reversal of the design in the weaving process.[36]

The attribution of the cartoons has been a matter of discussion among scholars. In 1661,

when five of the oil cartoons were acquired by a consortium of three artists led by the painter Jan Baptista van Eyck, it was said that they were painted by Anthony van Dyck (1599–1641) "after sketches by Rubens." When Van Eyck died in 1692, his family sold the cartoons, then listed as seven pieces, to

Prince Johann Adam von Liechtenstein through the intermediary Marcus Forchondt, and at this time they were said to be "designed by Rubens and completed by Van Dijck."[37] Giovanni Pietro Bellori also cited Van Dyck as the author of these canvases.[38] Recent scholarship has questioned the extent to which the eighteen-year-old Van Dyck could have been the principal executant of the cartoons, and although different hands can be discerned in the various panels, it is now thought that Rubens did play a substantial part in executing the oil cartoons himself, albeit assisted by Van Dyck.[39] While documentation relating to the 1692 sale refers to seven cartoons, a document of 1695 indicates that the cartoons were now eight in number. A clue to the whereabouts of the additional cartoon before 1695 is the seal with the arms of Emperor Leopold I (r. 1658–1705) on the back of the *Decius Mus Consults the Oracle* cartoon.[40]

None of the oil cartoons demonstrate the folds, cuts, or damage that would normally have resulted from use on the low-warp looms employed for tapestry production in Brussels in the seventeenth century. It therefore seems that the weavers must have made working copies of the originals for the actual production of the tapestries—either the more traditional watercolor on paper or simply chalk or ink outlines on paper—referring to

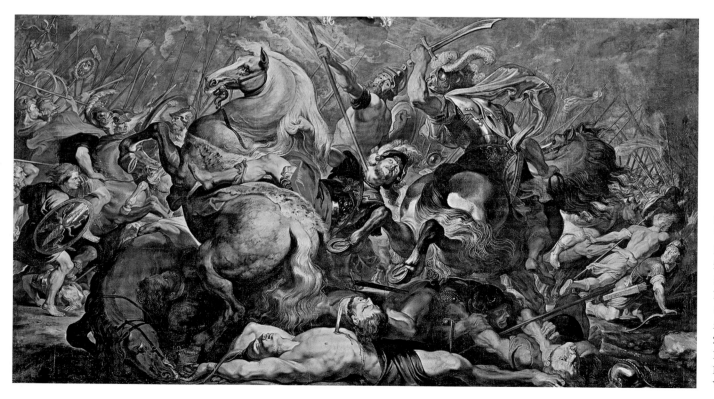

Fig. 45. *The Battle of Veseris and the Death of Decius Mus.* Cartoon for the tapestry in the *Story of Decius Mus,* by Peter Paul Rubens, 1616–17. Oil on canvas, 289 x 518 cm. Sammlungen des Fürsten von und zu Liechtenstein, Vaduz–Vienna (GE51)

Detail of cat. no. 11

the originals for guidance on colors and detail. Four *Decius* cartoons executed in tempera on paper and possibly corresponding to such working models were sold in London in 1773 (at which time they were said to come from Brussels) and then in Brussels in 1779.[41] Their subsequent fate is unknown. As Held noted, given the persistent seventeenth-century tradition that Van Dyck assisted Rubens in the execution of the cartoons, it is conceivable that he may also have played a part in preparing the working cartoons from Rubens's oil paintings.[42]

In creating the *Decius Mus* designs, Rubens departed markedly from the character of contemporary tapestry design, with its subordination of the principal figures within elaborate decorative settings. Instead he looked back to the grandiose compositions of Raphael's *Acts of the Apostles* designs that were conceived for Leo X and on which weaving began exactly one century earlier, in 1516. Rubens would have been familiar with this famous series from various sources. During his years at the Gonzaga court in Mantua, he must have seen the fine weaving of this design made for Cardinal Ercole Gonzaga sometime around 1550,[43] and he may also have seen the original weaving made for Pope Leo X on display at the Vatican during his periods in Rome in 1602 and between 1606 and 1608. He may also have seen the copy in the Spanish royal collection during his visit to Madrid in 1603. But above all, Rubens was probably inspired by the original cartoons themselves, which he would have been able to study in Genoa, where they were then located, during his residency in that city in 1605–6 (according to long-standing tradition, Rubens may have played a part in calling these cartoons to the attention of Prince Charles, who gave the order for their purchase in 1623, while he was in Madrid).[44] At any rate, the influence of Raphael's designs is readily evident in Rubens's compositions, which feature large dramatic figures in relatively shallow and simple settings that appear to be extensions of the viewers' space. Decorative and incidental detailing is kept to a minimum. Instead, the emphasis is on the drama of the moment, embodied by the physical gestures and expressions of the protagonists. In *Decius Mus Consults the Oracle*,

Rubens's debt to Raphael's composition *Sacrifice at Lystra* is particularly evident, as mentioned above, as is the inspiration Rubens derived from Leonardo da Vinci's *Battle of Anghiari* for his *Death of Decius Mus*. If the inspiration for the compositions of the tapestries derived from early sixteenth-century High Renaissance prototypes, the designs also reflect Rubens's profound knowledge of antique sculptures and studies of the ancient world. Several of the figural compositions are based on Roman monuments that glorified the *res gestae* of emperors, such as the Arch of Constantine and Trajan's Column, whose reliefs he is known to have sketched during his sojourn in Italy. Details of costume and equipment also reflect his knowledge of ancient sculptures and such treatises as *De militia romana* and *De vesta et vestalibus* of Justus Lipsius.

As noted above, the *Decius Mus* designs were unusual in that Rubens conceived the series in terms of oil on panel, even if the working cartoons may have been executed on paper. Traditionally, tapestry designers had conceived their designs with an emphasis on clearly defined linear components and with an eye on the colors of wool and silk available to the weavers. The saturated tones and glazes of Rubens's oil cartoons were much more challenging to reproduce and required the weavers to use a broader palette of colors, including innovative tones such as lemon yellow and lilac red that were to prove less colorfast than the tried and tested colors of traditional production.[45] Nonetheless, the fact that the weavers managed to reproduce the designs so effectively was a testament to the skills that had been developed in the Brussels workshops over the previous decades and to the range of dyed wools and silks now available to the weavers.

The Spanish Sets

The set with gold ("Decio de Oro") was woven by Jan Raes II in collaboration with Jacques Geubels II, as we know from the signatures and initials woven into the edges of the tapestries. Six of the panels in the set correspond to the sequence of cartoons in the Liechtenstein collection: the *Decius Mus Relates His Dream to His Officers*, *Decius Mus Consults the Oracle*, *Marcus Valerius Consecrates*

Decius Mus, *Decius Mus Dismisses the Lictors*, the *Battle of Veseris and the Death of Decius Mus* (fig. 45), the *Funeral Obsequies of Decius Mus*.[46] In addition, as noted above, the gold-woven set includes scenes of *Titus Manlius Presenting the Roman Senators with Plunder* and *Mars Appears before Rhea Silvia*.[47]

The date at which the two *Decius Mus* sets entered the Spanish royal collection is undocumented. The earliest record of their presence there is the inventory compiled after the death of Charles II (r. 1665–1700), when both the eight panels of the "Decio de Oro" and the seven panels of the "Decio en Lana" were in the Palacio del Buen Retiro.[48] In their 1986 catalogue of seventeenth-century tapestries in the Patrimonio Nacional, Paulina Junquera de Vega and Carmen Díaz Gallegos did not refer to this inventory, believing that the two sets were recorded for the first time in the testamentary inventory of Charles III (1788). They therefore proposed that both sets entered the royal collection during the reign of Philip V (r. 1700–1746).[49] Evidence that the sets were in the collection by 1700 suggests an altogether earlier date of acquisition because Charles II seems to have made few artistic additions to Buen Retiro, wheras his father, Philip IV, had lavished attention on it.[50] The Palacio del Buen Retiro was built during the 1630s, and its decoration was overseen by Philip IV's favorite, Gaspar de Guzmán y Pimentel, conde-duque de Olivares. Circumstantial evidence that the tapestries were acquired by Philip IV for this palace comes from documentation relating to other tapestry purchases for this location: for all the famous paintings that were acquired for the Buen Retiro, the palace was hung with tapestries in the winter months, and during the 1630s and 1640s Philip and his aides expended considerable sums to purchase tapestries for this purpose.[51] The richness of the materials, including the large amount of metal-wrapped thread used for the "Decio de Oro" set, and the high quality of the weaving testify to the importance of this commission.

The Weavers

The *Decius Mus* set with gold in the Spanish royal collection was woven in collaboration by two of the leading Brussels workshops of the day, those of Jan Raes II and Jacques

Geubels II. The signatures or monograms of both appear on three panels in the set, including the *Battle of Veserius and the Death of Decius Mus*; that of Jan Raes II alone appears on four, including *Decius Mus Consults the Oracle*. Jan Raes II (ca. 1570–1643) ran one of the most important manufactories in Brussels, supplying many tapestries to Archdukes Albert and Isabella during the 1610s, collaborating in the production of the *Triumph of the Eucharist* set for Archduchess Isabella in the late 1620s, and serving as burgomaster of Brussels between 1634 and 1635. Jacques Geubels II was the son of Jacques Geubels I (d. 1605) and Catherine van den Eynde. Raes had frequently collaborated in the production of tapestry sets with Van den Eynde during the 1610s, splitting the profits of any sales. The date of Van den Eynde's death is uncertain, but it took place between 1620 (the date of her will) and 1629 (the date of a docu-

ment that lists the most important tapestry workshop owners in Brussels, in which her name is no longer mentioned).[52] Jacques Geubels II is first documented in 1621 and in 1626–27 was appointed dean of the Brussels tapestry guild. Between 1626 and 1628 he was among the consortium of weavers who produced the *Triumph of the Eucharist* tapestries for Archduchess Isabella. He was still alive in January 1629, but since he too is missing from the 1629 list of the most important weavers, it seems that he must have died that year.[53] Therefore the set of the *Decius Mus* series with gold was probably woven at some point between 1620 and 1629.

Despite the difficulties that the designs presented to the weavers, they were to be profoundly influential on subsequent Flemish tapestry design, and during the 1620s and 1630s many duplicate sets were woven, both

by Jan Raes II and his son Jan III, as well as by François van den Hecke, Gerard van der Strecken, and others. Fragments of as many as twenty distinct seventeenth-century weavings of the series are known. Among the more notable examples are a set in the Kunst-historisches Museum in Vienna, the set in the Swedish royal collection in Stockholm, that of the prince of Liechtenstein, the one in Hluboká Castle, and another in the palace of the dukes of Bragança in Guimarães (Portugal). There are tapestries from the *Story of Decius Mus* with the monogram of François van den Hecke in the Museo Arqueológico Nacional in Madrid, another tapestry belonging to the confraternity of Santa Rita in the church of Las Calatravas in Madrid, and a tapestry in the Montserrat collection in Saragossa.[54]

CONCHA HERRERO CARRETERO

1. Fernández Bayton 1981, p. 253, no. 289.
2. Archivo General de Palacio (hereafter AP), Madrid, Registros 247, "Testamentaría de Felipe V. Inventario de bienes y alhajas del Oficio de la Real Tapicería por fallecimiento de Felipe V, 1747–1748," fols. 98–98v; see Herrero Carretero 1992–93, vol. 1, pt. 2, p. 404.
3. On December 24, 1734, there was an enormous fire in the Alcázar, the old royal palace in Madrid. Philip V's tapestry keeper, Nicolás Manzano y Marañón, took charge of twelve panels of the two sets of the *Story of Decius Mus* that decorated the former Council Chamber of Italy and escaped destruction. Antwerp weavers Frans (Francisco) and Jacob van der Goten, who had been established at the Madrid court since 1720, received the tapestries in 1747 to restore them, for they had been affected by smoke, the silver threads were damaged, and the panels needed cleaning and lining to prevent "the risk of further losses" (riesgo de echarse más a perder); Jefe del Oficio de Tapicería, AP, boxes 3041/30 and 614/49, and Bureo box 169/4. See Herrero Carretero 1992–93, vol. 1, pt. 2, pp. 357–58.
4. "[O]cho paños *Historia de Decio*, hechos en Bruselas, con hilo de oro, plata, seda y estambres, su estofa fina, bien tratados y de buen color"; AP, Registros 259, "Ynventario General y tasacion de los muebles correspondientes del Real Oficio de Tapiceria de S.M. Catolica, que quedaron por fallecimiento del Rey, el señor don Carlos 3.o (que este en Gloria)," 1788, vol. 3, fol. 224v. See also Junquera de Vega and Díaz Gallegos 1986, pp. 89–97.
5. AP, Registros 4807, "Testamentaria del Señor don Fernando 7.o de Bordon," 1834, vol. 1, fol. 201v.
6. Juan Crooke y Navarrot, conde de Valencia de Don Juan, and Pauline Saviron y Esteban, "Inventario y registro histórico de las Tapicerías de la Corona existentes en el Real Palacio de Madrid," 1880, Archivo del Servicio de Tesoro Artístico e Inventarios del Patrimonio Nacional, Madrid.
7. Tauss 2000, p. 273.
8. Held 1980, pp. 19–30; Baumstark 1988.
9. Junquera de Vega and Díaz Gallegos 1986, pp. 89–97.
10. Ibid., pp. 98–103.
11. Held 1980, p. 24.
12. Reinhold Baumstark in New York 1985, p. 343.
13. Modello: oil on wood, 74 by 140 cm, Sammlung Oskar Reinhart "Am Römerholz," Winterthur, Switzerland; cartoon: oil on canvas, 294 by 412.3 cm, Liechtenstein Museum, Vienna. Held 1980, pp. 26–27; Baumstark 1988, pp. 41–57.
14. New York 2002, p. 192, figs. 77, 78; T. Campbell in New York 2002, pp. 204–10, no. 18.
15. Baumstark in New York 1985, p. 352.
16. De Piles 1699, p. 168; Baumstark in New York 1985, p. 349.
17. Baumstark in New York 1985, p. 352; McGrath 1997, vol. 1, p. 75. For the question of whether this is a retouched drawing, see Zöllner 1991.
18. Vasari 1568/1912–14, vol. 4, p. 102.
19. Held 1980, pp. 27–29.
20. Baumstark in New York 1985, p. 352.
21. Acts of Notary G. Le Rousseau, 1616, pl. 237, for which see Tauss 2000, pp. 270–71.
22. Tauss 2000, pp. 276, no. 3.1.
23. "[O] fatto alcuni cartoni molto superbi a requisitione d'alcuni Gentilhuommi Gennoesi li quali adesso si mettono in opera." Rooses and Ruelens 1887–1909, vol. 2, p. 150; Held 1980, p. 21 (for the translation used here); Tauss 2000, p. 273.
24. "[D]el mio Cartone della storia di Decius Mus Console Romano che si devovò per la vittoria del Popolo Romano." Rooses and Ruelens 1887–1909, vol. 2, p. 171; Held 1980, p. 22 (for the translation used here); Tauss 2000, p. 275.
25. Rooses and Ruelens 1887–1909, vol. 2, p. 174. For detailed discussion of the original patron, see Tauss 2000, pp. 222–61, 304–14.
26. Baumstark in New York 1985, p. 340.
27. For Gruterus on Livy, *T. Livii Patavini Historicorum Romanorum principis recogniti et emendati a Iano Grutero* (Frankfurt: Impensis Iacobi Fischeri, 1612). J. Duverger 1976–78, pp. 19–20.
28. McGrath 1997, vol. 1, pp. 76–77.
29. Baumstark in New York 1985, p. 341; McGrath 1997, vol. 1, pp. 76–78.
30. The other three extant modelli are the one for *Decius Mus Relates His Dream to His Officers*, which is in the

National Gallery of Art, Washington, D.C. (1957.14.2); and those for *Marcus Valerius Consecrates Decius Mus* and the *Funeral Obsequies of Decius Mus*, which are in the Bayerische Staatsgemäldesammlungen, Munich (inv. 323/3964 and 304, respectively). For full details, see Held 1980, pp. 25–26, 29–30.
31. Held 1959, p. 133, no. 89, pl. 94.
32. Baumstark in New York 1985, pp. 11–12; Delmarcel 1997b, p. 45.
33. Held 1980, p. 19; Baumstark 1988, p. 124.
34. Böttiger 1895–98, vol. 3, pp. xxv–xxx; Blažková 1978, pp. 53–62.
35. Delmarcel 1997b, p. 45.
36. Held 1980, pp. 336–37. Delmarcel 1997b, pp. 44–45.
37. Rooses 1886–92, vol. 3, pp. 204–6; Crick-Kuntziger 1955, p. 19, n. 4; Held 1980, p. 20.
38. Bellori 1672, p. 254.
39. Crick-Kuntziger 1955, p. 19, n. 4; Blažková 1978, p. 50; Held 1980, p. 21; Baumstark in New York 1985, p. 340; Vittet 2004b.
40. Baumstark in New York 1985, p. 341.
41. Rooses 1886–92, vol. 3, p. 207; J. Duverger 1976–78, pp. 19–20.
42. Held 1980, p. 21.
43. C. M. Brown and Delmarcel 1996, pp. 107, 148–57.
44. Shearman 1972, p. 147; Jaffé 1977, p. 25; Baumstark in New York 1985, p. 339.
45. Delmarcel 1997b, p. 44; Delmarcel 1997c, pp. 30–31.
46. Patrimonio Nacional, TA-52/2 10005696, 418 by 477 cm; TA-52/3 10005846, 408 by 490 cm; TA-52/4 10013128, 405 by 330 cm; TA-52/5 10005845, 413 by 404 cm; TA-52/6 10076094, cat. no. 11; TA-52/7 10005607, 415 by 567 cm.
47. Patrimonio Nacional, TA-52/1 10005836, 392 x 535 cm; TA-52/8 10005696, 405 by 335 cm.
48. Fernández Bayton 1981, pp. 250–55, nos. 275, 289.
49. Herrero Carretero 1999 and Herrero Carretero 2004.
50. J. Brown and Elliott 1980, p. 239.
51. Ibid., pp. 98, 103, 105–6, 108–9.
52. Delmarcel 1999a, p. 365.
53. E. Duverger 1981–84, p. 177.
54. Steppe 1956, pp. 41–42; Sánchez Beltrán 1983, pp. 51–53.

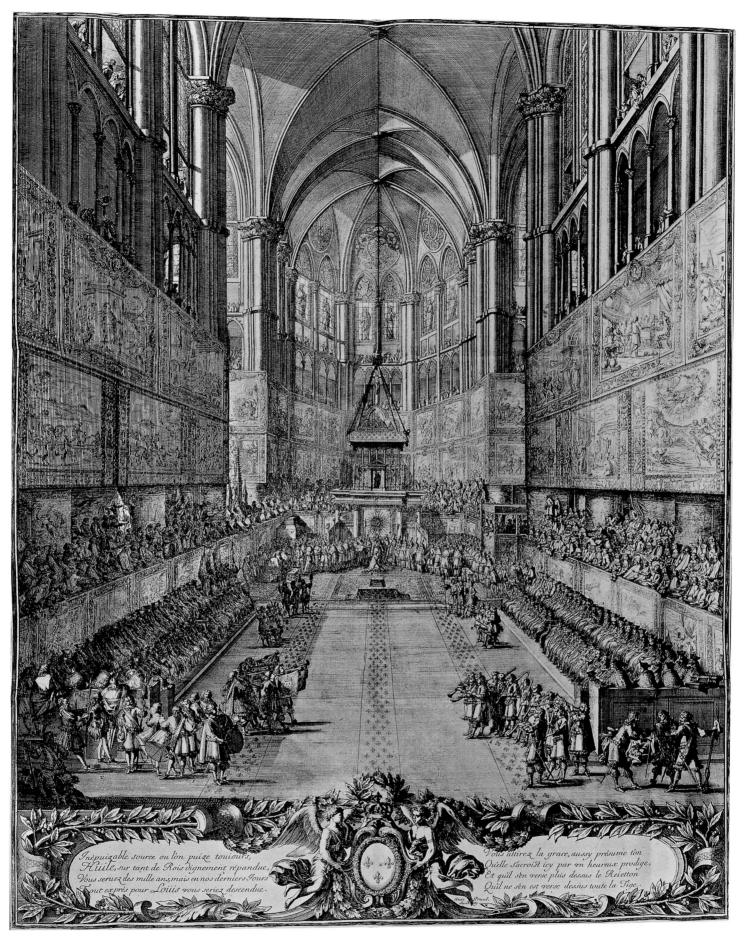

Fig. 46. *The Coronation of Louis XIV at Reims, June 7, 1654*, by Jean Le Pautre, 1655. Etching, 63.1 x 47.9 cm. The Metropolitan Museum of Art, New York, Harris Brisbane Dick Fund, 1953 (53.600.67)

Stately Splendor, Woven Frescoes, Luxury Furnishings: Tapestry in Context, 1600–1660

THOMAS P. CAMPBELL

On August 22, 1612, the Spanish court hosted an elaborate ceremony at the Alcázar, the royal palace in Madrid, to celebrate the formal betrothal of the eleven-year-old infanta, Anne, to Louis XIII, the eleven-year-old king of France, represented on this occasion by Henry of Lorraine, duc de Mayenne. A contemporary description records the appearance of the principal rooms at the palace, all of which had been specially hung with sixteenth-century Brussels tapestries.[1] The hall where the marriage contract was signed featured a gold-woven set known as the *Seven Deadly Sins*, a vast meditation on the destructive effects of human weakness exemplified by famous figures from history and mythology, woven in the 1540s from designs by Pieter Coecke van Aelst.[2] Closer to the king's quarters, the guard chamber and adjacent hall were hung with a gold-woven set of the *Conquest of Tunis*, the epic depiction of Charles V's 1535 campaign against the Muslim forces of Khayr ad-Dín (Barbarossa), made for Mary of Hungary during the 1550s from cartoons by Jan Cornelisz Vermeyen and Pieter Coecke. This set was a duplicate of the even richer set made for Charles V between 1548 and 1554, which hung further along in the sequence of chambers.[3] In the adjacent hall was a second gold-woven set of the *Seven Deadly Sins*. The walls of the next chamber, the Hall of Consultas, were hung with the *Honors*, an enormous allegorical set celebrating the virtues of the Habsburg emperors that had been designed by Bernaert van Orley and made for Charles V in the early 1520s at such vast cost that he was able to pay for the set only after he received the dowry attendant on his marriage to Isabelle of Portugal.[4] The adjacent hall, "where his Majesty carries out his business," was hung with a *Story of Noah* set commissioned by Philip II in the early 1560s after designs by Michiel Coxcie.[5] The Great Hall in which the royal party assembled for the ceremonial kissing of hands after the signing of the contract was hung with Charles V's set of the *Conquest of Tunis*, the largest and richest set in the entire collection. And the bedchamber was provided with a ceremonial bed and hung with a gold-woven set of the *Story of Vertumnus and Pomona*, gods of the seasons and of fruitfulness, woven in the 1540s from designs by Pieter Coecke.[6]

As this brief description makes clear, the sixteenth-century tapestries selected for the occasion provided a physical and iconographic framework in which allegorical, religious, historical, and mythological subjects combined to celebrate the power and continuity of the Habsburg dynasty and the personal and public ethics of the Spanish kings.[7] The use of these fabulous hangings in this momentous context provides an apposite introduction to a consideration of the use and perception of tapestry during the seventeenth century. To what extent were traditional practices maintained during this period? To what extent did changing tastes in the arts and in the style of interior decorations modify such practices?

Court Spectacle and the Use of Inherited Collections

The most striking fact that emerges from contemporary documentation is the central role that tapestries continued to play in court splendor throughout the century. The greatest collections of the day belonged inevitably to the royal families who had the wealth to purchase tapestries on the grandest scale, opportunities to absorb smaller collections, and a dynastic succession that favored the expansion of holdings rather than their dispersal. In the first half of the century, the largest assemblage of tapestries was that of the British Crown, which had grown to more than two thousand pieces by the end of Henry VIII's reign in 1547 and which still numbered about sixteen hundred pieces when Charles I was executed in 1649.[8] The Spanish royal collection amassed under Charles V, Mary of Hungary, and Philip II was smaller in number, some seven hundred items at the turn of the century in Madrid and Brussels, but it was even grander in terms of its artistic and material quality. Recognizing the extraordinary nature of his holdings, Philip II had taken the unusual step of designating that no part of it was to be sold at his death to

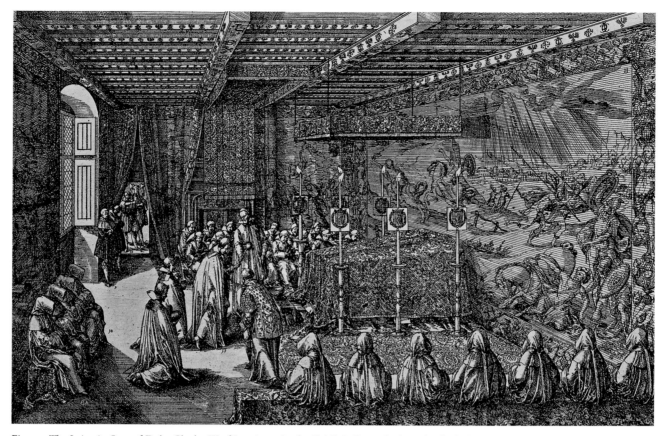

Fig. 47. *The Lying-in-State of Duke Charles III of Lorraine, 1608*, by Frédéric Brentel after Claude de la Ruette. Engraving, 23.5 x 30.5 cm. The Metropolitan Museum of Art, New York, The Elisha Whittelsey Collection, The Elisha Whittelsey Fund, 1959 (59.570.163[4])

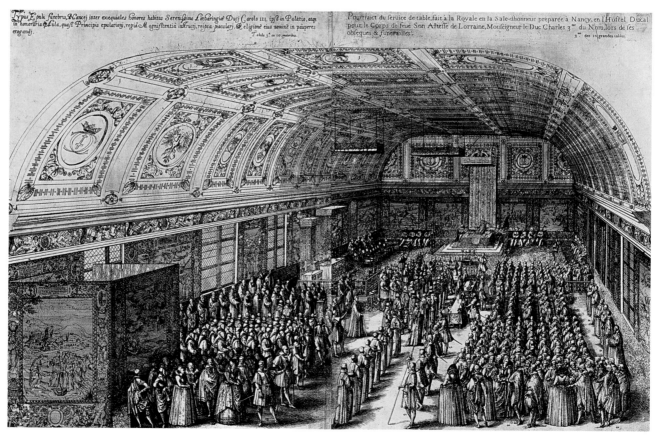

Fig. 48. *The Funeral of Duke Charles III of Lorraine, 1608*, by Frédéric Brentel after Claude de la Ruette. Engraving, 23.5 x 30.5 cm. The Metropolitan Museum of Art, New York, The Elisha Whittelsey Collection, The Elisha Whittelsey Fund, 1959 (59.570.163[5–6])

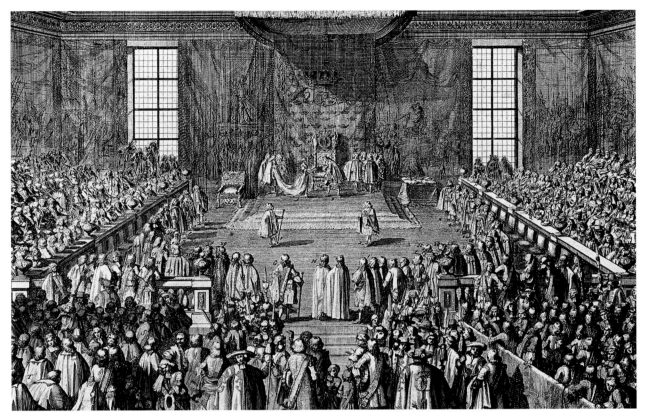

Fig. 49. *Queen Christina's Abdication, June 6, 1654*, by Willem Swidde after Erik Dahlberghe. Engraving, 29.3 x 36.8 cm. Nationalmuseum, Stockholm (NMTIG 2984)

pay royal debts, as had happened to the collections of some of his ancestors. Instead, it was to be held by the Spanish Crown in perpetuity.[9] The French royal collection also numbered several hundred tapestries in the early seventeenth century, including the gold-woven sets purchased by Francis I in the 1530s and 1540s.[10] While the size and quality of the British, French, and Spanish royal collections were exceptional, they were mirrored to a lesser extent by the holdings of all the European courts and principalities.

These were not collections in the modern sense of a self-consciously constructed selection of objects. Rather, they were assemblages, accumulated over time, often divided among many different residences, and embracing tapestries of a wide variety of date, style, quality, and subject matter. Yet if a sizable portion of the hangings were of moderate or low artistic value, the finest gold-woven pieces had a monetary worth above anything else in the royal collections except the most lavish pieces of jewelry. As such, they were highly esteemed both as works of art and as venerable components of crown regalia. These star sets provided the literal staging against which the monarchs of the day performed their official functions. All of the courts had wardrobe departments whose staff was responsible for the care and display of the tapestries and other precious fabrics. The

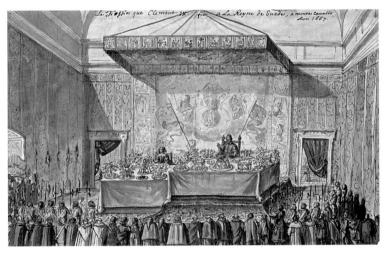

Fig. 50. *Queen Christina Dining with Clement IX, December 9, 1668*, by Pierre Paul Sevin, 1668. Pen and watercolor, 24.8 x 37.6 cm. Kungliga Biblioteket, Stockholm (Huts–B89)

most valuable items were kept in storage to protect them from damage caused by light or excessive exposure to smoke and damp. The deployment of these rarely seen items thus lent an additionally theatrical element to royal funerals, coronations, marriages, baptisms, ambassadorial receptions, and other state occasions (figs. 46–49, 52). For the most important court spectacles, tapestries were also hung outside in palace courtyards or along processional routes.

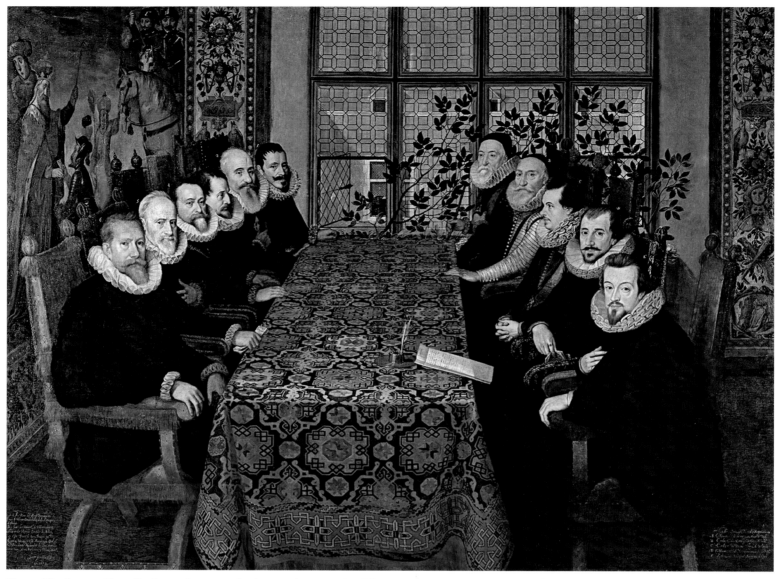

Fig. 51. *The Somerset House Conference, August 19, 1604*, by an unknown artist. Oil on canvas, 205.7 x 268 cm. National Portrait Gallery, London (NPG665)

The grandest court displays incorporated a mix of antique and modern tapestries. Many of the older sets were linked by tradition with particular events. For example, the *Story of Gideon* tapestries commissioned by Philip the Good in the 1440s as a backdrop to ceremonies of the Order of the Golden Fleece remained in Brussels, along with a significant number of the medieval tapestries that the Habsburg rulers had inherited from their Burgundian forebears. These sets continued to be displayed for periodic meetings of the Order of the Golden Fleece and other important events.[11] In Madrid, the most valuable sixteenth-century sets were used for all the major court festivals throughout the seventeenth century. The description of the 1612 reception of the duc de Mayenne cited above typifies those of many other occasions. The two *Conquest of Tunis* sets were especially favored because the subject matter was so reso-

nant with the ideals and self-image of the Spanish monarchy.[12] Charles V's set, the larger and richer of the two, was evidently associated by tradition with the Great Hall at the Alcázar, although it was also displayed elsewhere for important occasions. Besides the 1612 reception, its presence is recorded at more than fifteen grand ceremonies that took place during the century, including the funeral obsequies held at the death of Isabella of Bourbon in 1644 and those for Philip IV in 1665.[13] Mary's set, which was slightly smaller and less richly woven than Charles's, was also regularly displayed in Madrid and elsewhere, and it may have been this set that so impressed Charles, Prince of Wales, when he visited the queen's apartments at the Alcázar in 1623.[14] Philip III took one of the sets to Lisbon in 1619, and one was also taken to Saragossa for the visit of the Spanish prince Baltasar Carlos in 1645.[15] While the *Conquest of*

Tunis tapestries enjoyed particular esteem, they were by no means alone. For example, the temporary pavilion built in 1659 for the signing of the Treaty of the Pyrenees by Philip IV and Louis XIV incorporated hangings from Philip II's *Story of Noah*. The subsequent wedding between Louis XIV and the Infanta Maria Theresa took place beneath one of the *Seven Deadly Sins* sets.[16]

At the English court, grand tapestries, including many antique pieces, were constantly moved from one royal palace to another.[17] Thus, during the reign of Charles I, a fifteenth-century tapestry depicting Saint George was taken from Windsor to Whitehall on several occasions for celebrations associated with the Order of the Garter.[18] Similarly, the rich set of the *Story of Abraham* that Henry VIII had commissioned as a proxy celebration of the continuity of the Tudor monarchy from himself to his son Edward—just as God's covenant had been transferred from Abraham to Isaac—was transported from Hampton Court to Whitehall for various festivals and ambassadorial receptions. Later in the century, this set was to provide the backdrop to James II's coronation in Westminster Abbey in 1685 (fig. 223). The association between this set and the coronation ceremony may already have been a long-standing tradition.[19]

Analogous comments apply to the French court's use of sixteenth-century tapestries. When Cardinal Francesco Barberini celebrated Mass before the king and queen at the Chapelle de la Trinité for the Feast of the Virgin in August 1625, it was decorated for the event with tapestries from Francis I's sets of the Raphael *Acts of the Apostles* and the Giulio Romano *Triumphs of Scipio*.[20] These sets also occupied a prominent position above the nave in Reims Cathedral at the coronation of Louis XIV in 1654 (fig. 46). At the papal court, the tapestries woven in the 1510s and 1520s for Popes Leo X and Clement VII from cartoons by Raphael and his workshop continued to play a major part in the articulation of the religious calendar in the Sistine Chapel and in other Vatican ceremonies.[21] When Clement IX hosted Queen Christina of Sweden at a dinner in 1668, they sat beneath a tapestry throne canopy made for Clement VII in the 1520s (fig. 50).[22]

The selection of tapestries for such occasions—generally undertaken by the senior court officer responsible for the tapestries and precious textiles, sometimes in accordance with earlier tradition, sometimes in response to directions from the monarch, and sometimes on his own initiative—reflected a range of motivations. In many cases, it was a matter of selecting the richest or most venerable antiques. In others the iconography was evidently a factor. Quite apart from flattering compar-

isons that royal and princely patrons might wish to draw between themselves and particular role models, the larger collections provided a broad range of imagery that could be used to comment on ephemeral events. A telling visualization of such opportunistic display is provided by a painting of the signing of the Treaty of London by the Spanish and English delegations at Somerset House in 1604 (fig. 51). While the English delegation is portrayed in front of an olive bush, symbolizing peace, the Spanish delegation is shown in front of a tapestry that depicts King David giving Uriah the Hittite the sealed message that will send him to his death, a well-known exemplum of deceitfulness. In this case, we do not know whether the portrayal was a creation of the artist's imagination or a literal record. But an account of the 1613 wedding of the Stuart princess Elizabeth to the Elector Palatine, Frederick V, provides evidence that tapestries certainly were deployed in such confrontational ways. For this event, which seemed to promise so much to Protestant interests in northern Europe, the *Story of the Armada* tapestries, made for Charles Howard in the 1590s and purchased by James I in 1612 (see "Disruption and Diaspora: Tapestry Weaving in Northern Europe, 1570–1600"), were displayed in the Banqueting House at Whitehall. This overt triumphalism led the Spanish ambassador to feign sickness in order to avoid the proceedings.[23]

If the grandest tapestries of the day were used as a backdrop for important events, tapestry also remained the principal element in the decorations of the main reception rooms and galleries of the royal palaces on a more quotidian basis. In part, the appeal

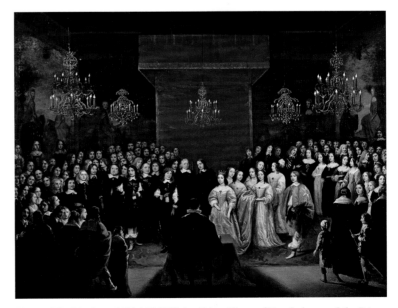

Fig. 52. *The Marriage of Friedrich Wilhelm, Prince Elector of Brandenburg, and the Princess Louise Henriette of Orange Nassau, December 7, 1646 at the Hague*, by Jan Mytens. Oil on canvas, wood, 58 x 74 cm. Musée des Beaux-Arts, Rennes (801.1.15)

of tapestry was still a practical one. Although seventeenth-century buildings were better heated and glazed than those of earlier periods, they remained large and drafty. Chambers of stamped leather and hangings of silk and velvet were being made in increasing numbers from the late sixteenth century, and in the seventeenth century such rooms were installed in many European royal suites, particularly in more private areas. For example, according to the 1598 inventory of Archduke Albert's Coudenberg Palace, the chambers were largely fitted out with leather and velvet hangings.[24] But these developments seem to have made little impact on the ongoing demand for tapestry. Albert, for example, was to purchase more than twenty sets of tapestry for the Coudenberg Palace over the following twenty years.[25] Hung edge to edge and draped across doorways (and often over other forms of decoration), tapestries provided a practical, robust, and portable form of insulation, much as they had done in the past. And as in the past, good pictorial tapestry was very expensive, making it a demonstration of wealth and a potent medium of visual suggestion. As such, it remained the most versatile and impressive large-scale wall decoration available. The diaries kept by Cassiano dal Pozzo when he accompanied Francesco Barberini to Paris and Madrid in 1625 and 1626 provide a fascinating glimpse of the ubiquitous presence of high-quality tapestries, old and new, at the French and Spanish courts.[26]

Generally speaking, tapestries were in use throughout the year at the northern courts. In central and southern Europe, by contrast, tapestries seem to have been hung in the winter and put into storage in the summer. For example, when Cardinal Barberini visited Fontainebleau in the summer of 1625, many of the tapestries had been replaced with lighter textile hangings; those that remained included a fifteenth-century set depicting the defeat of the English at the Battle of Formigny.[27] In Madrid, Charles V's *Conquest of Tunis* set seems to have been hung in the great hall at the Madrid Alcázar during the winter months. When not in use, it was replaced with paintings of Charles V's victories and other paintings of Spanish and foreign cities.[28] Similarly, at the Palacio del Buen Retiro, so famous now for the enormous collection of paintings that Philip IV amassed there, the paintings appear to have been removed or covered by tapestries during the winter. This is evident from a vivid description of a visit to the palace in February 1655 by the Englishman Robert Bargrave. Rich tapestries and hangings are mentioned in most of the grand reception rooms on this occasion, even the Hall of Realms, for which Diego Velázquez and his contemporaries had provided so many magnificent paintings.[29]

In northern Europe, where tapestries were used as decorations throughout the year, the most valuable weavings were kept in storage for special occasions, but the larger collections were sufficiently rich in hangings that many older sets were left in situ for much of the time, especially those that were past their prime. Many such sets had been made for specific chambers or had become associated with them through tradition, and in such locations they provided a resonant link with the past. For example, in England, the majority of the tapestries acquired by the crown during the late fourteenth and fifteenth centuries were located at the medieval palaces of the Tower and Windsor.[30] Several foreign dignitaries who visited these palaces in the early seventeenth century commented on the hangings, and much was made of the antiquity of particular pieces. At Windsor, special attention was paid to a tapestry throne canopy depicting King Clovis of France that had been looted from the French royal collection by the Duke of Bedford in the 1420s. According to one diarist, presumably relating what he had been told by the palace guardian, the French had frequently tried to buy back this tapestry but had been refused at any price.[31] While Windsor was hung with sets acquired by fifteenth-century monarchs, Elizabeth I preserved Hampton Court and its fittings much as her father Henry VIII had equipped it in the 1540s. It was here that the greatest Henrician tapestries were kept, some on display and some in storage, and many visitors commented on their splendor.[32] Subsequently, James I and Charles I maintained the archaic character of Hampton Court. Like Elizabeth, the Stuart monarchs hoped to benefit from an implied sense of continuity with the Tudor dynasty.[33]

New Court Workshops and Commissions as a Manifestation of Princely Magnificence

The taste for old tapestries coexisted with a strong appreciation for new designs. Indeed, if tapestry was a traditional art form, it was by no means a dowdy one. As the present exhibition makes abundantly clear, most of the monarchs who came to the European thrones in the early seventeenth century shared an enthusiasm for contemporary tapestries rivaling that of their sixteenth-century ancestors. Underlying this appetite was the assumption that tapestry was an appropriate accoutrement of princely magnificence as it had been in the past. When Sir Francis Crane wrote to King James I in 1623 to beg for funds to keep the new Mortlake workshop going, it was this aspect that he emphasized: "in the eye of the world [it] aupears as a worke of your Majestie's greatness, and brings with it both honor to your Majestie and profit to the kingdom."[34] For a

twenty-first-century audience, conditioned by modern scholarly priorities and market values to evaluate the artistic patronage of historic personalities largely in terms of their interest in painting and sculpture, it comes as something of a surprise to realize the extent to which tapestry was an overriding concern for the foremost rulers and princes of the day. But that was clearly the case. The tapestry projects that they instituted were among the most expensive and important artistic undertakings of their reigns: Albert and Isabella's numerous tapestry commissions for the Coudenberg Palace in the early 1600s; Duke Maximilian's commissions to Peter Candid for tapestries for the main chambers at the Munich court; Archduchess Isabella's commission to Peter Paul Rubens for the design of the *Triumph of the Eucharist* tapestries for the Descalzas Reales convent (cat. nos. 19–24); Charles I's project for the Whitehall Banqueting House to reproduce the Raphael *Acts of the Apostles* cartoons at Mortlake with new allegorical borders (cat. no. 16); Louis XIII's

expenditure on Rubens's *Story of Constantine* series (see cat. no. 14) and later his commission to Simon Vouet for a set of tapestries depicting scenes of the Old Testament (cat. no. 15); the Barberini commissions to Pietro da Cortona and Giovanni Francesco Romanelli for tapestries for the Palazzo Barberini and the Vatican; and those of the Medici dukes to Florentine artists for suites of new tapestries for the Pitti Palace. Such undertakings reflect the direct engagement of the principal patrons with leading artists in their circles in the creation of highly expensive artworks that were conceived to be the center of court ceremony.

This princely interest in the tapestry medium was undoubtedly stimulated by the diaspora of Flemish weavers during the last quarter of the seventeenth century and the opportunity that exodus provided for contemporary patrons to set up—or reinvigorate—their own workshops. Where their ancestors had been largely dependent on the Brussels workshops for their

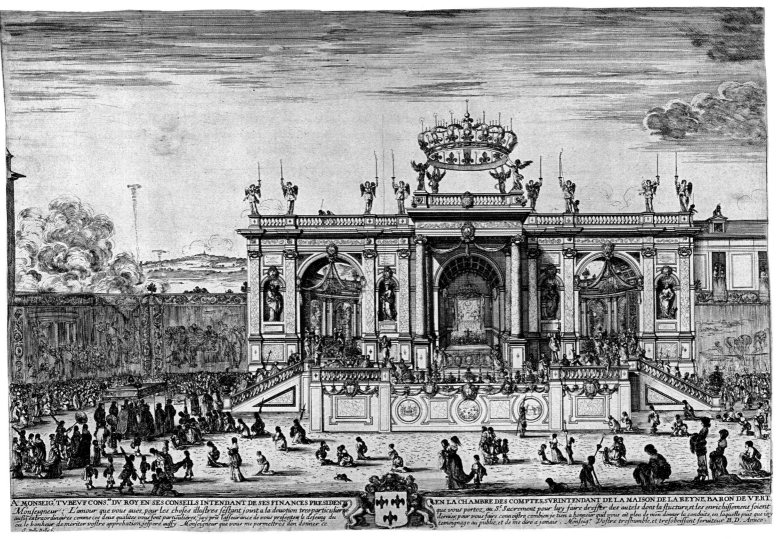

Fig. 53. *Procession of the Feast of Corpus Christi outside the Palais Royal, Paris, June 12, 1648*, by Stefano della Bella, ca. 1648. Etching, state III, 33.4 x 47.5 cm. The Metropolitan Museum of Art, New York, The Elisha Whittelsey Collection, The Elisha Whittelsey Fund, 1959 (59.570.383)

113

finest tapestries, the maecenases of the seventeenth century could now compete with products made locally from designs by artists associated with their entourage. Besides the expensive tapestries made for their own use, both the French and English kings followed the example of the States-General—so generous to its favored allies with tapestries from the Spiering manufactory—by presenting Paris and Mortlake tapestries to important ambassadors and dignitaries during their reigns (see, for example, cat. no. 18).[35] In the Spanish Low Countries, Albert and Isabella also presented Brussels tapestries to visiting dignitaries.[36]

Above all, however, seventeenth-century monarchs were utilizing these manufactories to obtain splendid tapestries for their own use. During the second quarter of the century, the inherited collections of the Spanish, French, and British courts were replenished with a dazzling array of new hangings obtained from, respectively, Brussels, Paris, and London. Other courts emulated their example. For example, in the late 1630s Frederic Hendrick, Prince of Orange (1584–1647), commissioned a set of equestrian portraits of his ancestors that partly copied a dynastic set woven in the early 1530s after designs by Bernaert van Orley. The new set was woven in the Delft workshop of Maximiliaen van der Gucht and included three additional panels after cartoons by Gerrit van Honthorst.[37] It is now lost, but some pieces are visible in the background of a painting of the marriage of Louise Henriette of Orange Nassau with Friedrich Wilhelm, elector of Brandenburg, at The Hague in 1646 (fig. 52). The tapestries provide the only wall decorations in what was presumably the most important reception room in the elector's palace.

In the Catholic Netherlands, the Spanish governors maintained the support of the Brussels workshops that Albert and Isabella had provided in the first two decades of the century. Archduke Leopold Wilhelm (1614–1662), governor between 1647 and 1656, purchased a number of fine tapestry sets after designs by Jacob Jordaens and was personally responsible for commissioning the *Allegory of Time* series from designs by Jan van den Hoecke (cat. nos. 27, 28). He also commissioned a set of designs from his court artist, David Teniers II, that was still in production at the time of his death. The subject is unknown, but it may have been the prototype of the genre scenes based on paintings by this artist that were to enjoy such popularity later in the century.[38] After the archduke's death and that of his heir, Archduke Charles Joseph, several of Leopold Wilhelm's finest sets passed to the emperor Leopold I, which accounts for their survival in the former Habsburg collection at the Kunsthistorisches Museum, Vienna.

Leopold I also patronized the Brussels and Bruges workshops. Before his marriage in 1666 to the Infanta Margaret Theresa he purchased six sets of Flemish tapestry through the agency of a Vienna-based merchant, including a variety of historical, religious, allegorical, and genre subjects, several of which survive in the Viennese collection today.[39] The Swedish and Danish courts also purchased numerous tapestries from the Delft manufactories in the 1610s and continued to acquire tapestries from both Dutch and Flemish workshops in later decades. For example, Queen Christina commissioned a large number of tapestries in 1647 in anticipation of her coronation. Delivered in 1649, these included narrative sets and decorative landscapes, many of which survive in the Swedish royal collection. Following her abdication and move to Rome in 1654, Christina ordered five more chambers of forest-work tapestries in 1662 from workshops in Delft.[40]

Ecclesiastic Splendor and Ceremony

If the grandest tapestry assemblages were those of the European royal families, the large ecclesiastic institutions also enjoyed a financial and physical security that encouraged their amassing important collections of textiles and tapestries over the years. Whereas such collections in Protestant countries were largely dispersed in the late sixteenth and early seventeenth centuries as a result of reformist or iconoclastic tendencies, those in Catholic countries were unaffected by these developments. Indeed, the Counter-Reformation and the decrees of the third Council of Trent (December 1563) stimulated new levels of splendor and theatricality in church liturgy, ceremony, and decoration during the late sixteenth and early seventeenth centuries. The tapestry medium, by virtue of its scale and portability, was ideally suited to this new demonstrative spirit.

On the Continent there was already a long-standing tradition for rich ecclesiastics to donate sets of tapestry to their benefices for display in the choir or naves of their institutions on important feast days. This tradition was especially the case in France, where large numbers of choir tapestries had been acquired in the sixteenth century.[41] Visiting Paris in 1598, the Venetian ambassador Pietro Duodo commented that even the smallest church had two sets of tapestries; he had seen many beautiful examples, such that even if Titian and Tintoretto had still been alive, they could not have done better.[42] The Gallic tradition of commissioning tapestries for ecclesiastic display continued with some vigor in the seventeenth century, and a number of significant sets were produced in Paris or the provinces during the second third of the century. These included the twenty-

nine-piece *Life of Christ* set commissioned in 1633 by the archbishop of Reims from Daniel Pepersack, a Flemish weaver, who had relocated his workshop from Charleville to Reims in 1629 (seven pieces remain at Reims Cathedral); and the fourteen-piece *Life of the Virgin* set commissioned in 1635 for Notre-Dame of Paris and woven during the following twenty-two years, primarily by the Paris workshop of Pierre Damour, after designs by Philippe de Champaigne, Charles Poerson, and Jacques Stella (now, Strasbourg Cathedral; fig. 73).[43] Spanish institutions acquired their devotional tapestries from the traditional Flemish centers, and many seventeenth-century tapestries still survive in the cathedral collections of towns such as Burgos, Saragossa, Tarragona, Toledo, and Zamora.[44] In Italy, cathedrals or their officers commissioned a number of religious sets during the late sixteenth and early seventeenth centuries, also in response to the same Counter-Reformation spirit. Some of these were acquired from the Medici workshops in Florence, such as the nine-piece *Story of the Virgin and of the Infant Christ* woven in the 1580s for Santa Maria Maggiore in Bergamo from designs by Alessandro Allori and the five-piece set of the *Old Testament Prefigurations of the Eucharist* that was woven in the mid-1590s for Como Cathedral from designs by Allori.[45] But

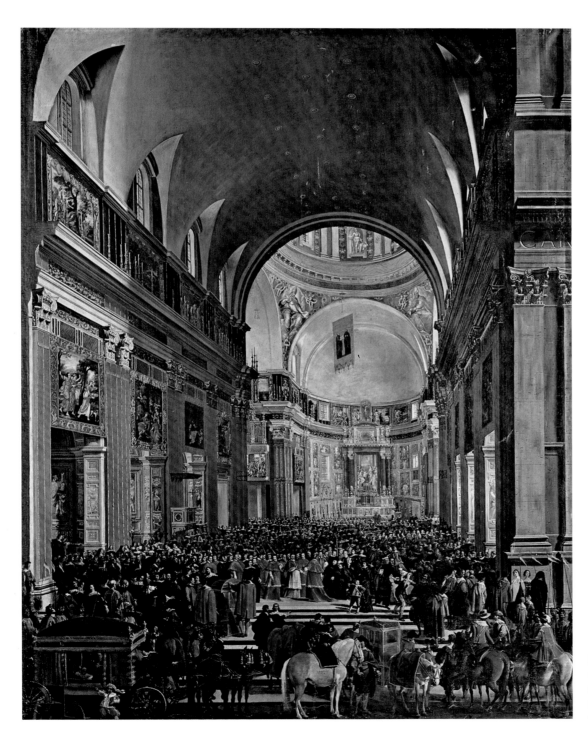

Fig. 54. *The Visit of Urban VIII to the Jesuit Church, 1639,* by Andrea Sacchi, Jan Miel, and Filippo Gagliardi, 1641. Oil on canvas, 336 x 247 cm. Galleria Nazionale d'Arte Antica, Palazzo Barberini, Rome

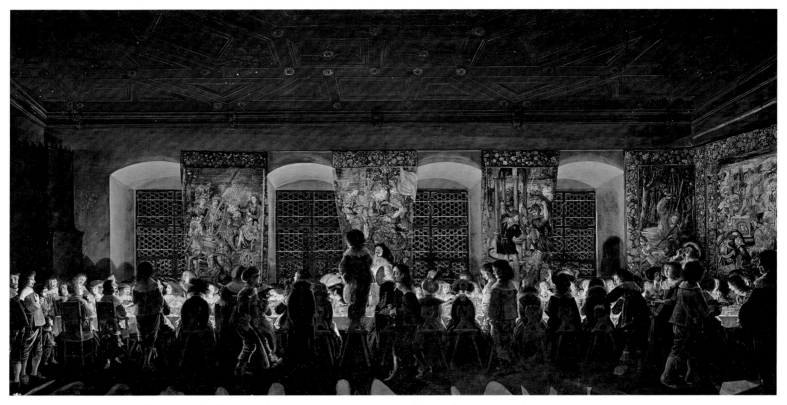

Fig. 55. *Night Banquet*, by Wolfgang Heimbach, 1640. Oil on copper, 62 x 114 cm. Kunsthistorisches Museum, Vienna

the vast majority of such commissions were obtained from the Low Countries, such as the *Life of Christ* set donated to Cremona Cathedral by its archbishop in 1591, or the *Story of Samson* set commissioned for the nave of Cremona Cathedral in 1629 by the prefects of that edifice.[46]

Thus, for many of the richer Continental benefices the exhibition of sets depicting biblical narratives or the life of the patron saint was an important feature of the liturgical year. The highlight of such displays took place on the Feast of Corpus Christi. From the late sixteenth century many religious bodies began to hang tapestries along the processional route through which the Eucharist was carried on this occasion. The primary exponent of this practice was the Vatican, where the Raphael school *Acts of the Apostles* and *Life of Christ* sets were displayed along the Borgo for this ceremony throughout the seventeenth and well into the eighteenth century.[47] The practice was imitated and encouraged in many other Catholic cities. Visiting Paris in 1608, Thomas Coryat recorded his amazement at such a spectacle: "As for the streets of Paris, they were ornamented more sumptuously than on any other day of the year, each road of any importance being hung on both sides, from the roof to the ground, with rich tapestries, the most costly that are to be found; the appearance of the street of Notre Dame was of the greatest pomp and greatly exceeded that of all the others."[48]

John Evelyn recorded seeing similar arrangements for the celebration of Corpus Christi at Tours, when he was there in 1644.[49] A print by Stefano della Bella records the procession held in Paris on June 12, 1648, when a temporary triumphal arch was erected in front of the Palais Royal. The courtyard is decorated with a seventeenth-century reweaving of Raphael's *Acts of the Apostles* (fig. 53).[50] Similar practices were followed in Spain. For example, on the Feast of Corpus Christi in 1626, the facade of the Madrid Alcázar was hung with both sets of the *Conquest of Tunis*.[51] The practice of hanging the streets of Toledo with tapestries from the cathedral collection still survives today.[52] It hardly needs be stated that such usage took a very heavy toll on the textiles involved.

Throughout Europe, there was also a long-standing tradition for guilds and wealthy households to hang textiles, rugs, and tapestries from the windows and balconies of their city residences for the grandest secular and religious festivals. For example, a depiction of the Procession of the Maidens of Notre Dame du Sablon in Brussels in May 1615 shows the square of this name hung with textiles, tapestries, altarpieces, and portraits (Galleria Sabauda, Turin).[53] The tapestries used for such civic displays were by no means exclusively religious, although some attempts were made to ensure the propriety of the subjects selected. In Flanders a decree of 1599 forbade the use of

"sujets scabrous" on these occasions.[54] But clearly, such strictures were not followed rigorously, even by rich ecclesiastics themselves. For example, in 1639, when Urban VIII visited the Jesuit church in Rome on the centenary of the founding of the order, it was decorated with tapestries from the Barberini collection, as can be seen in a painting commemorating the occasion by Andrea Sacchi, Filippo Gagliardi, and Jan Miel (fig. 54).[55] Despite the character of the event, all the tapestries that can be identified are secular in subject.

The Nobility and Princes of the Church

The example of the leading European courts ensured that tapestry also remained a central and fashionable component in the decoration of aristocratic residences throughout this period. The large number of antique hangings in the royal collections was exceptional, but most noble households retained a number of older sets or individual pieces well into the seventeenth century, and the tapestry displays in palaces and town houses, châteaux, and country estates across Europe must have provided the sensitive observer with much information about the ancestry, wealth, and taste of the owner. For this reason, there was a steady demand for secondhand tapestries among the courtiers and administrators who rose to rank and wealth in the course of the century. For example, during the 1610s, William Trumbull, the English agent in the Low Countries, was in frequent correspondence with members of James I's court regarding purchases of antique as well as new tapestries.[56] Then as now, the nouveaux riches were not always the most discriminating patrons. Writing to the Duke of Somerset, James's

favorite, Trumbull advised him that "whether you will have bespoke, or great imagery . . . remember where you have seen any fair modern hangings in England; and to inquire where they were made; I will get you the like."[57]

While the older hangings belonging to more prosperous households would have been carefully maintained, the sheer mutability of the tapestry medium ensured they were subject to a constant process of degradation. With the passage of time many must have been adapted for locations for which they were not originally intended. A painting of a night banquet by Wolfgang Heimbach, dated 1640, gives a vivid impression of such a display with tapestries hung between the windows as *entrefenêtres* (fig. 55). The tapestries can be identified as fragments from two sixteenth-century sets, one an allegory, the other a biblical narrative, that had been cut down and mixed together.[58] Clearly, in this case, the visual and iconographic integrity of these panels had been displaced by their role as atmospheric furnishings.

Antique tapestries gave ballast and splendor to the grand noble households, but it was with new tapestries that the wealthier members of the European aristocracy advertised their taste and refinement (figs. 56, 57). Like their royal patrons, the French and English nobility patronized the new workshops in Paris and Mortlake while still buying tapestries from the Flemish workshops. In many cases, they were acquiring designs that had first been conceived for the royal family, now modified for their own use by the addition of coats of arms and heraldic devices in the borders. For example, during the 1610s and 1620s the Paris workshops produced several sets of the *Story of Diana*

Fig. 56. *The Ball* (detail), by Abraham Bosse, 1634. Etching and engraving, 26.4 x 34.3 cm. The Metropolitan Museum of Art, New York, The Elisha Whittelsey Collection, The Elisha Whittelsey Fund, 1951 (51.501.2268)

Fig. 57. *The Return from the Christening* (detail), by Abraham Bosse, 1633. Etching, 26.1 x 33.5 cm. The Metropolitan Museum of Art, New York, Harris Brisbane Dick Fund, 1926 (26.49.41)

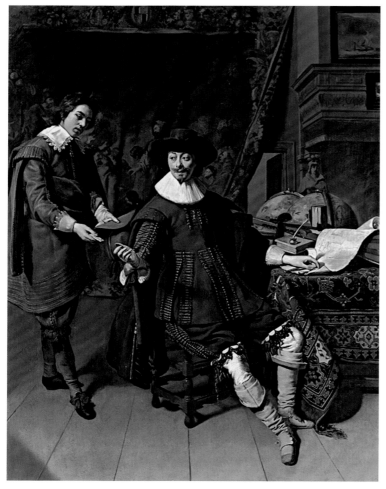

Fig. 58. *Constantijn Huygens and His Clerk*, by Thomas de Keyser, 1627. Oil on wood, 92.4 x 69.3 cm. National Gallery, London (NG 212)

with variant borders for leading French and Spanish noblemen (see cat. no. 13).[59] Similarly, during the late 1630s the Mortlake workshops produced variant sets of the *Acts of the Apostles* for select members of Charles's inner circle (see cat. no. 16). To an extent, commissions like these reflect the limitations of what was available in the marketplace, but they also served to demonstrate allegiance with royal taste and style. Contemporary inventories of both English and French noble houses reflect the ubiquity of tapestries in the reception rooms and private apartments. It seems to have been quite normal for noble families to have kept ten to twenty sets of tapestries at each of their major residences, comprising a mixture of old and new, fine and coarser sets, whose placement articulated the hierarchy of the rooms. In cases where detailed records survive, such as at Hardwick Hall or Ham House, it is clear that tapestries were moved from one room to another over the decades and adapted to various settings. But their presence remained constant, even as suites of less robust textiles came and went.[60]

Some of the richer families emulated the royal courts by commissioning sets that celebrated their dynastic aspirations. For example, in 1632, Jean-Louis de Nogaret, duc d'Épernon (1554–1642), established a tapestry workshop at his Château de Cadillac (Gironde) under the direction of the Paris weaver Claude de Lapierre, with the goal of creating a set of tapestries depicting the history of Henri III in which particular emphasis was placed on events in which the duke had played a part. The twenty-two-piece set was completed by 1636, at which time the atelier was closed. Two pieces survive today (Musée du Louvre, Paris, and Château de Cadillac).[61] For those without the capacity for such ambitious undertakings, there was always the recourse of dealing with the traditional centers of production in the Low Countries. For example, in the mid-1640s, the Taxis family commissioned an equestrian portrait of Leonard de Taxis (1594–1628) and his wife that was woven in the Brussels workshop of Daniel Eggermans (Thurn and Taxis Schloss, Regensburg).[62] And for those without the resources to commission new designs, existing series could always be customized by adding an armorial cartouche in the border (fig. 58).

The continuing market for Flemish tapestries was not limited to patrons north of the Alps. As discussed elsewhere in this book, discriminating Italian patrons like Cardinals Alessandro Montalto and Scipione Borghese directed commissions to the Paris and Brussels workshops in the first decades of the seventeenth century. The ongoing enthusiasm for tapestry in Rome in the following decades is demonstrated by the patronage of the Barberini family.[63] As Montalto's agent in Paris in 1606, Maffeo Barberini had taken advantage of his time there to acquire tapestries for himself.[64] Two decades later, in 1625, Maffeo, now Pope Urban VIII, sent his nephew Francesco Barberini to Paris as a papal legate. During this visit, Louis XIII presented Francesco with a set of *Constantine* tapestries, the first weaving of this design (see cat. no. 35).[65] In the following years, Francesco also acquired Paris tapestries on his own behalf, which he subsequently gave to his brother Antonio, including the *Artemisia* set of which part survives today at the Minneapolis Institute of Arts (cat. no. 12).[66] Francesco's exposure to the Paris tapestry workshops and subsequently to the riches of the Spanish royal collection in Madrid in 1626 evidently encouraged him to establish his own workshop in Rome in 1627.[67] Correspondence between Francesco and his agents in northern Europe regarding local methods of production reflect his intense interest in the enterprise (see James G. Harper, "Tapestry Production in Seventeenth-Century Rome: The Barberini Manufactory"). It hardly needs to be said that in commissioning cartoons from Pietro da Cortona and Giovanni Francesco Romanelli, Francesco was

paralleling the practice of the northern courts in giving commissions to leading artists in their circles.

The Barberini enterprise was exceptional, but most of the Italian nobility shared this taste for tapestry. Hundreds of sets of hangings of a range of qualities were imported to Italy for use in the Baroque palaces of the day, even as Cortona and his contemporaries were painting the frescoed ceilings and walls for which the palaces are now more famous.[68] For example, documentation relating to the Farnese family reflects not only the large numbers of sixteenth-century tapestries at their various residences in Parma, Rome, and Naples but also the acquisition of new sets throughout the seventeenth century.[69] Most of these are long since lost, but a number of imposing ensembles are extant, such as the Brussels set of the *Story of Scipio* now at the Palazzo del Quirinale. Woven about 1650–65 from second-generation cartoons based on the originals of Giulio Romano but with elaborate Baroque borders, this was acquired sometime in the last third of the century by either Duke Ranuccio II or his brother, Alessandro, governor of the Spanish Netherlands between 1678 and 1680.[70]

Subject Matter and Disposition in the Noble Residence

While the richest patrons could order custom-designed sets with subjects specific to their own purposes, such commissions were rare because of their cost. As in previous eras, the vast majority of the tapestries purchased by the European aristocracy was acquired from merchants who had commissioned the designs on a speculative basis. Exemplary themes drawn from ancient history or biblical narrative had the broadest appeal and predominated among the larger narrative series produced in these circumstances. Many seventeenth-century patrons thus transacted their daily business under the towering presence of such figures as Alexander, Caesar, Scipio, Abraham, and Jacob, just as their female counterparts lived their lives against a backdrop of scenes from the lives of Judith, Esther, and other female personifications of virtue.[71] Such worthy examples were not necessarily to everyone's taste, as reflected by an episode in James Shirley's "The Lady of Pleasure," written in 1635, in which one of the characters, Celestina, complains about the hangings in her rooms:

> *I will have fresher, and more rich; not wrought*
> *With faces that may scandalize a Christian,*
> *With Jewish stories stuff'd with corn and camels.*
> *. . . I say I will have other,*
> *Good Master Steward, of a finer loom:*

> *Some silk and silver, if your Worship please*
> *To let me be at so much cost. I'll have*
> *Stories to fit the seasons of the year,*
> *And change as often as I please. (act 1, scene 2)*

Fortunately for those who shared Celestine's tastes, not all subject matter was biblical and exemplary. In the first third of the century, there was also a steady demand for more lighthearted subjects, depictions of the seasons, and other such traditional allegorical subjects, as well as scenes of Ovid's *Metamorphoses* and contemporary romances such as *Amadis of Gaul* and *Orlando furioso.*

The style of these tapestries varied widely from workshop to workshop, reflecting the artistic skills of the artists who had created the cartoons, the skill of the weavers in interpreting those designs, and the quality of materials in which they were executed. Generally speaking, the narrative tapestries produced in the Low Countries in the second third of the seventeenth century are characterized by the formula that Rubens initiated in the late 1610s and 1620s and that was developed by Jordaens in the 1630s: monumental figures in schematic settings framed by trompe l'oeil architectural structures. Apart from the amusing conceit that such illusionistic schemes provided to the patrons—equipping them with a portable architecture that foreshadowed the illusionism of high Baroque decoration—the format of broad borders around large figures was attractive for the commercial workshops because the architectural frames were less demanding to weave than more detailed landscapes. The success of this formula was emulated in other Flemish workshops, particularly in Antwerp, and Bruges and, to a lesser extent, at the Paris and Mortlake workshops. The market for large-figure tapestries also stimulated the production of a new generation of cartoons based on sixteenth-century designs, in which the original landscapes were minimized and the original borders replaced by wide Baroque borders (see Guy Delmarcel, "Tapestry in the Spanish Netherlands, 1625–60").

All of the European tapestry workshops also made weavings with purely decorative subject matter for use in smaller and more intimate settings. During the first third of the century the pergola and flower format replaced the verdures of earlier generations, although decorative motifs such as grotesques also enjoyed popularity among a more cultivated audience. From the 1630s, many workshops began to produce landscape tapestries framed by architectural components, sometimes populated with small genre or mythological figures. Floral motifs also abounded in the decorative table carpets and valances that were

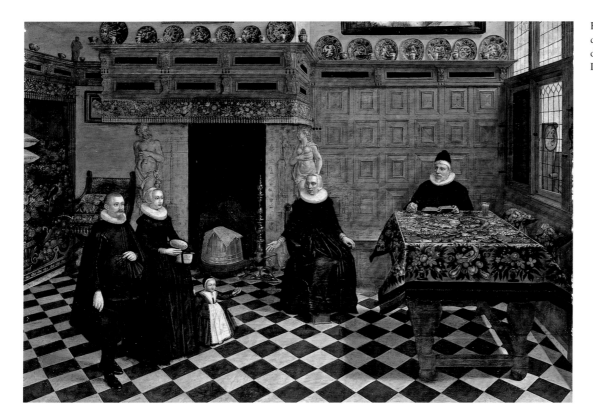

Fig. 59. *The Visit*, by Gonzales Coques, ca. 1630. Oil on wood, 86 x 118 cm. Musée d'Art et d'Histoire, Geneva, Fondation Lucien Baszanger (BASZ5)

made in considerable numbers in the Dutch provinces during the second third of the seventeenth century. These found a ready market among the prosperous burghers who could not afford larger tapestry sets (fig. 59).[72]

During the Middle Ages and early Renaissance, many households had carried substantial numbers of luxury textiles and tapestries with them as they traveled from one residence to another. This practice decreased during the sixteenth and early seventeenth centuries as the larger households accumulated sufficient quantities of such materials to have standing wardrobes at each of their most important dwellings. Equally, sets were undoubtedly moved as required from one property to another for special occasions or as the significance of particular houses rose or fell.[73] Careful practices of husbandry were maintained throughout this period, with the finer hangings being deployed when the owner was in residence and then returned to storage afterward. Or, if the hangings were left in situ, they were covered with dust cloths or the rooms were protected with shutters and curtains.[74] As in the royal palaces, usage in many of the richest households was seasonal, particularly in southern Europe, where tapestries would be hung in the win-

ter months and stored in the summer months.[75] In northern Europe, there is also evidence of rotations of various types of textiles according to the seasons. Thus, according to the 1601 inventory of Hardwick Hall, the high great chamber was equipped with two sets of hangings: a Brussels set of the *Story of Ulysses* that survives there today, and another set of painted and embroidered woolen hangings. Similarly, the 1677 inventory of Ham House records that the "Qween's Bed Chamber" had tapestries of the *Seasons* for use in winter and "spoted tabbie" hangings for the summer.[76]

While the most valuable tapestries owned by the European nobility continued to be subject to ad hoc display in a variety of locations, in the first half of the seventeenth century increasing numbers of tapestry sets were made to order or adapted to the specific measurements of smaller rooms; this was particularly the case with the verdure and decorative sets mentioned above. Set within paneling and attached to the walls with tacks, these installations were relatively permanent and must have been one factor that encouraged owners to hang paintings or mirrors over the tapestries, a topic that will be considered in greater detail below.

1. For the description in full, see Orso 1986, pp. 136–37.
2. For the two sets of the *Seven Deadly Sins* in the Spanish royal collection, see Junquera de Vega and Herrero Carretero 1986, pp. 143–54; for the design and further references, T. Campbell in New York 2002, pp. 381, 410–16 no. 47.
3. For the two sets of the *Conquest of Tunis* in the Spanish royal collection, see Horn 1989. For the design, T. Campbell in New York 2002, pp. 385–91.
4. Mechelen 2000; T. Campbell in New York 2002, pp. 175–85.
5. Buchanan 2006.
6. For the three sets of this design in the Spanish royal collection, see Junquera de Vega and Herrero Carretero 1986, pp. 105–33; also T. Campbell in New York 2002, pp. 384–90; Paredes 2005.
7. Orso 1986, p. 138, suggests that the *Seven Deadly Sins* were chosen for their material richness rather than for their subject. While opulence was undoubtedly a goal, the use of these vast moralistic sets seems more likely to have been intended as a public statement of the ethics of the Spanish rulers. Interestingly, the *Seven Deadly Sins* was also chosen as the backdrop to the marriage of Maria Theresa to Louis XIV in 1659.
8. For Henry VIII's collection, see Starkey 1998 and T. Campbell 2007; for the state of the collection at the Commonwealth sale, see Millar 1972 and King 1989.
9. Delmarcel 1999b.
10. Although no late 16th-century inventories for the French royal collection survive, an idea of the scope of the collection at this time can be assessed by comparison between the inventories of Francis I's collection taken in 1542 and 1551, and those taken of Louis XIV's collection in the late 17th century; see, respectively, Schneebalg-Perelman 1971 and Guiffrey 1885–86.
11. By the late 17th century, the *Gideon* set seems to have been on semipermanent display in the Coudenberg Palace, hanging in the chapel between the Feast of Saint Andrew and Lent, and in the great hall from Palm Sunday onward; Pinchart 1878–85, p. 75. For a list of the Burgundian tapestries still extant in Brussels after the fire that destroyed the Coudenberg Palace in 1731, see Saintenoy 1932–35, vol. 3, pp. 150–54.
12. Orso 1986, pp. 140–41.
13. Ibid., pp. 140–41; Horn 1989, pp. 136–40.
14. Horn 1989, pp. 136–37; Brotton 2006, p. 92.
15. Horn 1989, pp. 136–40, 168–72.
16. Lefébure 1995, pp. 146–47.
17. Much information about the use and disposition of the British royal tapestries survives in documentation relating to the Office of the Lord Chamberlain, now at the National Archives (hereafter NA), Kew.
18. NA LC5/132, fol. 356 (April 19, 1634), LC5/134, fol. 56 (April 18, 1635).
19. T. Campbell 2003, pp. 59–60; T. Campbell 2007, pp. 297, 363, 365–66.
20. Bertrand 2005, p. 47.
21. Shearman 1972, pp. 141–43; Bertrand 2005, pp. 36–39.
22. Stockholm 1966, p. 311, no. 711; for the canopy, see T. Campbell in New York 2002, pp. 241–43.
23. *Beschreibung der Reiss* 1613.
24. Saintenoy 1932–35, vol. 3, pp. 35–39. For extensive discussion of the various types of wall coverings that came into vogue in the early 17th century, see Thornton 1978.
25. Saintenoy 1932–35, vol. 3, pp. 40–44.
26. Bertrand 2005, pp. 46–49.
27. Ibid., p. 46.
28. Orso 1986, pp. 121–25.
29. Quoted in J. Brown and Elliott 1980, pp. 107–9; J. Brown and Elliott 2003, pp. 109–12.
30. T. Campbell 2007, pp. 319–23, 351–55.
31. Platter 1937, pp. 213–15, 239; T. Campbell 2007, pp. 331, 335.
32. Thurley 2003, pp. 99–103; T. Campbell 2007, p. 352.
33. Thurley 2003, pp. 112–13; T. Campbell 2007, p. 354.
34. Thomson 1906, pp. 296–97.

35. Loomie 1987, pp. 86, 221, 272, 302–3.
36. Purnell and Hinds 1924–40, vol. 2, p. 31, vol. 4, p. 53.
37. Fock 1969; Fock 1975.
38. Bauer 1999, pp. 116–18.
39. E. Duverger 1986; Bauer 1980; Bauer 1999, pp. 118–20.
40. Nordenfalk 1966.
41. L. Weigert 2004; Toulouse–Aix-en-Provence–Caen 2004.
42. Albèri 1839–63, vol. 10, p. 115.
43. Lejeaux 1948; Lefébure 1995, p. 173.
44. See, respectively, Beauvois-Faure 1959; Batlle Huguet 1946; Torra de Arana, Hombría Tortajada, and Domingo Pérez 1985; Gómez Martinez and Chillón Sampedro 1925.
45. Meoni 1998, pp. 81–84, 100–103.
46. Voltini 1987, pp. 62–67.
47. Shearman 1972, pp. 141–42.
48. Quoted in Lough 1984.
49. Evelyn 1955, vol. 2, pp. 94–95.
50. Brassat 1992, pp. 50–51.
51. Horn 1989, p. 138.
52. Standen 1981, p. 19, fig. 6.
53. Ibid., p. 16, fig. 1.
54. Wauters in Brussels 1882, p. 210.
55. Bertrand 2005, pp. 79, 81–83.
56. See, for example, Purnell and Hinds 1924–40, vol. 2, pp. 3, 31, 100, 434, vol. 4, p. 165; Howarth 1994.
57. Brotton 2006, p. 58.
58. For identification of the series, see Delmarcel 1979, esp. pp. 164–65.
59. Boccardo 1999.
60. Thornton 1978, pp. 106, 123, 134.
61. Lefébure 1995, pp. 154, 173.
62. Piendl 1978.
63. Bertrand 2005, pp. 33–36.
64. Lefébure 1995, pp. 151–52; Bertrand 2005.
65. Bertrand 2005, pp. 49–50.
66. Adelson 1994, pp. 170–74; Bertrand 2005, pp. 103–7.
67. Bertrand 2005, pp. 46–49.
68. Bertrand 2005, passim, esp. pp. 79–81, 88–89.
69. Bertini 1999; Forti Grazzini 1999.
70. Forti Grazzini 1994b, vol. 1, pp. 206–45; Forti Grazzini 1999, p. 159.
71. The most comprehensive publication on European tapestry production in this and other periods remains Heinrich Göbel's six-part *Wandteppiche* (1923–34). For more recent scholarship and bibliographies, see D. Heinz 1995; Joubert, Lefébure, and Bertrand 1995; and Delmarcel 1999a. Visual resources in the field remain scattered. For the broadest survey of extant tapestries from this and other periods readily accessible to researchers, see the Marillier Tapestry Subject Index, deposited with the Textile Department of the Victoria and Albert Museum, London. A more up-to-date, but private, subject index has been compiled by the S. Franses Gallery, London. Large collections of tapestry photographs organized by subject can also be found in the textile department of the Musée Cinquantenaire, Brussels; at the Getty Research Center, Los Angeles (many of these are also available online); and the Antonio Ratti Textile Center at The Metropolitan Museum of Art, New York.
72. Amsterdam 1971.
73. For an account of the disposition and display of the Farnese tapestry collection between the late 16th and early 17th century, see Bertini 1999 and Forti Grazzini 1999; for the disposition and use of tapestries in the various Barberini residences across the century, see Bertrand 2005, pp. 63–78.
74. Thornton 1978, p. 105.
75. Bertrand 2005, p. 63.
76. Thornton and Tomlin 1980, p. 143; Thornton 1978, pp. 106, 123.

The Parisian Workshops, 1590–1650

ISABELLE DENIS

The significant role that Paris tapestry production played in French art and culture during the first half of the seventeenth century is still only partly recognized and has yet to receive full monographic treatment. In the late nineteenth century, the tapestry scholar and historian Jules Guiffrey, through his tireless research in the Paris archives, gathered much evidence about the key workshops whose renown had been obscured by time.[1] This formed the basis for a large part of what was written about Paris production in the surveys of French and European tapestry in the first two-thirds of the twentieth century. Then, in 1967, the exhibition "Chefs-d'oeuvre de la tapisserie parisienne (1597–1662)," organized by Jean Coural at the Orangerie of Versailles, stimulated further research and new respect for the artistic and technical excellence of the tapestries produced in those workshops.[2] Since then, the many studies devoted to French painting of the first half of the seventeenth century have shown the time and effort that the leading artists of the day devoted to tapestry design, as well as the demand for these products from the most significant patrons of the period. Indeed, it is no exaggeration to say that the engagement of these artists in major tapestry commissions was an important component of the revitalization of French art during the first half of the seventeenth century. The following essay provides a brief overview of this period of vigorous and innovative production, which established the foundations for the achievements of the Manufacture Royale des Gobelins later in the century.

Henry IV and the New Workshops at the Louvre and the Faubourg Saint-Marcel

The existence of tapestry workshops in Paris is attested throughout the sixteenth century, and a number of pieces can be linked to them, especially during the years 1540 to 1560.[3] Insufficient evidence survives to make secure connections between archival records and any of the surviving weavings.

Except for Diane de Poitiers's *Story of Diana*, Parisian production was, generally speaking, of moderate rather than high technical and pictorial quality, although the weavers were capable of producing excellent work if the funds and designs were forthcoming, as the short-lived arrangement at Fontainebleau amply demonstrates.[4] When Henry IV came to power, however, the workshops were scattered, mobile, and disorganized. As early as 1583 he had conceived a plan to attract to the Béarn region Flemish craftsmen who had been driven from their own country by religious persecution. Although this was never realized, his interest in tapestry may have been revived when, in 1594, he had the opportunity to admire, on the looms installed in the former Hôpital de la Trinité in Paris, a tapestry from the series the *Life of Christ*, after cartoons by Henri Lerambert (ca. 1550–1608).[5]

The Hôpital de la Trinité was a charitable institution, founded by Henry II in 1551, where orphans and impoverished children could learn professions, one of which was tapestry weaving.[6] By the 1570s, the weaving workshop at the Trinité was directed by the master weaver Maurice Dubout (d. 1611). In addition to armorial tapestries, documented commissions from the Trinité workshop were mainly religious sets for patrons outside the courtly milieu. In 1572, for example, a *Life of François de Paule*, the fifteenth-century Italian saint who had attended both Louis XI and Charles VIII of France, was made for one Pierre Passart, citizen of Paris; in 1575 a *Life of Saint Roche* was woven for another Parisian, a merchant named Michel le Sec; and in 1584 the *Life of Christ* was woven for the chapter of the church of Saint Mederic, and it was apparently still in the workshop ten years later during a visit by Henry IV.[7]

In 1597, with the end of the troubles that marred the first half of Henry IV's reign, he decided, in the words of the eighteenth-century historian Henri Sauval, to "reestablish in Paris the tapestry manufactories that the disorder of the previous reigns had abolished."[8] His goal was primarily an economic

one, to counter Flemish imports. This was an opportune move, since Flanders was being ravaged by Spanish troops whereas France was returning to civil peace.

Henry IV's first initiative involved two Paris weavers, Girard Laurent (d. 1616) and the director of the Trinité shop, Maurice Dubout. In 1597 Laurent was named director of a new workshop that the king caused to be installed in the former home of the Jesuits on the rue Saint-Antoine.[9] The accounts of the Royal Works, or Bâtiments du Roi, in the following years are peppered with expenses for construction repairs and alterations to the "logis des Jésuites," together with payments for tapestry designs and weavers' wages.[10] By August 1600 Laurent was signing contracts with journeymen weavers to boost his workforce at the workshop in the Logis des Jésuites. Although Dubout's Trinité workshop and Laurent's establishment at the Jésuites existed simultaneously for a while, by 1606 both master weavers and their assistants joined forces, moving into lodgings below the Grande Galerie in the Palais du Louvre, which they shared with a number of artisans with privileges. Both weavers received an annual stipend of 300 livres from the king, in addition to compensation for the three apprentices that each was committed to train. They were known as "master high-warp tapestry makers" ("maîtres tapissiers de haute lisse"), meaning that they worked on vertical looms.[11] As early as 1606, Maffeo Barberini remarked in a letter to Cardinal Alessandro Peretti Montalto that the high-warp weaving technique used in the Louvre workshop meant that the weavers could keep a close eye on their work and correct it, whereas Flemish weavers saw their work only after it was completed.[12] Their work attracted comment: George Carew, English ambassador to the court of Henry IV, wrote in his report entitled "Relation of the State of France" (1609) that "In his new buildings at the Louvre, the first places finished were delivered to some Netherlanders, who work in high warp, with such curiousness as every Flemish ell of that tapestry amounteth to sixteen crowns, though it has neither silver nor gold in it; and at that price some cardinals and other princes of Italy cause suites thereof to be made for them."[13]

In 1601, when Laurent's workshop was just getting under way, Henry IV was already actively nurturing a second weaving establishment, which was evidently conceived as an altogether more commercial venture. To this end, he recruited two Flemish weavers, Marc de Comans (1563–1644) from Antwerp and his brother-in-law François de La Planche (Frans van der Plancken, 1573–1627) from Oudenaarde, who signed a partnership agreement in 1601.[14] Comans established his shop in the Faubourg Saint-Marcel, within the walls of the Hôtel des Gobelins; La Planche set up his in the former Palais des Tournelles. In 1607 the two workshops merged, with both master weavers sharing premises in the Hôtel des Gobelins. The two entrepreneurs were granted letters patent by Henry IV to operate a tapestry manufactory, which conferred many privileges, including a monopoly, tax exemptions, 100,000 livres toward installation costs, annual wages, and, above all, a ban on importation of foreign tapestries into France. In turn, Comans and La Planche agreed not to sell their products for a higher price than that paid for tapestries previously imported from Flanders and to maintain eighty operating looms, sixty in Paris, the rest in workshops in Amiens and Tours, which opened in 1604 and 1613, respectively. Unlike the Louvre workshop, the tapestries woven by the Flemings at the Faubourg Saint-Marcel were done on low-warp, or horizontal, looms. Because Comans and La Planche produced for the open market, their tapestries had to have an identifying mark: the fleur-de-lis and the first letter of the city where they were made; thus, the P for Paris, the A for Amiens (which appears primarily on tapestries after Simon Vouet's cartoons; see below), and the rarer T for Tours.[15] In practice, the weavers often also included their own identifying weavers' marks, sometimes accompanied by an FM monogram, which was probably an additional identification for products of Faubourg Saint-Marcel manufacture, although its exact significance remains debated.[16]

The Mannerist Legacy and New Stylistic Developments
Both the Louvre and the Faubourg Saint-Marcel weaving establishments enjoyed a measure of royal protection and were overseen by Jean de Fourcy, superintendent of the Bâtiments du Roi, named administrator of the high-warp shops in 1599 and of the low-warp shops in 1601. By 1606 the Louvre looms were commissioned to produce a tapestry set of either the *Story of Coriolanus* or the *Story of Artemisia* for Cardinal Montalto, vice chancellor of the Holy See, with the proviso that they be the same as those that Dubout had already begun for Henry IV.[17] Further *Coriolanus* tapestries were woven in both manufactories, with sets subsequently recorded in the French royal collection (fig. 61) as well in the possession of Cardinal Francesco Barberini.[18]

The royal inventories name the designer of the *Coriolanus* tapestries as Henri Lerambert, although two drawings (now in the Bibliothèque Nationale) related to the designs were once attributed to Antoine Caron (1521–1599).[19] It is possible that Lerambert painted the *Coriolanus* cartoons with an earlier, unexecuted scheme in mind. Henri Lerambert held the post of

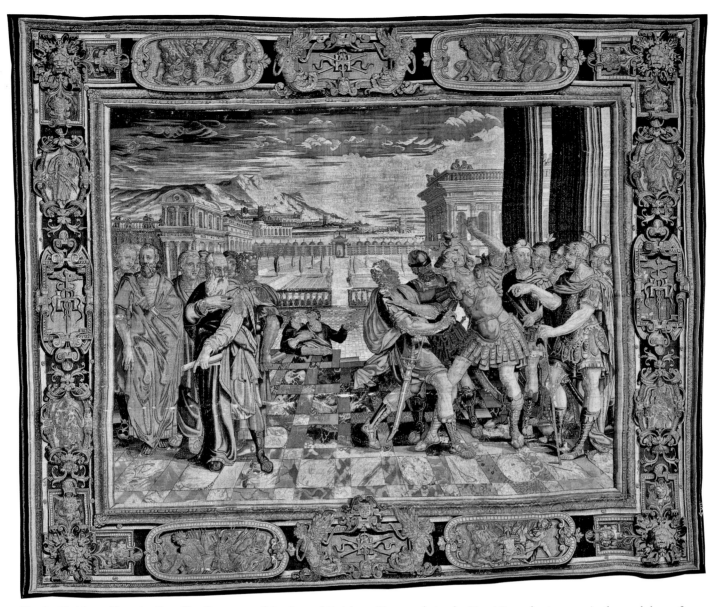

Fig. 61. *Coriolanus Ejects the Councillors* from a set of the *Story of Coriolanus*. Tapestry design by Henri Lerambert, woven in the workshop of François de La Planche, Paris, before 1606. Wool, silk, and gilt-metal-wrapped thread, 463 x 539 cm. Mobilier National, Paris (GMTT 14/8)

Royal Tapestry Cartoonist.[20] His name has been linked with various other sets woven in the Louvre and Faubourg Saint-Marcel workshops. About 1600 his predecessor in the post of Royal Tapestry Cartoonist, Toussaint Dubreuil (ca. 1561–1602), created designs for a set of the *Story of Diana*, based in part on an earlier sixteenth-century tapestry series usually attributed to Jean Cousin the Elder (ca. 1500–ca. 1560) or Luca Penni (ca. 1500–1557). Lerambert assisted in painting the cartoons after Dubreuil's modelli and may, indeed, have altered and added some scenes after Dubreuil's death (see cat. no. 13). A similar design history was attached to the *Story of Artemisia*. As with the *Diana* tapestries, the inspiration for *Artemisia*'s composition was a sixteenth-century project, in this instance, drawings by Antoine Caron. A set of this subject was in production in the

Louvre workshop as early as 1601, possibly after cartoons painted by Lerambert after Caron's drawings. Then, in 1607, another artist, Laurent Guyot (ca. 1575–after 1644), was contracted to work up and paint as tapestry cartoons more of Caron's drawings (see cat. no. 12). The Louvre workshop produced at least six editions of the *Story of Artemisia*, which was subsequently woven numerous times in the Faubourg Saint-Marcel manufactory. One of the Louvre editions was displayed in the Château de Fontainebleau on the occasion of the christening of the dauphin and his sisters in 1606.[21]

After Lerambert's death in 1608, Henry IV held a competition for the post of Royal Tapestry Cartoonist, requiring entrants to design a cartoon illustrating a scene from *Pastor fido* (1590), a romance by the Italian Giovanni Battista Guarini.[22] The post

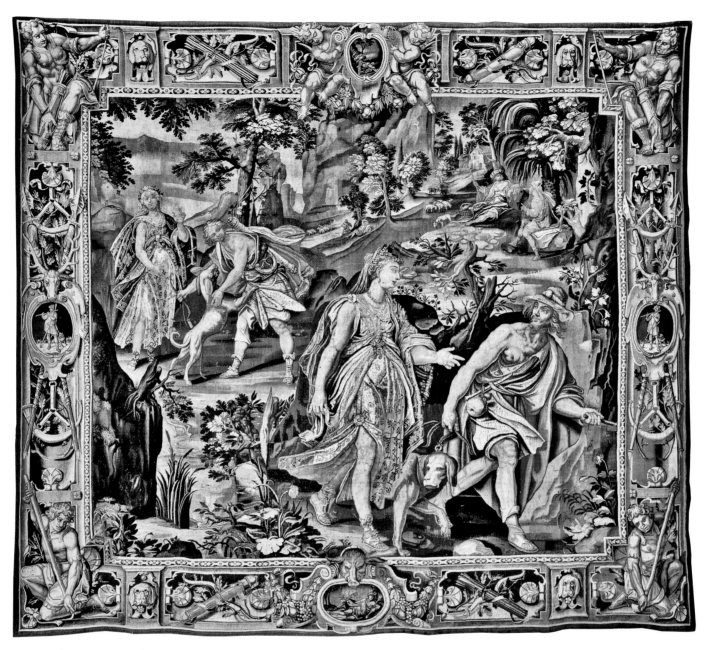

Fig. 62. *Silvio and His Dog* from a set of the *Story of Pastor Fido*. Tapestry design by Laurent Guyot and Guillaume Dumée, probably woven in the Faubourg Saint-Marcel workshop of François de La Planche, Paris, ca. 1610–20. Wool and silk, 410 x 435 cm. Château de Chambord (DPOM 647)

was awarded to two artists, Laurent Guyot, already practiced in the art of cartoon painting, and his brother-in-law, Guillaume Dumée (fig. 62). Dumée, who was also the king's appointed custodian of paintings at the Château de Saint-Germain-en-Laye, was probably less active painting cartoons than Guyot, whose name is mentioned often as designer of tapestries in the royal inventories.[23] In addition to the *Artemisia* cartoons, numerous border designs are attributed to Guyot (see cat. nos. 13, 14). Indeed, part of the commercial appeal of the Paris workshops came from the decorative and original character of border designs for their tapestries. These borders are easily recognizable,

with their cartouches simulating leather strapwork at the corners and in the centers of the side borders, and by their very structured appearance. Inside a formal, well-defined frame there developed a new repertoire that allied the weavers' traditional taste for realistically rendered flowers and animals with an arrangement that was precise yet flexible (see, for example, fig. 64).

With production from the Louvre and Faubourg Saint-Marcel ateliers, the Paris workshops had a substantial output by the mid-1610s. To some extent, the workshops continued to benefit from court patronage, which placed orders for *Artemisia* and *Pastor Fido* tapestries even after Henry IV's death in 1610.

Most notably, new cartoons were added to the *Story of Artemesia* series for the widowed queen, Marie de' Medici, and for her son Louis XIII (see cat. no. 12). However, generally speaking, many of the designs that continued in use for more commercial production in the mid- to late 1610s lacked the verve of their Flemish competitors. Several were based on sixteenth-century schemes, such as the *Diana* and *Artemesia* series. Another popular Faubourg Saint-Marcel series, the *Story of Gombaut and Macée* (fig. 63), illustrating in a naive and sometimes rather risqué manner the lives of two peasants and the pleasures of country life, was based on the somewhat archaic designs of late sixteenth-century engravings by Jean Leclerc (ca. 1587–1633).[24] Similarly, the cartoons for a set known as the *Hunts of Francis I*, painted between 1610 and 1618, were inspired by engravings by Antonio Tempesta (1555–1630) (fig. 64).[25] Again, this series represents a conscious return to the Valois kings, including some recognizable views of Francis I; the sets purchased for the French royal collection were subsequently described in inventories as "Chasse du roi François" and "Chasse de François Premier."[26]

Although the quality of the tapestries woven in the Louvre and Faubourg Saint-Marcel workshops tended to be high and although the tapestries habitually displayed a decorative, Mannerist elegance, the conservatism of their designs did not go unnoticed. When Cardinal Scipione Borghese sought to procure tapestries from the Parisian market in the spring of 1617,

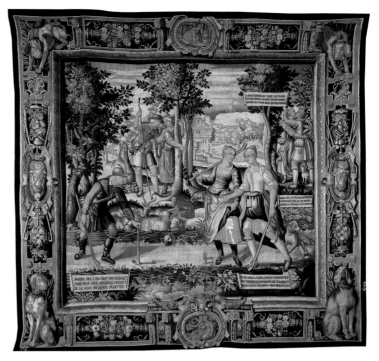

Fig. 63. *The Ball Game* from a set of the *Story of Gombaut and Macée*. Tapestry design by Laurent Guyot after 16th-century engravings, woven in the Faubourg Saint-Marcel workshop of François de La Planche, Paris, before 1627. Wool and silk, 414 x 425 cm. Mobilier National, Paris (GOB 147)

Cardinal Guido Bentivoglio warned him that "All the designs are new and in the hand of a French painter who, in my view, has hardly progressed beyond mediocrity. . . . The fable of Diana is in the same hand. The material is very fine, rich in silk and gold. The workmanship as well is very good, and the border very well

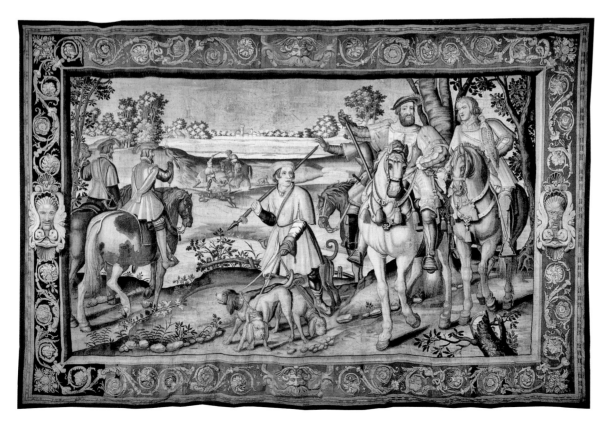

Fig. 64. *Arrival in the Countryside* from a set of the *Hunts of Francis I*. Tapestry design by Laurent Guyot, woven in the Faubourg Saint-Marcel workshop, Paris, ca. 1620. Wool and silk, 335 x 505 cm. Château de Chambord

done and pleasing, but the anima, the soul, that is, the design, is missing."[27] The cardinal's solution did not bode well for Guyot, Dumée, and their associates: "His Majesty's tapestry maker has proposed that if we wanted to send some beautiful design from Rome, he would contribute toward half the expense."[28] Fortunately for the local artists, the next thirty years would see Parisian tapestry manufacture reach new summits of success, matched by an invigorated and revived school of tapestry design.

The first artist to whom the workshops turned for new designs was Peter Paul Rubens (1577–1640). In 1622 and 1623 his cartoons for the *Story of Constantine* arrived in Paris. This was probably the result of a royal commission, although the evidence is ambiguous and there is also a possibility that the weavers Comans and La Planche set up this private initiative with their Flemish compatriot, perhaps in an effort to encourage more ambitious local tapestry designs (see cat. no. 14). However, Rubens's *Story of Constantine*, while critically successful, was not significantly influential in subsequent Parisian tapestry manufacture. Bertrand Jestaz pointed out how alien Rubens's monumental but severe art, which made no concessions to the picturesque, was to the traditions of the Paris weavers.[29] Furthermore, the weavers confined themselves to a spectrum of saturated and contrasting colors that was very different from Rubens's palette.

Continuity and Development: Existing Workshops and the New Workshop in the Faubourg Saint-Germain

The *Constantine* cartoons were woven into tapestries in the Faubourg Saint-Marcel workshop beginning about 1623. In 1625 the privileges of the Faubourg Saint-Marcel monopoly were renewed for another eighteen years.[30] Marc de Comans died in 1644, having ceded the directorship of the manufactory to his son Charles in 1628; Charles was later succeeded by his two brothers, Alexandre and Hippolyte. Although Jean (Jan) Jans (1618–1668) from Oudenaarde was referred to in 1654 as "master high-warp tapestry maker," the Flemish weavers in the Faubourg Saint-Marcel continued to work mostly "on the treadle," that is, on low-warp looms.[31] In 1627, when an inventory was taken after the death of François de La Planche, the manufactory had sixty-two active looms, one of them high warp, and about ten dismantled looms.[32] It is therefore possible to estimate that more than 250 weavers were working there. But the activities of the manufactory were not confined to the weaving of tapestries. Located in the Hôtel des Gobelins in Paris on the banks of the Bièvre, the manufactory succeeded the famous Gobelins dye works at that site. A survey carried out

for Cardinal Francesco Barberini about 1631, which considered tapestry workshops throughout Europe, indicates that the dyes made in Paris, particularly at the Gobelins, were better than those produced anywhere else in France.[33] The blues, especially, made from Toulouse woad, were excellent. The wool used for the tapestries came from England, the silk from Lyon, imported from Italy or the Levant.[34]

The partnership between the Comans and La Planche families lasted until 1633, at which time Raphaël de La Planche, son of François, left the Faubourg Saint-Marcel to set up shop in the rue de la Chaise in the Faubourg Saint-Germain.[35] The tapestries woven in the Faubourg Saint-Germain bore the mark of an R woven into the right selvage to distinguish them from Faubourg Saint-Marcel productions. In 1639 Raphaël de La Planche purchased a post as treasurer of the Bâtiments du Roi and was granted the position only on the express condition that he continue to serve as director of the tapestry manufactory, which he was apparently considering abandoning.[36] In a petition to the king in 1655, he complained that for ten years he had not received the subsidies due him. He had to advance 6,500 livres a year "for food for the apprentices and lodging for the masters and workers, that is, three or four hundred people, without which lodging he could not have kept them here, just as the archduke could not keep them in Brussels if he did not offer them lodging at his own expense."[37] In 1634 the workers at the manufactory had numbered "120 and more," according to Raphaël de La Planche's separation terms with Charles Comans,[38] so if his figures are accurate, even taking into account the inclusion of dependents, the manufactory in the Faubourg Saint-Germain exhibited tremendous growth over the course of twenty years. An inventory made in 1661, after the death of Raphaël de La Planche's first wife, listed fifty-two looms, forty-four of them active, and some one hundred tapestries in stock.[39] As at the Faubourg Saint-Marcel, so also at the Faubourg Saint-Germain there was a dye works and, of course, the indispensable brewery.

Most of Raphaël de La Planche's work was undertaken on commission. In the 1661 inventory, 130 of the 133 tapestries at his manufactory (44 in progress, 89 in stock) were for twenty-one patrons, listed by name, and encompassing the entire milieu of financiers, parliamentarians, and highly placed court functionaries, including the likes of Henri de Guénégaud du Plessis-Belleville, secretary of state of the Maison du Roi, and Thomas de Bragelongne, Président de Maisons.[40] Royal and princely commissions were gradually being supplemented by those from a social class, enriched by service in public or

financial positions, whose luxurious mansions, decorated by Simon Vouet, Michel Corneille, or Eustache Le Sueur, arose in the new Parisian neighborhoods of the Marais and the Île Saint-Louis. In 1661 Raphaël de La Planche retired and entrusted the directorship of the manufactory to his son Sébastien-François, who is last mentioned as director in 1668.

From Vouet to Corneille

After the short-lived collaboration between the French workshops and Rubens in the early 1620s, the long-awaited design stimulus came from Italy via Simon Vouet (1590–1649). In 1627 King Louis XIII summoned him to return to France from Rome, appointed him First Painter, and entrusted him, in the words of the seventeenth-century historian André Félibien,

with "the supervision of tapestry cartoons."[41] As head of an organized painting workshop, Vouet created large decorations that rivaled those being produced in fresco in Italy. In 1631, for example, he painted the *Story of Rinaldo and Armida* for Henri de Fourcy in the Château de Chessy; in 1634–35 he produced the *Story of Ulysses* and twelve paintings of the *Story of Theagenes and Chariclea* for Claude de Bullion, superintendent of finance. These cycles were then used as the basis for series of tapestries, the first of which seems to have been *Rinaldo and Armida* (fig. 65).[42] In January 1635 the posthumous inventory of the wife of Girard Laurent the Younger included a set that had already been woven by Maurice Dubout in the Louvre workshop for the king, which suggests that the cartoons went on the looms very soon after the paintings for de Fourcy's residence were

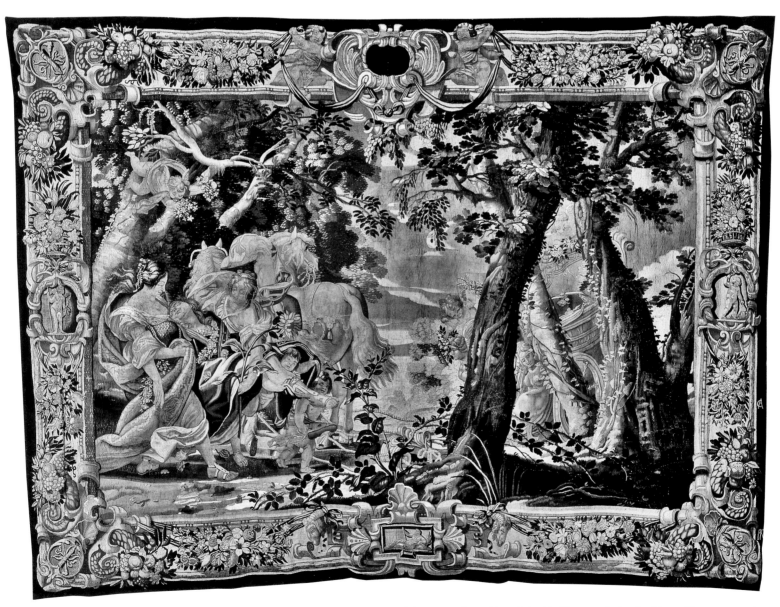

Fig. 65. *The Sleeping Rinaldo Carried off by Armida and Her Servant* from a set of the *Story of Rinaldo and Armida*. Tapestry design by Simon Vouet, woven in the Faubourg Saint-Marcel workshop of Alexander de Comans, Paris, 1635–50. Wool and silk, 340 x 444 cm. Château de Chateaudun

executed.[43] This is hardly surprising since Henri de Fourcy, who had taken over the post of administrator of the tapestry manufactories from his father in 1625, would have been central to any efforts to revitalize Parisian tapestry design. Some years earlier, in 1626, de Fourcy had commissioned cartoons of *Rinaldo and Armida* from Quentin Varin, but the work seems never to have been completed. The translation of Vouet's paintings into tapestries maintained the lyricism and clarity of his compositions and his sense of narrative. The tapestries respected both the scale and the luminous palette of his monumental paintings and constituted a major innovation in interior decoration. Two other tapestry series after Vouet's designs also enjoyed great success: the *Loves of the Gods*, which might have shared the same designs as his lost paintings in the Château de Chilly for the marshal Antoine Coeffier-Ruzé d'Effiat, and the *Old Testament* series (cat. no. 15).[44] Although the *Old Testament* series has traditionally been characterized as Vouet's first contribution to the art of tapestry, newly discovered documents attest that it actually came later (see cat. no. 15). Vouet also breathed new life into the treatment of landscapes, notably forests, which figure prominently in his tapestry designs. The oblique lines formed by the tree trunks and the large, luminous clearings successfully evoke a succession of planes, creating the impression of an expansive space that seems to extend beyond the borders of the represented scene. Vouet's feeling for nature and his effective spatial devices profoundly influenced Parisian tapestry design. These qualities can be found not only in a number

of series associated with Vouet, such as the *Story of Adonis*, and Ovid's *Metamorphoses*, but also in tapestry designs by artists working in Vouet's circle, like the mid-seventeenth-century *Story of Orlando Furioso* (fig. 66).[45]

Vouet's influence on Parisian tapestry design extended to his characteristically wide borders, which increasingly infringed on the central scene and became important parts of the tapestries' overall aesthetic effect. The grisaille trompe l'oeil border designs recall the stucco frames of Vouet's painted decorations. Satyrs and putti are captured in a great variety of poses and activities in gray relief against yellow, golden, or pale blue grounds. Numerous drawings by Jean Cotelle (1607–1676), long known to have been one of Vouet's collaborators, have been linked to these opulent frames.[46]

Simultaneous to production of the new repertoire of designs developed by Vouet, older sets of cartoons continued in service. Although only fragments survive of the *Story of Pastor Fido* (fig. 62), this pastoral series was continuously woven over the course of some twenty years; the fragments display a gradual evolution, similar to that in more prestigious series, away from large Mannerist compositions to simpler, more clearly organized scenes. The success of *Pastor Fido* started a trend for romances, which continued with series inspired by Ludovico Ariosto's *Orlando furioso* and Torquato Tasso's *Aminta*. Such subjects were presented as though staged theatrically, with declamatory gestures as well as realistic treatment of the figures and continuing interest in developing the landscapes. The *Story of Theagenes and*

Fig. 66. *Zerbino Expires in the Arms of Isabella*, by an unknown artist, ca. 1630. Design for the tapestry in the *Story of Orlando Furioso*. Oil on canvas, 200 x 295 cm. Musée d'Art Roger-Quilliot, Clermont-Ferrand (52-5-2)

Fig. 67. *The Meeting of Clorinda and Tancred* from a set of the *Story of Tancred and Clorinda*. Tapestry design by Michel Corneille, woven in the Faubourg Saint-Germain workshop, Paris, ca. 1645–60. Wool and silk, 321.3 x 385 cm. Château de Châteaudun

Chariclea appears to have been based directly on as-yet-unidentified engravings illustrating the romance by Heliodorus, while Jean Desmarets de Saint-Sorlin's *Ariana*, illustrated by Claude Vignon, was woven both at Aubusson, after engravings, and in Paris, after more developed cartoons.

Among Vouet's favorite students was Michel Corneille (1601/3–1664), one of the twelve founding members of the Académie Royale de Peinture et de Sculpture in 1648. The extent of his often-overlooked contribution to Parisian design during these years can be gauged by the tapestry series attributed to him: the *Story of Abraham*, the *Story of Daphne*, the *Story of Dido and Aeneas*, the *Story of Tancred and Clorinda* (fig. 67), and

Children's Games.[47] Although, like Vouet, Corneille produced large decorative paintings for Paris mansions, his tapestry models were specifically designed to be woven. The classical rhythm of his compositions is evident in these weavings—in the friezes of human figures with measured gestures, sweetness radiating from their faces, their large, wide-open eyes, S-shaped mouths, blond locks, and dreamy expressions. The major difference between the tapestries and Corneille's painted works lies in the importance he gave to landscape in his hangings, which, as Emmanuel Coquery aptly noted, present a repertoire distinct from that seen in his other work.[48] Under the influence of Vouet, forest clearings dominate in Corneille's compositions, but they tend to

Fig. 68. *Diana and Her Nypmhs* from a set of *Mythological Scenes*. Tapestry design by Laurent de La Hyre, 1644, probably woven in the Faubourg Saint-Marcel workshop of Hippolyte de Comans, Paris, before 1662. Wool, silk, and gilt-metal-wrapped thread, 345 x 551 cm. The Metropolitan Museum of Art, New York, Rogers Fund, 1920 (20.44.3)

unfold onto vast prospects, opening up the compositions in a characteristic manner that he made his own. Corneille subscribed to the current of classicism that was circulating in the 1650s, a trend echoed in the work of other Paris-based tapestry designers. This classicizing style reappears in the popular *Mythological Scenes* designed by Laurent de La Hyre (1605–1656), which were woven in the Faubourg Saint-Marcel workshops from 1645 onward (fig. 68), and particularly in the series of large religious tapestries being woven on the Louvre looms, discussed below.[49] The return to classicism also found expression in the revival of famous sixteenth-century series—a recurring phenomenon in the history of French tapestry that may be considered a gauge of the aesthetic preoccupations of the time. Among the designs revived in the 1650s was the *Story of Psyche* (fig. 69). Woven in both the Louvre and the Faubourg Saint-Germain workshops, this series was based on a since-destroyed tapestry set that was delivered to Henry II in 1550, which was designed in part after engravings by the Master of the Die, themselves inspired by designs sometimes attributed to Michiel Coxcie (1499–1592).[50] The narrow borders filled with

arabesques and grotesques reflect the renewed taste for such ornamentation.

Michel Corneille took a close interest in the specifics of tapestry-cartoon painting, especially in the creation of the borders. Two types in which his characteristic putti are recognizable can be attributed to him. One displays garlands of brightly colored flowers against light yellow or black grounds; the other, with foliated scrolls and candelabras, signals a return to the tradition of grotesques initiated by Raphael. Compared with borders by Vouet, those by Corneille are considerably more modest in scale: the width of the frame is narrower, the motifs are generally separate from one another, and the elements in grisaille disappear in favor of a lustrous polychromy. Corneille's agreeable art was well served by the fine craftsmanship of Raphaël de La Planche at the Faubourg Saint-Germain, which seems to have had almost exclusive rights to distribute the weavings made from the artist's models. In the absence of workshop marks on the tapestries, this is attested by the bright colors and the extensive palette, which certainly justify the high prices listed

Fig. 69. *Psyche at the Temple of Ceres* from a set of the *Story of Psyche*. Tapestry design based on a 16th-century Brussels series, woven in the Faubourg Saint-Germain workshop of Sébastien-François de La Planche, Paris, 1650. Wool, silk, and gilt-metal-wrapped thread, 390 x 390 cm. Mobilier National, Paris (GMTT 1078/6)

in La Planche's workshop inventory of 1661.[51] The cartoons for Corneille's tapestry series were also appraised in this inventory. Surprisingly, however, the estimates were extremely low: 1½ livres per square ell for *Daphne*; 3 for *Clorinda*; and 5 for *Dido and Aeneas*. Only the *Children's Games*, at 33 livres, came close to the prices originally charged by the artist and to the 50 livres per "square ell of painting" he requested from the Ursulines in 1649 (which was the same sum Eustache Le Sueur was paid for his large paintings of Saint Gervasius discussed below).[52] It is conceivable that an error was made by the clerk drawing up the valuation lists. Alternatively, it is possible that

the cartoons showed some wear and, above all, that this low valuation indicates the cartoons were not by Corneille himself but represented significant workshop participation.

Raphaël de La Planche's workshop at the Faubourg Saint-Germain succeeded in making decorative verdures based on Vouet's designs something of a specialty (fig. 70).[53] The wide vistas and gamut of greens and blues in these works provided a successful foil to the profuse decoration of Vouet's borders surrounding them. Even in 1661, more than a dozen years after Vouet's death, his name was still linked to the "Verdures et oiseaux" listed in the Faubourg Saint-Germain inventory,

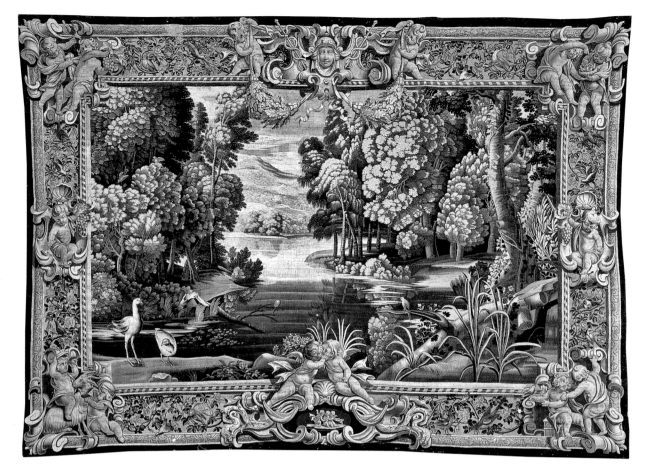

although collaborators Jacques Fouquières and François Bellin also played significant roles in this field of tapestry design.[54] Verdures constituted the bread and butter of the weavers' business. These less costly tapestries, which owners did not hesitate to hang mirrors or paintings over, have suffered enormous losses.

The Louvre Manufactory and Religious Commissions, 1625–60

Meanwhile, steady production also continued at the Louvre workshop over these years. Laurent and Dubout's descendants occupied the Louvre premises until the late 1650s and were joined in 1655 by Pierre Lefebvre, who from 1630 had been the head of the workshop in Florence, and by his son Jean.[55] The Louvre workshops occupied a relatively small space; when Dubout's workshop closed in 1657 it had five looms.[56] Thus the two workshops together contained an estimated ten looms and employed thirty to forty weavers. The Louvre weavers continued to provide works for the king; indeed the royal decree confirming their privileges in 1623 reiterated that the tapestries they executed for the king would be "at his expense, based on and in accordance with the designs and patterns that would be provided to them for that purpose on the order of M. de Fourcy."[57] However, a significant proportion of the weaving undertaken at the Louvre workshop was for private patrons.

Fig. 71. *The Martyrdom of Saint Regina* (detail), ca. 1621. Oil on canvas, 287 x 283 cm. Cartoon for the seventh panel of the *Life of Saint Regina.* Chapelle de l'hopital, Alise-Sainte-Reine (Côte d'Or)

Laurent and Dubout carved a niche as the preferred weavers for time-consuming special commissions of religious subjects intended for various churches in the capital. In 1625, for example, a tapestry after cartoons of an unknown subject by Guillaume Dumée was woven for the church of Saint Mederic, as well as two pieces of the *Acts of the Apostles* in 1628.[58] For a period of almost twenty years, from 1625 to 1644, the workshop steadily produced a tapestry series of the *Life of Saint Regina* in thirteen pieces for the church of Saint Eustache (fig. 71).[59] In 1644 the price for the last piece of the *Life of Saint Regina* was 90 livres per square ell. In 1634 the cobblers' confraternity commissioned a four-piece set of the *Lives of Saint Crispin and Saint Crispinian*, designed by Georges Lallemant (1580–1636), as a gift to the church of Notre-Dame.[60] Perhaps most celebrated was the six-piece *Story of Saint Gervasius and Saint Protasius*, after cartoons by Eustache Le Sueur (1616–1655), Sébastien Bourdon (1616–1671), and Philippe de Champaigne (1602–1674), commissioned in 1652 for the church of Saint Gervasius (fig. 72).[61]

Le Sueur's paintings of the subject certainly attracted praise, causing Denis Diderot to exclaim, "When returning from Saint-Martin-des-Champs, do not forget to stop by Saint Gervais and see the two paintings of the *Martyrdom of Saint Gervasius and Protasius*. And when you have seen them, raise your arms to heaven and cry: 'Sublime Le Sueur! Divine Le Sueur!'...Read Homer and Virgil, and do not look at any more paintings, because everything is in those, everything imaginable."[62] The elaborate *Story of Saint Gervasius and Saint Protasius* was considerably more expensive than the *Saint Regina* had been, reaching 125 livres per square ell. This price is comparable to the 120 livres per square ell promised in 1646 by the churchwardens of Saint-Étienne-du-Mont to Antoine Le Sueur (b. 1610), brother of the painter Eustache and a "master painter and tapestry maker in Paris," for high-warp weavings of the *Story of Saint Stephen* after designs by Laurent de La Hyre.[63] When the first tapestry of the *Saint Stephen* series was judged unsatisfactory, one Pierre Laneron, resident of Saint Eustache

Fig. 72. *Saint Gervasius and Saint Protasius Appearing to Saint Ambrose* from the set of the *Story of Saint Gervasius and Saint Protasius*. Tapestry design by Philippe de Champaigne, woven in the Louvre workshop of Girard Laurent, Paris, ca. 1660. Wool and silk, 490 x 757 cm. Hôtel de Ville, Paris (T9)

Fig. 73. *Birth of the Virgin* from the set of the *Life of the Virgin*. Tapestry design by Philippe de Champaigne, probably woven in the Louvre workshop, Paris, ca. 1640. Wool and silk, 490 x 623 cm. Strasbourg Cathedral (98 67 21 VA)

parish, was engaged in 1648 to continue the work, again in high warp. It would be interesting to establish the details of the relationship between Pierre Laneron, called a "master in the manufacture of the king's tapestries," and the nearby Louvre manufactory. The tapestries for the *Story of Saint Stephen*, now lost, are known through a magnificent group of drawings by La Hyre, which marks a significant stage in the painter's evolution toward "Atticism," of which he would become one of the principal representatives.

One of the reasons the Louvre was awarded such prestigious commissions may have had to do with the technique used there. Low-warp weaving required that the cartoons be cut into strips, whereas with the high-warp looms, the design could be transferred directly onto the warp without damaging the car-

toons. Each large religious series was unique, and the cartoons, commissioned from major painters, cost a great deal. For this reason the patrons presumably wished to preserve the cartoons whenever possible. At Saint Gervasius, for example, the tapestries were exhibited only for major events; the rest of the year, visitors could admire the painted cartoons, which were hung in the same locations as the woven versions. When, in 1649, the Ursulines of Dijon were thinking of commissioning cartoons for a *Life of Saint Ursula* from Michel Corneille and expressed concern about having the cartoons cut up for the weaving process, Corneille assured them that the cartoons would not need to be cut since "the tapestries . . . [of] Monsieur Laurens at the Louvre galleries, being high warp, are made on the same side as the painting. Therefore the scenes, which will be a

double [of the] tapestry as in several churches in Paris, will be seen correctly."[64] This provides an interesting case of an artist, Corneille, who was very close to another Parisian manufactory, Raphaël de La Planche's Faubourg Saint-Germain, recommending the Louvre workshops for a religious commission, apparently in deference to their weaving technique. The desire to preserve and to display the painted cartoons must have been equally important for more modest works, such as the thirteen cartoons for the *Life of Saint Regina* recently discovered in the chapel of the hospital in Alise-Sainte-Reine (Côte d'Or), where they have been recorded since the end of the seventeenth century (see fig. 71). The cartoons for the *Story of Saint Gervasius and Saint Protasius*, for the *Life of the Virgin*, and for the *Life of Saint Regina* are practically the only full-size models dating to the first half of the seventeenth century that survive from the Paris workshops.[65]

The Louvre workshops were probably at least partially responsible for the fourteen-piece *Life of the Virgin* woven for the choir of Notre-Dame in Paris over a period of nearly twenty years, between 1638 and 1657.[66] The cartoons, begun by Philippe de Champaigne in 1638, were continued by Jacques Stella (1596–1657) and completed by Charles Poerson (1609–1667) in 1657. The first two tapestries, delivered in 1640, were executed in the same direction as the cartoons painted by Philippe de Champaigne and were therefore probably high warp (fig. 73). The quality of the weaving, the sophistication of the colors, and the mastery of the design and the modeling distinguish them from the other pieces woven later. If, as seems plausible, they were woven in Paris, it would appear that only the weavers at the Louvre could have produced such masterpieces. After a gap of nearly ten years, and the production of one piece in Brussels, the rest of the series was assigned to an otherwise undocumented weaver called Pierre Damour, who apparently left his workshop in Reims for this commission and moved to Paris, near Notre-Dame, where he established a workshop in which at least two of the pieces were woven.

In 1659 Maurice Dubout, grandson of the original Dubout, died; his remaining colleagues at the Louvre workshop, including Girard Laurent, son of the workshop's first director, gradually transferred to the new workshops of the Manufacture Royale des Gobelins on the site of Comans's Faubourg Saint-Marcel premises, established under Colbert's initiative in 1662. Five years later, the Faubourg Saint-Germain workshop also closed, having completed the much-admired *Rinceaux*, crowned with the sun emblem of the young Louis XIV, and woven after

splendid designs that, according to royal inventories, were from the hand of Polidoro da Caravaggio (ca. 1499–ca. 1543).[67]

The Character and Quality of Parisian Tapestry

Thanks to invaluable documentary records such as the posthumous inventories of François de La Planche (1627) and Charles de Comans (1635) at the Faubourg Saint-Marcel, of Girard Laurent the Younger's widow at the Louvre (1635), and of Raphaël de La Planche's wife at the Faubourg Saint-Germain (1661), we are able to glean further information about which sets were woven where, which were made on speculation and kept in stock in the shops, and the valuations placed on these tapestries. The inventory taken at the Faubourg Saint-Marcel manufactory in 1627, for example, listed 265 tapestries in stock belonging to 37 sets.[68] The French ell (118.8 cm) was used to measure tapestries in stock; tapestries on the looms were measured in Flemish ells (68.58 cm). The prices listed in the 1627 inventory of the Faubourg Saint-Marcel ranged from 8 livres per square ell for tapestries woven with simple repeating patterns of fleur-de-lis motifs to 270 livres per square ell for the pieces with gilt-metal-wrapped thread. To set these prices in context, it is known that Michel Corneille paid his woman servant 36 livres per year. There were 51 tapestries woven with metal thread, divided among the *Story of Constantine*, the *Story of Artemisia* (165–270 livres), and a set of the *Story of Pastor Fido* "with a little gold" (66 livres). Of the tapestries without gold, some of those with human figures and more elaborate compositions sold for between 60 livres (*Artemisia, Story of Diana*) and 75 livres (*Story of France*) per square ell. But the most common sets comprised eight pieces and depicted verdures, pastorals, or hunting scenes, such as *Gombaut and Macée, Pastor Fido*, the *Hunts of Francis I*, and were valued at 36 livres per square ell; that was the case of 135 tapestries, divided among 16 sets of eight pieces and one set of seven pieces. Fifty-nine tapestries were on the looms, 14 with gold (*Artemisia, Story of France*) and 45 without gold. Those without gold were equally divided between the *Story of Pastor Fido* (23 pieces) and verdures, all valued at the same price, 36 livres per square ell. Cardinal Barberini's tapestry weaving survey of about 1631 asserted that previously the tapestries had been of higher quality because at that time only the rich and powerful ordered them, whereas "today all sorts of people own them, hence the need to make them inexpensively."[69] Yet the prices seem to have risen sharply. Although there are almost no tapestries with gold listed in the 1661 inventory, the weavings often cost as much as 160 livres per square ell, that is, more than double the price given in the 1627 inventory.[70] As

in 1627, there was a large proportion of verdures in 1661: ten sets, to which can be added six sets of the *Story of Daphne*, all with valuations between 105 and 110 livres per square ell.

In 1718, a half century after Sébastien-François de La Planche took over as the last director of the workshop in the Faubourg Saint-Germain, the statutes of the Paris weavers paid tribute to the now-defunct manufactory: "We have always admired the beauty of the designs and valued their reliability. Its beautiful verdures with birds and its magnificent landscapes have always earned it much praise. Its taste in hues was delicate and enduring, the colors very beautiful, closely imitating the complexions of Raphael and Rubens. Its draperies were artistically varied, naturally wrought, and beautifully arranged. That manufacture was fine, full, harmonious, and easy to distinguish from the others by its extreme beauty."[71] Although such descriptions encourage us to try to distinguish among the products of the various workshops, it is difficult to do so, especially since the cartoons often circulated from one atelier to another. Nevertheless, a few technical considerations may be taken into account. The tapestries produced in Paris were relatively luxurious, and silk was almost always used, even for hangings made for general use, but gilt-metal-wrapped thread initially seems to have been the privilege of the Faubourg Saint-Marcel workshops. Coloration was considered a manufactory hallmark: great attention was paid to the quality of the colors, and the Barberini survey indicates that each workshop jealously guarded the secrets to its own dye recipes. There are noticeable differences from one tapestry set to another; the quality of the threads, colors, and fabrication cover a wide range depending on the purse and status of the patron. Such variations can be seen, for example, in the surviving editions of the highly popular and frequently woven *Story of Artemisia*. Some sets woven with gold but hastily produced at the Faubourg Saint-Marcel display careless modeling and much less refined weaving than others, with or without gold, made for prestigious patrons, such as the sets woven at the Louvre in 1607, for Henry IV and for Cardinal Alessandro Montalto, nephew of Pope Sixtus V (see cat. no. 12).[72]

The relative commercial success of the Paris workshops was due in large part to their ability to find their niche subjects, retaining cartoons of a few well-chosen, popular series in each of these genres that were then woven numerous times. Among the greatest successes of the Paris-based workshops were the *Story of Artemisia* with initial cartoons by Laurent Guyot and Henri Lerambert, of which some thirty sets have been identified, Dubreuil and Lerambert's *Story of Diana*, the *Pastor Fido* originally designed by Guyot and Dumée, Vouet's *Rinaldo and Armida* and his *Old Testament*, of which about twenty sets have been identified, and Corneille's *Story of Daphne*. There are also countless different series of the *Metamorphoses*, providing as they did the opportunity for variations on the enduring theme of verdures and landscapes that the workshops strove constantly to keep refreshed. Sixty years before Jean-Baptiste Colbert gathered the Paris tapestry workshops in the Manufacture Royale des Gobelins, Henry IV was the true founder of the initial Gobelins manufactory with the Faubourg Saint-Marcel workshops. Henry's desire to establish a Flemish-led weaving industry in Paris gave rise to one of the most famous French manufactories. In those early decades of research, experimentation, and revitalization, the artists and artisans who were engaged in a productive dialogue between decoration and great painting were sometimes able to achieve the pleasing balance that is the hallmark of masterpieces.

1. Guiffrey 1879a; Guiffrey 1885–86; Guiffrey 1892; Fenaille 1903–23, vol. 1; Guiffrey 1923. The research of Jules Guiffrey and Maurice Fenaille remains the fundamental source for our knowledge of the Paris workshops, and this essay is in large part indebted to them.

2. J. Coural 1967 provides an essential and remarkable synthesis of his archival research in the Minutier Central des Notaires (hereafter MCN) in the Archives Nationales (hereafter AN), Paris.

3. See J. Coural 1967, p. 16; Standen 1985, pp. 247–59, no. 40; T. Campbell in New York 2002, pp. 462–65; Bertrand and T. Campbell in New York 2002, pp. 477–80, no. 56 (with bibliography).

4. See Stockhammer in New York 2002, pp. 465–68, no. 55 (with bibliography).

5. Guiffrey 1892, pp. 46–50.

6. Sauval 1724, p. 505; Göbel 1928, pp. 48–51.

7. AN, MCN, LXXXVI 80, LXXXVI 83, LXI 81; J. Coural 1967, p. 16; Guiffrey 1892, p. 15; Sauval 1724, p. 506.

8. "[R]établir à Paris les manufactures de tapisseries que les désordres des règnes précédents avaient abolies"; Sauval 1724, p. 506.

9. Ibid., pp. 506–7; Göbel 1928, pp. 52–57; J. Coural 1967, p. 16.

10. Laborde 1877–80, vol. 1, pp. 46, 47.

11. Contrary to Pascal-François Bertrand's claim (2005, pp. 106–7), "high-warp" is a technical term here and does not simply designate "works of excellent quality." Later, Dubout seems to have worked on low-warp looms as well; see J. Coural 1967, p. 18.

12. F. Boyer 1930, p. 25.

13. Guiffrey 1878–85, pp. 110–11.

14. Göbel 1928, p. 58; J. Coural 1967, p. 19.

15. For the Tours production, see Machault 1996. For the different existing marks, see de Reyniès 2002.

16. See Guiffrey 1892, p. 38; Jestaz 1968; Denis 1992, p. 26; Adelson 1994, pp. 180–81; and in this volume, cat. nos. 12, 13.

17. AN, MCN, XIX, 356; J. Coural 1967, p. 16.

18. Versailles 1967, pp. 40–41, no. 10.

19. Béguin 1960, p. 133.

20. Guiffrey 1898, p. 221; Adelson 1994, pp. 186–87.

21. Godefroy 1649, p. 177.

22. Guiffrey 1892, pp. 77–78; J. Coural 1967, p. 22. For *Pastor fido*, see de Reyniès 1999.

23. For mention of Guyot in the royal inventories, see Guiffrey 1892, pp. 77–78; for Dumée, see Adelson 1994, pp. 187–88 (with bibliography).

24. See Guiffrey 1882. Flemish tapestries woven after the same sources are discussed in Standen 1985, pp. 171–76, no. 23; Delmarcel and E. Duverger in Bruges 1987, nos. 19–26, esp. pp. 253–55; Adelson 1994, pp. 154–59, no. 15.

25. See Denis in Gien 1994, pp. 255–58; de Reyniès in Chambord 1996, pp. 85–121.

26. Guiffrey 1892, pp. 87, 89; Guiffrey 1885–86, vol. 1, p. 332.

27. "Tous les dessins sont nouveaux et de la main d'un peintre français qui toujours, à mon sens, n'a guère passé la médiocrité. . . . De la même main est la fable de Diane. La matière est très-fine, riche de soie et d'or; le travail aussi est très-bon, et la bordure très-réussie et gracieuse; mais il y manque l'*anima*, l'âme, c'est-à-dire le dessin"; Baschet 1861–62, p. 35.

28. "Le tapissier de Sa Majesté propose que si de Rome on voulait envoyer quelque beau dessin, il concourrait à la moitié de la dépense"; ibid., p. 36.

29. Jestaz 1968.

30. Bibliothèque Nationale de France, Paris, MS fr. 17 311, fol. 42; J. Coural 1967, pp. 19–20.

31. Treadle looms, or looms "à la marche," are not to be confused with "La Marche," a term that designates the region of Aubusson. Emmanuel Coquery's claim (2002, p. 153) that the cartoons for *Artemisia* were commissioned for Aubusson is therefore unfounded.

32. For the inventory, see Guiffrey 1892; Guiffrey 1923, pp. 37–56 (the more complete version).

33. Biblioteca Apostolica Vaticana, MS Barb. Lat. 4373; see Barberini 1950.

34. Müntz 1875, pp. 510–12.

35. Göbel 1928, pp. 83–84; J. Coural 1967, p. 20.

36. J. Coural 1967, p. 20.

37. "[P]our la nourriture des apprentis et pour le logement des maîtres et ouvriers, qui consistent en trois ou quatre cent personnes, sans lequel logement il n'aurait pu les conserver ici, non plus que l'Archiduc ne les pourroit conserver à Bruxelles s'il ne leur donnait logement à ses dépends"; Guiffrey 1892, pp. 84, 88.

38. For the 1634 agreement, see ibid., pp. 106–9.

39. For the inventory of 1661, see Guiffrey 1923, pp. 59–71.

40. Excluded from this count are old tapestries (*Artemisia*) and ones whose place of manufacture was uncertain (verdures, for example). Manufactory directors were entitled to import a certain number of tapestries from Flanders every year.

41. "[L]a conduite despatrons de tapisseries"; Félibien 1705, vol. 3, p. 307. On Vouet, see Paris 1990; Denis in Chambord 1996, pp. 156–89.

42. For the *Rinaldo and Armida* cartoons, see Versailles 1967, pp. 68–75, nos. 27–30; Chambord 1996, p. 158.

43. AN, MCN, VII 24; J. Coural 1967, p. 18.

44. For the *Loves of the Gods*, see Denis in Chambord 1996, pp. 170–89.

45. For the *Metamorphoses*, see Denis in Chambord 1996, pp. 192–97; for *Orlando Furioso*, see Standen 1985, pp. 275–77, no. 43, and Sylvain Laveissière in Meaux 1988, pp. 86–90.

46. Denis 1996a, Coquery 2002, de Lacroix-Vaubois 2005.

47. For Corneille, see Coquery 1996 and Orléans 2006. For *Abraham*, see de Reyniès 1999, pp. 25–27. For *Daphne*, see de Reyniès in Chambord 1996, pp. 252–57; Cavallo 1967, nos. 37, 38. For *Clorinda and Tancred*, see de Reyniès in Chambord 1996, pp. 240–49. An earlier set of cartoons for *Children's Games* probably predated Corneille's, for while the Garde-Meuble de la Couronne paid 120 livres per square ell for a set by Corneille, the 1661 inventory of Raphaël de La Planche's workshop

included a different *Children's Games* valued at only 50 livres per square ell; see Vittet 2007, pp. 193–95.

48. Coquery 1996; Orléans 2006, p. 69.

49. For La Hyre's *Mythological Scenes*, see Versailles 1967, pp. 90–97, nos. 40–43.

50. See T. Campbell in New York 2002, p. 390; for the attribution to Coxcie, see Vasari 1568/1912–14, vol. 6, p. 116. See also Fenaille 1903–23, vol. 1, pp. 287–93.

51. Guiffrey 1923, pp. 59–71.

52. Ronot 1976, p. 62.

53. Denis 1996b; Coquery 2002; de Lacroix-Vaubois 2005.

54. Numerous landscape drawings attributed to Fouquières are in the Département des Arts Graphiques, Musée du Louvre, for example, inv. 19969r, 19970r, 19971r.

55. AN, O-1055, p. 198; see J. Coural 1967, p. 18.

56. Huard 1939, p. 35.

57. "[À] ses despens sur et selon les desseings et patrons qui leur seront à ceste fin fourniz de l'ordonnance dudict sieur de Fourcy"; full text published in J. Coural 1967, p. 17.

58. AN, MCN, LXXXVI 209, CXII 296; J. Coural 1967, p. 17.

59. AN, MCN, LXXXVI, 232; J. Coural 1967, p. 17. See also Kagan 1997.

60. AN, MCN, LXVII, 90; J. Coural 1967, p. 18; Versailles 1967, pp. 76–77, no. 31.

61. Dumolin 1933, pp. 64–65; Versailles 1967, pp. 102–5, nos. 47, 48; Mérot 1987, pp. 300–306; Coquery in Paris 2002, pp. 172–74, nos. 100, 101.

62. "En revenant de Saint Martin des Champs, n'oubliez pas de faire un tour à Saint Gervais et d'y voir les deux tableaux du Martyre de Saint Gervais et Protais, et quand vous les aurez vu, élevez vos bras vers le ciel et écriez-vous: Sublime Le Sueur! divin Le Sueur! . . . Lisez Homère et Virgile, et ne regardez plus de tableaux. C'est que tout est dans ceux-ci, tout ce que l'on peut imaginer"; Denis Diderot, *Le Salon de 1763*, cited in Mérot 1987, p. 304.

63. Grenoble–Rennes–Bordeaux 1989, pp. 50–52. Five weavings were apparently completed.

64. "[L]es tapisseryes . . . [de] Monsieur Laurens au Galleryes du Louvre se font du mesme costé que la peinture estant de haute lisce et par ainsy les tableaux qui seront une double tenture ainsy que dans quelques églises de Paris se verront a droit"; Ronot 1976, p. 62.

65. Arras 1996; Coquery in Paris 2002, pp. 162–63, no. 92; Kagan 1997; de Reyniès in Metz 1997, pp. 142–67.

66. Versailles 1967, pp. 98–101, nos. 44–46.

67. Ibid., pp. 82–89, nos. 34–39.

68. Guiffrey 1923, pp. 37–56.

69. "[A]ujourd'hui toutes sortes de gens en possèdent d'où la nécessité de les faire à bon marché"; Müntz 1875, p. 513.

70. Guiffrey 1892, pp. 141–60.

71. "[O]n a toujours admiré la beauté de ses dessins et estimé leur régularité; ses belles verdures à oiseaux et ses magnifiques paysages lui ont toujours fait donner beaucoup de louanges; son goût dans les nuances était tendre et de durée, le coloris fort beau, imitant beaucoup les carnations de Raphaël et de Rubens, ses draperies artistement nuancées, d'un travail naturel et d'une belle ordonnance. Cette fabrique étoit fine, ronde, unie et facile à distinguer des autres par une extrême beauté"; Deville 1875, p. 111.

72. Denis 1992.

12.
The Riding Lesson

From an eight-piece set of the *Story of Artemisia*
Cartoon by Laurent Guyot, 1607, after a drawing by
Antoine Caron, ca. 1560
Woven in the Faubourg Saint-Marcel workshop,
Paris, ca. 1611–27
Wool and silk
408 x 600 cm (13 ft. 6⅝ in. x 19 ft. 8¼ in.)
8 warps per cm
Manufactory mark FM in right selvage
Minneapolis Institute of Arts, The Ethel Morrison
Van Derlip Fund (48.13.7)

PROVENANCE: Ca. 1627, acquired by Cardinal
Francesco Barberini; by 1636–40, Cardinal Antonio
Barberini, Rome, then Barberini family; 1889, Charles
Mather Ffoulke, Washington, D.C.; 1896, Mrs. Phoebe
Apperson Hearst; 1903, John R. McLean, Washington,
D.C.; May 27, 1948, sale, Parke-Bernet, New York,
no. 4; 1948, Minneapolis Institute of Arts through
French and Company, New York.

REFERENCES: Ffoulke n.d., pp. 10, 16–17 no. 5;
Ffoulke 1913, pp. 185 no. v, 189–90, illus.; Fenaille
1903–23, vol. 1, pp. 174, 201, 210; Guiffrey 1923, p. 42;
sale cat., Parke-Bernet, May 27, 1948, no. 4, illus.;
"Artemisia Tapestries" 1948, pp. 121, 132, pl. vi;
Minneapolis 1955, p. 6, no. 27; Cavallo 1957, pp. 20
fig. 11, 21 n. 14; Ffolliott 1986, pp. 237–38; Ffolliott
1993, pp. 17–18, cover illus. and pl. 5; Adelson 1994,
pp. 234–44, no. 16e, illus.; Bertrand 2005, p. 105, illus.

The *Story of Artemisia* is based on a partly historical, partly fictional narrative assembled by the apothecary Nicolas Houel about 1561–62 in a direct homage to France's recently widowed queen regent, Catherine de' Medici. Houel constructed the character of Queen Artemisia as an amalgam of two historical figures from Asia Minor: Artemisia I, ally of Xerxes, female warrior at the Battle of Salamis about 480 B.C., and mother of King Lygdamis; and Artemisia II, widow of King Mausolus in 353 B.C., who famously erected a splendid tomb to her husband's memory, the Mausoleum at Halicarnassus, which became one of the seven wonders of the ancient world. To this framework, Houel added some fictive episodes to enhance the flattering analogy with Catherine de' Medici and her own situation and political significance. Houel wrote his epic, the *Histoire de la Royne Artémise* (History of Queen Artemisia), in prose in two books, or volumes,[1] which Catherine received favorably. Houel then reworked the material into sonnets that recounted the principal episodes and commissioned drawings from Antoine Caron (1521–1599) to illustrate the manuscript.[2] Presenting this manuscript to the queen, Houel noted in his preface that the drawings might serve to "make beautiful and rich tapestry painting."[3] The religious wars that beset France during the last decades of the sixteenth century made carrying out such an ambitious plan impossible. Forty years later, King Henry IV turned the tapestry project to his own account and, in paying homage to Catherine de' Medici, reaffirmed the dynastic ties that linked him to the last of the Valois rulers.

The various *Story of Artemisia* tapestries, woven from cartoons based on Caron's drawings accompanying Houel's manuscript, enjoyed considerable success during the rapid growth of the Paris workshops in the first decades of the seventeenth century.[4] Woven numerous times during the 1610s and 1620s,[5] this tapestry series bears witness to the revitalization of designs still indebted to Mannerist models.

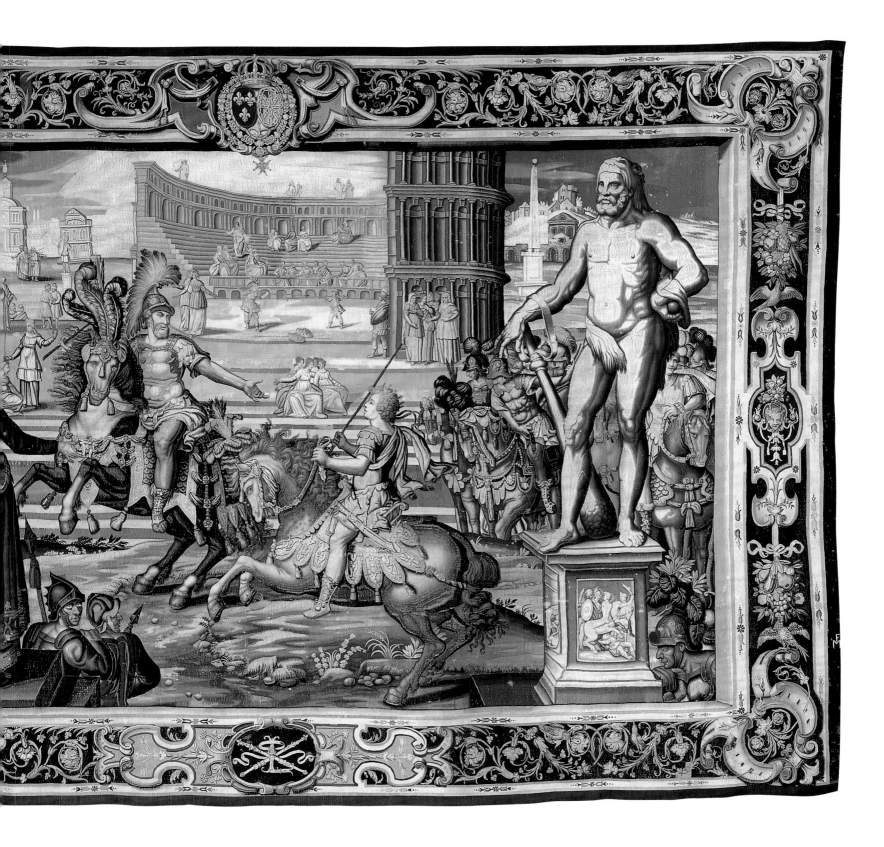

From the drawings by Antoine Caron to the cartoons executed in the early seventeenth century and the new compositions added later, a formal evolution from Mannerism to a proto-Baroque style is evident. The *Story of Artemisia* is a vast work that lends itself to multiple interpretations, as attested by the selection of subjects that found their way to the looms. Catalogue number 12 is part of a set of at least eight surviving pieces that reached the collection of Cardinal Antonio Barberini in Rome about 1636.[6] This set includes weavings from cartoons commissioned by Henry IV in 1607 based on Caron's drawings for the Houel project, as well as episodes woven from cartoons that were prepared for Marie de' Medici, second wife of Henry IV, after his death in 1610.

Description and Iconography

Artemisia, resplendent in her richly embroidered robe, large belt, and elaborate hairstyle and veil, and holding a fleur-de-lis topped scepter in her left hand, witnesses a military commander directing the young King Lygdamis in the arts of horsemanship. Under the watchful eyes of Artemisia, courtiers, and soldiers on horseback, Lygdamis causes his horse to execute a dressage movement called the pesade. The action takes place in an imaginary esplanade that combines the Roman Colosseum with the famous Hippodrome of Constantinople, evoked by the Column of Plataea with its three coiled serpents and the monumental statue of Hercules.[7] The sense of court spectacle is heightened by the inclusion, anachronistic for the ancient context, of a horseman in the background tilting at a quintain in front of a double-gabled building. Courtly tournaments are also evoked by the horses' multicolored plumes and sumptuous saddlery with pompons and gilt festoons. This episode comes from the second book of Houel's *Histoire de la Royne Artémise*, dedicated to Artemisia's fulfillment of her regal and maternal duties, overseeing the education of her son, Lygdamis. Equitation was considered an essential part of the instruction of young nobles destined for a military career.

Caron's drawing of this episode in the sonnet version of Houel's *Histoire* survives (fig. 74); it reminds us that he was trained in Paris and at Fontainebleau alongside Francesco

Primaticcio. Laurent Guyot (ca. 1575–after 1644, the painter of the cartoon from which catalogue number 12 was woven, was evidently aware of this drawing and based his design on it. This is confirmed by a contract of 1607 that assigned Parisian artist Guyot to "paint on canvas in oils the large patterns for the series of Artemisia depicting the exercises she taught her son, the king, during her widowhood, in accordance and conformity with the small drawings in paper made by the hand and invention of the late Antoine Caron, an excellent painter and draftsman."[8] Cartoons for numerous later prestigious tapestry projects have been attributed to Guyot, who subsequently shared the post of Royal Tapestry Cartoonist with his future brother-in-law Guillaume Dumée.[9] The 1607 contract engaged Guyot to execute enlargements of Caron's drawings to be woven "by Flemish tapestry makers," "but adding to them his art and industry to render them in the greatest perfection possible."[10] None of the cartoons survives, but an examination of the present tapestry reveals how the artist used the freedom he was granted, introducing some stylistic revitalization. By lowering the viewpoint, Guyot abolished the Mannerist distancing of the viewer from the scene depicted. The immediacy that the composition gains from this change goes hand in hand with the simplified forms, which have become more monumental, and with a clarifying reduction in the number of figures. Guyot's restyling is manifest in the arrangement of the three chief protagonists of the scene: the figures are closer together, and their scale has changed completely. They are also set apart from the other figures in the scene by their ostentatious costumes. Above all, Guyot's expressions of a majestic and flowery pomp move away from the somewhat austere erudition of Caron's drawing. The vivid and distinct colors, very different from the subtle halftones and muted shades suggested by Caron's designs, also compartmentalize aspects of the composition in order of importance, accentuating the figures in the foreground who stand out from the bluish tones of the background.

The borders on catalogue number 12 and the other seven surviving tapestries of this particular set provide one indication that this

is a later reweaving of Guyot's cartoons. King Louis XIII's monogram and the coats of arms of France and of Navarre are centered in the horizontal borders. Around them, foliated scrolls with grotesques and cartouches imitate cut leather in the Mannerist tradition of Fontainebleau; birds and cascades of flowers and fruit stand out from the black ground. The contrast between bright and dark colors recalls the ebony furniture encrusted with hard stones or the strewn flowers on knotted-pile carpets that were popular during Louis XIII's reign. The border design is typically Parisian, with its structured aspect and ornamental repertoire. Despite its decorative success, this border was rarely used for other woven editions of the *Story of Artemisia* cartoons; it is derived from a border that was created for the 1610 tapestry series *Pastor Fido*, designed by Laurent Guyot and Guillaume Dumée.[11]

Circumstances of the Commission

Although Houel proposed in the preface to his sonnets that Caron's illustrations would make excellent tapestry designs, Catherine de' Medici did not follow this suggestion, and interest in such a project was not reignited until four decades later, by King Henry IV. The earliest documented set was on the looms by 1601, woven in Maurice Dubout's workshop in the Louvre.[12] Henry's motives in commissioning the *Artemisia* tapestries have been ascribed variously to a desire to align himself, as a Bourbon, with the preceding Valois dynasty; to celebrate his own Medici alliance, his marriage to Catherine's distant cousin, Marie; and to identify himself with Artemisia's son, Lygdamis, as a propaganda vehicle calling attention to his education and youthful presence at the court of Catherine de' Medici.

It can be seen, however, that Henry IV chose to shift the emphasis of the *Story of Artemisia*, for when it was woven, it took on a very different meaning from that given it by Houel. An analysis of two surviving sets woven about 1606, one for Cardinal Montalto and one for Henry IV, reveals that only the subjects from Houel's first book, devoted to the death of Mausolus and his burial, were woven in the Louvre workshop. This was also the case with two other, since-lost sets known

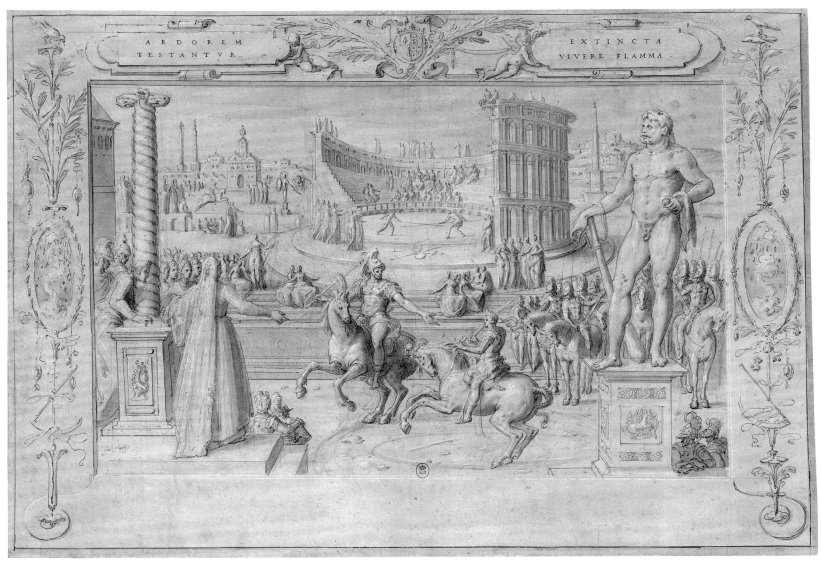

Fig. 74. *The Riding Lesson*, by Antoine Caron, ca. 1562–65. Pen, brown ink, brown wash, highlights in white, strokes in black chalk on beige paper, 39.7 x 55.4 cm. Bibliothèque Nationale de France, Paris (Est. Rés. Ad 105, fol. 31r)

through the inventory of the property of the French Crown. In all four of these sets, the funeral cortege was transformed into a triumphal procession, more festive than martial, in which, curiously, Artemisia was depicted only once, in the *Triumph of Artemisia*.[13] Ten new compositions, for which there exist five drawings attributed to Henri Lerambert (ca. 1540/50–1608), were added: they depict vase-, trophy-, and standard-bearers and richly caparisoned horses; in the inventories of crown property they are sometimes designated as the "suite du triomphe" (triumph series). Simpler in design than the drawings by Caron, and hence less expensive to weave, the new scenes show human figures of more massive proportions arranged in a frieze in the foreground. Square or vertical (rather than

horizontal) in format and easily adaptable to the dimensions desired by the patrons, these tapestries at first complemented the large hangings designed after Caron's drawings, then replaced them altogether. Of episodes of the *Story of Artemisia*, only two types went to the looms: those relating to the funeral cortege and those portraying the deeds of Artemisia, a selection that emulated the famous *Deeds and Triumphs of Scipio* woven for Francis I in the 1530s after designs by Giovanni Francesco Penni and Giulio Romano.[15]

The first sets of the *Story of Artemisia* were woven for Henry IV in the Louvre workshop. It was one of these sets that Cardinal Maffeo Barberini, future Pope Urban VIII, remarked on at Fontainebleau, during the baptismal

ceremonies for the dauphin and his sisters in 1606. Lamenting its melancholy subject matter, he nonetheless advised Cardinal Alessandro Peretti Montalto, nephew of Pope Sixtus V, to acquire a version of it.[16] The small tapestry workshop at the Louvre, although renowned for the quality of its weaving, was able to provide only a limited production. The Louvre looms are to be credited with six fine sets of *Artemisia*, none of which included metallic threads, slightly more than forty pieces, some fifteen of which are now identified.[17] More sizable production was facilitated with the creation of the manufactory in the Faubourg Saint-Marcel in 1607, which operated sixty low-warp looms. Catalogue number 12 can be identified as a product of this workshop on the basis of the

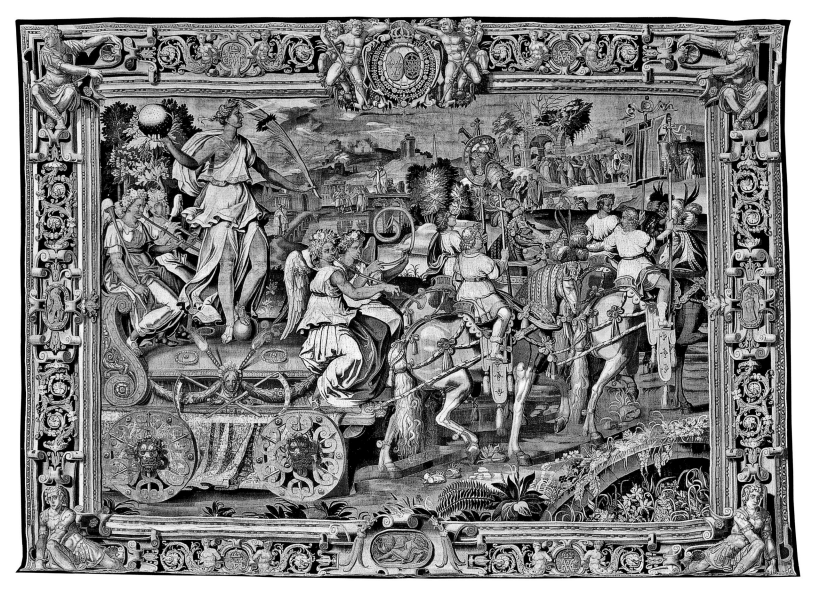

Fig. 75. *Triumphal Scene* from a set of the *Story of Artemisia*. Tapestry design by Laurent Guyot, woven in Paris, ca. 1620. Wool and silk. Mobilier National, Paris (GMTT 11/4)

monogram FM toward the bottom of the right-hand selvage. The full significance of this mark, very common on the weavings from the Faubourg Saint-Marcel, has yet to be convincingly explained. It appears on other tapestries in the set, accompanied by another workshop mark. Five of the other tapestries from this set also bear the unidentified mark HA, and two display an LVD monogram, probably that of Lucas Wandandalle.[18]

Henry IV's death in 1610 did nothing to lessen enthusiasm for the *Artemisia* tapestries. Indeed, the newly widowed queen regent, Marie de' Medici, commissioned at least five new scenes, whose designs are attributed to the circle of Laurent Guyot and Guillaume Dumée, that were added to the existing assemblage of cartoons. To a certain extent, the continuing appeal of *Artemisia* might be explained by the vogue for heroines during this period, exemplified and nurtured by the interests of the salon of Madame de Rambouillet during Louis XIII's reign and the regency of Anne of Austria. However, since Artemisia herself is infrequently depicted in the *Artemisia* tapestries, the *Story of Artemisia* differs from pictorial cycles devoted to other more or less legendary queens, such as Cleopatra, Zenobia, and Dido, or to significant female protagonists from the Bible, such as Judith. In the eight-piece set to which catalogue number 12 belongs, for example, she appears in only three of the tapestries. When she is represented, it is not in battle scenes, with all the vicissitudes of war, or in the equally traditional scenes of seduction or despair, but instead in the newly introduced theme of good government. The new subjects created for Marie de' Medici evoke the peaceful display of royal power and the grand principles assuring the state's foundations: justice granted to all, civil concord, and the divine right of kings, of which the prince must make himself worthy through his education. The new designs echo the flattering description provided by François de Malherbe's *Ode à la Reine mère du Roi sur les heureux succès de la régence* (Ode to the Queen, mother of the King, on the happy success of the regency) of 1610, in which the poet celebrated the return of peace, which "... de la majesté des

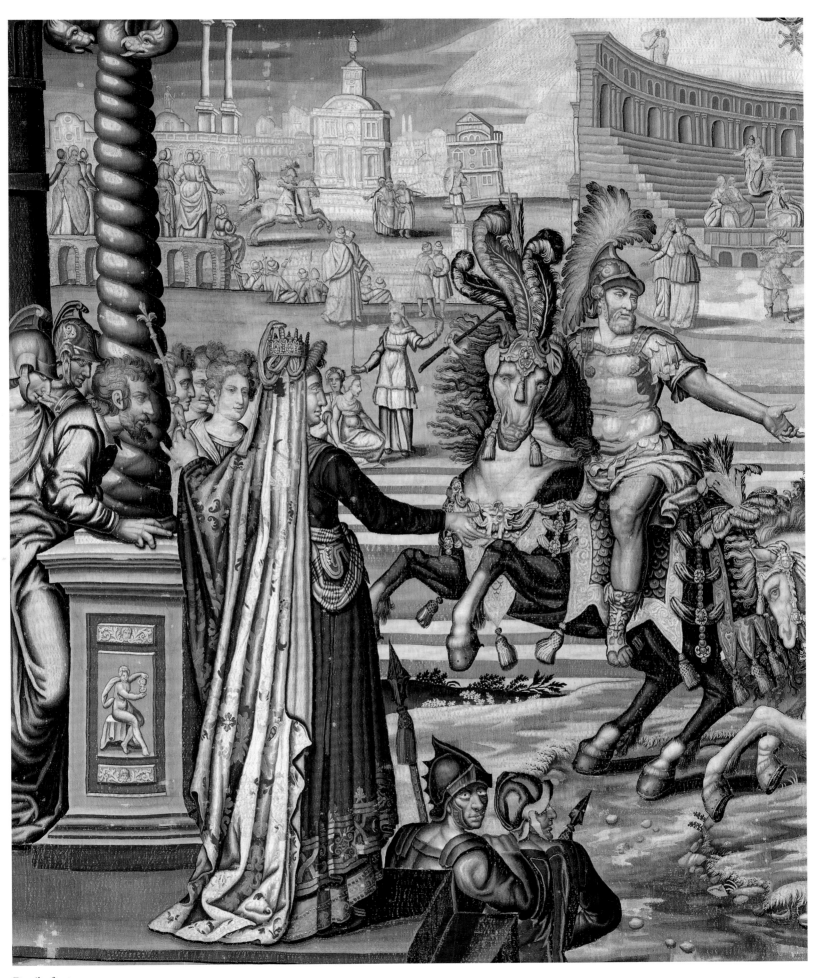

Detail of cat. no. 12

lois / Appuyant les pouvoirs suprêmes / Fait demeurer les diadèmes / Fermes sur la tête des rois" (...from the majesty of laws / Supporting powers supreme / Makes diadems rest firmly / On the heads of kings).

Thus following Henry IV's death, the character of new Artemesia sets shifted from the triumphal and militaristic toward sets in which the emphasis was placed on the peaceful and judicious exercise of power and the young king's education. This shift is graphically demonstrated by the inventory of the Faubourg Saint-Marcel workshop taken in 1627 following the death of François de la Planche.[19] This described six Artemesia sets in the warehouses and on the looms at the Hôtel des Gobelins, allowing us to identify the twenty-four subjects still being produced at that date. Only about ten replicate compositions based on Caron's drawings. Other compositions were added, of which three of the more elaborate ones are attributed to Laurent Guyot: the *Heralds on Horseback,* the *Coronation Sacrific,* and the *Gifts.* Several of the major scenes were truncated to fit specific locations; the 1627 inventory lists examples of these sometimes very narrow pieces, usually done on commission, which are much like ones in the set produced for Charles-Emmanuel, duc de Savoie, beginning in 1620.[20]

Numerous variations and combinations from the *Artemisia* cartoons continued to be woven throughout the regency of Marie de' Medici (1610–17) and into the reign of Louis XIII. More than twenty-two sets of the *Story of Artemisia,* about two hundred pieces, can be attributed to the Faubourg Saint-Marcel workshop, two-thirds of them woven with gold thread. In addition to Henry IV, Marie de' Medici, and Louis XIII, purchasers of these prestigious weavings included Don Pedro Álvarez de Toledo, Spanish ambassador (1610), Maximilian III, archduke of Austria (1612; Residenz, Munich), Charles-Emmanuel de Savoie (after 1620), and Cardinal Francesco Barberini (ca. 1627; Minneapolis Institute of Arts). Sets of *Artemisia* tapestries also appear in the posthumous inventories of the marshals Antoine Coeffier-Ruzé d'Effiat (1633) and François-Annibal d'Estrées (1636), of Nicolas Fouquet (1661), of Princess Henrietta Anne of England, duchesse d'Orléans (1671), of Michel Particelli d'Hémery and later of the duc de

Penthièvre (1644; Mobilier National, Paris, GMTT 13). Since 1727, the Cathedral of Hildesheim has possessed a tapestry set in eight pieces of unknown provenance.[21]

The presence of the coat of arms of France in the borders of catalogue number 12 suggests that the set to which it belongs was originally intended for the crown or as a diplomatic gift; in the 1627 inventory of the Faubourg Saint-Marcel workshop, it can be identified in the warehouses of the Gobelins. It was purchased about that date by Cardinal Francesco Barberini, nephew of Urban VIII, for his younger brother Antonio, who became cardinal that year at age nineteen.[22] In October 1639, during celebrations marking the centennial of the Jesuit order, the pope visited the church of the Gesù in Rome. Cardinal Antonio lent his most beautiful tapestries for the occasion. The *Riding Lesson,* suspended from the north transept, is clearly visible in the painting by Andrea Sacchi, Jan Miel, and Filippo Gagliardi commemorating the event (fig. 54).[23]

In addition to the Minneapolis example, four other panels of the *Riding Lesson* survive. The most complete is the tapestry in the Mobilier National, Paris, from a set woven with gold for Henry IV. Other, narrower versions exist—at the Vatican, in the set in the Cathedral of Hildesheim, and in a private collection. Two other examples appeared in the royal collections, and two more were described in 1627 at the Faubourg Saint-Marcel manufactory.[24]

The Minneapolis Institute of Arts owns two tapestries of the *Story of Artemisia* from a set different from the one to which the *Riding Lesson* belonged. Richly woven with gilt-metal-wrapped thread, they display a border that was frequently used in the 1620s for weavings from the *boutique d'or* (gold shop). The monogram AM appearing in the side cartouches is that of Artemisia and Mausolus, not that of Anne of Austria, as has long been claimed. It seems that the last weavings of the *Story of Artemisia* were made long before Louis XIII's death in 1643. The decorative repertoire of the borders on all the various weavings of the *Story of Artemisia* are, in fact, still in the Mannerist tradition, remote from Simon Vouet's influence, which became so noticeable in the 1630s.

ISABELLE DENIS

1. Bibliothèque Nationale de France, Paris, Cabinet des Manuscrits, MS fr. 306.
2. For detailed discussion of Caron's drawings for the sonnet version of the *Histoire de la Royne Artémise,* see Ehrmann 1986, p. 57; Denis 1999, pp. 33–34; Barcelona–Paris 2003, pp. 237–38. Several albums of sonnets and drawings survive: Bibliothèque Nationale de France, Paris, Est. Rés. Ad 105 (see fig. 74), and Rés. B5; and Musée du Louvre, Paris, Département des Arts Graphiques, inv. 25138–39, RF 29728*bis* 1–4, and RF 29752, 1–7.
3. "[D]e faire des belles et riches peintures à tapisseries"; Fenaille 1903–23, vol. 1, p. 122. On Antoine Caron, see Ehrmann 1986.
4. The most accessible and complete text on the *Story of Artemisia* tapestries, especially on the Barberini set of which cat. no. 12 is a part, is Adelson 1994, pp. 160–288. See also Denis 1992; Denis 1999; Bertrand 2005, pp. 103–7.
5. Denis (1992, pp. 21, 33 n. 2) notes more than two hundred pieces.
6. Inventory of the household effects of Cardinal Antonio Barberini, 1636–40, Biblioteca Apostolica Vaticana, quoted in Adelson 1994, p. 191.
7. For the engravings of monuments that inspired Caron, see Adelson 1994, pp. 238–39.
8. "[P]eindre sur thoille de couleurs a huille les grands pattrons de la suitte d'Artémise représentant les exercices qu'elle faisoit apprendre au Roy son fils pendant son vefvage selon et conformément aux petits desseeings en papier faictz de la main et invention de feu Anthoine Caron, excellant peintre et desseigneateur"; J. Coural 1967, p. 21.
9. For more on Guyot, see Félibien 1725, vol. 3, p. 327; Göbel 1928, pp. 60, 67–70; Le Blant 1988, pp. 48, 53–55.
10. "[P]ar les tappissiers flamands"; "y apportant toutefois, son art et industrie pour les rendre en la plus grande perfection que faire se pourra"; J. Coural 1967, p 21.
11. Sale cat., American Art Association, New York, January 13–15, 1927, nos. 428–32, illus. (*Pastor Fido* tapestries with the same border). Fragments of borders of this design are in the State Hermitage Museum, Saint Petersburg, and at the Toledo Museum of Art; Adelson 1994, pp. 179 fig. 80, 185.
12. J. Coural 1967, p. 16; Denis 1992, p. 21.
13. For the Montalto set, see F. Boyer 1930; Denis 1992; Denis 1999, pp. 39–43. The *Triumph of Artemisia,* whose subject is found at the end of the second book of Houel's prose *Histoire,* was woven a single time, as a complement to the funeral cortege of Mausolus, confirming the latter's triumphal character. The king owned three tapestry sets from the Louvre workshops (Inventaire général du mobilier de la Couronne, nos. 6–8; see Guiffrey 1885–85, vol. 1, p. 333; no. 8 is at the Mobilier National, GMTT 11). Two pieces relating to the death of Mausolus and to Henry IV's monogram (Inventaire général, nos. 47 and 47 under miscellaneous tapestries) are clearly from the first tapestry set woven at the Louvre; Fenaille 1903–23, vol. 1, pp. 206–8.
14. The five drawings attributed to Lerambert are in the Bibliothèque Nationale, Cabinet des Estampes, Rés. B5, no. 1, and Rés. B6. The subjects are *Soldiers Carrying Trophies, Soldiers Carrying a Vase on a Litter, Soldiers Carrying Vases, Children on Horseback,* and *Horses with Decorative Trappings.* Two drawings in the Louvre, *Soldiers Carrying Trophies and Standards* (inv. 25145) and *Cavalry Ensigns* (inv. 25144) are very close to these but cannot be related directly to any existing *Artemisia* tapestries. See Gisèle Lambert in Barcelona–Paris 2003.
15. Also noted in Adelson 1994, p. 266.
16. See F. Boyer 1930; J. Coural 1967, p. 16; Denis 1992, pp. 21–26.
17. Seven tapestries from Cardinal Montalto's set are known:

Soldiers Carrying Tower- and Turret-Shaped Trophies (Musée des Beaux-Arts, Dijon) and *Chariot of Lions* (Musée Jacquemart-André, Paris). There are three other pieces in the Musée Boucher de Perthes, Abbeville: *Trumpeters on Horseback*, *Soldiers Carrying Large Vases*, and *Captain on Horseback*; Denis 1999, pp. 38–43. Two other tapestries from Cardinal Montalto's set have since been identified: one is in the Palais Royal, Brussels (de Reyniès 2002, p. 216), and the other is the *Chariot of Elephants* previously in the Braquenié collection, now in the Mobilier National.

18. HA is on the *Heralds on Horseback*, the *Coronation Sacrifice*, the *Philosophers*, the *Education of the Young King*, and the *Soldiers with Vases and a Litter*; Adelson 1994, pp. 201–33 no. 16a–d, 262–68 no. 16h. LVD is on the *Exercise in the Assault and Defense of a Bastion* and the *Queen Distributing the Booty*; ibid., pp. 245–61, no. 16f, g.

19. Published and discussed in Fenaille 1903–23, vol. 1, pp. 200–202, and Guiffrey 1923, pp. 41–42, 44, 46.

20. These are a set now in the Mobilier National, GMTT 12/1–7 (Inventaire général, no. 16, woven with gilt-

metal-wrapped thread, seven pieces) and the set previously at Naworth Castle, purchased by the Mobilier National with the participation of the Natixis Society. These two sets, with the coat of arms of France and the initials of Henry IV, have a common origin ; see Vittet 2007.

21. Of the 200 tapestries attributed to the Faubourg Saint-Marcel, about thirteen sets were woven with gold thread (130 pieces) and ten were woven without gold (70 pieces). Six sets belonged to the French Crown, four woven with gold (Inventaire général, nos. 12, 15, 16, 29) and two without (Inventaire général, nos. 31, 47 [the Fouquet set]); Fenaille 1903–23, vol. 1, pp. 203–10; Vittet 2007, p. 188. For the other sets mentioned, see: J. Coural 1967, p. 19 (Toledo); Volk-Knüttel 1980 (Munich); Denis 1992 (duc de Savoie); Archives Nationales, Paris, Minutier Centrales des Notaires, XIX, 404, January 17, 1633 (Effiat; my thanks to Jean Vittet); Coquery in Paris 2002, pp. 153–54, no. 85; Vittet in L. Beauvais 2000, pp. 13–15, no. 3, illus., and Vittet 2004c, (Particelli / Penthièvre); Göbel 1928, p. 65 (Hildesheim).

22. For the rejected alternate theory that Francesco Barberini purchased one of the *Artemisia* sets listed for sale in a pre-1627 document (preserved among the Barberini archives) summarizing the activities of northern European workshops assembled for the cardinal before he established his own tapestry workshop in Rome, see Dubon 1964, pp. 13–14.

23. The painting is on loan to the Museo di Roma from the Galleria Nazionale d'Arte Antica, Palazzo Barberini, Rome; see Denis 1992, pp. 30–32; Denis 1999, pp. 34–36.

24. Mobilier National, GMTT 12/2 (Inventaire général, no. 16, with gold; Guiffrey 1885–86, vol. 1, p. 296; Paris 2007, pp. 46–47, illus.); Monumenti, Musei e Gallerie Pontificie, Vatican City, inv. 3790–81; Hildesheim (Habicht 1917, pp. 276–77, pl. 40); formerly Cossette collection (Ehrmann 1986, pp. 82–83, fig. 70). The *Riding Lesson* was also mentioned in two royal sets: Inventaire général, no. 12, with gold, and no. 31; see Fenaille 1903–23, vol. 1, pp. 203, 208. Two sets listed in La Planche's 1627 inventory included the *Riding Lesson*; ibid., pp. 201 (2/4), 202 (8/2).

13.
Diana and Apollo Slaying the Children of Niobe

From an eight-piece set of the *Story of Diana*
Cartoon attributed to Toussaint Dubreuil or to Henri Lerambert, before 1606, after a design by Toussaint Dubreuil, ca. 1600
Woven in the Faubourg Saint-Marcel workshop, Paris, ca. 1620–30
Wool, silk, and gilt-metal-wrapped thread
415 x 540 cm (13 ft. 7⅜ in. x 17 ft. 8⅝ in.)
8 warps per cm
Manufactory and weaver's marks, P fleur-de-lis, in lower selvage at right; FM and HT, in right lower selvage
Kunstkammer, Kunsthistorisches Museum, Vienna
(T XXIV 4)

PROVENANCE: 1765, listed in the postmortem inventory of Holy Roman Emperor Francis I (Francis Stephen III, duke of Lorraine); inherited by Joseph II, Holy Roman Emperor; imperial collection, Vienna.

REFERENCES: Birk 1883–84, pt. 1, p. 235; Baldass 1920, p. 25, pt. 9, no. xxiv; Vienna 1920, no. 68; Buschbeck and Strohmer 1949, p. 36, no. 153; Denis in Chambord 1996, p. 128; Bauer 1999, p. 120; Boccardo 1999, p. 55; Bertrand 2005, p. 112.

*T*he *Story of Diana* of which *Diana and Apollo Slaying the Children of Niobe* is a part was originally designed by court artist Toussaint Dubreuil (ca. 1561–1602) for King Henry IV of France; an early edition, woven with silver and gilt-metal wrapped thread, was displayed at Fontainebleau in 1606.[1] As with the tapestries of the *Story of Artemisia*, Henry IV looked to a considerably earlier artistic scheme as inspiration for his designer to follow, in this case a tapestry series of the *Story of Diana* that was woven approximately fifty years earlier for Diane de Poitiers, mistress of Henry II.[2] By choosing a model that was so closely associated with Diane de Poitiers and the reign of Henry II, Henry IV likely wished to lay claim to the legacy of the Valois, just as he had done with the *Story of Artemisia*. Dubreuil, for his part, broke away from the Mannerism of Diane de Poitiers' examples; although he carefully examined her tapestry set, from which he borrowed many elements, he

blended them into an aesthetic governed by new laws. The monumentality of the figures, the landscape arranged around them, and the dynamism of the composition so convincingly rendered in *Apollo and Diana Slaying the Children of Niobe* attest to a vision that is already Baroque, demonstrating the pivotal role that this artist played in contemporary stylistic developments.

The gold-woven *Story of Diana* tapestries at the French court embodied the continuing tradition that made tapestries an essential element of royal pomp. Cardinal Scipione Borghese, for example, was moved to describe one of the *Diana* sets that he saw at the Faubourg Saint-Marcel workshop in March 1617, admiring "the colors [which] are extremely vivid; it is enriched with a great deal of gold; the border especially is very beautiful, both in its unusualness and in its magnificence, being almost entirely of gold."[3] Subsequently, Henry IV's *Story of Diana*, like

the *Story of Artemisia*, enjoyed considerable success during the first decades of the seventeenth century and was frequently woven.[4] The series of which catalogue number 13 is a part is one of the later weavings, a sumptuous example woven with precious metal-wrapped threads. It belonged to the dukes of Lorraine until it became part of the Imperial Collection in Vienna in 1765.[5]

Description

Diana and Apollo Slaying the Children of Niobe illustrates the cruel vengeance of Latona's children in response to the disrespect Niobe showed to their mother. The scene, taken from Ovid's *Metamorphoses*, unfolds on the plains outside Thebes, where Niobe's sons were training their horses. Hidden behind a cloud, Apollo and Diana unleash their murderous arrows. Caught in an inescapable melee below, the group of brothers is dominated by the gestures of fear of the two on horses rearing in opposite directions directly beneath the deadly bows of the celestial archers, and by that of the one falling from his horse in the left foreground. The women cower in the right foreground, resigned to their fate, with the exception of one who is attempting to flee at the far right, her hair streaming behind her. In the foreground, Niobe clasps the youngest of her daughters tightly, as Ovid describes them: ". . . above her with spread cloak / And body shielding her. 'O not this smallest, / The youngest one,' she cried. 'Leave her to me—/ Of all my many, leave this last, this one!'"[6]

The border of catalogue number 13 evokes the theme of the hunt traditionally associated with Diana. In the upper corners, falconers lean on their elbows, their horns slung across their shoulders and lures in their hands, while, in the lower corners, huntsmen restrain their dogs. In the vertical borders, crossed pikes, quivers, and bows support the heads of a boar and a hind. Garlands of flowers and fruit complete the rich frame, providing a colorful decorative counterpoint to the dramatic central scene. In the medallion in the lower border Niobe, numbed by despair, has been transformed into a rock. The medallion in the upper border was meant to bear the owner's coat of arms; the fact that it remained empty

implies that the tapestry was not produced for a particular patron.

The set in Vienna of which catalogue number 13 is a part includes seven other episodes selected from the legend of Diana and her twin brother, Apollo, recounted in Ovid's *Metamorphoses*.[7] The first tapestry depicts the cruelly comic episode *Latona Transforming the Lycian Peasants into Frogs*—they had refused to give Latona water. In the second, the *Assembly of the Gods*, Diana asks her father, Jupiter, to grant her eternal virginity. Next, in the *Blasphemy of Niobe*, Queen Niobe of Lydia, inordinately proud of her divine origins and of her fourteen children, interrupts a ceremony dedicated to Latona (fig. 78). *Apollo and Diana Slaying the Children of Niobe* (cat. no. 13) illustrates Latona's ensuing revenge. The following three pieces are *Diana Killing Orion*, her erstwhile hunting companion; the *Death of Chione*, a too-proud mortal; and the *Drowning of Britomartis*, to preserve her chastity from Minos's advances. Finally, in *Diana between the Giants*, Diana pits the brothers Othus and Ephialtes against each other because they dared aspire to marry Diana and Juno.

Other woven editions of this *Diana* series also include *Latona Giving Birth to Diana and Apollo* and *Diana the Huntress with Her Hounds*. Finally, two subjects are mentioned in a five-piece set woven for Louis XIII: the *Sacrifice of Iphigenia* and the *Death of Meleager*.[8]

Design Sources

Over the centuries, the *Story of Diana* remained one of the favorite subjects of weavers. It allowed them, while showing their expertise in the treatment of verdure and foliage, to evoke the hunt, a favorite pastime and privilege of the nobility. The theme had acquired a particular resonance in mid-sixteenth-century France because of the sparkling personality of Diane de Poitiers, mistress of King Henry II. Prior to Diane de Poitiers' ascent to court influence, the subject of Diana had already been represented in the baths and on the vault of the Gallery of Ulysses of the Château de Fontainebleau. These compositions, now lost, are recalled in an engraving after Francesco Primaticcio.[9] This may have provided the inspiration for

the tapestry set of this subject—comprising ten or more pieces of which six hangings survive (in New York, Rouen, and Écouen), which was made for her in Paris about 1550.[10] The insignia and devices of Henry II and Diane de Poitiers decorate the borders and, according to sixteenth-century tradition, the tapestries were commissioned to hang in Diane's splendid Château d'Anet, rebuilt for her after designs by Philibert Delorme beginning in 1543. The features of the king and his mistress appear in the tapestries on the figures of Diana and Jupiter. The subjects chosen for representation in Diane de Poitiers' *Diana* set depart from the usual hunting themes, and appear to have been selected to provide specific allusions to the political turmoil of the times.[11]

The design of Diane de Poitiers' *Diana* tapestries has traditionally been attributed to Jean Cousin the Elder (ca. 1500–ca. 1560), perhaps with the assistance of the Orléans painter Charles Carmoy. Cousin was working at Fontainebleau in the late 1530s and was the appointed painter to Diane de Poitiers in 1551. Drawings from the school of Fontainebleau and a series of engravings by Étienne Delaune (ca. 1519–1583) disseminated the images. Such was the importance of Diane de Poitiers' *Diana* tapestries that it would be inexplicable if Toussaint Dubreuil had not looked to their example when he designed the *Story of Diana* set for Henry IV fifty years later. Although no tapestry of *Apollo and Diana Slaying the Children of Niobe* in Diane de Poitiers' mid-sixteenth-century set is known, a drawing that has been associated with the earlier set suggests that the weaving of this episode was, if not produced for Diane de Poitiers, then at least conceived for her (fig. 76).[12] From it, Dubreuil borrowed the pyramidal composition of the group of women, dominated by the fleeing figure on the right. In the later *Diana* sets that include the *Drowning of Britomartis*, such as the Vienna set to which catalogue number 13 belongs, that composition is taken almost line for line from the one in Diane de Poitiers' series. It is possible that Dubreuil did not conceive a *Drowning of Britomartis* as part of his group of designs for the *Story of Diana* and that it was only later, in subsequent reweavings, that a

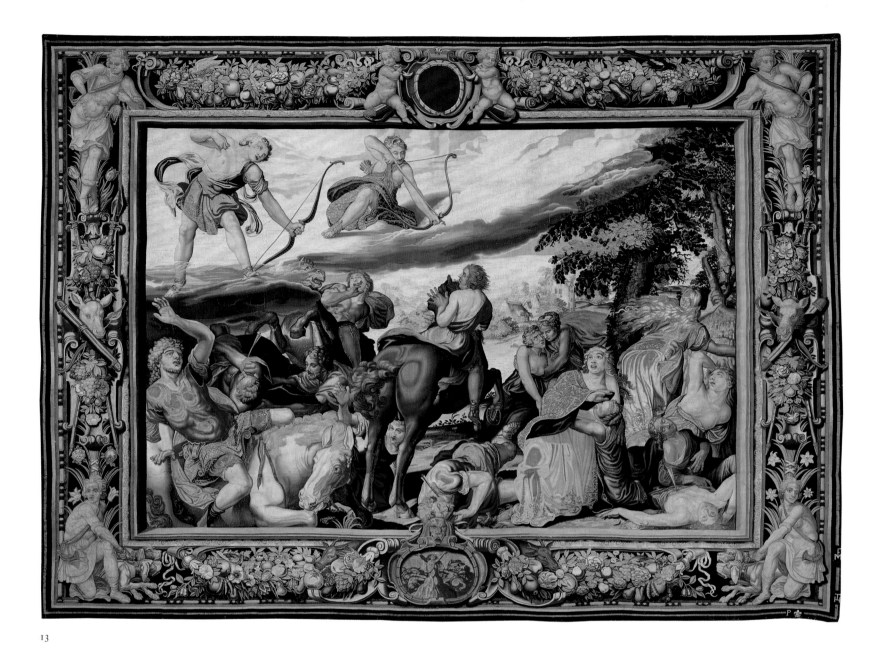

13

cartoon for this subject was hastily created, in the main scene resurrecting the older composition familiar from Diane de Poitiers' set and Delaune's engravings.

Dubreuil also looked further afield for design sources. In *Apollo and Diana Slaying the Children of Niobe*, for example, the horse in the foreground, rearing back, seems to have been inspired by an engraving by Antonio Tempesta, from which the spectacular staging of the scene is also borrowed.[13] The design of *Apollo and Diana Slaying the Children of Niobe* makes reference to the Niobids, a group of fifteen statues of the children of Niobe and Amphion from classical antiquity that were

rediscovered in Rome in 1583 and engraved in 1594. The heads were admired above all for the way the artist expressed attitudes of entreaty, despair, and terror without relinquishing their beauty. Their influence can be seen here: the parted lips and the eyes raised heavenward, more than declamatory gestures, express the passions.[14] Dubreuil accentuated the dramatic tension and pathos of the scene, and through his reflections on classical models, he pursued his interest both in plastic form and in the expression of passions, thus placing himself within the perspective of seventeenth-century artistic debates. The dozen known weavings of this

scene vary only minimally, for the coherence of the composition made it difficult to add or remove anything.

The Artists
Although no contemporary documentation survives linking Toussaint Dubreuil to Henry IV's initial commission of the new *Story of Diana* tapestries, references in the first part of the Inventaire général du mobilier de la Couronne (inventory of royal furnishings), completed by February 1673, names Dubreuil as the designer of the tapestries.[15] This identification is substantiated by stylistic evidence that securely locates the one surviving design

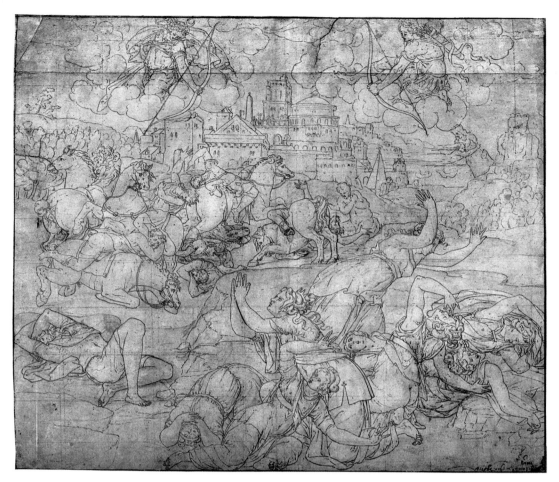

Fig. 76. *Apollo and Diana Slaying the Children of Niobe*, by an unknown artist, 16th century. Brown ink with light wash over chalk, 43 x 48.5 cm. Bibliothèque Nationale de France, Paris (Est. Rés. B5[2] fol., pl. 52)

for the set, the *Assembly of the Gods*, within Dubreuil's oeuvre.[16]

Research by Sylvie Béguin and Dominique Cordellier has made it possible to better grasp the personality of Toussaint Dubreuil.[17] Trained at Fontainebleau, he also worked at the Louvre and at Saint-Germain-en-Laye. Although it has been possible to identify only a few fragments of his large painted decorations, his drawing oeuvre is much more coherent. Henry IV, who appreciated him a great deal, installed him in 1597 at the Hôpital de la Trinité alongside Maurice Dubout, a high-warp weaving entrepreneur. About this time, Dubreuil must have begun work on the *Diana* designs. He was surrounded by collaborators in his workshop, and it is difficult to confirm the extent to which each contributed. There is evidence, for example, that a different, younger artistic personality assisted in painting the *Diana* cartoons after Dubreuil's designs and might even have completed the project after Dubreuil's death in 1602. Com-parison of Dubreuil's drawing for the *Assembly of the Gods* with the tapestries reveals that a change was made in the framing of the scene, which moves closer to the viewer and implies the touch of a quite different artistic personality. The figures become more imposing and acquire a greater presence in the architecture. In the distance a mountainous landscape appears, together with a round temple, adapted from one in Diane de Poitiers' 1550s set. The slanting ray of light that glances off the Solomonic pillars in the foreground also brightens the background. The figure of Diana draws its force from its isolation, orchestrated by a very studied play of tensions in the lines and contrasts in the tones.

Diana the Huntress with Her Hounds also departs from Dubreuil's typical style: the superimposed tunics, the rich mantle concealing the body, and the overly elaborate hairstyle evoke a more mannered approach, similar to certain compositions in the *Story of Artemisia* attributed to Henri Lerambert (see cat. no. 12).[18] In *Latona Giving Birth* that same frontal and static composition is again found, along with the heavy drapery and a certain uneasy integration of the figures into the landscape, which is also rather rigid. Detailed comparison of the dated existing sets, discussed below, brings to light some evidence to suggest that the cartoons underwent a gradual alteration over the years following their first weaving. Perhaps undertaken by Lerambert, these introduced some modernizing changes and, conceivably, added a couple of extra episodes in two new cartoons.

The design of the border of catalogue number 13, which first appears on *Diana* tapestries of about 1620 and was frequently reused, can be attributed to Laurent Guyot, whose role as a tapestry cartoon painter is discussed in catalogue number 12, the *Riding Lesson*.[19]

Weaving

At the right corner of the lower selvage of *Diana and Apollo Slaying the Children of Niobe* is a P accompanied by a fleur-de-lis, the trademark of the Flemish weavers working in Paris. The monogram HT to the right belongs to Jean Tayer, or Hans Taye in Flemish, who was the head of the *boutique d'or* (gold shop) at the Faubourg Saint-Marcel manufactory in the Hôtel des Gobelins. It was long assumed that the letters FM in the right selvage were the mark of Philip de Maeght (sometimes called Maecht), the Flemish weaver active in Paris before he moved to Mortlake. This hypothesis was called into doubt in 1968, however, and has now been abandoned. It has alternatively been suggested that the letters might be a generic mark of the Flemish manufactories of Paris, an appealing hypothesis that requires further research.[20]

The *Diana* set now in Vienna of which catalogue number 13 is a part was woven without a specific patron and would therefore have been intended for the open market. The space for a patron's arms in the top border has been left blank. It is apparent that multiple high-quality *Diana* sets woven after Dubreuil's designs were made for sale on speculation at the Faubourg Saint-Marcel. The dimensions of the set in Vienna, for example, correspond to those of another stock set of eight pieces listed in the 1635 inventory of the director of the Faubourg Saint-Marcel workshop, Charles

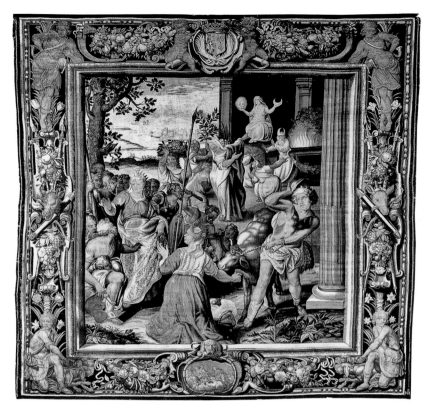

Fig. 77. *The Blasphemy of Niobe* from a set of the *Story of Diana*. Tapestry design by Toussaint Dubreuil, woven in the Faubourg Saint-Marcel workshop, Paris, ca. 1625–30. Wool and silk, 470 x 480 cm. Palazzo Reale, Turin

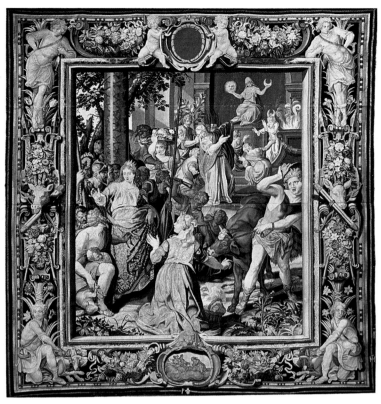

Fig. 78. *The Blasphemy of Niobe* from a set of the *Story of Diana*. Tapestry design by Toussaint Dubreuil, woven in the Faubourg Saint-Marcel workshop, Paris, ca. 1635. Wool and silk, 415 x 375 cm. Kunsthistorisches Museum, Vienna (KK T XXIV 3)

de Comans; since the borders of the inventoried set are described as woven "with gold background," explaining its high appraisal value of thirty thousand livres, it cannot have been the set now in Vienna. Another splendid, gold-woven *Diana* set apparently created for the market, with blank armorial spaces in the borders, was subsequently acquired by Cardinal Richelieu for display in his château at Rueuil and is now part of the collections of the Mobilier National.[21] A lost but documented set, perhaps made for the market and also "highlighted with gold and silver," appeared in 1633 at Chilly, in the home of Antoine Coeffier-Ruzé d'Effiat.[22]

The first weavings of the *Story of Diana*, however, were commissioned. Two sets were woven for Henry IV; although neither survives, both are well documented. One, for example, hung in the guest bedroom of Elizabeth, future queen of Spain, during celebrations at the Château de Fontainebleau for the baptism of the dauphin and his two sisters in September 1606.[23] Another commissioned early weaving does survive, however, the set made about 1608–10 for Don Pedro Álvarez

de Toledo, Spanish ambassador to France.[24] Its borders probably record Dubreuil's original scheme and correspond to a fine drawing attributed to Dubreuil that is now in the Louvre.[25] A further well-documented set survives, shared between the Palazzo Reale in Turin and the Ashmolean Museum, Oxford. This set was the dowry of Marie de Bourbon, comtesse de Soissons, at the time of her marriage to Thomas de Savoie, prince de Carignan, and it would have been completed by about 1620.[26] A specially commissioned set, now dispersed among the Sommer Foundation, Chambord, and various private collections, bears the coat of arms of Cardinal Dominique Séguier, dating it to the 1630s.[27] A six-piece set with a border with a gold ground is also known; it displays the coat of arms of the Pallavicini family and is now in Geneva.[28] The coat of arms of Joseph-Anne de Valbelle, marquis de Tourves, has recently been identified on a piece from a *Diana* set previously in Rufford Abbey.[29]

A five-piece set without any identifying armorials, different from the set in Vienna, is now in the Cincinnati Art Museum.[30]

Another five-piece set, with different borders displaying hunting hounds, was shared between the Galleria di Palazzo Reale, Genoa, and the Kunstgewerbemuseum, Berlin, although the two pieces in Berlin were destroyed in 1945.[31] Fragments of further sets, with attributed dates ranging from the 1620s to the 1640s, are spread among the Victoria and Albert Museum, London, the French Mobilier National, and various private collections.[32]

All these weavings were produced in the Faubourg Saint-Marcel workshop, except for a fragmentary five-piece set with a border decorated with arabesques and putti in cameos, typical of those made fashionable by Jean Cotelle, which was last recorded on the art market in 1994.[33] This bears the weaver's mark of Raphaël de La Planche (R), who was based in the Faubourg Saint-Germain.

Comparison of the same compositions from different sets among the surviving tapestries reveals that the cartoons gradually underwent nuanced changes, perhaps during repainting necessitated by wear from their considerable reuse. It has been shown, for example, that *Latona Transforming the Lycian*

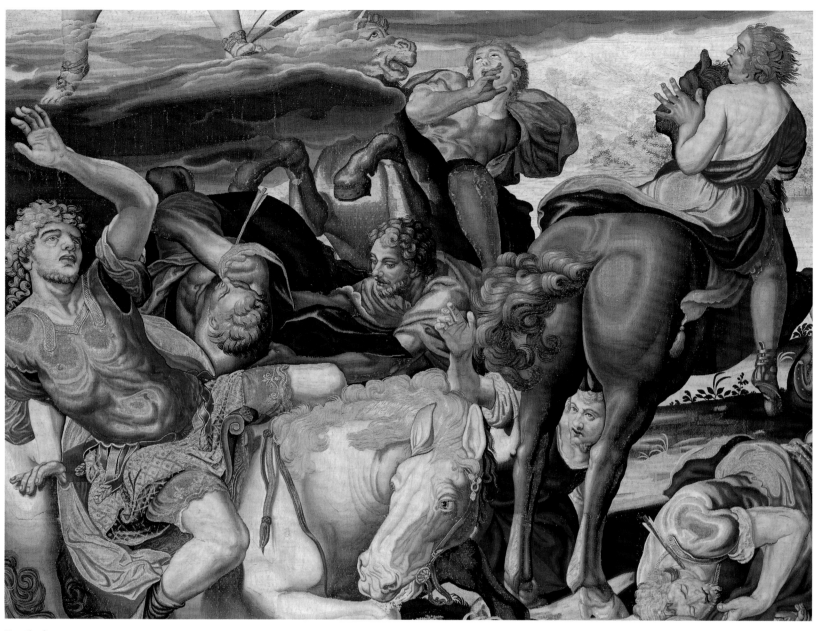

Detail of cat. no. 13

Peasants into Frogs was altered from the earlier to the later weavings, and the burlesque side of the metamorphosis was gradually abandoned as the peasants recovered their human form and even clothing.[34] At the same time, the buildings visible along the water in the background of this composition were replaced in later weavings by the scene of Latona giving birth. It is recorded that during a visit to Fontainebleau in October 1606, Maffeo Barberini admired the tapestry set of *Diana*, though he expressed reservations about the first subject, the childbirth scene, which he found indecent.[35] Except for the two sets woven for Henry IV and the other early commissions for Don Pedro Álvarez de

Toledo (Patrimonio Nacional) and for the comtesse de Soissons (Turin and Oxford), this episode, *Latona Giving Birth*, was rarely woven. It is not part of the Vienna set, for example. The episode's exclusion from the later weavings would explain the need to incorporate it, for narrative clarity, in the background of the tapestry that came after it, *Latona Transforming the Lycian Peasants into Frogs*.

Comparable changes are noticeable in the *Blasphemy of Niobe*. In the earlier sets, such as that woven for the comtesse de Soissons, a vast space opens on the left, which accentuates the diagonal that runs from Niobe's head to the statue of Latona, linking the two protagonists of the scene in a dynamic pro-

gression (fig. 77). In the later sets, including the example in Vienna, that space is occupied by a thick pillar, with a male figure appearing behind it; the tree that framed the composition on the left now curves in front of the sanctuary walls, which are rendered in perspective (fig. 78). Similarly, the young man leading a bull, who is represented in full in the first composition, is later deliberately amputated. The scene seems compressed and cramped, in marked contrast to the earlier version of the composition in which air circulates between the figures. The clarity of the subject matter has been sacrificed, and the opulence of the staging produces a certain confusion. There is a similar tendency to fill in

Detail of cat. no. 13

the background, to a lesser degree, in the other episodes, eliminating empty spaces without regard for the role Dubreuil had intended them to play in the composition. In the later weavings of the *Assembly of the Gods*, for example, a large tree appears behind Diana, adding both a picturesque note and an incongruous vertical to the composition; in the earlier versions made for Don Pedro Álvarez de Toledo and the comtesse de Soissons, the diagonals of the steps, repeated in the hills and mountains, was balanced by the pyramidal figure of the kneeling goddess.

In addition to these gradual alterations to the cartoons occasioned between the early commissioned weavings and the later sets pro-

duced on speculation, it is also possible to argue that the choice of episodes included underwent some rearrangement. If the first cartoon of *Latona Giving Birth* was used less, two further episodes not included in the early commissions appear more frequently—the *Drowning of Britomartis* and, occasionally, *Diana the Huntress with Her Hounds*. The *Drowning of Britomartis* is very close to the mid-sixteenth-century composition used in Diane de Poitiers' set and, as already mentioned, raises the possibility that it was a hastily painted cartoon, created almost as a stopgap long after the conception of Dubreuil's original designs and quite possibly after his death. It has also been suggested that *Diana the Huntress with*

Her Hounds, included in Don Pedro Álvarez de Toledo's set and in the Genoa-Berlin set, was the work of a later artist, perhaps Henri Lerambert, supplementing Dubreuil's original set of designs, either during the initial campaign of painting Dubreuil's designs or as a later addition to the *Diana* cycle.[36]

The *Diana* series in Vienna, of which catalogue number 13 is a part, postdates the spatial rearrangements within the cartoons, visible in the *Blasphemy of Niobe*. It is also among the later weavings that did not include the first panel, *Latona Giving Birth*, but did add the *Drowning of Britomartis* to the group.

ISABELLE DENIS

Detail of cat. no. 13

1. Godefroy 1649, p. 177.

2. See T. Campbell in New York 2002, pp. 464–65.

3. "[L]es couleurs sont des plus vives; elle est enrichie de beaucoup d'or; la bordure surtout est très-belle tant en singularité qu'en magnificence, étant presque toute d'or"; Baschet 1861–62, p. 35.

4. More than 130 tapestries belonging to twenty-eight different sets have been identified, taking into account the surviving tapestries (about a hundred) and the precisely documented sets, that is, those for which the subjects are listed or which have coats of arms in the borders; see Fenaille 1903–23, vol. 1, pp. 231–40; Van Tichelen 1990; Denis in Chambord 1996, pp. 123–41; Boccardo 1999 (although Boccardo's discussion of certain sets is tainted by descriptions that are too succinct to clearly identify them).

5. Bauer 1999, p. 120.

6. Ovid, *Metamorphoses* (6.146–312), translated by Horace Gregory (New York: Viking, 1958), p. 156.

7. Six of the hangings are discussed in Vienna 1920, nos. 67–69, and Vienna 1921, nos. 35–37.

8. For these extra scenes, see Fenaille 1903–23, vol. 1, pp. 234–36, nos. 15, 17, 18; Junquera de Vega and Díaz Gallegos 1986, pp. 6–14; Elisabetta Ballaira and Silvia Ghisotti in Turin 1989, pp. 147–48; Boccardo 1999, pp. 53, 55; and Denis in Chambord 1996, p. 128, n. 3. Isabelle van Tichelen (1990) also links a *Diana and Endymion* to the *Story of Diana*. That composition, made later than the other known models, seems to be unique and may have been commissioned.

9. Cordellier in Paris 2004, pp. 356–57, no. 189.

10. The Diane de Poitiers tapestries were as follows: *Latona Transforming the Lycian Peasants into Frogs*, the *Death of Meleager*, the *Death of Orion*, and *Diana Saving Iphigenia* (all destroyed in a fire in 1997); the *Assembly of the Gods* (Musée des Antiquités, Rouen); the *Drowning of Britomartis* and the *Blasphemy of Niobe* (The Metropolitan Museum of Art, New York, 42.57.1, 2); and the *Triumph of Diana* (private collection, New York). For this *Story of Diana*, see Bardon 1963, pp. 66–73; Standen 1985, pp. 247–59, no. 4a, b; T. Campbell in New York 2002, pp. 464–65; and Béguin 1991 (who calls into question the alternative attribution of the drawings to Luca Penni).

11. Bardon 1963, pp. 70, 83–84. Two tapestries, which were completely unknown until recently, have been purchased by the Musée National de la Renaissance, Château d'Ecouen. They show *Latona Fleeing Juno's Wrath* and *Latona Giving Birth to Apollo and Diana* (they do not yet have an inventory number, according to Thierry Crépin-LeBlond).

12. Ibid., p. 70 and pl. XVIII.

13. Antonio Tempesta, *Horses of Different Lands* (1594); Illustrated Bartsch (Buffa 1983), no. 954 (161).

14. Haskell and Penny 1981, pp. 274–79, no. 66.

15. Guiffrey 1885–86, vol. 1, pp. 296–97, 334–35.

16. Musée du Louvre, Paris, inv. 26250. Details of the composition also bear comparison with another drawing attributed to Dubreuil, *Hyanthe Awaiting Francus near the Temple of Hecate* (Louvre, inv. 26267).

17. See Cordellier 1987; Cordellier in Meaux 1988, pp. 58–66, nos. 5–7 (with bibliography); Béguin 1991; Béguin 1995.

18. On Henri Lerambert (ca. 1540/50–1608), named "painter for the king's tapestries" in 1600, see Adelson 1994, pp. 186–87, and Denis 1999, p. 34.

19. For more on Guyot, see Félibien 1725, vol. 3, p. 327; Göbel 1928, pp. 60, 67–70; Le Blant 1988, pp. 48, 53–55.

20. Guiffrey 1892, p. 38; Jestaz 1968; Denis 1992, p. 26; and Adelson 1994, pp. 180–81 (who adopts Jestaz's hypothesis). A possible objection to the generic manufactory mark idea is that the Flemish weavers in Paris used the P followed by a fleur-de-lis, thus perhaps making redundant this second monogram, which is never mentioned in the texts.

21. J. Coural 1967, pp. 44–45; Levi 1985, p. 34, no. 415; Boccardo 1999, pp. 53–54.

22. Archives Nationales, Paris, Minutier Central des Notaires, XIX, 404, January 17, 1633, posthumous inventory of the marshal d'Effiat.

23. Godefroy 1649, p. 177. The two *Diana* sets of Henry IV, which were woven with gold and which disappeared during the French Revolution, are described in the Inventaire général du mobilier de la Couronne under nos. 17 and 18; Fenaille 1903–23, vol. 1, pp. 234–35.

24. Patrimonio Nacional, Madrid; see Junquera de Vega and Díaz Gallegos 1986, pp. 6–14.

25. Musée du Louvre, Paris, inv. 26289; see Denis in Chambord 1996, p. 126.

26. R.-A. Weigert 1950; Elisabetta Ballaira and Silvia Ghisotti in Turin 1989, pp. 147–48.

27. Denis in Chambord 1996, pp. 140–41. In 1649 Dominique Séguier, bishop of Auxerre from 1635, received the collar of the Order of the Holy Spirit, which does not appear on the tapestries.

28. Private collection; see Niclausse 1971.

29. Sale cat., Christie's, London, November 14, 2002, no. 200.

30. Cincinnati Art Museum, inv. 1941.98–102.

31. See Boccardo 1999.

32. Victoria and Albert Museum, inv. T.130-1960; sale cat., Christie's, London, November 20, 1982, no. 217; Swain 1988, pp. 50–55; Denis in Chambord 1996, pp. 123–41.

33. Sale cat., Christie's, New York, January 11, 1994 nos. 220–24; see Denis in Chambord 1996, pp. 127–28.

34. Denis in Chambord 1996, pp. 130–33.

35. F. Boyer 1930, p. 26.

36. For an alternative, considerably earlier dating of the Genoa-Berlin set to ca. 1610, see Boccardo 1999.

The Battle of the Milvian Bridge

From a six-piece set of the *Story of Constantine*
Design by Peter Paul Rubens, 1622
Border design attributed to Laurent Guyot,
ca. 1622–23
Woven in the Faubourg Saint-Marcel workshop,
Paris, ca. 1623–27
Wool, silk, and gilt-metal-wrapped thread
470 x 710 cm (15 ft. 5 in. x 23 ft. 3½ in.)
8–9 warps per cm
Manufactory and weaver's marks, P fleur-de-lis in
lower selvage at right, HT and FM in lower right
selvage
Kunstkammer, Kunsthistorisches Museum, Vienna
(T XVIII 3)

PROVENANCE: 1627, François de La Planche,
Faubourg Saint-Marcel, Paris; 1664, Charles de La
Porte, duc de La Meilleraye, Paris (?); 1699, Palais
Mazarin, Paris (?); 1714, Palais Mazarin, Paris (?); 1883,
Kunsthistorisches Museum, Vienna.

REFERENCES: Birk 1883–84, pt. 1, pp. 230–31;
Buschbeck and Strohmer 1949, p. 36, no. 154;
Van Tichelen 1997, p. 67; Bauer 1999, p. 121; Bertrand
2005, p. 117.

T
he *Story of Constantine*, designed by
Peter Paul Rubens, introduced the
verve and innovations of modern Flemish
tapestry design to Paris production. In addi-
tion, it occupies a special place in the history
of Parisian tapestry because, partly as a result
of Rubens's renown, the series is exception-
ally well documented. Not only have all the
artist's sketches been preserved, unique in the
history of the Paris workshops, but the surviv-
ing correspondence of Nicolas-Claude Fabri
de Peiresc (1580–1637), an influential patron
and scholar and a great friend of Rubens's,
provides relatively precise information on the
genesis of the series and on the reactions of
Parisian connoisseurs to the artist's composi-
tions.[1] One of the earliest weavings of the
cartoons, perhaps the editio princeps, woven
with gilt-metal-wrapped thread and bearing
the royal armorials of France and Navarre,
was given by King Louis XIII to Cardinal
Francesco Barberini in 1625; it is now in the
Philadelphia Museum of Art.[2] The six-piece
set now in the Kunsthistorisches Museum in
Vienna, of which catalogue number 14 is a
part, is another early weaving after Rubens's
cartoons; we propose to identify it with a
documented set in the posthumous inventory
of François de La Planche's workshop at the
Faubourg Saint-Marcel, which would mean
that it was woven before 1627.

Description

The *Battle of the Milvian Bridge* illustrates a
crucial episode during Constantine's military
campaign against the usurper Maxentius. The
decisive scene unfolds on the Milvian Bridge,
which crosses the Tiber at the gates of Rome.
Maxentius, fleeing across the bridge, which
he has just sabotaged, is caught in his own
trap and drowns. Rubens captured the crucial
moment: an arch has just collapsed and several
horsemen are plunging into the void in a
tangle of limbs and falling masonry in which
the triangular composition contributes to
the sense of vertiginous collapse and chaos.

Maxentius can be seen in the immediate fore-
ground, knocked over on his back, arms
spread; his troops on the bridge are attempt-
ing to turn back but run into Constantine's
men. Amid the melee, the soldier trying to
restrain his mount from falling inevitably and
fatally off the ruined bridge embodies the
dramatic moment, from which, oddly,
Constantine is absent.[3]

The battle of the Milvian Bridge on
October 28, 312, ended the struggle for the
Roman Empire following the death of
Emperor Galerius in 310. Constantine, in an
alliance with his brother-in-law Licinius,
waged battle against his other brother-in-law,
Maxentius, son of Emperor Maximian. On
the eve of the confrontation, the chrismon
appeared to Constantine in a dream, accom-
panied by a motto, "By this sign you will
prevail," prompting him to display the Christian
symbol on his standards and eventually lead-
ing to his baptism in Rome. Instead of the
classical biography of Constantine by Eusebius
of Caesarea, Rubens followed the version
propounded in Cardinal Cesare Baronio's
Annales ecclesiastici, a copy of which Rubens
acquired in February 1620.[4] The tapestries,
combining historical and legendary events,
illustrate the life of the first Christian emperor
in twelve episodes: *Marriage of Constantine and
Fausta and Constantia and Licinius*, *Constantine's
Vision of the Chrismon*, the *Labarum*, the *Battle
of the Milvian Bridge*, *Constantine's Entry into
Rome*, the *Trophy*, the *Baptism of Constantine*,
*Constantine Investing His Son Crispus with
Command of the Fleet*, *Constantine Defeating
Licinius*, *Constantine Worshipping the True
Cross*, *Constantine Directing the Building of
Constantinople*, and the *Death of Constantine*.
In an eighteenth-century engraved edition
of Rubens's *Constantine* designs, a repre-
sentation of *Rome Triumphant* replaced the
Death of Constantine, leading to suggestions
that this might record Rubens's original
scheme and that Rubens's royal patrons chose
to alter the final scene from an allegorical

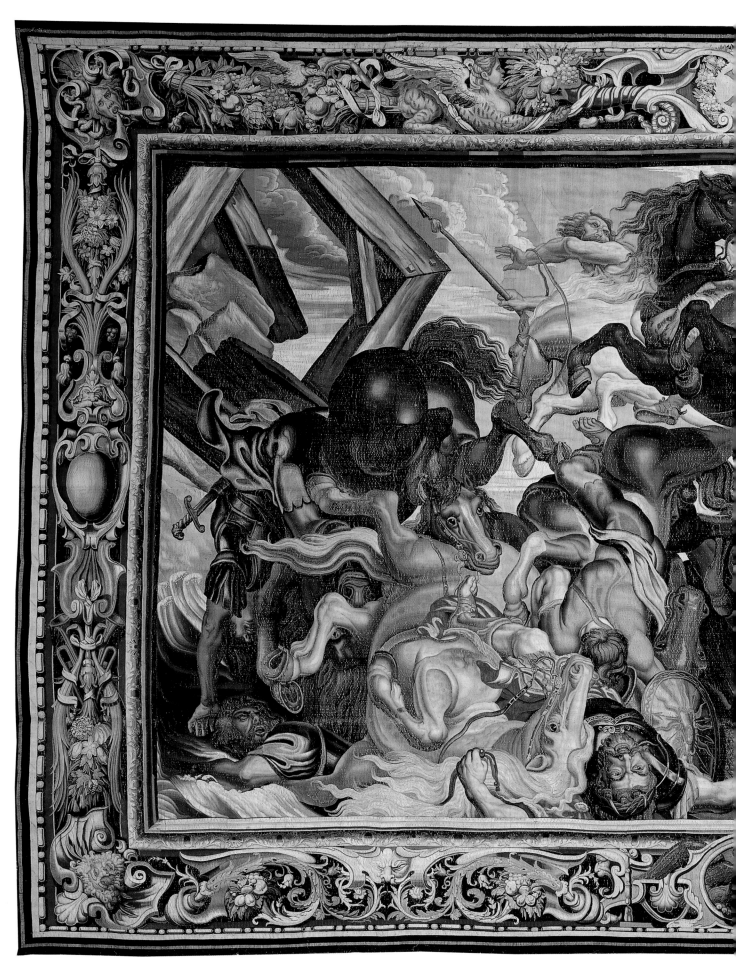

14

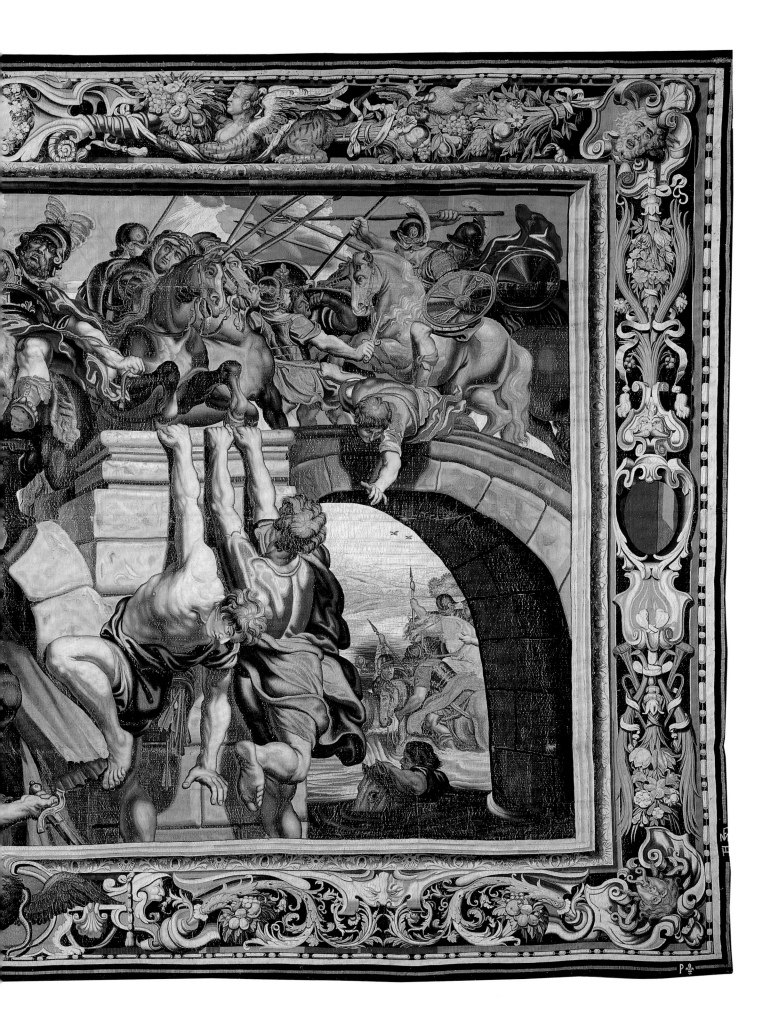

Fig. 79. *The Battle of the Milvian Bridge*, by Peter Paul Rubens, 1622. Modello for the tapestry in the *Story of Constantine*. Oil on wood, 38.3 x 64.5 cm. Wallace Collection, London (520)

to an altogether more sovereign-oriented conclusion to the series.[5] The exact relationship between the *Rome Triumphant* design and the larger series remains to be determined.[6]

The borders on the present tapestry probably record the original framing arrangement. These borders also appear, with the inclusion of armorials in the cartouches, on the set that Louis XIII presented to Cardinal Barberini (Philadelphia), and they correspond to those on the two oldest surviving reeditions of the *Constantine* tapestries in the Mobilier National. Four other border designs are known from different later weavings of the *Constantine* tapestries. None of the surviving modelli for the *Story of Constantine* attributed to Rubens includes borders; he likely did not supply border cartoons, instead leaving the weavers free to arrange locally produced designs. The type of borders on the Philadelphia and Vienna sets can be attributed on stylistic grounds to Laurent Guyot (ca. 1575–after 1644), the Royal Tapestry Cartoonist responsible for some of the cartoons for the *Story of Artemisia* (cat. no. 12), to whom the

borders of the *Story of Diana* (cat. no. 13) have also been attributed. Situated well within the Parisian tradition, the border displays a characteristic decorative vocabulary, with imitation cut leather, foliated scrolls, and cascades of flowers. Medallions reserved for the owner's coat of arms are centered in the vertical borders. The cartouche in the middle of the upper horizontal border contains the chrismon; in the lower border the cartouche has an eagle holding a snake in its beak. Imposing and rather archaic, the border seems not to keep pace with the movement displayed in the central compositions, particularly in the *Battle of the Milvian Bridge*. This kind of border predates Rubens's advances in subsequent tapestry designs, such as the *Triumph of the Eucharist*, in which he liberated himself from the traditional frames that he respected in his *Decius Mus* and *Constantine* series.

Rubens's Designs

Four cartoons, including the one for the *Battle of the Milvian Bridge*, were sent from Flanders to Paris, arriving toward the end of 1622.[7]

A further batch arrived in January 1623. The posthumous inventory of François de La Planche's workshop in the Faubourg Saint-Marcel in 1627 shows that the Paris weavers kept Rubens's twelve modelli as well as the twelve cartoons.[8] The inventory also discloses that, unlike Rubens's other tapestry design campaigns, the cartoons for the *Story of Constantine* were painted in distemper on paper rather than in oil. Reference to the *Constantine* cartoons in Peiresc's correspondence with Rubens reveals that the cartoons were painted not by Rubens but by his workshop assistants. This is reflected in the valuations accorded the works in the 1627 inventory: the twelve small oil modelli were appraised as worth more than double the twelve full-size cartoons on paper.

None of the cartoons has survived, but some of Rubens's initial sketches and all of his modelli for the *Story of Constantine* have. The modello for the *Battle of the Milvian Bridge* is now in the Wallace Collection, London (fig. 79).[9] The modelli were painted in oil on wood panels, in mirror image to the tapestries to

account for the reversal of the image during the weaving process. Comparing the oil sketches with the tapestries shows that the design evolved significantly during the cartoon stage. There was a tendency to fill in the backgrounds, tightening already very dense compositions. For example, the landscape view under the Milvian Bridge in the modello (fig. 79) nearly disappears in the tapestry behind the figures of soldiers and horses battling in the river. Above all, the color is different; the translucent oil glazes could not be replicated in distemper in the cartoons. The tapestries display sharp contrasts and clearly defined shadows, and the saturated reds, browns, and blues of the weavers' usual spectrum are a long way from the light, silvery tones of Rubens's palette.

On November 22, 1622, the *Battle of the Milvian Bridge* was among the cartoons inspected by Peiresc and six public-works court dignitaries. In a letter to Rubens of December 1 that year, Peiresc conveyed their reaction to the artist: "In the large cartoon of the broken bridge, we admired an infinity of things, especially the two human figures hanging by their hands. The wounded man holding on with one hand appeared altogether excellent and inimitable, though a few criticized the proportions of his hanging leg; and the other one, who clings with both hands, was found to be superb. But once again a minuscule flaw was discovered: one leg falls lower than the other. We might have wished you had retouched those two legs with your own hand." Peiresc explained that, although they realized that the cartoons were done by assistants, even so "no painter in France could hope to create such a work."[10]

The paucity of art criticism in France at the time makes this document all the more interesting and important. The experts, no doubt bewildered by a work so different from those they were accustomed to judging, enlarged upon minor points. Rubens's extensive knowledge of the costumes of classical antiquity was particularly lauded, even in the details: the nails in the shoes of the horseman following Maxentius off the bridge, for example, excited their admiration. They focused their praise on the historical, documentary aspect of the cartoons, and explained the subject matter, but seemed oblivious to Rubens's lyricism and the monumentality of his compositions. His naturalism shocked them, and they repeatedly criticized the legs of the human figures, which were judged "distorted" and not consistent with the ancient canon.[11]

Detail of cat. no. 14

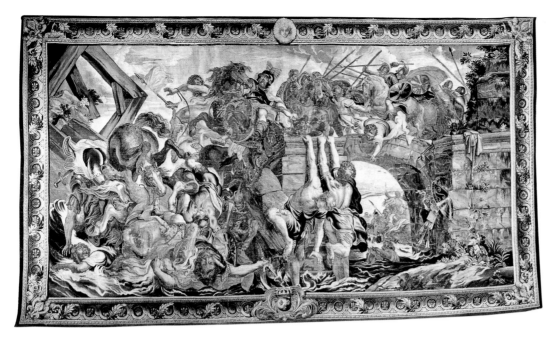

Fig. 80. *The Battle of the Milvian Bridge* from a set of the *Story of Constantine*. Tapestry design by Peter Paul Rubens, 1622, woven in the Faubourg Saint-Germain workshop of Raphaël de La Planche, Paris, ca. 1650. Wool, silk, and gilt-metal-wrapped thread, 460 x 769 cm. Mobilier National, Paris (GMTT 41/4)

Even so, bas-reliefs from classical antiquity and exempla from the Italian Renaissance both served as great inspiration to Rubens.[12] The *Story of Constantine* was the second tapestry series he worked on, after the *Story of Decius Mus*, both characterized by their Roman subjects and a concern for narration. In contrast to Rubens's recent project for a gallery of Maria de' Medici's Palais du Luxembourg, allegorical figures are absent from nearly all the scenes in the *Constantine* series. By its vitality and dynamism, the *Battle of the Milvian Bridge* distinguishes itself from Rubens's other *Constantine* compositions, which unfold in a more classical manner, on a single plane. The *Constantine Defeating Licinius,* in particular, shows a traditional cavalry fight, with the two leaders, surrounded by their troops, facing off directly. It does not have the controlled disequilibrium of the *Battle of the Milvian Bridge,* a tour de force of Baroque design.

The Tapestry Sets
The *Story of Constantine* is always said to have been a great success, an assertion that may need to be qualified. Although most of the sets contain gold thread and have high appraisal values, unlike other Parisian tapestry series they do not seem to have been widely dispersed. The chief client for them seems to have been the king.

Four sets with gold thread were woven at the Faubourg Saint-Marcel manufactory. In 1625 Louis XIII offered the most famous, perhaps the editio princeps, to Cardinal Francesco Barberini, the pope's legate in Paris (see cat. no. 35). It comprised seven pieces with the king's coat of arms (Philadelphia Museum of Art). The selvages of this set bear the P for Paris production, together with weavers' marks including the HT of Jean Tayer, or Hans Taye, director of the *boutique d'or* (gold shop) at the Faubourg Saint-Marcel, and the FM monogram (discussed in catalogue numbers 12 and 13), which has long been misunderstood as the mark of Philip de Maeght, but which was possibly instead a mark associated with the Flemish weavers working at the Faubourg Saint-Marcel. Five complementary tapestries, offered to Barberini about 1630, can no longer be identified.[13] Another splendid set, in eight pieces, retained by the king, was also woven with gilt-metal-wrapped thread and bore the armorials of France and Navarre; it could equally have been the editio princeps. It was sold during the French Revolution and is presumed to have been destroyed.[14]

A third very luxurious set, in nine pieces, had a border with a gold-woven ground. It was appraised at 48,000 livres in the manufactory's inventory of 1627 and was acquired

between that date and 1630 by Antoine Coeffier-Ruzé d'Effiat, superintendent of finance in 1626, marshal of France in 1631, and Henri de Fourcy's brother-in-law. It then became part of the collection of Antoine's son Henri Coeffier-Ruzé d'Effiat, marquis de Cinq Mars, whence it passed to the La Meilleraye family. From there, it went to the home of Cardinal Armand Gaston de Rohan; eight pieces are now preserved in the Château des Rohan, Strasbourg, occupying the places arranged for them in the eighteenth century.[15]

The set now in the Kunsthistorisches Museum, Vienna, of which catalogue number 14 is a part, displays the marks of Paris, Hans Taye, and FM in its selvages. These six tapestries were probably part of the full twelve-piece set mentioned in the 1627 inventory of the Faubourg Saint-Marcel, also included in a list of tapestries offered to Cardinal Barberini but which he apparently chose not to purchase.[16] The dimensions of the documented pieces and the surviving tapestries correspond. These six tapestries and two other hangings from the twelve-piece set were sold by 1635; the remaining four pieces of the set stayed at the manufactory, where they were included in Charles de Comans's 1635 inventory. In 1662 these four hangings were purchased by the king for 6,000 livres and entered the French royal collection.[17]

A *Constantine* set of six pieces was listed in the 1664 posthumous inventory of Charles de La Porte, duc de La Meilleraye (1602–1664), Richelieu's cousin and, through La Meilleraye's first marriage in 1630, son-in-law of the marshal d'Effiat and nephew by marriage of Henri de Fourcy. The six pieces reappear in the 1699 and 1714 inventories of the Palais Mazarin.[18] Also woven with gilt-metal-wrapped thread, the set has the same dimensions as those of the Vienna set. It is tempting to propose that this six-piece set last documented in the Palais Mazarin might be the *Constantine* set now in Vienna.

Four surviving sets of the *Story of Constantine* were woven in the workshop in the Faubourg Saint-Germain, under the direction of Raphaël de La Planche. Three of these were inventoried in the French royal collection and remain in the Mobilier National: one, in twelve pieces woven with gilt-metal-wrapped thread and bearing the king's coat of arms, was purchased

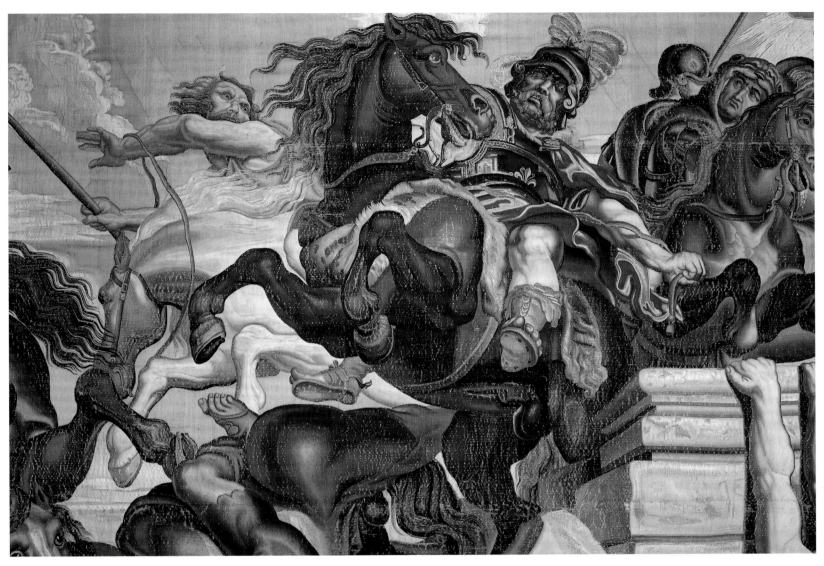

Detail of cat. no. 14

for 31,593 livres in 1667 from Sébastien-François de La Planche;[19] a second, also of twelve pieces woven with gilt-metal-wrapped thread and bearing the king's coat of arms, was in the royal collection by 1701 (see fig. 80);[20] a third was initially a twelve-piece set, of which five tapestries remain in the Mobilier National and six pieces are now at the State Hermitage Museum in Saint Petersburg.[21] They decorated the apartments of Czar Alexander I during the Congress of Erfurt in September and October 1808 and were subsequently given to Count Tolstoy by Napoleon. The twelfth piece of the set, the *Battle of the Milvian Bridge*, has been lost. Finally, a fourth tapestry set, which cannot be linked with any of the known documented sets, also woven at the Faubourg Saint-Germain but smaller in dimensions than the

others, has partially survived: two pieces from it have been on the art market.[22] They have a rich border and, in the corners, putti taken from tapestries by Michel Corneille; they are the only currently identified tapestries from the *Story of Constantine* that are not in public collections. These two pieces and the set shared by the Mobilier National and the Hermitage are the only weavings of the *Constantine* series that do not contain metal-wrapped thread.

The tapestries woven at Faubourg Saint-Germain are noticeably different from those made at Faubourg Saint-Marcel. Since the borders were much narrower, the compositions were extended upward and also widened through the addition of figures, trees, and birds, which gives them a more picturesque look. These modifications may have been the

work of Laurent Guyot, perhaps explaining the seventeenth-century connoisseur Félibien's mistaken attribution of the design of the entire *Constantine* series to Guyot.[23] Not all the changes can be attributed to Guyot, however, since some appear to have come about at a later date. The color scheme was also altered, with less clearly defined colors and subtler shades, although this was not considered detrimental; a 1718 document on the status of the weavers praised the workshop of Raphaël de La Planche for "its very beautiful color scheme, greatly imitating the complexions of Raphael and Rubens."[24]

Commission

The commission for the *Story of Constantine* is usually associated with Rubens's visit to Paris in January 1622 to undertake work for Marie

Detail of cat. no. 14

de' Medici at the Palais du Luxembourg. It remains uncertain, however, whether the *Constantine* cartoons were a royal commission or whether the project was a private initiative instigated by Rubens's Flemish compatriots Marc de Comans and François de La Planche that was then co-opted by the crown.

In support of the second hypothesis, it is known that Rubens had a business relationship with the two weaving entrepreneurs, who by July 1622 owed him 500 livres.[25] Further, some years later, in 1627, the cartoons and sketches for the *Story of Constantine* were still in the possession of François de La Planche, included in his posthumous inventory. Two other pieces of evidence, however, seem to point clearly to Louis XIII's involvement at approximately the same dates. The first is Peiresc's letter to Rubens of December 1, 1622, referred to above, in which he described the receipt of the cartoons in Paris. That it was deemed appropriate that the cartoons be examined by those "whom the king entrusts to inspect public works" suggests that this was a royal commission. In addition, a letter of

February 26, 1626, Rubens wrote to Peiresc's brother, Palamède Fabri de Valaves, complains that he has not been paid "the balance for the tapestry cartoons [he] made in the service of His Majesty"; Rubens's inclination to lay particular blame on Fourcy, superintendent of the Bâtiments du Roi and administrator of the tapestry manufactories, again implies significant royal involvement with the commission.[26]

It seems likely that the *Story of Constantine* did go through the official channels of royal commissions. The manufactory in the Faubourg Saint-Marcel was directly under royal patronage, and cartoons commissioned by the king, most notably those for the *Story of Pastor Fido*, were listed in the 1627 inventory.[27] As Rubens learned to his cost, King Louis XIII was bad at paying his debts; the whole history of the tapestry manufactories is marked by complaints from the entrepreneurs requesting outstanding payments, sometimes going back more than ten years.[28] It is conceivable that Rubens needed payment in order to settle costs with the assistants to whom

he had subcontracted the cartoons; Comans and La Planche might have retained the king's modelli and cartoons as a bargaining tool to ensure payment for their own work or as compensation in case of default of payment.

The choice of Constantinian iconography was particularly appropriate for Louis XIII and his entourage. Even without adopting the proposal by John Coolidge[29] that considers the tapestry campaign a manifesto against Marie de' Medici, with each of the *Constantine* episodes an allusion to a specific event during the king's reign, the choice of the story of Constantine, as first Christian emperor, had political resonance. One of Constantine's perceived modern counterparts was Henry IV, Louis XIII's father, to whom Louis had been devoted. Henry's conversion to Catholicism led to him being celebrated on several occasions as a new Constantine.[30] The commission must also be seen in the context of the eventful history of France in the 1620s. Louis XIII, struggling to gain the upper hand against the rebellion of the Huguenot nobility, undertook several military campaigns in Béarn and Anjou to reestablish the Catholic faith. In 1622 the decrees of the Council of Trent were promulgated in France, putting an end to a dispute with the papacy that had lasted nearly sixty years. That same year Gregory XV founded the Sacra Congregatio de Propaganda Fide (Sacred Congregation for the Propagation of the Faith) and canonized Ignatius of Loyola. Within the context of the Counter-Reformation, the choice of Constantine appears exemplary.

In its potent subject matter, celebrating the divine support granted to temporal powers; in the splendid richness of the weavings; and in the repeated French royal purchase of reeditions, the *Story of Constantine* illustrates the significance that Louis XIII and his court continued to accord to tapestries. Rubens was the first highly admired painter to give models to the Parisian weavers that unequivocally abandoned the Mannerist legacy. Yet it was not from Flanders that the long-awaited revival of French tapestry making would come, but rather from Italy, with Simon Vouet's arrival in Paris in 1627.

ISABELLE DENIS

1. For the sketches and modelli, see Held 1980, pp. 70–85; for Peiresc's correspondence, see Rooses and Ruelens 1887–1909, vol. 2, p. 333, vol. 3, pp. 83–93.

2. See Fenaille 1903–23, vol. 1, pp. 245–55; Göbel 1928, pp. 77–81; Dubon 1964; Coolidge 1966; Held 1980, pp. 65–85; Krüger 1989; Le Pas de Sécheval 1992, pp. 554–63; Van Tichelen 1997; Delmarcel 1999a, pp. 229–30; Merle du Bourg 2004a; Merle du Bourg 2004b; Merle du Bourg in Lille 2004, pp. 279–91, nos. 153–57; Vittet 2004a; Bertrand 2005.

3. Against all likelihood, Fumaroli (1995) identified that horseman as Constantine. This tapestry is the only subject in the series in which the emperor does not appear.

4. The *Annales ecclesiastici* was published in twelve volumes between 1588 and 1607; the story of Constantine is in vol. 3 (1594). Held 1980, p. 70; Jaffé 1989, p. 266; Fumaroli 1995, pp. 89–91.

5. See, for example, Fenaille 1903–23, vol. 1, p. 245, and Held 1980, p. 65.

6. Van Tichelen 1997, p. 60.

7. Rooses and Ruelens 1887–1909, vol. 3, p. 78.

8. Fenaille 1903–23, vol. 1, p. 245.

9. See Held 1980, p. 74, no. 42.

10. Rooses and Ruelens 1887–1909, vol. 3, pp. 83–87; Dubon 1964, pp. 6–7. The identity of Rubens's collaborators is not known; Held (1980, p. 67) suggested that Jacob Jordaens might have contributed. Merle du Bourg (2004a, p. 29) named the individuals witnessing the presentation of the cartoons.

11. Dubon 1964, p. 6; Merle du Bourg 2004a, pp. 91–99.

12. Rubens cited frescoes in the Vatican (by Giulio Romano and Giovanni Francesco Penni in the Sala di Costantino and by Raphael in the Stanza d'Eliodoro) in the arrangement of the two men hanging from the bridge; Giulio Romano and Giovanni Francesco Penni's *Deeds of Scipio* (*Battle of Zama*) for the figure of Maxentius; and Titian's *Battle of Cadore* for the effect of the fight on the bridge; Held 1980, pp. 74–75.

13. No tapestry of the *Story of Constantine* series went to the looms in 1627. The only *Constantine* pieces woven after that date seem to have been four of the five tapestries intended to complete Cardinal Barberini's set, which were offered to the cardinal in 1630; Dubon 1964, p. 13.

14. Fenaille 1903–23, vol. 1, p. 249.

15. Mobilier National, GMTT 42; Fenaille 1903–23, vol. 1, p. 255; Guiffrey 1923, p. 41; Ludmann 1968; Ludmann 1979–80, vol. 1, pp. 14, 288–89, 299; Merle du Bourge in Lille 2004, pp. 282–84, no. 154. In the 18th century, one piece, described as the *Triumph of Constantine*, was cut in two to be displayed in the Cabinet du Roi in the Château des Rohan, on either side of a niche containing a bust of Louis XV. This was *Constantine's Entry into Rome*, now lost, and not the *Battle of the Milvian Bridge*, as Ludmann assumed.

16. Guiffrey 1899, p. 34; Fenaille 1903–23, vol. 1, pp. 250, 255; Guiffrey 1923, p. 41; Dubon 1964, p. 13; J. Coural 1967, p. 20.

17. Vittet 2007, p. 188. The four hangings were listed in the Inventaire général du mobilier de la Couronne of 1663 (no. 28, with gold) and are now in the Mobilier National, GMTT 43.

18. The Palais Mazarin inventories are in the Bibliothèque Nationale de France, Paris, MS NAF 22 876, fols. 60v, 65v. The six pieces in Vienna are the same height as the four in the Mobilier National, and their subjects are complementary.

19. Number 46 in the Inventaire général du mobilier de la Couronne; Mobilier National, GMTT 40; Vittet 2007, p. 187. Errors by Fenaille (1903–23, vol. 1, p. 251) recently repeated by Merle du Bourg (2004b, pp. 16–18) have cast some confusion over the analysis of the tapestry series *Story of Constantine*. The tapestry set GMTT 40 did in fact comprise twelve different pieces. Two hangings, the *Entry into Rome* and *Constantine Worshipping the True Cross*, on deposit at the French embassy in Warsaw, disappeared in 1945.

20. Number 111 in the Inventaire général; Mobilier National, GMTT 41. This set does not have any duplications, contrary to the assertions in Fenaille 1903–23, vol. 1, p. 252, repeated in Merle du Bourg 2004b, p. 18.

21. Number 166 listed in the Inventaire général between 1685 and 1697; five pieces, Mobilier National, GMTT 45; Fenaille 1903–23, vol. 1, p. 253; Biriukova 1961, pp. 36–40; Biriukova 1974, nos. 11–15; Biriukova 1999, pp. 193–95. The dimensions of the tapestries in the Hermitage listed in Biriukova 1974 are not accurate, as the proportions in photographs show. The archival documents cited by Nina Biriukova leave no doubt about the provenance of the set.

22. Jellinek Mercedes sale, American Art Association, New York, February 20, 1926, no. 23; Hôtel Drouot, Paris, June 29, 1998, no. 298. For the borders, see Orléans 2006, p. 127.

23. Félibien 1725, vol. 3, p. 327.

24. "[L]e coloris fort beau, imitant beaucoup les carnations de Raphaël et de Rubens"; Deville 1875, p. 111.

25. Rooses and Ruelens 1887–1909, vol. 2, p. 466–68, vol. 3, pp. 12, 21, 26. See Held 1980, pp. 67–68.

26. "[Q]ue' che hanno carico del Re sopra le opere publiche"; Rooses and Ruelens 1887–1909, vol. 3, p. 85. "[Q]uei cartoni de tapesaria fatti per servicio di Sua Maestà"; ibid., pp. 430–31.

27. Laurent Guyot and Guillaume Dumée, the artists responsible for the cartoons for *Pastor Fido*, were paid by the king, but the cartoons appear in the inventory of 1627, next to those of *Constantine*; Guiffrey 1892, p. 40; Guiffrey 1923, p. 46.

28. For the king's debts, see Guiffrey 1923, pp. 5, 20.

29. Coolidge 1966.

30. On Henry IV as the new Constantine, see Fumaroli 1995, pp. 91–92.

15.
Moses Rescued from the Nile

From a proposed six-piece set of the *Story of the Old Testament*
Cartoon by Simon Vouet, with several collaborators, ca. 1640
Woven in the workshop of Girard Laurent, in the galleries of the Palais du Louvre, Paris, begun before 1643
Wool and silk
495 x 576 cm (16 ft. 2⅞ in. x 18 ft. 10¾ in.)
8 warps per cm
Mobilier National, Paris (GMTT 23/1), deposited at the Musée du Louvre, Paris

PROVENANCE: Commissioned by Louis XIII before 1643; 1663, delivered to the Garde-Meuble de la Couronne; 1666, listed in the Inventaire général du mobilier de la Couronne under no. 20 in the section of "dessorties" tapestries (incomplete sets) in wool and silk; 1797, set aside for the Musée Central des Arts; 19th century, in the collections of the Garde-Meuble; 1907, sent to the Musée du Louvre, Paris.

REFERENCES: Guiffrey 1885–86, vol. 1, p. 370; Guiffrey 1892, p. 17; Paris 1902, no. 26, illus.; Migeon 1909, pp. 304–5, illus.; Guiffrey 1913, p. 36; Migeon 1920, pp. 8–9, illus.; Fenaille 1903–23, vol. 1 (1923), p. 313, illus. facing p. 312; Guiffrey 1923, pp. 17–18; Göbel 1928, p. 53, fig. 30; Migeon 1929, pp. 358–59, illus. p. 361; Paris 1930, no. 73; Niclausse 1938, pp. 35–36; London 1947, no. 74; R.-A. Weigert 1949, pp. 12, 14, 18 fig. 1; Versailles 1967, pp. 64, 66, no. 25 (with bibliography), illus.; Jestaz 1968, p. 133; Thuillier 1984–85, p. 769; B. Brejon de Lavergnée 1987, pp. 67–68, illus.; Lavalle in Paris 1990, p. 506, no. 142, illus.; Cantarel-Besson 1992, p. 104; D. Heinz 1995, p. 123, pl. 8; Lefébure 1995, pp. 143, 182, illus. pp. 141–42, 198; Bertrand in Colorno 1998, p. 31, fig. 1 (reversed); Richefort 1998, pp. 185–86; N. Coural 2001, p. 47, fig. 25; Paris–Geneva–New York 2001, pp. 54–57, fig. 1; Guido 2002, illus.; Coquery in Paris 2002, no. 89, illus.; Le Pas de Sécheval 2002, p. 31; Vittet 2007, pp. 190–91, fig. 12.

The Parisian artist Simon Vouet (1590–1649) spent his early career in Italy where his precocious abilities led to his appointment in 1624 as the president of the Accademia di San Luca in Rome. In 1627 he was summoned back to France by Louis XIII, specifically to paint tapestry cartoons, according to André Félibien's *Entretiens sur les vies et sur les ouvrages des plus excellens peintres anciens et modernes*.[1] He was appointed First Painter to the King, and the commissions he executed for the king and leading members of the court during the following years included a number of tapestry designs which, like his easel paintings and decorative schemes, reflected his profound response to contemporary Italian painting. This influence was manifested in the graceful poses of his figures,

the idealized landscapes in which they were represented, and in his use of vivid colors and novel effects of light and space. Like his successor Charles Le Brun at the Gobelins some years later, Vouet delegated the execution of his tapestry cartoons to a team of skilled French and Flemish cartoonists, some specializing in figures, others in landscapes and border design. Their combined efforts ensured the visual richness and design quality of the final product. With its harmonious combination of richly costumed figures—reminiscent of those of Paolo Veronese—deep landscape, and decorative border, *Moses Rescued from the Nile* typifies Vouet's best work in tapestry.

Description and Iconography

Moses Rescued from the Nile relates an episode in the Old Testament (Exodus 2:5–10), in which the pharaoh had ordered all male children of the Hebrew people to be drowned in the Nile, and Moses's mother, Jochebed, to spare her child, laid him in a basket and put it in the river. The pharaoh's daughter, who went to the Nile to bathe with her friends, saw the baby and took pity on him. She rescued Moses and, through the intercession of Moses's sister, she unknowingly entrusted him to his own mother as his nurse. It is the moment of discovery that is depicted in the tapestry, though the abundant vegetation and the elements of classical architecture hardly evoke an Egyptian context. The pharaoh's daughter, richly attired, wears a long blue mantle.

The sumptuous border, imitating gilt stucco decoration on a blue ground, is filled with grotesques, medallions with male or female profiles, and cartouches supported by cupids. The cartouches contain, in the upper border, the coats of arms of France and of Navarre; in the side borders, the monogram (L) of King Louis XIII; and in the lower border, a club, the king's emblem, and his motto, ERIT HAEC / QVOQVE COGNITA / MONST[R]IS (They will be recognized, them also, with their brilliant deeds). The cast-shadow effects, evident throughout the border, confer a striking impression of relief.

Moses Rescued from the Nile is one of two pieces in an unfinished set, the second being the *Daughter of Jephthah* (fig. 81). The inscription accompanying six engravings by François Tortebat, executed in 1665 after scenes of the Old Testament by Vouet (Bibliothèque Nationale de France, Paris), provide evidence that these two weavings were the only elements executed of a six-piece set that remained unfinished. The engravings are, in addition to *Moses Rescued from the Nile* and the *Daughter of Jephthah*, the *Sacrifice of Abraham*, *Samson at the Philistines' Banquet*, the *Judgment of Solomon*, and *Elisha Receiving the Mantle from Elijah*. Five engravings are inscribed *Simon Voüet in. pinxit*, while the sixth, the *Samson* engraving, is additionally inscribed *Regiorum peristromatum apparatus a Simone Voüet Inventus, et Ludovici XIII Regis Christianissimi jussu, decorandae Luparae depictus* (Plan for royal tapestries conceived and painted by Simon Vouet by order of the most Christian king Louis XIII to decorate the Louvre), which indicates that this tapestry project—no doubt as well as the others—was commissioned from Vouet by Louis XIII for the Palais du Louvre. The religious nature of the subjects suggests a liturgical destination for the tapestries. Jacques Lemercier, architect to the king, had put a chapel on the main floor of the Large Pavilion (now the Pavillon Sully) that he built between 1639 and 1642 on the Cour Carrée of the Louvre, but he was uncertain whether the *Old Testament* tapestries were destined to be hung in that sanctuary because its interior walls were embellished with bays and niches that were incompatible with the display of tapestries.[2] The royal commission of this series has recently been interpreted as a metaphor for the divine influence guiding monarchical power. Thus, *Moses Rescued from the Nile* symbolized Divine Providence; the *Judgment of Solomon*, Divine Justice; *Samson at the Philistines' Banquet*, Divine Power; in the *Daughter of Jephthah*, Jephthah rending his garments stood for Divine Wrath; the *Sacrifice of Abraham*, submission to the will of God; and *Elisha Receiving the Mantle from Elijah* represented Piety.[3]

Date and Artists

Vouet's original cartoons for the *Story of the Old Testament* have disappeared, and information concerning their date of execution is sparse and imprecise, particularly since royal record keeping was irregular throughout Louis XIII's reign. In addition, the few surviving drawings related to the tapestry series are not dated. The inventory taken after the death of Virginia da Vezzo, Vouet's first wife, of his lodgings and workshop in the Louvre in 1639, lists "a large painting serving as a tapestry design, in which the story of Samson is represented, painted on canvas."[4] Clearly linked to the *Story of the Old Testament*, this inventory entry suggests that the cartoons for the series were under way at that date, but since the other subjects are not mentioned, it is not clear whether those cartoons had already been delivered, or whether they had not yet been executed. Circumstantial evidence for the former likelihood is provided by the fact that at the time, the king owed Vouet the very large sum of 10,690 livres "for tapestry designs, oil and tempera."[5] This payment may have pertained to the *Old Testament* series, since the other tapestry cycles Vouet conceived were either already on the looms (*Rinaldo and Armida*, *Loves of the Gods*) or the replicated mural decorations executed about 1634–35 (*Story of Ulysses*, *Theagenes and Chariclea*).[6] The inventory taken after the artist's death in 1649 lists the cartoons for *Samson* and *Elijah*[7] but not the four other *Old Testament* cartoons. At that date, those four cartoons might again have been in the Louvre workshops of the weavers assigned to that set. A probable terminus ante quem for the *Moses* cartoon is provided by Louis XIII's death in May 1643 and the likelihood that work on the present tapestry had either been completed or was in an advanced state of completion by that date. (Had weaving been interrupted at an earlier stage, and only restarted in the 1660s shortly before the eventual delivery of this piece to the royal wardrobe, one would expect the armorial cartouches to have been adapted for Louis XIV. In addition, the heavy, ornate style of the border is consistent with Vouet's work in the 1640s.)

Twenty-one known drawings by Vouet related to the six subjects in the *Old Testament* series attest to his role in creating the designs for these tapestries.[8] All depict human figures, such as the two studies of attendants to the pharaoh's daughter for *Moses Rescued from the Nile* (fig. 82).[9] Nonetheless, according to Félibien, Vouet did "tapestry designs that he had executed either in oil or in tempera," which suggests that he did not paint the car-

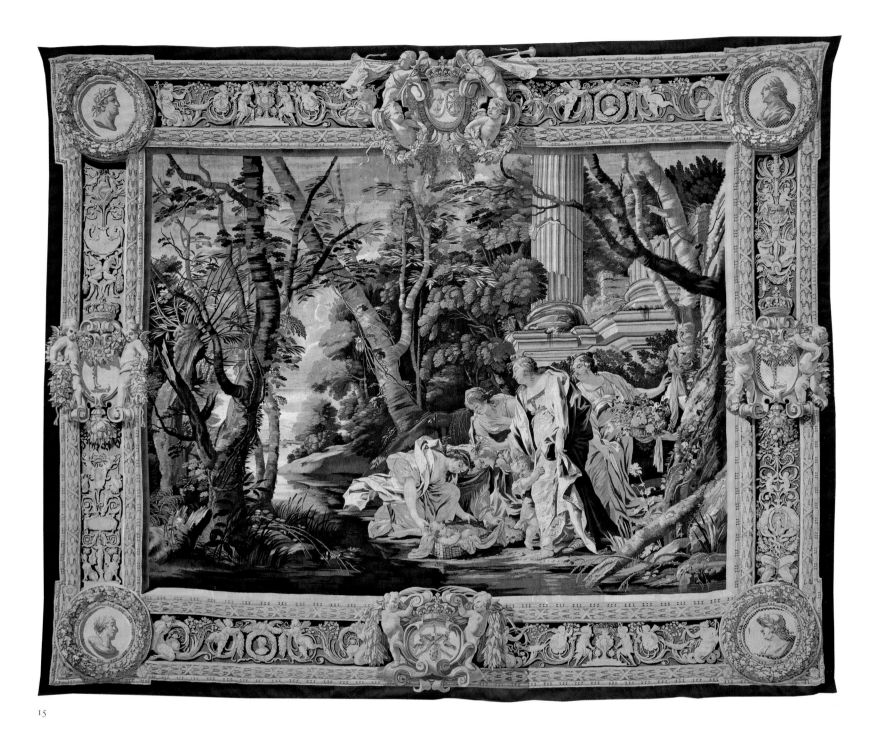

15

toons himself but that work was done by his collaborators. Félibien went on to say that when Vouet "had to do patterns for tapestries in every kind of style, he also used several painters to work in accordance with his designs, on the landscapes, the animals, and the ornaments. Of them, I can name for you Justus van Egmont and Vandrisse, both Flemish; Scalberge, Pastel, Belin, Vanboucle, Bellange, and Cotelle."[10] The name of the landscape painter François Bellin (d. 1661) stands out here, for he seems to have painted the forest surrounding the figures in *Moses*.

Indeed, among Vouet's papers at the time of his death was a memorandum dated 1648 and headed "Ouvrage faict par Monsieur Belin pour Monsieur Vouet" (Work done by M. Bellin for M. Vouet).[11] Vouet may have turned to Jean Cotelle (1607–1676) for help with the borders for the royal set of the *Story of the Old Testament*, but a drawing by Vouet, attributed to the 1640s, of two studies for one of the putti with the cartouche in the lower border suggests otherwise.[12] Vouet was also the author of *Livre de diverses grotesques* (Book of Various Grotesques), engraved by Michel

Dorigny (1647), and some of its plates display ornaments suggestive of those that appear in the tapestry border.[13]

Weavings and Collections
The date at which work commenced on Louis XIII's set of the *Story of the Old Testament* is undocumented, and the earliest record of their existence is provided by the treasury accounts of 1663, when three tapestries—*Moses Rescued from the Nile*, *Jephthah*, and a piece of the *Story of Rinaldo and Armida*—were delivered to the king. The

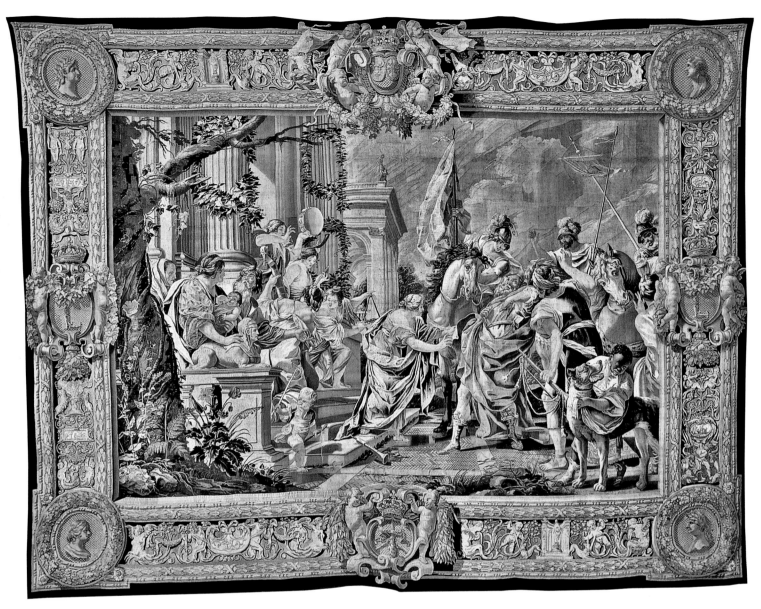

Fig. 81. *The Daughter of Jephthah* from a set of the *Story of the Old Testament*. Tapestry design by Simon Vouet, woven in the Louvre workshop, Paris, begun before 1643. Wool and silk, 480 x 595 cm. Mobilier National, Paris (GMTT 23/2)

director of one of the two workshops of the Louvre manufactory, Girard Laurent the Younger (ca. 1588–1670), received 2,520 livres in payment for that "piece of tapestry representing *Moses Found on the Nile*, measuring five and a quarter ells across by four ells high, making twenty-one square ells at 120 livres per ell [a French ell measured 118.8 cms], these three pieces of tapestry being provided by them in the service of His Majesty and taken on his order to the Garde-Meuble de la Couronne."[14] In light of contemporary developments at the Gobelins manufactory, it seems highly unlikely that the two *Story of the Old Testament* tapestries had been woven in their entirety by Laurent at Louis XIV's command, and much more likely that this payment

reflects the conclusion of a project that had been interrupted by Louis XIII's death twenty years before.

Other than the two pieces commenced for Louis XIII, the first documented weavings of the *Story of the Old Testament* were undertaken in 1644, according to two contracts commissioning them. Although the artist who produced the cartoons is not named in either contract, the subjects listed in the documents allow a certain identification with the series created by Vouet. The first contract of June 20, 1644, is for a six-piece set to be woven in the Faubourg Saint-Marcel workshop for Jacques-Auguste de Thou: "Present in his person was the nobleman Alexandre de Comans, director of the manufactories of the

king's tapestries, residing in the Faubourg Saint-Marcel of Paris in the Hôtel des Canayes, known as the Gobelins, Saint Hippolyte parish. He contracted with, did and does promise to M. Jacques-Auguste de Thou, adviser to the king in his councils and in his court of the Parlement de Paris, residing there in his home on the rue des Poutremis, Saint-André-des-Arts parish, hereby agreeing to provide and deliver to him, on the first day of the coming November, a tapestry set of Holy History containing six pieces of various widths, eighteen ells across or thereabouts by two and seven-eighths ells high. The first of these pieces, on which the Story of Samson will be represented, will measure five ells across, the second, Jephthah, four and a half ells, the third, the

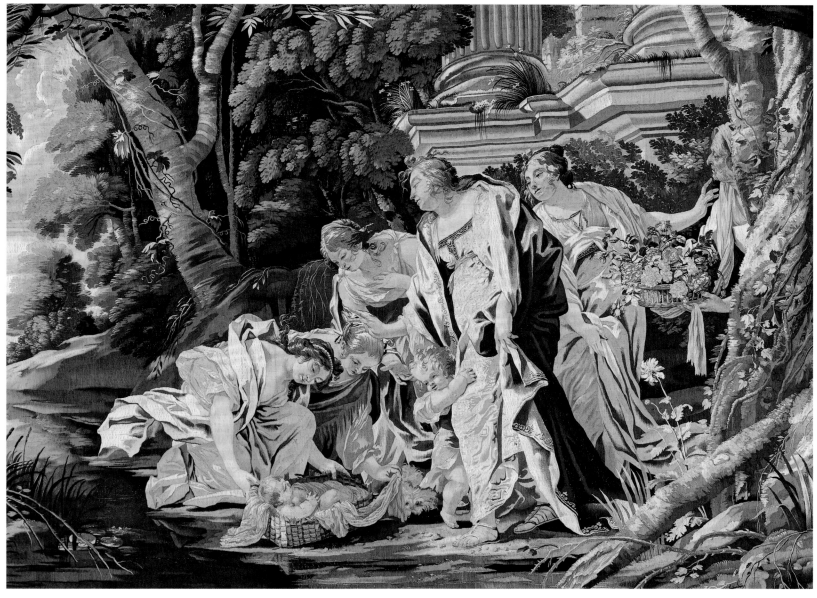

Detail of cat. no. 15

Birth of Moses, two and three-quarters ells, the fourth, the Judgment of Solomon, three and a quarter ells, the fifth, the Story of Lot, one and a half ells. The sixth, the Story of Abraham or of Judith, at M. de Thou's discretion, will be one and a quarter ells wide. The aforesaid tapestry set will be of the same fineness, quality, and manufacture as the first piece of Samson, the largest piece in the set, which he has already delivered to M. de Thou. That contract is concluded in exchange for the price and sum of one hundred and five livres tournois per square ell."[15]

The second contract, of August 27, 1644, is also for a six-piece set, this one for Jean de Choisy:[16] "Present was the nobleman Alexandre de Comans...who contracted

with, did and does promise to the high and powerful Seigneur Jean de Choisy, regular adviser to the king in his councils and in the chamber of his royal highness, residing in Saint-Germain-des-Prés in Paris, on the rue de Vaugirard, Saint-Sulpice parish, hereby agreeing to provide and deliver to him on the last day of next November, a tapestry set of Holy History containing six pieces of various widths, in all sixteen ells across or thereabouts by three and a quarter ells high. The first of these pieces, which will represent the Judgment of Solomon, will measure four and seven-eighths ells, the second, Jephthah, four ells, the third, the Birth of Moses, two and five-eighths ells, the fourth, the Sacrifice of Abraham, two and five-eighths ells. The fifth,

which will be an *entrefenêtre*, will represent Elijah in the chariot of fire and will be one and a quarter ells. The sixth will also be an *entrefenêtre* and will similarly measure one and a quarter ells across. The aforesaid tapestry set will be of similar fineness, quality, and manufacture as the first piece from the Judgment of Solomon, the largest piece of the tapestry set, which he has already delivered to M. de Choisy. That contract is concluded in exchange for the price and sum of one hundred and five livres tournois per square ell."[17]

In addition to the securely dated sets woven for Jacques-Auguste de Thou and Jean de Choisy in 1644 (delivered with incredible speed after the signing of the contract—four and three months, respectively, although in

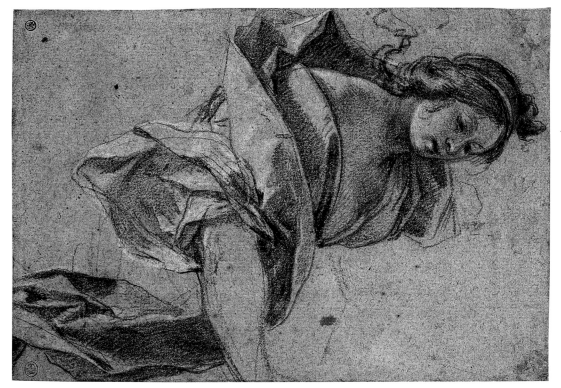

Fig. 82. *Study of a Woman*, by Simon Vouet, ca. 1640. Black chalk with white highlights, 14.5 x 20 cm. École Nationale Supérieure des Beaux-Arts, Paris (M. 1280)

both cases it was indicated that the largest piece was finished before the contracts were signed), a fourteen-piece set was woven at the Louvre for Michel Particelli d'Hémery, superintendent of finance in 1647. It passed to his daughter Marie and was described at her death in 1672 as "A high-warp tapestry set from the galleries of the Louvre containing fourteen pieces measuring thirty-eight ells across by three and two-thirds ells high, each piece containing a story from the Old Testament, including the Judgment of Solomon, Lot, Samson, Jephthah, Elisha, Rachel, Elijah, and others, whose border has a yellow background"; it was appraised at 14,000 livres.[18] Jules Guiffrey mentioned an eight-piece set of the *Old Testament* by Vouet that had belonged to the duc de La Meilleraye (1664) and was also very tall (416 cm).[19] It is also to be noted that at his death in 1683, the painter Benoît de Savoye owned four *Old Testament* tapestries with borders with corner medallions.[20]

Extant Weavings

Although there are no other known tapestries with borders identical to those on the royal weavings of *Moses* and *Jephthah*, several pieces with very similar borders, also imitating stuc-

cowork and with medallions containing male or female profiles in the corners, are known.[21] Even more numerous are the *Old Testament* tapestries of Vouet's designs that have borders filled with garlands of flowers and numbers of children supporting cartouches, placed both at the corners and in the center of the borders.[22] That same border is also found on an *Esther and Ahasuerus*, a previously unknown subject, whose high-quality composition may have been produced by a student in Vouet's workshop.[23] Weavings of *Abraham* and *Elijah* at the Mobilier National have borders that include both medallions in the corners and cupids, offering a synthesis of the two types of borders.[24] Rare as well in this series is a border of foliate scrolls with acanthus leaves, designed by Jean Cotelle (drawing, Ashmolean Museum, Oxford), which appears on a *Samson* (State Hermitage Museum, Saint Petersburg),[25] a *Moses*,[26] the right-hand part of *Elijah* (formerly in the Galerie Chevalier, Paris), and yet another with *Eve and Her Children* (Detroit Institute of Arts). An *Old Testament* tapestry set in seven pieces (including four *entrefenêtres*), currently in Poitiers (Direction Régionale des Affaires Culturelles du Poitou) but originally from the Château de Roquesérière near

Toulouse,[27] has a heavy border of flowers with baskets or goblets. A narrow piece of *Abraham* from the collections of the Château de La Roche-Guyon has a still different border, with children, garlands, and blue ribbons,[28] which matches a horizontal piece, *Daughter of Jephthah* (location unknown).

Two tapestries with borders on yellow grounds, seen in public sales, may have belonged to the sets woven for Particelli or La Meilleraye.[29] An *Old Testament* set, certainly after Vouet, belonged to the minister Henri-Auguste de Loménie, comte de Brienne (1595–1666), or to the administrator of Limousin Mathias Poncet (d. 1693), at his residence on the rue des Francs-Bourgeois in Paris.[30]

Since most of the extant pieces do not have workshop marks, it is difficult to know where they were woven. A few of them, however, have the mark of the Amiens workshop (A fleur-de-lis), founded in 1604 by Marc de Comans and François de La Planche, or that of Alexandre de Comans (AC), active between 1635 and 1650, or of Raphaël de La Planche (R), the last operating in the Faubourg Saint-Germain in Paris from 1633.

JEAN VITTET

1. "Le Roy ayant résolu de se servir de luy [Simon Vouet], tant pour les Peintures necessaires à faire dans ses Maisons Royales, que pour la conduite des patrons de Tapisserie ausquels Sa Majesté vouloit que l'on travaillast; Monsieur de Bethune alors Ambassadeur à Rome eût ordre au commencement de l'année 1627 de le faire partir pour venir en France" (The king having resolved to use his services as much for the paintings needed in the royal houses as for making tapestry cartoons that His Majesty wished him to work on, Monsieur de Béthune, then ambassador to Rome, ordered [Simon Vouet] to leave for France at the beginning of 1627); Félibien 1685–88, vol. 2, p. 184.
2. A. Gady 2005, p. 375.
3. Bertrand 2005, p. 51.
4. "[U]ng grand tableau qui sert pour desseing de tapisserie où est représenté l'histoire de Sanson, pint sur thoille, sans bordure, prisé la somme de deux cens livres tournois"; Archives Nationales (hereafter AN), Paris, Minutier Central des Notaires (hereafter MCN), VII, 28, January 31, 1639; Brière 1951, p. 143.
5. "Plus déclare ledict sieur Vouet qui luy est deubd la somme de deniers pour ouvrages cy-après mentionnez, sçavoir: par le Roy, pour desseins de tapisserye, huille et destrempe, dix mil six cens quatre vingts dix livres"; AN, MCN, VII, 28, January 31, 1639; Brière 1951, p. 168.
6. Denis in Chambord 1996, pp. 158, 173; Thuillier in Paris 1990, pp. 120–21; Lavalle in Paris 1990, pp. 519–20.
7. "209. Item deux grands desseints de tapisserie peints sur thoille dont l'ung est l'histoire de Sanson et l'autre d'Hélie, prisez L livres"; AN, MCN, L, 30, July 3, 1649; J. Coural 1967, p. 23; A. Brejon de Lavergnée 2000, p. 266, no. 209.

8. B. Brejon de Lavergnée 1987, pp. 61–69, nos. 28–39 and XVIII–XXIV, illus.; B. Brejon de Lavergnée in Paris 1990, pp. 376–77 no. 75, illus.; Munich 1991, no. 3, illus.

9. One drawing is at the École Nationale Supérieure des Beaux-Arts, Paris (M. 1280); Paris–Geneva–New York 2001, pp. 54–57, illus. The other is at the Louvre; B. Brejon de Lavergnée 1987, pp. 67–68, no. 37, illus.

10. "[D]es desseins de Tapisserie qu'il faisoit executer, tant à huile qu'à détrempe"; "faisoit faire des patrons de Tapisserie de toutes sortes de façons, il employoit encore plusieurs Peintres à travailler sous ses desseins, aux païsages, aux animaux, & aux ornemens. Entre ceux-là, je puis vous nommer Juste d'Egmont & Vandrisse Flamans; Scalberge, Pastel, Belin, Vanboucle, Bellange, Cotelle"; Félibien 1685–88, vol. 2, pp. 185, 189.

11. A. Brejon de Lavergnée 2000, p. 283, no. 47.

12. The studies are on a single sheet at the Louvre (RF 28212); B. Brejon de Lavergnée 1987, p. 68, no. 38, illus.

13. Mérot 1992, pp. 563–72, illus.

14. "[P]ièce de tapisserie représentant *Moyse trouvé sur les eaues* de cinq aunes un quart de cours sur quatre aunes de haut faisans XXI aunes en carré à six vingts livres l'aune, lesquelles trois pièces de tapisserie ont esté par eux fournies pour le service de Sa Majesté et portées par son ordre au garde-meuble de la Couronne"; Bibliothèque Nationale de France, Paris, Manuscripts, Mélanges Colbert 267, fols. 28r–v; Vittet 2007, pp. 190–91.

15. "Fut présent en sa personne noble homme Allexandre de Comans, directeur des manufactures des tappisseryes du roy, demeurant au fauxbourg Sainct-Marcel-lez-Paris en l'hostel des Canayes dit des Gobelins, parroisse Sainct-Hipolite, lequel a faict marché, promis et promet à messire Jacques Auguste de Thou, conseiller du roy en ses conseilz et en sa cour de parlement à Paris, y demeurant en son hostel rue des Poutremis, paroisse Sainct-André-des-Artz, à ce présent et acceptant, de luy fournir et livrer dans le premier jour de novembre prochain venant, une tanture de tappisserye de l'Histoire Saincte contenant six pièces de diverses largeurs, de dix-huit aunes de cours ou environ sur deux aunes trois quartz et demy de hault, la première desquelles pièces où sera représenté l'Histoire de Sanson contiendra cinq aulnes de large, la seconde Jesveté quatre aulnes et demye, la troisième la Naissance de Moyse deux aulnes trois quartz, la quatrième le Jugement de Salomon trois aulnes un quart, la cinquième l'Histoire de Loth une aulne et demye, et la sixième l'Histoire d'Abraham ou de Judith, au choix dud. Sr de Thou, aura une aulne un quart aussi de large, laquelle tanture sera de pareille

finesse, bonté et fabrique que lad. première pièce de Sanson qui est la plus grande pièce de lad. tanture qu'il a desjà livrée aud. sieur de Thou, ce marché faict moyennant le prix et somme de cent cinq livres tournois pour chacune aulne quarrée"; AN, MCN, LXXIII, 375. The contract with de Thou came to a total of 5,676 livres; Denis (in Chambord 1996, pp. 158–59) proposed that that weaving was the one Fenaille (1903–23, vol. 1, pp. 316–17, illus.) indicated was in the collection of Edward Lawton. The piece with *Judith and Holofernes* was woven after Peter Paul Rubens. With thanks to Isabelle Denis for her help.

16. Jean de Choisy owned a set of *Rinaldo and Armida*, after Vouet; Lavalle in Paris 1990, pp. 512–18, nos. 145–48, illus.

17. "Fut présent noble homme Alexandre de Comans... lequel a faict marché, promis et promect à hault et puissant seigneur messire Jean de Choisy, conseiller ordinaire du roy en ses conseilz et chambre de son altesse royale, demeurant à Sainct-Germain-des-prez-lez-Paris, rue de Vaugirard, paroisse Sainct-Sulpice, à ce présent et acceptant, de luy fournir et livrer dans le dernier jour de novembre prochain, une tanture de tapisserie de l'Histoire Saincte contenant six pièces de diverses largeurs, le tout de seize aulnes de cours ou environ sur trois aulnes ung quart de hault, la première desquelles pièces où sera représenté le Jugement de Salomon contiendra quatre aulnes trois quartz et demy, la seconde Jesveté quatre aulnes, la troisième la Naissance de Moyse deux aulnes et demyes demy quart, la quatriesme le Sacrifice d'Abraham deux aulnes et demye demy quart, la cinquième qui sera une entrefenestre où sera représenté Hélye dans le chariot de feu contiendra une aulne ung quart, la sixième qui sera aussy une entrefenestre contiendra pareillement une aulne ung quart de cours, laquelle tanture sera de pareille finesse, bonté et fabrique que lad. première pièce du Jugement de Salomon qui est la plus grande pièce de lad. tanture qu'il a desjà livrée aud. Sr de Choisy, ce marché faict moyennant le prix et somme de cent cinq livres tournoiz pour chacune aulne quarrée"; AN, MCN, LXXIII, 376.

18. "Une tanture de tapisserie de haulte lisse des galleries du Louvre contenant quatorze pièces faisant trente huict aulnes de cours sur trois aulnes deux tiers de hault dont chaque pièce porte son histoire de l'Ancien Testament et entre autres le Jugement de Salomont, Loth, Sanson, Jefthé, Elizée, Rachelle, Hélie et autres, dont la bordure est à fondz jeaune"; Fenaille 1903–23, vol. 1, p. 313; Vittet 2004c, p. 174. The set was also in the inventory of Marie Particelli's husband, Louis Phélypeaux de La Vrillière, which in addition listed a *Sacrifice of Abraham*.

19. Guiffrey 1899, p. 34.

20. These were described by Guiffrey (1892, p. 109) as "Une tenture de tapisserie des Gobelins, à personnages, faisant 17 aunes [20.23 m] de cours sur 3 et ¼ [3.87 m], en quatre pièces, la première est l'Histoire de Sanson, la seconde l'Histoire de Jephté, la troisième le Jugement de Salomon, la quatrième Moyse exposé; dans la bordure sont des médailles aux coings; prisé 2000 livres" (A tapestry set from the Gobelins with human figures, measuring 17 ells across by 3 and ¼, in four pieces. The first is the Story of Samson, the second the Story of Jephthah, the third the Judgment of Solomon, the fourth Moses Exposed; the border has medallions in the corners; appraised at 2,000 livres).

21. Estate of the comte de Chaudordy, sale, Hôtel Drouot, Paris, halls 5 and 6, April 20–23, 1903, nos. 405, 406 (*Solomon, Jephthah, Moses Rescued from the Nile*, this piece illus.); no. 405 also included a fourth subject, *Eve and Her Children*, the design of which cannot be attributed to Vouet; Fenaille 1903–23, vol. 1, pp. 316–17; *Solomon* illus. facing p. 314. *Moses* was resold at the Galerie Charpentier, Paris, March 20, 1953, no. 123, illus.; *Eve* was resold at the Hôtel Drouot, hall 6, November 17, 2000, no. 207, illus. And the estate of Lottin de Laval, sale, Château des Trois-Vals in Menneval, near Bernay, May 17, 1903, *Samson* (illus.) and *Jephthah. Samson*, undoubtedly the same one that was in the Laval sale, was resold in Nantes on November 15, 2005.

22. For example, an *Abraham*, with the coat of arms of the comtes de Vertus, Musée du Louvre, Paris; Lefébure 1995, p. 182, illus. And weavings of *Solomon* and *Samson*, sale, Sotheby's, London, October 3, 2006, nos. 249, 250, illus.

23. This tapestry, on the San Francisco art market about 1988, was identified by Isabelle Denis, for which we thank her. There is a second weaving of the right half of *Esther and Ahasuerus*; photo at the Mobilier National, Paris, Braquenié collection.

24. Versailles 1967, pp. 64, 65, no. 24, illus.

25. Whiteley 2000, p. 100, no. 267, illus.; Denis 1996a, pp. 36–38, illus.

26. Sale, Hôtel Drouot, Paris, halls 5 and 6, March 29, 1985, no. 106, illus.

27. Lavalle in Chambord 1996, pp. 143–53, illus.; Bertrand 1999, p. 95.

28. De Reyniès 1999, pp. 22–25, fig. 9, which lists all the tapestries on this subject.

29. *Moses*, Hôtel Drouot, Paris, hall 12, May 31, 1967, no. 159, 410 x 300 cm, illus.; the left part of *Abraham*, Christie's, London, November 10, 2005, no. 166, 416 x 270 cm, illus.

30. Guiffrey 1892, p. 18; Béchu 1992, p. 238.

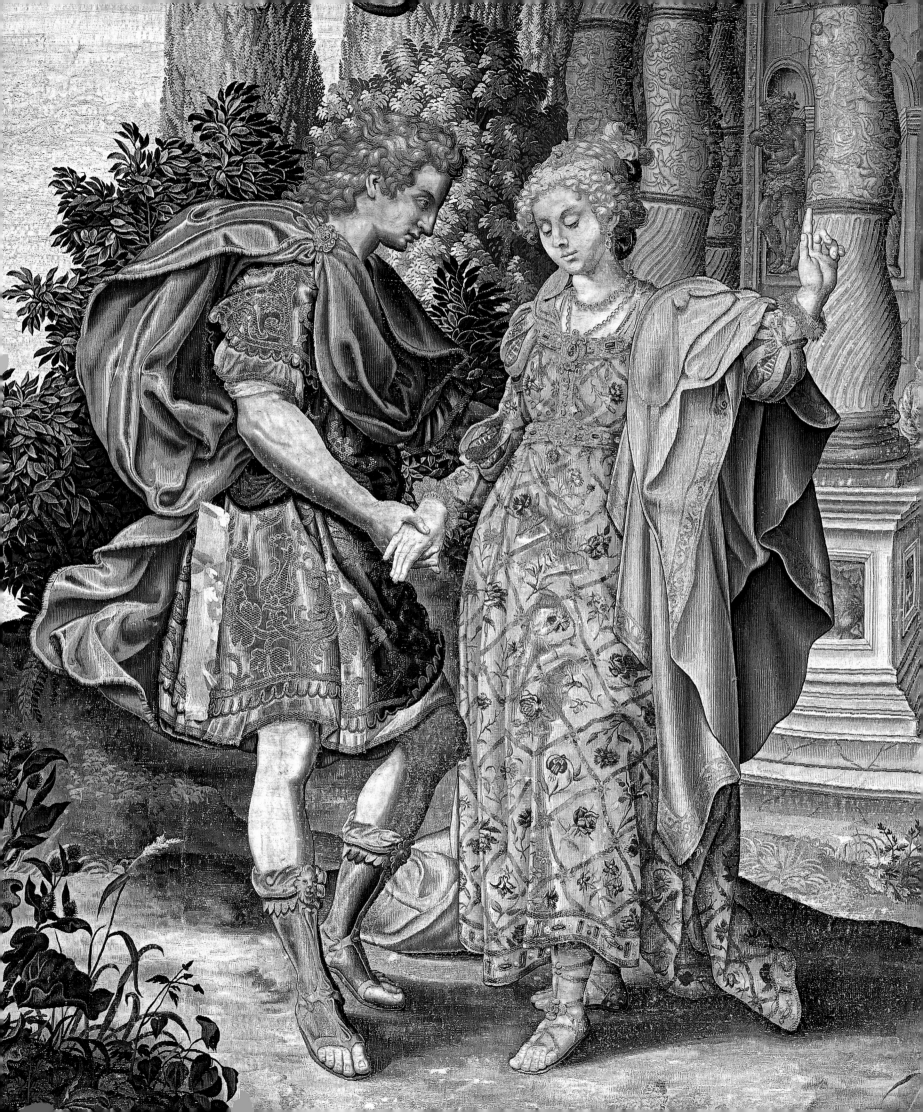

The Mortlake Manufactory, 1619–49

WENDY HEFFORD

When James VI of Scotland (1566–1625) became James I of England on the death of Queen Elizabeth in 1603, he inherited with his second kingdom a vast collection of tapestry hangings amassed by his predecessors. Tapestries noted in the inventory of Henry VIII[1] can be detected again one hundred years later among the goods of James's heir, Charles I, sold or retained for the Commonwealth's use by Parliament after the execution of the king in January 1649.[2] Although King James had no great need to add to the royal collection, he nevertheless impressed by the success of Henry IV of France in establishing a flourishing tapestry industry at Paris, accepted proposals from Sir Francis Crane for setting up a manufactory in England[3] and assisted the enterprise financially. An initial royal grant in 1619 and one in 1623, after Crane had complained to the king that he so far had invested 16,000 pounds of his own money for only 2,500 pounds' return,[4] were followed in January 1625 by a substantial promise of 1,000 pounds a year "to contribute towards the maintenance and settling of the Manufacture of Tapestries which . . . S[i]r ffrancis Crane by his Ma[jes]ties Com[m]andment, and at his owne charge did lately bring into this kingdome."[5]

Crane, owner of the manufactory rather than director, as he was later called, served Charles Prince of Wales as his auditor-general from 1617.[6] Appreciative of all forms of art, the prince may have been the catalyst bringing Crane and King James together to create the manufactory. An enthusiastic purchaser of tapestry, Charles advanced 2,000 pounds for the first set of *Vulcan and Venus*, woven between September 16, 1620, and June 5, 1622, and another 1,000 pounds in 1623 toward a set of the *Months*, which he gave to the Duke of Buckingham. In March 1625 he owed 6,000 pounds for three sets rich with gold.[7] Charles also purchased designs, most famously bringing seven of Raphael's cartoons for the *Acts of the Apostles* from Genoa,[8] and secured the services of Francis Clein (1582–1658), who became resident designer at Mortlake. As king, Charles confirmed his father's

annual 1,000 pounds subsidy for ten years, spent lavishly on tapestry, and, after Sir Francis died in 1636, acquired the Mortlake manufactory from Crane's brother Richard, making it "The King's Works."

Encouraged by James I's first grant, on August 11, 1619, Sir Francis purchased land and two houses on the south bank of the Thames in Mortlake, Surrey, about eight miles from the cities of London and Westminster. This important date is known only from information given concerning disputed ownership, noted by Parliament's surveyors in 1651 when they made a detailed description of the property.[9] Above accommodation for weavers on the ground floor were two workshops, containing in total eighteen looms, and a large room for the "limner" to paint tapestry-sized cartoons. On a third floor were other sizable rooms. Before civil war in 1642 ended royal payments and restricted sales, there may have been more looms in operation; the Mortlake manufactory, however, was never on the scale of the industry in Paris.

Tapestry weavers for Mortlake came mainly from the Spanish Netherlands, whose ambassador in London, already alarmed in November 1619, wrote in November 1620 of whole families leaving the archduchy, with fifty individuals, including some "principal masters," settled at Mortlake.[10] Most of these were from Brussels, where the magistrates suspected that they were being recruited by James I's resident diplomatic agent,[11] a detail confirmed by Crane's letter of thanks to that agent, William Trumbull, on October 20, 1620.[12] Some weavers with Flemish names, however, possibly came to Mortlake from Paris with Philip de Maeght, who became Crane's director of workshops and weavers. He had been *maître de la boutique d'or* (director of the workshop weaving tapestry with gold thread) in the Faubourg Saint-Marcel, according to an inventory taken in 1627 of that manufactory's assets, which included De Maeght's record books.[13] At Mortlake, De Maeght also noted weaving costs for every set made, with dates when begun and completed—

Fig. 83. Detail of cat. no. 17, *Meeting at the Temple of Venus* from a set of *Hero and Leander*

Fig. 84. *Vulcan's Forge* from the *Story of Vulcan and Venus*, with arms of the king of Sweden and the Marquis of Buckingham. Tapestry based on mid-16th-century Brussels tapestry, the borders after Henri Lerambert, ca. 1602–6, woven at Mortlake, 1622–23, for George Villiers, Marquis of Buckingham. Wool, silk, and gilt-metal-wrapped thread, 436 x 332 cm. The Royal Collections, Stockholm (H.G.K. 55)

all now lost, except for details of the first set of *Vulcan and Venus* tapestries fortuitously preserved to support a claim that Sir Francis had overcharged Prince Charles.[14] De Maeght's importance to the manufactory is shown in the provision there of a "Master Workman's house"; in his denization in 1625; and in the inclusion of his monogram (PDM overlapping, sharing the first upright) along with that of Sir Francis Crane (FC superimposed) on Mortlake tapestries. A third mark, the red cross on a white shield of Saint George, England's patron saint, has frequently been termed "the Mortlake mark," but it actually indicates manufacture in England rather than at Mortlake in particular.

English clergyman and author Thomas Fuller (1608–1661) wrote of the Mortlake tapestry works that "Here they only imitated Old Patterns, until they had procured one *Francis Klein* a *German* to be their Designer."[15] All three series—the *Story of Vulcan and Venus*, the *Months*, and the *Queen of Sheba*—that are known to have been in production by 1623[16] came from sixteenth-century

designs for Brussels tapestries. As Crane in 1622 was trying (unsuccessfully) to purchase from a Brussels workshop cartoons by Giulio Romano for the *Fructus Belli* series,[17] he may previously have acquired original cartoons for these three Mortlake series, although *Vulcan and Venus* could have been copied from Henry VIII's set of *Vulcanus Mars and Venus*, which was new in 1548.[18] De Maeght's accounts tell us that the borders of the first set of *Vulcan and Venus* woven at Mortlake contained "stone heads," probably from designs for a Brussels border like those on five *Vulcan and Venus* tapestries of the 1540s–50s now at Biltmore House, North Carolina.[19] Borders on a Mortlake set (fig. 84) completed in 1623 for the Marquis, soon to be the Duke, of Buckingham, and to a lesser extent those on a second set made for the Prince of Wales, with his insignia (fig. 85), contain elements copied from border designs of about 1602–6 by Henri Lerambert that were used on the French tapestries of Coriolanus and Artemisia.[20] These designs were probably obtained through Philip de Maeght, who may also have brought a dyer from Paris, given the similarities of coloring in early Mortlake and Faubourg Saint-Marcel tapestries.

No earlier equivalents of two *Queen of Sheba* tapestries with Buckingham's arms, or their borders, have yet been found, but their style is close to other Brussels series of the mid-sixteenth century. The Mortlake *Occupations of the Months* share some figures and settings with a seventeenth-century series of designs woven by the Leyniers family of Brussels,[21] which in turn, and with at least two changes of background, were based on sixteenth-century Flemish tapestries in borders dating from the 1520s.[22] Nonetheless, the Mortlake version seems to have come more directly from a lost version of finer quality from the 1530s–40s. All these designs relate to calendar months in illuminated manuscripts and may have been based on the work of Simon Bening (1483/4–1561).[23] It is not known whether the 40 pounds paid by Prince Charles to Abraham van Blyenberch in August 1620 for a cartoon of the month of December was for this series.[24] The only surviving set of Mortlake *Months* is in Genoa,[25] with the arms of De Franchi, a Genoese family, replacing those of the original owner (fig. 86); it was made for John Williams, bishop of Lincoln and Keeper of the Great Seal before he lost that office in 1625.[26] By 1625 at least three sets of *Vulcan and Venus* had been woven, one of the *Queen of Sheba*, and two of the *Months*. When he became king, Charles owed Crane for two further sets with gold (besides the *Vulcan and Venus* set with his insignia, fig. 85), and by then Crane had also exported three unnamed sets of tapestry through the East India Company.[27]

Fig. 85. *Neptune and Cupid Plead for the Release of the Lovers* from the *Story of Vulcan and Venus*. Tapestry based on mid-16th-century Brussels tapestry, the borders partly after Henri Lerambert, ca. 1602–6, woven at Mortlake, ca. 1620–25, for Charles, Prince of Wales. Wool, silk, and gilt-metal-wrapped thread, 450 x 579 cm. Victoria and Albert Museum, London (T.170-1978)

Francis Clein at Mortlake under Sir Francis and Richard Crane

Fuller's account of Clein's visit to England in 1623, invited by Prince Charles (unfortunately then in Spain), and sent back to Denmark with a letter dated July 8, 1623, from King James requesting his services for the prince, ended: "But the K. of *Denmark* detained him all that summer (none willingly part with a *Jewel*) to perfect a piece which he had begun for him before. This ended, then over he comes, and settled with his Family in *London*, where he received a *Gratuity* of an hundred pounds *per annum*, well paid him, until the beginning of our Civil Wars."[28] The date of "that summer" is uncertain, as Christian IV paid Clein in September 1624 for two views of Copenhagen.[29] By 1625 Clein was well established in England, denizened in May along with Philip de Maeght. A bill of extremely varied work for Charles I, including seven months with two assistants spent painting the Queen's Closet and possibly other rooms at Somerset House in the Strand, was headed "March A[nn]o 1625," date of

the king's accession to the throne.[30] By November 1625 Clein's family was in Mortlake, where his son Francis was baptized.[31]

Clein created at least three complete series of tapestry designs for Mortlake; two, the *Senses* and *Hero and Leander*, in the later 1620s; and one, the *Horses*, about 1635. He was also employed to provide several adaptations of and additions to older series, accurate copies of paintings, and many border designs of outstanding quality. His most popular series was *Hero and Leander* (cat. no. 17). This was probably designed shortly after a set of grotesques of the *Senses* in sixteenth-century style, for Charles I's first order to pay for tapestry after his accession included two sets of "Crotesco" to one of *Hero and Leander*, purchasing a second set of the latter the following year. These two series have stylistically similar borders, which include curving, club-shaped, monochrome pendants of close-packed leaves and flowers that taper toward ribbons attached to pierced strapwork. In the only surviving set of the *Senses*, at Haddon Hall,

Fig. 86. *March–April* from the *Occupations of the Months*, with arms of Gio. Andrea De Franchi. Tapestry based on 16th-century designs, woven at Mortlake, ca. 1624–25, for John Williams, bishop of Lincoln. Wool, silk, and gilt-metal-wrapped thread, 330 x 475 cm. Palazzo Bianco, Genoa (P.B. 1908)

Derbyshire,[32] this strapwork forms grotesque masks at the corners (fig. 87). A border of about 1635 for Clein's series of the *Horses* (cat. no. 18) survives intact only on a later set of *Alexander* tapestries (fig. 97). There, high on the sides, ribbon ties on leaf-and-flower pendants of the same type appear through symmetrical scrollwork and form grotesque faces. After Clein's death in 1658, some sets of the *Horses* reused vertical border designs of the 1620s *Senses* in combination with horizontal borders of lesser quality (fig. 96).

Superbly decorative borders contributed greatly to the appearance of Mortlake tapestry. To designs of the 1620s and 1630s that were conceived as three-dimensional carved frames through which the scene would be viewed, Clein added in the later 1630s and early 1640s more fashionable options based on monumental architectural forms: an architrave supported on columns (fig. 92) or on elegant terminal figures (fig. 90), linked beneath by a simple sill. These were perhaps inspired by Italian tapestries of the sixteenth century that Clein might have seen while

studying in Italy. An alternative influence possibly came from Rubens's border designs featuring columns for the *Triumph of the Eucharist* tapestries woven by 1628,[33] or from his *Achilles* series, designed about 1630–35, which utilized terminal figures to separate the scenes. Nineteenth- and early twentieth-century writers stated that Rubens's *Achilles* tapestries were designed for Charles I, but later studies have refuted this assumption.[34]

Clein's facility for creating new designs did not end the use of older patterns. In the seventeenth century a copy of a work of art lacked the negative connotations it holds today and might even have been sought out at considerable expense. Charles I's sculptor, Hubert le Sueur, was employed in France for four months to bring back "Moulds and patterns of sundry figures and antiques there."[35] Daniel Mytens, the king's picture drawer, was paid 120 pounds for "a Coppye of Titians great Venus,"[36] and among royal possessions to be sold after the execution of Charles I were copies by Rubens of Titian's paintings *Diana and Acteon* and *Diana and Calisto*.[37] The latter, valued at

Fig. 87. *The Sense of Smell* from a series called *Crotesco* (Grotesque). Tapestry design by Francis Clein, woven at Mortlake, ca. 1625–35. Wool, silk, and gilt-metal-wrapped thread, 350 x 457 cm. The Duke of Rutland, Haddon Hall

30 pounds was probably the model for the tapestry noted in the same sale as valued at 420 pounds[38] that had cost the king 504 pounds in 1636.[39] Another work by Titian copied at Mortlake was the *Supper at Emmaus*, one of the paintings purchased by Charles I from the Gonzaga collection at Mantua in 1627. The earliest surviving tapestry version, bearing the marks of Crane and De Maeght, is at St. John's College, Oxford. Francis Clein prepared cartoons for such copies, and also for woven contemporary portraits after Anthony van Dyck, of which two survive: a double portrait at Knole, Kent, of Endymion Porter and Van Dyck himself, after the painting now in the Prado, Madrid, and a fine portrait of Sir Francis Crane wearing the badge of Chancellor of the Order of the Garter (fig. 88).

The Acts of the Apostles: Sir Francis Crane and Sir James Palmer

Mortlake's most famous "old patterns" were Raphael's cartoons of 1515–16 for the *Acts of the Apostles* (cat. no. 16), seven of which Prince Charles was arranging to purchase in 1623. His wish to employ Clein at that time may have stemmed from an intention to preserve the original cartoons by having them copied for use in the manufactory. Clein's bill headed March 1625, passed for payment in April 1631, contained as items six

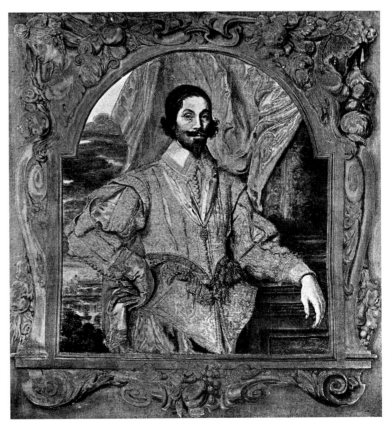

Fig. 88. Tapestry-woven portrait of Sir Francis Crane, from a cartoon after Van Dyck, woven at Mortlake, ca. 1626–36. Wool, silk, and gilt-metal-wrapped thread, 157.5 x 140 cm. Lord Petre, Ingatestone Hall

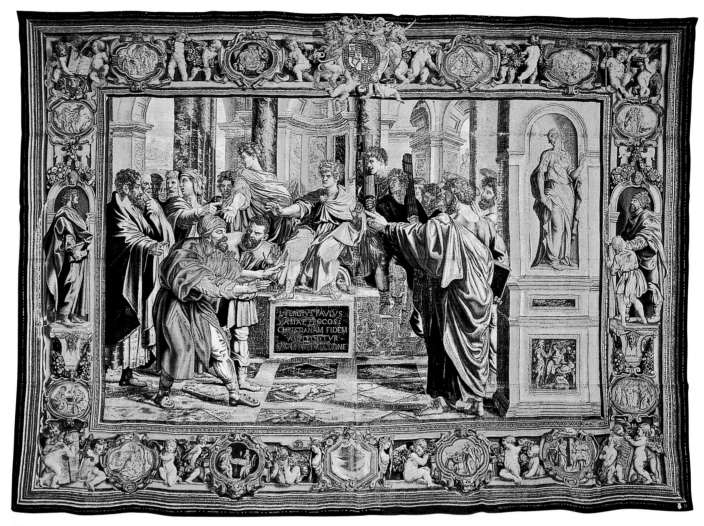

Fig. 89. *The Blinding of Elymas* from the *Acts of the Apostles*, with arms of Charles I. Tapestry design by Raphael, 1515–16, the part beyond the figures at right and the border designed by Francis Clein, ca. 1630–34, woven at Mortlake, ca. 1631–36. Wool, silk, and silver and gilt-metal wrapped thread, 538 x 713 cm. Mobilier National, Paris (GMTT 16/3)

and seven "The Apostle piece of Ananias" (70 pounds) and "The greate border about it with his Ma[jes]ties Armes" (40 pounds); item fourteen, the last, being "The Apostle piece of Elymas" (60 pounds).[40] Clein's copy of the *Death of Ananias* cost more than that of the *Blinding of Elymas* because Raphael's cartoon for *Elymas* then lacked the vertical strip depicting an architectural feature seen at the right of Brussels *Elymas* tapestries. Instead of copying this missing feature from Henry VIII's set of the *Acts of the Apostles*, the decision was taken to commission a new design, presumably by Clein, for the Mortlake series. This depicts an elegant statue above a low-relief scene of the martyrdom of Saint Paul (fig. 89). A new border design was also needed, since Mortlake's editio princeps bearing the royal arms was to have distinctly different borders for each subject, apart from three unifying elements: the royal arms, supporters, and four putti with the regalia above; the cartouche for inscriptions below; and the moldings that frame the whole (compare fig. 89

and cat. no. 16). No bill or payment is known for copying Raphael's other five cartoons owned by Charles I, or for any additions to them, or for border designs other than that of *Ananias*. Possibly it was agreed at some time in the 1630s that the series should become available for general sale after the first set had been made for the king, burden of payment for the working cartoons therefore being transferred to Sir Francis, whose records do not survive.

The *Ananias* border, having in the lower corners seated figures of Ananias and his wife, Sapphira, both struck down for withholding money from the apostles, would have been equally appropriate for an eighth subject, the *Death of Sapphira*, woven only at Mortlake. No piece of *Sapphira* in the special border survives. Creation of this eighth scene presumably followed a failed attempt in 1627 to obtain copies of Raphael's missing cartoons, the *Conversion of Saint Paul* and the *Stoning of Saint Stephen*, thought to be owned by Cosimo II of Tuscany.[41] A

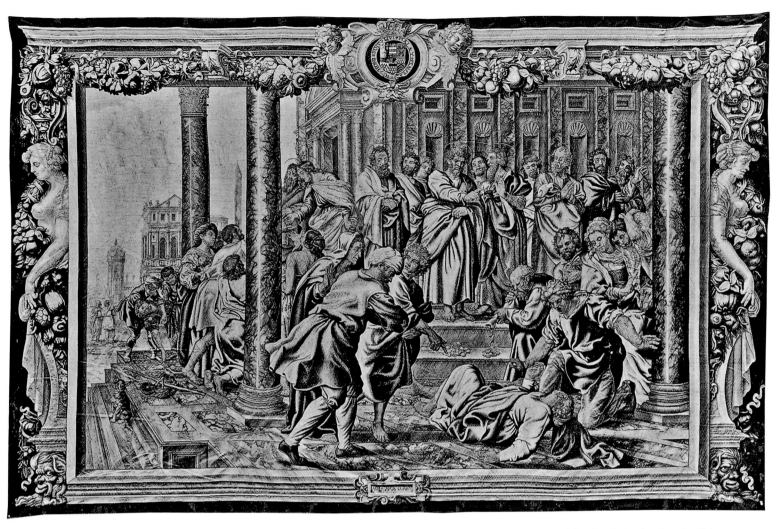

Fig. 90. *The Death of Sapphira* from the *Acts of the Apostles*, with arms of Philip Herbert, Earl of Pembroke. Tapestry and border design by Francis Clein, ca. 1628–35, woven at Mortlake, ca. 1636–37. Wool and silk, 432 x 648 cm. The Duke of Buccleuch

warrant of July 19, 1628, to the keeper of the standing wardrobe at the Tower of London to deliver to Sir Francis Crane, "A peece of Hangings of ye story of Acts of ye Ap[ost]les . . . Ananias or any other peece which hee shall desire,"[42] suggests that Henry VIII's tapestry of *Ananias* was needed either to check against dubious details in Raphael's cartoon, or else to assist Clein when he was working on the *Sapphira* design (fig. 90), which features some figures—grouped apostles, dying sinner, and three of the same foreground characters reacting—posed with reference to Raphael's *Death of Ananias* (fig. 92).

The *Acts of the Apostles* tapestries made for Charles I (cat. no. 16) represent the apogee of Mortlake production. Before his set was complete, another was begun with the same individually designed borders, differing only in changing the red ground to gold, and in providing four new putti supporting a cartouche that encloses a blue cabochon as replacement for the royal arms with attendant figures. Crane's pride in these two sets of tapes-

tries shows in the incorporation of his own coat of arms,[43] tiny by comparison with the king's, beneath the inscription cartouche in the lower border. Sadly, Sir Francis died in June 1636 having seen few subjects of the series woven. Of the extant *Acts*, only pieces of the *Death of Ananias* and the *Blinding of Elymas* are marked with Crane's monogram, found on these two subjects both in the royal sets and in a five-piece set bearing the arms of Philip Herbert, Earl of Pembroke, now at Boughton House, Northamptonshire (fig. 90). The *Blinding of Elymas* with the blue-cabochon-and-gold-ground border, still in the royal collection, has lost Crane's monogram[44] but retains his arms. This *Elymas* tapestry was recorded as already delivered to the king in a list of gifts made by Richard Crane to Charles I in 1637, which also noted a *Death of Sapphira* about to be returned from Spain,[45] so both tapestries were complete in 1636–37. *Sapphira* may therefore have been a third subject to have borne Crane's mark and arms, especially if Richard Crane

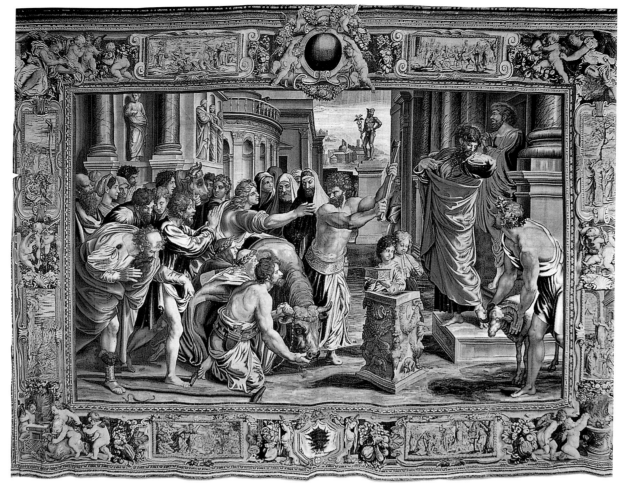

Fig. 91. *The Sacrifice at Lystra* from the *Acts of the Apostles*. Tapestry design by Raphael, 1515–16, border by Francis Clein, probably ca. 1638, woven at Mortlake, ca. 1638–39. Wool, silk, and silver and gilt-metal-wrapped thread, 530 x 715 cm. Mobilier National, Paris (GMTT 17)

continued to use his brother's mark until the king acquired the manufactory. As no more than three subjects of the series could have been completed in Sir Francis's lifetime, it is no wonder that the artist Orazio Gentileschi, commenting in October 1636 on the fine tapestries of this series being woven at Mortlake, wrote of the king's possession of a set in the future tense.[46]

The identification of a monogram replacing that of Sir Francis Crane on all of the other subjects in the Mortlake *Acts of the Apostles* proves that they were woven in the period of royal control of the manufactory. The mark in question was repeatedly published by W. G. Thomson as PS, although Jules Guiffrey in 1913 correctly catalogued it as incorporating the letter I (also used for J) in the upright of the P.[47] Thomson suggested that PS possibly stood for either Peter Schriver or Paul van den Steen,[48] both of whom were recorded in Mortlake parish records from the 1620s; neither weaver, however, was of sufficient importance to be among the Mortlake tapestry makes with whom Charles I contracted for future production in June 1638.[49] Only in 1991 was the monogram, with component let-

ters possible to be read in any order, identified as that of Sir James Palmer (1584–1657), "Governor of his Majesty's Tapestry Works at Mortlake."[50] Contemporary incorporation of initial letters of honors into a monogram can be seen in a valence, embroidered between 1631 and 1640, that has not only SCC, for Sir Colin Campbell, but also DIC for his wife, Dame Juliana.[51] Incontrovertible evidence that Sir James used the SIP mark can be found on the *Miraculous Draft of Fishes* (cat. no. 16) and the *Charge to Peter* in the royal set of the *Acts*, where the monogram and arms of Palmer[52] replace those of Sir Francis Crane.

Sir James was acting as governor of the tapestry works by July 1637, when he presumed to challenge the right of the master of ceremonies to present tapestries to an ambassador.[53] His mark appears on five pieces of the royal *Acts* (see cat. no. 16); on the only surviving piece of the four tapestries in the comparable border with blue cabochon and gold ground that Cardinal Mazarin and Louis XIV acquired (fig. 91); on all seven tapestries with the arms of the Earl of Holland (fig. 92) that are now in

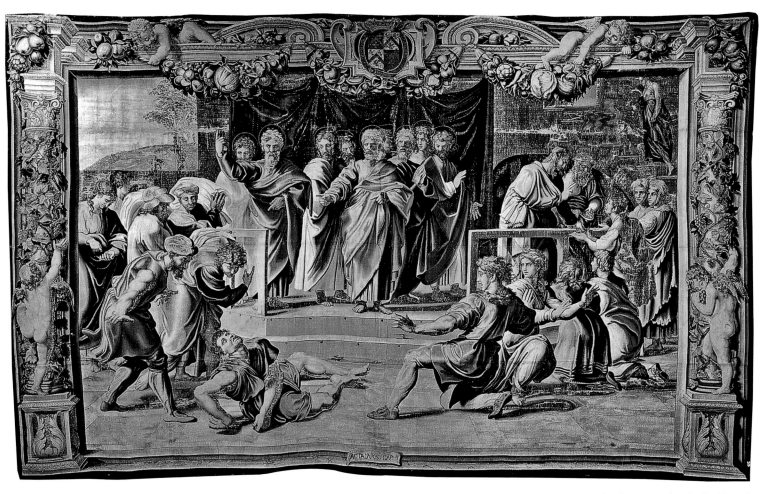

Fig. 92. *The Death of Ananias* from the *Acts of the Apostles*, with arms of Henry Rich, Earl of Holland. Tapestry design by Raphael, 1515–16, border by Francis Clein, ca. 1630–36, woven at Mortlake, ca. 1637–39. Wool, silk, and gilt-metal-wrapped thread, 410 x 630 cm. Mobilier National, Paris (GMTT 19/6)

the Mobilier National, Paris; on three pieces of Pembroke's set of five now at Boughton House (*Sapphira* [fig. 90], *Christ's Charge to Peter*, and the *Miraculous Draft of Fishes*); and on the three subjects missing from Pembroke's set, in the same border as his tapestries that are now in the Palazzo Ducale, Urbino, with the arms of Mazarin.[54]

The King's Works, Civil War, Decline and Survival of the Mortlake Manufactory

Charles I had intended to purchase the tapestry works from Richard Crane. On March 17, 1637, warrants were issued from the Privy Council to make valuations for that purpose.[55] Ensuing negotiations terminated in a settlement more advantageous to the king, who by a warrant dated June 7 purchased only three partly woven sets of tapestries then on the looms and a stock of silk and wool for weaving.[56] Richard Crane gave him buildings, looms, cartoons, and also tapestries from the incomplete set of *Acts* with the blue-cabochon-and-gold-ground border.[57] These concessions were not, as has been suggested, to

cancel out a debt of 3,141 pounds, 7 shillings, and 9 pence owed by Sir Francis to the king[58]—that sum was audited in November 1636 as owed to Sir Francis by the king to repay 5,000 pounds that Crane had paid into the Exchequer at 8 percent interest[59]—but presumably Richard Crane's gift recognized past royal financial assistance to the manufactory as well as current benefits allowed to him.[60]

Delay in signing an indenture of June 1638 between Charles I and six leading tapestry makers at Mortlake may have been influenced by the loss of Philip de Maeght, who was not included. He was dead by April 1640.[61] Possibly, too, Crane was still employing some weavers to finish commissioned sets that had been partly paid for, while others worked for the king. The indenture, incorporated in full in Sir James Palmer's accounts of 1637 to 1641,[62] regulated annual payments of 2,000 pounds for given amounts of tapestry categorized by content of gold or silk at fixed prices for the Flemish ell.[63] Clein was included in this agreement, his 100 pounds gratuity and piecework payments for designs and cartoons commuted to 250 pounds a

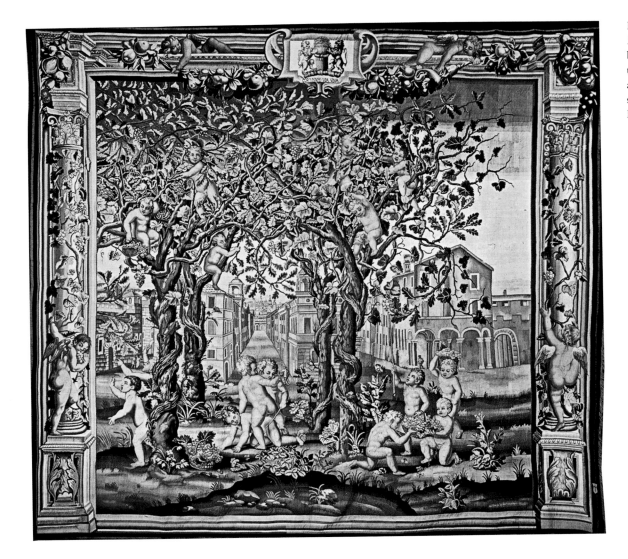

Fig. 93. *The City* from the *Naked Boys*. Tapestry copied ca. 1637–39 by Francis Clein from a Brussels tapestry design of the 1550s, woven at Mortlake, ca. 1650–70. Wool and silk, 406 x 427 cm. The Burghley House Collection, Stamford

year, out of which he might employ an assistant. Palmer's first quarterly payment to the weavers from Exchequer funds was made retrospectively for tapestry worth 500 pounds delivered before May 8, 1638.[64] Other funds available earlier to Palmer included money received in January 1638 from sale to the Earl of Pembroke of the five early Mortlake *Acts of the Apostles* now at Boughton.[65]

Most of the tapestry woven in this period continued to be based on sixteenth-century designs, although with more adaptation than was found in the closer copies of the 1620s. One contemporary artist other than Clein may have provided designs. According to Abraham van der Doort's catalogue of Charles I's works of art, compiled about 1637–39, the king sent to Mortlake through Palmer five drawings from eight presented by Orazio Gentileschi.[66] Nothing more, however, is known of these. An oil sketch by Van Dyck (now in the Ashmolean Museum, Oxford) of the king and the Knights of the Garter in procession on Saint George's day was also catalogued by Van der Doort.[67] This much published and exhibited sketch[68] has nat-

urally been associated with a scheme said to fail through prohibitive cost, recorded in Giovanni Pietro Bellori's *Life* of Van Dyck, to create a set of hangings commemorating the ceremonies of the Order of the Garter for Whitehall, which Sir Kenelm Digby attempted to negotiate between artist and king.[69] Bellori, however, may have mistaken the medium. Van der Doort, who was well informed concerning the connection of other works of art with Mortlake, called Van Dyck's sketch merely "a model for a bigger piece"; and Horace Walpole, in his *Anecdotes of Painting*, described this sketch as part of a plan, proposed through Digby, to paint the walls of the Banqueting House in Whitehall. The design, moreover, would have been impracticable to weave, with lifesize figures occupying under one third of the height.

Strongly dependent on sixteenth-century designs were seven pieces of a set "called ye Naked boyes" valued at 1,377 pounds in the inventory of the late king's goods.[70] That set has not survived, but its designs, except for one tapestry of which only the upper half remains,[71] are reproduced in later sets found

at Boughton House,[72] Burghley House, Belvoir Castle, and Holyrood Palace.[73] These show the *Naked Boys* to have been based on two series of *Puttini* made for members of the Gonzaga family: one series from designs by Giulio Romano woven about 1539–45 in the Mantua workshop of Nicolas Karcher, the other a Brussels series of the 1550s from the workshop of Willem de Pannemaker, which has backgrounds that include Italianate buildings.[74] Although each of these sixteenth-century series features boys picking fruit and playing in and around decoratively grouped trees, their designs and styles are completely different. Giulio Romano's designs are of poetic, watery landscapes with varied fruit trees and many different creatures, besides sensuous putti. Two pieces of the hybrid Mortlake series have similar trees and backgrounds featuring graceful but wingless boys, some copied from the Italian designs, others supplied in emulation by Clein. Other Mortlake pieces contain in their upper halves less attractive boys picking grapes among branches of the oak trees that occur in all six pieces of the more prosaic Brussels series, three of these copying the whole composition of the Brussels subjects now known for identification as the *Goat*, the *Hare*, and the *City*.

Some figures in the 1550s Brussels series have an earlier source[75]—an engraving by the Master I.B. dated 1529[76] presenting twenty children filling a vat with grapes and playing, grouped in one long frieze. From this engraving come three boys playing in the center of the *City*; three boys with a goat and a platter of grapes in the *Goat*; two boys carrying a third at the right of the *Dance*; and, in the *Winepress*, the nine boys filling the vat with grapes, and a boy stooping far left. At Mortlake, these figures from the 1520s appear in two copied Brussels subjects, the *City* (fig. 93) and the *Goat*. One subject of Mortlake's *Naked Boys*[77] also copies almost exactly the whole frieze of children in the engraving, plus a few additional figures. One addition is a boy in a tree urinating, differing in design from those similarly occupied in the *Puttini* series. His presence in the tapestry and the unusually large number of children involved suggest that the immediate source of the Mortlake cartoon was not the 1529 engraving but a related painting owned by Charles I. It is recorded in Abraham van der Doort's catalogue that the king personally delivered to Sir James Palmer, to be sent to Mortlake as a pattern for hangings, a painting attributed to "Michaell Coxsee or the Sotecleaf" (Joos van Cleef) depicting some twenty-two children with a goat, one boy up a tree "pissing down."[78]

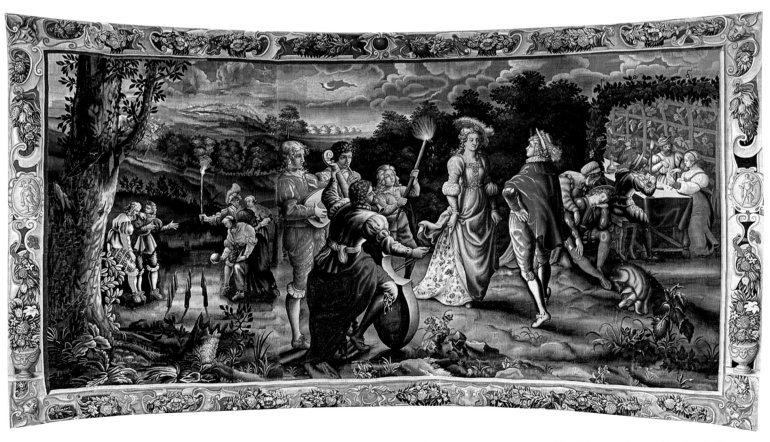

Fig. 94. *The Evening Entertainment* from the *Hunters' Chase*. Tapestry design by Francis Clein, ca. 1637–40, woven at Mortlake, ca. 1645–75. Wool and silk, 335 x 620 cm. Musée d'Art et d'Histoire, Brive-la-Gaillarde, France

Another Mortlake series mixing sixteenth- and seventeenth-century designs is the *Hunters' Chase*, which has five tapestries that are based on scenes in the *Hunts of Maximilian*, designed by Bernaert van Orley about 1531–33,[79] and four that are the work of Francis Clein.[80] His contributions to this series are among Clein's most attractive tapestry designs, as can be seen from the central section of a tapestry at Brive-la-Gaillard, France (fig. 94), which has later additions at the sides and in the horizontal borders. This series was extremely popular, pieces surviving from at least eight different sets, most of which were woven later in the century. In 1878 Alphonse Wauters wrote of a *Hunts of Maximilian* in the French Garde-Meuble that bore the mark of Sir Francis Crane.[81] Although no such tapestry appears in Guiffrey's inventory of 1913, it is possible that Crane was making the series before 1637. Cartoons existed in the impoverished Mortlake manufactory to make a set of the *Hunters' Chase* in 1645 (see below). A tapestry of the *Boar Hunt* acquired by the Victoria and Albert Museum in 2002 has an architectural border with terminal figures of different design to those in Clein's border on Pembroke's *Acts of the Apostles* of the 1630s, but of the same quality. At Chatsworth House, Derbyshire, is a set possibly woven in the later 1640s, having a slightly deteriorated version of the border on the Earl of Holland's *Acts* sold in 1639 (fig. 92).

Edith Standen discovered that the *Hunters' Chase* tapestry of *News of the Stag*, after the piece *July* in the *Hunts of Maximilian*, was adapted not from the Brussels tapestry in the Louvre but from one of the twelve drawings of that series also preserved there.[82] This is also the case with other pieces of the *Hunters' Chase*. It is possible that Charles I owned the drawings, which might have been purchased in the sale of his possessions by the collector Everard Jabach, who sold them to Louis XIV.

Six paintings acquired by Charles I in 1637, friezes *all'antica* of winged and wingless boys, nymphs, and satyrs by Polidoro Caldara, called Polidoro da Caravaggio (d. ca. 1543), were also adapted by Clein, who added landscapes and adjusted the placement of some of the figures to form a scene rather than a frieze. Later tapestries known as *Polidore* were popular after the restoration of the monarchy in 1660, Charles II purchasing a set in 1667–68 from his yeoman arrasworker, Francis Poyntz. Clein's hand in the series might not have been detected from the surviving examples of lesser quality made by Poyntz but for the existence of paintings in his style decorating the cove of the ceiling in the Green Closet at Ham House, Surrey, based on Polidoro's figures and displaying landscapes related to but differing from the later tapestries. These paintings in the cove are in tempera on paper, as were tapestry cartoons. It has therefore been questioned whether they might be the original cartoons of the *Polidore* series, as none are listed at Mortlake in 1651.[83] Yet they fit too well the relatively low height of the cove and angles of the chimney breast, suggesting that they were painted specifically for that location, though presumably adapted from Clein's cartoons for the series.

Other Mortlake cartoons that existed in this period are also missing from the parliamentary list of reserved items. It does not include seven cartoons of the story of *Dido and Aeneas*, which Nicholas Mortlet, usually employed to clean pictures and gild frames, had been sent to Flanders to purchase before June 1641, when Sir James Palmer was authorized to sell existing hangings in order to reimburse Mortlet.[84] Given Charles I's appreciation of sixteenth-century tapestry design, these cartoons were possibly used at Brussels to weave the *Dido and Aeneas* tapestries designed by Perino del Vaga for Andrea Doria in the 1530s.[85] In the Doria inventories this set was titled the *Navigatione d'Enea*, which accords well with a set on sale in London in 1650 called the *Voyages d'Énée*, made at "Mortlac sur la Tamise," as described in a notice sent to Cardinal Mazarin of the finest tapestries then available.[86]

Charles I's personal rule at Mortlake was all too short. Financial problems that were to precipitate civil war ended payments to the manufactory through the Exchequer in 1641. First Sir James, then the weavers were allowed to sell goods to defray costs. After the court was forced to abandon London for Oxford in 1643, Mortlake, being in an area controlled by parliamentary forces, was cut off from royal government. Sir James Palmer's authority at Mortlake had ended by the time Philip Hullenberch, who became the manufactory's leading tapestry maker,[87] was selling tapestries to the Prince of Orange in 1643–44.[88] These sales were of the *Naked Boys* and *Dido and Aeneas*, possibly sets begun for Charles I. Appeals from the Protestant weavers at Mortlake to their brethren in the Dutch Church in London—first unsuccessfully asking them to lend money for making a third set for the Prince of Orange, then offering to make their brethren a set of the *Acts of the Apostles*, and finally achieving a contract late in 1645 to weave six pieces of the *Hunters' Chase*, some 240 ells, in the next ten months[89]—managed to keep the manufactory from closing. Although Mortlake survived the Interregnum (1646–60) to last until the reign of Queen Anne (1702–14), its days of splendor ended with the loss of its chief patron and connoisseur of art and tapestry, Charles I.

All aspects of this manufactory's history and production have been treated in greater detail by the present author in a forthcoming book on English tapestry of the 17th and 18th centuries to be published by the Victoria and Albert Museum, London. A Leverhulme Emeritus Fellowship assisted two years of research.

1. Starkey 1998.
2. Millar 1972; King 1989, T. Campbell 2007, pp. 355–61.
3. Thomson 1914, pp. 67–68, published the relevant documents.
4. Letter published in the *European Magazine*, October 1786, p. 285; Anderson 1894, pp. 7–8; Thomson 1914, p. 75; Thomson 1930, pp. 281–82; L. Martin 1981, p. 93.
5. National Archives (hereafter NA), Kew, PSO 5/4, "January 1624" (officially the year in England then began on March 25).
6. Documents in the Duchy of Cornwall Office; NA, E 101/434 to 101/436 (payments of annual fee, 100 pounds). For other posts, honors and family, see L. Martin 1981 and *Oxford Dictionary of National Biography* (2004 ed.), s.v. "Crane, Sir Francis (*c.* 1579–1636)" (by Wendy Hefford).
7. NA, SP 16/180, item nos. 36 pt. 1, 38, and E 407/62.
8. Piero Boccardo (2006, p. 182), having found in a publication of 1615 reference to a Genoese gentleman, Andrea Imperiale, owning seven or eight large paintings by Raphael, has deduced that these were probably the seven cartoons of the *Acts of the Apostles*.
9. NA, E 317/Surrey/37, in Thomson 1914, pp. 90–91.
10. Pinchart 1868; Thomson 1914, pp. 69, 70; Hefford 2002, pp. 49–51.
11. Pinchart 1868.
12. Howarth 1994, pp. 151–52.
13. Guiffrey 1892, p. 95.
14. Thomson 1914, p. 81.
15. Fuller 1662, Surrey, p. 77.
16. Hefford 1999.
17. Howarth 1994, p. 155.
18. Starkey 1998, p. 209, item no. 9729.
19. Siple 1938; Siple 1939.
20. Adelson 1994, pp. 178–79, 184–85.
21. Forti Grazzini 2003, pp. 90–103, nos. 11, 12.
22. Tapestries of *February* and *May* (sale cat., Drouot-Richelieu, Paris, March 14, 1994, nos. 22, 23) have lost their borders but retain supports for a zodiac sign as seen on a *July* with borders complete. See Hefford 2006, pp. 176, 178 (translated).
23. Hefford 2006, pp. 178–81 (translated).
24. NA, E 407/78/1.
25. Pieces still in the Royal Collection described as early Mortlake (Thomson 1930, p. 307, illus. facing p. 290) were made in London for Charles II (Hefford forthcoming).
26. Hefford 1999, p. 92; Hefford 2006, p. 172 (translated).
27. *Calendar of State Papers, Colonial Series* 1860–1969, vol. 6, p. 420, no. 556, November 2–9, 1627.
28. Fuller 1662, Surrey, p. 77.
29. Beckett 1936, pp. 9–10.
30. NA, E 404/153, pt. 1 [pp. 9, 10], warrant of April 1631 to pay this bill for 483 pounds. The date could be interpreted as March 1626, but it is more likely to be the date from which work began for Charles as king, following the heading: "Made by me Franciscus Clein from his Ma[jes]ties especiall command for his Ma[jes]ties Service these ensuing." This and other documents concerning Clein are appendixes in Thomas Campbell's (1987) perceptive reappraisal of Clein's work.
31. Anderson 1894, p. 6.
32. Manners 1899, pp. 13–16; Thomson 1914, p. 86; Thomson 1930, pp. 307–8.
33. De Poorter 1978.
34. J. Smith 1829–42, vol. 2 (1830), p. 250; repeated in Thomson 1914, p. 86; refuted in Haverkamp-Begemann 1975, pp. 15–17.
35. NA, E 403/2565, fol. 139v (1630).
36. NA, E 403/2563, fol. 48v (1625).
37. Millar 1972, pp. 187, 201.
38. Ibid., pp. 201, 207.
39. NA, E 403/2568, fols. 19–19v.
40. NA, E 404/153 pt. 1, fols. 9–10 (bill in full following warrant).
41. Howarth 1994, pp. 156–58.
42. NA, LC 5/132, p. 43.
43. Per bend, azure and or. Illustrated; British Library, London, Harleian MS 1105, fol. 7 (*Coates & Creasts* [sic] *passed by Severall Kings of Armes*); L. Martin 1981, p. 90 (memorial stone).

44. Thirty ells of edges and 5 ells of border were rewoven in 1696–98. NA, LC 9/223 (estimate), LC 11/5, acc. no. 56, fol. 132v (bill).
45. Bodleian Library, Bankes Papers, MS 16/39, in Howarth 1994, p. 159. The *Death of Sapphira* sent to Spain was perhaps testing whether Clein's design would be acceptable there in a set designed by Raphael.
46. Cataldi Gallo 2003, pp. 346, 353.
47. Guiffrey 1913, pp. 38–40. The catalogue of the Paris 1983b exhibition followed Thomson, not Guiffrey.
48. Thomson 1914, p. 71.
49. Hefford 2002, p. 52.
50. Hefford, "The Unknown Mortlake Monogram: Who Was 'IPS'?" delivered at the CIETA conference, Copenhagen, 1991.
51. Standen 1957.
52. Or, on two bars gules, six trefoils argent, three and three. Papworth 1874, vol. 1, p. 34.
53. Loomie 1987, p. 143.
54. Cardinal Mazarin had the three Mortlake tapestries augmented in Paris to create a full set of Raphael's *Acts*. See Hefford 1977; conclusions drawn in that article are revised in Hefford forthcoming in the light of her more recent discoveries.
55. Howarth 1994, p. 158, quoting one of two relevant warrants in NA, PC 2/47, fol. 120v.
56. Thomson 1914, p. 83; Thomson 1930, p. 293.
57. University of Oxford, Bodleian Library, Bankes Papers (hereafter Bankes Papers), MS 16/39.
58. Bankes Papers, MS 16/39, in Howarth 1994, pp. 158–59.
59. Bankes Papers, MS 16/11. Eight percent interest was allowed by a privy seal of July 16, 1631 (NA, PSO 5/5).
60. See Hefford forthcoming.
61. Hefford 2002, p. 52.
62. NA, E351/3415.
63. The linear Flemish ell was 27 inches; the square ell, 729 square inches. Nonsense of making payment for hangings involving tapestry of the 2-foot and 3-foot square (Thomson 1914, p. 83) was derived from Anderson 1894, p. 12.
64. NA, PSO 5/7, warrant of July 21, 1638.
65. NA, PSO 5/7, warrant of January 19, 1638, and E 351/3415.
66. Millar 1960, pp. 126 and n. 2; relevant entries quoted in full in London–Bilbao–Madrid 1999, p. 99.
67. Millar 1960, p. 158.
68. London 1972, pp. 57–59, no. 85; Julius Held in Washington 1990, pp. 364–66, no. 102 (with bibliography).
69. Bellori 1672, pp. 253–64, translated in New York–Fort Worth 1991, pp. 21–22.
70. Millar 1972, p. 322.
71. Kendrick 1918.
72. Birrell 1914, p. 189; Hefford 1992, pp. 105–6.
73. The Holyrood Palace tapestries are not a royal set. Margaret Swain stated that this set was purchased for the palace in 1864. Swain 1988, pp. 8–11.
74. C. M. Brown and Delmarcel 1996, pp. 74, 120–28 (documents), 174–93 (tapestries, nos. 4, 5).
75. Hefford 1992, pp. 105–6, and Hefford forthcoming.
76. In the Illustrated Bartsch (Koch 1980, p. 78, no. 35), the engraving is still listed as the work of Georg Pencz, though no longer attributed to him.
77. Illustrated in Thomson 1930, facing p. 308; and Hefford 1992, fig. 106.
78. Millar 1960, p. 70 and n. 1. A later Mortlake tapestry of this subject is illustrated; Thomson 1930, illus. facing p. 308, and Hefford 1992, pp. 105–6.
79. See Balis et al. 1993; Delmarcel in New York 2002, pp. 329–39, nos. 37–40.
80. Wace 1935; de Pazzis-Chevalier and D. Chevalier 1984; Hefford forthcoming.
81. Wauters 1878, p. 124.
82. Standen 1985, p. 710.
83. Clifford 1976, pp. 282–84; T. Campbell 1987, pp. 53–54.
84. NA, E 351/3415, PSO 5/7 (under date).
85. See Davidson 1990 on the Perino del Vaga designs and Brussels tapestries. Thomas Campbell suggested the Mortlake origin of two 17th-century tapestries to the present author.
86. Cosnac 1884, p. 419.
87. Hefford 2002, pp. 52, 54; Hefford forthcoming.
88. Van Ysselsteyn 1936, vol. 2, p. 255 no. 556, pp. 260–61 no. 567.
89. Hessels 1887–97, vol. 3, pt. 2, nos. 2797, 2821, 2827, 2872.

16.
The Miraculous Draft of Fishes

From an eight-piece set of the *Acts of the Apostles*
From seven designs by Raphael, 1515–16, copied by
Francis Clein with additions and new border designs
between ca. 1625 and ca. 1639
Woven in the Mortlake workshop, Surrey, this piece
ca. 1636–37; the set, late 1620s to early 1640s
Wool, silk, and gilt-metal-wrapped thread
530 x 580 cm (17 ft. 4½ in. x 19 ft. ¼ in.)
8 warps per cm
Marks of England at bottom right, Sir James Palmer
at lower right
Mobilier National, Paris (GMTT 16/4)

PROVENANCE: Made for Charles I; 1659, inventoried
on the death (February) of Abel Servien, superinten-
dent of finance, purchased (August) by Cardinal
Mazarin; 1661, in the after-death inventory of
Mazarin, acquired by Louis XIV.

REFERENCES: Thomson 1906, pp. 282–83; Guiffrey
1913, pp. 38–40; Thomson 1914, pp. 72–74, 82–84, 88;
Kumsch 1914, pp. 16, 48–49, pls. 24–27 (borders);
Thomson 1930, pp. 281, 283–84, 292–94; Göbel
1933–34, vol. 2, p. 173; Birmingham 1951, p. 19, no. 18;
Shearman 1972 (on the cartoons); Coural in Paris
1983b, pp. 398–408, nos. 1–6; Howarth 1994, pp.
155–59; Hefford forthcoming.

CONDITION: The blue silk in the sky and water is
faded; there is some reweaving of the background and
the lower-left border corner scene, as well as the hair,
wings, lion, and unicorn; the silver has oxidized and
darkened.

The *Miraculous Draft of Fishes* was the initial subject of those illustrating acts of Saint Peter in Raphael's cartoons of the acts of the apostles Peter and Paul.[1] These cartoons were painted for Pope Leo X about 1515–16 for tapestries woven in Brussels between 1517 and 1521, to hang in the Sistine Chapel. These prestigious tapestry designs were copied repeatedly over three centuries, with varying degrees of accuracy, in Flemish, French, and English manufactories.[2] Nowhere were Raphael's designs reproduced more faithfully than at Mortlake in the 1630s and early 1640s, after Charles I had purchased seven of the original cartoons when he was Prince of Wales. This piece of the *Miraculous Draft of Fishes* is from Mortlake's editio princeps, undoubtedly woven for King Charles, given the presence of his coat of arms with the regalia, above, and a personal statement, below: *Car. Re. Reg. / Mortl.* (*Carolo rege regnante / Mortlake*). The set presumably left the country before the execution of the king, as it does not figure in the Parliamentary inventory of his goods from 1649 to 1651.[3]

It is likely that eight tapestries originally comprised this set, for Francis Clein's original design, the *Death of Sapphira* that was added to his seven cartoons copying those of Raphael, existed as tapestry by 1637 in a set comparable in size and splendor to that with the royal arms—using the same borders individually designed for each subject, but with a plain blue cabochon supported by four different putti in place of those with the royal arms and regalia (fig. 91) and on a gold ground, not red. After Charles I's set with his arms passed into French possession, however, only seven pieces were noted. Possibly Abel Servien, the French superintendent of finance, in whose posthumous inventory of February 1659 these seven pieces were recorded along with a four-piece set of *Acts*[4] (presumably those with a gold border that had the same subsequent history, see below), repudiated the subject that had not been designed by Raphael. Possibly,

in spite of the royal arms, the person making that inventory did not recognize the Sapphira subject, in borders of such variable design, as part of the set. In any case, the *Death of Sapphira* was not purchased by Cardinal Mazarin in August 1659 with the seven pieces after Raphael that were noted in his inventory of 1661.[5] Acquired by Louis XIV after Mazarin's death, Charles I's seven-piece set with the royal arms and the four-piece set with a gold border and blue cabochon[6] eventually became property of the French State, deposited in the Mobilier National, Paris. *Saint Paul Preaching at Athens* was in use at the French embassy in Warsaw at the time of World War II and is presumed to have been destroyed. Fortunately, it had been catalogued by Jules Guiffrey[7] and illustrated in Heinrich Göbel's *Wandteppiche*.[8]

Description and Iconography

Raphael's *Miraculous Draft of Fishes* illustrates a New Testament Gospel story about the calling of the first four apostles to follow Jesus (Luke 5:1–11). After preaching to a large crowd from the fishing boat of Simon Peter, Jesus instructed him to "Launch out into the deep and let down your nets for a draught." Although no fish had been caught all night, the resulting catch was so great that the net broke, and Simon Peter's partners, James and John, sons of Zebedee, had to be summoned to help. Falling down in the boat at Jesus' knees, Peter said, "Depart from me, for I am a sinful man, oh Lord"; to Peter and his three fellow fishermen, Christ replied, "Henceforth thou shalt be fishers of men." In the early Church, fish were used as symbols for Christ and for Christian souls. The five letters of the Greek word for "fish" could be seen as initials of the words "Jesus Christ, of God the Son, Saviour." In addition, there was a particular association with the water of baptism and so with the saving of souls, hence the Latin word "piscina" (fishpond) for a font.

In a small boat brimming with several varieties of fish, Peter kneels, his hands joined in

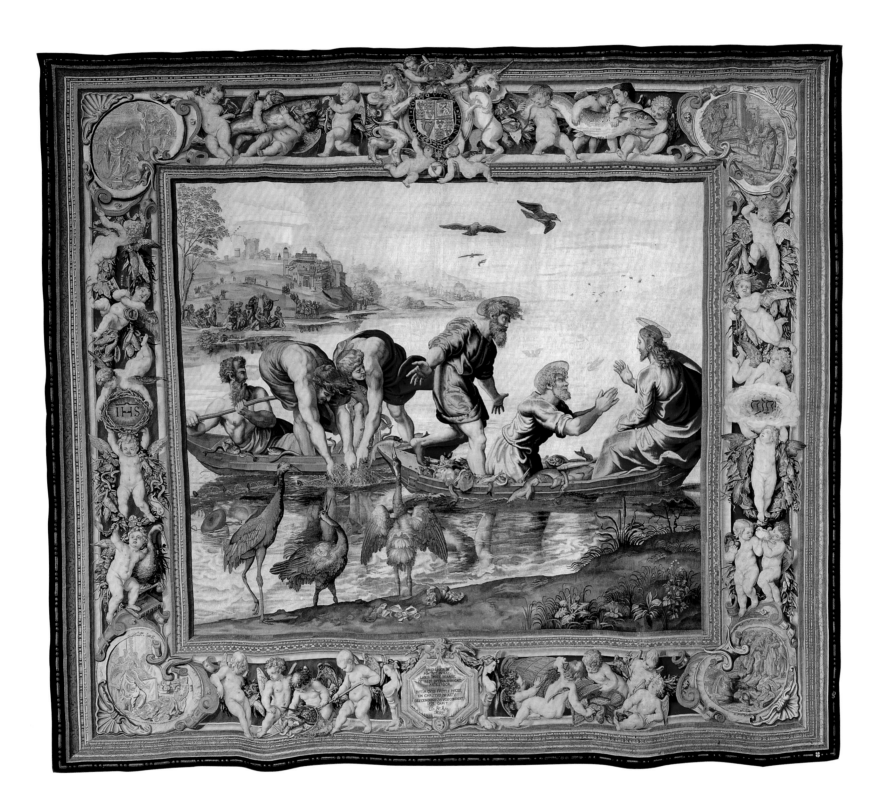

prayer toward Jesus, who, seated serenely at the right, holds up a hand as he replies. Behind Peter, the bearded man moving impetuously toward Jesus, his spread hands expressing astonishment, is Peter's brother, Andrew, who is named in a variant version of the story of the four fishermen leaving their trade to follow Jesus as his disciples (Matthew 4:18–22). James and John, muscular young men still hauling up a net full of fish in a second boat, are accompanied by an older bearded man steering the boat, presumably their father, Zebedee. The clothing of the men in the two boats is strongly contrasted: Christ is dignified in robe and cloak; Peter and Andrew are sensibly clad for work in tunics; but all three men in the second boat, regardless of age, wear only loosely wrapped draperies that leave their torsos bare, invoking a sense of classical antiquity heightened by the pose of Zebedee, which is similar to that of a river god.[9] The haloes of the four men about to become apostles are formed of concentric circles; Christ's halo also contains an equal-armed cross. Zebedee has no halo.

These six figures are reflected in the still waters of the lake, as are remaining groups of the crowd lingering on the far shore. On the near shore, silhouetted against the reflection of Christ's red cloak, are bulrushes and a leafless plant bearing small, spiky twigs. To a Christian contemporary with Raphael, these plants would have recalled the bulrush scepter and Crown of Thorns from the mocking of Christ before the Crucifixion. Four plants below, in the lower-right corner, are probably also symbolic. The dandelion was a common Christian symbol of grief, found in paintings of the Crucifixion and other Passion scenes.[10] Given such symbolism, a scattering of shells by the cranes positioned beneath the boat with James and John may have been intended as a reference to the scallop shell on pilgrim's garb associated with Saint James, as the apostle was to become, and perhaps the watchful cranes alluded to Saint John, as seems to be the case in the seventeenth-century border design. If so, then the crustacean-like remains beside the cranes beneath the figure of Saint Andrew may have had some connection with him.

The three cranes on the foreshore, besides their general symbolic meaning of Vigilance,

have been shown by John Shearman to represent the vigilant care or *custodia* of the papacy.[11] Shearman also detected further papal allusions, in a compliment to Pope Leo X, in distant buildings that include three churches of Sixtus IV and the Leonine wall on the Mons Vaticanus, thus transferring features of papal Rome to the Holy Land.[12]

Raphael's Design

Shearman proposed two more specific sources for details of Raphael's design for this tapestry. He noted that the head of Christ in profile is similar to a surviving bronze medal of about 1500, believed to copy an emerald cameo purported to be the *Vera effigies*, a true portrait of Christ, given by Sultan Bajazet II to Pope Innocent III.[13] For the composition of the two small, overlapping boats, Shearman suggested that Raphael might have seen in the library of Leo X another papal treasure, an illuminated Greek gospel of the eleventh century showing, in one illustration, Christ preaching from Simon Peter's boat plus the two overlapping boats containing Christ and the four future apostles, with Peter kneeling to Jesus.[14]

Raphael's more sophisticated treatment of the frieze of figures in overlapping boats manifests conversion from the old to the new. Zebedee, in an antique pose, and the *Vera effigies* of Christ face each other in profile across the width of the scene. Between them, the four future apostles are represented progressively turning away from Zebedee and toward Christ. Next to Zebedee but with his back toward him, Zebedee's elder son James (age indicated by a slight beard) still concentrates on raising the net of fish; his brother John, though helping, looks toward Jesus; Andrew, next, strides toward Jesus; Peter acknowledges Christ and kneels before him. At the same time the composition stresses that this is the story of Peter. The importance of his dialogue with Christ is emphasised by the lack of obtrusive detail above and below: the lake that stretches to the horizon and sparse plants on the shore are in contrast to the eye-catching cranes, distracting reflections of limbs and a face, and exquisite background scenes that compete for attention with the figures at the left in the tapestry. Whereas a study for this subject attributed to Giovanni Francesco

Penni[15] groups together Raphael's four proto-apostles between isolated figures of Christ and Zebedee, Raphael's cartoon decreases the space between Zebedee and James and increases it between Andrew and Peter, setting Peter slightly apart and making him more prominent.

Border: Description and Iconography

Francis Clein's meticulous copies of Raphael's cartoons were admirably complemented by his own fine border designs. In this border created specifically for the *Miraculous Draft of Fishes*, fish and eels are bound with blue ribbon to leafy garlands and festoons on a red ground. Groups of putti in the upper border struggle to hold giant fish, and in the lower border examine the contents of a small net and a trap. Central in the side borders, supported by putti, are devices of the New Testament and the Old: the Crown of Thorns encircling a blaze of light emanating from the letters IHS, an abbreviation of the name Jesus in Greek, opposite a cloud that surrounds Hebrew letters representing the name of Jehovah. Above these devices are putti holding attributes: at the left, the keys of Saint Peter; at the right, held by a distressed putto, cords that bound Saint Andrew to his saltire cross. It would seem logical that attributes shown below the devices should refer to James and John. Adjacent putti, right, have a heart and a dove, symbols of love and sacrifice not known to be specific to Saint James. The putto at lower left, however, is provided with symbols of watchfulness and a book, possibly with reference to Saint John as author of the Book of Revelation in which chapter 16, verse 15 states, "Blessed is he that watcheth." This putto, treading on a book, holds an oil lamp, recalling the watchfulness of the wise virgins (Matthew 25:1–13), and embraces a crane depicted in its traditional pose of vigilance, standing on one foot while the other holds a stone that would drop and wake the bird were it overcome by sleep.

Colorful cartouches in the corners contain miniature scenes of Christ's miracles in gold-toned "monochrome" with highlights of precious metal thread. In the upper corners are two instances of raising the dead: left, Lazarus, who steps from his tomb (John 11:1–44); right, the widow of Nain's son, met

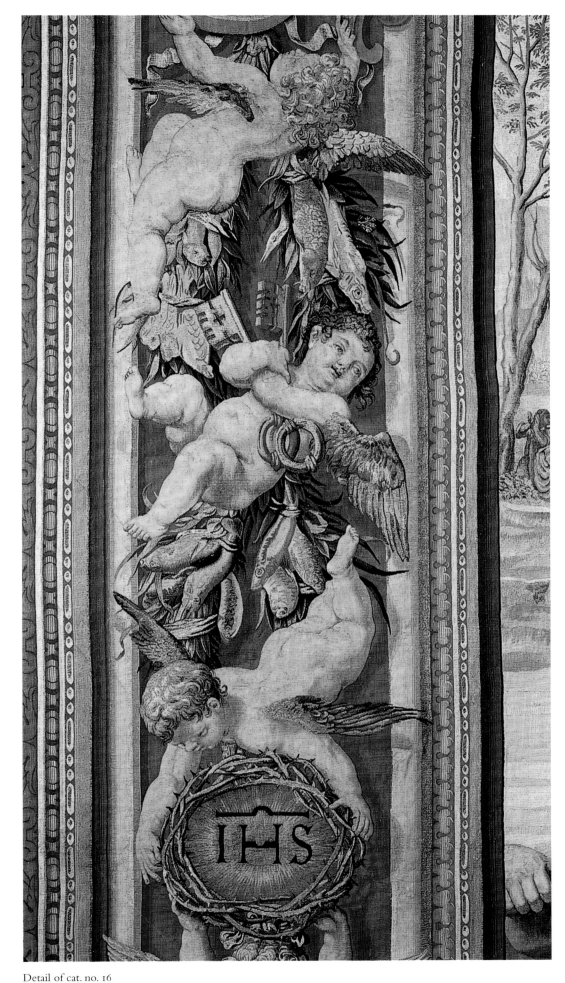

on his bier at the gate of the city (Luke 7:11–15). At lower right, Christ casts out a devil that is tormenting a boy whose father kneels in supplication beside him (Matthew 17, 14–21). The scene at lower left is subject to two interpretations. In the more likely of the two, Christ, at supper in the house of a Pharisee, forgives the sins of a woman who washed his feet with her tears and wiped them with her hair (Luke 7:36–50). As forgiveness of sins required supernatural power comparable to driving out devils or raising the dead, this fourth scene would both have completed a choice of four other miracles to complement the *Miraculous Draft of Fishes* and have reminded viewers of Peter's words, as he knelt before Christ in the boat, proclaiming himself a sinful man.

Only three features of this border design are common to the whole set: the moldings of the frame all around; the royal arms in full panoply of lion and unicorn supporters, with the royal regalia held by putti, plus the Garter with the Order of the Garter's motto, HONI SOIT QUI MAL Y PENSE (Shamed be he who thinks evil of it), in the upper border; and, in the bottom border, an elaborate cartouche with an inscription relevant to each subject on a fictive cloth. In this particular tapestry, the Latin inscription[16] contrasts the lack of success laboring in the deep without divine direction to the positive result obtained when Christ himself ordered the nets to be lowered.

On a tiny cabochon at the base of this decorative cartouche is the coat of arms of Sir James Palmer,[17] whose SIP monogram is in the bead-and-reel edging peculiar to the two sets of *Acts of the Apostles* with these special borders (see "The Mortlake Manufactory, 1619–1649").

Chronology of the Royal Set of the Acts of the Apostles

As discussed in the essay on the Mortlake manufactory, production of this series under Sir Francis Crane had a slow start, necessitating completion after 1637 under Sir James Palmer, whose mark on this royal set appears on five of the seven subjects after Raphael,[18] while Crane's mark and arms are on only two: the *Death of Ananias* and the *Miraculous Draft of Fishes*. First woven of this set was *Ananias*. Clein claimed payment for its cartoon and

border, as well as for a truncated *Blinding of Elymas* without a border design, that was not passed for payment until April 1631.[19] Actual payment for the first "piece of the Apostles enriched with gold," 84 ells at 8 pounds the ell, was ordered in June 1631.[20] As this tapestry was not included in the pre-vious warrant of July 31, 1630,[21] for three sets made between 1625 and that date, completion of *Ananias* presumably occurred between August 1630 and June 1631. "One peece of the Acts of the Apostles of St. Paul and Elymas the Sorcerer," 83 ells, costing 664 pounds, was not named

until a warrant of March 11, 1636, to pay Sir Francis 2,872 pounds for tapestries.[22] The *Blinding of Elymas* was therefore completed between June 1631 and March 1636. Within this period the cartoon for the *Death of Sapphira* must have been available, in that a completed tapestry in the comparable border had been sent to Spain and was due for return by the summer of 1637 (see "The Mortlake Manufactory, 1619–49"); but lacking documentation for a tapestry of this subject in the first royal set, more precise dating cannot be established.

At more than seventeen feet high, these tapestries may have needed larger looms than those already in use at Mortlake, and the great number of faces and amount of naked flesh to be woven would have slowed weaving, requiring more painstaking specialist work. But these cannot have been major factors delaying production, or the second set in similar yard-wide borders filled with figures would not have been begun before the royal set was finished. Delay must therefore have been occasioned by the provision of cartoons.

Between 1625 and 1635 Clein was working for several clients besides Sir Francis and Charles I. He would, however, like Crane, have wished to give priority to work on the king's *Acts of the Apostles*. Clein's friend Edward Norgate commented on Clein's "almost incredible diligence" in the demanding task of accurately reproducing Raphael's seven cartoons.[23] The greatest delay was probably due to devising and approving a different appropriate border design for each tapestry. Clein would not have invented these programs, and he may have had to wait for each set of instructions before submitting alternative designs for selection. All the borders may have been finally approved only shortly before Abraham van der Doort compiled his catalogue of Charles I's works of art, completed by 1639, for among the works he catalogued was a manuscript explaining the content of the borders of the king's *Acts of the Apostles* after Raphael.[24]

As Charles I's set had to be the editio princeps, the need to decide this content of the special borders would have delayed the weaving of each similar subject in all other sets of the series. The fourth piece of the king's set to be woven was probably *Christ's Charge to Peter* ("Feed my sheep"). The cartoon of its individually designed border, containing six scenes from the life of Christ, two large seated figures, and twenty-three putti, would have been available for weaving by late 1636, as the same border, without the royal arms and on a gold rather than red ground, was on 46½ ells of an incomplete *Charge to Peter* given by Richard Crane to the king in the summer of 1637.[25] Although state papers and Exchequer accounts give no subjects for three partly woven sets of tapestry purchased from Crane by the king at this time,[26] a document arrang-

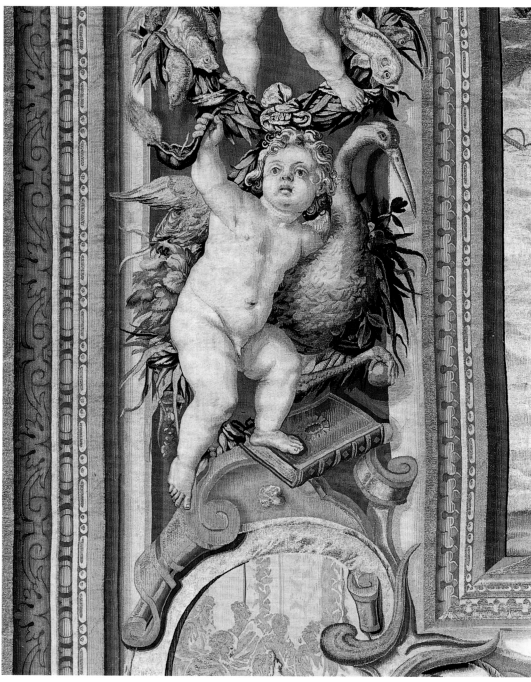

Detail of cat. no. 16

ing payment of royal debts to the Cranes and transfer of the Mortlake manufactory by purchase and gift names each piece—all of which belong to the *Acts of the Apostles*.[27] The fact that four incomplete pieces of *Christ's Charge to Peter* ("of the sheep"), as compared to only two fragments of the *Miraculous Draft of Fishes* ("of the fishers") were listed, suggests that the latter was the fifth subject of the royal set to be ready for weaving. Only the above five subjects are documented by 1637. Lack of any mention of *Healing the Lame Man*, the *Sacrifice at Lystra*, or *Paul Preaching*, and sales of sets of only five pieces to Philip Herbert, Earl of Pembroke, in January 1638[28] and to Henry Rich, Earl of Holland, in December 1639[29] indicate that the last three subjects in the royal set may not have been in production until late 1639 and the early 1640s.

A later date for the last three subjects to be woven is corroborated by the omission of Palmer's arms, which are found only on *Christ's Charge to Peter* and the *Miraculous Draft of Fishes*. These other three subjects in the royal tapestries have the cross of Saint George where first Crane's, then Palmer's arms were placed. Objection may have been taken to Palmer—who after all was merely the governor, not the owner of the works—introducing his arms into the king's tapestries, while Crane's less conspicuous armorial of two plain juxtaposed colors, disguised by being incorrectly woven with highlights and shading, may even have gone

completely unnoticed. Neither coat of arms has hitherto been mentioned by cataloguers.

Peter Cannon-Brookes in conversation with the present author has expressed the opinion that the royal set of the *Acts of the Apostles* was too close to Raphael's cartoons not to have been woven from the originals. It is hard to discern any significant difference in interpretation of design between this royal set and the contemporary sets of lesser cost purchased by the Earls of Pembroke and Holland. Yet the discovery that at least four tapestries of *Christ's Charge to Peter* were in simultaneous production in 1637 makes it difficult to see how the Mortlake weavers could have managed with only Clein's copy, even if slips of the cartoon could be moved from one loom to another as each vertical strip was woven. In this context, the record in Van der Doort's catalogue stating that around 1639 only Raphael's cartoons for *Ananias* and *Elymas* were in storage at Whitehall—the other five having on the king's instructions been sent to Francis Clein at Mortlake, by which to make hangings for the king[30]—may be interpreted to mean not simply that Clein still had these five to hand, with three of them not yet copied,[31] but that, once copied, they were in fact needed for use in weaving these last five pieces of the royal set. In which case, the tapestry of the *Miraculous Draft of Fishes* exhibited here would have been woven from Raphael's original cartoon.

WENDY HEFFORD

1. Shearman 1972.
2. Kumsch 1914.
3. Millar 1972.
4. Coural in Paris 1983b, p. 405.
5. Jean Coural (in Paris 1983b, p. 406) states that this set was not in Mazarin's inventory of 1661 (Cosnac 1884, pp. 277–411), failing to realize that in transcription of item nos. 1704, 1705 (Cosnac 1884, pp. 392–93) measurements, numbers of pieces, and border descriptions had been confused, and the formula "tapisserie de laine et soie relevée d'or fabrique d'Angleterre" was garbled as "tapisserie de laine et soie relevée des fables d'Angleterre." In each set only the border with eight small scenes was noted in this inventory (*Sacrifice at Lystra*, Mobilier National, Paris, GMTT 16/5, GMTT 17 [fig. 91]).
6. Guiffrey 1885–86, vol. 1, p. 300, nos. 34, 35.
7. Guiffrey 1913, pp. 38–40.
8. Göbel 1933–34, vol. 2, fig. 131a.
9. T. Campbell and Karafel in New York 2004, pp. 215–16, no. 24.
10. Hall 1974, p. 90.
11. Shearman 1972, p. 54.
12. Ibid., pp. 51–54.
13. Ibid., pp. 50–51.
14. Ibid., p. 118, fig. 73.
15. Ibid., fig. 41.
16. QUID LABOR IN / PONTUM SUDAT / LABOR OMNIS INANIS / SE NISI DIVINA DIRIGIT / ARTE LABOR / RETIA QUID FUGITIS PISCES / EN CHRISTUS IN ALTUM / DESCENDENS QUI VOS CONDIDIT / IPSE CAPIT.
17. Or, on two bars gules, six trefoils argent, three and three.
18. The royal set of the *Acts of the Apostles* is in the Mobilier National, Paris, GMTT 16/1–7 (see fig. 89 above).
19. National Archives (hereafter NA), Kew, E 404/153, pt. 1.
20. NA, E 403/2566, fol. 54v.
21. NA, E 403/2566, fol. 3v.
22. NA, E 403/2568, fols. 19–19v; repeated in a new warrant to Richard Crane, June 7, 1637 (NA, E 403/2568, fol. 36v); finally paid: Pells Issue Book (NA, E 403/1751), December 20, 1637.
23. Norgate 1919, p. 63.
24. Millar 1960, p. 126.
25. University of Oxford, Bodleian Library, Bankes Papers, MS 16/39.
26. NA, SP16/361, item no. 29, and E 403/2568, fol. 36v.
27. University of Oxford, Bodleian Library, Bankes Papers, MS 16/14.
28. NA, PSO 5/7, January 19, 1638, and E 351/3415.
29. NA, PSO 5/7, December 31, 1639, and E 351/3415.
30. Millar 1960, pp. 171–72, 179.
31. As previously assumed by the present author, in that the cartoons were sent to Clein rather than to Crane or Palmer.

From a six-piece set of *Hero and Leander*
Design by Francis Clein, ca. 1625–28
Woven in the Mortlake workshop, Surrey, ca. 1630–36
Wool, silk, and gilt-metal-wrapped thread
420 x 444 cm (13 ft. 9¼ in. x 14 ft. 6¾ in.)
8 warps per cm
Marks of Sir Francis Crane in lower-right vertical edge, of Philip de Maeght and England at bottom, near the right corner
The Royal Collections, Drottningholm Palace (H.G.K. 51)

PROVENANCE: Woven for Charles I; 1634, reputedly given by him to Count Johan Oxenstierna, Swedish legate in London; 1654, presented by Oxenstierna to King Charles X of Sweden on the occasion of the latter's marriage; thereafter, recorded in the Swedish royal collection.

REFERENCES: Böttiger 1895–98, vol. 2, pp. 39–45, pls. X–XIII, vol. 3, pp. 30–31, vol. 4, pp. 71–75, pl. II; Thomson 1914, pp. 75–76, illus. pp. 77, 78; Thomson 1930, pp. 285–86; Göbel 1933–34, vol. 2, pp. 174–75; Birmingham 1951, pp. 20–21, nos. 20–23; Whinney and Millar 1957, pp. 127–28; T. Campbell 1987, pp. 25–26, 35–36; Fogelmarck 1988, p. 174; Hefford forthcoming.

CONDITION: There is a little fading and some minor deterioration of the light silk and dark brown wool; a vertical repair runs top to bottom in line with a patch on Leander's tunic.

The *Meeting at the Temple of Venus* is the first subject in a series of six tapestries that tell the tragic story of Hero and Leander, lovers separated by the waters of the Hellespont, she in Sestos and he in Abydos. Their story, based on the fifth-century A.D. narrative of Musaeus, is here more directly taken from the poem by Christopher Marlowe published in 1598, completed after Marlowe died in 1593 by George Chapman, whose translation of *The Loves of Hero and Leander, the Divine Poem of Musaeus* was published in 1616. Art historian John Böttiger, curator of the Swedish royal collection of tapestry and textiles, identified the main literary sources in his monumental catalogue of tapestry in that collection (published 1895–98), noting also that the inscription on the fifth tapestry in the series came from a couplet in Ovid's *Amores* (2.16).[1] Böttiger equated the *Hero and Leander* set to which the *Meeting at the Temple of Venus* belongs with six tapestries given by Count Johan Oxenstierna to King Charles X of Sweden on the occasion of his marriage in 1654[2] and traced their history through royal inventories to 1724, the last mention of the full set. Between that date and the research for his catalogue, the fourth piece of the story, depicting Leander telling his parents of his love for Hero, was lost. Almost lost, too, were fragments of this set found discarded in attics and outbuildings, which Böttiger reassembled. One large fragment had to be repurchased by King Oscar II of Sweden in 1894 from an auction in Cologne.[3]

In the second subject of the Mortlake series, Leander swims toward Hero's isolated tower for the first of their clandestine meetings. His clothes are left on the near shore at the feet of his sister, Hermione, who prays for his safety. On a stone by her feet in the tapestry in the Swedish royal collection are the initials HDB (or R),[4] which may stand for Hendrik de Bock, who was at Mortlake between at least 1628 and 1634, according to the recorded baptisms of his children.[5] The third tapestry[6] shows Leander as he arrives, swimming, at the tower where Hero, beckoned by her servant, peers coyly round the door at her naked visitor. Leander's body, partly seen beneath the water, is designed and woven in a masterly fashion. Returned to Abydos in the fourth tapestry of the series, Leander confesses his love to his parents, who agree that he shall marry Hero and bring her by ship from Sestos. In the fifth scene Leander prepares to swim the Hellespont by night.[7] As Hermione watches anxiously, he strides into the water by moonlight, the moon and a torch held by Cupid reflected in the water. In the sky the Three Fates prepare to sever Leander's thread of life in the storm that will extinguish Hero's guiding beacon and drown her lover. The series ends in the sixth tapestry with the death of the lovers. Apollo's chariot appears in a blaze of light on the horizon and is mirrored in a sea once more calm. Cupid sits mourning on a rock at the right. Leander's body lies across the rocks at the foot of Hero's tower, and she, kneeling with arms raised, is about to collapse in death onto his corpse (as in Chapman's end to Marlowe's poem). Her sympathetic servant stands, wringing her hands. In the tapestry of this subject in the Swedish royal collection,[8] the servant's head is shown in profile, as she looks at her mistress (fig. 95), but in all other surviving tapestries from this design, early and late, she looks directly at the viewer.

"Six peeces of Leander" were listed among "Designes at Mortlack for making of Tapistry hangings" in 1651, and all contemporary references to the tapestries were to sets of six subjects.[9] Heinrich Göbel added a seventh subject: Hero committing suicide.[10] This, however, was not part of the Mortlake series, for that followed more closely the ending of the Marlowe/Chapman poem. Hero jumping from her tower into the Hellespont occurs only in two Flemish series of the story. One of these, of Antwerp origin, is mistakenly illustrated in H. C. Marillier's *English Tapestries of the Eighteenth Century*.[11]

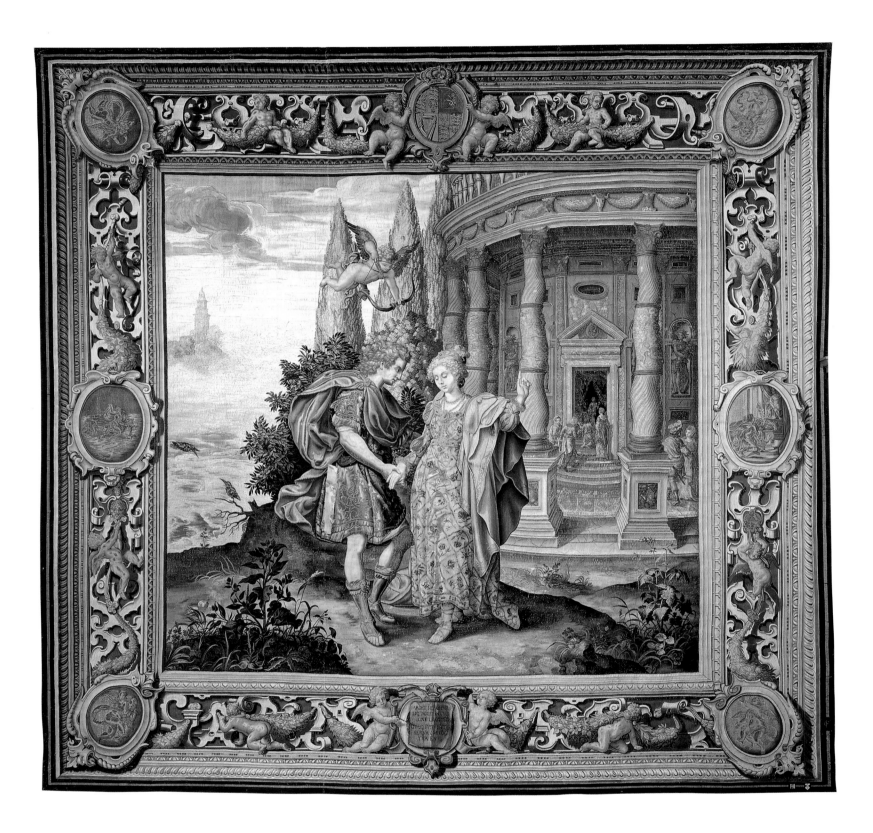

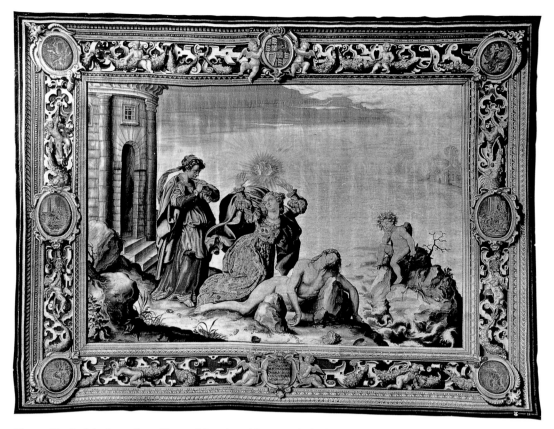

Fig. 95. *Death of the Lovers* from *Hero and Leander*, with arms of Charles I. Tapestry design by Francis Clein, ca. 1625–28, woven at Mortlake, ca. 1630–36. Wool, silk, and gilt-metal-wrapped thread, 425 x 542 cm. The Royal Collections, Stockholm (H.G.K. 54)

Most surviving *Hero and Leander* tapestries date from later in the century. Only one other comparably rich and early set of the Mortlake *Hero and Leander* exists, now reduced to four hangings. The first three subjects of the series are at Lyme Park, Cheshire; the sixth subject was purchased from Lord Newton by the Victoria and Albert Museum in 1910. The tapestry of Leander and his parents, which also might have been purchased by that museum, was burnt at the Brussels exhibition of 1910. This set has a border almost identical to the one in Sweden, differing only in color and in most of the small scenes in the cartouches at the sides. Although these are the same, telling the story of Helle and Phrixus for the *Meeting at the Temple of Venus*, they vary at Lyme from tapestry to tapestry, augmenting the story.

Description and Iconography

Leander stands gazing intently at Hero, his right hand holding hers. She, with eyes modestly lowered, points heavenward to indicate her service as virgin priestess of Venus, while Cupid hovers overhead, bow drawn with an arrow pointing at Hero's heart. The scene perfectly illustrates an inscription in the lower border[12] that can be translated as "Leander burns with the fire of love and Hero is equally enflamed: she is your servant, Cupid, who was the servant of Venus." Their stance seems to have been designed to depict Marlowe's line, "These lovers parled by the touch of hands" and to recall his famous line, "Who ever lov'd that lov'd not at first sight." Behind the lovers are bushes probably meant for myrtle, symbol of undying love, sacred to Venus, and cypress trees, associated with death. Presaging more specifically the fates of the lovers are two kingfishers at the left, their plumage stark against the waters of the Hellespont in which Leander will drown while swimming to Hero's tower, which can be seen in the distance. These kingfishers are the metamorphoses of Ceyx, who died by drowning, and his devoted wife, Halcyone, who died on finding his body[13]—the fate of Hero. According to Chapman's ending to Marlowe's poem, Hero and Leander after their deaths were also changed into birds, "thistle-

warps" (goldfinches), that shun the sea.

Tendrils of Hero's fair hair, caught up in a jeweled scarf, and her delicate complexion, in contrast to Leander's ruddier features and darker locks, were exquisitely woven by Mortlake's weaver of faces, who fully deserved his higher pay. The lovers' garments, highlighted with gold thread, are also finely detailed. Hero's white gown has a yellow lattice pattern, with stars at the interstices, enclosing isolated flowers variegated in form and color. Undersleeves, banded in red and green, show though the ribbonlike puffs of the over-sleeves at shoulders and elbows. Leander is dressed in the conventional garb of a young mythological hero—cloak, tunic, and buskins. His cloak is a light tannish red, which, along with the deep pinkish red of the border of this piece, is most often found in early Mortlake tapestry, where little bright scarlet is seen, appearing only in small touches like the handgrip on Cupid's bow. Leander's blue tunic is exceedingly rich in gold thread, not only with tapestry-woven highlights but also with a large-scale textile pattern boldly created with gold thread in a staggered-brick formation over groups of warp threads.

There is gold, too, in the decorative frieze of the round Temple of Venus. Though the columns of the peristyle are reminiscent of the Solomonic columns in Raphael's *Healing the Lame Man* from the *Acts of the Apostles*, the central section of each column here, carved with naked boys playing among foliate stems, does not copy Raphael's symbolic boys among vines, which would have been unsuitable for this pagan temple. A statue of the goddess can be seen through the open temple doorway, toward which small figures of worshippers are congregating. In niches on the outer walls of the rotunda are statues of Bacchus and Ceres, representing the saying "Sine Bacchus et Ceres friget Venus" (Love grows cold without wine and victuals).

Border

Cast shadows produce an outstanding illusion of three dimensions for the fictive frame through which this scene is viewed. Moldings appearing like deeply carved painted wood enclose scrolling pierced strapwork in shades of blue and white that cast shadows on the red ground. Strapwork and ground together

back of the ram with the golden fleece; at the right, Phrixus sacrifices the ram. These scenes are not in strict accord with the Greek myth, in which the ram flies, not swims, across the water; and the sacrifice is made to Zeus (Jupiter), not to a figure accoutred like Ares (Mars).

Design

Böttiger thought that the face of Hermione resembled Anthony van Dyck's mistress, Margaret Lemon, and paid Francis Clein, Mortlake's chief designer, the compliment of suggesting Van Dyck as a possible designer of this series of *Hero and Leander*,[14] which Böttiger considered to be among the finest of the seventeenth century. Two art historians in the twentieth century were less enthusiastic. Margaret Whinney and Oliver Millar wrote of this series, "The figures in their rich costumes are a rather clumsy echo of Paolo Veronese.... It cannot be claimed that the compositions are very distinguished, though they tell the story clearly enough."[15]

Clein's contemporaries thought highly of the series. His friend Edward Norgate enthused at length, commenting on Clein's "six rare peeces of the story of Heroe and Leander, all done most accurately, and with excellent Lanscape of Sestos, and Abydos, the Hellespont, Temple of Venus, &c. which by him done in water Colours to the Life, were wrought in rich Tapistry, in silke and gold, with bordures and Compartments in Chiaroscuro of the same hand alluding to the story."[16] A Monsieur de Bordeaux, writing on March 12, 1654, to inform Cardinal Mazarin of tapestries available for purchase in England, wrote of a *Hero and Leander* set, "Le dessin en est fort estimé"; Mazarin purchased this set and bequeathed it to the brother of Louis XIV.[17] In 1670 Sir Sackville Crow wrote to the Countess of Rutland confirming the popularity of the series, naming Clein's *Hero and Leander* among six "in England worth the making": "a very good patterne... grown very common of late."[18] The designs were still in use in 1708–9, after the Mortlake manufactory had closed.

Clein's artistic education was largely formed by his appreciation of painting and tapestry of the sixteenth century, which he developed through years of study in Italy during the second decade of the seventeenth century[19] and through a presumed earlier visit

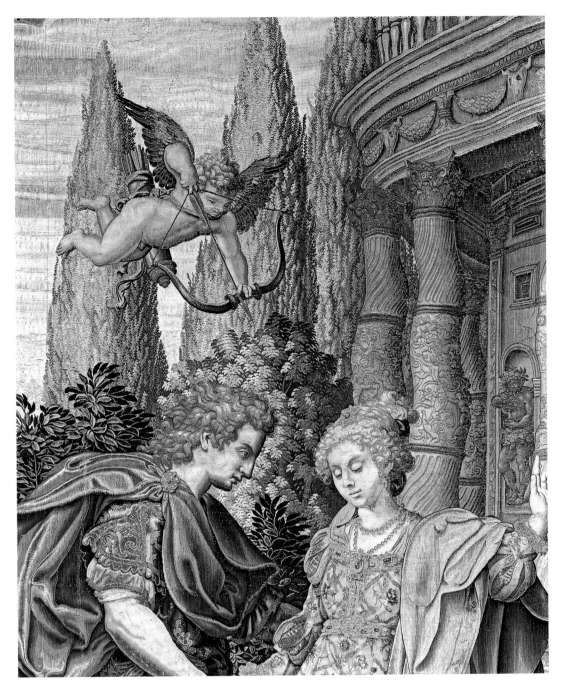

Detail of cat. no. 17

are shadowed by festoons and pendants of closely packed leaves and flowers managed by lithe putti and wingless boys, all colored like gilt metal, with highlights of silver or silver-gilt. Varying distances of these shadows from the bodies of the boys, the putti, and the ribbons supporting the tapering pendants emphasize their three dimensionality. Superimposed and casting yet more deep shadows are eight stone-colored cartouches spanning the framework of the border. Those at center top and bottom are supported by more conventional putti, one of whom in the lower border indicates with a pointer the inscription

in Latin peculiar to each scene. The center top cartouche displays the arms of the Stuart kings of England (also claiming, anciently, France), Scotland, and Ireland. Angled cartouches at the corners contain putti flying inward with fluttering drapery in monochromatic warm browns, highlighted with gold thread, on a raised gold background in brick formation over grouped warp threads. Similarly rich monochrome scenes at the centers of the vertical borders tell the story of how the Hellespont received its name: at the left, Helle falls and is drowned while escaping over the water with her brother, Phrixus, on the

Detail of cat. no. 17

to the Netherlands.[20] In the border of this set, however, the putti in the corner cartouches are portrayed in a style so different from that of the naturalistic boys and putti managing the festoons and pendants, or of those supporting the cartouches, that they seem to represent Clein experimenting with more baroque forms. These corner flying putti, their limbs outflung in ecstasy, presented at unusual angles in undefined space, are similar in these aspects to putti in Rubens's oil sketch (now in the National Gallery, London) for the proposed "great piece for the ceiling" of the Duke of Buckingham's closet at York House, possibly commissioned when Rubens and Buckingham met in 1625.[21]

Date of Manufacture

Charles I purchased three sets of *Hero and Leander* rich with gold and silver thread from Sir Francis Crane. Clein presumably designed this series, along with the *Grotesque Senses*, as one of his first commissions for Mortlake, for on July 31, 1630, the king gave an order under privy seal to pay Crane for "three suites of Tapestries made in his house at Mortlake," two of "Crotesco" and one of *Hero and Leander*.[22] This, the first payment for tapestry (3,000 pounds for sixteen hangings) ordered since the start of Charles's reign in March 1625, was followed on June 23, 1631, by orders to pay for nineteen more Mortlake tapestries (4,314 pounds), among them another set of

Hero and Leander, 308 ells costing 6 pounds the ell.[23] As thirty-five hangings represented several years of weaving, the first set of *Hero and Leander* can be dated no more closely than the later 1620s, the second set being completed between August 1630 and June 1631.

Before these purchases were authorized, each *Hero and Leander* set had been given by the king to departing ambassadors extraordinary. Sir John Finet, Master of Ceremonies, recorded in his notebook that in April 1630 the French ambassador, "Monsieur de Chasteauneuf" (Charles de l'Aubespine, marquis de Châteauneuf-sur-Cher), "receyved by my handes a present from his majesty of 6 peeces of rich tapestry of Arras hangings made here in England, and valewed at three thousand pounds but well worth 2,000." And on February 15, 1631, the ambassador from Spain, "Don Carlos Coloma" (marqués de Espinar), inspected "the rich sute of hangings valued at £3000 prepared for his majestyes present to him. (It was the same story of Hero and Leander that was presented to the French, and of the same hands, but some what more large in price...)."[24]

As mentioned above, Böttiger identified the set now in the Swedish royal collection as a gift from Count Johan Oxenstierna to King Charles X on his marriage in 1654.[25] Oxenstierna (1611–1657), sent on diplomatic missions to England by his father, Axel Oxenstierna, chancellor to King Gustav Adolph, was reputedly given these *Hero and Leander* tapestries by Charles I when in London in 1634.[26] No such present, however, is recorded by Finet, who in 1634 noted only that "the baron of Oxensterne, Henry [*sic*]" refused the customary gift of 2,000 ounces of gilt plate made to a departing ambassador because he had not succeeded in obtaining troops for his master. And in 1635 Finet recorded merely that Gabriel Oxenstierna (uncle of Johan) was one of four of the ambassador's gentlemen to be knighted.[27] Perhaps a gift of tapestry was made privately, without the assistance of Finet. Without any documentation of such a gift, there is unfortunately no confirmation that this set was complete by 1634.

However and whenever Johan Oxenstierna obtained these tapestries, the combination of Charles I's arms and the monograms of Sir

Francis Crane and Philip de Maeght indicate that the set was woven for the king before he acquired the Mortlake manufactory in 1637. A warrant for its purchase would therefore have been necessary, and as the two other sets of this subject recorded in the warrants are accounted for as having been presented to the ambassadors, this set must have been the king's third purchase of *Hero and Leander*: 1,704 pounds to be paid for a set of 284 Flemish ells enriched with gold, at 6 pounds the ell, the warrant dated March 9, 1636.[28] That warrant also covered the purchase of two single pieces of tapestry at 8 pounds the ell, the *Blinding of Elymas* from the *Acts of the Apostles*, and *Diana and Calisto* after Titian. Their higher price did not reflect differences in quality so much as the greater number of faces and amounts of naked flesh to be woven, Raphael's designs for the *Acts* being packed with figures, and the discovery of Calisto's pregnancy being set when Diana and her nymphs disrobed to bathe, involving much nudity. Although these large single tapestries and at least some of the *Hero and Leander* pieces must have been completed between February 1631 and March 1636, as they figured in the latter warrant and not the former, it is not possible from existing evidence to know when the set that includes the *Meeting at the Temple* exhibited here was begun. Weaving might have been started to replace either the set given to the French ambassador in 1630, or the one presented to the Spanish ambassador in 1631. The date of this third set can therefore be assigned only approximately, to between 1630 and March 1636.

Of the few early Mortlake *Hero and Leander* tapestries with gold thread that survive, this set in the Swedish royal collection, though incomplete and damaged, is the largest extant and remains incomparably the finest in color and condition, demonstrating the skill of Mortlake weavers and the artist's understanding of good tapestry design.

WENDY HEFFORD

1. Böttiger 1895–98, vol. 4, p. 75, vol. 3, p. 31, set P no. IV.
2. Ibid., vol. 2, pp. 39–41, vol. 4, pp. 71–72.
3. Ibid., vol. 3, p. 31, set P no. IV, H.G.K. inv. 352; Fogelmarck 1988, p. 174.
4. Böttiger 1895–98, vol. 3, p. 31, set P no. III, H.G.K. inv. 53, vol. 2, pl. XII. As only half of this tapestry remains, the word in the inscription identifying Leander's sister is missing, and so in 1895 Böttiger thought the figure was Hero, leading him to transpose the second and third sub-

jects in the series. He identified Hermione, taken from Marlowe's poem, by the time of the French text volume published in 1898 (Böttiger 1895–98, vol. 4, p. 75).
5. Hefford 2002, pp. 51, 53.
6. Böttiger 1895–98, vol. 3, p. 30, set P no. II, H.G.K. inv. 52, vol. 2, pl. XI.
7. Ibid., p. 31, set P no. IV, H.G.K. inv. 352.
8. Ibid., p. 31, set P no. V, H.G.K. inv. 54.
9. Millar 1972, p. 423.
10. Göbel 1933–34, vol. 2, p. 309, n. 94.
11. Marillier 1930, pp. 49–51, pl. 18c.
12. ARDET HERO PARI / LIQ. ACCENDITUR / IGNE LEANDER / QUAEQ. FUIT VENERIS / SERVA CUPIDO / TUA EST.
13. Ovid, *Metamorphoses* 11.410–748.
14. Böttiger 1895–98, vol. 2, p. 45.
15. Whinney and Millar 1957, pp. 127–28.
16. Norgate 1919, p. 63.
17. Cosnac 1884, p. 214 and note.
18. Letter of May 7, 1670, in Thomson 1930, p. 302.
19. Fuller 1662, Surrey, p. 77; Symonds's notebooks, British Library, London, Egerton MS 1636, fol. 89v.
20. Croft-Murray and Hulton 1960, pp. 285–86.
21. London 1972, pp. 19–20, no. 12, ill.
22. National Archives (hereafter NA), Kew, Exchequer, E 403/2566, fol. 3v. Payment (E 403/1744) was on July 26, 1631.
23. NA, E 403/2566, fol. 54v; paid by installments (E 403/1744, July 26, 1631; E 403/1746, November 6, 1632; E 403/1748, July 23, 1634).
24. Loomie 1987, pp. 86, 100–101.
25. Böttiger 1895–98, vol. 2, pp. 39–41, vol. 3, p. 30, vol. 4, pp. 71–72.
26. Whinney and Millar 1957, p. 128, n. 1.
27. Loomie 1987, pp. 150, 158–59, 176–78.
28. NA, E 403/2568, fols. 19–19v.

18.
Perseus on Pegasus Rescuing Andromeda

From a six-piece set of the *Horses*
Design by Francis Clein, ca. 1635–36
Woven in the Mortlake workshop, Surrey, ca. 1636–37
Wool, silk, and gilt-metal-wrapped thread
304.8 x 322.5 cm (10 ft. x 10 ft. 7 in.)
7–8.6 warps per cm (most 7.4–7.8)
No marks; border missing. Mark of Sir Francis Crane on fragment of associated border
Victoria and Albert Museum, London, purchased with the assistance of the National Art Collections Fund (T.228-1989)

PROVENANCE: 1904, Wentworth Castle, Yorkshire; November 20, 1919, sale, Christie, Manson and Woods, no. 104; 1970s, James R. Herbert Boone collection, Baltimore; November 22, 1988, sale, Sotheby's, New York, no. 302, purchased by S. Franses Ltd. on behalf of the Victoria and Albert Museum.

REFERENCES: Latham 1904, p. 188; Hefford 1990, p. 102; T. Campbell in London 1995, pp. 168–70, no. 116; Hefford forthcoming. On the series: Marillier 1927; Standen 1985, pp. 700–707; T. Campbell 1987, pp. 31–32, 38–39.

CONDITION: The border is missing. There is much fading and deterioration of silk in sea and sky, some weft loss in areas of dark brown, and small amounts of reweaving. The silver-gilt used for highlights has become worn, tarnished, and darkened.

*I*n the series known as the *Horses* only this tapestry tells the story of Perseus; all the other hangings have each a different story, most—if not all—taken from the wealth of myths preserved in Ovid's *Metamorphoses*.

In the mid-sixteenth century a series comprised of differing Ovidian subjects was known by the general name of *Poesia*, or *Poesie*.[1] Antwerp tapestry merchants in the early eighteenth century more prosaically sold sets of "Verdures avec de figures du Metamorphose d'Ovide."[2] In England, references to sets of "the horses" in documents of the 1630s to the 1670s gave no indication of any literary origin. From this laconic description, writers on the history of English tapestry took it for granted that the tapestries in this series featured horses from the royal stables.[3]

In 1926 the more complex identity of the series began to emerge. At Drayton House, Northamptonshire, H. C. Marillier discovered a room full of tapestries—some of which he

recognized as different stories from Ovid's *Metamorphoses*—with large horses so prominently represented that he wondered whether they might not be "the mysterious Mortlake 'Horses.'"[4] In 1927 he published a seminal article on the Drayton and similar tapestries, some marked as made at Lambeth, from later seventeenth-century sets, no early Mortlake tapestries of this series then being known to survive. Still at Drayton House are tapestries illustrating the stories of Perseus and Andromeda (*Metamorphoses* 4.670–764); of Meleager (8.270–546), who gallops with the head of the Calydonian boar on his spear; and of Scylla, admiring the horsemanship of Minos, who was besieging her father's city (8.6–151). Three other pieces formerly at Drayton are now in museums: Picus, "lover of horses," accosted when hunting by the enchantress Circe (14.320–96);[5] the slaughter by Apollo and Diana of all Niobe's children (fig. 96) as her daughters watch her sons exercising their horses (6.147–312); and an uncertain subject. Since the 1920s this subject had been thought to depict either Ajax or Agamemnon seizing the Trojan princess Cassandra during the sack of Troy (13.410–14), but this identi-fication has been made highly debatable by discrepancies of subject matter indicated by Edith Standen.[6]

These six subjects probably comprised the entire series. "Six peeces of the Horses" were listed among cartoons reserved from sale at Mortlake in October 1651;[7] the Duke of Ormonde's inventory of 1675 noted six pieces made at Lambeth;[8] and only six subjects have survived from all known early and late Mortlake and Lambeth sets. Although Marillier thought there was a seventh subject at Drayton, he had not recognized the subject of *Scylla and Minos* and so did not realize that it had been divided into two tapestries.[9] Until recently, eight "of the horses" tapestries noted at Whitehall in the inventory made for the sale of Charles I's possessions after his execution in January 1649[10] were considered to belong to a set of Mortlake *Horses*; but their cumulative size of 567 square Flemish ells is far greater than the largest possible combination of the six Mortlake designs, even if two more were added. It may be that these eight pieces were the set of "horses and horse-

manship" that Charles I purchased through his jeweller in April 1635.[11] That was probably a set of Brussels tapestries combining mythological and manège scenes, like the *Horsemanship* series by Jacob Jordaens.[12] If the first set of the Mortlake *Horses* was made for Charles I, its conception may have stemmed from a wish to produce tapestries with a theme of horses differing from that *Horsemanship* series. Scenes including riding horses found in Ovid's *Metamorphoses* possibly came to mind in that Mortlake's designer, Francis Clein, had recently provided illustrations to George Sandys's translation of the *Metamorphoses* into English (1632).

Perhaps finding such subjects proved more difficult than expected. When Charles I purchased two sets of the *Horses* from Richard Crane in 1637, each had only five pieces; it is tempting to assume that the so-called *Ajax and Cassandra* piece was added only later, when niceties of concept had to be abandoned in order to create a larger series. Strict adherence to Ovid's stories had already faltered. Meleager's hunt of the Calydonian boar had presumably been a subject chosen for the participation of the semi-divine twins Castor and Pollux on their milk-white steeds, Castor being famous as a horseman—yet they were omitted from the tapestry design. And Ovid's provision of winged sandals for Perseus is made superfluous by mounting him on a winged horse.

Description and Iconography

Andromeda, naked and chained to a rock as food for a sea monster (in atonement for her mother, Cassiope, offending the Nereids, daughters of a sea god), is here relegated to the background at the right, her story merely an excuse for depicting Perseus on Pegasus. The great brown horse with wings dominates the scene, caught in the moment of transition from earth to air as he leaps out over the sea, hind hooves still in contact with rocky foreground at the left. Winged sandals and a curved sword, borrowed from Mercury, confirm the identity of the rider as Perseus. He wears a Renaissance interpretation of Roman armor. His helmet is ornamented with a winged mask, acanthus scrolls, and a grotesque creature in the round, as a crest,

supporting a large horizontal plume. Garments and accoutrements are highlighted with gold thread.

Perseus flies with raised shield and drawn sword to rescue Andromeda. Around the monster's thrashing coils and threatening jaws, violently disturbed water is effectively depicted in dark blues and white. Paler blues of sea and sky nearer the horizon, woven in silk for luminosity, have faded and discolored. Buildings on a distant shore are now scarcely visible beneath the tail of Pegasus. Straggling, windblown clouds; Pegasus's streaming tail and tilt of wings; and Perseus's dramatically billowing red cloak and feathery crest all provide a sense of movement in the composition.

According to the story told in Ovid's *Metamorphoses*,[13] Perseus should be flying to aid Andromeda on winged sandals. In Greek mythology Pegasus, created when Perseus beheaded the gorgon Medusa, had no further connection with the hero. In Roman times the winged horse became a symbol of immortality, interpreted by Fulgentius around the late fifth century A.D. as Fame. The *Ovide moralisé* and Christine de Pisan's *Épitre d'Othéa* in the late fourteenth century reinterpreted the Perseus legends as moral allegory. In Christine's allegorical gloss, Perseus, "bon chevalier," borne by Good Renown (Pegasus), achieves the salvation of his soul (Andromeda).[14] Manuscripts of this work were illustrated with Perseus, in full medieval armor, riding Pegasus and armed with Mercury's scythe.[15] In the complex iconographical program of the Brussels tapestry series of about 1520–25 known as *Los Honores*, Perseus, holding aloft the head of Medusa, rides a fiery Pegasus to symbolize Good Fame in the tapestry depicting the Temple of Fame, but he appears standing (with scythe) by Andromeda to represent Good Fortune in the tapestry of *Fortune*.[16] Bernard Salomon's woodcuts of the mid-sixteenth century illustrating Ovid popularized the image of Andromeda rescued by Perseus on Pegasus; and as Elizabethan and Jacobean writers frequently alluded to Perseus riding Pegasus, the concept was sufficiently commonplace by 1632 to feature in the rescue of Andromeda staged in London for the Lord Mayor's pageant. Francis Clein's illustrations to George Sandys's translation of the

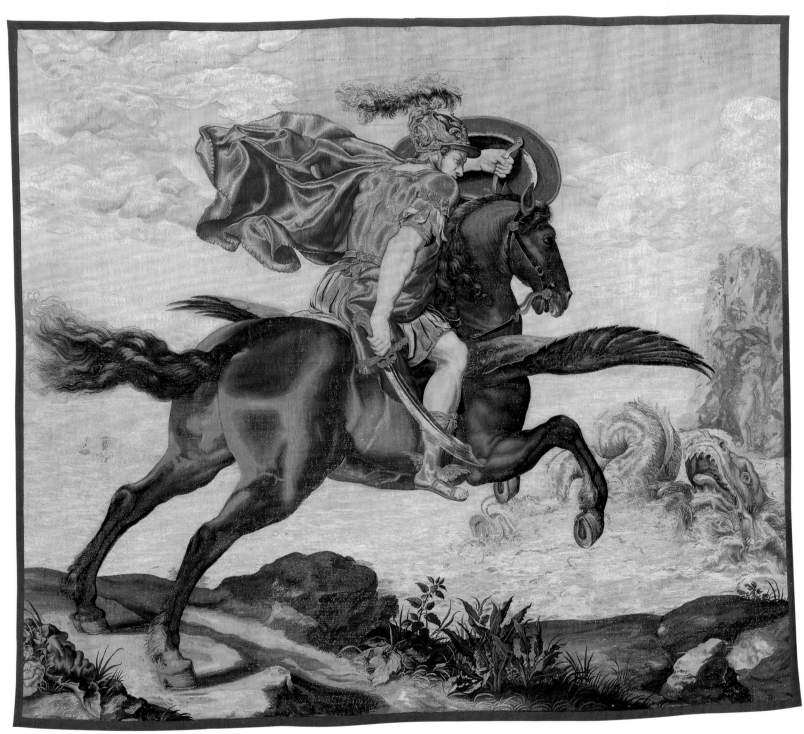

18

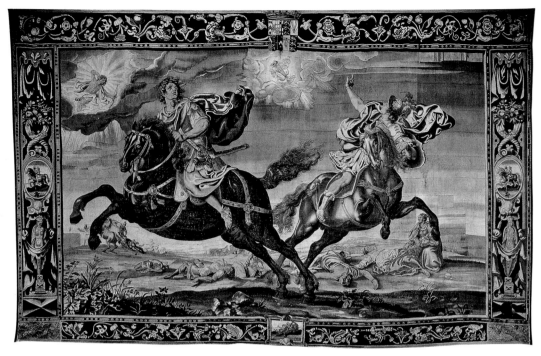

Fig. 96. *The Destruction of the Children of Niobe* from a set of the *Horses*, with arms of Mordaunt impaling O'Brien. Tapestry design by Francis Clein, ca. 1635–36, woven at Mortlake or Lambeth, ca. 1660–80, for Henry Mordaunt, Earl of Peterborough. Wool and silk, 386 x 589 cm. The Metropolitan Museum of Art, New York, Gift of Christian A. Zabriskie, 1936 (36.149.1)

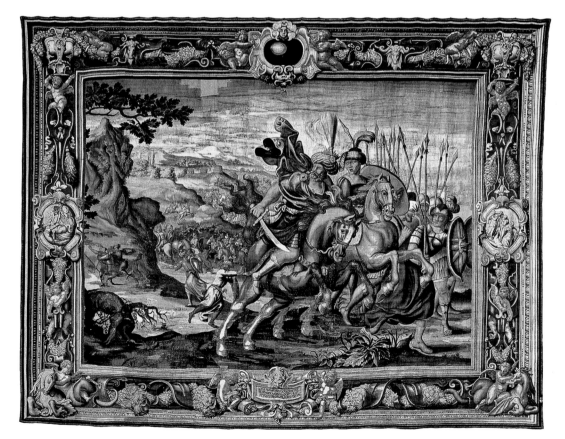

Fig. 97. *The Flight of Darius* from an *Alexander* series woven at Mortlake, ca. 1660–80, in a border, formerly used for the *Horses*, designed by Francis Clein, ca. 1635–36. Wool and silk, 425 x 527 cm. Winnipeg Art Gallery, Gift of Lord and Lady Gort (G-73-58)

Metamorphoses, also published in 1632, correctly made Perseus fly on winged sandals. In the Mortlake tapestries of the *Horses*, however, Clein's choice of locomotion for Perseus was dictated by the chosen visual emphasis of the series.

The Missing Border and Tapestry "en suite"
Although *Perseus on Pegasus Rescuing Andromeda* unfortunately now lacks a border, it is possible to reconstruct how it looked. Two tiny, coral-colored prongs hanging incongruously in the sky can be identified as the tips of snakes' tails protruding from a mask beneath a cartouche central in the upper border found now only on a later, unrelated tapestry from an *Alexander* series (fig. 97). Close examination of this border proves that it was designed for the series of the *Horses*. Scenes in cartouches at the sides continue two stories from Ovid's *Metamorphoses* featured in that series: at the left, abandoned Scylla tries to reach the departing ship of Minos, her betrayed father hovering as a bird above; at the right, the mother of Meleager stabs herself, his sisters weeping over the corpse of the son she has killed.

Thomas Campbell discovered that *Perseus on Pegasus*, even then without its border, was illustrated in 1904 hanging on a staircase in Wentworth Castle, Yorkshire,[17] and was sold through Christie, Manson and Woods, on November 20, 1919, along with pieces *en suite* described as woven with an "Amazon on horseback in border of Amorini and strapwork," and "Various borders and fragments of tapestry."[18] The "amazon" was probably one of Clein's fair-faced, youthful heroes, Picus or Meleager being the most likely candidates in this series. Campbell also found, in the National Monuments Record, another photograph of the staircase at Wentworth Castle showing part of a left side border similar to the border on the *Alexander* tapestry, confirming the use of this design on the missing border.[19]

In 2005 it was possible to identify in an auction catalogue several fragments of a finer, earlier border of this design,[20] enriched with silver-gilt thread as is the *Perseus on Pegasus* tapestry. Among these border fragments are putti on sea horses from the lower corners, the putto from top left, two putti seated

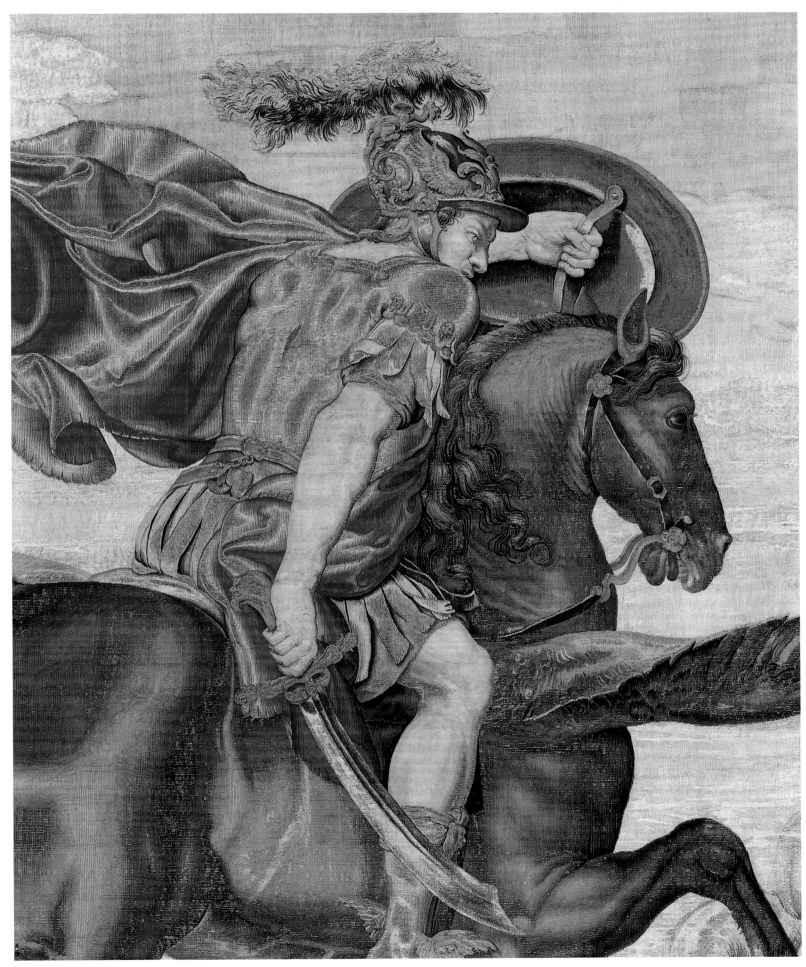

Detail of cat. no. 18

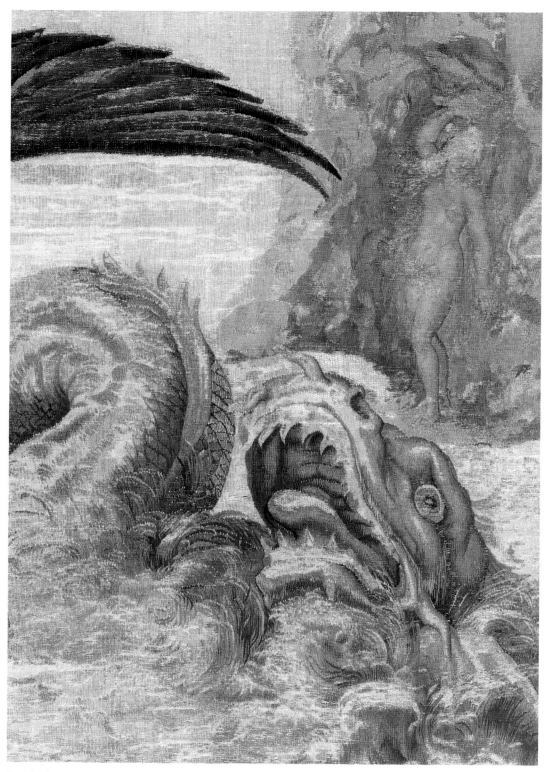

Detail of cat. no. 18

in 1898 William Evelyn Long of Hurts Hall, Suffolk, married Muriel Hester Vernon-Wentworth of Wentworth Castle. It further transpires that a member of the seller's family still retains a fragment of this *Horses* set: the figure of the man holding the horse, with a little of the scene behind him, at the right of the tapestry with the uncertain subject. This and *Perseus on Pegasus* are the only pieces of early Mortlake *Horses* known to survive, but it is now to be hoped that other fragments of the set, or even the whole tapestry of the "amazon on horseback" may come to light.

Design

Sir Sackville Crow, reporting to the Countess of Rutland on tapestries available in 1670, commented that "The Horses... are by Clyne, the figures Noble enough, but the rest of the designe not soe excellent."[21] Confirmation of the designer's identity is superfluous, given similarities of figure style between this series and other work by Clein, among them Mortlake tapestries of the late 1620s and 1630s such as *Hero and Leander* (cat. no. 17) and the *Hunters' Chase* (fig. 94); etchings, particularly the *Seven Liberal Arts* of 1645;[22] and illustrations to John Ogilby's *Virgil*, published in 1654. Elements of costume decoration favored by Clein are also present: scattered flowers on garments worn by Circe and by Niobe's youngest daughter can be compared with those on Hero's robe (see cat. no. 17) and are again seen in the *Hunters' Chase* (fig. 94).

Clein's *Horses* have a theatrical quality. Life-size figures, seen slightly from beneath, pose dramatically on a narrow foreground as though on a stage, in front of a backdrop in which subsidiary figures and scenery appear on a different plane. Such staging may derive from prints showing series of *Worthies* on horseback, or from Antonio Tempesta's *Horses of Different Lands* (1590), where, also, postures of two horses combined can be compared with Pegasus.[23] Edith Standen detected that the horse on the right in the Niobe tapestry (fig. 96) was taken from Tempesta's *Aetas Ferrea* illustration from Ovid's *Metamorphoses* in an edition of 1606.[24] The "whale" disgorging Jonah in Tempesta's illustration to the Bible has the same eye, tongue, and triangular teeth as Andromeda's monster.[25] Thomas Campbell sees Clein's figure of Andromeda as possibly

beside snarling dogs' heads, and the satyr mask that should be above the missing description, between them in the lower border. They also include strips of inner and outer frame moldings of exactly the same patterns as those on the *Meeting at the Temple of Venus* from the series of *Hero and Leander* (cat. no. 17) (which are more numerous than those on the inferior version of the *Horses* border around the

Alexander tapestry), and most importantly, a fragment of blue outer edging containing the FC monogram of Sir Francis Crane. Subsequent enquiries linked these border fragments to the *Horses* tapestries at Wentworth Castle. Information from the previous owner established that they came to him from cousins of his wife named Long, living in Suffolk; and Burke's *Landed Gentry* reveals that

deriving from Bernard Salomon's woodcut in *La Metamorphose d'Ovide figurée* of Jean de Tournes (Lyon, 1557).[26] But even if these trivial similarities were conscious, rather than subliminal or coincidental, Clein's re-creation in scale and painterly detail make them his own: powerful designs that best exemplify the spirit of the Baroque in English tapestry.

No tapestry in this set was meant to be seen in isolation. The great horses—viewed from varying angles and portrayed in different types of motion, galloping, leaping, cantering, prancing and standing still—work as a set hung round a room, with horses moving to left or to right from the hanging where two sons of Niobe diverge in terrified flight (fig. 96). Perseus and Minos ride to the right, Meleager and Picus to the left; movement ends at the tapestry with the three stationary horses. The effect created would have been overwhelming.

Date and Manufacture

Discovery of a border with the monogram of Sir Francis Crane, apparently from the very set of the *Horses* that included this *Perseus on Pegasus*, dates the weaving of at least one piece of the set either before the death of Sir Francis in June 1636 or, if his brother continued using the mark, before the weavers all became employees of the king by the indenture of June 1638.[27] Two documented sets of early Mortlake *Horses* made for Charles I fall within this period. One, given to the departing French ambassador, was possibly not quite finished when a warrant of July 12, 1637, instructed Richard Crane to deliver five pieces "or so many as is ready" for presentation by the Master of Ceremonies, though they were complete by July 31, when payment was ordered.[28] Issues of the Exchequer paying for this set on December 22, 1637, and February 16, 1638, describe the border as "crotesco."[29] This was presumably the grotesque border found on the *Senses* at Haddon Hall (fig. 87), for the side borders of that design are on at least three later sets of the *Horses*.

This unusual description of a border design was necessary to differentiate that particular purchase from Richard Crane of a set of *Horses* in five pieces from one slightly earlier, with payment (1,204 pounds) in full on December 20, 1637.[30] The warrant of June 7, 1637, ordering payment for this set of 301 square ells at 4 pounds the ell, "enriched with gold," included also debts owed to Sir Francis Crane for tapestry, and the king's purchase of quantities of silk and worsted and some unfinished tapestries in the looms at Mortlake.[31] That distinctive warrant mentions no border details for the *Horses*, but in an undated memorandum of these same payments to be made to Crane, this set is recorded as having a "Stone" border.[32] The recently discovered fragments from a missing border have scrollwork and putti woven in the color of stone—not faded, as no flesh tones are discernible on the reverse. And this set to which *Perseus on Pegasus* seems to belong, with its gold thread and "stone" border, might well have had one or more pieces woven with the mark of Sir Francis Crane, for instructions were given on March 17, 1637, for the set, already delivered into the Whitehall Palace wardrobe, to be measured and valued.[33] Any sixth piece woven for the king after he acquired the manufactory would have had no documented purchase. Absence of any set of five or six pieces of the *Horses* in the sale of the king's goods might be explained by gift or sale in the time of the civil war to promote or finance the royalist cause.

Tempting though it may be to see *Perseus on Pegasus* as having been made for Charles I, there is the possibility that it comes from a set sold to a private individual, given the lack of documentation surviving on sales of this type made in the time of Sir Francis and Richard Crane. As suggested above, the apparent hiatus between the king's appointment of Sir James Palmer as Governor at Mortlake, with powers to pay the weavers from May 1637, and the formal contract in June 1638 between the king and the weavers, regarding agreed amounts of tapestry to be produced each year in return for a fixed income, was possibly due to the existence of sets commissioned earlier from Crane that were still awaiting completion. The *Horses* would have been in demand as Mortlake's most recent series and of wide appeal in a society not only well versed in Ovid's *Metamorphoses* but also dependent for so much of its work and pleasure on the quality of its horses.

WENDY HEFFORD

1. See C. Paredes in New York 2002, pp. 424–28, no. 49.
2. Denucé 1936, p. 369 and passim, offering options of large or small figures and variations in individual subjects from this prolific source.
3. Marillier 1927, quoting Thomson (1914, p. 84) on "the royal *Horses*," which Göbel (1933–34, vol. 2, pp. 176–77) turned into "The Royal Horses."
4. Letter to A. J. B. Wace, June 10, 1926, archives with Marillier's subject catalogue of tapestries, Department of Furniture, Textiles and Fashion, Victoria and Albert Museum, London.
5. Victoria and Albert Museum, London: see Hefford forthcoming. Illustrated in Göbel 1933–34, vol. 2, fig. 134, as "The Royal Horses"; exhibited Birmingham 1951, no. 28, as "Penelope taking farewell of Ulysses"; subject identified and tapestry illustrated in Hefford 1990, pp. 100, 98.
6. Standen 1985, pp. 700–707, nos. 124a (Niobe), 124b (uncertain subject).
7. Millar 1972, p. 423.
8. Graves 1852–53, p. 6.
9. Illustrated in Marillier 1927, p. 12, fig. E; Hefford 1990, pp. 100, 102, both parts illus. p. 101.
10. Millar 1972, p. 332, recorded also on p. 397.
11. National Archives (hereafter NA), Kew, Exchequer, E 403/2567, fol. 104.
12. Hefford 2003.
13. *Metamorphoses* 4.610–5.249 tells all his adventures; 4.670–764, the rescue of Andromeda.
14. Tuve 1966, pp. 33–36, illus., p. 35.
15. Frank Justus Miller's translation of Ovid's *Metamorphoses* (Loeb Classical Library) consistently describes Mercury's sword lent to Perseus as "hooked." In medieval art this weapon was often depicted as a sickle or scythe, but by the sixteenth century it was usually rationalized as a curved sword.
16. See Mechelen 2000, pp. 34, 54, 103–6.
17. Latham 1904, p. 188.
18. T. Campbell in London 1995, pp. 168–70, no. 116.
19. Thomas Campbell's notes and photograph in the S. Franses Archive, London.
20. Sale cat., Holloway's, Banbury, Oxfordshire, May 10, 2005, no. 306, a panel 107 by 114 cm composed of a collage of fragments, and nos. 307–9, single putti. See Hefford forthcoming for fragments of border given to the Victoria and Albert Museum.
21. Thomson 1930, p. 302, letter of May 7, 1670, quoted in Historical Manuscripts Commission 1889, p. 16.
22. All illustrated in London 1998, pp. 118–21.
23. Hefford 1990, p. 100; T. Campbell in London 1995, p. 168.
24. Standen 1985, p. 704; comparing the horse on the left to one in Clein's own illustration of the story of Niobe in George Sandys's translation of 1632.
25. Illustrated Bartsch (Buffa 1984), no. 217 (128).
26. T. Campbell in London 1995, p. 168.
27. NA, E 351/3415.
28. NA, LC 5/134, 188, and E 403/2568, fol. 44v.
29. NA, E 404/1751 (under dates).
30. NA, E 404/1751 (under date).
31. NA, E 403/2568, fol. 36v.
32. University of Oxford, Bodleian Library, Bankes Papers, MS 16/14.
33. NA, PC 2/47, fol. 120v.

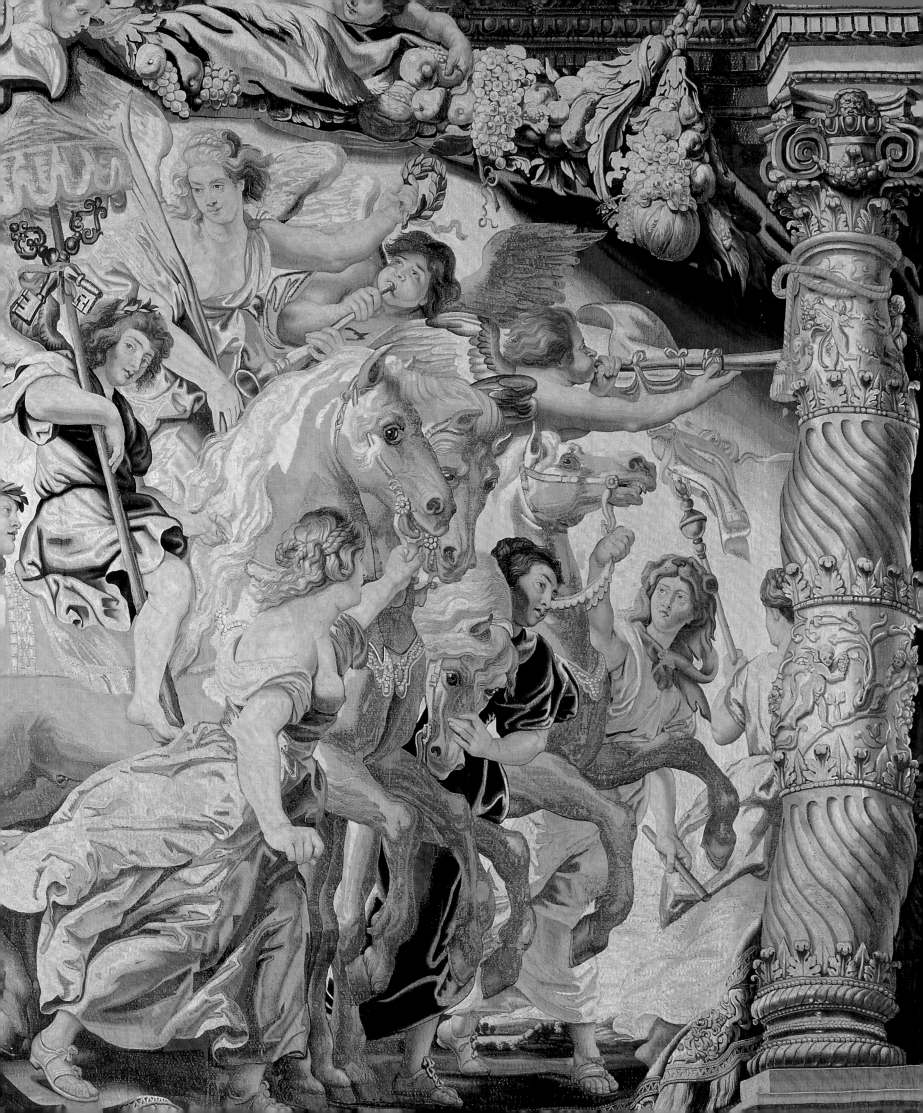

Tapestry in the Spanish Netherlands, 1625–60[1]

GUY DELMARCEL

The Spanish branch of the House of Habsburg continued to rule over the southern Netherlands throughout the seventeenth century, and its viceroys remained significant patrons of the tapestry workshops there. Under the Archdukes Albert (r. 1595–1621) and Isabella (r. 1599–1633), many sets were bought from the Brussels ateliers, as has already been discussed. After the death of her husband in 1621, Isabella intended to withdraw to the convent of the Descalzas Reales (the Barefoot Royals, or Poor Clares) in Madrid. However, affairs of state required her presence in Brussels—she died there in 1633—so she commissioned an exceptional series of tapestries to present to the convent. This, the Triumph of the Eucharist, was designed by Peter Paul Rubens, her court painter, and woven jointly by four Brussels workshops (cat. nos. 19–24).[2] The exact circumstances of the order are not known, but the entire set of twenty tapestries was delivered to Madrid in July 1628. Of the eleven wide pieces—the number was an allusion to the eleven weavings around the Ark of the Covenant—five have scenes of prefiguration from the Old Testament and six depict allegorical triumphs related to the Eucharist. As such, they form an explicit and magnificent illustration of the mystery of the Transubstantiation (the real presence of God in the Eucharist), a central post-Tridentine theme of the Roman Catholic Church in countering the Reformation. The twenty tapestries were conceived as a trompe l'oeil two-level gallery of columns from which hang depictions of tapestries containing the pictures in the series. In the lower-level hangings, the columns bordering each side are in the Tuscan style, and in the upper-level hangings, the columns are twisted and have Corinthian capitals. The artistic impact and influence of this series was immediate and far-reaching. Although the original cartoons remained the property of the crown and were kept in the palace in Brussels, Rubens's compositions were proliferated through copies of the modelli—small oil paintings—then through engravings, and finally through sets of new cartoons.

The woven reeditions, done almost exclusively in the Brussels workshop of François van den Hecke, were apparently produced from about 1650 on. But as early as the 1630s, such artists as Jacob Jordaens in Antwerp and Anthonis Sallaert in Brussels were adapting Rubens's style and its heroic, large-size figures full of life and movement.

The Spanish rulers already had the numerous acquisitions made by their predecessors, Charles V and Philip II. As Philip II had taken the remarkable step of making all valuable tapestries a part of Spanish patrimony, forbidding their disposal after his death, Philip IV (r. 1621–65) had inherited the greatest tapestry collection in the world, and this may, in part, explain why his patronage of the figurative arts largely focused on paintings. Nonetheless, he certainly made a number of tapestry purchases. For example, courtiers acting on his behalf purchased a set of the Story of Diana and of the Story of Alexander, probably to be identified with tapestries of these subjects that survive today in the Spanish royal collection, the former woven in Paris in the 1610s and the latter in Brussels in the workshops of Jan Raes and Jacques Geubels II. In 1638 Philip acquired two sets after designs by Anthonis Sallaert: a Story of Theseus and an Allegory of the Life of Man, as well as numerous sets of Landscapes with Animals.[3]

Archduke Leopold Wilhelm (1614–1662), governor-general of the Netherlands from 1647 to 1656, was in his turn an avid collector. He acquired contemporary tapestries from the Brussels workshops. His court painter, Jan van den Hoecke, was entrusted with the design of full-size cartoons for a series of the Allegory of Time, woven in 1650 (cat. nos. 27, 28). Evidence of other purchases is provided by his wills, drawn up in 1661 and 1662. According to them, he bequeathed to Archduke Karl Josef a Story of Decius Mus, made after the design by Rubens and incorporating gold thread, and he left to his master of ceremonies, Count Johann Adolf von Schwarzenberg, the famous series of Proverbs (Hluboká Castle; fig. 99) and another of

Fig. 98. Detail of cat. no. 21, *Triumph of the Church over Ignorance and Blindness* from a set of the *Triumph of the Eucharist*

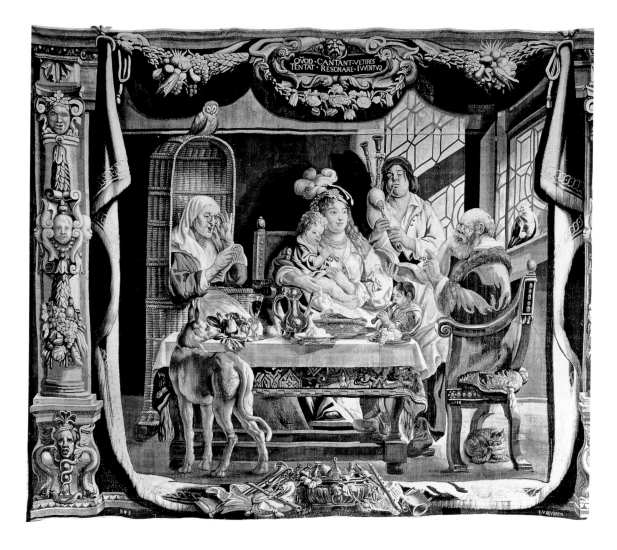

Fig. 99. *As the Old Sing, so Pipe the Young* (detail) from a set of *Proverbs*. Tapestry design by Jacob Jordaens, woven by Baudouin van Beveren, Brussels, 1646–47. Wool and silk, 380 x 468 cm. Hluboká Castle

Horsemanship (Kunsthistorisches Museum, Vienna; cat. no. 26), both after designs by Jordaens as well as a *Story of Judith* (Hluboká Castle) and *Landscapes* after Lucas van Uden, some of which are still in the Schwarzenberg family collection.[4]

On the whole, manor houses in the Spanish Netherlands had few tapestries, and the rooms were mostly hung with a wide variety of gilded leather. It is therefore all the more remarkable that many Italian merchants who settled in the Netherlands decorated their sumptuous patrician houses with Flemish tapestries. For example, in a room of the Antwerp house of the Genoan merchant Gian Battista Pallavicino (according to the inventory of his possessions drawn up in 1665), there were "fine tapestries hanging on all sides of the room, depicting flowerpots and columns," and in another room, "fine tapestries, also of flowerpots and columns."[5] The pergola type of tapestry, portraying vases of flowers beneath flower-wreathed trellises, probably originated in Brussels in the early part of the century. Decorative and easier to weave than tapestries incorporating large figures, the formula was copied and adapted by tapestry makers in both Oudenaarde and Antwerp, and many examples

survive in a range of qualities (fig. 103).[6] Another Italian merchant living in Antwerp, Giovanni Stefano Spinola, is recorded in 1669 as having in his possession rooms of tapestries, the subjects of which are not mentioned.[7] In 1649 the Milanese Giacomo Antonio de Carenna acquired a stately patrician house on the Meir at Antwerp. After his elevation to the nobility in 1656, he bought a set of the *Story of Achilles* after cartoons by Rubens from Jan or Frans Raes. His coat of arms was added to the lowest border of an existing series, which was, moreover, framed with a border that Raes had had designed in 1649 for several *Pastorales* intended for Ottavio Piccolomini, commander in chief of the Spanish army in the Netherlands. In 1669, when Carenna drew up his will, bequeathing the series to his son, he described the tapestries specifically as having been made to fit the largest room of his house.[8]

Another significant aspect of Flemish tapestry production in the mid-seventeenth century is the continuing use of Renaissance models. The market for new and important designs supplied by painters from Antwerp and Brussels, most of whom followed in the wake of Rubens, coexisted with

patrons' lively interest in the older models. Many cartoons were still available, and these were now largely copied and reinterpreted in terms of contemporary Baroque style, with changes made to both the personages and the borders. This was the case with the *Story of Moses*, after a design by Giovanni Battista Lodi da Cremona, a follower of Giulio Romano, of which there are no fewer than sixteen remakes dating from the seventeenth century, most of them woven in the workshops of Reydams and Auwercx.[9] Of the *Story of Jacob*, the large series created about 1530 after Bernaert van Orley, of which an early example is now preserved in Brussels (Musées Royaux d'Art et d'Histoire), a number of remakes dating from the second third of the seventeenth century are also known, including those by Jan Raes (private collection, Montevideo) and especially by Jacob van Zeunen (fl. 1644–80; Kunsthistorisches Museum, Vienna, and the cathedrals of Laon, Kraków, and Cuenca).[10] The series that became best known because of its many reeditions, however, is undoubtedly the *Deeds and Triumphs of Scipio*, the first edition of which was made after models by Giulio Romano and Giovanni

Francesco Penni for King Francis I of France.[11] These cartoons came into vogue again in the early seventeenth century, and shortly after 1650 large editions were woven by the leading Brussels workshops, in a remarkable collaborative effort undertaken by Everaert Leyniers III (1597–1680), Hendrik Reydams I (fl. 1629–69), Jan van Leefdael (1603–1668), and Gerard van der Strecken (fl. 1644–77). Sets of this design were purchased, if not ordered, by the Farnese dukes of Parma (Palazzo del Quirinale, Rome), by Duke Charles IV of Lorraine (Kunsthistorisches Museum, Vienna), by Venetian patricians (Palazzo Labia, Venice), and by Don Luis de Benavides, governor of the Spanish Netherlands from 1659 to 1664 (now divided among the Fondation Toms Pauli, Lausanne; Museo de Bellas Artes, Buenos Aires; Wawel Royal Castle, Kraków; and Muzeum Narodowe, Warsaw).[12] To this last set Benavides had his coat of arms applied, as well as his emblem—a putto, sitting on an eagle and looking through a telescope at the stars, an allusion to the name "bena vides"—while the borders were adapted to display extravagant decorations in the Baroque style (fig. 100).

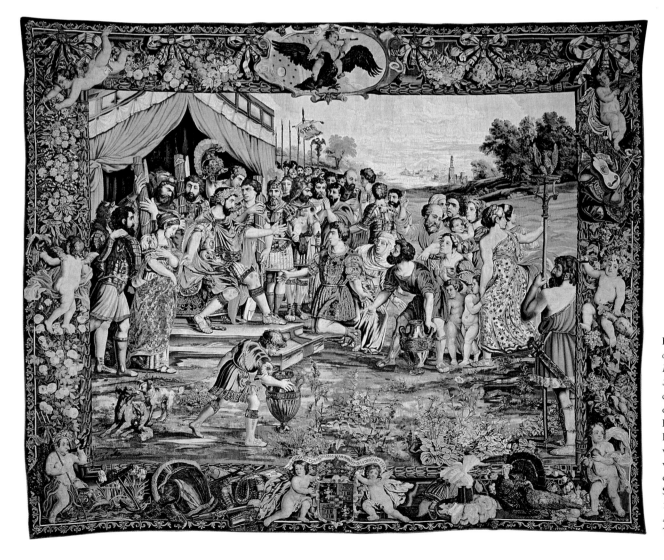

Fig. 100. *The Continence of Scipio* from a set of the *Deeds and Triumphs of Scipio*. Tapestry from cartoons, ca. 1655, based on designs by Giulio Romano and Giovanni Francesco Penni, ca. 1523, with borders, ca. 1655, woven in the workshop of Gerard van der Strecken, Brussels, 1660–64. Wool and silk, 470 x 540 cm. Fondation Toms Pauli, Lausanne (25)

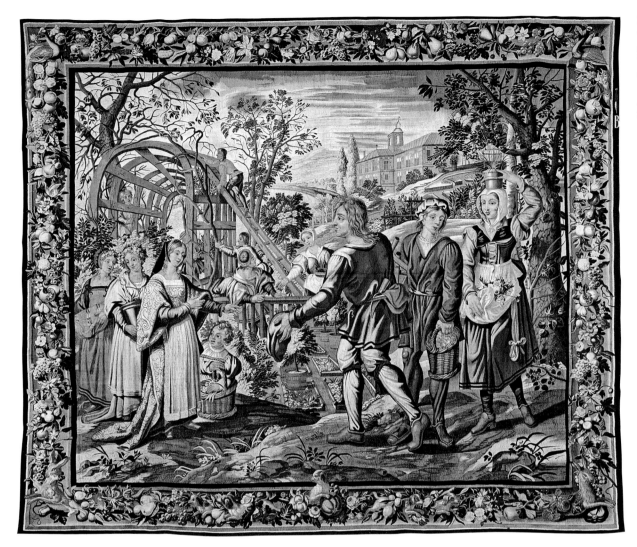

Fig. 101. *April* from a set of the *Months of the Year* (known as the *Months of Lucas*). Tapestry woven in Bruges, ca. 1650. Wool and silk, 350 x 393 cm. Kunsthistorisches Museum, Vienna (KK T XXXVIII 3)

Not only the models but Flemish Renaissance tapestries themselves continued to be eagerly sought after by collectors and princes alike, especially when they contained silver and gilt-metal wrapped thread. Such sets were presented as princely gifts on special occasions. At the conclusion of the Treaty of the Pyrenees (1659), for instance, the ministers authorized to sign the document exchanged famous Flemish tapestries: Luis Méndez de Haro, first minister of the Spanish king, presented Jules Cardinal Mazarin, the representative of France, with sixteenth-century sets of the *Fruits of War* (*Fructus belli*), the *Labors of Hercules* "after Titian," and another of the *Twelve Months*, woven in Bruges. Mazarin, in turn, presented Haro with a set of *Bestions*, or fighting animals (perhaps akin to cat. no. 9), and an otherwise unspecified "Bachanales de Leonard Davinci."[13] The Bruges *Months* were contemporary tapestries but were based on the older cartoons of the so-called *Months of Lucas*. A similar series was bought in 1666 by the court in Vienna (where it is still preserved) for the marriage of Emperor Leopold I and

Margaret Theresa (fig. 101).[14] The preference for old Flemish tapestries is demonstrated by their listings in the inventories of the estates of illustrious persons. Cardinal Richelieu (1585–1642), for example, owned a costly Brussels set of *Grotesques*, a *Story of Tobias* in twelve pieces, and a *Story of Caesar* produced in Bruges, all made in the sixteenth century.[15] His successor, Cardinal Mazarin, was drawn almost exclusively to older series. The new creations failed to hold his interest; as he himself said, "le nuove non fanno per me" (the new ones do not work for me).[16] He went eagerly in search of the valuable, old sets when the British Crown collection was sold under Cromwell in 1649, and he cunningly managed, with the help of the young Jean-Baptiste Colbert, to acquire the set of the *Hunts of Maximilian* from the Guises. He also owned a very fine mid-sixteenth-century edition of Romano's *Scipio* cycle. It was this set—originally woven for the marshal of France Jacques d'Albon de Saint-André and subsequently owned by Catherine de' Medici—that was hanging in the small gallery of his palace in Paris when

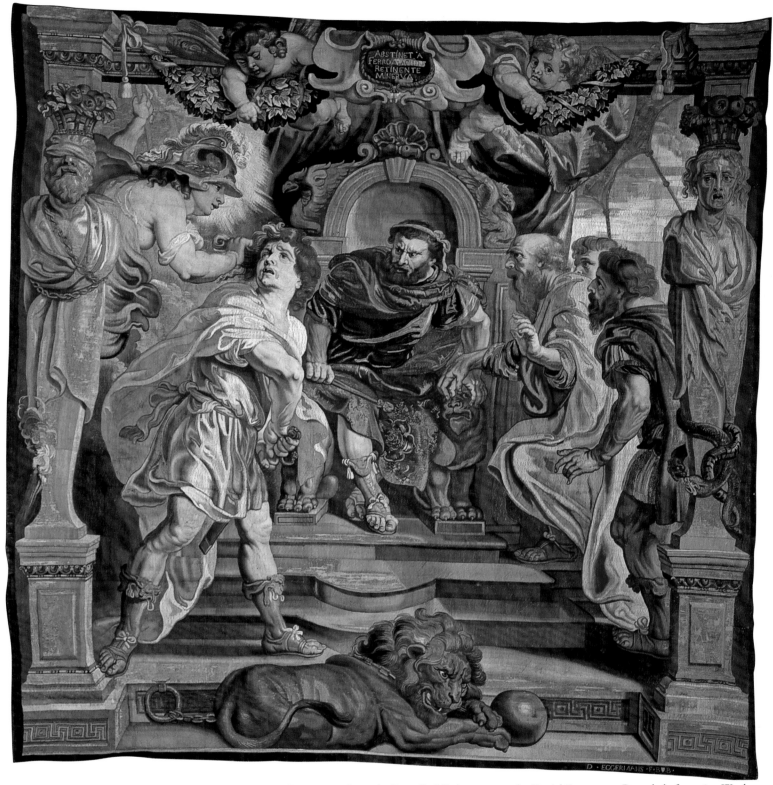

Fig. 102. *The Wrath of Achilles* from a set of the *Story of Achilles*. Tapestry design by Peter Paul Rubens, woven by Daniel Eggermans, Brussels, before 1642. Wool, silk, and silver metal-wrapped thread, 417 x 390 cm. Museum Boijmans Van Beuningen, Rotterdam (MBT60[KN&V])

the chronicler Brienne, hiding behind the tapestry, heard Mazarin muttering over and over again: "Et dire qu'il faut quitter tout cela!" (And to think that one must leave all of this!),[17] as he contemplated his favorite works of art shortly before his death in 1661.

The Age of Rubens and Jordaens

As discussed earlier in this volume, Rubens's *Decius Mus* and *Constantine* designs were revolutionary in a number of ways, and their influence on seventeenth-century tapestry design was as profound as that exerted a century earlier by the designs of

207

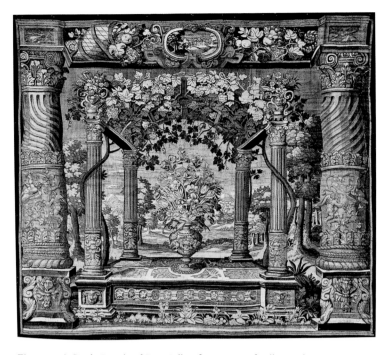

Fig. 103. *A Single Pergola of Four Pillars* from a set of *Pillars and Vases*. Tapestry woven in the workshop of Jacob Wauters, Antwerp, before 1661. Wool and silk, 302 x 269 cm. The Royal Collection, deposited at Holyrood House, Edinburgh (27893)

the Raphael school. The *Eucharist* series introduced even more dramatic innovations. Conceived as a woven gallery hung with tapestries, the series created a new incentive to hang textiles, border to border, to create the effect of a spatial continuum. Although there were precedents for this, Rubens developed this illusion to a far greater degree than ever before. Under Rubens's influence, architectural elements now began to replace the borders containing flowers and grotesques. The first steps in this direction had already been taken in the *Decius Mus* series, in which the borders were articulated by means of sculptural cartouches (cat. nos. 10, 11), a decorative element frequently used in Italian tapestries of the sixteenth century. In the *Story of Achilles*, possibly Rubens's last series, this architectural framework is further embellished by a complex symbolism of herms and emblematic animals on the lowest plinth (fig. 102).[18] As the *Achilles* designs were much simpler and smaller in format, the set was well adapted for commercial production.

Rubens's designs restore the primacy of the human figure over its natural surroundings. In the half century before him, the figures had gradually become subsumed in the surrounding vegetation, often with gardens and parks in the background. In the work of Rubens, nature is nearly absent, in contrast to the creations of his French contemporary Simon Vouet, who succeeded in preserving a harmonious balance between figures and landscape (see cat. no. 15; figs. 66, 81).

Rubens's architectural framing was immediately adopted by his contemporaries, including Jordaens (*Country Life*, examples in the Kunsthistorisches Museum, Vienna [cat. no. 25]; *Proverbs*, examples in the Hluboká Castle and Tarragona Cathedral). In particular, the so-called Solomonic columns, which Rubens introduced in the uppermost row of tapestries in the *Triumph of the Eucharist* (cat. nos. 19–24), were also adopted by other centers of tapestry production—Oudenaarde and Antwerp, for instance—as a device for framing greenery or pergolas with flowerpots (fig. 103). It is indeed striking that after Rubens's death in 1640, and certainly from the mid-seventeenth century onward, the Brussels weavers quickly reverted to more old-fashioned floral decor for the borders.

The continued success of Rubens's designs—even after the death of the master, and especially in tapestries woven for Spanish patrons—can perhaps be explained in part by the fame of this internationally renowned artist and in part by the parallel drawing style still being employed by Jacob Jordaens (1593–1678) after 1650. Even more so than Rubens, Jordaens made an important contribution to tapestry design, and his creations, too, were woven in Brussels. The chronology of most of Jordaens's series is difficult to determine with any accuracy. His production is now dated between about 1630 and about 1670, the only definite year being 1644, when he signed the contract for the *Proverbs*. A son of a linen merchant, Jordaens started by painting decorative works on canvas; he registered in the Guild of Saint Luke in Antwerp in 1615 as a *waterschilder*, or painter in watercolor on canvas.[19] This may explain why he always kept a fine balance between the figure and its surroundings (whether architecture or nature), having developed a strong sense of ornament. However, it is certain that he soon drew on Rubens's formulas from the 1620s as a source of inspiration, and even measured his own efforts against them in formal *emulatio*, evident from his very first series. In the *Story of Alexander*, made about 1630, he succeeded—especially in the scene *Alexander Wounded at the Battle of Issus* (fig. 104)—in achieving unrivaled Baroque drama. The scene reflects his awareness of compositional elements in Rubens's *Battle of the Milvian Bridge* in the *Constantine* series (cat. no. 14).

Jordaens treated not only historical subjects (*Alexander* and *Ulysses* in the 1630s and *Charlemagne* in the 1660s) but also—and primarily—such emblematic and moralizing themes as *Scenes of Country Life* (cat. no. 25), *Horsemanship* (cat. no. 26), and the *Proverbs*. In 1644, when the Brussels merchant-weavers concluded their contract with Jordaens for this last series, he had already painted such scenes many times. The weavers thus

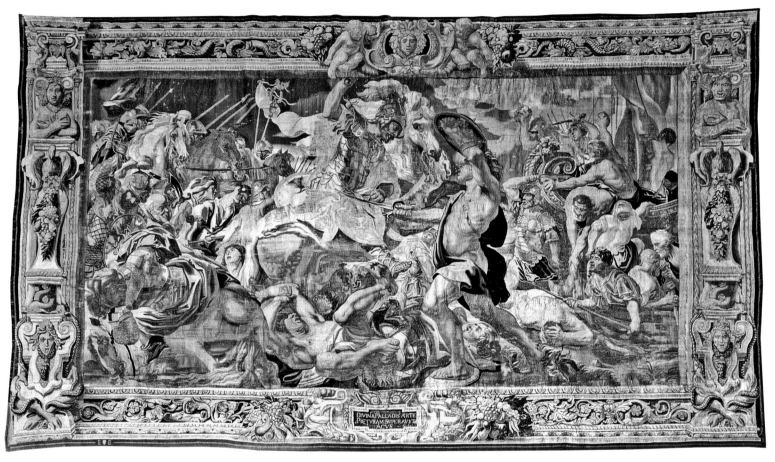

Fig. 104. *Alexander Wounded at the Battle of Issus* from a set of the *Story of Alexander.* Tapestry design by Jacob Jordaens, woven in the workshop of Jacques Geubels II, Brussels, ca. 1628–30. Wool and silk, 420 x 770 cm. Civiche Raccolte d'Arte Applicata, Milan, on deposit at the Palazzo Marino (Arazzi no. 41)

adopted a successful genre but left it up to the painter to choose suitable subjects for them to depict (fig. 99).[20] To this end, Jordaens made a number of preparatory drawings and watercolors, and even at this early stage in the work's creation he situated the scenes on a trompe l'oeil tapestry-within-a-tapestry, the formula invented by Rubens for the *Triumph of the Eucharist* (cat. nos. 19–24).[21]

History still belonged, as it had two centuries earlier, to the literature of exempla, and the recently rediscovered Jordaens set of *Theodosius and the Apple* also contains a moral tale about the ruler's behavior.[22] Peculiar to this period is the nearly systematic appearance of cycles devoted to heroines. Series with Esther and Ahasuerus and Judith and Holofernes were known from earlier times, of course, but now one saw ensembles containing more profane figures. Jordaens's *Famous Women from Antiquity* of about 1660 belongs to this genre, and especially the sets designed by Justus van Egmont, such as *Zenobia and*

Aurelianus (Musées Royaux d'Art et d'Histoire, Brussels) and above all *Cleopatra with Caesar* or *Cleopatra with Antony* (for example, in the Art Institute of Chicago). Van Egmont (1601–1674) had assisted Rubens in Paris in work on the Palais du Luxembourg (1622–25), and he stayed there until 1658, when he returned to Antwerp. He produced the sets just mentioned in this later period of his career. These historical series have their counterpart in the late cycle—woven in Bruges, possibly after 1650—of *Heroines from the Bible*.[23]

Lesser known contemporaries, all of them in the artistic orbit of Rubens and Jordaens, also supplied models for tapestry series with moralizing connotations. For example, a cycle repeatedly woven in Bruges between 1655 and 1675 of the *Seven Liberal Arts* after models by Cornelis Schut (1597–1655) was conceived from the beginning as an allegory of war and peace (figs. 105, 106). And many of the designs of the very productive Anthonis Sallaert (ca. 1590–1650), active in Brussels,

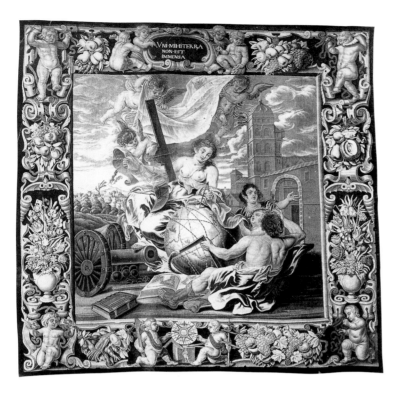

Fig. 105. *Geometry* from a set of the *Seven Liberal Arts*. Tapestry design by Cornelis Schut, woven in the workshop of Carolus Janssens, Bruges, ca. 1650 and later. Wool and silk, 380 x 370 cm. Vatican Museums, Vatican City

Fig. 106. *The Consequences of War* from a set of the *Seven Liberal Arts*. Tapestry design by Cornelis Schut after Peter Paul Rubens, woven in the workshop of Carolus Janssens, Bruges, ca. 1650 and later. Wool and silk, 355 x 455 cm. Fondation Toms Pauli, Lausanne (48)

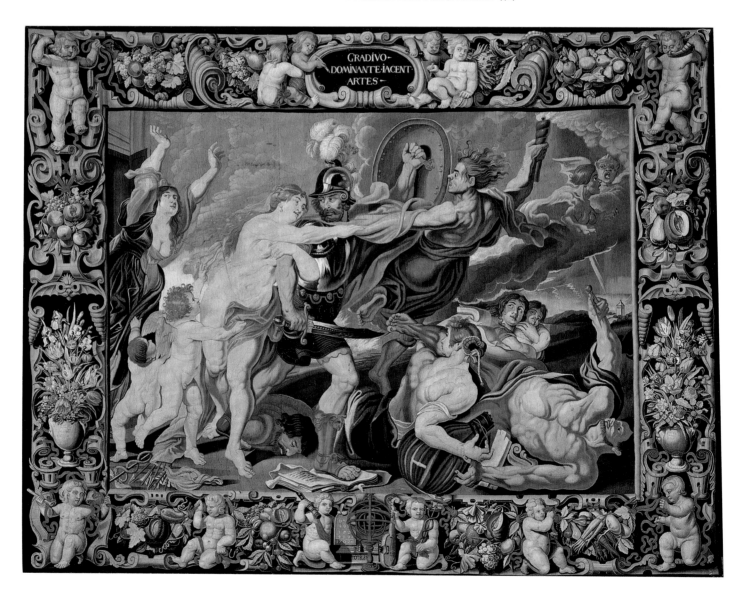

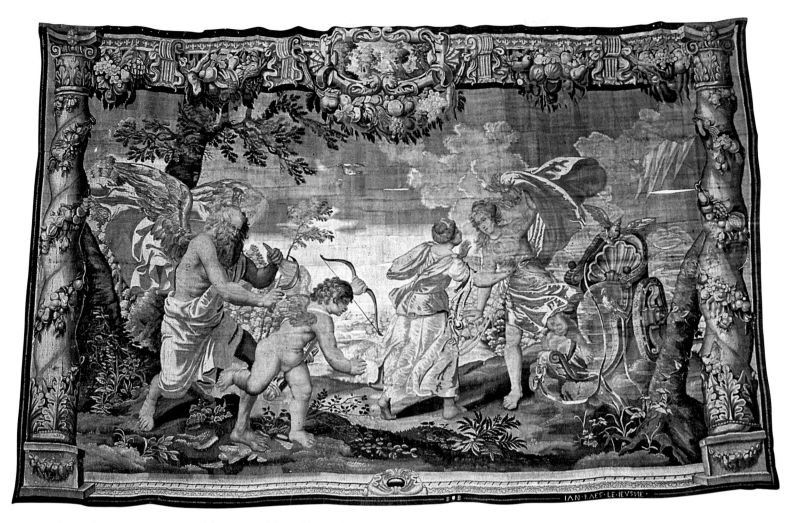

Fig. 107. *Time and Temperance Detain Cupid* from a set of the *Sufferings of Cupid*. Tapestry woven by Jan Raes, Brussels, 1630. Wool and silk, 372 x 255 cm. Patrimonio Nacional, Palacio Real de Madrid

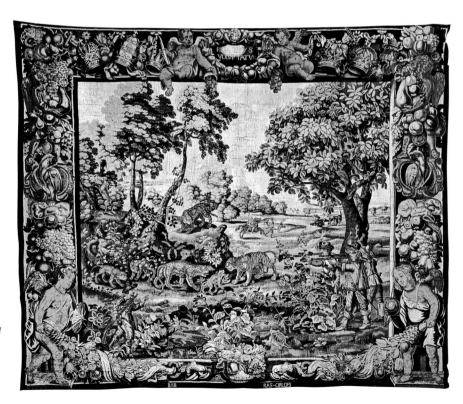

Fig. 108. *Landscape Verdure with Tiger, Panthers, and Hunting Scenes.* Tapestry design by an unknown artist, woven by Erasmus Oorlofs, Brussels, ca. 1650. Wool and silk, 349/347 x 401/400 cm. Rijksmuseum, Amsterdam (BK-NM-1594)

also represent edifying images of human life: the *Sufferings of Cupid* (fig. 107), based on the *Emblemata amoris* by Otto Vaenius; the *Life of Man* (Patrimonio Nacional, Madrid);[24] and the *Sapientia* or the *Powers that Rule the World* (Kunsthistorisches Museum, Vienna).[25]

If the large-figure narrative tapestries remained in vogue for the grand chambers of the palaces of contemporary rulers, there also continued to be a thriving market for landscape tapestries, both for more informal use by those same magnates and—at the cheaper end of the market—for use by a broader merchant class. Replacing the earlier verdures, in which greenery covered the entire surface, these landscapes became, in the late sixteenth century, lively hunting scenes situated before a backdrop of trees with a few palaces visible in the distance. As seen in the contemporary paintings by Jacques d'Arthois and Lodewijk de Vadder, these were views of woodland glades in which sun and shadow alternate, and several small figures, often representing personages from classical mythology, provide some small measure of human presence. A good example of this is the series, now preserved in the Rijksmuseum, Amsterdam, woven about 1650 by Erasmus Oorlofs (fig. 108).[26] Although most inventories list such landscape tapestries, the cartoon painters usually remain anonymous. Exceptions are the previously mentioned *Landscapes* drawn and signed by Lucas van Uden, which were first commissioned from the Brussels weaver Jan Raes in 1649–50 by Ottavio Piccolomini.[27]

Brussels Manufacturers and the Tapestry Trade

The documentary information available from trading companies suggests that at this time the tapestries made in Brussels were still considered the most valuable among those produced in the southern Netherlands. The Antwerp firm of Le Candele–Schrijnmakers sold a considerable volume of verdures—in that period mostly wooded landscapes—made in the various Flemish centers of tapestry production. For this kind of fairly common textile, the prices per square Flemish ell (equivalent to 68.58 square cm) quoted between 1644 and 1648 were: in Oudenaarde, from 9 stivers to 3 guilders 19 stivers (twenty stivers to a guilder); in Antwerp, from 6 guilders 16 stivers to 7 guilders 17 stivers; and in Brussels, from 10 guilders 15 stivers to 15 guilders 15 stivers.[28]

Similar price differences existed for armorial tapestries, which were woven in the Netherlands and much sought after, particularly by the Spanish nobility. This is well illustrated by orders placed by the Antwerp merchant Louis Malo: in 1650 in

Brussels he ordered from Jan Raes nine pieces at 18 guilders per ell for unnamed Spanish clients, and in 1658 he ordered from François van den Hecke eight pieces priced at 17 guilders—"de tapisseries d'armorie qu'on appelle reposteros" (the armorial tapestries one calls *reposteros*). By contrast, in 1659 he paid 6 guilders 6 shillings to Joost van Butsel in Antwerp for six armorial tapestries "de la bonté ordinaire de la fabrique d'Anvers" (of the ordinary quality of Antwerp fabric), but only 4 guilders to Abel Regelbrugge in Oudenaarde for eight "reposteros ou armoiries de tapisserie" (*reposteros* or armorial tapestries).[29]

During the seventeenth century, a few large businesses dominated tapestry manufacture in Brussels. In 1613 nine firms purported to be the largest producers, a status that would entitle them to exemption from taxes. Later on this standing was disputed by other members of the Brussels weaving community, and the petition to this effect, which was signed by the smaller suppliers, contained no fewer than eighty names.[30] Most of them have no extant series of tapestries to their name, others a few at most.[31] At this time the important manufacturers were already beginning to consolidate their forces, establishing family ties through marriage and by acting as godparents to one another's children. Everaert Leyniers III, for example, called on his colleagues Hendrik Reydams I and Gillis van Habbeke—in 1639 and again 1641—to act as godfather to his sons. This partly explains his collaboration with Van Habbeke in 1650 for the series of the *Months* made for Leopold Wilhelm (cat. nos. 27, 28), and especially with Reydams for many other commissions undertaken between 1641 and 1669.[32] The most important tapestry manufacturers also played a role in the political life of the city: François van den Hecke repeatedly held the post of collector of city taxes between 1650 and 1666; Gillis van Habbeke and Everaert Leyniers III were town councillors; and Jan Raes I and II fulfilled both these functions and even served as mayor.[33] This is evidence of the socioeconomic importance of the tapestry works to the city of Brussels. The dyeing industry, indispensable to the tapestry weavers, was also concentrated in the hands of a few producers and even came to be monopolized by the Leyniers family soon after Daniel I entered the profession in 1632, a monopoly that continued until 1711.[34]

Both the owners of the factories and the dealers who specialized in textiles and tapestries strove to acquire the full-size cartoons necessary to tapestry weaving. The weavers themselves could enter into contracts with the artists, as Frans van Cottem, Jan Cordys, and Baudouin van Beveren did in 1644 in the case of Jordaens's *Proverbs* (fig. 99).[35] Other firms sometimes appeared to hold the exclusive rights to certain cartoons. Thus

nearly all the sets of *Horsemanship*, both the wide and the narrow versions—here, too, based on models by Jordaens, among others—were produced jointly by Everaert Leyniers III and Hendrik Reydams I (cat. no. 26).[36] Some of the original cartoons of Rubens's *Triumph of the Eucharist*, which were preserved in the ducal palace in Brussels, were destroyed by fire in 1731, but copies of them came into the possession of the manufacturer François van den Hecke and were used by him for numerous reweavings from about 1650, and after his death in 1675 his son Jan-François also produced the designs (examples are in Toledo Cathedral and the John and Mable Ringling Museum of Art, Sarasota).[37] The Van Leefdael and Van der Strecken workshops were almost the sole producers of the late Baroque series by Justus van Egmont, portraying the *Story of Antony and Cleopatra*; after the death of Jan van Leefdael (1668), the cartoons were used by his son Willem, and after the death of Gerard van der Strecken (1677) by his son-in-law Gerard Peemans as well (a fourteen-piece set is in the Art Institute of Chicago).[38] In many cases, however, temporary agreements were undoubtedly made for the collaborative use of cartoons, the kind of leasing system that is better known from the following period.[39] This is perhaps how the great Brussels collaborative effort came about that produced the Baroque remakes of the *Deeds of Scipio* from about 1655 (see above).

Cartoons by famous masters also circulated in the art trade. Rubens's paintings for the *Decius Mus* series were bought and sold, passing through the hands of various dealers until 1692, when they were offered by the well-known Marcus Forchondt to the prince of Liechtenstein, who purchased them in 1696.[40] All the Flemish series based on cartoons by Rubens went through numerous reweavings until the late seventeenth century. In the process the cartoons moved from one workshop to another. Rubens's *Story of Achilles* is known only from 1642 through an order placed with the Brussels workshop of Jan Raes, but in 1643 both the models and the cartoons appeared to be in the possession of Daniël Fourment, a silk trader and Rubens's father-in-law. The cartoons, which were leased to workshops to serve as models for tapestries, changed hands in 1653, when they were bought jointly by Hendrik Lenaerts, an Antwerp trader, and the Brussels weavers Jan van Leefdael and Gerard van der Strecken, who wove no fewer than thirteen editions of them between 1653 and 1665.[41]

To facilitate production, the traders often gave the weavers money in advance for series that were still being made. If the manufacturers then found themselves in financial difficulties, the traders were entitled to seize part of their stock. Thus in 1644–45 the Antwerp trading partners Peter Fourment and Peter van Hecke the Younger demanded various sets of tapestries from Brussels weavers: a *Diana* set after models by Rubens from Andries van den Dries, a verdure set and a *Judith* set from Gillis van Habbeke, and other goods from the widow of Daniël Eggermans the Elder and from Jan Raet.[42] We have already pointed out the commercial ties between the merchant Lenaerts and the weavers Van Leefdael and Van der Strecken. Indicative of their connection is an agreement reached between the two parties in 1660: the weavers declared themselves in possession of the cartoons for Rubens's *Achilles* series, for a *Story of Constantine* series by Abraham van Diepenbeeck and a *Story of Domitian* series by Pieter van Lint (1609–1690), and also acknowledged that Lenaerts owned a one-third share of the series by Rubens and Van Diepenbeeck and was, moreover, the sole owner of the eight cartoons by Van Lint.[43]

For the production of so many valuable and varied suites of tapestries, the industry required financial support. At various times (1628, 1642, 1658) the authorities granted Brussels tapestry makers subsidies or loans, as well as exemption from all kinds of taxes, such as levies on beer and requirements to lodge soldiers.[44] In seeking these benefits, the tapestry makers had pointed out the privileges enjoyed by compatriots who had left the country to start up workshops under more favorable circumstances abroad.[45] To continue receiving these tax exemptions, the weavers were required from 1647 onward to supply proof of the annual production of at least "twee caemeren wercx" (two series).

During the 1650s the Brussels tapestry trade sought to advance another step by establishing their own Tapissierspand (Tapestry Hall). This was prompted in part by the decline in economic importance of Antwerp's hall and in part to steal this profitable role away from Antwerp.[46] Permission was received in 1655, and the sales and exhibition room was later set up in the town hall itself. All tapestries were supposed to be inspected and given a seal of approval there. It was decided that a number of traders would supply their cartoons to various masters to have editions woven. From 1657 on, traders were allowed to give their cartoons to only two master weavers to have an edition made, and only these masters were allowed to sign the tapestries. This underlines yet again the importance of traders who themselves owned cartoons.[47] From 1658 the tapestry makers also sought to involve the administration of the Tapissierspand in regulating the sale of cartoons and the involvement of middlemen. In 1657 the administration of the Tapissierspand was leased to a director, Jean-François de Grousseliers. The following year

this "factor" reported that the hall housed 150,000 guilders worth of tapestries, not only from Brussels but also from Antwerp and Oudenaarde. He also accepted tapestry cycles as collateral, paying two-thirds of their value in the form of a loan. Thus the Brussels Tapissierspand functioned to some extent as a credit union for the manufacturers.[48]

Some of the tapestries from this period bear inscriptions that have nothing to do with the subject depicted; instead, they are actually slogans or mottos of the weavers themselves. On one of the editions of the *Decius Mus* series—now dispersed among the museums of Guimarães (Portugal), Prague, and Hamburg— Jan Raes wove the text *Ars et vis divina superant omnia* (Art/Craftmanship and divine power overcome everything).[49] And the *Alexander* editions after Jordaens, all made in the workshop of Jacques Geubels II, bear two such texts: *Divina Palladis arte picturam superavit acus* (Through the divine art of Pallas, the needle has conquered painting) and *Cum bissum pingo, non ita ut pictor fingo* (When cloth I weave, not as a painter do I deceive).[50] These testify to the weavers' self-awareness and the pride they justifiably took in their profession.

Flemish Tapestries outside Brussels

Even though Brussels continued to dominate Flemish tapestry production up until the time of the French Revolution, mention must be made here of valuable sets of tapestries made in other centers of what was then the Spanish Netherlands.

In Oudenaarde countless sets of low and moderate material quality and design were woven for export. There was considerable trade with France in particular, as evidenced by surviving documents. For instance, between 1631 and 1663 the tapestry dealer Frans de Moor, a native of Oudenaarde who later settled in Ghent, exported no fewer than thirty-six sets with the *Story of Diana* to France, but from this entire production only a single tapestry is known (municipality of Eindhoven).[51] The Oudenaarde production from this period is often difficult to identify, owing to a lack not only of makers' marks but also of documented designs and designers. The best-known history cycles woven in Oudenaarde derive their models from other centers, such as the Brussels cycle of the *Story of Decius Mus*, after the Rubens designs,[52] and the Antwerp version of the *Acts of the Apostles* after Abraham van Diepenbeeck.[53]

More so than in Oudenaarde, in Bruges sets of tapestries were woven that followed the Baroque style of Flemish—especially Antwerp—painting.[54] A rather heavy drawing style characterizes the series of *Diana*, of *Astrée and Céladon*, and of *Pompeius*, all dating from the second quarter of the century. The

Astrée series marks an attempt by the weavers of Bruges to share in the success of the French pastoral romance of Honoré d'Urfé (1607–27), yet *Pompeius* had been based on reused cartoons from the Brussels workshop of Van Brustom. The models of a splendid series of the *Twelve Months* even bear a resemblance to the sixteenth-century *Months of Lucas* (fig. 101).[55]

A few Bruges series are assumed to be based on the designs, if not the cartoons, of Antwerp painters from the circle of Rubens. The *Story of the Virgin Mary*, dated 1639 and still preserved in the Potterie convent in Bruges, seems to have been inspired by models made by Pieter van Lint, and the *Life of Emperor Charles V* (Palais Granvelle, Besançon) is based on paintings made by Gaspar de Crayer (1584–1669) for the triumphal entry of Prince-Cardinal Ferdinand at Ghent in 1635. All these cycles can be attributed to Bruges, as evidenced by the city's marks, which are woven into the borders, as well as by their exceptional palette, dominated by deep blues and bright reds. Unfortunately, it is impossible to link these tapestries to specific workshops.

The best-known tapestries produced in Bruges are indisputably those belonging to the series the *Seven Liberal Arts,* after paintings by Cornelis Schut (1597–1655).[56] This series was certainly woven from 1654 on, and specimens with the years 1666 to 1675 woven into them are preserved in various collections. It is also one of the few Bruges products of which we know, if not the weaver, at least the trader-middleman, namely Carolus Janssens, recorded in a contract of 1655, whose name and monogram occur on a number of pieces. The complete series comprises eight tapestries, one for each of the seven liberal arts and one depicting their combined apotheosis. The various inscriptions, as well as details of the compositions themselves, allow one to view the series as an allegory of war and peace. The tapestry portraying Geometry, for example, implies the application of geometry to ballistics as well as to architecture (fig. 105), and in some editions the series of eight is supplemented with the *Consequences of War*, after the famous painting by Rubens (Palazzo Pitti, Florence) in which Venus struggles to restrain Mars (fig. 106).[57]

In Antwerp the Tapissierspand continued to function as a depot and sales room for the tapestry production of the Spanish Netherlands. The surviving Antwerp tapestries of the seventeenth century include many original designs, although their state of preservation often leaves much to be desired. Apparently the Antwerp dyers were not as skillful as their counterparts in Brussels and Bruges. Many of the hues are extremely discolored if not altogether faded, so that brown

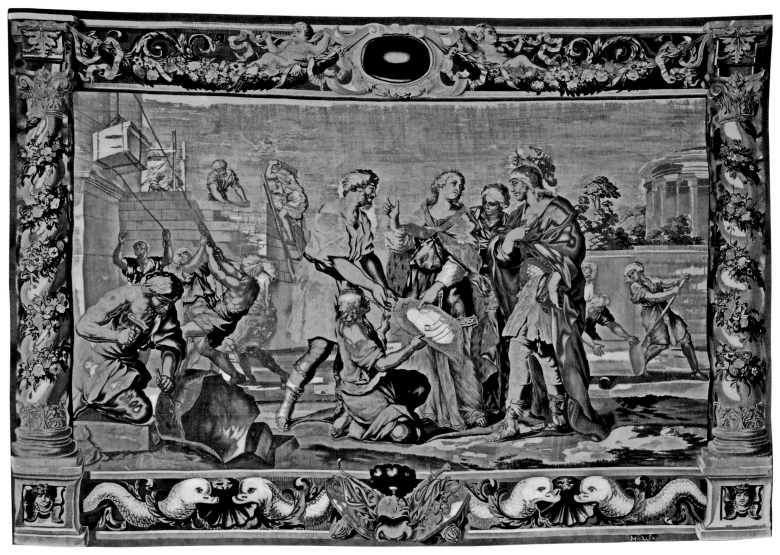

Fig. 109. *Dido Shows Aeneas the Plans for the Fortifications of Carthage* from a set of the *Story of Dido and Aeneas*. Tapestry design by Giovanni Francesco Romanelli, woven by Michiel Wauters, Antwerp, 1679. Silk and wool, 416.4 x 563.6 cm. The Cleveland Museum of Art, Gift of Mrs. Francis F. Prentiss, in memory of Dr. Dudley P. Allen (1915.79.4)

and gray now predominate, greatly impairing the three-dimensionality of the composition. The firm of Wauters was undoubtedly one of the most important in Antwerp. This enterprise, launched by Jacob Wauters (fl. 1619–60), experienced its heyday under his two sons, Michiel and Filips, both of whom died in 1679. The inventory of their estate lists no fewer than twenty-six different figurative series, of which they had either the cartoons or woven editions in stock, which amounted to more than two hundred distinct tapestry designs. A number of those series were being held on consignment by agents abroad—in Stockholm, Rome, Lisbon, Paris, and Vienna.

It is somewhat surprising that no Rubens designs were produced in Antwerp itself. Apart from a couple of editions of *Decius Mus* (by Jacob Wauters, Musée Ariana, Geneva; by Michiel Wauters, Basilica di Sant'Ambrogio, Milan), no

significant Rubens tapestries were made in Antwerp, possibly owing to the fact that the Antwerp tapestry industry did not blossom until after the painter's death. Does this explain the choice of less-talented contemporary masters, or was it simply impossible to obtain the cartoons from the Brussels workshops? This question remains unanswered. One can only state that the most beautiful series woven in Antwerp from the mid-seventeenth century, namely the *Story of Dido and Aeneas*, made use of cartoons by the Italian Giovanni Francesco Romanelli (1610–1662) (fig. 109),[58] of which six of the original eight have survived (Norton Simon Museum, Pasadena). From 1655 to 1658 Romanelli lived in Paris, where he executed the murals and ceiling paintings in four rooms in the Louvre. In any case, the Wauters brothers maintained close business relations with Paris, either directly or through dealers such as the Forchondts.

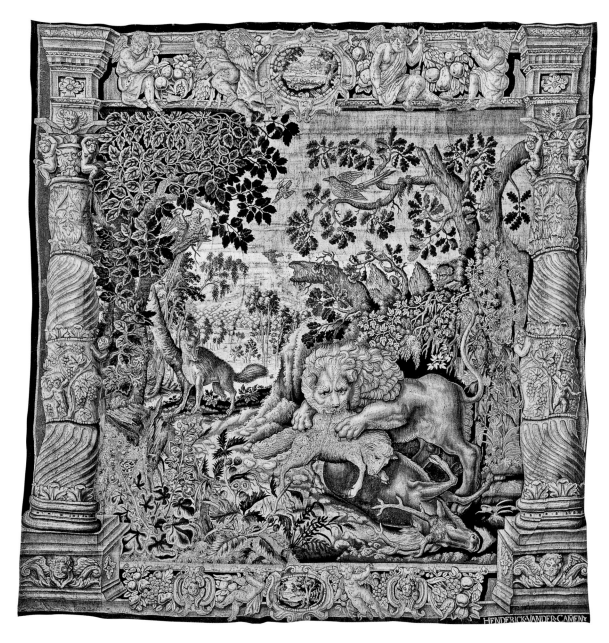

Fig. 110. *The Lion Hunting* from a set of *Animal Combats*. Tapestry woven in the workshop of Henry van der Cammen, Enghien, 17th century. Wool and silk, 360 x 338 cm. Philadelphia Museum of Art, Gift of Mr. and Mrs. Bayard T. Storey, 1969 (1969-156-1)

The art of Romanelli is classicizing, in the vein of Pietro da Cortona. It is worthy of note that, some fifteen years after Rubens's death, the Wauters workshop turned to a painter who worked more in the style of Poussin, at a time when Jacob Jordaens and Justus van Egmont were still working in Antwerp in a late Baroque idiom. The *Dido* series by Wauters and Romanelli was very successful. Four complete editions have survived to this day (Cleveland Museum of Art; Collegio Alberoni, Piacenza; Drottningholm Castle; Town Hall, Nijmegen), as well as thirty individual pieces belonging to at least eight different editions. The Wauters workshop, moreover, had at its disposal at least four different border designs that could be woven—according to the client's wishes—around the scenes of the Dido story.

The decorative genre was also practiced in the Antwerp workshops. Among the oldest examples are the *Pergolas* from the workshop of Jacob Wauters, which adhere to the type of the old columns with May flowerpots of the previous century but adapted to prevailing fashions, with side borders containing the large twisted columns introduced in Rubens's *Eucharist* series (fig. 103).

The last southern Netherlandish center of weaving worthy of mention is Enghien. In this small town southwest of Brussels, cycles of varying grades of tapestries—for which Brussels models were repeatedly used—had been produced since the sixteenth century. It is possible that these Enghien workshops carried out work subcontracted to them by Brussels firms. Their technical skill was also known abroad, as evidenced by the activities of Hans van der Biest, who at the beginning of the century headed a temporary workshop in Munich (cat. no. 8). The most important local manufacturer was the firm of Van der

Cammen, which had been active for many generations. About 1640 this firm was responsible for weaving a splendid set of *Animal Combats* in the tradition of the *Pugnae ferarum* of the Renaissance (Palazzo Borromeo, Isola Bella), though now supplied with borders containing the Solomonic columns intro-duced in Rubens's *Eucharist* series. The Enghien *Animal Combats* are now dispersed among three collections: the castle of Gaasbeek (Belgium), the Museum of Fine Arts, Boston, and the Philadelphia Museum of Art (fig. 110).[59] The last workshop in Enghien stopped production in 1685.

1. For an extensive survey of this period, see Delmarcel 1999a, pp. 209–304.
2. See, for details, De Poorter 1978, passim.
3. Herrero Carretero 1999, p. 105; the series mentioned are in the Patrimonio Nacional, Madrid, nos. 35, 56, 58–59. Series 35 in fact comprises parts of two sets, one from the late 16th century, the other by Raes and Geubels.
4. Bauer 1999, p. 116.
5. "de fyne tapisserye rontomme deselve camer hangende wesende van Blompotten ende Pileiren"; "de fyne tapyten oock van Blompotten ende Colommen." Denucé 1934, p. 139; E. Duverger 1995, p. 440 (inventory of June 12, 1665).
6. Regarding Oudenaarde, see E. Duverger 1960, p. 68; concerning Antwerp, see Swain 1988, pp. 17–19.
7. E. Duverger 1997, p. 177.
8. Delmarcel in Brussels 1977, pp. 103–6; Denucé 1932, p. 259, no. 80: "le tapisserie fine di Brusselles, fatte a giusta misura, con le quali la detta saletta maggiore è adornata, rappresentando la historia d'Achilles" (the fine tapestries of Brussels, made to the correct size, with which the aforementioned main drawing room is decorated, representing the story of Achilles); the series is now preserved in the Musées Royaux d'Art et d'Histoire, Brussels.
9. Vianden 1995, pp. 54–55.
10. De Reyniès in Bourg-en-Bresse–Montélimar–Roanne 1990, pp. 28–29. For the reedition of the *Jacob* in Kraków Cathedral, see the fundamental analysis in Hennel-Bernasikowa 1994, pp. 85–103 (English summary, pp. 176–78).
11. See T. Campbell in New York 2002, pp. 341–63, and T. Campbell and Karafel in New York 2002, pp. 364–70, nos. 41–43.
12. The best overview is to be found in Forti Grazzini 1994b, vol. 1, pp. 206–8; he dates the Quirinale series to between 1652 and 1665; for Benavides, see Delmarcel 1997a, pp. 25–26.
13. Michel 1999, p. 293.
14. E. Duverger in Bruges 1987, p. 416.
15. Lefébure 1995, pp. 152–54.
16. Michel 1999, p. 293.
17. See ibid., pp. 310–11, 450–52.
18. See Haverkamp-Begemann 1975, pp. 37–41.
19. Nelson 1998, p. 3.
20. "[S]ekere vuytgebeelde *spreeckwoorden* die den voors. Sr Jordaens daer toe bequaem sal vinden" (certain proverbs which will be chosen as appropriate by Mr. Jordaens); see ibid., app., pp. 192–93, no. 3 (incorrectly dated 1655).
21. Ibid., pls. 58–81.
22. See Brosens 2007c.
23. Delmarcel 1999a, pp. 230–31, 275–76.
24. Series 58 to 60.
25. Series 78.
26. Smit in Hartkamp-Jonxis and Smit 2004, pp. 123–28, no. 36a–d.
27. Blažková and E. Duverger 1970, p. 79.
28. Denucé 1936, pp. 66–77.
29. Blažková and E. Duverger 1970, pp. 96–101.
30. Delmarcel 1999a, pp. 211–14; Crick-Kuntziger 1936, p. 179; an excerpt from this document was published in J. Duverger 1971, p. 115.
31. By Frans van Maelsack, for example, only a *Hannibal* series; by Willem van de Vijvere, series of *Verdures*, *Iphigenia*, and *Amazons*.
32. Brosens 2004a, pp. 65–67.
33. Ibid., p. 64.
34. Ibid., pp. 32–37.
35. Nelson 1998, pp. 192–93.
36. Hefford 2003.
37. De Poorter 1978, p. 237.
38. Standen 1985, pp. 206–8.
39. See the unusual agreements between Valdor and four Brussels workshops in 1672 and 1673, published in Brosens 2004a, pp. 187, 192–93.
40. E. Duverger and Maufort 1996, p. 108.
41. Delmarcel 2003, pp. 33–37.
42. E. Duverger 1972, pp. 57–60.
43. E. Duverger 1971a, pp. 158–59; for the *Domitian* series, see Delmarcel 2006.
44. Wauters 1878, pp. 214–16.
45. See Brosens 2004c, pp. 276–77.
46. Brosens 2005b, pp. 71–73.
47. I am indebted to Dr. Koenraad Brosens for his interpretation of this document.
48. Wauters 1878, pp. 227–32; Göbel 1923, pp. 336–37.
49. See Delmarcel in Antwerp 1997, pp. 55–57.
50. Nelson 1998, pp. 61, 65, 70.
51. See E. Duverger 1960, p. 68; De Meûter 1999, pp. 190–91.
52. E. Duverger 1960, pp. 66–67; between 1636 and 1662 De Moor supplied 17,000 ells of this series.
53. De Meûter 1999, pp. 199–200.
54. Delmarcel and E. Duverger in Bruges 1987, pp. 286–512, nos. 27–76.
55. E. Duverger in Bruges 1987, pp. 376–85, nos. 46–51; Delmarcel in Bruges 1987, pp. 426–29, nos. 57–62; E. Duverger in Bruges 1987, pp. 410–17, nos. 54–56.
56. Delmarcel in Bruges 1987, pp. 453–89, nos. 65–72; Delmarcel 1999a, pp. 299–303.
57. Delmarcel 1997a, pp. 23–24.
58. Delmarcel 1999a, pp. 295–98.
59. Delmarcel 1980, pp. 56–61; Delmarcel 1999a, pp. 278–80.

19.
The Triumph of the Church over Ignorance and Blindness

Bozzetto for the tapestry in the *Triumph of the Eucharist*
Peter Paul Rubens, ca. 1626–27
Oil on panel
16.2 x 24.5 cm (6⅜ x 9½ in.)
Lent by the Sydics of the Fitzwilliam Museum, Cambridge (228)

PROVENANCE: 1825, probably purchased from Samuel Woodbury by the Reverend Thomas Kerrich; 1872, donated by his son Richard Edward Kerrich to the Fitzwilliam Museum, Cambridge.

REFERENCES: Earp 1902, p. 170; Fitzwilliam Museum 1912, p. 150; London 1927, no. 328; Fitzwilliam Museum 1929, p. 177; Tormo Monzó 1942, p. 299; Tormo Monzó 1945, pp. 39–40; Essen 1954, p. 37; Elbern 1955, p. 85, fig. 46; Gerson and Goodison 1960, p. 103, pl. 50; Held 1968, pp. 13, 15; Antwerp 1977, no. 72; De Poorter 1978, vol. 1, pp. 326–27, no. 11a, vol. 2, fig. 150; Held 1980, p. 155, no. 105, pl. 108; De Poorter in Brussels 1985, vol. 2, pp. 591–94, no. C84; Jaffé 1989, p. 293, no. 843.

20.
The Triumph of the Church over Ignorance and Blindness

Modello for the tapestry in the *Triumph of the Eucharist*
Peter Paul Rubens, ca. 1626–28
Oil on panel
87 x 106 cm (34¼ x 41¾ in.); extended at top and bottom by a later hand from the original 63 x 106 cm (24⅞ x 41¾ in.)
Inscribed ECCLESIAE TRIUMPHUS in central cartouche
Museo Nacional del Prado, Madrid (1698)

PROVENANCE: Ca. 1628, Archduchess Isabella Clara Eugenia; 1633, bequeathed to Cardinal Infante Ferdinand; 1641, bequeathed to Philip IV, king of Spain; ca. 1648–49, transported to Spain; 1650, presented to Luis Méndez de Haro, marqués del Carpio; before 1687, Gaspar Méndez de Haro, marqués de Heliche and viceroy of Naples; 1689, obtained for the royal collection of Charles II, king of Spain; 1694, in the apartment of Luca Giordano, first court painter, in the Palacio Real, Madrid; 1722, Palacio Real, Madrid; 1819, deposited in the Museo del Prado as part of the royal collection.

REFERENCES: Cruzada Villaamil 1874, pp. 377–78, no. 43; Rooses 1886–92, vol. 1, pp. 58–59, no. 43; Oldenbourg 1921, p. 293; Tormo Monzó 1945, pp. 39–40; Van Puyvelde 1951, p. 32, no. 3a; Essen 1954, p. 37; Elbern 1955, p. 85; I. Lavin 1974, pp. 78–79; Díaz Padrón 1975, pp. 292–93, no. 1698; Scribner 1975, p. 520; De Poorter 1978, vol. 1, pp. 327–30, no. 11b, vol. 2, fig. 151; Held 1980, pp. 155–56, no. 106, pl. 109; Jaffé 1989, p. 293, no. 844; Museo del Prado 1990, p. 464, no. 1735; Museo del Prado 1996, p. 340, no. 1698.

21.
The Triumph of the Church over Ignorance and Blindness

From a twenty-piece set of the *Triumph of the Eucharist*
Design by Peter Paul Rubens, ca. 1626–28
Woven in the workshop of Jan Raes II, Brussels, ca. 1626–33
Wool and silk
490 x 752 cm (16 ft. 1 in. x 24 ft. 8 in.)
7–8 warps per cm
Brussels mark in bottom selvage at far right; weaver's name IAN.RAES.F. in bottom selvage at right; inscribed ECCLESIAE TRIUMPHUS in central cartouche
Patrimonio Nacional, Monasterio de las Descalzas Reales, Madrid (TA-D/3 00610325)

PROVENANCE OF CAT. NOS. 21 AND 24: Ca. 1625–26, commissioned by Archduchess Isabella Clara Eugenia, daughter of Philip II of Spain, and governor of the Spanish Netherlands, from Peter Paul Rubens; ca. 1626–28, the twenty panels were woven in the Brussels workshops directed by Jan Raes II and Jacques Geubels II; 1628–36, successive arrival of the panels at the convent of the Descalzas Reales in Madrid;[1] 1632, hung next to the *Conquest of Tunis* tapestries in the plaza in front of the convent;[2] 1756, hung on the facade of the convent facing the plaza; 1881, hung in the cloister of the convent for the Holy Friday procession and the Octave of Corpus Christi;[3] 1882–85, cleaned and lined at the Royal Tapestry Factory, Madrid;[4] 1938, sent to the Library of the Society of Nations in Geneva for the duration of the Spanish Civil War;[5] 1942, tapestries returned to the convent of the Descalzas Reales by the Servicio de Recuperación y Defensa del Patrimonio Artístico Nacional, inventoried by Elías Tormo Monzó and photographed and reproduced as lithographs by Hauser y Menet;[6] 1969, installed in dedicated Tapestry Room following the remodeling of the convent; 1985–87, restored at the Fundación de Gremios for exhibition in Brussels.[7]

REFERENCES FOR CAT. NOS. 21 AND 24: Bellori 1672, pp. 233–35; Wauters 1878, pp. 241–42, 307–10; *Descripción de los tapices de Rubens* 1881, pp. 1–19; Rooses 1886–92, vol. 1, pp. 59, 70, nos. 43, 53; Göbel 1923, pp. 207–8, 355–57, 424–26; Tormo Monzó 1942; Tormo Monzó 1945; Essen 1954; Elbern 1958; Elbern 1963; d'Hulst 1967, pp. 263–70, no. 31; Held 1968; Junquera de Vega and J. J. Junquera 1969; Scribner 1975; De Poorter 1978; De Poorter 1979–80, pp. 211, 220, 222; Held 1980, pp. 139–43; E. Duverger 1981–84, p. 175; Scribner 1982; De Poorter in Brussels 1985, vol. 2, pp. 591–94, no. C85; Scribner 1989, pp. 96–97; Brassat 1992, pp. 220–22; Tanner 1993, pp. 218–21; De Poorter 1997; Rodríguez G. de Ceballos 1998, p. 15; Delmarcel 1999a, pp. 216–17, 219, 230, 233, 234; Madrid 1999, pp. 274–75, no. 92; García Sanz 1999; Hans Devisscher in Lille 2004, pp. 288–91, nos. 156, 157.

22.
The Adoration of the Eucharist

Bozzetto for the arrangement of five tapestries—the *Secular Hierarchy in Adoration*, two *Angels Playing Music*, the *Monstrance Held by Two Cherubs*, and the *Ecclesiastical Hierarchy in Adoration*—in the *Triumph of the Eucharist*
Peter Paul Rubens, ca. 1626–27
Oil on panel
31.5 x 32 cm (12⅜ x 12⅝ in.)
The Art Institute of Chicago, Bequest of Mr. and Mrs. Martin A. Ryerson (37.1012)

PROVENANCE: 1640, probably remained in Rubens's studio until his death; 1769, sold in Antwerp by Jan van Lancker; sold in Antwerp by Canon P. A. J. Knyff; 1914, Dowdeswell, Paris; 1937, donated by Mr. and Mrs. Martin A. Ryerson to The Art Institute of Chicago.

REFERENCES: Rooses 1886–92, vol. 1, nos. 55–57; Valentiner 1946, p. 167, no. 126; Held in Goris and Held 1947, pp. 34–35, no. 57; Larsen 1952, p. 218, no. 74; Held 1968, p. 12; Maxon 1970, pp. 45–46, no. 285; Scribner 1975, pp. 519–20; De Poorter 1978, vol. 1, pp. 258–62, nos. 1–5a, vol. 2, fig. 95; Held 1980, p. 159, no. 111, pls. 12, 114; Jaffé 1989, p. 294, no. 852; De Poorter 1997, pp. 83, 89, 91; Delmarcel 1999a, pp. 216, 230; García Sanz 1999, p. 112.

23.
The Ecclesiastical Hierarchy in Adoration

Modello for the tapestry in the *Triumph of the Eucharist*
Peter Paul Rubens, ca. 1626–28

Oil on panel
66.7 x 47.6 cm (26¼ x 18¾ in.)
Speed Art Museum, Louisville (66.16)

REFERENCES: J. Smith 1829–42, vol. 2, p. 185, no. 644; Rooses 1886–92, vol. 2, p. 199; "Bibliografía" 1965, pp. 368–69, no. 127*bis*; "La chronique des arts" 1967, p. 76, no. 279; Held 1968; J. F. Martin 1973, p. 131; J. B. Speed Art Museum 1978, p. 64; De Poorter 1978, vol. 1, pp. 272–73, no. 4b, vol. 2, fig. 108; Held 1980, pp. 160–61, no. 113, pl. 115; A. E. Bennett 1983, p. 142.

24.
The Secular Hierarchy in Adoration

From a twenty-piece set of the *Triumph of the Eucharist*
Design by Peter Paul Rubens, ca. 1626–28
Woven in the workshop of Jan Raes II, with the assistance of Hans Vervoet and Jacob Fobert, Brussels, ca. 1626–33
Wool and silk
480 x 320 cm (15 ft. 9 in. x 10 ft. 6 in.)
7–8 warps per cm
Brussels mark in bottom selvage at center; weaver's name IAN.RAES.F. in bottom selvage at right; weavers' marks of Hans Vervoet and Jacob Fobert in right selvage at bottom
Patrimonio Nacional, Monasterio de las Descalzas Reales, Madrid (TA-D/13 00614217)

REFERENCES: See under cat. no. 21

The tapestries that Peter Paul Rubens conceived to illustrate the theological allegory of the Triumph of the Eucharist represent the epitome of his revolutionary style in Flemish tapestry design. The inventiveness of the compositions is coupled with the technical bravura of the best of the Brussels weavers, extending the illusionistic boundaries of tapestry production further than ever before. The tapestries were commissioned by Archduchess Isabella Clara Eugenia, regent of the Spanish Netherlands, as a pious gift for the convent of the Descalzas Reales (Barefoot Royals) in Madrid. The ambitious set included twenty tapestries, which were apparently designed taking into specific account each hanging's intended location within the convent church. Although the church interior has been dramatically altered since the mid-seventeenth century, considerable information pertaining to Rubens's perception of the tapestries within the space and the nature of their display can be gleaned from numerous surviving oil sketches, as well as several preserved cartoons, all produced within his workshop. Such was the success of the *Triumph of the Eucharist* series that the designs continued to be rewoven decades after the deaths of both the archduchess and of Rubens.

Description and Iconography of the Triumph of the Church over Ignorance and Blindness
A glorious procession takes place in the tapestry of the *Triumph of the Church* (cat. no. 21). Ecclesia, the embodiment of the Church, is seated in a shiplike chariot; in her hands, she holds a monstrance that glows with such intensity that it lights the scene around it. Ecclesia is dressed in papal vestments, and a putto hovers above her, about to crown her with the papal tiara. In front of her a putto takes the reigns of three splendid horses, ridden by angels carrying the palm and laurel attributes of Victory and the papal cross-keyed golden umbrella. The horses' bridles are held in check by three elegant female figures that have alternatively been identified as personifications of the theological virtues, Faith, Hope, and Charity, or of three of the Cardinal Virtues.[8] A trumpeter-angel and a standard-bearer lead the procession, already passing beyond view behind the column at the right side of the design. The Church's enemies, powerless to halt her relentless progress, are crushed beneath the chariot's wheels: the snake hair and burning torch of one conform to the description of Envy in the *Prosopographia*, published in Antwerp about 1600–1620, by the Flemish emblematist Filips Galle.[9] In Ecclesia's wake, a lamp-bearing woman leads personifications of Blindness and ass-eared Ignorance toward the light. It has been suggested that Rubens may have been alluding, more specifically, to the Church's triumph over the Jews, by adopting the blindfold traditionally worn by Ecclesia's counterpart Synagoga, and over the Pagans, by giving the ass-eared figure the features of Socrates.[10]

Instead of a traditional border, Rubens designed an ingenious framing device: it is as though the tapestry is being suspended by putti within an actual architectural space, loosely tied by ropes to flanking Corinthian columns. This trompe l'oeil tapestry within the tapestry seems to hang behind a sculpted cartouche, fixed to the entablature, which, with its inscription ECCLESIAE TRIUMPHUS, identifies this scene as the Triumph of the Church. Heavy swags of fruit hang to either side of the cartouche, as if attached from metal rings driven into the stonework. The fictive tapestry is made to seem almost too large for the space, as though it is caught in swathes on the stone ledge below it and is hitched up to reveal a globe, decorated with an oak crown and palm fronds, encompassed by a snake, and bearing a rudder. With this device, Rubens combined the traditional symbols of, respectively, victory, eternity, and guidance to embody the notion of the Church triumphant, eternal and all-encompassing guide and dominator of the world.

This magnificent tapestry, the largest in the *Triumph of the Eucharist* series, is characterized by a sense of movement and energy, which even extends to the supposedly static elements like the column shafts, coiled like those in apocryphal descriptions of King Solomon's temple, embellished with alternating bands of diagonal ribs and intricate carvings of putti and foliage.

Description and Iconography of the Secular Hierarchy in Adoration
A pair of fantastical Doric columns, their shafts ornately decorated with fluting and alternating vermiculated bands, flank the narrow scene in catalogue number 24. Between the columns, six figures are represented. These are members of the most Catholic Habsburg dynasty, who believed

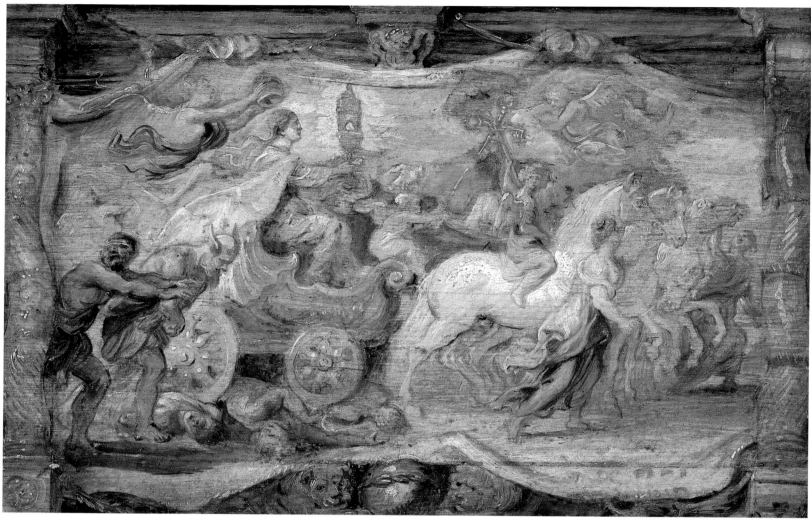

19

themselves, in the words of the seventeenth-century Aragonese Jesuit Baltasar Gracián, to have been "strengthened by God to be the hammer of the heretics of Bohemia, Hungary, Germany, Flanders, and even France. A house that God formed to [give us] a very large number of saints, emperors, empresses, kings, queens, and archdukes. A house that God extended over all the circumference of the earth to spread throughout it his Holy Faith and Gospel."[11]

The protagonists in the composition, like paladins of Catholicism, are Holy Roman Emperor Ferdinand II (1578–1637) with, behind him, King Philip IV (1605–1665). The emperor wears an imperial mantle bearing the shield and two-headed eagle of the House of Habsburg. On the ground beside him are a

crown, a scepter, and a globe, the symbols of the Holy Roman Empire. Philip IV, wearing the gold chain with the pendant of the Order of the Golden Fleece, and with his hand on the pommel of his sword, is accompanied by his wife, Isabella of Bourbon (1603–1644). The older woman beside Isabella of Bourbon, dressed in a Franciscan habit, is probably Archduchess Isabella Clara Eugenia (1566–1633), patron of this tapestry series, who had taken vows as a Franciscan of the Third Order in Brussels in 1621 following the death of her husband, Archduke Albert. Alternatively, the Belgian tapestry historian Nora de Poorter has suggested that the figure may be Sor Margarita de Austria, the fifth daughter of Emperor Maximilian II and Empress Maria, who had rejected the proposal that she marry

her uncle Philip II, had taken her vows in the Descalzas Reales in the presence of the royal family, and, years later, as a courtesy to her sister-in-law, had received Archduchess Isabella at the convent.[12] Standing beside them are two armor-clad figures with the flags of His Most Catholic Majesty and the Burgundian cross of Saint Andrew. These are probably standard-bearers, as De Poorter suggests, although the Spanish scholar Elías Tormo chose to identify them as Leopold and Rudolf, warrior princes of the house of Austria.[13]

The sovereigns kneel in prayer; their gaze is directed upward by the putto hovering above them. Rubens's oil sketch of the tapestry in situ (cat. no. 22) reveals the object of their veneration to be a shimmering mon-

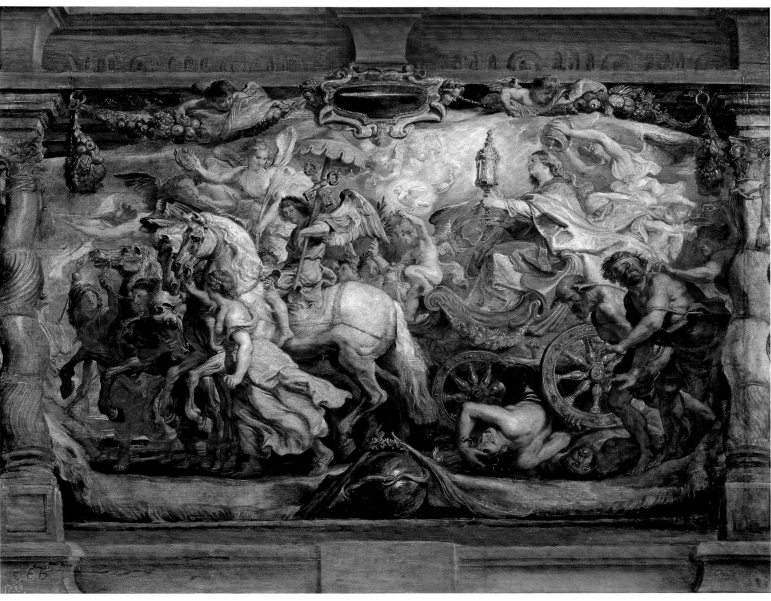

20

strance, held aloft by putti, represented in the central tapestry of the scheme. Emperor Ferdinand, King Philip, Queen Isabella, and the other protagonists of catalogue number 21 represent the most powerful figures of the secular realm, their crowns and other trappings of authority laid aside as they piously kneel in veneration of the Eucharist. This tapestry has come to be called the *Secular Hierarchy in Adoration*. This had as a foil on the opposite side of the arrangement the *Ecclesiastic Hierarchy in Adoration*, of which catalogue number 23 is the modello.

The Commission

The patron of the *Triumph of the Eucharist* tapestry series was Archduchess Isabella Clara Eugenia, daughter of Philip II of Spain and

Elizabeth of Valois. Isabella was regent of the Spanish Netherlands, and Rubens (1577–1640) served her as painter, adviser, and diplomat. Just as her grandfather Charles V had withdrawn to the Hieronymite monastery at Yuste and her father Philip II to the Hieronymites at El Escorial, Isabella had hoped to retire to Madrid, to the Descalzas Reales convent of Franciscan nuns called Clarisas or Poor Clares after Saint Clare. The Descalzas Reales was founded in 1556 by Isabella's aunt Infanta Juana (1535–1573).[14] It was the burial place of her mother, Elizabeth of Valois (1547–1568), and domicile of both her aunt Empress Maria of Austria (1528–1603), widow of Maximilian II, and her cousin Sor Margarita de la Cruz (1567–1633), of whom she was godmother. Although

Isabella did not carry out her plan to retire to the convent, hindered as she was by political events and the express wish of her nephew Philip IV that she remain as governor of the Spanish Netherlands, she conceived the idea of making a gift to the convent, commissioning the sumptuous set of tapestries to decorate the interior of its church.

It was probably after a visit to Rubens's workshop in 1625 that Isabella decided to commission a tapestry series that would demonstrate her love and veneration for the convent of the Descalzas Reales.[15] The precise dating of the commission remains undocumented. Surviving correspondence of September 1627 between Isabella's chaplain, Philippe Chifflet, and the papal nuncio and art collector Cardinal Gian Francesco Guidi

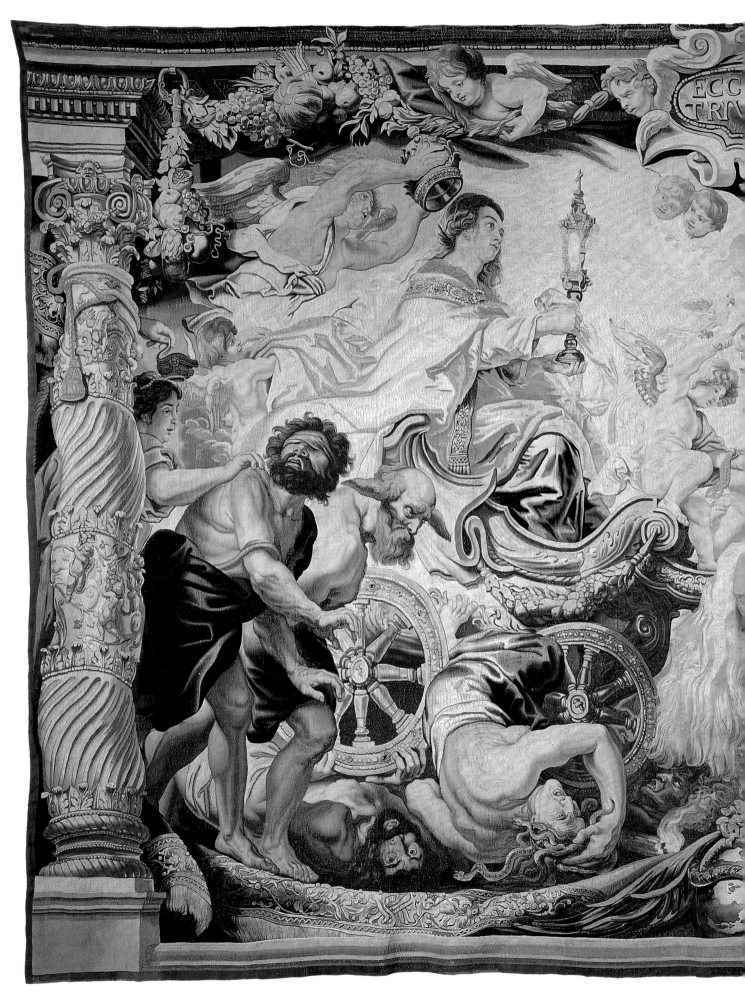

21

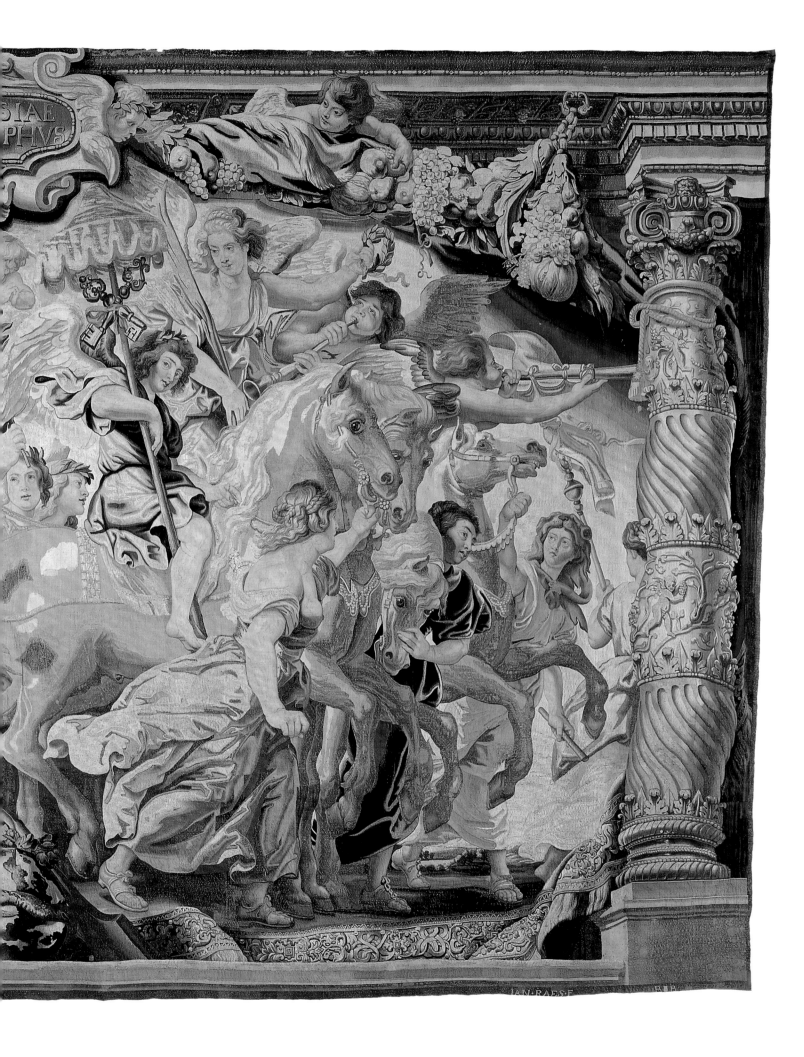

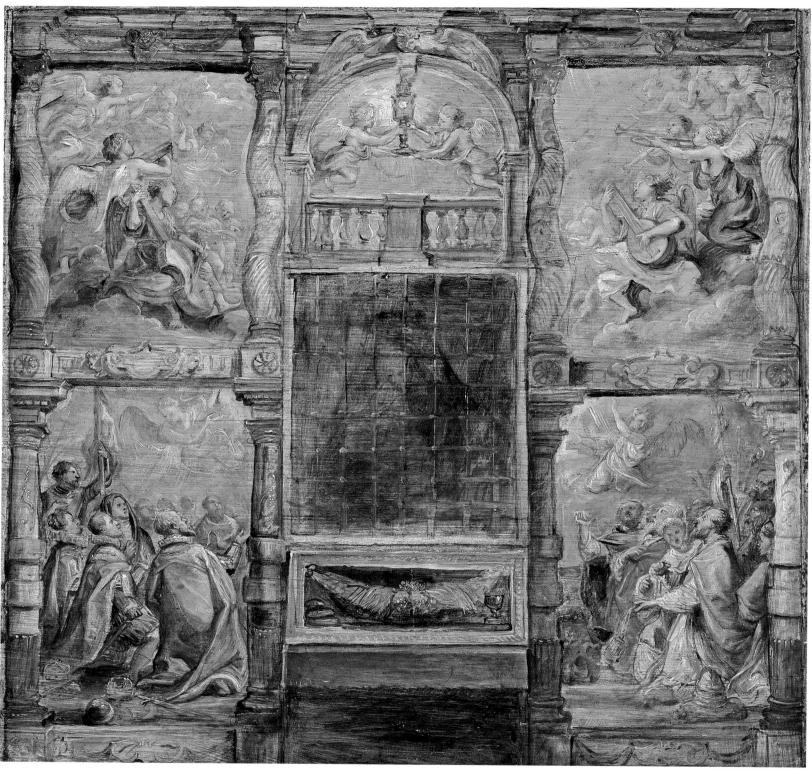

di Bagno refers to the preparation of cartoons by Rubens, probably for the *Triumph of the Eucharist* series.[16] The cartoons were apparently finished by January 1628, when Rubens was rewarded for his labors.[17] It is believed that the tapestries were being woven from the earliest completed cartoons while Rubens and

his workshop were still working on the later ones. Certainly, in December 1626 one of the weavers of the set, Jacques Geubels II, referred to tapestries he needed to complete, ones commissioned by the archduchess.[18] Since no other work by Geubels for Isabella is known, this was probably already a reference to the

weaving of the *Triumph of the Eucharist*. By July 1628 Isabella was sending tapestries to Madrid, and definitely before 1633 the reaction of the nuns to the tapestries was being recorded.

The choice to celebrate the theme of the Holy Eucharist reflected the convent's special

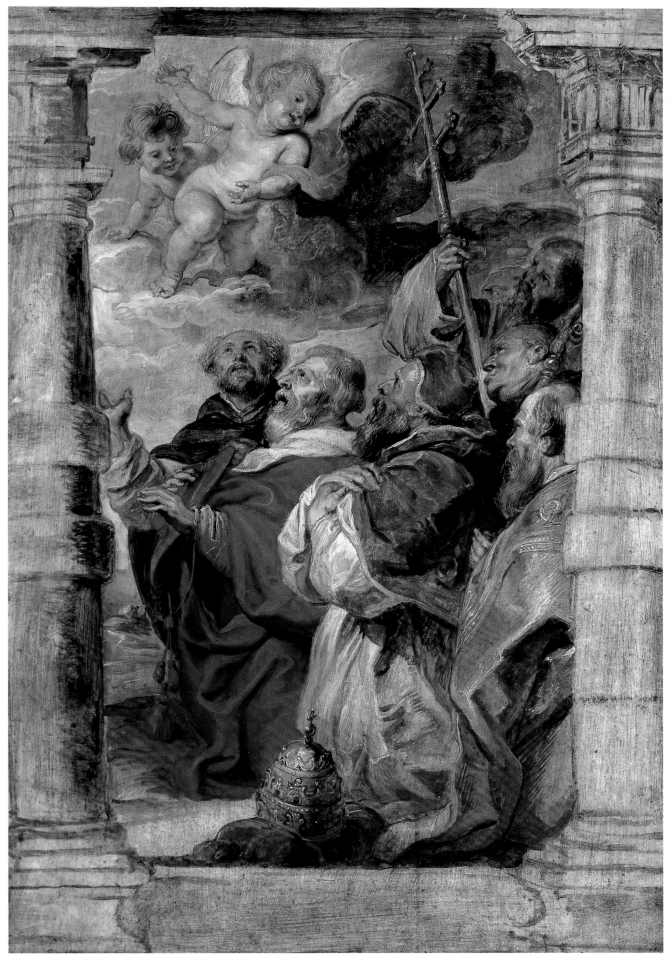

veneration of the cult, encouraged by the convent's founder, Infanta Juana. Following a papal dispensation, the nuns at the Descalzas Reales were permitted to keep the Sacrament on display on Good Friday.[19] They marked the feast of the Entombment, on Good Friday, with a solemn Eucharistic procession through the cloister at twilight. In addition to the celebration of the divine offices, a monstrance was inserted into a hollow "wound" in the side of a medieval wooden sculpture of the recumbent dead Christ and processed around the cloister while acolytes sang a lament.[20] A second procession took place after the Easter liturgy, celebrating the feasts of the Resurrection and of Corpus Christi. This was of a very different nature, marked by fervor and sumptuous pageantry and attended by the royal family. The monstrance was held aloft at the head of a procession that passed through the interior of the convent and out into the streets of Madrid. A father confessor at the convent, Juan Carrillo, recorded in 1615 that Juana insisted on a staggering element of splendor to the Easter procession, adorning the monstrance with her own jewels and decreeing that the convent be decorated with the most sumptuous of furnishings.[21] Carrillo noted that "she ordered that the Church and Cloister be adorned with the most precious decorations," and that the whole cloister be hung "with a very rich tapestry series, which is that of the war at Tunis, which . . . King Philip II gave to her on the condition that it be hung in the cloister on this day."[22]

Perhaps envisaging that her new tapestry set would occasionally be hung in conjunction with, or even replacing, the *Conquest of Tunis* tapestries (Patrimonio Nacional, Palacio Real, Madrid), Archduchess Isabella set aside huge sums for the commission. No contracts, accounts, or receipts for the commission survive, but among the documentary material gathered by Chifflet was a note recording that "The Infanta sent to the Descalzas in Madrid a tapestry with the figures and mysteries of the Holy Eucharist, for which the cartoons were made by Rubens and cost thirty thousand florins. The tapestries are valued at nearly one hundred thousand."[23] Archduchess Isabella was evidently pleased with Rubens's efforts, since in addition to his fee of 30,000 florins, Chifflet noted that "In January 1628 several

pearls were given to Peter Paul Rubens for the tapestry cartoons for the Franciscan nuns in Madrid."[24]

Designer

Twenty tapestries in the *Triumph of the Eucharist* series survive at the Descalzas Reales. The set is probably preserved in its entirety, as Nora de Poorter has argued.[25] These twenty tapestries were intended to decorate the convent church, covering all the walls, and were thus designed to fit the space precisely. Building on experience gained from earlier designs for the tapestry cycles of *Decius Mus* (cat. nos. 10, 11) and the *Story of Constantine* (cat. no. 14), Rubens organized the activity of his workshop systematically so as to control production. In order to keep track of the complex commission, to envisage how the tapestries would appear in situ, and to transmit his design ideas to both his patron Archduchess Isabella and his workshop assistants, Rubens worked to a structured campaign of small-scale oil sketches (bozzetti), larger oil sketches (modelli), and the complete, full-size, fully colored cartoons. He executed the bozzetti and modelli in oil on small wood panels. His workshop assistants and collaborators were then assigned the task of creating cartoons to the same scale as the intended tapestries, with the proportions of the modelli enlarged using a grid system. This working process, which Rubens wrote about in his correspondence, has recently been verified by study of the cartoons for the *Story of Achilles*, Rubens's final tapestry series.[26]

Many of the oil sketches and seven of the cartoons for the *Triumph of the Eucharist* have survived.[27] In catalogue number 22, Rubens illustrated, in reverse, how he envisaged five tapestries hanging against the altar wall in the Descalzas Reales church. This ensemble has come to be known as the *Adoration of the Eucharist*. In the smaller, central hanging, putti with a monstrance appear above the actual altar of the convent church. To either side of the altar, the walls are covered by tapestries two tiers high: the lower tier, including Rubens's initial designs for the *Ecclesiastical Hierarchy* and the *Secular Hierarchy* (cat. nos. 23, 24), are articulated by Tuscan columns with Doric capitals. The upper tier of tapestries, in contrast, has sinuous, Solomonic coiled shafts with Corinthian capitals. A sketch like

this would have enabled Rubens to explain to the archduchess the subtlety of his design: not only would the tapestries fit within the architecture of the convent church, they would actually create their own architecture. By replacing traditional borders with architectural elements, the distinction between the real and depicted space would become blurred. Rubens even made certain to conform to the rules of classical architecture, with the orders becoming more decorative and embellished on each successive tier. In addition, the bozzetto clarifies how Rubens adapted the designs to suit this overall architectural scheme. The tapestries of the lower register are seen from a slightly elevated viewpoint, revealing the ground on which the protagonists are seated and the foreground architecture's steps. The tapestries of the upper tier are viewed as if from below, with glimpses of the skies, the soles of the figures' feet, and the bottoms of the architectural surrounds, as if the viewer is looking upward beneath an actual entablature.

Bozzetti for particular tapestries are also preserved, such as catalogue number 19, Rubens's initial design for the *Triumph of the Church*. This reveals how the principal elements of the finished tapestry's design (cat. no. 21) were already envisaged: Ecclesia in her chariot with the monstrance, the angels bearing the papal tiara and umbrella, the female allegorical figures leading the horses, the device of the loosely draped represented tapestry within the tapestry, and the swags, cartouche, and coiled columns. Sketches such as this were presumably submitted for Isabella's approval, with their schematic compositions enabling her to envisage the whole ensemble of tapestries, just as they would finally be seen in the Descalzas Reales. As such, their compositions are represented in the orientation intended for the finished tapestry and they progress from left to right, in the order the tapestries would be installed.

In the second design phase, Rubens prepared larger and considerably more detailed oil sketches as modelli. These incorporated the more nuanced design, sharpening details left vague in the bozzetti, and perhaps taking into account points raised by Isabella and her advisers on the basis of the initial designs. In the modello for the *Triumph of the Church* (cat. no. 20), for example, the women leading the

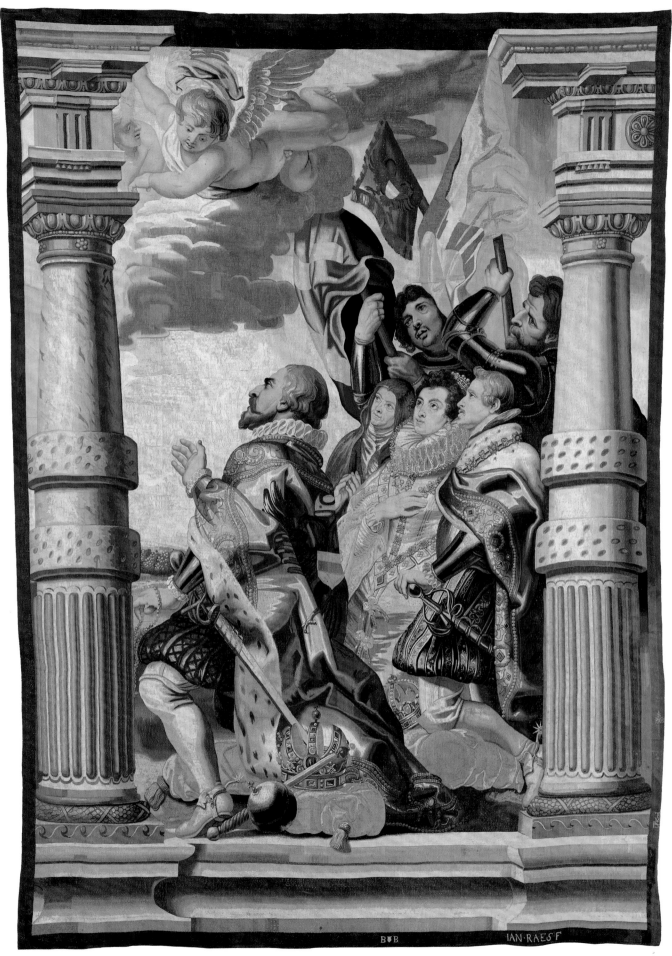

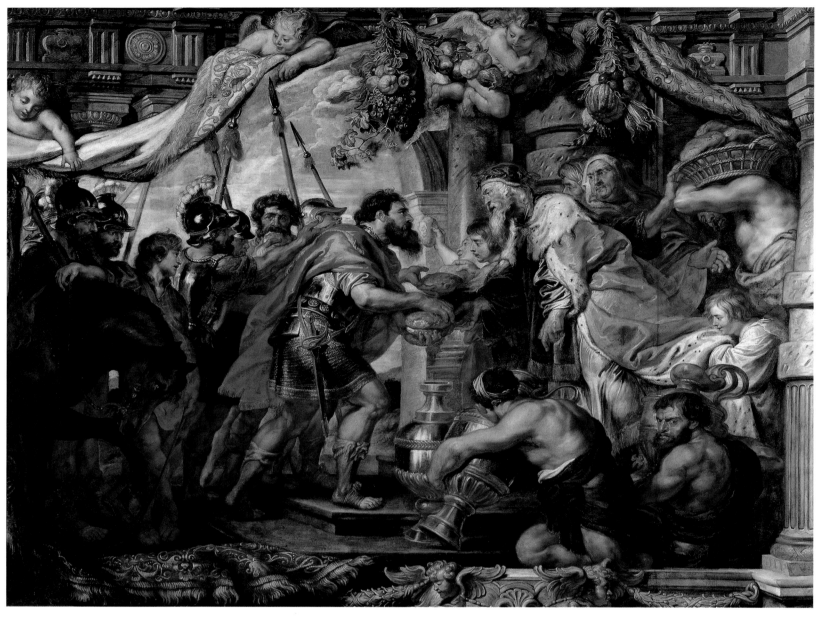

Fig. 111. *Abraham and Melchizedek*, by Peter Paul Rubens and workshop, ca. 1626–28. Cartoon for the tapestry in the *Triumph of the Eucharist*. Oil on canvas, 445.1 x 570.9 cm. John and Mable Ringling Museum of Art, Sarasota, Bequest of John Ringling (SN212)

procession and raising the banner are more clearly defined than their counterparts in the bozzetto (cat. no. 19). Certain details have been changed: the globe representing Earth, which is at the bottom of the scene, partially covered by the border of the fictive tapestry, is no longer crowned with laurel, as in the bozzetto, but is circled by a serpent biting its tail, a symbol of eternity. The lions that flanked the globe have also disappeared, replaced by the rudder of temporal power and the palm of victory.

Comparison of the modello for the *Ecclesiastical Hierarchy in Adoration* (cat. no. 23) with Rubens's initial design for this tapestry, glimpsed in the lower right corner of the

bozzetto for the altar wall (cat. no. 22), reveals a similar sharpening of the design. The bishop, pope, cardinal, and Dominican gain a restrained monumentality slightly lacking in the initial scheme. For example, whereas in the bozzetto Rubens envisioned an angel drawing the prelates' attention to the monstrance above, in the modello this has been transformed into two much lighter putti. The group below was vigorously edited: in the modello, the foreground pope, whom some have chosen to identify as Clement VIII,[28] gazes upward, his hands clasped in quiet awe, compared to the more frenetic scheme in the bozzetto, in which he shares his space with an acolyte and swings an incense censer. Modelli like this

were, above all, the working designs that Rubens provided his assistants to give them a clear model to follow when painting the full-size cartoons: the precise and detailed execution defines the figures, colors, and compositional details. Most importantly, the modelli were executed in reverse, reflecting the need for the cartoons to be composed as mirror images of the finished tapestries due to the design reversal taking place during the weaving process.

Although many of the smallest sketches, the bozzetti, remained available to artists in Antwerp, Rubens retained neither the modelli nor the cartoons in his workshop for reuse. Archduchess Isabella purchased the modelli

and cartoons from Rubens, and these were presumably delivered to her along with the tapestries once the weavers had finished with them. According to clauses in her will (December 26, 1616) and a codicil (November 30, 1633), her most precious possessions, including Rubens's creations for the *Triumph of the Eucharist* tapestries, were left to her nephew, the Cardinal Infante Ferdinand (1609–1641), who succeeded her as governor of the Spanish Netherlands.[29] The modelli and cartoons were stored in Coudenberg Palace in Brussels until Ferdinand's death, when many of them were transported to various destinations in Spain. The cartoons that were not sent to Madrid but remained in Brussels (*Sacrifice of the Old Covenant*, *Triumph of the Church*, *Victory of the Eucharist Overcoming Pagan Sacrifices*, and the *Victory of Truth over Heresy*) were lost in the 1731 fire in the Brussels palace.[30]

The Iconographic Scheme of the Triumph of the Eucharist

Although the idea of the commission and the choice of subject matter venerating the Eucharist were undoubtedly Isabella's, Rubens seems to have contributed substantially to the iconographic program. Isabella's chaplain, Chifflet, for example, considered Rubens the most erudite artist in the world; certainly, his library, which contained Jesuit publications, iconological treatises, books on architecture, and studies of both antique and Christian archaeology, was one of the most important collections in Antwerp or anywhere in the Southern Netherlands.[31]

Since no record of the original sequential display of the tapestries survives and the plan and elevations of the convent church have been altered considerably since the 1630s, Rubens's exact iconographic program remains uncertain. Bearing in mind the direction of shadows cast in the tapestries, viewpoints, and architectural orders, Nora de Poorter proposed a convincing reconstruction of the scheme; the possible arrangement of the hangings has also been compellingly discussed by Ana García Sanz.[32] Using architectural elements already familiar from Raphael's *Acts of the Apostles*, Rubens developed a two-tiered arrangement of tapestries that would cover both walls of the nave and culminate with

five hangings on the altar wall. A combination of Old Testament episodes that prefigure the Eucharist and allegorical triumphal scenes such as catalogue number 21 were represented as if on fictive draperies, hung between Tuscan or Solomonic columns, intended to line the nave. The tapestries are nearly five meters high, and some are as long as seven and a half meters. They were probably hung in two registers, one above the other, in an arrangement similar to that of the *Adoration of the Eucharist* bozzetto (cat. no. 22). The five tapestries framed by Tuscan columns, which thus correspond to the lower tier are *Defenders of the Eucharist*, the *Triumph of Divine Love*, the *Triumph of Faith*, *Abraham and Melchizedek* (see fig. 111), and the *Sacrifice of the Old Covenant*. The ones with coiled columns intended for the upper tier are the *Four Evangelists*, the *Triumph of the Church* (cat. no. 21), the *Victory of Truth over Heresy*, *Prophet Elijah Being Fed by an Angel*, the *Victory of the Eucharist Overcoming Pagan Sacrifices*, and the *Gathering of Manna*. There are four smaller tapestries, three without architectural embellishments—*Charity Enlightening the World*, the *Succession of Popes*, and *Historiography*—and one with ornamental pilasters, *King David Playing the Harp*. These De Poorter convincingly suggested were also intended for the nave walls rather than the altar wall, probably with *King David* in the upper register, perhaps between the *Triumph of the Church* and the *Victory of Truth*. As there are at least seven, and as many as ten, of these upper-register tapestries and only five for the lower register, the ensemble cannot have been symmetrical.

The familiar Old Testament scenes would have needed little explanation. Rubens did, however, endeavor to identify the allegories, providing the three triumphal chariots with Latin inscriptions in their cartouches: AMOR DIVINUS, FIDES CATHOLICA, AND ECCLESIAE TRIUMPHUS. These were conceived as triumphal processions in the classical tradition of Petrarch and emulating the sixteenth-century example of Giulio Romano's *Triumphs of Scipio*.[33]

The processions depicted in the tapestries for the nave walls carried the protagonists—and the tapestries' beholders—to a triumphant culmination on the altar wall. As the surviving bozzetto shows (cat. no. 22), this united the earthly authorities, both secular (cat. no. 24)

and ecclesiastical (cat. no. 23), in the lower, earthbound register with musical angels in the heavens, represented in the three tapestries above. All the protagonists—secular, ecclesiastical, and angelic—look upward in awed veneration and adoration at the shimmering monstrance, held aloft by two angels, directly above the church's actual altar. The distinction between heavenly and actual space is distorted by the trompe l'oeil representation of a balustrade and architrave around the monstrance-bearing angels, as if the space of the church is actually enclosing this celestial vision. The angelic choirs flanking the central tapestry introduce an element of music to the dramatic lighting and visual theater of the scheme. Musicians and minstrels create harmony with their voices and instruments, their lutes, violas, sackbuts, trumpets, and hornpipes, all echoing actual instruments used in the Easter celebration of the Eucharist in the convent.

Weavers

Even while delegating tasks, Rubens retained tight control over the production of cartoons for the *Triumph of the Eucharist*, unmistakably stamping his personality on their designs. The weaving campaign of the tapestries, in contrast, was not dominated by a single master but was instead the result of collaboration between at least two significant weaving workshops, with marks acknowledging four named master weavers overseeing the works. The *Triumph of the Church* (cat. no. 21) has IAN.RAES.F. woven in the right corner of its lower selvage. Jan Raes's name is also woven into the *Secular Hierarchy in Adoration* (cat. no. 24), together with two additional weavers' marks, which have been identified as those of Jacob Fobert and Hans Vervoet. These same three masters are acknowledged on eight other tapestries in the set, and Jan Raes's name and Hans Vervoet's mark appear without that of Fobert on one piece, the *Succession of Popes*. Jan Raes's name appears alone on a tapestry besides catalogue number 21, *Charity Enlightening the World*. A thirteenth tapestry, *Abraham and Melchizedek*, has Raes's name and the marks of Fobert and Vervoet, as well as IACQ. GEVBELS for Jacques Geubels. Six further tapestries display the name and/or the mark of Geubels alone. The twentieth remaining tapestry, the *Victory of Truth*, does not retain its selvages.

Jan Raes II (ca. 1570–before 1643) was identified in documents of 1613 and 1629 as one of the nine most important weavers working in Brussels.[34] His highly successful workshop produced numerous admired tapestry sets and also participated in various collaborative projects, including the weaving of the *Story of Decius Mus* (cat. nos. 10, 11). Raes was the signatory weaver of the 1616 contract for the *Decius Mus* tapestry series, and it is possible that he again played the dominant role of directing weaver in the instance of the *Triumph of the Eucharist*. The vast size of the *Triumph of the Eucharist* set, including at least the twenty surviving tapestries of almost 8,000 square meters, demanded the collaboration of several workshops weaving simultaneously on different tapestries in the set in order to complete it with as little delay as possible. Nora de Poorter estimated that the set must nevertheless have taken at least a year to be woven.[35]

The principal workshop with which Raes chose to collaborate, that of the Geubels family, had a similarly prestigious standing. Six of the *Eucharist* tapestries are marked IAQ.GEVBELS, probably for Jacques Geubels II: Jacques Geubels I had died in 1605, and his widow, Catherine van den Eynde, continued to run the workshop until her death some time between 1620 and 1629.[36] Among the works produced under her direction was a different, considerably earlier set of *Sacraments* tapestries for the Leuven Confraternity of the Holy Sacrament in collaboration with Jan Raes II.[37] After her death, direction of the workshop was continued by her son Jacques Geubels II, who was documented as a weaver in 1621. There is some uncertainty whether the Geubels workshop was being directed by Catherine van den Eynde or by Jacques Geubels II when the *Triumph of the Eucharist* tapestries were being woven in it, although if the later 1620s dating is accepted, it was probably Jacques Geubels II. This would certainly be the case if the December 1626 statement by Jacques Geubels II about tapestries that he was to weave for the archduchess indeed referred to the *Triumph of the Eucharist*.[38]

Jan Raes II and Jacques Geubels II marked tapestries produced in their workshops with their names. Jacob Fobert and Hans Vervoet, on the other hand, are indicated only by their weavers' monograms, which always appear with either Raes's name or Geubels's or both, and never on a tapestry to themselves. Fobert and Vervoet probably played a subsidiary role, perhaps producing tapestries for Raes and Geubels as subcontractors. Vervoet might, however, have claimed a certain prestige: according to a posthumous account of 1685, he had been employed as tapestry weaver to Archduke Albert and Archduchess Isabella, although this claim, made by his grandson, might have been an exaggerated reference to his work for Isabella on the *Triumph of the Eucharist*.[39]

Both Jan Raes II and the weavers in the Geubels workshop were experienced at weaving stylistically experimental and dramatic cartoons, having already tackled Rubens's *Decius Mus* series and, perhaps, one version of the *Horsemanship* series (see cat. no. 26). In catalogue numbers 21 and 24, the weavers achieved a balance of colors to obtain the sharply cast shadows, ethereal glow, and different textural effects of sculpture, fruit still lifes, and dynamic figures envisioned by Rubens. As such, they admirably managed to translate the artist's painterly designs into a workable, woven format.

The quality of the tapestries' weaving is reflected by their tight warp count. The surprising absence of any silver or gilt-metal wrapped threads was probably a result of the limited availability of these raw materials due to the political instability of the Spanish Netherlands during this period. Chifflet's reference to the 100,000 florins that Isabella reputedly paid for the tapestry set has been deemed strikingly expensive: Nora de Poorter established that this would rank them as more than 100 guilders per ell, considerably more than even the most expensive, precious-thread-woven tapestry purchases of the period.[40] It is possible that Chifflet's figure covered all accompanying logistical expenses or was simply an exaggeration.

The Triumph of the Eucharist Tapestries at the Descalzas Reales

The tapestries arrived in Madrid in August 1628, having been transported overland in covered carts, just as the eight tapestries of the *Apocalypse* from the workshop of Willem de Pannemaker had been sent from Brussels to Philip II in Madrid in 1561.[41] Chifflet reported that "Her Majesty has sent, two days ago, two carts to Spain, loaded with tapestries, cloths and geographical maps, and some paintings."[42] The tapestries might have arrived in one shipment, as De Poorter suggests.[43] However, customs records preserved in the Archivo Histórico Nacional in Madrid imply that their arrival was staggered over the years 1628–36.[44] Rubens visited the convent of the Descalzas Reales in the autumn of 1628 and may have been able to see at least some of his tapestries hanging in the church.[45]

By all accounts, the nuns appreciated Isabella's spectacular gift. In his biography of the archduchess's cousin Sor Margarita de la Cruz, published in 1636, Juan de Palma remarked that "during these past years . . . [Isabella] sent to Her Highness for the church of the Convent of the Descalzas Reales, a rich series of tapestries about the Triumphs of the Church, of strong design, in its quality and art, among the most outstanding in Spain."[46] Although the tapestries were almost certainly conceived for precise placement within the convent church, there is evidence that they were taken outdoors for the feast of Corpus Christi. Tapestries had always played a significant role in the embellishment of the cloister for the Corpus Christi procession, as is made clear in Carrillo's description of the foundress Infanta Juana's instructions for this use of the *Conquest of Tunis* set. A reference in a description of the convent by J. A. de la Peña, published in 1632, describes how the *Triumph of the Eucharist* tapestries were apparently also hung outdoors, overlooking the little plaza in front of the monastery, alongside the *Conquest of Tunis* tapestries.[47]

Although documentary references throughout the seventeenth and the eighteenth centuries to the incorporation of the *Triumph of the Eucharist* tapestries into the cloister decorations at Easter are plentiful, our knowledge of their placement in the church is much more scant. The convent and, particularly, the church underwent major transformations by architects such as Juan Gómez de Mora, Francisco Sabatini, and Diego de Villanueva, and in 1861 a fire destroyed the magnificent altarpiece created by Gaspar Becerra and necessitated completely rebuilding the presbytery and the main altar.[48]

Detail of cat. no. 24

Later Weavings of the Triumph of the Eucharist

Once the twenty tapestries in the *Triumph of the Eucharist* set arrived at the convent of the Descalzas Reales, they became relatively inaccessible, certainly to the craftsmen of the Flemish tapestry weaving industry. Rubens's designs, however, remained in circulation. Although Archduchess Isabella purchased both the modelli and the cartoons, Rubens retained his bozzetti. The *Adoration of the Eucharist* sketch (cat. no. 22), for example, probably remained in Rubens's studio until his death.[49] Rubens also had detailed copies of the compositions made in his studio by Willem Panneels.[50] In addition, a series of five

engravings after some of the designs was published by Nicolaas Lauwers (1600–1652) about 1650. Numerous drawn and painted later copies survive.[51]

Tracings might have been taken of the full-scale cartoons, either while they were still in Rubens's possession or once they had reached the weavers' shops; alternatively, a new set of cartoons might have been made after the available design sources once the original modelli and cartoons had entered Isabella's possession. At any rate, from about 1650 onward, many later editions of the set were woven. None of these was produced in the Raes or Geubels workshops, but they were made by another successful Brussels weaver,

François van den Hecke, assisted by his son, Jan-François van den Hecke.[52] The bulk of these sets were probably made on speculation by the weavers and then sold on the open market, many to collectors outside Flanders.[53]

The sets were particularly popular on the Iberian Peninsula, probably because of their association with the prestigious commission for the Descalzas Reales. In Spain, the most important later sets of the *Triumph of the Eucharist* are in ecclesiastical collections where their use is also liturgical, to decorate the church interiors or as processional hangings for the feast of Corpus Christi. In the workshop of the Van den Heckes, all the *Eucharist* tapestries were woven of silk and wool. The

Detail of cat. no. 24

Cathedral of Toledo has six panels commissioned and given to it in 1701 by Cardinal Luis Manuel Fernández Portocarrero (1635–1709). Those panels (*Abraham and Melchizedek*, the *Triumph of Divine Love*, the *Triumph of Faith*, the *Victory of the Eucharist over Idolatry*, and the *Defenders of the Faith*), together with the splendid collection of other tapestries belonging to the cathedral chapter, are still hung outside the cathedral each year as part of the procession of the Most Holy Sacrament on the date of Corpus Christi.[54] The Palacio de Navarra in Pamplona is decorated with six panels (the *Sacrifice of the Old Covenant*, *Prophet Elijah Being Fed by an Angel*, the *Triumph of Divine Love*, the *Triumph of Faith*, the *Triumph*

of the Church, and the *Victory of the Eucharist Overcoming Pagan Sacrifices*) that probably came from the cathedral or convent of the Agustinas Recoletas in that city.[55] A set that once belonged to the chapter of the Cathedral of Valencia was given sometime after 1796 to the parish church of San Millán de Oncala (Soria) by Archbishop Juan Francisco Ximénez del Río (1736–1880).[56]

A further group of cartoons based on Rubens's *Triumph of the Eucharist* designs was copied from engravings. These contributed eleven scenes to a twenty-nine-piece set representing the *New Testament*, commissioned in 1697 by the Grand Master Ramón Perellos y Rocafull of the Order of the Knights of Malta

as a gift to Saint John's Cathedral in Valletta.[57] The tapestries were woven in the Brussels workshop of Judocus de Vos after cartoons assembled by a knight of the order, Mattia Preti (1613–1699).

That tapestries were still being woven based on the *Triumph of the Eucharist* designs more than seventy years after Isabella's commission attests to just how revolutionary and successful Rubens's compositions were. With their tour de force of spatial complexity, dynamic figures, and lack of traditional borders, these works by Rubens radically questioned the norms of tapestry composition and stimulated cartoon design for decades to come.

CONCHA HERRERO CARRETERO

1. Morán Turina 1994, p. 546; García Sanz 1999, p. 110.
2. Palma 1636, fol. 168.
3. Archivo del Monasterio de las Descalzas Reales, Madrid, boxes 7, 79.
4. Archivo del Monasterio de las Descalzas Reales, Madrid, restoration dossiers, 1881–85, boxes 10, 80.
5. Álvarez Lopera 1982, vol. 2, p. 34.
6. Archivo General de Palacio, Patronatos, Madrid, box 2291/97; Tormo Monzó 1942.
7. Brussels 1985, vol. 2, no. C85.
8. Elbern (in Essen 1954; Elbern 1955) identified them as the theological virtues; De Poorter (1978, vol. 1, p. 322) proposed that they were three of the Virtues, citing Bellori (1672, p. 234), who called two of them Fortitude and Justice.
9. Galle, cited by De Poorter 1978, vol. 1, p. 324; a copy survives in the Bibliothèque Royale de Belgique, Brussels, II17.121A(RP).
10. I. Lavin 1974, pp. 78–79.
11. "[L]a fortaleció Dios para ser martillo de los herejes en Bohemia, Hungría, Alemania, Flandes, y aún en Francia. Casa que la formó Dios para riquísimo número de santos, emperadores, emperatrices, reyes, reinas y archiduques. Casa que la extendió Dios por toda la redondez de la tierra, para dilatar por toda ella su Santa Fe y Evangelio"; Gracián y Morales 1640/1967, p. 71.
12. Held (in Goris and Held 1947, p. 34) repeated the traditional identification; De Poorter (1978, vol. 1, pp. 275–76) suggested Sor Margarita as an alternative.
13. De Poorter 1978, vol. 1, p. 276; Tormo Monzó 1945, p. 22.
14. Portús 1998.
15. Elbert 1955, pp. 43–48; Held 1980, p. 139.
16. The correspondence, in the Bibliothèque Nationale de France, Paris, Fonds Baluze, no. 162, fol. 138v, was published in De Maeyer 1955a, no. 214, and De Poorter 1978, vol. 2, doc. 6.
17. Note recorded by Chifflet, now in the Bibliothèque Municipale, Besançon, coll. Chifflet, no. 97, fol. 190; published in De Maeyer 1955a, no. 219, and De Poorter 1978, vol. 2, doc. 7.
18. Legal declaration preserved in the City Archives, Antwerp, Vierschaar Lakenhalle, V, 1687 (unbound document); published in De Poorter 1978, vol. 2, doc. 5, and discussed in context by E. Duverger 1971b.
19. De Poorter 1978, vol. 1, pp. 28–30.
20. Tormo Monzó 1942, p. 5; De Poorter 1978, vol. 1, p. 29, vol. 2, fig. 6; Herrero Carretero 1992–93, vol. 3, pp. 84–85; Herrero Carretero 1994, pp. 292, 306.
21. Carrillo 1616.
22. "[O]ctavas del santísimo Sacramento…no faltase cosa alguna en majestad y…mandaba componer toda la Iglesia y Claustro con los más preciados adornos…todo el claustro con una tapicería riquísima, en que está la guerra de Túnez, la cual…la dejó el Rey don Felipe Segundo, con condición que se haya de colgar este día el claustro con ella"; Carrillo 1616, Real Biblioteca, Patrimonio Nacional, VI/1585, fols. 25v, 36–38; Herrero

Carretero 1992–93, vol. 3, pp. 84–85, and Herrero Carretero 1994, pp. 292, 306.
23. "L'Infante envoya à Madrid aux Déchaussées une tapisserie contenant les figures et mistères de la Saint-Eucharistie de laquelle les patrons sont faites par Rubens, ont cousté trente mille florins. La tapisserie en valoit près de cent mille"; Bibliothèque Municipale, Besançon, coll. Chifflet, no. 69, fols. 297, 301–2v; published in De Maeyer 1955a, no. 266, and De Poorter 1978, vol. 2, doc. 9.
24. "En janvier 1628 furent données à Pierre Paul Rubens plusieurs perles, a bon compte des patrons de tapisserie pour les cordelières de Madrid"; Bibliothèque Municipale, Besançon, coll. Chifflet, no. 69, fol. 190; published in De Maeyer 1955a, no. 219, and De Poorter 1978, vol. 2, doc. 7.
25. De Poorter 1978, vol. 1, pp. 40–44.
26. Rotterdam–Madrid 2003.
27. Seven of the bozzetti were purchased by the Reverend Thomas Kerrich in the early 19th century and were subsequently bequeathed by his son to the Fitzwilliam Museum, Cambridge, where they remain; see Antwerp 1997, nos. 10a, 11a; De Poorter 1978, vol. 1, nos. 7a, 12a, 13a, 14a, 15a, 17a. Two bozzetti that had belonged to the Antwerp painter Victor Wolfvoet (d. 1652) are now in the Musée Bonnat, Bayonne; De Poorter 1978, vol. 1, nos. 8a, 9a. A bozzetto is in the Musée des Beaux-Arts, Tournai, and one is in a private collection; De Poorter 1978, vol. 1, nos. 19a, 21. Of the modelli purchased by the archduchess, eight had reached Spain by 1649, of which six were accessioned into the collection of the Museo del Prado in 1819; De Poorter 1978, vol. 1, nos. 7b, 13c, 15c, 19b, 17b. Other modelli are in the Bildergalerie, Postdam; the Barnes Foundation, Merion, Pa.; National Gallery of Art, Washington, D.C.; Los Angeles County Museum of Art; Musée Bonnat, Bayonne; Fine Arts Gallery, San Diego; Sudeley Castle, Winchcombe, England; Musées Royaux des Beaux-Arts de Belgique, Brussels; and a private collection in Topsfield, Mass.; De Poorter 1978, vol. 1, nos. 2b, 3b, 6b, 7c, 8b, 9b, 18b, 14b, 12c, 10b. Fifteen of the cartoons were transported to the Alcázar, Madrid, for Philip IV in 1648 and were presented to the Carmelite convent of the Descalzas in Loeches, where they were later described by the historians Antonio Palomino (1717) and Antonio Ponz (1787). Sold during the Spanish War of Independence, two are now in the Musée du Louvre, on loan from the Musée des Beaux-Arts in Valenciennes (De Poorter 1978, vol. 1, nos. 9c, 12d), and five are in the John and Mable Ringling Museum, Sarasota, Fla. (De Poorter 1978, vol. 1, nos. 7d, 8c, 13d, 14c, 15d).
28. Held (1980, p. 161) identified him as Clement VIII, whereas De Poorter (1978, vol. 1, p. 271) rejected the identification of specific portraits and instead regarded all as universal, representational figures.
29. Piot 1885; Rooses 1886–92, vol. 2, pp. 429–30.
30. See Rooses 1886–92, vol. 2, p. 45, and De Poorter 1997, p. 83.

31. See Antwerp 2004.
32. De Poorter 1978, vol. 1, pp. 95–108; García Sanz 1999.
33. See T. Campbell and Karafel in New York 2002, pp. 364–70, nos. 41–43.
34. Göbel 1923, pp. 328–31; Delmarcel 1999a, p. 368.
35. De Poorter 1978, vol. 1, p. 162.
36. E. Duverger 1981–84; see also De Poorter 1979–80.
37. E. Duverger 1981–84, pp. 169–70, 171.
38. E. Duverger 1971b.
39. Declaration preserved in the City Archives, Brussels, XIe Register ter Tresorye gehouden, fol. 243; published in Wauters 1878, p. 225, and cited in De Poorter 1978, vol. 1, p. 161.
40. De Poorter 1978, vol. 1, p. 163.
41. Junquera de Vega and Herrero Carretero 1986, p. 54.
42. "S. A. a faict partir dès deux jours ençà, deux chariots qu'elle faict passer en Espagne, chargez de tapisseries, de toiles et de chartes géographiques, et de quelques peintures"; Bibliothèque Nationale de France, Paris, Fonds Baluze, no. 162, fol. 195; published in De Maeyer 1955a, no. 222; see also De Poorter 1978, vol. 2, doc. 8.
43. De Poorter 1978, vol. 1, p. 36.
44. Archivo Histórico Nacional, Madrid, Sección Consejos, libro 363-E, fols. 221v, 265–68 (1631–33). See Morán Turina 1994, p. 546; García Sanz 1999, p. 110.
45. For accounts of Rubens's visit, see Rooses and Ruelens 1887–1909, vol. 5, p. 7; De Maeyer 1955a, p. 105; De Poorter 1978, vol. 1, pp. 36–37.
46. "Envió estos últimos años…a Su Alteza, para el templo del Real Monasterio de las Descalzas, una rica tapicería de los Triunfos de la Iglesia, de valiente dibujo, y en la estofa y en el arte, de las más señaladas de España"; Palma 1636, fol. 168.
47. De la Peña 1632, fol. 11v; see Real Biblioteca 1999, p. 493, no. 2423.
48. Tormo Monzó 1927/1972, pp. 127, 131; De Poorter 1978, vol. 1, pp. 55–62; Ortega 1998; Ortega Vidal 1998.
49. Muller 1975, p. 374.
50. For Panneels's copies, see Depauw 1993.
51. For Lauwers's engravings, see Cologne 1977, pp. 109–11, and Antwerp 1997, no. 9. For other drawn and painted versions, see De Poorter 1978, vol. 1, pp. 223–36.
52. For François van den Hecke, see Göbel 1922 and E. Duverger 1981.
53. See, for example, De Poorter 1978, vol. 1, pp. 243–48, and De Poorter 1997, pp. 86–87.
54. Cortés Hernández 1996; De Poorter 1978, vol. 1, p. 250; De Poorter 1997, pp. 87, 88.
55. Martinena Ruiz 1998. I am grateful to Pepa Garrido for enabling me to study the works while they were being restored and to Mercedes Jover for kindly providing me with bibliographic references.
56. Argente Oliver 1995; De Poorter 1978, vol. 1, pp. 247–48.
57. De Poorter 1978, vol. 1, pp. 253–54; De Poorter 1997, p. 87; Delmarcel in Antwerp 1997, nos. 18b, 19b; Delmarcel 1983.

25.
Maidservant with a Basket of Fruit

From an eight-piece set of *Scenes of Country Life*
Design and cartoon by Jacob Jordaens and workshop, ca. 1627–28
Woven in the workshop of Conrad van der Bruggen, Brussels, ca. 1635[1]
Wool and silk
380 x 327 cm (12 ft. 5⅝ in. x 10 ft. 8¾ in.)
9 warps per cm
Brussels mark, center of lower selvage; weaver's mark, lower right border
Kunstkammer, Kunsthistorisches Museum, Vienna
(T C 8)

PROVENANCE: Imperial collection, exact provenance unknown; 1883–84, Ernst Ritter von Birk inventory; 1921, this set became part of the Kunsthistorisches Museum holdings.

REFERENCES: Crick-Kuntziger 1940; d'Hulst 1956; Blažková 1957, pp. 47–49; Blažková 1959; J. Duverger 1959–60, pp. 48–49; Bauer in Brussels 1977, pp. 19–38, nos. 1–8; De Poorter 1979–80, pp. 219–24; Nelson 1998, pp. 29–36, 85–100 nos. 16–25, pls. 38–57; Delmarcel 1999a, pp. 290–94.

CONDITION: The tapestry is generally in good condition. The light-colored silk threads are fragile in places. There are large areas of old restoration and repair, including overpainting in places.

The *Scenes of Country Life* series from which this tapestry derives was one of Jacob Jordaens's earliest essays in the tapestry medium. Representations of peasants and courtiers engaged in daily activities had been popular in tapestry designs since the Middle Ages, but they had generally been couched in terms of allegorical contexts, such as the Months or the Ages of Man. In this series, Jordaens abandoned such conventions in favor of vignettes in which his subjects are caught in moments of artless, unposed activity. The spontaneity is heightened by the lifesize scale of the figures and the way they are presented in a faux architectural setting, immediately adjacent to the viewer. The focus of each scene on such ephemeral activities as a pair of lovers whispering in the darkness or a huntsman petting his dogs, and the careful observation of domestic details, some of which provide a sly commentary on the main action, combine to evoke a whimsical, gentle observation of the fleeting pleasures of life. The trompe l'oeil architectural setting was inspired by Ruben's *Eucharist* series (conceived in 1626), but the dramatic lighting of the scenes was a novelty in Brussels tapestry, and it would become a characteristic of many of Jordaens's tapestry designs. Quite apart from the pleasing effect that Jordaens obtained by placing lifesize figures in shallow architectural settings, this formula was also advantageous for the weavers because these elements were less demanding to weave than complex landscape backgrounds. Such issues were of considerable significance for the Brussels workshops, which had no royal subsidies, and this may have been partly why the series enjoyed great commercial success during the 1630s and 1640s.

Subject and Iconography
The tapestry depicts a young woman of solid stature in rustic dress, her hair gathered in a net at the back of her head, carrying an overflowing basket of fruit in her muscular arms. She stands in a shallow but lavishly embellished architectural setting. Behind her, a parrot perches on an elaborate stand, the colors of its feathers matching the woman's clothing. In the center of the picture two figures in shadow are visible through an open door, the woman holding a lighted candle and the man draping his arm familiarly around her right shoulder. A low bench in the foreground supports a still life of dead game birds, including a peacock and a duck. There is a large basin at the right, and in front of it a ewer is perched precariously on the ledge. Elaborate columns supporting a heavy entablature ornamented with garlands, masks, and a cartouche frame this scene. To left and right of the doorway, carved-stone figures are seen in profile against marble pilasters with Ionic capitals. The one on the left is largely obscured by the parrot, and the one on the right is a satyr with a goat. Every surface of the architectural setting is decorated with such elements as masks, foliate scrollwork, swags of leaves, fruit, and vegetables, and dolphin heads, snakes, and putti.

This scene is one of eight in the series. The others depict similar seemingly casual observations of country life: a *Huntsman Resting with His Hounds*, a *Hunter on Horseback Carrying a Falcon*, a *Kitchen Scene*, a *Lute-Playing Cavalier with His Lady*, a *Pair of Lovers in a Bower*, a *Maid Feeding Chickens*, and a *Chicken Coop Threatened by Two Falcons*.[2] The sequence of the panels is not known. Indeed their subject matter and composition are autonomous so the panels could be arranged in any order without compromising their comprehensibility or aesthetic impact. The unifying factor in each case is the shallow architectural framework in which each scene is depicted.

The subject matter of these tapestries has its origin in the paintings of market and kitchen scenes, such as those by Pieter Aertsen (1509–1575) and his nephew Joachim Beuckelaer (1530–1574), which enjoyed great popularity in the sixteenth century and profoundly influenced still-life painting in Flanders. During the late 1610s and early 1620s Jordaens developed his own interpretation of this theme in a series of genre

Fig. 112. *Maidservant with a Basket of Fruit in Front of an Open Door*, by Jacob Jordaens, ca. 1627–28. Watercolor and gouache over black chalk on paper, 37 x 37 cm. Staatliche Museen Preussischer Kulturbesitz, Kupferstichkabinett, Berlin (2276)

paintings in which the pleasures of the senses and erotic connotations were evoked by the presence of kitchen maids and farm girls. In Flemish seventeenth-century painting, the maid was generally shown as a young unmarried woman, available for sexual exploitation.[3] In addition, the representation of dead birds has its roots in the market and kitchen scenes by Aertsen and Beuckelaer and transfers this association. The underlying eroticism of the scene in *Maidservant with a Basket of Fruit* is emphasized, for instance, by the carving of the satyr and goat, which represent the abundance and abandon of life in nature as well as a certain lasciviousness. The objects in the foreground enrich the observation of this fleeting moment with well-established symbolic resonances. Also the relationship between the maid in the foreground and the couple behind is ambiguous. Is she their knowing

accomplice or, like the viewer, an accidental voyeur?

The showy basin and ewer at the lower right are doubtless symbols of *luxuria*, evidence of wealth and prosperity. The peacock with its shimmering plumage is another sign of luxury. Indeed, game birds can generally be understood as signs of abundance and well-being, although here they also act as a gentle memento mori, much as the ripe fruit in the servant girl's basket also invites familiar associations of ripeness and decay. The presence of the parrot in the tapestry could be interpreted the same way, as such birds were unquestionably expensive. Moreover, the parrot is a symbol of sexual lust and is often shown in genre scenes such as depictions of brothels.[4]

If the relationship between the various scenes eludes any direct narrative interpretation, the coherence of the series as a whole

is established by the striking architectural frames by which each scene is encompassed. Although such architectural frames had been featured in a number of sixteenth-century Italian series,[5] such compositions were rare, and the vast majority of sixteenth- and early seventeenth-century tapestries were framed by decorative borders. In rejecting this convention and fusing border and subject matter, Jordaens was following the recent example established by Rubens in the *Triumph of the Eucharist* series, conceived for Archduchess Isabella in 1626 (cat. nos. 19–24). The Rubens series incorporates an elaborate trompe l'oeil scheme of faux tapestries suspended within a faux architecture of columns and architrave. Jordaens's conceit is simpler, involving doorways and windows, but it is innovative in the extent to which it brings the characters of the tapestries into close proximity with the viewer. In *Maidservant with a Basket of Fruit*, the base of the ewer and the woman's right foot extend over the lower ledge, pulling the viewer into the pictorial space and enhancing the spontaneity of the scene. Indeed, the basin and the ewer seem about to fall into the viewer's space.

Designer

The design of the *Country Life* series can be firmly attributed to Jacob Jordaens (1593–1678) on the basis of the style and subject matter of the scenes and the close affinity with paintings and tapestries from his workshop.[6] Jordaens, one of the most important artists of the Flemish Baroque, was born in Antwerp and at fourteen began an apprenticeship with Adam van Noort (1562–1641), who also taught Peter Paul Rubens. In 1615 Jordaens, by then an independent master, was initiated into the Guild of Saint Luke as a "waterschilder" (watercolor painter).[7] Between the late 1620s and the early 1650s he and his workshop assistants produced the designs for at least seven tapestry series. Jordaens's tapestry series reflect a broad range of subject matter, from traditional history and mythology, such as the *Story of Alexander the Great* and the *Story of Odysseus*, to genre and exemplary subjects for which he was so renowned in painting.[8]

Neither the designs nor the cartoons for the *Country Life* series have survived, but four

preparatory drawings are known: *A Huntsman Resting with His Hounds* in the Victoria and Albert Museum, London;[9] *Return from the Hunt* in the British Museum, London;[10] *Kitchen Scene* in the Musée du Louvre, Paris;[11] and *Maidservant with a Basket of Fruit* in the Kupferstichkabinett, Berlin (fig. 112).[12] The last sketch shows the same composition as the tapestry, reversed, with slightly divergent details and without the frieze of foliate scrolls running along the bottom edge of the picture. A sketch similar in style and subject to these four, the *Boating Party* (British Museum), could also be considered a design for a tapestry in this series, but it was never translated into the medium of tapestry. It shows a rowboat next to a dock, apparently ready to pick up three pairs of lovers. On the right stands a statue of Mercury holding the caduceus in his outstretched right hand. The softly drawn background landscape is close in style to the London drawing *A Huntsman Resting with His Hounds*.[13]

The dating of the *Scenes of Country Life* has been the subject of considerable debate. The framing architecture of the series, tied directly

to the picture space, is obviously influenced by the architectural framing of Rubens's *Triumph of the Eucharist* series, and previous commentators have generally taken the completion of the editio princeps of that set as the terminus post quem for the *Country Life* series.[14] However, the date of conception can be tied down with greater certainty because of evidence that a weaving of *Maidservant with a Basket of Fruit* was made before the end of 1629. A weaving of this design, now at Hardwick Hall, carries the signature of Jacques Geubels II, who is thought to have died sometime in 1629. If one takes the end of 1629 as a terminus ante quem and allows approximately one year for the manufacture of the tapestries (they are all relatively small), then the cartoons for the series must have been executed by mid- to late 1628 at the latest. This, in turn, puts the conception of the series back to late 1627 or early 1628, a year or so after Rubens conceived the *Eucharist* series. In other words, Jordaens seems to have responded very quickly to Rubens's innovative *Eucharist* designs by developing this smaller, more commercial series. (We may be

able to pinpoint Jordaens's response to an even earlier date. The Hardwick set derives from the collection of the Earls and Dukes of Devonshire; William Cavendish, second Earl of Devonshire, died on June 20, 1628, and was succeeded by his eleven-year-old son of the same name. If we assume that the tapestries have been in the family collection since their creation and that the acquisition of this very early weaving of the design is more likely to have been made by the father, we can posit a date of commission or acquisition before June 1628, which may indicate that Jordaens conceived and designed the series as early as late 1626.)

As noted above, the dramatic light effect in this scene was innovative for tapestry design and reflects Jordaens's awareness of the work of Caravaggio. Though Jordaens never traveled to Italy, he could have seen Caravaggio's *Madonna of the Rosary* in the Dominican Sint-Paulus Kerk in Antwerp,[15] but he learned most about chiaroscuro from the works that Rubens created, such as the Deposition from the Cross (1611–14, Amsterdam Cathedral) in Antwerp under Caravaggio's influence.[16] In this context, it is interesting to note that Jordaens subsequently reused this component of the composition in an oil painting now in Glasgow (fig. 113; atelier copy, Koninklijk Museum voor Schone Kunsten, Antwerp).[17] In that version the three main figures are seen in half-figure, together with the parrot and the carved-stone satyr. This reuse of a motif was not unusual in the work of Jordaens's workshop. Indeed, perhaps in response to the commercial success of his products, he frequently reused components from one composition to another and from one medium to another.

Weaver

The circumstances of conception of the *Scenes of Country Life* series are undocumented. The earliest known weaving of the design is that at Hardwick.[18] Five tapestries of the Hardwick series carry the mark of the Brussels master Jacques Geubels II (first mentioned in 1621 and last in 1629),[19] who took over the atelier of his father (d. 1605), running it together with his father's widow, Catherine van den Eynde (d. between 1620 and 1629), until his death about 1629.[20] Catherine van den Eynde

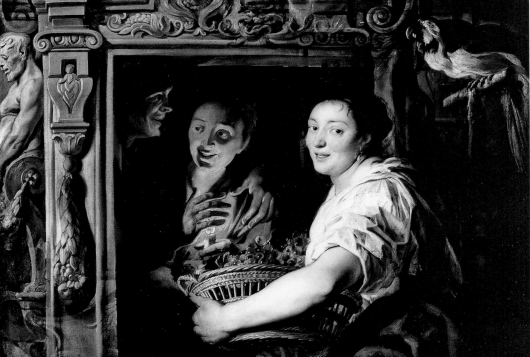

Fig. 113. *Maidservant with a Basket of Fruit and Two Lovers*, by Jacob Jordaens, ca. 1630. Oil on canvas, 119.7 x 156.5 cm. Museum and Art Galleries, Glasgow (84)

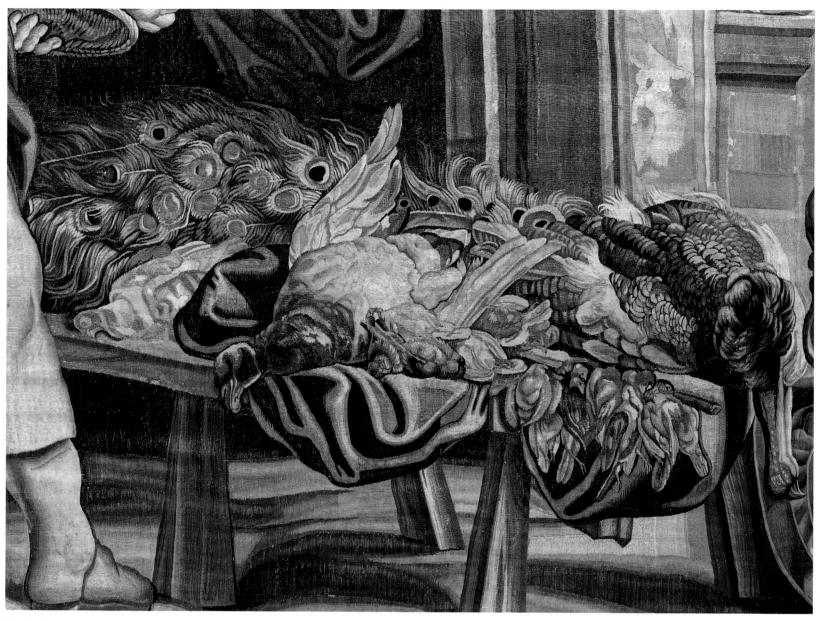

Detail of cat. no. 25

and Jacques Geubels II were among the leading entrepreneurs in Brussels, and it is quite conceivable that they commissioned the designs directly from Jordaens. Following the death of Jacques Geubels the cartoons evidently changed hands because the Vienna set was woven in the Brussels shops of Hendrik Reydams I (fl. 1629–69)[21] and of Conrad van der Bruggen (ca. 1615–in/after 1671).[22] Reydams's mark is woven into *Maid Feeding Chickens*, and Van der Bruggen's is on the *Lute-Playing Cavalier with His Lady* and *Woman Carrying Fruit*. Like the Geubels business, the Reydams enterprise was one of the most important in seventeenth-century Brussels.

Hendrik Reydams I was accepted into the Brussels weavers' guild in 1629 and remained active until 1669. In the 1640s he employed two or three apprentices in addition to ten journeymen.[23] The Van der Bruggen manufactory was also a substantial business. A Van der Bruggen is documented in 1586 when a Gaspard van der Bruggen is mentioned as tapestry weaver.[24] Conrad was a master in Brussels from as early as 1622, while Gaspard was active between 1640 and 1665.[25] On two tapestries in the Vienna set the weaver's monogram is an O inscribed in a C or G, for which reason Conrad appears to have been the more likely author of these hangings.

In addition to the *Scenes of Country Life* sets at Hardwick Hall and the Kunsthistorisches Museum, Vienna, there are five hangings at Náchod Castle, Bohemia, woven by Conrad van der Bruggen and an unknown weaver I.T.B.[26] about 1649–56,[27] which were purchased in Brussels by Prince Ottavio Piccolomini when they were woven. This seems to be the last acquisition of a *Country Life* set after designs and cartoons by Jordaens.[28] There are a few extant single panels of the series. A panel of the *Maidservant with a Basket of Fruit*, woven in Brussels, is in the Acton Collection, Florence,[29] and another is at Wawel Castle, Kraków.[30] The whereabouts

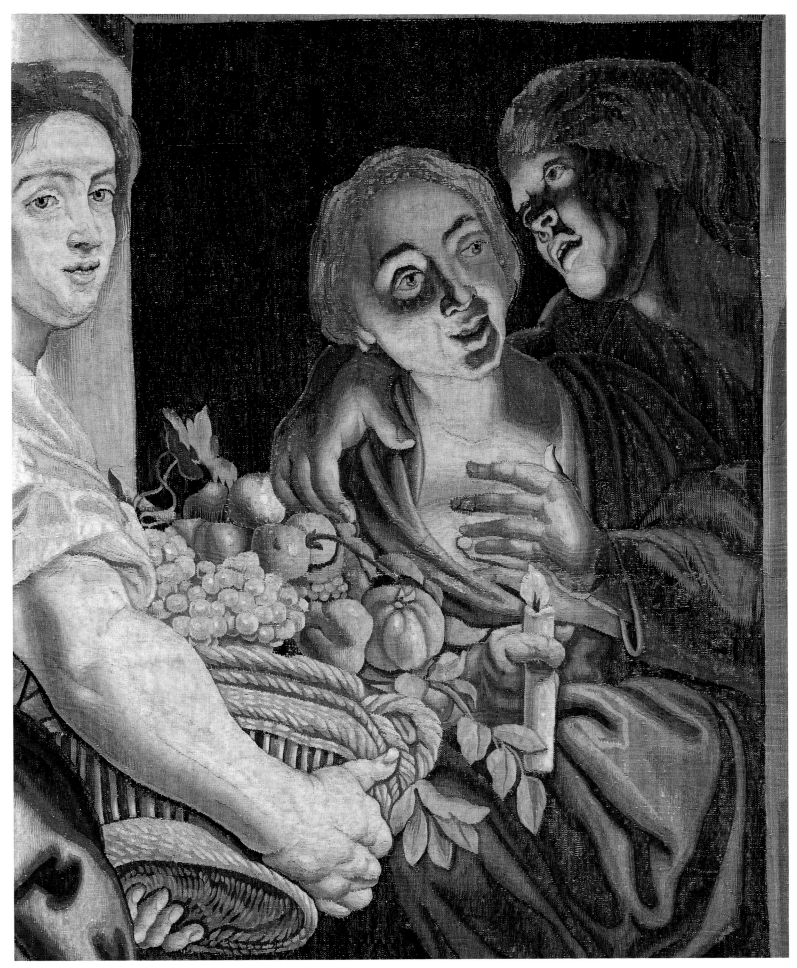

Detail of cat. no. 25

of two other nearly identical panels that were on the art market are unknown.[31]

KATJA SCHMITZ–VON LEDEBUR

1. Nelson (1998, p. 85) dates the tapestries 1635; Delmarcel (1999a, p. 290), on the other hand, dates them between 1629 and ca. 1650.
2. For reproductions of the tapestries, see Brussels 1977, pp. 23–37; Nelson 1998, pls. 38, 40, 42, 46–48, 49, 51; Delmarcel 1999a, pp. 290–94.
3. Sonntag 2006, pp. 113–15.
4. Ibid., pp. 118–19.
5. See, for example, the *Furti di Giove* series designed for Andrea Doria in the early 1530s by Perino del Vaga; T. Campbell in New York 2002, pp. 352–57.
6. The designs for the series have not always been universally attributed to Jordaens. They have also been attributed to Peter Paul Rubens and Frans Snyders (1579–1657); Walpole 1927–28, p. 28; cited in Nelson 1998, p. 29. And as late as 1957 Jarmila Blažková was of the opinion that the numerous animals depicted in the wall hangings were based on designs by Jan Fyt (1611–1661); Blažková 1957, pp. 47–48. Blažková (in Blažková and E. Duverger 1970, p. 37) later revised her attribution, however, espousing the generally accepted scholarly opinion, based on stylistic comparisions, that the designs for this series were all from the hand of Jordaens. See Ottawa 1968, p. 229; d'Hulst 1974, p. 186; Bauer in Brussels 1977, p. 19; Nelson 1998, p. 29.

7. D'Hulst 1993.
8. For an overview of Jordaens's tapestry production, see d'Hulst 1956; d'Hulst 1982, pp. 294–308; Nelson 1998, pp. 3–16.
9. Nelson 1998, p. 88, no. 16a, pl. 39; Antwerp 1993b, vol. 2, pp. 32–33, no. B16.
10. Nelson 1998, pp. 89–90, no. 17a, pl. 41; Antwerp 1993, vol. 2, p. 34, no. B17.
11. Nelson 1998, pp. 91–92, no. 18b, pl. 44.
12. Ibid., pp. 97–98, no. 23a, pl. 52.
13. Ibid., p. 99, no. 24a, pl. 55.
14. Blažková (in Blažková and E. Duverger 1970, p. 37) dated the sketches ca. 1625–30; d'Hulst (1974, p. 186) and De Poorter (1979–80, pp. 219–22) placed them ca. 1635. And Jaffé (in Ottawa 1968, p. 229) and Bauer (in Brussels 1977, p. 20) gave a terminus ante quem of 1628 for the cartoons of the series.
15. The painting is now in the Gemäldegalerie, Kunsthistorisches Museum, Vienna; see Kunsthistorisches Museum 1991, pl. 163.
16. D'Hulst 1982; Van Hout 2002.
17. De Pooter in Antwerp 1993b, vol. 1, pp. 138–41, no. A39; Nelson 1998, pp. 98 no. 23b pl. 53, 98–99 no. 23c pl. 54.
18. Nelson 1998, pp. 85, 87–100.
19. E. Duverger 1981–84, p. 177; Delmarcel 1999a, p. 365. The tapestries at Hardwick Hall and their marks are *Huntsman Resting with His Hounds*, two monograms of Jacques Geubels II; *Return from the Hunt*, Geubels's name and the monogram of an unidentified weaver; *Interior of a Kitchen*, Geubels's monogram; *Lute-Playing Cavalier with His Lady*, cut on both sides; *Pair of Lovers in a Bower*,

monogram of an unidentified weaver; *Maid Feeding Chickens*, indecipherable weaver's mark; *Barnyard with Falcons Threatening Chickens*, Geubels's name and monogram; *Maidservant with a Basket of Fruit*, Geubels's name.
20. Göbel 1923, p. 322; Delmarcel 1999a, p. 214.
21. Delmarcel 1999a, p. 368; Brosens 2004a, pp. 334–35.
22. Brosens 2004a, pp. 351–52.
23. Among the tapestries woven by Hendrik Reydams I, for example, are *Life of Judith* (Hluboká Castle) and *Life of Man* (Cotehele House, near Saltash, Cornwall). He was also involved in the production of *Deeds of Scipio* after Giulio Romano, Kunsthistorisches Museum, Vienna; Collection Toms Pauli, Lausanne) and *Months* after Jan van den Hoecke (Royal Collection, Stockholm). See Halbturn 1975, pp. 17–18; Delmarcel 1999a, p. 368.
24. Halbturn 1975, p. 17.
25. Brosens 2004a, pp. 351–52.
26. This weaver's mark appears on the tapestry *Lute-Playing Cavalier with His Lady*.
27. The subjects of the set at Náchod Castle are *Huntsman Resting with His Hounds*, *Kitchen Scene*, *Lute-Playing Cavalier with His Lady* (with the unknown weaver's mark I.T.B.), *Maid Feeding Chickens*, and *Maidservant with a Basket of Fruit*.
28. Halbturn 1975, p. 18.
29. Ottawa 1968, p. 98; Halbturn 1975, p. 33.
30. Hennel-Bernasikowa 1991.
31. One was sold at Sotheby's, London, November 19, 1982, no. 20, and the other at Christie's, London, January 4, 1982, no. 8.

26.
The Creation of the Horse

From an eight-piece set of *Horsemanship*
Design by Jacob Jordaens, ca. 1633–35
Woven by Everaert Leyniers III, Brussels, ca. 1665–66
Wool, silk, and silver and gilt-metal wrapped thread
410 x 521 cm (13 ft. 5⅜ in. x 17 ft. 1⅛ in.)
8 warps per cm
Brussels mark at center of bottom selvage; weaver's initials E.L. in bottom selvage at right
Kunstkammer, Kunsthistorisches Museum, Vienna
(T XL 1)

PROVENANCE: 1666, purchased by the Viennese court dignitary Bartholome Triangl to decorate the imperial court on the occasion of the nuptials of Leopold I, Holy Roman Emperor, and Infanta Margarita Teresa of Spain;[1] remained in the imperial tapestry collection until, in 1921, the tapestry collection became part of the Kunsthistorisches Museum holdings.

REFERENCES: Birk 1883–84, pt. 1, p. 246; Rooses 1906, p. 184; Donnet 1908, pp. 82, 85–86; Baldass 1920, no. 188; Vienna 1920, no. 32; Göbel 1923, pp. 336, 428; Marillier 1927, p. 13; Held 1949; Crick-Kuntziger 1955, pp. 25–28; Blažková 1957, p. 40; Blažková 1959, pp. 85–86; J. Duverger 1959; J. Duverger 1959–60, p. 51; Blažková 1965, p. 17; d'Hulst 1967, pp. 275–76; Ottawa 1968, p. 235, no. 280; Halbturn 1975, pp. 37–38, no. 1; Bauer in Brussels 1977, pp. 44–45, no. 9; Florence 1977, p. 158; d'Hulst 1982, p. 303; d'Hulst in Antwerp 1993b, vol. 1, pp. 291, 292 no. A94; Nelson 1998, pp. 37–42, 118–22; Bauer 1999, p. 118; Delmarcel 1999a, p. 235; Hefford 2003, pp. 117, 119, 122.

CONDITION: The tapestry is in good condition. In Amphitrite's face and in the contours along the proper left side of her torso painted color has been added.

A splendid, large, and expensive eight-piece tapestry set, designed by Jacob Jordaens illustrating the arts of horsemanship, was among the various furnishings acquired to decorate the Viennese court in suitably sumptuous style during the wedding festivities of Emperor Leopold I.[2] The *Creation of the Horse* is the first piece of that set. The subject of horsemanship was well suited to the courtly milieu, taking as its theme elements of a modern princely education, the deep-seated ideals of the chivalrous life, and the drama of mythology. The *Horsemanship* tapestries that Emperor Leopold I purchased were not made from brand-new cartoons but instead were

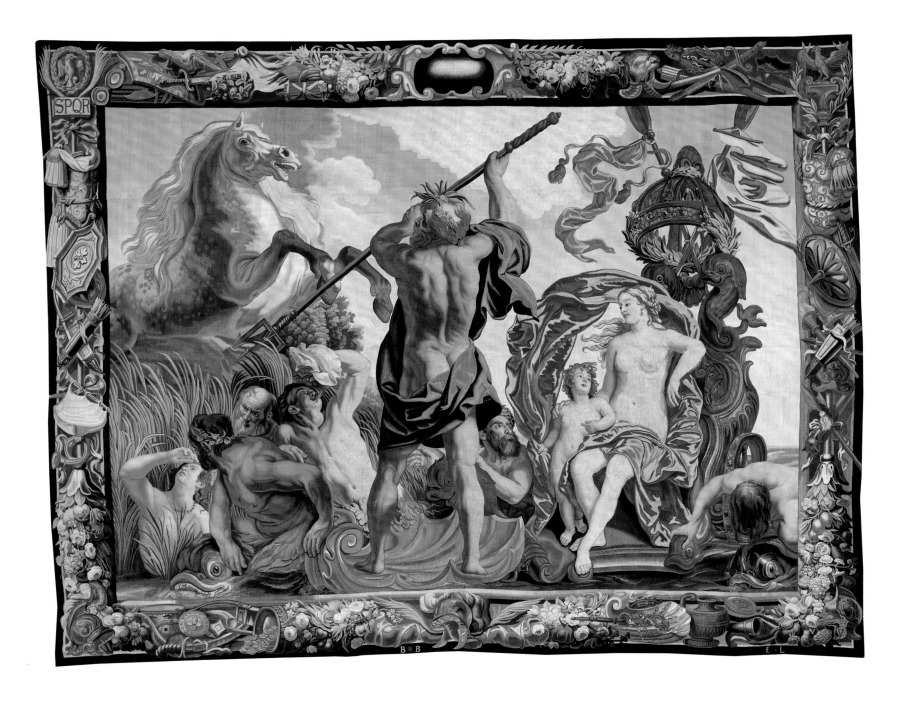

based on designs that had been conceived about thirty years earlier, which, in various incarnations, had already entered other royal collections in Europe. By portraying images of equitation within sumptuous tapestries, the *Horsemanship* series achieved a combination of the two great loves of princely patrons and, as such, were ideal hangings for display at court.

Design and Iconography

Catalogue number 26, as the first piece in the set, illustrates the Creation of the Horse. Since antiquity, Neptune had been considered the god of horses and, according to Pausanias and Diodorus Siculus, the father of equitation.[3]

Jordaens has adhered to Ovid's account of the episode, perhaps taking as his source Pontanus's edition, published in Antwerp in 1618.[4] Neptune stands in the center, nude except for a length of green cloth, which, artfully gathered around his hips and draped over his right arm, displays his athletic, muscular body. Riding a conch shell, holding his trident with both hands, he strikes a rock, causing a high-spirited white stallion to rear up out of the ground. To the right, Neptune's golden-haired consort Amphitrite is seated in an elaborate gold chariot, beneath a baldachin supported by dolphins. Beside her stands Palaemon, or Portunes. Billowing red fabric encircles

her nude body. A pair of crossed oars with pennantlike ribbons, waving in the wind above the chariot, are a possible allusion to Fortuna.

Dolphins, Nereids, and Tritons flank Neptune's shell. His constant attendants, the Tritons, as "heralds of the sea" carry the *buccina*, a twisted shell they used as a trumpet, with which they could produce a frightening sound. The upper halves of their bodies are human, the lower halves fishlike. Dolphins were the sea god's favorite creature, always found in Neptune's retinue after one of them had served as a persuasive messenger of his love to his wife, the Nereid Amphitrite.

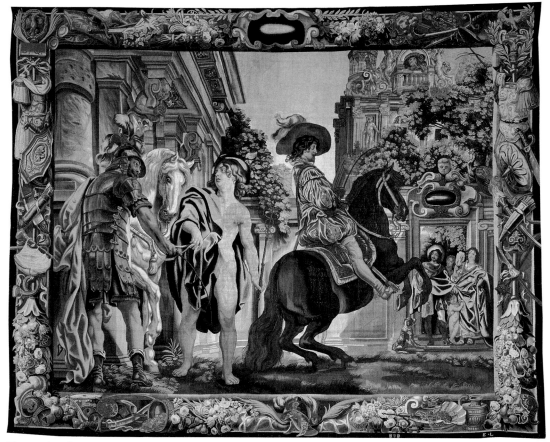

Fig. 114. *Pesade or Courbettes in the Presence of Mercury and Mars* from a set of *Horsemanship*. Tapestry design by Jacob Jordaens, woven by Everard Leyniers III, Brussels, ca. 1665–66. Wool, silk, and silver and gilt-metal wrapped thread, 410 x 508 cm. Kunsthistorisches Museum, Vienna (KK T XL 6)

The remaining seven tapestries in the set illustrate horses in a more contemporary, seventeenth-century courtly context.[5] In some of the scenes, the horsemen are accompanied by riding instructors, while others include Mercury, the winged messenger of the gods, vigilant and attentive in his role of harmonizer, facilitating the relationship between horse and rider. Mars, god of war, appears in some, guiding the art of keeping the horse, symbol of unbridled passion, in check (fig. 114)[6]

Whereas the tapestries illustrate the schooling of horses and the courtly interest in dressage, the borders of the set in Vienna of which catalogue number 26 is a part subtly allude to the legions of the Roman Empire and the horse in the service of warfare, decorated as they are with garlands of fruit and flowers, scrollwork, military trophies, armor, shields, and weapons. Atop a suit of armor in the upper left corner is a standard bearing the inscription SPQR, the abbreviation of the Latin motto *Senatus populusque romanus* (the Senate and the Roman People).

Although the art of equitation was not as central to the life of the seventeenth-century nobility as it had been to their medieval forebears, it was still one of the principal distinguishing characteristics of the upper classes, an essential prerequisite to military life and the ever-popular civilian substitute, the hunt. As such, it was an essential component of a nobleman's education. During the sixteenth century, the art of dressage—precise maneuvers by a schooled horse and a trained rider—gained new cachet as a science and discipline in its own right. Federico Grisone, who in 1532 established a riding school in Naples that would become the leading training center for persons of rank, based his teaching methods in large part on the earliest surviving treatises on equitation, notably the work of Xenophon (430–354 B.C.), thought of as the founder of hippology.[7] One of Grisone's pupils, Giovanni Pignatelli, taught Antoine de Pluvinel, who in turn was riding instructor to the French dauphin Louis (later King Louis XIII). Conversations that had purportedly taken place during the dauphin's

riding lessons between the riding instructor, the dauphin, and other dignitaries of the court were published in 1623, soon after Pluvinel's death, under the title *Le maneige royal de Monsieur de Pluvinel*. With illustrations by Crispijn van de Passe the Younger, the treatise proved to be extremely popular.[8] In 1648 William Cavendish, Duke of Newcastle (1592–1676), opened a riding academy in the Rubens house in Antwerp, where he was then living in exile following the defeat of the Cavalier forces in the English civil war. Jordaens, also living in Antwerp, is certain to have known of it. Cavendish published his theories on dressage as *Le méthode et invention nouvelle de dresser les chevaux* (Antwerp, 1658), with illustrations by Abraham van Diepenbeeck (1596–1675).[9] In the late 1670s and 1680s these engravings served as patterns for a tapestry series executed in Antwerp in the workshop of Michiel Wauters.[10]

Equestrian portraiture was an established tradition.[11] Depictions devoted to equitation began to be seen in the realm of tapestry in the mid-sixteenth century. As early as 1530–33, Bernaert van Orley had conceived an equestrian portrait series of the House of Nassau,[12] and in Ferrara in the 1540s and 1550s, Flemish weavers worked on a set of *Horses* tapestries after cartoons designed by Camillo Filippo, Lucas Cornelisz, and Jacopo Vighi d'Argenta.[13] In 1621 the Delft-based tapestry weaver Balthasar van der Zee referred to a cartoon for "the piece with the horse" painted by Karel van Mander the Younger.[14] Meanwhile, by about 1635, Francis Clein designed a six-piece series known as the *Horses* for the English tapestry works at Mortlake that featured mythological figures on horseback (see cat. no. 18).[15]

Designer

An oil painting on canvas signed by Jacob Jordaens (1593–1678), now in the Palazzo Pitti, represents *Neptune Creating the Horse* (fig. 115).[16] It has long been identified as one of Jordaens's designs for the *Horsemanship* series. The composition broadly corresponds to that of catalogue number 26 in reverse, showing Jordaens designing in mirror image to compensate for the inversion of the cartoon that takes place in the low-warp weaving process.

The *Creation of the Horse* captures much of the dynamism and energy of Jordaens's

painted design, in particular the whinnying horse with its swirling mane and the dramatic shaft of light, highlighting the horse's chest and the vulnerable, supine Triton below the rearing hooves. The tapestry also replicates Neptune's powerful nude form and other details, such as Amphitrite's elegant chariot and fluttering drapery. There are, however, some differences. In Jordaens's painting, Amphitrite in her chariot is practically in the center of the composition, whereas in the tapestry Neptune is the pivotal figure, with Amphitrite's chariot relegated to the right half of the scene. The left edge of the painted design, including a clutch of airborne putti and dripping Tritons in the reeds, has been excluded from the weaving. Above all, the figure of Amphitrite has been changed from the crouching *Venus frigida* type painted by Jordaens to the more stately, enthroned nude seen here.

Two other surviving tapestries based on the same design as catalogue number 26, in Brussels and in Hluboká Castle, include the left edge of Jordaens's design that is missing from the tapestry discussed here.[17] They retain elements of Jordaens's Amphitrite, above all

the positioning of her hand at her breast, but rearrange her figure to be seated in her chariot. As such, the Brussels and Hluboká tapestries are considerably closer to Jordaens's design than the present weaving. In addition, their borders are more ambitious than those seen here and on the other pieces of the set in Vienna: the space represented within the tapestries seems to spill over into the frame composed of flanking herm figures on decorative pedestals, piles of military paraphernalia in the foreground, and, above, swags of fruit and vegetables, supported by putti.

Weaver

All of the *Horsemanship* tapestries in Vienna bear the Brussels city mark. Two of the Vienna tapestries display the weaver's mark of Hendrik Reydams I (fl. 1629–69), who became a member of the Brussels weavers' guild in 1629.[18] The other six, including catalogue number 26, have the mark of Everaert Leyniers III (1597–1680), also active in Brussels.

The earliest known surviving document that refers to "cartoons of scenes of horses painted by Jordaens" dates from July 5, 1651, at which time the cartoons for this series were

apparently not yet in the possession of Leyniers and Reydams but belonged to the Antwerp dealer Frans de Smit, who lent two of the cartoons "as samples and proofs" to two merchants in Hamburg, Peeter van Houte and Peeter Tonnet.[19] In November of the same year, reference was made to two tapestry sets of *Horsemanship* jointly produced in the Leyniers and Reydams workshops: those with "large scenes with horses accompanied by figures, painted by Jacob Jordaens" and those with "small scenes with horses." In this document of November 21, 1651, a contract was concluded before an Antwerp notary in which the Antwerp-based merchant Carlos Vincque commissioned a set of seven Brussels tapestries of a "groote actie van peerden geaccompaigneert met figueren" (large scenes of horses accompanied with figures) after cartoons by Jacob Jordaens, woven by Everaert Leyniers III and Hendrik Reydams I.[20] The same contract mentions that Vincque had already purchased from these weavers two sets "van cleynder actie van peerden" (of small scenes with horses), with no reference to the designer of the cartoons. On November 18, 1654, the Antwerp merchant Jan de Backer

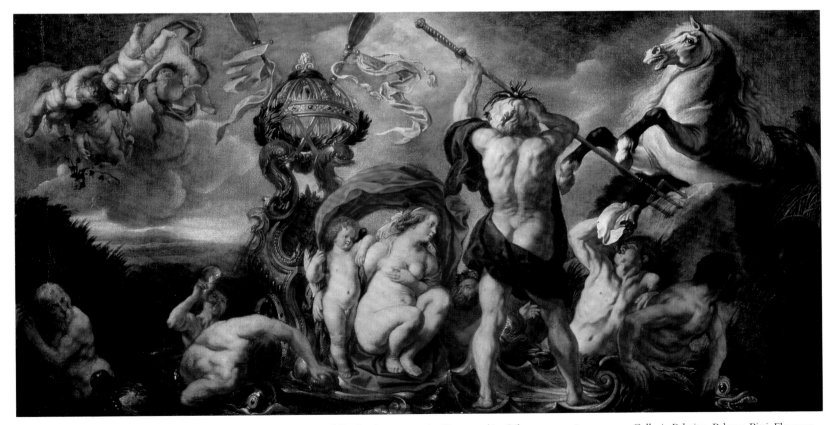

Fig. 115. *The Creation of the Horse*, by Jacob Jordaens, ca. 1633–35. Modello for the tapestry in *Horsemanship*. Oil on canvas, 67 x 131 cm. Galleria Palatina, Palazzo Pitti, Florence (1890 no. 1234)

ordered from Leyniers and Reydams yet another seven-panel set of the "large scenes with horses after the cartoons painted by Jordaens," to be of the same quality as the earlier set supplied to Vincque.[21]

The set in Vienna of which catalogue number 26 is a part has been identified as an example of the "large scenes." The "small scenes with horses" type of *Horsemanship* tapestries has traditionally been associated with a set of hangings in Hluboká Castle. Also woven by Everaert Leyniers III and Hendrik Reydams I, it was probably purchased by Archduke Leopold Wilhelm in 1647.[22] These tapestries incorporate some of Jordaens's designs, including the similar *Creation of the Horse*, combined with figures obtained from Van de Passe the Younger's engravings for the *Maneige royal de Monsieur de Pluvinel*.[23]

Recently, it has been suggested that the "small scenes with horses" were originally independent from Jordaens's "large scenes with horses" designs, including the *Creation of the Horse*, and were based, above all, on Van de Passe the Younger's engravings from Pluvinel's *Maneige*.[24] Certainly, almost two hundred years later, Antoon Le Roy de Saint Lambert, purchasing agent for the marquis de Grane, referred to "le Manège des petits" as the "manège de chevaux de Pluvinel."[25] Wendy Hefford has proposed that although Reydams and Leyniers later owned both sets of cartoons, the earlier "small scenes with horses" cartoons might originally have been woven by the Geubels family of weavers.[26] Heinrich Göbel, the German tapestry historian, cited a reference of 1626 to a set of eleven tapestry panels, now lost, illustrating the riding instruction of Louis XIII in the French royal collection, woven by Jean Geubels—perhaps a misreading of Jacques.[27] It is likely that the engravings in Pluvinel's book served as the inspiration for it, since they represented the riding lessons of the future French king, who is clearly identifiable among the portraits. A further reference to another tapestry set, which has not survived, of "le Manège" bought in England on behalf of Cardinal Mazarin, which might originally have belonged to the British king Charles I, has traditionally been interpreted as another example of this "small scenes of horses"

series.[28] Hefford has recently argued very convincingly that Charles I was indeed the original owner of this lost set, having purchased it in 1636 from Jacques Geubels's onetime business partner Jan-Baptist Lemmens, who at that time owned the *Horsemanship* cartoons and might have engaged Leyniers and Reydams to weave a new version of them for the British king, among the first of many such weavings.[29] In addition, bearing in mind evidence of cost, size, and subsequent descriptions, Hefford suggests that this 1636 set was one of the first editions of the "large scenes of horses" designed by Jordaens. This, combined with stylistic evidence of figure types and the cartoons' relation to Jordaens's *Scenes from Country Life*, has led her to propose a date for the design of the "large scenes of horses" *Horsemanship* series in the early 1630s. This is significantly earlier than the 1640s dating usually attributed to the cartoons.[30]

The exact nature of the link between the "small" and "large" series of *Horsemanship* tapestries, repeatedly rewoven by Reydams and Leyniers, remains unclear. It is likewise a point of debate whether both series initially included Jordaens's dramatic designs. Hefford has observed that the Hluboká set is a later, debased version of the "small" type, with an impoverished and derivative border.[31] This being so, she has further pointed out that lack of original "small scenes of horses" tapestries and cartoons means that it is impossible to know how many subjects the series originally depicted, which compositions borrowed Crispijn van de Passe the Younger's designs and which differed from his example, and what their relationship was to Jordaens's cartoons for the "large scenes of horses." It is likely that once Everaert Leyniers III and Hendrik Reydams I owned sets of cartoons for both the "small scenes of horses" and "large scenes of horses" they were free to adapt each newly woven set according to the demands of their purchasers. The set purchased for Emperor Leopold I in 1666 is not one of the principal sets since some of its pieces, including catalogue number 26, are reduced versions of Jordaens's surviving modelli and omit details included in other surviving woven versions. The weaving of the

Vienna set has been dated as early as about 1645 and as late as 1665–66.[32]

Catalogue number 26 provides a technically proficient, well-preserved example of the "large" *Horsemanship* tapestry type. In his scenes of *Horsemanship*, Jordaens breathes new life into iconography already familiar from the illustrations by Van de Passe the Younger and Van Diepenbeeck in popular manuals and from earlier and contemporary tapestry series designed by Filippi, Cornelisz, and Vighi d'Argenta, and by Francis Clein. By including episodes such as that seen here, with nudes endowed with rippling muscles, Jordaens was able to imbue the tapestries with a sense of unexpected drama, uniting mythology with courtly etiquette. His *Horsemanship* cartoons would prove popular, with some of the episodes apparently reused and incorporated into other sets. This example from Leopold I's set benefits from an excellent state of preservation, with vivid coloration, dramatic effects of light and shade, and, as such, provides a fabulous demonstration of Jordaens's abilities as a tapestry designer, learning from and matching the verve of Rubens.

KATJA SCHMITZ-VON LEDEBUR

1. Bauer 1999, p. 118, correcting Birk 1883–84, pt. 1, p. 246.
2. J. Duverger 1959, p. 136; Bauer 1999, p. 118.
3. Pausanias, *Description of Greece*, 7.21.7–9 (trans. W. H. S. Jones, Loeb Classical Library [London, 1918]); Diodorus Siculus, *Bibliotheca Historica*, 5.69 (trans. C. Bradford Welles, Loeb Classical Library [London, 1963]).
4. Ovid, *Metamorphoseon Libris XV* (Antwerp: Jacobus Pontanus, 1618), 6.75; see Nelson 1998, p. 123.
5. For illustrations of the complete set in the Kunsthistorisches Museum, Vienna, see Antwerp 1993b, vol. 1, pp. 290–301, nos. A94–A100; Nelson 1998, pp. 123–32, nos. 35–46, pls. 82–98.
6. See Held 1949.
7. Grisone 1550; see Nelson 1998, p. 37.
8. J. Duverger 1959, p. 124; Nelson 1998, p. 37.
9. See Nelson 1998, pp. 37–38.
10. J. Duverger 1959, pp. 153–59.
11. See Liedtke 1989.
12. Fock 1969; Fock 1975.
13. J. Duverger 1959, p. 127; Göbel 1928, pp. 373–74.
14. J. Duverger 1959, p. 127.
15. Marillier 1927; Hefford 2003, p. 124.
16. Palazzo Pitti, Florence, inv. 1890 no. 1234, 67 x 131 cm; discussed by Jaffé (in Ottawa 1968, pp. 118–19, no. 81), Bodart (in Florence 1977, p. 158, no. 55), and d'Hulst (in Antwerp 1993b, vol. 1, p. 228, no. A72).
17. Musées Royaux d'Art et d'Histoire, Brussels, 377 x 507 cm; see Crick-Kuntziger 1955, pp. 25–28. Hluboká Castle, inv. 1286, 380 x 530 cm; see Blažková 1959, pp. 85–86; Nelson 1998, p. 123, no. 35 (1A).
18. Donnet 1908, p. 79.
19. Antwerp town archives, Notaris Pieter van Breuseghem N 744; published and discussed in J. Duverger 1959, p. 171, no. 1; and in Nelson 1998, app., pp. 193–94, no. 5.

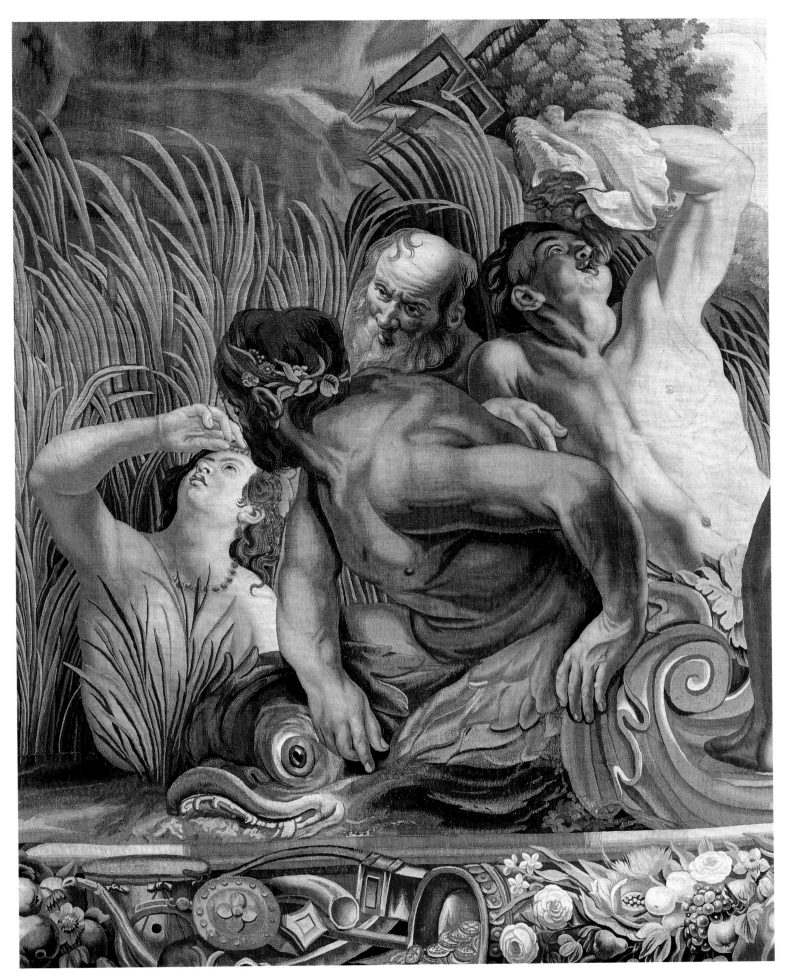

Detail of cat. no. 26

20. Antwerp town archives, Notaris A. Sebille N 3011; published and discussed in J. Duverger 1959, p. 172, no. 2; and in Nelson 1998, app., pp. 195–96, no. 6.

21. First published in Van den Branden 1883, p. 827; republished with translation and discussion in Nelson 1998, app., p. 196, no. 7.

22. See Blažková 1957, p. 40; Blažková 1959, pp. 85–86; Blažková 1965, p. 17; Nelson 1998, pp. 118, 123–25, set A.

23. Discussed in detail in Nelson 1998, pp. 39–40, 123–25.

24. Hefford 2003, p. 120.

25. Ibid., referring to letters of October 27 and November 24, 1679, published in J. Duverger 1959, pp. 175–76, nos. 7 and 8; and in Nelson 1998, app., p. 200, nos. 14, 15.

26. Hefford 2003, p. 120.

27. Göbel 1923, p. 323. Unfortunately Göbel did not cite his source for this document, causing Jozef Duverger (1959, p. 129) to cast some doubt on the reliability of this reference. However, Bauer (in Brussels 1977, p. 41), Nelson (1998, p. 38), and Hefford (2003, p. 117) accepted the existence of this set, even if, as Hefford suggested, Göbel may have been working from a 19th-century transcription of a lost inventory.

28. J. Duverger 1959, pp. 122, 146, 148, 172, and pp. 172–73, no. 3; Nelson 1998, app., pp. 201–2, no. 7.

29. Hefford 2003, pp. 117–20.

30. For example, by d'Hulst (1960, pp. 271–78, no. 32), in

Antwerp 1993b (vol. 1, pp. 228 nos. A72, 290–301 nos. A94–A100), by Jaffé (in Ottawa 1968, pp. 118–19 no. 81, 235 no. 280), by Bauer (in Halbturn 1975, p. 38) and in Brussels 1977 (pp. 39–60, nos. 9–16), and by Bodart (in Florence 1977, no. 55).

31. Hefford 2003, p. 120.

32. The earlier dating was suggested, for example, by d'Hulst (in Antwerp 1993b, vol. 1, pp. 290–301, nos. A94–100) and Bauer (in Brussels 1977, pp. 39–60, nos. 9–16). Nelson (1998, p. 119, set H) more cautiously proposed "before 1666"; Hefford (2003, p. 123) suggested that the Vienna set is a "late, reduced" reweaving.

27.
January and February

Modello for the tapestry in the *Allegory of Time*
Jan van den Hoecke, ca. 1647–50
Oil on canvas
61 x 77 cm (24 x 30⅜ in.)
Inscribed in central cartouche IANVARIVS FEBRVARIVS
Gemäldegalerie, Kunsthistorisches Museum, Vienna
(2652b)

REFERENCES: G. Heinz 1967, pp. 130–34, 142–43; Forti Grazzini in Colorno 1998, p. 137; Stockholm 2002, p. 71.

PROVENANCE: Ca. 1647, commissioned in Brussels by Archduke Leopold Wilhelm; 1650, all the modelli and cartoons and a set of tapestries of the Allegory of Time are in the collection of Archduke Leopold Wilhelm, Vienna; 1662, bequeathed to his nephew Archduke Karl Joseph, Vienna; 1664, bequeathed to Emperor Leopold I, Vienna, and became part of the imperial art collection; 1891, transferred to the holdings of the new Kunsthistorisches Museum, Vienna.

28.
January and February

From a set of the *Allegory of Time*[1]
Design by Jan van den Hoecke with Pieter Thijs and Adriaen van Utrecht, ca. 1647–50
Woven in the workshop of Everaert Leyniers III, Brussels, ca. 1650
Wool, silk, and gilt-metal-wrapped thread
377 x 450 cm (12 ft. 4⅜ in. x 14 ft. 9¼ in.)
9 warps per cm
Brussels mark in bottom selvage at left; EVERAERT

LEYNIERS FESIT in center of bottom selvage; IOES VAN HOECKE INV ET PINX in bottom selvage at right; Kunstkammer, Kunsthistorisches Museum, Vienna (T XLVII 1)

PROVENANCE: The originally fourteen-piece set of the *Allegory of Time*, comprising the *Months*, *Seasons*, *Elements*, *Day*, *Night*, and four decorative *Pillar* pieces, was commissioned by Archduke Leopold Wilhelm, probably soon after he began his governorship of the Spanish Netherlands in 1647;[2] 1650, the set was delivered to Leopold Wilhelm, and that date was also woven into one piece in the set (*March and April*); 1662, at Leopold Wilhelm's death, the set was bequeathed to his nephew Archduke Karl Joseph;[3] 1664, at his death, the set was inherited by Emperor Leopold I and became part of the imperial tapestry collection, where it remained until, in 1921, the tapestry collection became part of the Kunsthistorisches Museum; at an unknown date between the 1662 inventory and Ernst Ritter von Birk's inventory (1883–84), seven of the pieces (*Day*, the *Seasons*, the *Elements*, and the four *Pillar* pieces) were lost.

REFERENCES: Birk 1883–84, pt. 2, pp. 168–69; Mareš 1887, pp. 347–48, 362; Vienna 1921, no. 65; Göbel 1923, pp. 350, 373, 427; D. Heinz 1963, p. 7; Blažková 1965, pp. 15, 16; G. Heinz 1967, pp. 130, 138, 139, 142; Halbturn 1975, pp. 55–59; Bauer in Brussels 1977, pp. 70–71, no. 18; Blažková 1981, p. 203; Forti Grazzini in Colorno 1998, pp. 136–38; Bauer 1999, pp. 117–18; Delmarcel 1999a, pp. 232, 248; Stockholm 2002, p. 72; Smit in Hartkamp-Jonxis and Smit 2004, pp. 131–32, 134.

CONDITION: The tapestry is in good condition. The light-colored silk threads are fragile, and there are numbers of water stains. There have been some provisional repairs.

Archduke Leopold Wilhelm, famous as a collector of paintings, was also active commissioning important tapestry sets. *January and February* is the first piece of one such set: the designs were supplied by the archduke's court artist, Jan van den Hoecke, probably soon after Leopold Wilhelm arrived in Brussels to take up the post of governor of the Spanish Netherlands in 1647. For the painting of the cartoons, Van den Hoecke collaborated with a group of talented figure and still-life specialists, including Jan Breughel the Younger, resulting in a set of tour de force designs in which each artist contributed his area of greatest strength to the cartoons.[4] Examples of both Van den Hoecke's initial oil sketch modelli and the full-size cartoons have survived, since Leopold Wilhelm apparently acquired them when he got the tapestry set itself. *January and February* demonstrates the continuing appreciation of tapestries along with paintings in the mid-seventeenth century, with one of the most active patrons of the day displaying a parallel interest in both.

Design and Iconography
Jan van den Hoecke's *Allegory of Time* consisted of two tapestries representing Day and Night six tapestries each illustrating a pair of consecutive Months, accompanied by one tapestry depicting the Seasons, another of the

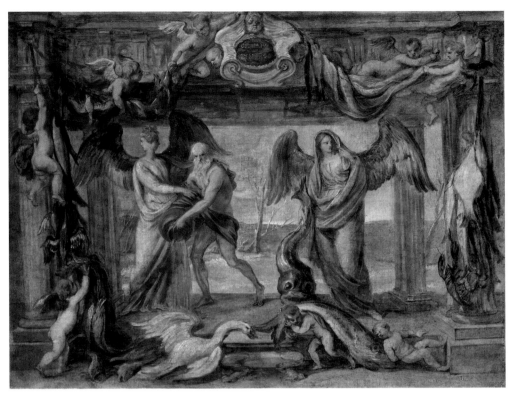

27

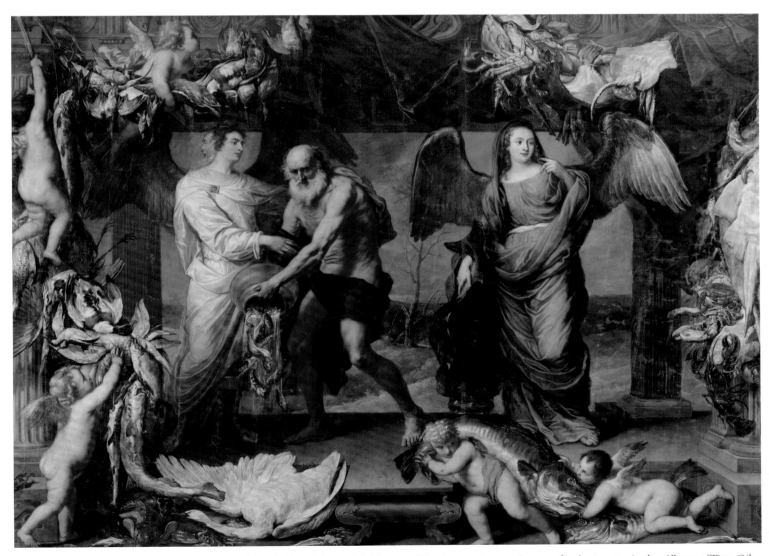

Fig. 116. *January and February*, by Jan van den Hoecke with Pieter Thijs and Adriaen van Utrecht, ca. 1647–50. Cartoon for the tapestry in the *Allegory of Time*. Oil on canvas, 318 x 436 cm. Kunsthistorisches Museum, Vienna (GG 3549)

Elements, and four supplementary decorative weavings described as "pillar pieces." The six *Months* and *Night* are the only pieces of this set to have survived.[5]

The inscription in the cartouche in the upper register of catalogue number 28 identifies this as a representation of the months of January and February. These *Months* do not, however, follow the traditional iconographic scheme, depicting tasks of the agricultural calendar or pastimes appropriate to the month in question, such as, for example, Peter Candid did in the *Months* of his *Months, Seasons, and Times of the Day* for Duke Maximilian I of Bavaria three decades earlier (fig. 32). Instead, Van den Hoecke adopted the symbolic program for the *Months* outlined by Cesare Ripa (1555–1622) in his *Iconologia*, a handbook of allegorical and mythological figures and their attributes, originally published in Rome in 1593.[6] Van den Hoecke probably used the edition published in Antwerp in 1644.[7] Two genies embody the months, their wings alluding to the inevitable transience of the year, the month, the day, and the hours. To the right stands the figure of January. As Ripa suggests, this figure has the two-faced head of Janus, the Roman god of gates, entrances, and exits. His youthful face gazes toward the new, coming year, while his bearded old man's face looks into the past, to the year just ended.[8] The figure of January supports an old man, slightly stooped, nude except for a green cloth around his loins, who, with both hands, empties a vessel, spilling fish and water to the ground. This is the personification of Aquarius, the water carrier, the zodiacal sign for January. To the left is the female embodiment of the month of February, clad in blue and red garments. Her left hand rests on a dolphin, representing the sign of Pisces. Behind the figures is a hazy landscape; the single central bare tree and cool sky capture the chill of winter. The figures are standing within a classical loggia, whose decoration of fish, waterfowl, and crustaceans continues the watery theme of Pisces and Aquarius. A pair of putti exert all their strength to secure swags of dead fish and fowl to the column on the right. Four more putti laboriously attach additional garlands of the same sort to the entablature, while others tackle the foreground display.

This compositional arrangement is reused throughout all six *Months* tapestries, with winged allegorical figures accompanied by still lifes appropriate to the season, each contained within the same architectural framework. Although each hanging functions as a self-contained, balanced composition, the tapestries hung in order side by side give the impression of a continuous colonnade with a background landscape panorama that changes with the seasons.

The right-to-left reading of the scenes has often been discussed as an unintentional aberration, caused by the reversal inherent in the weaving process. However, it is probable that Van den Hoecke intended the sequence to be read in the counterclockwise direction always used for the zodiacal cycle.[9]

Designer

Jan van den Hoecke (1611–1651) trained in Antwerp in the workshop of Peter Paul Rubens.[10] He spent two years perfecting his craft in Rome before settling in Vienna, where he entered the service of Archduke Leopold Wilhelm. Van den Hoecke produced a large number of religious paintings as well as portraits for him. In 1647 he traveled back to Flanders, taking up residence as court painter during the archduke's governorship. The 1659 inventory of Leopold Wilhelm's collection of paintings includes eight of the modelli made for the *Allegory of Time* set (the six *Months*, the *Elements*, *Night*, and *Day*) and notes that all are "Original von Johann von der Hoeckh."[11] Van den Hoecke's authorship of the tapestry designs is categorically confirmed by the tapestries themselves. In addition to the Brussels mark, weavers' names, and, on *March and April*, the date 1650, each of the tapestries bears the inscription IOES VAN HOECKE INV ET PINX. This is one of the earliest surviving examples of such acknowledgment of the designer.[12]

Van den Hoecke's cartoons for the *Allegory of Time* are inventive not just because of their unusual iconography but also for the innovation of their design. Developing Rubens's idea for a flowing transition between the picture space and the border in the *Triumph of the Eucharist* series (cat. nos. 19–24), Van den Hoecke dispensed with formal borders altogether. The formal framing device is fulfilled

by the piers, entablature, and foreground step of the architecture, while sumptuous festoons of game, fowl, fish, flowers, and fruit stand in for more traditional enclosed floral borders. By extending the architecture behind and around the protagonists, Van den Hoecke achieved a sense of figures within three-dimensional space. The decorative success of *January and February* and the other *Months* is achieved by incorporating the popular genre of painted still life within the more established tapestry conventions of monumental figures and architecture.

Documentary evidence reveals that Van den Hoecke enlisted other Antwerp-based artists to help paint the large cartoons: eight of the cartoons (the six *Months*, *Day*, and *Night*) became part of Leopold Wilhelm's painting collection and were inventoried in 1659, with the added note that they were "alle inventiert von Johann von Hoeckh unndt von underschiedlichen Mahleren auszgemacht, nemblichen von Thyssens, Willeports, von Uytrecht, jungen Breugel etc." (all designed by Jan van den Hoecke and executed by various painters, namely [Pieter] Thijs, [Thomas] Willeboirts [Bosschaert], [Adriaen] van Utrecht, [Jan] Breughel the Younger etc.).[13] This is further substantiated by a reference that Jan Breughel made in his journal to his work on the cartoon paintings for *May and June* and *July and August*.[14] Both Adriaen van Utrecht and Jan Breughel the Younger, in particular, were renowned still-life painters, the former specializing in game, fowl, and foodstuffs, the latter in flowers, foliage, and fruits.

The survival of Van den Hoecke's modelli and of many of the painted cartoons enables comparison with the finished tapestries, providing a clearer sense of which aspects were part of Van den Hoecke's original scheme and which areas were changed by his collaborators. As has been mentioned, Leopold Wilhelm owned the modelli for the *Months*, the *Elements*, and *Day* and *Night*. Of these only the *Elements*, *Day* and *Night*, *January and February* (cat. no. 27), and *September and October* remain in Vienna in the collection of the Kunsthistorisches Museum.[15] The modelli for the other four *Months* also survive and are now in the Castle of Miramare in Trieste, probably taken there from Vienna by Archduke

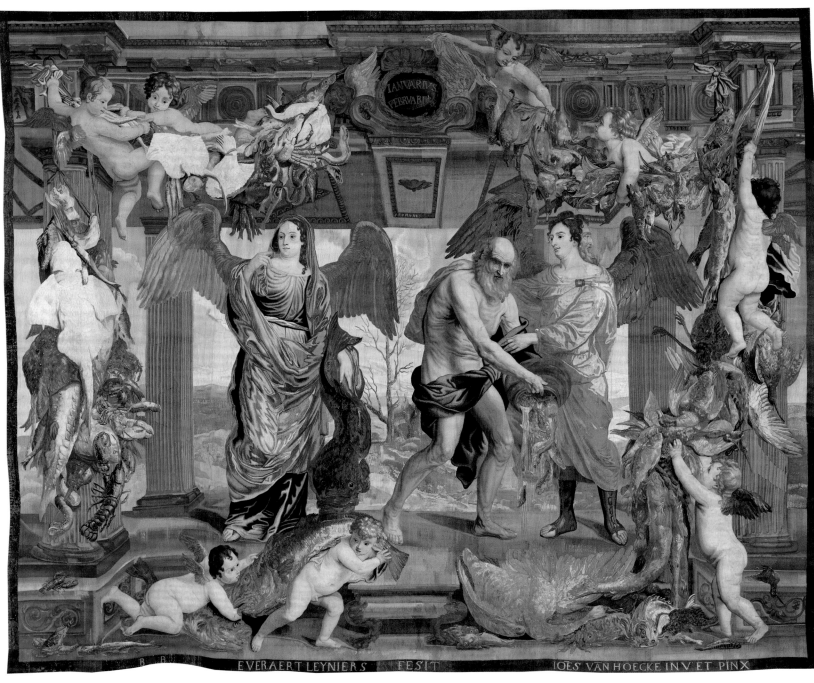

IANVARIVS
FEBRVARIVS

EVERAERT LEYNIERS FECIT IOES VAN HOECKE INV ET PINX

28

Detail of cat. no. 28

Maximilian (1832–1867), emperor of Mexico.[16] Like all the modelli, catalogue number 27 is painted in oil on a canvas support; it has a very muted palette, showing that Van den Hoecke was concentrating on aspects of line and composition rather than color.

The eight cartoons that Leopold Wilhelm obtained, listed in the 1659 inventory, have all remained in Vienna and are now in the Kunsthistorisches Museum.[17] They represent the six *Months*, *Day*, and *Night*; *Day* and *Night* are both considerably narrower than the *Months* and, bearing in mind their conjoined modello, it is possible that they originally formed one cartoon that was cut in half and woven as two separate tapestries.

Comparison of the modello of *January and February* (cat. no. 27) with the tapestry (cat. no. 28) reveals some areas of change. In the foreground, for example, the dead swan was inverted, creating a much more arresting ensemble with the dead fish and crabs than the considerably weaker arrangement in Van den Hoecke's modello. The pale stream of water emptied by Aquarius becomes a cascade of fish. These alterations are present in the painted cartoon (fig. 116), confirming that these probably represent the participation of the still-life specialist Adriaen van Utrecht. Certain weaker aspects of the figures in the modello have also been improved: January's gender has been transformed, and in addition

his two faces are more clearly differentiated by their ages, one receiving a mane of dark hair and firm, young face, the other being considerably more aged and given a beard. By overturning the putto in the foreground, the group with the giant dead fish gains considerably more impetus. These changes, which, again, took place during the painting of the large cartoon, imply a figure specialist and have been attributed to another of Van den Hoecke's collaborators, Pieter Thijs.[18]

Weaver

On the bottom selvages of all six *Months* and the *Night* surviving from Wilhelm Leopold's *Allegory of Time* set is the city mark of Brussels

Detail of cat. no. 28

and the inscription EVERAERT LEYNIERS FESIT. This refers to the successful weaver Everaert Leyniers III (1597–1680), a member of the fifth generation of a Brussels-based tapestry weaving and dyeing family, who became dean of the tapestry weavers' guild in 1635.[19] Everaert Leyniers III worked on numerous collaborative ventures, such as the various large and small *Horsemanship* sets with Hendrik Reydams I (cat. no. 26). It is apparent that the *Allegory of Time* set of which *January and February* is a part is another example of Leyniers pooling resources with weaving colleagues. Catalogue number 28 and the tapestries *September and October* and *Night* bear Leyniers's name alone; the other surviving four *Months* tapestries display the names of both Everaert Leyniers III and Aegidius, or Gillis, van Habbeke. Van Habbeke had been active as a tapestry weaver in Brussels from at least 1643, when he entered into contract with the Antwerp dealer Baptist Franco; he was godfather to one of Hendrick Reydams I's children, but the subsequent financial ruin of his workshop led to his flight from the city in 1659.[20]

Although Archduke Leopold Wilhelm owned the cartoons of the *Months*, *Day*, and *Night*, Leyniers must have either borrowed them before the archduke's return to Vienna in 1656 or retained copies of them, since at least three further sets of the *Allegory of Time* were woven. A set with the six *Months*, *Day*, *Night*, and the *Elements* survives in the Swedish royal collection.[21] It is of such high quality that it has sometimes been proposed as the editio princeps,[22] although it is difficult to envisage such a scenario excluding Leopold Wilhelm as instigator of the series. The tapestries now in Sweden were purchased in 1686 by Count Niels Bielke for Queen Mother Hedwig Eleonora, who gave it to Queen Ulrika Eleonora as a new year's gift. Bielke's set was created in a group of Brussels weaving workshops, with different panels in the set bearing the names of Everaert Leyniers III, Hendrik Reydams I, Willem van Leefdael, and Gerard van der Strecken.

Two other fragmentary sets survive, neither of which bear any weavers' markings. In the Villa Medicea della Petraia in Florence are tapestries after Van den Hoecke's designs of the *Seasons*, the *Elements*, and *May and June*: these are what is left of a ten-piece *Allegory of Time* that was already inventoried in the Farnese collection at the ducal palace of Parma in 1695.[23] In the Rijksmuseum in Amsterdam are further duplicate tapestries of the *Seasons* and the *Elements*, as well as *January and February* and *March and April*, plus fragments of *May and June* and *September and October*.[24] A fourth, reduced edition of *January and February*, without markings, is in a private collection in Buenos Aires.[25]

In the case of other *Allegory of Time* sets produced in collaboration, such as that now in the Swedish royal collection, each piece displays only one name, that of the weaver in whose workshop it was woven. The tapestries of *March and April*, *May and June*, *July and August*, and *November and December* in Leopold Wilhelm's set, in contrast, are unusual since they display both Leyniers's name and that of Gillis van Habbeke, side by side. The German tapestry historian Heinrich Göbel suggested that the inclusion of the two names might imply that both master weavers supervised different aspects of the weaving of each piece, with each master concentrating on his own area of expertise, as was normal in the field of painting and had, indeed, been the case with the cartoons of this group.[26] However, shifting half-woven tapestries between looms and journeymen would seem highly impractical unless both master weavers shared the same workshop space. It is perhaps more likely that Leyniers wove the tapestries that bear his name alone, *January and February*, *September and October*, and *Night*, and then subcontracted the other four *Months* to Van Habbeke, perhaps retaining a supervisory role and, as such, requiring his name to be included as cocreator.

The felicitous combination of an enthusiastic patron and collaboration in both the cartoon-painting and weaving stages has resulted in a tour de force tapestry production. Jan van den Hoecke reinvigorated a traditional theme by combining it with novel iconography, trompe l'oeil architecture, and a plethora of still-life arrangements. From a distance, his tapestry designs are articulated by strong, bold figures, in the manner popularized by Rubens, but as the beholder draws closer to the tapestry, Van den Hoecke and his collaborators celebrate the decorative traditions of Flemish tapestry design, with an abundance of diverting details.

KATJA SCHMITZ-VON LEDEBUR

1. Described in early documents as the *Months, Seasons, Elements, Day, and Night*, the set is here referred to as the *Allegory of Time*, following the sensible proposal made in Delmarcel 1999a, p. 248.
2. The inventory of Leopold Wilhelm's tapestries, drawn up in February 1662, describes "Die zwölf Monate des Jahres. Darzu gehört ein Stück, bezeugt die 4 Jahreszeit, und eines die 4 Elemente und eins den Tag und das andere die Nacht, auch 4 Stück auf die Pfeiler. Summa 14 Stück"; published in Mareš 1887, p. 362. It has traditionally been assumed that the set was commissioned in 1647, although no documentary evidence has been recorded to substantiate this. Mareš (1887, p. 347) records the date of delivery as 1650.
3. Bauer 1999, p. 117.
4. The 1659 inventory of Leopold Wilhelm's paintings identifies the artists of the six *Months* cartoons as Pieter Thijs, Thomas Willeboirts Bosschaert, Adriaen van Utrecht, and Jan Brueghel the Younger, working from the designs of Van den Hoecke; see G. Heinz 1967, p. 130, n. 35.
5. Kunsthistorisches Museum, Vienna, inv. XLVII:2–7; see Halbturn 1975, pp. 55–68; and Bauer in Brussels 1977, pp. 65–84, nos. 18–24.
6. Ripa 1603/1970; Okayama 1992.
7. Smit in Hartkamp-Jonxis and Smit 2004, p. 131.
8. Ripa 1603/1970, p. 320.
9. Delmarcel 1999a, p. 248; Smit in Hartkamp-Jonxis and Smit 2004, p. 131.
10. Gerson and Kuile 1960, p. 141.
11. Inventory nos. 838 and 841; published in G. Heinz 1967, pp. 130 n. 35, 131 n. 36.
12. Delmarcel 1999a, p. 248.
13. Inventory no. 786; published in G. Heinz 1967, p. 130, n. 35.
14. Hairs 1965, p. 185.
15. Kunsthistorisches Museum, Vienna, inv. 2652A–D; all illustrated and discussed in G. Heinz 1967.
16. Castello di Miramare, Trieste; all illustrated and discussed by Forti Grazzini in Colorno 1998, pp. 142–45, nos. 20–23.
17. Kunsthistorisches Museum, Vienna, inv. 1679, 1698, 3549, 3551, 3550, 1863, 1864, 3552; all illustrated and discussed in G. Heinz 1967.
18. Ibid., p. 142.
19. Delmarcel 1999a, p. 367.
20. See Göbel 1923, pp. 335, 372–73; Delmarcel 1999a, p. 256.
21. Stockholm 2002, nos. 9–18.
22. In G. Heinz 1967, p. 130.
23. Villa Medicea della Petraia, Florence, inv. 192, 194, 195; illustrated and discussed by Forti Grazzini in Colorno 1998, pp. 138–41, nos. 17–19.
24. Rijksmuseum, Amsterdam, inv. BK-15310A–D, BK-1959-64, 65; all illustrated and discussed by Smit in Hartkamp-Jonxis and Smit 2004, pp. 131–41, no. 38a–f.
25. Ibid., p. 134.
26. Göbel 1923, p. 350.

29.
Bedcover with Scenes from the Story of Tobias

Design partly based on prints by Maarten van
Heemskerck and Maarten de Vos
Woven in the workshop of Pieter and Aert Spiering,
Delft, 1626
Wool and silk
268 x 265 cm (8 ft. 9½ in. x 8 ft. 8⅜ in.)
9–10 warps per cm
Weaver's mark in lower part of right selvage; weaver's
signature and date in center lower inner border; city
mark in left side of lower selvage
The Royal Collections, Stockholm

PROVENANCE: 1898, acquired for Kungliga
Husgerådskammaren (Royal Collections).

REFERENCES: Böttiger 1895–98, vol. 4, p. 59; Van
Ysselsteyn 1936, vol. 1, pp. 256, 258; Setterwall,
Fogelmarck, and Petersens 1950, p. 63; Delft 1962, no.
73; Amsterdam 1971, no. 31; D. Heinz 1995, p. 108;
Hartkamp-Jonxis 2006, p. 55.

Traditionally identified as a table carpet, this luxurious and extremely fine tapestry was more probably made as a bedcover because only three of the four scenes in the broad border face outward; the one in the upper border is oriented toward the center. If it were a table carpet, all four scenes would be oriented outward, so they would be legible when the broad border hung down from a tabletop. The orientation of the scene in the top border suggests that that edge of the tapestry could be seen when laid on a bed placed against the wall. Figurative tapestry bedcovers were luxury items, and considerable numbers are listed in the inventories of the richer medieval and Renaissance courts.[1] Although seventeenth-century inventories include mentions of tapestry bedcovers, unfortunately few extant examples have been identified. From pictorial sources, however, it is clear that floral bedcovers, table carpets, and other tapestries for domestic use were made with similar designs.[2] The prominent figural scenes make this bedcover unique in Dutch tapestry.

The five scenes (four in the borders and the central scene) represent the story of Tobias, an appropriate choice for a bedroom since the apocryphal book of Tobit is concerned with human morality, particularly with conjugal fidelity. Because they told a story of matrimonial fidelity, Tobias tapestries were popular as marriage gifts among the European elite from the sixteenth century on. A six-piece set of the *Story of Tobias*, probably woven in the late seventeenth century, covered the walls of the large bedroom in the palace of the stadtholder of Friesland in the city of Leeuwarden in 1764.[3]

In 1898 Jan Böttiger, curator of the tapestry collections of the Swedish king, bought the present bedcover for the royal collections. From inventories of the royal household and other archival sources, it is known that the Spiering workshop delivered a large number of tapestries to King Gustav II Adolph (r. 1611–32). Even though the documents pertaining to deliveries from Spiering to the king do not mention tapestry bedcovers, Böttiger felt that this "rarity" could have belonged to Gustav Adolph.[4]

Description and Iconography
The central scene depicts the introduction of Tobias to his niece and future wife, Sara, by the archangel Raphael. The scene is framed by an oval cartouche decorated with scrollwork, shells, and volutes.[5] The shadows cast by the cartouche on the floral background project the illusion of a picture hanging on a floral tapestry with a dark ground, which in turn is surrounded by a rectangular frame. Woven into the bottom edge of the frame is the signature ARNOLDVS SPIRINGIVS, the Latinized spelling of the name of the Delft weaver Aert Spiering (1593–1650), as well as the date 1628. In the broad border appear four more scenes from the story of Tobias, each set in rectangular frames decorated with lavish scrollwork. The shadows of these frames again create an illusionistic effect. Against the light ground of the border, festoons consisting of fruits, flower arrangements, and lambrequins—some with birds—stand out, tied to the inner border with ribbons. In the corners bouquets are depicted, those in the upper corners framed by scrolled ornament.

The story of the God-fearing Tobit and his son, Tobias, begins when Tobit is sleeping outside, forbidden by Jewish law to be inside following his burial of a fellow exile in Nineveh in Assyria, which rendered him unclean. Droppings from birds made him blind. Despite his suffering, Tobit continued his strict adherence to Jewish law. Discord grew between him and his wife, Anna, when he accused her of stealing a young goat that she had in fact received as payment for making household textiles—an indication of her domestic virtue. Tobit fell into despair and began to long for his death. Making arrangements for his son Tobias included sending Tobias to the city of Rages to collect a loan Tobit had made to a relative there. On the dangerous journey to Rages, Tobias was

accompanied by a man called Azarias, who was the archangel Raphael in disguise. In the picture in the left border, the young Tobias is represented in the company of the archangel Raphael, taking leave of his parents. On the road, when bathing in the river Tigris, Tobias was attacked by a large fish. Azarias told Tobias to kill the fish and also to keep its intestines. The scene at the bottom shows Raphael instructing Tobias what to do with the fish. In Ecbatana in Media, Tobias met Sara; their meeting is depicted in the largest, central scene. Sara had had seven husbands, each of whom had been killed on their wedding night by an evil demon. Tobias and Sara married, and Tobias, again with Raphael's help, drove away the evil demon by burning the heart and liver of the fish. The scene in the right border shows Tobias and Sara kneeling by their bridal bed next to a smoking fireplace. Once home, Tobias cured his father's blindness by applying the gall of the fish on his eyes (top image). Thereupon Tobias's companion made himself known as the archangel Raphael. The book of Tobit ends with Tobit's hymn of praise to God and a last admonition to Tobias to go with his family to the safer region of Media. After his parents died, Tobias buried them honorably and went. Before his own death, the city of Nineveh fell, which ended the Jews' Babylonian exile. The book of Tobit is a consolatory story about God's guidance, which can turn misfortune into fortune. With its many admonitions and expositions on matrimonial fidelity and other moral matters, it is part of the Jewish literature of wisdom.

Since the sixteenth century the story was rendered numerous times on tapestries. In painting of the sixteenth and early seventeenth century, the journey of Tobias and the archangel Raphael was a particularly popular subject, set in broad landscapes. This is not so for the scenes on the bedcover, however, in which the human figures are the dominant elements.

Design Sources
The figural scenes are an interesting mixture of sixteenth-century design sources and early Baroque style. The rich garments and interaction among the figures, particularly in the

large, central scene, recall paintings executed in Antwerp in the early seventeenth century and those made by Pieter Lastman and Rembrandt van Rijn in Amsterdam in the 1620s. The scenes in the left and right borders, by contrast, are based on sixteenth-century prints. A woodcut and an engraving by Maarten van Heemskerck (1498–1574) provided the model for the scene of Sara and Tobias kneeling by their matrimonial bed,[6] while an engraving by Maarten de Vos (1532–1603) was the model for the scene in the left border of Tobias taking leave of his parents.[7] This engraving was included in the *Thesaurus sacrarum*, a Bible published in Antwerp in 1585 by Gerard de Jode.[8] The festoons and floral arrangements in the broad border of the bedcover were also likely based on Dutch or Flemish engravings, but by 1626 such lavishly rendered compositions could be found not only on tapestries but also in other materials, particularly in woodcarving.

The Spiering Workshop and Its Tapestry Weavings for Gustav Adolph
In 1620, when François Spiering (1549/51–1630), the founder of the Spiering workshop in Delft, retired, his sons Aert and Pieter (ca. 1595–1652) took over the firm. Pieter apparently took charge of new commissions for the company. Accordingly, in 1618 or 1619, or even some four years earlier, he visited Stockholm, accompanied by his brother Isaac (d. after 1650).[9] Aert remained in Delft in charge of the studio. On November 30, 1619, a contract was signed in Stockholm for a large consignment of tapestries for the Swedish Crown.[10] They were to be delivered by Spiering on the occasion of the marriage of Gustav Adolph to Maria Eleonora of Brandenburg (1599–1655), which took place a year later. Twenty-seven tapestries arrived in the autumn of 1620. Among these was a thirteen-piece set of the *Story of Scipio*,[11] of which at least one tapestry has survived.[12] Another set with episodes from *Orlando furioso* was composed of four tapestries.[13] It is unclear whether one or more of the still-existing pieces belong to the edition for Gustav Adolph.[14] Both series were designed by Karel van Mander II (1579–1623).[15] Ten *Diana* tapestries were also delivered, with

scenes from Ovid's *Metamorphoses*, especially those in which the goddess Diana was involved. This last set, the so-called *Small Diana* series, was probably designed by David Vinckboons (1576–1633).[16] Five tapestries of that series, with the signature of François Spiering, are preserved, but it is uncertain whether these belong to the edition for Gustav Adolph or to another one, which was presented by the States-General of the Netherlands in 1613 to Elizabeth Stuart, the bride of the Elector Palatine Frederick V.[17] One of two horse caparisons woven in the Spiering workshop in the Swedish royal collection is marked A and (in mirror image) S, for Aert Spiering, and is dated 1621; the other bears the Delft town mark H D, for Holland Delft. They are the remains of four caparisons ordered by Gustav Adolph, each consisting of three pieces, described in the royal inventories of 1650–60.[18]

Pieter Spiering's contacts with Sweden were personally rewarding. He took up residence in that country and became a Swedish citizen. He was appointed inspector general of the state tax office; in 1634 he became agent for Sweden in the Dutch Republic, and from 1636 was the resident diplomatic representative for Sweden in The Hague. He was raised to the Swedish nobility, which involved changing his name to Spierinck-Silfvercrona.[19] About 1635 the Spiering workshop closed. By that time Maximiliaen van der Gucht (1603–1689) had started a large tapestry company in Delft, with two workshops, one housed in the former premises of the Spiering workroom in what used to be the Convent of Saint Agnes.

EBELTJE HARTKAMP-JONXIS

1. For examples in the collection of Henry VIII, see Starkey 1998, pp. 185, 201, 214–15, 284–85, 300–301, et infra.
2. See cat. no. 30.
3. Drossaers and Lunsingh Scheurleer 1974–76, vol. 1, p. 602, no. 144, vol. 3, p. 56, no. 663.
4. "[C]onstitue, tout au moins pour nos collections, une rareté, peut fort bien avoir appartenu au roi Gustave-Adolphe"; Böttiger 1895–98, vol. 4, p. 59, n. 1.
5. Tobias's dog in the foreground, looking up at its master, exemplifies marital fidelity.
6. See Veldman 1993, nos. 186 (Tobias and Sara praying), 195/1 (Tobias burning the heart and liver of the fish), including Sara and Tobias kneeling by the bed. A drawing of the latter scene, dated 1555, is in the Kongelige Kobbestiksamlig, Statens Museum for Kunst, Copenhagen.
7. Schuckman 1995–96, vol. 44, no. 167/1, illus. vol. 45, p. 78.

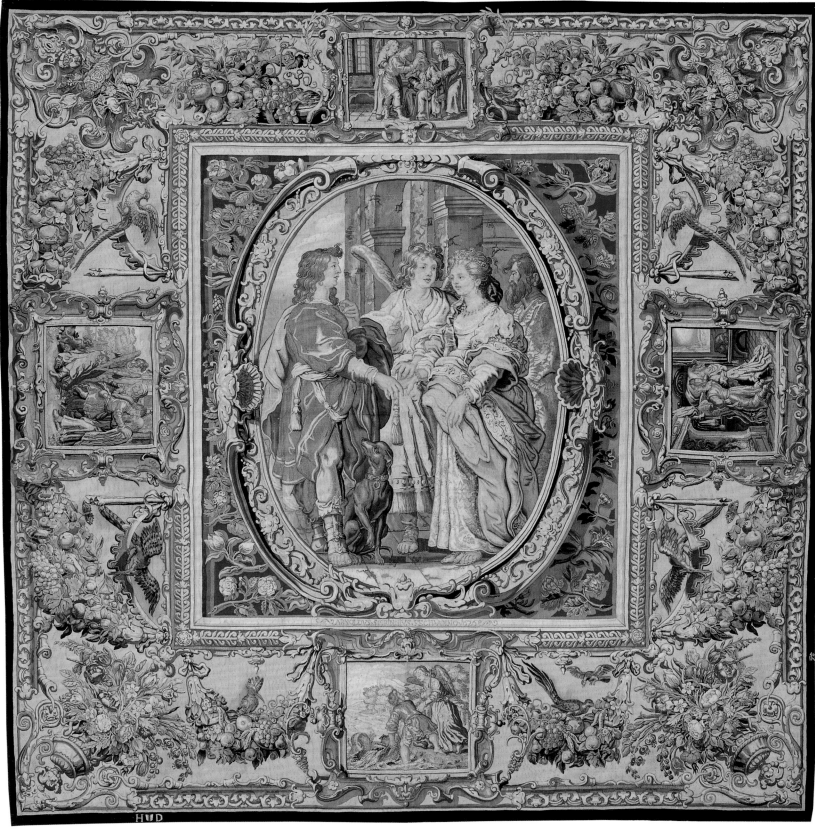

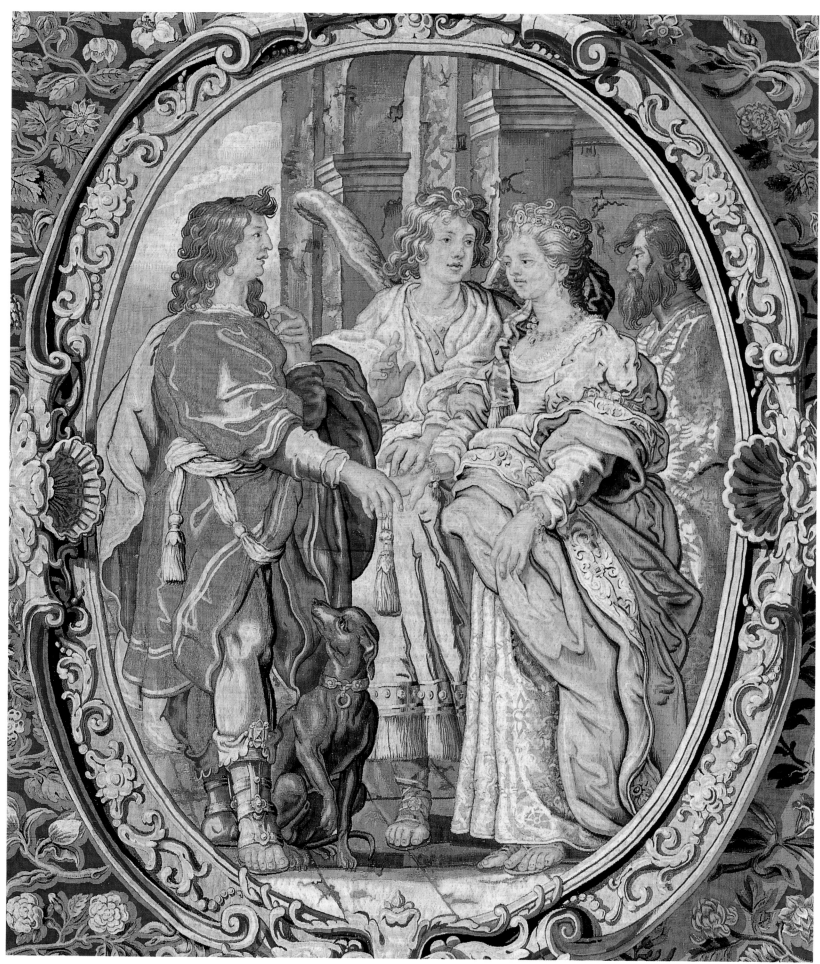

Detail of cat. no. 29

Detail of cat. no. 29

8. *Thesaurus sacrarum historiaru[m] veteris (et novi) testame[n]ti...* ([Antwerp], 1585), p. [157], Rijksprenten-kabinet, Rijksmuseum, Amsterdam (RP-P-1988-312).

9. Noldus 2005, p. 102 and n. 489.

10. Böttiger 1895–98, vol. 4, pp. 54–55. See also Hartkamp-Jonxis 2006, pp. 53–55.

11. Böttiger 1895–98, vol. 4, p. 55.

12. Gustav Adolph's daughter and successor, Queen Christina, took the set with her to Italy after her abdication in 1654. One tapestry is preserved in the town hall of Cagliari. Carl Nordenfalk has proposed that a *Scipio* tapestry in the Nationalmuseum in Stockholm, and another one in the collection of the de Bank voor Handel en Scheepvaart, Rotterdam (presently in the Museum het Prinsenhof, Delft) also belonged to the edition of *Scipio* tapestries for Gustav Adolph; Nordenfalk 1966, pp. 276–78.

13. Böttiger 1895–98, vol. 4, p.55.

14. See Hartkamp-Jonxis in Hartkamp-Jonxis and Smit 2004, pp. 221, 222 n. 110.

15. Ibid., pp. 218, 221.

16. On the bill, the *Diana* tapestries were listed separately in two lots, one of two and the other of eight pieces. See Böttiger 1895–98, vol. 4, p. 55. See also Hartkamp-Jonxis in Hartkamp-Jonxis and Smit 2004, pp. 178, 179 fig. 58.

17. All five are probably on the art market. See Hartkamp-Jonxis 2002b, pp. 26–28; Hartkamp-Jonxis in Hartkamp-Jonxis and Smit 2004, pp. 203, 205 n. 31.

18. Kungliga Livrustkammaren (Royal Armory), Stockholm. See Böttiger 1895–98, vol. 4, p. 58.

19. See Noldus 2005, p. 103.

30.
Table Carpet

Design based partly on prints attributed to Jan Snellinck the Elder and on a print after Michiel Coxcie
Woven in the northern Netherlands, 1652
Wool, silk, and some metal-wrapped thread
202 x 281 cm (6 ft. 7½ in. x 9 ft. 2⅜ in.)
8–9 warps per cm
Unidentified weaver's initials, TCDB, at bottom right
Rijksmuseum, Amsterdam (BK-16395)

PROVENANCE: 1949, with Joseph M. Morpurgo, Amsterdam, then entered the Rijksmuseum.

REFERENCES: *Verslagen omtrent 's rijks verzamelingen van geschiedenis en kunst* 71 (1949), pp. 16–17; Copenhagen 1969, p. [4] and no. 10; Woldbye 1969, pp. 74, 76; Amsterdam 1971, no. 12; Hartkamp-Jonxis 2002a, pp. 18, 22; Hartkamp-Jonxis in Hartkamp-Jonxis and Smit 2004, pp. 277–78, 289–90 no. 69.

CONDITION: Good, with some fading in the lighter shades of blue and red. The remains of the silk fringe appear to be original.

Tapestry-woven table carpets with floral designs, some in combination with biblical or mythological scenes, were produced mainly in seventeenth-century Holland. Some forty Dutch floral table carpets are preserved, dating from about 1620 to about 1690.[1] In Flanders, millefleurs tapestries—tapestries with a pattern of small flowers—were produced from the third quarter of the fifteenth century through the late sixteenth century. The flowers on these are usually rendered as whole plants, in an upright position, and depict what was known of the plant world at the end of the Middle Ages. Seventeenth-century Dutch floral table carpets show picked flowers, always rendered on stalks, often including recently introduced specimens, strewn over the surface. As many as twenty different species can be identified on floral table carpets and other seventeenth-century weavings made for the

home, often including bulbous plants and a variety of fruit. These tapestries testify to a new floral abundance and the burgeoning commercial market for exotic flowers of all kinds. Tulips and other bulbous specimens that are conspicuous on these tapestries can be associated with tulipomania, a craze that made the price of tulips soar in early seventeenth-century Holland. The bubble burst in February 1637 and speculators went bankrupt, but paintings, furniture, and table carpets with bulbous plants continued to be in demand. The present table carpet combines a lavish design of flowers and cornucopias filled with fruit and vegetables, with five scenes of the story of Joseph from the Old Testament.

Description
The flowers on the dark blue background of this table carpet are loosely arranged in circles

and semicircles. They include anemones, crocuses, cyclamen, fritillaries, iris, roses, and tulips; interspersed among the flowers are flies, butterflies, and dragonflies. The scene in the center is surrounded by a wreath of flowers made of carnations, a fritillary, roses, tulips, and violets. The four smaller scenes are set in oval cartouches formed of stylized foliage. The cornucopias in the corners are filled with apricots, apples, grapes, pomegranates, gourds, cherries, ears of corn, artichokes, and pea pods. The scenes and the cornucopias on the long sides of the textile are oriented so they would be legible when the tapestry was placed on a table.

The scenes telling the story of Joseph follow the sequence of events in the book of Genesis. We see, at bottom left, Joseph relating his dreams of sheaves of corn and the sun, moon, and stars to his parents and his brothers (37:5–11); at top right, Joseph interpreting Pharaoh's dream of the fat and lean cows and the fat and thin ears of corn (41:14–36); at top left, Joseph's brothers bowing down to him and asking for corn (42:6–17); at bottom right, the discovery of Joseph's cup in his brother Benjamin's sack of corn (44:12–13); and in the center, Jacob and Joseph meeting in Egypt (46:28–34).

Design Sources and Meaning

The fascination with botany, which is obvious in seventeenth-century Dutch flower painting and, for that matter, in tapestry weavings for domestic use, can be traced back to illustrated plant books by several botanists published in the second half of the sixteenth century by the house of Plantijn in Antwerp.[2] This was the era when bulbous plants, particularly the tulip, were introduced to and cultivated in Europe. These publications sparked a number of *Florilegia*, compilations of often newly discovered botanical specimens, published from the late sixteenth century on in Munich, Antwerp, Paris, Frankfurt, Arnheim, and Utrecht alike. Their focus varied. Pierre Valet, for example, the compiler of *Le Jardin du Roy très chrestien Henri IV* (Paris, 1608), wrote in the foreword of his book that the illustrations could serve as a source of inspiration for artistic handicrafts (he was embroiderer to the king). Johann Theodor de Bry's *Florilegium novum* (Oppenheim, 1612) is organized as a catalogue of rare flowers. These publications were frequently reprinted and expanded. Such was the case with the *Florilegium renovatum et auctum* (Frankfurt, 1641), published by De Bry's son-in-law, Matthäus Merian the Elder. The title plate of a series of flowers that the Amsterdam publisher and engraver Nicolaes Visscher I (1618–1679) brought out with the title *Novae florum icones* shows a flower wreath that is close to those on a number of Dutch table carpets, including the one in the center of catalogue number 30.[3] Designers looking for flower designs to use on silverware, woodwork, Delftware, or floral tapestries found a rich source in these illustrations.

The prints that served as models for three of the five scenes of the story of Joseph have been traced to the *Thesaurus* Bible of Gerard de Jode, which was first published in 1585.[4] The engraving for *Joseph Relating His Dreams* is probably by Michiel Coxcie (1499–1592), while those for *Joseph Interpreting Pharaoh's Dreams* and *Joseph's Brothers Asking for Corn* are attributed to Jan Snellinck the Elder (ca. 1549–1638). De Jode's *Thesaurus* was reprinted from 1639 by the Amsterdam printer Claes Jansz Visscher under the title *Theatrum biblicum*, while some of the illustrations were incorporated at midcentury into other Bibles.

It is not clear whether Dutch floral table carpets with biblical scenes and other objects in Dutch houses decorated with stories from the Bible should be viewed as personal statements made by an individual or as decorative objects in a society in which religious practice was incorporated into daily life. One may ask whether the flowers on the table carpet refer to the concept of transience as phrased in Psalm 103:15–16, where we read that the days of man are like the grass and flowers in a field, which vanish when the wind blows over them. It is also not clear if the story of Joseph in the five cartouches carries a moralistic or Christological message, with Joseph as the example of a virtuous man overcoming hardships through his belief in God or as one of the figures in the Old Testament whose sufferings were considered analogous to those of Christ. The cornucopias in the corners, symbolizing abundance, could fit such a religious scheme. We should be careful, however, in interpreting these elements too strictly. Although biblical scenes on various seventeenth-century Dutch household objects show that the Bible was very much alive, they functioned as a reference to faith rather than as an integral part of life, as they had done in late medieval households. The biblical scenes that decorated cupboards, spoons, and linen tablecloths, often in combination with flowers, appeared just as that, decoration, as much as precepts by which to live.

Patrons and Customers

Few members of European princely homes are known to have ordered Dutch floral table carpets; presumably they bought them readymade. Nonetheless, a floral table carpet with a design of strewn flowers on stalks and cornucopias in the corners similar to those on the carpet under discussion has the coat of arms of the small princedom of Sachsen-Weimar in Germany at its center, which indicates it was specially ordered.[5] Another example, this one with strewn flowers in the central area and scenes representing the four elements along the sides, was acquired by a member of the Zu Dohna family in the third quarter of the seventeenth century for their castle in Schlobitten in former East Prussia. A member of the Zu Dohna family, which was related to the Dutch stadtholder, may have specially ordered that table carpet since the representation of the four elements is unique on Dutch table carpets.[6] In general, however, city councils and private citizens in Holland were the ones who furnished their rooms with floral tapestry carpets.[7] Inventories contain ample evidence.

Six cushion covers with scenes of the life of Joseph were probably woven in the same workshop as the table carpet discussed here, since four of the scenes closely resemble those in the corners of the table carpet. The two others show Joseph in prison and Joseph and Potiphar's wife.[8] In addition, the quality of the weaving of the cushions seems to be similar to that of the table carpet. It is conceivable that the table carpet and cushion covers once formed an ensemble, for the weaving of floral tapestries en suite is known from Dutch inventories. For example, a 1650 list of goods that a prosperous woman took when she went to live with her second husband in Leiden (no. 61 Rapenburg) includes various tapestry-woven items for domestic use that may have

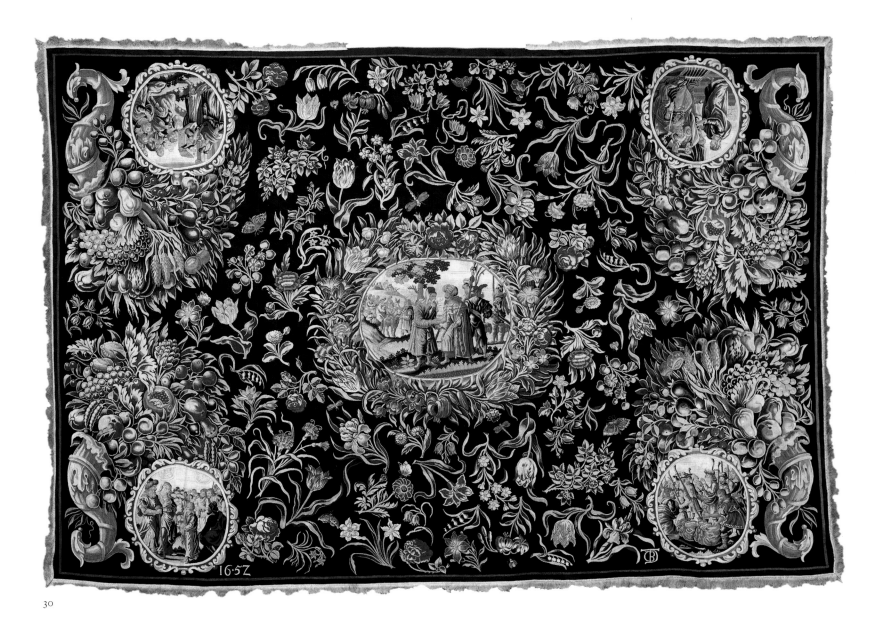

30

been parts of an ensemble: two bedspreads, a table carpet, twelve cushions, and six chairs upholstered with tapestry.[9] This habit of using floral tapestries in various ways is substantiated by other inventories, by a painting of an interior in North Holland (fig. 59), and by a floral table carpet and eight chairs with matching upholstery that are preserved in situ in Amsterdam.[10]

Workshop
A number of the floral tapestries that were incorporated into the Leiden household mentioned above had earlier belonged to the deceased first husband of the woman, the Amsterdam merchant Nicolaes Spiljeurs. Spiljeurs kept account of his purchases, including a green tapestry-woven table carpet decorated with what is described as green

leafwork, together with upholstery panels made of tapestry for the seats and the backs of six Spanish chairs and matching small panels to cover the uprights between the seat and the back of the chairs, all decorated with flowers. He had bought these weavings in 1646 from Pieter de Cracht, a tapestry dealer in Amsterdam who had workshops in Gouda and nearby Schoonhoven.[11] That year De Cracht had taken over the tapestry firm that belonged to the family of his wife, the Nauwincx workshop. The new firm prospered while he was in charge, until 1662. The De Cracht workshop was by no means the only one that produced floral tapestries for interiors at this time. In Delft, for example, Maximiliaen van der Gucht (1603–1689) and his sons Pieter and Bartholomeus ran a successful business, which included the execution

of an order placed with them in 1662 by the aldermen of the city of Delft for forty-one chair covers, presumably with floral patterns.[12] In Gouda itself several other workshops were active, such as the Goossenson studio (before 1660–75), which in 1660 worked with the Delft-based Van der Gucht in the weaving of tapestries, upholstery panels for chairs, and a table carpet for the lodgings in The Hague of the town councillors of Delft and Gouda. Various members of the De Lepelaer family were involved in the tapestry industry in Gouda in the mid-seventeenth century, as was the father-and-son Schaep workshop. But how many floral tapestries these firms actually produced is unclear, as none of them is signed. Therefore, the monogram TCDB on the present table carpet cannot be linked to any known shop, so we must limit ourselves

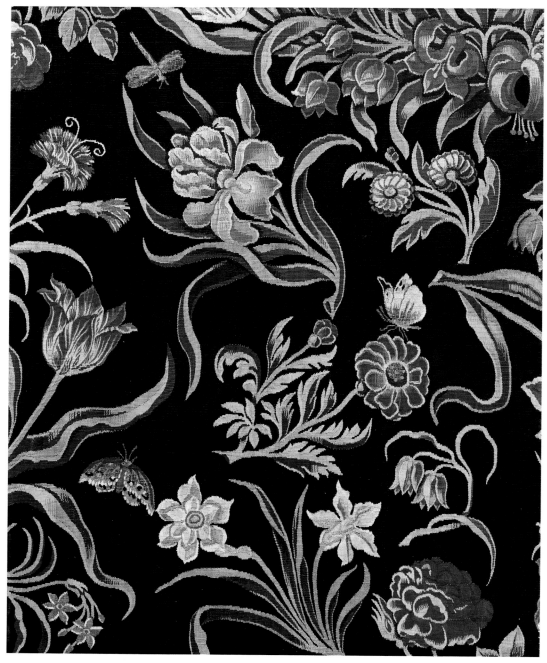

Detail of cat. no. 30

to proposing Delft, Gouda, or nearby Schoonhoven as the place of origin of this beautiful table carpet.

EBELTJE HARTKAMP-JONXIS

1. For a more extensive discussion of Dutch floral table carpets, see the chapter "Floral Table Carpets: A Dutch Product," by Hartkamp-Jonxis in Hartkamp-Jonxis and Smit 2004, pp. 273–83.
2. See Brenninkmeijer-de Rooij 1996, esp. pp. 35–37.
3. British Museum, London; see Schuckman 1991, pp. 89–104; Hartkamp-Jonxis and Smit 2004, fig. 109.
4. *Thesaurus sacrarum historiaru[m] veteris (et novi) testame[n]ti* ([Antwerp], 1585). For a more detailed discussion of the prints on which the scenes are based, see Hartkamp-Jonxis in Hartkamp-Jonxis and Smit 2004, pp. 289–90, no. 69.
5. Germanisches Nationalmuseum, Nürnberg; see Amsterdam 1971, p. 53, illus. Wilhelm IV, duke of Sachsen-Weimar (1598–1662), who had regular contacts with the Dutch Protestant nation, may have ordered the table carpet from the same workshop as the present table carpet, possibly through Sachsen-Weimar's agent in the Netherlands, Joachim van Wickefort. The Sachsen-Weimar tapestry is the only Dutch floral tapestry so far known on which a coat of arms is prominently rendered.
6. Rijksmuseum, Amsterdam, inv. BK-1975-75. For its possible patron, see Hartkamp-Jonxis in Hartkamp-Jonxis and Smit 2004, pp. 287–88, no. 68.
7. A number of Dutch floral table carpets were also bought by clients abroad, particularly in Denmark and Sweden. Political, mercantile, and cultural ties between the Dutch Republic and the Nordic countries were strong during the greater part of the 17th century. For examples in Swedish and Danish collections, see Woldbye 1969.
8. In 1967 these were in the collection of Count Leon Moltke-Huitfeld, Denmark. See Hartkamp-Jonxis in Hartkamp-Jonxis and Smit 2004, p. 290.
9. See Lunsingh Scheurleer, Fock, and Van Dissel 1992, pp. 220–21.
10. The anonymous painting of ca. 1630–35, depicting a family group in what is probably a North Holland interior, shows bed hangings, a valance along the chimneypiece, cushions, and a table carpet, all of matching floral tapestry (Musée d'Art et d'Histoire, Geneva). The table carpet and eight chairs with floral tapestry of ca. 1650 are preserved in an almshouse, the Deutzenhofje, that the owner of the set, Agneta Deutz, had built in Amsterdam in 1695. See Hartkamp-Jonxis and Smit 2004, figs. 105, 106.
11. "'[E]en groen loofwerc tapijten tafelcleed met 6 Spaense tappijtte stoelbladeren mette ruggen en pilaeren in bloemen,...'"; see Lunsingh Scheurleer, Fock, and Van Dissel 1992, p. 162. So-called Spanish chairs are straight Dutch chairs, with legs linked by rungs, a back consisting of a rectangular upholstered frame attached to the seat by uprights. The chair type goes back to one from Spain.
12. See Van Ysselsteyn 1936, vol. 2, p. 313, no. 686.

260

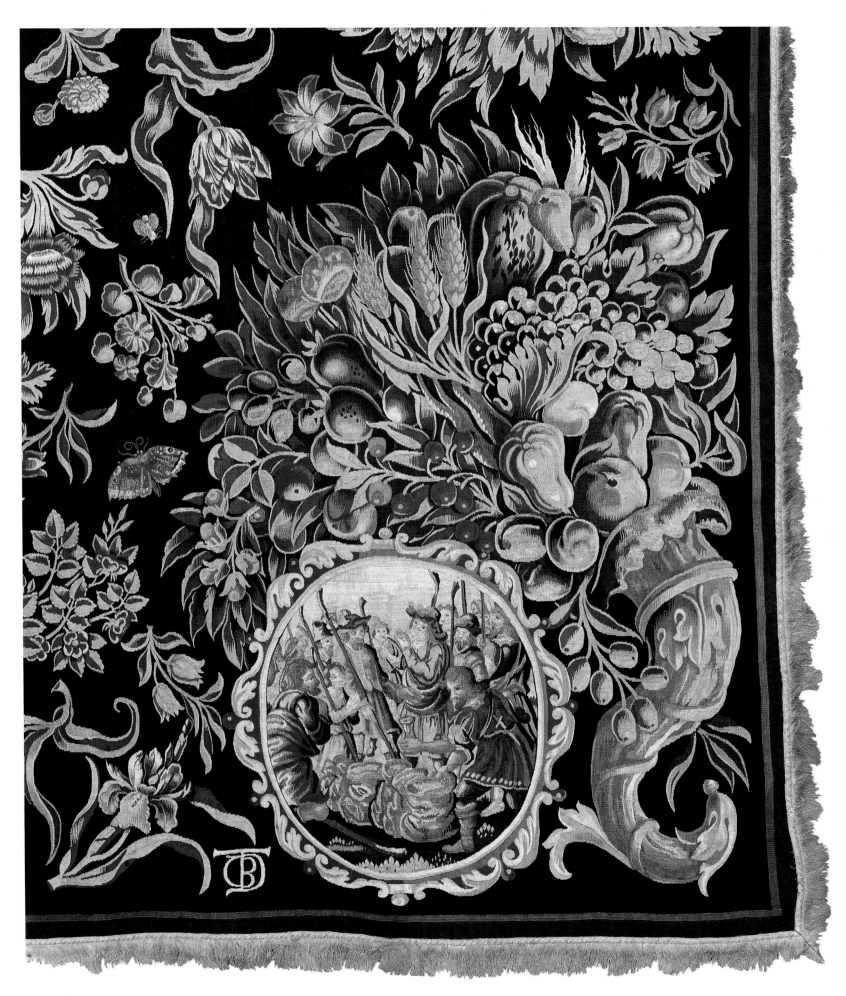

Detail of cat. no. 30

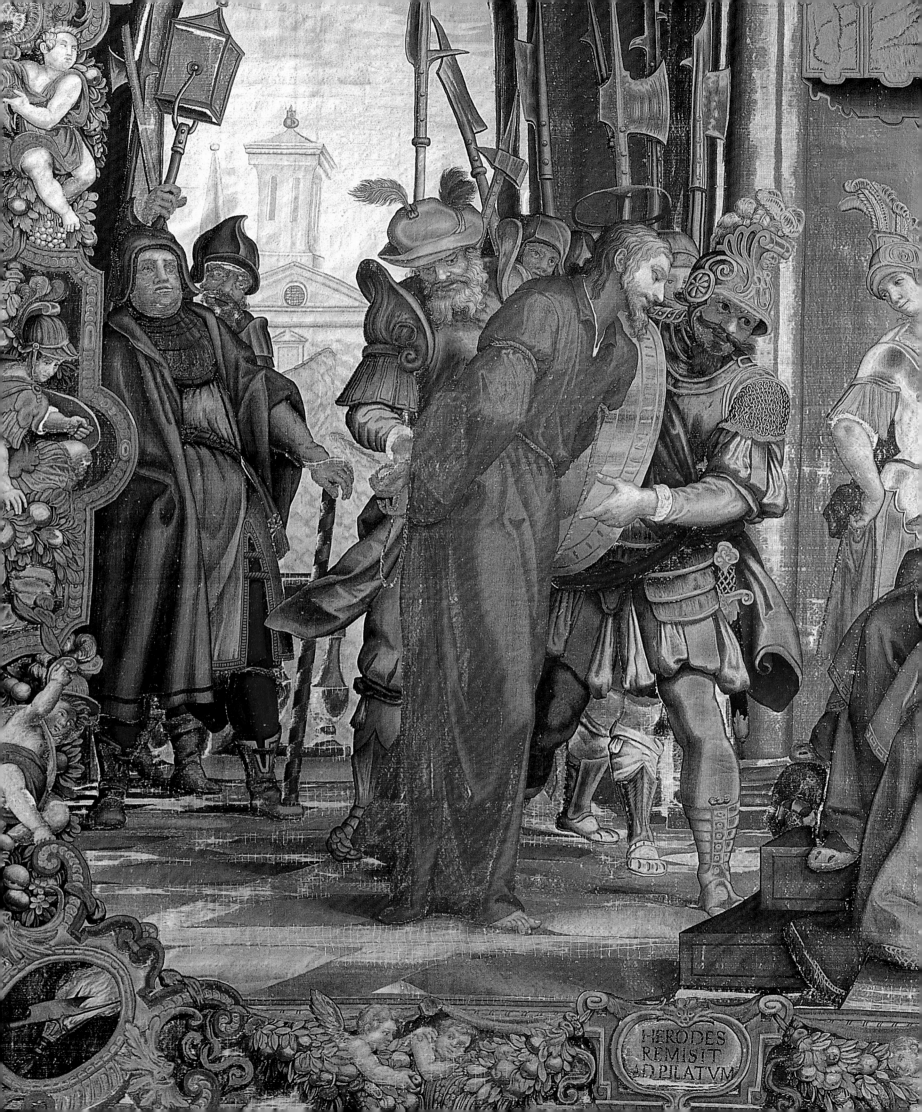

HERODES
REMISIT
AD PILATVM

Tapestry Production in Florence: The Medici Tapestry Works, 1587–1747

LUCIA MEONI

O n June 24, 1588, during the feast of Saint John the Baptist, Florence's patron saint, and less than a year after Ferdinando I de' Medici (b. 1549) had become grand duke of Tuscany, numerous tapestries were put up on the main facade of the Palazzo Vecchio (the seat of government), in the Loggia de' Lanzi, and in nearby streets in a display of pomp and magnificence characteristic of the reign of this farsighted politician. Many of these tapestries had been made at the state tapestry works begun by Ferdinando's father, Cosimo I (r. 1537–74).[1] The display of tapestries in Florentine streets on feast days was a custom already established in the fifteenth century, and it was to be continued well into the seventeenth century (fig. 118), providing one of the many visible symbols of the Medici dominion of Florence.[2] From a political point of view, Ferdinando's reign is notable for the steps he took to consolidate the position of Tuscany in late sixteenth-century Europe through such diplomatic efforts as the marriage of his niece Maria de' Medici (1573–1642) to the king of France, Henry IV (r. 1589–1610).[3] This farsighted approach also characterized his attitude to artistic patronage. From the beginning of his reign, he worked to change the direction of the tapestry works, reviving his father's plan to make the enterprise economically profitable.[4]

The two workshops that Cosimo set up in 1545 for the Flemish weavers Jan Rost (fl. 1535–64) and Nicolas Karcher (ca. 1498–1562) in the Piazza San Marco and the via dei Cimatori produced a number of extremely fine sets during the first nine years of production. Of these, the most ambitious was the *Story of Joseph* (fig. 17) for the Palazzo Vecchio, which was made from cartoons by the best artists of the period, among them Jacopo da Pontormo (1494–1556/57), Agnolo Bronzino (1503–1572), and Francesco Salviati (1510–1563). In addition, the two workshops also fulfilled commissions from other clients, including the patrician Salviati family, the humanist and historian Bishop Paolo Giovio, the merchant Cristofano

Rinieri, and Cardinal Benedetto Accolti.[5] Although the weavers' contracts allowed them a certain independence, they were required to teach their art to young Florentines and Tuscans. This led in 1554–55 to the creation of a new state tapestry manufactory, initially located in the via del Cocomero and the via de' Servi. From the beginning, these workshops were devoted to producing tapestries for Medici villas and palaces, especially the Palazzo Vecchio, where many new spaces had been created during the renovation carried out by Giorgio Vasari (1511–1574)—who had also ordered tapestries for the palace based on his own designs. Among Vasari's collaborators, the Flemish Jan van der Straet (Joannes Stradanus, 1523–1605), called Giovanni Stradano, distinguished himself in tapestry design, becoming the principal cartoonist of the Medici manufactory after 1577.[6] While Karcher's workshop closed in 1554, Rost's continued to operate until 1565 under his son Giovanni (fl. 1550–65). This workshop accepted outside commissions, which were later taken on by the Medici manufactory.

Direction of the two ducal workshops was consolidated in 1568, and in 1574 they were transferred to Rost's former space. Under Francesco I de' Medici (r. 1574–87), elder brother of Ferdinando, external orders gradually increased, encompassing sets like the *Story of the Virgin and the Infancy of Christ*, designed by Alessandro Allori (1535–1607) and woven by Benedetto Squilli (fl. 1555–88), one of the locals trained by the Flemish weavers, for the basilica of Santa Maria Maggiore in Bergamo. However, most tapestries were still produced for the court.[7]

The Tapestry Works under Ferdinando I, 1587–1609

Ferdinando I put his own man, Guasparri Papini (ca. 1540–1621), at the head of the tapestry works on March 21, 1588, reviving its activity and, especially, increasing the non-court commissions, in an effort to transform the manufactory into a profitable enterprise. Ferdinando's new vision was not limited to a reorganization in production, but rather encompassed a

Fig. 118. *View of the Piazza della Signoria with a Procession*, early 17th century. Oil on canvas, 151 x 331 cm. Soprintendenza Speciale per il Polo Museale Fiorentino, Florence (1890 no. 2601)

net change in the aesthetic and cultural politics of the manufactory.[8] He had become a cardinal in 1563, at age fourteen; from 1565 until he became grand duke in 1587, he lived mainly in Rome,[9] where his villa on the Pincian hill was noted for its important collections of antiquities and contemporary art. Ferdinando's predilection for the work of Scipione Pulzone (ca. 1550–1598), who later became one of the principal protagonists of Counter-Reformation painting in Rome, indicates the cardinal's precocious involvement in a new religious and artistic movement that arose out of the post-Tridentine dictums for verisimilitude and narrative clarity in religious art.[10] While Florentine painters had responded to these new demands in the 1570s,[11] it was not until Ferdinando became grand duke—having renounced his cardinalship and married Christine of Lorraine (1565–1637)—that the tapestry works also reflected this development, producing new subjects based on precepts promoted by the Counter-Reformation.[12] The introduction of obsolete iconographies, such as the Descent into Limbo, as well as a depiction particular to the Byzantine tradition in which angels sustain the dead Christ,[13] seems to derive from a strong desire to affirm the original purity of the Roman Catholic Church. Ferdinando was likely particularly involved in determining this direction because he had an intimate knowledge of the pontifical court.

With a view to stimulating new commissions, Ferdinando ordered seven tapestries of the *Passion of Christ* for the Sistine Chapel shortly after his accession. The iconography and style of this set demonstrate the new commitment to Counter-Reformation ideals. They were to be hung during Advent and Lent, whereas Raphael's *Acts of the Apostles* were put up during other periods of the liturgical year. Plans for this project originated with a promise made by Cosimo I to Pope Pius V on the occasion of Cosimo's coronation as grand duke in 1569, but

that plan was abandoned soon after because of the deaths of Pius, Cosimo, and Vasari.[14] When the promise was revived by Ferdinando, the ensuing set of the *Passion* tapestries was woven by Guasparri Papini in two periods between 1589–91 and 1616.[15] Alessandro Allori prepared the cartoons for four of the first five hangings, and Ludovico Cardi, called il Cigoli (1559–1613), created *Christ before Herod* (cat. no. 33), his only known work for the manufactory.[16] Even though the elderly Allori, with his successful pictorial verisimilitude, showed himself to be abreast of new artistic developments, Cigoli's cartoon was of a whole new tenor with its warm luminosity, *sfumato* effect, and pathos, which reconciled Florentine draftsmanship and Venetian color with Caravaggesque realism, introducing for the first time a Baroque tendency in Florentine tapestry design.[17] Engravings by Giovanni Stradano of the Passion of Christ were a source of inspiration for Allori and Cigoli.[18] The last two tapestries in the series, *Christ Shown to the People* and the *Kiss of Judas*, woven about ten years after the first five, are exact copies of Stradano's compositions. Their cartoons can be attributed to Francesco Mati (ca. 1585–1648), an associate of Michelangelo Cinganelli (1558–1635), and Bernardino Monaldi (fl. 1588–1614).[19] All of these artists were pupils and collaborators of Bernardino Poccetti (1548–1612), who worked for the manufactory from 1607 until his death.[20] Monaldi may also have been responsible for the three overdoors of the series.[21] Following completion of the first part of the set, Ferdinando decided to keep it for his own use, and in 1600, instead of the tapestries, sent Pope Clement VIII a gift of liturgical vestments and altar furnishings, woven by Papini from cartoons by Allori, for the celebration of High Mass in the Sistine Chapel (cat. nos. 31, 32).

The influence of post-Tridentine precepts was also manifested in other projects undertaken at the Medici workshops

during these years. For example, a series depicting the *Pentecost, Abraham and Melchizedek*, and the *Gathering of Manna*, Old Testament prefigurations of the Eucharist, was designed by Allori and woven by Papini in 1596 for the Cathedral of Como. After completion of these three, however, the grand duke decided to present them to Cardinal Alessandro de' Medici (1535–1605; later Pope Leo XI), archbishop of Florence, who took them to France as papal legate.[22] A second set was then woven for Como.[23] Thirteen overdoors with scenes from the New Testament, also executed by Allori and Papini in 1597–1600, glorify human aspects of the sacred stories.[24]

The preference for coherent, realistic representations—so characteristic of the Counter-Reformation—was not limited to religious tapestries. Raffaello Borghini, in *Il Riposo*,[25] an influential art text published in 1584, called for a renewed emphasis on drawing from nature—in contrast to the inventive Mannerist style—which affected the design and production of tapestries with secular subjects as well. This new tendency expressed itself also in the choice of scenes tied to contemporary daily life. In 1593–1602 Allori and Papini created a set of eight tapestries, *Providence*, celebrating Grand Duke Ferdinando's good government, plus eighteen small panels with trophies.[26] Allori depicted the subjects as allegories but in contemporary settings, offering a new version of visual celebrations of the Medici family, which in earlier series had been represented as actual events in the lives of its protagonists, including Cosimo the Elder (1389–1464), Lorenzo the Magnificent (1449–1492), and Pope Clement VII (Giulio de' Medici; r. 1523–34).[27]

This desire for realistic subject matter, coupled with the need to stimulate outside commissions, seems to have been the motivation behind a cycle of the seasons with several pieces dedicated to each period of the year. A traditional theme for tapestries, it was probably considered commercially viable. The tapestries, numbering more than fifty pieces and about ten sets, were woven between 1603 and 1625. Most of these pieces are lost, including a set of *Winter* that was sent in 1620 as a gift to an unknown Neapolitan patron. While fewer than a dozen individual pieces or fragments survive in Tuscany, Nello Forti Grazzini has identified in a private collection a probable tapestry from the set of *Summer* that was woven in 1616 for Cardinal Alessandro Peretti Montalto.[28] The success of this promotional policy, which was conceived by Papini, bore fruit during the reign of Cosimo II (1590–1621) when international commissions started to pour in, prompting the Medici manufactory in 1611 to prepare a still-extant catalogue to send abroad, which detailed the tapestries it could supply, with prices calculated in Flemish square ells and information on the various threads that could be used.[29]

The Tapestry Works under Cosimo II, 1609–21

After the death of his father, Ferdinando I, in 1609, Cosimo II, then only nineteen years old, became grand duke. He had married Maria Magdalena of Austria (1589–1631), a Habsburg princess, in 1608.[30] Although afflicted from infancy with bad health, Cosimo showed a lively interest in the sciences and mathematics, maintaining a close friendship with Galileo Galilei, who dedicated his 1610 treatise *Sidereus Nuncius* to him, and also named the satellites of Jupiter that he discovered after the Medici family.[31]

Guasparri Papini's last series of tapestries, completed in 1617, was woven for Maria Magdalena's rooms in the Palazzo Pitti.[32] Illustrating the story of Phaeton, the series was designed by Michelangelo Cinganelli, who from at least 1614 until his death in 1635 was the principal cartoonist of the state manufactory.

Cosimo II had already decided on a successor to the eighty-three-year-old head weaver Papini, recalling from Paris the Fleming Jacopo van Asselt (ca. 1578–1629).[33] Van Asselt was well known in Florence since he had worked for the manufactory in 1578–82 and in 1590–1600, weaving tapestries for such prestigious clients as Doge Marino Grimani.[34] There is no mention in the Medici archive of where Van Asselt was employed in Paris. He returned to Florence in October 1620 and managed the workshop from 1621 until his death.[35]

The Tapestry Works under Ferdinando II, 1621–70

Ferdinando II (1610–1670) succeeded his father as grand duke at age eleven. In 1634 he married Vittoria della Rovere (1622–1694), whose dowry enriched the Medici art collections with masterpieces like Titian's *Venus of Urbino* and Raphael's *Pope Julius II della Rovere*, now both in the Uffizi.[36] Like his father, Ferdinando's principal passions were the sciences, and in 1657 he and his brother Leopoldo founded the Accademia del Cimento, dedicated to physics, the first such organization in Europe.[37]

During the long regency (1621–28) before Ferdinando came of age, his mother, Maria Magdalena of Austria, and his grandmother Christine of Lorraine ruled.[38] Decoration of the Palazzo Pitti continued, and Maria Magdalena's preferred painter, Cinganelli, designed large pictorial cycles, including, in 1625–27, part of the vault and lunettes in the Sala della Stufa,[39] where between 1637 and 1641 Pietro da Cortona frescoed the

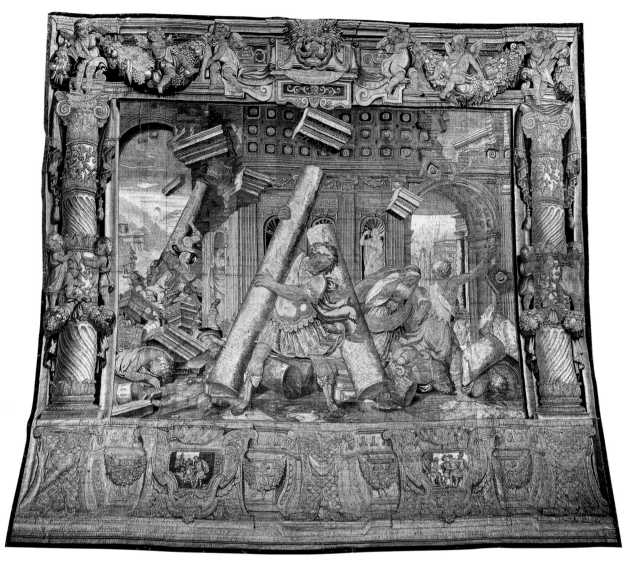

Fig. 119. *Destruction of the Palace of the Philistines and the Death of Samson* from a set of the *Story of Samson*. Tapestry cartoon by Michelangelo Cinganelli, woven by the Florence workshop of Jacopo van Asselt, 1627–29. Wool, silk, and gilt-metal-wrapped thread, 674 x 679 cm. Depositi Arazzi Palazzo Pitti, Florence (Arazzi no. 662)

walls with the *Four Ages of Man*.[40] Cinganelli also executed the drawings and cartoons for a set of tapestries of the *Story of Samson* for the palace. His bill to the manufactory, dated October 10, 1627, indicates that the series was already being made by head weaver Van Asselt, who used expensive gold thread in it. It was finished over the next two years.[41]

The subject of Samson had not previously been tackled in the Medici workshop, and it was rarely treated in contemporary Florentine painting, so Cinganelli, probably with Van Asselt's help, had to look elsewhere for iconographic sources. The compositions of the six tapestries are very similar to prints of the subject by Anton Wierix after drawings of about 1585 by Maarten de Vos, a celebrated Antwerp painter and perhaps a tapestry cartoonist himself.[42] Of the *Destruction of the Palace of the Philistines and the Death of Samson* (fig. 119) there

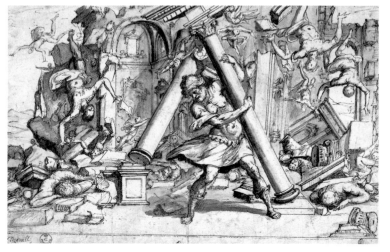

Fig. 120. *Destruction of the Palace of the Philistines and the Death of Samson* by Michelangelo Cinganelli, before 1627. Prepatory sketch for the tapestry in the *Story of Samson*. Pen and blue watercolor on white paper, 25.7 x 38.6 cm. Gabinetto Disegni e Stampe degli Uffizi, Florence (5637 S)

exists a previously unpublished preparatory drawing in the Uffizi (fig. 120).[43]

Cinganelli brought his experience of designing for the Medici theater—in collaboration with the architect Giulio Parigi—to his tapestry cartoons, which indeed look like stage sets on which the action unfolds.[44] Under his influence, tapestry design moved away from its dependence on easel and history painting, which had characterized the manufactory's products designed by Allori, making it a more scenographic art in which the new Baroque style is manifested. From his sojourn in Rome in 1610, Cinganelli would have also become familiar with the perspectival experiments of Cigoli, as seen in the frescoes of the Pauline Chapel of Santa Maria Maggiore, and the innovative illusionistic faux-architectural settings found in the frescoes of the brothers Cherubino (1553–1615) and Giovanni (1558–1601) Alberti.[45] Van Asselt, who returned from Paris in 1620, could also have informed Cinganelli about the compositions resembling theatrical backdrops for various tapestries then being woven in the Faubourg Saint-Marcel manufactory (with the *Stories of Artemisia, Diana,* and *Coriolanus*);[46] it is even possible that Van Asselt had worked there.

The borders of the *Samson* tapestries have Solomonic, or twisted, columns, which imitate those found inside the scene of Raphael's *Healing of the Lame Man* for the Sistine Chapel. Such columns abound in the tapestries of the Faubourg Saint-Marcel, but not as elements of their borders. The use of these columns in the side borders of the Florentine set seems to have been inspired by Francesco Salviati's 1545–48 drawing *Autumn* (now in the Uffizi), conceived for the planned tapestry series of the *Seasons* and the *Four Ages of Man*.[47] In the *Samson* series, just as in Salviati's *Autumn*, the twisted columns are decorated with acanthus leaves and putti holding grapevines. Cinganelli, in his above-mentioned bill of 1627 (see note 41), said that he reduced the cost of seven cartoons made for borders because they had already been painted, but he did not mention the painter's identity. Possibly at least two of these cartoons are those for which Francesco Mati, a Cinganelli collaborator, was paid on March 16, 1619; the payment specifically states that Mati's work was based on a drawing by Salviati, but that the cartoons were not woven because Grand Duke Cosimo II did not like them.[48]

About the same time, in 1626–27, Peter Paul Rubens also used twisted columns in the borders of the *Triumph of the Eucharist* (cat. nos. 19–24) for the convent of the Descalzas Reales in Madrid. The convent's mother superior, Sor Margarita de la Cruz (Margaret of Austria), and the regent

grand duchess of Tuscany, Maria Magdalena of Austria, were cousins. Letters of May 30 and June 27, 1628, from Maria Magdalena to Sor Margarita about the shipment of a crate of "drappi" (fabric) to serve as "paramenti di chiesa" (church decorations and/or vestments) indicate that the women communicated about such matters, quite possibly also exchanging information on tapestries then being woven in Florence.[49] It is conceivable that Rubens, like Cinganelli for the Samson series, may have been inspired by Salviati's drawing *Autumn*. The cousins' correspondence aside, Salviati's designs for the Seasons were known in Brussels; a tapestry series of the *Seasons*, based on them, was made in the first half of the seventeenth century in the workshop of Jan Raes II, and the tapestry of *September* (or *Autumn*) has the same columns in its borders.[50] Raes also collaborated with the weaver Jacques Geubels for Rubens's *Story of Decius Mus*, as well as for the *Eucharist* series for the Descalzas Reales.[51] The fictive architectural structure introduced in Cinganelli's *Samson* borders, so different from the frames designed by Allori, would have a following in Medici tapestries of the 1650s and 1660s and would become a fundamental component of their production in the late seventeenth century.

The *Samson* series, left in storage and forgotten in subsequent years—probably because of its very large dimensions—was much appreciated at the time of its manufacture. The Florentine wool merchant Giovanni Mariani called it a "very beautiful thing" ("cosa bellissima") in a letter sent on February 18, 1634, to the canon Bartolomeo Passerini, master of the household of Cardinal Francesco Barberini, in Rome.[52] At the time the letter was written, the Frenchman Pierre Lefebvre (known in Italy as Pietro Févère; ca. 1592–1669) was weaving the overdoors *Delilah Seduces Samson* and *Samson Bound and Brought to Prison* from Cinganelli's cartoons,[53] and Mariani's letter brought Passerini up-to-date on the Medici tapestry works, reminding him that they had corresponded previously on such matters. Writing of the excellent treatment that weavers received in Florence—good pay and all the necessary materials—Mariani may have been guessing that Passerini would try to hire some of the Medici weavers for the Barberini tapestry works.

During the nine years that Van Asselt directed the Medici manufactory, various individual tapestries and small series were woven for clients outside the court, nearly all from designs by Cinganelli and his workshop. A popular subject was the life of Scipio Africanus, two sets of which were made, one for Cardinal Gaspare Borgia and one for an unknown Genoese

client.[54] The story of Scipio, made especially famous by the Italian translation of Petrarch's *De viris illustribus* by Donato degli Albanzani da Pratovecchio about 1397,[55] had been undertaken in 1604–8 by the tapestry manufactory under Papini.[56] A cartoon, painted in 1628 by the Antwerp artist Cornelis Schut, of *Scipio Africanus in Exile in Liternum Receiving Homage from the Corsairs*[57] depicted a subject that was often specifically cited in documents of orders for these two sets. In the Florentine state tapestry collections there is a third weaving of *Scipio Africanus in Exile*, made as an overdoor for the grand duke and delivered by Pietro Févère on September 30, 1630.[58] After Cinganelli's death in 1635, Filippo Tarchiani (1576–1645) and Baccio del Bianco (1604–1657), who were probably already collaborating with him,[59] finished some projects, including a new edition of the *Seasons* and the overdoors and portieres for the *Samson* hangings.[60]

The man chosen to succeed Jacopo van Asselt as head weaver in 1629 was Pietro Févère, who had been in Florence since November 9, 1618, when he was twenty-six.[61] Perhaps as early as 1624 he introduced high-warp weaving to the Medici manufactory in a workshop set up for him in the Palazzo Vecchio. When Févère became head weaver, he transferred to the San Marco location, where low-warp looms continued to be used primarily. These looms, described as "a Calcola" in Florence, incorporated foot pedals to manipulate the warp threads during weaving and were thus faster. Their products, although less expensive to make, were in no way inferior in quality to those woven on high-warp looms. In fact, Pietro (ca. 1600–1644) and Bernardino van Asselt (ca. 1616–1672), sons of Jacopo, used only low-warp looms.[62]

In the 1630s and 1640s Pietro da Cortona revolutionized traditional Florentine mural painting with a new Baroque concept of space based on aerial perspective and architectural illusionism, conveying historical facts through allegories and mythologies, which gave them a symbolic value and universal magnitude.[63] The people in charge of the artistic direction of the Medici tapestry works and the general artistic environment in Florence were still tied to the didactic culture of the Counter-Reformation and resisted this revolutionary language.[64] Grand Duke Ferdinando II, however, embraced it fully; in June 1637, Michelangelo Buonarroti the Younger (1568–1647) convinced him to engage Cortona, already known for his innovative *Triumph of Divine Providence* frescoed on the ceiling of the great hall in the Palazzo Barberini in Rome.[65] Buonarroti, a noted intellectual, had been in Rome in 1629–30 as the guest of Carlo Barberini, the pope's brother. Buonarroti

had studied with Pope Urban VIII, to whom he dedicated an edition of the poems of Michelangelo, his relative and namesake.[66] Cortona's first work in Florence was the frescoed decoration of the Sala della Stufa in the Palazzo Pitti; then, in 1641, he frescoed the ceilings in the audience rooms in the winter quarters on the same floor, subsequently called the Sale dei Pianeti (Planetary Rooms) because of their astrological subject matter. Cortona worked on the project until 1647. The last room, the Sala di Saturno (Saturn Room), was finished by his collaborator Ciro Ferri (1634?–1689) in 1665.[67] The iconographic program of the Planetary Rooms, conceived by Francesco Rondinelli (1589–1665), the grand duke's librarian, set forth a parallel between the ages of life and the mythological personifications of the planets and contains some veiled allusions—especially in the Sala di Giove (Jupiter Room)—to Galileo's discoveries (even though the scientist died in 1642, in exile in his house in Arcetri, under a *damnatio memoriae* of the Inquisition).[68] In spite of the involvement of these learned men who supported Galileo and his theories, the order of the planets in the Palazzo Pitti rooms follows the old Ptolemaic and Aristotelian systems, which was rationalized by cloaking the scheme in the language of mythology.[69] For these newly frescoed rooms, Ferdinando commissioned cartoons from Florentine painters for many tapestries to be woven, as can be documented in notebooks dating to 1648–49, when the fresco and stucco decoration of the rooms was still in progress.[70]

The suite of rooms in the winter quarters followed the layout that had been established some years earlier on the ground floor in the summer quarters, where the visitor gradually progressed toward the audience chamber, a model that may later have influenced French court etiquette.[71] Of the first two Planetary Rooms that Cortona frescoed, the Sala di Venere (Venus) was intended for every class of person, and the Sala di Apollo, for gentlemen.[72] They were furnished with a sixteenth-century set of eight tapestries of the *Story of Saint John the Baptist*, as well as four new panels, based on pairs of cartoons by Sigismondo Coccapani (woven in 1637–39) and Agostino Melissi (woven by 1651).[73] The Sala di Marte (Mars), where only courtiers were admitted, was hung with a new set of six tapestries of the *Story of Moses* and an overdoor of the *Personification of the Law*.[74] The Sala di Giove, the throne room for grand ducal audiences, had a set of seven gold-woven tapestries of the *Seasons and Hours* (fig. 129), including overdoors of *Time*, *Night*, and *Day* and three portieres with the Medici coat of arms.[75] In the Sala di Saturno (Saturn), intended for the grand duke's private audiences, were six of the eight

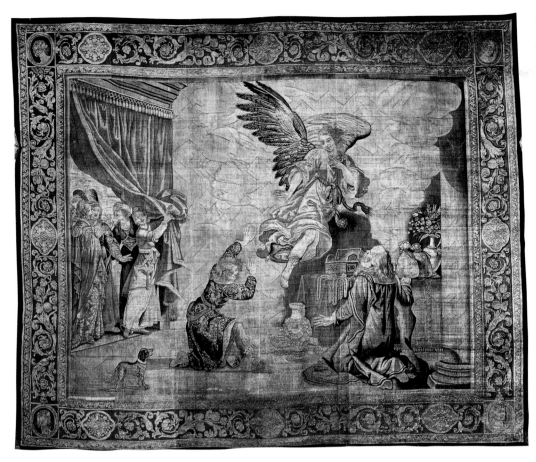

tapestries of the *Story of Cosimo I*, the predecessor to whom Ferdinando II was most devoted.[76] In the grand-ducal bedroom—today the Sala di Ulisse (Ulysses)—hung a set of the *Story of Alexander the Great*, and the audience room of Grand Duchess Vittoria was adorned with the *Story of Tobias* and a ceiling tapestry of *Two Genii Crowning Fortitude (?) with Oak Leaves* (fig. 124).[77]

By 1663–64, the audience room of the winter apartment of Grand Prince Cosimo had a wool-and-filoselle (a lower grade of silk) replica (cat. no. 34) of the *Seasons and Hours* that hung in the Sala di Giove.[78] The cartoons for these tapestries, which were woven in the 1640s, were painted by Iacopo Vignali (1592–1664) and Lorenzo Lippi (1606–1665). For the compositions of *Spring* and *Summer*, Vignali obviously looked at drawings of these subjects by Salviati,[79] whereas for *Autumn* and *Winter* he created scenes of daily life. Lippi would pick up on this in his second rendering of the *Chariot of the Sun* (cat. no. 34), in which the aulic charioteer of the first edition is transformed into a physically active driver. That tapestry well represents Lippi in this decade. The historian Filippo Baldinucci (1625–1696) exalted Lippi as "the genius of pure veracious imitation."[80] A singular figure in the artistic panorama of the period, he was the principal proponent of the necessity of simple natural imitation. In reaction to the all-encompassing dimension of Roman Baroque art, Lippi put forth a purist language and proposed a return to Tuscan classicism as represented by painters such as Andrea del Sarto (1486–1530), Fra Bartolomeo (1472–1517), and Bronzino.[81] Yet in the second weaving of the *Chariot of the Sun*, the urgent young coachman's stance might also be defined as moderately Baroque in style.

The reluctance of Florentine artists to adopt a modern Baroque vocabulary, as introduced by Cortona, is evident in the *Story of Tobias*, with cartoons by various painters and borders and two *entrefênetres* by Baccio del Bianco, woven in 1647–51 by Bernardino van Asselt and Pietro Févère. In this series the response of painter Cecco Bravo (1601–1661) to Cortona's innovations can be seen in the sketchy manner of his cartoon for the overdoor *Tobias Blamed by Raguel*, while the scenes by Giovanni Rosi (1597–1675) are dull, and their architectural representations old-fashioned. Melissi's designs for the series demonstrate a certain liveliness in their narrative depictions and offer pleasing effects of light and color.[82] In the *Archangel Raphael Leaving the House of Tobias* (fig. 121), Melissi inserted the date 1647 (woven in reverse and unidentified until now); according to Baldinucci, that date corresponded to the beginning of the painter's collaboration with the Medici tapestry

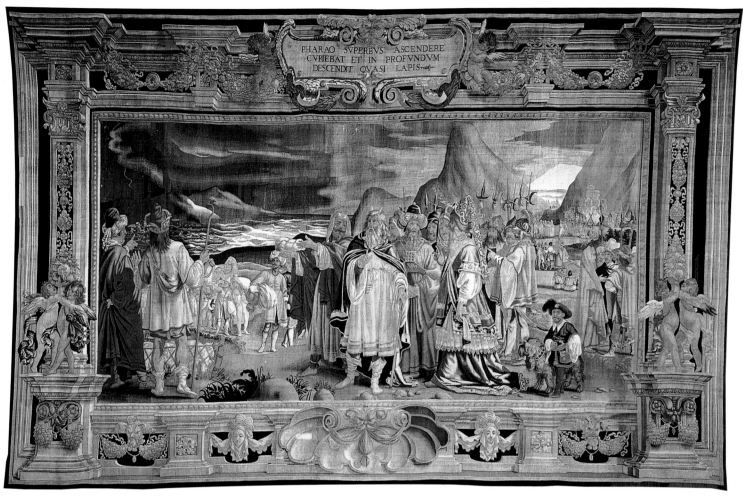

Fig. 122. *The Crossing of the Red Sea* from a set of the *Story of Moses*. Tapestry cartoon by Agostino Melissi, woven in the Florence workshop of Pietro Févère, 1652–53. Wool and silk, 535 x 800 cm. Montecitorio, Roma (Arazzi no. 85)

works. Thanks in part to his brother-in-law Baccio del Bianco, Agostino Melissi (1616?–1683) would be the principal cartoonist for the next thirty years.[83]

The first series for the Palazzo Pitti woven entirely from Melissi's cartoons were the *Story of Alexander* (completed in 1651) and the *Story of Moses* (completed in 1659); Bernardino van Asselt and the workshop of Pietro Févère carried out the work.[84] In these, Melissi showed his awareness of the products of other tapestry workshops. His *Battle of Issus*, for example, recalls the *Sea Battle betweeen the Fleets of Constantine and Licinius* in the *Constantine* tapestries woven in the Barberini manufactory in Rome in 1630–41 from cartoons by Cortona,[85] whom Melissi probably met in Florence before 1647. Through Févère, who in 1648–59 worked intermittently at the Louvre workshop in Paris with his son Jean Lefebvre—who later directed a Gobelins high-warp shop[86]—Melissi probably knew drawings or reproductions of the models for tapestries woven in the Parisian workshops. As has been suggested, his *Finding of Moses*

contains references to compositions by Simon Vouet for a series woven about twenty years earlier in the Louvre tapestry workshops.[87] Melissi's *Crossing of the Red Sea* (fig. 122), on the other hand, consists of solid masses of figures in ample spaces and light effects that derive from his master, Giovanni Bilivert (1576–1644), a pupil of Cigoli. In this series, Melissi seems to have been seeking to bring a Baroque language to Florentine tapestry production. The *Story of Moses* was woven in two editions of six tapestries each, and Melissi appears to have painted most of the cartoons.[88] In 1663 the Florentine painter Vincenzo Dandini (1609–1675), who had been a pupil of Cortona in Rome thirty years before, designed a cartoon for four identical overdoors of the *Personification of the Law*, which were added to the *Moses* series.[89] This series saw the return of architectural borders in Florentine tapestries, originally introduced in the *Samson* series by Jacopo van Asselt and Cinganelli.

Giacinto Gimignani (1606/11–1681) adopted this type of border for the *Story of Cosimo I*, for which he painted a single

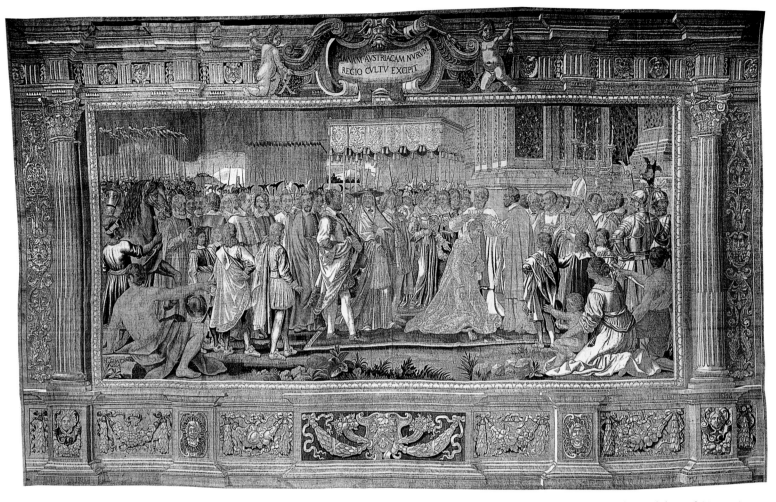

Fig. 123. *The Coronation of Johanna of Austria* from a set of the *Story of Cosimo I.* Tapestry cartoon by Giacinto Gimignani, woven in the workshop of Giovanni Pollastri, Florence, 1655–56. Wool and silk, 539 x 844 cm. Depositi Arazzi Palazzo Pitti, Florence (Oggetti d'Arte Pitti no. 1229)

cartoon, the *Coronation of Johanna of Austria* (fig. 123).[90] About 1630–32 Gimignani had followed Cortona to Rome, where he also worked with the classicizing painter Andrea Sacchi, who probably persuaded him to reconsider the great art of the cinquecento. The *Coronation of Johanna of Austria* pays tribute to Raphael's Vatican Stanze, notably the *Coronation of Charlemagne*, in which the subtle rapport between the viewer and the participants in the depicted event is similar.[91]

The two editions of *Cosimo I*, consisting of eight tapestries each, were woven in 1655–68 by Giovanni Pollastri (fl. 1654–69) and Bernardino van Asselt. Vincenzo Dandini provided the designs for the *Allegory of Cosimo I Ordering the Draining of the Pisan Swamplands* and for four identical overdoors of the *Infant Jupiter Playing with the Goat Amaltea*, using a bright range of colors. Melissi painted two of the cartoons for the series, and Cosimo Ulivelli (1625–1704/5) another four.[92]

Iacopo Chiavistelli (ca. 1621–1698) deserves credit for introducing to the tapestry manufactory perspectival architectural compositions, known as *quadratura* from the contemporary practice of decorative wall painting,[93] in his cartoon of 1663 for two editions of the above-mentioned *cielo d'arazzo* (ceiling tapestry) *Two Genii Crowning Fortitude (?) with Oak Leaves* (fig. 124).[94] The creation of another reality through the artifice of a fictional perspective that serves as a background for allegorical inventions corresponds to the desire of Baroque artists to incite a sense of wonder in their viewers.

On his return from Paris in 1659, Févère established a new workshop when he worked at the Galleria degli Uffizi until his death in 1669, never resuming his directorship of the San Marco workshop, which by then was managed by Giovanni Pollastri. During that decade Févère wove many successful tapestries after paintings in the collection of Ferdinando II and Vittoria della Rovere, working on his loom directly in front of the canvases.[95] Among these, his tapestry copy of the *Madonna of the Cat* in the Uffizi (fig. 125), from the painting of about 1598 by Federico Barocci that the grand duchess inherited,

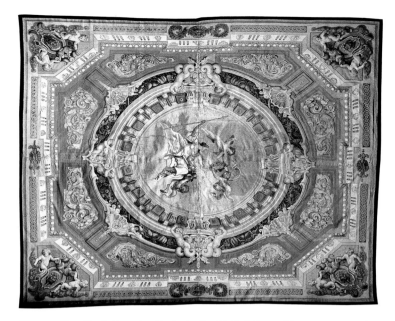

Fig. 124. *Two Genii Crowning Fortitude (?) with Oak Leaves.* Tapestry cartoon by Iacopo Chiavistelli, woven in the workshop of Giovanni Pollastri, Florence, 1663–64. Wool and silk, 896 x 730 cm. Depositi Arazzi Palazzo Pitti, Florence (Arazzi no. 123)

manufactory occupied an important place in the diary kept by the scientist and diplomat Lorenzo Magalotti when he went to Paris in 1668,[102] probably to prepare for Cosimo's visit there the following year. Cosimo returned to Florence from that trip with eight Gobelins tapestries of the *Elements*, given to him by Louis XIV (cat. no. 39).[103] With his solitary personality and excessive religious zeal, Cosimo III showed little capacity for governing, but he nevertheless continued the Medici enterprises he had inherited.[104] All decisions about the tapestry works were turned over to the *guardaroba maggiore* (wardrobe master). After Févère's and Pollastri's deaths in 1669, Matteo Benvenuti (fl. 1654–97) took over the San Marco workshop, which after his death continued to produce for the court, but without a director. In 1703 Giovan Battista Termini (ca. 1673–1717), who had worked there on the high-warp looms, took over, but he moved to Rome in 1684 because of a dispute with the administration of the tapestry manufactory.[105]

obtained rare praise from the influential critic Baldinucci, who extolled its replication of the original and emphasized its sale value, though he did not name Févère.[96] Baroque artists sought to astound their viewers by duplicating oil paintings in materials such as semiprecious stone or tapestry, inspiring a passion for copies that pervaded the entire seventeenth century.[97] In Rome, for example, Giovanni Francesco Romanelli's *Adoration of the Magi* fresco in Sant'Eligio degli Orefici was copied at the Barberini manufactory by Caterina della Riviera in 1649–50 from a cartoon by Paolo Spagna.[98]

These translations of famous paintings into tapestries must have captivated Ferdinando II, for he requested a much more complex undertaking, the weaving of the *Story of Saint John the Baptist* after the frescoes by Andrea del Sarto and Franciabiagio in the Chiostro dello Scalzo in Florence. The cartoons, painted almost entirely by Melissi, replicated the frescoes in reverse for use on low-warp looms and were woven in two editions between 1665 and 1679 by Pollastri and Bernardino van Asselt and, at their deaths, by weavers whom they had directed.[99] There was also a plan to copy Cortona's frescoes the *Four Ages of Man* in the Sala della Stufa. Begun in 1675–76, only the *Golden Age* was woven.[100]

The Tapestry Works under Cosimo III, 1670–1723

With the accession to the grand ducal throne in 1670 of Cosimo III (1642–1723), who had married Marguerite Louise d'Orléans (1645–1721), cousin of Louis XIV, in 1661, diplomatic relations with France became closer.[101] News of the Gobelins

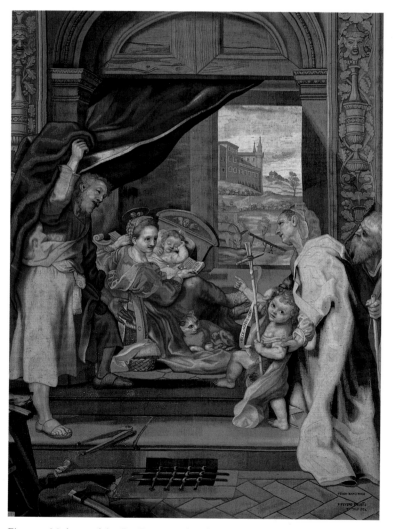

Fig. 125. *Madonna of the Cat.* Tapestry after the painting by Federico Barocci, ca. 1598, woven in the Florence workshop of Pietro Févère, 1663–64. Wool and silk, 247 x 175 cm. Royal Apartments, Palazzo Pitti, Florence (Mobili di Palazzo Pitti no. 13637)

From 1678 to 1697 the principal cartoonist of the Medici manufactory was Alessandro Rosi (1627–1707), who in his frescoes of 1650–52 in the Palazzo Corsini had looked to Simon Vouet's murals, such as those in the Hôtel Séguier in Paris, which Rosi would probably have known from prints by Michel Dorigny (1616/17–1665) issued in the 1640s.[106] Rosi's talents as a perspectival painter are evident in his tapestry cartoons. By the end of the century, Rosi had created designs for a very large number of portieres, overdoors, and ornamental friezes, most of them woven for the Palazzo Pitti, in which the illusionistic architectural settings overflow with ornamental, heraldic, and allegorical subjects. His *Virtues* of 1695–97, produced in several editions, display bright and luminous tones that show he was current with the newest trends in late Baroque painting.[107] The influence of Rosi's abundant production continued to be noticeable in eighteenth-century tapestries, owing particularly to the work of his nephew (and probably also his pupil) Antonio Bronconi (ca. 1680–1733), both as a painter and, from 1717, as head weaver.[108]

Tapestry weaver Giovan Battista Termini's return from Rome in 1703 helped relaunch the fortunes of the Medici tapestry works. Availing himself of the authority assigned to him as new director, he recruited Leonardo Bernini (fl. 1705–37) and Vittorio Demignot (fl. 1715–43) from Rome, where Demignot had been one of the most esteemed tapestry weavers at the manufactory of San Michele a Ripa.[109] Termini entrusted the preparation of cartoons to Giovanni Camillo Sagrestani (1660–1731), who is credited with the scenes of the *Four Continents* (with borders by Stefano Papi, fl. 1703–30), woven in 1711–29 by Demignot, and Bernini (fl. 1701–5).[110] The iconography of that series, particularly of *Europe* (completed in 1723; fig. 126), with its open landscape background, seems modeled after the *Four Continents* woven from cartoons by Lodewijk van Schoor in various editions in the Brussels

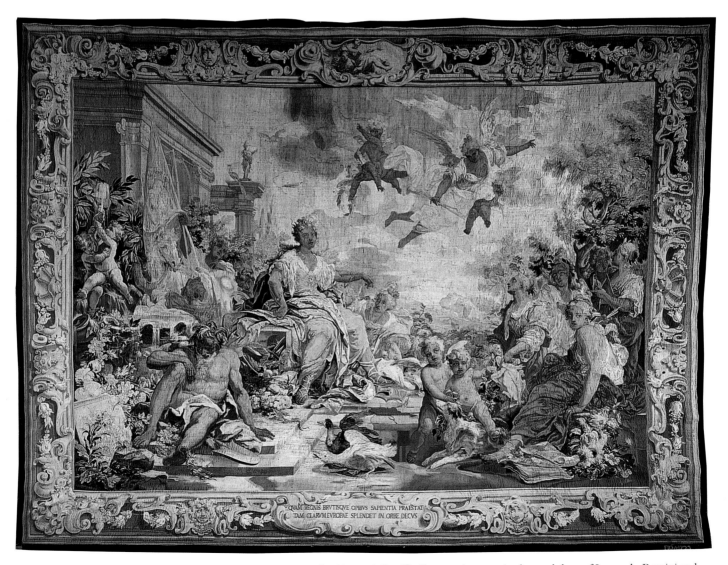

Fig. 126. *Europe* from a set of the *Four Continents*. Tapestry cartoon by Giovanni Camillo Sagrestani, woven in the workshop of Leonardo Bernini and Vittorio Demignot, Florence, 1720–23. Wool and silk, 454 x 576 cm. Depositi Arazzi Palazzo Pitti, Florence (Arazzi no. 602)

workshop of Albert Auwercx by Jan-François van den Hecke in 1690–1700 and by Judocus de Vos in 1713.[111] The luminous, bright colors of the Florentine *Four Continents* suggest a French influence. Sagrestani was stimulated in his development not only by French models, but also by the Florentine paintings of Luca Giordano and by his own experiences in the Veneto and Emilia.[112] According to the art historian and collector Francesco Maria Niccolò Gabburri (1675–1742), writing with a polemical tone, Sagrestani often based his compositions on "prints, especially of Simon Vouet, to whom he was particularly devoted."[113] Overall Sagrestini played an important role in introducing Rococo innovations to tapestry design.[114]

In 1717 Antonio Bronconi replaced Termini as director of the Medici manufactory. In addition to concluding projects already begun, the tapestry works under Bronconi produced purely decorative tapestries, portieres, overdoors, and *entre-fenetres*, which recall the style and the subjects of Alessandro Rosi. In 1728 the manufactory took on a series of the *Elements* based on designs and cartoons by Sagrestani, Lorenzo del Moro (1677–1735), Gian Domenico Ferretti (1692–1768), Giuseppe Grisoni (1699–1769), and Vincenzo Meucci (1694–1766).[115]

Late Production

By international accord, the Habsburg-Lorraines succeeded Gian Gastone de' Medici (1671–1737), the last grand duke.

During this transition Leonardo Bernini was weaving one of the *Elements*, the *Fall of Phaeton (Air)*, from a cartoon by Meucci—a subject that seems emblematic of the very end of the Medici dynasty. Bernini finished it a month after Gian Gastone's death on July 9, 1737.[116] The tapestry works closed down for a short period, and the last Medici head weaver, Giovan Francesco Pieri (fl. 1734–65), who replaced Bronconi in 1734, and other Medici weavers transferred to Naples, giving rise there to a local court production. In Naples their first project was the *Elements*, with borders similar to those designed for the Florentine set.[117]

When the San Marco workshop reopened in January 1738 under the painter Lorenzo Corsini (fl 1738–44), there was an attempt to finish the *Elements*, and the portiere of *Fire*, based on designs by Matteo Bonechi (1669–1756) and del Moro, was woven. Corsini delivered it on July 30, 1740, but the project was then abandoned.[118] Low-warp production continued until 1744, when the San Marco workshop shut down. Weavers from Lorraine imported by the new regime established a manufactory with high-warp looms in the Villa di Poggio Imperiale shortly after the accession in 1737 of Grand Duke Francis Stephen I Habsburg-Lorraine (in 1745, Holy Roman Emperor).[119] Work continued at Poggio Imperiale until 1747, when the Florentine tapestry works finally closed.[120]

1. The chroniclers who recounted the display of 1588 are Francesco Settimanni (1681–1763), Archivio di Stato, Florence (hereafter ASF), Manoscritti F. Settimanni 130, fols. 54v–55r; Baccio Cancellieri (fl. 1588–1614); and, particularly, Valerio Ruggeri (1588), both cited in Gori 1926/1987, pp. 137–42, 144–45. See also Meoni 1998, pp. 35–61, 94–95, 116 nn. 20–27; Meoni in New York 2002, pp. 514–29, nos. 60–63; T. Campbell in New York 2002, pp. 493–501.
2. Florence 1994, pp. 85 no. 23, 88–89 no. 28c, 97 no. 35c; Meoni 1998, pp. 20–22 and fig. 2, 43 fig. 18, 46.
3. Pieraccini 1986, vol. 2, pp. 264–304; Barocchi and Gaeta Bertelà 2002, pt. 1, pp. 91–92, 147.
4. Meoni 1998, pp. 93–94.
5. Ibid., pp. 35–61; T. Campbell in New York 2002, pp. 493–501.
6. Meoni 1998, pp. 63–78; T. Campbell in New York 2002, pp. 501–4.
7. Meoni 1998, pp. 72–73, 81–85.
8. Ibid., pp. 97–98.
9. Langedijk 1981–87, vol. 2, p. 719, no. 37.
10. Cecchi 1999; Hochmann 1999.
11. Gregori 1986, p. 22.
12. Frezza 1983, pp. 237–40; Meoni 2001a, pp. 107–8.
13. Hamann-MacLean 1976, pp. 147–50; Mancinelli 1983, pp. 261, 263–64.
14. Heikamp 1969, pp. 61, 74 no. 35; Meoni 1998, pp. 97, 500.
15. Meoni 1998, pp. 97–98, 302–23 nos. 106–19.
16. There is no trace in the account books of tapestries having been woven for Cardinal Alessandro Montalto from several well-known drawings for tapestries by Cigoli; Florence 1992, pp. 35–38, nos. 22, 23.
17. Chappell in Florence 1992, pp. VII–IV; Chappell 1998.
18. Frezza 1983, pp. 237–40.
19. Meoni 1998, pp. 302–5, 316–19 nos. 115, 116.
20. Ibid., pp. 106–12.
21. Ibid., pp. 320–23, nos. 117–119.
22. Ibid., p. 101. The *Gathering of Manna*, acquired by the Metropolitan Museum in 2003 (2004.165), is the only one of the set that has been located; T. Campbell 2004a, p. 17.

23. Forti Grazzini 1986, pp. 61–81, nos. 6–10; Lecchini Giovannoni 1991, pp. 284–85, no. 139.
24. Meoni 1998, pp. 98–99, 412–29 nos. 172–82.
25. Borghini 1584, pp. 45, 139–40.
26. Only one tapestry of the set survives intact; two fragments exist of another two tapestries, but only eight of the small trophy panels survive, of which several copies were woven. Meoni 1998, pp. 98, 440–59 nos. 190–97.
27. Ibid., pp. 232–47, nos. 59–68.
28. Ibid., pp. 105–8, 324–41 nos. 120–24; Meoni 2001a, p. 109; Forti Grazzini 2002, pp. 157–59, 160–61 figs. 14, 15.
29. Meoni 1998, pp. 111–14, 518. The catalogue is in the ASF, Guardaroba Medicea (hereafter GM) 213, fol. 24v.
30. Langedijk 1981–87, vol. 1, p. 531, no. 28.
31. Pieraccini 1986, vol. 2, p. 332; Barocchi and Gaeta Bertelà 2002, pt. 1, pp. 162–63.
32. Meoni 1998, pp. 108, 342–59 nos. 125–33.
33. ASF, GM 818, file 8, fols. 714r–v, no. 1; Meoni 1998, pp. 114, 119 no. 173, 524; Meoni 2002b, p. 165.
34. Meoni 1998, pp. 103, 513; Meoni 2002b, pp. 163–64.
35. Meoni 1998, pp. 93, 115 no. 4; Meoni 2001a, pp. 109–10; Meoni 2002b, pp. 163–69.
36. Langedijk 1981–87, vol. 2, p. 769, no. 38; Barocchi and Gaeta Bertelà 2005, pt. 1, pp. 60–68.
37. Galluzzi in Florence 2001, pp. 12–17.
38. Pieraccini 1986, vol. 2, pp. 483–503.
39. Acanfora 1998a, p. 37; Acanfora 1998b, pp. 150–54.
40. M. Campbell 1977, pp. 3–62.
41. ASF, GM 953, file 25, fol. 73v; GM 417, fol. 16 left; GM 444, fols. 6v–7r, 7v; Meoni 2001a, p. 110; Meoni 2002b, pp. 165–68, esp. n. 16. On November 16, 1688, six tapestries of the *Samson* series were moved from the Guardaroba Generale to the Palazzo Pitti; ASF, GM 977, fol. 4 right.
42. Schuckman 1995–96, vol. 44, pp. 29–31 nos. 91–97, vol. 45, pp. 44–47 figs. 91–97; for the theory on Maarten de Vos as a tapestry cartoonist, see Forti Grazzini 2005, pp. 44–45.

43. Gabinetto Disegni e Stampe degli Uffizi (hereafter GDSU), Florence, inv. 5637 S.

44. Mannini 1994, pp. 225–27.

45. Acanfora 1998a, pp. 36–37; Acanfora 1998b, p. 150.

46. See, for example, Bertrand 2005, pp. 103–12, 136–37, 138, 306–12 figs. 100–117.

47. GDSU, Florence, inv. 611 F. The *Seasons* and *Four Ages of Man* tapestries based on Salviati's drawings in the Uffizi were woven in Flanders in the 17th century; Gaeta Bertelà in Florence 1980, pp. 67–68, nos. 107–9 and illus. Detlef Heikamp (1969, pp. 43–45 and figs. 8–14, 70 no. 8) identified an earlier set of tapestries after Salviati's drawings with those recorded in a 1583 inventory of Jacopo Salviati's palace in the via del Corso in Florence: "Nove pezzi di tappezzeria di seta, e lana, dentrovi le 4 stagioni dell'anno a figure nuovi. Compresovi un pezzo, dentrovi il carro solare alti b. 7 incirca per la cammera grande su la sala" (Nine new pieces of silk and wool tapestries, with the 4 seasons of the year, with figures. One of the pieces has the chariot of the sun, about 7 braccia high for the big bedroom that is next to the room).

48. Meoni 1998, pp. 107–8, 326, 522.

49. ASF, Mediceo del Principato (hereafter MdP) 4957, unnumbered folios, Medici Archive Project (hereafter MAP) nos. 11867, 12001; for the Habsburgs, see Vocelka and Heller 1997, pp. 324–25.

50. Adelson 1994, p. 39; Forti Grazzini 1998a.

51. Delmarcel 1999a, pp. 365, 368.

52. Biblioteca Apostolica Vaticana, MS Barberiniano Latino 4373, fols. 61r–62v.

53. ASF, GM 1043, file 56, fol. 98r. Until now it was unknown that Cinganelli painted the cartoons of the overdoors *Delilah Seduces Samson* and *Samson Bound and Brought to Prison*. Those were published in Müntz 1878–85, p. 73; Rigoni 1884, pp. 12–13 no. 24, 19–20 no. 37; Göbel 1928, pp. 391–92, and fig. 406; Ferrari 1968, p. 7, illus.

54. ASF, GM 444, fols. 5r, 7r, 7v; GM 1043, file 16, fol. 27r; Meoni forthcoming a.

55. Francesco Petrarca, *De viris illustribus*; Italian translation by Donato degli Albanzani, Pojano, Felice Feliciano, e Innocente Zileto, October 1, 1476 (see *Indice generale degli incunaboli delle biblioteche d'Italia* [Rome, 1943–81], no. 7584; copy consulted, Biblioteca Nazionale Centrale di Firenze, incunaboli C. 1. 25). For the date of the Donato degli Albanzani's translation, see Canova Mariani in Padua and Rovigo 1999, p. 179.

56. Meoni 1998, pp. 106–10 and figs. 67–70, 72, 74–75.

57. Wilmers (1996, p. 182, no. B63) lists Schut's tapestry cartoon of Scipio Africanus among paintings known only through description.

58. ASF, GM 444, fols. 8v, 9r; Soprintendenza Speciale per il Polo Museale Fiorentino, inventario Arazzi 1912–25, no. 236; Meoni forthcoming a.

59. Acanfora 1998a, pp. 36–37.

60. Meoni 2001a, p. 111, esp. n. 20. For the overdoor and the portiere, see ASF, GM 1043, file 56 fol. 98r, file 90 fol. 156r, file 417 fol. 43 right.

61. We can deduce Févère's birth date as 1594 from the document that testifies to his burial at age seventy-five; Archivio Arcivescovile, Florence, S. Marco Morti 1639–1713, fol. 71v; Meoni 2002b, p. 165, n. 14. On November 9, 1618, Févère was already in Florence; ASF, GM 359, fol. 17 left, and Meoni forthcoming a.

62. Meoni 1998, p. 39; Meoni 2001a, p. 110; Meoni 2002b, pp. 168–69 and nn. 27, 28, 173 and nn. 43, 44.

63. Gregori 1990; Gregori 2006.

64. Meoni 2001a, pp. 111–13.

65. M. Campbell 1977, pp. 8–22.

66. Rossi 1972; M. Campbell 1977, pp. 9–11; Casa Buonarroti 1993, pp. 42–43.

67. M. Campbell 1977, pp. 43–44, 166–68, 231–32 no. 22.

68. M.Campbell 1977, pp. 12 and n. 36, 79–81; Bulst 2003; Righini 2003.

69. Galileo Galilei entrusted to Francesco Rondinelli his house in Arcetri when he went to Rome to face the Inquisition. See M. Campbell 1977, pp. 78–82; Righini 2003.

70. ASF, GM 624, fols. 2 left, 6 left, 108 left, 12 left; GM 494, fol. 89v. See also Meoni 2001a, pp. 111–12; Meoni 2002b, pp. 171–77; Barocchi and Gaeta Bertelà 2005, pt. 2, pp. 934–1047.

71. Aschengreen Piacenti 1986, p. 78; Gregori 2006, p. 93.

72. ASF, GM 725, fols. 51v, 52r; GM 932, fols. 71v, 72r.

73. Meoni 1998, pp. 270–77, 296–301; ASF, GM 1043, file 77, fol. 130r; file 444, fol. 13v; Contini 1986, p. 125.

74. ASF, GM 725, fol 52v; GM 932, fol 72v. See also Meoni 2001a, p. 112; Meoni 2002b, p. 171.

75. ASF, GM 725, fol. 53v; GM 932, fols. 73r–v. See also Meoni 2001a, p. 112; Meoni 2002b, pp. 169–71.

76. ASF, GM 932, fols. 73v–74r. See also Meoni 2001a, p. 112; Harper 2001; Meoni 2002b, p. 177.

77. ASF, GM 725, fols. 60v, 67r. See also Meoni 2001a, p. 112; Meoni 2002b, pp. 171–72.

78. ASF, GM 725, fol. 109r.

79. Frezza 1983, p. 241; Meoni 2001a, p. 112; Meoni 2002b, pp. 169–72.

80. "[G]enio alla pura imitazione del vero"; F. Baldinucci 1681–1728/1845–47, vol. 5, p. 262.

81. D'Afflitto 2002, pp. 107–57.

82. Meoni 2001a, pp. 112, 113; Meoni 2002b, pp. 171–72.

83. The date 1647 and what may be the painter's initials are woven on one of the bags of money in the tapestry. F. Baldinucci 1681–1728/1845–47, vol. 4, p. 318, vol. 5, p. 20.

84. Meoni 2001a, pp. 112, 113; Meoni 2002b, pp. 171–73.

85. Bertrand 2005, pp. 112–18.

86. Meoni 2003b, pp. 123, 126, 136 nn. 19, 21–22. Jean Lefebvre and his father, Pierre, are documented at the Louvre workshop in 1655; Müntz 1878–85, p. 71; Fenaille 1903–23, vol. 1, p. IX; Guiffrey 1923, p. 57. And Jean is documented among the "entrepreneurs de Haute lisse" of Gobelins workshop from 1662 to 1700; Fenaille 1903–23, vol. 2, p. VII.

87. Viale Ferrero 1961, p. 44; Lavalle 1990; Lavalle in Paris 1990, pp. 504–25, nos. 142–52; Meoni 2001a, pp. 112 fig. 8, 113.

88. Meoni 2001a, p. 113; Meoni 2002b, pp. 171, 174–77.

89. Meoni 2001a, p. 113; Bellesi 2003, pp. 14–20, 154–55.

90. ASF, GM 531, file 183, fol. unnumbered; GM 538, fol. 119 right. These previously unpublished documents pertain to Gimignani's bill to the manufactory and payment to him for the cartoons of the borders and the scene.

91. Fagiolo dell'Arco 2001, pp. 97–124; *Raffaello* 1993, p. 311.

92. Meoni 2001a, p. 113; Meoni 2002b, pp. 176–77; Meoni in San Giovanni Valdarno 2003, pp. 82–83; Harper 2001; Bellesi 2003, pp. 17–19, 154.

93. M. Campbell 1977, p. 169.

94. ASF, GM 663, file 2, fol. 162. Meoni 2001a, p. 112.

95. Meoni 2003b, p. 126.

96. F. Baldinucci 1681–1728/1845–47, vol. 3, p. 403; Natali 2003, pp. 32, 43 n. 17; Meoni 2003b, pp. 134–35.

97. Meoni 2003b; Meloni Trkulja 1997.

98. De Strobel 1989, p. 38, fig. 31; Bertrand 2005, pp. 56, 126, 137, 185 n. 273, fig. 49.

99. Meoni 2001a, pp. 114–16; Meoni 2002b, p. 177.

100. Conti 1875, pp. 77–78; Meoni 2001a, p. 116.

101. Langedijk 1981–87, vol. 1, p. 589, n. 29.

102. Magalotti 1668/1991, pp. 11, 117–23.

103. ASF, GM 741, fol. 498 left; Fenaille 1903–23, vol. 2, p. 57; Meoni in Florence 2005, pp. 277–78, no. 154.

104. Pieraccini 1986, vol. 2, pp. 635–60.

105. Meoni 2001a, p. 116; Meoni 2002a, pp. 135–36.

106. B. Brejon de Lavergnée 1984; Théveniaud 1984; Acanfora 1994, pp. 23, 45–46.

107. Acanfora 1994, pp. 107–8, nos. 100–103.

108. Müntz 1878–85, p. 76; F. S. Baldinucci ca. 1725–30/1975, p. 232; Acanfora 1994, pp. 39–48; Meoni 2001a, p. 116.

109. Meoni 2002a, pp. 135–36.

110. Ibid., pp. 136–39; Meoni in Florence 2002, p. 310, no. 106.

111. Meoni 2002a; Meoni in Florence 2002, p. 310, no. 106. See also Riegl 1890, p. 82; Hyde 1924, pp. 260–61; J. Boccara 1988, p. 291, fig. 29.

112. Florence 1965, pp. 35, 58–60 nos. 36–42; Barbera 1979; Giannini 1993.

113. "[S]tampe, specialmente di Simon Vouet, di cui era molto devoto"; Francesco Maria Niccolò Gabburri, "Vite di Pittori," Biblioteca Nazionale Centrale di Firenze, MS Palatino E. B. 9.5 [1719–41], III, fol. 1203.

114. Meoni 2002a, p. 136; Meoni in Florence 2002, p. 310, no. 106.

115. Meoni 2002a, pp. 138–41 and figs. 4–6; Meoni in Florence 2002, p. 309, no. 105. On the set series of the *Elements*, see Meoni forthcoming b.

116. Meoni 2002a, pp. 139–40; Meoni in Florence 2002, p. 309, no. 105.

117. Meoni in Florence 2002, p. 309, no. 105. For the Neapolitan set, see Spinosa 1971, pp. 10–11, 21, 69 nos. 1–3, pl. 2.

118. ASF, GM Appendix 65, fol. 106r, no. 433; GM 1212, fols. 12 right, 156 right, 160 left and right, 161 left.

119. There are documents for this workshop from 1739; ASF, GM 1220, fol. 44r; GM 1458, fol. 11r.

120. Meoni 1998, pp. 35–61, 93, 115 no. 1.

31.
Altar Frontal

32.
Cope

From the vestments and altar furnishings of
Pope Clement VIII
Design and cartoons by Alessandro Allori and collab-
orators (Giovanni Maria Butteri, here attributed),
between May 1592 and April 1593
Woven in the Medici manufactory under the direc-
tion of Guasparri Papini, Florence, by May 31, 1595
Silk and gilt-metal-wrapped thread
Altar frontal 102 x 372 cm (3 ft. 4⅛ in. x 12 ft. 2½ in.);
cope 151 x 319 cm (4 ft. 11½ in. x 10 ft. 5⅝ in.)
10–13 warps per cm
Vatican Museums, Vatican City (62773 [cope]; 62780
[altar frontal])

PROVENANCE: June 6, 1595, altar frontal and cope
delivered by the Medici manufactory to the
Guardaroba Generale (General Wardrobe) of
Ferdinando I de' Medici;[1] between December 23,
1595,[2] and December 24, 1600,[3] they were back at
the manufactory for alteration of the grand ducal and
papal arms; December 28, 1600, vestments and altar
furnishings sent to Rome as a gift to Pope Clement
VIII;[4] stored in the Treasury of the Sistine Chapel and
used occasionally for sacred observances there;[5]
January 22, 1726, cope worn, perhaps for the last time,
by Pope Benedict XIII;[6] 1935, vestments and altar
furnishings transferred from the Sistine Chapel
Treasury to the Museum of Sacred Art in the Vatican
Library; 1957, altar frontal transferred to the Vatican
Museums; since 1964, vestments transferred to the
storerooms, Vatican Museums, and altar frontal and
cope exhibited in the Pio IX room, Christian
Museum, Vatican Museums.[7]

REFERENCES: Rome 1870, p. 22; Gentili 1874,
pp. 40–41; Conti 1875, pp. 19, 58–60, 106–7 no. 5;
Müntz 1878–85, p. 68; Farabulini 1884, p. 83; Göbel
1928, p. 387, and fig. 393; Viale Ferrero 1961, p. 39;
Frezza 1982, pp. 57–75, figs. 29, 30 (cope), 31 (altar
frontal); Mancinelli in New York–Chicago–San
Francisco 1982, pp. 72–79 no. 25, esp. nos. 25A (altar
frontal), 25B (cope); Frezza 1983, pp. 237, 246 n. 53
(altar frontal); Mancinelli 1983, pp. 257–75 (esp.
pp. 263–64: altar frontal; 265–67: cope); Rome 1984,
p. 48, III, 3.10; Lecchini Giovannoni 1991, pp. 276–77,
no. 122; Meoni 1998, pp. 97 and fig. 60 (altar frontal),
302, 306, 308, 310, 509, 510, 511, 515; Meoni 2000,
p. 254; Meoni 2001a, p. 108.

CONDITION: Both the altar frontal and the cope are
in good condition. The earliest recorded restoration
of the pieces is in 1789.[8] The altar frontal was restored
in 1957, and the cope was again most recently
restored between 1978 and 1981.[9]

The altar frontal and cope are part of a
set of liturgical vestments and altar fur-
nishings that were woven between 1592 and
1600 in the Medici tapestry manufactory in
Florence from designs and cartoons by
Alessandro Allori and his associates.[10] In 1600
Grand Duke Ferdinando I de' Medici and his
wife, Christine of Lorraine, sent them as a gift
to Pope Clement VIII, for use in the Sistine
Chapel especially during Advent and Lent
(see note 4). The innovative iconography of
the two pieces embodies the Counter-
Reformation spirit of the period. On the altar
frontal, the use of the body of Christ symbol-
izes the Eucharist that is so central to Roman
Catholic doctrine, and the complex decora-
tive program of the cope is an affirmation of
the Church's privileged relationship with the
figure of Christ.

Description and Iconography
The complete set of vestments and altar fur-
nishings consists of the altar frontal and the
cope shown here, as well as a chasuble, two
dalmatics, two stoles, three maniples, a corpo-
ral case, a chalice veil, and three missal covers.
However, a pair of cushion covers for kneel-
ing and another for books are lost, while the
faldstool, listed in the December 28, 1600,
shipment to Rome, may have been made
up of some of the six "bruste per camici"
(surplice cases), which are documented only
in the grand-ducal payment records to the
manufactory.[11]

The altar frontal, probably the first piece
produced, sets the Eucharistic tone of the
entire group. In the center, two angels support
the dead Christ before an altar with two chal-
ices on it. In the scene on the right, Christ

appears to the Virgin Mary, a theme appropri-
ate to the Sistine Chapel, which is dedicated
to the Virgin of the Assumption.[12] On the left,
Christ descends into Limbo to liberate the
Good who have not had the benefits of the
sacraments—a subject that is linked to both
the Resurrection and the Eucharist.[13] The
reintroduction during the Counter-
Reformation of subjects such as the Descent
into Limbo, combined here with a depiction
particular to the Byzantine tradition of
angels supporting the dead Christ at the
altar,[14] seems to derive from a strong desire
to reaffirm the original purity of the
Catholic Church.

Depictions of the sacraments were of great
importance to the Council of Trent, which
published a decree on the Eucharist in 1551,
reaffirming the centrality of the doctrine of
transubstantiation—so contested by the
Protestant reformers—which asserted the
true presence of the body of Christ in the
consecrated communion wafer. Indeed, just
nine months later, on August 13, 1552, the
installation of Baccio Bandinelli's *Dead Christ
Supported by an Angel* on the high altar of
Florence Cathedral gave a visual representa-
tion—without parallel in Europe—to the
theological arguments that the Council of
Trent used to refute heretical doctrines.[15]
Alessandro Allori had also explored the
theme: in 1579–80, he depicted the dead
body of Christ as the Eucharist in the frescoes
in the chapel of the Palazzo Salviati in
Florence,[16] and in a painting of Christ in the
tomb (Museo Statale, Arezzo), dated 1580,
he placed a chalice on the edge of the tomb,
signifying the sarcophagus as altar.[17] The
Descent into Limbo in the background of
that painting has an iconographic parallel
with the Sistine Chapel altar frontal, in
which the inanimate body of Christ, placed
between the altar and a basin with the instru-

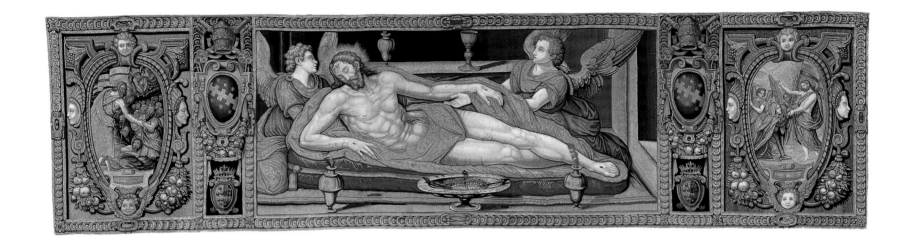

31

ments of the Passion, represents the actual Eucharist. The scene on the altar frontal takes place in a tomblike space, but one with an entrance on the right side, suggesting a church building where, during the celebration of Mass, Christ's body is renewed through the act of transubstantiation. Presumably the tapestry's prestigious Sistine Chapel destination prompted Allori to elaborate on his previous representations of the dead Christ. Also for this reason, the altar frontal was probably the model for Allori's three contemporary small paintings on copper, listed as in the Medici Guardaroba on May 24, 1593, and described as "Cristo con due Angeli nel Sepolcro" (Christ with two angels in the tomb).[18] The Eucharistic iconography, so much a focus of the theoretical deliberations of the Council of Trent, was well suited to the highly religious climate of the Florence of Ferdinando I and Christine of Lorraine.[19]

The borders that Allori created look like narrow, carved-wood frames, similar to those he designed for the above-mentioned frescoes in the Palazzo Salviati, as well as those for the tapestries of the Passion (cat. no. 33). The two scenes at the sides are inside elaborate shields adorned with festoons of fruit and small heads, which are typical of Allori's decorative repertory. Between the side scenes and the

main scene are the armorial devices of Pope Clement VIII (Ippolito Aldobrandini, r. 1592–1605) and the arms of Ferdinando I de' Medici and his consort surmounted by the grand-ducal crown.[20]

The cope presents the genealogy of the Hebrew people and Christ and the institution of the Eucharist.[21] The band along the upper edge has a central medallion depicting Adam and Eve's original sin (Genesis 3:6) and other medallions showing the genealogical successions of Jacob, patriarch of the Jewish people, and David, progenitor of the race to which Christ belonged (Matthew 1:1). To the right are Jacob ([JA]C[OB]; Genesis 25:26), his son Judah (JUDAS; Genesis 29:35), and Pharez ([P]HARE[S]), son of Judah (Genesis 38:29). To the left are David (DAVID; 2 Samuel 1:14), his son Solomon (SOLOMON; 1 Kings 1:12), and Rehoboam (ROBOAM), son of Solomon (1 Kings 11:43). The two genealogies continue on the body of the cope with Hezron (ESRON), son of Pharez (1 Chronicles 2:5), and Abia, son of Rehoboam (1 Chronicles 3:10), each inside cartouches framed by elaborate grotesques. The hood, depicting the Sacrifice of Isaac (Genesis 22:9–12), is surrounded by grapevines, a symbol of Christ (John 15:1–17), growing from urns on the top corners of the cartouche with the priest Melchizedek

(Genesis 14:18). Below are the Aldobrandini, Medici, and Lorraine arms. Four additional cartouches along the curved outer edge contain a sacred building and three altars. The background consists of interlacing grotesque motifs that include olive branches, small bunches of roses, other vines, and angels holding such objects as censers, scrolls, a miter, and the papal tiara. The clasp (now separated from the cope) depicted the bound hands of Christ.[22] The choice of the cope's iconography was clearly intended to emphasize the bond between Christ and the Church of Rome.

All of the key scenes relate to Eucharistic iconography. The Sacrifice of Isaac foreshadows the Crucifixion, and the Old Testament priest Melchizedek changed the nature of the expiating sacrifice by offering bread and wine to Abraham, as Christ did at the Last Supper. There are also allusions to the Virgin Mary, among them red roses and olive branches, for it was through Mary's incarnation of Christ that Eve's original sin was redeemed.[23]

Commission
The Sistine Chapel destination for the vestments and altar furnishings of Clement VIII is associated with a promise made in 1569 by Grand Duke Cosimo I de' Medici to Pope

Pius V on the occasion of Cosimo's coronation. That promise is referred to in a letter written by then Cardinal Ferdinando I from Rome, on December 27, 1577, to his brother Grand Duke Francesco I de' Medici, after meeting with Pope Gregory XIII: Ferdinando asked Francesco whether he knew of the existence of drawings by Giorgio Vasari for a series of tapestries on the Passion of Christ that Cosimo, their father, had planned to have woven for Pope Pius V for use in the Sistine Chapel during Advent and Lent. Ferdinando explained to Gregory that the project was not carried out because Pius had died in 1572, and he repeated the proposal—that a series of seven tapestries of the Passion would be woven from cartoons by Alessandro Allori.[24] Although this was also not carried out, the first tapestry series made by the Medici manufactory after Ferdinando assumed the throne was on the theme of the Passion, for which seven hangings were produced (see cat. no. 33). The first piece, *Christ in the Garden of Gethsemane*, woven from a cartoon by Allori, may not have seemed adequate for the Sistine Chapel, with its frescoes by Michelangelo and tapestries of the *Acts of the Apostles* by Raphael. It was decided instead that liturgical vestments and altar furnishings should be created for the papal chapel. Ferdinando gave these, including the present altar frontal and cope, to Clement VIII, then pontiff.[25]

Don Giovanni de' Medici, the legitimatized bastard son of Cosimo I[26] and artistic consultant to Ferdinando, could have conceived the iconography. In a memorandum to Ferdinando dated May 14, 1592, Girolamo Seriacopi, superintendent of the Medici tapestry manufactory, mentioned the presence of Don Giovanni at a meeting with head weaver Guasparri Papini (ca. 1540–1621), Allori, and Seriacopi concerning this project.[27] The principal decisions made at that meeting seem to have been related to the cost, about 1,500 scudi, and, especially, the doubling of weekly payments to the weavers who had to work in silk and gold. Only after these things were discussed did the meeting turn to the iconography and decoration ("concetti e belli campimenti") of the tapestries.

Most likely Ferdinando I was also involved in decisions about the iconography, since he intimately knew the pontifical court and con-

temporary Counter-Reformation culture, of which he was an enthusiastic promoter in Florence. The workshop took more than eight years to complete the vestments and altar furnishing. According to expenses submitted by Papini on December 24, 1600, Ferdinando I needed to require that the weavers work "sin a mezanotte" (until midnight) in order to finish.[28] The completed vestments and altar furnishings were sent a few days later, on December 28, 1600, to the Medici ambassador in Rome, Giovanni Niccolini, charged with delivering them to the pontiff (see note 4). They were housed in the Treasury of the Sistine Chapel and used especially during Holy Week, with the altar frontal displayed on Holy Thursday, and also on other occasions.[29]

Artist and Weaver

Alessandro Allori (1535–1607), who had entered Agnolo Bronzino's workshop at a very young age,[30] from 1549 participated in the execution of his master's cartoons for borders of the tapestries of the *Story of Joseph* for the Palazzo Vecchio.[31] In 1576 Allori became the principal cartoonist of the Medici tapestry works, taking over from Giovanni Stradano (1523–1605).[32] Atuned to the refined artistic tendencies of the new grand duke, Francesco I, Allori became the official artist of the court, with responsibilities and powers similar to those of Vasari during the previous reign. In addition to his cartoons for a series of the hunt, Allori worked on many mythological subjects for tapestries. Throughout his thirty years as a cartoonist for the Medici, he was able to stay abreast of the ever-changing artistic environment in Florence, coming around to the Counter-Reformation ideas promoted by the next grand duke, Ferdinando I. During Ferdinando's reign Allori made the present works as well as the *Passion of Christ*, the overdoors with stories from the New Testament, and some important external commissions, such as the stories of the Virgin and the Infancy of Christ in 1583–86 for the Basilica of Santa Maria Maggiore in Bergamo,[33] and those of the biblical prefigurations of the Eucharist for Como Cathedral, paid for by the confraternity of the Holy Sacrament.[34]

For the Sistine altar frontal, Allori seems to have been responsible for the central scene of the dead Christ with two angels, demonstrat-

ing the naturalistic rendering of figures that characterized his work in the 1590s. Even taking into account the stiffness of the tapestry medium as compared to painting, the modeling of the body of Christ has a softness and a *sfumato* effect, as does the smoke coming from the incense burners, and the clothing and ecclesiastical furnishings simulate the rich materials of velvet, gold, and lapis lazuli.

The artist was aided in his designs and cartoons for the vestments and altar furnishings by "soci pittori" (painter associates), among whom the only recorded name is that of Giovanni Maria Butteri (1540?–1606).[35] Allori's regular collaborator for tapestry cartoons, Butteri is recorded as having painted cartoons for borders and small scenes for other series.[36] In the altar frontal he appears to have been responsible for cartoons of the Descent into Limbo and Christ appearing to Mary. A rigidity in the outline of the figures—particularly of the eyes—can also be seen in his fresco of the Virgin and Child with Saints in the Abbey of San Salvatore in Vaiano, near Prato.[37] The same strikingly expressive gestures appear in frescoes by Butteri in the oratory of Sant'Elena e Santa Croce alle Masse in Serpiolle, near Florence.[38]

The cope, including the hood and the clasp, was made between 1592, the year in which Papini noted the expenses for the gold and silver thread, and May 31, 1595, when, at the conclusion of the weaving, it is listed after the altar frontal.[39] In a document of January 4, 1595, Allori and his associates are called its cartoonists.[40] As was common with Allori's designs, many of the cope's details come from works he had previously created. The Sacrifice of Isaac, for example, replicates (except for the ass that replaces a goat) his painting on copper of the same subject in the Saibene collection in Milan, dating from the early 1570s;[41] indeed, the artist employed the composition again in 1597–98 in one of the tapestries for the Como Cathedral.[42] Allori's use of grotesques as decorative motifs on the cope is unusual considering the ecclesiastical context. The designs for the busts of the patriarchs, however, can be attributed to Butteri (see notes 37, 38); the figure of Melchizedek is similar to that of God the Father in a fresco in the oratory of Sant'Elena e Santa Croce alle Masse.[43]

Guasparri Papini made moderate use of precious-metal-wrapped threads in weaving the altar frontal. In contrast, the cope displays an extraordinary abundance of gold that suffuses the entire background. The head weaver undoubtedly took into account the distinct uses of the two pieces, one in front of the altar and the other worn by the pontiff, whose duty during Mass was to appear to the faithful radiating an aura of holiness. To produce the effect, Papini employed specialized weavers in silk and gold ("atti a lavori di seta e oro"; fit to work in silk and gold), who were perhaps Flemish.[44]

The heraldic elements and their placement were topics of much discussion during the weaving, in part because of the possibility that the pope might change during the long period it took to weave the vestments and altar furnishings. On December 23, 1595, when the cope and altar frontal were already woven, Ferdinando I asked to substitute the Aldobrandini arms with the grand-ducal ones and not to weave the papal arms on the other pieces.[45] As it turned out, all the arms were rewoven.[46] During the 1957 restoration of the altar frontal, traces of the Medici-Lorraine arms were found under those of the Aldobrandini, and other, unidentifiable arms (though probably those of the Aldobrandini) appeared under the Medici-Lorraine arms.[47] During the 1978–81 restoration of the cope, a single large Medici-Lorraine coat of arms was found under the actual Aldobrandini and Medici-Lorraine arms.[48]

LUCIA MEONI

1. In the account of the grand-ducal manufactory, at the entry for May 31, 1595, listing the expenses for weaving the cope, there is an added notation, "consegnato alla Guardaroba come per ricievuta filza no. 171" (consigned to and received at the Wardrobe, series no. 171); Archivio di Stato, Florence (hereafter ASF), Guardaroba Medicea (hereafter GM) 116, fol. 51r. A note pertaining to the same series no. 171, on June 6, 1595, mentions consignment of the altar frontal to the wardrobe ("consegnato in Guardaroba a dì 6 di giugnio come per ricievuta del Sig. Vincenzo Giugni filza n. 171"); ASF, GM 116, fol. 50v; Frezza 1982, p. 65.

2. ASF, GM 116, fol. 60v; Conti 1875, pp. 106–7, no. 5.
3. ASF, GM 220, fol. 8r; Frezza 1982, p. 73.
4. The vestments and altar furnishings were sent to Rome in 1600: "tutto messo in dua casse di legniame rozzo con libbre 30 d'incerato e libbre 20 di canovaccio rozzo in dì 28 dicembre [1600]" (all put in two cases of rough timber with 30 pounds of water-proofed cloth and 20 pounds of rough canvas on December 28, [1600]); ASF, GM 236, file 3, no. 154, fols. 261r, 262r, 266r. Previously the date of the shipment to Rome of the vestments and altar furnishings was regarded as two years later—August 7, 1602—by Frezza 1982, pp. 74–75; Mancinelli 1983, p. 257; Lecchini Giovannoni 1991, p. 277; Meoni 1998, pp. 97, 515.
5. Farabulini 1884, p. 83; Mancinelli in New York–Chicago–San Francisco 1982, pp. 73–74; Mancinelli 1983, p. 260.
6. Gentili 1874, p. 40.
7. Mancinelli in New York–Chicago–San Francisco 1982, p. 72; Mancinelli 1983, p. 258.
8. Mancinelli in New York–Chicago–San Francisco 1982, p. 72; Mancinelli 1983, p. 257.
9. Mancinelli in New York–Chicago–San Francisco 1982, p. 72; Mancinelli 1983, pp. 258, 260 (altar frontal), 265 (cope).
10. For the exhaustive archive references, see Frezza 1982, pp. 57–75, figs. 29–40.
11. Conti 1875, pp. 58, 60; Frezza 1982, pp. 57, 59, 66–69, 74–75; Mancinelli in New York–Chicago–San Francisco 1982, pp. 72–79, no. 25; Mancinelli 1983, p. 257; Lecchini Giovannoni 1991, pp. 276–77, no. 122; Meoni 1998, pp. 97, 510, 511, 512.
12. Mancinelli 1983, pp. 260–61.
13. Réau 1955–59, vol. 2, pt. 2, pp. 531–37; Hall 1974, p. 279.
14. Hamann-MacLean 1976, pp. 147–50; Mancinelli 1983, pp. 261, 263–64.
15. Today Bandinelli's Dead Christ Supported by an Angel is in the crypt of the Basilica of Santa Croce in Florence. Verdon 1996, p. 22; Lecchini Giovannoni 1996, pp. 29–30; Waldman 2004, pp. xxv, 504 no. 900.
16. Lecchini Giovannoni 1996, pp. 28 fig. 4, 29, 31.
17. Ibid., pp. 31–34, 32 fig. 6.
18. Lecchini Giovannoni 1991, pp. 278–79, nos. 125–27. The paintings are in the Szépművészeti Múzeum, Budapest; in the Seminario Maggiore, Venice; and a third, which was on the art market in 1966, is now in an unknown private collection.
19. De Benedictis 1996.
20. Mancinelli 1983, pp. 263–64.
21. Ibid., pp. 265–67.
22. Mancinelli in New York–Chicago–San Francisco 1982, p. 79, no. 25M and illus.
23. Hall 1974, pp. 2–3, 5, 228, 268.
24. The letter from Ferdinando to Francesco of December 27, 1577 (ASF, Mediceo del Principato [hereafter MdP], file 5089, doc. 268), was published in Heikamp 1969, pp. 61, 74 no. 35. Fabrizio Mancinelli (1983, p. 258) connected that letter to the vestments and altar furnishings but attributed the promised gift to Francesco rather than to Cosimo. For the reattribution of the promised gift to Cosimo, see Meoni 1998, pp. 97, 302.
25. The hypothesis of such a judgment on the first tapestry of the Passion series is based on the assertion, in a copy

of the memorandum to the grand duke on May 14, 1592, that "torneranno [pianeta, tonicella, paliotto e altro] assai più belli del panno di seta e oro che si è mostro a V.A.S." (the [chasuble, dalmatic, altar frontal and other] will come out even more beautiful than the silk and gold hanging that has been shown to Your Highness). See Frezza 1982, p. 61; Meoni 1998, pp. 306–7 no. 110, 509.
26. Langedijk 1981–87, vol. 2, p. 1020.
27. ASF, Scrittoio Fortezze e Fabbriche Medicee (hereafter FM) 121, fol. 45r; Frezza 1982, pp. 59, 61.
28. ASF, GM 220, fol. 8r; Frezza 1982, p. 73.
29. Farabulini 1884, p. 83; Gentili 1874, p. 40; Mancinelli in New York–Chicago–San Francisco 1982, pp. 73–74; Mancinelli 1983, p. 260.
30. Lecchini Giovannoni 1991, passim.
31. ASF, GM 18, fols. 33v, 40r, 78v; FM 1, fol. 40 left; for previous bibliography, see Meoni 1998, p. 476.
32. Meoni 1994, pp. 95–97.
33. Meoni 1998, pp. 78–85, 95–106, 124, 224–31 nos. 55–58, 248–77 nos. 69–82, 279–87 nos. 84–91, 290–311 nos. 102–12, 314–15 no. 114, 324–41 nos. 120–24, 360–85 nos. 134–51, 388–90 nos. 153–54, 409–35 nos. 169–87, 440–61 nos. 190–98.
34. Forti Grazzini 1986, pp. 61–81, nos. 6–10.
35. For Allori, see ASF, FM 121, fol. 45r; GM 116, fols. 48r, 56v, 66r; Frezza 1982, pp. 57–61, 63, 67, 72; Mancinelli in New York–Chicago–San Francisco 1982, pp. 73–75, nos. 25A, 25B; Mancinelli 1983, pp. 258–59; Lecchini Giovannoni 1991, pp. 276–77, no. 122. For Butteri, see ASF, GM 116, fols. 48r, 56v; Frezza 1982, pp. 60, 63, 67–68.
36. See, for example, Hercules and the Ceryneian hind in the left border of Zacharias Blessing John the Baptist before He Goes into the Desert in the series Story of Saint John the Baptist; Meoni 1998, pp. 297, no. 106. For Butteri's collaboration in the Florentine tapestry workshop, see ibid., pp. 79, 81–82, 90 nn. 150 and 169, 101, 104, 105 n. 12, 117 n. 83, 118 n. 105, 268, 270–76 nos. 79–82, 290–300 nos. 102–9, 302, 310 no. 112, 360 no. 134, 412, 452 no. 194.
37. Terradura 1996, esp. pp. 59–60 and fig. 3.
38. A. Spagnesi 1996.
39. ASF, GM 116, fols. 42r–v, 50r; Frezza 1982, pp. 61–63, 65–66.
40. ASF, GM 116, fols. 48r, 56v; Frezza 1982, pp. 63, 67–68.
41. Frezza 1982, p. 60 and n. 6 (citing its location as the Richter collection); Lecchini Giovannoni 1991, pp. 233–34 no. 40, 277.
42. Forti Grazzini 1986, pp. 79–81, no. 10 and illus.; Meoni 1998, pp. 101–3 fig. 64, 512, 513.
43. A. Spagnesi 1996, pp. 46, 51 fig. 15.
44. ASF, GM 116, fol. 60v; Conti 1875, p. 106; Meoni 1998, p. 511. It is likely that for such fine weaving Papini resorted to Flemish weavers, always present in the Medici manufactory and employed particularly for the most prestigious and most technically complicated commissions. Meoni 1998, pp. 85, 91 n. 186, 499–500, 502–3, 505, 511.
45. ASF, GM 116, fols. 60r–v; Conti 1875, pp. 106–7, no. 5.
46. ASF, GM 220, fol. 8r; Frezza 1982, pp. 73–74.
47. Mancinelli in New York–Chicago–San Francisco 1982, p. 73, no. 25A; Mancinelli 1983, pp. 260, 263 and fig. 2.
48. Mancinelli in New York–Chicago–San Francisco 1982, p. 74, no. 25B; Mancinelli 1983, p. 265.

From a ten-piece set, including three overdoors, of the *Passion of Christ*

Design and cartoon for the main scene by Ludovico Cardi, called il Cigoli, between December 28, 1598, and September 22, 1599

Design and cartoon for the border by Alessandro Allori, between August 12, 1589, and August 22, 1591

Woven on a low-warp loom in the Medici manufactory under the direction of Guasparri Papini, Florence, before February 27, 1601

Silk and gilt-metal-wrapped thread

371 x 375 cm (12 ft. 2⅛ in. x 12 ft. 3⅝ in.)

10 warps per cm

Deposito Arazzi della Soprintendenza Speciale per il Polo Museale Fiorentino, Galleria degli Uffizi, Florence (Arazzi no. 517)

PROVENANCE: February 27, 1601, consigned by the manufactory to the Guardaroba Generale (General Wardrobe) of Ferdinando I de' Medici;[1] May 22, 1609, September 26, 1637, and September 28, 1640, recorded in inventories of the Guardaroba Generale;[2] December 19, 1651, sent from the Guardaroba Generale to the Palazzo Pitti;[3] 1667, sent from the Guardaroba Generale to Rome to furnish the chamber of Grand Duke Ferdinando II in the Palazzo di Piazza Madama;[4] November 6, 1688, and February 4, 1691, sent from the Guardaroba Generale to the Palazzo Pitti;[5] 1721, 1769, 1804–16, 1829–60, set described in the inventories of the Guardaroba Generale;[6] between 1865 and 1883, *Christ before Herod* exhibited in the Vasari Corridor between the Uffizi and the Palazzo Pitti; 1883–84, *Christ before Herod* listed as in the Magazzini (storerooms) of the Palazzo della Crocetta (today the Museo Archeologico);[7] between 1884 and 1922, exhibited in the Regia Galleria degli Arazzi e Tessuti in the Palazzo della Crocetta; February 13, 1922, Galleria degli Arazzi closed and tapestry transferred to the Magazzini of the Palazzo Pitti;[8] 1925, exhibited in the third corridor of the Galleria degli Uffizi; October 27, 1987, moved to the Depositi Arazzi (tapestry depositories) of the Palazzo Pitti; 1999, transferred to the new Deposito Arazzi of the Galleria degli Uffizi, Florence.[9]

REFERENCES: Müntz 1878–85, pp. 68–69; Rigoni 1884, p. 17 no. 32; Geisenheimer 1907, col. 300; Busse 1911, pp. 27, 66; Battelli 1922, pp. 11–12, fig. 30; Göbel 1928, pp. 388–89; Venturi 1901–40, vol. 9, pt. 6, pp. 82, 83; Turin 1952, p. 85; Thiem 1958, p. 104, n. 61; Bucci in San Miniato (Pisa) 1959, pp. 80–81, no. 28, fig. XXVIII; Viale Ferrero 1961, p. 40; Darmstadt 1964, no. 19; Paris 1971, p. 21 no. 14, fig. VII; Matteoli 1974, p. 155; Gaeta Bertelà 1979, p. 1068, Ar34, illus.; Frezza in Florence 1980, p. 100, no. 172; Gaeta Bertelà 1980, p. 128, n. 27; Matteoli 1980, pp. 165, 411–12, no. 133.A; Frezza 1983, pp. 239, 246–47 nn. 67–70, figs. 7, 8; Chappell in Florence 1986, vol. 2, pp. 122–23, no. 2.68

and illus.; Faranda 1986, p. 147, no. 51; Chappell 1989, pp. 200, 212 n. 34, pl. 9; Lecchini Giovannoni 1991, pp. 279–80, no. 129; Chappell in Florence 1992, pp. XIII, 83–84 no. 49 and figs. 49a,b; Meoni 1998, pp. 97–98, 302–5, 312–13 no. 113 and illus., 513, 514, 515; Meoni 2000, pp. 254–55 and illus.; Meoni 2001a, pp. 107, 108 fig. 1.

CONDITION: Fair. The tapestry was restored in Florence for this exhibition.[10]

*C*hrist before Herod was woven from a cartoon by Ludovico Cardi, called il Cigoli (1559–1613), between 1598 and 1601.[11] The model was made to complement four other scenes of the *Passion of Christ* that had been designed by Alessandro Allori between 1589 and 1592 and executed in the Florentine workshop of Guasparri Papini during the intervening years. The lapse of almost ten years before Cigoli received the commission was due to the shortage of weavers who specialized in working with fine silk and gold.[12] The set may originally have been conceived for the Sistine Chapel, but as early as 1592 the decision was taken to keep it in Florence, and it was allocated instead to the Palazzo Pitti.[13] In contrast to the scenes made after Allori's designs, *Christ before Herod* manifests a new sense of drama and theatricality, reflecting the important contribution that Cigoli was then making to the development of a Baroque sensibility in Florentine painting.

Description and Iconography

In the cartouches in the center of the top and bottom borders are the inscriptions PILATUS MISIT EUM AD HERODEM (Pilate sent him to Herod) and HERODES REMISIT AD PILATUM (Herod sent him again to Pilate). These phrases quote Luke 23:7–11, in which Pontius Pilate orders Christ to Herod, and then Herod orders him back to Pilate. The inscriptions have sometimes led the tapestry's scene to be interpreted as Christ before Pilate,[14] but most critics recognize the episode as Christ before Herod.[15]

In the four corners of the borders are medallions with torches and lanterns, under-

scoring the darkness of the interior where the Jewish dignitaries carry lamps and a soldier holds a torch (in fact, in the documents that mention the subject, this scene is supposed to take place at night).[16] However, nocturnal light effects were not easily achieved in tapestries. In addition, weavers knew that the dark threads of black and brown were vulnerable to deterioration. Here the tapestry's relatively sharp contrasts of light and dark between the figure of Herod in shade on the right and the plain daylight of the background convey the sense that the story takes place in a dark interior; the artificial light of the torch carried by the soldier next to Herod, falling on the central figure of Christ, is the sole source of illumination. This play of light and shadow was new in Medici tapestries and indeed to tapestry in general.

Cigoli's composition was inspired by drawings of Giovanni Stradano (1523–1605) in the Uffizi, which were conceived for a series of thirty-eight prints dedicated to the Passion; according to his contemporary biographer Raffaello Borghini, Stradano executed the drawings about 1580 for Antwerp engravers, notably Philip Galle.[17]

Alessandro Allori (1535–1607) designed the borders for the tapestry set, with the exception of the corner medallions of *Christ before Herod*, which Cigoli or his workshop most likely conceived.[18] The exuberant and complex border decoration, which overlays a fictive wood frame motif (seen in Allori's frescoes for the chapel of Palazzo Salviati ten years earlier), is perhaps one of the most innovative elements of Allori's inventions for this series, for which he also designed four scenes.[19]

Commission

Christ before Herod comes from the *Passion of Christ*, the first tapestry project undertaken during the reign of Grand Duke Ferdinando I de' Medici (r. 1587–1609).[20] Ferdinando, who after an ecclesiastical career in Rome[21] returned to Florence in 1587, assuredly participated in drafting the iconographic program of the series, which is in tune with the contemporary

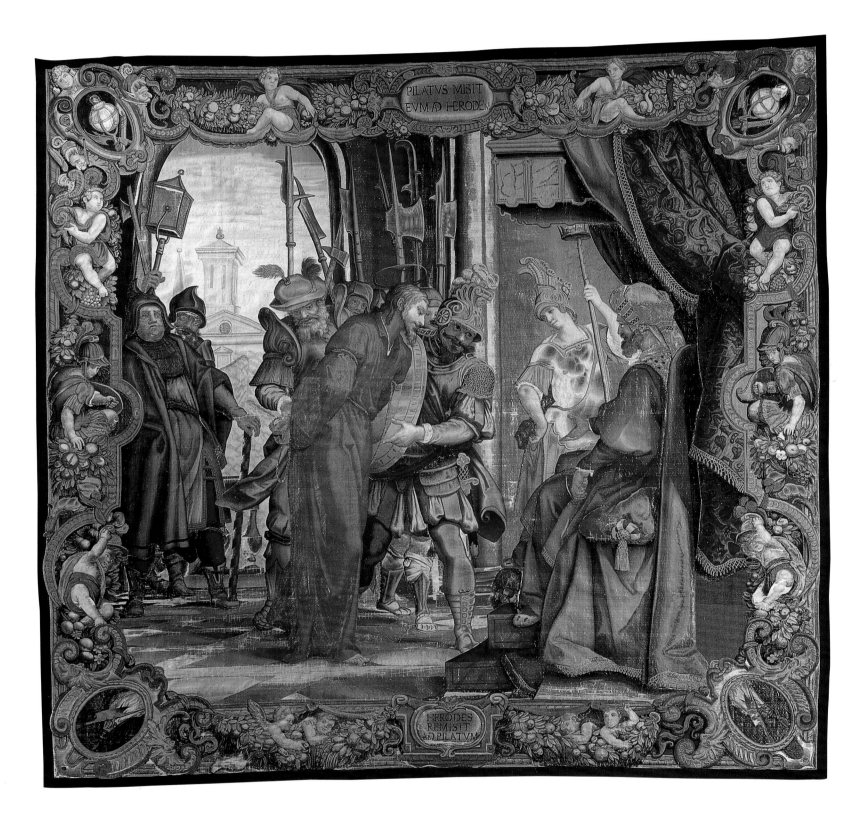

PILATVS MISIT
EVM AD HERODEM

HERODES
REMISIT
AD PILATVM

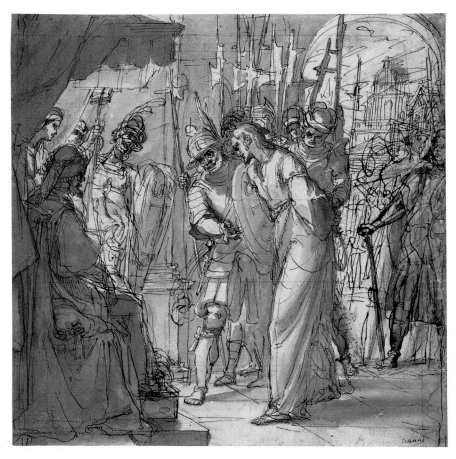

Fig. 127. *Christ before Herod*, by Ludovico Cardi, il Cigoli, 1598–99. Preparatory sketch for the tapestry in the *Passion of Christ*. Pencil, pen, and brown watercolor on white paper, 31.3 x 30.2 cm. Kupferstichkabinett, Hessisches Landesmuseum, Darmstadt (AE 1633)

Fig. 128. *Head of Christ*, by Ludovico Cardi, il Cigoli, 1598–99. Preparatory study for the tapestry *Christ before Herod*. Oil on paper mounted on canvas, 43 x 28.9 cm. The Metropolitan Museum of Art, New York, Purchase, Mrs. Carl L. Selden Gift, in memory of Carl L. Selden, 1987 (1987.198)

culture of the Counter-Reformation. He may have had assistance from Don Giovanni de' Medici, who often had an influential role in the artistic commissions of the court.[22] Guasparri Papini began the weaving of the set with *Christ in the Garden of Gethsemane*, the cartoon for which Allori painted between August 12, 1589, and August 22, 1591.[23] This *Passion* commission seems to relate to a promise made in 1569 by Cosimo I de' Medici to Pope Pius V to have tapestries of the Passion woven for the Sistine Chapel. On December 27, 1577, Ferdinando, then a cardinal, wrote to his brother Grand Duke Francisco I de' Medici about a conversation with Pope Gregory XIII, in which Gregory had asked about Cosimo's promise to Pius.[24] Ferdinando replied by proposing to Gregory a *Passion* series of seven tapestries to be woven from cartoons by Allori. While that plan was not followed through at the time, Ferdinando took it up again when he became grand duke in 1587. After the first panel was woven,[25] a decision seems to have been made—during a meeting in 1592 among Allori, Papini, Giovanni de' Medici, and Girolamo Seriacopi, the Medici tapestry manufactory superintendent—not to send the set to Rome.[26] Ferdinando instead commissioned liturgical vestments and altar furnishings for Pope Clement VIII (cat. nos. 31, 32). The use of precious threads of silk, gold, and gilt-silver in this weaving of the *Passion* is evidence of the importance of its original destination, the Sistine Chapel.[27]

Don Giovanni, whom Ferdinando I may well have asked to oversee the project, was probably behind the decision to bring in Cigoli. It was he who introduced Cigoli to the grand duke, who in 1590 commissioned the artist to paint the *Resurrection* for the Cappella de' Forestieri in the Palazzo Pitti.[28]

Various scholars have suggested that the *Passion* tapestries were used to decorate the Palazzo Pitti or the Palazzo Vecchio during the feast of Corpus Christi, which falls on the Thursday following Trinity Sunday.[29] Although no record of this has been found in inventories or other documents, it is very possible considering the subjects. From the mid-seventeenth century, the set was sent from the Guardaroba Generale to the Palazzo Pitti a number of times during the winter season, and once it was sent to

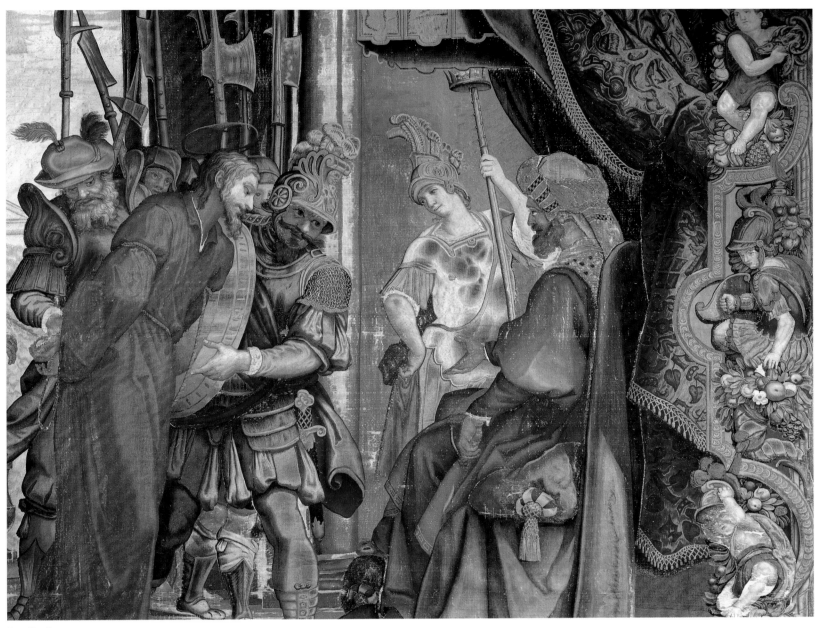

Detail of cat. no. 33

Rome to furnish the bedroom for Grand Duke Ferdinando II in the Palazzo di Piazza Madama (see notes 3–5).

Artist

Cigoli began his career during the Counter-Reformation. In the late 1580s, together with Gregorio Pagani and Domenico Passignano, he created an informal art academy. Its intent, according to Filippo Baldinucci, was "to find a natural and true way of coloring"[30] through the study of the chromatism of Correggio and Federico Barocci. In the 1590s Cigoli developed his mature style, as can be seen in the *Last Supper* (Collegiata di Santo Stefano, Empoli) of 1591 and the *Martyrdom of Saint Stephen* (Galleria Palatina, Florence) of 1597,

which is a masterpiece of dramatic action. By transforming the narrative simplicity of his earlier Counter-Reformation style into efficacious visual dramas, Cigoli gave rise to the Baroque style in Florence. Cigoli's design for *Christ before Herod* was thus conceived at a crucial point in his career.

While Cigoli received payment for the cartoon of *Christ before Herod* on December 24, 1600, just two months before Papini finished weaving the tapestry on February 27, 1601,[31] he had finished it some time before. A letter of September 22, 1599, from the *guardaroba maggiore* (wardrobe master), Vincenzo Giugni, to Belisario Vinta, first secretary of the grand duke, gives an account of the first five tapestries of the set and reports that Cigoli had

completed the cartoon for the fourth tapestry of the *Passion* but had yet to deliver it.[32] Work preparatory to the weaving of *Christ before Herod* may already have begun, for in a letter of December 28, 1598, Giugni wrote he had had a panel of gold and silk put on the loom and at the earliest convenience another would be put on, for which the warp was already set.[33]

Cigoli made a number of studies before executing the cartoon. He considered drawing to be at the center of his practice and saw it as the only way to come to terms with contemporary notions about verisimilitude in art, which called for accurately rendered figures.[34] For this tapestry, as for all his works, Cigoli drew his thoughts about figure groupings before methodically going onto more elabo-

rate compositions and detail studies.[35] In the last months of 1598 he could have made the rapid sketch of Christ before Herod that is in Darmstadt (fig. 127), which is a study, in reverse, for the cartoon.[36] It depicts Herod in darkness, partially delineates the Jewish officials, and summarily indicates the fall of light. On a recto of a sheet in the Uffizi, dating after the Darmstadt sketch, there is a nude study of the soldier with the torch, and on the verso a seated old man for Herod.[37] Cigoli frequently sketched early nude studies of figures that would be clothed in the final composition in order to work on their poses and expressions.[38]

The tapestry cartoon itself has not survived. However, an oil study on paper of Christ's head in the Metropolitan Museum (fig. 128) gives a good idea of how Cigoli's expressive pathos and intense realism must have come across in it.[39] Christ before Herod was probably his only painting for the Medici tapestry works. The painter's nephew Giovanni Battista Cardi recalled that he made "many drawings for tapestry panels" for Cardinal Alessandro Montalto, but there is no trace of these in the manufactory records; perhaps that project never got beyond the planning stage.[40]

With its rich palette of colors the composition is reminiscent of the sixteenth-century Venetian masters. The sumptuous curtain of the baldachin over Herod's throne, for example, recalls Titian's *Pesaro Madonna* (ca. 1519–26; Frari, Venice), a model that Cigoli had already used for the chasuble worn by Saint Augustine in his 1595 *Madonna of the Rosary* in Pontedera.[41] The date of the tapestry *Christ before Herod* falls between two important works by Cigoli that signal the arrival of Baroque tendencies in Florence: the *Stoning of Saint Stephen* (dated 1597; Galleria Palatina, Florence), which Pietro da Cortona judged "the most beautiful of so many exceptional pictures our city [Florence] possesses,"[42] and *Saint Jerome in His Study* (1599; San Giovanni dei Fiorentini, Rome).[43]

Weaver

Guasparri Papini was responsible for the weaving of the entire luxury set of the *Passion*. As head weaver for over thirty years (1588–1621), he organized the Medici manufactory's projects and managed its finances, which

included coordinating and collecting payments for non-ducal orders.[44] Papini used specialized weavers for silk and gold tapestries.[45] Some of these were probably Flemings then working in the manufactory,[46] and he may also have personally done this type of weaving.

Between 1592 and 1605 the first five tapestries in the set were finished: *Christ in the Garden of Gethsemane*, the *Last Supper*, the *Washing of the Feet*, and the *Road to Calvary* were woven from cartoons by Alessandro Allori, who also designed the borders; and *Christ before Herod*, from Cigoli's cartoon. The sixth and seventh pieces of this edition, the *Kiss of Judas* and *Christ Appearing to the People*, were woven between 1614 and 1616 from cartoons that can be attributed to Bernardino Monaldi and Francesco Mati, respectively. In 1614 three overdoors depicting themes and symbols of the Passion, almost certainly meant to accompany the set, were completed; today they are in the Galleria Palatina of the Palazzo Pitti.[47]

As indicated above, weaving of this silk-and-gold edition of the *Passion* stopped in 1605 and did not resume until 1613. Causes for the interruption are not known, but among them may have been the deaths of Allori in 1607 and of Ferdinando I in 1609, in addition to Cigoli's move to Rome in 1604. In 1595 the tapestry manufactory had also started reproducing single panels of the first four designs in wool.[48] The cartoon for *Christ before Herod* was put back on the loom for weaving in wool on July 28 and 31, 1601. Papini delivered these two panels on January 17, 1602, and on November 26, 1607, he finished weaving all of the first five designs in wool.[49] They may have been intended for use by the grand duke as a gift or to publicize the manufactory's products. Unfortunately, we have no other information on these wool examples, all of which have been lost.

LUCIA MEONI

1. Archivio di Stato, Florence (hereafter ASF), Guardaroba Medicea (hereafter GM) 212, fols. 16 left and right, 30 left and right; GM 220, fol. 8v. Frezza 1983, p. 246, n. 67; Meoni 1998, pp. 312–13 no. 113, 514.
2. ASF, GM 289, fol. 54 right; GM 521, fol. 39v; GM 572, fol. 32v.
3. ASF, GM 624, fol. 43 right.
4. ASF, GM 711, file 4, fol. 280v: "per l'adobbamento del

Palazzo di Piazza Madama di Roma del Ser:mo Gran Duca di Toscana" (for the adornment of the Palazzo di Piazza Madama in Rome of His Highness the Grand Duke of Tuscany). The palace was enlarged and rebuilt in 1642 on the wishes of Grand Duke Ferdinando II. Gianfranco Spagnesi (1988, pp. 244–46) gives the 1667 floor plan of the palace by Pietro Ferrerio.
5. ASF, GM 977, fols. 4 right and 37 right.
6. ASF, GM 1289, fol. 374r; GM 1301*bis*, fol. 211 left; Imperiale e Real Corte 3357, fol. 330 no. 3145; 3368, fol. 193 left no. 2278; 3378, fol. 168 left, nos. 2276, 3052.
7. Biblioteca degli Uffizi, MS 397, nos. 3052, 154; MS 398, nos. 49, 517; MS 399, nos. 49, 517; MS 401, no. 53; MS 402, no. 32. See also Gaeta Bertelà 1980, pp. 128 n. 27, 131–32 and n. 43.
8. Rigoni 1884, p. 17, no. 32; Gaeta Bertelà 1980, p. 128, n. 27.
9. Caneva 2000, pp. 18–19 and fig. 8.
10. The tapestry's prolonged exposure during use caused irretrievable losses of entire areas, especially those woven with beige and brown silk thread. Intervention to recover the structure of the textile was based on stabilizing the entire delicate surface by placing linen supports on the back. Partial restoration of missing weft was achieved through a measured thickening of the warps. The selvages, completely missing, were loom-woven in the original brown color and then sewn along the edges of the cloth (observations of Carla Molin Pradel, who coordinated the restoration of the tapestry carried out by the Opera Laboratori Fiorentini).
11. See note 1; also ASF, GM 213, fol. 6r; GM 220, fol. 7v; Mediceo del Principato (hereafter MdP) 893, vol. 1, fol. 227r; Meoni 1998, pp. 312–13, no. 113 and illus. Cigoli's tapestry was displayed at Roberto Longhi's exhibition on Caravaggio and the Caravaggeschi in Milan in 1951 (but was not included in the catalogue). The exhibition was a groundbreaking new look at Caravaggio and naturalism in 17th-century painting. The inclusion of the tapestry was an important early recognition of the work and would seem to place the painter among those artists whom Longhi considered open to Caravaggio's innovations—Longhi's so-called "schiera dei risvegliati" (band of the awakened); Longhi 1951/1999, p. 65. Cigoli has since been credited with taking Florentine painting from Mannerism to the Baroque; Chappell 1998.
12. As early as 1595, Papini spoke of the shortage of specialized weavers; Conti 1875, p. 106, no. 5.
13. Meoni 1998, pp. 97–8, 302–23 nos. 110–19.
14. Müntz 1878–85, p. 69; Frezza 1983, p. 239.
15. Rigoni 1884, p. 17, no. 32; Göbel 1928, p. 388; Turin 1952, p. 85; Viale Ferrero 1961, p. 40; Gaeta Bertelà 1979, p. 1068, Ar34; Frezza in Florence 1980, p. 100, no. 172; Chappell in Florence 1986, vol. 2, p. 122, no. 2.68; Faranda 1986, p. 147, no. 51; Meoni 1998, pp. 312–13 no. 113, 514.
16. ASF, GM 538, fols. 48 right, 50 right, 51 right, 52 left and right; GM 543, fol. 13v; GM 544, fol. 10r; Meoni 1998, p. 312, no. 113.
17. See, in particular, Gabinetto Disegni e Stampe degli Uffizi (hereafter GDSU), Florence, inv. 7762 F, 7767 F; Borghini 1584/1967, p. 584; Thiem 1958, pp. 104, 106; Frezza 1983, pp. 237–38; Baroni Vannucci 1997, pp. 264–72 nos. 375–421, 389–92 no. 694.
18. ASF, GM 116, fol. 31r; Meoni 1998, pp. 304, 306 n. 110.
19. Lecchini Giovannoni 1991, p. 248, no. 70, figs. 144–46.
20. Meoni 1998, pp. 97–98, 302.
21. For Ferdinando I's years in Rome, see Rome 1999.
22. Frezza 1982, pp. 59, 61; Chappell in Florence 1992, pp. XVI, 17–19 no. 10; see also cat. nos. 31, 32 in this volume.
23. ASF, GM 116, fols 30v–31r; GM 121, fol. 67 left. Müntz (1878–85, p. 69) and Viale Ferrero (1961, p. 40) thought that this cartoon was by Domenico Passignano. For an erroneous interpretation of a letter of September 22,

1599 (ASF, MdP 893, vol. 1, fol. 227r), see Frezza 1983, pp. 238, 246 n. 60; Meoni 1998, pp. 306–7 no. 110, 507, 508, 509, 514.

24. The letter of December 27, 1577, was published in Heikamp 1969, pp. 61, 74 no. 35, and related to the *Passion* series in Meoni 1998, pp. 97, 302, 500.

25. ASF, GM 116, fol. 35r; Frezza 1982, pp. 59–63; Meoni 1998, pp. 97, 303, 306 no. 110, 509.

26. ASF, Scrittoio Fortezze e Fabbriche Medicee 121, fol. 45r; Frezza 1982, pp. 59, 61; Meoni 1998, pp. 306, 509.

27. Conti 1875, pp. 106–7, no. 5; Frezza 1983, pp. 237, 246 n. 55; Meoni 1998, pp. 97, 302, 507–16, 519–20.

28. Cardi before 1628/1974–75, pp. 46–47; Chappell in Florence 1992, pp. XVI, 17–19 no. 10.

29. Geisenheimer 1907, col. 300; Busse 1911, p. 27; Bucci in San Miniato (Pisa) 1959, p. 80; Paris 1971, p. 21, no. 14; Gaeta Bertelà 1979, p. 1066, Ar30–Ar36; Faranda 1986, p. 147, no. 51; Lecchini Giovannoni 1991, pp. 279–80, no. 129.

30. "[G]iungere ad un modo di colorire naturale e vero"; F. Baldinucci 1681–1728/1845–47, vol. 3, pp. 37, 240.

31. ASF, GM 212, fols. 16 right, 24 left and right, 27 left and right, 30 left and right; GM 220, fols. 7v, 8v; Frezza 1983, 246, n. 67; Meoni 1998, pp. 312–13, no. 113.

32. "[P]anni d'arazzo d'oro e seta che sono de' misteri della Passione che dua n'è fatti, di un altro n'è fatti e dua terzi et il quarto n'è fatto il cartone dal Cigoli ch'ancora non s'è hauto, l'altro cartone non s'è ancora cominciato" (tapestry panels of gold and silk of the mysteries of the Passion of which two were made, of another two thirds has been woven, and of the fourth there is the cartoon by Cigoli that has still not been delivered, and another cartoon has not yet been begun); ASF, MdP 893, vol. 1,

fol. 227r. See Meoni 1998, pp. 303, 310–13 nos. 112, 113, 514.

33. "[H]o fatto mettere in telaio nell'arazzeria di V.A. un panno d'arazzo d'oro et seta, et con primo comodo sene metterà un altro che di già è ordito" (I have put in the loom of the tapestry works of Your Highness a panel of gold and silk and at the earliest convenience I'll put another that has already its warp); ASF, GM 213, fol. 6r; Meoni 1998, pp. 310 no. 112, 312 no. 113, 513.

34. "[D]i continuo disegnando qualcosa dal naturale e dal rilievo" (continually drawing something from life and from sculpture), as Cigoli's nephew wrote; Cardi before 1628/1974–75, p. 42.

35. Chappell in Florence 1992, p. XIII.

36. This sketch was recognized as a study for the tapestry cartoon by Philip Pouncey, whose unpublished attribution is cited by Bergsträsser in Darmstadt 1964, no. 19; Bergsträsser in Paris 1971, p. 21, no. 14; Chappell in Florence 1986, vol. 2, pp. 122–23, no. 2.68 and illus.

37. GDSU, Florence, inv. 8840 F. Chappell (in Florence 1992, pp. XIII–XIV, 83–84 no. 49 and figs. 49a, b) identified this sheet as preparatory for the cartoon. Two other drawings in the Uffizi, once believed to be preparatory for this tapestry, have been removed from the artist's oeuvre: GDSU, Florence, inv. 1934 S and 2045 S; see Chappell in Florence 1992, p. 83, no. 49.

38. See, for example, Faranda 1986, pp. 116 nos. 6, 6a, 118–19 nos. 9, 9a, 123–25 nos. 16, 16c, 126–27 nos. 18, 18d, 130–33 nos. 23, 23f, 136–37 nos. 29, 29a, 141 nos. 37, 37a, 155 nos. 65, 65a, 175 nos. 93, 93a.

39. Chappell 1989, pp. 200, 212 n. 34, pl. 9. Chappell (in Florence 1992, p. 83, no. 49) connected this drawing to the tapestry.

40. "[M]olti disegni per far fare panni di arazzo"; Cardi before 1628/1974–75, p. 55. Some of these drawings have been found and identified: GDSU, Florence, inv. 124 Orn. recto and verso, 14022 F recto and verso; Istituto Nazionale per la Grafica, Rome, Fondo Corsini no. 130678; Cabinet des Dessins, Musée du Louvre, Paris, inv. 889; sale cat., Sotheby's, London, July 2, 1984, no. 73 (collection of Dr. and Mrs. Malcolm W. Bick, Longmeadow, Mass.). See Matteoli 1980, pp. 300–303, no. 133; Viatte 1988, pp. 76–78, no. 131; Chappell in Florence 1992, pp. 35–38, nos. 22–23.

41. Contini 1991, pp. 44–45, no. 5.

42. "[L]a più bella di quante egregie pitture possiede la nostra città"; F. Baldinucci 1681–1728/1845–47, vol. 3, pp. 251–52. For the painting, see Chiarini in Chiarini and Padovani 2003, vol. 2, pp. 128–29, no. 188.

43. Contini 1991, pp. 66–67, no. 14.

44. See Meoni 1998, pp. 93–119.

45. ASF, GM 116, fol. 60v; Conti 1875, pp. 106–7, no. 5.

46. Meoni 1998, pp. 85, 91 n. 186, 499–500, 502–3, 505, 511.

47. The attributions of the last two tapestries to Mati and Monaldi and of the three overdoors to Monaldi were made in Meoni 1998, pp. 302–23, nos. 110–19.

48. ASF, GM 116, fols. 54r, 64r; GM 212, fols. 16 right, 28 right, 30 left and right, 32 right, 37 right, 41 left and right, 42 left and right, 60 right, 66 left, 71 left and right; GM 213, fol. 14v; GM 220 fols. 10r, 11r, 12r, 18r and v; Meoni 1998, pp. 303, 306, 308, 310, 511, 512, 515, 516.

49. ASF, GM 212, fols. 37 right, 41 left and right, 42 left and right, 60 right, 66 left, 71 left and right; GM 213, fol. 14v; GM 220, fols. 11r, 12r, 18r–v; Meoni 1998, pp. 312, 515, 516.

34.
Chariot of the Sun

From a thirteen-piece set, including three overdoors and three portieres, of the *Seasons and Hours*
Design and cartoons of the main scene and borders by Lorenzo Lippi, before April 27, 1643
Woven on a low-warp loom in the Medici manufactory under the direction of Pietro Févère, Florence, before January 11, 1645
Wool and filoselle
590 x 500 cm (19 ft. 4¼ in. x 16 ft. 4⅞ in.)
5–6 warps per cm
Deposito Arazzi della Soprintendenza Speciale per il Polo Museale Fiorentino, Palazzo Pitti, Florence (Arazzi no. 146)

PROVENANCE: January 11, 1645, consigned by the manufactory to the Guardaroba Generale (General Wardrobe) of Ferdinando II de' Medici;[1] September 23, 1648, October 9, 1649, and July 30, 1655, transferred from the Guardaroba Generale to the Palazzo Pitti and back;[2] 1663–64, the inventory of the Palazzo Pitti

describes the set as hanging in the audience chamber of Grand Prince Cosimo;[3] 1688–96, recorded in the inventory of the Guardaroba of Palazzo Pitti;[4] 1865–90, recorded in the inventories of the Magazzini (storerooms) of the Galleria degli Uffizi;[5] February 13, 1922, in the Magazzini of the Palazzo Pitti;[6] October 18, 1946–2006, on loan to the Accademia delle Arti del Disegno, Florence; 2006, returned to the Depositi Arazzi of the Palazzo Pitti.[7]

REFERENCES: Dorothy Traversi 1974, Soprintendenza Speciale per il Polo Museale Fiorentino, catalogue, entry OA no. 09/00016693; Frezza in Florence 1980, p. 113; Mosco 1982, pp. 35–36 n. 9; Frezza 1983, p. 248, n. 93; D'Afflitto 2002, pp. 102–3, 246–47 nos. 72–76; Meoni 2002b, p. 169 and nn. 30, 31; Meoni forthcoming a.

CONDITION: Good. The tapestry was restored in Florence for this exhibition.[8]

*T*he edition in wool and filoselle (a lesser grade of silk deriving from damaged silk-worm cocoons) of the *Seasons and Hours*, of which the *Chariot of the Sun* is a part,[9] replicates the first edition, which was woven with gold thread in 1640–44 and hung in the throne room of Grand Duke Ferdinando II de' Medici in the winter quarters of the Palazzo Pitti.[10] The second edition, woven in 1643–45, was made with less precious materials, a common practice for replicas woven in Florence from the 1580s.[11] In the inventory of 1663–64, the audience room of the winter apartment of Grand Prince Cosimo in the Palazzo Pitti, located on the floor above that of the grand duke, is listed as hung with a wool and filoselle suite of the *Seasons and*

Fig. 129. *Chariot of the Sun* from a set of the *Seasons and Hours*. Tapestry design by Lorenzo Lippi, woven in the Florence workshop of Pietro Févère, 1642. Wool, silk, and gilt-metal-wrapped thread, 580 x 495 cm. Italian Embassy, London, on loan from the Soprintendenza Speciale per il Polo Museale Fiorentino (Arazzi no. 34)

Hours.[12] The grand prince's choice of these tapestries reflects not only his desire to imitate his father but also the importance of this series.

Lorenzo Lippi designed and painted the cartoons for both the first and the second editions of the *Chariot of the Sun*.[13] The first version depicts a classicizing charioteer similar to the figure in a drawing by Francesco Salviati.[14] In the present work, Lippi reinterpreted the figure of Apollo more freely, portraying him as a young coachman propelling his team of horses urgently across the sky.

Description and Iconography

The scene is dominated by the Greek god Apollo, worshipped during Roman times as god of the sun, driving a chariot pulled by four horses.[15] Manufactory documents list the subject as "Febo" (Phoebus),[16] a Greek word

that means radiant, describing Apollo's role as god of light. The gold ring in the cartouche in the top border is decorated with signs of the zodiac, symbolizing the journey of the sun god in his chariot over the course of the year.[17]

The first set of the *Seasons and Hours* consisted of the seven tapestries *Spring*, *Summer*, *Autumn*, *Winter*, *Chariot of the Sun*, *Dusk*, and *Dawn*; three overdoors of *Day*, *Night*, and *Time*; and three portieres woven with the Medici coat of arms.[18] Of the second version only select tapestries survive: *Chariot of the Sun*, *Dawn*, the overdoors *Night* and *Time*, and one portiere.[19] The *Seasons* tapestries depict activities typical for each time of year: a rural feast in *Spring*, harvesting in *Summer*, crushing grapes in *Autumn*, and cutting ice in *Winter*. The upper border of each features the primary zodiac sign of that season, such as the lion (Leo) on *Summer*.

The celestial and terrestrial cycles of the year—represented by the zodiac, months, and seasons—were favorite subjects in European tapestries, especially Flemish examples, including the so-called *Months of Lucas* and the *Allegory of Time* designed by Jan van den Hoecke (cat. no. 28).[20] From its beginning, the Medici manufactory produced tapestries with these subjects, from the set of the *Months* in 1550–53 by Jan Rost and Nicolas Karcher based on cartoons by Francesco Bachiacca, to the *Seasons* and the *Ages of the Man* designed by Salviati and Giovanni Stradano in 1545–48, to numerous sets of the *Seasons* woven under the direction of Guasparri Papini, Jacopo van Asselt, and Pietro Févère.[21]

The borders of the *Seasons and Hours*, which are the same in both editions, resemble an elaborate stucco-and-gold frame decorated with clusters of putti amid festoons, drapes, cartouches, vases of fruit and flowers, balls (alluding to the Medici coat of arms), and oak branches (the heraldic device of Vittoria della Rovere, grand ducal consort of Ferdinando II and mother of Grand Prince Cosimo). This simulated stuccowork may have been conceived to harmonize with the stuccos of the Sala di Giove (Jupiter) in the Palazzo Pitti, the throne room in which the gold-woven set of the *Seasons and Hours* hung. The border designs appear more similar to stuccos executed by Florentine artists in 1625–27 in the Sala della Stufa, however, than they do to those in the Sala di Giove, which, like all the stuccowork in the Sale dei Pianeti (Planetary Rooms) of the Palazzo Pitti, were made by Roman artisans who came to Florence with Pietro da Cortona in 1641.[22]

Commission

The first edition of the *Seasons and Hours* was woven in 1640–44 while Pietro da Cortona was painting the frescoes in the Sale dei Pianeti (1641–47; see "Tapestry Production in Florence: The Medici Tapestry Works, 1587–1747"). Indeed, the decision to hang the *Seasons and Hours* in the Sala di Giove could have been made while that room was being frescoed, between 1642 and 1644.[23]

On January 19, 1642, the tapestry manufactory obtained 2,500 scudi from Ferdinando II to pay for the cartoons and the materials to finish the first edition of the series,[24] and a

few days later Iacopo Vignali submitted to the manufactory a bill for the cartoons of *Spring, Summer, Autumn,* and *Winter.*[25] Lorenzo Lippi designed the rest of the tapestries, billing the manufactory for his cartoons on April 27, 1643. Extant payments show that he had already worked on the project: in 1641 he painted the border for Vignali's *Winter.*[26] Weaving of the second version in wool and filoselle began in 1643, while work was still progressing on the first version. The same cartoons were used for the second set, with the exception of the single figure of Apollo in the *Chariot of the Sun.*[27]

Winter (now lost), the first tapestry of the second set of the *Seasons and Hours* to be finished, was the only piece that was completed in the Palazzo Vecchio workshop of the Medici manufactory while it was headed by Pietro van Asselt, who delivered the hanging to the Guardaroba on November 18, 1643.[28] After Pietro's death on June 22, 1644, the Palazzo Vecchio workshop was taken over by his brother Bernardino. By June 30 two low-warp looms there already held *Spring* and a portiere "con le penerate" (with a fringed banner). This description allows us to identify easily the surviving portieres, of which there is only one from the second edition (now in the Prefettura, Florence). When the *Spring* and the portiere woven by Bernardino were measured on January 11, 1645, the record says that they had both been woven from the same cartoons as the ones with gold.[29] On January 11, 1645, the officials of the Guardaroba measured Févère's work for the second edition, produced in the San Marco workshop, which included the *Chariot of the Sun, Summer, Autumn, Dusk,* and the three overdoors. On February 18, 1645, Bernardino van Asselt delivered *Dawn* and the two remaining portieres. These were measured at the Guardaroba on April 6, 1645.[30]

Of the thirteen pieces of the *Seasons and Hours* in the second edition, five complete tapestries are still preserved in the Florentine state collections (see note 19). Some fragments of *Summer* were appropriated by the province of Siena after the unification of Italy in 1861, and others, together with pieces of *Spring,* are in a private collection in Florence.[31]

Artist and Weaver

The cartoonist of this series, the Florentine painter Lorenzo Lippi (1606–1665), trained with Matteo Rosselli (1578–1650), whose decorative and theatrical style he continued to imitate until the 1640s. In that decade Lippi began to develop a new pictorial language based on the study of the great Florentine masters of the sixteenth century, as can be seen in the tapestries of the *Seasons and Hours.*[32]

Lippi's bill of April 27, 1643, included mention of the new design for the figure of Phoebus in the *Chariot of the Sun.*[33] In his reelaboration of the dignified charioteer of the first version, whose act of urging on his horses with his whip shows a suggestion of classical boldness derived from a drawing by Francesco Salviati (1510–1563), Lippi transformed Phoebus Apollo into a young, physically active coachman driving his team of horses at full gallop. This change represents the new naturalistic phase of Lippi's art, as best illustrated by his contemporary canvases for the Ardinghelli Chapel in San Gaetano, Florence, in which the artist picked up on the chromatism of Orazio Gentileschi, showing, as the critic Filippo Baldinucci wrote, an interest in a Caravaggesque style—usually associated with tenebrous tones—that is light in hue.[34] The coherent, simplified composition of the *Chariot of the Sun* points to Lippi's desire to recover the models of the Renaissance masters as they had been reinterpreted by the Counter-Reformation painter Santi di Tito. The latter was a point of reference for a new Florentine manner, which has been termed "normalità rappresentativa" (representative normality).[35] Rejecting the bizarre compositions and subject matter of Florentine Mannerism, this new generation of artists sought to reestablish a more direct rapport with its viewers. Lippi was against the tendency of the followers of the Florentine painter Ludovico Cardi, il Cigoli (see cat. no. 33), who were attracted by the novelties of Pietro da Cortona's work in the Palazzo Pitti. While the spectacular rush of the team of horses in Lippi's tapestry shows he was not completely foreign to such influence, in general he favored less theatrical compositions that instead play on subtle psychological effects with which the viewers can identify.[36]

The French weaver Pietro Févère (Pierre Lefebvre, 1594–1669) wove the second edition of the *Chariot of the Sun*[37] on one of the eight low-warp looms in the San Marco workshop.[38] Lippi noted on his bill for the cartoon that it was for a low-warp loom. This is the first known documentation of a cartoon produced for a loom of this kind in the San Marco workshop during Févère's period.[39] Earlier scholars have maintained that his entire production was in the high-warp technique that he had introduced to Florence.[40]

LUCIA MEONI

1. Archivio di Stato, Florence (hereafter ASF), Guardaroba Medicea (hereafter GM) 538, fols. 13 right, 33 right, 39 right, 41 left and right, 48 right; GM 543, fol. 13r; GM 544, fol. 9v; Dorothy Traversi 1974, Soprintendenza Speciale per il Polo Museale Fiorentino (hereafter SSPMF), catalogue entry OA no. 09/00016693; Meoni forthcoming a.
2. ASF, GM 494, fol. 89v; GM 624, fol. 2 left.
3. ASF, GM 725, fols. 109r, 157v.
4. ASF, GM 932, fol. 178v.
5. Biblioteca degli Uffizi (hereafter BU), Florence, MSS 398 no. 146; 399 no. 146; 400 no. 33.
6. Gaeta Bertelà 1980, p. 137 and n. 52.
7. BU, Florence, MS 403, fol. 59 right, no. 146.
8. According to Carla Molin Pradel, who coordinated the tapestry's restoration by the Opera Laboratori Fiorentini, the tapestry was cleaned, the separated areas resewn, and new warps inserted to fill countless moth holes. A new, loom-woven selvage was applied along the lower edge to replace the original, extremely decayed one.
9. For the tapestries in this second edition, see ASF, GM 531, files 30, 41, 47; GM 538, fols. 3 right, 5 left, 13 right, 27 right, 33 right, 38 right, 39 right, 41 left and right, 42 right, 43 right, 44 left and right, 48 right, 52 left and right; GM 543, fols. 11r–v, 12r, 13r–v, 14r, 24r; GM 544, fols. 8v, 9v, 10r–v. Dorothy Traversi 1973, SSPMF, catalogue entry OA nos. 09/00014252, 09/00014254; Dorothy Traversi 1974, SSPMF, catalogue entry OA nos. 09/00016685, 09/00016693; Frezza in Florence 1980, p. 113; Frezza 1983, p. 248, n. 93; Ciatti and Avanzati 1990, pp. 282, 290–91, n. 45, fig. 7.10; D'Afflitto 2002, pp. 246–47 nos. 72–76 and illus., 366; Meoni 2002b, p. 169 and nn. 30, 31; Meoni forthcoming b.
10. For the dates of weaving and the arrangement in the Palazzo Pitti of the first edition of the *Seasons and Hours,* see ASF, GM 531, files 30, 41, 47; GM 538, fols. 5 left and right, 22 left; GM 543, fols. 6r, 8v–9v, 10v; GM 544, fols. 5v, 6r–v, 7v; GM 725, fol. 53v. Conti 1875, p. 65; Dorothy Traversi 1973, SSPMF, catalogue entry OA nos. 09/00014234–39; M. Campbell 1977, pp. 63–164, esp. pp. 74–75 and nn. 39–41, 127–30; Mosco 1982, pp. 33, 35–36 n. 9 and figs. 3, 8 (without archive references); Frezza 1983, pp. 241–42, 248 nn. 90–94; Meoni 2001a, p. 112; Meoni 2002b, pp. 169–71 and nn. 29–38; Meoni forthcoming a.
11. The *Story of Centaurs* is one of the first known examples; Meoni 1998, pp. 85, 290–95 nos. 102–5 and illus.
12. For the Palazzo Pitti apartment of Prince Cosimo, see Barocchi and Gaeta Bertelà 2005, pt. 1, p. 124 and n. 468.
13. ASF, GM 531, file 41, fol. [1r–v].
14. Gabinetto Disegni e Stampe degli Uffizi, Florence (hereafter GDSU), inv. 14612 F; Frezza 1983, pp. 241, 248 n. 91, fig. 28.

15. Hall 1974, pp. 26, 63.

16. ASF, GM 531, file 41, fol. [1r].

17. Hall 1974, p. 26.

18. *Spring, Summer, Autumn, Winter, Dusk,* and *Dawn* (Arazzi nos. 652–57) are all in the Sala delle Stagioni of the Amministrazione Provinciale, Palazzo Medici Riccardi, Florence. The first edition of *Chariot of the Sun* is on loan to the Italian Embassy in London (Arazzi no. 34); see *L'ambasciata d'Italia a Londra* 2003, pp. 42, 44–45, figs. 37, 38. As for the three overdoors, *Time* is in the Archivio di Stato, Florence (Arazzi no. 761); *Night* is in the Biblioteca Laurenziana, Florence (Arazzi no. 66); and *Day* (according to inventario Arazzi 1912–15 no. 65) was lost in the Italian Embassy in Berlin during World War II (photo Florence, SBAS, 5678). Of the three portieres, two are in Florence, one in the Palazzo Medici Riccardi (Arazzi no. 627) and one in the Depositi Arazzi Palazzo Pitti (Arazzi no. 746); the third is in the Art Institute of Chicago (1944.412, Gift of Robert Allerton; formerly collection of Elia Volpi, sold, Jandolo and Tavazzi, Rome, April 25–May 3, 1910, no. 388, illus.).

19. Four tapestries survive in Florence: *Chariot of the Sun* and *Dawn*, in the Depositi Arazzi Palazzo Pitti (Arazzi nos. 146, 313); one portiere in the Prefettura, Palazzo Medici Riccardi (Arazzi no. 363), and one overdoor, *Time*, in the Biblioteca Laurenziana (Arazzi no. 270). The overdoor *Night* is on loan to the Italian Embassy in London (Arazzi no. 248).

20. Hall 1974, p. 314. For these themes in Flemish tapestry, see Delmarcel 1999a, pp. 126, 232, 248, 273, 278, 308, 333, 357, 365–69.

21. Meoni 1998, pp. 48–54, 66–68, 105–8, 324–41, 473, 476–77, 480, 482–83, 485–86, 490–94, 498, 502, 515–24; Meoni 2000, pp. 236–40, 242, 244; Meoni 2001a, pp. 107, 109–13.

22. For the stucco workers of the Sala della Stufa, see Acanfora 1998b, p. 154 and n. 76. For the stucco workers from Rome, see M. Campbell 1977, pp. 65–66, 234, 237, 238.

23. M. Campbell 1977, pp. 127, 240–44.

24. ASF, GM 543, fol. 6r; Meoni forthcoming a.

25. ASF, GM 531, file 30. Frezza in Florence 1980, pp. 112–14 no. 207; Frezza 1983, pp. 241–42, 248 nn. 90–93; Meoni 2002b, pp. 169–71 and nn. 34–38.

26. ASF, GM 531, file 41, fols. [1r–v]; Meoni 2002b, p. 171 and n. 35; Meoni forthcoming a.

27. Ibid.

28. ASF, GM 543, fol. 11r.

29. ASF, GM 543, fols. 11v, 13v.

30. ASF, GM 543, fols. 13r, 14r.

31. Ciatti and Avanzati 1990, pp. 282, 290–91 n. 45, fig. 7.10; Meoni forthcoming a.

32. D'Afflitto 2002, pp. 107–17.

33. ASF, GM 531, file 41, fol. [1r–v].

34. F. Baldinucci 1681–1728/1845–47, vol. 5, p. 262; D'Afflitto 2002, p. 100.

35. Gregori 1962, p. 24; D'Afflitto 2002, pp. 112–13.

36. D'Afflitto 2002, pp. 111–14.

37. ASF, GM 543, fol. 13r.

38. For the kinds of looms in the San Marco workshop during those years, see Meoni 2002b, p. 173 and n. 44, and "Tapestry Production in Florence: The Medici Tapestry Works, 1587–1747" in this volume.

39. "[P]er avervi fatto una figura di Febo che ha prima fu fatta adiritto per l'alto liccio e questa serve per tessere a Calcula" (for having made a figure of Phoebus, which was first made straight on [not reversed] for the high-warp [loom], and this one is for weaving on a low-warp loom); ASF, GM 531, file 41, fol. [1r].

40. Conti 1875, p. 25; Müntz 1878–85, p. 75; Viale Ferrero 1961, p. 45; Ferrari 1968, p. 28.

Tapestry Production in Seventeenth-Century Rome: The Barberini Manufactory

JAMES G. HARPER

Though Rome was never a true center for tapestry production as Paris and Brussels were, some of the most ambitious suites of the Baroque period come from the papal city. Seventeenth-century Roman production is distinguished above all by its dependence on a single patron, Cardinal Francesco Barberini (1597–1679), who founded his own private manufactory in 1627 and maintained relatively tight control of it over its half century of activity. His ambition, in combination with his awareness of the power of the medium, inspired the production of six important cycles, as well as some smaller projects. In the end, though, the Barberini *arazzeria* (workshop or manufactory) was so closely identified with and dependent on the cardinal that it folded shortly after his death in 1679.[1]

Francesco Barberini inherited a love of luxury textiles from his uncle Maffeo Barberini, who had assembled a major tapestry collection in the years leading up to his 1623 election to the papal throne, when he became Urban VIII (fig. 131). The young nephew's aesthetic education was further honed on a diplomatic trip to Paris in 1625, at the culmination of which King Louis XIII presented him with seven newly woven panels from the *Story of Constantine* series.[2] These tapestries, produced by the Paris workshop of Marc de Comans and François de la Planche after designs by Peter Paul Rubens, were a gift of regal splendor, with gold and silver threads adding to the visual and material richness of the ensemble. But because the king had requisitioned the panels while the Paris workshop was little more than halfway through weaving Rubens's twelve-piece narrative, the set that the cardinal brought back to Rome was essentially a fragment. Among the iconographic omissions, the *Vision of Constantine*, the key conversion moment in the legend of the first Christian Roman emperor, was particularly conspicuous.

The most expedient way to fill out the set would have been to order the five additional panels from Comans and La Planche, who kept Rubens's cartoons in stock and produced several additional versions of them after completing a replacement set for Louis XIII.[3] Instead, Cardinal Barberini decided to customize

the set, modifying the iconography with new scenes designed by Pietro da Cortona. Even having done so, he could have sent Cortona's new cartoons to France or the Netherlands, where established workshops actively solicited this sort of custom commission. Pope Leo X had followed this model a century before, when he sent Raphael's celebrated *Acts of the Apostles* cartoons to Pieter van Aelst for production in Brussels. In light of these considerably easier and less expensive

Fig. 131. *Urban VIII Receiving from His Great-Nephews a Copy of the Aedes Barberinae by Girolamo Teti*, by Johann Friedrich Greuter after Andrea Camassei, 1642. Engraving, plate in the *Aedes Barberinae*, 35.6 x 23.5 cm. The Metropolitan Museum of Art, New York, Harris Brisbane Dick Fund, 1948 (48.106.2)

Fig. 130. Detail of cat. no. 35, *Constantine Fighting the Lion* from a set of the *Story of Constantine*

options, the cardinal's decision to establish a workshop—hiring master weavers, building looms, and seeing to the training of assistants—was extraordinary. Likewise, his decision to bankroll the operation himself rather than have the Vatican assume responsibility for it is notable, indicating that the patron's motives were private and dynastic rather than public.

Unlike the Medici, Cardinal Barberini was not motivated by an interest in diversifying his city's economy by establishing and nurturing a new industry.[4] Instead, his actions are best understood in the contexts of Aristotelian *magnificenza* and the competition among the leading noble families of Rome. The papacy was an elective monarchy, a system that inevitably left a number of former "first families" jockeying for status at the papal court. Beyond this most elite circle, other ambitious families cherished hopes of ascending through a future election. The result was a hothouse atmosphere in which patrons vied with each other to display a princely magnificence, within the bounds of decorum.[5] Cardinal Francesco surely recognized that founding and owning a private tapestry workshop would make the Barberini unique among the families with whom they competed. The only other manufactory of high-quality tapestry on the Italian peninsula in the seventeenth century was that of the sovereign grand dukes of Tuscany (the Medici), while the previous century had seen manufactories flourish under the sponsorship of the sovereign dukes of Ferrara (the d'Este) and of Mantua (the Gonzaga). Sponsorship of tapestry production carried an implicit claim of parity with these crowned heads.

Significantly, the founding of the Barberini manufactory coincided precisely with the period in which the cardinal and his brothers were constructing the Palazzo Barberini alle Quattro Fontane, the massive new palace-villa on the slopes of Rome's Quirinal Hill (fig. 132).[6] Criticizing the Barberini for reaching too far, one contemporary called the building "a royal work," a remark that could equally apply to the founding of the manufactory.[7] The cardinal would certainly have anticipated having to fill the new palace's acres of wall space, and it seems fair to consider the Barberini *arazzeria* an extension of the palace project (paralleling the relationship between the Medici *arazzeria* and Cosimo I's redecoration of the Palazzo Vecchio). Francesco Barberini planned to reside in the new palace, but in 1632 the lucrative and prestigious office of papal vice chancellor fell vacant and Urban VIII gave his nephew the appointment for life. It came with a splendid official residence, and henceforth Cardinal Barberini held court at the Palazzo della Cancelleria. Though the cardinal could hardly have anticipated

Fig. 132. *The Facade of the Palazzo Barberini alle Quattro Fontane*, by Camillo Cungi after Guido Ubaldo Abbatini, 1642. Engraving, frontispiece of the *Aedes Barberinae*, 35.6 x 23.5 cm. The Metropolitan Museum of Art, New York, Harris Brisbane Dick Fund, 1948 (48.106.2)

the move (which was contingent on the unexpectedly early death of the previous vice chancellor), his change in plans was served well by the choice of tapestry as a medium of self-representation. Monumental yet also easily portable, tapestry enabled Francesco Barberini to use his major cycles of visual imagery at his primary residence but also to have them moved across town for display at his family's dynastic seat when needed.[8] And while any permanent decorations installed at the Cancelleria would eventually devolve (with the residence itself) to subsequent vice chancellors, the cardinal could be assured that his ephemerally installed decorations would pass into the control of his own family after his death. Unlike fresco, tapestry ensured the tenant prince that the legacy of his patronage would always remain in sympathetic hands.

Because there had been no active production of high-quality, monumental tapestry in Rome since the fifteenth century, when Pope Nicholas V founded a short-lived *arazzeria* at the

Vatican, Cardinal Barberini had to look abroad for expertise.[9] He did careful research, corresponding with experts all over Europe and continuing to do so during the first few years the manufactory was up and running. The architect Luigi Arigucci, who had served the Barberini in other capacities, reported on the Medici tapestry workshop at Florence.[10] Papal diplomats, bishops, and other agents of the cardinal reported on methods and materials from Brussels, Paris, Avignon, Venice, and Naples.[11] Samples of dyed wool and silk, procured from various European workshops and still attached to the manuscript correspondence, helped the cardinal educate himself in the manufacture of tapestry. Inquiries sent from Rome included well-organized surveys with numbered questions, in response to which correspondents like Archbishop di Corsa, the papal nuncio to Brussels, gathered answers. The most challenging query seems to have been about how to make a bright and lasting green. The archbishop left this question unaddressed in his first letter and in a subsequent communiqué apologized, explaining that his failure to respond was "because here there is not a single dyer" willing to part with this closely guarded trade secret.[12] Flemings were known to be the best-trained weavers, and it is not surprising that when payments relevant to the Barberini *arazzeria* begin in 1627, they are to Jacob van den Vliete, a master weaver from Oudenaarde who Italianized his name as Giacomo della Riviera.

Though scholars have long assumed that Filippo Baldinucci was correct in claiming that the Barberini imported their weavers from Flanders, evidence has recently surfaced indicating that Cardinal Barberini found della Riviera right there in Rome.[13] Though born abroad, the weaver was in Rome as early as January 1625, when he inscribed himself on the membership rolls of the confraternity of San Giuliano dei Fiamminghi, providing a firm terminus post quem for his presence in the papal city. He would later serve as *provveditore* of the confraternity, which was located in the immediate vicinity of the Barberini family's original Roman palace, the so-called Casa Grande ai Giubbonari. Della Riviera took on at least two assistants, a Frenchman named Antoine and a Fleming named Michel.[14] The workshop also included some local craftsmen, among them Gaspare Rocci, who married della Riviera's daughter and ran the workshop after the master's death in 1639.[15] After his own death in 1648, Rocci was succeeded by his wife, Giacomo's daughter Caterina della Riviera (d. 1653). She was, in turn, succeeded by her sister, Maria Maddalena della Riviera (1611–1678), who supervised the manufactory until her death. For the short time that the workshop continued in oper-

ation after that, it was run by one Anna Zampieri, whom Candace Adelson has speculated may be a descendant or relative of the painter Domenichino.[16]

Though this workshop occupied several locations over its half century of activity, none was far from the cardinal's daily rounds: the initial site at the Palazzo Cesi was adjacent to Barberini's apartment at the Vatican Palace, as was the subsequent location around the corner in the Palazzo Rusticucci. Later, during the weaving of the *Constantine* series, the operation moved to the Casino degli Accoramboni, very near the Palazzo Barberini, where the cardinal kept his library. The final location, in the Viccolo dei Leutari, was just a few yards from the Cancelleria.[17]

A second workshop, charged with lesser tasks including tapestry repair and the production of border panels, portieres, and carpets, was run by a weaver from Picardy named Pierre Lascot.[18] He always had several assistants and was joined by another master weaver, named Lorenzo Castellani, in about 1647. The odd jobs that fell to him included the adaptation of a Brussels set of hunt scenes to Barberini use, a task that involved creating borders as well as a new panel of an *Ostrich Hunt* (1643–45, after the design of Clemente Maioli). Like Giacomo della Riviera, Lascot seems to have been present from the very earliest years of the manufactory's activity: one seventeenth-century source even credits him with the construction of the Barberini looms.[19] Unlike della Riviera's workshop, however, Lascot, Castellani, and company took in work from patrons outside the Barberini family. Cardinal Grimaldi paid Lascot for a set of portieres in 1646, Cardinal Flavio Chigi paid for a tapestry of the two Saints John that Castellani began in 1668, and evidence also suggests that this workshop did work for the Colonna and the d'Este families.[20] Della Riviera's workshop, meanwhile, seems to have worked exclusively on Cardinal Francesco's projects and Urban VIII's Vatican commissions, nearly all of which were designed by Pietro da Cortona or members of his school. Della Riviera and his successors interpreted the vivid high Baroque style of Cortona and his followers faithfully, careful not to embellish or misinterpret the cartoons and bringing the scenes to life with what Lucia Meoni has characterized as a "refined chromatic harmony."[21]

Though the *Constantine* project had provided the impetus for the founding of the Barberini workshop, it was not the first set that Giacomo della Riviera produced. Instead, he and his weavers began with a smaller-scale undertaking. The *Castles* series, woven between 1627 and 1630, juxtaposed Barberini country seats like Palestrina (fig. 133) and Monterotondo with

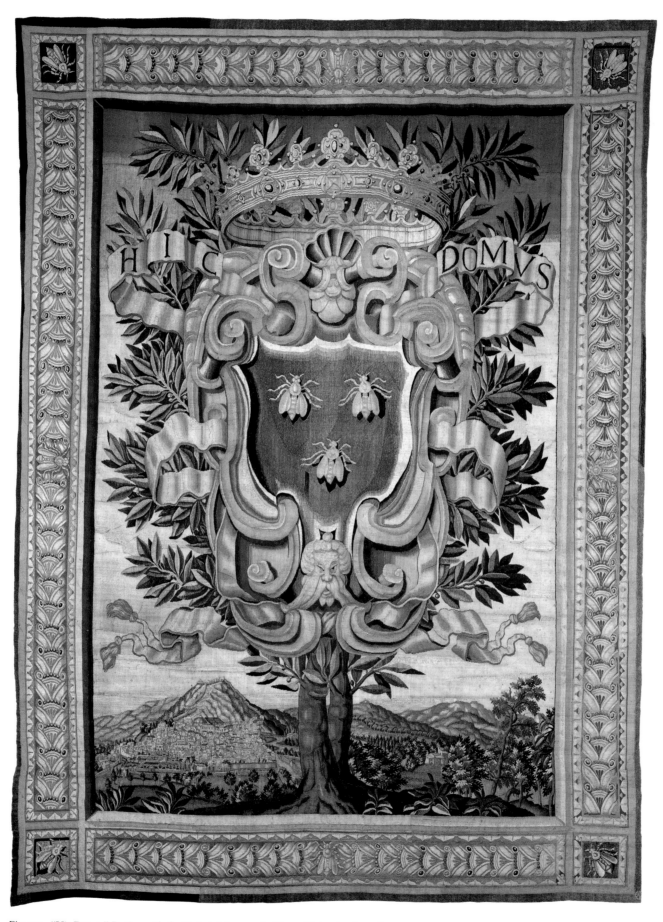

Fig. 133. *"Hic Domus" Portiere with the Barberini Arms and a View of Palestrina* from the set of the *Castles*. Tapestry cartoon by Francesco Mingucci, woven in the Barberini workshop under the direction of Giacomo della Riviera, Rome, 1627–30. Wool and silk, 315 x 220 cm. Private collection, Rome

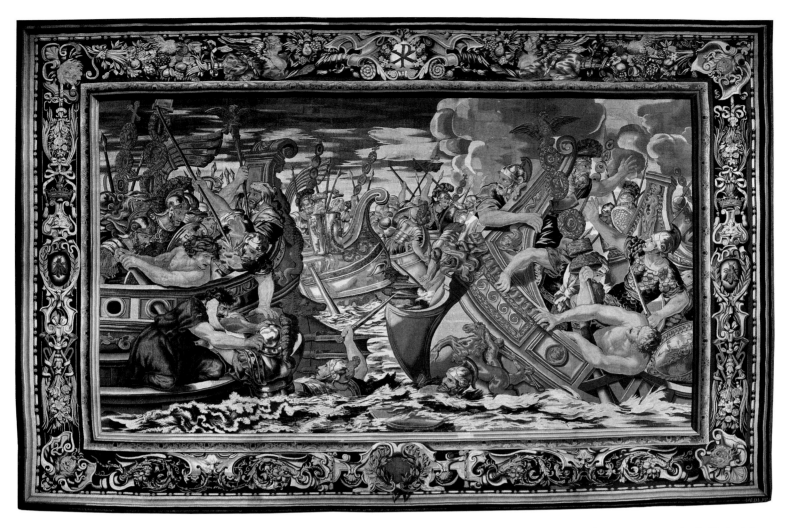

Fig. 134. *Sea Battle between the Fleets of Constantine and Licinius* from a set of the *Story of Constantine*. Tapestry design by Pietro da Cortona, woven in the Barberini workshop under the direction of Giacomo della Riviera and Gaspare Rocci, Rome, 1634–35. Wool, silk, and silver and gilt-metal wrapped thread, 508 x 711.2 cm. Philadelphia Museum of Art, Gift of the Samuel H. Kress Foundation, 1959 (1959-78-9)

some of the most famous royal palaces of Europe, including Louis XIII's Fontainebleau and Philip IV's Aranjuez. In all, six main panels, two portieres, two overdoors, and two *cantonate* (panels to fill the corners of a room) were made after the designs of Filippo d'Angeli and Francesco Mingucci, both under the supervision of Pietro da Cortona.[22] Though both della Riviera and his patron must have been anxious to get to the *Constantine* panels, this smaller assignment allowed the weavers to practice working together on the new looms.[23] The stakes were high, after all: the completion of the *Constantine* series would inevitably be seen in terms of *paragone* (competitive comparison), with the new Roman manufactory compared with the established French professionals, Pietro da Cortona compared with Rubens, and the Barberini family compared with the royal families they were doing so much to emulate.

The panels of the *Constantine* series are the most materially precious of the Barberini workshop's production, as copious

use of gold and silver threads was necessary to match the effect of the French panels. Between 1630 and 1641 the workshop did just that, producing five large narrative panels, a number of smaller overdoors and *entrefenêtres*, and a matching baldachin with a dossal representing a statue of Constantine.[24] Giacomo della Riviera signed the *Constantine* panels with an abbreviated version of his name, IAC.D.L.RIV. And though he died in 1639, before the series was completed, his successor and son-in-law Gaspare Rocci used his name on the remaining panels. The narrative panels of the series and the dossal with the statue of Constantine survive in the collection of the Philadelphia Museum of Art (fig. 134, cat. no. 35).

While imitating the overall scheme and general compositional massing of the Rubens-designed French tapestries, the Roman panels adapted Louis XIII's gift to Barberini use.[25] On the most obvious level, the Barberini heraldic bees replaced the French fleur-de-lis and the chains of Navarre in the borders.

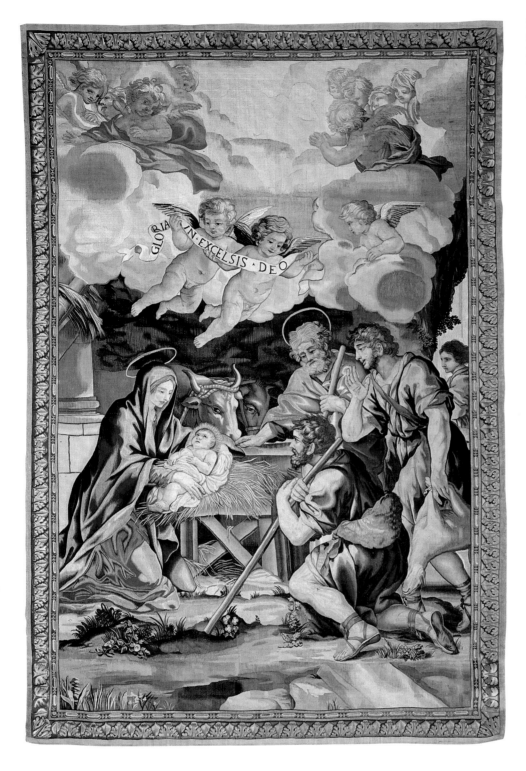

Fig. 135. *The Nativity*, altarpiece dossal from the Sistine Chapel baldachin project. Tapestry design by Pietro da Cortona, woven in the Barberini workshop under the direction of Giacomo della Riviera, Rome, 1635–36. Wool and silk, 385 x 248 cm. Vatican Museums, Vatican City (43739)

Likewise, the selection of narratives referenced topics that were dear to the Barberini, emphasizing papal precedence and the subsidiary role of kings as champions of the church. The addition of the overdoors and *entrefenêtres*, moreover, customized the set for use in the specific spaces of the Palazzo Barberini, the main representational seat of the family.[26] Though they would also be displayed in other spaces, both indoors and out, they would have harmonized most perfectly with the *Divine Providence* ceiling fresco that Pietro da Cortona was painting in

the great hall of the palace between 1633 and 1639, years that coincide closely with the production of the tapestries.

The cardinal diverted resources from the production of the *Constantine* series just once, for the weaving of a baldachin and altarpiece ensemble for the Sistine Chapel at the Vatican Palace. Begun in 1635, this commission initially included a tapestry altarpiece of the Nativity (designed by Pietro da Cortona; fig. 135) and a matching six-panel tapestry baldachin.[27] This phase of the project was completed in 1637, whereupon the workshop

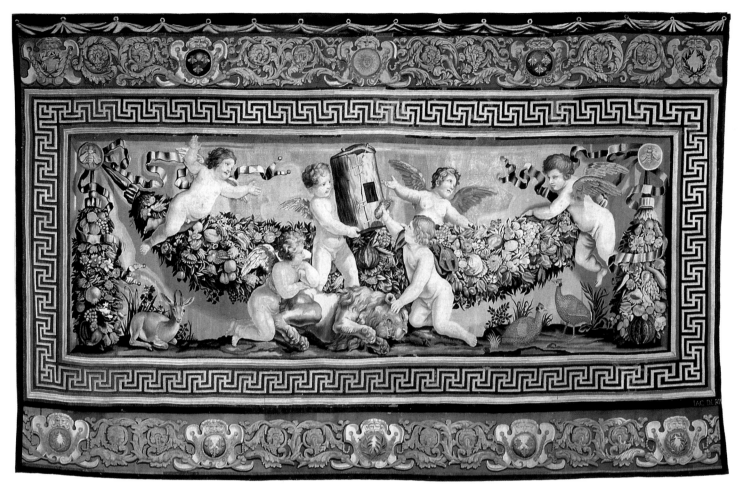

Fig. 136. *Lion Stung by a Bee* from the set of the *Giochi di putti*. Tapestry design by Giovanni Francesco Romanelli, woven in the Barberini workshop under the direction of Giacomo della Riviera, Rome, 1637–39. Wool, silk, and silver and gilt-metal wrapped thread, 345 x 510 cm. Museo Nazionale del Palazzo Venezia, Rome

resumed full-time work on the *Constantine* series. Once that was finished, they took up the Sistine project again, adding two more interchangeable dossals, the 1642 *Resurrection* and the 1643 *Pasce oves meas* (Feed My Sheep). Both were paid for by the Vatican, and both followed the designs of Giovanni Francesco Romanelli. Fifteen years later, in 1658, the Barberini *arazzeria* would add a fourth interchangeable altarpiece depicting the Annunciation, paid for by Cardinal Barberini and presented to Pope Alexander VII as a gesture of goodwill.[28] This gift would have encouraged the new pope to display the ensemble, the baldachin of which was swarming with the heraldic Barberini bees. The commingling of these with the heraldic devices of Alexander's Chigi family in the borders of the new panel would have broadcast a desirable message of alliance and allegiance from the very epicenter of the Roman court. The Vatican commissioned six extra border panels, designed by Ciro Ferri, from Pierre Lascot's workshop a year later, in 1659, an addition that suggests adaptation of the interchangeable dossals for simultaneous display in the manner of a conventional tapestry series.[29]

Another project for Vatican use that overlapped the production of the *Constantine* series is the *Giochi di putti*, begun in 1637 and finished in 1642 (fig. 136). This set of smaller-scale panels, also designed by Romanelli, followed the stylistic and compositional model of Tommaso Vincidor's celebrated early sixteenth-century *Giochi di putti*, which remained in the Vatican collection up through 1770.[30] Playful yet poetically erudite, the new panels customized the Raphaelesque theme to Urban VIII's personal iconography and taste.[31] As with the *Constantine* series, these were begun under the master weaver Giacomo della Riviera and finished after his death under Gaspare Rocci, who signed them with the initials IAC D L RIV, as a tribute to his father-in-law. Five of the eight panels survive in the Museo Nazionale del Palazzo di Venezia in Rome, while Romanelli's cartoons survive at the Villa Lante in Bagnaia.

Cardinal Barberini called on Giovanni Francesco Romanelli again for the design of the next workshop's project, a *Life of Christ* that was comparable in scale to the *Constantine* series. Though Romanelli coordinated the design process, he delegated

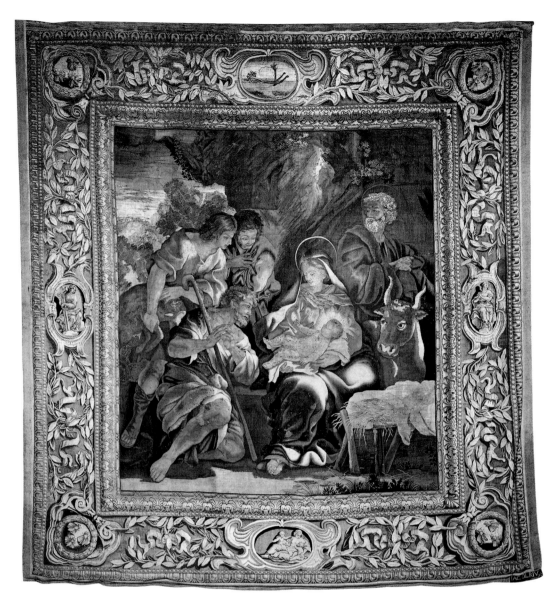

Fig. 137. *The Adoration of the Shepherds* (before conservation) from the set of the *Life of Christ*. Tapestry cartoon by Paolo Spagna after Giovanni Francesco Romanelli, woven in the Barberini workshop under the direction of Caterina della Riviera, Rome, 1649–50. Wool and silk, 477.5 x 416.6 cm. Cathedral Church of Saint John the Divine, New York (82.1.6)

some of the individual cartoons to others, including Paolo Spagna, Giuseppe Belloni, and Clemente Maioli. The weaver Gaspare Rocci seems to have been responsible for one of the cartoons, a copy of the *Crucifixion* that Pietro da Cortona had painted in the chapel of the Palazzo Barberini. Several other panels also featured recycled designs: Romanelli reused his cartoon for the Sistine Chapel *Resurrection*, and the cartoons for the *Adoration* (fig. 137) and the *Last Supper* copy works that Romanelli had painted for churches in Rome and Viterbo.

The project occupied the energies of the workshop from 1643 to 1656. These were difficult years for the Barberini family: with the death of Pope Urban in 1644 and the election of the inimical Innocent X (Pamphili, r. 1644–55), Cardinal Francesco and his brothers found themselves under investigation for, among other things, the misappropriation of funds during the First War of Castro. The Barberini brothers fled to France in January 1646, and the della Riviera workshop (which had received its last payment a month before the Barberini left) was not paid again for over a year.[32] Lascot's workshop continued in operation, as his correspondence with the exiled cardinal attests.[33] His request, in one of these letters, for one of the looms from the della Riviera workshop suggests the inactivity of the latter. Production resumed in full in April 1647, however, as the situation of the Barberini brightened. Some ten months later the cardinal was back in Rome. The series was finished in 1656 and must be credited to three master weavers in succession: Gaspare Rocci, Caterina della Riviera, and Maria Maddalena della Riviera. The set survives in the Cathedral of Saint John the Divine in New York City, though two panels were severely damaged in a fire there in December 2001.

With the completion of the *Life of Christ* and still under the leadership of Maria Maddalena della Riviera, the workshop

undertook the weaving of a five-piece series of the *Stories of Apollo*. Contemporary audiences would have readily understood the Greco-Roman sun god as an allegory of the Barberini, who often used Apollonian imagery in their self-promoting propaganda.[34] Designed by the painter Clemente Maioli and featuring small-scale figures in grand classical landscapes, these panels were completed from 1659 to 1663. Unlike the other major series of the Barberini manufactory, these eschew the heroic manner for a more lyrical style akin to the mythological landscapes of Nicolas Poussin and Claude Lorrain. Panels from the set survive in the Minneapolis Institute of Arts and the Fondation Toms Pauli in Lausanne (cat. no. 37).[35]

The final product of the workshop, the *Life of Pope Urban VIII*, was arguably its most ambitious (fig. 138, cat. no. 38).

Celebrating the dynasty directly through its focus on the Barberini pope and its inclusion of other family members throughout, this set of ten large-scale narratives and their figurated borders was designed to fill the upper register of the great hall of the Palazzo Barberini (though that intention certainly did not preclude display elsewhere). Though documents do not specify the size of the Barberini looms, they were built with the *Constantine* series in mind and were apparently not wide enough to produce panels scaled to the space that Cardinal Barberini intended to fill. To compensate, the workshop came up with the clever solution of detachable borders, relegating the superscription to a horizontal upper border and filling a lower border with a secondary narrative scene, articulated as a fictive bas-relief (figs. 139, 140). Pietro da Cortona

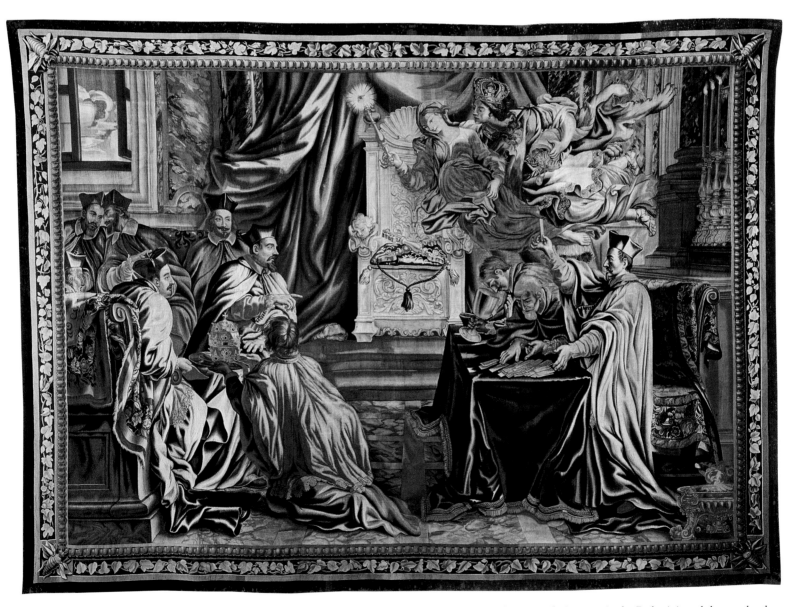

Fig. 138. *The Election of Pope Urban VIII* from the set of the *Life of Pope Urban VIII*. Tapestry cartoon by Fabio Cristofani, woven in the Barberini workshop under the direction of Maria Maddalena della Riviera, Rome, 1667–68. Wool and silk. Vatican Museums, Vatican City

Fig. 139. *Allegory of Maffeo Barberini's Florentine Birth,* pilaster *termine* panel from the set of the *Life of Pope Urban VIII.* Tapestry design by Antonio Gherardi with the collaboration of Lazzaro Baldi, woven in the Barberini workshop under the direction of Maria Maddalena della Riviera, Rome, 1663. Wool and silk, 540 x 120 cm. Philadelphia, Philadelphia Museum of Art, Gift of Vicomte Charles de Noailles (1960-95-1)

Fig. 140. Detail of the *Double Portrait of Antonio Barberini and Camilla Barbadori, Parents of Pope Urban VIII,* pilaster *termine* panel from the set of the *Life of Pope Urban VIII.* Tapestry design by Antonio Gherardi with the collaboration of Lazzaro Baldi, woven in the Barberini workshop under the direction of Maria Maddalena della Riviera, Rome, 1663. Wool and silk, 563.9 x 121.9 cm. Museum of Fine Arts, Boston, Gift of Eugene L. Garbáty in memory of his parents, Josef and Rosa Garbáty (50.3586)

supervised the design of the ensemble and probably provided sketches for the narrative scenes. However, as Romanelli had done for the *Life of Christ,* Cortona turned over responsibility for the actual cartoons to a succession of artists, beginning with Antonio Gherardi and including Fabio Cristofani and Giuseppe Belloni. At Cortona's death in 1669, Ciro Ferri assumed artistic oversight of the project, availing himself of the services of Cristofani, Giacinto Camassei, Pietro Lucatelli, Urbano Romanelli, and Giuseppe Passeri.[36] The project occupied the Barberini looms from 1663 to 1679, longer than any of the previous series had taken. The last payments for the *Life of Pope Urban VIII,* for a trio of lateral borders, came on November 29, 1679, just two weeks before the death of the aged Cardinal Barberini.[37] There is still some debate as to whether the series was fully completed or whether its production was brought to an expedient conclusion just as the workshop anticipated losing its sustaining patron. In any case, the date of 1683, sometimes given for the termination of production, is in error.[38]

More than twenty years after the demise of the Barberini workshop, Arcangelo Spagna, a courtier, dramatist, and Barberini intimate who also wrote a manuscript biography of Cardinal Francesco, was asked to pen a brief account of the Barberini manufactory's history.[39] As a member of the cardinal's inner circle, Spagna was well equipped to do so, and though his memory does not always serve him with absolute precision, this document helps us imagine the end of the *arazzeria.* The manuscript poignantly recounts the fates of the tapestry workers on the death of the cardinal: "All those connected to the works were dismissed, selling the looms for scrap wood . . . and the poor tapestry weavers were cut off without employ, becoming nearly beggars: Monsu Giovanni opened up a little shop in the Via dei Coronari to make a living, taking in only old tapestries in need of repair. Francesco was hired as the attendant of the *guardaroba* [wardrobe] at the Palace of Monterotondo [one of the Barberini country seats], where he died. Monsu Giovanni likewise died, as had the female weavers, so no direct memory remains anymore of this enterprise."[40]

It should come as no surprise that the Barberini tapestry works did not outlive the cardinal by more than a year, as its ties to him were so close. Unlike the Medici manufactory, which took in work from outside patrons to mitigate high operating costs and gain a measure of independence, the Barberini shop existed primarily to serve the desires of one individual owner. Moreover, the cardinal maintained possession of the cartoons, ensuring that each product was a unicum, yet also denying the manufactory the opportunity to make money by repeating series for other patrons. With the demise of the Barberini workshop, the production of high-quality monumental tapestry disappeared from the papal city. It would return, however, in the space of a generation: Pope Clement XI, who had requested Spagna's account as part of a preparatory information-gathering process, would revive tapestry production (this time on a public scale) with the founding of the San Michele manufactory in 1710.[41]

1. While scholars like Pascal-François Bertrand (2005) and Anna Maria De Strobel (1989) get the date right, others follow Italo Faldi (1967). For more on this, see Harper 2005, pp. 51–52.

2. Bertrand 2005, pp. 46–49, gives a summary of the cardinal's movements during the legation to France (and the 1626 legation to Spain), with particular attention to viewing tapestries at various French residences.

3. Manuscript evidence (in Biblioteca Apostolica Vaticana [hereafter BAV], MS Barb. Lat. 4373, fols. 71–79), cited by Urbano Barberini (1950, p. 49) and further discussed by De Strobel (1989, p. 21), suggests that Barberini at least considered the option of ordering from France.

4. Here I disagree with Bertrand 2005, p. 54.

5. The fundamental analysis of these conditions is Haskell 1963.

6. The Palazzo Barberini project was begun in 1628. J. B. Scott 1991, pp. 16–18; Waddy 1990, pp. 173–271.

7. BAV, MS Vat. Lat. 8781. J. B. Scott 1991, p. 17, cites Ranke 1901, vol. 3, p. 7, for the document.

8. In this sense, discussion of whether a series was meant for one palace or another (as in Meoni 2002b, p. 179) becomes more idle the more rigidly it is conducted.

9. For the production of tapestry in Rome between 1451 and 1458, see De Strobel 1989, pp. 9–10; and Bertrand 2005, p. 54.

10. For Arigucci's report, dated February 1628, see BAV, MS Barb. Lat. 4373, "Raccolta di diverse Relationi circa il fabricare Arazzi," fols. 18–20.

11. BAV, MS Barb. Lat. 4373, "Raccolta di diverse Relationi circa il fabricare Arazzi," passim.

12. See BAV, MS Barb. Lat. 4373, "Relationi da Bruxelles, da Mons. Ill.mo Archivescovo di Corsa Nuntio," fols. 43–50, 64–70. These documents are discussed and partially transcribed in Harper 1998, pp. 24–25.

13. Meoni 2002b, p. 178, esp. n. 71.

14. The discovery of the names of the French assistants was first published in Müntz 1876, p. 230. See also Cavallo 1957, pp. 21–22; and De Strobel 1989, p. 15. For the suggestion that the Fleming "Michel" may have been the young Michiel Wauters, see Forti Grazzini 1997, p. 143.

15. De Strobel 1989, p. 15, lists the names of other workers including Lorenzo Castellani, Francesco Salvatori, and five assistants, named Alessandro, Leonardo, Michelangelo, Lucino, and Benedetto.

16. Adelson 1994, p. 405.

17. See Barberini 1968, p. 92, who asserts that the proximity of the arazzeria to the Barberini residences reflects the patron's closeness to the enterprise and his probable inclination to drop in from time to time to check progress.

18. Bertrand 2005, p. 158, n. 85.

19. For the question of Lascot's participation, and the confusion of the sources on this matter, see De Strobel 1989, p. 16.

20. Bertrand 2005, p. 55.

21. Meoni 2002b, p. 181.

22. De Strobel 1989, p. 18.

23. Meoni 2002b, p. 179, has further suggested that the Castles were a means of "get[ting] used to making cartoons in reverse which was necessary for weaving with a low-warp loom."

24. Dubon 1964, passim; Barberini 1950, p. 146.

25. For the "customization" of the Constantine tapestries to Barberini use, see Zurawski 1979, pp. 102–9.

26. For an attempted reconstruction of this installation, see (with some caveats), ibid., p. 167.

27. De Strobel 1989, pp. 24–32.

28. The chronology and authorship of the Vatican series are worked out (and supported with archival references) in ibid., pp. 24–32.

29. The number of borders, six, compared to the number of narrative panels, four, suggests the reuse of borders from the baldachin ensemble for one panel and the creation of equivalent borders for the remaining three panels. De Strobel (1989, pp. 31–32) publishes these documents and offers an interpretation of them different from the one presented here.

30. Maria Selene Sconci in New York–Kansas City 1999, pp. 171–72, no. 41.

31. Weddigen 1999; T. Campbell in New York 2002, pp. 254–56.

32. De Strobel 1989, p. 37, n. 83; see also Bertrand 2005 p. 158, n. 104.

33. BAV, MS Barb. Lat. 6539, fols. 47r–48r, transcribed and discussed in Harper 1998, pp. 27–28.

34. For more on this question, see cat. no. 37.

35. See De Strobel 1989, pp. 41–42; Adelson 1994, pp. 395–405; Bertrand 2005, p. 136; and Delmarcel in Payerne 1997, pp. 76–79, nos. 19–20.

36. For the authorship (and other salient details) of each panel of the Life of Pope Urban VIII, see the catalogue in Harper 1998, pp. 556–77.

37. Ibid., p. 574, no. III.9.e.

38. For the question of the date of the completion of weaving, see Harper 2005, pp. 51–52. For the question of whether or not the series was "complete," see Harper 1998, pp. 96–100, 509–17. I plan to expand upon these remarks in a future publication.

39. Archivio Segreto Vaticano, MS Albani 16, "Sopra l'introduzione in Roma dell'arte di fare gli arazzi," fols. 40r–41r. Spagna's account is transcribed in full (with commentary) in Harper 1998, app. B, no. 7, pp. 596–98. Although some scholars have spoken loosely of this document as "seicento," internal evidence dates it to after Clement XI's accession to the throne in 1700 and before that pope's founding of the San Michele manufactory in 1710.

40. Archivio Segreto Vaticano, MS Albani 16, fol. 40v.

41. For the San Michele manufactory, see De Strobel 1989, pp. 52–59; De Strobel 1998.

35.
Constantine Fighting the Lion

From a twelve-piece set, plus baldachin with dossal, of the *Story of Constantine*
Design and cartoon by Pietro da Cortona, ca. 1636
Woven in the workshop of Giacomo della Riviera, Rome, 1636–37
Linen, silk, wool, and silver and gilt-metal wrapped thread
500 x 294 cm (16 ft. 4⅞ in. x 9 ft. 7 in.)
Weaver's mark in lower selvage at right, IAC.D.L.RIV.
Philadelphia Museum of Art, Gift of the Samuel H. Kress Foundation, 1959 (1959-78-11)

PROVENANCE: Barberini family, Rome; 1889, Charles Mather Ffoulke, Washington, D.C.; 1896, Mrs. Phoebe Hearst; 1913, John R. McLean; . . . ; 1948, sold, Parke-Bernet, New York; before 1956, Mitchell Samuels; 1957, Samuel H. Kress Foundation; 1959, Philadelphia Museum of Art.

REFERENCES: Göbel 1928, p. 419; Barberini 1950, pp. 48, 50, 146, 149; Viale Ferrero 1961, p. 47; Dubon 1964, p. 117; Ferrari 1968, pp. 15, 48, 49; Zurawski 1979; De Strobel 1989, pp. 21–24; J. B. Scott 1991, p. 197; Bertrand 1998b, pp. 62, 65, 66, 72; Bertrand 2005 pp. 52, 115.

Constantine Fighting the Lion is one of the early products of the Barberini tapestry manufactory in Rome. The scene shows a heroic, semilegendary episode from the youth of Constantine (A.D. 272–337), the first Christian emperor of Rome. Pietro da Cortona (1596–1669), who designed the panel at the commission of Cardinal Francesco Barberini (1597–1679), conceived it as one of several in a series that was originally designed by Peter Paul Rubens for King Louis XIII of France. The Paris workshop of François de La Planche and Marc de Comans began weaving the Rubens set in 1622, but in 1625, with only seven of the panels completed, the king requisitioned them for use as a diplomatic gift. The weavers began the series anew, while Cardinal Francesco Barberini, the recipient of the gift, took the seven finished panels back with him to Rome. There the cardinal, the eldest nephew and secretary of state of Pope Urban VIII (r. 1623–44), decided to complete the set by commissioning five more narrative panels and a baldachin with a dossal that depicts a statue of the emperor. It is notable that while he could have accepted weavings after the remaining Rubens designs from France (see cat. no. 14), the cardinal decided to have his own artist generate new, original compositions. The French workshop would go on to produce the full set after Rubens's designs, but the Barberini *Constantine* series is unique in its commingling of designs by Pietro da Cortona with those of Rubens. The full set survives in the Philadelphia Museum of Art: the French panels are *Constantine's Entry into Rome*, the *Marriage of Constantine*, the *Battle of the Milvian Bridge* (see cat. no. 14), the *Baptism of Constantine*, *Constantine Worshipping the True Cross*, *Constantine Directing the Building of Constantinople*, and the *Death of Constantine*. The newer Italian panels are *Constantine Ordering the Destruction of the Pagan Idols*, the *Sea Battle between the Fleets of Constantine and Licinius* (fig. 134), the *Apparition of the Cross before Constantine*, *Constantine Burning the Memorials*, *Constantine Fighting the Lion* (cat.

no. 35), and the *Statue of Constantine* (a dossal).

In their narrative selections and iconography, as well as in the deployment of Barberini heraldic devices in the borders, Cortona's additions customized Rubens's set to the Roman context in which they would be displayed. The new scenes, including *Constantine Fighting the Lion*, are specifically responsive to the propagandistic needs of the Church and of the dynasty, allegorizing events in Urban VIII's papacy and emphasizing the divinely sanctioned aspect of rulership. Although Cardinal Barberini displayed the *Constantine* tapestries on a variety of occasions and in several locations, most scholars agree that the set's intended primary locus of display was the great hall of the Palazzo Barberini alle Quattro Fontane, the family complex that was rising on Rome's Quirinal Hill during the same years that the Barberini *Constantine* panels were in production.

Description and Iconography
Constantine Fighting the Lion shows the future emperor's combat with a fearsome wild beast, early proof of his courage and prowess. In the center foreground, the graceful yet tense protagonist plunges a sword down the lion's throat and through the back of its head. Blood spills down the animal's mane and coat, staining the ground below. The rearing lion and the swirling, billowing drapery enhance the drama established in Constantine's vigorous pose. Behind them, soldiers watch excitedly from the other side of a stockade fence, a barrier that underscores the sense of danger and at the same time provides a neutral backdrop to set off the foreground action. The setting, a military camp, is established through the tops of campaign tents visible behind the spectators' heads. The form of these tents, as well as the archaeologically accurate details of costume, legionary standards, and weapons, all reflect Cortona's careful study of classical antiquity.

Constantine's life was a fairly popular subject in the Renaissance and Baroque eras, because it allowed imperial references while

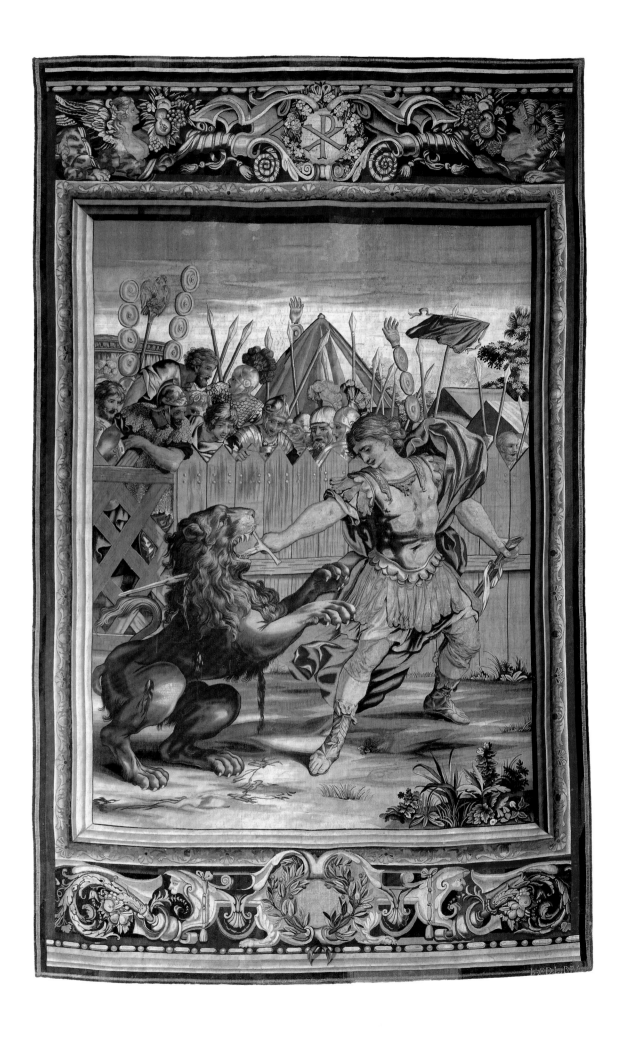

Fig. 141. *Constantine Fighting the Lion*, by Pietro da Cortona and workshop, ca. 1636. Cartoon for the tapestry in the *Story of Constantine*. Tempera on paper, 338 x 268 cm. Galleria Nazionale d'Arte Antica, Palazzo Barberini, Rome

featuring a Christian exemplar.[1] Constantine's rise to power was, moreover, one of the most compelling narratives of ancient history. He was the illegitimate son of Constantius, a general who rose to the rank of caesar (junior emperor within the Roman tetrarchy) and subsequently augustus (senior emperor). The boy was educated at court while Constantius soldiered on the northern frontier of the empire. In 306 he joined his father's campaign against the Picts, and when Constantius died at York, the troops (ignoring the proper rules of succession) proclaimed Constantine augustus. Over the next six years, he steadily consolidated power, and on his defeat of Maxentius at the Milvian Bridge in 312 (cat. no. 14), he became sole ruler of the western half of the empire. By 323 Constantine had defeated his coemperor in the east and abolished the tetrarchy, uniting the entire empire under his own rule. His radical accomplishments include the legalization of Christianity and the transfer of the capital from Rome to the new city of Constantinople. Whether he converted in 312 or on his deathbed, Constantine's place in history as the first Christian emperor is undisputed.

Urban VIII actively fashioned himself as a New Constantine, a self-identification fueled by the French gift to his nephew. The pope had made sure, for instance, that his consecration of New Saint Peter's Basilica took place on the thirteen-hundredth anniversary of the A.D. 326 consecration of Constantine's Old Saint Peter's Basilica.[2] Urban's choice is all the more striking for its redundancy under canon law: since the basilica had been in continuous liturgical use throughout the various phases of demolition and construction, consecration was unnecessary. Another Barberini undertaking, the renovation and redecoration of the Lateran Baptistery (widely believed to be the site of Constantine's baptism), directly juxtaposed medallic images of Urban VIII and the first Christian emperor. If Francesco Barberini's tapestry additions to the *Story of Constantine* are allegories of Urban's papacy, *Constantine Fighting the Lion* may be read as a reference to Urban VIII's protection of Rome from the plague of 1629–32, an accomplishment that would be represented more directly in the later tapestry series of the *Life of Pope Urban VIII* (cat. no. 38).

Scholars have yet to identify a specific literary or historic source for the tapestry's scene of Constantine and the lion. Given the protagonist's youthful appearance and the military camp setting, the narrative must belong to the brief period during which Constantine accompanied his father on military campaign. His acclamation, by his father's troops, as augustus was the most significant milestone of this period, but it is notable that neither Rubens's nor Cortona's series dedicates an independent panel to this event. There was good reason to avoid direct representation of the acclamation, for it would have reminded viewers of the awkward but undeniable fact that Constantine's rise began with a military coup. In Rome, where the papacy contended that earthly authority requires divine sanction and further held that the pope (not the army) was the arbiter of princes, such an emphasis would have been even less desirable than it would have been in Paris. *Constantine Fighting the Lion*, by contrast, explains the rise of this extraordinary man as rooted in the divinely granted virtues of fortitude and courage.[3] Simone Zurawski, author of the most systematic iconographic study of the *Constantine* series, assumed that the invention of the lion-fighting scene was Cortona's own. This seems unlikely, however, especially considering Francesco Barberini's intense interest in literature and the history of the early Church, as well as Cortona's tendency to look to his patrons to determine programs. Though no stories of lion fighting appear in the major biographies like Eusebius's fourth-century *Life of Constantine*, there is doubtless some source among the panegyrics (surviving or vanished) generated by poets at Urban's court.[4]

The imagery of lion hunting as an indication of fitness for rulership has roots in ancient Persia, whence it was appropriated and brought west by Alexander the Great. The ancient Romans continued the tradition, merging it with the exemplary myth of Hercules. Constantine, for instance, issued a coin with his portrait on the obverse and an image of Constantine/Hercules fighting the Nemean Lion on the reverse.[5] It is possible that this coin provided direct inspiration for Cortona's invention. Similarly, the inclusion of leonine combat in the tapestry series may have been suggested by the sculptural

Detail of cat. no. 35

program of the Arch of Constantine, on which seventeenth-century Romans could see a roundel with the emperor standing over a dead lion. Though this second-century hunt scene originally depicted Hadrian, whose features were recut to resemble those of Constantine, its relocation on the fourth-century arch cemented the association between the lion and Constantine's identity.

Regardless of the origins of *Constantine Fighting the Lion*, the appeal of the episode is obvious, and its multifaceted meaning connects to a series of flattering references. Hercules' defeat of the Nemean Lion read, to the seventeenth-century erudite, as an allegory of (among other things) the protection

and delivery of peoples from suffering.[6] The Judeo-Christian tradition underscored the link between leonine combat and protective rulership through the figure of King David who, as a young shepherd, "went out after [the lion that had violated the flock he was tending] . . . and smote him, and slew him" (1 Samuel 17:34–35). Urban VIII identified himself with both David (who, like the pope, was a poet-ruler) and Hercules, who figures prominently as an allegory of Barberini rule on the ceiling of the great hall at the Palazzo Barberini. The 1634 edition of Urban's own poems, published two years before Cortona designed this tapestry, features a frontispiece depicting Samson wrestling a lion.[7]

A scene of Constantine fighting a lion evoked, moreover, the legendary persecutions in the time of the emperor's youth in which Christians were thrown to lions as popular entertainment. Cortona's composition, with the enclosed arenalike area and audience, emphasizes these associations. Yet while the early martyrs accepted death by mauling, Cortona inverted the situation by having his "Christian" triumph over the beast. This is a particularly apt reference, as it was during Constantine's reign that the Church evolved from victim to triumphator, leaving behind its marginal, often-persecuted position to assume an institutional, officially sanctioned status.

The borders of this and all the Cortona-designed panels in the *Story of Constantine* are meant to harmonize closely with the French designs. Their overall layout is copied directly from the example of the gifted panels, with a fictive gilt frame around the main scene and a beaded frame that marks the horizontal outer edges of the panel. Between these elements, the decorative cartouches, strapwork, cornucopias, sphinxes, and grotesques that fill the horizontal zones at top and bottom follow the lead of Rubens and Laurent Guyot. The monogram of Christ, in a floral-garlanded cartouche at top center, is consistently applied throughout the series as well, referring of course to Christ but also to Constantine's vision before the Battle of the Milvian Bridge. Amid the continuities, however, the Roman designs introduce a few subtle variations: in place of Rubens's and Guyot's eagle, the lion-legged cartouche at bottom center features a laurel crown, a favorite device of the Barberini. And though this panel, deliberately slender, has no lateral borders, those panels that do substitute the Barberini armorial bearings for the French royal coats of arms.

Patron

Cardinal Francesco Barberini was one of the leading cultural and political figures of seventeenth-century Rome. Born in Florence in 1597 to a wealthy family of minor nobility, he studied canon and civil law at the University of Pisa. The family's fortunes rose with the ecclesiastical career of his paternal uncle Maffeo Barberini, who was made a cardinal in 1606 when Francesco was nine years old. In 1623 Cardinal Maffeo was elected to the papacy, taking the name Urban VIII. In keeping with the entrenched system of papal nepotism, the new pope summoned his nephews to Rome, integrating them into his administration and rewarding them richly for their services. Francesco was made cardinal and became his uncle's secretary of state and right-hand man.

One of Cardinal Francesco's first important assignments came in 1625–26, when Urban sent him as legate to France and Spain in an attempt to settle the Valtellina controversy, a dispute over the control of Alpine passes. These diplomatic trips were an education for the cardinal both politically and culturally, and

he emerged as a Francophile in both senses. His stay in Paris occasioned a gift that had significant repercussions for the history of tapestry. Aware that they were disappointing the legate politically, King Louis XIII and First Minister Cardinal Richelieu sought to sweeten the pill by presenting Francesco with the newly woven Rubens-designed *Constantine* tapestries. Cardinal Barberini was under specific orders to accept no gifts, but this one was hard to refuse. Cunningly selected, it reflected French awareness of the Barberini interest in tapestry, the aptness of Constantinian imagery to the Roman court, and the cardinal's own predilection for modern art. Cassiano dal Pozzo, the erudite connoisseur who served in the cardinal's entourage, described the dramatic presentation of the tapestries in his diary of the trip. Returning to his apartments one day, Barberini found one panel, the *Baptism of Constantine*, already hung in his antechamber. The king's master of ceremonies was on hand to implore him to accept the gift. Showing the first Christian emperor kneeling before the saintly Pope Sylvester, the *Baptism* was a canny choice. The scene of an ancient ruler accepting the authority of an ancient pontiff provided symbolic compensation and consolation for the modern ruler's defiance of the modern pontiff. After some deliberation, Cardinal Barberini accepted the gift, immediately penning an explanatory letter to his uncle.[8] Returning to Rome, the cardinal added the seven Constantine tapestries to his *guardaroba* and decided to establish a workshop there to complete the series (see "Tapestry Production in Seventeenth-Century Rome: The Barberini Manufactory").

Between his commissions and purchases, Cardinal Barberini amassed one of the richest tapestry collections of his day, but this was only one facet of his patronage and collecting. One of the chief tastemakers of the high Baroque, he employed painters, sculptors, and architects on a multitude of public and private projects. His account books read as a Who's Who of the period, with payments to Gian Lorenzo Bernini, Pietro da Cortona, Nicolas Poussin, and Francesco Borromini.[9] Aside from his considerable private patronage, he also held sway over public projects through his roles as cardinal nephew, papal vice chancellor, and prefect of the Reverenda Fabbrica

di San Pietro (the board that oversaw construction and decorative projects at Saint Peter's Basilica). Cardinal Francesco assembled extensive collections of ancient, medieval, Renaissance, and Baroque material in a variety of media, storing and displaying them at his official residence at the Palazzo della Cancelleria and at his family palace, the Palazzo Barberini. His sponsorship of music and theatrical spectacle at both palaces enhanced the cultural life of Rome and has earned him credit from historians for fostering the early development of opera. He was also a patron of science and learning, corresponding with intellectuals across Europe and amassing a vast library at the Palazzo Barberini, which he opened to scholars. The cardinal's friendship with Galileo Galilei indicates his scientific interests and personal curiosity, even as his participation in Galileo's condemnation shows his loyalty to the papacy and capacity for realpolitik. Most of the time, however, his intellectual interests coalesced more comfortably with his political interests, as the *Story of Constantine* demonstrates.

During Urban VIII's pontificate, Francesco Barberini accumulated numerous offices, titles, and benefices, becoming one of the wealthiest men in Rome. On the death of his uncle in 1644, however, his situation changed. Urban's successor, Pope Innocent X, initially maintained cordial relations with the Barberini, conferring, for instance, the prestigious bishopric of Sabina on Cardinal Francesco in 1645. But as official inquests probed more and more aggressively into the Barberini brothers' activity during the First War of Castro, Francesco became increasingly uncomfortable at the papal court. Fleeing Rome in 1646, he took refuge in Paris, where his old protégé Cardinal Jules Mazarin had succeeded Richelieu as First Minister to the King. By 1648 tensions with Innocent X had diminished, and Cardinal Barberini was able to return to Rome. The pope, won over by the cardinal's diplomatic efforts, restored his confiscated property as well as his titles and offices. From this point onward, Cardinal Barberini energetically set about rehabilitating the reputation and position of his family, deploying the arts in general and tapestry in particular as a means to this end. He was successful enough in doing so that he was

considered *papabile* (electable to the papacy) in several subsequent conclaves. In 1666 he became dean of the Sacred College of Cardinals, a position of seniority that he held until his death in 1679.

Artist and Design

Pietro da Cortona's cartoon for *Constantine Fighting the Lion* survives in the collection of the Galleria Nazionale d'Arte Antica at the Palazzo Barberini in Rome (fig. 141). One of the central figures of the Roman high Baroque, Cortona was foremost a painter but also practiced as an architect and a designer of sculpture, tapestry, and decorative objects.[10] Born Pietro Berrettini in the Tuscan city of Cortona in 1596, he made his career primarily in Rome, where powerful patrons like the Barberini family knew him by the name of his hometown. Cortona enjoyed an international reputation and influenced a generation of painters, including students like Giovanni Francesco Romanelli and Ciro Ferri (both of whom also participated in tapestry design) and admirers farther afield like Luca Giordano and Charles Le Brun.

After early training in Tuscany, Cortona went to Rome, where he sought further training and gradually developed his signature style. Drinking in the startling chiaroscuro realism of Caravaggio and the academic classicism of the Carracci, Cortona sought to wed both to a brushy colorism that he learned from the examples of Titian and the Venetian school. He rose to prominence in the 1620s, honing his skills as a history painter with a series of increasingly prestigious commissions in both fresco and oil. During the same decade, he collaborated on the Museo Cartaceo (Paper Museum), a project commissioned and coordinated by Cassiano dal Pozzo, the same learned antiquarian who accompanied Cardinal Barberini to France. By hiring young draftsmen like Cortona and Poussin to draw ancient Roman monuments, fragments, and artifacts, Cassiano created an encyclopedic "collection" of the artistic heritage of classical antiquity.[11] Participation in this enterprise gave Cortona an invaluable training in both the archaeological and the compositional aspects of classicism, training on which he would draw when designing the *Constantine* tapestries.

Cortona came to the attention of Pope Urban VIII through the Sacchetti, for whom he had painted a series of large canvases, including his celebrated *Rape of the Sabine Women* (Pinacoteca Capitolina, Rome). From 1624 to 1626 the pope had him fresco three monumental scenes from the life of Saint Bibiana in the nave of the church dedicated to her in Rome. In 1628 Cardinal Francesco Barberini and the Reverenda Fabbrica of Saint Peter's Basilica gave Cortona the commission for a major altarpiece of the Holy Trinity in Saint Peter's. In 1630, while still working on the altarpiece, he was hired to work on designs for the Barberini tapestry manufactory, and in 1631 he (with several assistants) also began to decorate a small chapel in the main apartment of the Palazzo Barberini. His work on these projects evidently pleased Cardinal Barberini, who rewarded him with the most prestigious commission of the day, the decoration of the vast vault of the palace's great hall. His brief, the glorification of the Barberini family through reference to Divine Providence, was not unusual by Roman standards, yet the way in which he interpreted it showed ambitious spatial and figural imagination. The successful completion of this assignment, which took him from 1633 to 1639, cemented his reputation as one of the leading painters of the papal city. Cortona's work on the *Constantine* tapestries coincided with his work on the ceiling, and the powerful vigor of his robust figures in the fresco—a stylistic breakthrough for the artist—is connected to the experience of the tapestry commission, which placed him in implicit competition with the celebrity artist Peter Paul Rubens.

From 1634 to 1638, years that overlap the painting of the cartoon for *Constantine Fighting the Lion*, Cortona held the elective office of *principe* of the Accademia di San Luca, the top position at the Roman artists' academy, which was an indication of the esteem of his peers. After the Barberini ceiling was unveiled, he found himself in demand abroad. When Grand Duke Ferdinando II de' Medici, ruler of Cortona's native Tuscany, asked for his services to fresco rooms in the Palazzo Pitti in Florence, the pope agreed to let him go, though with some reservations and with an awareness on all sides that Cortona's time in Florence was a form of

diplomatic gift. The results, the Sale dei Pianeti (Planetary Rooms) and the Sala della Stufa, occupied him on and off from 1641 to 1647 and single-handedly brought the Roman high Baroque style to Tuscany.[12]

During the last two decades of his life, spent in Rome, Cortona executed major frescoes like the vault and dome of the Chiesa Nuova (1647–51; 1665–60, 1664–65) and the gallery of the Palazzo Pamphili (1651–54), while also focusing increasingly on architecture. The Villa Sacchetti (1648–50), the facade of the church of Santa Maria della Pace (1656–59), the church of Santa Maria in via Lata (1658–62), the dome of San Carlo al Corso (begun 1668), and the completion of the church of Santi Luca e Martina all occupied him during these years.[13] In 1656–57 he was put in charge of the decoration of the Gallery of Pope Alexander VII in the Palazzo Quirinale, designing an overall decorative scheme and supervising a team of artists who painted the individual Old Testament narrative scenes. This experience has strong parallels to his final work for the Barberini tapestry manufactory, the coordination of the *Life of Pope Urban VIII* series. The weaving of this cycle began in 1663, and at Cortona's death in 1669 supervision of this and several other works in progress passed to Ciro Ferri, one of the master's most loyal students.

Weaver

Payments preserved in the Barberini archive have allowed scholars to date the completion of *Constantine Fighting the Lion* to July 1637.[14] Production must have begun sometime shortly after August 1636, when the completion of the *Statue of Constantine* freed up a loom at the Barberini tapestry manufactory. At this point Jacob van den Vliete, the master weaver from Oudenaarde who was the founding director of the manufactory and who began the weaving of the *Constantine* series in 1630, was still alive. The signature in the selvage at lower right abbreviates the Italianized version of his name, Giacomo della Riviera. He died in 1639, and the series was completed under the direction of his son-in-law Gaspare Rocci.[15]

JAMES G. HARPER

309

1. For the applicability of Constantine's story to early modern purposes, see Fumaroli 1995.
2. Zurawski 1979, pp. 110–20, lists fourteen points of comparison between Urban VIII and Constantine. For the Constantinian references of Urban's consecration of Saint Peter's, see Harper 1998, pp. 293–303; and for the context of these among the pope's broader programs, see Rice 1997.
3. In this vein, Pascal-François Bertrand (1998b, p. 62) has gone further, suggesting that the scene is an allegory of the superiority of divine power (embodied in Constantine) over earthly power (embodied in the bestial lion), and thus an affirmation of pontifical authority over earthly princes.
4. Eusebius's *Vita Constantini*, generally considered the most authoritative of the ancient sources, is available in a number of editions, including the *Life of Constantine* (ed. Averil Cameron and Stuart G. Hall [Oxford: Clarendon Press, 1999]). On the question of Cortona and invention, Joseph Connors (1998, p. 320) goes so far as to state that "Cortona never invented his own subjects and insisted that his patrons give him ready-made programs."

5. On the lion hunt in Persian, Hellenistic, and Roman usages, see most recently Tuck 2005. The connection of the Constantinian coin to Cortona's design was made by Mercedes Viale Ferrero (1982, pp. 146–47), and cited in Bertrand 2005, p. 52.
6. Zurawski (1979, p. 46) goes even further in this vein, reading the lion as a specific reference to Protestant heresy.
7. *Maphaei S.R.E. Card. Barberini nunc Urbani PP. VIII Poemata* (Antwerp, 1634). The frontispiece, designed by Peter Paul Rubens and engraved by Cornelius Galle, is illustrated in J. B. Scott 1991, fig. 143.
8. The story of the presentation of the tapestries, first told in Cassiano dal Pozzo's diary of the legation to France, is retold by Barberini (1950, pp. 46–47), Dubon (1964, pp. 11–12), Zurawski (1979, pp. 26–50), and Magnanimi (1983, pp. 155–84). For Cassiano's original, see Biblioteca Apostolica Vaticana, MS Barb. Lat. 5688, fols. 329r–v, relevant passages of which are transcribed in Zurawski's documentary appendix.

9. The range of the cardinal's activity is well represented by the documents transcribed in M. Lavin 1975.
10. For recent publications on Cortona, each with an extensive bibliography, see Rome 1997; *Pietro da Cortona* 1998; and Merz 2005.
11. The drawings of Cassiano's Museo Cartaceo, many of which survive in the Royal Library at Windsor Castle, the British Museum, the Institut de France, and other collections, are published in a multivolume catalogue raisonné. For the antiquities, see I. Campbell 2004, pt. 9 of The Paper Museum of Cassimo dal Pozzo: Series A, Antiquities and Architecture, a 17-volume series being published by Harvey Miller.
12. See M. Campbell 1977.
13. See Merz forthcoming.
14. Barberini 1950, p. 146.
15. De Strobel (1989, p. 15) lists the names of the master weavers as well as a number of the craftsmen who worked under their direction.

36.
The Resurrection of Christ

Cartoon for the tapestry in the *Life of Christ*
Giovanni Francesco Romanelli, 1642
Tempera on paper
294 x 288 cm (12 ft. 11½ in. x 12 ft. 8¾ in.)
Galleria Nazionale d'Arte Antica, Palazzo Barberini, Rome (2270)

PROVENANCE: Commissioned by Cardinal Francesco Barberini; by descent in the Barberini family; and from them to the Galleria Nazionale d'Art Antica.

REFERENCES: Göbel 1928, p. 418; De Strobel 1989, pp. 27, 37; J. B. Scott 1991, p. 187; Hammond 1994, p. 56; Bertrand 2005, pp. 56, 137.

Giovanni Francesco Romanelli painted this cartoon of the *Resurrection of Christ* in 1642 as part of the design for a baldachin and dossal ensemble that was meant for display at the altar of the Cappella Pontificia. Most scholars agree that by this the documents mean the Sistine Chapel of the Vatican Palace.[1] Weaving took place in the Barberini manufactory in Rome, under the direction of Gaspare Rocci. Unlike most of the products of the Barberini looms, which were paid for by Cardinal Francesco Barberini and reserved for his personal use, the Sistine Chapel project was paid for by the Vatican, where the cardinal's uncle reigned as Pope Urban VIII. Initiated in 1635, the commission had originally called for a tapestry altarpiece of the *Nativity*, designed by Pietro da Cortona, and surmounted by a matching six-panel tapestry baldachin. These were completed in 1637. A second phase, carried out in 1642 and 1643, expanded the project with the addition of two more interchangeable altarpieces. Designed by Romanelli, these are the *Pasce oves meas* (Feed My Sheep) and the *Resurrection*, to which this cartoon pertains. Fifteen years later, during the pontificate of Alexander VII,

the Barberini manufactory wove a fourth interchangeable altarpiece, depicting the Annunciation, which Cardinal Barberini presented to the new pope as a gesture of goodwill.[2] These panels all remain in the possession of the Vatican and are sometimes on display at the Lateran Palace.

Almost certainly inspired by the success of the second phase of the Sistine Chapel project, Cardinal Barberini commissioned a twelve-piece set of the *Life of Christ*, the weaving of which began in late 1643.[3] He engaged Romanelli to coordinate the design of the new series, which would reach its inevitable narrative climax in another *Resurrection*. The artist adapted the Sistine cartoon for reuse by adding strips at the margins, repainting Christ's banner, and adjusting several other details to make the composition better fit the new, wider field. The *Resurrection* was the first panel to be woven in the *Life of Christ*, and the expedient reuse of the cartoon may have been a way to get the project moving as quickly as possible. The series remained in the Barberini family until 1889, when Charles Mather Ffoulke purchased it, took it to the United States, and sold it to Elizabeth

Coles, who presented it to the Cathedral Church of Saint John the Divine in New York in 1891. Panels from the Barberini *Life of Christ* were hanging in the nave of the cathedral during the fire of December 2001, and the *Resurrection* was one of the two that were damaged beyond repair. The cartoon, however, survives (cat. no. 36).

Description and Iconography

While all four books of the New Testament acknowledge the bodily resurrection of Jesus Christ, none explicitly describes it. Matthew, Mark, Luke, and John all refer to the event obliquely and retrospectively, describing Christ's followers discovering the empty tomb. As they puzzle over this, an angel, angels, or even, in John's case, the resurrected Christ appears to explain what had happened. Matthew is the only one to mention the Roman guards who figure in most Renaissance and Baroque treatments, including Romanelli's. Describing the arrival of the two Marys at the tomb he wrote, "there was a great earthquake: for the angel of the Lord descended from heaven, and came and rolled back the stone from the door, and sat upon it. His countenance was like lightning, and his raiment white as snow: And for fear of him the keepers did shake, and became as dead men" (Matthew 28:2–4). Romanelli's scene imagines not this moment but rather the guards' initial fright as the tomb door blasts open from the inside, awakening them with the vision of the triumphant Christ.

At the center of the composition, Christ emerges from the tomb surrounded by a billowing, radiant cloud. He raises his hand in blessing as he soars heavenward. Though the cloud obscures most of the opening of the sepulcher, the architectonic backdrop is conveyed through the vertical and horizontal joints of laid masonry. In the lower foreground, the stone slab that had covered the door of the tomb lies on the ground, its dramatic foreshortening leading the eye back toward the climactic central figure. To either side is a pair of guards, one on the ground and the other on his feet. Aside from the sleeper at the lower left, they reel and flail, their frantic cringing contrasting with and thus emphasizing Christ's graceful movement. Likewise, their evident agitation provides a counter-

point to the confident tranquility of Christ's blandly classical face. The drama of the scene is furthered by the blazing radiance around his head, the roiling of the clouds behind him, and the majestic, sweeping lines of his drapery and banner. While the wounds in Christ's hands, feet, and torso allude to the Crucifixion that he had suffered only two days before, there is no suffering in this triumphant figure of the Redeemer. Indeed, he bears the cross as his emblem, both on the cruciform banner and on the tip of the flagpole from which that banner unfurls.

Though compelling, Romanelli's solution is hardly original. In both northern and southern European Resurrection imagery one can find ample precedents for the vertically oriented composition with Christ constituting a center axis, around which dismayed guards symmetrically dispose themselves. Famous examples that also deploy the diagonally foreshortened tomb slab include the print from Albrecht Dürer's *Large Passion* series and the Raphael-school tapestry from the Vatican *Scuola nuova* series, both examples that Romanelli would have known. Yet Romanelli's interpretation is infused with a high Baroque verve that distinguishes it from these precedents. Two tapestries were woven from this cartoon; one was meant to hold its own below Michelangelo's Sistine ceiling, while the other was meant to harmonize the *Divine Providence* ceiling in the Palazzo Barberini, on which Romanelli had assisted his master, Pietro da Cortona.[4] The harmony would not just have been stylistic: as John Beldon Scott has pointed out, the juxtaposition would have strengthened the meaning of both the fresco and the tapestries: the Christological scenes (the *Resurrection* perhaps more than any other) provided direct evidence of the beneficial workings of Divine Providence, allegorized on the ceiling above.

Patron

Because Romanelli's cartoon was initially conceived for the Sistine Chapel project, payment for his work on it came directly from the Vatican.[5] It seems fair to assume that Pope Urban VIII (r. 1623–44) took an active role as patron: he was a ruler who took a keen and specific interest in artistic projects and who had a particular passion for and expertise in

tapestry. In his younger years, during his stint as a diplomat in Paris, he had acted as an agent facilitating the commissions of others, and it is difficult to imagine him not taking an involved role in the ideation and programming of the Sistine set.

While the Barberini workshop tended to undertake one major project at a time, the weavers diverted resources from the production of the *Story of Constantine* to carry out the first phase of the project, the baldachin and the *Nativity*. The other two interchangeable altarpieces would have to wait, however, until the *Constantine* series was finished. This sequencing indicates a few things. The pope supported his nephew's enterprise and must have shared his desire to see the *Constantine* panels finished, but at the same time he was clearly eager to showcase the manufactory's skills in the Vatican Palace. As always, the cardinal sought to accommodate his uncle, and the workshop carried out the first phase of the project alongside the weaving of the *Sea Battle between the Fleets of Constantine and Licinius, Constantine Ordering the Destruction of the Pagan Idols*, and *Constantine Fighting the Lion* (cat. no. 35).

The second phase of the project to which the cartoon of the *Resurrection* belongs began after the *Constantine* series was completed and occupied the looms in 1642 and 1643. These years were trying ones for the septuagenarian pope, who found himself embroiled in the First War of Castro, a conflict with a rebellious vassal that had escalated beyond his control. In September 1642 Urban faced the organized enmity of a league of sovereign Italian princes, rulers of those same states over which he had always seen himself as a particular guardian and shepherd. At such a time the production of more panels for the Sistine altar would have provided pleasurable distraction from his policy failures, while the subjects (the hopeful *Resurrection* and the pastoral *Pasce oves meas*) would have provided symbolic consolation.

Pope Urban VIII's interest in tapestry, which he passed on to his nephew Francesco, developed over the course of his career. Born Maffeo Barberini to a wealthy family of minor nobility in Florence in 1568, the future pope entered the church hierarchy with the help of an uncle who was an official at the court of Pope Clement VIII. As his career pro-

gressed and benefices accumulated, Maffeo was increasingly able to satisfy his growing interest in luxury textiles. When Clement VIII dispatched him as nuncio to Paris in 1604, the inventory of his goods listed twenty-four panels of tapestry as well as five portieres. In Paris, a center for tapestry production and the tapestry market, he honed his connoisseurship of the medium. Six years later, once he was back in Rome and wearing the cardinal's hat Paul V had designated for him in 1606, his collection had grown to sixty-five pieces. He had purchased many of these, like the *Stories of Ulysses*, on the Parisian market and seems to have had an eye for value. His expertise was recognized at the highest levels, and while in Paris he served as an agent for Alessandro Peretti Montalto, nephew of the late Pope Sixtus V and one of the richest collectors in Rome. In this capacity the future pope represented the former papal nephew in the commissioning of the *Artemisia* series from the Parisian workshop of Maurice Dubout.[6]

Returning from Paris, Cardinal Maffeo Barberini set about consolidating offices and collections, positioning himself as a magnificent prince of the church. He founded a chapel in the fashionable church of Sant'Andrea della Valle and was an early patron of Gian Lorenzo Bernini.[7] A poet himself, he saw the sponsorship of artistic and literary activity as a key part of his public image. His collections grew apace, and when he was elected to the papacy in 1623, he ceded seventy-seven tapestries to his brother Carlo.[8] Henceforth, the pope's own possessions would be indistinguishable from those of the Church, which is why later commissions like the *Resurrection* tapestry and the other Sistine altarpiece panels were paid for by the Vatican and remain possessions of the Vatican to this day. The *Resurrection* cartoon remained in the workshop, where it was reused and eventually mounted for display as an independent art object in the Barberini family collections.[9]

Artist and Design

Giovanni Francesco Romanelli, sometimes also called il Viterbese for his origins in the central Italian city of Viterbo, is the most prominent member of the first generation of Pietro da Cortona's followers. Of these, he is

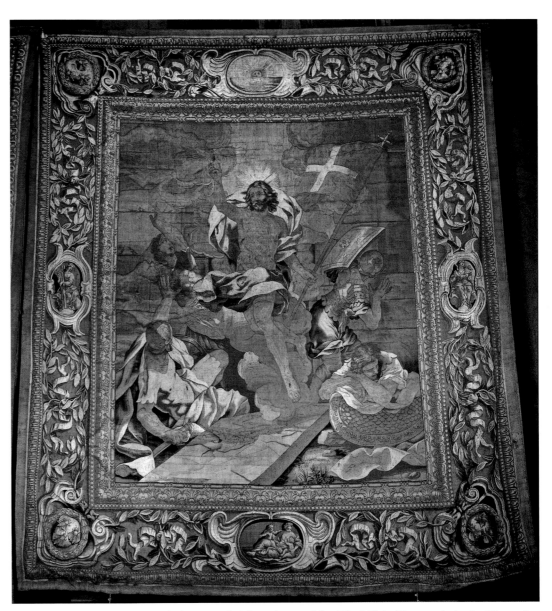

Fig. 142. *The Resurrection of Christ* (before 2001 fire) from the set of the *Life of Christ*. Tapestry design by Giovanni Francesco Romanelli, woven in the Barberini workshop under the direction of Gaspare Rocci, Rome, 1643–44. Wool and silk, 477.5 x 416.6 cm. Cathedral Church of Saint John the Divine, New York (82.1.9)

arguably the one who spent the most time on the design of tapestry.[10] Born in 1610, he is first recorded in Rome in 1631, assisting Cortona on decorative projects at the Palazzo Barberini. According to Giovanni Passeri, a biographer who was an exact contemporary of Romanelli, the young artist first entered the Roman workshop of Domenichino and was passed on to Cortona when Domenichino moved to Naples.[11] This helps explain Romanelli's classicism, which remained part of his style even after he had synthesized it to Cortona's more ebullient high Baroque.

Under Cortona, Romanelli worked on the chapel at the Palazzo Barberini, where he was responsible for the *Rest on the Flight into Egypt* fresco, and the great hall of the same palace, where he assisted in the creation of the *Divine Providence* ceiling. Romanelli painted a series of gallery pictures during the 1630s as well and came increasingly into his own after 1637, when Cortona began spending more and more time working in Florence. Cardinal Francesco Barberini took an interest in Romanelli and got him the commission to fresco a room in the Vatican Palace (1637–42) with scenes from the life of Matilda of Canossa. The cardinal also engineered his election to the prestigious position of *principe* at the Roman Accademia di San Luca in 1638, where he was Cortona's direct successor.[12]

During this same period, Cardinal Barberini assigned Romanelli his first commissions for tapestry cartoons. In 1636, working under Cortona, who reserved the design of the *Nativity* altarpiece for himself, Romanelli probably produced the cartoons for the baldachin panels that would surmount the altarpiece.[13] Later, in the early 1640s, he provided two more altarpiece designs for the same project. In the meantime, he was put in charge of providing cartoons for the *Giochi di putti*, a playful, medium-scale set for the Vatican Palace that was in production from 1637 to 1642.[14] This assignment, which required him to design eight panels to match the Raphael school's 1520 *Giochi di putti*, was ideally suited to the classicist side of Romanelli, one of whose nicknames was il Raffaellino. His designs for the *Giochi* balance old and new, continuing the overall Raphaelesque scheme and aesthetic while introducing some modern stylistic touches and flattering references to the pope and his family. Romanelli's most important tapestry commission was the subsequent *Life of Christ*, for which he oversaw the design and contributed several of the cartoons. This series, to which this cartoon pertains, occupied the Barberini looms from 1643 to 1656. Romanelli's role in the next major Barberini series, the *Stories of Apollo*, is a matter of some debate: though an early inventory mentions his name in connection with the series, none of the payments that have surfaced to date are to him (for more on this question, see cat. no. 37). It is probable that he generated the ideas for the *Apollo* scenes but delegated the painting of the cartoons to Clemente Maioli, with whom he had also collaborated on the *Life of Christ*. While Romanelli's relationship with the Barberini manufactory was the decisive factor in his development as a tapestry designer, he also made cartoons at least once for a Flemish workshop: his *Dido and Aeneas* series was woven multiple times in the Antwerp manufactory of Michiel Wauters.

One of those sets was acquired by the Barberini family.

Romanelli also worked for other Roman families, including the Costaguti and the Altemps, though he was most closely tied to the Barberini. When Urban VIII died in 1644 and his nephews fell into disgrace, Romanelli's own position on the Roman scene suffered. When Cardinal Francesco fled to Paris in 1646, Romanelli chose to follow him, a decision that injected the Cortonesque high Baroque into the heart of France. Jules Mazarin, an old Barberini protégé who had risen to the position of First Minister of France, had the artist fresco the gallery ceiling of his residence, the Hôtel de Chevry-Tubeuf.[15] In these mythologies and the decorative structure that surrounds them, Romanelli deployed a muted form of the illusionistic ceiling painting style he had learned in Rome. During this French sojourn, he also collaborated with Eustache le Sueur on the decoration of the Cabinet de l'Amour at the Hôtel Lambert. Both this project and the one at the Hôtel de Chevry-Tubeuf exercised a determinant influence on the nascent Louis XIV style, which would reach its apogee in the decoration of the Château de Versailles.

In 1648 Romanelli returned to Rome, where he took on more prestigious commissions, frescoing a room for the Palazzo Lante, painting the *Virgin of the Rosary* altarpiece (arguably his finest) at the church of Santi Domenico e Sisto, as well as resuming work for the Barberini. In 1655 he was called back to Paris to decorate four rooms of the Queen's Summer Apartment at the Louvre, and he remained in the French capital until 1658. His last years were spent working on commissions in his hometown of Viterbo and in Rome, including one final commission at the Palazzo Barberini. He died in Viterbo in 1662.[16]

Despite his many successes, Romanelli never received unanimous approbation from contemporary critics or from later historians,

many of whom consider him a secondary figure. Though he developed a distinct and graceful synthesis of Cortonism and Baroque classicism, and though this was to prove influential in both Italy and France, Romanelli is still regarded as derivative. His choices were often safe ones, and the results can often feel sumptuously flat. Yet at his best, Romanelli is a painter of elegance and a decorator of certain verve, and Cardinal Francesco Barberini chose well when he asked him to translate the high Baroque style of painting to the medium of tapestry.

JAMES G. HARPER

1. On the basis of documents that refer to the design as for the "Cappella Pontificia," De Strobel (1989, pp. 24–25) logically concludes that this "con ogni probabilità" refers to the Sistine Chapel. Though this is cautiously worded, no subsequent scholar has disputed it.
2. The chronology and authorship of the Vatican series is worked out (and supported with archival references) in De Strobel 1989, pp. 24–32.
3. For the *Life of Christ* cycle, now at the Episcopal Cathedral Church of Saint John the Divine in New York, see ibid., pp. 36–42; Barberini 1950, pp. 150–51; and Bertrand 2005, pp. 56–57, 125–26, 137.
4. Filippo Baldinucci, writing only a few decades after the series was made, attested that the *Life of Christ* was meant to hang on the walls of the latter room. F. Baldinucci 1681–1728/1845–47, vol.5, p. 423.
5. De Strobel 1989, p. 26, n. 51.
6. For Maffeo Barberini's activity in France and its implications, see Bertrand 2005, pp. 34–35.
7. For the Barberini Chapel and the young Bernini's role there, see Grilli 2003, esp. pp. 69–88.
8. Biblioteca Apostolica Vaticana, MS Arch. Barb. Ind. II, 331, transcribed partially in D'Onofrio 1967, pp. 424–31; M. Lavin 1975, pp. 65–71; and Bertrand 2005, p. 193.
9. The mounting of the cartoon happened sometime before 1692, when it and other cartoons from the *Life of Christ* appear (six framed and three unframed) in the inventory of Cardinal Carlo Barberini. Biblioteca Apostolica Vaticana, MS Arch. Barb. Comp. 345, fol. 192, items 806 and 807; transcribed in Bertrand 2005, p. 226.
10. For Romanelli's activity as a designer of tapestry, see Bertrand 1998b, pp. 68–71; Bertrand 2005, pp. 125–30.
11. Pascoli 1730–36/1992, pp. 163–66.
12. Barroero 1997, p. 181, n. 7.
13. De Strobel 1989, p. 25, n. 48.
14. For this series, see Weddigen 1999; T. Campbell in New York 2002, pp. 254–56.
15. For Romanelli's sojourn in France, see Laurain-Portemer 1973.
16. For a summary of Romanelli's career, with bibliography, see Nigel Gauk-Roger, "Giovanni Francesco Romanelli," in Grove 1996, vol. 26, pp. 565–66.

37.
Apollo and Daphne

From the five-piece set of the *Stories of Apollo*
After a cartoon by Clemente Maioli, 1659
Woven in the Barberini workshop under the direc-
tion of Maria Maddalena della Riviera, Rome,
April 1659–August 1660
Wool and silk
419 x 477 cm (13 ft. 9 in. x 15 ft. 7⅞ in.)
6–7 warps per cm
Fondation Toms Pauli, Lausanne (87)

PROVENANCE: Cardinal Francesco Barberini
(d. 1679), Rome; Barberini family, Rome; 1889,
Charles Mather Ffoulke, Washington, D.C.; by 1908,
Mrs. Hamilton McK. (Ruth Vanderbilt) Twombly,
New York; 1955, sold at Parke-Bernet, New York;
April 29, 1965, sold at Sotheby's, London, no. 72, and
entered the Toms Collection, which was left to the
Canton of Vaud, Switzerland.

REFERENCES: Göbel 1928, p. 420; De Strobel 1989,
p. 42; Adelson 1994, pp. 397, 404; Payerne 1997, pp. 26,
78–79 no. 20; Bertrand 1998b, p. 69; Bertrand 2002;
Bertrand 2005, pp. 57–58, 136.

Apollo and Daphne is one of a set of five panels of the *Stories of Apollo* that Cardinal Francesco Barberini commissioned between 1659 and 1663. Though this tapestry series is sometimes referred to as the *Metamorphoses*, its stories are not taken exclusively from Ovid's celebrated first-century text, nor do they exclusively treat themes of metamorphosis. The scene of *Apollo and Daphne*, however, interprets one of the best-known tales from Ovid's *Metamorphoses*, in which the god of the sun becomes infatuated with Daphne, a wood nymph. When he tries to seduce her, she runs away, and ultimately he is thwarted by her transformation into a laurel tree. The Barberini workshop in Rome, by this time under the supervision of master weaver Maria Maddalena della Riviera, produced this panel in 1659–60 after a cartoon by Clemente Maioli, a minor figure in the school of Pietro da Cortona. Some evidence suggests that Giovanni Francesco Romanelli may have overseen the design process, though this is a matter of debate.

Description and Iconography

The tapestry places the narrative of Apollo and Daphne in a bucolic setting. The composition, with its framing trees, owes much to the landscape style of Nicolas Poussin and Claude Lorrain, both of whom were active in Rome during the period in which Maioli was designing the *Stories of Apollo* (the stylistic allegiance to Poussin is so strong, in fact, that the designs were once attributed to him).[1] The small scale of Maioli's figures in relation to the landscape sets the *Stories of Apollo* apart from most of the other narrative series woven on the Barberini looms. While the *Life of Constantine*, the *Life of Christ*, and the *Life of Pope Urban VIII* are all heroic Grand Manner histories, the *Apollo* tapestries are essentially populated landscapes. Conceptually, they stand somewhere between histories and verdures, those decorative tapestry panels of greenery that were popular at the time (and of which Cardinal Francesco Barberini owned multiple sets).[2]

As Ovid tells the story, Apollo, the Greco-Roman god of the sun, became infatuated with a beautiful nymph named Daphne and descended to earth in an attempt to woo her. Confused and frightened, she fled. He gave chase, and as he gained on her she prayed to her father, the river god Peneus. "'O Father, help!' she cried, 'if your waters hold divinity; change and destroy this beauty by which I have pleased o'er well!'"[3] Peneus, though unable to do much against an Olympian like Apollo, transformed his daughter into a laurel tree, just in time to save her from his embrace. Maioli, like Gian Lorenzo Bernini before him, depicted the moment of highest action: just as Apollo is on the point of seizing Daphne, she metamorphoses before his eyes. Her upflung hair turns into sticks and leaves, her arms and fingers into branches, her toes into roots, and her skin to bark. An astonished Apollo lays his hands not on soft feminine flesh but on a stiffening tree trunk.

Maioli used the central stand of trees to divide his scene into two zones: to the left unfolds the fraught drama of Apollo and Daphne, while to the right Peneus sits on his tranquil riverside. There, he strikes the canonical reclining pose and leans on the equally canonical gushing urn of a Roman river god. The compositional division emphasizes Daphne's distance from her home, her father, and her safety: though physically near, they have become unattainable. The central trees also underscore her transformation: as she runs toward them, she becomes one of them.

Later, Apollo would designate the laurel as his sacred tree; symbol of Olympian virtue, it became the crown of the victor and the poet alike. Because of these ennobling associations, laurel was a favorite personal symbol of Pope Urban VIII, who wrote and published poetry in a neo-Pindaric style and fashioned himself the poet-pope. Laurel references abound in Barberini projects like the baldachin at Saint Peter's Basilica, where giant bronze branches entwine the great spiral columns. Laurel is a recurring motif at the Palazzo Barberini as well, the most conspicuous instance being at

the center of Pietro da Cortona's *Divine Providence* ceiling, where allegorical figures surround the family's heraldic bees with laurel branches, creating a massive organic stemma. As the figure representing Rome places the papal tiara atop this coat of arms, a putto flies in from the side to add the laurel wreath of the poet, in effect crowning laurel with laurel. In his *Aedes Barberinae*, a contemporary text describing the Palazzo Barberini, Girolamo Teti praised the palace as a new Parnassus.[4] And indeed, a fresco of Apollo presiding over the Muses on Mount Parnassus decorated another room, while in the garden behind the palace a colossal statue of Apollo stood guard over one of the major axes. Apollo and the story of the origin of the laurel's symbolic significance were apt subjects for a Barberini tapestry project.

The decorative borders of the tapestry establish an illusionistic architecture and underscore the Barberini references of the subject. A laurel wreath encircles the family coat of arms, which seems to sit on a shallow ledge at the bottom of the panel. Maioli treated the main narrative as a *quadro riportato*, a fictive painting enclosed in a fashionable gilt frame. This, in turn, is set within a shallow boxlike space with gilt, beaded trim running along its outer edges. Flanking the central scene two marble caryatids support golden vases brimming with tulips and other flowers. Half polychrome and half white marble, these caryatids are draped with garlands of flowers and ribbons. The golden pedestals on which they stand, modeled on ancient Roman altars, feature rams' skulls and sphinxes. Augmenting the festive tone of the ensemble, a garlanded satyr's head appears at the center of the upper border, and a pair of goat-legged satyr putti flank the Barberini coat of arms in the lower border. These satyrs strike an appropriately sylvan note that echoes the landscape's fecund abundance, the beribboned cornucopias above, and the garlands of ripe fruits and vegetables below.

Patron

Cardinal Francesco Barberini, also patron of the *Constantine* series, the *Life of Christ* series, and the cycle of the *Life of Pope Urban VIII* (see cat. nos. 35, 36, and 38, respectively), was the eldest nephew and right-hand man of Pope Urban VIII. His career is summarized in catalogue number 35. Like many of the cardinal's commissions, the subject of the *Stories of Apollo* is self-referential in an erudite fashion.

Noting King Louis XIV's interest in solar and Apollonian imagery, Candace Adelson has suggested a connection between the commission of the *Apollo* series and the cardinal's two years of exile in France following his uncle's death and his own fall from favor at the papal court.[5] In such a reading, the *Apollo* series is an acknowledgment of French protection and a declaration of Barberini francophilia. Adelson has even gone so far as to suggest that these tapestries were conceived for use in France or as a gift to Louis XIV.[6] But it is important to remember that Urban VIII and the Barberini had favored solar imagery long before their French exile (for decades, in fact, before Louis XIV was even born), as the publication of the solar "Aliusque et Idem" impresa in Giovanni Ferro's 1623 *Teatro d'imprese* indicates.[7] Though there may be some secondary reference to the Sun King, it seems more likely that the choice of Apollo was primarily self-referential. And though the imagery is indeed connected to the Barberini history of exile and return, the link is more nuanced and complex.

Cardinal Francesco Barberini, taking the lead role in negotiating his family's reinstatement at the papal court, came back to Rome from France in 1648. His diplomacy with Innocent X smoothed the way for the return of the rest of the exiled family members, and by 1653 his brother and nephews were back in Rome. The *Life of Christ* tapestries, production of which was suspended during the darkest months of the crisis, was resumed, and the Barberini workshop completed that set in 1656. The *Stories of Apollo*, the manufactory's next major project, is significant as the first new commission conceived in the post-exile period. Its unusual narrative selections make sense in this context, for in them one can discern an allegory of exile, return, and vindication. In such a reading, Apollo may be taken to represent the Barberini in general and Cardinal Francesco in particular.

The *Apollo and Daphne*, the first panel of the set to be woven and presumably the starting point for any sequential reading of it, represents the delusion and disappointment of Apollo/Francesco on the death of his uncle in 1644 and the subsequent, metamorphic evaporation of his power. Just as the pleasurable idea of Daphne hardened beneath Apollo's touch, so Francesco's favorable situation at the papal court hardened before his very eyes. The *Apollo* series' subsequent narratives further the allegory, referring to exile in the *Apollo Tending the Herds of Laomedon*, but concluding with a happy scene of Apollo/Francesco back in his proper place, presiding over the Muses on Mount Parnassus.

The use of the Deluded Apollo as a symbol for the fallen papal nephew was not new: Cardinal Scipione Borghese had hired Gian Lorenzo Bernini to sculpt an *Apollo and Daphne* the year after his uncle Pope Paul V died. Maioli was certainly referring to Bernini's marble in his composition, which Guy Delmarcel has already recognized "paraphrases [it] explicitly."[8] But the borrowing came with a rich set of associations. Borghese had asked his friend Maffeo Barberini (later Urban VIII) to compose a moralizing epigram to be inscribed on its base. It read "Quisquis amans sequitur fugitivae gaudia formae / fronde manus implet baccas seu carpit amaras" (Whoever, loving, pursues the joys of fleeting beauty fills his hands with leaves or seizes bitter berries). In a general sense, the moral had to do with *vanitas* and the fleeting nature of earthly pursuits. But to Borghese insiders (and subsequently, Barberini insiders) the "bitter berries" would have had a more pointed meaning specific to the situation of a fallen cardinal nephew. By 1659, when the weavers set to work on the *Stories of Apollo*, the political situation had stabilized enough so that Francesco could include in his personal propaganda references to his own loss. By turning loss into a poetic symbol, Francesco emulated Apollo's appropriation of the laurel parallel.

During his lifetime, the cardinal kept the *Apollo* series and its custom borders at his official residence at the Palazzo della Cancelleria in Rome, where it appears in the inventories of 1663 and 1679. As with other tapestries in his collection, though stored at the Cancelleria, it would have been displayed both there and at the Palazzo Barberini alle Quattro Fontane. After his death in 1679 it moved to the latter palace, where it appears in the inventories of his nephews.[9]

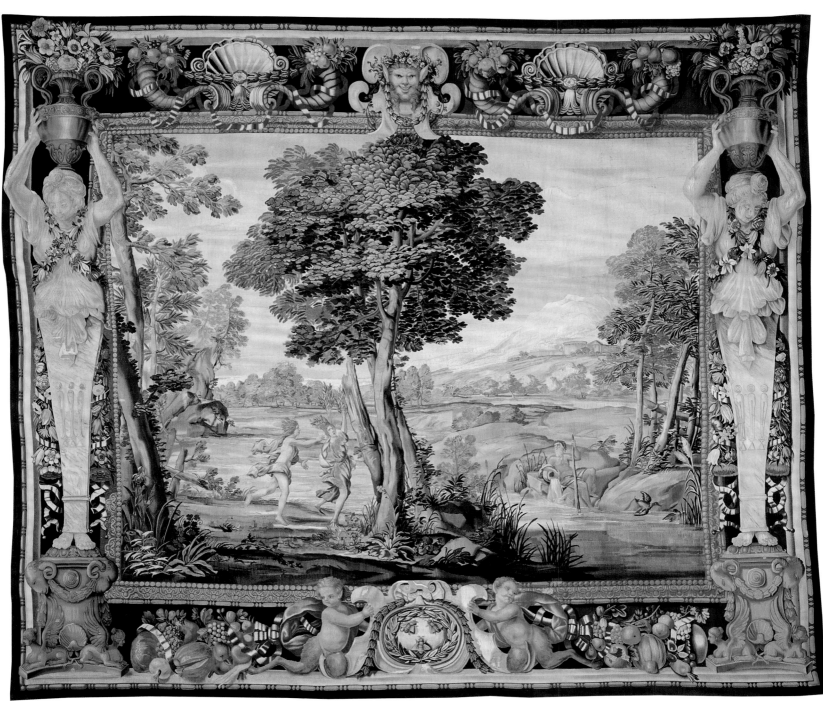

37

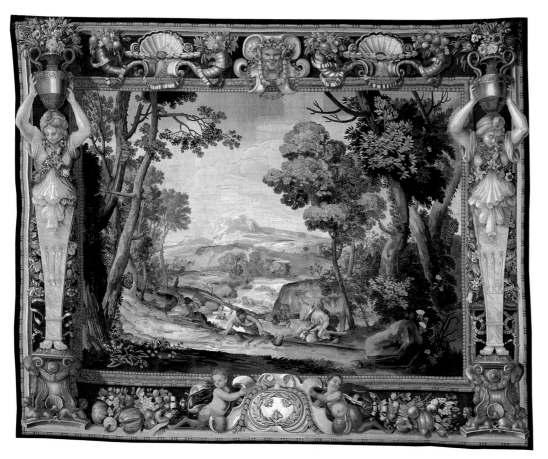

Fig. 143. *Latona Changing the Lycian Peasants into Frogs* from the set of the *Stories of Apollo.* Tapestry design by Clemente Maioli, woven in the Barberini workshop under the direction of Maria Maddalena della Riviera, Rome, 1659–63. Wool and silk, 419 x 484 cm. Fondation Toms Pauli, Lausanne (86)

Artist and Design

Clemente Maioli, a minor follower of Pietro da Cortona and a Barberini favorite, received payment for the cartoon for the *Apollo and Daphne* panel on June 19, 1659. Similarly, payments firmly document his authorship of two other cartoons for the five-panel series, the *Mount Parnassus* and the *Apollo Tending the Herds of Laomedon* (the latter of which is sometimes alternately titled *Apollo and Mercury*).[10] No painter's name has been firmly attached to the remaining two cartoons, but the stylistic consistency of all five designs suggests that the full set is by the hand of Maioli. To what extent Maioli benefited from Giovanni Francesco Romanelli's supervision remains an open question. There are no payments to Romanelli for work on the *Apollo* series, and he was living primarily in Viterbo during much of the period it was designed (dying there in 1662). None of the Barberini inventories mentions the designer in their entries for the narrative panels of the *Apollo* series, but in two of them, several pages after the entry for the set, a separate entry describes

a pair of lateral borders as those "that accompany Romanelli's little landscapes" or "that serve for the tapestries of Ovid's *Metamorphoses* by Romanelli" (1692).[11] Likewise, the 1692 inventory of Cardinal Carlo Barberini lists the cartoons as "dissegno del Romanelli."[12] Romanelli was clearly connected somehow to the project, probably in an oversight capacity parallel to that which Pietro da Cortona filled for the *Life of Pope Urban VIII*, or which Romanelli himself filled for the *Life of Christ*. Maioli had been Romanelli's junior collaborator on the latter project, painting the cartoon of *Christ Consigning the Keys to Saint Peter.* But Romanelli's contribution to the *Apollo* series seems to have been less than his contribution to the *Life of Christ*, for which he painted some of the cartoons. In the *Stories of Apollo*, his work was probably limited to conceptualization and the sketching of *primi pensieri*, while Maioli was charged with working the ideas up into painted cartoons.

The biography of Clemente Maioli (also called Majoli, Maggioli, Maggiolino, or Maggiolini) is still fragmentary. While the date

of neither his birth nor his move to Rome is known, this Ferrara-born painter established himself in the papal city sometime before 1634, the year he was elected to membership in the Accademia di San Luca.[13] Some sources claim that he studied with Pietro da Cortona, the leading master of the Roman high Baroque, while others have him as a pupil of Cortona's follower Romanelli.[14] Maioli's painting style shows strong allegiance to both, but he was particularly interested in the classicizing inflections of the latter, and his first documented work for the Barberini, in 1642, was to copy a Madonna by Romanelli. He served the family for decades, in capacities ranging from copyist to art restorer to independent painter and portraitist. In 1643 he was paid for work on the design of an ostrich hunt tapestry, the weaving of which effectively customized a set of Flemish hunt tapestries that Cardinal Francesco Barberini had acquired on the market. He returned to tapestry design again in 1656, when Romanelli involved him with the Barberini *Life of Christ* series. In 1663, the year the weavers finished his *Apollo* series, Maioli was up on the scaffold at the Palazzo Barberini, carrying out restoration work on Andrea Sacchi's *Divine Wisdom* ceiling.[15]

Maioli also worked for other prominent patrons on projects that included altarpieces and frescoes in Roman churches like San Lorenzo in Damaso, San Bernardino, Santi Domenico e Sisto, and the Pantheon.[16] He also painted in his native Ferrara, where his commissions included frescoes at the church of Santa Maria dei Teatini. His most important public commission was the *Triumph of Religion*, frescoed on the vault of the Biblioteca Alessandrina, the university library at the Sapienza (1661–65). While scholars have not yet determined the date of Maioli's death, he is last recorded on the rolls of the Accademia di San Luca in 1673.[17] Though he is largely forgotten today, his renown in the late Baroque period was sufficient to inspire Giovanni Antonio Bruzio, in his description of the artist's Saints Lawrence and Agnes altarpiece at the Pantheon, to refer to "the celebrated brush of Clemente Maioli."[18]

Workshop

The Barberini workshop in Rome produced the *Apollo* series from 1659 to 1663: the *Apollo*

and *Daphne* was the first of the five scenes to be woven, occupying the looms from April 1659 to August 1660.[19] The master weaver by this time was Maria Maddalena della Riviera, the daughter of the founding director Giacomo della Riviera (Italian form of Jacob van den Vliete). She had held the position since the death of her older sister Caterina in 1653 and would hold it until her own death in 1678. The panels all have integral borders, but an extra pair of lateral borders, slender vertical panels with terms bearing vases, was produced in a secondary workshop: Cardinal Barberini's 1663 inventory lists these as having been done by "Lorenzo arazziere," a probable reference to Lorenzo Castellani.[20]

JAMES G. HARPER

1. For the history of attribution, see Adelson 1994, pp. 397–98.
2. Bertrand 2005, p. 143.
3. Ovid, *Metamorphoses* 1.452–567. The translation of lines 545–47 quoted here is that of Frank Justus Miller, Loeb Classical Library 42 (Cambridge, Mass., 1951), vol. 1, p. 41.
4. Tetius 1642/2005. Bertrand (2005, pp. 64–65) also mentions this.
5. See, for instance, Adelson 1994, p. 397.
6. Ibid., pp. 397, 405 n. 7. Adelson's statement that the cardinal was "a frequent visitor at the French court" is exaggerated: Francesco sojourned at the French court only twice, once in 1625 and again during his time of exile in the late 1640s. Referring to Cardinal Francesco's exile in Paris, Adelson says of the *Apollo* tapestries, "perhaps this set was conceived for his use there, as a compliment to the young King Louis XIV, who came of age in 1659."
7. Giovanni Ferro, *Teatro d'imprese*, 1623. The impresa is further discussed in J. B. Scott 1991.
8. Delmarcel in Payerne 1997, p. 78, no. 20.
9. For a list of citations of the set in Barberini inventories, as well as the partial transcription of these inventories, see Bertrand 2005, p. 136.
10. Adelson 1994, p. 404, n. 2.
11. Cardinal Francesco Barberini's 1663 inventory, items 563, 600 (transcribed in Bertrand 2005, pp. 211–14); Cardinal Carlo Barberini's 1692 inventory, items 783, 799 (transcribed in ibid., pp. 225–26).
12. Cardinal Carlo Barberini's 1692 inventory (as in note 10), items 812 and 815.
13. Some sources, like Thieme-Becker, give a birth date of 1625 for Maioli, which is clearly impossible in light of his election to the academy in 1634. Thieme-Becker gives dates of ca. 1625–after 1671 for him, while Adelson 1994 pushes these to ca. 1610–after 1673.
14. Titi (1763, p. 361) called Maioli "allievo di Romanelli."
15. For documentation of Maioli's further work for Francesco Barberini, see Biblioteca Apostolica Vaticana, MS Arch. Barb. Comp. 86, Mandato 2506 and 2570.
16. For fuller summaries of Maioli's activity, see Lo Bianco 1987, pp. 98–103, and the entry on him in *La pittura in Italia* 1988, vol. 2, p. 797.
17. 1673, and not 1671, as is sometimes repeated. See Lo Bianco 1987, p. 100.
18. "[D]al celebre pennello di Clemente Maioli, allievo del Romanelli"; Giovanni Antonio Bruzio, "Pantheon illustratum," transcribed in Lo Bianco 1987, p. 99, and n. 69, with a fuller reference to Bruzio's text in n. 1.
19. De Strobel 1989, pp. 41–42; Adelson 1994, pp. 395–402.
20. Cardinal Francesco Barberini's inventory of 1663, item 600; transcribed in Bertrand 2005, p. 214.

38.
The Protection of Rome from Plague and Famine

From the ten-piece set, plus borders, of the *Life of Pope Urban VIII*
Design by Ciro Ferri and Giacinto Camassei, cartoon by Camassei, 1673
Woven in the Barberini workshop under the direction of Maria Maddalena della Riviera, Rome, May 1673–July 1675
Wool and silk
404 x 503 cm (13 ft. 3 in. x 16 ft. 3 in.)
Vatican Museums, Vatican City (43827)

PROVENANCE: Cardinal Francesco Barberini (d. 1679), Rome; Barberini family, Rome; 1811, by inheritance to the Colonna da Sciarra family, Rome; 1892, sold to de Somzée; May 20–25, 1901, sold with de Somzée collection at Galerie Jos. Fievez, Brussels; 1947, purchased on the art market in Paris by Angelo Roncalli (later Pope John XXIII) and donated by him to the Vatican Museums.

References: Göbel 1928, p. 421; Calberg 1959, p. 102; Faldi 1967; Barberini 1968, pp. 92, 97–98; Ferrari 1968, p. 60; De Strobel 1989, pp. 43, 49; J. B. Scott 1991, p. 189; Bertrand 1994, pp. 643, 655, 677–78; Bertrand 1998b, p. 67; Harper 1998, pp. 340–50, 516–22, 560; Mochi Onori 2003, p. 92; Bertrand 2005, pp. 59, 191.

The *Protection of Rome from Plague and Famine* is the seventh of ten monumental narratives that (along with their borders) constitute the *Life of Pope Urban VIII*. Woven from 1663 to 1679 at the commission of the pope's nephew Cardinal Francesco Barberini, the series aimed to immortalize the deeds of Urban's pontificate and, by so doing, to bolster the reputation of the Barberini family. Pietro da Cortona (and, after his death in 1669, Ciro Ferri) oversaw the design of this project, delegating the production of individual cartoons to students and followers such as Giacinto Camassei, who painted the cartoon for this scene in 1673 (fig. 144).[1] This panel, like the others in the series, was woven at the cardinal's private tapestry manufactory under the direction of Maria Maddalena della Riviera.[2]

The subject refers to the turbulent years of the early 1630s, a period in which war, a plague epidemic, and famine threatened the states of the Italian peninsula. Rome escaped the worst, this tapestry claims, because of the spiritual and temporal leadership of the pope. Mingling history and allegory, Camassei used the heroic language of high Baroque Cortonism to deliver this message. Whether hung in the great hall of the Palazzo Barberini (the primary locus of display for which the series was designed) or elsewhere, the *Protection of Rome from Plague and Famine* and the set to which it belongs would have served as a sumptuous reminder of the debt the Roman people owed the Barberini family.

Description and Iconography

This tapestry condenses a full narrative sequence into a single scene. In the center foreground, Pope Urban VIII hears news from a kneeling messenger and responds by turning to the heavens in a plea for divine assistance. The messenger's gesture points the viewer to the source of distress, in the right background. There, a group of armed soldiers surges over a makeshift stockade, scattering the civilians who had taken refuge there. Obviously not meant as literally taking place in the pope's

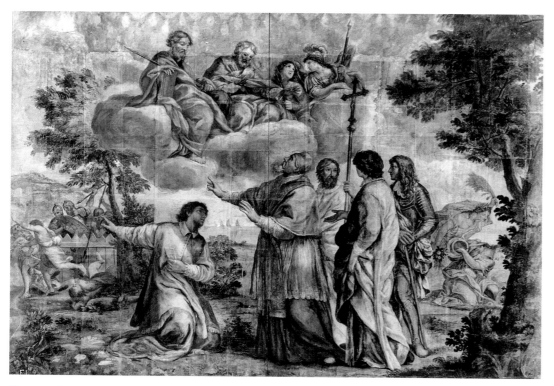

Fig. 144. *The Protection of Rome from Plague and Famine*, by Giacinto Camassei, 1673. Cartoon for the tapestry in the *Life of Pope Urban VIII*. Tempera on paper, 318 x 474 cm. Galleria Nazionale d'Arte Antica, Palazzo Barberini, Rome (2265)

presence, this violent vignette represents the 1629 invasion of northern Italy by German troops, who brought the plague with them over the Alps. Describing the invasion symbolically rather than literally, Camassei lets the few stand for the many. Likewise, in his symbolic landscape, the short interval between foreground and background represents the distance from Rome to northern Italy.

The epidemic of 1629 spread from the plains of Lombardy down the Italian peninsula, eventually reaching Tuscany as well as the northern reaches of the Papal States. In many locales the results were devastating: the papal city of Bologna, for instance, lost an estimated quarter of its population. Taking action to keep the plague from spreading to Rome, Urban VIII implemented a two-pronged strategy. On the administrative side, he authorized a public health board to devise and enforce measures like quarantines, travel bans, and sanitation standards. On the spiritual side, he led his people in prayers of penitence and called on God and the saints to deliver Rome from danger. The entourage that accompanies the pope in the tapestry, including an armored officer and some priests, represents these two approaches. Though some scholars have tried

to identify the figures in the procession behind the pope, they are generic: another case of letting the few stand for the many, they microcosmically evoke the devotional processions of thousands that Urban led through the streets of Rome during this time of crisis.

Among the mortals in the tapestry scene, only the pope seems to see the quartet of saints hovering above. His spiritual connection to them, established through gaze and gesture, is underscored by the crucifix, the only other bridge between the heavenly and earthly groups. Up in the clouds, the two saints to the right, Peter (with the keys) and Paul (with the sword), are the traditional patrons and protectors of Rome. The two to the left, Sebastian (holding the arrows) and Michael (wearing a helmet and holding a spear), are traditionally invoked plague saints. These four are the same saints who figured on the votive banner that Pietro da Cortona painted for the 1632 procession of thanksgiving, led by the pope himself, that marked the passing of the crisis. As the culmination of this happy ritual, the pope presented Cortona's banner to the miraculous icon of the Virgin and Child known as the *Salus Populi Romani*.[3]

When Camassei was designing this tapestry, the banner (now lost) was still on display in the icon's chapel at the Roman church of Santa Maria Maggiore. It certainly served the artist as an iconographic source and may have been a compositional source for him as well.

As with all the ten major narrative scenes in the *Life of Pope Urban VIII*, the *Protection of Rome from Plague and Famine* is presented as a *quadro riportato*, surrounded by a fictive carved frame. Decorated with gilded ivy, it has a heraldic Barberini bee at each corner. Beyond this frame, the tapestry originally had four detachable borders. The lower border, also designed by Camassei, included a subsidiary narrative, articulated as a fictive bas-relief.[4] The lateral borders featured medallions suspended from terms, and the upper border bore an inscription in a cartouche. Praising the pope, it read, "[with] Sicily and soon Italy suffering under the plague, he saves nearly the entire region of the Papal States, which he also relieves with grain, despite the high price of foodstuffs. [Rome is] unharmed by flooding, and he looks out for the salubriousness of the air."[5] The final phrases refer to the pope's flood-control work on the Tiber River, the theme treated in the lower border.

As its inclusion in the superscription suggests, reference to famine was important to the overall program. Camassei's condensing of it into the main scene alongside references to invasion and epidemic was expedient, but also natural: plague, famine, and war often come together in historical fact and in scriptural tradition.[6] Thus, in the middle ground to the left, the artist included an allegorical wrestling match in which a figure of Abundance thrashes a figure of Famine. Abundance is a beautiful woman with a garland in her hair and a cornucopia in her hand, following the prescription of Cesare Ripa's *Iconologia*, the most popular iconographic handbook of the day.[7] Though Camassei's figure is conventional and hence recognizable, he renders her specific to the situation by emphasizing grain wherever possible. She is, therefore, Cereal Abundance, with her cornucopia brimming over with grain and with a cereal garland in place of Ripa's floral garland. Even the scourge she brandishes against her opponent is a sheaf of grain. Famine, clearly losing the contest, is articulated as a haggard figure,

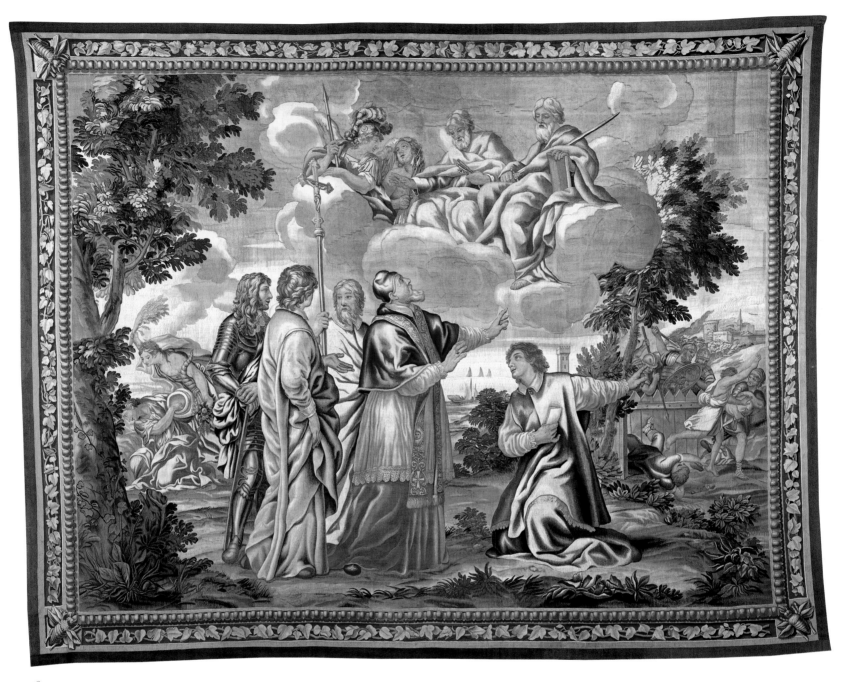

38

scrabbling vainly in an empty jar. Her defeat is Rome's victory.

Among Baroque plague images, the *Protection of Rome from Plague and Famine* is extraordinary. It has none of the raw horror that one normally associates with a category that generally focuses on the heaps of the dead, the gasps of the dying, and the desperation of the fearful.[8] As a celebratory image of a plague that wasn't, the tapestry image belongs to a rarer category. And while it

seems more difficult to describe something that did not happen than something that did, the preservation of Rome, as a central accomplishment of the pontificate, was not to be overlooked. Moreover, by 1663, when the weaving of the tapestry series began, intervening events had thrown Urban's achievement into higher relief. Another epidemic had swept the Italian peninsula in 1656, and this time, despite the efforts of the reigning pope (Alexander VII), Rome did not escape

unscathed. Relatively fresh memories of this disaster, in which an estimated fifteen thousand Romans died, would have enhanced the impact of this tapestry on its intended audience. Its depiction of Urban's delivery of Rome from war, plague, and famine was a reminder to a younger generation (who might not remember the events of 1629–32) of the debt that Rome owed the Barberini. Ultimately, and like the other panels of the *Life of Pope Urban VIII* that treat the deeds of

the pontificate, Camassei's panel is an image of good government in both an allegorical and a historical sense.

Patron

Cardinal Francesco Barberini, the eldest nephew of Pope Urban VIII, served as the pope's right-hand man and prime minister over the course of the Barberini pontificate (1623–44). His political career and his role as one of the central cultural figures of seventeenth-century Rome are outlined in the discussion of the *Life of Constantine* series (cat. no. 35). In response to the threat of plague in 1629, the pope appointed Francesco to head the Congregazione della Sanità, the commission authorized to deal specifically with the problem. As its prefect, the cardinal convened the commission twice a week for the duration of the crisis. It enacted rigorous hygienic regulations, organized lazarettos and hospitals, got the streets cleared of filth, and suspended trade and traffic between Rome and regions that were already afflicted. In addition, it organized a citizen militia to guard the gates of Rome and even had incoming mail fumigated.[9] Recognizing that a well-fed populace was less susceptible to infection, Cardinal Francesco and his commission took particular care to ensure that an adequate food supply reached Rome so that even the poorest and most vulnerable citizens would be fed.

The protection and feeding of Rome during these years was regarded as a major accomplishment in itself, and when the crisis had passed, the grateful civic government of Rome (an authority distinct from that of the Vatican) erected a monumental inscription praising the pope in the church of Santa Maria in Aracoeli. His achievements were cited again in 1635, when the same group voted to erect a statue of Urban on the Capitoline Hill. This extraordinary honor required the officials first to invalidate their own decree forbidding statues of living persons in this symbolically loaded place. Even more extraordinary was their offer of a statue to Cardinal Francesco Barberini, who had shared in the accomplishment but who prudently declined the honor.[10] He understood that any celebration of his uncle's rulership implicitly praised his own role. This same thinking informed the

conception of the tapestry series, where the cardinal appears in several scenes but is implicitly present throughout.

The tapestry series of the *Life of Pope Urban VIII* is the culminating episode in Cardinal Francesco Barberini's effort to rehabilitate the reputation of his family. This reputation had suffered after Urban's death, reaching a nadir in the late 1640s with the Barberini brothers' flight from Rome and exile in France. By the time weaving began in 1663, however, the Barberini had been restored to power and prominence for a full decade: Cardinal Francesco was dean of the Sacred College of Cardinals and was even considered *papabile* (a viable candidate for the papacy).[11] Aside from using the series to respond to old criticisms, the ambitious cardinal probably also meant it as a sort of campaign document. Reminding its audiences of the accomplishments of Urban's reign, the tapestries eloquently argued that Francesco, who had taken some part in all of the deeds of the pontificate, would be a worthy candidate for the tiara himself.

Tapestry is inherently versatile, and there is evidence that the *Life of Pope Urban VIII* was displayed both indoors and outdoors, both in part and as a whole. The innovative detachable borders that originally accompanied each panel (including the *Protection of Rome from Plague and Famine*) enhanced the versatility of the series. Without sacrificing the flexibility of display that the medium allows, Francesco Barberini intended that the series be primarily displayed in the great hall of the Palazzo Barberini. Most scholars have agreed that the series was designed for this room: only recently has documentary evidence surfaced for their actual installation there.[12] In the great hall, the *Life of Pope Urban VIII* would have been seen in conjunction with Pietro da Cortona's *Divine Providence* ceiling, the two functioning in tandem as an engine of dynastic propaganda. At its center, Cortona's ceiling expresses the divine selection of the Barberini family as rulers through allegorical references to their virtues. The four coves of the vault allegorize the events of the pontificate through mythological analogy, implying that Divine Providence not only blessed the Barberini but also acted through them.[13] Hanging directly below these coves, the tapes-

tries would have rendered their references explicit, recounting the history of the pontificate through images and accompanying inscriptions.

Walter Vitzthum's ambitious hypothesis that the series hung along with the *Life of Christ* and the *Constantine* series, constituting "no less than a baroque analogy to the walls and ceiling of the Sistine Chapel," must be discarded: even this vast room is not large enough to accommodate so many tapestries.[14] The panels of the *Life of Pope Urban VIII* (with their borders restored to them), however, perfectly fit within the available wall space.[15] They would have occupied the upper register of the four walls, wrapping around the entire room with a luxurious decorative effect. Unfortunately, Cardinal Barberini was never to see them there: he died in his bed in 1679, while the final panel was still on the looms.

Artist and Design

Giacinto Camassei was a Roman painter and printmaker whose documented artistic activity spans the years 1672 to 1683. Though his birth date (like many of his biographical details) remains to be discovered, he first appears in Rome in 1648, when the *stati d'anime* list him as residing in the house of his uncle the painter Andrea Camassei.[16] His introduction to the Barberini must have come through the elder Camassei, who had frescoed a ceiling with the *Creation of the Angels* in the main apartment of the Palazzo Barberini. The uncle had also been one of the three finalists for the great hall commission in the same palace. Though Pietro da Cortona won that commission, Andrea Camassei was nevertheless a well-connected painter of some eminence and would have been in a position to provide his nephew with a solid artistic training and helpful introductions. Yet despite these advantages, Giacinto Camassei's career seems to have had a slow start.

Camassei's first documented work as an artist is a tapestry cartoon for one of the borders for the Barberini *Life of Pope Urban VIII*. In September 1672 Cardinal Francesco Barberini's accountants paid Camassei for a small grisaille cartoon that showed Urban VIII conducting the Ceremonial of the Porta Santa during the Jubilee Year of 1625.[17] A fictive bas-relief, this design was for the lower border

of the *Consecration of New Saint Peter's Basilica*, a panel designed by Fabio Cristofani. Design work on the series had been supervised by Pietro da Cortona until his death in 1669, and Cristofani's main scene and Camassei's thematically related border were the first panels of the series to be designed under Cortona's successor Ciro Ferri.[18] Ferri must have been pleased with Camassei's work on the design of the border panel, for in the following year (May 1673) the Barberini accountants paid him for the design of a major narrative panel, the *Protection of Rome from Plague and Famine* (fig. 144) Camassei also designed the lower border that accompanied it, a fictive bas-relief depicting Urban VIII's efforts to control the flooding of the Tiber River.

Ferri's supervision of Camassei's work on the *Protection of Rome from Plague and Famine* seems to have been closer than usual, probably because Camassei was a relatively untested artist. The highly detailed preparatory design for the scene in Ferri's hand, now at Windsor Castle, is the only case for which evidence is known for the supervising artist (whether Ferri or Cortona) assuming such a personal role in the composition of a panel for the *Life of Pope Urban VIII*.[19] Likewise, this is the only one of the panels in the series for which a bozzetto (oil sketch) is known, a fact that suggests that Ferri wanted Camassei to prove himself on a small scale before he allowed him to go ahead with the cartoon. Camassei performed well, as the tapestry proves, but once he finished this scene and the fictive bas-relief for its border, Ferri did not have him provide cartoons for any subsequent panels. Most of the remaining design work for the series went to Pietro Lucatelli, whose personal and stylistic closeness to Ferri must have trumped Camassei's success. Camassei continued to

work for Cardinal Francesco Barberini, however, frescoing a ceiling at the Palazzo Barberini with a scene of Ulysses and the Sirens in 1675–78.[20] His position within Rome's artistic establishment is reflected in his 1679 induction to the Accademia di San Luca, where in 1683 he was elected to the administrative office of *provveditore*.

Workshop

This panel was produced on the looms of the Barberini tapestry manufactory in Rome from 1673 to 1675. The founding and development of the manufactory are discussed more fully in "Tapestry Production in Seventeenth-Century Rome: The Barberini Manufactory." By the time the manufactory undertook the production of this series, the workshop was under the direction of Maria Maddalena della Riviera and located (along with other satellites of the cardinal's household) in the via dei Leutari, a small street near Cardinal Francesco Barberini's primary residence at the Palazzo della Cancelleria. Maria Maddalena was the surviving child of Giacomo della Riviera, the Italianized Fleming whom the cardinal had brought to Rome to found the workshop. She inherited her position from her sister in 1653 and held it until her death in 1678. Cardinal Barberini died a year later, and the manufactory was subsequently closed by his heirs.[21]

The last payments for the *Life of Pope Urban VIII*, for a trio of lateral borders, came on November 29, 1679.[22] Though there is still some debate as to whether the series was fully completed or brought to an expedient conclusion, the *Life of Pope Urban VIII* stands as a splendid swan song for both patron and workshop.

JAMES G. HARPER

1. The four payments (spanning from May 1673 to January 1674) to Camassei for his work on the cartoon are cited and partially transcribed in Harper 1998, p. 560, no. I.7.d.
2. De Strobel 1989, p. 15.
3. For the banner (which does not survive), see Briganti 1982, p. 374. For the context of plague votives, see Puglisi 1995, and for the *Salus Popoli Romani,* see Wolf 1990.
4. Though the border is lost, it is described in sale cat., de Somzée collection, Galerie Jos. Fievez, Brussels, May 20–25, 1901, no. 593, as "Personnification de la Rome antique procédant aux travaux du Tibre. A droit, le fleuve est représenté sous les traits d'un homme accoudé sur une urne d'où s'échappent des flots d'eau; près de lui se tient la louve avec Romulus et Rémus. Rome, sous les traits d'une jeune femme vêtue d'une tunique, donne des ordres à des ouvriers munis de pelles et de hoyaux."
5. The full inscription, in the original Latin, reads, "Sicilia Et Mox Italia / Peste Laborantib Totam Fere Pontificiam / Regionem Frumento in Annonae Caritate / Levatum Servat Incolumen Inundationib / Et Aeris Salubritati Prospicit."
6. See, for instance, Revelation 6:8, 2 Samuel 24:10–25, and 1 Chronicles 21:10–27.
7. Ripa 1618/1992, p. 3.
8. For the bibliography on Baroque plague imagery and a range of examples, see Worcester 2005.
9. For a summary history, based primarily on archival material, of Urban's efforts in the face of the plague of 1629–32, see Harper 1998, pp. 340–50.
10. For the Capitoline statues and the issues these raise, see Wittkower 1966, pp. 206–7, no. 38, and pl. 69; Gigli 1608–70/1994, vol. 1, p. 248; and Nussdorfer 1992, pp. 181–82.
11. See, for instance, the discussion of Francesco Barberini as *papabile* in the conclave of 1669 in the manuscript "Discorso sui Cardinali Papabili nel conclave in cui fu eletto Clemente X," Biblioteca Apostolica Vaticana, MS Barb. Lat. 4721, fols. 26–72.
12. The documentary evidence, presented at the conference "I Barberini e la cultura europea" (Rome, December 2005), is the subject of a forthcoming article by James Harper. For two different takes on the installation of the series, see Harper 1998, pp. 517–52, and Bertrand 1994.
13. J. B. Scott 1991, pp. 186–92.
14. Vitzthum 1965. Vitzthum's error has been followed by other scholars including, most recently, Bertrand 2005, p. 60.
15. For the measurements and the fit, see Harper 1998, pp. 518–24.
16. "Giacinto Camassei," in Saur 1992–, vol. 2 (1999), p. 654.
17. Harper 1998, pp. 567 no. II.6.d, 243–47.
18. For a reconstruction of the design process and the supervision of Cortona and Ferri, see Harper 2005.
19. The attribution of this drawing (Windsor 4507) to Ferri, made by Anthony Blunt and Hereward L. Cooke (1960, p. 36) has been upheld by Bruce Davis (1986, pp. 37–38).
20. Montagu 1971.
21. De Strobel 1989, pp. 49–50; Bertrand 2005, p. 143. The date of 1683, sometimes given for the latest documented activity of the workshop, is false. For the arguments for and against it, see Harper 2005.
22. Harper 1998, p. 574, no. III.9.e.

Collectors and Connoisseurs: The Status and Perception of Tapestry, 1600–1660

THOMAS P. CAMPBELL

In a letter of May 16, 1650, the French agent in London, Sieur de Croullé, informed Cardinal Mazarin that he had seen his Spanish counterpart Don Alonso de Cárdenas at Somerset House, one of the British palaces where the royal art collections had been assembled by the Commonwealth government prior to their sale after the execution of King Charles I. Cárdenas was viewing the royal tapestries and paintings on behalf of Don Luis Méndez de Haro, marqués del Carpio, the official court favorite and principal minister of King Philip IV of Spain, and according to Croullé he had already made several purchases.[1] Croullé's letter marks an early stage in what was to become one of the most famous rivalries in the history of European art collecting, as the agents of Mazarin, Haro, and other connoisseurs sought out the finest works from the Commonwealth sale.[2] Yet while the competition for the paintings has been the subject of much discussion, the rivalry of these collectors over the tapestries has received less attention, despite the fact that the valuations of some of the richer sets dwarfed those placed on the old master paintings from the same source.[3] The efforts made by Continental patrons to acquire highlights from the royal tapestry collection and the disparity in prices between the best tapestries and the best paintings raise a number of questions about the perception of the two media at this time. What was the relationship between paintings and tapestries in the collections of the grandees of the day? Were the two mediums perceived to be in competition? And to what extent did the developing market for old master and modern paintings influence the psychology of tapestry acquisition?

Courtier Painting Collections and the Modern Perspective

For historians of northern European art, one of the most significant aspects of the first half of the seventeenth century was the extent to which rich patrons began to accumulate sizable collections of old and new paintings and to articulate a sophisticated appreciation of these works.[4] In the course of the second quarter of the century Charles I of England, Philip IV of Spain, and Archduke Leopold Wilhelm, the governor of the Spanish Netherlands (fig. 146), amassed enormous painting collections. The leading courtiers in their circles, such as Don Luis de Haro, the Duke of Buckingham, and the count of Fuensaldaña, were not far behind them. Indeed, on the strength of most art history surveys one could be forgiven for thinking that the competitive acquisition of paintings by these patrons must have sounded the death knell for the European tapestry manufactories. Yet, as the essays and catalogue entries in this book indicate, the notion that paintings simply displaced tapestries as the key component of figurative decoration at the great courts during the second third of the seventeenth century is not supported by the documentary or material evidence. Indeed, the creation of the Gobelins manufactory in the early 1660s was a resounding affirmation of the continuing status and significance of tapestry as a medium of courtly art and magnificence. So how did the mania for picture collecting that developed in the first half of the seventeenth century coexist with the more traditional practices of acquiring and displaying tapestries?

In assessing the relationship between the two media, the first factor to keep in mind is the large difference between the way seventeenth-century patrons regarded the tapestry medium and the way it is viewed now. The present-day art world takes little interest in tapestry compared to its attention to painting. In most museums, tapestries hang like wallpaper behind objects presented, overtly or by implication, as of more compelling artistic interest; few books are published on the subject; and in the commercial market, tapestries are cheap compared with paintings. Many factors have contributed to the neglect of the tapestry subject over the years, not the least of which is the fragility of the medium and the poor condition of surviving examples. But the most significant intellectual development that contributed to this situation was the gradual change in the

Fig. 145. Detail of fig. 147, *Ceremony of the Contract of Marriage between Władysław IV, King of Poland, and Louise Marie Gonzaga, Princess of Mantua, at Fontainebleau*

325

Fig. 146. *Archduke Leopold Wilhelm in His Gallery*, by David Teniers II., 1651–56. Oil on copper, 104.8 x 130.4 cm. Museo del Prado, Madrid

perception of the painting medium in the course of the seventeenth and eighteenth centuries, whereby it ceased to be considered a manual craft and instead came to be considered a Liberal Art. This change paved the way for connoisseurs and practitioners to champion painting, particularly history painting, as the elite pictorial medium in the course of the mid-eighteenth century.[5]

The elevation of the status of painters and history painting during the eighteenth century and the institutionalization of this esteem by existing or newly founded academies of artists in various European capitals effectively undermined the stature of the tapestry medium because of the criteria by which painting was then judged. The framework of eighteenth-century connoisseurship had its roots in attitudes that developed in Renaissance Italy, memorably codified in Giorgio Vasari's groundbreaking *Lives of the Artists* (1550, 2nd ed., 1568).[6] This famous survey of European art was largely focused on Italian artists with whose work Vasari was familiar, and it celebrated creative inspiration and bravura execution above other artistic qualities. It also propagated a romantic notion of the heroic artist working alone and struggling against adversity. Vasari's conception of artistic endeavor and quality was to have a profound influence, not always of the most enlightened kind, on subsequent connoisseurship in Western Europe. For example, one of the prejudices it encouraged was the celebration of work by Italian artists at the expense of the achievements of

northern artists. Since most tapestries were produced in northern Europe, this imbalance tended to downplay the significance of the medium. In addition, Vasari's preoccupation with the autograph work of the individual artist was particularly inimical to tapestry because the weaving process involved the translation of the original conception into a different medium by a second party, the weaver (and if the cartoon was executed by an artist different from the one who did the modello, the distance between original conception and final product was even greater). In very simplistic terms, these were among the limiting concepts that would become intrinsic to art connoisseurship by the mid-eighteenth century and have continued to color our perspective of the tapestry medium up to the present day.

Yet at the period covered by this exhibition, such attitudes had just begun to develop. For most of the rich patrons of the seventeenth century, tapestry remained a traditional form of figurative art that was ideally suited to decorating large areas of wall space, both in northern Europe, where fresco was inappropriate because of the climate, and in southern Europe during the cold winter months. In its more expensive form, it was also the prestigious figurative medium par excellence of court display at any time of the year: its scale allowed the depiction of complex iconographic programs and its material splendor provided a physical demonstration of wealth and power. As such, it continued to be an entirely suitable subject for expenditure of time and money by the rich. The pertinent issue, then, is

how the ideas, expectations, and collecting habits that developed in association with the medium of oil painting in the first half of the seventeenth century coexisted with and influenced the perception and use of tapestry.

Tapestries and Paintings in Place

The most obvious respect in which the new picture collections first affected the traditional role and status of tapestry was the question of where they were displayed. During the opening decades of the seventeenth century, paintings were much cheaper than tapestries, and because of their size and the sheer numbers available in the marketplace, they were much more collectible. Some of the collections of contemporary rulers and noblemen were enormous, particularly those amassed on a wholesale basis as, for example, the case of Charles I's purchase of a significant part of the Gonzaga painting collection in 1628.[7] Or the case of the Spanish court, where Philip IV was adding so many paintings by Velázquez, Rubens, and their contemporaries to an already sizable collection.[8] Estimates suggest that Philip IV may have added more than 2,500 paintings to the Spanish royal collection in the course of his long reign and that the collection may have exceeded 5,000 items by the time of his death in 1665.[9] Yet the size and significance of these picture collections did not immediately provoke the conflict of priorities that we might now assume on the basis of our own value systems. The patrons who had the resources to develop large painting collections were also, by and large, owners of numerous palaces and noble residences in which there was ample room to hang paintings alongside more traditional displays of tapestry. Thus, the two media could coexist in separate, equally important spaces or be rotated with one another on a seasonal basis. The accommodations and compromises that such parallel displays entailed varied over the years from court to court and patron to patron, which is a complex subject that requires more detailed study than it has yet received. Generally speaking, however, inventories of the possessions of the richer collectors indicate that while many of their most valuable paintings and sculptures were displayed in dedicated cabinets and galleries in or close to their private apartments, paintings were not introduced in significant numbers and on a permanent basis into formal reception rooms, where tapestry traditionally played a large role, until well into the eighteenth century.

Of course, the use of tapestry and paintings in, respectively, public and private spaces was by no means universal. In the Spanish Netherlands, the sheer number of paintings that the regent Archduke Leopold Wilhelm accumulated during the

1640s and 1650s must have displaced tapestries from a number of chambers they traditionally occupied at the Coudenberg Palace.[10] In Spain, Philip IV did introduce large oil paintings as the principal decoration in a number of significant audience chambers in his palaces, starting with the Madrid Alcázar in the 1620s.[11] At the Palacio del Buen Retiro, built and decorated during the early 1630s, the decorative scheme in the main reception rooms comprised paintings by Velázquez, Zurbarán, and their contemporaries.[12] Yet at both palaces these schemes appear to have been seasonal, alternating with tapestry displays in the winter months.[13] To this end, both Philip and the courtiers acting on his behalf expended considerable sums on tapestries for Buen Retiro during the 1630s and 1640s.[14]

If the arrangements at the Spanish court indicate that tapestries and paintings were displayed in rotation on a seasonal basis in certain important areas, the distinction between chambers decorated with tapestries and those in which paintings were displayed was not always so clear-cut. This is demonstrated by various engravings made in France in the same period by Abraham Bosse (1602–1676). One of these depicts Louis XIV's bedchamber at Fontainebleau in 1645 on the occasion of the wedding contract between Władysław IV, king of Poland, and Louise Marie Gonzaga, princess of Mantua. The walls of the boy-king's bedchamber are hung with tapestries, but they have been overhung with four devotional paintings and a number of sconces, sufficient in size and number to break up the pictorial unity of the tapestries (fig. 147). In the inner sanctum of the richest patrons, some especially important paintings and pieces of furniture may certainly have been hung over the tapestries.

Fig. 147. *Ceremony of the Contract of Marriage between Władysław IV, King of Poland, and Louise Marie Gonzaga, Princess of Mantua, at Fontainebleau* (detail), by Abraham Bosse, 1645. Etching, 47.9 x 63.1 cm. The Metropolitan Museum of Art, New York, Harris Brisbane Dick Fund, 1930 (30.54.32)

Fig. 148. *Wives at Table during the Absence of Their Husbands* (detail), by Abraham Bosse, ca. 1636. Engraving, 26 x 33.7 cm. The Metropolitan Museum of Art, New York, The Elisha Whittelsey Collection, The Elisha Whittelsey Fund, 1951 (51.501.2267)

Similarly, in the homes of the nobility and gentry it may have been quite common to find looking glasses and a few important paintings hung over tapestries in bedchambers and private apartments, particularly in locations where the tapestries were not being rotated on a regular basis (fig. 148).

It would be misleading, however, to assume that this practice of superimposing paintings and furniture extended to the grander tapestries deployed in state and parade rooms or to tapestries that were still fresh and colorful, as many other paintings,

engravings, and descriptions also demonstrate (see, for example, figs. 47–52, 55, 56, and 149). After all, patrons were hardly likely to spend large sums if the tapestries were only to be used as wallpaper behind cheaper paintings. The great Baroque tapestries with trompe l'oeil architectural borders were especially ill-suited to visual impediment, for to be fully appreciated, they needed to be hung in sequence, edge to edge, in large uninterrupted spaces. And that does seem to have been the way high-quality artistic tapestries were used in the larger reception rooms until well into the early eighteenth century, as attested by written and visual evidence.[15]

For much of the seventeenth century, then, the competition between paintings and tapestries for display space was probably most acute in smaller households, where wall area was more limited, the artistic quality of the hangings was lower, and, by contrast, the paintings were more visually engaging. In such circumstances, tapestries were more likely to be treated as decorative backgrounds. But at the European courts and in the grandest noble households, tapestry and paintings coexisted in discrete areas or were rotated on a seasonal basis. Not until the second half of the eighteenth century did the institutionalization of an empirical Vasarian concept of artistic priorities—combined with changing fashions in interior decoration and the large numbers of paintings, sculptures, and other mementos that young noblemen were taking back to northern Europe from the Grand Tour—displace tapestry from its traditional place.

Fig. 149. *Signing of the Peace of Breda, 1667* (detail), by Romeyn de Hooghe. Engraving, 41.5 x 51.2 cm. The Metropolitan Museum of Art, New York, The Elisha Whittelsey Collection, The Elisha Whittelsey Fund, 1949 (49.95.722)

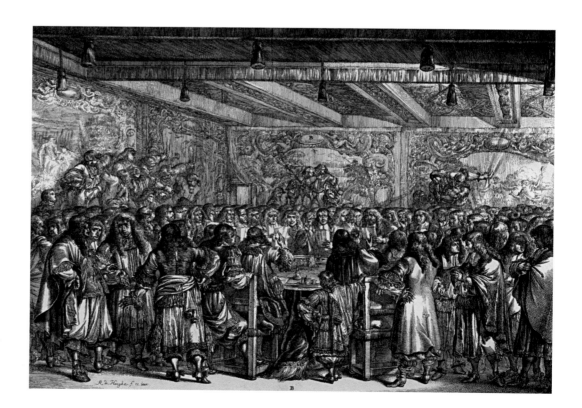

If the expanding market for oil paintings during the first half of the seventeenth century had a limited impact on tapestry displays in the grandest reception rooms, as it seems to have, did connoisseurship attendant on the new picture collections influence the way contemporary patrons thought about the tapestry medium? One impediment to investigation of this issue is the apparent paucity of commentary by seventeenth-century patrons regarding their tapestry collections, which itself raises the questions of why there is so much less discussion of tapestries than of paintings in contemporary documentation. In fact, this perception is partly a reflection of the neglect of the tapestry medium by present-day historians. Alongside documentation relating to the historic connoisseurship of paintings, there is also much information relating to tapestries that has not yet been given full consideration.[16] That said, the volume and sophistication of literature relating to paintings are undoubtedly much larger than that relating to tapestry. That phenomenon is partly explained by the sheer number of old master and contemporary paintings that were available in the first half of the seventeenth century and their accessibility to collectors by virtue of their smaller size and lower price. A moderate-size canvas by a well-known master was much cheaper than even a relatively coarse set of tapestries and vastly cheaper than a fine one. As a consequence, even patrons of modest means might acquire one or two pictures and thus have a stake in the discussion of current art.

Another reason that paintings seem to have attracted so much more discussion resulted from the different ways the values of paintings and tapestries were calculated. The crux of this matter was encapsulated in a comment Rubens made to Sir Dudley Carleton in the spring of 1618, when he was negotiating to acquire the English diplomat's collection of antique sculptures in exchange for a number of paintings and a set of tapestries. Rubens explained, "one evaluates pictures differently from tapestries. The latter are purchased by measure, while the former are valued according to their excellence, their subject, and number of figures."[17] Rubens's comment simplified the issue by ignoring, first, the cost of the original tapestry designs and the execution of the cartoons, and second, the complexity of the criteria that determined the unit valuation of tapestries, namely the quality and detail of the design, the quality of the materials, and the condition and color of the tapestry. Nevertheless, he was correct in a basic sense. Tapestries were indeed valued in terms of surface area because, as with buildings,

the main component of their production cost was dictated by the labor and raw materials involved, both directly proportional to the size of the final object. In contrast, paintings cost relatively little to produce and depended for their value on the esteem in which they were held, a subjective issue that provided artists and collectors with an incentive to talk up their works from the moment they were created. Rubens was the prime exponent of such self-promotion, as is demonstrated by his copious correspondence with patrons all over Europe, much of it devoted to discussion of his own work.

In assessing seventeenth-century patrons' responses to the tapestry medium, we therefore need to look at the documents with fresh eyes and a new sensitivity to the evaluation of tapestries. We must, in doing this, recognize that the criteria for judging tapestries, while similar to those for judging paintings, were nonetheless different, and that the continuing use of tapestry was not simply the result of some worn-out medieval convention. As this catalogue demonstrates, tapestry was a subject of reflection and connoisseurship at the highest level. The correspondence of connoisseurs like Alessandro Peretti Montalto and Scipione Borghese shows the discriminating terms in which Italian patrons were considering tapestry acquisitions early in the seventeenth century. Another fascinating echo of the discussions that must have taken place in front of grand tapestry displays is provided by the record that Cassiano dal Pozzo kept of his journeys to Paris and Madrid with Francesco Barberini in 1625 and 1626. Along with other works of art, dal Pozzo made extensive notes on the tapestries he saw, demonstrating considerable knowledge about the origins and ownership of a number of sets. He also manifested discrimination regarding their material quality, their relation to other weavings of the subjects he had seen, and the quality and iconographic interest of their design.[18]

Another sort of documentary evidence that requires more extensive analysis is the scale of financing that seventeenth-century patrons committed to tapestry and of the valuations placed on tapestries in contemporary inventories. For example, the inventory of Cardinal Richelieu's collections in 1643 includes approximately fifteen sets of tapestries, of which two alone were valued at 52,000 livres, while his entire painting collection was valued at 81,000 livres.[19] One has only to consider the enormous sums of money that many ardent painting collectors invested in tapestry sets to realize the extent to which tapestry in its finest manifestations continued to be a major preoccupation for the leading patrons. Nor was this simply a question of conspicuous consumption and material extravagance. As this

exhibition and publication make clear, only in the finest grades of production could the full artistry of ambitious designs be realized. The most striking example of someone who was a major collector of paintings but who was also extremely vested in the production and appreciation of high-quality tapestry was Charles I (r. 1625–49). Charles was profoundly influenced by the cultivated taste of his older brother, Prince Henry (d. 1612), and he began collecting paintings avidly on his own behalf from the late 1610s. During the 1620s he expended enormous sums on purchasing old master and contemporary paintings, including the aforementioned Gonzaga collection of paintings that cost him approximately 18,000 pounds in the late 1620s. Yet, in the course of his reign, he spent as much on tapestries as on paintings, a fact that has been obscured by the complexity of the financial arrangements relating to the Mortlake manufactory and the sale of all but one Mortlake tapestry from the royal collection after his execution in 1649.[20] And when Charles's purchases of old master paintings waned in the 1630s, his financial investment in the Mortlake works remained constant. Indeed, the sums he lavished on Mortlake are breathtaking. The first set of *Acts* made there between 1626 and the early 1640s (cat. no. 16) seems to have cost approximately 500 pounds for each piece. As such, it was the most expensive individual work of art that he commissioned during his reign, and it embodies the extent to which tapestry and high art were united in his mind—in this case, the reweaving of Raphael's famous cartoons with new borders that appropriated the papal imagery to Charles's own purpose and established him as a neo-Renaissance patron in the vein of the greatest sixteenth-century Maecenases. The intellectual interest he took in this set is reflected in the fact that among the treasures in his inner cabinet was an illuminated manuscript that elucidated the iconographic program of the tapestry borders.[21]

While Charles's interest and investment in the tapestry medium were exceptional, many of the other famous collectors of paintings also undertook major tapestry commissions that have been relatively overlooked by present-day historians. For example, as noted elsewhere in this volume, for all of his interest in collecting paintings, Archduke Leopold Wilhelm also purchased several tapestry sets after designs by Jacob Jordaens and commissioned Jan van den Hoecke to design an allegorical set of the *Months* (cat. nos. 27, 28). In addition, he commissioned a series of designs from his court artist, David Teniers II, that was still in production at the time of his death, and he purchased at least one set of tapestries from the sale of Charles I's collection in 1652.[22] While such activities in no way diminish

the significance of his activities as a collector of paintings, they suggest the extent to which a balanced assessment of the artistic interests of the major patrons of the day remains to be written.

The Influence of Oil Painting on the Style of the Tapestry Medium

The investment of patrons such as Charles I in the tapestry medium demonstrates the high esteem in which it continued to be held as a traditional form of art and splendor, but did the nascent connoisseurship of oil paintings influence the style of tapestries that contemporary patrons were acquiring? During the late 1610s, 1620s, and early 1630s, when a number of leading oil painters such as Rubens and Van Dyck were gaining an international reputation and an unprecedented degree of prestige, some of those same artists were commissioned to undertake high-profile tapestry designs even though they had little or no previous experience of such work. Their individual responses to the challenges and opportunities of the medium varied widely. For example, Rubens's *Decius Mus* and *Constantine* designs were ambitious attempts by the leading Flemish oil painter to push the tapestry medium as far toward painting as it could be taken. Rubens's preliminary sketches for both series were executed in oil on panel, and the cartoons of the *Decius* series were executed in oil on canvas, even though the tapestries themselves were copied from full-scale watercolor copies of those canvases. Neither series was an unqualified success. Rubens did not receive any more tapestry commissions for the Brussels workshops for at least a decade after completing the *Decius* designs. In the case of his Constantine cartoons, the letters of Rubens's friend the connoisseur Nicolas-Claude Fabri de Peiresc provide intriguing testimony of the close scrutiny the cartoons received from prominent members of Louis XIII's court shortly after their arrival in Paris.[23] In this case, the cartoons were executed by Rubens's assistants in watercolor on paper from the master's oil sketches. Although they received high praise, not all the comments were positive, and several shortcomings were noted in the execution of the figures. Peiresc tactfully attributed these failings to the assistants who had executed the cartoons. Again Rubens received no more tapestry commissions, this time from the French court. Louis XIII turned instead to Simon Vouet for new tapestry designs, recalling him from Rome in 1627. Apart from the more classical character of Vouet's figural compositions and the careful attention he paid to line and proportion, his overall style of tapestry design reflects a greater accommodation of the decorative character of the medium. Such divergent approaches by Rubens

and Vouet must have caused considerable discussion in Paris, both in the tapestry workshops and between patrons and merchants.

Analogous discussions about the aesthetic values of tapestries and paintings may have been taking place at the English court. During the 1630s, the Mortlake works produced exquisite copies of portraits by Van Dyck and various paintings by Raphael and Titian, which suggest that there may have been debate in Charles's circle about the two media, akin to the renowned *paragone* (comparison) debate in Renaissance Florence regarding the relative merits of painting and sculpture.[24] Similar discussions must have been occurring in Brussels: the inscriptions that were woven in the borders of various Brussels tapestries in the 1630s and 1640s, in which the tapestry medium was vaunted as a Liberal Art in its own right, attest to a growing sensitivity by the weavers to a comparison between tapestry and painting.[25]

Yet, while these examples suggest a growing debate among patrons and artists regarding the aesthetics of the two media, there is no evidence that the leading patrons perceived the difference between tapestry and painting in terms that meant the subjection of one to the other. If anything, the participation of famous artists in the production of new designs brought a new cachet to modern tapestry production. Thus far, the Vasarian model of art appreciation, with its emphasis on conception and bravura execution, had not displaced the criteria by which tapestry had traditionally been appreciated: the nobility and inventiveness of the design, the mastery of execution, and the quality of the materials. For the time being, at least, the two figurative media coexisted, with a certain amount of cross-fertilization from one medium to the other.

Tapestries as Collectible Objects
As the skills and prestige of the famous artists of the day were adding luster and new ideas to contemporary tapestry production, how much did the rapacious collecting habits that were developing in association with paintings influence those associated with tapestries? Rich patrons commissioning or purchasing tapestries during the sixteenth century seem not to have thought of themselves as collectors of tapestry per se. Rather, they were acquiring trappings of magnificence appropriate to their rank. Some individuals did accumulate enormous numbers of tapestries—servants of Cardinal Wolsey and Henry VIII boasted of the number of tapestries owned by their masters—and many patrons evidently had a sophisticated appreciation of the medium's aesthetic and material strengths and weaknesses.[26]

But there is little evidence of people collecting tapestries as a goal in itself. As for the question of the extent to which this changed in the seventeenth century, that requires more research. There is certainly evidence of a growing market for antique tapestries, as there is of new levels of discrimination among increasing numbers of rich patrons regarding both old and new designs.

For example, when Marie de' Medici gave birth to the dauphin in 1601, the Paris authorities presented her with a sixteenth-century set of the *Story of Scipio* made for the marshal Jacques d'Albon de Saint-André about 1550 that she was known to have admired in the premises of a local German dealer.[27] Also in 1601, Henri IV purchased two fine sets of sixteenth-century tapestries from an Italian banker, Sébastien Zamet (ca. 1552–1614), who seems to have specialized in such sales in Paris. When Zamet died, an inventory of his possessions included fourteen sets of Flemish tapestries, including one of the *Triumphs of Petrarch*, which, as subsequent evidence has shown, was probably a high-quality early sixteenth-century version of this subject. During the early 1610s, members of the English nobility were extremely interested in the possibility of purchasing tapestries from the sale of the duke of Aerschot's collection.[28] In the early 1640s, we find Cardinal Richelieu eagerly seeking to acquire tapestries from the estate of Marie de' Medici, including the *Story of Scipio* given her in 1601.[29] In the event, Mazarin got that set. Some years later, when Queen Christina abdicated and went into exile in Rome in 1654, she took with her some of the finest tapestries from the Swedish royal collection, including a number of sixteenth-century ensembles. These included a *Triumphs of Petrarch* set dating from about 1525 that she had purchased in Paris in 1651 from the dispersal of Cardinal Mazarin's collection during the Fronde, which is perhaps to be identified with the set earlier in Sébastien Zamet's inventory.[30] Subsequently, this set was one of three that Queen Christina had to leave in the hands of Cardinal Mazarin in 1657 as security for a loan, and her correspondence with him reflects her keen desire to get it back. It was eventually redeemed in the early 1660s.[31] These, and many other examples, reflect the efforts of contemporary patrons to get their hands on the limited supply of good-quality vintage tapestries that came into the marketplace.

As we have seen elsewhere in this publication, the demand for "old master" tapestries was also catered to by adapting sixteenth-century designs to contemporary tastes and adding new borders. The large numbers of such Brussels tapestries in the Spanish royal collection and the similar copies that were

made for the French and English kings at the Paris and Mortlake workshops attest to the keen appetite for such products by the monarchs of the day. Most of these reproductions were of designs created by the Raphael school or the Romanist designs of Flemish artists like Pieter Coecke and Michiel Coxcie. But the *Story of the Trojan War* tapestries that the house of Alba purchased sometime in the 1610s, copied from the late fifteenth-century Tournai design series, provide evidence of a more esoteric taste.[32] Considering the time, effort, and cost involved in making such a reproduction, this was no casual commission, but a thoughtful and time-consuming effort to reproduce a late medieval design.

Indeed, appreciation of historic tapestries seems to have been very sophisticated in Spanish court circles. While Philip IV's interest in modern tapestry was not as pronounced as that of his English counterpart and unquestionably took second place to his compulsive interest in painting, he nonetheless evinced a continuing regard and interest in earlier tapestries, of which he owned many exquisite examples. As we have seen, the great sixteenth-century tapestries made for his ancestors continued to play a key role in Spanish court ceremony and decoration throughout the seventeenth century. And when the opportunity came to acquire sixteenth-century tapestries from the English royal collection, Philip was the first to do so—albeit with great discretion and through a third party, Don Luis de Haro's agent, Cárdenas—purchasing, for more than 5,000 pounds, two magnificent sets that had originally belonged to Henry VIII (see below).

Other Spanish grandees evidently shared the esteem for antique tapestries.[33] For example, as noted in the introduction to this essay, Haro was one of the most active purchasers of tapestries as well as paintings at the sale of Charles I's collections.[34] Subsequently, on the occasion of the Treaty of the Pyrenees in 1659, he presented three sets of very fine tapestry to Cardinal Mazarin, of which two dated to the sixteenth century. In return, Mazarin presented Haro with two equally fine sixteenth-century sets.[35] When Haro died, he took legal steps to incorporate two sets of tapestry in his possession, one of the *Acts of the Apostles* and one of the *Story of Phaeton*, along with various paintings, to the estate of the house of Carpio so they would not be dispersed with his personal belongings.[36]

Similar observations apply to the tastes and collecting habits of the leading French nobility and clergy.[37] Cardinal Richelieu was actively acquiring tapestries in the 1630s, and the inventory taken at his death gives precise details of the tapestries in his Paris residence (twelve sets) and his Château de Rueil (six sets).

As discussed elsewhere in this volume, these included a mix of old and new tapestries from both Flemish and French workshops. While some sets were evidently considered to be essentially furnishing components, others were among the most valuable objects in his collection, including a sixteenth-century set of gold-woven *Grotesques*, valued at 32,000 livres, that was taken for the crown, and a *Story of Lucretia* that Richelieu had purchased from the duc de Chevreuse and which he left to his grand nephew to decorate the future "hôtel de Richelieu" in perpetuity.[38] Richelieu's collection was probably fairly typical of many rich European nobles, reflecting a mix of practicality and artistic appreciation.

While the foregoing examples all suggest an intellectual climate in which rich and sophisticated patrons sought to acquire good-quality examples of both vintage and modern tapestries, it is questionable how much this activity corresponded to the competitive behavior that was a regular component of the painting collector's world. Generally speaking, tapestries were simply too large, expensive, and unwieldy and the supply of good-quality sets too limited for the tapestry medium to receive the frenzied attention that was sometimes manifested over paintings. Most of the finest antique sets were valued components of royal and noble collections from which they were unlikely to be sold, and new sets were produced at an agonizingly slow pace. Individuals pulled what strings they could when good sets became available. For example, the Marquess (soon to be Duke) of Buckingham was keen to obtain fine tapestries that had been made in the Spiering manufactory in 1620, but his hopes were disappointed when they were instead consigned to the Swedish court.[39] By and large, however, the supply of old and new sets of high-quality tapestry was just too limited during the 1630s and 1640s to generate competitive attention on a sustained basis.

Yet there was one individual, Cardinal Mazarin (fig. 150), who stands out during these years for the extraordinary tenacity he demonstrated in acquiring tapestries of the finest quality and of all periods. Mazarin grew up in Rome, and his tastes as a connoisseur and collector were nourished from the earliest years by exposure to leading patrons and artists of the day. During his first trips to France as papal nuncio in 1632 and 1634–36, he arranged gifts of artworks for members of the French court and informed his Roman patrons, particularly Antonio Barberini, of works they might wish to purchase, including tapestries.[40] Mazarin entered the service of Cardinal Richelieu in 1636, and subsequently of Anne of Austria, regent for her son Louis XIV following the death of her husband,

Fig. 150. *Cardinal Mazarin in His Palace*, by Robert Nanteuil and Pierre van Schuppen, 1659. Engraving, 49.2 x 58.6 cm. The Metropolitan Museum of Art, New York, Rogers Fund, 1962 (62.602.112)

Louis XIII. Mazarin had a genius for administration, politics, and gambling, which rapidly provided him with the resources to indulge his own acquisitive tendencies. After he purchased the Palazzo Bentivoglio in Rome in 1641, he began to amass the enormous and eclectic collection for which he is now famous.[41] Correspondence with his agents in Italy includes frequent references to tapestries that were available from the dispersal of various distinguished estates and the competition for certain key sets. In Paris his main supplier was a man called Renard, with whom, according to the writer Saint-Évremond, he often talked at length about such matters.[42] During the early 1640s Mazarin acquired a number of important sets from the estate of Marie de' Medici, including the so-called *Grand Scipio* woven for the marshal de Saint-André about 1550 (fig. 151), which was later copied at the Gobelins for Louis XIV; important sets from the Barberini collection in 1646, including the so-called *Barberini Hunts* (now lost); and other tapestries from England, including a nine-piece set of the *Story of Vulcan and Venus* made for the Marquess of Buckingham between 1620 and 1623.[43] (In 1657 this set was presented by Louis XIV to King Karl Gustav X of Sweden. One panel and a number of fragments survive in Stockholm today; see fig. 84).[44]

The growth of Mazarin's collections was temporarily checked by the political unrest known as the Parliamentary Fronde (1648–49) and the Fronde of the Princes (1650–53), during which he was twice temporarily exiled from Paris. On both occasions, parts of Mazarin's collection were dispersed by

sale, although he and his agents managed to hide or secure some of the more precious items. As soon as he regained royal favor in the summer of 1652, he began reconstituting his collections.[45] The man responsible for this work was Jean-Baptiste Colbert, who a decade later would play such a significant role in directing the artistic patronage of Louis XIV and the creation of the Gobelins workshops.

Mazarin's interest in high-quality antique tapestry was unusual in its scale and in the amount of money he expended. During the early 1650s this interest provided an influential example when a large number of high-quality sixteenth- and seventeenth-century tapestries were introduced to the European market as a consequence of the English Civil War and the dispersal of many of the greatest Cavalier art collections. Suddenly, in a span of fewer than ten years, an unprecedented supply of tapestries was available. For a brief period the richest Continental patrons competed to purchase the finest vintage and modern tapestries as avidly as they were pursuing important old master paintings. The greatest spoils were those to be had from the British royal collection.

The Sale of Charles I's Goods

The main events of the sale of Charles I's art collections are well documented.[46] Following the execution of the king on January 30, 1649, the Commonwealth government directed that the royal art collections be sold to pay the royal debts, and the sale was under way by the end of the year. The inventories drawn up for this purpose list more than sixteen hundred

Fig. 151. *The Continence of Scipio* from a set of the *Deeds of Scipio*. Tapestry cartoons by an artist in the circle of Michiel Coxcie after Giulio Romano and Giovanni Francesco Penni, woven in Brussels, ca. 1550. Wool and silk, 447 x 658 cm. Hearst Castle, San Simeon

tapestries. Of these, more than one thousand dated from the fifteenth and sixteenth centuries, the surviving part of the enormous collection that had been amassed under Henry VIII. The rest derived from purchases by Charles himself, many from the Mortlake manufactory.[47] While the valuations of the paintings reflected their market value, which had been stimulated during the second quarter of the seventeenth century by competition between English and Continental collectors, the tapestries were valued in a more summary manner, reflecting the government trustees' ignorance, prejudice, and uncertainty as to how such large numbers of tapestries would fare in the open market.[48] Unless a set contained metal thread or was exceptionally large, most were valued in the region of 20–30 pounds for the set, equivalent to the valuations on large old master paintings by well-known artists but considerably below the replacement value of the tapestries. Many of the older fragments and individual pieces were valued even lower. The cloth of state depicting the *Story of Clovis* that had been an object of admiration at Windsor Castle for many years was appraised at only 2 pounds. The highest valuation placed on a fifteenth-century

set was 366 pounds, given to a very large *Story of the Trojan War* set that Henry VII had purchased in 1488 from the Tournai merchant Pasquier Grenier.[49] Many of the sixteenth-century tapestries fared little better. In striking contrast to these lower appraisals were those placed on about thirty sets of high-quality tapestries that, because of their size and condition and the large amount of gilt-metal thread they included, received estimates ranging from hundreds to thousands of pounds, greater than any other works of art. Most of these sets derived from purchases made by Henry VIII during the 1540s, including the *Story of Abraham* (fig. 152), which had the highest valuation in the entire collection, 8,260 pounds. Some of the Mortlake sets also received very high valuations.[50]

The initial response to the sale of the royal artworks was slow because the English nobility, who in previous years would have been the obvious clientele, had been decimated by the Civil War. Moreover, few foreign collectors had agents and funds in London to take advantage of the situation, and foreign monarchs were hesitant to appear to benefit from the regicide of a fellow monarch. The government therefore decided to

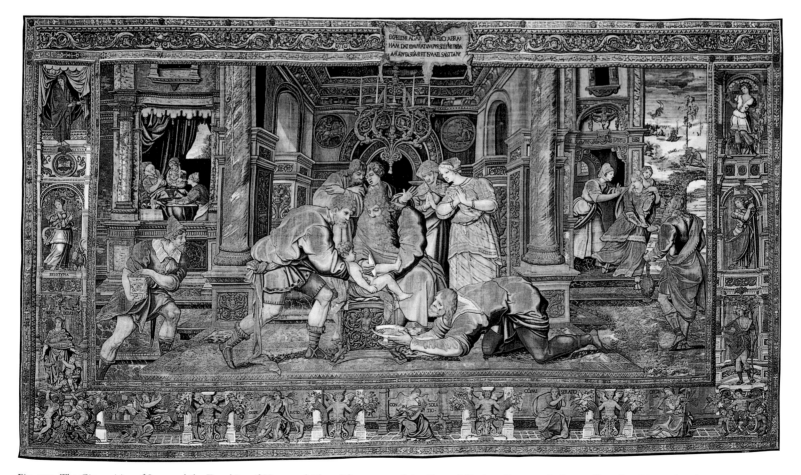

Fig. 152. *The Circumcision of Isaac and the Expulsion of Hagar and Ishmael* from a set of the *Story of Abraham*. Tapestry design attributed to Pieter Coecke van Aelst, woven in the workshop of Willem de Kempeneer, Brussels, ca. 1541–43. Wool, silk, and gilt-metal-wrapped thread, 482 x 805 cm. The Royal Collection, Hampton Court Palace

apportion works of art to the royal creditors in lieu of payment, and the dispersal of goods took place in October 1651.[51] By early 1652, almost a thousand tapestries had been transferred into private hands, and it was from individual dealers that the agents of foreign collectors like Don Luis de Haro and Cardinal Mazarin subsequently made many of their purchases.

Haro's agent, Don Alonso de Cárdenas, had an initial advantage because he had full diplomatic status at a time when Cardinal Mazarin had no agent in London. In the course of 1649 and 1650, Cárdenas's purchases for Haro—many of which were actually intended for Philip IV—comprised fifty-six paintings, including Raphael's *Holy Family with Saint Elizabeth and Saint John* (Museo del Prado, Madrid), the most expensive painting in the whole collection. The total paid was 5,872 pounds, of which 700 pounds were for the Raphael, reduced from its original valuation of 2,000 pounds. During the same period, Cárdenas also negotiated for and purchased two gold-woven tapestry sets: a *Verdure* with exquisitely rendered naturalistic flowers that Henry VIII had purchased in 1520, and a set of the *Acts of the Apostles* that Henry bought in 1542 (fig. 153).[52] The cost totaled 5,799 pounds, that is, equivalent to the price of the fifty-six paintings that Cárdenas had selected as the cream of that collection. The *Acts* set was on display in the Alcázar in Madrid by March 1651, at which time the Venetian ambassador reported it to be "an exquisite set of hangings . . . of incomparable design and delicacy." But he was mistaken when he reported that they had been purchased "as cheaply as if they had been of plain cloth." In passing, it is worth noting that while a number of the paintings purchased by Cárdenas on Philip's behalf now count among the greatest treasures of the Museo del Prado in Madrid, the subsequent fate of the tapestries typifies that of so many others from the sale and helps to explain why the British royal tapestry collection is a footnote in the art history of this period. The *Verdure* set was probably destroyed in a fire at the Alcázar in 1734.[53] The *Acts* subsequently passed into the collection of the dukes of Alba, from which it was sold in 1823. Acquired by the Kaiser Friedrich Museum in 1844, it remained in Berlin until 1945, when it was destroyed or looted during the final days of World War II.[54]

Mazarin was at a disadvantage during 1651–52 because of his temporary exile from Paris and his lack of an accredited agent in London, but the balance shifted with his return to Paris and the arrival of his new agent, Antoine de Bordeaux, in London early in 1653. From that point, Bordeaux's correspondence is peppered with references to tapestries that he had heard about or already bought, and in August he was shown some of the finest tapestries that remained in the collection, including the *Story of Abraham* set.[55] He reported to Mazarin that it was in almost perfect condition, having been displayed only for special occasions, an interesting reflection of the extent to which careful husbandry had preserved the great sets in the royal collections of the day. Mazarin urged Bordeaux to purchase the set at the best price possible, but definitely not to let it get away.[56] In the event, all the tapestries that still remained in the royal collection were reserved for the use of Oliver Cromwell when he was appointed Lord Protector in late 1653, and many of them were subsequently hung in the apartments created for him at Hampton Court.[57] While the discontinuation of the Commonwealth sale meant that Mazarin had no hope of acquiring any more tapestries directly from the royal collection, it is evident from Bordeaux's correspondence and the inventories of Mazarin's possessions taken in 1653 and 1661 that he did succeed in securing a substantial number of the royal tapestries that continued to circulate in the English market.[58]

The inventory of Mazarin's goods compiled late in 1653 shows that by this date he had already benefited substantially from the dispersed English courtier collections.[59] Six large Mortlake sets can be identified, not all from the British royal collection. The largest was the already mentioned nine-piece set of the *Story of Vulcan and Venus* with the arms of the Marquess of Buckingham. Also of note were three panels of a set of the *Acts of the Apostles* with the Earl of Pembroke's arms (see fig. 90). Mazarin subsequently commissioned seven complementary *Acts* tapestries from a Paris workshop to complete the set, in itself a highly ambitious exercise.[60] Besides the Mortlake sets, Mazarin's 1653 inventory also records approximately fifty other tapestries, which were said to be "fabrique d'Angleterre," but for which no analogous Mortlake designs are known. Several were woven with silk and gold, and many were described as old or as having designs by Lucas or Dürer, generic identifications applied in the inventories of the time to early sixteenth-century tapestries. Some of these tapestries, such as a panel of the *Glorification of Christ* that survives today at the National Gallery of Art in Washington (fig. 154), can certainly be identified as early sixteenth-century Flemish tapestries and probably as deriving from the English royal collection.[61] Why these pieces were described as "fabrique d'Angleterre" is uncertain, but the likely explanation is that the officers responsible for compiling Mazarin's inventory were confused because these old tapestries did not carry manufactory marks—which were not instituted for Brussels tapestries until 1528 and for tapestries made in other Flemish centers until 1544—and since the

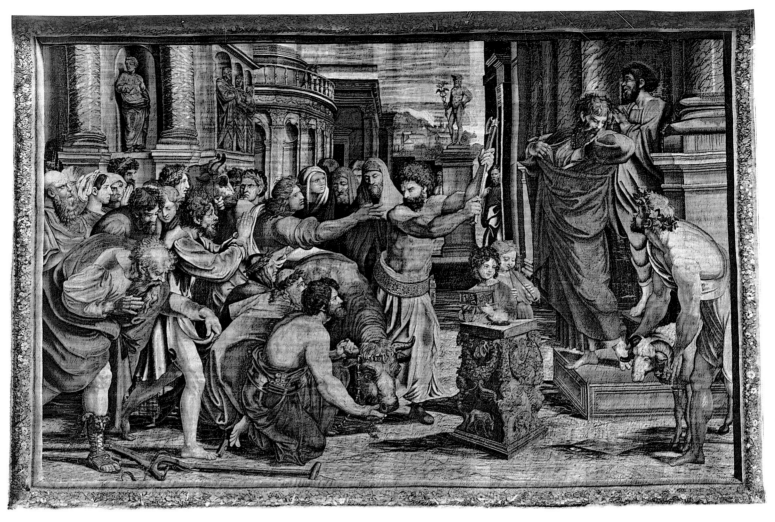

Fig. 153. *The Sacrifice at Lystra* (fragment, after removal of outer borders) from Henry VIII's set of the *Acts of the Apostles*. Tapestry cartoon by Raphael, woven in an unidentified Brussels workshop, ca. 1540–42. Wool, silk, and gilt-metal-wrapped thread. Current location unidentified, formerly Kaiser Friedrich Museum, Berlin

tapestries were purchased in England the officers simply assumed that they had been made there.[62] At any rate, Mazarin's collection of sixteenth-century tapestries was extraordinary in its range and variety. Another rare early piece that he acquired from the English royal collection was the tapestry depicting the marriage of Henry VII and Elizabeth of York that Henry VII had commissioned about 1500, now lost.[63]

Despite the large numbers of tapestries that Mazarin had already acquired from the dispersal of the English courtier collections by 1653, this only seems to have whetted his appetite, and during the mid- and late 1650s he purchased many more outstanding sets from a variety of sources. In 1655 he embarked on a complex series of negotiations that eventually resulted in the acquisition of two famous sets from the collections of the Guise family, including the so-called *Hunts of Maximilian* (fig. 9) and another rich sixteenth-century set, grotesques of the *Twelve*

Planets.[64] And in 1658–59 he negotiated, unsuccessfully, for the famous set of the *Loves of Jupiter*, which had been made for Andrea Doria after designs by Perino del Vaga in the early 1530s, requesting his agent to give him precise details of the design, the colors of the wool and silk, and the abundance of gold thread.[65] These criteria were typical of those he applied in many of his purchases.[66] The scale of the collection that Mazarin had amassed by the time of his death in 1661 was truly exceptional, comprising superlative examples of the finest sixteenth-century Brussels sets, as well as exquisite products of the contemporary ateliers in Paris, Brussels, London, and Rome.[68]

Mazarin was the most active tapestry collector of the day, but other French dignitaries also availed themselves of the opportunity to acquire tapestries from the English market, either in London or from French merchants. Thus Abel Servien, one of

Louis XIV's superintendents of finance, acquired two Mortlake sets of the *Acts of the Apostles*, one being that with Charles I's arms (cat. no. 16) at some point in the 1650s. He sold both to Mazarin in 1659.[68] Another high-quality Mortlake set of this subject was acquired by the abbé Jacques le Normand, councillor to Louis XIV, and Mazarin also purchased this in 1659, thus acquiring his fourth Mortlake set of the *Acts*.[69] The 1661 inventory of the possessions of Nicolas Fouquet, Louis XIV's other superintendent of finance, mentions a set of the *Story of Vulcan and Venus* that can be identified with a Mortlake set now in the Mobilier National, Paris. In addition, several other sets listed in Fouquet's inventory also derived from the English royal collection.[70] Many of the tapestries from Mazarin's and Fouquet's collections were subsequently purchased or appropriated by Louis XIV and thus entered the French royal collection. This explains why the largest extant group of high-quality Mortlake tapestries now belongs to the French state (Mobilier National).[71]

During the succeeding years, many other tapestries from English collections found their way onto the French market. Fouquet's brother François, archbishop of Narbonne, acquired a ten-piece, gold-woven set of the *Redemption of Man* that had been purchased by Henry VII in the opening years of the sixteenth century. The archbishop left this to the Chapter of Saint-Juste in February 1673, and one piece survives today in Narbonne Cathedral (fig. 155). Tapestries said to be "fabrique

Fig. 154. *The Glorification of Christ*. Tapestry woven in the southern Netherlands, probably Brussels, ca. 1500. Wool, silk, and gilt-metal-wrapped thread, 343 x 416 cm. National Gallery of Art, Washington, D.C., Widener Collection (1942.9.446)

d'Angleterre" are also listed in the inventories of Jean-Baptiste Colbert, Louis's minister of finance and director of royal buildings and art works; Michel Le Tellier, chancellor and minister of war; and his son, François Michel Le Tellier, marquis de Louvois, minister for royal buildings.[72] Other tapestries from English collections traveled farther afield, entering collections in northern Italy, such as the set of Mortlake *Occupations of the Months* with the arms of John Williams, bishop of Lincoln and Keeper of the Great Seal, that was in Genoa before 1650 when it was mentioned in the will of Giovanni Andrea De Franchi (fig. 86).[73] A similar fate appears to have befallen a fine-quality *Triumphs of Petrarch* set with portraits of Cardinal Wolsey and Henry VIII that had been made for one of them about 1520. This was also in Genoa by the late 1650s.[74] Another remarkable ensemble from the English royal collection that emerged in Genoa in the mid-nineteenth century, but which had probably been there much longer, was a *Story of David* set that Henry VIII purchased at enormous cost in 1528 (fig. 156).[75] Not all the tapestries that traveled to France, Italy, and Spain came from English courtier collections. The *Life of Christ* tapestries that had been donated to Canterbury Cathedral by officers of that church in 1513 were purchased in 1656 by the cathedral chapter of Saint-Sauveur in Aix, where they survive in part today.[76]

In summary, the sale of the British royal collection and those of other members of the English aristocracy in the late 1640s and 1650s released large numbers of tapestries of a range of qualities into the Continental market. The continuing demand for tapestries, both old and new, ensured that the ones from English collections were widely disseminated across Europe. It is important to reiterate that the finer pieces were, at this stage, still prized as works of art in their own right. No evidence has emerged of tapestries being burned to extract their gold content, as would happen to many of the tapestries from Francis I's collection after the French Revolution.[77] The high-quality Mortlake products made for Charles I and his circle that passed into French hands during the 1650s must have been among the examples that stimulated Nicolas Fouquet to establish his own workshop at Vaux-le-Vicomte in 1658. They must also have been among the examples that inspired Colbert to establish the Gobelins workshop in 1662, following the disgrace of Fouquet. The model of King Charles I's royal tapestry manufactory would be copied at the Gobelins and developed on an unprecedented scale, ensuring that tapestry remained at the forefront of European court splendor for the next fifty years.

Fig. 155. *The Creation* from a set now known as the *Redemption of Man*. Tapestry woven in the southern Netherlands, probably Brussels, ca. 1500–1502. Wool, silk, and gilt-metal-wrapped thread, 420 x 785 cm. Cathédral Saint-Juste, Narbonne

Fig. 156. *The Assembly of the Troops* from a set of the *Story of David*. Tapestry woven in Brussels, ca. 1526–28. Wool, silk, and gilt-metal-wrapped thread, 450 x 815 cm. Musée National de la Renaissance, Château d'Écouen

338

1. Loomie 1989, p. 260.
2. For a recent account of this rivalry, with further bibliography, see J. Brown 2002a, pp. 59–68.
3. The silence on this matter is particularly marked in the literature by English and American art historians; see, for example, Madrid 2002, and Brotton 2006, both of which treat the Commonwealth sale almost exclusively in terms of paintings and sculptures. Brotton is especially dismissive in his comments about the royal tapestries. French historians have been more balanced on this subject, in particular the exemplary studies included in Schnapper 1994 and Michel 1999.
4. For a convenient introduction to royal and courtly painting collections, see J. Brown 1995.
5. For discussion and bibliography on this development, see Gibson-Wood 1988, and Posner 1993. For history painting, see Rochester–New Brunswick–Atlanta 1987.
6. For extensive discussion and bibliography on Vasari's attitudes and legacy, see *Il Vasari storiografo* 1976.
7. For Charles I's acquisition of the Gonzaga collection, see Haskell 1989; J. Brown 1995, pp. 40–47; Brotton 2006, pp. 107–44.
8. For Philip IV's collection, see J. Brown 1995, pp. 114–45; Bassegoda 2002; J. Brown and Elliott 2003.
9. J. Brown 1991, p. 204; M. Burke and Cherry 1997, pp. 124–25.
10. J. Brown 1995, pp. 146–83.
11. Orso 1986.
12. J. Brown and Elliott 1980; J. Brown and Elliott 2003.
13. Orso 1986, pp. 124–25, 142; J. Brown and Elliott 1980, pp. 105–6, 108–9; M. Burke and Cherry 1997, p. 62; J. Brown and Elliott 2003, pp. 108, 276 n. 4.
14. J. Brown and Elliott 1980, pp. 103, 105–6; Herrero Carretero 1999, p. 105; J. Brown and Elliott 2003, pp. 105, 107–8.
15. For further discussion, see below, "Continuity and Change in Tapestry Design and Usage, 1680–1720." See also Standen 1981, pp. 6–15; Brassat 1992; Bertrand 1995; Lefébure 1995; Lefébure 1996.
16. For example, the exhaustive survey of historic Spanish inventories in M. Burke and Cherry 1997 is devoted exclusively to paintings, even though many of the inventories cited also refer to tapestries. Tapestry was outside of the scope of that survey, obviously, but the fundamental assumption on which that parameter was based says much about the partial treatment of historic figurative art by modern art historians.
17. Rubens to Carleton, June 1, 1618, in Magurn 1955, p. 67.
18. Bertrand 2005, pp. 46–49.
19. Schnapper 1994, p. 45.
20. J. Wood 1996; Brotton 2006, pp. 12–13; and Hefford, "The Mortlake Manufactory, 1619–49," in this volume.
21. Millar 1960, p. 126.
22. Bauer 1999, pp. 116–18; Brotton 2006, pp. 269–70.
23. Held 1980, pp. 65–66.
24. See Hefford, "The Mortlake Manufactory, 1619–49," in this volume.
25. See Delmarcel, "Tapestry in the Spanish Netherlands, 1625–60," in this volume.
26. For comments on the size of the tapestry collections of Wolsey and Henry VIII, see T. Campbell 2007, esp. pp. ix–x, 140. For the taste and appreciation of the tapestry medium by 16th-century patrons, see New York 2002, passim.
27. Bournon 1880–81; Schnapper 1994, p. 126.
28. Purnell and Hinds 1924–40, vol. 4, pp. 160, 169.
29. Schnapper 1994, pp. 125–26.
30. Ibid., pp. 119–20.
31. Nordenfalk 1966, pp. 282–84, 286–87; Michel 1999, pp. 199, 287–88.
32. Sale cat., collection of the Duke of Berwick and Alba, Hôtel Drouot, Paris, April 7–20, 1877, nos. 17, 18; McKendrick 1991, p. 62.
33. While no comprehensive survey of 17th-century Spanish tapestry collections has yet been undertaken, much crucial information about patrons and archival sources is published in M. Burke and Cherry 1997.
34. For recent discussion and bibliographic references on Don Luis de Haro as a collector, see M. Burke 2002. This essay barely touches on his interest in tapestry, but the documentary appendix in Madrid 2002 (J. Brown 2002b) includes valuable information about tapestry acquisitions.

35. Michel 1999, p. 293; also Guy Delmarcel, "Tapestry in the Spanish Netherlands, 1625–60," in this volume.
36. M. Burke 2002, p. 103. The *Acts* set comprised twelve pieces and can be identified with the Raes and Geubels set now at Hampton Court, in which a number of panels were woven in two separate sections. At some point after Haro's death, those panels that had been woven in two sections were joined. The set, which entered the Alba collection when the houses of Carpio and Alba were joined by marriage, was sold with the Alba collection in 1877 and purchased by Baron d'Erlanger, who presented it to the English Crown in 1905.
37. Schnapper 1994, passim.
38. Ibid., pp. 150, 153–54.
39. Howarth 1994, p. 150.
40. Michel 1999, pp. 26–27.
41. Michel 1999. See also De Conihout and Michel 2006.
42. For the early formation of Mazarin's tapestry collection, see Michel 1999, pp. 160–67.
43. Ibid., pp. 163, 166.
44. Hefford 1999; Michel 1999, p. 166; Stockholm 2002, pp. 42–61.
45. Michel 1999, pp. 184–92, 197–200.
46. For the inventory of the sale, see Millar 1972; for general discussions of the dispersal of the collections and further bibliography, see the essays in MacGregor 1989, and Brotton 2006. For the tapestries, see King 1989, and T. Campbell 2007, pp. 355–61.
47. This estimate is based on comparisons between the inventory taken after Henry VIII's death, published in Starkey 1998, and the Commonwealth inventory published in Millar 1972.
48. Brotton 2006, pp. 221–22. The author incorrectly states that a "Flemish ell" was equivalent to 45 inches. It was actually calculated in England at 27 inches.
49. Millar 1972, pp. 290, 292.
50. Ibid., passim, esp. pp. 4–7, 55, 73–76, 125–26, 158–59, 207, 322, 362. For a list of the most valuable sets sent by Cárdenas to Haro, see J. Brown 2002b, p. 284; for a comparable list sent by Croullé to Mazarin, see Cosnac 1884, pp. 419–20.
51. Millar 1972, pp. xi–xxii.
52. For the sale details, see Loomie 1989; for discussion of these sets, see T. Campbell 1996b, and T. Campbell 2007, pp. 147–48, 261–67.
53. Loomie 1989, pp. 264–65, n. 42.
54. T. Campbell 1996b, p. 70.
55. Cosnac 1884, p. 186; Michel 1999, pp. 200–213.
56. Cosnac 1884, p. 186.
57. Law 1885–91, vol. 2, pp. 277–308; Thurley 2003, pp. 126–28; Brotton 2006, p. 278; T. Campbell 2007, pp. 358, 361.
58. Michel 1999, pp. 210–13, 216–17.
59. For the 1653 inventory, see Aumale 1861, and Michel 1999, pp. 614–25.
60. Hefford 1977; Michel 1999, pp. 289–91.
61. Michel 1999, p. 447.
62. Ibid., p. 442; T. Campbell 2007, pp. 358–59.
63. Cosnac 1884, pp. 402–3; Michel 1999, p. 447.
64. Michel 1999, pp. 281–84.
65. Ibid., pp. 280–81.
66. Ibid., p. 293.
67. Ibid., passim, esp. pp. 438–62.
68. Ibid., pp. 284–86.
69. Ibid., p. 284.
70. Schnapper 1994, pp. 224–25.
71. Michel 1999, pp. 313–15.
72. For Colbert, see Macon 1913, and Schnapper 1994, pp. 365–66; for Le Tellier and Louvois, see respectively Grouchy 1892 and Grouchy 1894, and Schnapper 1994, p. 376.
73. Tagliaferro 1981; Hefford 1999, p. 92.
74. T. Campbell 2004b, p. 608.
75. T. Campbell 1996a.
76. Toulouse–Aix-en-Provence–Caen 2004, pp. 102–11.
77. Guiffrey 1887.

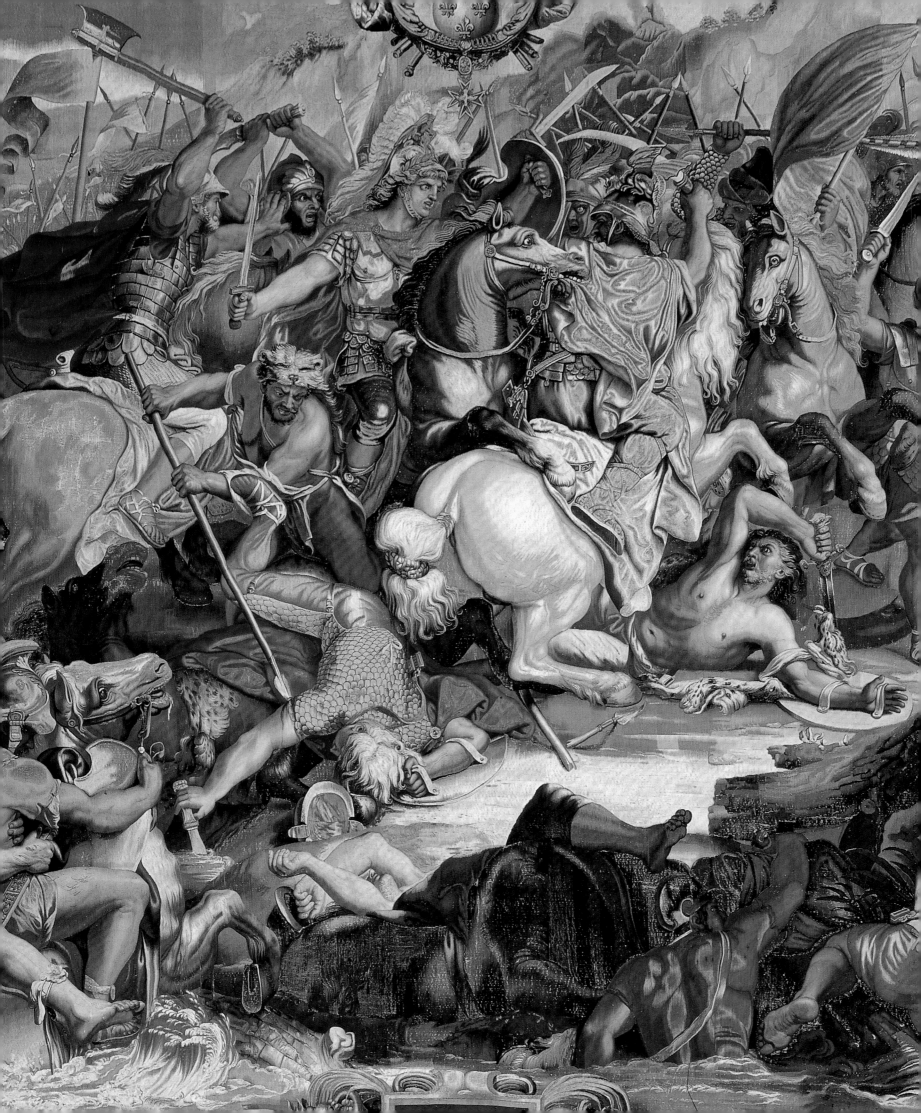

Tapestry Production at the Gobelins during the Reign of Louis XIV, 1661–1715

PASCAL-FRANÇOIS BERTRAND

The famous Manufacture Royale des Gobelins was created by Jean-Baptiste Colbert between 1662 and 1664, in the period immediately after Louis XIV had decided to take over personal rule of his kingdom. As superintendent of the Bâtiments du Roi (the royal office in charge of building and public works), Colbert gathered together the most exemplary collection of artists and craftsmen—not just weavers but also painters, sculptors, goldsmiths, cabinetmakers, and metal workers—with the goal of creating sumptuous furnishings that would contribute to embellishing the royal dwellings and, even more important, provide a manifestation of the sovereign's glory. The factory was established on the site of an existing tapestry workshop in the Faubourg Saint-Marcel in Paris and derived its name from that of an old family of scarlet dyers that had originally occupied this premises. In succeeding years the factory's renown would become so great that its name became synonymous with "tapestry" in several languages, including German, Danish, Norwegian, Romanian, and Russian, just as in Italian the term *arazzo* derived from the tapestry center Arras. In splendor and quality, Gobelins tapestries surpassed those of all other weaving centers, even equaling the finest sixteenth-century Brussels tapestries.[1] Reflecting on this achievement some years later, André Félibien (1619–1695), historiographer to the king and art theoretician, attributed the success of the Gobelins works to the quality of design and the talent of the weavers; "These works [the tapestries] . . . are priceless objects. I don't just mean that they are laden with silk and gold; I mean that the greatness of the design and the beauty of the workmanship infinitely surpass the richness of the material."[2] The renown of this achievement continued to be celebrated by the most influential French intellectuals well into the eighteenth century. For example, Voltaire mentioned the Gobelins in his *Siècle de Louis XIV* (1751), hinting at an explanation for its phenomenal rise: "The tapestries of Flanders yielded to those of *Les Gobelins.* . . . [T]he finest painters directed the work, which was executed either from their designs or copied from those of the old Italian masters."[3]

The activity of the Gobelins during the reign of Louis XIV can be divided into two distinct periods. The first, the period of the tapestries on which the manufactory's reputation was based, was interrupted by the temporary closing in 1694 because of economic difficulties resulting from the high cost of the war against the League of Augsburg (1688–97). This was the second major conflict between Louis XIV and a vast coalition that included the rulers of Austria, Holland, England, and Spain, and several German princes. Drastic measures to replenish the royal treasury were decreed, such as minting new coins and melting down silverware (edict of December 14, 1689) so it could be recast into money.[4] The tapestries of the *History of the King* and the *Royal Palaces* (or the *Royal Residences*) depict some of the silver furnishings and decorations designed by Le Brun that were destroyed in this process. The second period began with the manufactory's reopening in 1699 and corresponded with the last years of Louis XIV's reign, and it yielded charming decorative works.

Maincy: A Short-Lived but Exemplary Workshop

The catalyst that led to the creation of the Gobelins was a tapestry workshop established at Maincy in 1658 by the superintendent of finance Nicolas Fouquet (1615–1680). Establishing a tapestry workshop was no common undertaking and speaks to its founder's ambitions. Apart from the king, no other seventeenth-century French prince had attempted this except Jean-Louis de Nogaret (1554–1642), duc d'Epernon, one of Henry III's favorites, who established a short-lived workshop at Cadillac, near Bordeaux (1632–36).[5] Even the ardent art-patron First Ministers Cardinal Richelieu (1585–1642) and Cardinal Mazarin (1602–1661) purchased tapestries rather than setting up their own manufactories. We would have to look to the British Mortlake factory and the Italian workshops in Florence

Fig. 158. Preparatory drawing by Charles Le Brun for the *Portière des renommées* with the arms of Fouquet, a rampant squirrel, superimposed by the snake of Colbert. Black chalk on beige paper, 34.7 x 25.1 cm. Musée des Beaux-Arts, Besançon (D 1786)

(Medici) and Rome (Barberini) to find examples comparable to Maincy, their success measured in numbers of weavers employed and hangings undertaken or planned. The factory that Fouquet created in an abandoned convent in Maincy, near his Château de Vaux-le-Vicomte, is therefore notable, both for the character of its product and also as a demonstration of the aspirations of this powerful man, aspirations that were shortly to result in his downfall. The Maincy workshop was, in effect, the precursor to the Gobelins, because the château and its splendid decorations established the prototype of royal art under Louis XIV.

Fouquet had accumulated a vast personal fortune at the state's expense. Descending from a line of affluent and enterprising parliamentarians, and appointed as superintendent of finance by Mazarin in 1653, Fouquet helped replenish the coffers of the royal treasury by putting his personal fortune in the service of the king, before exploiting it to his own purposes. He was a patron and collector of the arts on the grandest

scale, and for the majestic residence he built at Vaux in 1657–61, he employed three artists who were subsequently to play a major role in defining the appearance of Louis XIV's palaces: the architect Louis Le Vau drew up the plans, the painter Charles Le Brun created the interior decorations, and the gardener André Le Nôtre designed the grounds. The château at Vaux was the incarnation of an artistic ideal, and as a traditional component of artistic splendor, tapestry was, of course, a key component of its decorations.

The tapestry workshop that had been established in the fall of 1658 at Maincy was intended to satisfy Fouquet's desire for prestige by producing wall hangings necessary to furnish the château (fig. 158).[6] Charles Le Brun (1619–1690) created the designs. Director of paintings at Vaux, Le Brun served Fouquet for an allowance of 12,000 pounds, not counting his per-project fee and his lodgings at the château. He was to provide designs for all the château decorations, which would celebrate his patron's triumph and glory. Between 1658 and 1661, Le Brun oversaw painters, sculptors, and weavers, who implemented his designs in completing the building and decorating the interior. Jean Valdor (1616–1675) handled the Maincy manufactory's administrative functions. An influential figure in Cardinal Mazarin's entourage, Valdor was involved throughout his life in the manufacture and marketing of tapestries, among other things. He recruited weavers, many from Flanders, for the Maincy workshop and hired others to work on his own account, including Jean Jans (1618–1668), the future workshop foreman at the Gobelins. Jean Jans's contract was for six years, and about the same time, he was also working for Louis Hinart at the Beauvais manufactory, according to an agreement dated 1666.[7] But Valdor's role is especially remarkable for the way he functioned much like a modern-day impresario: he commissioned cartoons and then fully or partially financed their transformation into tapestries. Such was the case with the *Story of Meleager*, a series treating the universal theme of destiny and associated with the virtues of valor and courage (fig. 159). Le Brun provided the designs about 1658, apparently his first large-scale narrative tapestry series. He was assisted in the landscapes by the painter François Bellin. Claude Nivelon, in his biography of Le Brun, emphasized the expressions of the subjects in the *Meleager* compositions, for Le Brun was particularly interested in matters pertaining to the human figure. The *Meleager* cartoons, painted in oil on canvas, were ordered by Valdor in 1659 and were woven a first time in the private Paris workshop of Jans, not at Maincy, as often stated, and finished at the royal manufactory in the Jans workshop. Subsequently, the designs were woven again in

Fig. 159. *The Hunt of Meleager and Atalanta*, by Charles Le Brun, before 1658. Oil on canvas, 310 x 511 cm. Musée du Louvre, Paris (2899)

Brussels workshops. Practically the only surviving weavings of Le Brun's *Story of Meleager* are from the Brussels looms.[8]

Two facts concerning the Maincy factory are particularly significant. The first is that in May 1660 Louis XIV granted the factory privileges similar to ones accorded the Paris workshops at the beginning of the seventeenth century (ennoblement of the director, tax exemption for the factory's products, and authorization to sell wine and brew beer, privileges that extended for ten years).[9] This action suggests that the king recognized the prominence of the Maincy establishment and its value for the country's economy and indicates the extent to which the manufactory was an object of discussion and interest at the highest levels of the French court.[10] The second fact of note concerns the artistic character of the work undertaken at Maincy. The most ambitious tapestries Fouquet commissioned were a *Story of Constantine* (1658–62) from designs by Le Brun (fig. 160). In the event, only the first two pieces of this set were woven at Maincy. The rest of the set was finished at the Gobelins. (In 1668, the set was given by Louis XIV to Peter Potemkin, ambassador from Moscow.)[11] The first three tapestries of Le Brun's *Constantine* series are transpositions of the

frescoes in the Sala di Costantino in the Vatican, which were painted to imitate tapestries. These frescoes were by students of Raphael based on his drawings, although in the seventeenth century they were assumed to be by the master himself, who was then considered the perfect artist. Le Brun was quite familiar with the painted cycle, having copied it during his stay in Rome in 1642–45. The last two tapestries of the series are Le Brun's compositions, in a style emulating Raphael's and Giulio Romano's. Le Brun was thus both taking his stylistic lead in tapestry design from Raphael as well as measuring himself against the Roman master.[12] In these designs he was also confronting the powerful art of Peter Paul Rubens, who some thirty years earlier had provided the designs for a *Story of Constantine* that was woven in Paris for Louis XIII.[13] The outcome of this ambitious exercise was to raise Le Brun out of Mazarin's entourage, where he was little known. At Vaux, he proved himself a brilliant designer of large-scale decoration, a great organizer of painting and tapestry cycles, and an effective leader of teams of painters, sculptors, and weavers.

The early success of the Maincy workshop was short lived. If Vaux-le-Vicomte was the incarnation of an artistic ideal, it

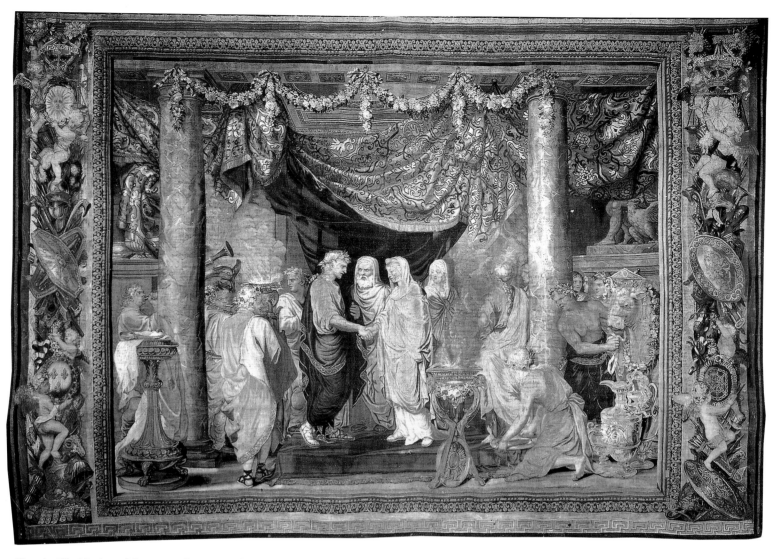

Fig. 160. *The Marriage of Constantine* from a set of the *Story of Constantine*. Tapestry design by Charles Le Brun, woven at the Manufacture Royale des Gobelins workshop of Jean de La Croix, Paris, before 1667. Wool, silk, and gilt-metal-wrapped thread, 430 x 590 cm. Musée National du Château de Fontainebleau (GMTT 44/3)

also symbolized the way in which Fouquet had exploited his office for his own enrichment. Mazarin had been too implicated in similar schemes to act against him, but following Mazarin's death in 1661, Fouquet was an easy target for his successor, Jean-Baptiste Colbert, formerly Mazarin's private intendant and Louis's future chief minister, whose rise to power paralleled the king's desire to build a strong modern state with men directly and completely answerable to him. With the king's approval, Colbert decided to ruin Fouquet by holding him responsible for all the financial mismanagement during the previous years. Fouquet and his followers were not powerful enough to stand up to the Colbert clan.[14] On August 17, 1661, Fouquet organized a magnificent celebration for the king at Vaux. Jean de La Fontaine, Fouquet's personal poet, recounted the event: a dinner prepared by the great chef Vatel; a comic

ballet, *Les fâcheux*, written by Molière with set designs by Le Brun and music by Jean-Baptiste Lully; and finally a spectacular fireworks display. But the spectacle was the last straw. Three weeks later, Fouquet was arrested at the king's order by the comte d'Artagnan, one of his musketeers, in Nantes on September 5 (the king's birthday). Then Louis XIV took Fouquet's most talented artists, Le Vau, Le Brun, and Le Nôtre into his own service.[15]

Colbert, Le Brun, and the Glory of the King, 1661–83

The crown had intermittently supported tapestry production in Paris and elsewhere since the reign of Francis I (see Isabelle Denis, "The Parisian Workshops, 1590–1650"). With the beginning of Louis XIV's personal reign in May 1661, there was a concerted effort to integrate this production into the powerful

arts organization that was now established to regulate all representations of royal grandeur from then until the relocation of king and court to Versailles in the early 1680s. This body was composed of the academies (the official associations of writers, scholars, artists, and scientists), the Bâtiments du Roi, and the factories that operated under them. Based in part on existing institutions, this organization was novel in the scale and scope of its ambitions and the extent to which the artistic output of the various métiers and even individual artists were closely coordinated through centralized supervision and planning. This ambitious plan was the work of Jean-Baptiste Colbert (1619–1683), who, after working for Mazarin, joined the king's service, first as a member of the Conseil Royal des Finances in 1661, then, beginning in 1664, as superintendent of the Bâtiments.[16] Colbert championed the tapestry medium and collected tapestries himself, and he planned to give a set after designs by Le Brun to Saint-Eustache, his parish church in Paris.[17] A portrait of Colbert, engraved by Pierre-Louis van Schuppen (1627–1702) after a drawing by Le Brun, clearly shows this interest: in the portrait, Colbert's likeness (based on a painting by Philippe de Champaigne) is being embroidered by Minerva, protector of craftsmen and herself an expert weaver; the border of Minerva's tapestry features medallions representing Colbert's virtues (fig. 161).[18] Even before being appointed head of the Bâtiments in 1664, on June 6, 1662, Colbert purchased the Hôtel des Gobelins in his own name so the king would have a place to house the Maincy weavers (on June 26), along with weavers from the

Fig. 161. *Minerva Embroidering a Portrait of Jean-Baptiste Colbert* (detail), by Pierre-Louis van Schuppen after Philippe de Champaigne and Charles Le Brun, 1664. Engraving, 43.5 x 51 cm. Bibliothèque Nationale de France, Paris (N 4)

favored Paris workshops. Thus was founded the Manufacture Royale de Tapisserie des Gobelins, renamed five years later as the Manufacture Royale des Meubles de la Couronne.

Le Brun was officially named director on March 8, 1663.[19] His mission was to conceive tapestry projects, have them carried out correctly, and supervise and inspect the workmen. The Gobelins was a strictly hierarchical institution, with a director, inspectors, workshop foremen, painters, and weavers. The production was intended exclusively for the king, to furnish his residences and create decorations for special occasions and to spread the image of the reign's grandeur to foreign courts via diplomatic gifts. The workshop foremen, however, were permitted to take orders for work from private clients.[20] In a society dominated by rivalry among nations, especially between France and Spain, symbols of power and wealth played a dominant role. The works created at the Gobelins under Colbert's and Le Brun's direction, crafted by the best artisans in Europe, were an expression of Louis XIV's civilizing power and a visible sign of his magnificence. What distinguishes the Gobelins manufactory from other producers—whether in Brussels or another major center—is the fact that it adhered to an integrated system, capable of producing enormous tapestries of very high quality with a consistent iconography and style in the goal of aggrandizing the king. At the end of 1662 Le Brun began creating both the designs and the cartoons for five large series, which were woven in the years following: the *Four Elements* and the *Four Seasons*, put on the loom in 1664, as was the *Story of Alexander*, then the *History of the King*, on which weaving began in 1665, and finally the *Royal Palaces,* initiated in 1668.[21]

All of these series had the glorification of the king as their main purpose, reflecting Colbert's philosophy that this was the object of painting and the arts. The image of the monarch, reflecting greatness, order, and beauty, could be presented three ways: through his noble features, with his insignia, or by allegory.[22] Allegory and emblems were to play a large part in the presentation of the regal image during the early years of his personal rule, reflecting the contemporary perception that allegory provided a means to say "what words alone cannot express with sufficient force."[23] The king's emblem was created in 1662, with the sun as its center and *Nec Pluribus Impar* (Not inferior to many) as its motto, and this motif was to inform much of the imagery undertaken during the 1660s. For example, in the Gallery of Apollo in the Louvre, on which construction began in 1661, the king is depicted with the features of Apollo, surrounded by the months of the year, the signs of the zodiac, the four continents, and the nine Muses. (The theme of

Fig. 162. *Queens of Persia at the Feet of Alexander*, by Charles Le Brun, 1661. Oil on canvas, 298 x 453 cm. Château de Versailles (MV 6165)

Apollo was subsequently developed at Versailles, in the planetary rooms and the gardens—Grotto of Thetis, Fountain of Latona, Fountain of Apollo—then at Marly, in the Pavilion of the Sun and the twelve smaller satellite pavilions, each related to a sign of the zodiac.)

Much of the material for the allegorical schemes and insignia in which Louis was celebrated was provided by the Petite Académie (later the Académie des Inscriptions et Belles-Lettres).[24] This was created in 1663 to draw up plans for the royal residences, write programs for court festivities, provide subjects for operas, devise schemes for large-scale decorations (painted and woven) in the royal dwellings, and relate the history of the reign in medals (such a History of Louis XIV was published in 1702). The academy was initially composed of four members, Charles Perrault, Jean Chapelain, the abbé Amable de Bourzeis, and the abbé Jacques de Cassanges; a fifth man, François Charpentier, was admitted shortly afterward. Paul Tallemant and Philippe Quinault succeeded Bourzeis (1672) and Chapelain (1674). The group met twice a week at Colbert's

residence; the members proposed their various ideas and the minister made his final selection.

The role of the academy was especially marked in the first two series of tapestries that were designed and completed wholly at the Gobelins, allegorical representations of the *Four Elements* (cat. no. 39) and the *Four Seasons*, whose complex iconography, derived from a broad range of medieval philosophy and humanist culture, was specifically designed to celebrate Louis XIV's monarchy. Mythological allegories in the main scenes, showing gods with attributes representing the seasons and the elements, are linked to moralistic devices in the borders, drawing a correspondence between the allegories and the king's personal virtues: in the *Elements*, magnanimity and valor, piety and goodness; in the *Seasons*, various aspects of the magnificence of the king in action. The elements and the seasons are related to the iconography of Apollo and the sun—the celestial body associated with the French monarchy since Charles V—which were also being developed in ceiling paintings in the grand apartments of the Louvre and Versailles at this

time. The use of heraldic devices was meant to symbolize good government, embodied by Louis XIV and the absolute monarchy he established. The two tapestry series directly celebrated the king, for whom a miniature painted version was prepared for his private pleasure (Bibliothèque Nationale de France, Paris; fig. 170). Subsequently, the images were widely disseminated, through André Félibien's descriptions of them (1665 and 1667) and through engravings by Sébastien Leclerc (1670–71).[25]

If the allegorical mode determined the character of the *Elements* and *Seasons* series, the next series on which work began in the early years of Gobelins production celebrated Louis XIV in another traditional means, that of comparison to a heroic prototype, Alexander the Great, who was also to become prominent in the imagery of Louis' court.[26] The initiative for this series was provided by Le Brun's painting of the *Queens of Persia at the Feet of Alexander* (1661; fig. 162), undertaken just after Fouquet's downfall. In this, Le Brun styled Louis as a new Alexander, a virtuous, gallant, and generous one, courageous but not unmoved by pity—for the king had not yet been tested in war. This was a hero of romance rather than epic.[27] Félibien, in a laudatory critique in 1663, sang the painting's perfection, pointing out how Le Brun's genius resided in his commanding use of light, his union of colors, and his expression of emotions.[28] The work met with such success that Le Brun was assigned to paint a series of large-scale canvases, this time showing the king as victorious conqueror, which may have been intended for a large gallery in the Louvre or another royal residence but instead was made into tapestries. Weaving on the first set commenced in 1664.

While the iconography in the hangings based on Le Brun's cartoons was not new, it was used in a novel way. The Gobelins tapestries contributed to the spread of a national style that the painter was in the process of developing. Le Brun understood how to adapt his work to the demands of Colbert and the Petite Académie. As Perrault said, the challenge was to depict the king in a way that pleased the king. In return, Louis XIV/Alexander made Le Brun his new Apelles.[29] The painter's great strength lay in his ability to develop projects on a grand scale, and this subject was a perfect match for his talents. The enormous battles staged a host of figures in a violent setting: warriors battling, fleeing, screaming; horsemen colliding; shattered chariots and heaps of bodies. These figures were contained within meticulously constructed compositions that followed artistic theory in subordinating the painting's colors to the overall design, its three-dimensionality to clarity of line, and its intense emotions to a mastery over expressions.[30] Le Brun clearly indicated his masters: Raphael's Vatican Stanze and Loggia, and Poussin.[31] He also referred to Rubens in forming groups composed of masses and in sharp contrasts of light depending on the time of day, thus creating a complex and thoughtfully organized whole. Observing his treatment of light is essential to understanding the distinct atmosphere of each battle: sunrise for the *Battle of the Granicus* (cat. no. 40), the noontime sun for the *Battle of Arbela* (fig. 163), and late afternoon for the *Defeat of Porus* (or *Porus before Alexander*). The paintings, shown at the Salon of 1673, are part of an unfinished cycle. Later hung in the galleries of the Académie Royale de Peinture, they became models of the "Grand Manner" and "noble style"

Fig. 163. *Battle of Arbela*, by Charles Le Brun, 1669. Oil on canvas, 400 x 1,265 cm. Musée du Louvre, Paris (2895)

Fig. 164. *Meeting between Louis XIV and Philip IV* from a set of the *History of the King*. Tapestry design by Charles Le Brun, ca. 1665–66, woven in the Manufacture Royale des Gobelins workshop of Jean Mozin, Paris, 1665–80. Wool, silk, and gilt-metal-wrapped thread, 378 x 559 cm. Mobilier National, Paris (GMTT 98/3)

in French painting and were widely disseminated as engravings and tapestries.

Weaving of the first set of the *Story of Alexander* was completed in 1673. Ironically, this was a period in which the character of royal iconography was changing and glorification of the king's person with antique imagery was abandoned in favor of explicit depictions of contemporary history in which the king was represented as a conquering hero.[32] This shift was partly in response to the events of recent years. The king was no longer a young untried ruler. He now had a specific expansionist agenda of his own and had recently embarked on the campaigns that were to be known as the Dutch War (1672–78). In this context it was only fitting that he should be portrayed as a conquering hero in his own right. In addition, the shift in iconography reflected the success of another major design series that had been initiated at the Gobelins in the early 1660s, which depicted events in the life of the king himself and was to become known as the *History of the King*. During the early

1660s there was evidently much discussion among the members of the Petit Académie and other influential figures at Louis XIV's court regarding the best way in which to promote the king in visual schemes. Thus, in tandem with the allegorical and comparative celebrations afforded by the *Elements*, *Seasons*, and *Story of Alexander* series, a scheme was discussed at the end of 1662 to create a tapestry series that would depict the key events in the life of Louis XIV. In a letter of June 10, 1664, Chapelain convinced Colbert that rather than using allegory to celebrate the king, he should choose realistic representations of the facts. Perrault, secretary of the Petite Académie and Colbert's top aide at the Bâtiments, exhorted Le Brun to paint the "famous conquests / Wherein the Prince, in the midst of the fray, / Inspired his troops with his valorous ways"—since the royal state was validated by the act of war.[33] The intermingling of historical fact, mythology, and allegory, such as Rubens had used to paint the life of Marie de' Medici for the Palais du Luxembourg (now in the Louvre), was no longer a criterion for

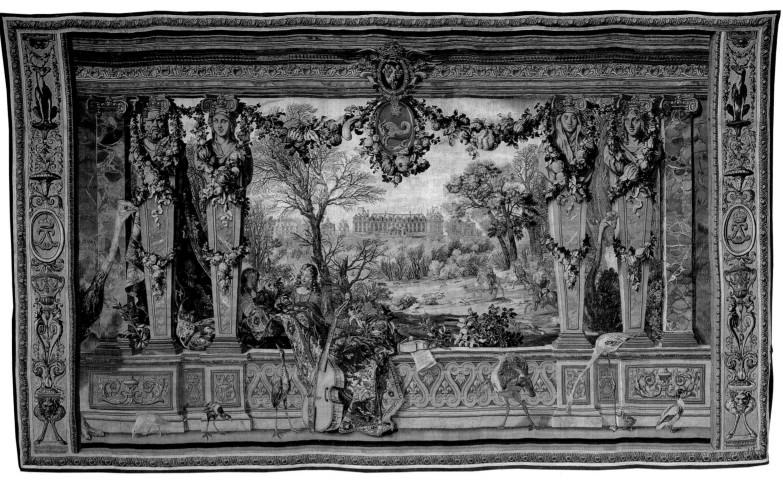

Fig. 165. *The Month of December (Château de Monceau)* from a set of the *Months* (also known as the *Royal Palaces*). Tapestry design and cartoons by Charles Le Brun and associates, woven at the Manufacture Royale des Gobelins, Paris, ca. 1670–80. Wool, silk, and gilt-metal–wrapped thread, 405 x 625 cm. Mobilier National, Paris (GMTT 108/12)

modernity, according to Félibien.[34] In response to these injunctions, the tapestry series of the *History of the King* depicted the most significant events from the beginning of the Sun King's reign to the taking of Dôle (1668). Various episodes celebrate the monarch's divine right, his coronation (1654), and his marriage (1660). Others, more numerous, describe the most visible manifestations of the king's glory, his sieges of cities and battlefields, such as the *Siege of Tournai*, in which the king risked his life by personally joining the battle and rising above the others at the head of the entrenchment, or the *Siege of Douai*.[35] Other scenes from the *History of the King* depict alliances and diplomatic triumphs: the *Meeting between Louis XIV and Philip IV*, for instance, celebrated the reconciliation of France and Spain with the Treaty of the Pyrenees after thirty years of conflict (fig. 164). Diplomatic victories often meant the humiliation and submission of the enemy, as in the *Audience of the Conde de Fuentès*[36] and the *Audience with Cardinal Chigi* (cat. no. 44). The weaving of this last piece, interrupted in 1684 on orders of the marquis de Louvois, superintendent of the Bâtiments, was resumed in 1704, when new scenes were also added to the series.[37] By then, times had changed, however, and the king was no longer shown at war but in the splendor of the royal family.

From a stylistic point of view, Le Brun's designs for the *History of the King* departed from the Grand Manner that had characterized compositions and harmonies of the *Story of Alexander* paintings and tapestries and offered instead a formula connected to the omnipotent conception of the king that would thereafter govern artistic representations of the monarch: the image of the immobile king orchestrating elements in motion around him, neither ruled by any will other than his own nor dominated by his passions. Le Brun codified affects— his hieratic depiction of the king was a model to follow, the impassive face inspiring mastery over the self. The king was always at the center of the compositions with a space separating him from the various protagonists, which provided an image of power exerted absolutely—that is, without constraint.[38] (Such portrayals were to play a major part in the art and propaganda of Louis XIV's court from the mid-1670s. For example, the Ambassadors' Staircase at Versailles (1676–80; now demolished)

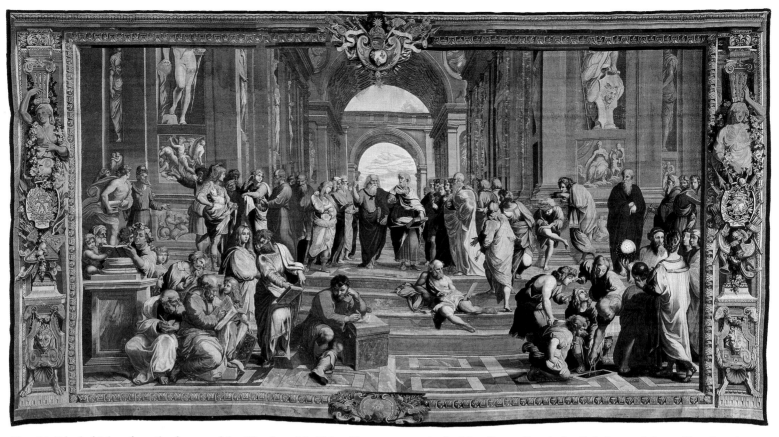

Fig. 166. *School of Athens* from the first set of the *Chambers of the Vatican*. Tapestry woven in the Manufacture Royale des Gobelins workshop of Jean Jans the Younger, Paris, 1683–87. Wool, silk, and gilt-metal-wrapped thread, 500 x 890 cm. Mobilier National, Paris (GMTT 173/1), deposited at the Musée National du Château de Fontainebleau

mixed depictions of real events with allegorical ones. The vaulted ceiling of the Hall of Mirrors (1678–84) is entirely devoted to the history of the king, from the start of his personal reign to the Treaty of Nimwegen (1678).

The *History of the King* was complemented by the series called the *Months* or the *Royal Palaces* (or *Royal Residences*), which shows the king and his court in peaceful pursuits (fig. 165). The series combines views of the royal dwellings with images of activities appropriate to the seasons and the months of the year, in a type of representation deriving from medieval tradition and maintained during the Renaissance in large cycles of weavings such as the *Hunts of Maximilian* (fig. 9), a series that by this date had entered the French royal collection via the collection of Cardinal Mazarin. The royal residences and the king's pleasures are shown within a rich trompe l'oeil frame based on a design by Le Brun, composed of a portico with rugs, gold and silver vessels belonging to the crown, and animals from the royal menagerie.[39]

The extraordinary achievements of the Gobelins workshops during the 1660s and 1670s were in large part due to the vision and ability of Charles Le Brun. Like Raphael, Bernaert van

Orley, Simon Vouet, and Pietro da Cortona, to name but a few of the most innovative tapestry designers, Le Brun was outstanding at coordinating teams of artists whose job it was to translate his first thoughts, sketches, and designs into oil-on-canvas cartoons, which were given to the weavers to be made into tapestries. For the *Royal Palaces*, for instance, Baudrin Yvart (1611–1680) was assigned to paint the main figures, carpets, and drapery; Jean-Baptiste Monnoyer (1636–1699), flowers and fruit; Pieter Boel (1622–1674), animals and birds; Guillaume Anguier (1628–1708), the architecture; Adam Frans van der Meulen (1632–1690), the minor figures and some of the landscapes; and Abraham Genoels (1640–1723) and Adrian Frans Baudoin (Boudewyns; dates unknown), the rest of the landscapes.[40] Van der Meulen, who had come from Brussels in 1662, went to work at the Gobelins two years later as a "peintre ordinaire du Roy" (ordinary painter to the king) and then "peintre de l'Histoire du roi" (painter of the *History of the King*).[41] He followed the king on his military campaigns and made precise sketches of the battle sites (cat. no. 43). In these drawings, the king is depicted the midst of a group of generals that dominates the scene. In the convincingly realistic landscapes,

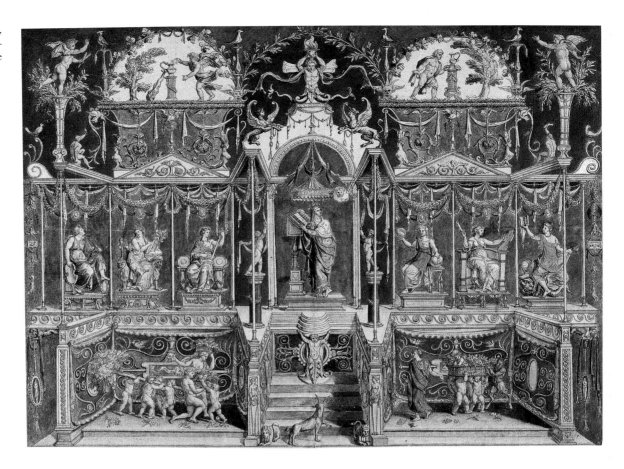

planes of clear sky, with their delicate light, occupy half the composition. The battles are scrupulously rendered: the villages under siege, troop movements, and uniforms—all are drawn with meticulous care.[42] In recognition of his work, Van der Meulen was inducted into the Académie Royale de Peinture in 1673 without having to submit a presentation piece.

Finally, Le Brun was particularly vigilant about the quality of the weaving. The work was divided among four or five studios: three high-warp shops, overseen by, respectively, Jean Jans (whose son succeeded him in 1668), Jean Lefebvre, and Henri Laurent; and two low-warp studios, the first run by Jean de La Croix and the second (opened in 1667) by Jean-Baptiste Mozin, who was succeeded in 1693 by Dominique de la Croix. Paul Fréart de Chantelou, in his journal of Gian Lorenzo Bernini's French travels, recorded remarks by Colbert: "M. Colbert said that at first [Jans] was a very mediocre craftsman, that he had merely copied tapestries, but quite poorly, and that they would have dismissed him from Gobelins altogether if he hadn't begged them to give him a little more time, during which he hoped to show them what he was capable of. He said he had gotten used to current standards, when no one knew what good workmanship was anymore and good workmen were paid no better than poor ones. Since he and his son had

greatly improved, the King gave the latter two thousand écus with which to be married."[43] Perrault, in his 1668 poem *La peinture*, praised both Le Brun's genius and the skill of the craftsmen weaving the *History of the King*: "But we need only see what to us you hand down, / These summits of Art that even Art do astound, / Which in your great studios, in myriad ways, / The hands of the Craftsmen make 'neath your gaze. / It is there that Painting, with silk and with gold, / On the richest of fabrics its charms does unfold. . . ."[44]

Louvois and the New Designs, 1683–95

The death of Colbert in 1683 and the rise of his rival and successor, François Michel Le Tellier, marquis de Louvois (1641–1691), entailed a change in the strategy of royal artistic policy, although not in its objective.[45] During the last years of Colbert's life, and to his detriment, the king shifted his favor to Louvois and his followers—the "clan of lizards," so named after the three reptiles in the Le Tellier coat of arms. At Colbert's death, his fourth son, the marquis d'Ormoy and de Blainville, inherited the position of superintendent of the Bâtiments (1663–84), but he did not acquit himself satisfactorily. Louvois bought the title and thereby gained control of the Bâtiments, the academies, and the manufactories.[46] The situation posed a threat to Le Brun,

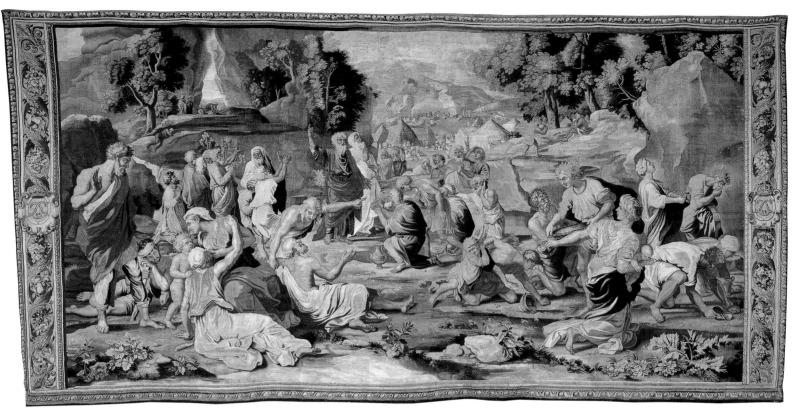

Fig. 168. *Gathering of Manna* from the second set with gold of the *Story of Moses*. Tapestry after a painting by Nicolas Poussin, woven in the Manufacture Royale des Gobelins workshop of Jean Jans the Younger, Paris, before 1687. Wool, silk, and gilt-metal-wrapped thread, 337 x 656 cm. Mobilier National, Paris (GMTT 33/8)

although this was tempered by the fact that the new superintendent could not dismiss the First Painter outright and hire his own protégé, Pierre Mignard, for this would have been tantamount to saying that the king had made an error. Louvois had to wait until Le Brun's death in 1690 before replacing him with Mignard as First Painter to the King and director of the Gobelins. Mignard hardly exercised his functions as director of the royal manufactories, however, since the administrative portion had been taken over several years earlier by Henri de Bessé, sieur de La Chapelle, who was a protégé of Louvois, first clerk of the Bâtiments, secretary of the Petite Académie, and fellow of the Académie Royale de Peinture.[47]

Gobelins production during this period is often considered artistically less successful, which is usually explained as a consequence of economic recession. In fact, crippling expenses from the war against the League of Augsburg, which caused ruination in the public sector, did force the Gobelins to shut down temporarily in 1694. Still, this view of an artistically less successful period is unconvincing and is hardly borne out by Louvois's grandiose public works projects, which doubled the expenses at Versailles. At the Gobelins, an academy was founded for drawing from antique and live models, and while Louvois did interrupt the weaving of the *History of the King* because of

his rivalry with Colbert and Le Brun, many other tapestries were made.

During this period, the Gobelins produced only a single original tapestry series from specially created cartoons. This was the *Indies*, also called the *Old Indies* to distinguish it from a later, related series known as the *New Indies*. The idea for this series came from the Dutch prince Johan Maurits of Nassau-Siegen. Returning from a stay in Brazil as governor of the Dutch West India Company (1637–44), Nassau conceived a tapestry cycle depicting the "merveilles du Brésil" (marvels of Brazil), which was executed in 1667 in Delft by the weaver of his cousin Frederick William, elector of Brandenburg (now lost). In 1679, Nassau gave Louis XIV a group of eight large-scale paintings showing Brazilian subjects, with the specific intent that they be made into another series of tapestries, this one at the Gobelins, thereby giving people the opportunity "de voir le Brésil sans traverser la mer" (to see Brazil without crossing the ocean), as Nassau wrote to the marquis de Pomponne on December 21, 1678.[48] The cause was most noble: to gain recognition for recent discoveries in natural history, botany, and zoology, as well as the customs of distant lands.[49] The paintings were by Albert Eckhout (1605/15–1666), who had been with Nassau in Brazil, and this gift demonstrates not only the use to which tapestry

could be put—spreading news of scientific progress—but also the prestige of the Gobelins. The series, begun in 1687, reveals a fascinating world, part real and part fantasy (cat. no. 48).

Aside from this series, the ten or so tapestry cycles of this period were derived from easel paintings, stage sets, and drawings, or they were reweavings of earlier works by the factory. This was a practice used before, as at Maincy some twenty years earlier, but what was different was the extent to which new designs were derived from old masters, a way of creating new tapestry designs without either asking the First Painter for cartoons or offending the king.

Félibien characterized tapestry as "the surest way to preserve, and even reproduce, paintings by the most talented men."[50] It was also a way to disseminate the most perfect examples of a painter's art. What constituted "perfect examples" was defined by the Académie Royale de Peinture et de Sculpture, whose function as set out at its founding was to develop the principles of painting. At the Gobelins, with Le Brun out of favor, La Chapelle was the one who disseminated academy-approved models. The production of the Gobelins during Louvois's years rested on three principles: first, the imitation of older designs in order to create something new; second, the principle of authority, of an absolute model of perfect painting; and third, the goal of making Paris the artistic capital of Europe.[51]

Under Colbert, there was a move to gather and copy the best that Rome had to offer. But whereas casts of portions of the Column of Trajan were then acceptable, now the issue was to cast the column in its entirety. Louvois carried out this policy by having all the frescoes in the Vatican Stanze and Loggia by Raphael and his followers replicated in tapestry. To accomplish this, the director of the French Academy in Rome had the resident students make copies of the frescoes to serve as cartoons, which afforded these young artists the opportunity to further their training by copying antiquities and the Renaissance masters and also served the royal manufactory. The first two editions of the *Chambers of the Vatican*, with gilt-metal-wrapped thread, were woven between 1683 and 1689 (fig. 166).[52] One of the most celebrated sets in the papal collection, the *Grotesques of Leo X* (known now only from later weavings), first woven in Brussels in 1520 from models by followers of Raphael,[53] was similarly copied. Noël Coypel (1628–1707) "invented" the new series, referred to as "Rabesques" or "Arabesques de Raphael," thus modernizing the old compositions (fig. 167, cat. no. 49). The Gobelins thus spread images of some of the most significant examples of perfect painting, for Raphael was then considered the uncontested master of modern painting. By analogy, such tapestries brought the Vatican to Paris and Versailles, to the heart of a realm that, according to medieval lore, held its religious and political authority directly from God, and so the tapestries were highly symbolic in debates over royal prerogative (la Régale) and the four articles of the Declaration of the Clergy of France, in which the French Crown opposed the Vatican.[54]

Finally, paintings in the king's collection by Nicolas Poussin, the "doctus pictor" whom Bellori and Félibien exalted as the perfect painter, were selected for the tapestry series the *Story of Moses* (fig. 168).[55] And Bâtiments superintendent Louvois was at last able to involve his protégé Pierre Mignard by ordering in 1686 the tapestry series the *Galerie de Saint-Cloud*, based on Mignard's decoration of the Gallery of Apollo in the Château de Saint-Cloud for Philippe d'Orléans, the king's younger brother, in 1677–78.[56] Such weavings could not fail to please the king, since the theme was his brother's prowess as a warrior-prince. The policies instituted by Louvois and his successor, Édouard Colbert de Villacerf, thus developed several ideas already defined and tested by Colbert, and led to a reconsideration of the concept of tapestry, the aesthetic of the models, and the notion of Grand Manner—all with the same end in mind: to glorify the king.

Jules Hardouin-Mansart and the Resumption of Activity, 1699–1715

Shut down in April 1694, the manufactory reopened five years later, in January 1699. As a consequence of the closing, some workmen from the Gobelins enlisted in the French army, others returned to their native Flanders, and still others found

Fig. 169. *The Swooning of Esther*, by Antoine Coypel, 1697. Oil on canvas, 105 x 137 cm. Musée du Louvre, Paris (3500)

work with the entrepreneur Philippe Behagle in his Paris workshops and at the Manufacture Royale de Beauvais, of which he was then director.[57] The reopening was marked by a change in directorship, with architects in control. Jules Hardouin-Mansart (1646–1708), who had designed the Château de Versailles and the Dôme des Invalides, was quickly appointed superintendent of the Bâtiments and elected patron of the Académie Royale de Peinture et de Sculpture. The architect and controller of the Bâtiments, Antoine Desgodetz (1653–1728), was made director of the Gobelins in 1699, and architect Robert de Cotte (1656/57–1735) succeeded him in 1706 and remained until 1735. The artistic management of the Gobelins was handled by a chief inspector and an inspector: respectively, de Cotte, who combined this office with that of director in 1706, and the painter Pierre Mathieu (ca. 1657–1719).[58] It is difficult to define a distinct artistic policy for this period because previously painted cartoons were still being put on the looms. Allegorical motifs were being updated to suit contemporary tastes, however, and new religious subjects were developed, something that had not been done before at the Gobelins.

In the last years of the seventeenth century, Jean Bérain, designer of Menu Plaisirs du Roi (royal entertainments), instituted a lighter aesthetic in his design work, reviving grotesques and anticipating a refreshing new style, the Rococo. This period of Louis XIV's reign is considered, since Fiske Kimball's 1943 study, the precursor of the Louis XV style.[59] Claude Audran III (1658–1734), nephew of the celebrated engraver Girard Audran, revived the traditional motifs of the seasons and the elements when he designed the models for the *Portieres of the Gods*

(fig. 228), which were quite successful since they were woven throughout the eighteenth century.[60]

At the Salon of 1699, Antoine Coypel (1661–1722) showed seven paintings with subjects from the Old Testament, which were painted for private individuals, including the duc de Chartres, the future regent and Coypel's protector (fig. 169). And at the Salon of 1704, Jean Jouvenet (1644–1717) exhibited four large-scale works depicting scenes from the New Testament, painted for the Benedictine monks of Saint-Martin-des-Champs, and in 1705 he presented them to Louis XIV at the Trianon. The king so admired these cycles of paintings that he ordered them to be woven at the Gobelins. At this late period of his reign, he felt the need to request tapestries with religious subjects, something he had not done before, except for the *Story of Moses* after Poussin and Le Brun. He admired the intelligence and devoutness of Madame de Maintenon; he attended to his confessors Père la Chaize and Père le Tellier; he increased his good works; he was particularly obsessed with his health. For all this, he was not really devout, but he was constant,[61] and throughout his reign he kept a close watch over his image. The *Old Testament* series was begun in 1710, the *New Testament* the following year. The compositions by Jouvenet and Coypel, heirs to the art of Le Brun and to the discussions about painting in the second half of the seventeenth century, illustrate on a grand scale and in dazzling colors the artistic doctrine that Coypel himself formulated several years later: "A great painter must so perfectly convey his characters by their gestures that the viewer imagines he is seeing the real thing when he is only seeing a representation of it: that he will be convinced he is hearing words, when none are being spoken."[62]

1. The indispensable study of the Gobelins workshops during the reign of Louis XIV remains Fenaille 1903–23, vols. 2 and 3. Also of value are Göbel 1928, pp. 110–12 (Maincy), 113–70 (Gobelins); Niclausse 1938; Paris 1939; Paris 1962; Paris 1966; Fontainebleau 1993; Paris 1993; Beauvais 1998.
2. "Ces Ouvrages [les tapisseries] . . . sont des Ouvrages sans prix. Quoy qu'ils soient tout étofféz de soye & d'or, la grandeur du dessein & la beauté du travail surpasse infiniment la richesse de la matiere"; Félibien 1666–88/1972, second interview, vol. 1, p. 284.
3. Voltaire, *The Age of Louis XIV*, trans. by Martyn P. Pollack, Everyman's Library (1926; repr. London, 1978), p. 324.
4. Mabille 2004.
5. D'Welles 1957.
6. Montagu 1962.
7. The contract between Valdor and Jans is dated 1659; see Uhlmann-Falin 1978, pp. 171–74. On the agreement between Valdor and Hinart, see ibid., pp. 75–76.
8. See Montagu 1994, esp. chap. 3, "Charles Le Brun: Painter of Expression," pp. 31–49. On the *Story of Meleager*, see B. Gady 2007, and also Brosens 2003–4, which clarifies its complicated history. On Nivelon and his biography of Le Brun, see Nivelon 1700/2004.
9. Cordey 1922, p. 47, which concurs with a report of the weaver Jean Bontemps (d. 1661): "Nous sommes bien logés et traittés, mais surmenés, et quoiqu'on embauche toujours, nous avons bien ouvrage taillé pour dix ans" (We are housed

and treated well, but overworked, and although they are still hiring, we have our work cut out for us for the next ten years).
10. By granting the privileges, the king paid homage to Fouquet's service to the state. But this action can also be seen both as the king co-opting a prosperous factory and as a way for a threatened Fouquet to protect himself, at least this time, from attacks by the Colbert faction.
11. Montagu 1962, pp. 532–35; Carlier in Fontainebleau 1993, pp. 18–21; Montagu 1994, pp. 14–15, 41–42.
12. Nivelon (1700/2004, pp. 269–70) wrote that Le Brun's delineation sustained comparison with that of Raphael.
13. It was common practice for a painter to adapt his brush to another painter's technique. Pietro da Cortona, for example, had done the same when he designed additional scenes to complement the panels of Rubens's *Story of Constantine* set that Louis XIII gave to Cardinal Francesco Barberini (cat. no. 35).
14. Dessert 1987. On Fouquet, see also Petitfils 1998, as well as Schnapper 1994, pp. 215–28, for his taste.
15. Fumaroli 1997, p. 177.
16. P. Burke 1992, pp. 61–64; Sabatier 2000. See most recently Milovanovic 2005, pp. 56–69.
17. Chantelou (1665/2001, p. 182) related that Colbert "avait pensé aux tapisseries dès le temps qu'il n'était pas surintendant des Bâtiments" (was interested in tapestries even before he became superintendent of the Bâtiments). On the tapestry plan

for the church of Saint-Eustache, see L. Beauvais 2000, vol. 2, pp. 759–60, nos. 2635–641, illus.

18. See Véronique Meyer in Nantes–Toulouse 1997, p. 282, no. 169, illus.

19. According to the manufacturing regulations of 1667, article 3, "La conduite partic-
ulière des manufactures appartiendra au sieur le Brun, nostre premier peintre,
soubs le titre de directeur, suivant les lettres que nous lui avons accordées le 8ᵉ
mars 1663" (The specific operation of the manufactories shall be the domain of
M. Le Brun, our First Painter, who shall hold the title of director, as per the letters
that we granted him on March 8, 1663); Lacordaire 1853, p. 55.

20. The Manufacture Royale de Beauvais remained a private establishment that
enjoyed royal privileges. Its production was intended for major French and foreign
heads of state. The Manufacture Royale d'Aubusson was a label given to private
workshops that supplied less wealthy individuals.

21. Mention should also be made of the series the *Enfants jardiniers* (Child Gardeners),
after 1685, woven after painted decoration by Le Brun in the Pavillon de l'Aurore
in the Parc de Sceaux; Fenaille 1903–23, vol. 2, pp. 86–97.

22. See Marin 1981; P. Burke 1992, pp. 19, 22; Sabatier 2004.

23. "[C]e que des paroles n'exprimeroient pas avec assez de force"; Félibien 1665, and
Félibien 1689a/1973, p. 98.

24. P. Burke 1992, p. 67; Milovanovic 2005, pp. 60–69.

25. On the devices of the Elements and the Seasons as painted by Jacques Bailly
(1629–1679), see Grivel and Fumaroli 1988. Félibien's text was also published in
1687 in Augsburg, in German, the language of one of Louis XIV's great rivals, the
Holy Roman Emperor. On the Gobelins tapestries of the *Four Seasons* and the
Four Elements, see Mayer Thurman and Brosens 2006. The art of devices was also
used in the series of portieres with arms that Le Brun had originally designed for
Fouquet, with the disgraced superintendent's coat of arms replaced by those of
the crown (France and Navarre). The king's emblem, with its central sun and *Nec
Pluribus Impar*, appears in the *Portieres with the Triumphal Chariot*, associated with
the royal crown and the scales of justice (examples in The Metropolitan Museum
of Art, New York; J. Paul Getty Museum, Los Angeles; J. B. Speed Museum,
Louisville; and the Louvre and Mobilier National, Paris). On the Gobelins
portieres, see Bremer-David 1997, pp. 2–9, no. 1, and Standen 1999.

26. Grell and C. Michel 1988, esp. pp. 62, 79, 109–21.

27. Duro 1997.

28. See Félibien 1663, and Félibien 1689c/1973; Nivelon 1700/2004; Cornette 1996;
Pericolo 2001.

29. By having Le Brun depict him with Alexander's features (1661), and by then nam-
ing him First Painter (1664), Louis XIV in effect made Le Brun his Apelles, the
painter whom Alexander insisted be the only one to paint his portrait. Both
Félibien, in *Les Reines de Perses aux pieds d'Alexandre* (1663; 1689c/1973, p. 66), and
Perrault, in *La Peinture* (1668/1981, p. 232), urged Le Brun to move from veiled
portrayals of the king (using the features of the Greek monarch) to direct depic-
tions of Louis XIV's most noteworthy exploits.

30. On the subordination of color to line, see Félibien's *Les Reines de Perses aux pieds
d'Alexandre* (1663; 1689c/1973, p. 66); see also Grell and C. Michel 1988, esp. pp. 62,
79, 109–21. On the role of light, see especially Sébastien Bourdon's lecture of 1669
(Bourdon 1669/1996). On the expression of emotions, see Le Brun 1668/1996,
and Montagu 1994.

31. For the *Battle of Arbela* (Louvre), Le Brun turned also to Pietro da Cortona, repris-
ing both the overall composition and the posture and expression of the horrified
man fleeing in the foreground of the *Victory of Alexander over Darius*, painted for
the Sacchetti (Palazzo dei Conservatori, Rome); Posner 1959.

32. On the paintings of the *History of Alexander*, see most recently Birkenholz 2002.
The series was woven eight times during Louis XIV's reign. On the tapestries of
the *History of Alexander*, see Halbturn 1976, pp. 43–60; and Bauer in Thessaloníki
1997, pp. 120–22, 178, 199, 204.

33. "[F]ameuses conquêtes, / Où le Prince lui-même au milieu des combats, / De son
illustre exemple animait les soldats"; Perrault 1668/1981, p. 230.

34. Félibien, 1666–88/1972, seventh interview, vol. 4, p. 279. See Brassat 1993; Brassat
1997; Sabatier 1999, pp. 277–79.

35. A tapestry of *Crossing the Rhine* (1672), the most glorious episode of the Dutch
War, was planned, but it was not woven, perhaps because of the change in prepara-
tory sketches that introduced allegorical figures. Allegorical figures appear in certain
additions from after 1704, such as the *Founding of the Military Pensioners' Hospital*.

36. Fuentès had come to offer his king's apologies to the French monarch after a snub
over the precedence of French and Spanish ambassadors in Europe. The incident,
which took place at the Court in London during the official entrance of the
Ambassador of Sweden, had been calculated to assert Louis XIV's authority over
his uncle and father-in-law, Philip IV. (In 1615, Louis XIII had married Anne of
Austria, sister of Philip IV, whose own first wife had been Elisabeth of France,
Louis XIII's sister. In June 1660, Louis XIV had married his cousin, Infanta Maria
Theresa, Philip IV's daughter.)

37. Depictions of the history of the king were not confined to the tapestry series.
Painted silks illustrated the crossing of the Rhine (Mobiler National). The Dutch

War was depicted at Versailles on fictive tapestries painted in the Ambassadors'
Staircase, and on the ceiling of the Hall of Mirrors, for which Le Brun created an
exemplary representation of political and military authority. The *Conquests of the
King* were painted by Adam Frans van der Meulen for the royal pavilion at the
Château de Marly. See Versailles 1990; Beauvais 1991; Cornette 1993, pp. 231–47;
Sabatier 1999, pp. 334–85; Castelluccio 1998; and Castelluccio in Dijon–Luxembourg
1998, pp. 232–41, nos. 95–101.

38. Brassat 1993.

39. See Bremer-David 1997, pp. 20–27, no. 3.

40. Fenaille 1903–23, vol. 2, p. 129.

41. Van der Meulen was called "peintre ordinaire du Roy" in private notary acts,
then "peintre de l'Histoire du roi" (December 1688), and in his death inventory
"peintre ordinaire de l'Histoire du Roy"; Richefort 1988; Gastinel-Coural 1998,
p. 118, n. 11.

42. Loire 1998, pp. 59–61.

43. "M. Colbert a dit qu'au commencement il n'était que très médiocre ouvrier, qu'il
avait copié des tapisseries, mais fort mal, qu'il avait voulu le chasser des Gobelins,
sans qu'il priât qu'on l'y laissât encore quelque temps, pendant quoi il espérait
faire voir ce qu'il savait faire, disant qu'il s'était accommodé au temps courant, où
l'on ne connaissait pas trop les belles choses, ni ne les payait-on pas plus que les
mauvaises; que comme lui et son fils se sont fort perfectionnés, le Roi a donné à
celui-ci deux mille écus pour le marier"; Chantelou 1665/2001, p. 182.

44. "Mais il suffit de voir ce que ta main nous donne, / Ces chefs-d'œuvre de l'Art,
dont l'Art même s'étonne, / Et ce qu'en mille endroits de tes grands ateliers, /
Travaille sous tes yeux la main des Ouvriers. / C'est là que la Peinture avec l'or
et la soie / Sur un riche tissu tous ses charmes déploie . . ."; Perrault 1668/1981,
pp. 228–29.

45. P. Burke 1992, pp. 91–97; J.-C. Boyer 1996.

46. Sarmant 2003.

47. Lacordaire 1853, p. 81.

48. See Forti Grazzini 1994b, vol. 2, pp. 456–57 (with bibliography); Fenaille 1903–23,
vol. 2, pp. 371–98; Bremer-David 1997, pp. 10–19, no. 3. On the paintings, see
Buvelot 2004.

49. Cardinal Francesco Barberini had a similar idea when he asked his friend the
learned Nicolas-Claude Fabri de Peiresc for drawings of animals on which to base
a weaving of a landscape with animals. Curiosity about botany and zoology was
also at the origin of the series *Birds from the Royal Menagerie*, woven at the Beauvais
manufactory at the end of the 17th century. See Bertrand 2005, pp. 76–77; and
Charissa Bremer-David, "Manufacture Royale de Tapisseries de Beauvais,
1664–1715" in this volume.

50. Félibien 1666–88/1972, second interview, vol. 1, pp. 281–82.

51. This topic is discussed in Bertrand 2007.

52. On tapestries based on the Vatican Stanze and Loggia by Raphael and his followers
at the Gobelins, see Brassat 2002.

53. See T. Campbell in New York 2002, pp. 225–29, 246–52 no. 26, illus.

54. The series symbolized the dogmatism of Rome and the unjustified acquisitions
that the pontifical authority was trying to preserve, which were denounced by the
tenets of the Gallican church; the church's demands for autonomy were rejected
by Rome. The pope, who had not condemned the four articles, nonetheless
refused decrees granting canonical investiture to the deputies of the clerical assem-
bly, whom Louis XIV had appointed bishops. The Declaration of the Clergy was
mainly written by Louvois's brother, Charles-Maurice Le Tellier, archbishop of
Reims. See Waquet 1989, p. 288, and Fumaroli 1997, p. 88.

55. The idea to weave tapestries after Poussin's paintings was not new. Chantelou
(1665/2001, pp. 181–82) had proposed it to Colbert several years earlier, but with-
out success. Not all the paintings for the *Story of Moses* were in the Cabinet du Roi;
some were chosen from private collections. On the *Story of Moses*, see Krause 2005.

56. Fenaille 1903–23, vol. 2, pp. 399–418; Berger 1993.

57. Standen 1998.

58. De Cotte was appointed First Architect to the King in 1708. That same year,
Mathieu was inducted into the Académie Royale de Peinture.

59. Kimball 1943; K. Scott 1995.

60. See Forti Grazzini 1994b, vol. 2, pp. 416–39. In 1709 Audran furnished the designs
for the fantastic *Grotesque Months* (*Les Douze Mois Grotesques* or *Les Douze Mois
Arabesques*) for the Cabinet du Grand Dauphin at Meudon. See Pons 1991. The
series was later rewoven for private clients.

61. Bluche 1986, pp. 587–91.

62. "Le grand peintre doit exprimer si parfaitement les caractères par les gestes, que le
spectateur s'imagine voir en effet les choses dont il ne voit que la représentation;
qu'il se persuade, pour ainsi dire, entendre des paroles, quand même on ne parle
pas"; Coypel 1708–21/1996, p. 495. On Coypel's paintings, see Garnier 1989,
pp. 121–29, 165–67, 175–76, 196–98, 264–66; on the Coypel tapestries, see Beauvais
1998, pp. 4–5. On Jouvenet's paintings, see Schnapper 1974, pp. 131–33, 179, 211–14
nos. 117–20, 218–19 nos. 132–36, 221 no. 141; on the tapestries, see Forti Grazzini
1994b, vol. 2, pp. 440–55, and Beauvais 1998, pp. 8–9.

39.
Water

From a four-piece set, plus four *entrefênetres*, of the
Four Elements
Design by Charles Le Brun after a scheme devised by
the Petite Académie, 1664
Cartoon for the main scene by Baudrin Yvart, 1664
Cartoon for the borders by Isaac Moillon, 1664
Woven in the workshop of Jean Jans the Elder at
the Manufacture Royale des Gobelins, Paris, 1666
Wool, silk, and gilt-metal-wrapped thread
488 x 688 cm (16 ft. x 22 ft. 6⅞ in.)
9 warps per cm
Inscribed JANS 1666 above the lower selvage at right
Deposito Arazzi della Soprintendenza Speciale per Il
Polo Museale Fiorentino, Palazzo Pitti, Florence
(Arazzi no. 7)

PROVENANCE: September 16, 1669, given as a diplo-
matic gift by Louis XIV to Cosimo III de' Medici,
grand prince of Tuscany, during his visit to France;[1]
thereafter, in the ducal, then national, collection.

REFERENCES: Fenaille 1903–23, vol. 2, pp. 50–66;
Vanuxem 1955; Grivel and Fumaroli 1988, pp. 44–53;
Germer 1997, pp. 225–35; Morgan Zarucchi 1999;
Saunders 1999; Meoni in Florence 2005, pp. 277–79,
no. 154.

*T*he tapestries of the *Four Elements* con-
stitute the first set to be wholly designed
and executed at the newly established Manu-
facture Royale de Tapisserie des Gobelins.
They are based on an allegorical scheme that
was initiated by the finance minister and super-
intendent of the Bâtiments (buildings), Jean-
Baptiste Colbert (1619–1683), and developed
between 1663 and 1664 by the members of
the Petite Académie, a group of scholars who
had been charged by Colbert with devising
programs of propagandistic iconography to
celebrate Louis XIV. The designs were created
in 1664 by the director of the Gobelins and
First Painter to the King, Charles Le Brun
(1619–1690). Each of the four main scenes
depicted the classical god associated with one
of the four elements: in *Fire*, Vulcan and the
Cyclopes (as well as Jupiter, Love, and Venus in
the air); in *Air*, Juno and Iris; in *Water*, Neptune
and Thetis; and in *Earth*, Cybil and Ceres.[2]
These scenes are framed by richly decorated
borders depicting the French royal coat of
arms in the center of the upper border, a Latin

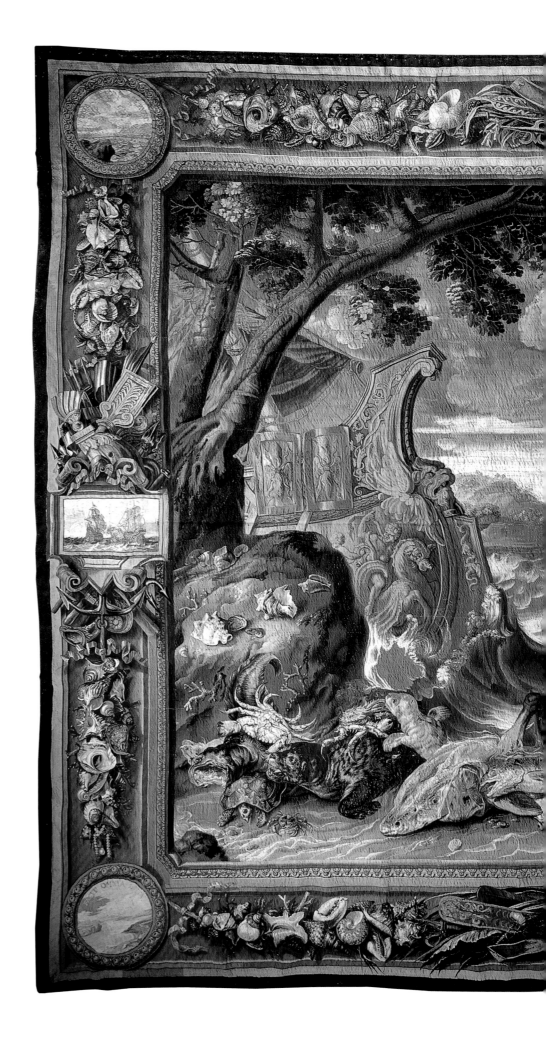

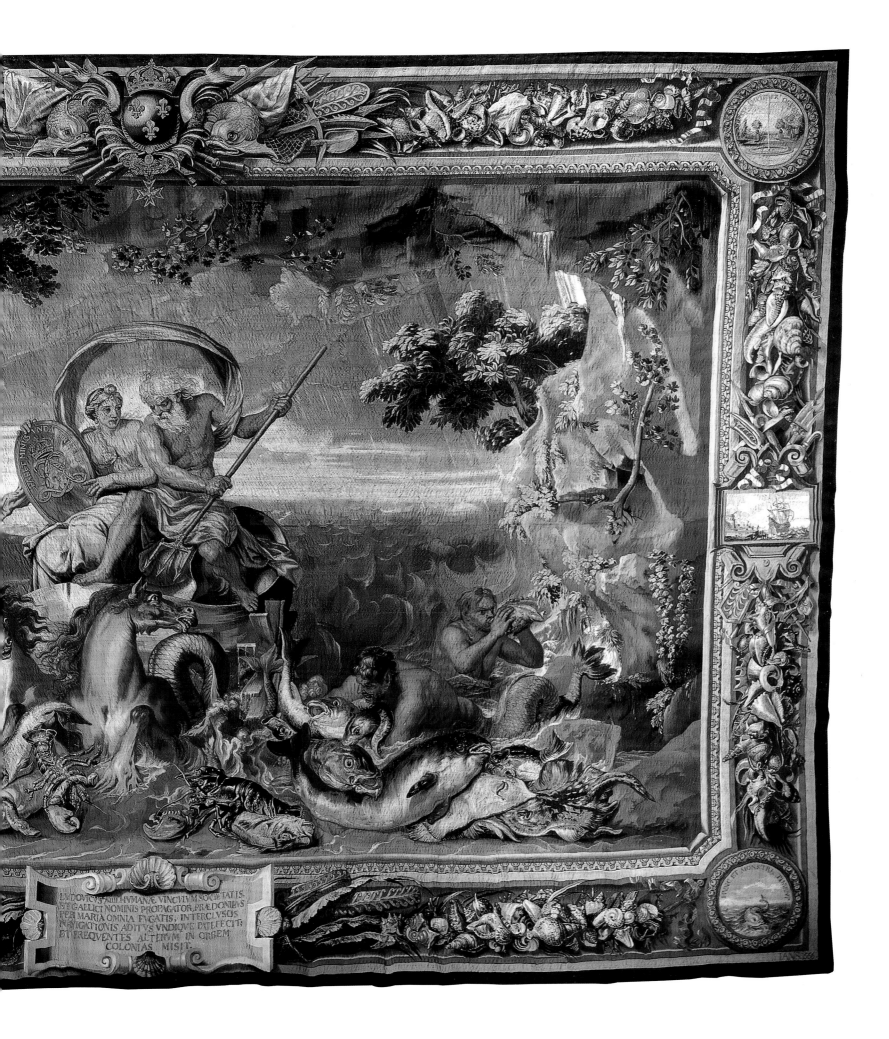

LVDOVICVS XIIII HVMANÆ VINCVLVM SOCIE TATIS,
ET GALLICI NOMINIS PROPAGATOR, PRÆDONIBVS
PER MARIA OMNIA FVGATIS; INTERCLVSOS
NAVIGATIONIS ADITVS VNDIQVE PATEFECIT;
ET FREQVENTES ALTERVM IN ORBEM
COLONIAS MISIT.

inscription in the center of the lower border, two scenes of events in the king's history in the middle of the side borders, and circular medallions in the corners, each depicting an allegorical device relating to the king's virtues. The *Four Elements* series constituted the Gobelins' first essay in propagandistic imagery. Prints after the tapestries accompanied by textual explanations were published by André Félibien in 1665 and, together with an extended reprint in 1667, spread the program of the *Elements* even before the first set of tapestries was completed in 1669. Five more sets of the design were woven before 1680, a reflection of the esteem in which the series was held during the early years of Gobelins production.

Description

The tapestry of *Water* was made by Jean Jans the Elder (1618–1668) in 1666 as part of the first set of this design series that was given as a diplomatic gift by Louis XIV to the prince of Tuscany in 1669.[3] It represents Neptune and Thetis surrounded by the oceanic world. The two allegorical figures are riding on a shell-like carriage pulled by horses, and although physically on top of his subjects, Neptune is shown as having lost control of the sea and its inhabitants, many of which have been washed ashore. The inscription on Thetis's shield, PARET MINUS UNDA TRIDENTI (The wave adheres less to the trident), clearly expresses the diminishing effectiveness of Neptune's scepter. The allegorical application of this scene to Louis XIV is explained by the lower inscription: LVDOVICVS XIIII. HVMANAE VINCVLVM SOCIETATIS / ET GALLICI NOMINIS PROPAGATOR, PRAEDONIBVS / PER MARIA OMNIA FVGATIS, INTERCLVSOS NAVIGA / TIONIS ADITVS VNDIQVE PATEFECIT ET FREQVEN / TES ALTERUM IN ORBEM COLONIAS MISIT (Louis XIV, bond of human fellowship and purveyor of the good name of the French people, with the pirates having been chased throughout all the seas, reopened the maritime blockades everywhere and sent his countrymen into the world toward the abundant colonies). In other words, Louis XIV alone had the power and goodness to ensure the safety of the maritime routes. The small pictures to either side of the central scene further indicate the strength of the French navy. The left-hand tableau depicts a

French frigate hunting a pirate vessel to gain control over the sea, while on the right, French emigrants on board a ship of the merchant navy leave home for colonies abroad.

The four corner emblems provide a meditation on the king's virtues; piety, magnanimity, kindliness, and valor, as manifested in the element Water. Royal piety is represented in the top left corner by the boundless expanse of the sea and described by the words NVSQUAM DATA LITTORA TRANSIT (Never does he transgress the coastline); magnanimity is depicted in the top right corner by a high-spouting fountain and the motto PETIT IMPIGER ORTVS (He seeks the relentless font); kindliness is shown in the lower left corner by the smooth-running river bringing fertility to the land and the text FACIT OMNIA LÆTA (He makes all things prosperous); and valor is explained in the lower right corner by a courageous dolphin and the words HVNC ET MONSTRA TIMENT (And there he fears no portent). The borders are richly decorated with seashells, pearls, coral, and other motifs characterizing the element of water. (See below for further discussion of the allegorical significance of this scene as defined by the texts and engravings published between 1665 and 1670.)

The Conception and Iconography of the Four Elements

Founded in 1663, the Petite Académie was a small circle of scholars who were charged by Colbert to invent and organize the production of textual and iconographic programs celebrating the king.[4] Jean Chapelain, the director of the Petite Académie, had grand ambitions right from the start.[5] In a letter of November 18, 1662, to Colbert, Chapelain declared his interest in the use of architectural monuments and objets d'art for the distribution of propaganda, in addition to literary sources, particularly history writing as it had developed under Richelieu.[6] According to the academy's institutional history, the *Histoire de l'Académie des Inscriptions* (1694), Colbert followed Chapelain's lead and suggested that ceilings, paintings, statues, fountains, tapestries, and so forth be used for propagandistic purposes and that the academicians develop the iconographic programs.[7] While Colbert acknowledged the role of the ancient media of monumental architecture and sculpture in

propagating royal achievements, he urged that the more modern media of tapestries, frescoes, and prints should also be put to this service. He thereby assigned a heightened status to the production of tapestries, recognizing, no doubt, that like prints, the tapestry medium enabled the multiplication and distribution of images celebrating Louis XIV in a way that was impossible to achieve with fixed paintings and monuments. Although both printing and weaving had been important vehicles for the representation of noble wealth and status in the fifteenth and sixteenth centuries, the institutionalization of this process at the Gobelins in the early 1660s was remarkable for the scale and vision it embodied, as also for the elevated status it assigned to the tapestry medium.

The *Four Elements* series was the first project that realized Chapelain's ambition to move from purely textual description to visual imagery. The mode of representation chosen for this series was allegory, which effectively allowed the combination of the two genres. The combined use of allegory and emblematic representation in the *Elements* drew in part on a sixteenth-century tradition in French festive decoration and tapestry design.[8] But it was to be developed to an unprecedented degree in the *Four Elements* through the complexity of the emblems that accompanied the central images. The concept of allegory was evidently the subject of much careful consideration in the early 1660s among the members of the academy, and Charles Le Brun, the artist charged with elaborating the program, was a great proponent of the mode, in both practice and theory. Le Brun explained the attraction of allegory for the artist in a lecture he gave at the Académie Royale de Peinture et de Sculpture in 1667, published the following year in the *Conférences*. As he saw it, the painter of allegories was allowed to disregard some truthfulness and historical correctness in the name of invention, especially if it improved the efficacy of his pictorial narrative.[9] Le Brun's efforts to champion allegory were reinforced by André Félibien's preface to the *Conférences*, which articulated a hierarchy for the different genres of painting. The highest place was assigned to allegory: "one must know how, by means of allegorical compositions, to conceal the

Detail of cat. no. 39

virtues of great men and the loftiest mysteries under the veil of fable. It is he who acquits himself well in such undertakings who is called a great painter."[10] The allegorical mode was to serve Le Brun well: his most highly regarded interior decorations in the Petite Galerie in the Louvre and the Grande Galerie at Versailles were also based on his *histoire allégorique*.[11]

The scheme of the *Four Elements* series was worked out between 1663 and 1664 by the members of the Petite Academie, particularly Jean Chapelain, Charles Perrault, François Charpentier, and the abbé Jacques de Cassagnes.[12] The main scenes were designed by Charles Le Brun, presumably in discussion with Chapelain and his colleagues.

André Félibien composed the Latin inscriptions that appear below the tapestries. The sophisticated devices that appear in the corner medallions were elaborated by other members of the academy. An insight to this process of conception is provided by Perrault's *Mémoires*. He recalled that "Mr. Colbert commissioned from us designs for tapestries to be woven at the Gobelins manufactory. He chose the *Four Elements* because they seemed best suited to express the King's glory. . . . I observed that all the devices are mine. . . . Forty-eight devices were presented to Colbert, sixteen by [Amable de] Bourzeis, sixteen by Cassagnes, and sixteen by me, all mixed together, and, finally, he chose sixteen without knowing their author; among those were fourteen of mine."[13]

Perrault also claimed to be responsible for formulating nine of the sixteen devices that were conceived at the same time for a set of the *Four Seasons*, a second allegorical series whose content complemented that of the *Four Elements*. The emblems that Colbert selected from this process for the *Elements* series may then have been developed into a more finished form by the French miniaturist Jacques Bailly (1629–1679), who subsequently executed an illuminated manuscript featuring these emblems in elaborate frames for Louis XIV (described below; fig. 170).

As mentioned, each of the four principal scenes of the series represents one of the Four Elements. Like *Water*, described above, the tapestries *Air*, *Fire*, and *Earth* developed a

La mer n'a point de bords, de gouffre ny d'abime,
Dont il ne soit Roy legitime,
Et qui ne rende homage à sa noble valeur,
Elle à des monstres effroyables,
Mais il est pourtant vray que des plus redoutables
Dans son juste combat il demeure vainqueur.

Fig. 170. *Pour la valeur* (*Water*), by Jacques Bailly. Gouache, in Jacques Bailly and Sébastien Leclerc, *Devises pour les tapisseries du Roy* (Paris, 1668). Bibliothèque Nationale de France, Paris (Français 7819)

The fourth panel, *Earth*, depicts Cybele and Ceres seated in a chariot holding a shield inscribed UBERTAS MAJOR AB ILLO (His magnificence brings abundance from there). They are surrounded by exotic animals, agricultural instruments, fruit, and vegetables, displaying both variety and abundance. The tapestry's inscription proclaims LVDOVICVS XIIII TERRÆ FRVGVM ET OPVM CVRATOR / PRVDENS AC MVNIFICVS, FAME IN GALLIIS SÆVIENTE, / POPVLOS FRVMENTARIA LARGITIONE RECREAVIT, / ET DVMKERKAM DE SACRIS SOLLICI-TAM, INGENTI / AVRO, IN PRISTINAM VINDICAVIT LIBERTATEM (Louis XIV, skilled and munificent guardian of the crops of the earth and of wealth, while the famine raged in France, restored the people with generous portions of grain, and with the city of Dunkirk having been incited to riot on account of holy rites, with vast quantities of gold, he claimed their former liberty).[15]

The borders of all the tapestries are similarly structured with a cartouche with the royal cipher in the center of the upper border, the Latin inscription in the lower border, two small images in the center of the lateral borders, and medallions with emblems of the royal virtues in the corners. The virtues—piety, magnanimity, kindliness, and valor—remain constant from one tapestry to another, but the devices and mottoes are varied to relate the virtue to the Element in question.

In addition to the principal scenes, Le Brun also prepared four *entrefenêtres* for the series, which continue its general theme. Thus, the *entrefenêtre* that goes with *Water* extends the symbolism of that panel with a depiction of a large frigate with the French royal arms anchored in a tropical bay, where it is being unloaded of supplies for the patriotic emigrants.[16] The piece accompanying *Fire* shows a man fleeing from a burning town passing a woman and two children on his flight. The *entrefenêtre* for *Air* depicts a landscape with trees bent by strong wind and two people seeking shelter from a storm. In the supplementary piece for *Earth* a young woman sits in a chair in a park, handing flowers from a basket to a young man seated on steps beside her. The *entrefenêtres* do not have the wide allegorical borders of the main scenes but instead have only upper and lower borders that repeat the decoration

sophisticated celebration of Louis XIV's military and diplomatic victories. In *Air*, Juno, goddess of light, and Iris, goddess of the rainbow, are shown seated on a cloud and surrounded by exotic birds both in the air and the ground below. Iris holds a shield inscribed with the motto CITIVS VENTOS ET NVBILA PELLIT (He quickly repels the winds and clouds). The inscription in the lower border describes the tranquility and peace achieved through the king's marriage: LVDOVICVS XIIII HOSTIVM SVIQUE IPSIVS VICTOR, / FORTISSIMAM GENTEM BELLO FRACTAM GEMINO / PACIS AC CONNVBII FŒDERE SIBI DEVINXIT; IAMQUE / AER TVRBV-LENTO ARMORVM STREPITV NVPER COMMOTVS / FESTIVIS PVBLICÆ LÆTITIÆ CONCENTIBVS PER-SONABIT (Louis XIV, conqueror of enemies and his own passions, united through a treaty of peace and marriage the strongest people, who were disheartened through repeated war; already, in our time the air was filled with noise from the turbulence of love, the commotion

resounded with the feasting of the people and with the concord of joy).

In *Fire*, Vulcan and his Cyclopes are forging instruments and armor. Above them, Venus, with Love, and Jupiter appear in a cloud. Jupiter is holding a shield inscribed MAGIS IPSO FVLMINE TERRET (He terrifies even more than lightning). Here, the text in the lower border reads LVDOVICVS XIIII POTENTISSIMVS REGIÆ DIGNITATIS / CVSTOS ET VINDEX POST-QVAM IGNI VIM INIMI / CAM ERIPVIT, TVM SOLA FVLMINIS MINITANTIS / CORVSCATIONE ET MARSALII FIRMISSIMAM ARCEM / EXPVGNAVIT ET VIOLATAM APVD ROMANOS / IN LEGATO MAJES-TATEM ASSERVIT (Louis XIV, the most powerful one, rescued the guardians of courtly stature, and afterward like a defender stripped the force from the harmful flames, at that time he assaulted both the single flash of threatening lightning and the most substantial stronghold of Marsal, and released the dishonored sovereign before the Roman ambassadors).[14]

surrounding the main panels without the inserted pictures, emblems, and inscriptions. They do not seem to have been the subject of deep cogitation by the Petite Académie. Neither Félibien nor any of the other contemporary scholars concerned with the propaganda value of the series commented on the *entrefenêtres*.[17]

The Cartoons and the First Weaving

The cartoons for the *Four Elements* series were elaborated from Le Brun's designs by a team of artists. It should be noted that two sets of cartoons were made, one for the high-warp looms (in the same orientation as the designs) and one for the low-warp looms (reversing the designs because the low-warp weaving process reversed the cartoon). The fact that two sets of cartoons were prepared indicates the degree to which Colbert envisaged rapid production (relatively speaking) of a number of sets of these designs. The cartoons for the high-warp tapestries were executed by Baudrin Yvart (1611–1680; center images) and Isaac Moillon (1614–1673), Delarque, and Duhamel (borders); those for the corresponding *entrefenêtres*, by Jean Dubois (1604–1676) and Abraham Genoels (1640–1723). The cartoons for the low-warp weaving were painted by Adam Frans van der Meulen (1632–1690) (*Fire*), Joseph Yvart (1649–1728) (*Air*), Michel Ballin (ca. 1619–1706) (*Water*), and Claude Audran (1641–1684) (*Earth*); those for the *entrefenêtres*, by Genoels and Dubois.[18] The Mobilier National preserves two incomplete cartoons for *Water*.[19]

The task of weaving the first set of tapestries was shared by three of the workshops that had recently been established at the Gobelins, those of Jean Jans the Elder (1618–1668) and Jean Jans the Younger (1650–1731), Jean Lefebvre (active at the Gobelins 1662–99), and Henri Laurent (active at the Gobelins 1662–69).[20] This suggests that the set was produced under time pressure and alongside, rather than at the expense of, other projects. Weaving of all eight pieces was completed by 1669.

Fig. 171. *Fire*, by Charles Perrault after a gouache by Jacques Bailly, 1670. Engraving, in *Les Tapisseries du Roy*. The Frick Collection, The Frick Art Reference Library, New York (F 094 P42 //)

Detail of cat. no. 39

Publications Produced to Accompany the Series

The iconography of the *Four Elements* was exceptional in its complexity, and explanatory texts seem to have been envisaged from its initial conception. In 1665 Félibien published *Les quatre élémens peints par M. Le Brun et mis en tapisseries pour Sa Maiesté*, a thirty-one-page book that included engravings of Le Brun's original designs for the *Four Elements* along with the Latin inscriptions for the borders. In 1667 a second edition of Félibien's text was published by Pierre Le Petit in thirty-five pages.[21] This contained a new preface by Félibien, which further explained the political allegory of the main scenes. For example, *Water* was said to represent the pacifying consequences of the royal marriage of Louis XIV to Maria Theresa of Spain (1638–1683) in 1660: "This painting must be considered a depiction of calmness which the tranquility and the marriage of His Majesty brought to

the state after the discord and unrest of civil wars. And these fish thrown up on the beach and out of the water are like a picture of those who have been displaced from their lands by these disturbing squalls, which His Majesty, by royal benevolence and the care worthy of a true father, has brought back and returned to their Element."[22] The 1667 edition also included madrigals by Charles Perrault, with further elucidation of the virtues of piety, magnanimity, kindliness, and valor depicted in the corner medallions of the tapestries: "*Piety*: Though my empire spans the universe, though the stoutest heart fears my wrath and trembles at my slightest blows, I never surpass the limits the Almighty has prescribed for my vast power, not even in my fiercest rage. // *Magnanimity*: Even as you see my fellows creep on the ground or wallow in misery, soft in their idleness; by the divine impulse of a divine virtue, I rise and ascend swiftly, high as my origin. // *Kindliness*: Away

from me, all perishes, all languishes in weakness, all withers in sadness for want of my help; near me, all flourishes, thrives, and goes forth. And you see me bringing joy and plenty wherever I direct my course. // *Valor*: The sea has no shores, no eddies, no depths, of which he is not the legitimate king, none that do not pay homage to his noble valor: it has fearsome monsters, indeed; but in a just battle he remains the victor over the most formidable of these."[23]

As these publications were in preparation, the iconographic scheme was being further developed by Jacques Bailly in an elaborate illuminated manuscript with gouache drawings of the tapestries, followed by exquisitely rendered miniatures of each individual emblem, surrounded by inventive and witty frames (fig. 170).[24] This volume, bound in tooled morocco leather, was presented to Louis XIV some time before May 1668, when it was among the rare items that the king's

librarian, Pierre de Carcavy (ca. 1600–1684), showed to the Italian scientist Lorenzo Magalotti (1637–1712), who was then visiting France on behalf of Grand Prince Cosimo III of Tuscany.[25] Magalotti was interested in contemporary design and craftsmanship and noted in his diary that the "miniatures are very charming, and the book altogether is beautiful."[26] At the same time Bailly was preparing this work, his emblems were engraved by Sébastien Leclerc (1637–1714) and printed by Jean Goyton at the Gobelins. C. Blageart published these prints, which were sold individually and as complete sets from Bailly's workshop at the Louvre in 1668 and 1669.[27]

In 1670 the Petite Académie gave orders to publish yet another edition of Félibien's *Quatre élémens*.[28] This included his 1667 text, Perrault's madrigals, and Leclerc's engravings of the tapestries, and was published under Félibien's name as *Tapisseries du Roy* (fig. 170).[29] The new preface in this volume provided still further explanation of the political allegory underlying Le Brun's designs. For example, the image of Water was now said to represent the calmness and the return to order and prosperity that followed Louis XIV's successful suppression of the Fronde (1653) and the peace treaty he signed with Spain (1660).[30]

Félibien's *Tapisseries du Roy* proved greatly successful and was reprinted in Paris in 1679, 1690, and 1727. In the "Registre des Livres de figures et Estampes qui ont esté distribuées suivant les ordres de Monseig' le Marquis de Louvois, depuis l'Inventaire fait avec M' l'abbé Varés au mois d'aoust 1684," numerous copies of these later prints of the *Four Elements* and *Four Seasons* are recorded as royal gifts and, together with prints after other tapestries, such as those of the *History of Alexander* (designed by Le Brun beginning in 1661), the *History of the King* (by Le Brun and Adam Frans van der Meulen, from 1664), and depictions of the Grande Escalier by Le Brun or the Petite Galerie by Nicolas Mignard at Versailles were often bound in morocco leather and finely tooled and decorated with the coat of arms of Louis XIV.[31] From 1684 through 1701 these royal gifts were distributed to such far-flung recipients as Jesuit missionaries in China and ambassadors to the king of Siam. Similar diplomatic presents were given

to members of the French court and the royal administration, including André Le Nôtre, head gardener of Louis XIV; Jacques-Louis, marquis de Beringhen, first squire to the king; Louis-Henri de Loménie, comte de Brienne, councilor and secretary of state for foreign affairs; Girard Audran, engraver (in exchange for one hundred copies of his representation of the dome of the church of Val-de-Grâce); Édouard Colbert de Villacerf, superintendent of the Bâtiments du Roi; Guy-Crescent Fagon, first doctor to the king, as well as European diplomats and courts, such as the baron de Spanheim, envoy of Brandenburg, and the marqués de Castell dos Rios, ambassador of Spain, indicating that these royal gift books served as a means both of expressing gratitude and of disseminating propaganda.

In addition to the later French publications, Félibien's 1670 edition was reproduced by Johann Ulrich Kraus in Augsburg, Germany, in 1687. Kraus copied the plates (hence the prints reverse the orientation of Leclerc's), reprinted Félibien's text and translated it, literally and by forming his own rhyme scheme, so that his version presents both the original French and his German translation of the description of the *Four Elements* and *Four Seasons*.[32] This publication was later reprinted twice, and a Dutch version was published in Utrecht (1691–1710), indicating a widespread distribution and appreciation of this series and its intrinsic message, as intended by the Petite Académie.[33]

Later Weavings of the Four Elements
In tandem with the publications explaining and disseminating the *Four Elements*, the Gobelins workshops continued to produce tapestries based on Le Brun's designs. In total, five sets were completed before 1673, and a sixth by 1680, all consisting of eight hangings: the four large panels of the *Elements* and the four corresponding *entrefenêtres*. The execution of each of these sets was allocated to single workshops, except for the fifth set, which was woven in two workshops, those of Laurent and Jans the Younger together.[34] Thereafter, the designs seem to have been put aside because of the shifting tastes in French court art and the new emphasis on more overt celebrations of Louis XIV in the form of the *History of the King* tapestries that required

so much attention from Le Brun and his assistants during the 1670s. In the early eighteenth century, two final sets were woven of the *Four Elements,* but these did not include the *entrefenêtres.*[35]

FLORIAN KNOTHE

1. Fenaille 1903–23, vol. 2, p. 57.
2. Ibid., pp. 53–55.
3. Ibid., p. 57.
4. Cassagnes to Colbert, Paris, March 12, 1664, in Colbert 1861–82, vol. 5, pp. 499–500; Perrault 1759, pp. 36–38.
5. Klaits 1976, p. 3; K. Scott 1995, pp. 177–78.
6. Chapelain's letter was last reprinted in Jacquiot 1968, vol. 1, no. 2, pp. 87–90.
7. *Histoire de l'Académie des Inscriptions*, quoted in Jacquiot 1968, vol. 1, no. 4, pp. 90–94.
8. See Fenaille 1903–23, vols. 1 and 2, for the production of tapestries in the 17th century. See also Germer 1997, p. 226.
9. Le Brun 1667/1668, pp. 101–6.
10. "[I]l faut representer de grandes actions comme les Historiens, ou des sujets agreables comme les Poëtes; Et montant encore plus haut, il faut par des compositions allegoriques, sçavoir couvrir sous le voile de la fable les vertus des grands hommes, & les mysteres les plus relevez. L'on appelle un grand Peintre celuy qui s'aquite bien de semblables entreprises"; Félibien 1668, preface.
11. Mai 1975, pp. 213–23.
12. Vanuxem 1955.
13. "M. Colbert nous demanda des desseins pour des tapisseries qui devoient se faire à la manufacture des Gobelins. Il ne fut donné plusieurs entre lesquels on choisit celui des quatre élémens, où l'on trouva moyen de faire entrer plusieurs choses à la gloire du Roi.... J'observerai seulement que toutes les devises sont de moi.... Ayant porté à Colbert 48 devises pour cette tapisserie, seize de l'abbé de Bourzeis, seize de l'abbé Cassagnes, & seize de ma façon toutes mêlées les unes avec les autres, afin qu'il en choisit seize sans sçavoir qui en étoit l'auteur; il s'en trouva quatorze des miennes"; Perrault 1759, pp. 36–38.
 Further, he wrote, "Consequently, one executed the designs for the set of the *Four Seasons* based on the models of the *Four Elements*: these were also engraved and accompanied by similar explanations. Nine of the sixteen devices decorating this set are mine" ("On fit ensuite le dessein de la tenture des quatre saisons de l'année sur le modele de celle des quatre élémens: on l'a aussi gravée & accompagnée de semblables explications. Des seize devises qui ornent cette tenture, il y en a neuf de moi"); ibid.
14. Marsal, in Lorraine, was captured by Louis XIV on September 1, 1663. A representation of this military victory was also included in the *History of the King*; see Meyer 1980, pp. 61–68.
15. Dunkirk was bought by Louis XIV from Charles II of England for 4 million livres on October 27, 1662. The depiction of the arrival of the French army in Dunkirk (December 2, 1662) is also included in the *History of the King*; see Meyer 1980, pp. 45–52, and cat. no. 41 in this volume.
16. Fenaille 1903–23, vol. 2, p. 56.
17. Félibien 1671, pp. 115–66; Germer 1997, pp. 225–35; Morgan Zarucchi 1999; Saunders 1999; Kirchner 2001, pp. 423–25.
18. Fenaille 1903–23, vol. 2, p. 52; Perrault 1759, pp. 39–41; Grivel and Fumaroli 1988, p. 110.
19. One of the cartoon sets consists of four strips, measuring 270 by 400 cm overall (inv. GOB 703/2), and the other is composed of five strips, 305 by 445 cm overall (inv. GOB

712). First described by Fenaille (1903–23, vol. 2, p. 51), these cartoons were moved from the Louvre to, and newly inventoried by, the Mobilier National about 1938. I am indebted to Jean Vittet for this information.

20. The first suite consists of eight pieces with gilt-metal-wrapped thread: *Air*, Jean Lefebvre (low-warp, completed in 1669), and *entrefenêtre*, Jean Jans the Younger (high-warp, 1669); *Earth*, Henri Laurent (high-warp, 1668), and *entrefenêtre*, Laurent (high-warp, 1668); *Water*, Jean Jans the Elder (high-warp, 1666), *entrefenêtre*, Lefebvre (high-warp, 1666); *Fire*, Jans the Elder (high-warp, 1666), and *entrefenêtre*, Jans the Younger (high-warp, 1666). It was inventoried by the Mobilier de la Couronne as no. 51. Fenaille 1903–23, vol. 2, pp. 57–58; Guiffrey 1885–86, vol. 1, p. 303.

21. Félibien 1667a. Also in 1667, Félibien issued *Les quatre saisons peintes par M. Le Brun et mises en tapisseries pour Sa Maiesté*, containing descriptions of the paintings of the *Four Seasons* and madrigals by Perrault; Félibien 1667b. The madrigals and the inscriptions by Félibien, without his description of the pictures of both the Elements and the Seasons, were reprinted in 1671 by Jean de La Fontaine in his *Recueil des poesies chrestiennes et diverses*. In 1667 Félibien's Latin inscriptions were reworked by miniature painter Jacques Bailly and calligrapher Nicolas Jarry, and—separated now from the decorative composition of the tapesty—they formed part of a new manuscript presented to the king. See Cordey 1926; Vanuxem 1955.

22. "Cette Peinture doit estre considérée comme vne figure de calme que la Paix & le Mariage de S.M. ont mis dans l'estat après le troubles & les agitations des guerres civiles. Et ces poissons jettez sur le rivage & hors de l'eau sont comme vne image de ceux qui avoient esté jettez de leurs païs par ces bourasques si fascheuses, lesquels S.M. par vne bonté toute royale & des soins dignes d'vn veritable pere a rappellez auprés d'elle & remis dans leur Element"; Félibien 1667a, p. 24; Germer 1997, pp. 231–33.

23. "*Piété*: Bien qu'en tout l'Vnivers mon Empire s'étende / Que le plus ferme cœur ma colere apprehende, / Et tremble au moindre de mes coups: / Je ne m'étends jamais au-de-là des limites / Qu'à mon vaste pouvoir l'Eternel a prescrites, / Même au plus fort de mon courroux. // *Magnanimité*: Pendant que l'on vois mes semblables, / Ou ramper sur la terre, ou croupir miserables / Dans une molle oisiveté; / Par les divins ressorts d'une vertu divine / Je monte & je m'éleve avec rapidité / Aussi haut que mon origine. // *Bonté*: Loin de moy tout perit, tout languit de foiblesse, / Et séche de tristesse /

Faute de mon secours; / Prés de moy tout fleurit, tout profite, & s'avance, / Et l'on me voit porter la joye & l'abondance / Par tout où je porte mon cours. // *Valeur*: La Mer n'a point de bords, de gouffre, ny d'abysme, / Dont il ne soit Roy legitime, / Et qui ne rende hommage à sa noble valeur: / Elle a des monstres effroyables; / Mais il est pourtant vray que des plus redoutables / Dans un juste combat il demeure vainqueur"; Félibien 1667a.

24. Jacques Bailly and Sébastien Leclerc, *Devises pour les tapisseries du Roy ou sont representez les quatre elemens et les quatre saisons de l'année, peintes en mignature par I. Bailly, peintre du Roy en son Academie Royale de Peinture et sculpture. Et gravées par S. Le Clerc, a Paris, de l'Imprimerie de C. Blageart, rüe S. Iacques. Et se vendent aux galleries du Louvre chez ledit Bailly, avec privilege de Sa Maiesté* (Paris, 1668), Bibliothèque Nationale de France, Paris, Cabinet des Manuscrits, MS fonds français 7819.

On March 14, 1668, Bailly received his final payment of a total of 1,551 livres "pour un livre de devises qu'il a peint pour le Roy"; Guiffrey 1881–1901, vol. 1, col. 275.

25. Magalotti 1668 / 1991, pp. 86–87.

26. "Le miniature son molto vaghe, e il libro tutto assieme è bellissimo"; ibid., p. 87.

27. Whereas Félibien presented the Elements as Fire, Air, Water, and Earth, Bailly changed the order, showing Air first, then Fire, Water, and Earth. The plates are not signed, either by him or by Leclerc; only the text is marked Perrault. For a detailed description, see Jombert 1774, vol. 1, pp. 93–101, no. 88; Préaud 1980, vol. 9, pp. 58–67, nos. 1541–77.

28. See Archives Nationales, Paris, O¹ 1964.

29. In Félibien 1670, each element is presented on a double-page spread, followed by the four devices, each illustrated above the corresponding madrigal by Perrault. Whereas the large plates of the *Elements* and *Seasons* are inscribed with at least one of the names of Le Brun, Leclerc, or Goyton, and the text is signed by Perrault, the madrigals are not marked, as in the previous editions. The title page does not give the authors' names but refers to Sébastien Mabre-Cramoisy as the printer. See Jombert 1774, vol. 1, pp. 134–40, no. 98; Préaud 1980, vol. 9, pp. 68–77, nos. 1579–97; Germer 1997, pp. 227–28.

Félibien's descriptions of the *Elements* and the *Seasons*, without Leclerc's illustrations, were republished in his *Description de divers ouvrages de peinture faits pour le Roy* (Paris: Sébastien Mabre-Cramoisy, 1671), his *Recueil de descriptions de peintures et d'autres ouvrages faits pour le Roy* (Paris: widow of Mabre-Cramoisy, 1689), and his *Description du château de Versailles, de ses peintures et d'autres*

ouvrages faits pour le Roy (Paris: Mariette, 1696).

30. See Félibien 1670.

31. See "Registre des Livres de figures et Estampes qui ont esté distribuées suivant les ordres de Monseig' le Marquis de Louvois, depuis l'Inventaire fait avec M' l'abbe Varés au mois d'aoust 1684," Bibliothèque Nationale de France, Paris, Est. Res. Ye 144.

32. Kraus 1687.

33. See Vanuxem 1955, p. 69. As Antoine Schnapper (1986, p. 196) pointed out, Félibien clearly described the virtue of engravings by saying that "it is again by the means of these prints [of architecture, as much as of decorative artifacts] that all nations can admire the sumptuous edifices which the king has built everywhere, and the rich ornamentation which embellishes them."

34. The second set (eight pieces) was completed in the low-warp technique with gilt-metal-wrapped thread by Jean Delacroix in 1669; it was inventoried by the Mobilier de la Couronne as no. 53. According to Fenaille (1903–23, vol. 2, p. 59), nos. 53 and 60 were exchanged mistakenly in Du Metz's inventory, so that Guiffrey (1885–86, vol. 1, pp. 304, 306) printed no. 53 as no. 60 and vice versa.

The third set was identical (inventoried as no. 54); Fenaille 1903–23, vol. 2, p. 60; Guiffrey 1885–86, vol. 1, p. 304.

The fourth suite (eight pieces; inventoried as no. 65) was completed in the high-warp technique with gilt-metal-wrapped thread by Jans the Younger in 1673; Fenaille 1903–23, vol. 2, p. 61; Guiffrey 1885–86, vol. 1, p. 307.

The fifth set (inventoried as no. 66) was begun in 1669 and finished in 1673, the two pieces of *Fire* woven by Laurent and the rest by Jans the Younger; it was woven in high-warp with gilt-metal-wrapped thread. Fenaille 1903–23, vol. 2, p. 62; Guiffrey 1885–86, vol. 1, p. 307.

The sixth weaving (eight pieces; inventoried as no. 75), finished before 1680 by Delacroix, was woven in low-warp with gilt-metal-wrapped thread; Fenaille 1903–23, vol. 2, pp. 62–63; Guiffrey 1885–86, vol. 1, p. 309.

35. The seventh suite (four pieces) was begun in 1703 and finished between 1706 and 1712 by Louis-Ovis Delatour, woven in high-warp with gilt-metal-wrapped thread; Fenaille 1903–23, vol. 2, pp. 63–66.

The eighth set (four pieces) was begun between 1707 and 1713 and finished between 1713 and 1717 by Delatour, woven in high-warp without gilt-metal-wrapped thread; Fenaille 1903–23, vol. 2, pp. 64–66.

40.
The Battle of the Granicus

From a five-piece set of the *Story of Alexander*
Design by Charles Le Brun, 1664–65
Cartoon by Louis Licherie, 1665
Woven in the workshop of Jean Jans the Younger at
the Manufacture Royale des Gobelins, Paris, 1680–87
Wool, silk, and gilt-metal-wrapped silk thread
485 x 845 cm (15 ft. 11 in. x 27 ft. 8⅜ in.)
9 warps per cm
Inscribed I.L.F. 1672 in lower border at right
Kunstkammer, Kunsthistorisches Museum, Vienna
(TV 2)

PROVENANCE: November 29, 1699, given as a diplo-
matic gift by Louis XIV to Leopold Joseph (1679–
1729), duke of Lorraine; passed to his son Francis
Stephen (1708–1765), duke of Lorraine; 1736, taken to
Vienna when Francis Stephen (later Emperor Francis I)
married Maria Theresa (1717–1780); in the royal, then
national, collection ever since.

REFERENCES: Nivelon 1700/2004, pp. 311–14;
Havard and Vachon 1889, p. 115; Fenaille 1903–23,
vol. 2, pp. 166–85; Halbturn 1976, pp. 46–50; Brassat
1992, pp. 87, 143, 149, 199–200; Bauer in Thessaloníki
1997, pp. 119–22, no. VI. 1–3; Birkenholz 2002, esp.
pp. 51–52, 63–64.

The tapestry depicting the Battle of
the Granicus is, chronologically, the
first in a five-piece set of tapestries illustrating
the *Story of Alexander* woven from designs
by Charles Le Brun (1619–1690) at the
Manufacture Royale des Gobelins from 1680
to 1687. According to his biographer Claude
Nivelon (1648–1720), when Le Brun was
commissioned by Louis XIV (1638–1715) for
the first time in 1661, he compared the king
to Alexander the Great by painting the *Tent of
Darius* in the king's presence at the Château
de Fontainebleau, thereby drawing a corre-
sponding analogy between himself and
Alexander's painter Apelles.[1] This painting,
repeatedly described by contemporaries as his
most complex and artistically demanding
work to date, led to Le Brun's promotion
to the position of First Painter to the King
and, thereby, secured him lifelong employ-
ment by the crown. The acclaim that this first
Alexander painting received resulted in a
commission for four more scenes, which Le
Brun painted between 1661 and 1668.
Depicting the diplomatic and military suc-
cesses of Alexander the Great, they evoke a
parallel between the glorified hero of the
ancient world and Louis XIV and between
the noble virtues of the two leaders. The
four additional scenes illustrate, in narrative
sequence, the Battle of the Granicus, the Battle
of Arbela, the Triumphal Entry into Babylon,
and the Defeat of Porus. All the depictions
were monumental in scale—the *Battle of the
Granicus* measures 4.7 by 12.09 meters.[2]

At the same time the paintings were being
executed, the crown ordered that they be
reproduced in the richer medium of tapestry.
Accordingly, two sets of cartoons were pre-
pared on the basis of Le Brun's paintings, one
for the high-warp workshops by Louis
Licherie (1629–1687), Gabriel Revel, Joseph
Yvart, Henri Testelin, and René-Antoine
Houasse, and a second for the low-warp
weavers by François Bonnemer, Guy-Louis
Vernansal, Revel, and Yvart.[3] During this
process, Le Brun's series of five original paint-
ings was enlarged by adding two smaller

scenes on either side of each of the first three
principal tableaux and one additional *entre-
fenêtre*, thereby expanding the illustration of
the *Story of Alexander* into a twelve-piece set.[4]
Between 1664 and 1688 four sets were pro-
duced on high-warp looms in the workshops
of Henri Laurent, Jean Jans the Elder, Jean
Jans the Younger, and Jean Lefebvre. Another
four sets were woven on low-warp looms by
Jean-Baptiste Mozin, Jean de La Croix, Jean
Lefebvre, and Jean Jans the Younger.[5] The first
three sets of high-warp tapestries each contain
twelve pieces. All the others include eleven
hangings, with the exception of the third
low-warp set, which comprised only six tap-
estries. All of these sets were woven from the
original cartoons and at great speed and were
destined for the royal wardrobe. They repeat
closely the editio princeps but show various
original borders and differ slightly in size, as
was common practice, suggesting that the ini-
tial set, like the paintings, was produced for a
specific interior, whereas subsequent weavings
were employed as temporary decorations and
diplomatic gifts.

Description

This tapestry illustrating the Battle of the
Granicus was woven in the high-warp tech-
nique by Jean Jans the Younger in 1680–87
as part of the fourth weaving of the *Alexander*
series and illustrates the Macedonian army
of Alexander the Great crossing the river
Granicus and its first encounter with the hos-
tile Persian soldiers in March 334 B.C. By
traversing this river and invading Asia Minor,
Alexander's troops definitively conquered
Persia. Armed only with spears, the Macedon-
ians fought a much larger Persian phalanx
that was equipped with swords and clubs and
won the battle by virtue of a superior military
strategy. The dynamism of this lively battle
scene is enhanced by the sweeping diagonal
arrangement, rising from the lower left to
the upper right. In the left foreground cavalry
and footmen cross the river. Foot soldiers are
in boats, some clinging to the horsemen to
avoid being carried away by the river's strong

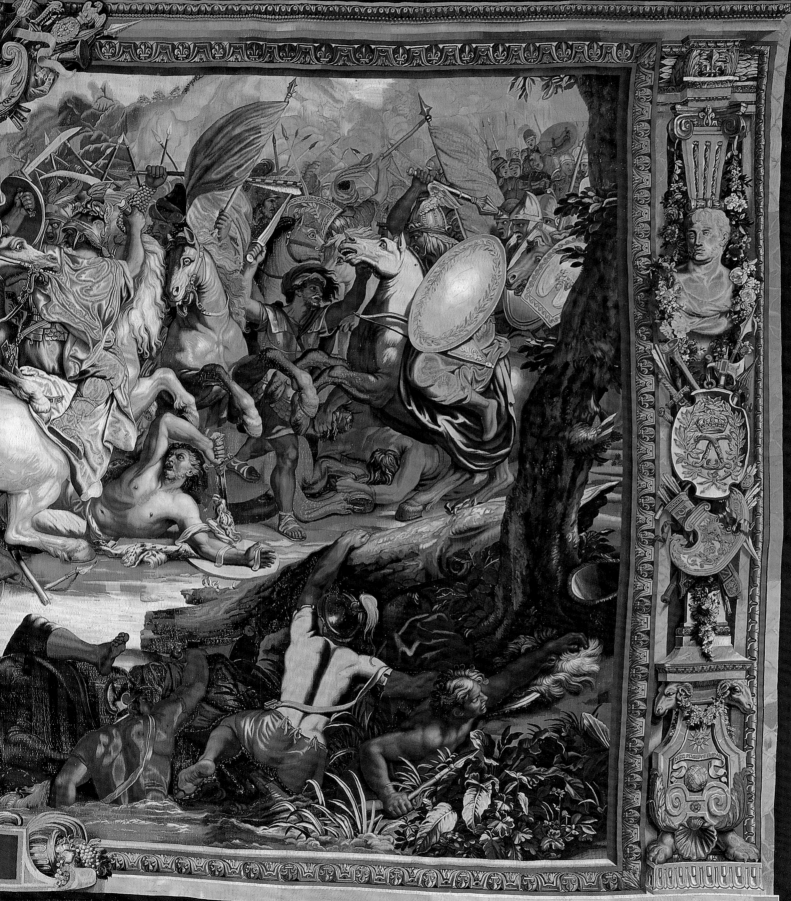

Fig. 172. *The Battle of the Granicus*, by Charles Le Brun, 1664. Red chalk with some marks in black chalk, squared off in black chalk, 284 x 471 cm. Département des Arts Graphiques, Musée du Louvre, Paris (29427)

current. Fearsome combat takes place in the center and in the background at the right. In the center of the scene, Le Brun dramatically illustrated the climax of this combat by showing Alexander leading his cavalry to break through the Persian front line. Himself endangered by two hostile horsemen, Alexander is saved by Clitus, his friend and officer, who fights the second assailant.

The image is framed at top and bottom by a simple border woven in imitation of carved wood and embellished only by the French

Fig. 173. *Group of Warriors*, by Charles Le Brun, ca. 1665–73. Red chalk with white chalk highlights, on beige paper, 256 x 303 cm. Département des Arts Graphiques, Musée du Louvre, Paris (27952)

royal coat of arms at top center and by a cartouche inscribed NEC PLURIBUS IMPAR (Not inferior to many) in the center of the lower border. This comparatively plain frame was used frequently on its own and also in conjunction with highly decorative borders that extended the tapestry's iconography beyond the primary scene. Both the central panel of the Granicus tapestry and its accompanying side panels are flanked on left and right sides by woven borders that imitate pilasters. These show male busts embellished with flower gar-

lands above shields with crowned interlaced Ls, the emblem of the Bourbon monarchy, framed by laurel and surrounded by weapons and war trophies.

The lower right-hand corner of the border is inscribed I.L.F. 1672. This signature indicates that Jean Jans the Younger (Ians le fils) was responsible for weaving the tapestry, yet the date, 1672, is problematic since Jans did not begin work on this fourth set of tapestries until 1680, when a different pay scale was introduced at the Gobelins, as recorded in the administrative archives.[6] This inconsistency can only be explained by the fact that Jans copied the first tapestry or the cartoons produced for the very first set of borders, both of which would have been executed about 1672, since the earliest tapestries of the first weaving were delivered to the royal wardrobe in 1673.[7]

Celebrated as one of the greatest victories won by the Greeks against a larger number of enemies, the Battle of the Granicus was vividly described by the Greek historian Plutarch (ca. 46–127) in A.D. 79 in an account that Le Brun closely followed to develop his composition. A dozen surviving drawings in the Cabinet des Dessins at the Musée du Louvre demonstrate that Le Brun drew individual pairs of fighting horsemen in order to study their movement and expression and combined these to form the large image (figs. 172, 173).[8] This working method is unlike the

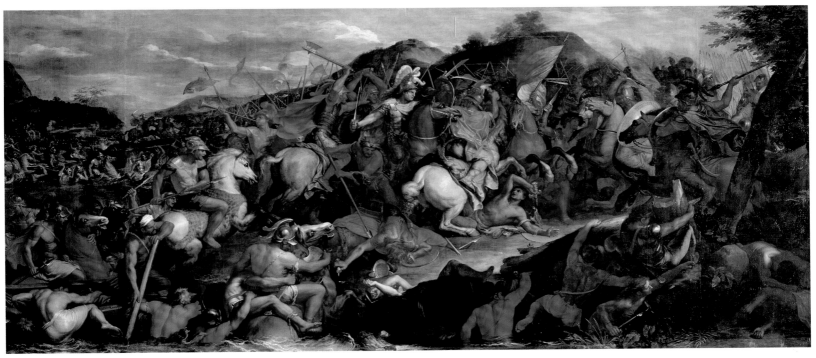

Fig. 174. *The Battle of the Granicus*, by Charles Le Brun, 1664–65. Oil on canvas, 470 x 1209 cm. Musee du Louvre, Paris (2890)

one Le Brun followed in painting the *Tent of Darius*. For that composition, Le Brun turned to a tapestry of this subject in a high-quality Brussels set of the *Story of Alexander* that was woven by Adrian Blommaert in the 1560s after designs by Michiel Coxcie. If Le Brun's depiction of the Battle of the Granicus does not relate to an earlier tapestry,[9] it does show some influence from Sodoma's (Giovanni Antonio Bazzi, 1477–1549) and Pietro da Cortona's (1596–1669) frescoes in Rome, sources Le Brun would have known from his sojourn there in 1642–45.[10]

Iconography

In selecting the *Story of Alexander* for his first royal commission, Le Brun was following well-established artistic practice. A youthful, energetic war hero of incomparable bravery and military strength, the king of Macedon (356–323 B.C.) expanded his territory eastward to include most of the Middle East and India within just over a decade of warfare (338–326 B.C.). Ever since, Alexander has been celebrated for both conquering the world (or, at least, that part of the world known to the Greeks) and his thoughtful and charitable nature. His persona initiated a long tradition in propaganda imagery repeatedly employed by later European monarchs who attempted

to identify themselves with the heroic historical figure. At least since the late fourteenth century tapestries illustrating scenes from Alexander's life were common across western Europe.[11] From the early 1660s, the royal administration in France sought to project Alexander's moral principles upon Louis XIV.[12] Whereas the *Tent of Darius* represents the humane quality of saving and pardoning the innocent, and the *Triumphal Entry into Babylon* and the *Defeat of Porus* relate to the takeover of conquered territory, the *Battle of the Granicus* and the *Battle of Arbela* recall the strategic intelligence and superior military command of the youthful leader. Louis XIV, who knew earlier depictions of the Alexander cycle from the Château de Fontainebleau (where Le Brun executed the initial painting), was in his mid-twenties when the story of Alexander was appropriated to enhance his image.[13]

In addition to the pictorial program, Jean Racine (1639–1699), historiographer to Louis XIV from 1677, wrote the five-act play *Alexandre le Grand* that, produced by Molière (1622–1673) and first performed on December 4, 1665, lauded Alexander's human qualities more than his military victories and emphasized Alexander's noble treatment of the Indian king Porus, addressing, thereby, the social values of the courtly French audience.[14]

This focus and the fact that Racine's play predates the completion of Le Brun's last two canvases might have influenced the latter to include the *Defeat of Porus* and to end the four Persian episodes with an Indian one, a choice that otherwise seems strangely out of context.[15] Fittingly, the 1676 edition of the play was illustrated with an engraving by François Chauveau (1613–1676), that reproduced the central scene of Le Brun's *Defeat of Porus*, thus creating an explicit link between the subject of the play and the imagery of Le Brun's composition. The parallel presentation of this theme on stage testifies to the ambition of the Petite Académie to exploit different media in celebrating the monarch.

In adapting the Alexander theme on behalf of a young king whose military experience was limited to overcoming the comparatively peaceful Fronde (1648–53), this series announced the scale of Louis's ambitions for his own reign, reiterated by the motto woven in the borders of the tapestry "Not inferior to many," meaning "Superior to all." It is somewhat ironic that as the multiple sets of this design were being woven in the course of the next forty years, Louis's military campaigns—the War of Devolution (1667–68), the Dutch War (1672–78), the War of the Grand Alliance (1688–97), and the War of the Spanish

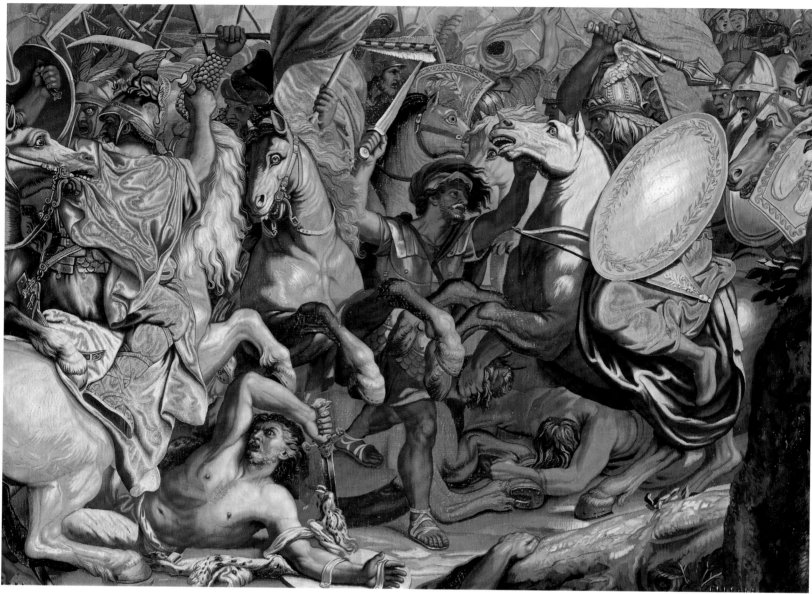

Detail of cat. no. 40

Succession (1701–14)—had considerably less success than those of his classical antecedent.

Publicizing and Disseminating Royal Imagery

All of Le Brun's large oil paintings of the story of Alexander, not just the early celebrated *Tent of Darius*, were well received as independent works of art. When Louis XIV visited the workshops of the Gobelins in the summer of 1665, the painted *Battle of the Granicus* (fig. 174) was exhibited outside Le Brun's studio in one of the manufactory's courtyards for the king to see in bright daylight.[16] This viewing, akin to that shown in the famous tapestry commemorating the king's

visit to the Gobelins on October 15, 1667 (cat. no. 47, fig. 218), took place shortly after the painting was completed and was mentioned by Paul Fréart de Chantelou (1609–1694), the chronicler of Gian Lorenzo Bernini's (1598–1680) trip to France in 1665.[17] According to Chantelou's diary, Bernini himself went to the Gobelins twice, on September 6 and October 10, and was shown the "two big pictures of *The Battle of Granicus* and *The Triumph of Alexander* [Triumphal Entry into Babylon]" on his second visit.[18] Again, as for the king, Le Brun took the *Granicus* painting into the courtyard, where the "Cavaliere looked at it again from every side and withdrew as far as possible so as to see it from a distance. Then

he repeated many times 'It is beautiful, beautiful.'"[19] Since, on other occasions, Bernini proved to be extremely critical of Le Brun's work and, indeed, of French art in general, his appreciation of these paintings and their consequent publicity is noteworthy.

Bernini also commented on the style of the tapestry borders woven at the royal manufactory and rejected the idea of weaving flowers, "children," and other attributes "in the same tint as they appear in the main subject," a design decision he considered to be a "bad mistake." In his opinion, "the border should be like a gold frame or simply a decoration of bronze-colored leaves" so that one would understand it was distinct from the central

image.[20] Bernini's refined taste anticipated subsequent developments in the style of border designs employed at the Gobelins.

Another important visit to the Gobelins, also involving the *Alexander* series, was documented some thirty years later. An etching by Sébastien Leclerc (fig. 175) commemorates the official visit of Édouard Colbert de Villacerf (1629–1699) to the manufactory, where as superintendent and director of buildings (1691–99) and therefore of the royal manufactories, he was guided through the workshops and into the Galerie des Gobelins and was shown a set of *Alexander* tapestries.[21] In retrospect, the display of these particular tapestries is noteworthy, as it both celebrates the *Story of Alexander* a generation after its conception and, if Leclerc's depiction is historically correct, draws attention both to the height of the Gobelins' production in the 1670s and 1680s and to the king's noble qualities at a time when the French army was devastated in the War of the Grand Alliance, and royal funding of the arts in general, and of the royal manufactories in particular, was severely decreased. This visit to the royal workshops took place while their activity was seriously reduced (1694–99).

Like the paintings, the first three sets of high-warp tapestries as well as the second set of low-warp weavings remained in the possession of the royal wardrobe until the Revolution. Recorded at different times in Paris, Versailles, and Fontainebleau, some hangings were permanently installed to decorate the royal interiors, whereas others were occasionally used for temporary decoration. Le Brun's painting of the *Tent of Darius* was exhibited within the state apartments at Versailles continuously until the Revolution and again from 1934. The other four paintings were kept at the Louvre beginning in 1686.[22]

Unlike the three sets listed above, the fourth weaving of high-warp tapestries from which this tapestry derives was presented as a diplomatic gift by Louis XIV to Duke Leopold Joseph of Lorraine on November 29, 1699. It was inherited by the duke's son Francis Stephen in 1729 and taken to Vienna on his marriage to Maria Theresa, archduchess of Austria, in 1736, and became part of the Habsburg collection upon his succession as Emperor Francis I of the Holy Roman Empire in 1745.[23] The first set of eleven low-warp tapestries was given to Philippe I, duc d'Orléans (1640–1701), brother of Louis XIV, in 1681.[24] The third low-warp suite was presented to the king of Denmark in 1682, and the last low-warp weaving was given by Louis XIV to his cousin Anne-Marie-Louise d'Orléans, duchesse de Montpensier (1627–1693).[25]

In addition to the *Alexander* tapestries woven at the Gobelins, numerous copies were produced by weavers in Aubusson, Felletin, Oudenaarde, and, most importantly, Brussels.[26] From 1676 until the early eighteenth century, Jan-François van den Hecke, Gerard Peemans, and Marcus de Vos, first, and Judocus de Vos, Jan Frans van der Borcht, and Pieter van den Hecke later, reproduced Le Brun's designs after engravings by Girard Audran and Gérard Edelinck (see Koenraad Brosens, "Flemish Production, 1660–1715").[27]

The *Alexander* designs were engraved more than any other Gobelins series. They were reproduced by, among others, Girard Audran and Gérard Edelinck in 1670–78, and Sébastien Leclerc in the early 1690s, engravers who worked at the Gobelins manufactory and who were celebrated for their skill and faithful interpretation of Le Brun's work.[28] Audran's large *Battle of the Granicus* covered four plates—the print measures 71 by 150 centimeters. A tour de force in contemporary printmaking, it has been recognized as one of his masterpieces for its fidelity to the original, variety of tones, and mixed techniques of etching and engraving.[29] It includes a second motto, VIRTUS OMNI OBICE MAIOR (Virtue surmounts all obstacles), in addition to the representation of the woven inscription of the lower border of

Seb. le Clerc fecit.

LA GALERIE DE L'HOSTEL ROYAL DES GOBLINS
ou l'on fait voir
A MONSEIG.R COLBERT

MARQUIS DE VILLACERF ET DE PAYENS, SEIGNEUR DE S.T MEMIN, COURLANGE, LA COUR, S.T PHAL, FONTAINE ET AUTRES LIEUX : CONSEILLER DU ROY EN SES CONSEILS,
PREMIER MAISTRE D'HOSTEL DE LA FEUE REINE, SURINTENDANT ET ORDONNATEUR GENERAL DES BASTIMENS, JARDINS, ARTS ET MANUFACTURES DE SA MAJESTÉ.
Quelques actions d'Alexandre representées en Tapisseries sur les Tableaux de Mons.r le Brun

Fig. 175. *The Visit of Colbert de Villacerf to the Gobelins*, by Sébastien Leclerc, 1696. Etching, 14.5 x 23.8 cm. The Metropolitan Museum of Art, New York, Harris Brisbane Dick Fund, 1953 (53.600.2612)

the tapestry, emphasizing once more the political message conveyed by this theme. The *Battle of the Granicus* as well as Audran's *Battle of Arbela*, *Triumphal Entry into Babylon*, and *Defeat of Porus*, and Edelinck's *Tent of Darius* were sold as a single set of prints, as well as individually, from Audran's shop in the rue Saint-Jacques in Paris from 1676.[30] Two decades later, on July 2, 1694, Leclerc received the royal commission to engrave the principal scenes of the *Story of Alexander en petit*.[31] Nicolas Langlois, a Parisian publisher and bookseller, also in the rue Saint-Jacques, sold Leclerc's prints of the *Battles of Alexander* from 1696.[32] Interestingly, his set contained six engravings, *La Galerie de l'Hostel Royal des Gobelins* (*The Visit of Colbert to the Gobelins*) followed by the five principal scenes after Le Brun, and included both the motto from each tapestry and Audran's mottoes as well as the coat of arms of Colbert de Villacerf. They were first announced in the *Mercure Galant* in August 1696, are of comparatively small size—the *Battle of the Granicus* measures 14.2 by 24.4 centimeters—and remained popular throughout the eighteenth century.[33] In December 1783 the *Mercure de France* referred to their quality and renown by stating that the "Battles by Le Brun represent his chef-d'oeuvre, too well known for the need of any recommendation" and that Leclerc, "one of the famous engravers of the previous century" had already proven himself "worthy to translate the production of [this] great painter."[34]

Further, according to the "Registre des Livres de figures et Estampes qui ont esté distribuées suivant les ordres de Monseig' le Marquis de Louvois, depuis l'Inventaire fait avec M' l'abbe Varés au mois d'aoust 1684," numerous copies of prints of the "cinq grandes pieces de l'Hist' d'alexandre" were

distributed as royal gifts.[35] These and other prints, including the *Elements* (designed by Le Brun beginning in 1664), were typically presented in sets comprising sheets of different subjects.

FLORIAN KNOTHE

1. Nivelon 1700/2004, p. 274.
2. Posner 1959, p. 238.
3. Fenaille 1903–23, vol. 2, p. 168.
4. Ibid., pp. 172–83.
5. The first three sets include twelve tapestries in high-warp technique with gilt-metal-wrapped thread woven in 1664–80, 1670?–82, and 1670?–85, respectively. They were registered in the royal inventory under numbers 74, 96, and 97 respectively. The fourth weaving (inv. 104) consists of eleven high-warp pieces with gilt-metal-wrapped thread (1680–88); the fifth (inv. 67 and 80) and sixth (inv. 70) sets each contain eleven tapestries in low-warp technique with gilt-metal-wrapped thread (1670?–80 and 1668–80, respectively); the seventh weaving (inv. 81) has a mere six low-warp pieces with gilt-metal-wrapped thread (completed in 1682); and the eighth set (unrecorded) contains eleven hangings in low-warp technique without gilt-metal-wrapped thread (completed in 1686). Ibid., pp. 184–85; and Guiffrey 1885–86, vol. 1, pp. 307–9, 311, 315–16, 318.
6. Halbturn 1976, p. 45.
7. An entry in the inventory of the Garde-Meuble clearly states that the borders of the fourth set (inv. 104) equal those of the first (inv. 74). See Guiffrey 1885–86, vol. 1, p. 318.
8. The surviving preliminary sketches and drawings for this series, produced while Le Brun was First Painter to the King, were among the bulk of Le Brun's artistic oeuvre confiscated by the crown after his death in 1690. The royal administration considered these drawings as its property and made several thousand of Le Brun's drawings part of the royal collection. They are today preserved in the Cabinet des Dessins at the Louvre. See specifically inv. 27952, 27954, 27955, 27957, 29249r–v, 29427r, 29430r–v, 29621r.
9. Junquera de Vega and Herrero Carretero 1986, p. 257; T. Campbell in New York 2002, pp. 401–2. I am indebted to Tom Campbell for bringing the Flemish set of tapestries to my attention.
10. Donald Posner was the first to comment on the stylistic relationship of Le Brun's paintings and the Roman frescoes; see Posner 1959, p. 245.
11. Franke 2000, p. 121; Rapp Buri and Stucky-Schürer 2001, pp. 158–70, 230–45.
12. In 1663 the Petite Académie was founded under Jean-Baptiste Colbert (1619–1683) in Paris to oversee the production of royal propaganda; see cat. no. 39.
13. At the Château de Fontainebleau the principal chamber in the apartment of Anne d'Heilly de Pisseleu, duchesse

d'Etampes (1508–1576), next to the so-called Galerie François Ier, is decorated with two fresco paintings (1541–44) by Francesco Primaticcio (1504/5–1570), *Alexander Subdues Bucephalos* and *Alexander's Marriage to Roxane*. See Aldovini 2004; and Catherine Jenkins in Paris 2004, pp. 232–33, no. 96.
14. Racine 1676, reprinted Paris 1829; the first edition of *Alexandre le Grand* was published by Pierre Trabovillet in Paris in 1666.
15. See Posner 1959, p. 244; see also Birkenholz 2002, pp. 64–65, 67–68, 236–37.
16. Only the oil painting was available for presentation to the king in 1665. The tapestry itself would still have been on the loom, from which it could not be removed. See Fenaille 1903–23, vol. 2, pp. 172–73.
17. Chantelou 1665/1985, p. 278.
18. Ibid.; see Birkenholz 2002, esp. p. 64.
19. Chantelou 1665/1985, p. 278.
20. Ibid., p. 283.
21. Brassat 1992, p. 149.
22. For the original installation of Le Brun's painting of the *Tent of Darius* in the Chambre de Mars in the state apartments at Versailles, see "Description de la Galerie, du Sallon, & du grand Apartement de Versailles, & tout ce qui s'y passe les jours de Jeu," *Mercure Galant*, December 1682, p. 28. For the tapestries, see Fenaille 1903–23, vol. 2, pp. 185–86.
23. Halbturn 1976, p. 43.
24. Ibid., p. 179.
25. In the "Recueil des présents faits par le Roy en pierreries, meubles, argenterie et autres," 1662–1752, Archive du Ministère des Affaires Etrangères, Paris, "Fonds France—Mémoires et Documents" (no. 2037), the set given to the king of Denmark is described as comprising seven pieces with a total value of 12,800 livres.
26. Havard and Vachon 1889, p. 115.
27. Vanhoren 1999, p. 62.
28. See Guiffrey 1881–1901, vol. 1, cols. 474, 543, 642, 709, 806, 927, 994, 1088, 1208, for a total of 10,795 livres paid to Audran; cols. 544, 709, 806, 874, 927, for 5,500 livres paid to Edelinck; entries for Leclerc do not list payments specifically for the prints of the *Story of Alexander*.
29. Saur 1992–, vol. 5, p. 602.
30. Duplessis 1892, p. 26.
31. Archives Nationales, Paris, O¹ 1082.
32. Préaud 1980, vol. 8, pp. 128–30, nos. 458–63.
33. *Mercure Galant*, August 1696, pp. 167–71.
34. "Les Batailles de Lebrun sont des chef-d'oeuvres trop connus pour avoir besoin d'aucune recommandation. Quant au Graveur (Leclerc) il s'étoit déjà montré digne de traduire les productions d'un grand Peintre. C'étoit un des fameux Graveur du siècle dernier, & qui est mort en 1714"; *Mercure de France*, December 1783, p. 91.
35. See "Registre des Livres de figures et Estampes qui ont esté distribuées suivant les ordres de Monseig' le Marquis de Louvois, depuis l'Inventaire fait avec M' l'abbe Varés au mois d'aoust 1684," Bibliothèque Nationale de France, Paris, Est. Res. Ye 144.

Detail of cat. no. 40

41.
The King's Entry into Dunkirk

From a fourteen-piece set of the *History of the King*
Design by Charles Le Brun; cartoon by Antoine
Mathieu the Elder, completed by Pierre de Sève, 1667
Cartoon for the border attributed to Jean Lemoyne
le Lorrain, 1665
Woven in the workshop of Jean Lefebvre at the
Manufacture Royale des Gobelins, Paris, 1668–71
Wool, silk, and silver and gilt-metal wrapped thread
518 x 688 cm (17 ft. x 23 ft. 6⅞ in.)
9 warps per cm
Musée National du Château de Fontainebleau
(F 2175 C), deposited at the Mobilier National, Paris

PROVENANCE: June 20, 1677, delivered to the Garde-
Meuble de la Couronne; listed in the Inventaire général
du mobilier de la Couronne (General Inventory of
Crown Property), among tapestries woven with gold,
under no. 68, then under no. 86; 1789, in the Garde-
Meuble on the Place Louis XV, Paris; 19th century, in
the collections of the Garde-Meuble; 1866, sent to the
Château de Fontainebleau; 1985, delivered to the
Mobilier National.

REFERENCES: Guiffrey 1885–86, vol. 1, p. 308; Jouin
1889, p. 537; Fenaille 1903–23, vol. 2, pp. 107, 114–15,
126; Guiffrey 1913, p. 67; Göbel 1928, p. 128; Meyer
1980, p. 138; Florence 1982, p. 62; Meyer 1982, p. 21;
Stein 1985, no.V/1; Starcky 1988, p. 46.

CONDITION: Moderate; the tapestry was conserved
for this exhibition at the Mobilier National in
2006–7.

42.
The King's Entry into Dunkirk

Preliminary drawing for the tapestry in the *History of
the King*
Charles Le Brun, ca. 1667
Black chalk, red chalk, and gray wash on paper,
squared in black chalk
29 x 19.5 cm (11⅜ x 7⅝ in.)
The State Hermitage Museum, Saint Petersburg
(15820)

PROVENANCE: Collection of the Academy of Fine
Arts, Saint Petersburg; 1924, entered the Hermitage.

REFERENCES: Moscow 1955, p. 78; Novosselskaya
1970, pp. 125–26, illus.; Prague 1972, no. 63;
Manchester 1974, no. 43, illus.; Aarhus 1975, no. 42;

Copenhagen 1975, no. 42; Melbourne–Sydney–
Adelaide 1978, no. 26, illus.; Stein 1985, no.V/9,
fig. 25; Bogota 1986, illus.; Buenos Aires 1986, no. 48,
illus.; Montevideo 1986, no. 49, illus.; Belgrade–
Ljubljana–Zagreb 1987, no. 19, illus.; Bonn 1997, no.
104, illus.; Novosselskaya in Saint Petersburg 1999, no.
64, illus.; Novosselskaya in London 2001, no. 28, illus.
(with bibliography).

43.
View of the City of Dunkirk

Adam Frans van der Meulen, 1665
Watercolor over graphite on three joined sheets of
paper, squared in graphite
28.3 x 185.7 cm (11⅛ x 72⅞ in.)
Annotated at upper left in pen and brown ink,
Dunkerke
Mobilier National, Paris (93)

PROVENANCE: Workshop of Van der Meulen; 1690,
collections of the Gobelins manufactory; 1937, collec-
tions of the Mobilier National.

REFERENCES: Darcel 1902, p. 118; Paris 1931, no. 21;
C.-Starcky 1988b, no. 1, illus.; Beauvais 1991, no. 31;
Richefort 2004, p. 19, illus.

44.
The Audience with Cardinal Chigi

From a fourteen-piece set of the *History of the King*
Design by Charles Le Brun, cartoon by Antoine
Mathieu the Elder, 1664
Cartoon for the border attributed to Jean Lemoyne
le Lorrain, 1665
Woven in the workshop of Jean Lefebvre at the
Manufacture Royale des Gobelins, Paris, 1665–72
Wool, silk, and silver and gilt-metal wrapped thread
510 x 715 cm (16 ft. 9 in. x 23 ft. 5½ in.)
9 warps per cm
Mobilier National, Paris (GMTT 95/1), deposited at
the Musée du Louvre, Paris

PROVENANCE: June 20, 1677, delivered to the Garde-
Meuble de la Couronne; listed in the Inventaire
général du mobilier de la Couronne, among tapestries
woven with gold, under no. 68, then under no. 86;
1789, in the Garde-Meuble on the Place Louis XV,
Paris; thereafter, in the collections of the Garde-
Meuble; 1946, delivered to the Musée du Louvre.

REFERENCES: Guiffrey 1885–86, vol. 1, p. 308;
Guiffrey 1886, pp. 356, 359; Fenaille 1903–23, vol. 2,

pp. 107–8, 114–15, 126; Guiffrey 1913, p. 67; Göbel
1928, p. 128; Meyer 1980, p. 138; Florence 1982, p. 69;
Meyer 1982, p. 21; Stein 1985, no.VIII/1; Brassat 1992,
p. 182.

CONDITION: The light brown silks and wools are
damaged in places; the tapestry was conserved in
1988–94.

45.
The Audience with Cardinal Chigi

Preliminary drawing for the tapestry in the *History of
the King*
Charles Le Brun, 1664 or 1665
Black chalk and gray wash on beige paper
49.1 x 75 cm (19⅜ x 29½ in.)
Département des Arts Graphiques, Musée du Louvre,
Paris (27669)

PROVENANCE: Workshop of Le Brun; 1690, became
part of the royal collections.

REFERENCES: Paris, year X (1802), no. 407; Paris
1820, no. 535; Paris 1841, no. 1096; Jouin 1889, p. 538;
Fenaille 1903–23, vol. 2, p. 103, illus.; Jean Guiffrey
and Marcel 1913, no. 5936; Maumené and d'Harcourt
1931, no. 205; Meyer 1980, p. 129, illus.; Florence 1982,
no. 17, illus.; Stein 1985, pp. 72, 224, no.VIII/11;
Prosperi Valenti Rodinò 1990, p. 208, fig. 14; Meyer
1994, p. 101, illus.; Lefébure 1995, p. 189; L. Beauvais
2000, vol. 2, no. 2515 (with bibliography), illus.

46.
The Siege of Douai

Preliminary drawing for the tapestry in the *History of
the King*
Charles Le Brun, with his workshop, and Adam Frans
van der Meulen, 1667–68
Black chalk and gray wash on beige paper
48.9 x 78.3 cm (19¼ x 30⅞ in.)
Département des Arts Graphiques, Musée du Louvre,
Paris (27635)

PROVENANCE: Workshop of Le Brun; 1690, became
part of the royal collections.

REFERENCES: Paris 1820, no. 473; Paris 1841, no. 822;
Reiset 1869, no. 861; Jouin 1889, p. 539; Jean Guiffrey
and Marcel 1913, no. 5937, illus.; Maumené and
d'Harcourt 1931, no. 211; Versailles 1937, no. 133; Lugt
1949, p. 87; Meyer 1980, pp. 128–29, illus.; Florence
1982, no. 19, illus.; Paris 1985a, no. 117, illus.; Stein

1985, no. x/11, fig. 30; C.-Starcky 1988b, p. 57;
Lefébure 1995, p. 189; Dijon–Luxembourg 1998,
p. 131; L. Beauvais 2000, vol. 2, no. 2517 (with bibliog-
raphy), illus.; Richefort 2004, p. 78, illus.

47.
The King Visits the Gobelins

Preliminary drawing for the tapestry in the *History of
the King*
Charles Le Brun, ca. 1672
Black chalk on paper
58.1 x 92.7 cm (22⅞ x 36½ in.)
Département des Arts Graphiques, Musée du Louvre,
Paris (27655)

PROVENANCE: Workshop of Le Brun; 1690, became
part of the royal collections.

REFERENCES: Jouin 1889, p. 541; Fenaille 1903–23,
vol. 2, p. 111, illus.; Jean Guiffrey and Marcel 1913, no.
5946, illus.; Göbel 1928, p. 128 and fig. 85; Maumené
and d'Harcourt 1931, no. 218; Versailles 1937, no. 136;
Bern 1948, no. 32; Brussels–Rotterdam–Paris 1949,
no. 46; Paris 1960, no. 604, illus.; Paris 1962, no. 78;
Montagu in Versailles 1963, no. 145, illus.; Meyer 1980,
p. 129, illus.; Florence 1982, no. 23, illus.; Buckland
1983, p. 272, fig. 18; Gastinel-Coural in Paris 1983a,
p. 159; Stein 1985, no. XIII/7; Lefébure 1995, p. 189;
L. Beauvais 2000, vol. 2, no. 2523 (with bibliography),
illus.

While Charles Le Brun's initial designs for the Gobelins manufactory celebrated Louis XIV by allegorical means (the *Elements* and *Seasons*) and classical comparisons (the *Story of Alexander*), the propagandistic intent of the production became explicit in the most ambitious of these early series, the *History of the King*. Depicting elaborate scenes celebrating Louis's military prowess and bravery, his diplomatic skills, and his vision as a patron of the arts, the series was also the most ambitious of those undertaken at the Gobelins during its peak years of production. Although there was a long-standing tradition for illustrating historic events in tapestry designs, the series departed from its antecedents in the range of subject matter it embraced and the detailed observation of the events depicted. In order to achieve this ambitious series, Le Brun worked with a team of artists, chief of whom was Adam Frans van der Meulen, who undertook detailed studies of the topography of many of the battlefields and settings that were incorporated into the final designs. With their vivid portrayals of Louis XIV and members of his court, and the detailed rendering of settings, costumes, and interiors, these tapestries provide an extraordinary glimpse of the court of the Sun King.

The origin of the series is undocumented. Maurice Fenaille, author of the definitive study of the Gobelins manufactory, proposed that the series was initiated in 1662, perhaps because the creation of the Gobelins manufactory dates to the autumn of that year.[1] But the first documents mentioning the series date only to 1664. On March 12 of that year, the abbé Jacques de Cassagnes (1636–1679), one of the founding members of the Petite Académie, informed Jean-Baptiste Colbert that "a while ago [he had] sent M. Le Brun the large and small inscriptions with the accounts of the peace treaty and of the marriage."[2] This must mean that Cassagnes had sent the artist some narratives on which he could base his designs for the tapestries that would make up the *History of the King*, specifically the *Meeting between Louis XIV and Philip IV* and the *King's Marriage*. Thus the creation of these two models, which can be counted among the first subjects of the series, date to early 1664, with the warping of the loom dating to 1665. Further, in the *Audience of the Conde de Fuentès* (which took place in March 1662; fig. 176), Le Brun depicted Annibale Carracci's *Hunting* and *Fishing*, which were given to Louis XIV in 1665, from which we can conclude that the cartoon was done after 1665.

The creation of this series aroused substantive discussion regarding the mode of representation to be adopted. History painting was then enjoying preeminence, but there was much debate regarding the degree to which it should be embroidered with allegorical components. André Félibien in 1668 recommended that for an artist to reach the "high[est] perfection of Art ... [he] must know how, by means of allegorical compositions, to conceal the virtues of great men and the loftiest mysteries under the veil of fable. It is he who acquits himself well in such undertakings who is called a great painter."[3] But some years before, Jean Chapelain (1595–1674), a member of the Petite Académie, had already adopted the opposite principle, and his opinion was soon followed by the king and Colbert. On July 10, 1664, Chapelain wrote to the minister: "Sir, I have respectfully received the response you were kind enough to make to my letter regarding the use of allegory in the paintings and tapestries you have ordered for the story of the king, and I considered it a very great honor that neither he nor you disapproved of it. Those gentlemen who gather at your place [the Petite Académie] have been informed of my feelings on the subject and of the command His Majesty and you have given us to work tactfully to bring M. Le Brun around to our view, and to see that he is no less receptive of our arguments than you and Your Majesty have been. Regarding which, we will not waste a moment, Sir, and we may hope that that uncommon painter, being as judicious as he is, will not stray from them, especially if we are permitted to hint that, in accommodating himself to them, he would not be doing anything disagreeable to His Majesty, nor anything that you would find objectionable."[4] This letter appears to condemn the use of allegorical or mythological figures in the tapestries for the *History of the King*, but it also shows that there was still a great deal of hesitation about the project. Let us note especially Le Brun's reluctance to adopt the idea of a tapestry series whose noble figures would stoop to the level of present reality. A number of finished drawings by Le Brun (Musée du Louvre) attest to that discussion, and the artist's first studies for the *History of the King* include Olympian gods in which Louis XIV appears guided by Mars, Minerva, or Hercules. They suggest that the First Painter to the King made a strong argument for a mythological-style tapestry series.[5] We find further confirmation of this in two paintings in Budapest, the *Purchase of Dunkirk* and *Louis XIV Receiving the Ambassadors*,[6] in which the king seems to be taking inspiration from hovering gods. These paintings might well have been designs that were not selected for the *History of the King*.[7] Charles Perrault, another member of the Petite Académie, reported in his memoirs that "M. Colbert's intention was that we work on the story of the king, and to accomplish this he had me write, in the registry I have just mentioned, several things the king

had told me, in order to include them in his story."[8] In 1668 Perrault also published a poem titled "Painting," completed in the autumn of 1667, in which he mentioned the production of Le Brun's *History of the King* tapestry series then under way.[9] He particularly noted the eight subjects for the beginning of the series (see below), from the *Anointing of the King* through the *Audience of Cardinal Chigi*, as well as two others, the *Birth of the Dauphin* and the *Battle of Rab*. There are no known drawings for these last two and they were not woven, but they were apparently intended to be included in the cycle. Perrault also set out the program for future tapestries that would relate episodes in the War of Devolution, which had just begun. Through that war, Louis XIV wished to assert the rights over Flanders of Queen Marie-Thérèse, whose dowry had not been paid. In particular, Perrault invited Le Brun to render the siege of Douai, during which the king had shown his bravery ("But mind you not forget, when with intrepid step, / he [the king] stood before the homicidal trench / Which, astonished, trembled with so brazen an intent, / At the perilous moment he entered it") as well as the queen's entry into Douai and the taking of Lille.

Ultimately, the completed series would comprise fourteen subjects devoted to the major civil, political, and military events from the early years of Louis XIV's reign, from his anointing on June 7, 1654, to the capture of Dole on February 14, 1668. The first of these following the *Anointing* focused on the young ruler's diplomatic or political successes: the *Meeting between Louis XIV and Philip IV on Pheasant Island*, the *King's Marriage*, the *Audience of the Conde de Fuentès*, the *King's Entry into Dunkirk*, the *Capture of Marsal*, the *Renewal of the Alliance with the Swiss*, and the *Audience with Cardinal Chigi*. Subsequent tapestries relate the episodes in the War of Devolution (1667–68), in which the monarch personally took part: the *Siege of Tournai*, the *Siege of Douai*, the *Taking of Lille*, and the *Defeat of the Comte de Marsin*. Finally, the *King Visits the Gobelins* constitutes a sort of crowning achievement for Le Brun, while the *Taking of Dole* is the only scene to illustrate the conquest of Franche-Comté.

42

Iconography of the King's Entry into Dunkirk

Among Louis XIV's first territorial conquests was his acquisition of Dunkirk in 1662, accomplished through wholly peaceful means. King Charles II of England was short of money and agreed to sell to France both Dunkirk and Mardyck, which the English had occupied since 1658. The French ambassador, Godefroy Louis, comte d'Estrades, negotiated that agreement, which was signed on October 27, 1662, at a cost of 3½ million livres, paid in cash toward the 4 million stipulated in the treaty. This led Louis XIV to write in his memoirs: "I even made five hundred thousand livres on that deal, without the English noticing."[10] The tapestry shows Louis XIV entering Dunkirk on December 2, 1662 (cat. no. 41).[11]

On the left side of the tapestry, the king points to the city with his royal staff. He is followed, in all likelihood, by Henri Jules de Bourbon, duc d'Enghien (1643–1709), whose participation in the entry into Dunkirk is attested, and by Henri de La Tour d'Auvergne, vicomte de Turenne, marshal of France (1611–1675), who had already taken Dunkirk from the Spanish in 1658. The duc de Saint-Aignan (1610–1687) is recognizable beside Turenne. Behind them, finally, is Philippe, duc d'Orléans, brother of Louis XIV, known as Monsieur.

This episode was considered a victory of Catholicism over Protestantism as much as a territorial conquest. The design of the tapestry was the result of a collaboration between Le Brun (1619–1690) and Adam Frans van der Meulen (1632–1690). A portion of Le Brun's

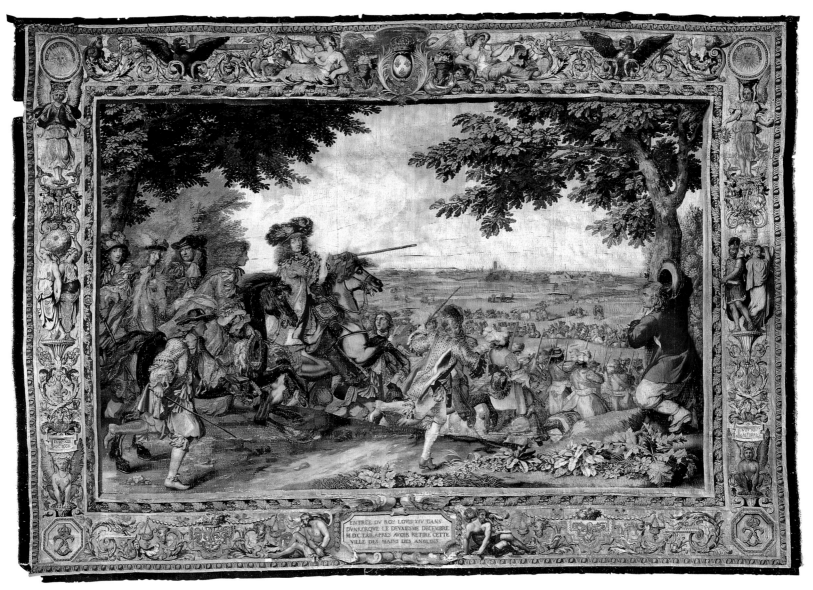

41

drawing in which the king and his entourage are precisely positioned survives at the Hermitage Museum in Saint Petersburg (cat. no. 42). Meanwhile, Van der Meulen, according to his record of his work for the king, "painted, behind the king on horseback [done] by M. Le Brun, the king's progress making his entrance into the city of Dunkirk."[12] Although the artist did not say so specifically, this undoubtedly corresponds to work for the tapestry in the *History of the King*. We know that Van der Meulen went to Dunkirk at the end of September 1665 to draw the city, as attested in a letter he wrote to Colbert on October 1.[13] He brought back several surveys that made it possible for him to produce the view of the city (cat. no. 43) that was used for the background of the tapestry. The

subject of the tapestry, composed by the Petite Académie, is set out in the inscription in the lower border: ENTREE DV ROY LOVIS XIV. DANS / DVNKERQVE LE DEVXIESME DECEMBRE / M.D.C.LXII. APRES AVOIR RETIRE CETTE / VILLE DES MAINS DES ANGLOIS (Entry of King Louis XIV into Dunkirk on December 2, 1662, after taking this city from the hands of the English). Part of the original lining with the Garde-Meuble annotations is preserved on the back of the piece.

The borders of the *King's Entry into Dunkirk*, like those of all the tapestries in the first two sets woven on high-warp looms, albeit with variations,[14] are filled with allegorical figures and inscriptions combined with foliate scrolls on a background woven in gilt-metal-wrapped thread. In the lower part, a

prisoner wearing a mask on the back of his neck leans against the left side of the cartouche inscribed with the subject of the tapestry, while a man with donkey ears is seated on the right. These are symbols of Fraud and Ignorance. In the lower corners is the crowned monogram of the king (LL). In each side border, above the medallion with the monogram, a sphinx holds a cartouche containing the beginning and ending dates of the weaving of that tapestry, in this case, LVD.VS XIIII / AN.O 1668. on the left and on the right LVD.VS XIIII / AN.O 1671. In the middle of the left lateral border, two standing women symbolize unidentified virtues; in the right, Mars stands next to a woman bearing a pillar, who incarnates Constancy. In the upper left lateral border is an allegorical figure of Renown; in

43

the right, a figure of Victory. In the upper corners, a medallion encloses a sun, emblem of the king, and his motto, NEC PLVRIBVS IMPAR (Not inferior to many). In the upper border is a cartouche with the coat of arms of France, with a figure of Renown resting an elbow on either side of it and, beside each of them, an eagle with wings outspread.

Iconography of the Audience of Cardinal Chigi

Along with the *King Visits the Gobelins*, the *Audience with Cardinal Chigi* is certainly one of the most successful civil scenes in the *History of the King* (cat. no. 44).[15] Its subject derives from a quarrel between Louis XIV and the Holy See, which flared with an incident in Rome on August 20, 1662. During the night, following a dispute he had had with one of the pope's Corsican guards, a servant of the French ambassador, the duc de Créqui, was chased to the Palazzo Farnese by other Corsican guards, who had come to help their fellow. They filled the streets leading to the Palazzo Farnese, holding the building under siege for three hours, firing their muskets, and joined by the unruly papal police. Meanwhile, the duchesse de Créqui, returning from church, witnessed one of her pages killed by soldiers. When the pope refused to make amends, the ambassador left Rome in early December, and Louis XIV sent troops to occupy Avignon. A peace treaty, signed in Pisa on February 12, 1664, stipulated that Avignon

be returned to the pope and that an obelisk marking papal apologies to the king of France be erected in the Corsican district of Rome. Pope Alexander VII's apologies were carried to Louis XIV by his nephew Cardinal Chigi, who was named a *legato a latere*. The reparation ceremony was held on July 29, 1664,[16] in the king's chamber at the Château de Fontainebleau, the event depicted in the tapestry. Several accounts of it have come down to us, one of the most valuable from Paul Fréart de Chantelou (1609–1694): "At three o'clock H.E. [His Eminence] was at the audience with the king . . . who came halfway across his chamber to receive H.E. The legate greeted the king with a very deep bow, and His Majesty gave him a very hearty welcome and led him to the space between his bed and the wall, where the first gentlemen of the privy chamber and the master of the wardrobe were standing. They each sat in an armchair, His Majesty's facing the gate to the balustrade and the legate's against that same gate. H.E. read the text that had been agreed upon, after which the king spoke to him with the greatest affability imaginable and listened to him in the same way, to judge by His Majesty's face. When the legate arrived, M. de Saint-Aignan[17] came forward to follow the king, who was going to meet H.E. Having seen this, M. de Noailles,[18] who was against the fireplace with M. de Lionne, came forward as well, believing it was his duty to be near His Majesty. M. de Saint-Aignan,

on the contrary, claimed that the captain of the guard has no responsibilities in the chamber, and a little dispute occurred of which notice was taken. When the dispute later reached the king's ears, he ordered M. de Mortemart[19] and M. de Charost[20] to see that he heard no more about it. The audience with the legate lasted about half an hour. Afterward, the king rose and, taking the legate on his left side, escorted him the entire length of the chamber and two or three steps beyond."[21]

Another interesting account comes from Hugues de Lionne (1611–1671), minister of foreign affairs, who witnessed the event: "The next day, the twenty-ninth, was reserved for the public audience, and the comte d'Harcourt[22] went to get the legate at his apartment and led him into His Majesty's chamber. . . . The king received him near the door of his chamber and, taking his right hand without compliments, led him to the space between his bed and the wall, commanding M. Bloin,[23] when he came inside the balustrade, to bring a chair for the legate exactly like his own, which was velvet with gold embroidery. The gentlemen of the privy chamber and the master of the wardrobe were, as usual, behind His Majesty's chair. The legate said something to His Majesty that no one heard . . . after which, donning his cap, which His Majesty had just asked him to put back on, he began to recite the terms of the treaty in a voice so loud that all in atten-

dance heard them."[24] And the account in *La Gazette*, particularly emphasized the beauty of the garments.[25]

According to these accounts, Cardinal Chigi was seated in a chair identical to that of Louis XIV. In the tapestry, however, he has only an ordinary chair, whereas the king has an armchair, emphasizing the humiliation endured by the legate.[26] Contrary to historical truth, the comte d'Harcourt, standing behind the legate, has his hat on his head in the presence of the king.[27] Louis de Rouvroy, duc de Saint-Simon, railed in his memoirs against that depiction, which he saw on a weaving of this tapestry at the Château de Meudon in 1698, since only the legate was allowed to keep his head covered during the audience.[28] In addition, Le Brun was not faithful to the decor of the room as it existed at the time of the event: contrary to Yves Bottineau, followed by Daniel Meyer, the furnishings depicted in the tapestry do not correspond to objects known to have been at Fontainebleau or in the Garde-Meuble at the time.[29] For example, there was a portrait of Louis XIII by Philippe de Champaigne, not a landscape, over the fireplace. The only object that comes close to historical accuracy is a piece of metalwork visible on the left, one of the four silver pedestals of which there is a preliminary drawing from the workshop of Le Brun in the Nationalmuseum, Stockholm.[30] But since the pedestals were not delivered to the Garde-Meuble until January 1668, we

believe that the preliminary drawings of the pedestals were used for the tapestry cartoon.[31] In the account that he kept of the work he did for the king, Van der Meulen recorded, "In addition, at the time of the cardinal legate, I did several drawings at Fontainebleau of what had happened at that time,"[32] but he does not seem to have participated in the execution of the tapestry cartoon. The drawing by Le Brun in the Louvre (cat. no. 45) shows that the scene as a whole was invented by the First Painter himself. There is also a portrait study for the depiction of Louis XIV in the tapestry, again in Le Brun's hand, at the Barber Institute of Fine Arts, Birmingham, and the model for the portrait of the duc de Saint-Aignan is at Versailles.[33] The inscription in the lower border identifying the event reads, AVDIENCE DONNEE PAR LE ROY / LOVIS XIV. A FONTAINEBLEAV AV CARDINAL / CHIGI NEVEV ET LEGAT A LATERE DV PAPE / ALEXANDRE VII. LE XXIX IVILLET MDCLXIV. / POVR LA SATISFACTION DE L'INIVRE FAITE / DANS ROME A SON AMBASSADEVR (Audience given by King Louis XIV in Fontainebleau to Cardinal Chigi nephew and *legato a latere* of Pope Alexander VII on July 29, 1664, for righting the wrong done in Rome to his ambassador).

The borders on this tapestry are like those on the *King's Entry into Dunkirk*. The dates in the side borders of the *Audience with Cardinal Chigi* are, on the left, LVD.VS XIIII. / AN.º 1665., and on the right LVDVS XIIII / AN.º 1672.

The Siege of Douai and the King Visits the Gobelins

During the War of Devolution, Louis XIV arrived outside the city of Douai on July 2, 1667. A trench was dug on July 3, and the city was captured three days later. To show the king's bravery, he is depicted on July 4, just after he had descended into the trench accompanied by the comte de Duras and the vicomte de Turenne, when a bodyguard's horse beside him was hit by a bullet (cat. no. 46). Later that year, on October 15, 1667, the king visited the Gobelins Manufactory with Colbert and Monsieur. That scene was intended to vaunt the dazzling artistic success of the manufactory, under Le Brun's direction, in the areas of metalwork, furniture, and tapestry. In the preparatory drawing for the tapestry in catalogue number 47, only the figures have been placed by Le Brun.

The Drawings, Modelli, and Cartoons

As with the creation of any tapestry, before the *History of the King* was put on the loom, the designs were elaborated through a process of several stages: preliminary drawings and sketches of details, modelli, and finally, full-size cartoons.

To execute the drawings, Le Brun hired Van der Meulen, who had arrived in France in the spring of 1664 and whose talents as a landscape painter were to prove useful to Le Brun.[34] The surviving drawings reveal what Le Brun and Van der Meulen each contributed toward

the creation of the *History of the King.* Some ten preliminary drawings survive; eight of them are in the Musée du Louvre and pertain to the following tapestries: the *Anointing,* the *Audience with Cardinal Chigi* (cat. no. 45), two drawings for the *Siege of Tournai,* the *Siege of Douai,* the *Taking of Lille,* the *Defeat of the Comte de Marsin,* and the *King Visits the Gobelins* (cat. no. 47).[35] There are also fragments—of the *Audience of the Conde de Fuentès* at the Fogg Art Museum, Cambridge, Massachusetts, and of the *King's Entry into Dunkirk* in Saint Petersburg (cat. no. 42). Of these ten drawings, only the *Audience with Cardinal Chigi,* the *King Visits the Gobelins,* and the drawings at the Fogg and the Hermitage can be regarded as entirely in Le Brun's hand. The others were the result of Le Brun's collaboration with his workshop, especially with Van der Meulen, who drew the backgrounds, with troops, panoramas of cities, and sometimes the figures themselves (one of the

Tournai drawings and those for *Douai* and *Lille*). Sometimes he even executed the works in their entirety (the other drawing for *Tournai* and the one for the *Defeat of Marsin*). The drawing for the *Queen's Entry into Douai,* also by Le Brun and Van der Meulen,[36] can be linked to the group of drawings relating to the War of Devolution,[37] but it was never woven. To give the compositions the greatest veracity, Van der Meulen was assigned to accompany the king during the Flanders campaign, from which the artist brought back many sketches and views of cities, that were used for the tapestries.[38] It is to be noted that there are sometimes major differences between the drawing and the tapestry, as is the case with the *Audience with Cardinal Chigi,* in which the fireplace and the position of several figures were modified (cat. nos. 44, 45).

On the basis of the drawings executed by both Le Brun and Van der Meulen, two series of works were undertaken jointly: on the one

hand, small painted sketches (modelli), which were used as models for the cartoon painters; on the other, portraits of the most important personages or of certain details that needed to be carefully studied.

All the modelli known are in Van der Meulen's hand. The artist, in his record of work he did for the king, listed the sketches he created for tapestries in the *History of the King;* they were for the *Meeting between Louis XIV and Philip IV,* the *Audience of the Swiss at the Louvre,* the *Taking of Lille,* the *Capture of Marsal,* the *Siege of Tournai,* the *Siege of Douai,* the *Queen's Entry into Douai,* and the *Defeat of the Comte de Marsin.*[39] The principal sketches painted by Van der Meulen that survive are for the *Audience of the Swiss at the Louvre,* the *Siege of Tournai,* the *Taking of Lille,* and the *Defeat of the Comte de Marsin.*[40]

Regarding studies for details in the tapestries, Le Brun's beautiful portrait of the vicomte de Turenne was used for the *Meeting*

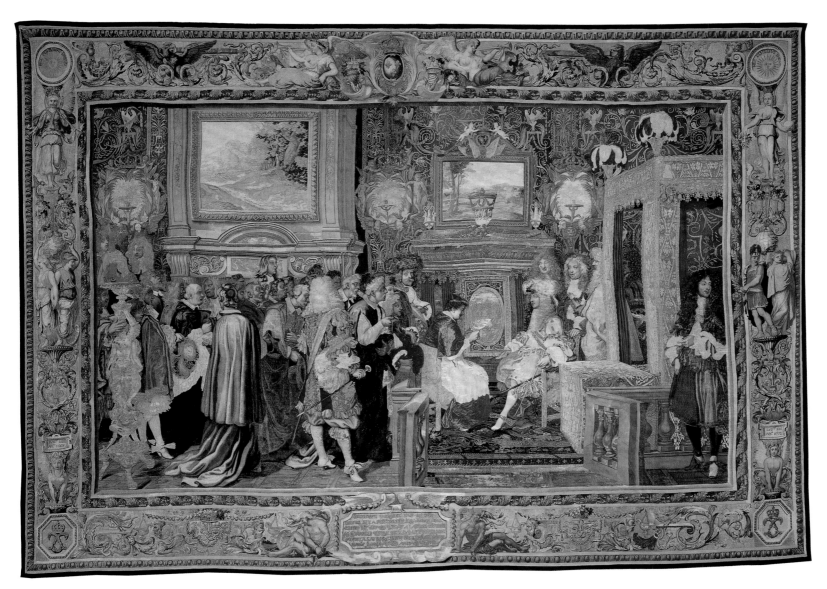

44

between *Louis XIV and Philip IV* and the *King's Entry into Dunkirk*, and a pastel portrait he made of Louis XIV was used for the the the *Marriage* and the *Alliance with the Swiss*.[41] There is also a study of a saddle for the *Siege of Tournai* that is attributed to Van der Meulen.[42] A hint of the painstaking detail of Van der Meulen's work is provided by the inventory taken shortly after his death which lists one of the costume props that he was copying, "a jerkin of blue moiré embroidered gold and silver, being used to paint from life the pictures from the Story of the King."[43]

Two sets of cartoons were made for weaving the *History of the King*, one for the high-warp looms, the other for the low-warp looms. The cartoon painters are known, thanks to the "General Inventory of the Painted Works Done at the Manufacture Royale at the

Gobelins, for the Tapestry Designs," compiled by Joseph Yvart in 1690—some length of time after they were executed.[44] According to that inventory, the cartoons intended for the high-warp tapestries were the originals, and those for the low-warp, copies of them. The painters of cartoons for the high-warp tapestries, which face in the same direction as the tapestries, were Baudrin Yvart (1611–1680), the *Anointing* and the *Siege of Douai*; Henri Testelin (1616–1695), the *Marriage*, the *Siege of Dole*, the *Capture of Marsal*, and the *Taking of Lille*; Antoine Mathieu the Elder (1631–1673), the *Meeting between Louis XIV and Philip IV*, the *Audience with Cardinal Chigi*, and *Dunkirk*; and Pierre de Sève (1623–1695), the *Audience of Fuentès*, the *Alliance with the Swiss*, the *Siege of Tournai*, the *Defeat of Marsin*, and the *King Visits the Gobelins*.[45] As for the cartoons for

the low-warp tapestries, François Bonnemer (1638–1689) painted the *Anointing*;[46] Simon Renard de Saint-André (1613–1677), the *Marriage*, the *Meeting between Louis XIV and Philip IV*, the *Audience with Cardinal Chigi*, the *Alliance with the Swiss*, the *Taking of Lille*, and the *King Visits the Gobelins*; Michel Ballin (1619–1706), the *Audience of Fuentès*, *Dunkirk*, *Marsal*, and *Defeat of Marsin*; Louis de Melun, *Dole*, *Douai*, and *Tournai*.[47] All the cartoons from which tapestries were woven, whether on high- or low-warp looms, were cut into strips to facilitate the weavers' work, which explains their poor condition today.

Maurice Fenaille, in his attribution of designs for the sumptuous borders used on the first two sets of the *History of the King* woven on high-warp looms, gave the figures to Le Brun and the ornamental portions to

46

Guillaume Anguier, attributions that were repeated by all subsequent authors. It is true that two drawings by Le Brun were reused in the borders for the figure of Constancy and a figure of Domination.[48] The cartoon for the left lateral border, dated 1665, also survives, as does another cartoon for the border of other pieces.[49] The 1690 inventory of Gobelins manufactory models does not name the designer of the borders.[50] Anguier can no longer be accepted as their creator, and stylistic considerations lead us to attribute them to the ornament painter Jean Lemoyne le Lorrain (ca. 1638–1709), who later did the borders for weavings of *Sujets de la fable*, after Raphael, and the *Story of Psyche*, after Giulio Romano. There is insufficient space here to argue in detail for this new attribution, but all the ornaments (incense burners, lambrequins, foliate scrolls, cornucopias) and all the figural poses of both people and animals (raised arms, grotesque masks, eagles) visible in the borders of the *History of the King* are found in nearly

identical form on works known to be by Lemoyne le Lorrain, such as the silk portiere from the Manufacture de la Savonnerie (Musée du Louvre) or his ornamental engravings.[51]

The Weaving

The first weaving of the *History of the King*, to which the *King's Entry into Dunkirk* (cat. no. 41) and the *Audience with Cardinal Chigi* (cat. no. 44) pertain, was done beginning in 1665 in the three high-warp tapestry workshops of the Gobelins manufactory, overseen, respectively, by Jean Jans the Elder (succeeded by his son in 1668), by Jean Lefebvre, and by Henri Laurent (d. 1669). According to the documents, the Janses executed ten pieces, Lefebvre three, and Laurent only one (the *Alliance with the Swiss*), which was completed by Jans the Younger.[52] The weavers' signatures or marks do not appear on any of the pieces, except on the *Marriage*, which has Jans the Elder's mark (I.I.ˢ).

The order in which the first set was woven was as follows: the *Anointing*, the *Meeting*

between *Louis XIV and Philip IV*, the *Marriage*, and the *Audience with Cardinal Chigi*,[53] beginning in 1665; the *Alliance of the Swiss* in 1667; the *Entry into Dunkirk* and the *Siege of Douai* in 1668; *Marsal* in 1669; the *Defeat of the Comte de Marsin* and *Tournai* in 1670; *Lille* in 1671; *Dole* in 1672; *Gobelins* in 1673; and the *Audience of Fuentès* in 1674. Based on the earliest beginning date woven into the borders, 1665, and the latest ending date, 1679, it took some fifteen years to finish weaving this initial fourteen-piece set, all of which is in the Mobilier National, Paris. The men who undertook the work were paid between 400 (Laurent, Lefebvre) and 450 (Jans) livres per square ell of high-warp tapestry, by far the highest fee then offered at the Gobelins. The tapestries were delivered to the Garde-Meuble de la Couronne between 1669 and 1683, including ten pieces in June 1677, which were to be used during Corpus Christi at Versailles.[54] Certain pieces were also hung in the Église Saint-Hippolyte, parish of the

47

Gobelins, for the Feast of Saint Louis in 1679.[55]

In 1669 a second set to be woven in the high-warp technique and with gold was placed on the loom. The only tapestries completed were *Dunkirk* (1669–73) and the *Audience with Cardinal Chigi* (1671–76), woven in the workshop of Jans the Younger, and *Douai* (1672–85), woven in the workshop of Lefebvre. Subsequent work on this set was suspended in 1683 on the order of François-Michel Le Tellier, marquis de Louvois, when he replaced Colbert as superintendent of the Bâtiments du Roi. A third set, low-warp this time, was initiated in 1670 in the workshop of Jean-Baptiste Mozin (at 260 livres per square ell), twelve pieces of which were delivered to the Garde-Meuble in April 1680. The weaving of this set was interrupted at the fourteenth piece (*Gobelins*) when the Gobelins manufactory closed in 1691.

In 1704 weaving of the *History of the King* was resumed, and between then and 1742,

fifty-three pieces or *entrefenêtres* were produced in Gobelins workshops (almost always low-warp; figs. 164, 176). Three tapestries were woven between 1716 and 1730 from the new cartoons commissioned in 1710 (in high-warp and with the first borders but without gold): the *Establishment of the Hôtel des Invalides*, the *Reparation Made to the King by the Doge of Genoa*, and the *Baptism of the Dauphin*.[56] A few of the most beautiful tapestries from the first set were disseminated through engravings, especially those done by Sébastien Leclerc.[57]

Subjects Planned but Not Woven

The *History of the King* gave rise to numbers of drawings, modelli, and cartoons corresponding to projects intended to be part of the tapestry series but never carried out. At Versailles there are a modello and a cartoon (fig. 177) by Henri Testelin for the tapestry the *Academy of Sciences*.[58] Also at Versailles are a modello by Van der Meulen (fig. 178) and a

cartoon by Baudrin Yvart for the *Queen's Entry into Douai*.[59] The 1690 inventory of models at the Gobelins lists, in addition, the *Surrender of the Governor of Cambrai* by Testelin, the *Crossing the Rhine* by Pierre de Sève, unfinished cartoons of a second version of *Crossing the Rhine* in three parts by Van der Meulen, and allegorical figures by François Verdier.[60]

The Musée du Louvre owns several drawings that show allegorical representations of the Dutch War (1672–78), that is, in a different mode than that chosen for the *History of the King* as it was woven. These drawings, most often resulting from a collaboration between Le Brun, who drew allegorical figures, and Van der Meulen, or else the work of Van der Meulen alone, are sometimes very complete compositions: in particular, *Beginning of the 1672 Campaign* (fig. 179),[61] *Crossing the Rhine*, *March of the Cavalry*, *Pontoniers*, *Taking of the Fort of Schenck*, *Siege of Doesburg*, *Surrender of Doesburg*, *Meeting of Doesburg*, *Surrender of*

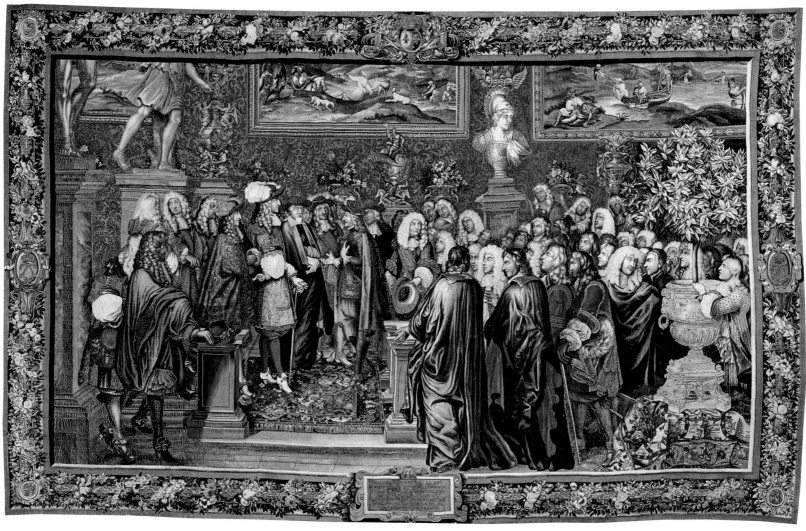

Fig. 176. *The Audience of the Conde de Fuentès*. Tapestry design by Charles Le Brun, ca. 1665–66, woven at the Manufacture Royale des Gobelins, 1732–35. Wool, silk, and gilt-metal-wrapped thread, 376 x 573 cm. Mobilier National, Paris (GMTT 98/7), deposited at the Musée National du Château de Versailles (MV 384/3)

Utrecht, and *Louis XIV at Utrecht*.[62] Finally, a drawing relating to this first series on the Dutch War—*Louis XIV at the Head of His Army, Restrained by Peace*—was adapted by the tapestry maker Philippe Behagle for a series of the *Glorification of Louis XIV*, woven in Tournai about 1680.[63] Another series also includes several fairly finished drawings that have been grouped together around the theme of the king's love life, but which seem to be related to the War of Devolution. In that series, the narrative is again presented allegorically.[64] One drawing, *Louis XIV Leaving for War*, was also interpreted as a tapestry in Behagle's workshop in Tournai.[65] And three isolated drawings by Le Brun were not pursued as tapestries: *Louis XIV Holding the Seal*, *Louis XIV Receiving the Ambassadors of Siam*, and *Reception of Louis XIV at the Hôtel de Ville*.[66]

New Subjects for the History of the King beginning in 1710

At the end of his reign, Louis XIV, undoubtedly encouraged by Louis Antoine de Pardaillan de Gondrin, duc d'Antin (1665– 1736), the new director of the Bâtiments du Roi beginning in 1708, wished to continue weaving the *History of the King*. In 1710 commissions were handed out, divided up among the best painters of the time. The king had lost much of his taste for war, and family events and official ceremonies were now chosen for commemoration.[67] Eleven artists were assigned to execute the following compositions, for which they were required to provide a sketch:[68] Nicolas Bertin (1668–1736), the *Marriage of the Duc de Bourgogne*;[69] Joseph Christophe (1662–1748), the *Baptism of the Dauphin*; Antoine Dieu (1662–1727), the *Birth*

of the *Duc de Bourgogne*; Pierre Dulin (1669–1748), the *Establishment of the Hôtel des Invalides*; Claude-Guy Hallé (1652–1736), the *Audience of the Doge of Genoa*; René-Antoine Houasse (1645–1710), the *Reception of the Ambassadors of Siam*;[70] François Marot (1666–1719), the *Order of Saint-Louis*; Louis de Silvestre (1675–1760), *Arrival in France of the King and Queen of England*;[71] Jean-François de Troy (1679–1752), *Promotion of the Order of the Holy Spirit*;[72] Alexandre Ubeleski (ca. 1650–1718), *Lit de justice*;[73] and Guy-Louis Vernansal (1689–1749), *Louis XIV at Notre Dame after Restoration of His Health*. If all these artists had executed their cartoons, the commission would practically have doubled the number of subjects in the series of the *History of the King*, but six were not able to, or, like Marot, they painted only a preliminary sketch.[74] Only the full-size cartoons

by Christophe, Dieu, Dulin, Hallé, and Vernansal were actually produced; Bertin's was completed by Dieu. As for Houasse's model, it seems to have been adapted somewhat later by Louis-Michel Dumesnil (1680–after 1746), but with a different subject—*Louis XIV Giving an Audience to the Persian Ambassador in the Grande Galerie at Versailles.*

In 1715 Christophe delivered the cartoon for the *Baptism of the Dauphin*,[75] and the same year Dieu submitted *Birth of the Duc de Bourgogne.*[76] A sketch for this composition, titled *Louis XIV Placing the Cordon Bleu on Monsieur de Bourgogne*, by Jean-Antoine Watteau (1684–1721), an artist not expected in that role, was recently rediscovered at the Muzeum Narodowe, Warsaw.[77] Also in 1715 Dieu submitted the *Marriage of the Duc de Bourgogne to Marie-Adélaïde de Savoie.*[78] In 1717 Dulin delivered the cartoon for the *Establishment of the Royal Hôtel des Invalides*, the only composition in the series containing allegorical figures.[79] Also in 1717 Dumesnil produced *Louis XIV Giving Audience to the Persian Ambassador*,[80] while in 1715 Hallé painted the *Reparation Made to the King by the Doge of Genoa.*[81] In 1710 Vernansal delivered *Louis XIV at Notre Dame after Restoration of His Health.*[82]

JEAN VITTET

1. Fenaille 1903–23, vol. 2, pp. 99–127.
2. Depping 1850–55, vol. 4, p. 534; Clément 1861–82, vol. 5, pp. 499–500.
3. "[H]aute perfection de l'Art"; "il [lui] faut par des compositions allegoriques, sçavoir couvrir sous le voile de la fable les vertus des grands hommes, & les mysteres les plus relevez. L'on appelle un grand Peintre celuy qui s'aquite bien de semblables entreprises"; Félibien 1668, preface.
4. "Monsieur, j'ay receu avec respect la response qu'il vous a pleu de faire à ma lettre touchant l'employ de l'allégorie dans les tableaux et les tapisseries que vous avés ordonné de faire pour l'histoire du roy, et j'ay tenu à très grand honneur que Sa Majesté ni vous ne l'ayez pas désapprouvé. Ces messieurs qui s'assemblent chez vous [la Petite Académie] ont eu communication de mes sentimens sur ce sujet et du commandement que Sa Majesté et vous nous faites de travailler avec addresse pour porter Mr Le Brun à en convenir avec nous et à ne gouster pas moins nos raisons qu'elle et vous les avez goustées. C'est à quoy, Monsieur, nous ne perdrons pas un moment, et nous voulons espérer que ce rare peintre, estant aussy judicieux qu'il est, ne s'en éloignera pas; surtout s'il nous estoit permis de luy insinuer qu'en s'y accommodant il ne feroit pas chose désagréable à Sa Majesté, ni à quoy vous trouvassiés rien à redire";

Clément 1861–82, vol. 5, p. 596; Tamizey de Larroque 1880–83, vol. 2, p. 362.
5. L. Beauvais 2000, vol. 2, nos. 2552–66, illus. The existence of cartoons (Louvre; ibid., nos. 2554, 2555, illus.) and of several studies of details in pastel, sometimes in Le Brun's own hand, shows that the allegorical version of the *History of the King* project was pursued at some length.
6. The paintings, perhaps sketches (70 x 116 cm), are in the Szépművészeti Múzeum.
7. Sabatier 1999, pp. 321, 332, figs. 105, 114. The preliminary drawings for the two paintings are at the National Galleries of Scotland in Edinburgh.
8. "[L]'intention de Mr Colbert estoit que nous travaillassions à l'histoire du roy, et pour y parvenir il me faisoit écrire, dans le registre dont je viens de parler, plusieurs choses que le roy avoit dittes, pour les insérer dans son histoire"; Bibliothèque Nationale de France, Paris, MS fr 23991, p. 17r; Perrault ca. 1703/1993, p. 133.
9. Perrault 1668/1992, pp. 111–21.
10. "Je gagnai même sur ce marché cinq cent mille livres, sans que les Anglais s'en aperçussent"; Dreyss 1860, vol. 2, p. 560; Lemaire 1924, pp. 1–224; Stein 1985, pp. 42–49.
11. As described in *La Gazette*, "[Louis XIV] se rendit à Dunkerque sur les deux heures après midi. A son entrée, marchoyent devant Elle, premièrement treize compagnies de cavalerie de celles qui sont logées sur cette frontière là, ayans à leur teste le comte de Bussy Rabutin, mestre de camp de la cavalerie légère, la compagnie des petits mousquetaires du roy, puis celle des grand mousquetaires, avec les chevaux légers de la garde; et enfin paroissoit Sa Majesté sur un superbe cheval, suivie à l'ordinaire de ses compagnies des gardes du corps et environnée d'une troupe de princes, d'officiers de la

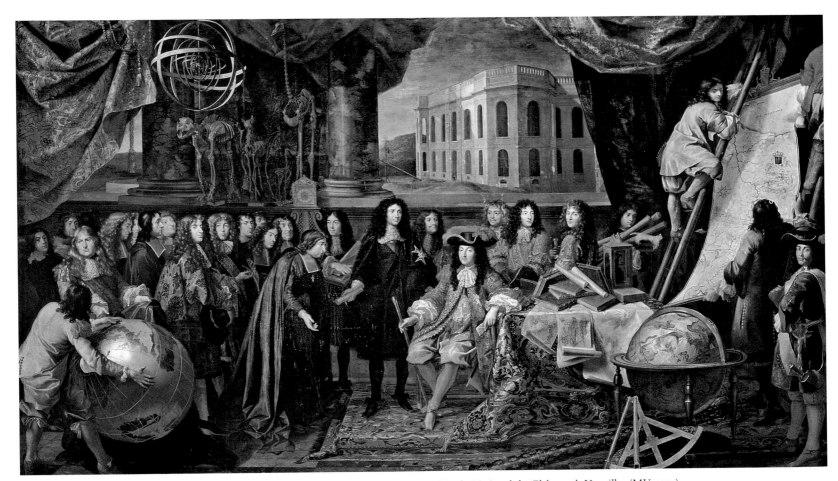

Fig. 177. *The Academy of Sciences*, by Henri Testelin, after 1667. Oil on canvas, 348 x 590 cm. Musée National du Château de Versailles (MV 2074)

385

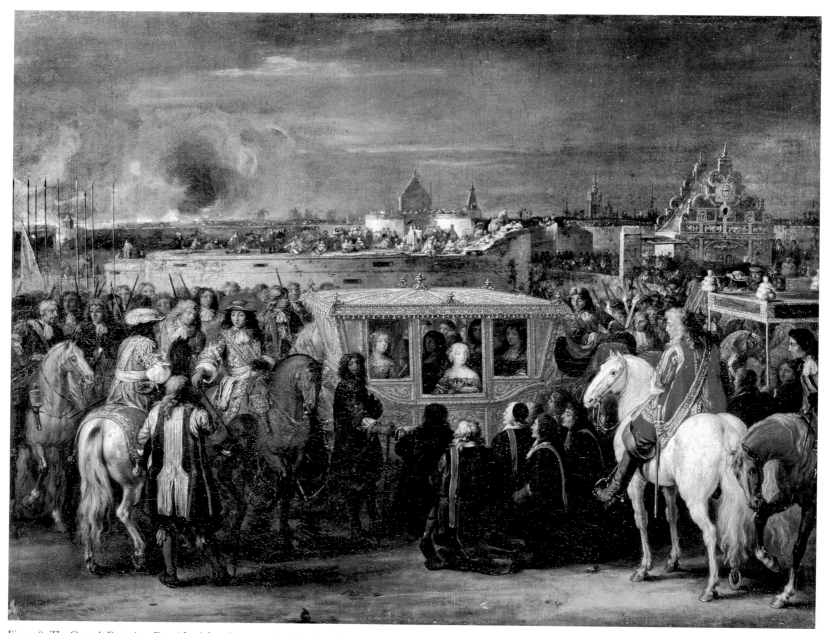

Fig. 178. *The Queen's Entry into Douai*, by Adam Frans van der Meulen, after 1667. Oil on canvas, 63 x 81 cm. Musée National du Château de Versailles (MV 5906)

couronne et de seigneurs et gentils-hommes de marque" ([Louis XIV] arrived in Dunkirk at two o'clock in the afternoon. Marching before him as he entered were, first, thirteen of the cavalry companies quartered on that border, led by Roger de Rabutin, comte de Bussy, head of the light cavalry; the company of the king's lesser musketeers; then that of the greater musketeers, with the light horses of the guard; and finally, His Majesty appeared on a superb horse, followed as usual by his companies of bodyguards and surrounded by a band of princes, officers of the crown, and distinguished lords and gentlemen"; *Recueil des gazettes nouvelles, ordinaires et extraordinaires* (1662), pp. 1208–9.

12. Guiffrey 1879b, p. 124.

13. Richefort 2004, p. 19.

14. Stein 1985, pp. 131–51, no. XIX/1–4, illus.

15. Ibid., pp. 67–73, 220–24.

16. Not July 28, 1664, as indicated in Meyer 1980, p. 70, followed by others.

17. François de Beauvillier, duc de Saint-Aignan, first gentleman of the privy chamber (1608–1687).

18. Duc Anne de Noailles, captain of the Scottish company of the king's bodyguards (d. 1678).

19. Gabriel de Rochechouart, duc de Mortemart, first gentleman of the privy chamber (ca. 1600–1675).

20. Louis de Béthune, comte de Charost (1605–1681), captain of the king's bodyguards. In the light of Chantelou's account, it is no longer possible to concur with all the identifications of characters proposed in Meyer 1980, p. 70. Similarly, according to Saint-Simon, Monsieur, Louis XIV's brother, refused to attend the event.

21. "Sur les trois heures S.E. fut à l'audiance chez le roy... qui vint recevoir S.E. à la moitié de sa chambre. M. le légat salua le roy avec une inclination fort profonde et Sa Majesté luy fit un fort grand accueil et la mena dans la ruelle de son lict où estoyent Messieurs les premiers gentilhommes de la chambre et [le] Me de la garderobbe; ils s'assirent dans chacun un fauteuil, celuy de Sa Majesté regardant la porte du balustre et celuy de M. le légat opposé à la mesme porte; S.E. leut l'escrit qui avoit esté concerté, après quoy le roy luy parla avec la plus grande affabilité du monde et l'escouta de mesme à ce qui se vit

au visage de Sa Majesté. Quand M. le légat arriva, M. de Saint-Agnan s'estoit avancé pour suivre le roy qui alloit au-devant de S.E. Ce qu'ayant veu M. de Noailles qui estoit contre la cheminée avec M. de Lionne, il s'avança aussy, jugeant qu'il estoit de sa charge d'estre près de Sa Majesté; M. de Saint-Aignan au contraire prétendant que le capitaine des gardes n'a nulle fonction dans la chambre, il y eut un petit différend qui fut remarqué, lequel estant depuis venu aux oreilles du roy, il commanda à M. de Mortemard et à M. de Charost de l'accommoder en sorte qu'il n'en entendist plus parler. L'audiance de M. le légat dura environ demie heure; le roy après s'estant levé et tenant M. le légat à sa gauche le remena la longueur de toute sa chambre et deux ou trois pas au-delà"; Bibliothèque Nationale de France, Paris, MS fr 6143, fol. 24r–v.

22. Henri de Lorraine, comte d'Harcourt, master of the horse (1601–1666).

23. Jérome Blouin, the king's personal valet (d. 1665).

24. "Le lendemain 29ᵉ jour destiné à l'audience publique, M. le comte d'Harcourt fut prendre M. le légat à son appartement et le conduisit en la chambre de Sa

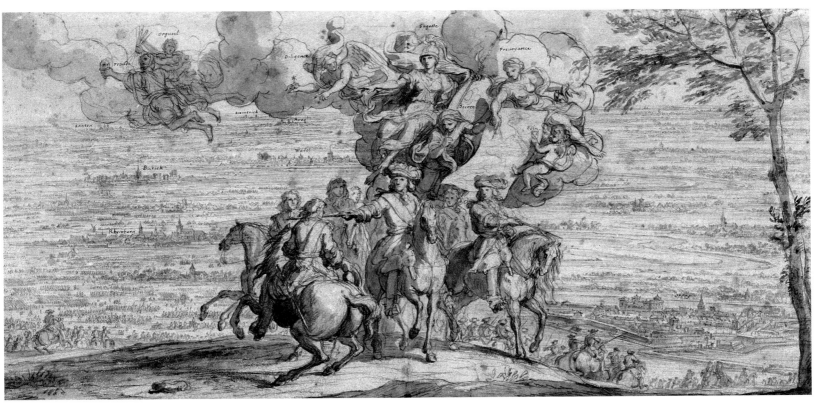

Fig. 179. *Beginning of the 1672 Campaign,* by Charles Le Brun and Adam Frans van der Meulen, after 1672. Black chalk, graphite, and gray wash on beige paper, 29.7 x 60 cm. Département des Arts Graphiques, Musée du Louvre, Paris (27661)

Majesté. . . . Le roy le receut auprès de la porte de sa chambre et prenant la main droite sans compliment le conduisit à sa ruelle, commandant au Sr Bloin lorsqu'il entra dans le balustre d'apporter une chaize pour M. le légat toute pareille à la sienne qui estoit de velours en broderie d'or. Mrs les gentilshommes de la chambre et Mr de la garderobbe estoient à l'accoustumée derrière la chaize de Sa Majesté. M. le légat dit quelque chose à Sa Majesté que personne n'entendit . . . après quoy mettant son bonnet à la main que Sa Majesté eut peine à luy faire remettre, il commença à réciter les termes du traité d'un ton si haut que toute l'assistance les entendoit"; Archives of the Ministry of Foreign Affairs, Paris, political correspondence, Rome, 164, fols. 95v–96r.

25. "Son Eminence, ainsi qu'à son entrée, estoit vestue d'une soutane rouge, en rochet et camail, avec le bonnet en teste; et ses pages et estafiers avoyent des habits de drap violet chamarrez de galons d'or veloutez de soye, avec des pourpoints de brocart d'or à fleurs de soye violette, les premiers ayans des manteaux de velou[r]s de mesme couleur et les autres des casaques de drap doublées de pareil brocart, et tous une infinité de rubans et de plumes. Ils alloyent à la teste de la noblesse de la suite de Son Eminence, qui avoyent aussi des habits brodez d'or et d'argent avec de fort beaux bouquets de plumes; après quoy marchoit le porte-croix vestu de violet et à sa gauche le maistre des cérémonies du cardinal légat, qui estoit immédiatement précédé de celuy qui tenoit son chapeau rouge et de divers prélats avec de pareils habits violets. Le roy, superbement vestu, mais qui paressoit beaucoup plus par sa haute mine et son air tout majestueux que par la pompe et l'éclat de ses habits, estant accompagné des principaux de la cour, alla au devant de Son Eminence jusques auprès de la porte de sa chambre; et, après y avoir receu son compliment, la conduisit en la ruelle de son lit, où il la fit seoir dans un fauteuil [sic] et, s'estans couverts, elle lui parla dans les termes portez en l'article du traité de Pise, en sorte que

Sa Majesté en fut très satisfaite. Ensuite Sadite Majesté la reconduisit juques à la mesme porte de sa chambre" (His Eminence, as at his arrival, was dressed in a red cassock with surplice and cape, and had a cap on his head; and his pages and swordsmen were dressed in violet cloth adorned with velvety silk gold braid, and in gold brocade pourpoints with violet silk flowers. The pages had velvet mantles of the same color, the swordsmen cloth jackets lined with the same brocade, and all had an infinite number of ribbons and plumes. They walked ahead of the nobility of His Eminence's suite, who also wore clothing embroidered with gold and silver with very beautiful tufts of plumes. After them came the cross bearer dressed in violet, and, on his left, the master of ceremonies of the cardinal legate, who was immediately preceded by one holding his red hat and by various prelates with similar violet clothes. The king was superbly attired, but seemed much more so by virtue of his lofty manner and his wholly majestic bearing than by the pomp and luster of his garb. Accompanied by the principals of the court, he went over to meet His Eminence close to the door of his chamber; and, after receiving his compliments there, led him to the space between his bed and the wall, where he had him sit in an armchair. When they had covered their heads, His Eminence spoke in the terms contained in the article of the Treaty of Pisa, in such a manner that His Majesty was very satisfied. Then His Majesty escorted him back to the same door of his chamber); *Recueil des gazettes nouvelles, ordinaires et extraordinaires* (1664), pp. 763–64. Lefèvre d'Ormesson explained in his journal (1860–61, vol. 2, p. 189) that, during the audience, the king carried "a sword and crossbelt adorned with diamonds worth nine hundred thousand livres."

26. That version of the facts is also confirmed by the baron de Breteuil (Bibliothèque de l'Arsenal, MS 3859, fols. 175–76).

27. In the tapestry, the comte d'Harcourt's face is taken from the portrait painted by Nicolas Mignard (now lost) and

engraved by Antoine Masson; Avignon 1979, p. 113, no. 87, illus.

28. Saint-Simon 1983–88, vol. 1, pp. 450–52.

29. Bottineau 1954, pp. 712–14; Meyer 1980, p. 74. The cabinet behind the king in the tapestry, however, does have features in common with item no. 5 in the Inventaire général du mobilier de la Couronne.

30. Paris 1985b, no. M4, illus. The four pedestals, nos. 678–81, in the Inventaire général du mobilier de la Couronne, are described as "faits par de Bonnaire, dont le corps est de trois figures qui portent un vase, au-dessus duquel est le plateau, lesdites figures portées sur un pied à trois consoles terminées en pattes de lion, au milieu desquelles il y a une cassolette cizelée de godrons, lesdits guéridons chacun de six pieds" (done by de Bonnaire, the body is composed of three figures carrying a vase, above which is the top, the figures supported by a foot with three brackets ending in lion's paws, in the middle of which is an incense burner engraved with boss beading, each pedestal being six feet).

31. Bimbenet-Privat 2002, vol. 1, pp. 136, 296.

32. "Plus, du temps du Cardinal-légat, j'ay fait plusieurs desseins, à Fontainebleau, de ce qui s'est passé dans ce temps là"; Guiffrey 1879b, pp. 123–24; Dijon–Luxembourg 1998, no. 15.

33. Inv. MV 2918.

34. On Van der Meulen's contribution to *History of the King,* see Dijon–Luxembourg 1998, pp. 110–66; and Richefort 2004, pp. 73–83, 88–92, 222–26.

35. Inventory numbers of the six drawings in the Département des Arts Graphiques, Musée du Louvre, that are not catalogued here are the *Anointing,* 27654; the *Siege of Tournai,* 27634 and 20055; the *Siege of Douai,* 27635; the *Taking of Lille,* 27636; and the *Defeat of Comte de Marsin,* 20059.

36. Musée du Louvre, inv. 27633.

37. L. Beauvais 2000, vol. 2, nos. 2514–24, illus. This set of drawings includes two horse studies by Le Brun for the

Siege of Douai. Drawings of lesser quality are also housed at the Mobilier National; Stein 1985, nos. X/10, XII/10, XVI/2.

38. In particular, views of Douai, Lille, and Dole: Louvre, RF 4902, RF 4918, RF 4900; Guiffrey 1879b, pp. 127–28; Richefort 2004, p. 285.

39. Guiffrey 1879b, pp. 123–26; Guiffrey 1892, p. 159.

40. The *Audience of the Swiss at the Louvre,* Versailles, MV 2139; the *Siege of Tournai,* Musée Magnin, Dijon, inv. 187, Dijon–Luxembourg 1998, no. 24, illus.; the *Taking of Lille,* Versailles, MV 2141, Bajou 1998, pp. 120–21, illus. (this may be a workshop replica); and the *Defeat of the Comte de Marsin,* Louvre, inv. 1483, Dijon–Luxembourg 1998, no. 28, illus.

41. The portrait of Turenne is at Versailles, MV 3488, and Le Brun's pastel of Louis XIV is at the Louvre, inv. 29873.

42. The study of a saddle is at Versailles, MV 8974.

43. "Un justaucorps de moire bleue brodé or et argent, servant à peindre d'après nature dans les tableaux de l'histoire du Roy"; Guiffrey 1879b, p. 143.

44. The "Inventaire général des ouvrages de peinture qui ont esté faits aux manufactures royales des Gobelins, pour les desseins de tapisserie" is preserved in the Archives Nationales, Paris; Guiffrey 1892, pp. 143–46, 175–76, 211.

45. The high-warp cartoons preserved at Versailles are the *Anointing* (MV 2058), the *Siege of Douai* (MV 2077), the *Siege of Dole* (MV 1070bis), the *Capture of Marsal* (MV 2072), the *Taking of Lille* (MV 2105, wrongly attributed to Renard de Saint-André), the *Audience with Cardinal Chigi* (see MV 1070, copy by Ziegler), the *Alliance with the Swiss* (MV 2073), the *Siege of Tournai* (MV 2076), the *Defeat of Marsin* (MV 2106). Those at the Mobilier National are *Dunkirk* (GOB 751, incomplete; completed by Pierre de Sève; deposit of the Louvre), the *Audience of Fuentès* (GOB 750, incomplete; deposit of the Louvre), and the *Visit to the Gobelins* (GOB 749, incomplete; deposit of the Louvre).

46. The models for *History of the King* currently held at the Mobilier National were sent there by the Musée du Louvre in 1938.

47. The cartoons for low-warp tapestries preserved at Versailles are the *Marriage* (MV 2092), the *Meeting of the Two Kings* (MV 1068), the *Visit to the Gobelins* (MV 2098), the *Audience of Fuentès* (MV 1069), *Dunkirk* (MV 1067). Those at the Mobilier National are the *Anointing* (GOB 707; deposit of the Louvre), the *Audience of Cardinal Chigi* (GOB 748, incomplete; deposit of the Louvre), the *Defeat of Marsin* (GOB 709; deposit of the Louvre), and the *Siege of Tournai* (GOB 701; deposit of the Louvre). The *Capture of Marsal* is at the Musée du Louvre (inv. 2978), and the *Taking of Dole* is in the Musée des Beaux-Arts de Lille.

48. The two drawings are in the Louvre, inv. 28026, 28012; L. Beauvais 2000, nos. 2525, 1138, illus.

49. The two border cartoons are in the Louvre, inv. 3033, 3034.

50. Guiffrey 1892, pp. 144, 158. Conversely, the archives specify that Claude Audran had done the flower border used on the low-warp sets; Fenaille 1903–23, vol. 2, p. 100.

51. Verlet 1982, pp. 109–10, fig. 52; Préaud 1989, pp. 86–89, 96–97, nos. 1–6, 20–23, illus. These engravings were done by Jean Lemoyne le Lorrain (not the Lemoyne from Paris).

52. Guiffrey 1892, pp. 175, 181–83.

53. Contrary to the claims of many authors, who cite 1667 as the date the weaving of the *Audience with Cardinal Chigi* began, it commenced in 1665.

54. Archives Nationales, Paris, O¹ 3304, fol. 146r; O¹ 3305, fols. 37v, 44r, 129r.

55. J. Coural 1982, p. 13.

56. Guiffrey 1892, p. 211; Fenaille 1903–23, vol. 2, pp. 117–27.

57. Préaud 1980, nos. 617–21, illus.

58. The modello for the *Academy of Sciences* is MV 6344. For the cartoon, see Bajou 1998, pp. 112–13, illus. There is a portrait in pastel at the Louvre of a man in armor, whose head appears in the composition; L. Beauvais 2000, vol. 1, no. 1963, illus.

59. The cartoon is MV 2078.

60. The *Surrender of the Governor of Cambrai* (MV 1071; repainted by Jean-Baptiste Mauzaisse [1784–1844]), *Crossing the Rhine* by Sève (MV 126), and with allegorical figures by Verdier (MV 2033) are all at Versailles. The *March of the Cavalry* (MV 6769; companion to *Crossing the Rhine* by Van der Meulen and Verdier) is also at Versailles. On *Crossing the Rhine* by Van der Meulen and Verdier, see Guiffrey 1879b, pp. 127, 140, 143; Guiffrey 1892, p. 169; and L. Beauvais (2000, vol. 2, p. 731), who corrects Stein (1985, p. 274) and Starcky (1998, p. 151). It is not possible to concur with Richefort (2004, p. 89), when she asserts that *Crossing the Rhine* was not intended to be woven into a tapestry. Henri de La Chapelle-Bessé, *premiere commis* of the Bâtiments, mentioned these works in a letter of May 4, 1692: "Il y a un tableau aux Gobellins en trois pièces, une grande et deux moyennes, que vous pourriés faire achever par les sieurs Martin et Le Comte qui ne font rien: c'est le Passage du Rhin, un fort beau sujet presque tout peint de la main de M. Vandermeule. M. Houasse finiroit fort bien les figures du devant. C'est pour une suitte des Actions du Roy, dont il y a plusieurs pièces faites en tapisserie et livrées au Garde-Meuble. La dépense n'iroit pas à 1000 livres" (There is a painting at the Gobellins in three pieces, one large and two medium-sized, which you could get finished by Mssrs. Martin and Le Comte, who are not doing anything: it is Crossing the Rhine, a very fine subject, painted almost entirely in M. Vandermeule's hand. M. Houasse could very well finish the figures in the foreground. It is for a series of King's Deeds, several pieces of which have been done in tapestry and delivered to the Garde-Meuble. The cost would not be more than 1,000 livres); Archives Nationales, Paris, O¹ 2040A, dossier 4. The three cartoons of *Crossing the Rhine,* though not transcribed into tapestry, were transposed into painting on silk; Château de Compiègne and Mobilier National; Dijon–Luxembourg 1998, nos. 48, 49, illus. The preliminary cartoons are at the Louvre; L. Beauvais 2000, vol. 2, nos. 2587–2630, illus.

61. Dijon–Luxembourg 1998, no. 33.

62. *Crossing the Rhine,* inv. 27663 and 20066; *Pontoniers,* inv. 20061 (companion to *Crossing the Rhine*); *Taking of the Fort of Schenck,* inv. 27637; *Siege of Doesburg,* inv. 20060; *Surrender of Doesburg,* inv. 27696; *Meeting of Doesburg,* inv. 27662; *Surrender of Utrecht,* inv. 20069; and *Louis XIV at Utrecht,* inv. 27650. See L. Beauvais 2000, vol. 2, nos. 2526–49, illus. Other drawings in Van der Meulen's hand can also be found at the Louvre and the Mobilier National: *Crossing the Rhine,* the *Fort of Schenck, Siege of Doesburg, Surrender of Doesburg, Meeting of Doesburg,* and *Surrender of Utrecht;* Stein 1985, nos. XXI/2–3, XXII/2, XXIV/2, XXV/2–3, XXVI/2–4, XXVII/2, XXVIII/2–3, illus. Studies survive for the allegorical figures in *Crossing the Rhine,* several by François Verdier; Stein 1985, no. XXII/4–9, illus.

63. The drawing is in the Louvre, inv. 29622. For the tapestries, see Standen 1998, figs. 20–22. A full-size cartoon fragment of this composition survives; L. Beauvais 2000, vol. 2, nos. 2548–49, illus.

64. L. Beauvais 2000, vol. 2, nos. 2567–78, illus.

65. Standen 1998, figs. 11, 12; L. Beauvais 2000, vol. 2, no. 2569, illus.; Richefort 2004, p. 92.

66. *Louis XIV Holding the Seal* and the *Reception of Louis XIV at the Hôtel de Ville* are at the Louvre (inv. 29627 and 29766); L. Beauvais 2000, vol. 1, no. 1955, vol. 2, no. 2550, illus. *Louis XIV Receiving the Ambassadors of Siam* belongs to the École Nationale Supérieure des Beaux-Arts, Paris; Paris–Geneva–New York 2001, no. 82, illus.

67. Engerand 1901, p. 97.

68. Guiffrey 1881–1901, vol. 5, cols. 430–31. Each received an advance of 200 livres for the sketch he was to provide.

69. Lefrançois 1981, p. 52.

70. Engerand 1901, p. 171, n. 3. Guiffrey 1881–1901, vol. 5, col. 437. Surprisingly, in 1687 Tessin had noticed in the artist's workshop "d'après un dessin de Mr Le Brun, une Audience des ambassadeurs de Siam aussi grande que nature" (a lifesize Audience of the Ambassadors of Siam, after a drawing by M. Le Brun); Paris–Geneva–New York 2001, p. 315. The drawing by Le Brun is at the École Nationale Supérieure des Beaux-Arts, Paris; see note 66 above.

71. Engerand 1901, p. 444, n. 2.

72. Ibid., p. 464; Leribault 2002, p. 223 (P26).

73. Engerand 1901, p. 97, n. 3.

74. Marot's sketch is at Versailles (MV 2149); Bajou 1998, pp. 308–9, illus.

75. Cartoon and sketch are at Versailles, MV 2099 and MV 5830; Guiffrey 1881–1901, vol. 5, col. 872; Engerand 1901, p. 97. The artist was paid 4,000 livres for the painting.

76. Versailles, MV 2094.

77. Eidelberg 1997, fig. 2. Dieu's preliminary drawing is in Berlin (Staatliche Museen); Eidelberg 1997, fig. 4.

78. The cartoon is at Versailles, MV 2095; Guiffrey 1881–1901, vol. 5, col. 872; Engerand 1901, pp. 160–61. Dieu received 8,000 livres for that painting and the *Birth of the Duc de Bourgogne.* His sketch for the *Marriage of the Duc de Bourgogne,* on the art market, is reproduced in Eidelberg 1997, fig. 5.

79. The cartoon is at Versailles, MV 2100; Engerand 1901, p. 170. Dulin received 4,000 livres for this work. His preliminary drawing is at the Schlossmuseum in Weimar; Weimar–New York–Paris 2005, no. 38, illus.

80. The cartoon is lost; the sketch may be at Versailles, MV 5461; Engerand 1901, p. 171. The artist received 4,000 livres for this work. Two other versions of the Versailles sketch are in Niort (municipal museum) and Kraków (Muzeum Narodowe). For stylistic reasons, the attribution of that composition to Dumesnil is still uncertain; Bajou 1998, pp. 322–23, illus. The sale of one of these examples under Dumesnil's name is mentioned, however, in the *Annonces, affiches et avis divers* of June 15, 1752, p. 365: "Ventes . . . Le tableau représente Louis XIV environné de toute sa cour donnant audience à l'ambassadeur de Perse. Ce fut la dernière que donna ce monarque. Il y est représenté avec Louis XV et Monseigneur le duc d'Orléans régent. Ce tableau est de la composition de *Duménil* alors peintre du roi et de la ville de Paris. Il a 3 pieds ½ de long sur 2 pieds 2 pouces de haut. La bordure est aussi sculptée à jour"; (Sales . . . The painting depicts Louis XIV surrounded by his entire court giving audience to the Persian ambassador [on February 19, 1715]. It was the last one that the monarch gave. He is depicted here with Louis XV and Monsignor the duc d'Orléans regent. That painting is from the composition by Dumesnil at the time the painter of the king and of the city of Paris. It is 3½ feet long by 2 feet 2 inches high. The frame is also openwork carving).

81. The event had taken place on May 15, 1685. The cartoon is at Versailles, MV 2107; sketches are at the Musée des Beaux-Arts, Marseilles, and the Musée des Augustins, Toulouse; Engerand 1901, pp. 221–22; Willk-Brocard 1995, pp. 74–75, 287–89 no. C54, illus. The artist received 4,000 livres for this work.

82. The cartoon is lost, but there is a sketch at The Metropolitan Museum of Art, New York (1984.400); Guiffrey 1881–1901, vol. 5, col. 872; Engerand 1901, p. 500; Bean 1986, no. 305, illus. The artist received 4,000 livres for this work.

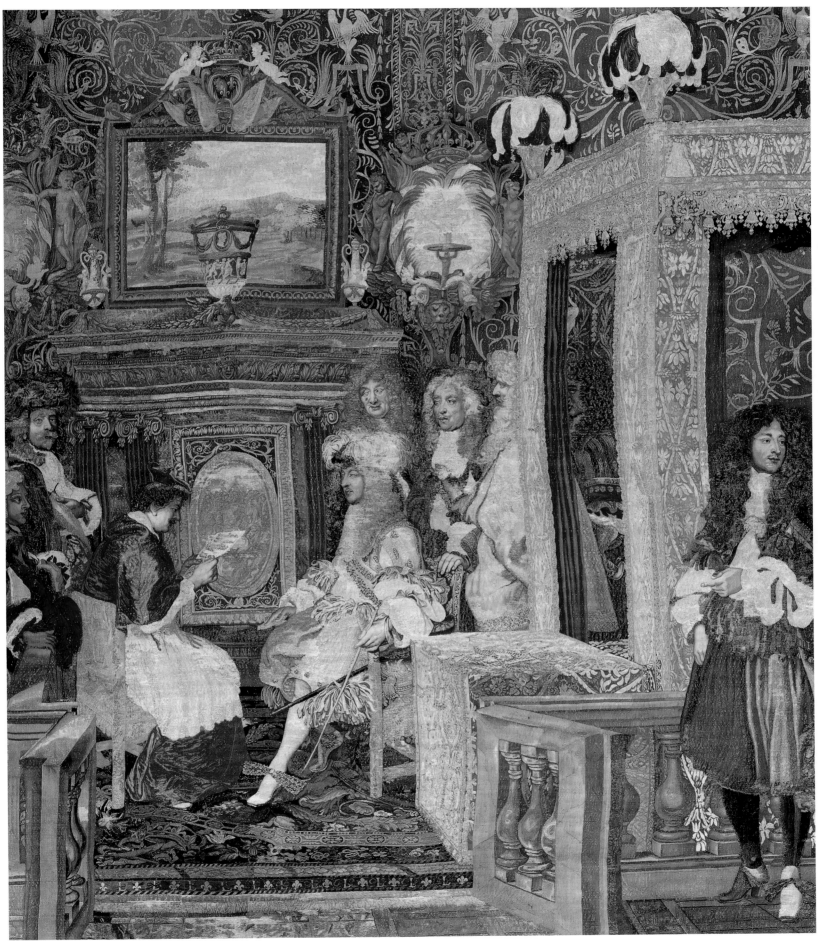

Detail of cat. no. 44

48.
The Striped Horse

From a ten-piece set of the *Old Indies*
Cartoon by Albert Eckhout and Frans Post, 1644–67;
retouched and probably adapted by Jean-Baptiste
Monnoyer, Jean-Baptiste Belin de Fontenay, René-
Antoine Houasse, and François Bonnemer, 1687–88;
retouched and adapted again by Alexandre François
Desportes, 1692–93; and restored by Claude
Audran III, 1703
Woven in the workshop of Étienne Claude Le Blond
at the Manufacture Royale des Gobelins, Paris,
1708–10
Wool and silk
470 x 504 cm (15 ft. 5 in. x 16 ft. 6½ in.)
Council Chamber, Presidential Palace (originally the
Palace of the Grand Masters of the Order of Malta),
Valletta, Malta

PROVENANCE: June 2, 1710, the set of ten tapestries
was shipped from Paris via Lyon and Marseille to
Malta; since then, they have hung in the room for
which they were commissioned, except for the years
1895–1910, when they were sent to Paris for restora-
tion at the Gobelins manufactory.

REFERENCES: Darcel 1881; Darcel 1882; Guiffrey
1897; Fenaille 1903–23, vol. 2 (1903), pp. 383–84, 397;
Guiffrey 1904; Geffroy n.d., pls. 510–20; Jarry 1958;
Zerafa 1975; Joppien 1979, pp. 355–56; Jarry in Aix-
en-Provence 1984, p. 17; Whitehead and Boeseman
1989, pp. 119, 120–21, 123; Ellul 1996, pp. 44–57;
Bremer-David 1997, pp. 15, 18; Delmarcel in Antwerp
1997, p. 137; Forti Grazzini 1998b.

The tapestry presents a detailed visual
compendium of the animals, plants, and
landscape of northeast Brazil, with the addi-
tion of non-native animals. In the middle of
the scene is a horse with the white-and-black
markings of an African zebra. It rears on its
hind legs and turns its head backward,
alarmed by the attack of a South American
jaguar that sinks its teeth and claws in the
horse's back. Behind the zebra-horse, a placid
Indian rhinoceros (*Rhinoceros unicornis*) turns
its head to the left, while an animal that is a
cross between a goat and a gazelle jumps
toward the zebra. Two birds fly from under
the zebra-horse's front legs, a jabiru (the one
with the black head) and a *Sarkidiornis mela-
notos*.[1] A brook fed by a waterfall flows in the
right foreground: to the left of the brook one
sees, from the left, what is probably an African
suricata (a kind of monkey), two armadillos,

and a small alligator; to the right of the water-
fall, amid small plants and flowers, there are
various kinds of crabs, a lizard, a small snake, a
tortoise, and a red crayfish. Among the fish
swimming in the water are one with a long
horn (the cuacua, *Ogcocephalus longirostris*) visi-
ble at left, a mullet, a sawfish, and a porcupine
fish;[2] a flying fish leaps over the waterfall.
Some stalks of sugarcane close the composi-
tion at left, where one sees the branches,
leaves, and long dangling fruits of two *Cassia
grandis* trees, in which a *Passiflora* and an
Aristolochia brasiliensis vine are enveloped.
Various birds perch on the branches: the most
notable are a black and brown hawk, a white
and blue fish eagle, an owl, and a vividly col-
ored ara macaw. In the background a river
flows through a valley bounded by hills,
which seem to merge with the bright yellow-
rose sky.

The border, which simulates a carved and
gilt wood frame, is decorated by an entwined
acanthus leaf and guilloche motif against a
blue ground, edged inside and out by narrow
molding, with an agrafe in each corner. At top
center is the coat of arms of Ramón Perellos
y Rocafull, Grand Master of the Order of
Malta from 1697 to 1720, quartered, with gules
a cross argent (the emblem of the Order of
Malta) in the first and fourth quarters, and or
three pears vert (the device of the Perellos y
Rocafull family of Aragon) in the second and
third quarters, surmounted by a gold crown
representing the high rank connected to the
title of Grand Master of the Order.

The Cartoons and the Weavings

The *Striped Horse* is one of ten tapestries
forming the *Old Indies* set, dated 1708–10,
which was made for and still hangs on the
walls of the Council Chamber of the Palace
of the Grand Masters of the Order of Malta
(now the Presidential Palace) in Valletta. The
Old Indies set made for Valletta was the fourth
"official" weaving of the series made by the
Gobelins manufactory. Details of the several
weavings and the making and use of the car-
toons are known, though some points remain
unclear. Between 1636 and 1644 the Dutch
colony of northeast Brazil was governed by
Johan Maurits, prince of Nassau-Siegen
(1604–1679), a well-off and well-connected
military man, statesman, and art patron.[3] He

was the nephew of William I of Orange and
a cousin of Frederick III, king of Denmark,
and of Frederick William, elector of Branden-
burg. During Johan Maurits's governorship,
the colony was extended, threats posed by the
Portuguese were kept in check, and a new
city—Mauritsstad, present-day Recife—was
founded. But his finest achievement was to
set in motion the first systematic enquiry into
the natural history of the New World. He
took to Brazil two experienced scholars from
Holland, the doctor Willem Pies (or Piso)
and the cartographer Georg Marcgraf: their
Historia naturalis Brasiliae (Leiden, 1648),
printed at Johan Maurits's expense, was for
more than a century the fundamental refer-
ence work on tropical diseases and the plants
and animals of Brazil. Two Dutch artists taken
to South America (the "West Indies") by the
prince of Nassau, Albert Eckhout (1605/15–
1666) and Frans Post (ca. 1612–1680), were
charged with recording the flora and fauna,
the inhabitants, and the landscape of Brazil.
Eckhout, a specialist in still life but also a
portraitist and a painter of animals, made hun-
dreds of sketches in pencil, watercolor, and
oil of the native people, animals, and plants.
Possibly in Brazil but certainly after his return
to Holland, he used his sketches to execute
paintings whose unquestionable quality is on
a par with their ethnographic and scientific
importance. The landscapist Post was given
the task of mapping sites and drawing plans of
palaces and fortifications, and he also made
many sketches of the scenery of the colony,
on which he based enchanting canvases that
for the first time showed Europeans the land-
scape of Brazil.[4]

On Johan Maurits's return to Europe,
laden with Brazilian images (Eckhout and
Post made more for him after 1644) and spec-
imens of every kind, which were installed in
the Mauritshuis, his palace in The Hague,
he distributed his images of Brazil to select
recipients, in this way disseminating a realistic
picture of the New World.[5] In 1652 he
gave the elector of Brandenburg several
magnificent albums containing watercolors
and oils by Eckhout (the so-called *Libri pic-
turati*, now in Kraków), and seven large and
nine smaller paintings to be hung as fictive
tapestries. In 1654 he gave Frederick III of
Denmark twenty-six oil paintings by Eckhout:

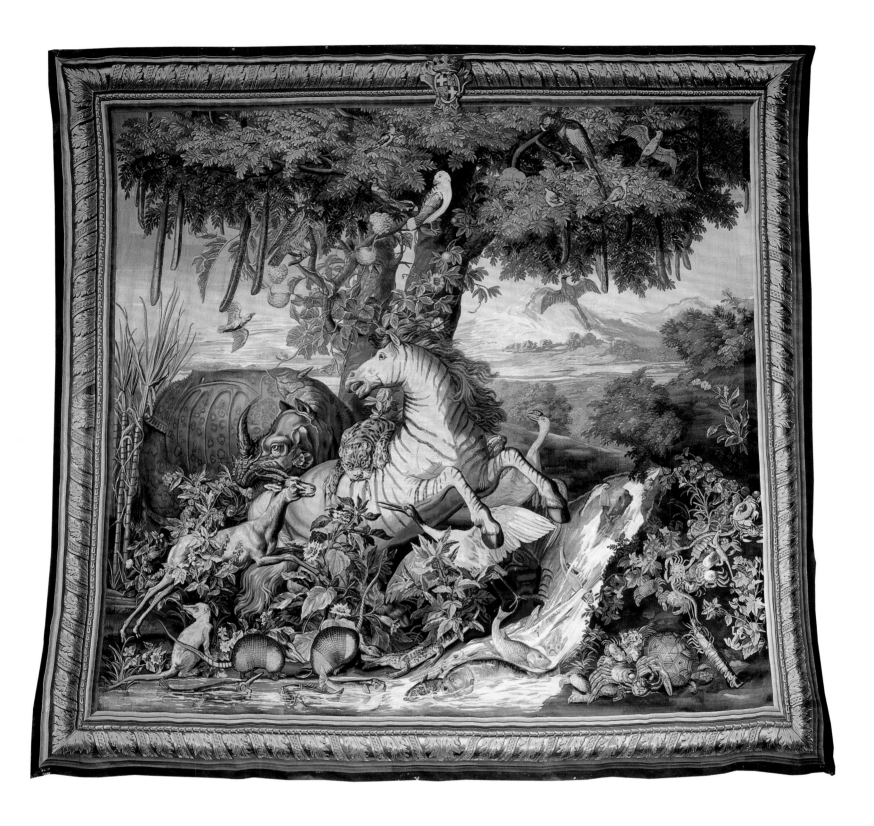

eight large portraits of Indians and eighteen still lifes of tropical fruits (Nationalmuseet, Copenhagen), considered Eckhout's masterpieces. In a letter from Delft dated April 16, 1667, the weaver Maximiliaen van der Gucht informed Frederick William of Brandenburg that he had received from the prince of Nassau eight large and three small "Indian" cartoons to be reproduced within four months in tapestries for the elector, and that no other weavings would be done except the ones for Nassau himself. The tapestries Van der Gucht made for the elector and Johan Maurits, which today are lost, were probably the "Neuen Tapeten von wilden Leuthen und Thieren" (nine tapestries with wild men and animals) listed in inventories of the elector's goods in 1691 and 1699, and those of Brazilian subjects mentioned in a description of the Mauritshuis in 1681.[6]

In 1679 the prince of Nassau gave Louis XIV of France thirty-four paintings of Brazilian subjects, including "eight large paintings . . . representing lifesize figures of

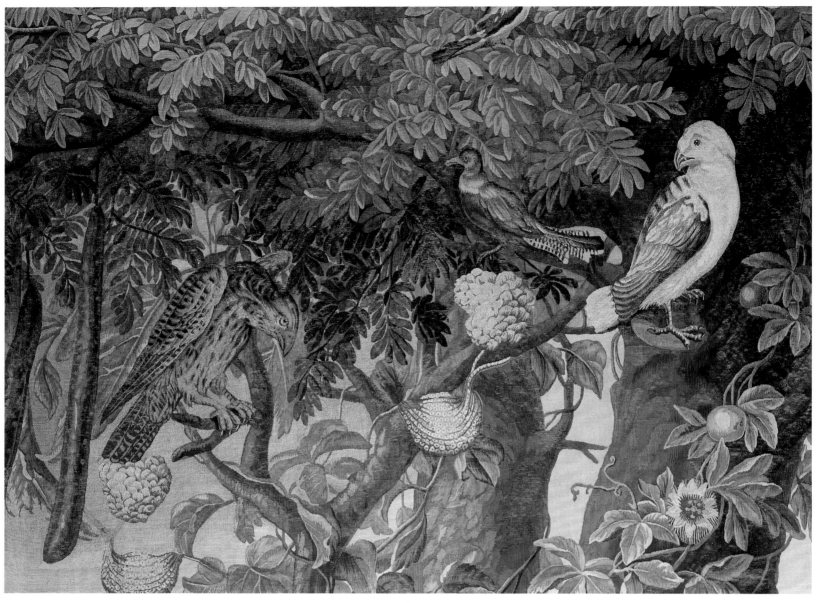

Detail of cat. no. 48

men and of women, many plants, fruit, birds, animals, fish, and scenery of Brazil," the cartoons of the *Old Indies* tapestries, together with thirty-four sketches that may have been the sketches for the paintings.[7] Reproduced as tapestries, they would have formed a series "without equal in the world," as Johan Maurits wrote on December 21, 1678, to the marquis de Pomponne, the French secretary of state, since "it would have been possible, by the tapestries, to see Brazil without crossing the ocean."[8] In a letter to the French king dated February 8, 1679, he repeated that the eight paintings—at the time still in The Hague—were cartoons for tapestries with which a great hall or gallery might be decorated, and he offered to send the king an

expert cartoonist who would be familiar with the designs and the animals represented, so the king could order cartoons to be modified as he wished.[9] It is not known whether these cartoons were the same ones that were sent to the elector of Brandenburg in 1652 (he received seven, not eight), but they were probably the same eight sent in 1667 to the Van der Gucht workshop, already woven twice. It is documented that, before being sent to Louis XIV, the cartoons included the coat of arms of the prince of Nassau, which was probably added to the tapestries destined for the Mauritshuis.[10] In any event, the gift was accepted. Sent to Paris in July 1679 and exhibited in the Salle de la Comédie in the Louvre, the paintings of the *Old Indies* were

greatly admired by the king, his family, his minister Jean-Baptiste Colbert, and the great numbers of people who came to see them day after day "as in a procession."[11] But it was not until eight years later, when the low-warp weavers at the Gobelins had no work, that Louis XIV ordered the paintings be translated into tapestries.

In 1687–88 four French painters were charged to work on the cartoons: Jean-Baptiste Monnoyer (1636–1699) and Jean-Baptiste Belin de Fontenay (1653–1715) were paid 900 livres for "repainting" the plants and the birds, and René-Antoine Houasse (1645–1710) and François Bonnemer (1638–1689), 1,550 livres for retouching the remaining elements.[12] The extent of their work has been debated by

392

Fig. 180. Council Chamber of the Presidential Palace, Valletta, hung with a set of the *Old Indies*

modern scholars, but the size of the payments (corresponding more or less to the price of a single new cartoon) indicates that they restored the existing models, refreshed the colors, and introduced just a few new elements (presumably copied from the sketches provided by the prince of Nassau), so the cartoons basically retained their original appearance.[13] And, since the paintings were later referred to as "les originaux faits... par les peintres hollandais" (the originals made... by the Dutch painters), this fact and the style and elements of the scenes reproduced in the tapestries make it clear that the cartoons given by Johan Maurits to Louis were those painted by the Dutch artists Eckhout and Post. Thus, it was Eckhout who interpolated from the beginning some African features into the Brazilian foregrounds, conferring on the *Old Indies* such ethnographic and zoological variety and an exotic and spectacular appearance that their scientific value as faithful visual reports of the Dutch colony of Brazil was partially compromised.

The eight cartoons were the models for the *Striped Horse*, the *Two Bulls*, the *Elephant*, the *Indian Hunter*, the *Animal Combat*, the *King Carried in a Hammock*, the *Indian on Horseback*, and the *Fishermen*. In the first five sets produced at the Gobelins, the tapestries were completed with the same borders—coat of arms excluded—as those on the set at Valletta.[14] The first two editions (except for the Malta group, all the *Old Indies* sets comprised eight pieces) were woven in the low-warp ateliers of Jean de La Croix and Jean-Baptiste Mozin, in 1687–88 and 1689–90.[15] The editio princeps was consigned to the royal Garde-Meuble but left it after 1793: four tapestries of this group—*Animal Combat*, *King Carried in a Hammock*, *Indian on Horseback*, and *Fishermen*—were auctioned in Paris with the Braquenié collection on May 18, 1897, then again in Venice with the Beistegui collection at the Palazzo Labia on April 6–10, 1964 (no. 577a–d), and have recently been on the market again, with the collection of the late Alberto Bruni Tedeschi (Sotheby's, London, March 21, 2007); the other four are in a private collection in the province of Córdoba, Argentina.[16] The second edition was also given to the Garde-Meuble and is still the property of the Mobilier National.

In 1692–93 the paintings, which had been cut into strips for use on the low-warp looms, were reassembled by the painter Joseph Yvart (1649–1728) and retouched and maybe modified in some details by Belin de Fontenay (who worked on the fruit and flowers), Alexandre François Desportes (1661–1743; who refreshed the animals), and Houasse (who worked on the human figures),[17] and were reproduced (reversed) in the third edition of the *Old Indies*, woven in the high-warp technique by Jean Jans the Younger and Jean Lefebvre between 1692 and 1700. In 1717 this set was presented as a diplomatic gift to Peter the Great of Russia; a fire in the Winter Palace of Saint Petersburg destroyed it nearly completely in 1837 (only a fragment of the *Animal Combat* is said to survive).[18]

In 1703 the cartoons were refreshed again by Claude Audran III (1658–1734), and they may have been used for private commissions in the years immediately following, before they were rearranged and reproduced in the fourth set, the one woven in 1708–10 by Étienne Claude Le Blond (fl. 1700–57) for Grand Master Perellos y Rocafull. That weaving was followed in 1718–20 by the fifth edition produced on high-warp looms by Jean Jans the Younger and Jean Lefebvre. This set remained at the Gobelins until 1769, when it was presented by Louis XVI to Etienne-Michel Bouret, *fermier général*; its components cannot be identified today.[19] In 1722 the deteriorated cartoons were restored again by Desportes, or he may have produced completely new cartoons by copying the older ones and reducing their height.[20] These were the models reproduced in the last three official sets of the *Old Indies*, half a French ell (60 cm) shorter than the first five, the so-called *Petites Indes* (*Small Indies*), all made in the high-warp technique and decorated with a different border ("second design") comprising the French royal arms and the king's initials at the center of the horizontal frames and shells at the corners. The sixth set, woven by Lefebvre, Louis de la Tour, and Jans the Younger in 1723–27, was sent to Rome and is still preserved intact there, at the Académie de France in the Villa Medici.[21] Four complementary *Old Indies* panels were also sent to Rome between 1726 and 1731, and three survive at the Mobilier National (*Indian Hunter*, *Animal Combat*, and *Fishermen*).[22] The seventh and eighth sets were woven by the same weavers in 1725–32 and 1726–30. Three pieces of the seventh set have been lost or were destroyed by fire (*Striped Horse*, *Indian on Horseback*, *Bulls*), while the other five were given to Henri d'Ormesson, the first president of the Parlement de Paris, in 1788; some

survive in Paris. Five pieces of the eighth set, which was still complete at Versailles in 1789 and referred to as the *Small Indies*, have had their borders cut and are preserved in Museu de Arte in São Paulo, Brazil.[23] After these sets were completed, the cartoons, again in poor condition, were not restored.[24] In 1735–41 Desportes painted eight new cartoons, repeating the subjects and compositions of the *Old Indies*, but he introduced many revisions: these were the *New Indies*, which were woven many times at the Gobelins from 1740 to the beginning of nineteenth century.[25]

The Malta Set

The chronology of the fourth *Old Indies* set made for Valletta, which Maurice Fenaille placed generally between 1700 and 1718,[26] was determined by Madeleine Jarry on the basis of documentary records in the archives of the Order of Malta in the Royal Library at Valletta.[27] Commissioned by Grand Master Ramón Perellos y Rocafull, all ten tapestries are personalized with his coat of arms in the upper borders. Perellos was a generous patron of tapestries. In 1699–1700, he ordered from Judocus de Vos, in Brussels, an enormous group of twenty-nine religious tapestries as a gift to the church of Saint John, the Cathedral of Valletta, which are still preserved in situ.[28] And a few years later Perellos ordered another set of tapestries, a commission that was overseen in Paris by an emissary, Knight Jean Jacques de Mesmes, a commander and a governor of the Order of Malta. On October 28, 1708, de Mesmes signed a contract with "Etienne Le Blond, tapissier ordinaire du Roi en sa Manufacture des Gobelins," for a set of tapestries to be made "en basse lisse." The set was to be completed by March 1710, and it was to comprise ten pieces 4 ells high, for a total length of 36 ells, plus five overwindows and one overdoor of a different design but with the coat of arms of Grand Master Perellos; the hangings were to cost 120 livres per square ell, and Le Blond would be paid 1,000 livres per month.[29] In a letter from Paris dated November 11, 1708, de Mesmes reported to Perellos that the subject of the set was to be the *Old Indies* and that the king had already granted permission for the cartoons to be reproduced; the subject was chosen, he wrote, because various persons of good taste

had told him that it was the best series in the king's Garde-Meuble and because it would cost less then a set of history tapestries and half the price of a set made from newly designed cartoons. He had discarded the idea of Monsieur le Bailly de Noailles, the ambassador of the Order of Malta in Paris, that the tapestries for Perellos might be copied from original models with personalized religious content. In the meantime, de Mesmes had given Le Blond a gift of 1,000 livres and an advance of 2,000 livres for the work. On December 20, 1708, as reported to Perellos in a second letter from de Mesmes, the cartoons for the coat of arms to be reproduced on the large tapestries and on the complementary pieces were nearly finished, though de Mesmes requested clarification of the exact dimensions of the walls on which the tapestries would be hung.[30] In a letter dated January 18, 1709, Perellos approved everything de Mesmes had done in Paris. On June 2, 1710, de Mesmes announced to Perellos that the finished tapestries had left Paris, packed in four "ballots" carried on two mules. Commander de Maubourg would receive them in Lyon and send them on to Commander Daubiguez in Marseille. Thanks to a passport granted by Louis XIV, no customs duties were to be paid on their travel through France.[31]

In the palace in Valletta, the rectangular room in which the grand masters convened the Council of the Order, under a frieze of painted canvases showing naval victories of the order and allegorical female personifications, the ten *Old Indies* tapestries completely cover the walls, two hanging on each of the short sides, separated by a door, and three on each of the long sides, separated by windows (fig. 180).[32] Beginning at the entrance of the chamber and looking to the left, the tapestries are the *Ostriches* (470 by 313 cm), the *Fishermen* (470 by 400 cm), the *Indian on Horseback* (470 by 430 cm), the *Striped Horse* (cat. no. 48), the *King Carried in a Hammock* (470 by 450 cm), the *Animal Combat* (470 by 458 cm), the *Two Bulls* (470 by 511 cm), the *Indian Hunter* (470 by 350 cm), the *Elephant* (470 by 408 cm), and the *Isabella Horse* (470 by 298 cm).[33] The *Fishermen* and the *Elephant* show the signature of the weaver, LE BLOND, in the lower selvages. The decoration of the chamber is completed by six heraldic tapestries

made with the *Old Indies* group, each of them displaying Perellos y Rocafull's coat of arms between palm leaves and flags of the Order of Malta, with a seated nude prisoner, with bound hands, on each side of Perellos's arms, over a plumed turban surrounded by arms (alluding to the secular war fought by the order against the Turks): five of them (each measuring 130 by 175 cm)[34] are overwindows in the chamber (a sixth window is decorated by a Flemish Teniers tapestry), while the sixth is an overdoor (181 by 200 cm) and hangs above the entrance. The naturalistic and totally secular vision of Brazil represented by the ten large tapestries is in striking contrast to the kind of decorations that the grand masters of the Order of Malta had ordered for centuries for their palace, which centered on the celebration of the mission, the victories, and the leaders of the order. The tapestries may have been interpreted in that context as an allusion to the universality of the mission of the order—to defend and enlarge Christendom—and it was perhaps also important that Johan Maurits of Nassau-Siegen, who originally ordered the cartoons of the tapestries, was himself a knight of the Order of Malta. But the set was probably chosen for a political or diplomatic reason: it was French and was copied by cartoons owned by King Louis XIV. At a time of contention between France and Spain, it would have balanced the "Spanish" preference demonstrated by the provenance of the tapestries for the cathedral, woven in Brussels.[35] In addition, as has been noted, it was not as expensive as a specially designed set would have been.

In view of its destination—the Council Chamber of the Grand Masters' Palace in Valletta—the "fourth" edition of the *Old Indies* was not only completed with the six minor pieces and personalized with coats of arms, but a specific extension of the program was planned. Two cartoons were divided and refashioned to create the models for four tapestries: the *Elephant* was divided to form the *Elephant* and the *Isabella Horse*, and the *Indian Hunter* was turned into the *Hunter* and the *Ostriches*. Moreover, scenes were enlarged with the introduction of animals or plants copied from other cartoons of the series or designed anew. There is not space here to give a detailed analysis of these modifications, in

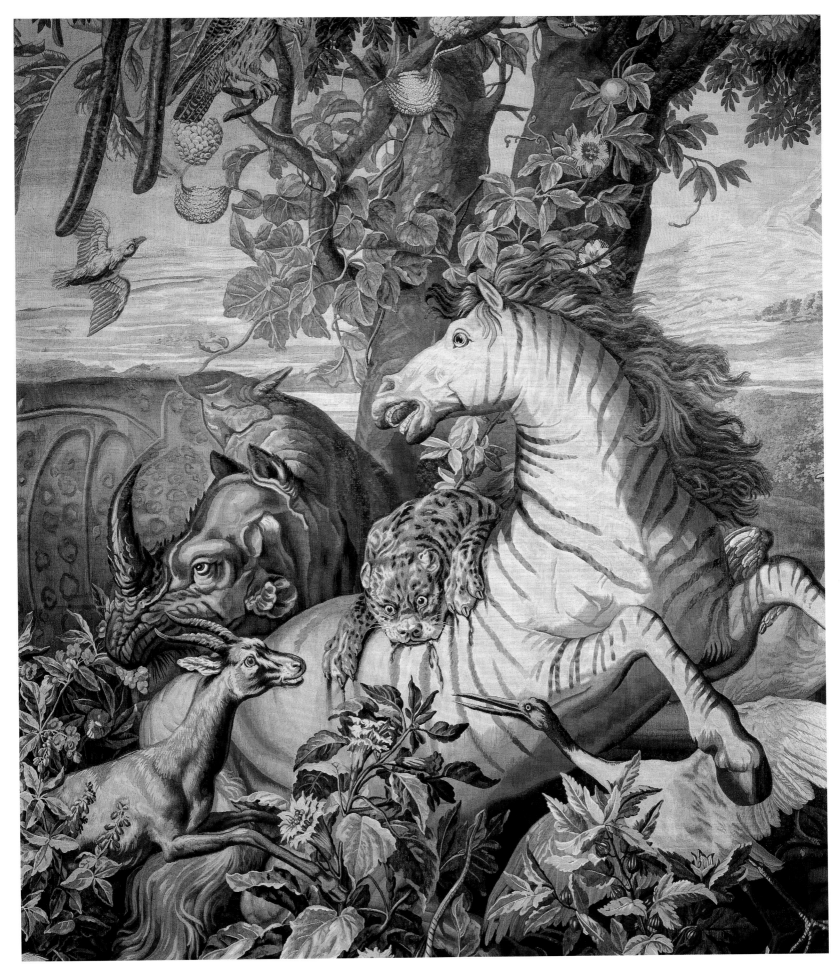

Detail of cat. no. 48

which Desportes probably had a relevant significant (and undocumented) role.[36]

The scene reproduced as the *Striped Horse* at Valletta, like the others of the same set, is the result of the consecutive reworkings of its cartoon since 1644. Its place in the chronology of the *Striped Horse* scene in the various editions of the *Old Indies* must be determined by comparison with the corpus of the painters involved in the making and remaking of the cartoons, and with the other extant tapestries of the same subject. This is difficult, since the *Striped Horse* of the first edition of the *Indies* (private collection, Argentina) is unpublished and the one from the third group is lost. The only earlier comparable example is the one woven (by de La Croix) with the second edition, owned by the Mobilier National.[37]

The composition of the foreground of our tapestry was basically invented by Eckhout, who designed most of the animals and plants. Many correspondences between the elements of the scene and Eckout's sketches and paintings are listed by Peter James Palmer Whitehead and Marinus Boeseman and by Charissa Bremer-David.[38] The *Cassia grandis* trees and the birds in their branches, the sugarcane, the brook and its fish, the small animals, and the two large birds were surely painted by him (or copied from models by him). The rhinoceros, though not drawn from a live specimen but based on a famous etching by Albrecht Dürer dating to 1515, was probably introduced by Eckhout, too. As Bremer-David has demonstrated, the zebra-jaguar group is based on a bronze statue of a horse attacked by a lion. Several models exist, dating between the end of the sixteenth and the beginning of the seventeenth century, by Antonio Susini, a pupil of Giambologna, and his nephew Giovanni Francesco Susini, which in their turn are based on a fragmentary Greco-Roman marble of the same subject that existed in Renaissance Rome.[39] Though a copy of the ancient fragment entered the French royal collection at Versailles in 1685, it is probable that the zebra-jaguar group of the tapestry was designed by Eckhout and not by the French painters who worked on the cartoon in 1687–88. But it was probably Desportes—who retouched the *Striped Horse* cartoon several more times and copied some of its animals for three designs

preserved in the archives of the Manufacture Nationale de Sèvres[40]—who designed the crabs, the tortoise, and the other animals on the right side of the waterfall (this part of the scene was not represented in the narrower *Striped Horse* tapestry of the second set and was probably added to the cartoon in 1692–93),[41] and who also redesigned the hybrid goat-gazelle from the more realistic gazelle (by Eckhout) represented on the tapestry of the second set. Then, some features represented in the *Striped Horse* held by the Mobilier National, designed by Eckhout, do not appear in the version at Valletta: a fox attacking the jabiru in front of the front legs of the zebra, and a small guinea pig near the suricata; some plants of the foreground were also changed.

The *Striped Horse* as made for Valletta was then reproduced in nearly identical form (but reversed) in the later *Small Indies* series woven at the Gobelins except for the integration of a flying bird and a very small frog near the red crayfish: the only extant example of this is the *Striped Horse* of the sixth set, signed by Lefebvre, at the Villa Medici, Rome.[42] Some *Striped Horse* tapestries from the *Old Indies* sets made for private commissions also survive. One exemple without borders is at the Château de Chantilly,[43] where a section of the same subject (the rhinoceros, the gazelle, and one armadillo) is also reproduced on a large weaving that combines the *Elephant* and the *Bulls*.[44] Another *Striped Horse* of the *Small Indies*, without borders, was the property of the dealer Bernheimer (Munich), who sold it to an American collector.[45] Various privately commissioned versions of the *Striped Horse* show the scene enlarged by an Indian hunter at each side, one with a spear and the other with a bow, but the central section is copied from the *Small Indies* cartoon, so all these tapestries must be later than 1722, even though they are framed by a border from the "first design." One example, with the arms of the Camus de Pontcarré de Viarmes de la Guiborgère family, is at the J. Paul Getty Museum in Los Angeles;[46] another, in which the jaguar and the rhinoceros are missing, was auctioned with the collection of Achille Leclerq in 1904 and is now the property of M. Babin at the Château de Saint-Rémy-en-l'Eau near Saint-Julien-en-Chausée;[47] a third,

with all the animals represented, is at the Louvre;[48] a fourth, one of a group of seven *Old Indies* tapestries, is in the Wattenwyl-Haus collection in Bern, Switzerland;[49] and a fifth, showing only one of the two hunters, was the property of Chevalier (Paris) and is now in an American collection.[50]

NELLO FORTI GRAZZINI

1. Whitehead and Boeseman 1989, p. 124.
2. For a complete identification of the fish represented, see ibid.
3. On the prince of Nassau, see Van den Boogaart, Hoetink, and Whitehead 1979; Kleve 1979; Van der Straaten 1998.
4. On Eckhout, see Thomsen 1938; Schaeffer 1965; de Vries 2002; Recife and other cities 2002; Buvelot 2004. On Post, see Larsen 1962; de Sousa-Leão 1973; Basel–Tübingen 1990; Silva 2000; P. Corrêa do Lago and B. Corrêa do Lago 2007. On their work in Brazil, see Joppien 1979; Whitehead and Boeseman 1989.
5. Washington–Cleveland–Paris 1975, pp. 99–111, 142–43.
6. Lemmens 1979, pp. 270–71; Whitehead and Boeseman 1989, pp. 107–9.
7. "Huit grands tableaux … représentant des figures d'hommes et de femmes de grandeur naturelle, plusieurs plantes, fruits, oyseaux, animaux, poisons et paysages de Brésil"; Guiffrey 1885–86, vol. 2, pp. 22–23; de Sousa-Leão 1961.
8. Larsen 1962, pp. 254–55.
9. Whitehead and Boeseman 1989, p. 115.
10. Ibid., pp. 110–11.
11. Ibid., p. 110.
12. Fenaille 1903–23, vol. 2, pp. 371–72.
13. Joppien 1979, p. 355; Whitehead and Boeseman 1989, p. 115.
14. For a general view on the *Old Indies* sets produced, see Fenaille 1903–23, vol. 2, pp. 371–98; Göbel 1928, pp. 145–47; Benisovitch 1943; Jarry 1959; Jarry 1976; Verdier 1980, pp. 46–49; Aix-en-Provence 1984; Whitehead and Boeseman 1989, pp. 109–38; Pallmert 1992; Bremer-David 1994; Bremer-David 1997, pp. 15–18.
15. Fenaille 1903–23, vol. 2, pp. 376–79.
16. Whitehead and Boeseman 1989, p. 120.
17. Fenaille 1903–23, vol. 2, p. 380.
18. Ibid., pp. 380–83.
19. One or the other of two tapestries with *Fishermen*—one in the Rijksmuseum, Amsterdam (Hartkamp-Jonxis and Smit 2004, pp. 348–50, no. 105), the other once owned by Seligman and since 1907 at the Musée Jacquemart-André, Paris (Aix-en-Provence 1984, p. 94, no. 43; J. Boccara 1988, p. 301)—might have been part of the fifth edition.
20. Fenaille 1903–23, vol. 2, p. 387. Desportes is documented by the Comptes des Bâtiments to have received 230 livres, but this surely was just a partial payment for his work.
21. Arizzoli-Clémentel in Aix-en-Provence 1984, p. 16; Arizzoli-Clémentel 1985.
22. Fenaille 1903–23, vol. 2, pp. 387–89. The fourth complementary tapestry was a *Striped Horse*, mistakenly identified by Fenaille with a surviving tapestry of the same subject but of the *New Indies* series.
23. De Sousa-Leão 1947; Whitehead and Boeseman 1989, p. 122.
24. Five of them, in poor or fragmentary condition, are at the Gobelins manufactory. Of the *Striped Horse* an unpublished strip survives (GOB 746), formed by three pieces stitched together and mounted on canvas, measuring 392 x 112 cm. See Fenaille 1903–23, vol. 2, p. 373; Bremer-David 1994, p. 29, n. 35.

25. Forti Grazzini 1994b, vol. 2, pp. 456–79, with bibliographic references.
26. Fenaille 1903–23, vol. 2, p. 383.
27. Jarry 1958.
28. Delmarcel 1983; Delmarcel 1985a; Delmarcel in Antwerp 1997, pp. 136–43.
29. Jarry 1958, p. 309. The figures on the overwindows and the overdoor at Valletta resemble those represented in the *Story of the Emperor of China* series produced at Beauvais, from cartoons (ca. 1680–90) by Guy-Louis Vernansal the Elder, Jean-Baptiste Monnoyer, and Jean-Baptiste Belin de Fontenay. Thus, Vernansal or Belin de Fontenay (Monnoyer died in 1699) might have been the painter who provided the designs for the complementary pieces for Valletta.
30. Jarry 1958, p. 309.
31. Ibid., p. 310.
32. For a plan of the tapestries in the chamber, see Jarry 1958, p. 310, and Ellul 1996, p. 45 (on p. 46, there is a general view of the chamber with the tapestries on the walls).
33. See the reproductions of the tapestries in Ellul 1996, and in Forti Grazzini 1998b.
34. One is reproduced in Jarry 1958, fig. 15.
35. Delmarcel in Antwerp 1997, p. 137.
36. But see Forti Grazzini 1998b.
37. Mobilier National, Paris, GMTT 193/1, 482 x 382 cm; see Bremer-David 1994, fig. 2.
38. Whitehead and Boeseman 1989, pp. 123–24; Bremer-David 1994, p. 28, n. 16.
39. Bremer-David 1994, pp. 24–25, figs. 4, 5.
40. Paris 1982, nos. 89, 91, 96; Aix-en-Provence 1984, nos. 18, 20, 23.
41. A design by Desportes in which some of the crabs and the tortoise of the tapestry are represented is at Sèvres; Paris 1982, no. 101.
42. Aix-en-Provence 1984, pp. 19–20, no. 1, illus. p. 32.
43. Fenaille 1903–23, vol. 2, p. 395.
44. Bremer-David 1997, p. 18.
45. Whitehead and Boeseman 1989, list between pp. 120–21.
46. Bremer-David 1994; Bremer-David 1997, pp. 10–19, no. 2.
47. Sale cat., Hôtel Drouot, Paris, May 30–June 1, 1904, no. 315; Göbel 1928, fig. 121; Whitehead and Boeseman 1989, p. 122; Bremer-David 1997, p. 18.
48. Château de Coppet 1962, pp. 154–55, no. 60.
49. Cetto and Hofer 1964, pp. 24–27; Whitehead and Boeseman 1989, p. 221; Bremer-David 1997, p. 18.
50. Brive-la-Gaillard 1989, fig. 6.

49.
The Triumph of Venus

From an eight-piece set of the *Triumphs of the Gods*
Cartoon by Noël Coypel, 1690–93; the scene copied, with small variants, from a Brussels tapestry by Frans Geubels, ca. 1560–70, from a cartoon of the *Grotesques of Leo X* painted by Giovanni da Udine probably with Giovanni Francesco Penni and Perino del Vaga, 1519
Woven in the workshop of Jean Jans the Younger at the Manufacture Royale des Gobelins, Paris, 1692–1703
Wool, silk, and gilt-metal-wrapped thread
502 x 693 cm (16 ft. 5⅜ in. x 22 ft. 8⅞ in.)
8–9 warps per cm
Deposito Arazzi della Soprintendenza Speciale per Il Polo Museale Fiorentino, Pitti Palace, Florence (Arazzi no. 41)

PROVENANCE: 1703, consigned to the Garde-Meuble de la Couronne, Paris, together with the second set of the *Triumphs of the Gods*; 1789, in Versailles, where the Revolutionary government tried to sell the set (1794–95), then sent it back to the Garde-Meuble in Paris; 1805, transferred to the Gobelins manufactory; November 1810, by order of Napoléon I, *Venus* became part of a new eight-piece ensemble of *Triumphs* comprising pieces from the second and third sets made at the Gobelins, which was sent to Florence to Elisabetta Baciocchi, Napoléon's sister and grand duchess of Tuscany, for decoration of the Palazzo Pitti, her seat;[1] January–February 1811, letters exchanged between the grand duchess and the Garde-Meuble indicating her disappointment with the tapestries, which she judged too expensive (valued at 10,000 francs) and not fine enough, but she was told that, being among the most ancient and precious hangings of the imperial Garde-Meuble, they were not expensive and, moreover, their cost would not have strained the budget of Tuscany;[2] 1884–1922, *Venus* exhibited in the Regia Galleria degli Arazzi e Tessuti Antichi in the Palazzo Crocetta, Florence;[3] from 1922, after the gallery's closing, *Venus* transferred to the Salotto Celeste in the Palazzo Pitti.[4]

REFERENCES: Conti in Florence 1880, p. 20, no. 28; Rigoni 1884, p. 25, no. 51; Marmottan 1901, pp. 134–37; Fenaille 1903–23, vol. 2, pp. 230–32, 244, illus. between pp. 224 and 225; Göbel 1928, p. 137; Viale [Ferrero] in Turin 1952, pp. 109–10; Erkelens 1962a, pp. 123, 135; Worsdale 1977, p. 238, fig. 5; J. Coural 1982, p. 11; Forti Grazzini 1994b, vol. 2, p. 379; Meoni in Florence 2005, pp. 275–77, no. 153; Chiarelli and Giusti 2006, p. 6.

The scene shows a golden ship, its hull enriched by carvings and statues, on which Venus, amid nymphs and Cupids, celebrates her triumph. Halfway between an ancient Roman boat and a modern *bucintoro*, it is an imaginary ship, but its perfectly symmetrical structure (bow and stern are indistinguishable) provides a stage on which Venus is exalted and a grid that allows the figures to be distributed on different levels. The goddess, inside a shrine at the middle of the deck, stands on a great throne at whose base crouches a sea monster; two Cupids offer her doves, sacred to her, as are the dolphins represented on the pendentives of the shrine. Atop the shrine, a round pavilion supports a mermaid, symbolizing the attraction exerted by the goddess of love. The red background against which the mermaid is silhouetted is symbolic of passion, as are the four flying Cupids shooting their love-inducing arrows. On the deck, eight beautiful maidens, in vividly colored garments, tenderly embrace one another, arrange garlands, and burn incense. Sometimes identified as the Muses,[5] they are more likely nymphs attendant on Venus, such as the Graces or the Hours. A long festoon is fixed to the yards, which are wrapped by leafy vines; the Cupids stand side by side on the festoon, playing, dancing, or hanging long garlands of roses (also sacred to Venus), whose wavelike pattern contrasts with the severe linearity of the image. Two swelling sails bring a suggestion of volume to this flat area of the composition. In the foreground, along the side of the ship, a second, more dynamic triumph is celebrated. At its center, Neptune, represented frontally, nude, and silhouetted against his blue mantle, stands on his shell boat, pointing his trident at the water with one hand and holding the reins of his restless sea horses with the other. From each side, three Tritons supporting Nereids on their backs converge on him, blowing into conches or offering shells, corals, and other precious products of the sea. Dolphins are presented by two young swimming Tritons.

The border simulates a carved and gilt wood frame with a dense sequence of acanthus leaves twisted around a blue molding flanked by thin rectilinear moldings. In the center of the upper border are the arms of the French monarch, surmounted by a crown and

surrounded by the collars of the Orders of Saint Michael and of the Holy Spirit; in the center of the lower border, a circular cartouche beneath a crown has the initials LL, for Louis XIV.

Triumphs of the Gods

Venus is one of the eight subjects of the *Triumphs of the Gods* series, of which the Gobelins Manufactory produced seven complete editions from 1686–87 until 1713, all during the reign of Louis XIV and thus ordered by the French Crown.[6] The other seven subjects are the Triumphs of Bacchus, Minerva, Mars, Hercules, Apollo, Faith among the Virtues (sometimes incorrectly called the Triumph of Religion), and Grammar among the Liberal Arts. Although *Venus* is given a maritime setting, the mythological and allegorical figures and episodes of the other subjects, frequently copied from or inspired by ancient statues and reliefs, are enclosed or arranged—with a similar sense of symmetry, harmony, and order—in front of or above slender classical galleries and stages influenced by the architecture represented in the Roman frescoes of the so-called Fourth Style (A.D. 1st century). From the same sources—more precisely, the frescoes of Nero's Domus Aurea discovered in Rome at the end of the fifteenth century, which were studied with great interest by Renaissance artists[7]—derive the grotesque decorations that, though not evident in the *Triumph of Venus*, enrich the series, especially in the upper empty fields of the tapestries, above the architecture.

As documented in the Comptes des Bâtiments du Roi, the cartoons were painted between 1684 and 1693 for Louis XIV by the French painter Noël Coypel (1628–1707), who was paid 24,000 livres in all, receiving the final payment in 1695.[8] By 1690 six cartoons were ready, but *Venus* was not among them: that cartoon, the last one executed, was consigned to the Gobelins manufactory on April 6, 1693, when some tapestries of the editio princeps of the *Triumphs* were already being woven. The same cartoons were used for all the sets produced, completed with identical borders, whether on high-warp looms (the first set, 1687–1701; the second, 1690–1703; the fifth, 1702–11; the sixth, 1702–12; the seventh, 1705–13; and aug-

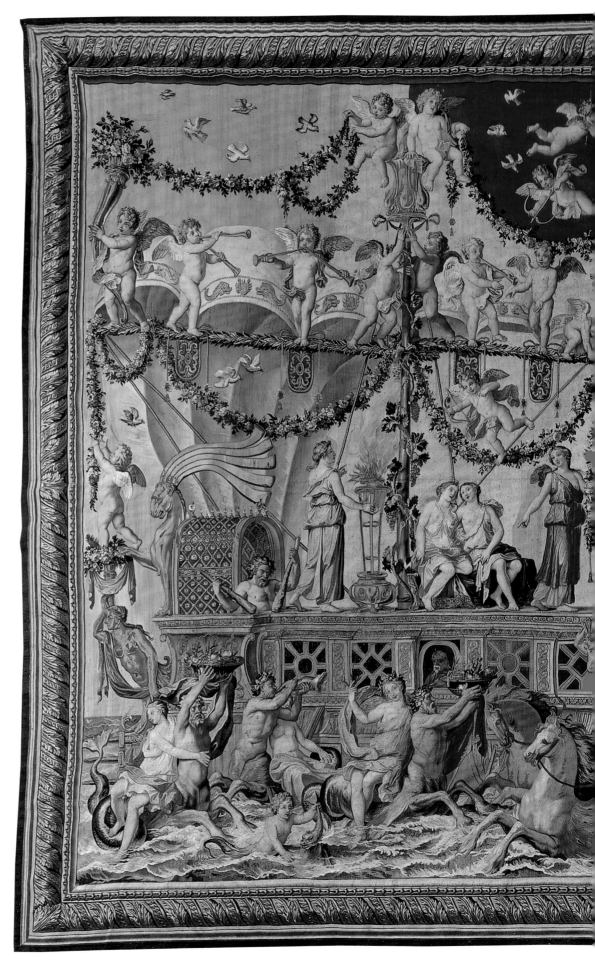

49

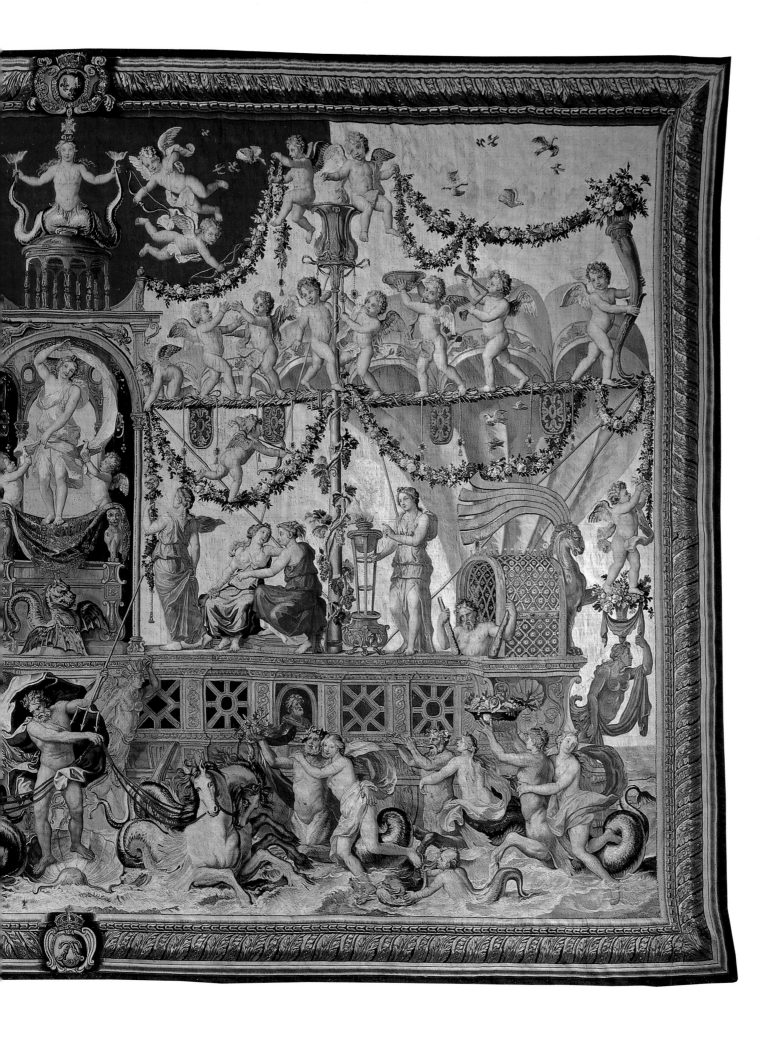

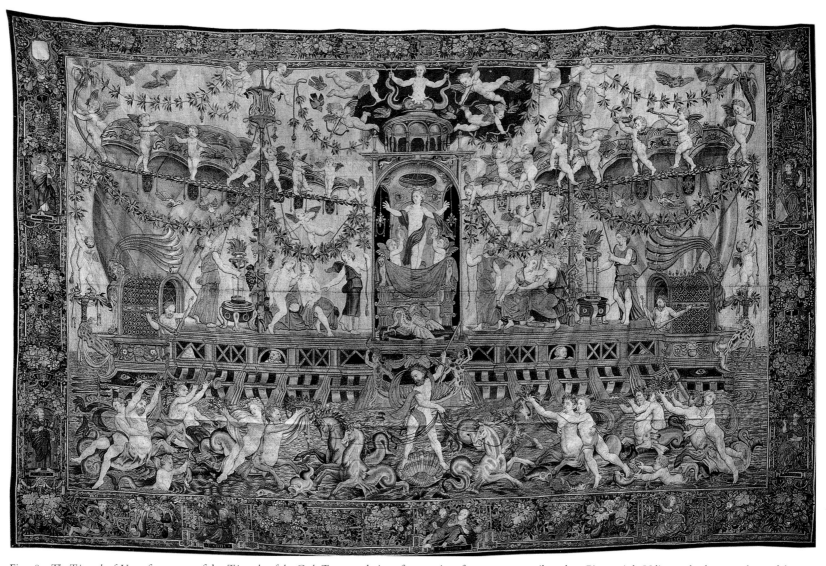

Fig. 181. *The Triumph of Venus* from a set of the *Triumphs of the Gods*. Tapestry design after a series of ca. 1517–20 attributed to Giovanni da Udine and other members of the Raphael Workshop, woven by Frans Geubels, Brussels, ca. 1560. Wool and silk, 501 x 739 cm. Mobilier National, Paris (GMTT 1/2)

mented by complementary panels, 1723–25), or on low-warp looms, with the images reversed (the third set, 1701–6; and the fourth, 1702–11). For work on the low-warp looms, the cartoons were cut into strips, a procedure that explains the condition of the fragments that survive at the Louvre: parts of four strips of *Minerva*, four of *Mars*, five of *Bacchus*, and three parts of a strip of *Apollo*.[9] Modelli of *Mars* and of *Grammar*, designed by Coypel as the basis for the cartoons, are also preserved at the Louvre,[10] while copies of the modelli of *Bacchus* and of *Mars* (ca. 1702–3) by Claude Audran III are in the Nationalmuseum, Stockholm.[11]

It is sufficient to note here that, while the editio princeps of the *Triumphs* was still being woven in the workshops of Jans the Younger and Jean Lefebvre, the second set, of which

our *Venus* is a part, was begun in 1690 in the same ateliers (Lefebvre executed only *Faith*). The work was interrupted while the Gobelins was closed during 1694–99 but was resumed when the manufactory reopened and was completed in 1703.[12] It remains unclear how, as the documents published by Maurice Fenaille state, the work on the *Venus* tapestry could have begun in 1692 (and in 1690, on the corresponding piece of the editio princeps) if the weavers did not receive the cartoon until 1693. In any event, *Venus*, completed in July 1703, was the last piece of the second set to be made, while five different low-warp workshops of the Gobelins were already working on the third and fourth sets of the *Triumphs*.[13] *Venus* was transferred to Florence in 1810, as part of a composite set of the *Triumphs*, made up of five tapestries of the

second set (*Venus, Bacchus, Apollo, Mars*, and *Grammar*, all by Jans the Younger) and three of the third (*Minerva* by Dominique de La Croix the Elder, *Hercules* by Jean Souet, and *Faith* by Jean de La Fraye).[14] All these tapestries survive and are the property of the Gallerie Fiorentine, six in storage at the Palazzo Pitti, and two (*Apollo* and *Hercules*) on loan to the Palazzo del Quirinale in Rome, the seat of the president of the Italian Republic.[15]

Sources of the Designs
The scenes of the *Triumphs* were not conceived anew by Coypel. Seven of the eight cartoons were copied, with minor changes (except for the newly designed borders), from a seven-piece set of the *Triumphs of the Gods* made in Brussels by Frans Geubels about 1560–70 that was in the French royal collec-

tion. Three pieces (*Venus*, *Apollo*, and *Faith*, called *Triomphes de l'amour*) were in the Garde-Meuble in 1663, and in 1673 they were joined by the other four (*Bacchus*, *Minerva*, *Mars*, and *Hercules*, called the *Divertissements des dieux*), bought by Louis XIV from the heirs of the late Johannes Casimirus Vasa, king of Poland; their designs were attributed to Giulio Romano.[16] A comparison of the *Triumphs* woven at the Gobelins with the three surviving pieces of Geubels's set (*Venus*, *Minerva*, and *Bacchus*) in the Mobilier National,[17] and other Brussels sixteenth-century tapestries copied from the same cartoons used by Geubels shows how closely Coypel adhered to his Renaissance models.[18] Comparing the *Venus* tapestry by Geubels with the corresponding Gobelins piece demonstrates that, except for the differing borders and the colors, which are more brilliant in the Gobelins weaving, the figural elements are nearly identical. Some variants introduced by Coypel go almost unnoticed— for example, the triumph of Neptune is raised a bit, and some female nudes are covered by garments. His only notable revisions were to the figures of Neptune and Venus. He

redesigned Neptune to make him seem more vigorous, and he changed the gesture of the goddess. In the Renaissance version, Venus's open arms expressed her benevolent power to pacify storms (see below), whereas in the version by Coypel she holds the ends of her mantle that swells out behind her like a sail, so she looks like a personification of Fortuna.[19]

While the sets made at the Gobelins were from the beginning called the *Triumphs of the Gods*, their cartoons were mentioned in the payment accounts as "Rabesques" or "*Arabesques . . . d'après Raphaël.*"[20] This reveals that Louis XIV and his advisers were very much aware, just as Coypel was, that, through the intermediary of Geubels's set, the series was a remaking of a famous woven prototype conceived in Rome during the High Renaissance by Raphael's circle, now lost but still in existence in the late seventeenth century: the *Grotesques of Leo X* in the Vatican Collection, in inventories of which it is mentioned from 1544 until 1767.[21] Its first description in 1544, as an eight-piece set of grotesques, of various colors, woven with gold and silk threads ("Pannetti otto d'oro et seta, grotteschi di diversi colori, in tutto ale 630¾"), lists the

subjects—the same reproduced by Coypel— opening with "the ship and the triumph of Venus" ("la nave et trionfo di Venere").[22] An inventory of 1608 stated that the tapestries had been made for Pope Leo X (Giovanni de' Medici; r. 1513–21).[23] No documentation survives on the execution of the cartoons and weavings of the Vatican set, but Giorgio Vasari, in his *Vite* (1550 and 1568), mentions the *Grotesques* hanging in the Vatican Palace, "in the first rooms of the Consistory," as copied from cartoons by Giovanni da Udine, the specialist of grotesques in Raphael's studio.[24] In fact, the gracious, miniature figures and classical decoration seen in the Flemish and French reweavings may be easily connected to the frescoes and stucco reliefs that Giovanni executed in the Stufetta (1516) and the Loggetta (1517) of Cardinal Bibbiena, in the Vatican Logge (1517–19), and on the vault of the Sala dei Pontefici (with Perino del Vaga, 1518–20) under the direction of Raphael and, after Raphael's death, in the Loggia of the Villa Madama (with Giulio Romano, from 1520). In the best recent discussion on the *Grotesques*, Thomas Campbell suggests that their cartoons were painted by Giovanni in Rome, with the

Fig. 182. *Bas-Relief with Three Cupids*, by Marco Dente da Ravenna, 1519. Engraving, 16.8 x 34.2 cm. The Metropolitan Museum of Art, New York, Harris Brisbane Dick Fund, 1941 (41.72[2.147])

aid of two collaborators of Raphael, Giovanni Francesco Penni and Perino del Vaga, probably about 1517–18, and certainly between 1515 and 1516, when Raphael completed the cartoon for the *Acts of the Apostles* (the first set of tapestries ordered by Leo X), and 1520, when Tommaso Vincidor left for Brussels. There, on the basis of designs he took with him from Rome, he painted the cartoons of the third set ordered by the pope, the *Giochi di putti*. Campbell suggests also that the *Grotesques* were planned for the walls of the Sala dei Pontefici and that, as was the case with the *Acts* and the *Putti*, they also were woven in Brussels, maybe in 1519–21, in the workshop of Pieter van Aelst.[25] Remaining in Brussels, the cartoons were later used for the Flemish reweavings already mentioned.

Iconography

As a work of the age of Louis XIV and a deliberate revival of the gracious, delicate repertoire of ancient and Renaissance grotesques, Coypel's *Triumphs* may be seen as foreshadowing the incipient Rococo style, which in fact was an invention of the late reign of the Sun King. But, taking into account the importance of the *Grotesques of Leo X* and the relatively little attention scholars have given them, it seems more valuable here to use the *Venus* Gobelins tapestry as an occasion to learn something about its lost Vatican prototype. The Gobelins piece and its Geubels model in the Mobilier National (an exact replica of Giovanni da Udine's lost cartoon; fig. 181) offer a precise chronological reference, heretofore unrecognized, for the work of Giovanni. The throne—reproduced unchanged by Coypel—on which Venus stands, with a cloth slung between the two arms carved as lions, their bases decorated by scrolls, and with a live sea monster at its base, reproduces a relief from the first century B.C., called the *Throne of Neptune* (San Vitale, Ravenna), known since the fifteenth century but published in an engraving dated 1519 by Marco Dente (fig. 182), from which Giovanni evidently copied this detail.[26] Giovanni might have seen a sketch for the etching before 1519, as Dente lived in Rome and was in close contact with Raphael and his assistants, but 1519 remains the best anchor for dating the "original" *Venus* cartoon. Other recognizable

quotations from ancient and contemporary sources do not offer any significant chronological references.[27]

This confirms the dating Campbell proposed for the *Grotesques*, and though no new element confirms this scholar's further hypothesis, that their destination was the Sala dei Pontefici, this proposal, too, is tempting. On the vault of that hall, intended for consistory meetings but also for feasts of the papal court, Giovanni and Perino depicted for Leo X, in fresco and in stucco, in the manner of the paintings of the Domus Aurea, an intellectualized astrological and heraldic program celebrating the propitious native horoscope of the pope and the Golden Age reopened by him for the Church.[28] This secular, learned, and classicizing homage would have been amplified by the *Grotesques* on the walls underneath, for the tapestries showed not mythological fantasies but a symbolic glorification of their patron in mythological guise. A study of the propagandistic messages hidden in the *Grotesques* (deciphered in the reweavings) is still to be written. Until now, only *Hercules* has been interpreted in this light,[29] but the analysis could be extended to other subjects. *Venus* would seem too pagan, too voluptuous an image for celebrating a pope were he not the son of Lorenzo the Magnificent and the head of the Church at the climax of the High Renaissance, when the pagan gods descended again to earth and were frequently represented in Rome and in papal circles.[30] That scene, too, will reveal a rousing homage to Leo X, if its iconography, as reproduced in the replicas, is explained with the answers to two main questions: Why is Venus placed on a ship? And why is her triumph associated with that of Neptune?

Some ancient literary sources report that Neptune and Venus were lovers and in some places that their cults were associated.[31] Their joint appearance in the *Grotesques of Leo X* is first explained by the maritime context, which is suitable for both. It goes without saying that Neptune was a sea god, but Venus was, too. Hesiod and other ancient writers, just as Angelo Poliziano and Sandro Botticelli did in Renaissance Florence (where Giovanni de' Medici/Leo X was born and educated), placed the birth of Venus in the sea, whence she floated to terra firma on a seashell.[32]

Apuleius described a later journey of Venus by sea, escorted by Tritons and Nereids.[33] Moreover, she was a protectress of navigation,[34] and in Roman Tunisia, a ship—called the Navigium Veneris—was dedicated to her during the feasts of March 5, which opened the season of taking to the sea (elsewhere this role was assigned to Isis or other goddesses).[35] A mosaic of the second–third century A.D. from Utica (Bardo Museum, Tunis) shows Venus at sea, aboard a small boat, in the context of a maritime triumph of Neptune and Amphitrite.[36] This mosaic was surely unknown to Giovanni da Udine, though he and his advisers might well have known that in antiquity the goddess of love was considered a protective and peace-making sea deity.[37] But Neptune, too, had the power of placating storms and waves. His most renowned intervention of this kind was the one in favor of Aeneas and his fleet described by Virgil.[38] It is this scene, the so-called *Quos Ego*, that was designed by Leonardo and Raphael,[39] and illustrated by Marcantonio Raimondi in a well-known etching after a design by Raphael (ca. 1515–16).[40] The same episode and literary reference, plus the illustrations mentioned above, are implicit in the representations of the god in *Venus*.

Now we begin to understand why Venus and Neptune are shown celebrating parallel triumphs on a tapestry made for Leo X. Succeeding Julius II and his bellicose and tumultuous pontificate, Leo X adopted pacification as the core of his political and papal mission and as the theme conveyed by his artistic commissions (this was the "message" entrusted to the *Meeting of Leo I and Attila* or the *Fire of the Borgo* frescoed by Raphael in the second and third Vatican Stanze). A storm at sea was then, as today, a common metaphor of troubles and dangers. Venus and Neptune as pacifiers of storms were surely intended in the *Grotesques* as doubles of Leo X, peacemaker of the Church. This identification was eventually reinforced by the fact that it was these gods who, in the first book of the *Aeneid*, help Aeneas to escape the storm at sea, and it was this very hero, escaping from burning Troy carrying old Anchises on his back, whom Raphael represented in the *Fire of the Borgo* (where Anchises appears as a portrait of Cosimo il Vecchio

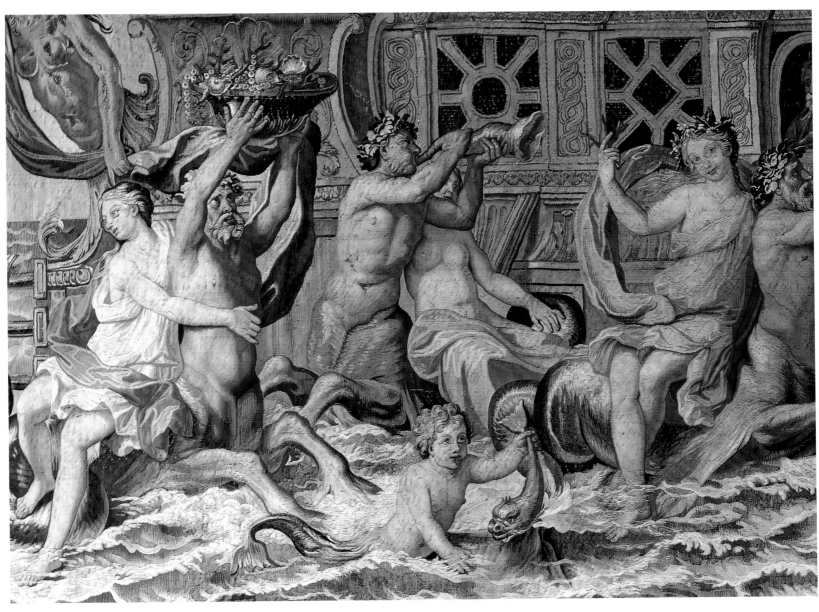

Detail of cat. no. 49

de' Medici, Leo X's great-grandfather) as a metaphor of the Medici pope, bringing the memories, honor, and power of his family, banished from Florence, to safety in Rome.

But there is more to consider. Though Venus was, for the Greeks and Romans, a tutelary goddess of sailing, the ancient image of her at sea shows her alone and on a small boat. There is no classical, medieval, or early Renaissance literary or visual reference describing her triumph aboard a large ship with her suite of nymphs and Cupids. This is nothing like the "floating chariot" drawn by swans transporting Venus in triumph (with Mars genuflecting before her) on the upper section of the fresco of *March* by Francesco del Cossa (1470) in the Salone dei Mesi of the Palazzo Schifanoia in Ferrara. The great ship of Venus was introduced for the first time by Giovanni da Udine in the *Grotesques*, and it should be understood as a very specific allusion requested of him by (or devised by him for) the pope, though the motif is not without an ancient literary source. Plutarch, in his life of Mark Antony in *Parallel Lives*, described the first meeting of Antony and Cleopatra along the river Cydnus. The queen arrived by the river "in a barge with gilded stern and outspread sails of purple, while oars of silver beat time to the music.... She herself lay all along under a canopy of cloth of gold, dressed as Venus in a picture, and beautiful young boys, like painted Cupids, stood on each side to fan her. Her maids were dressed like sea nymphs and graces, some steering at the rudder, some working at the ropes. The perfumes diffused themselves from the vessel to the shore."[41] With few differences, the ship of Cleopatra/Venus has become the ship of Venus in the *Grotesques*, the mermaid at the top of the shrine—an allegory of the attraction exerted by the goddess below—inspired by the same passage, which refers to the popular enthusiasm evoked by the ship of Cleopatra.[42]

Equally, even though Plutarch served as a textual reference for Giovanni da Udine, some details of the ship in the *Grotesques* were not taken from there, nor do they have any correlation with Venus: the yards enveloped by leafy vines, and the statues of lions at the two ends of the deck (as on the arms of the throne).

403

Vines and grapes carry a strong Christian (Eucharistic) connotation, while the lions, on a tapestry ordered by Leo X, were an obvious allusion to the name of the patron, indicating that the vessel was his. It was not a new, showy attribute of a generic Venus, but of the "leonine" Venus; it was a Christian, leonine ship, bearing a specific allusion inside the figurative celebration of the pope. For centuries, a boat had been a symbol of the Church, a symbol rooted in the Gospels. By the fact that Peter, a fisherman, was chosen by Christ as an apostle, he became a "fisher of souls." Then, as the head of the Christian community, as the first pope, his fishing boat was intended as a metaphor for the Church and its unity. Each successive pope was the helmsman (*gubernator*) of that boat. This allegory was naturally used during Leo X's papacy on many occasions, and John Shearman makes reference to it, with specific quotations, to explain the subject of the *Miraculous Draft of Fishes*, one of Raphael's *Acts of the Apostles* made for Leo X.[43] A passage Shearman quoted, from a letter sent to Leo by Pietro Delfin on March 13, 1513, immediately after Leo's election, is particularly revealing: "now God has put you at the helm of his vessel. All hope that with the helmsman's skill and care, and with favorable winds blowing,

after so many tempests and gales, it will be guided to the safest port."[44] Leo was saluted as the helmsman who, after many storms (provoked by Julius II) would lead the Church/boat to a safe harbor. A few years later, this desire seemed to have been fulfilled: the Church was pacified by the Lateran Council (1512–17) and had forged a close political alliance with France, the Church's worst enemy under Julius. Though with hindsight we know that the papacy was on the brink of the most momentous crisis of its history, the Protestant Reformation, in 1519 Giovanni da Udine might represent the safe boat of the Church guided by Leo X, in the guise of the ship of Venus, with nymphs and Cupids aboard, sailing on quiet waters, escorted by Neptune. The goddess was introduced not only as tutelary goddess of sailing, but also as goddess of love. This was explained by Florentine and Roman Neoplatonic philosophers and theologians, who maintained that there are different kinds of love, represented by different Venuses. The leonine Venus was surely the inspirer of a superior love, who turned the mind to the divine mysteries, such as the love of God, which is Charity, which the Cupids and the nymphs on board also represented and dispensed.[45] Venus/Leo's vessel—the hope embodied in the *Grotesques*—

would have attracted not only the multitudes but also the viewers of the tapestries, just as the inhabitants of Cilicia were enchanted by the ship of Cleopatra.

If the interpretation proposed here is correct, the *Grotesques of Leo X*, of which the Gobelins *Triumphs of the Gods* offer a matchless visual correlative, were one of the most conspicuous instances of pagan mythology being used in the Renaissance for expressing not just a Christian content but a program of papal propaganda, though their secular appearance and decorative content later made them suitable for non-papal patrons such as Henry VIII and Louis XIV. Some symbolic personages of the *Triumph of Venus* reappeared elsewhere on tapestries. The winged Cupids, geniuses of Charity and/or representatives of the renewal brought by Leo X, became the protagonists of the next set of tapestries ordered by the same pope, the *Giochi di putti*.[46] Venus at the helm of a boat full of fishing Cupids, under an arbor, functioned as an allegory of the good government of Mantua but also of the Church, in the *Barque of Venus* tapestry (Gulbenkian Museum, Lisbon), part of the *Puttini* set designed by Giulio Romano, woven by Nicolas Karcher for Cardinal Ercole Gonzaga about 1540–45.[47]

NELLO FORTI GRAZZINI

1. Fenaille 1903–23, vol. 2, pp. 230–31.
2. Marmottan 1901, pp. 134–37.
3. Rigoni 1884, p. 25, no. 51.
4. A photograph of the Salotto with *Venus* on a wall, ca. 1922–30, is in Chiarelli and Giusti 2006, p. 6.
5. W. Smith, Wayte, and Marindin 1890–91, vol. 2, p. 893; Meoni in Florence 2005, p. 275.
6. For a complete report of the sets produced and the extant tapestries, see Fenaille 1903–23, vol. 2, pp. 228–45; Forti Grazzini 1994b, vol. 2, pp. 379–80.
7. Dacos 1969.
8. Fenaille 1903–23, vol. 2, pp. 223–25. A follower of Poussin, Coypel made paintings for the King's Apartment at the Tuileries (1667–68), then for Versailles. He was the director of the Académie de France in Rome (1672–74), and the rector (from 1690), then director (1695–99) of the Académie Royale de Peinture et de Sculpture at Paris. His work has not been widely studied; for a first approach, see C. Klingsöhr-le Roy, "Coypel—Noël Coypel," in Grove 1996, vol. 8, pp. 88–89, where the artist's cartoons for tapestries are not mentioned.
9. Musée du Louvre, Paris, inv. 3482, 3484, 3485, 3489; Rosenberg, Reynaud, and Compin 1974, vol. 1, nos. 191,

192, illus.; Compin and Roquebert 1986, vol. 3, p. 174, illus.
10. Cabinet des Dessins, Louvre, inv. R.R. 1180, 1181 (entered 1881, from the Gatteaux Collection). Jean Guiffrey and Marcel 1909, p. 63, nos. 3132, 3133; Paris 1960, p. 116, nos. 601, 602; Costa 1981, pp. 44–45.
11. Paris 1950, no. 128 (*Mars*); London 1968, p. 44, no. 8, fig. 29 (*Mars*); Jarry 1969, p. 111, figs. 1, 2.
12. Fenaille 1903–23, vol. 2, pp. 230–33; Forti Grazzini 1994b, vol. 2, p. 379.
13. Other extant *Venus* tapestries made at the Gobelins from the same cartoon are a piece by Jans the Younger, first set, Mobilier National (Plourin 1955, fig. 178); one by de La Croix the Elder, third set, Mobilier National; one by de La Fraye, fourth set, Académie de France, Villa Medici, Rome; one by Lefebvre, fifth set, Mobilier National. Fragments of *Venus* from the sixth set, by Jans the Younger, were in Lelong collection, Paris, and one was sold at Galerie Jean Charpentier, Paris, June 25, 1937, no. 107; *Venus* from the seventh set, by Jans the Younger, its borders cut, sold at Christie's, London, April 8, 1976, no. 108, was later property of Franses, London (Franses 1986, pp. 27–30, no. 6), and is now in the Württembergisches Landesmuseum, Stuttgart.

14. Marmottan 1901, pp. 134–37; Fenaille 1903–23, vol. 2, p. 231; Göbel 1928, p. 137; Viale [Ferrero] in Turin 1952, p. 110; Worsdale 1977, p. 238; Forti Grazzini 1994b, vol. 2, p. 379; Meoni in Florence 2005, p. 276.
15. Forti Grazzini 1994b, vol. 2, pp. 380–87, nos. 140, 141.
16. The derivation of Coypel's cartoons from Geubels's *Triumphs* was first noted by Guichard and Darcel 1881, vol. 1, n.p.; see also Fenaille 1903–23, vol. 2, pp. 221–23; Erkelens 1962a, pp. 121ff.; Szmydki 1987, pp. 128, 130; Forti Grazzini 1994b, vol. 2, p. 378; T. Campbell in New York 2002, pp. 225–28. Though *Grammar* was not included in Geubels's set, Coypel copied this subject from another Renaissance model, probably by way of a drawing of the corresponding tapestry in the *Grotesques of Leo X* in the Vatican that was sent to him from Rome (see below).
17. Paris 1965, pp. 38–39, nos. 28–30.
18. Examples are the *Bacchus* and *Hercules* in the Royal Collection at Hampton Court, with marks of the Dermoyen (?) workshop, from a seven-piece set called the *Antiques*, bought in 1542 by Henry VIII of England; see Laking 1905, nos. 91, 92, fig. 24; Erkelens 1962a; T. Campbell 1996b, pp. 75–78; T. Campbell in New York 2002, pp. 225–26 fig. 88, 246–52 no. 26. And *Venus*,

Minerva, and *Bellona* (instead of *Mars*), which are the property of the Département de la Vendée (France), of the late 16th century; Saint-Sulpice-le-Verdon 2000, pp. 102–11; Bertrand 2005, pp. 151–52, n. 56.

19. According to Meoni (in Florence 2005, p. 277), Venus's new pose was influenced by the *Triumph of Neptune and Amphitrite* by Nicolas Poussin, ca. 1635, in the Philadelphia Museum of Art (fig. 195). An etching of that painting was made by Jean Pesne in 1686; see Paris–London 1994, no. 54.

20. Fenaille 1903–23, vol. 2, p. 223.

21. Erkelens (1962a) was the first scholar who linked the Gobelins *Triumphs* with the *Grotesques of Leo X* (whose cartoons she wrongly attributed to Amico Aspertini); on the *Grotesques*, see Müntz 1878–85, pp. 28ff.; Müntz 1897, p. 52; T. Campbell in New York 2002, pp. 225–29, 246–51.

22. Müntz 1878–85, p. 28.

23. T. Campbell in New York 2002, p. 225.

24. Vasari 1568/1912–14, vol. 8, p. 78. On Giovanni da Udine, see Dacos et al. 1987, though the *Grotesques of Leo X* are not mentioned.

25. T. Campbell in New York 2002, pp. 225–29.

26. For the relief and the etching, see Bober and Rubinstein 1987, p. 90, no. 52 A, pls. 52 A, 52 A-b; Mantua–Vienna 1999, p. 202–3, no. 136.

27. The flying Cupids shooting arrows in the upper part of *Venus* are partially copied from those in the *Galatea* fresco by Raphael in the Villa Farnesina, about 1512, and some of the ancient and modern figurative sources examined by Raphael for the poses and gestures of the Tritons and Nereids in that fresco (see Becatti 1968; Thoenes 1986) were considered by Giovanni for his image of the Triumph of Neptune in the cartoon. Giovanni's primary model was the relief from the *Marriage of Neptune and Amphitrite* sarcophagus (Cortile della Pigna, Vatican; Bober and Rubinstein 1987, fig. 99), showing a frontal view of the god driving his sea horses among the swimming Tritons with Nereids on their backs. The same relief had also inspired designs of *Neptune of the Quos Ego* by Leonardo (Windsor Castle; Bober and Rubinstein 1987, fig. 99a) and by Raphael (a copy is at the Accademia Carrara, Bergamo; Nees

1978, fig. 9), which were further sources for the cartoonist. From designs by Raphael, Giovanni also derived the poses of the embracing Nymphs on the right deck of *Venus*; see the *Marriage of Alexander and Rossana* (Albertina, Vienna, inv. 17634; Mantua–Vienna 1999, pp. 140–41, no. 81) preparatory for a fresco executed by Sodoma at the Villa Farnesina, and *Venus and Cupid* (Windsor Castle, inv. 12757; London–Toronto–Los Angeles 1999, pp. 118–20, no. 30), preparatory for a fresco by Giulio Romano in the Stufetta of Cardinal Bibbiena.

28. Cox-Rearick 1984, pp. 178–98.

29. Forti Grazzini 1994b, vol. 2, p. 387; T. Campbell in New York 2002, pp. 246–51.

30. For a general survey on the figure of Venus in Renaissance art, see Bull 2005, pp. 182–222, where it is remembered (p. 219, taking up the datum from Cruciani 1983, p. 397) that a statue of the goddess, with the inscription "Mars was, Minerva is, and I, Venus, always will be" was exhibited in Rome, in 1513, in occasion of the *possesso* of Leo X. If the inscription alluded to the beginning of an age of peace, love, and charity under the new pope, the figure of Venus was used in the early 16th century to convey a relevant part of the "message" that is going to be deciphered in the tapestry.

31. Meoni in Florence 2005, p. 275, with a reference to Daremberg and Saglio 1877–1919, vol. 1 (1919), p. 274.

32. Hesiod, *Teogony*, 188–200; Poliziano, *Stanze per la giostra*, bk. 1, stanzas 99–101. The painting by Botticelli is, naturally, the *Birth of Venus* at the Uffizi.

33. Apuleius, *Golden Ass* 4.31.

34. Ovid, *Fasti* 4.129–32: "Et formosa Venus formoso tempore . . . / Vere monet curvas materna per aequora puppes / ire nec hibernas iam timuisse minas" (the beautiful Venus in the good season . . . incites the rounded ships to go on the sea in which she was born, without fears of the threats of Winter).

35. Apuleius, *Golden Ass* 11.55.

36. Alexander and Ennaifer 1973, vol. 1, fasc. 2, pp. 51–58, no. 205, figs. XXXIV, XXXVI, L, LI.

37. Confirmation is given by a passage by the humanist Mario Equicola, who, in an apostrophe to Venus in his

Libro de natura de amore (published in 1525, but written in Mantua in 1509–11), praised her in this way (Equicola 1999, pp. 416–17): "Ad te supplico, et tua protectione chiedo, che gubernatrice te monstri se la mia nave in periculi di naufragio se ritroverà" (I implore you and I ask your protection, that you will show yourself to be my guide if my ship should ever find itself in danger of shipwreck).

38. *Aeneid* 1.135ff.

39. See note 24.

40. Nees 1978; Lawrence–Chapel Hill–Wellesley 1981, pp. 120–21, no. 32; Mantua–Vienna 1999, pp. 114–15, no. 53.

41. Plutarch, *The Lives of the Noble Grecians and Romans*, trans. John Dryden and rev. Arthur Hugh Clough (New York: Modern Library, 1932), pp. 1118–19.

42. According to Plutarch (ibid., p. 1119): "the shore . . . was covered with multitudes, part following the galley up the river on either bank, part running out of the city to see the sight. The market-place was quite emptied, and Antony at last was left alone sitting upon the tribunal; while the word went through all the multitude, that Venus was come to feast with Bacchus, for the common good of Asia."

43. Shearman 1972, pp. 63–65.

44. "[N]unc ad clavum naviculae suae posuit te Dominus: sperant omnes non defuturum per gubernatoris sapientiam & studium, quin felici stante desuper aura, post multas tempestates et procellas in portum tutissimum deducatur"; ibid., p. 64, n. 112.

45. The Erotes in the *Playing Putti* tapestries made for Leo X have also been explained as personifications of Charity, and the special devotion of the pope to this Christian virtue has been linked with the support he gave to the Sodalitas Caritas (the Company of Divine Love) in 1519; Quednau 1979, p. 735, n. 958; T. Campbell in New York 2002, p. 231.

46. T. Campbell in New York 2002, pp. 229–33, 253–56 no. 27.

47. Delmarcel and C. M. Brown 1988, pp. 112–14; Delmarcel in C. M. Brown and Delmarcel 1996, p. 182; Forti Grazzini in New York 2002, pp. 506–13, no. 58.

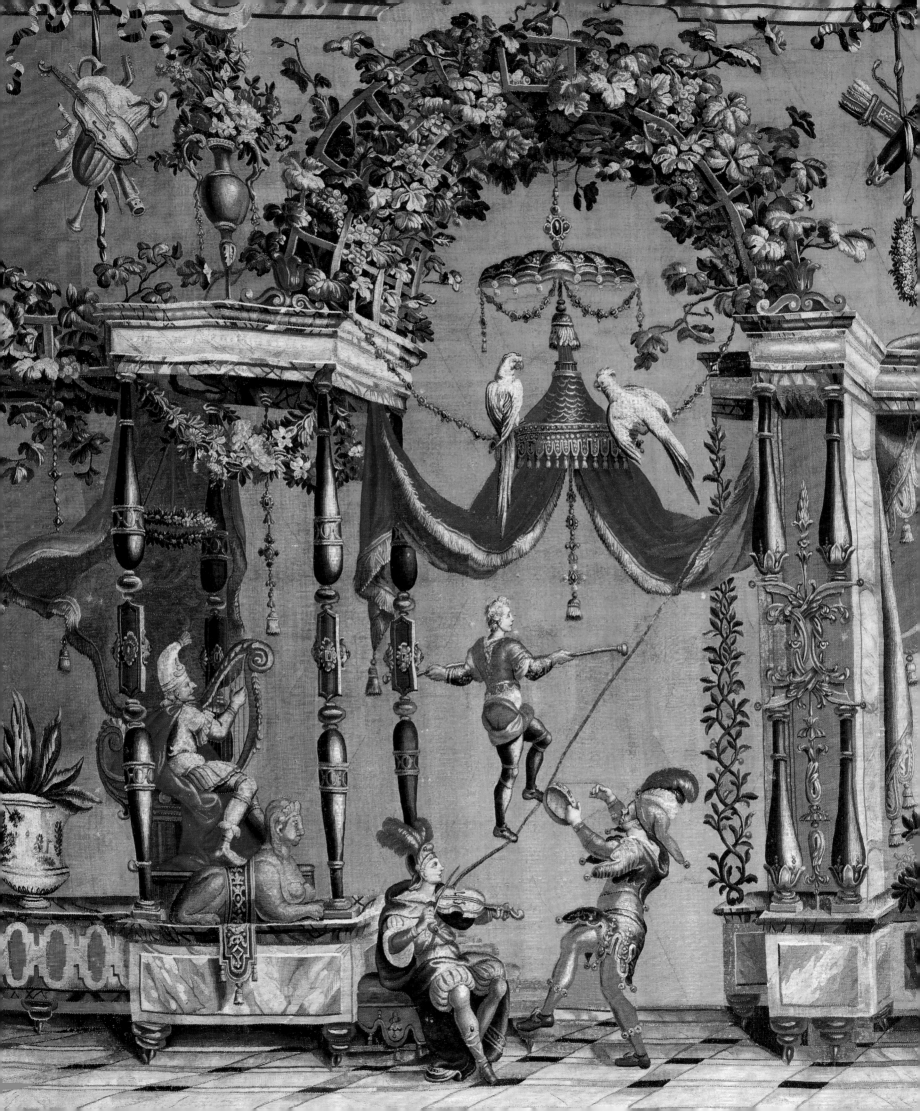

Manufacture Royale de Tapisseries de Beauvais, 1664–1715

CHARISSA BREMER-DAVID

The story of the first sixty years of the French royal tapestry manufactory founded in 1664 at Beauvais, a town forty miles to the north of Paris, is a tale of achievement in the face of adversity. The challenges of starting up the business, recruiting employees, and developing products and a client base were compounded by mismanagement, a disappointingly low volume of sales at reduced prices, and consequently a crippling lack of cash. The manufactory struggled to meet its ambitious objectives to design, weave, and profitably sell fine tapestries to the prosperous private sector in order to the benefit the greater French economy. Fiscal difficulties plagued the enterprise throughout the reign of Louis XIV (r. 1643–1715), even with substantial and repeated subventions by the royal treasury, and the first two directors ended their long careers and lives financially ruined. Yet despite these harsh realities, the Beauvais manufactory did produce during this period hundreds of superb tapestries, woven after a relatively small number of original and appealing designs. Not only enormously popular for decades, these works are now centerpieces of public and private art collections, prized as exemplars of late seventeenth-century fashionable taste. In addition, specialized workshops operating in Paris under the direction of Beauvais administrators filled exceptional private commissions from the highest ranks of society, from within France and beyond, weaving unique tapestries that equaled the finest products of the renowned Gobelins and Brussels looms.

Research into the early history of the Beauvais manufactory draws upon primary documentation that is fragmentary and dispersed.[1] No official production logs or weavers' pay registers survive from before 1723, and the activities of the manufactory during the later reign of Louis XIV are confused with those of the private weaving ateliers that the directors and their successors simultaneously managed in Paris. Furthermore, the original manufactory compound—weaving and dye workshops, offices, storage areas, living quarters, communal brewery, and bakery, all

built to purpose—no longer survives, as the site was destroyed during the bombardment of Beauvais in June 1940.[2] Yet the extant documents, though incomplete, reveal the sharp focus of intelligent planners, men with confidence and vision who founded and funded an enterprise that continues still, and communicate the remarkable intellectual, political, and economic origins of the tapestry manufactory at Beauvais.

Retail Trade in Tapestries

The creation of the Beauvais tapestry manufactory was part of a broad, overreaching economic initiative launched when the youthful Louis XIV first exercised independent authority, following the death of the minister Cardinal Jules Mazarin (1602–1661). Inspired by the protectionist policies of his grandfather Henry IV (r. 1589–1610), who had proclaimed a prohibition against imported verdure—or green landscape—tapestries as early as 1601, and by the mercantile plans of Mazarin's successor, Jean-Baptiste Colbert (1619–1683), the manufactory was one of several measures undertaken to develop new and to support existing industries, especially those involving luxury textile, lace, tapestry, and carpet production.[3] Modeled on the physical plant and organizational structure of the tapestry workshops within the crown's larger establishment recently unified at the Gobelins manufactory in Paris, the Beauvais enterprise was intended to complement the Gobelins, serving the needs of wealthy private customers rather than the king's household. Smaller initiatives in the towns of Aubusson and Felletin were organized in 1665 to produce weavings for the middle- and low-end markets.[4]

The Beauvais manufactory was founded to meet the increasing demands of the northern European market for tapestries, which, being both insulating and decorative, served a growing role in furnishing domestic interiors of households that spanned the social ranks. The center of consumption was the densely populated city of Paris, which supported an active

tapestry import trade and a brisk retail market. With about 450,000 inhabitants in the 1680s, Paris vied with London as the largest city in the world when measured in terms of population, wealth, and purchasing activity. A review of personal property listed in three thousand after-death inventories made by Parisian notaries during the period from 1640 to 1790 indicates that a surprising three out of every four households surveyed contained cloth or tapestry wall coverings in the interior spaces.[5] In many cases, the recorded dimensions of these textiles, which stretched all around the room or hung individually on the walls, provided the only sure indication of the size of these domestic quarters. Woven tapestries were the most highly valued type of wall coverings noted, sometimes designated by their region or city of origin, such as Flemish or Brussels, or by the type of loom on which they were woven, such as high or low warp. While the majority of the tapestries inventoried were described as verdures, often rendered with the addition of small animal and human figures into hunting scenes, there were also narrative stories from the Old Testament, mythology, history, and allegory. The insulation and pleasing summer greenery of the verdures were perhaps particularly appreciated in the record-setting cold winters of the mid-1690s and 1709.

The Parisian fashion for tapestries as interior wall coverings, springing from both practical and aesthetic considerations of comfort and beauty, represented a large sector of the consumer market during the reign of Louis XIV. The urban taste for tapestries reflected, in turn, the rich display of woven hangings at court, hung in the public parade rooms of the royal palaces. Meeting the demand for these decorative textiles and controlling the lucrative market were key concerns in the state's economic policy. Article one in the royal edict of August 5, 1664, that established a tapestry manufactory in the town of Beauvais clearly stated the motivations behind the act, the reasons for its foundation, and its purpose.[6] The location of the new French tapestry workshop was strategically positioned on the trade route to the southern Netherlands (modern-day Belgium), where the art of weaving had flourished for centuries. Intended to compete with the products of rival Flemish workshops, the tapestries made at the Beauvais manufactory were meant to appeal to both French domestic and foreign markets. The endeavor was conceived as a private enterprise that, though subsidized initially by royal grants and loans, eventually would be self-sustaining through the sale of its products to customers from the wealthy ranks of the court, landed gentry, financiers, bourgeoisie, religious orders, and foreign patrons.

The choice of Beauvais as the manufactory's site had decided advantages. Logically, the new enterprise could build upon the town's already distinguished production and trade in wool and linen cloth as well as its ancient but inactive tapestry-weaving tradition. Furthermore, the town authorities were in favor of the plan, which had originally been proposed a few months earlier than the royal edict by one of their own native sons, Louis Hinart (or Hinard, fl. 1639–78, d. 1697), a successful master weaver and tapestry merchant who managed a high-warp workshop employing four hundred weavers in the town of Oudenaarde, then part of the southern Netherlands, and who also stocked a retail shop in Paris, on the rue de Richelieu.[7] The civic leaders of Beauvais saw the enterprise as a potentially significant economic boon to the local community, one that would support the cottage industry of spinners living and working in the surrounding countryside and that would also offer apprenticeships to the town's young males. The town's geographic proximity to the busy Flemish centers of tapestry weaving in Tournai, Oudenaarde, and Brussels would act as a draw when recruiting Flemish master weavers as well as facilitate purchasing equipment from suppliers there. Beauvais was also within a convenient distance to Paris, where the manufactory's products were to be showcased to the buying public. Finally, the river Thérain, which flowed along the southern boundary of the town's walls, supplied the running water necessary for the factory's dye works and for its communal brewery.

Protectionist Policies and Commercial Enterprise
Hinart's oversight of the active workshop in Oudenaarde and the successful sale of its products in a Parisian outlet seem to have earned the attention and confidence of Colbert, who nominated him as the prospective director of the crown's new enterprise at Beauvais. Luring the manager of a lucrative weaving business away from the mighty Flemish network must have appealed to both minister and king, whose dual aims were to hire skilled foreign craftsmen for training indigenous talent while reducing the realm's consumption of imported luxury goods. To ensure the success of the venture, the edict that established the fledgling manufactory provided many important privileges and protections. In addition to the creation of the physical plant, with workshops, offices, and living quarters, attractive provisions were made to hire and retain staff, to engage and train apprentices, and to obtain all necessary equipment, supplies, and designs. Hinart and his workers were exempt from all taxation, from lodging military troops, and from duties on materials transported for factory business within

France. Immigrant workers were guaranteed naturalization after eight years of employment, and apprentices earned acceptance, without the usual fees, at the master level into the town's guild following completion of a six-year training program and two years' employment. The crown paid an additional 30 livres each year to cover the costs of room and board for every apprentice. Significantly, Hinart was awarded not only the right to operate in Beauvais for thirty years but also the monopoly within the larger encompassing region of Picardy to weave the ever popular "verdure and figured tapestries on high and low warp."[8] The manufactory's products were protected from copyists, who would be subject to a crushing fine of 10,000 livres and confiscation of counterfeit weavings.

Hinart, as it was hoped and expected, drew upon a network of family ties and the resources of his Oudenaarde workshop to begin the new commercial enterprise. Joining him were his brother, Parisian tapestry merchant Christophe Hinart, his two sons, Jean-Baptiste (b. 1640) and Louis the Younger, and, in 1674, his brother-in-law Marius Chasserat, a master weaver from Paris.[9] The royal edict instructed Hinart to employ one hundred workers within the first year of operation and to increase the workforce by another one hundred each of the following five years, with the goal of eventually operating five hundred high- and low-warp looms divided into five workshops. (Peak employment of six hundred staff, however, proved unsustainable.) While many weavers were hired from workshops in Paris and Aubusson, Jean-Baptiste Hinart also went abroad to lure master weavers from England, Holland, and the southern Netherlands. So many weavers immigrated from Brussels, Lille, Tournai, Antwerp, and Oudenaarde that by 1665 there were 127 Flemings at the Beauvais manufactory.[10] Foreign recruits were not limited to skilled weavers, for no fewer than three cartoon painters from Tournai and Antwerp were hired during the years of Hinart's directorship. Money certainly factored into the staffing arrangements: for each foreign worker, Hinart received an additional bonus of 20 livres.

The prevailing Flemish presence was so strong an influence that the fixed unit of linear measure, the ell, adopted at the manufactory was the Flemish standard length—seemingly measured there as 69.75 centimeters—rather than the French standard of 118.8 centimeters in use at the Gobelins manufactory and at the Garde-Meuble de la Couronne (the king's household furnishing agency).[11] All loom work was measured in a set way so that weavers were paid rates calculated to fractional, multiple, and squared units of the Flemish ell and according to the complexity of the tapestry design and subject.

Weavers tended to specialize in the representation of specific aspects of a composition, such as vegetation and flowers, animals, architecture, drapery, or human figures. It was normal practice that several specialized weavers collaborated on one hanging. History subjects and human forms, particularly faces and hands, earned the highest wages. The price paid by the crown for a tapestry supplied by Hinart typically fell between 30 and 40 livres per square ell (in contrast to the 200 to 250 livres paid per ell woven at the Gobelins manufactory), so that the average set of six pieces cost between 1,537 and 1,840 livres.[12]

Production and Patronage

The chronology of production and the identification of subjects woven during Hinart's directorship must be pieced together from a few undated memoranda, the records of French royal ministries, and inventories of individuals usually taken at the time of death. In theory, the tapestries made at Beauvais under Hinart bore the factory's woven mark (consisting of the initials LH for Louis Hinart, the shield of the town of Beauvais between two B's, and a fleur-de-lis) in the outer guard, but as these narrow, plain bands suffered damage over time from the nails used to suspend or secure the hangings, the original guards and the marks they contained rarely remain intact. Their loss renders efforts to match surviving weavings with seventeenth-century descriptions even more tenuous. A thorough review is needed of those tapestries still bearing Hinart's marks in order to understand the full activity of his tenure and to properly identify the subjects woven under his supervision.

From 1667 until 1683, the year Colbert died, the Garde-Meuble de la Couronne was the factory's principal customer, acquiring forty sets of Beauvais tapestries, or 254 separate hangings, worth a total of 94,666 livres.[13] True to the founding dictate, thirty-one of the sets were either verdures or landscapes, sometimes with animals or birds, buildings, and small-scale human figures or larger-scale figures in the manner of David Teniers (1610–1690). All were of modest value, woven of wool and silk, though one exceptional set contained a little metal-wrapped thread. Without their factory marks, these French hangings are now difficult to distinguish from their Flemish contemporaries, though the Garde-Meuble inventory recorded that the borders of the Beauvais tapestries often contained floral garlands or rinceaux against yellow backgrounds. In addition, the manufactory wove sets representing the *Gardens of Saint Cloud*, the *Village Wedding in Picardy*, and *Children's Games*. One hanging from the last series, after designs by the Brussels artist

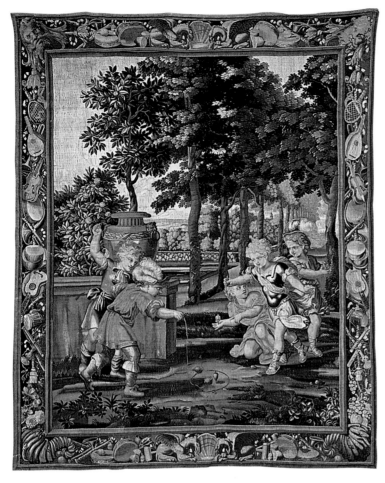

Fig. 184. *The Spinning Top* from a set of *Children's Games*. Tapestry design by Florentin Damoiselet, woven at Beauvais under the direction of Louis Hinart, ca. 1665–69. Wool and silk, 330 x 259 cm. Mobilier National, Paris (GMTT 59/2)

Florentin Damoiselet (b. 1644), survives with the woven mark of Louis Hinart (fig. 184).[14] His mark and that of the weaver, CB (possibly for Cornille Bacardt from Brussels), also remain on a curious set of tapestries representing an unidentified history subject with figures in strangely historicized dress. This set may be a reweaving of an earlier chivalric romance deriving from the medieval texts on the Trojan War, for the factory was known to have produced a *Story of Achilles*; alternately, it might be the enigmatic *Story of Polyphilo*.[15] At least two sets of the *Story of Polyphilo* were woven at Beauvais, of which one was acquired by Chancellor Michel Le Tellier (1603–1685) and the other was given as a diplomatic gift in January 1671 to the king of Guinea.[16] Colbert himself also acquired Beauvais tapestries for his private use, including a set of armorial hangings for his Parisian townhouse and a set of verdures for his country seat at the Château de Sceaux.[17] While these purchases reflected the depth of support the king and his ministers gave to the enterprise, they were not the only tangible forms of encouragement:

Louis XIV twice visited the manufactory, on June 7–8, 1670, and on July 14, 1680, when he expressed satisfaction with what he found, noting the weavers' ability to work with gold, silver, silk, and wool to the glory of his reign.[18]

The decade between the royal visits, however, was difficult. France's invasion of the Low Countries (known as the Dutch War, 1672–78) caused the crown not only to interrupt its acquisition of Beauvais tapestries but also to discontinue its cash supplements for the factory's foreign workers and apprentices. Hinart faced severe financial troubles, as sales to the private sector did not meet expectations and the initial government loans came due. As he spent more time in Paris, undoubtedly trying to improve the retail side of the business on the rue de Richelieu, his absences from Beauvais gave rise to accusations of mismanagement.[19] Claiming fatigue, Louis Hinart retired in 1678 in favor of his eldest son, Jean-Baptiste.[20] Fiscal matters only worsened. Facing insolvency, the Hinart family was forced to retire from Beauvais in 1684, and the factory reverted to the crown. Notwithstanding this setback, Jean-Baptiste Hinart went on to manage an independent Parisian workshop of twelve looms on the rue des Bons-Enfants, as well as the rue de Richelieu retail shop, winning important commissions in the 1680s and 1690s from princely patrons, much to the chagrin of his successor at Beauvais.[21]

Innovation and Taste

The manufactory's next director, Philippe Behagle (1641–1705), was an experienced tapestry weaver and workshop administrator who had earned the respect of both Colbert and the marquis de Louvois (François Michel Le Tellier, 1641–1691), Colbert's successor as superintendent of the Bâtiments du Roi (king's buildings bureau).[22] A Fleming by birth, born and trained in Oudenaarde, Behagle had moved to the Parisian tapestry workshop of the Comans family by 1660, and personally witnessed its incorporation in 1667 into the Manufacture Royale des Meubles de la Couronne at the Gobelins. In 1672 he returned to Oudenaarde (under French rule since 1667), where he set up a studio with another Oudenaarde native, Jean Baërt. In 1677/78 Colbert called both of them to the town of Tournai to establish a weaving studio of some fifty looms. During this successful six-year tenure, the Tournai workshop produced an extraordinary and ambitious series of allegorical tapestries glorifying the reign of Louis XIV that complemented the monumental Gobelins series known as the *History of the King* (see cat. nos. 41–47).[23] Of palatial scale (measuring just over fifteen feet in height) and woven with wool, silk, and

metal-thread, the figured scenes of the Tournai series followed earlier drawings attributed to Adam Frans van der Meulen (1632–1690), the artist who had accompanied the king on his military campaigns and had collaborated with Charles Le Brun (1619–1690) at the Gobelins (fig. 185). The grand subjects and sophisticated symbolism of the series, the designs based on the work of a Gobelins artist, the quality of materials, and the superior skill in execution all demonstrated the impressive expertise of Behagle, his connections to the circle of artists working for the crown, and his exceptional command as a manager. His appointment in 1684 as the next director at Beauvais indicated the king's renewed—and heightened—expectations for this tapestry manufactory.

New letters patent issued on March 10, 1684, to Behagle and his partners, Baërt and Georges Blommaert (another weaver from Oudenaarde who had been operating a workshop in Lille since 1677), reestablished the Beauvais manufactory and confirmed a thirty-year extension of the privileges first granted to Hinart.[24] While Blommaert traveled to obtain wool and supplies, Behagle stayed at Beauvais, repairing buildings and managing the operation. Both worked on recruitment, bringing to Beauvais seventy additional weavers from Tournai and Lille; by March 1685, ninety-two employees and fourteen apprentices staffed six workshops of high- and low-warp looms. One retail shop, supervised by Baërt, was opened in Paris on the rue Petit-Lyons and another followed in Lyon, located to compete with the trade of Brussels tapestries south to Italy.[25] The crown's contract with the new partners reemphasized the original mandate to stimulate the realm's economy through profitable commercial sales. Although the treasury again provided a substantial loan (payable in three years), the king's household was no longer to be the principal customer. Between 1684 and 1700 royal purchases of Beauvais tapestries declined, as the manufactory was weaned from its dependence on the crown. Indeed, only twelve sets of weavings were delivered to the Garde-Meuble de la Couronne during those years.

Behagle instigated several changes to improve the factory's products, broaden its marketability, and increase revenue. He hired an artist, Simon de Pape III (1663–1751), to provide regular drawing lessons to the apprentices, and he commissioned new designs from the circle of artists working at the Gobelins. The new subjects, more confidently drawn and composed, were executed at a more refined level of skill in fresh, fashionable colors that appealed to a wide range of customers. He raised the volume of production, reaching an output of approximately thirteen hundred pieces in the six-year span between 1684 and 1690, and he added tapestry-woven upholstery covers to the factory's repertoire before 1700.[26] To further supplement the income of his workers and their families in residence at the manufactory, he also set up a lace-making workshop to occupy the wives and children. Behagle's revitalizing changes and energy earned an acknowledgment from the king in the form of a royal visit to the manufactory in 1686.

Surviving examples of Behagle's woven signature in the perimeter guards of many tapestries show that the manufactory continued to weave in wool and silk the ever-popular verdure and hunt scenes with small-scale figures as well as the series *Birds from*

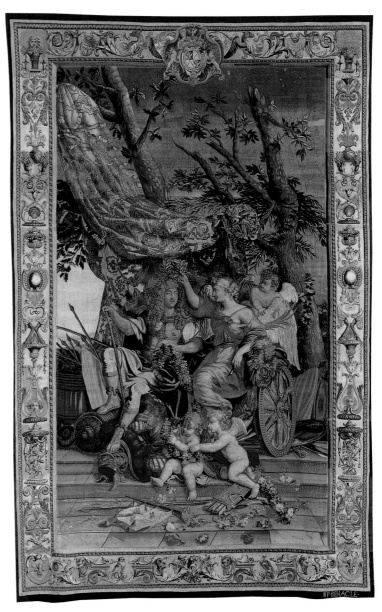

Fig. 185. *Louis XIV Crowned by Victory* from a set of the *Glorification of Louis XIV*. Tapestry design attributed to Adam Frans van der Meulen, woven at Tournai under the direction of Philippe Behagle, ca. 1680. Wool, silk, and gilt-metal-wrapped thread, 457.2 x 277.5 cm. Speed Art Museum, Louisville, Gift of Susan Barr Satterwhite (1947.28)

Fig. 186. *The Stag Hunt* from a set of the *Small Hunts*. Tapestry woven at Beauvais under the direction of Philippe Behagle, 1684–1705. Wool and silk, 307 x 314 cm. Château d'Azay-le-Rideau, Val de Loire, Caisse Nationale des Monuments Historiques

the Royal Menagerie after the cartoons first used during the directorship of his predecessor, Hinart (figs. 186, 187). The latter series borrowed elements from prints after the life studies of Pieter Boel (1622–1674), an animal painter who worked at the Gobelins and who had access to the royal collection of birds and animals housed in the menagerie at Versailles.[27] Behagle introduced a new series of seaport views designed by Jacques de Kerkove and Adrien Campion from Antwerp (member of the Academy of Saint Luc from 1676), who filled the foregrounds with shallow fields of vegetation and exotic birds derivative of Boel.[28] By the mid-1690s, dissemination of the *Seaports* reached the highest ranks of society, both domestically and internationally, for sets

were delivered to the king for use at the Château de Marly and abroad, to the Swedish minister Carl Piper (1647–1716).[29]

The late 1680s saw a period of intense creativity at Beauvais, as Behagle adroitly commissioned innovative designs from artists serving the crown at the Gobelins. Two of his most successful series were created by a talented trio of painters working there: Jean-Baptiste Monnoyer (1636–1699), Guy-Louis Vernansal (1648–1729), and Jean-Baptiste Belin de Fontenay (1653–1715). Monnoyer's models for the ornamental, yellow-ground series called the *Grotesques* (see cat. no. 51) and their collaborative cartoons for the novel *Story of the Emperor of China* (see cat. no. 52) launched a new era in which tapestry popular-

Fig. 187. *The Ostrich* from a set of *Birds from the Royal Menagerie*. Tapestry woven at Beauvais under the direction of Philippe Behagle, 1684–1705. Wool and silk, 310 x 310 cm. Marcel Benoist collection, Maison de Mon-Repos, Lausanne (155.2)

ized the taste for arabesque and chinoiserie styles in domestic interiors (fig. 188). Both series were woven repeatedly, for private orders and as stock for retail sale, for more than four decades, from 1688 until about 1732, by which time the cartoons were worn beyond use. Despite export duties, *Grotesques* tapestries reached the brisk German market through outlets in Leipzig and Ratisbon (former host city to the Holy Roman Imperial Diet, 1663–1806; modern-day Regensburg).

Production leapt forward, yet the factory's finances lagged behind. Sales did not cover expenses, and tapestries were put up as collateral to secure loans. The dissolution of the directors' partnership by 1690, Behagle's buyout of his associates, and the

pressure from creditors to liquefy assets at reduced values all left a notarial trail of documents listing (happily for posterity, if not for the contemporary parties) titles of other tapestry series woven at this time and their values.[30] Classical mythological subjects dominated, composed with large-scale figures set in sylvan groves and glades: the *Story of Cephalus and Procris*, after designs by Florentin Damoiselet in six pieces valued at 2,400 livres; the *Story of Psyche*, after designs by an unidentified artist in six pieces at 2,100 livres; and two different versions of scenes from Ovid's *Metamorphoses*—the first series, after designs by René-Antoine Houasse (1645–1710) in six pieces at 6,000 livres (fig. 189), and the second series, with small-scale figures, perhaps

Fig. 188. *The Audience of the Emperor* from a set of the *Story of the Emperor of China*. Tapestry design by Guy-Louis Vernansal, Jean-Baptiste Monnoyer, and Jean-Baptiste Belin de Fontenay, woven at Beauvais probably under the direction of Philippe Behagle, ca. 1700. Wool and silk, 400 x 508 cm. Musée du Louvre, Paris (OA 10446)

after Laurent de La Hyre (1605–1656), in four pieces at 2,200 livres. The fact that the Beauvais manufactory wove its own series interpreting the tale of *Psyche* and the *Metamorphoses* when the Gobelins workshops had already executed both suggests that these mythological narratives and idyllic subjects appealed to the broader consumer market of the social elite. In a memorandum of the period, Behagle recorded the sale in Brussels of one of his *Metamorphoses* sets to Duke Maximilian Emanuel of Bavaria, governor of the southern Netherlands, who reportedly "preferred my factory to that of Brussels."[31]

A sequence of unique commissions and exceptional weavings undertaken during Behagle's tenure overlapped with parallel weavings at the Gobelins. Although not proportionally representative of the Beauvais output, these tapestry masterpieces demonstrate that in terms of composition, color, and vir-

tuoso technique, the factory's weavers rivaled their celebrated counterparts in the execution of superlative hangings of the highest quality. One such commission, traditionally ordered from the Gobelins, was a set of *Chancelleries* (armorial tapestries presented by the king to each of his chancellors) that was woven instead on the high-warp looms at Beauvais for Louis Boucherat (appointed chancellor in 1685) in the mid-1680s (fig. 190).[32] A few years later Behagle chose to replicate one of the greatest Italian cycles of Renaissance sacred art, Raphael's renowned *Acts of the Apostles* tapestry set originally woven in Brussels for Pope Leo X.[33] The subjects had already challenged low-warp weavers at the Gobelins who, in the 1660s, had copied another edition of the same series in the French royal collection.[34] The cartoons for *Acts of the Apostles* lent to Beauvais in 1692, however, had been prepared by students at the French

Fig. 189. *The Abduction of Orithyia* from a set of the *Metamorphoses*. Tapestry design by René-Antoine Houasse, woven at Beauvais under the direction of Philippe Behagle, ca. 1690. Wool and silk, 309.9 x 528.3 cm. Fine Arts Museums of San Francisco, Gift of Mrs. Bruce Kelham and Mrs. Peter Lewis (1948.4)

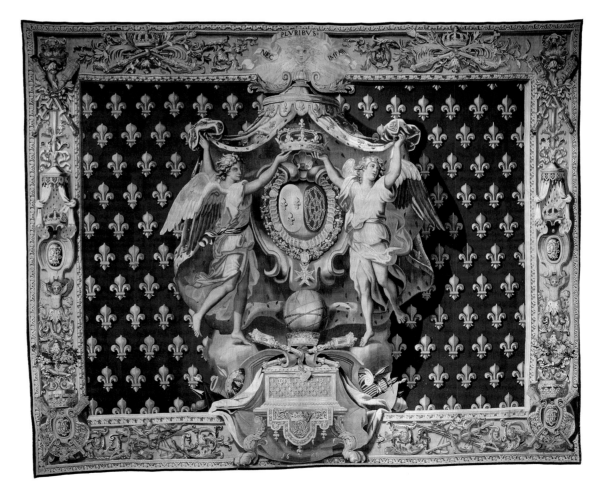

Fig. 190. *Chancellerie* for Louis Boucherat. Tapestry design by François Bonnemer and Jean Lemoyne, woven at Beauvais under the direction of Philippe Behagle, 1685–86. Wool and silk, 354 x 375 cm. Musée du Louvre, Paris, on loan from the Mobilier National (GMTT 153)

Academy in Rome in cooperation with the Vatican. The resulting eight-piece tapestry set entered the cathedral of Saint-Pierre at Beauvais in August 1695, valued at 7,000 livres.[35]

The closure of the Manufacture Royale des Meubles de la Couronne at the Gobelins during the war-torn and fiscally bleak years of 1694–99 actually brought some Gobelins weavers to Beauvais, where they were temporarily housed and employed, probably in weaving the copies of Charles Le Brun's famed allegorical set of *Elements* that bear Behagle's name.[36] It was at this time, in January 1695, that the Swedish diplomat Daniel Cronström (1655–1719) wrote to the architect Nicodemus Tessin the Younger (1654–1728) in Stockholm, "You could be astonished to hear my preference for Beauvais, from whence only refuse once came, over Gobelins but . . . Louvois has pulled from the best Gobelins workers to establish there a manufactory with great care."[37]

One of Behagle's most ambitious history series, a sequence of battle scenes called the *Conquests of King Louis XIV*, attracted patronage from the highest echelons of the French court. Consisting of at least five subjects portraying victories from the 1672–78 Dutch War, including four military and one naval engagement, the scenes followed the model of those conceptualized by Charles Le Brun and Adam Frans Van der Meulen for the previously mentioned Gobelins *History of the King* series.[38] One composition of the *Conquests*, the *Siege of Doesburg*, derived from an earlier print by Sébastien Leclerc (1637–1714) illustrated in the 1677 *Almanach royal*; overall, however, this and the companion compositions showed the influence of Van der Meulen (the cartoons have been attributed to his pupil and successor as painter of the king's campaigns, Jean-Baptiste Martin, called Martin des Batailles; 1659–1735). Each tapestry was woven with an elegant emblematic and armorial border, the lower center of which bore a cartouche filled with text describing the event (fig. 191). Although confusion surrounds the number of editions and dates of their execution, one document confirms that five cartoons for the series were in use at the manufactory before April 1710.[39] The king's former mistress, the marquise de Montespan (Françoise-Athénaïs de Rochechouart-Mortemart, 1641–1707), and her second surviving son by the king, the comte de Toulouse (Louis-Alexandre de Bourbon, 1678–1737), owned weavings from the series, the latter's set embellished with gilt-metal-wrapped thread.[40]

The legitimized sons of Louis XIV and Madame de Montespan became important clients of the Beauvais manufactory in the 1690s, ordering many sets of tapestries ranging in style from the stock verdures and hunts to the popular *Grotesques* and *Story of the Emperor of China*, as well as special commissions such as the *Conquests of King Louis XIV*. Their eldest son, the duc du Maine (Louis-Augustus de Bourbon, 1673–1736), hung in his apartments at the Château de Marly, in November 1698, a set of Beauvais verdures and, in June 1700, a set of the factory's *Métamorphoses* after La Hyre. He was, furthermore, the first to purchase a set of the *Story of the Emperor of China*, woven with gilt-metal-wrapped thread at the cost of 20,000 livres, thereby igniting the fashionable trend for chinoiserie.[41] His younger brother, the comte de Toulouse, made several private purchases that included seven pieces of *Grotesques* and ten of the *Story of the Emperor of China*; in his capacity as admiral of the navy, he also ordered a set with fields of fleurs-de-lis for the chambers of the Admiralty.[42]

The patronage of these influential members of the royal family attested to the success of Behagle's efforts in raising both the caliber and the reputation of the manufactory's production. In turn, agents representing royal, ducal, and elite households abroad recommended Beauvais tapestries to their clients. Cronström, for instance, wrote to Tessin in January 1695, "I advise you absolutely to not overlook the *Grotesque* of Beauvais. Surely it is a singular thing for its price and worthy of a man of your taste."[43] Before Behagle's death in 1705, suites of these decorative arabesques had been shipped to Sweden, Denmark, Saxony, and Savoy, and to the papal nuncio in France.

Auxiliary Parisian Workshops

"I resolved therefore to entrust [the commission] to either Hinard or Behagle, who are lately established in Paris. I prefer Hinard, whose low-warp weaving has been judged even more perfect than those of the Gobelins."[44] This curious excerpt from the Cronström–Tessin correspondence of February 1698 regarding an extraordinary commission for a suite of military history tapestries for Charles XI of Sweden (r. 1660–97) referred to the lucrative activities of two private Paris workshops that operated around this time under the rival management of Jean-Baptiste Hinart, on one hand, and Philippe Behagle, on the other.[45] Apparently family interests in Paris took priority over the concerns of the manufactory at Beauvais, as both ateliers seem to have been independent from, yet competitive with, the latter. Other forces factored into this complicated affair, as the then current superintendent of the Bâtiments du Roi (1691–99), Édouard Colbert de Villacerf, maneuvered to keep these workshops from becoming a combined threat to the preeminence of the Gobelins.[46] While the facts are not all known, it looks as if Hinart and Behagle, as

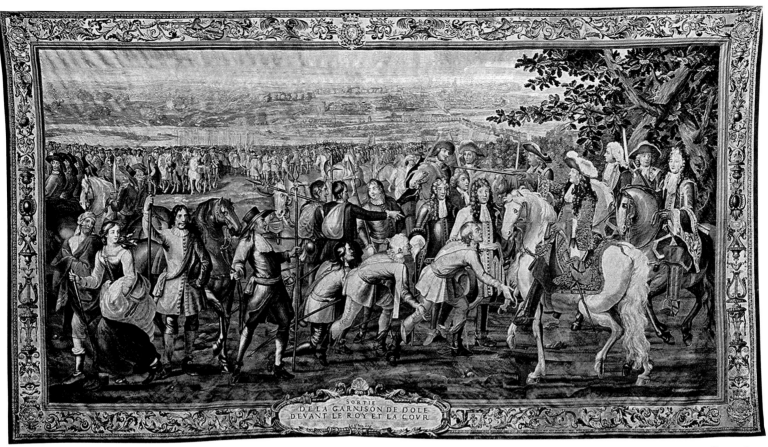

Fig. 191. *Surrender of the Garrison at Dole* from a set of the *Conquests of King Louis XIV*. Tapestry design attributed to Jean-Baptiste Martin, woven at Beauvais under the direction of Philippe Behagle, 1703. Wool, silk, and gilt-metal-wrapped thread, 460 x 795 cm. Château de Versailles (V4694)

private entrepreneurs, wiled away from each other orders that could have occupied the Beauvais looms, just as they vied to retain the best weavers who might have otherwise been employed there.[47] Only one of the four Swedish battle tapestries, the *Battle of Landskrona*, was actually woven at Beauvais; when it was presented publicly to Louis XIV in December 1699 the French court applauded (fig. 192).

Like Cronström, Madame de Montespan also entrusted an exceptional commission to Hinart, an allegorical set of *Marine Triumphs* for her younger son, the admiral comte de Toulouse (see cat. no. 50). But when Hinart was imprisoned for debt in 1697, both this and the Swedish commission were taken over by Behagle, who completed the weavings primarily in his Paris workshop on the Faubourg Saint-Martin.[48] In the ensuing contract of August 1697 with Cronström, Behagle was called "a merchant and entrepreneur of the royal tapestry manufactories at Paris and Beauvais."[49] More research is needed to fully understand these possible instances of double-dealing. Taken at face value, however, these two remarkable commissions won by Hinart, and the superlative tapestries then woven in Paris under

Behagle's direction, certainly substantiated the pair's well-deserved domestic and international prestige.[50]

The realm's deep and long fiscal downturn caused by France's prolonged War of the Grand Alliance during 1688–97 impacted retail sales of tapestries in general and the circumstances of the Beauvais manufactory in particular. Financial hardships, exacerbated by delayed reimbursements from the crown and probably compounded by the significant commissions deflected to Behagle's Paris workshop, afflicted the manufactory as loans came due in the 1690s. Troubles reached a crisis point in the first years of the next century, when the unpaid weavers struck on February 7, 1703, confiscating the tapestries on the looms. Creditors claimed all the stock and cash in the Paris showroom, accusing Behagle's younger son, Jean-Joseph (d. 1703), of embezzlement.[51] When Philippe Behagle's widow, Anne van Heuven, assumed the directorship at Beauvais in 1705, an audit revealed the bleak reality that the manufactory held assets valued only at 43,300 livres against debts that amounted to more than 160,000 livres and, furthermore, that the number of master weavers had dwindled to fifty-three.[52] Her term of

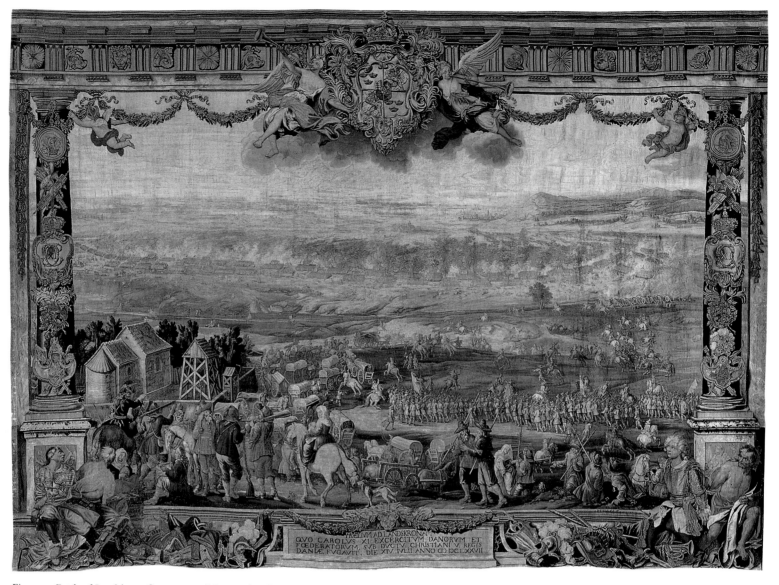

Fig. 192. *Battle of Landskrona* from a set of the *Battles of Charles XI of Sweden*. Tapestry design attributed to Jean-Baptiste Martin following Johann Philipp Lemke, woven at Beauvais under the direction of Philippe Behagle, 1699. Wool, silk, and gilt-metal-wrapped thread, 402.6 x 533.4 cm. The Royal Collections, Stockholm

management was short-lived, lasting only three years, and was followed by the equally brief term of her successor, the Behagles' older son, Philippe, who ceded the factory back to the crown in 1711 when on the brink of financial jeopardy.[53] Determined once more to preserve the enterprise, the crown again extended the 1664 privileges originally granted to Hinart to a succession of investors and managers, but with unsatisfactory results. The ruinous strain on the market for luxury goods of the 1701–14 War of the Spanish Succession, poor management, and

the lack of pleasing new designs undermined the endeavor for years. Falling back upon traditional best sellers, subsequent Beauvais managers frequently ordered repetitions of the still popular *Grotesques* and *Emperor of China* series from the worn cartoons. Until 1726, when Beauvais began to revive, largely under the influence of Jean-Baptiste Oudry (1686–1755), the activities of the manufactory continued to be undistinguished. The departure of the Behagle family from Beauvais marked a quiet end to an energetic era of inventive, fashion-setting tapestry production.

1. Those statements and accounts, preserved in the Archives Nationales, Paris (F^{12} 1456–1457), have not been published in full, but they were referenced by Jean Coural; see J. Coural 1977 and J. Coural and Gastinel-Coural 1992.

2. For a description of the compound before its destruction, see Quignon 1914, p. 148.

3. Archives Nationales, Paris, Conseil d'État, E 3B. For Henry IV's ineffective prohibition, dated September 11, 1601, against the importation and purchase of foreign verdures, see Guiffrey 1923, p. 32.

4. D. Chevalier, P. Chevalier, and Bertrand 1988.

5. Pardailhé-Galabrun 1991, pp. ix–x, 147–53, 214.

6. Archives Nationales, AD 373. For a transcription of the edict of August 5, 1664, signed by Louis XIV at Vincennes, see Dubos 1834.

7. J. Coural and Gastinel-Coural 1992, pp. 8, 14 n. 4. For a survey of tapestries woven in Oudenaarde at this time, see Oudenaarde 1999.

8. "[T]apisseries de verdures et personnages de haute et basse lice," from article 1 of the royal edict that established in the manufactory in August 1664, as transcribed in Dubos 1834, p. 24.

9. R.-A. Weigert 1964, pp. 334–35.

10. Quignon 1914, p. 147; Vanwelden 1999, p. 81.

11. The French word *aune* and English word *ell* derive from the Latin word *ulna*, for elbow, and refer to a unit of measure of approximately 1½ times an arm's length. The terms became associated with the linear measurement of textiles due, no doubt, to the flexing and extension of the elbows in folding and unfolding lengths of cloth. The length of the unit varied over time and region, but through labor migration and trade, certain standards gained acceptance over broad geographical distances. From the 14th century, as the Bruges aune gradually prevailed across international boundaries, it became identified as the Flemish aune in France and the Flemish ell in England. Historical conversion discrepancies abound, and scholars disagree on the exact modern equivalent of the Flemish aune in use at the Beauvais tapestry manufactory. According to 18th-century factory records, one Flemish aune equaled 25⅔ *pouces* (another pre-metric linear measure roughly based on the length of the thumb and now commonly converted to 2.7 cm). Although this length should have been equal to 69.3 centimeters, imperial factory records listed it as 69.75 centimeters. In 1964, Delesalle published a concordance table based on the rate of 69.75 centimeters, which Coural rounded to 69.7 centimeters. Metrological historians, however, otherwise covert the Flemish aune to precisely 68.58 centimeters. While such differences are minimal on a small scale, they grow exponentially when weavings extend several meters in length. Actual measurements for individual tapestries can fluctuate as they stretch, distorted by their weight when displayed over time, and as they change dimensions according to moisture levels, due to the water-sensitive, viscoelastic characteristics of wool. See Mobilier National, Paris, Manufacture Nationale de Beauvais, Prix des Ouvrages et Compte des Ouvriers 1769–1778, vol. B 170, frontispage; Machabey 1962, pp. 56, 71–75; Delesalle 1964; J. Coural 1977, p. 69; Zupko 1978, pp. 11–14; J. Coural and Gastinel-Coural 1992, p. 10.

12. Guiffrey 1881–1901, vol. 1, col. 555. As a comparison, Hinart was compensated 30 livres for the annual care and sustenance of each apprentice.

13. Badin 1909, p. 7; Guiffrey 1885–86, vol. 1, pp. 343–56.

14. J. Coural and Gastinel-Coural 1992, p. 161, nos. 4, 5.

15. Göbel 1928, p. 211 and fig. 203; Merten in Fandrey et al. 2002, pp. 127–31, no. 16a–e.

16. J. Coural and Gastinel-Coural 1992, pp. 13, 15 n. 23; Gastinel-Coural 1996.

17. J. Coural and Gastinel-Coural 1992, pp. 13, 15 n. 27.

18. Ibid., pp. 11, 14 n. 19.

19. R.-A. Weigert 1946a, p. 50.

20. J. Coural and Gastinel-Coural 1992, pp. 10, 14 n. 12.

21. De Reyniès 2002, pp. 211–12.

22. Standen 1998.

23. Zrebiec and Erbes 2000; Meyer 1980.

24. Archives Nationales, O^1 2040B; J. Coural and Gastinel-Coural 1992, pp. 17, 28 n. 5.

25. J. Coural and Gastinel-Coural 1992, pp. 17, 28 n. 8; R.-A. Weigert 1962, pp. 124–25.

26. Badin 1909, p. 13; Jestaz 1979, p. 188; Standen 1979b, pp. 212–15; J. Coural and Gastinel-Coural 1992, p. 21.

27. Paris 2001, pp. 43–44, 84–85; Lüscher 2001, pp. 22–29.

28. Quignon 1914, pp. 141, 143, 148.

29. J. Coural and Gastinel-Coural 1992, pp. 21, 29 n. 29, 162 no. 16.

30. Jestaz 1979, p. 188.

31. "Monseigneur le duc de Bavière, estant gouverneur alors du Pays-Bas, et a préféré ma fabrique à celle de Brusselle." Badin 1909, p. 12.

32. Fenaille 1903–23, vol. 2, pp. 421–23.

33. T. Campbell in New York 2002, pp. 187–203.

34. Fenaille 1903–23, vol. 2, pp. 43–49.

35. Quignon 1914, pp. 147–56; Bonnet-Laborderie 1982, pp. 48–58; J. Coural and Gastinel-Coural 1992, pp. 21, 27, 29 n. 26, 162 no. 14.

36. J. Coural and Gastinel-Coural 1992, p. 21; Bernardi 1959, pp. 122–23.

37. "Vous serez peut estre estonné de m'entendre préférer Beauvais, dont il ne sortoit autrefois que des ordeures aux Gobelins, mais vous n'en serez . . . que Mr. de Louvois a tiré des meilleurs ouvriers des Gobelins pour y establir une manufacture avec beaucoup de soin"; *Relations artistiques* 1964, p. 67, quoted in Standen 1998, p. 183.

38. Salmon 1998b.

39. J. Coural and Gastinel-Coural 1992, pp. 21, 24, 27–28, 29 n. 45.

40. Château de Versailles, inv. V4691–4694. J. Coural and Gastinel-Coural 1992, pp. 26, 162 no. 13. Pieces from another set, woven with metal-wrapped thread and later owned by Count von Brühl, adviser to the elector of Saxony, are at the Speed Museum, Louisville, inv. 1947.23 and 1947.25; see Zrebiec and Erbes 2000.

41. Badin 1909, pp. 12–13; J. Coural and Gastinel-Coural 1992, pp. 21, 29 n. 30.

42. Badin 1909, pp. 12–13; J. Coural 1977, p. 82.

43. "Je vous conseille absolument de ne pas laisser passer la Grotesque de Beauvais. C'est asseurement une chose singulière pour son prix et digne d'un homme de vostre goût"; *Relations artistiques* 1964, p. 67, quoted in J. Coural 1977, p. 82.

44. "Je resolus donc d'en charger Hinard ou Behagle, qui depuis peu est stably à Paris. Je donnoy la préférance à Hinard, dont la basse lisse a esté jugée encore plus parfaite que celle des Goblens [*sic*]"; Daniel Cronström, letter to Nicodemus Tessin the Younger, February 11/21, 1698, in *Relations artistiques* 1964, pp. 188, 212 n. 8, quoted in R.-A. Weigert 1964, p. 346, n. 7.

45. Böttiger 1895–98, vol. 3, pls. 29–32, vol. 4, pp. 81–86.

46. J. Coural and Gastinel-Coural 1992, pp. 24, 29 nn. 38–39.

47. Ibid., pp. 21, 24, 29 n. 33.

48. R.-A. Weigert 1964, p. 337. Coural, however, placed the workshop on the rue de la Verrerie, while de La Gorce located it in the Faubourg Saint-Denis. See J. Coural and Gastinel-Coural 1992, pp. 31, 33 n. 3; de La Gorce 1986, pp. 44–45.

49. "[M]archand et entrepreneur des manufactures royales de tapisserie de Paris et Beauvais"; J. Coural and Gastinel-Coural 1992, p. 29, n. 34.

50. Coquery 2003, pp. 65, 67 n. 38.

51. J. Coural and Gastinel-Coural 1992, pp. 24, 29 n. 41.

52. Ibid., p. 27; R.-A. Weigert 1964, p. 345.

53. Philippe Behagle the Younger subsequently helped to establish the tapestry manufactory founded by Peter the Great in Saint Petersburg after his 1717 visit to France. J. Coural and Gastinel-Coural 1992, p. 33, n. 2.

50.
The Triumph of Venus

From a four-piece set of the *Marine Triumphs*
Design by Jean Berain I, ca. 1696–97
Cartoon painted by Guy-Louis Vernansal
Woven in the Paris workshop of Philippe Behagle,
ca. 1697–98
Wool, silk, and silver and gilt-metal wrapped thread
425 x 330 cm (13 ft. 11⅜ in. x 10 ft. 10 in.)
Weaver's name, BEHAGLE, at embankment ledge;
designer's name, BERAIN IN., in outer guard at lower
right
Département des Objets d'Art, Musée du Louvre,
Paris (OA 8978), deposited at the Banque de France,
Paris

PROVENANCE: Louis-Alexandre de Bourbon, comte
de Toulouse (1678–1737); ca. 1719–shortly before
1787, displayed in the *cabinet du petit appartement* of
the Hôtel de Toulouse, Paris; by descent to his son,
Louis-Jean-Marie de Bourbon, duc de Penthièvre
(1725–1793); J. D. Court, until his death (ca. 1865);
February 22, 1866, sold as one of four tapestries,
Hôtel Drouot, Paris, nos. 61–64; Baron Maurice de
Hirsch, Paris, until his death (1896); his wife, until
her death (1900); February 22, 1906, sold, Paul
Chevallier, Paris, nos. 1–4 (*Triumph of Venus* sold as
Amphitrite, no. 1); April 24, 1923, sold, Jacques
Seligmann et Fils, Paris; François Coty; November
30–December 1, 1936, sold, Galerie Jean Charpentier,
Paris, no. 111; Banque de France, Paris.

REFERENCES: R.-A. Weigert 1937b; de La Gorce
1986, pp. 43–46; Coquery 2003, p. 59.

*T*he *Triumph of Venus* is one of a set of four tapestries called the *Marine Triumphs* that was commissioned about 1696 by Françoise-Athénaïs de Rochechouart-Mortemart, marquise de Montespan, to honor her legitimized son by Louis XIV, Louis-Alexandre de Bourbon, the comte de Toulouse, who had been appointed grand admiral of France in 1683 at the age of five.[1] In auction catalogues, the four scenes have traditionally been titled *Amphitrite*, *Venus and Adonis*, *Eurus*, and *Thetis*, and, as deities born of the sea or in control of its powerful elements, they served as suitable allusions to the comte's naval rank and, as well, to his mother's alluring beauty.[2] But while the common marine element may have loosely linked these divine figures, their essential associations remained tenuous and diffuse, for their respective mythologies intersected only briefly or not at all. If these identifications are accepted, the central figures of three of the tapestries come not from among the pantheon of foremost classical deities but rather from their lesser companions, the Nereids and one of the four winds.

The four scenes would constitute a much more cohesive and powerful allegory, however, if they were identified instead as scenes from the lore surrounding the goddess Venus: the birth of Venus, Venus and Adonis, Venus guiding Aeneas at sea during a storm brought on by the east wind Eurus, and Venus bringing arms to Aeneas.[3] Reinterpreted this way, the four subjects become unified by a common narrative that would have had significant relevance for both Madame de Montespan and her son. Venus, in her role as the deity of love and the mother of Aeneas, was an entirely appropriate association for Madame de Montespan, who was the king's mistress from about 1667 to about 1679–80 and the mother of six of his children. Similarly, Aeneas (represented by the youthful Louis-Alexandre in one of tapestries) receiving a set of armor from his divine mother was an equally laden association for the young Bourbon prince,

whose legitimization in 1681 and survival into adulthood disturbed the preeminence of rank at the French court.

The designer of the set, Jean Berain I (1640–1711), employed two well-established artistic metaphors: in one, characteristics of the patron are associated with those of a divine nature; in another, a benevolent deity intervenes in a mortal's life in order to direct him to his glorious destiny. The marine theme, of obvious relevance in this case, carried additional pertinence, having been recently utilized in another commission from Berain for tapestries celebrating the former minister of the marine, Jean-Baptiste Colbert, marquis de Seignelay, son of the so-called Grand Colbert and secretary of the navy from 1683. This earlier series, known as the *Attributes of the Marine*, consisted of eight large and four narrow arabesque tapestries woven between 1689 and 1692 in the Paris workshop of Jean-Baptiste Hinart (b. 1640; fig. 194).[4] Its composition called for the lavish use of metal-wrapped wefts *au crapautage* (a specialized weaving technique) for the ground, which created broad expanses of reflective surfaces suggestive of rippling water. The Seignelay tapestry commission happened to coincide with the famed group portrait of the marquise de Seignelay (in the guise of a marine divinity, perhaps Thetis) and two of her sons painted in 1691 by Pierre Mignard (1612–1695).[5]

From at least 1684, when he was forced to retire from the directorship of the tapestry manufactory at Beauvais, until 1697, Hinart operated an independent weaving workshop in Paris that attracted select commissions from the highest ranks of the French court and from the agents, domiciled in Paris, of foreign clients. Its virtuoso products cost less than the equivalent work performed at the Manufacture Royale des Meubles de la Couronne at the Gobelins (which, in any case, was temporarily closed from 1694 to 1699).[6] The location of the Paris studio, on the rue des Bons-Enfants, proved convenient

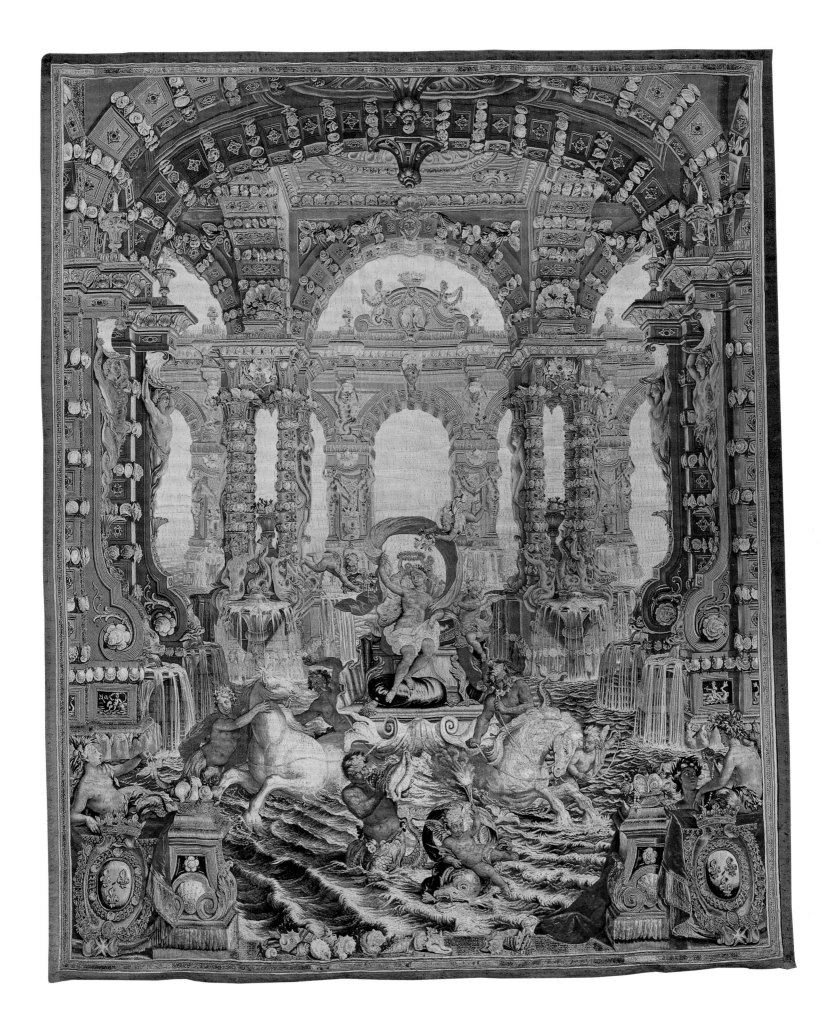

for Hinart's patrons, who could oversee the progress of their orders. Its proximity to the nearby Gobelins, furthermore, eased communication with the talented cartoon painters who continued to live there. It seems that Hinart's production of the exceptional Seignelay tapestries motivated Madame de Montespan to place her order with the same designer and atelier.

The renown of Hinart's workshop, staffed with extremely talented weavers, provoked his successor as director at the Beauvais tapestry manufactory, Philippe Behagle, to also establish a Parisian weaving studio about 1695. Whether Behagle initially intended his Paris atelier to be a satellite of the manufactory in Picardy or independent is not certain. In August 1697 Behagle allegedly forced Hinart into debtors' prison, purchased Hinart's looms, recruited the weavers from the rue des Bons-Enfants, and assumed Hinart's outstanding commissions.[7] The virtuosity of the *Marine Triumphs*, executed then under Behagle's supervision in Paris and woven with his name, has since come to epitomize his outstanding reputation as an esteemed entrepreneur, a reputation secured by his simultaneous and industrious tenure as director of the tapestry manufactory at Beauvais.

Description

The preparatory sketch for *Venus* (fig. 193) shows the attribute of the goddess, the white swan, prominently positioned center front, spreading its wings in the shallow water. The scene is set in an open-air maritime palace, in which an arcade of rusticated stone arches recedes symmetrically into the deepening water. A baldachin is suspended from above, its drapery carried to the four corners of the transept by winged putti. The goddess approaches the foreground embankment seated in a buoyant chariot in the form of a great hinged scallop shell, pulled by two stylized dolphins and escorted by garland-bearing Nereids and conch-trumpeting Tritons, two of whom clamber up to the balustrade to the right. The broken balustrade along the embankment bears, at left and right, the armorial shield of the comte de Toulouse encircled by two concentric collars, for the chivalric orders of Saint Michael and of the Holy Spirit. A crown designed for the exclusive use of *les*

enfants de France (royal children) and a marshal's baton surmount each shield, while the flukes and arms of an anchor appear from behind, at bottom.

The woven version of the goddess's *Triumph* is set in a similar aquatic arcade, but within a more foreshortened structure supported by buttressed pillars, columns, and many more marine caryatids. A profusion of shells arranged in horizontal bands punctuates the stonework; the draped baldachin of the sketch is gone. Overflowing fountains decorate the base of each pillar and each side of the quartets of columns. The deity arrives, seated on a throne in a single large cockleshell chariot, drawn by two hippocampi—one on the left controlled by a Nereid, and the other reined in by a bearded Triton. The drapery of the central figure billows with the wind in a sail-like arc. Putti hold a crown above her head, while another approaches with floral branches, and yet another with treasures from the sea. A Triton sounds a shell trumpet before the chariot, and a putto, holding up a flaming torch, rides toward the embankment on the back of a dolphin. The shallow ledge of the embankment displays an assortment of decorative shells; three Nereids await the goddess at the balustrade there, one to the left and two to the right, by the twin shields bearing the Toulouse arms. BEHAGLE is woven into the ledge of the embankment, among the shells, and BERAIN IN. in the outer guard, toward the lower-right corner.

Subject and Iconography

The only published seventeenth-century document to name this tapestry set called it simply "des *Attributs de la Marine* pour le grand Admiral de France" (*Marine Attributes* for the grand admiral of France), so there is no contemporary identification to confirm the titles of the individual subjects.[8] Eighteenth-century travelogues described the tapestries in the *cabinet* of the Hôtel de Toulouse in highly favorable but generic terms: "the tapestries of this rich set are of silk enriched with gold and with silver."[9] During the past century, the literature has repeatedly called this hanging the *Triumph of Amphitrite* after the Nereid who wedded Poseidon (later associated with the Roman god Neptune). Ancient images of Amphitrite commonly showed her

in the company of her husband, gripping his trident and the reins of the four hippocampi that pulled his sea chariot, a visual tradition to which Nicolas Poussin adhered when he reinterpreted the subject in his masterpiece of about 1635 (fig. 195). In other presentations, when she was portrayed without her husband but with her attributes of Tritons, dolphins, shells, and billowing drapery, there has been confusion over her identity; images of Venus Marina, Thetis, Galatea, and Amphitrite have confounded cataloguers and researchers since at least the seventeenth century. Poussin's canvas, thought to have been in the collection of Armand Jean du Plessis, Cardinal Richelieu, was identified, for instance, as *Le triomphe de Neptune* in 1672 and then possibly as *Venus triomphante sur les mers* in 1713.[10] Engraved by Jean Pesne (1623–1700) before 1700, when in a Parisian collection, the composition would surely have been available to Berain by that date, and the seated, frontal pose of Poussin's goddess, with the billowing arc of drapery above, may have served him as a model. But to confound the matter, Pesne's print after Poussin was titled *Le triomphe de Galatée* when it was catalogued in 1838.[11]

The triumphs of the gods enjoyed great popularity as tapestry subjects from the beginning of the sixteenth century, when such scenes were usually incorporated as layered allegories into cycles of the seasons or months of the year. One Renaissance precedent, the *Triumph of Venus* (fig. 181) from a set of the *Triumphs of the Gods*, entered the French royal collection, along with two others from the series, sometime before 1663 and could have been seen by Berain in 1673, when the set was reunited with the remaining four hangings (the other subjects were *Bacchus*, *Apollo*, *Minerva*, *Mars*, *Hercules*, and *Religion* or the *Virtues*). This complete set of seven triumphs was woven in the Brussels workshop of Frans Geubels about 1560 as a copy of the set originally designed about 1517–20 for Pope Leo X, possibly by Giovanni Francesco Penni and Giovanni da Udine.[12] In the original and the Brussels copy of the *Triumph of Venus*, the goddess stood on a throne secured within a small arcaded pavilion centrally placed on a great ship. She was flanked by attendant putti and maidens while more putti gamboled above on garland ropes. On a clamshell drawn

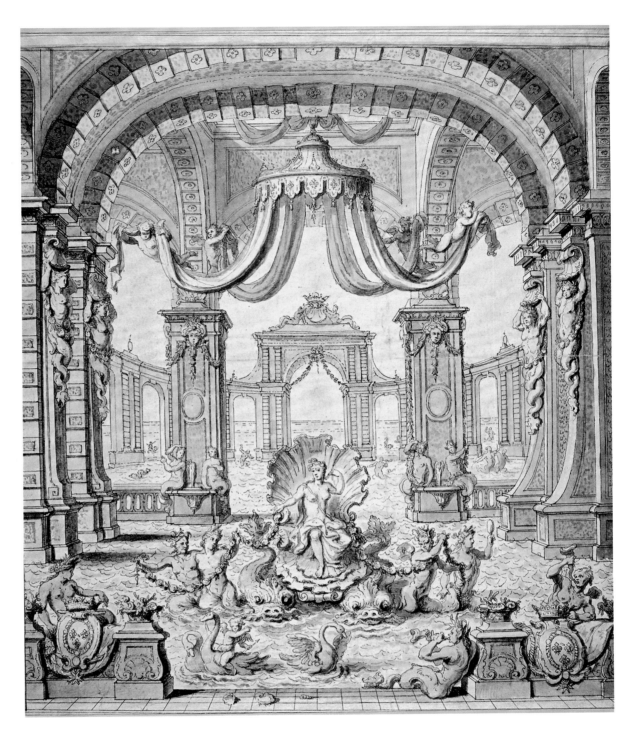

Fig. 193. *Venus*, by Jean Berain I, ca. 1696. Preparatory sketch for the tapestry in the *Marine Triumphs*. Pen and wash on paper, 37.3 x 30.2 cm. Musée des Beaux-Arts, Château Borély, Marseille

by four hippocampi in the waters below, Neptune led his Nereids and ichthyocentaurs in a parade of offerings from the sea. Beginning in 1684, as part of a large project to reweave the series at the Gobelins, Noël Coypel (1628–1707) prepared new cartoons after the Brussels hangings (at that time, thought to have derived from the designs of Raphael), but he did not finish the cartoon for the *Triumph of Venus* until April 1693 (see cat. no. 49).[13] Two separate weavings after Coypel's *Venus* were on the looms at the Gobelins during the 1690s, when Berain

would certainly have had the opportunity to see the work in progress. The centrality of the composition, the inclusion of the hippocampi, and the vigorous movement of waves were features that Berain adopted in his own design for the Toulouse commission.

Berain melded his subjects and their iconography. In the case of the present tapestry, multiple influences are evident. One likely source for the marine arcade setting was a physical structure called the Grotto of Thetis, built in the garden of Versailles, just to the north of the palace, in 1664. Although

destroyed in 1684, a series of engravings by Jean Le Pautre (1618–1682), published in 1676, showed that the walls of its arcaded interior were heavily imbedded with rocks and shells in geometric patterns.[14] Additionally, Berain drew inspiration freely from the diverse stage sets, props, and costumes he designed for court performances and the Opéra. The scholar Roger-Armand Weigert was the first to note the role that developing *tragédie lyrique* forms of operatic stage design had on Berain's tapestry conceptualizations, particularly for the *Marine Triumphs*. He cited

especially the set for the 1676 opera *Athys* by Jean-Baptiste Lully, which is known by an extant drawing.[15] But a more immediate precedent for the Toulouse commission would have been the 1696 opera by Pascal Colasse, the *Birth of Venus*, for which Berain designed the mechanical stage prop for the deity's dolphin-drawn chariot—an almost identical match to that of the sketch (fig. 193).[16]

The distinct differences between the sketch and the woven tapestry show that the composition moved closer toward the Seignelay prototype, as the dolphins and swans of the sketch were replaced by the pair of hippocampi and a Triton. Some elements also reflect the creativity of the cartoon painter, Guy-Louis Vernansal (1648–1729).[17] The shallow, shell-strewn embankment, for example, derives from another of his recent tapestry compositions, the *Emperor Sailing*, executed for the Beauvais manufactory's series the *Story of the Emperor of China* (see cat. no. 52).[18]

Artists

From 1674 until his death in 1711, Jean Berain I was the most prolific and influential ornamentalist working at the court of Louis XIV. His creative genius provided designs and engravings for a broad range of goods and services, from locks, guns, and weapons to chimneys, ceiling ornament, furniture, tapestries, textiles, garden plans, and ships, including the king's gondola that was used in the great canal in the park of Versailles. He also designed stage sets, mechanical props, costumes for dramatic and operatic performances, and entire entertainments in the form of masquerades, ballets, carousels, tournaments, fireworks displays, and even funerary decorations.[19]

Berain's earliest dated work was a series of engravings published in 1659, and it was by this medium that later he drew the attention of Charles Le Brun, who facilitated his employment as a court engraver in 1670. It was a medium that Berain pursued throughout his life, thereby widely disseminating his style and designs. In 1674 Berain secured the position of *dessinateur de la chambre et du cabinet du roi* within the Administration de l'Argenterie, Menus-Plaisirs et Affaires de la Chambre du Maison du Roi (designer of the bedroom and cabinet of the king within the king's household agency, in the bureau that was responsible for the king's silver, all forms of court entertainments, pageants, and ceremonies, plus the supervision of theaters in Paris). Five years later he was granted free lodging in the long wing of the Grand Galerie of the Palais du Louvre, among the community of other talented artists and craftsmen working for the crown.

Berain's great genius lay in his development of arabesque and grotesque ornament, which he applied in infinite variations to designs for parterres, ceiling and cornice plasterwork, furniture veneers, costumes, and tapestries.[20] His interpretation of the style inspired Jean-Baptiste Monnoyer (1636–1699) to create the most successful tapestry series ever woven at the Beauvais manufactory, the *Grotesques*, which was produced for more than forty years, from about 1688 to 1732 (see cat. no. 51). Berain is documented, however, as having contributed only one particular border for the series, a running strapwork pattern in red and blue called "broken batons."[21] Although in general Berain did not himself specifically paint cartoons for tapestry series, for three special commissions from private patrons he provided sophisticated figural allegories appropriately reflective of the status and position of the individual. The first order became the set known as the *Attributes of the Marine* (fig. 194), mentioned above, which had an aquatic theme suitable for his patron, the marquis de Seignelay, the minister of the marine who had recommended Berain to the post of *dessinateur des vaisseaux du roi* (designer of the king's ships) in 1687.[22] This set won him, in turn, two more commissions, one from the marquise de Montespan for another marine set, the *Marine Triumphs* (the subject of this entry), for her son the comte de Toulouse, grand admiral of France. The second was for the design of the border only for a magnificent set of historic battle scenes commissioned by the king of Sweden, Charles XI (see fig. 192).[23] Berain's tapestry work was actually a small part of his diverse oeuvre, but his style significantly influenced a circle of painters who provided tapestry cartoons for Beauvais, the Gobelins, and private Parisian weaving ateliers. Through prints, his influence extended to weaving enterprises in the Holy Roman Empire as well.[24]

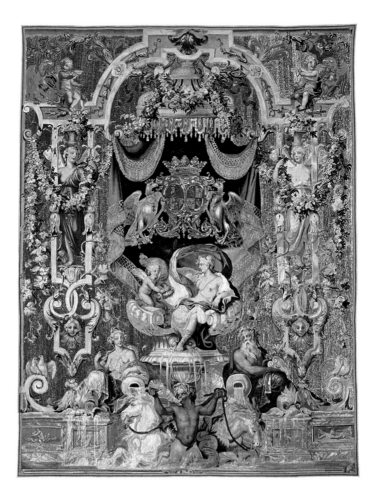

Fig. 194. *Venus* from a set of the *Attributes of the Marine.* Tapestry design by Jean Berain I, woven in the workshop of Jean-Baptiste Hinart, Paris, 1689–92. Wool, silk, and gilt-metal-wrapped thread, 305 x 253 cm. Département des Objets d'Art, Musée du Louvre, Paris (OA 11943)

An early travelogue for Paris, printed in 1723, recorded that Guy-Louis Vernansal was the artist actually responsible for painting the cartoons, following Berain's designs, for the present set of tapestries.[25] Since Eugène Thoison's research, published in 1901, no thorough biography of this artist has yet been written, perhaps because Vernansal trained and then worked in the shadow of Le Brun as a painter of history, mythological, and religious subjects at Versailles, Fontainebleau, the Tuilleries, and Meudon.[26] He became a member of the Académie Royale de Peinture et de Sculpture in 1687 and a professor in 1704. He was employed at the Gobelins as a *peintre ordinaire*, painting cartoons for several important tapestry cycles produced there, notably the *History of Alexander* after Le Brun and a set of armorial tapestries called *Chancelleries* for Louis Phélypeaux, comte de Pontchartrain.[27] Behagle also commissioned from him the *Story of the Emperor of China* for the Beauvais looms, as a complement to the famed Gobelins history series portraying Louis XIV, the *History of the King* (though this important commission was not in Thoison's list of Vernansal's oeuvre). The new Beauvais subject was to have immediate influence and a great legacy for it popularized a novel style, chinoiserie, by bringing the exotic theme of the Far East into the domestic interior. In addition, either Berain himself or the entrepreneur Hinart contracted with Vernansal to paint the cartoons not only for the *Marine Triumphs* but also for Berain's borders of the Swedish battle series.[28]

Patron

The collecting tastes of the marquise de Montespan, also known as Madame de Montespan, and those she instilled in her sons did much to support and advance contemporary French tapestry production through notable commissions. An early patron of the Oudenaarde-Tournai entrepreneurs Behagle and Jean Baërt before their move to Beauvais, she reputedly brought their weavings to the notice of connoisseurs at court: "The works that leave their hands are esteemed by connoisseurs. They made some tapestry sets for Madame de La Valière and then for Madame de Montsepan who made them known to the Court."[29] Furthermore, under her influence

her children developed a deep appreciation for the art form and, collectively, the extended family set the fashionable taste for tapestries. Her first son, born in wedlock, Louis Antoine de Pardaillon de Gondrin, duc d'Antin, as director of the Bâtiments du Roi (king's buildings bureau) from 1708 was responsible for the Gobelins manufactory, while her other sons by the king, the duc du Maine and the comte de Toulouse, grew into important, trend-setting patrons of the Beauvais manufactory. But it was she who ordered new designs, on behalf of her son, for the singular *Marine Triumphs* from Berain and then delegated their execution first to the Hinart workshop in Paris and then to the private atelier of his competitor Behagle. Although the extent of Madame de Montespan's commissions has not yet been fully explored, it is known that she continued collecting tapestries even after her retirement from court; just before her death she took delivery of the *Battle of Cassel* from the Beauvais looms.[30]

Louis-Alexandre de Bourbon, more commonly known as the comte de Toulouse, was the second surviving legitimized son of Louis XIV and the marquise de Montespan. From an early age he was granted ranks and

titles by his father, becoming successively grand admiral of the navy in 1683, an infantry colonel in 1684, duc de Danville in 1694, governor of Brittany in 1695, a marshal in 1696, a lieutenant general and duc de Penthièvre in 1697, and *grand-veneur de France* (master of the king's hunt) in 1714.[31] According to the duc de Saint-Simon, he was generally respected for his valor and "tranquility" both on the field and on the water.[32] As a youth, he accompanied the king in the 1690–92 campaigns during the War of the Grand Alliance, at which time he was wounded at Namur. Later, in 1702–6, during the War of the Spanish Succession, he commanded French warships in engagements against the English and Dutch. In recognition of his service and virtues he was made a knight of the chivalric orders of the Holy Spirit and of Saint Michael (1693) by Louis XIV, and of the Golden Fleece (1703) by his nephew, Philip V of Spain.

Around the time when the comte de Toulouse was granted the duchy of Penthièvre (1697) at the age of nineteen, he began to commission tapestries on a princely scale. The initial commands were for original or newly conceived designs: the *Marine Triumphs*, ordered for him by his mother from the Paris

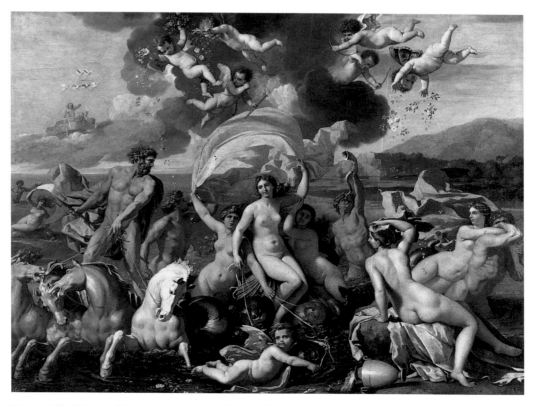

Fig. 195. *The Triumph of Neptune and Amphitrite*, by Nicolas Poussin, 1635 or 1636. Oil on canvas, 97.2 x 108 cm. Philadelphia Museum of Art, The George W. Elkins Collections, 1932 (E1932-1-1)

425

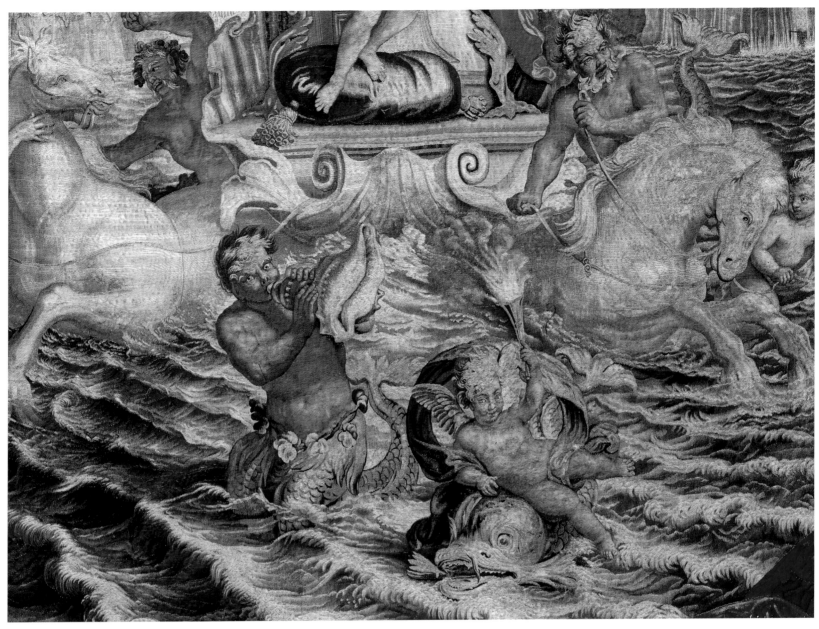

Detail of cat. no. 50

workshops of Hinart and Behagle, was followed by his own selection of the *Conquests of King Louis XIV*, the *Story of the Emperor of China*, and a set of *Grotesques*, all woven at the Beauvais tapestry manufactory under the direction of Behagle. His taste was also influenced by the royal collection of tapestries that he encountered daily at court. For the offices of the Admiralty, he ordered from Beauvais a set of ceremonial tapestries, bearing the Bourbon fleurs-de-lis of the type that decorated ministries across Paris. Later in his life he ordered from the Gobelins copies of two great sixteenth-century Brussels series in the Garde-Meuble de la Couronne (king's household furnishing agency), a set of the

Hunts of Maximilian, and, after his marriage in 1723, a set of the so-called *Months of Lucas*.[33] All of his commissions were woven with his coat of arms and usually with his monogram in the borders.

CHARISSA BREMER-DAVID

1. Daniel Cronström, February 11/21, 1698, to Nicodemus Tessin the Younger, in *Relations artistiques* 1964, pp. 188, 212 n. 9; and Piganiol de La Force 1742, vol. 3, p. 86.
2. The four hangings were said to relate to the history of Amphitrite in the catalogue of the J. D. Court sale at Hôtel Drouot, Paris, February 22, 1866 (nos. 61–64), but the individual subject titles did not appear until the catalogue of the baron de Hirsch sale at Paul Chevallier, Paris, February 22, 1906 (nos. 1–4). The four subjects were subsequently repeated, without an iconographic study, in some of the twentieth-century tapestry surveys. For an exactly parallel tangle of appropriated mother-son mythological identifications, see Wine 2001, pp. 244–54.
3. The mythology of Venus related to this tapestry cycle derived ultimately from several ancient literary sources. The anonymous Homeric *Hymn VI* sang of Aphrodite, the Greek goddess, as a beautiful, gold-crowned goddess who was carried by the soft breath of the western wind over the waves and foam. The Roman poet Ovid wrote of the love between Venus and the mortal Adonis in book 10 of his *Metamorphoses*. In book 1 of the *Aeneid*, Virgil described the terrible storm encountered by Venus's son Aeneas and his band: "I set out across the Phrygian sea with twenty ships, following my allotted destiny, with my goddess mother showing me the way; just seven survive, battered by the sea and by Eurus" (Andrew Wilson, *The Classics Pages (1994–2005)*: Virgil, *Aeneid*, 1.4.381–85, http://www.users.globalnet.co.uk/~loxias/aeneid1.4.htm); and in book 8, he recounted how Venus delivered the arms forged by Vulcan to Aeneas: "Meantime the mother goddess, crowned with charms, breaks through the clouds, and brings the fated arms" (*Aeneid*, trans. by John Dryden, http://classics.mit.edu/Virgil/aeneid.8.viii.html).

4. Six pieces of the suite, without their borders and possibly cut in the narrative field, are now in the Musée du Louvre, Paris, inv. OA11943–11948. The original Seignelay arms were replaced after the 1696 remarriage of Colbert's widow to Charles de Lorraine, comte de Marsan; Coquery 2003.

5. National Gallery, London, inv. 2967; Wine 2001, pp. 244–54.

6. De La Gorce 1986, p. 45.

7. Daniel Cronström, February 11/21, 1698, to Nicodemus Tessin the Younger, in *Relations artistiques* 1964, pp. 187–90, 212 nn. 8, 9; J. Coural and Gastinel-Coural 1992, pp. 24, 29 n. 39.

8. R.-A. Weigert 1937b, p. 330.

9. "Les tapisseries sont [*sic*] cette riche tenture de soye rehausée d'or et d'argent…"; Le Rouge 1723, p. 167, and repeated in Le Rouge 1742, p. 201.

10. Montreal–Cologne 2002, pp. 274–78.

11. Robert-Dumesnil 1835–71/1967, vol. 3, pp. 144–45.

12. T. Campbell in New York 2002, pp. 225–28, 243 n. 9.

13. Mobilier National, Paris, inv. GMTT1/1-3. Fenaille 1903–23, vol. 2, pp. 221–45; Beauvais 2004, no. 8.

14. *Description de la grotte de Versailles* (1676), reproduced in Préaud 1993, pp. 314–18; Lablaude 1998, pp. 48–49.

15. R.-A. Weigert 1937b.

16. De La Gorce 1986, pp. 44–47, 93–94.

17. Le Rouge 1723, p. 167; *Relations artistiques* 1964, p. 212 n. 9; de La Gorce 1986, pp. 45, 155 n. 32; Coquery 2003, pp. 63, 67 n. 23.

18. Standen 1976, p. 112; Bremer-David 1997, p. 94.

19. Two excellent biographical studies, by R.-A. Weigert (1937a) and de La Gorce (1986), outline Berain's career as he attained successively more important court appointments, influential connections, and international renown.

20. Kimball 1941.

21. Standen 1979b, p. 212.

22. Coquery 2003.

23. Böttiger 1895–98, vol. 4, pp. 81–86, vol. 3, pls. 29–32. For alternative border design proposals, see de La Gorce 1986, p. 21, and Gruber 1992, p. 192.

24. R.-A. Weigert 1948, pp. 165–72.

25. Le Rouge 1723, p. 167.

26. Thoison 1901; Standen 1976, pp. 115–16.

27. Fenaille 1903–23, vol. 2, p. 168, vol. 3, p. 134.

28. Fenaille 1903–23, vol. 6, p. 7.

29. "Les ouvrages qui sortirent de leurs mains étoient estimés des connaisseurs. Quelques tentures qu'il avoit fait pour Madame de La Valière et ensuite pour Madame de Montespan l'avaient fait connaître à la Cour"; J. Coural and Gastinel-Coural 1992, pp. 17, 28 n. 1.

30. Ibid., pp. 27, 29 n. 45.

31. De Sainte-Marie 1726, p. 176.

32. Hoefer 1853–66, vol. 45, col. 532.

33. Fenaille 1903–23, vol. 2, pp. 218–19, 222, 365–67, 370; Standen 1996; T. Campbell in New York 2002, pp. 297–99; Delmarcel in New York 2002, pp. 329–39, nos. 37–40.

51.
The Camel

From a six-piece set of the *Grotesques*
Design by Jean-Baptiste Monnoyer in the style of Jean Berain I; border design by Monnoyer and Guy-Louis Vernansal, ca. 1688
Woven at the Beauvais tapestry manufactory under the direction of Philippe Behagle or his successors, his widow Anne van Heuven or his son Philippe Behagle, ca. 1690–1711
Wool and silk
279 x 528 cm (9 ft. 2 in. x 17 ft. 4 in.)
8–9 warps per cm
The Metropolitan Museum of Art, New York, Gift of John M. Schiff, 1977 (1977.437.1)

PROVENANCE: Reputedly collection of Prince Murat; February 13, 1917, Jacques Seligmann et Fils, Paris, on consignment as one of five tapestries to French and Company, New York (stock no. 3971); June 22, 1938, Mortimer L. Schiff, New York, offered for sale as one of five tapestries by his heir John M. Schiff, Christie's, London, lot 75; the set of five tapestries bought at that sale by Mayer; 1956–57, John M. Schiff, New York, and temporarily consigned as one of five tapestries to French and Company, New York (stock no. 56281-X); 1977, The Metropolitan Museum of Art, New York, gift of John M. Schiff.

REFERENCES: Badin 1909, pp. 11–13, 15, 18–19, 21, 23, 56; Standen 1979a; Standen 1979b, pp. 209–13; Standen 1981, pp. 32–34 and pl. IV; Standen 1985, pp. 441–47, 454; Standen 1987, pp. 29–31, no. 18; K. Scott 1995, pp. 128–29, fig. 132.

*T*he *Camel* was one of a set of six *Grotesques* tapestries produced at the Beauvais manufactory during the directorship of the Behagle family; one of the companion pieces, *Musicians and Dancers*, bears the signature BEHAGLE woven into a narrow band below the lower-right corner of the narrative field.[1] The series was the factory's most successful production of the seventeenth century, and an estimated fifty full or partial sets were made. A set of *Grotesques* normally consisted of six hangings, though groups of greater or lesser numbers were sold according to the needs of the customer; the design of the series was ingeniously flexible and versatile. Like the popular, traditional verdure (or green landscape) tapestries, the narrative fields of the *Grotesques* were composed of interchangeable vignettes of figures and animals that did not follow a specific plot or chronology. And like the verdures, which brought nature's pleasant greenery indoors, the saturated yellow-gold ground color of the *Grotesques* brought a sense of sunlight and warmth to interiors in which illumination was limited to ambient daylight or firelight.

Ultimately, the style of the *Grotesques* tapestry series took inspiration from ancient wall paintings such as those preserved in the Domus Aurea, or Golden House, of the emperor Nero, built between A.D. 64 and 68 in Rome. When excavated in 1480, this famous antique dwelling was partially buried beneath street level, and the rooms found underground were likened to caves, or *grotti* in Italian, from which the term "grotesques" derived. The classical decoration surviving there showed polychromatic trophies, scrolls, garlands, human and divine figures, and mythological hybrid creatures starkly positioned against the flat white or solid-colored grounds of symmetrical geometric compartments following the lines of the interior architecture. Within the compartments, small figures were confined to cartouches, while larger-scale forms stood on plinths and pedestals or between columns. The style was readily adopted by Italian Renaissance artists and applied to contemporary interior decorative schemes, most notably by Raphael and his assistants in Cardinal Bibbiena's Loggetta at the Vatican, and then to tapestry, boldly utilizing the primary colors

of red, blue, and yellow for the backgrounds.[2] Widely disseminated through prints, the style evolved and was reinterpreted by successive generations of designers across an expanding geographic spread. Before long, grotesque motifs were entwined with arabesque (or Arabian) patterns of curling leafy scrolls, derived from traditional Moorish tracery decoration, and with geometric strapwork bands. By the 1680s the composite style had given birth to a whimsical visual space that the renowned ornamentalist Jean Berain I (1640–1711) populated with pantomime-performing theatrical figures and their accompanying musicians.[3]

Jean-Baptiste Monnoyer (1636–1699) capitalized on the enduring taste for the grotesque style and on fashionable French court and urban entertainments to create a highly appealing series of tapestry designs appropriate for contemporary domestic interiors.[4] The charming scenes were purely decorative and carried no historical, religious, or moralizing themes. Consequently, their dimension, number, and arrangement could be customized to meet individual specifications without loss to their narrative value. Furthermore, the composition of each could vary, to achieve greater height or width, according to taste. The full-size tapestry cartoons had optional extensions at the bottom and top: a pair of steps and rich green shrubbery could be added below the marble-tiled terrace, and an extra band of colorful marble moldings, birds, drapery, and swags could be placed above the latticed arches. Eventually, eight different border types were available for the choosing, ranging from narrow bands of guilloche and scrolls to a wide band of ornament and figures. Contemporary documents did not name the individual subjects of the series, but they have since become commonly identified as the *Offering to Bacchus*, the *Offering to Pan*, *Musicians and Dancers*, the *Elephant*, the *Camel*, and the *Animal Tamers*, though components of the last four were variously combined.

Description

A troop of entertainers in theatrical costume performs on a marble-tiled terrace, under a marble and wood trellised portico that is draped with red and blue curtains. A baldachin of red velvet is suspended from under each of the two trellis arches entwined with fruiting grape vines and floral garlands. A trio of musicians and a tightrope walker are stationed under the arch to the left; sounds from the harp, violin, and tambourine provide the aerial acrobat with musical accompaniment. Under the central architrave a flutist and mandolin player flank a square table amply covered in red velvet cloth, set with musical instruments that include a lute, a violin, and a horn. Two animal tamers handle a camel (or, more accurately, a dromedary), a leopard, and a lion, all before a bearded and turbaned elder, holding a rod or scepter, seated on the balustrade to the right. He sits opposite the harpist at the far left of the composition. A profusion of trophies, floral arrangements, and implausible strapwork ornament fill the upper register of the tapestry field, above the architrave. Suspended by blue ribbons from thin marble moldings at the very top of the field are three types of trophies: at left, a musical instrument trophy bundles together a violin, lute, harp, horn, and flute; in the middle, a pair of duplicate trophies hold two crossed quivers filled with arrows, above a leafy wreath; and at right, another musical trophy combines a turbaned and feathered mask, a tambourine, and a musette (a type of bagpipe). Although the performance appears to take place outdoors, there is no perspective into the distance; a golden ground color provides a flat backdrop across the tapestry.

The pictorial field is surrounded by a wide border of assorted elements set against a white field. The horizontal stretches repeat the same motifs top and bottom: female herms, colorful parrots, baskets of flowers, sphinxes, satyr masks, and smoking incense burners. The vertical extensions each contain a crouching satyr with panpipes, a variety of birds, tall and short baskets of flowers and fruit, and male and female herms. A cartouche containing a chinoiserie figure marks each of the four cardinal points of the border. The figure appearing in both the top and bottom cartouches reclines to drink within a tentlike interior. He is dressed as a warrior in a classical cuirass, though his head is shaved and he has a long, wispy mustache. The figure appearing at each side is a moustached man in theatrical garb evoking the Far East, with a red parasol, seated cross-legged on a platform within a niche. The border overall is set within narrow inner and outer bands of simulated carved moldings. Although the elements of the border seem disparate, they may together represent an allegory of the five senses: hearing (birdsong and panpipes), taste (fruit and drink), sight (colorful birds and flowers), touch (hands holding metal tongs and posts), and smell (incense and floral scents).

Artist and Design Sources

Long ascribed on stylistic grounds to Jean Berain I by nineteenth- and early twentieth-century historians, the design of the *Grotesques* series was actually created by Jean-Baptiste Monnoyer, according to a letter dated January 18, 1695. The Paris-based Swedish diplomat Daniel Cronström wrote, "It is of the design by Baptiste, excellent painter and designer of ornament here."[5] Monnoyer, or Baptiste as he was called by his contemporaries, was best known for his flower and still-life paintings, which were so admired by Louis XIV that some sixty of his canvases entered the royal collection before the close of the seventeenth century. Monnoyer's 1665 reception piece for the French Académie Royale de Peinture et de Sculpture, *Flowers, Fruits, and Works of Art*, already featured many elements that would later appear in the *Grotesques* cartoons: a sphinx lying across a segment of a stone balustrade, luxuriant drapery suspended by golden ropes from unseen anchor points, a marble-tiled pavement, ornately cast metal urns, exuberant floral and foliate garlands, and clusters of fruit including grapes, peaches, and pomegranates.[6] In addition, other examples of his work in this genre displayed his talent in portraying musical trophies with theater masks, blue-and-white porcelain vessels, exotic macaw parrots and monkeys, colorful marbleized moldings, and narrow bands of stylized acanthus-leaf relief ornament.[7]

Monnoyer's collaboration, since the 1660s, in the extensive interior decoration schemes devised by Charles Le Brun for the royal residences of Marly, Meudon, and the Grand Trianon at Versailles taught him to conceive and execute compositions in a proportion and scale that would resonate across the walls

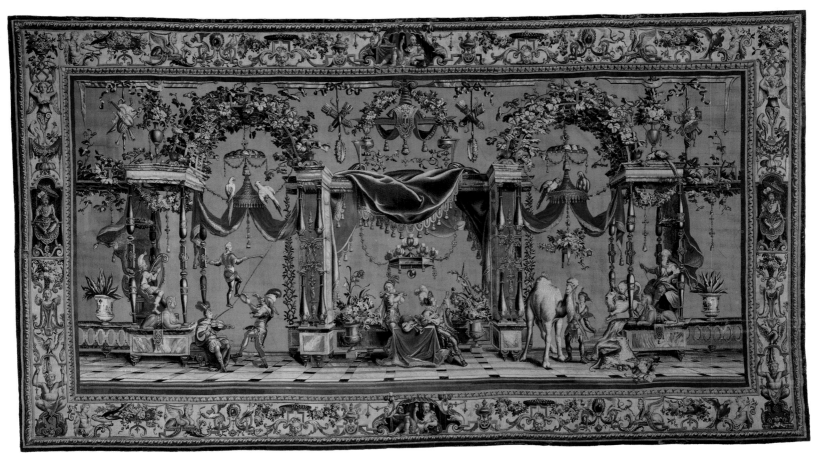

51

of a room. His work, beginning in 1666, for the Manufacture Royale des Meubles de la Couronne at the Gobelins, furthermore, trained him to paint detailed sections of tapestry cartoons according to specifications required by the weavers. Philippe Behagle must have become acquainted with Monnoyer during his own tenure as a weaver at the Gobelins from 1660 to 1672. When faced with the challenge of commissioning new designs for the Beauvais manufactory in the mid-1680s, Behagle astutely made excellent use of Monnoyer's creativity and skills in hiring him to design the *Grotesques*.

The ingenuity of Monnoyer's *Grotesques* designs lay in his combination of traditional grotesque vocabulary with the theatrical quality of Jean Berain's ephemeral staging and printed images. As official *dessinateur de la chambre et du cabinet du roi* with the Administration de l'Argenterie, Menus-Plaisirs, et Affaires de la Chambre du Maison du Roi (designer of the bedroom and cabinet of the

king within the king's household agency) from 1674, Berain was responsible for all aspects and forms of royal entertainments and spectacles, including stage sets and costume designs for the king's beloved ballets, operas, masquerades, carousels, and fireworks displays. Berain's spatial perspective, when contrived within the shallow field of the stage, was typically delineated by vertical tripartite divisions, arcades, pavilions, or baldachins. When Berain converted such compositions into printed form, they gained additional rhythm from geometric strapwork patterns or from a profusion of arabesque ornament. Such compositional and decorative devices ultimately inspired the vignette aspect and the shallow depth of field of Monnoyer's designs, an influence that sometimes resulted in the series being called the *Grotesques de Berain*. The only documented direct involvement of Berain in the project, however, was limited to the invention in 1695 of one of the border types applied to these weavings.[8] Berain's border

was the most geometric of the available choices, taking the form of red guilloche bands against a blue ground, with large-scale cartouches set into the four corners.

Monnoyer actually borrowed many specific figures and elements from other artists and seamlessly inserted them into his designs. This was best exemplified in the *Offering to Pan*, for which he took not only three human figures but also the central herm of the deity from the 1636 *Triumph of Pan* painted by Nicolas Poussin (1594–1665) for Armand Jean du Plessis, Cardinal Richelieu.[9] For the *Camel*, Edith Standen pointed out the affinity between the bearded, kingly figure seated on the balustrade at the far right of the tapestry and its counterpart in an image by Berain that was engraved by Jacques Le Pautre (ca. 1653–1684).[10] But other elements of the *Camel* had more direct inspirations. For instance, Monnoyer copied the study of a dromedary painted between 1669 and 1671 by his former colleague at the Gobelins, the

of polychrome emblems must have appealed
to contemporary taste.

Documentation and Dissemination of the Series

The earliest records naming the purchasers of
Grotesques tapestry sets indicated how rapidly
their popularity expanded from among the
ranks of the French nobles of the sword and
royal ministers to those of the financial com-
munity and then to the international ranks of
ruling families and peers. Within some eight
years of their design, these tapestry sets had
reached a geographical dispersal that stretched
from Sweden in the north, Saxony in the east,
and Savoy in the south, even before their first
appearance in a French royal palace. A docu-
ment dated April 2, 1689, mentioned an
assembled group of four *Grotesques* "à petits
personnages" (with small-scale figures) woven
with gilt-metal-wrapped thread, valued at
2,700 livres, that was offered by Philippe
Behagle as payment to a creditor, Jean Talon,
the royal *intendant* (administrator) who was
involved in recruiting Behagle to the Beauvais
directorship.[16] A later, undated document
drawn up by Behagle (but originating from
about 1695) listed sales of "grotexte" tapestries
produced at two differing levels of quality, a
"fine" gauge weave priced between 80 and
100 livres per unit of measure and a coarser
weave, or "common" type, priced at 57 livres

animal painter Pieter Boel (1622–1674), who
viewed his subjects live in the menagerie at
Versailles (fig. 196).[11] The peacock spreading
its wings in the central vignette of almost all
other versions of the *Camel* was also bor-
rowed from Boel's precedent, or from an
intermediary work by Jean-Baptiste Belin de
Fontenay (1653–1715).[12] Furthermore, the
costumes of Monnoyer's musicians and per-
formers reflected those of the contemporary
players in the Opéra, the Comédie-Française,
and the Commedia dell'Arte. These costumes
are now known through surviving fashion
prints from the period, such as those for a play
by Nicolas Bonnart (1637–1717), *Flautin*,[13]
whose masked character wore the same yel-
low and blue outfit with hussar-style buttons
as that of the master of ceremonies in the
variant *Camel* (fig. 197).

In overall color scheme and composition,
the border on the *Camel* ultimately derived
from the grotesque style of decoration found
in the Vatican's famed Loggie, painted in
1518–19 by Raphael's school of assistants.
A Beauvais manufactory memorandum of
1731 credited both of the cartoon painters,
Monnoyer and Guy-Louis Vernansal
(1648–1729), with the style's reinterpretation
into a border design for the *Grotesques* tapes-
tries, adding that it had "small Chinese
figures, by Batiste and Verensal [*sic*]."[14] The
phrase "small Chinese figures" referred to the
two types of figures positioned within the
cartouches at the cardinal points. Vernansal

was probably responsible for these, as they
related to similarly stylized Eastern figures in
his *Story of the Emperor of China* tapestry cycle
(see cat. no. 52). Standen assumed, based on
the superior draftsmanship, that Vernansal was
also responsible for the other figures within
the border, though Monnoyer, as already
noted, had previously exploited such motifs as
parrots, sphinxes, metal vessels, and floral gar-
lands.[15] This border type appears frequently
on surviving examples of *Grotesques* tapestries,
many of them woven with name BEHAGLE, so
its generous width, white ground, and variety

Fig. 197. *The Camel* from a set of the *Grotesques*. Tapestry design by Jean-Baptiste Monnoyer in the style of
Jean Berain I, woven at Beauvais under the direction of Philippe Behagle, ca. 1700–1715. Wool and silk,
198 x 360.7 cm. Victoria and Albert Museum, London (T.53-1955)

Detail of cat. no. 51

per unit of measure.[17] The first hanging of "fine" quality was acquired by Jacques-Henri de Durfort, duc de Duras, a renowned marshal of France and governor of Franche-Comté; successive sets went to the unidentified Monsieur Saint-Pouange (or Pange), the tax farmer Rousselin, the chancellor (either Michel Le Tellier, chancellor 1677–85, or Louis Boucherat, chancellor 1685–99), and the papal nuncio in France (most likely Giovanni Giacomo Cavallerini, 1692–99).[18] Sales abroad were recorded next, with three purchases either made in Brussels or destined for residents of Brussels, including two for the duke of Saxony (possibly John George IV, Elector of Saxony, 1691–94). Despite onerous export duties, tariffs, and shipping expenses

that depleted the profit margin, Behagle reported selling many sets of the "common" weave to Denmark (buyers unnamed) and one to the duke of Savoy, Victor Amadeus.

Correspondence of 1695 from Daniel Cronström to the architect Nicodemus Tessin the Younger in Stockholm regarding a commission for the influential Swedish chancellor Carl Piper revealed many details about the path of dissemination, the development of taste, and the intended function of these tapestries. Standen summarized how Cronström found the designs of "la Grotesque de Beauvais" to be suitable not only for lining the walls of the main bedrooms in Piper's fashionable residence but also, when combined with portieres (tapestries intended to be

hung across interior doorways), for preventing the smell of cooked food from spreading.[19] Piper's order was for a rather large amount of tapestry to be delivered on short notice, so it was proposed that preexisting weavings of this design could be cut into two or three pieces according to the desired dimensions, without harm to the patterns, either with adjustments made to the old borders or with new borders added. If Piper decided to order new weavings, as was the case, the work was promised within three months. Cronström also advised hanging coordinating "dawn"-colored (aurore) textiles in adjoining rooms of the house. In May 1695 Cronström reported that sixteen looms at Beauvais were devoted exclusively to the Piper order, of which the *Grotesques*

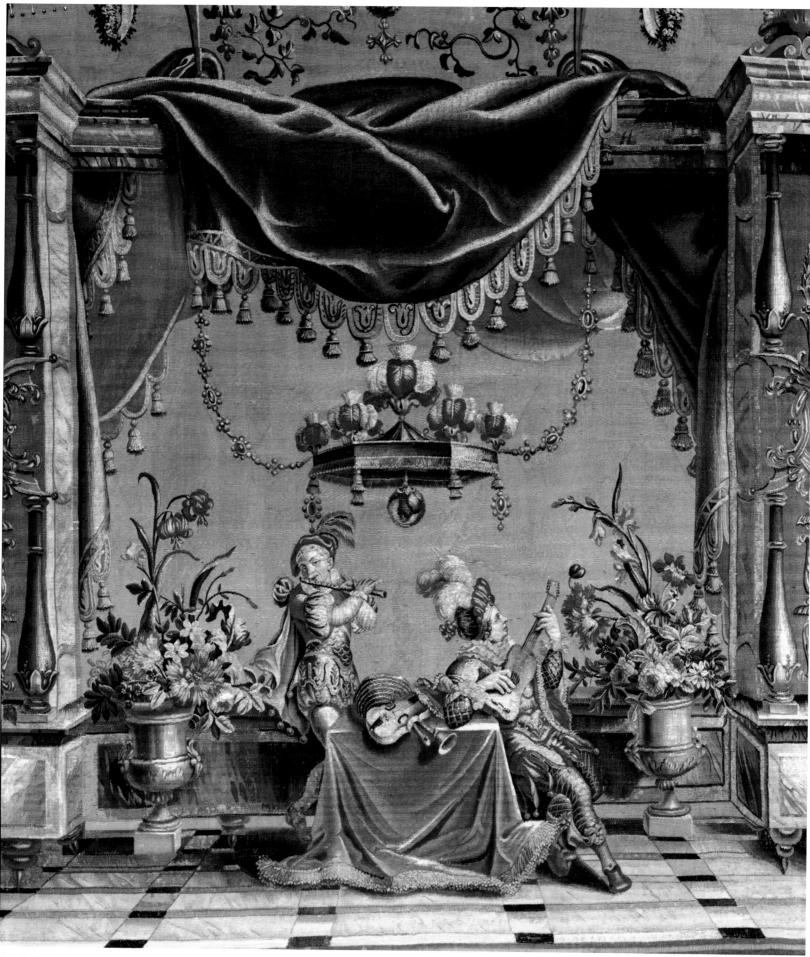

Detail of cat. no. 51

tapestries composed sixteen running French ells (about 19 linear meters, or about 62 feet), at the "low" cost of 2,500 livres. Taking the initiative, Cronström had the manufactory add borders in the "grotesque taste designed by Berain, of red strapwork against a blue ground instead of the ordinary one of curling parsley leaves."[20] Finally, one year later, in October 1696, complementary tapestry-woven upholstery seat covers, bearing the cipher CP for Carl Piper, were supplied through Cronström, presumably also from the Beauvais looms.[21]

The first French royal order for a set of six *Grotesques* hangings delivered to the Garde-Meuble de la Couronne (the king's household furnishing agency) in June 1696 was intended to serve Louis XIV at the Château de Marly, the sumptuous "hunting lodge" where the king went to escape the rigors of formal court life at Versailles.[22] The royal inventory described "a set of wool and silk tapestry made at Beauvais in the manufactory of Behagle, representing 'Crotesques' against a wool ground of dead leaves [the vibrant ground color of the series], within a border of green ovolo molding."[23] Though the designs were not considered appropriate for the formal parade rooms of the main palaces such as Versailles, they nonetheless appealed to the king's evolving taste as he began to favor lighter, less weighty designs and furnishing textiles in fashionable shades of yellow.[24] An ardent patron of tapestries, Louis XIV's legitimized son the comte de Toulouse also commissioned a set of seven *Grotesques*, which he hung in his country residence, the Château de Rambouillet, rather than in his Paris hôtel.[25] As testament to the longevity of this popular series, the second royal order for it was placed by the youthful Louis XV some thirty years later, in 1727, and its value of 3,000 livres was debited from the treasury's loan to the current director of Beauvais, Noël-Antoine de Mérou (director 1722–34).[26]

Cronström's correspondence implied that *Grotesques* tapestries were woven for stock even during the directorship of the Behagle family, and it is known, on the basis of additional factory records, that production of the series for stock and for private commissions continued for decades. Before 1722, two of the cartoons had to be retouched by the artist in residence, Simon de Pape III (1663–1751), presumably to repair damage from repeated use. When the last weaving was cut from the loom in April 1733, an estimated fifty full or partial sets had been made, of which some one hundred and fifty hangings survive.[27] The enduring popularity of the series was due to the appealing design and color scheme, the flexibility of the narrative compositions, and the variety of border designs (at least eight different patterns) that could be applied to the weavings. As Anna Bennett observed, the unmitigated success of the *Grotesques* was marked by its repetition and imitation.[28] Sales abroad, especially from outlets in the Holy Roman Empire located in Ratisbon (Regensburg) and Leipzig, spread the taste for the tapestry series and immediately generated active copyists, notably Jean Barraband II (1687–1725) in Berlin.[29]

CHARISSA BREMER-DAVID

1. Five of the set are in The Metropolitan Museum of Art, New York, Gift of John M. Schiff, 1977 (1977.437.1–.5); Standen 1985, pp. 441–55. The sixth hanging is in the Musée des Arts Décoratifs, Paris; Badin 1909, illus. facing p. 12.
2. See T. Campbell in New York 2002, pp. 225–29, 246–52 no. 26; T. Campbell and Karafel in New York 2002, pp. 371–77, no. 44; Meoni in New York 2002, pp. 514–17, no. 60.
3. Kimball 1941.
4. R.-A. Weigert 1946b.
5. "Elle est du dessein de Baptiste, excellent peintre et dessignateur d'ornement icy"; R.-A. Weigert 1933, p. 12; *Relations artistiques* 1964, p. 65.
6. Musée Fabre, Montpellier, inv. D.803-1-13; Hilaire 1995, pp. 44–45.
7. Pavière 1966.
8. *Relations artistiques* 1964, pp. 76–78; Adelson 1994, p. 313.
9. National Gallery of Art, London, inv. NG 6477; Wine 2001, pp. 350–65; A. G. Bennett 1992, pp. 259–61, no. 80.
10. Standen 1979b, pp. 209, 211 fig. 3; R.-A. Weigert 1937a, vol. 1, pl. 21, fig. 44.
11. Musée des Beaux-Arts, Reims, inv. D.892.1.1; Paris 2001, p. 108, no. 35.
12. Musée du Louvre, Paris, inv. 4032; Paris 2001, pp. 129–30 no. 62, 138–39 fig. 41.
13. Los Angeles County Museum of Art, inv. M.2002.57.156 (hand-colored); R.-A. Weigert 1939, p. 443.
14. "Une autre tenture du dessein de *Grotesques*, avec petites figures chinoises, par Batiste et Verensal"; Badin 1909, pp. 20–23.
15. Standen 1979b, pp. 209–10.
16. Göbel 1928, pp. 213–14; R.-A. Weigert 1933, p. 10, n. 1; J. Coural and Gastinel-Coural 1992, pp. 17, 19, 28–29 n. 18.
17. Badin 1909, pp. 12–13. The date of 1695 is proposed by the present author as the terminus ante quem for Behagle's document, since it did not mention the 1695 *Grotesques* tapestry commission of Count Carl Piper, the Swedish chancellor, nor the distinctive strapwork border designed for it. Standen 1979b; Adelson 1994, pp. 314, 320 n. 34.
18. A set of six *Grotesques* "fond feuille morte, fabrique de Beauvais" (with a background of dead leaves, made at Beauvais) was listed in the inventory made after the death of Le Tellier's son, Charles Maurice, archbishop of Reims; Standen 1985, pp. 444, 454 n. 20.
19. Standen 1979b, p. 211; *Relations artistiques* 1964, pp. 64–68.
20. "Je fais mettre à la *Grotesque*, une bordure d'un goust grotesque du dessein de Berain, à bastons rompus rouges sur un fond bleu, au lieu d'une bordure ordinaire de feuilles de persil tournantes sur un fond bleu"; *Relations artistiques* 1964, pp. 76–78; Franses 1986, n.p., "La Musique from the series *Grotesques de Berain*," which is now in the Whitworth Art Gallery, University of Manchester, inv. T.1986.28. It is woven with the signature BEHAGLE. An example of an *Animal Tamers* from the *Grotesques*, with broken strapwork border and the signature P.BEHAGLE F., was sold at Drouot-Richelieu, Paris, March 29, 2000, no. 112.
21. Standen 1985, pp. 459–60; Cederlöf et al. 1986, pp. 32–36.
22. J. Coural and Gastinel-Coural 1992, pp. 21, 29 n. 29.
23. "Une tenture de tapisseries de laine et soye, manufacture de Beauvais, et fabrique du sr. Béagle [*sic*], représentant des *Crotesques* sur un fond de laine feuille morte, dans une bordure d'oves vertes"; Guiffrey 1885–86, vol. 1, pp. 361–62, no. 169.
24. Bremer-David 1997, p. 76.
25. J. Coural and Gastinel-Coural 1992, p. 161, nos. 7, 8.
26. Badin 1909, p. 56.
27. Ibid., pp. 15, 77; Standen 1985, pp. 441–58; Adelson 1994, pp. 315, 320 n. 36.
28. A. G. Bennett 1992, p. 258.
29. R.-A. Weigert 1933.

From a ten-piece set of the *Story of the Emperor of China*
Design by Guy-Louis Vernansal, Jean-Baptiste Monnoyer, and Jean-Baptiste Belin de Fontenay, ca. 1686–90
Woven at the Beauvais tapestry manufactory under the direction of Philippe Behagle, ca. 1697–1706
Wool and silk
423 x 310 cm (13 ft. 10½ in. x 10 ft. 2 in.)
7–8 warps per cm
Signed VERNANSAL.INT.ET.PU in the border of the carpet in the narrative field
The J. Paul Getty Museum, Los Angeles (83.DD.336)

PROVENANCE: Louis-Alexandre de Bourbon, comte de Toulouse (1678–1737); by 1718, displayed in the Château de Rambouillet; by descent to his son, Louis-Jean-Marie de Bourbon, duc de Penthièvre (1725–1793); by descent to his daughter and heir, Louise-Marie Adélaïde de Bourbon (1753–1821); by inheritance to her eldest son, Louis-Philippe d'Orléans, King of the French (1773–1850); January 25–27, 1852, sold as one of a lot of six tapestries, Domaine de Monceaux, no. 8; duc d'Uzès, Château de Bonnelles, Seine-et-Oise; by descent to Thérèse d'Albert-Luynes d'Uzès, Château de Bonnelles, Seine-et-Oise; 1925, Georges Haardt and Company, New York; French and Company, New York (stock no. 27965): John Thompson Dorrance Sr., Newport, R.I.; by descent to John Thompson Dorrance Jr., Newport, R.I.; 1983, Rosenberg and Stiebel, New York; 1983, J. Paul Getty Museum, Los Angeles.

REFERENCES: Moutié and Dion 1886, pp. 208, 227; Badin 1909, pp. 11, 13, 15–16; Cavallo 1967, pp. 170–76; Standen 1976; Jarry 1980; Bremer-David 1984; Standen 1985, pp. 461–68; J. Coural and Gastinel-Coural 1992, p. 24; Bremer-David 1997, pp. 80–97; Wilson and Hess 2001, pp. 146–47; de Ribou 2004.

The *Collation* was one of a set of ten tapestries from the series called the *Story of the Emperor of China* that was commissioned by Louis-Alexandre de Bourbon, comte de Toulouse, about 1697. The Toulouse order, however, was not the editio princeps but rather the fourth set woven. The monumental series was conceived some ten years earlier in the sinophile ambiance of the French court of the mid-1680s, after two separate appearances at Versailles of travelers from the Far East: the first was the Chinese convert to Christianity Michael Alphonus Shen Fu-Tsung, in September 1684, followed by the trade delegation of Siamese "ambassadors" in September 1686. On the French side of this exchange, Louis XIV sent six of the greatest French Jesuit mathematicians and scientists (newly admitted to the French Académie Royale des Sciences) on a mission to China, via Siam, that departed from France in 1685. A letter from the king dated August 7, 1688 (but never actually delivered by the French missionaries), addressed his contemporary, the Manchu Qing dynasty Kangxi emperor (r. 1661–1722), as a peer and an ally: "Great, powerful and generous is the undefeatable prince, our valued friend."[1]

Beauvais was not far removed from these events, for the tapestry manufactory received visits from both the king and the Siamese delegation in 1686. Responding to the intense interest generated by these encounters, Philippe Behagle (1641–1705), newly appointed director of the Beauvais manufactory in 1684, contracted with a group of four French artists to design a set of tapestries portraying the Kangxi emperor as the counterpart of the French king. Behagle's bold vision called for a grand set of figural tapestries that would complement the famed Gobelins cycle *History of the King*, which portrayed the life of Louis XIV after designs conceived by Charles Le Brun (see cat. nos. 41–47).[2]

The cartoons for the nine individual scenes of the *Story of the Emperor of China* drew upon the wealth of information found in illustrated reports from the 1660s by European voyagers to China, notably those of the Dutch East India Company delegate Johannes Nieuhof and the Jesuit missionaries (printed by Athanasius Kircher), as well as eyewitness accounts from missionaries returning to Europe in the mid-1680s, among them Father Philippe Couplet. Six of the subjects showed the emperor performing a range of daily activities that demonstrated his self-discipline and dedication in balancing the divergent, demanding, and highly symbolic responsibilities deemed necessary to maintain the harmony of the empire. The *Audience of the Emperor* (fig. 188) and the *Emperor on a Journey* represented the dutiful fulfillment of official imperial ceremonies and inspection tours of state; the *Return from the Hunt* and the *Emperor Sailing* portrayed martial exercise and physical skill; the *Astronomers* exemplified diligence in scholarly pursuits and reverence for the emperor's role as arbiter between Heaven and Earth; and the *Collation* expressed appreciation of aesthetic pleasures and support of the arts. Three other subjects continued the overall propagandistic allusion to the sophisticated Qing program of good governance but were acted out by a female protagonist, presumably meant to be the empress: the *Pineapple Harvest* affirmed the critical importance of the empire's agrarian cycles; the *Empress's Tea* alluded to the significance of this beverage in daily Chinese life and its increasing value as a commodity in international trade; the *Empress Sailing* not only represented the pleasure of outdoor entertainments but also, as the companion piece to the *Emperor Sailing*, suggested the duality of marital life. Each scene, furthermore, conveyed in detail the exoticism of a foreign land, its people, culture, scenery, flora, and fauna.

The cartoons must have been completed by 1690, the year one of the painters, Jean-Baptiste Monnoyer (1636–1699), left France to work in England, where he later died.[3] From the 1690s until 1732, when the cartoons were worn beyond use, the Beauvais tapestry

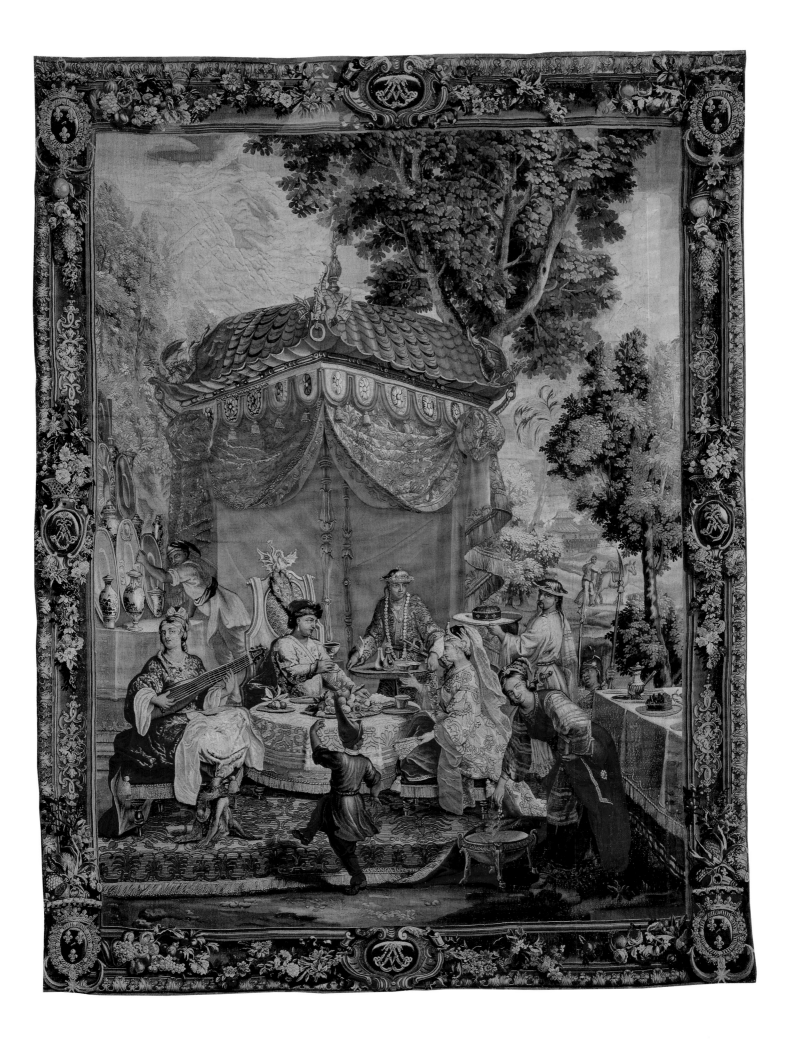

manufactory repeatedly wove the *Story of the Emperor of China*, producing no fewer than eighteen sets, a conservative estimate based on the number of extant examples of the *Audience* that can still be traced today.[4] The popularity of these tapestries in France attested to the broader intellectual movement toward a greater awareness of and fascination with chinoiserie, a taste that was fueled further by the growing importation of porcelain, lacquer, silk, spices, and tea from the Far East. The success of the Beauvais chinoiserie tapestry series was also due to the prevailing curiosity for novel and foreign objects and experiences, real or vicarious—the same curiosity that inspired the parallel production of a contemporary tapestry series at the Gobelins manufactory, called *Les anciennes Indes* (see cat. no. 48), portraying the peoples, flora, and fauna of Brazil.[5]

Description

Under a pavilion set outdoors in a glade, a couple partakes of a meal. Though supported only by attenuated poles, the roof of the pavilion implausibly bears heavy ceramic tiles glazed in red, blue, yellow, and brown, with a ceremonial guardian dragon fitted at each of the three visible corners. The pavilion is draped with a fringed crimson and gold damask curtain that has been pulled aside at the front and knotted at the top of two of the poles. Seated before a low, circular table covered with an embroidered cloth and laid with a platter of fruit and other dishes, the emperor sits on a high-backed chair embellished with a carved dragon on the crest rail. Distinguished by a large pendant pearl earring, the emperor also wears a fur-trimmed red cap set with peacock feathers and a blue robe decorated with stylized cloud or wave forms. The female opposite, presumably the empress, sits cross-legged on a taboret and gestures with a fan held in her left hand. Supporting the table is a platform covered with a wide, patterned carpet that has the phrase VERNANSAL.INT.ET.PU woven into its border. Servants bring two additional trays of refreshments, add incense to the burner, and adjust the brass or silver-gilt plate at the European-style buffet table to the side. A female musician sits cross-legged on another taboret as she plays a stringed

instrument, providing music for a dwarf who dances, while a monkey crouches at her feet. The vista beyond the glade reveals to the right a figure walking beside a pack mule and, farther back, roofed buildings behind a crenellated wall. The border is designed as if it were a carved picture frame hung with floral and fruit garlands, with an outer row of simulated carved acanthus leaves. At each side, a central gold cartouche encircles the monogram LA, for Louis-Alexandre de Bourbon, comte de Toulouse, set against a blue oval. In the vertical borders a basket of flowers rests above the central cartouche while strapwork ornament extends above and below. Each corner bears the Bourbon coat of arms for the comte de Toulouse, placed under a marshal's baton and the crown worn by *les enfants de France* (royal children); the flukes and arms of a ship's anchor appear suspended below. Each armorial shield is surrounded by the collars for the chivalric orders of Saint Michael and of the Holy Spirit.

Subject and Iconography

The remarkable *Story of the Emperor of China* tapestry series has long drawn the notice of historians and tapestry specialists for its fascinating large-scale portrayal of seventeenth-century China, the Qing court, and the Jesuit missionaries stationed there. Generally acknowledged as one of the first European expressions of chinoiserie, the series was a milestone in the history of taste and in the cross-cultural exchange between East and West. The context of its creation and its reception, initially among members of the French royal family and then among the ministerial ranks, reveal the growth of this fashionable trend; subsequently woven in full or partial sets for retail stock, the series rapidly increased in popularity.[6]

Because two of the nine subjects, the *Audience* and the *Astronomers*, contain recognizable portraits of historical figures and accurate renderings of actual scientific instruments that still survive, they have been studied extensively.[7] New scholarship published to coincide with two recent exhibitions now encourages a similar scrutiny of the other subjects in the series.[8] As the public and private lives of the Qing emperors are better

understood by the Western community, the abundance of visual details in these companion tapestry scenes confirms that the cartoon painters benefited not only from the printed images included in the aforementioned travel reports but also, and more significantly, from personal accounts of eyewitnesses to the imperial court.

The setting of the *Collation*, for example, may not be arbitrary, as it probably represented the grounds of an imperial summer residence or hunting reserve. The Qing dynasty emperors withdrew annually from formal court life to pass the summers in cooler locations and the autumns in game parks outside the Forbidden City. Government functions moved as well, and arranging accommodations for the entourage that followed the emperor must have been complex, as officials, wives, kinsmen, servants, and guards also traveled to the summer retreats.[9] The Kangxi emperor's first summer palace, Changchun yuan (Garden of Joyful Spring), was located close to the village of Haidian, near Beijing (then called Jingshi or Jingcheng). It was built on the site of a ruined garden that once belonged to the father-in-law of the Wanli emperor (r. 1573–1619) of the Han-controlled Ming dynasty. Apparently it was a large estate enclosing lakes and streams, with generous expanses of open ground suitable for archery drills on horseback. The compound probably included small pavilions and temporary tent structures that reflected the traditional Manchu outdoor way of life, such as those that were set up at the Kangxi emperor's second summer retreat at Rehe and that continued to be erected in successive reigns. As described by the British ambassador Lord George Macartney in 1793, "In the middle of the garden was a spacious and magnificent tent, supported by gilded or painted and varnished pillars.... Within the tent was placed a throne...."[10] The Kangxi emperor, in particular, adhered to the Manchu lifestyle during these months and enjoyed traveling with tents.[11] Another retreat, at Mulan, was an extensive hunting preserve located about 130 miles to the north of Beijing and outside the Great Wall; it contained large game bears and the prized white Père David (*Mi*) deer.[12] Excursions there

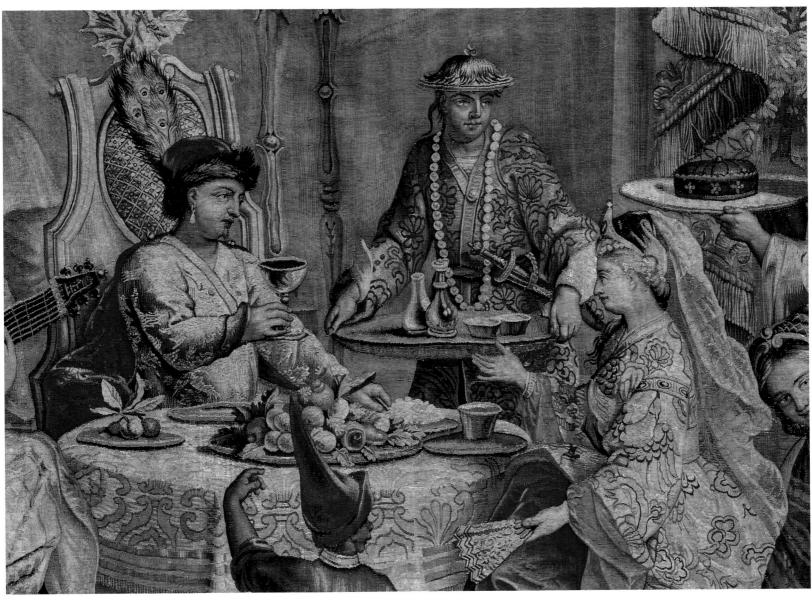

Detail of cat. no. 52

included exercises in horsemanship and archery competitions with the troops. The Jesuit missionary Philippe Couplet, who was stationed in China but temporarily returned to northern Europe in the mid-1680s when he visited Versailles together with Michael Alphonus Shen Fu-Tsung, may have relayed the personal accounts of his confrere Ferdinand Verbiest, the Jesuit friend of the Kangxi emperor who joined the imperial inspection tours and hunting parties of 1682 and 1683.[13] Such secondhand reporting may well have been the indirect source for the appearance of the tented pavilion in the *Collation* tapestry and the selection of game prominently visible in the *Return from the Hunt*.[14]

The style of dress worn by the Kangxi emperor in all of the *Story of the Emperor of China* tapestry subjects reflects a traditional Manchu garment. Unlike the more voluminous Han court robes (*chaofu*) normally retained by the Qing emperors for formal ceremonies, official functions, and state portraits, the three-quarter-length, straight-seamed, tapering robe with narrow sleeves and protective "horseshoe" cuffs (*matixiu*) of the characteristic Manchu attire seems to have been reserved for military exercise and recreational activities.[15] The latter form of dress appeared conspicuously in the illustrations of the emperor in the influential publications of the 1660s by Johannes Nieuhof and Athanasius Kircher, two sources that were

mined to great effect by the designers of the Beauvais tapestry series.[16] Additionally, the hat worn by the emperor in the *Collation* corresponds to a distinctive type worn at court during the winter, with sable trim, glossy red crown, and array of peacock feathers that symbolized courage in battle.[17] Even the large pendant earring hanging from the emperor's right earlobe had meaning, as an example of the giant freshwater pearls harvested in Manchuria, which were valued as the highest grade of precious gem.[18]

Admittedly, aspects of the composition of the *Collation* tapestry do seem, at first impression, to be imaginative inventions or associations of the French designers who never traveled to China. Nothing could be

more unlikely than the blond-haired female cast as the empress or the vervet monkey, in the foreground of the tapestry, that had been adapted by Jean-Baptiste Belin de Fontenay (1653–1715) from a model painted at least a decade earlier by Pieter Boel (1622–1674), the animal painter who worked at Versailles and at the Gobelins.[19] Other features of the design, especially the emperor's high-backed throne and the sideboard buffet, certainly manifested strong European influences. But even these furnishings echoed a subtle knowledge of Qing art patronage and aesthetics. As seen in the tapestry, a stylized rendering of the symbolic imperial dragon, for example, customarily designated all seat furniture reserved for the exclusive use of the emperor. The buffet arrangement in the tapestry reflected the usual display of ornamental vases on tables that were positioned under awnings during imperial garden banquets. Furthermore, the metal and porcelain vessels in the tapestry may have alluded to the products of the imperial workshops established by the Kangxi emperor beginning in 1661, some of which were located within the emperor's own domestic quarters (*Zaoban chu*) in the Forbidden City.[20]

Additional layers of exoticism were inserted into the *Collation*. The patterned carpet on the platform, the cross-legged musician seated on the low stool, and the stringed instrument she plays anticipated images of the north Indian Hindustani court later published by the Jesuit priest Joachim Bouvet, a member of the French mission to China who returned to France in 1697.[21] Moreover, the discreet presence of a woven signature in the border of the carpet, beside the foot of the dwarf, followed the traditional placement of artisans' signatures knotted into the borders of the highest-quality carpets made in the Near and Middle East, particularly in Persia, and imported into Europe in the sixteenth and seventeenth centuries. Its appearance here in the *Collation* would have been associated with the most luxurious wool and silk carpets produced by Muslim craftsmen.

Authorship and Design
The woven signatures in this example of the *Collation* and in companion tapestries from the *Emperor of China* set commissioned by the

Detail of cat. no. 52

comte de Toulouse affirm the authorship of the design and the workshop responsible for the series. The Latin phrase VERNANSAL.INT.ET.PU (Vernansal, Inventor and Painter) woven into the border of the carpet in the *Collation* indicated that the painter Guy-Louis Vernansal was not only the chief cartoon painter but also the creator of the compositions. The woven signature of BEHAGLE, for Philippe Behagle, director of the Beauvais tapestry manufactory from 1684 until his death in 1705, is present in four of the companion pieces, including the *Return from the Hunt* (in the lower-right corner of the narrative field).[22] In an undated document listing the tapestries produced during his tenure at Beauvais, Behagle mentioned a series of "Chinese design made by four illustrious painters" woven in four sets, the last one for the comte de Toulouse.[23] A second document, of 1731, dating from the tenure of a subsequent Beauvais director, Noël-Antoine de Mérou, identified three of the four artists of the series as Jean-Baptiste Monnoyer, Jean-Baptiste Belin de Fontenay, and Guy-Louis

Vernansal.[24] While the identity of the fourth collaborator has remained a mystery, a payment from the French Crown in 1710 to a "s^r Houasse" for a tapestry cartoon representing the *Audience of the Siamese* suggests that the last artist could have been René-Antoine Houasse (1645–1710), who from before 1690 had a working relationship with Behagle as the provider of cartoons for a series of *Metamorphoses* after Ovid (fig. 189) for the Beauvais manufactory.[25]

All four of these artists were admitted to the Académie Royale de Peinture et de Sculpture and worked regularly for the crown, providing canvases for the royal palaces or contributing to the larger decorative schemes executed under the supervision of Charles Le Brun. All four were also employed as collaborative painters of cartoons for various projects at the royal Gobelins tapestry manufactory, so they were skilled in adapting compositions to meet the needs of the weavers. Monnoyer and Belin de Fontenay specialized in the flower paintings admired and collected

by Louis XIV; both sometimes incorporated animals and birds, such as vervet monkeys and peacocks, into their works.[26] And Monnoyer's still-life arrangements occasionally included a rare piece of Chinese "blue-and-white" ware porcelain. Prior to collaborating on the cartoons for the *Story of the Emperor of China* tapestries, Belin de Fontenay and Houasse (if he was, indeed, the fourth artist) previously explored an Eastern theme when they painted the illusionistic *Perspective of Palaces with Figures in Oriental Dress* for the Queen's Staircase in the Château de Versailles in 1680–81.[27] Behagle's motives in bringing together these artists for this novel commission and the intellectual reasons behind his approval of its individual subjects have yet to be understood. Who was the well-informed adviser who provided copies of the Nieuhof and Kircher publications? Vernansal, the primary artist of this visionary and profoundly influential series, is now relatively unknown except for a few paintings of religious and mythological subjects that do not equal the originality and vivacity of the *Story of the Emperor of China*. His genius in this instance deserves further consideration.

The Commission and Its Documentation
Unlike the first three sets woven of the *Story of the Emperor of China* series, the commission of this set is unusually well documented within the early Beauvais production chronology, and its complete provenance is known even though the component pieces were separated in the nineteenth century. As noted above, Behagle recorded that the fourth set of this series was destined for Louis-Alexandre de Bourbon, comte de Toulouse, the second surviving legitimized son of Louis XIV and his mistress, Françoise-Athénaïs de Rochechouart-Mortemart,

marquise de Montespan. While Behagle did not state the overall running length of the set in the undated document previously mentioned, he did list the price, which at 10,565 livres provided a profit of about thirty percent.[28] The order must have been on the looms before 1703, for as Jean Coural and Chantal Gastinel-Coural published, the unpaid weavers at the Beauvais tapestry manufactory revolted on the night of February 7, 1703, and confiscated the *Return from the Hunt*, which was then in progress. They further stated that weaving of the full set had finished in 1706 and that the widow Behagle, Anne van Heuven, received payments in 1705 and 1706.[29] The complete set of ten pieces—one weaving of each of the nine subjects, plus a second narrower version of the *Emperor on a Voyage*—was included in a 1718 inventory of the Château de Rambouillet, the comte de Toulouse's primary country residence some twelve miles to the south of Versailles. The inventory listing described it as "the story of the king of China, three and a half [French] ells in height, made at Beauvais by Behagle" and registered six hangings in the king's antechamber, three in the king's bedroom, and one stored in the attic above the stables.[30] All survived into the twentieth century and are readily identifiable by the unique borders bearing the cipher and coat of arms of Louis-Alexandre de Bourbon. The present location of only one of the original ten, the *Emperor Sailing*, is not known.[31]

CHARISSA BREMER-DAVID

1. Hong Kong 1997, pp. 166–67, no. 54; Desroches 2004, p. 48; Versailles 2004, p. 243, no. 21.
2. Fenaille 1903–23, vol. 2, pp. 99–127; Meyer 1980.
3. Standen 1976, p. 115, n. 36.
4. Badin 1909, p. 78; Standen 1985, pp. 461–68; Bremer-David 1997, pp. 80–97.
5. Jarry 1980, pp. 179–82; Fenaille 1903–23, vol. 2, pp. 371–98; Bremer-David 1997, pp. 10–19.
6. See Standen 1985, pp. 464–67.
7. Jarry 1975; Standen 1976; Golvers 1993, pp. 9, 453; Bremer-David 2002, pp. 32–34.
8. Versailles 2004; London 2005.
9. Rawski 2005, p. 25.
10. F. Wood 2005, pp. 61–62.
11. Krahl 2005, p. 210.
12. On the significance of the imperial hunt and the Père David deer, see Childs-Johnson 1998, p. 42.
13. Heyndrickx 2004, p. 90.
14. The memoirs of another member of the Jesuit mission in China, Gabriel de Magaillans, who lived at the Beijing court from 1648 until his death in 1677, must have been read by the community there before their posthumous publication in 1688 under the title *Nouvelle relation de la Chine, contenant la description des particularitéz les plus considérables de ce grand Empire*.
15. London 2005, pp. 384–85, nos. 3–5.
16. Johannes Nieuhof, *Gezantschap der Neêrlandtsche Oost-Indische Compagnie, aan den grooten Tartarischen Cham* (Amsterdam, 1665), and better known by the title of the Latin translation, *Legatio batavica ad magnum Tartariae Chamum* (Amsterdam, 1668); Athanasius Kircher, *China Monumentis quà Sacris quà Profanis* (Amsterdam, 1667).
17. Dickinson and Wrigglesworth 2000, pp. 97–14.
18. London 2005, p. 384, no. 1.
19. Paris 2001, pp. 137–38, no. 75.
20. Krahl 2005, pp. 213–14.
21. Joachim Bouvet, *L'estat present de la Chine en figures* (Paris, 1697).
22. BEHAGLE is also woven into the *Pineapple Harvest* (J. Paul Getty Museum, Los Angeles), the *Audience*, and the wide version of the *Emperor on a Journey* (both, Musée National du Château de Compiègne). See Bremer-David 1997, p. 90; de Ribou 2004; Versailles 2004, p. 270, no. 140.
23. "Autre dessin de *Chinoise* faict par quatre illustre peintre"; Badin 1909, p. 13.
24. "Une tenture du dessein des *Chinois*, par les sieurs Batiste, Fontenay et Vernensal, en six pièces…"; Badin 1909, p. 21; Cavallo 1967, pp. 170–76; Standen 1976, pp. 115–16.
25. Guiffrey 1881–1901, vol. 5, col. 437; Jestaz 1979, p. 188.
26. Salmon 1998a; Paris 2001, pp. 137–38, no. 75.
27. Compin and Roquebert 1986, vol. 3, p. 313; Meyer 1988, p. 40.
28. Badin 1909, p. 13. As a point of reference, the crown reimbursed Behagle 30 livres per year for each apprentice's room and board.
29. "Le Roy chinois a la chasse sans un trosne"; J. Coural and Gastinel-Coural 1992, pp. 24, 162 no. 11.
30. "L'histoire du roi de la Chine, sur trois aunes et demi de haut, manufacture de Beauvais, faite par Behagle"; Moutié and Dion 1886, pp. 208, 227. Three and one half French ells (a unit of measure equivalent to 118.8 cm) is equal to 417 centimeters, which is very close to the modern dimension of the tapestry's height.
31. Wilson and Hess 2001, pp. 146–47, no. 296.

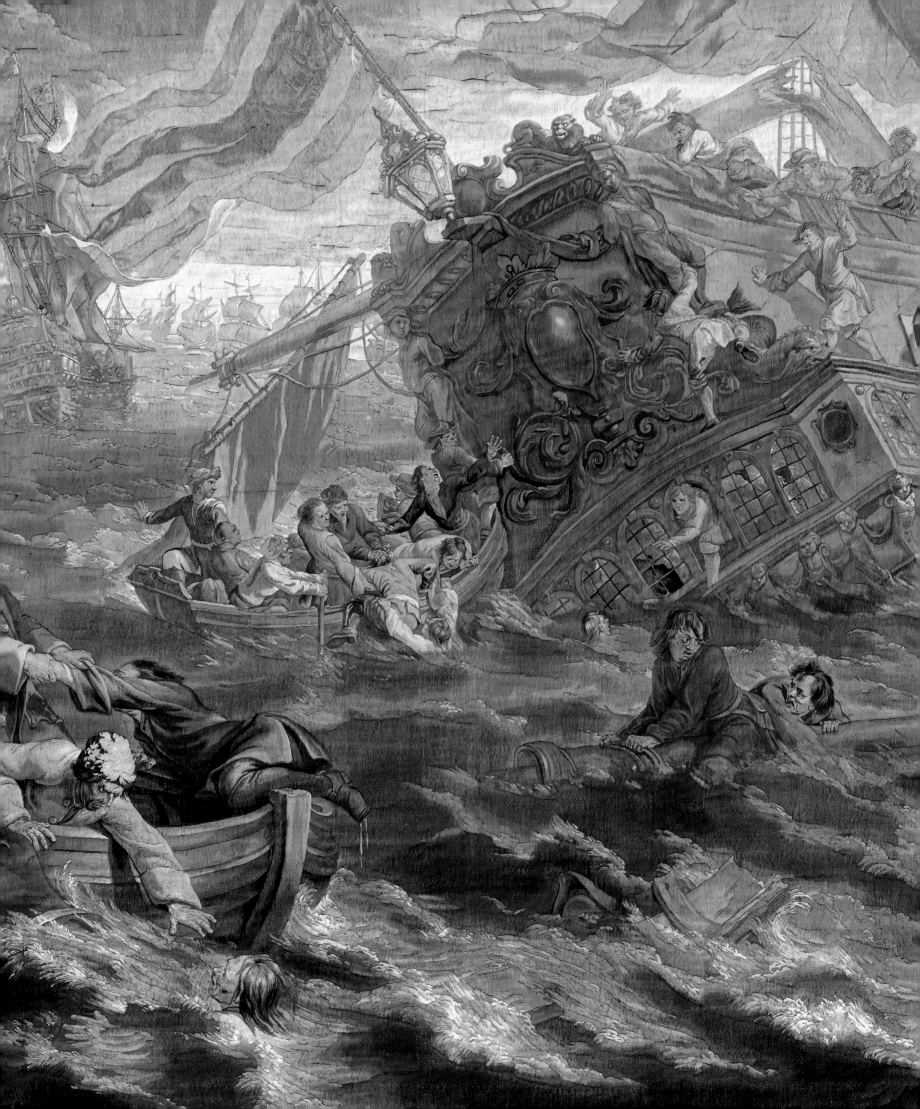

Flemish Production, 1660–1715

KOENRAAD BROSENS

Beginning about 1650 the well-established trade in tapestries at the Antwerp Tapissierspand declined markedly. To be sure, the Pand remained operational until about 1705; the Brussels tapestry producer François van den Hecke (1595/96–1675), for example, stored a part of his output at the Antwerp warehouse.[1] Yet its importance unquestionably diminished during the second half of the seventeenth century, as evidenced by an Antwerp tapestry dealer's statement that between 1650 and 1675 he had never made use of the Antwerp Pand.[2] The main cause of this decline was the opening of a rival Tapissierspand in Brussels in 1655.[3]

The tapestry storehouse in Brussels, located in the town hall, can be considered the locus of the Flemish tapestry trade during the second half of the seventeenth century. The Brussels Pand, or *magazin*, as it was mostly called by contemporaries, had a lively ambiance. Entrepreneurs from Brussels, Oudenaarde, Ghent, Enghien, "jae oock die van Antwerpen selver" (and even those from Antwerp) met at the Pand, discussed business, eavesdropped on conversations, and bought and sold tapestries.[4] French dealers in particular were eager customers. A letter of 1678 reveals that "tapestries made for the market . . . are extremely hard to find because of the French, who buy everything they can get their hands on without proper negotiations."[5] The French taste for Flemish tapestry remained intact even after tapestry production in Paris, Beauvais, and Aubusson was reorganized, about 1660. Certainly, French workshop managers took on private as well as royal commissions, but although they tried to obtain fashionable cartoons and the technological know-how and workforce required to produce top-quality tapestries, the Parisian guild of the *maîtres et marchands tapissiers*, which controlled the market for tapestry in the French capital, and independent *marchands* zealously kept on importing Flemish tapestries, embargoes and duties notwithstanding.[6]

In addition to merchants and producers, local representatives of the European nobility frequented the Brussels Pand, trying anxiously to match the wishes of their patrons with the sets on offer and the conditions set out by the tapestry entrepreneurs. During the second half of the seventeenth century Count Johann Adolf von Schwarzenberg, Cosimo III de' Medici, Count Ferdinand Bonaventura I von Harrach, and Vittorio Amedeo II, duke of Savoy, all engaged their agents in the southern Netherlands to examine sets and negotiate with producers at the "magazin de la ville de Bruxelles."[7]

Foreign and Renaissance Designs, 1660–75

Correspondence between these agents and their patrons sheds light on the wide range of tapestries displayed at the Pand. Evidently, suites after Flemish Baroque designs created prior to 1660, such as Peter Paul Rubens's *Achilles* (fig. 102) and *Triumph of the Eucharist* (cat. nos. 19–24), Jacob Jordaens's *Odysseus* and *Famous Women from Antiquity*, Justus van Egmont's *Zenobia* and *Cleopatra*, and Anthonis Sallaert's *Allegory of the Life of Man*, constituted part of the stock. Most of these editions and their cartoons were owned by the moguls of the previous period and their successors: François van den Hecke, his son Jan-François (ca. 1640–ca. 1705), Jan van Leefdael (1603–1668), his associate Gerard van der Strecken (fl. 1644–77), Jan's son Willem van Leefdael (1632–1688), and Van der Strecken's son-in-law Gerard Peemans (ca. 1638–1725).[8]

By 1665, however, the Flemish Baroque sets were losing their appeal, as is revealed by a clear preference for two other groups of tapestries that were marketed at the Pand. In 1663 Schwarzenberg's agent recommended four sets "on account of the style and perfection of both the cartoons and the tapestries": the *Story of Moses*, the *Story of Clovis*, the *Story of Titus and Vespasian*, and the *Story of Cleopatra*.[9] Ten years later Harrach's agent enumerated the three finest sets he had seen in

Fig. 199. *Moses Saved from Drowning* from a set of the *Story of Moses*. Tapestry design by Charles Poerson, woven by Jan Leyniers II, Brussels, ca. 1660. Wool and silk, 365 x 320 cm. Virgina Museum of Fine Arts, Richmond, Museum Purchase with funds given by Mrs. Alfred I. DuPont (48.1.3)

the Pand: the *Story of Meleager*, the *Story of Scipio and Hannibal*, and the *Story of Moses*.[10] None of these seven sets was designed by a contemporary Flemish painter.

The four series listed in 1663 have rightly been attributed to Charles Poerson (1609–1667), a French painter whose manner was characterized by a refined classicizing tone that differed significantly from the monumental Flemish and Baroque style (see also cat. no. 54).[11] Poerson's sketches and cartoons were imported and distributed in Brussels about 1650–60 by French or Walloon entrepreneurs based in that city.[12] They leased and sold the cartoons to a handful of Brussels workshop managers, including Jean Le Clerc (ca. 1600–1672), a Brussels tapestry entrepreneur with French roots (*Story of Cleopatra*; Musée des Tissus, Lyon); Jan Leyniers II (1630–1686), a member of the famous family of dyers and tapestry makers (*Story of Moses*; Palazzo Clerici, Milan, and Virginia Museum of Fine Arts, Richmond; fig. 199); Gerard Peemans (*Story of Titus and Vespasian*; Fondation Toms Pauli, Lausanne); and Jacob van der Borcht (ca. 1650–ca. 1713; *Story of Clovis*; Town Hall, Brussels).[13]

The *Story of Meleager*, which was ranked by Harrach's agent among the three finest sets for sale in 1673, was designed by the renowned French painter Charles Le Brun (1619–1690) about 1658. Like Poerson's sets, Le Brun's *Meleager* fused vigor with lyricism and a taste for theatrical settings, as is demonstrated by the *Death of Meleager* (fig. 200). Jean Valdor (1616–1675), a merchant from Liège who played an important role in the development of tapestry production in France, leased the *Meleager* cartoons to Peemans, Van der Strecken, and Willem van Leefdael in 1672 and to Jan Leyniers II and his father, Everaert Leyniers III (1597–1680), in 1673.[14] Valdor had commissioned the cartoons when he was director of the Maincy tapestry workshops, which had been established by Louis XIV's superintendent of finance Nicolas Fouquet (1615–1680). After Fouquet's disgrace in 1661, the *Meleager* cartoons had been used at the Gobelins, yet they had remained property of Valdor. Ulrika Eleonora of Denmark, queen of Sweden (d. 1697), King Louis XIV's younger brother Philippe d'Orléans (1640–1701), and Louis XIV's minister of war the marquis de Louvois (1641–1691) all commissioned Brussels *Meleager* suites.[15]

Encouraged by the commercial success of these series, Flemish tapestry producers expanded their range of foreign cartoons that had a classicizing tone. A *Story of Caesar* series woven in Brussels can be linked to the group of Poerson sets (see cat. no. 54). Brussels and Oudenaarde entrepreneurs commissioned sets of cartoons depicting Le Brun's *Story of Alexander*.[16] Because they could not use the original cartoons, which were at the Gobelins, they engaged a number of Flemish painters who copied widely disseminated *Alexander* prints that were made between 1672 and 1678 and were not protected by copyright. Michiel Wauters and his brother Filips, who dominated the Antwerp industry until their deaths in 1679, also capitalized on the new vogue for foreign classicizing sets by producing suites of the *Story of Dido and Aeneas* after cartoons (ca. 1660) by the Italian artist Giovanni Francesco Romanelli (1610–1662; fig. 109).[17]

The two remaining sets listed by Harrach's agent among the finest pieces on the market in 1673, the *Story of Scipio and Hannibal* and the *Story of Moses*, were woven after vintage sixteenth-century cartoons. According to Harrach's representative, the *Scipio* cartoons were "(dicono) di Rafaele," the *Moses* designs, "(dicono) del Cosia."[18] The *Story of Scipio* was actually made by Raphael's pupils Giulio Romano (ca. 1499–1546) and Giovanni Francesco Penni (ca. 1496–after 1528). The *Moses* series has been attributed to Giovanni Battista Lodi da Cremona.[19] These cartoons and those of other sixteenth-century

Fig. 200. *The Death of Meleager* from a set of the *Story of Meleager and Atalanta*. Tapestry design by Charles Le Brun, woven in the workshop of Jan Leyniers II, Brussels, ca. 1680. Wool and silk, 400 x 555 cm. The State Hermitage Museum, Saint Petersburg (T-2897)

sets had been refreshed and modernized, yet adapting Renaissance style to seventeenth-century standards was a delicate process as fashions changed and the public developed a true antiquarian interest. This is illustrated by the fate of Michiel Coxcie's famous *Story of Cyrus* cartoons.[20] About 1630 an unknown painter had transformed the original cartoons into Baroque compositions with simplified landscapes and monumental figures framed by heavy borders (Art Institute of Chicago),[21] yet the shift in fashion that occurred about twenty-five years later made the updated cartoons undesirable: Harrach declined to buy a *Cyrus* suite, "à cause de la grandeur des figures, qui passent le naturel" (because the size of the figures is larger than life). Likewise, the agent of the duke of Savoy complained in 1692 that "all cartoons by Raphael, Giulio Romano, and other important old masters are lost, damaged, and mutilated as they have been used too often and have been

restored by no-good painters."[22] According to the agent, only the *Fructus belli* cartoons were still in their original condition.[23] They were kept in Brussels, yet the representative unfortunately failed to be more specific.

At least one more set of sixteenth-century cartoons had remained intact, the set of the *Conquest of Tunis* by Jan Cornelisz Vermeyen (1500–ca. 1559) and Pieter Coecke van Aelst (1502–1550), woven between 1546 and 1554 for the emperor Charles V (Patrimonio Nacional, Madrid).[24] In 1680 Harrach toyed with the idea of sending the *Tunis* cartoons, erroneously attributed to "le fameux Titian," from Vienna to Brussels and to commission a suite.[25] This project, however, proved to be stillborn. The Brussels tapestry makers, whose names are not recorded, made it clear that the production cost would be enormous, given the detailed nature of the crowded cartoons. This decision provides circumstantial evidence that

443

Fig. 201. *May and June* from a set of the *Months*. Tapestry design by David Teniers III, ca. 1675, woven in the workshop of Daniel Leyniers IV, Brussels, ca. 1740. Wool and silk, 360 x 617 cm. Kunsthistorisches Museum, Vienna (KK T LIII 3)

the stylistic development of Flemish tapestry design between 1620 and 1660 was to a certain degree defined by Brussels producers who presumably encouraged Jordaens, Sallaert, and Van Egmont to increase the minimalist component of their monumental designs, which is exemplified by the schematic landscape and architectural settings. This cost-cutting strategy backfired about 1660, when the public again desired ingenious and detailed compositions by old or contemporary masters.

Brussels Classicism and Lower Genres, 1675–1700

In 1671 the Brussels workshop manager Albert Auwercx (1629–1709) complained with a fair amount of pathos, "nothing or hardly anything can be sold in these disastrous times."[26] Since he made this statement to obtain financial support from the city administration, Auwercx probably exaggerated. Still, his words reveal that from about 1670 onward Flemish tapestry was increasingly challenged by, among other factors, foreign and especially French competition. The Flemish tapissiers, however, proved resilient: Auwercx and his colleagues engaged Flemish painters who were capable of designing appealing new sets by emulat-

ing the characteristics of the fashionable French and Renaissance series.

Although his oeuvre still awaits a thorough study, David Teniers III (1638–1685) can be regarded as a key figure in the development of late seventeenth-century Flemish tapestry design.[27] His sets show rational and balanced compositions featuring graceful classicizing figures harmoniously integrated in delicately rendered architectural or landscape settings. This highly refined style mirrors sophisticated allegorical programs, as can be seen in his series of the *Months* (Castle, Prague), which is to a large extent based on Jan van den Hoecke's *Allegory of Time*. The reworked design was commissioned about 1675 by Gerard Peemans in an attempt to update his catalogue of cartoons.[28] The cartoons were subsequently acquired by Judocus de Vos (1661–1734) in 1711 and by Daniel Leyniers IV (1705–1770) after the De Vos workshop closed, about 1740/50. Leyniers's signature appears on a set in Vienna (fig. 201). Teniers III was also engaged to design armorial pieces, a genre that remained popular during the second half of the seventeenth century as is revealed by a number of hitherto unknown com-

444

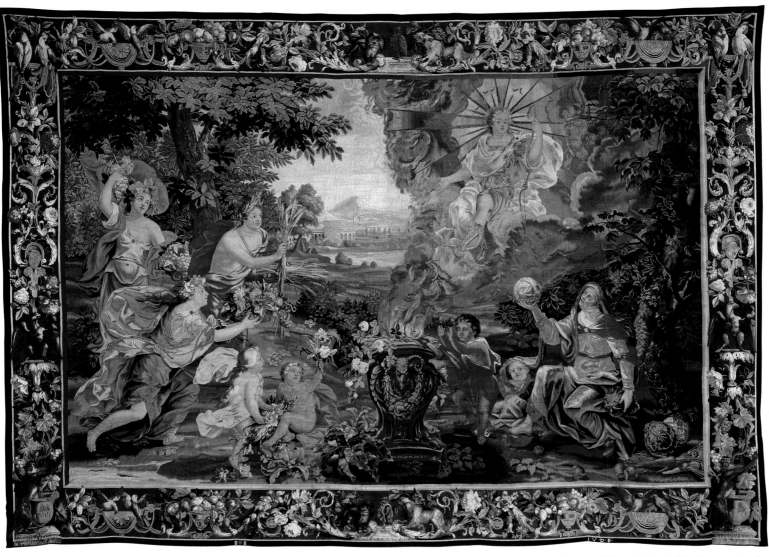

Fig. 202. *The Four Seasons Make an Offer to Apollo* from a set of *Mythological Scenes*. Tapestry design by Lodewijk van Schoor and Lucas Achtschellinck, woven in the workshop of Jacob van der Borcht, Brussels, ca. 1700. Wool and silk, 352 x 490 cm. Kunsthistorisches Museum, Vienna (KK T LXXIX 1)

missions.[29] Tapestries depicting the coats of arms of Count Filippo Archinto of Milan (1680), the duke of Medina Celi (1680), the duke of Arenberg (1683), and the Ayala family (1684) all bear Teniers III's signature.[30] Except for the Medina Celi pieces, these tapestries show coats of arms flanked by allegorical figures. Given Teniers III's familiarity with Van den Hoecke's classicizing design and his reputation as a designer of allegorical armorial tapestries, it is tempting to attribute the count of Monterey's armorial pieces to David Teniers III as well (cat. no. 53).

The successor of Teniers III was Lodewijk van Schoor (ca. 1650–1702).[31] He created or cocreated about fifteen sets that were produced in various centers in both the southern and northern Netherlands. The series by Van Schoor are recognizable by his idiomatic manner that is deeply influenced by

Teniers III's stylistic and iconographic vocabulary. In his earlier sets, such as the *Story of Perseus* (Kunsthistorisches Museum, Vienna),[32] Van Schoor failed to equal Teniers III, yet in his later cartoons he managed to develop a more refined and harmonious style. This mature and confident manner characterizes his series of *Mythological Scenes* (ca. 1695; Kunsthistorisches Museum, Vienna).[33] *The Four Seasons Make an Offer to Apollo* (fig. 202), for example, displays graceful figures and a vivid color scheme in keeping with contemporary French tapestry sets such as *La Galerie de Saint-Cloud* by Pierre Mignard (1612–1695).[34]

Van Schoor painted the cartoons of the *Mythological Scenes* in collaboration with the Brussels landscape painter Lucas Achtschellinck (1626–1699).[35] While Achtschellinck created dense wooded landscapes characterized by a lack of depth, his

445

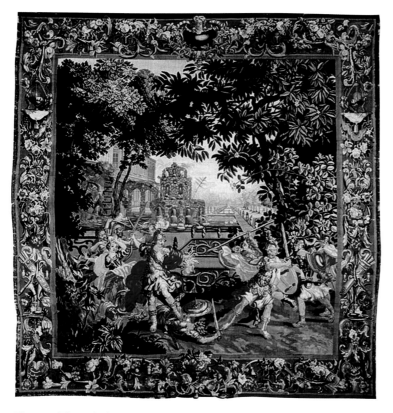

Fig. 203. *The Fight between Perseus and Phineus* from a set of the *Story of Perseus and Andromeda*. Tapestry design by Pieter Ijkens and Pieter Spierincx (attrib.), woven in the workshop of Jacob van der Goten, Antwerp, ca. 1700. Wool and silk, 356 x 316 cm. Kulturhistorisches Museum, Magdeburg

The genrelike quality of these sets and the vast numbers of them that survive have rendered them less appealing to art historians as subjects for study, yet it must be stressed that this group was of vital importance to the majority of the workshop managers in Brussels, Antwerp, and Oudenaarde, whose survival depended on these popular sets. Given the limited color range and lack of intricate large-scale figures in these tapestries, producing them cost less than making history sets. Tapissiers in Antwerp and especially Oudenaarde traditionally focused on the genre segment, thus aiming at a more general market. Indeed, apart from the aforementioned *Aeneas* series and one depicting the *Story of Tamerlan and Bajazet*, which was designed by Johannes Hoebraken and repeatedly woven by various producers,[40] most of the popular Antwerp sets produced in the second half of the seventeenth century represented small mythological scenes in landscape and parkland settings. *The Story of Odysseus and Circe*, designed by Pieter Ijkens (1648–1695) and Pieter Spierincx, was produced at least twenty times by Jeremias Cockx and Cornelis de Wael (d. 1723), who directed the former Wauters workshop from 1679 (Provincial Government, Antwerp).[41] Most of these suites were sold to English merchants. The success of the series is explained by its pleasing decorative manner and relation with contemporary

contemporary Pieter Spierincx (1635–1711) from Antwerp introduced the spacious classicizing landscape in Brussels tapestry.[36] Achtschellinck, Spierincx, and a handful of other landscape painters designed a rich body of sets of *Landscapes* and *Landscapes with Small Mythological Scenes*, the latter usually in collaboration with lesser-known history or genre painters working in Brussels and Antwerp. These sets were extremely popular. Cosimo III de' Medici bought a suite of *Landscapes with the Hunt of Diana* in 1668,[37] and the "Memoriael Naulaerts," a compilation of business records that surveys the activity of the Antwerp merchant Nicolaas Naulaerts (d. 1703) and his successors, shows that a great many sets of *Landscapes with Small Mythological Scenes* were marketed in Europe about 1700.[38] A number of unpublished documents can be added to these data. Count Filippo Archinto acquired a set of *Landscapes* by David Teniers I (1582–1649) in 1683; the duke of Savoy commissioned a set of *Landscapes* by "Spirincx d'Anvers" in 1693; Don Manuel Fonseca commissioned a suite of *Landscapes with Ovid's Metamorphoses* in 1695; and William III of England obtained an edition of *Landscapes with Scenes from Ovid's Metamorphoses* in the same year.[39]

Fig. 204 *Parkland with Birds* from a set of *Parklands with Birds*. Tapestry design by an unknown artist, woven in the Van Verren workshop (?), Oudenaarde, 1705. Wool and silk, 440 x 575 cm. Town Hall, Maastricht

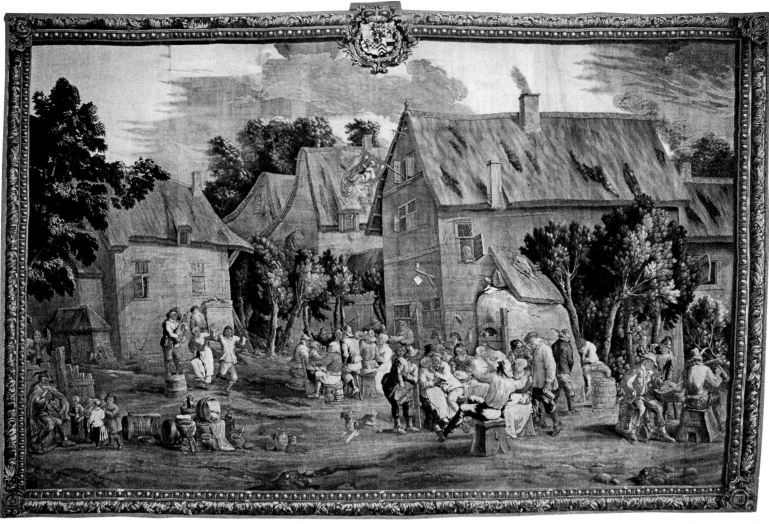

Fig. 205. *The Village Fair* from a *Teniers* set. Tapestry design by David Teniers II, woven in the workshop of Hieronymus Le Clerc or Jasper van der Borcht, Brussels, 1701–6. Wool and silk, 387.5 x 408 cm. Badisches Generaldepot Karlsruhe, Schloss Mannheim (G 7688)

literature. Ijkens and Spierincx presumably also codesigned the *Story of Perseus and Andromeda* that was woven by Jacob van der Goten. Although the *Fight between Perseus and Phineus* depicts a highly dramatic moment, the delicate parkland setting and Mannerist poses of the protagonists who appear to perform a dance convey a great sense of stylized theatrical entertainment (fig. 203). Van der Goten directed the last Antwerp workshop until he moved in 1720 to Madrid, where he opened the Santa Barbara manufactory.

Late seventeenth- and early eighteenth-century tapestry production in Oudenaarde also concentrated on verdures, landscapes, and parklands that were often enlivened by small scenes from history, mythology, and country life.[42] A set of five pieces of *Parklands with Birds* that was delivered to the town hall of Maastricht in 1705 can be ranked among the finest examples of Oudenaarde tapestry in this period (fig. 204). Historians have correctly recognized that the top rung of the Oudenaarde tapestry producers and merchants operated in close collabora-

tion with their Antwerp and Brussels colleagues and that these commercial networks were often secured by marriages.[43]

The artists' and weavers' increasing ability to adapt delicate small-scale oil paintings for monumental tapestry as well as the striking commercial success of the *genre mythologique* paved the way for two of the most typical and sought-after genres of late seventeenth- and early eighteenth-century tapestry, the *genre Teniers* and the *genre militaire*.

The *genre Teniers* is named after David Teniers II (1610–1690), whose paintings and prints of peasant scenes were immensely popular on the European art market.[44] The associated tapestry producers Hieronymus Le Clerc (1643–1722) and Jasper van der Borcht "A Castro" (1675–1742) capitalized on this success (Jasper used the Latin translation of his name, which means "from the fortress," to distinguish himself from a namesake). About 1680 they ordered a tapestry series from David Teniers II depicting *boerkens* (peasants). Scenes such as the *Village Fair* show that the dyers and weavers were able to adapt the delicate,

447

small-scale oil paintings for large-scale compositions "painted" with wool and silk (fig. 205). The set unleashed a flood of Brussels, Flemish, and European *Teniers* series that can be regarded as a continuation and an upgrade of the established tradition in Flemish and French tapestry for country life imagery.[45]

The *genre militaire* is a generic name for cabinet-size paintings and engravings depicting (fictive) battle scenes and the everyday life of soldiers. This genre, epitomized by such artists as Philips Wouwerman (1619–1668)[46] and Adam Frans van der Meulen (1632–1690),[47] was also to the liking of European connoisseurs around 1700.[48] Inspired by the success of the adaptation of the *genre Teniers* for tapestry, Le Clerc and Van der Borcht commissioned a *genre militaire* set from Lambert de Hondt (1650/60–1708), a painter of battle scenes, about 1695.[49] De Hondt's *Exercitieën van den oorloghe* (*Art of War I*) rapidly became one of the most popular and influential tapestry series woven in the beginning of the eighteenth century. The crème de la crème of the European rulers and commanders, including Maximilian Emanuel von Wittelsbach, elector of Bavaria (r. 1679–1726),[50] Ludwig Wilhelm of Baden (1677–1707),[51]

John Churchill, Duke of Marlborough (1650–1722),[52] Jean-Philippe-Eugène, count of Mérode and marquis of Westerlo (1674–1732), and William III of England (r. 1689–1702) each bought a suite of the *Art of War I*. William III further commissioned a set of *Teniers* from Le Clerc and Van der Borcht (1695) and no fewer than sixteen tapestries featuring the royal arms of England and the Nassau arms from an amalgamation of four Brussels tapestry makers, including Le Clerc and Van der Borcht (The Metropolitan Museum of Art, New York [fig. 220]; Rijksmuseum, Amsterdam).[53] The iconographic scheme of these pieces is derived from Le Brun's *Portières des renommées* designed about 1660, which again demonstrates the dominance of French art on the European artistic scene.

Brussels Neo-Baroque, 1700–1715

While Hieronymus Le Clerc and Jasper van der Borcht consolidated their position in the Brussels industry by engaging genre artists like David Teniers II and Lambert de Hondt, Albert Auwercx tried to develop his workshop by promoting a new style in history painting. Auwercx had been a minor yet

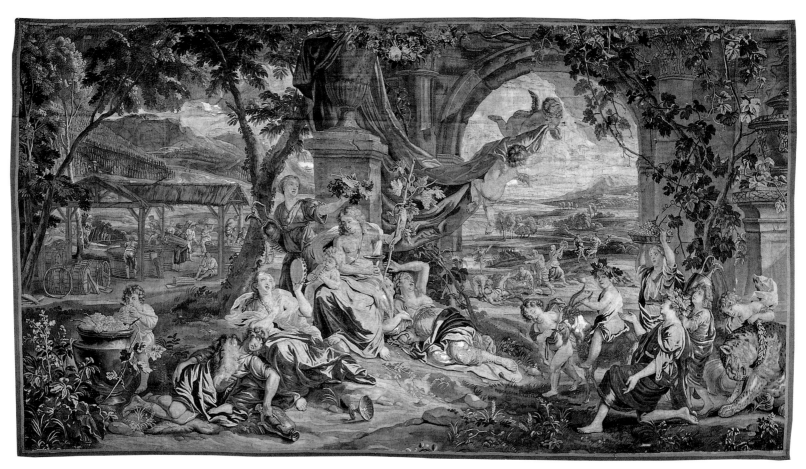

Fig. 206. *The Triumph of Bacchus* from a set of the *Triumphs of the Gods I*. Tapestry design by Jan van Orley and Augustin Coppens, woven in the Auwercx workshop, Brussels, ca. 1715. Wool and silk, 274 x 504 cm. Present location unknown

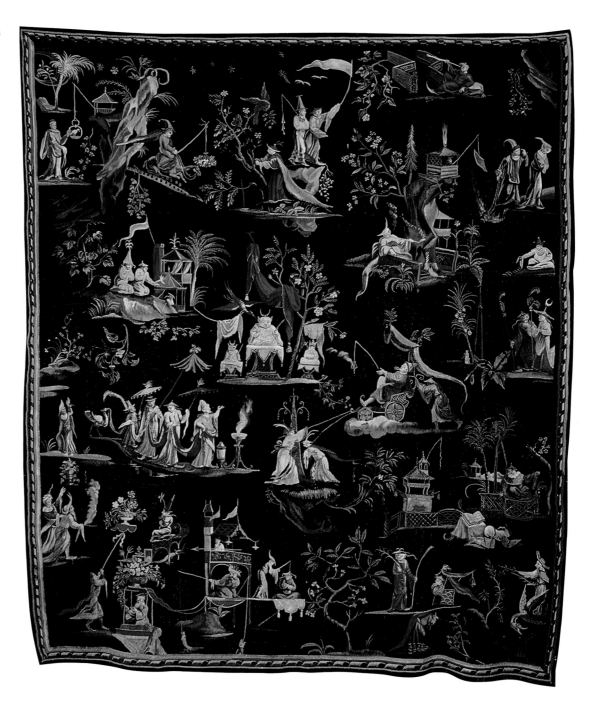

Fig. 207 *Altar of the Three Buddhas* from a set of *Chinoiseries*. Tapestry design by an unknown artist, woven in the workshop of Judocus de Vos, Brussels, 1717–34. Wool, silk, and gilt-metal-wrapped thread, 268 x 216 cm. Seattle Art Museum (2002.38.1)

omnipresent player in the tapestry field during the second half of the seventeenth century, but about 1700 he seized the opportunity to invest in new cartoons, as is revealed by an unpublished document.[54] About 1701 he commissioned the *Story of Rinaldo and Armida* from Victor Janssens (1658–1736).[55] Janssens had worked in Italy between 1678 and 1689, and his work reveals a growing desire and ability to fuse the Italian and French classicizing and decorative manner with the late Baroque vocabulary that he had absorbed in both Italy and the southern Netherlands.[56]

This sophisticated Brussels neo-Baroque style, with encyclopedic references to the art of Raphael, Francesco Albani (1578–1660), Rubens, and Le Brun, reached its zenith in the sets created by Jan van Orley (1665–1735). Jan van Orley was presumably trained by his father, Peter (1638–1709), a minor tapestry designer.[57] In his earliest known series, the *Story of Psyche* (ca. 1685; Fürstliches Schloss Thurn und Taxis, Regensburg), Jan van Orley displayed a familiarity with the elegant, decorative classicism propagated by Teniers III.[58] The *Triumphs of the Gods I* (the first of two series of this subject that he was to design; fig. 206) and the *Story of Telemachus I* (Patrimonio Nacional, Madrid),[59] both commissioned by Albert Auwercx about 1700, however, show that Van Orley rapidly

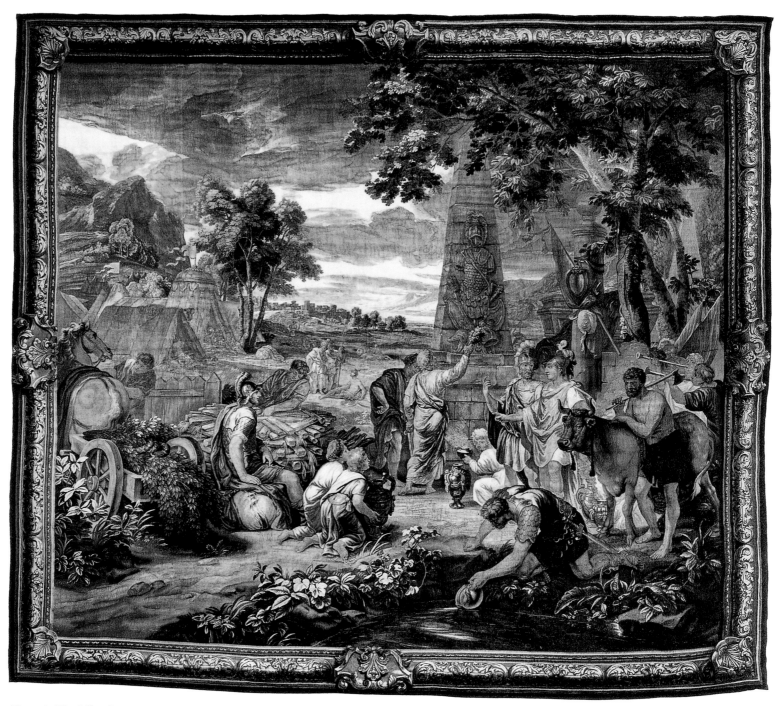

Fig. 208. *The Offer of Aristides* from a set of *Plutarch's Illustrious Men*. Tapestry design by Victor Janssens and Augustin Coppens, woven in the Leyniers workshop, Brussels, 1735–45. Wool and silk, 379 x 408 cm. Schloss Bruchsal (G 167)

developed a refined fusion of the Franco-Italian classicizing vocabulary and the native Baroque manner. The Brussels landscape painter Augustin Coppens (1668–1740) played an important role in the development of this Brussels neo-Baroque style, as he was able to create landscape settings that could support the stylistic aspirations of both Janssens and Van Orley. Coppens executed the landscapes of nearly all the sets designed by Janssens and Van Orley. Since Van Orley was also capable of

modulating the *genre Teniers*, as is shown by the inclusion of a set of *Teniers* in Auwercx's catalogue, he can be regarded as one of the key factors in the Indian summer of Brussels tapestry that originated in Auwercx's catalogue of cartoons.

While Auwercx, who also produced the remarkable set of "l'histoire de la très illustre et très ancienne decendance de la maison" for the duke of Montalto,[60] played a seminal role in this development during the last decades of the seventeenth

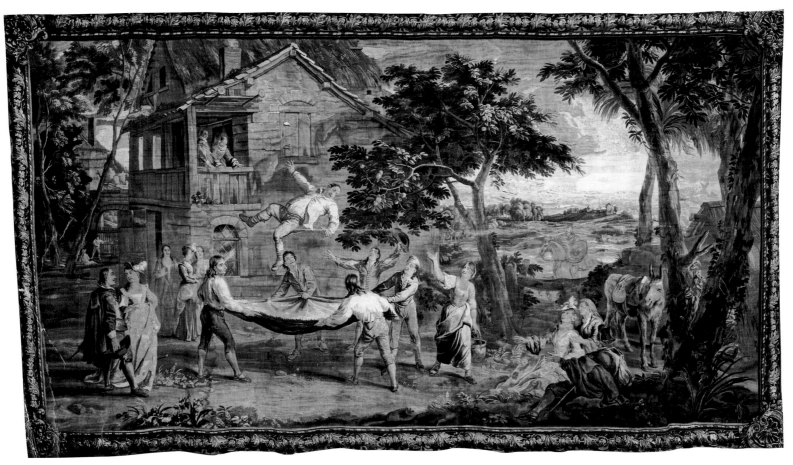

Fig. 209. *The Tossing of Sancho Panza* from a set of the *Story of Don Quixote*. Tapestry design by Jan van Orley and Augustin Coppens, woven in the Leyniers workshop, Brussels, 1719–29. Wool and silk, 308.4 x 523.2 cm. Present location unknown

century, Judocus de Vos capitalized on this new élan and became the leading tapissier at the beginning of the eighteenth century.[61]

Judocus de Vos was the son of Marcus (ca. 1635–ca. 1697), who ran a small workshop during the second half of the seventeenth century. Like Auwercx and numerous other Brussels tapestry makers, Marcus de Vos was part of an extensive production and trading network that also included such Antwerp and Oudenaarde tapestry merchants as Nicolaas Naulaerts and Jan van Verren.[62] After the death of his father, Judocus de Vos consolidated these commercial ties, as is demonstrated by his intensive business contacts with the Naulaerts firm.[63] De Vos was involved in the production of three tapestries of the *Victories of William II and William III of England* commissioned by William III to complete the sixteenth-century dynastic series the *Genealogy of the Nassau Family* (1698).[64] Unfortunately, the suite is lost. In 1699–1700 Judocus de Vos supervised the production of no fewer than twenty-nine tapestries of *Scenes from the New Testament* that were ordered by the Spanish nobleman Ramón Perellos y Rocafull, Grand Master of the Knights of Saint John

of Jerusalem, for Saint John's Cathedral in Valletta, Malta (see also cat. no. 48).[65] In 1705 the municipality of Brussels tallied all the managers of tapestry workshops and their looms; fifty-three looms were counted. The total reveals that Judocus de Vos, with twelve looms, directed the largest business; Auwercx had only five.[66]

Between 1707 and 1717 the Duke of Marlborough was one of De Vos's most important clients.[67] The duke had already bought a suite of the *Art of War I* from the Le Clerc and Van der Borcht workshops via the Naulaerts firm in 1705. In 1707 he again used the firm to commission sets of the *Story of Alexander the Great* and *Teniers*. De Vos executed a number of these tapestries. About 1709 the duke decided to buy three more sets; he cut out the middlemen and dealt directly with De Vos. These sets were the *Triumphs of the Gods I*, the cartoons of which were owned by Auwercx; a set of four tapestries entitled the *Virtues*; and the *Victories of the Duke of Marlborough* (cat. no. 56). The *Virtues*, like the *Victories* still preserved at Blenheim Palace, were designed especially for the duke; stylistic features allow attribution of the pieces to Jan van Orley. The tapestries show

Marlborough's coat of arms in an elaborate landscape setting that is populated by personifications and gods (cat. no. 55). In 1712 De Vos embarked on the production of a remake of the *Conquest of Tunis* that was commissioned by Emperor Charles VI, thus refreshing Harrach's idea. The weaving of the complex designs lasted about nine years (Kunsthistorisches Museum, Vienna).[68] In addition to these customized series, De Vos produced numerous sets for the market. Among his most magnificent and important series are the lyrical *Story of Venus and Adonis* by Van Orley after Albani (Houghton Hall, Norfolk), dazzling *Chinoiseries* by an unknown painter (Seattle Art Museum; fig. 207), and the *Art of War II* by Lambert's son Philippe de Hondt (1683–1741; cat. no. 57).[69]

In 1711, however, a business controversy known in Brussels as the Brinck affair curtailed the ambitions of Judocus de Vos and Albert Auwercx's son and successor Philippe (1663–1740).[70] This affair opposed De Vos, Auwercx, Jasper van der Borcht, Pieter van den Hecke (ca. 1675–1752), and nearly all the other Brussels workshop managers on the one hand, and Urbanus Leyniers (1674–1747) on the other. Leyniers directed the one remaining dye works in Brussels and was, in other words, of vital importance to all the tapestry makers in Brussels. About 1709 Leyniers seems to have had plans to start a tapestry workshop himself, which obviously distressed the tapestry producers. They therefore supported Jan Brinck (1634–1725) in his attempts to establish a new dye works in Brussels. Brinck had been supervisor of the Leyniers works, which means that he was familiar with the traditional, carefully guarded dyeing techniques used by Leyniers. Leyniers therefore tried to prevent Brinck from becoming enlisted as a dyer in the guild, yet after legal proceedings that dragged on for more than six months, Brinck was eventually allowed to open his dye works.

The outcome of the affair not only broke the Leyniers monopoly but also sidelined Urbanus Leyniers. Brinck could produce threads in the manner of Leyniers, and since almost all the Brussels tapestry makers had sided against Leyniers, the latter lost nearly all his clients. Yet Leyniers reacted immediately. He commissioned a set of sketches and cartoons of *Plutarch's Illustrious Men* from Victor Janssens and Augustin Coppens in 1711 (Schloss Bruchsal).[71] This series shows Janssens's mature synthesis of decorative and monumental painting, as is seen in the *Offer of Aristides* (fig. 208). Leyniers further ordered a series of *Ovid's Metamorphoses* from Zeger-Jacob van Helmont

(1683–1726), who copied paintings by the French artist Charles de La Fosse (1636–1716).[72] Leyniers also recognized the commercial potential of Jan van Orley and commissioned no fewer than five sets from him:[73] the *Story of Don Quixote* (ca. 1714; editions are in several European private collections; fig. 209),[74] the *Triumphs of the Gods II* (ca. 1716; Museum voor Schone Kunsten, Ghent),[75] *Teniers* (ca. 1717; Rijksmuseum, Amsterdam),[76] the *Story of Telemachus II* (ca. 1723; Stift, Klosterneuburg),[77] and the *Acts of the Apostles* after Raphael (ca. 1725; Collection Krupp von Bohlen und Halbach, Essen).[78] This impressive catalogue of cartoons and the fact that Leyniers operated no fewer than eighteen looms in 1713—De Vos had twelve looms in 1705—obviously explain why the Leyniers workshop dominated the scene between about 1712 and 1730. Urbanus Leyniers also traded extensively in Antwerp and Oudenaarde tapestries. He frequently visited Paris, since France remained an important market during the first half of the eighteenth century. Yet Flemish tapestry remained popular in other European countries as well, as is demonstrated by the numerous suites woven around 1700 that are now in German and English public and private collections.

Epilogue
The Brussels neo-Baroque style, which is epitomized by the work of Jan van Orley and Augustin Coppens, was also patronized and promoted by Jasper van der Borcht in that he produced Van Orley's *Story of Achilles* (ca. 1728; Musée Jacquemart-André, Paris),[79] *Story of Moses* (ca. 1730; Kunsthistorisches Museum, Vienna),[80] and *Triumphs of the Gods III* series (ca. 1725; cat. no. 58). Yet, just as he had been instrumental in introducing the *genre Teniers* and the *genre militaire* in Brussels tapestry in the last quarter of the seventeenth century, Van der Borcht also played a key role in the development of a new style that originated about 1725. The contemporary name of this new manner was *goût moderne* or *goût du temps*—now known as regency or Rococo—which reveals that it aimed for a break with the late Baroque tradition: the *goût moderne* favored the stylized and idealized loveliness of modern-day and everyday events over heroic ambition and power. Brussels regency tapestry was shaped by Philippe de Hondt, whose *Story of Don Quixote* (ca. 1725; Kunsthistorisches Museum, Vienna), the *Continents* (ca. 1735; Kunsthistorisches Museum, Vienna), and the *Elements* (ca. 1735) were woven repeatedly in the Van der Borcht workshop around the middle of the eighteenth century.[81]

1. E. Duverger 1981, p. 234.
2. E. Duverger 1999, p. 39.
3. Wauters 1878, pp. 230–32; Brosens 2005b, pp. 71–73.
4. Stadsarchief, Brussels (hereafter SAB), Register der Tresorije (hereafter RT), vol. 1297, fols. 323r–v (June 27, 1658), and vol. 1298, fol. 258r (November 16, 1661).
5. "[D]es tapisseries d'hazard . . . sont très rares à cause des Français, qui achètent tout ce qu'ils trouvent à vendre sans beaucoup marchander le prix"; Menčik 1911–12, p. xxxviii, no. 20272.
6. Brosens 2005a; Brosens 2007a.
7. Blažková and Květoňová 1959–60; Hoogewerff 1919, pp. 381–83; Menčik 1911–12; Algemeen Rijksarchief, Brussels (hereafter ARAB), Notariaat Generaal van Brabant (hereafter NGB), vol. 2583¹ (March 6, 1693).
8. For data on these producers, see Brosens 2004a.
9. "[P]our l'art et perfection tant de patrons que de la manifacture"; Blažková and Květoňová 1959–60, p. 66.
10. Menčik 1911–12, p. xxxvii.
11. De Reyniès in Metz 1997, pp. 111–37, 171–93.
12. Brosens 2005b; Brosens 2007b.
13. De Reyniès in Metz 1997, pp. 111–37, 171–93.
14. Brosens 2003–4. On Valdor, see Uhlmann-Faliu 1978.
15. Editions are in the Royal Collections, Stockholm (Böttiger 1895–98, vol. 2, pp. 38–39) and the State Hermitage Museum, Saint Petersburg. For a survey of *Meleager* pieces, see de Reyniès in Chambord 1996, pp. 266–83, and Brosens 2003–4.
16. Posner 1959; Vanhoren 1999. Suites by Jan-François van den Hecke and Gerard Peemans are at the Residenz in Würzburg.
17. Crick-Kuntziger 1935; Delmarcel 1999a, pp. 295–98 (with bibliography).
18. Menčik 1911–12, p. xxxvii, no. 20267.
19. T. Campbell in New York 2002, pp. 342–49 (*Scipio*), 392–93 (*Moses*).
20. The most complete edition is the Patrimonio Nacional, Madrid (series 39); Junquera de Vega and Herrero Carretero 1986, pp. 279–89.
21. A catalogue of the Art Institute of Chicago's tapestry collection is forthcoming. For the modernized cartoons, see also Bruges 1980, pp. 234–37.
22. Viale Ferrero 1968, p. 813.
23. On this set, see Delmarcel 1989.
24. Horn 1989; T. Campbell in New York 2002, pp. 385–92.
25. Menčik 1911–12, p. xlii, no. 20292.
26. "[D]en tegenwoordigen calamiteusen tijt alswanneer nijet off weijnich valt te vercoopen"; SAB, RT, vol. 1300, fol. 202r (February 18, 1671).
27. Vlieghe 1959–60.
28. Blažková 1981.
29. ARAB, NGB, vol. 704 (October 27, 1659: Jean-Maximilien de Lamberg and François van den Hecke); ARAB, NGB, vol. 704 (May 9, 1662: Claude Lamoral I and Hendrik Reydams I); ARAB, NGB, vol. 2574¹ (June 8, 1665: Louis de Moncada and François van den Hecke).
30. Crick-Kuntziger 1944, pp. 30–32; Delmarcel 1999a, p. 250.
31. Brosens 2004a, pp. 91–94.
32. Verpoort 2005.
33. Bauer in Halbturn 1991, pp. 81–86.
34. Berger 1993.
35. Brosens 2004a, pp. 97–98.
36. Ibid., pp. 99–100.
37. Hoogewerff 1919; see also Thomson 1913.
38. The "Memoriael Naulaerts," in the Stadtsarchief Antwerpen, is published in Denucé 1936, pp. 116–372.
39. ARAB, NGB, vol. 2058¹ (March 4, 1683); ARAB, NGB, vol. 2583¹ (March 6, 1693); ARAB, NGB, vol. 2584¹ (June 21, 1695); ARAB, NGB, vol. 2584¹ (July 11, 1695).
40. Neumann 1968.
41. Van Tichelen 1994.
42. De Meûter 1999, pp. 122–24.
43. Vanwelden 1999, pp. 93–94.
44. Antwerp 1991; Karlsruhe 2005.
45. Marillier 1932 is still the standard work on European *Teniers* tapestries. For Brussels *Teniers* sets, see Brosens 2004a.
46. Duparc 1993; Bürger 2002; Schumacher 2006.
47. Richefort 2004.
48. Chiarini 1998; Pfaffenbichler 1998.
49. Wace 1968, pp. 29–42.
50. The tapestries of this suite are distributed over several locations, including the Neues Schloss at Schleissheim; Smit in Hartkamp-Jonxis and Smit 2004, pp. 152–53, n. 100.
51. The suite is at Schloss Rastatt; Grimm in Fandrey et al. 2002, pp. 186–89, 190–93 no. 36a–f.
52. Still preserved in situ (Blenheim Palace); Bapasola 2005, pp. 33–41.
53. ARAB, NGB, vol. 2584¹ (July 11, 1695); Standen 1985, pp. 224–27; Smit in Hartkamp-Jonxis and Smit 2004, pp. 147–50, no. 42.
54. ARAB, NGB, vol. 4014 (December 3, 1718).
55. De Raadt 1894, p. 83.
56. Terlinden 1958; Brosens 2004a, pp. 100–102, 105–6.
57. For Van Orley, see Brosens 2004a, pp. 102–4, 106–9, 358–61 (with bibliography).
58. De Reyniès 1995b; Brosens 2005c.
59. Junquera de Vega 1977.
60. ARAB, NGB, vol. 4014 (December 3, 1718). See also Delmarcel 1999a, p. 243. Guy Delmarcel is currently working on a study of the tapestry collection of the Montalto family.
61. On De Vos, see Brosens 2002; Brosens 2004a, pp. 117–18, 311–18.
62. ARAB, NGB, vol. 1967² (November 19, 1686); ARAB, NGB, vol. 1968¹ (October 30, 1687, and July 27, 1687).
63. Denucé 1936, passim; see Brosens 2004a, pp. 312–15, for a survey.
64. Wauters 1878, pp. 269–71; Fock 1969, pp. 19–28; Fock 1975. The unpublished contract is in ARAB, NGB, vol. 2585² (February 2, 1698).
65. Delmarcel 1985a.
66. SAB, file 721; published in Brosens 2004a, p. 210.
67. Bapasola 2005.
68. Bonn–Vienna 2000.
69. Brosens 2002; Brosens 2004b; Brosens 2006–7.
70. Brosens 2004a, pp. 37–41.
71. Stratmann-Döhler in Fandrey et al. 2002, pp. 63–69, no. 6a–g; Brosens 2004a, pp. 141–44.
72. Adelson 1993; Brosens 2004a, pp. 145–46.
73. Brosens 2004a, pp. 147–72.
74. Brosens and Delmarcel 1998.
75. Bauer in Halbturn 1991, pp. 42–48.
76. Smit in Hartkamp-Jonxis and Smit 2004, pp. 160–66, no. 45a–d.
77. Neumann 1964; Bauer in Halbturn 1991, pp. 35–41.
78. Kumsch 1913.
79. De Reyniès 1995a.
80. Huygens 1994.
81. Brosens 2006–7.

Design by an unknown Netherlandish artist
stylistically related to Gerard Lairesse, ca. 1675
Woven by Jacob van der Borcht and Jan de Melter,
Brussels, ca. 1675
Wool, silk, and metal-wrapped thread
395 × 340 cm (12 ft. 11½ in. x 11 ft. 1⅞ in.)
9 warps per cm
Brussels mark at lower right; weavers' signatures
I.V.D.BEVRC[HT] at lower center, IAN DE MELTER FECIT
between lower center and lower right of main field
Rijksmuseum, Amsterdam (BK-1974-100)

PROVENANCE: Woven for the count of Monterey; …;
French and Co., New York; 1941, Mrs. Toby, United
States; March 23–24, 1973, sold, Sotheby Parke
Bernet, New York, no. 221; June 11–July 3, 1974, sold,
Mak van Waay, Amsterdam, no. 3551; 1974, acquired by
the Rijksmuseum as a gift of the Commissie voor
Fotoverkoop.

REFERENCES: *Bulletin van het Rijksmuseum* 22, no. 4
(1974), pp. 173–74, 178, fig. 6; *Nederlandse rijksmusea in
1974* (The Hague, 1976), pp. 40, 41 fig. 28; Filedt Kok
1992; Delmarcel 1999a, pp. 236–37, 250; Smit in
Hartkamp-Jonxis and Smit 2004, pp. 145–47, no. 41.

CONDITION: Restored in the Rijksmuseum work-
shop, ca. 1982–88. Areas of damage in the architecture
and along the edges have been repaired by securing
loose warps on a linen support. Old repairs in the red
garment of the female figure to the right have been
replaced. Gaps, especially in the upper right corner,
have been filled in with a linen support dyed in the
color of the surrounding area. Some especially con-
spicuous areas of damage, such as in the faces, have
been rewoven.

Tapestry was widely used as a means of
demonstrating dynastic stature from the
earliest development of the European tapestry
industry.[1] This practice continued into the
sixteenth century, and many armorial tapes-
tries were produced for the rich patrons of
the day, sometimes in sets, sometimes as soli-
tary pieces for use at the focal point of
important audience chambers. Some espe-
cially innovative and artistic designs were
produced at the Medici manufactory in the
late sixteenth century.[2]

During the seventeenth century the fash-
ion developed for using armorial tapestries as
portieres in the doorways of en suite
sequences of chambers. Especially notable
were the designs that Charles Le Brun con-
ceived for Nicolas Fouquet for production at
the Maincy workshop in 1659–60, subse-
quently adapted for Louis XIV's use at the
Gobelins manufactory. During the following
years, large numbers of these armorial
portieres were produced both at the Gobelins
and at the Beauvais manufactory for the
French Crown and nobility.[3] The French
example was emulated at the Brussels work-
shops, and during the last quarter of the
century many armorial tapestries were woven
for patrons around Europe, often incorporat-
ing allegorical figures. Such panels were
especially popular with the nobility in Spain
and the Catholic Netherlands. For example,
several high-quality tapestries with the arms
of the Arenberg and Alcaretto families were
woven in Brussels about 1683–84 after designs
by David Teniers III (1638–1685).[4] A set of
sixteen armorial tapestries for King William
III and Queen Mary Stuart II after designs by
Daniel Marot (1661–1752) were made in
Brussels between about 1689 and 1694 in
partnership by the workshops of Hieronymus
Le Clerc, Jacob van der Borcht, Jan Cobus,
and Jan Coenot (fig. 220).[5]

The *Armorial Tapestry of the Count of
Monterey* belonging to the Rijksmuseum in
Amsterdam is especially distinctive among
these armorial tapestries because of the striking

neoclassical character of the design, reflecting
the influence of contemporary developments
in French painting, and the exquisite weaving
of the figures.

Description

In front of an imposing architectural setting
under a partly clouded blue sky, a number
of figures stand on a checkered marble floor.
They are grouped around an oval frame
carved with a laurel wreath enclosing the
crowned armorial shield of the count of
Monterey in a scrollwork border. In heraldic
terms the arms are, quarterly, 1 or, five mullets
of six points gules (Fonseca); 2 argent, a bend
sable (Zúniga) with the addition, in ocher a
chain of eight links or; 3 chequer of fifteen or,
seven with three bars azure (Ulloa); 4 or, a
pale gules, on a bordure eight cauldrons sable
(Biedma); in the center, overall quarterly, 1
and 4 silver a tree vert, 2 and 3 or a wolf
courant sable, all within a bordure gules,
charged with eight saltires couped (Azevedo);
a red javelin cross fitched behind (the Order
of Saint James of the Sword).[6]

The coat of arms is supported on the left
by the muscular, bearded figure of Hercules,
wearing a laurel crown on his head and hold-
ing his attribute, the club, in his right hand.
He is wearing his other attribute, the lion's
skin, around his loins. Minerva, the goddess
of wisdom, wearing a helmet and holding a
spear in her right hand, stands behind him.
With her left hand she points to the armorial
shield while obliquely glancing at the spectator.
The seminude female figure on the right
wearing a robe with gold stars and a colorful
wreath of flowers on her head personifies the
Liberal Arts. She holds an open book in her
raised right hand, and with her left hand she
points to the armorial shield. Behind her, on
the ground, there is a partly concealed globe.
Six putti stand, kneel, and recline next to and
in front of the shield. They are playing with
various attributes: Hercules' club; a laurel gar-
land; such sculptor's implements as a hammer,
a chisel, a square, and a block of stone; and

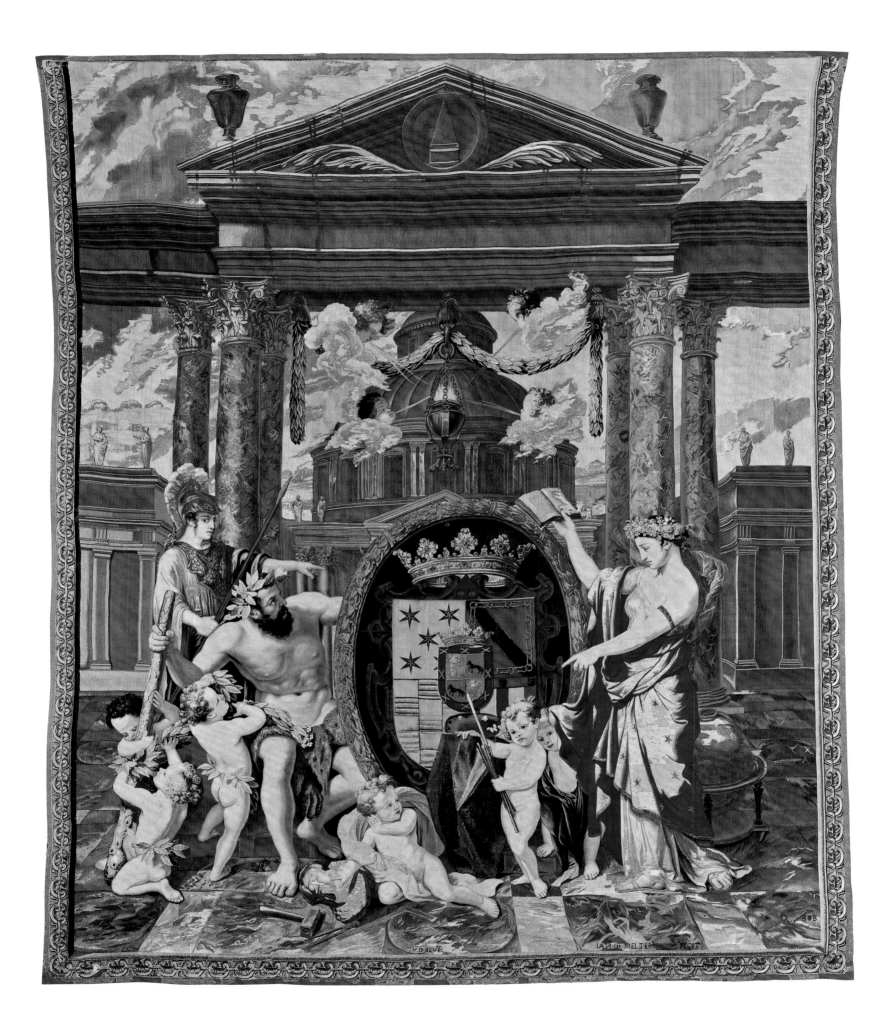

IV D BEVR IAN DE MELTER FECIT

such painter's attributes as a painting, easel, palette, and brushes.

Directly behind the group with the armorial shield is a portico of tall marble columns with Corinthian capitals. The portico is crowned by a fronton with a relief carved of two palm fronds on either side of a medallion containing an obelisk on a plinth. There is a vase on each side of the pediment. Hanging from the architrave between the columns is a laurel garland under which a sanctuary lamp burns, its flame fanned by the bodiless heads of the four winds. Behind the portico is a prospect of a complex of classical buildings: in the middle a cupola, flanked by curved wings to either side with classical statues on flat roofs.

The tapestry has narrow borders on three sides that are decorated with linked red-and-cream scallop shells on a sky blue ground and framed by a yellow-orange guard. The upper border is missing.

Patron and Iconography

The arms on catalogue number 53 are those of Don Juan Domingo de Zúniga y Fonseca, count of Monterey and Fuentes (1649–1716), also count of Ulloa, Biedma, and Azevedo, known as the count of Monterey. He was commander in chief and governor of the southern Netherlands for the Spanish king Charles II from 1670 to 1675. He had already served in the Netherlands as an officer beginning in 1666. After returning to Madrid in 1675, he remained involved with the Netherlands as chairman of the Consejo de Flandes. In 1710, the year his wife died, he left politics and entered the priesthood.

The count of Monterey was born Juan Domingo Haro y Guzman, the second son of the sixth marqués del Carpio.[7] His father's title was inherited by his brother Don Gaspar, the seventh marqués del Carpio (1629–1687), an important art collector and Spanish ambassador to the Holy See in Rome (1674–82). Don Juan Domingo himself bore the titles—with the concomitant coat of arms—that his wife, Doña Ines-Francisca de Zúniga y Fonseca, seventh countess of Monterey, had inherited in 1653 from her uncle Manuel, the sixth count of Monterey, also a patron and collector. After Don Juan Domingo's death, the important art collections of the Carpio and Monterey families passed by inheritance into the possession of the dukes of Berwick and Alba.

The elements in the composition of catalogue number 53 celebrate the count of Monterey both as a military leader and as a renaissance man. The figures surrounding the crowned armorial shield symbolize the combination of physical strength and courage, personified by Hercules, and the complementary virtue of moral strength or wisdom, personified by Minerva. The Arts and Sciences are personified by Minerva as patron of those disciplines and also by the figure of the Liberal Arts and the putti with their attributes of Painting and Sculpture.[8] There are also references to the fame of the count of Monterey and his lineage as well as his adherence to the creed of the Catholic Church: for example, the laurel garland hanging above the sanctuary lamp kept alight by the four winds, and the building in the background, which refers to the temple of Fame as well as Saint Peter's, the Roman Catholic mother church. The relief in the pediment of the portico is dominated by the symbolism of ruling power, for the palm fronds and the obelisk within the circle represent Fame, military victory, and peace.

Design and Date

The most striking aspect of catalogue number 53 is the architectural setting in which the arms of the count of Monterey are placed. An imaginary complex of buildings, it is based on contemporary French classicizing architecture reminiscent of the designs created by the architect Louis Le Vaux from 1661 to 1670 for the Collège des Quatre Nations (also known as Mazarin's College), now housing the Institut de France in Paris).[9] The austere architectural setting and harmonious arrangement of the figures gives the composition of this tapestry an aura of calm and order that contrasts with the more ebullient movement that had characterized Flemish tapestry design in the second third of the seventeenth century.

The designer of this tapestry is unknown. Its greatest stylistic similarity is with the series

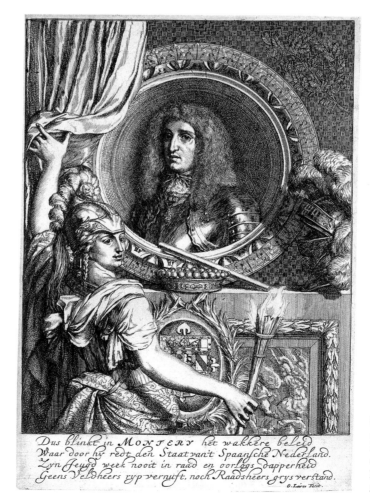

Fig. 210. *Don Juan Domingo de Zúniga y Fonseca, Count of Monterey*, by Gerard Lairesse, ca. 1672. Etching, 24 x 16.5 cm. Rijksmuseum, Amsterdam (RPK-A-1200)

the *Allegory of Time* after designs by the Antwerp painter Jan van den Hoecke, of about 1650, made for one of Monterey's predecessors as governor of the southern Netherlands, Archduke Leopold Wilhelm of Austria (see cat. nos. 27, 28).[10] These also contain figures of gods in harmonious, elegant poses and playful putti in a classical architectural setting. However, Van den Hoecke died well before the count of Monterey arrived in Brussels. It is still possible that his series was influential because sets of it continued to be woven in Brussels up to about 1680. The only artist who had been involved in painting the cartoons of the figures of the Van den Hoecke *Allegory of Time* and who was still alive at the time that catalogue number 53 was designed was Pieter Thijs (1624–1677), but there is insufficient stylistic evidence to attribute the present tapestry to him.

David Teniers III is documented as having made copies of the cartoons of the Van den Hoecke *Time* before 1661.[11] He also designed several armorial tapestries with allegorical figures, including some for various Spanish patrons in the southern Netherlands and in Spain.[12] However, his known work is stylistically different from catalogue number 53, with figures and putti that are generally less elegant.[13] In addition, there is no mention in the known documents of commissions for the count of Monterey that were executed by David Teniers III. This is particularly striking because in a document of 1683 Teniers explicitly stated that he made tapestry designs for two of Monterey's predecessors when each was governor in Brussels.[14]

We know of two artists who worked at the court of the count of Monterey in Brussels about 1671–75, Gonzales Coques (1614/18–1684) and Charles Emmanuel Biset (1633–1693/1713), but both painters specialized in group portraits, and their extant work is stylistically unrelated to this armorial tapestry.[15] In fact, during this period in the southern Netherlands there were few artists working in this classical vein.[16] Stylistically catalogue number 53 seems to have the closest relationship with the work of Gerard Lairesse (1640–1711), which is characterized by a monumental classicism and stillness.[17] Even more than in his paintings and interior and ceiling decorations, similarities with this tap-

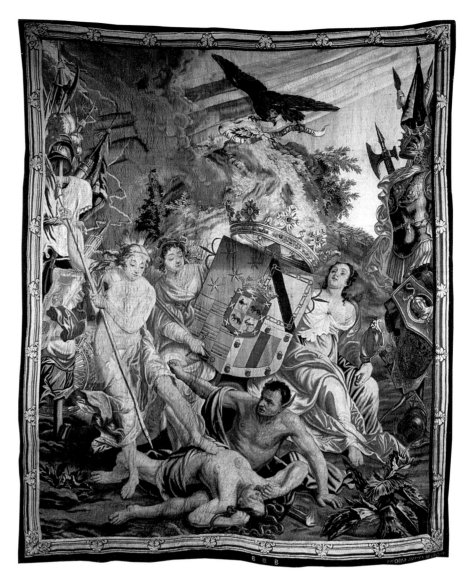

Fig. 211. *Armorial Tapestry of the Count of Monterey.* Tapestry design by an unidentified artist, woven in the workshop of Jacob van der Borcht, Brussels, ca. 1675. Wool, silk, and metal-wrapped thread, 360 x 285 cm. Private collection

estry can be found in his engravings of about 1670–83, in which we see similar facial types, allegorical figures, putti, architectural settings, and picture frames with laurel wreaths.[18] Lairesse came from Liège in the southern Netherlands, but from 1664 he was active in the northern Netherlands, particularly in Amsterdam. No other tapestry designs by Lairesse are known and no relationship with Monterey is documented, but evidence of a possible connection between them is provided by an etched portrait by Lairesse of Monterey of about 1672 (fig. 210), made as a pendant to one of Prince William III.[19] The etching is a much simpler composition than the tapestry, but there are similarities, for example, in the picture frames and in the lofty pose of the helmeted allegorical female figure.

Place and Date of Manufacture

The signatures of Jan de Melter and Jacob van der Borcht (spelled Beurcht) as well as the Brussels town mark are found along the bottom of the main scene of catalogue number 53. Both weavers are documented as working in Brussels from 1675 on. Since the count of Monterey was governor of the southern Netherlands until the beginning of that year, it is plausible that the tapestry was woven about 1675.

Jan de Melter (d. 1698) received privileges in Brussels in 1679 and became dean of the tapestry guild that same year. In 1688 he migrated to Lille (which had been a part of France since 1667), where in 1689 he had nine looms in operation.[20] From 1675 he had already executed several commissions for

French patrons. It is certainly possible that De Melter's work for the count of Monterey brought him into contact with other patrons in Spain. In any case, in 1694 De Melter negotiated with the Spanish government to establish a tapestry manufactory in Madrid, but these plans were not realized because of the poor financial situation in Spain.[21] After De Melter's death, his daughter Katharina married Guillaume Werniers (d. 1738) in 1700. Werniers continued and expanded the Lille workshop.

Jacob van der Borcht (ca. 1650–ca. 1713) was granted privileges in Brussels in 1676.[22] At the end of the seventeenth century he worked with the Brussels workshops of Judocus de Vos, Hieronymus Le Clerc, Jan Cobus, and Jan Coenot on a number of important commissions, including a set of armorial tapestries and a set of *Victories* for King William III of England and a set of *Continents*.[23] In 1705 he had eight looms in operation.

The *Armorial Tapestry of the Count of Monterey* is the only known example of the collaboration between Jan de Melter and Jacob van der Borcht. It is certainly possible that they wove this tapestry when they were among the four "des plus habiles fabriqueurs de cette ville" who were active in the workshop at the count of Monterey's court in Brussels in 1672. Documents of 1672 and about 1735 refer to this workshop in connection with the granting of a monopoly to the dye works of Gaspar Leyniers for dyeing yarns. The document of about 1735, the so-called "Memoire de Goís," describes the count of Monterey as a great lover of tapestries: "grand amateur pour l'art de la ditte fabricque de tapisserie."[24]

The borders of this tapestry were woven onto the tapestry, and this author's previous opinion that they were added about 1770 in the Santa Barbara workshop in Madrid is incorrect.[25] Instead, the Madrid workshop probably patterned after a Brussels tapestry the borders of the seventy-seven tapestries with arabesque designs by Guillermo Anglois and José del Castillo for the State Bedroom Apartments of King Charles III of Spain in the new palace in Madrid; these borders are identical to those of catalogue number 53.[26] Indeed, the *Armorial Tapestry of the Count of Monterey* was probably in Spain at that time and may have been the model. No other Brussels tapestries with identical borders have so far been traced.

There is another armorial tapestry of the count of Monterey, also with Jacob van der Borcht's signature but after a completely different design from catalogue number 53 (fig. 211). In this hanging, the coat of arms is held not by classicizing figures in an architectural setting but by allegorical figures in typically lively Baroque poses placed in a landscape and surrounded by trophies of war.[27]

HILLIE SMIT

1. Brassat 1992, pp. 75–76.
2. Meoni 1998, pp. 362–409.
3. Fenaille 1903–23, vol. 2, pp. 1–15.
4. Delmarcel 1999a, pp. 236, 250.
5. Smit in Hartkamp-Jonxis and Smit 2004, pp. 147–50, no. 42.
6. For a further explanation of the arms, see Smit in Hartkamp-Jonxis and Smit 2004, p. 147, nn. 71–76.
7. Grove 1996, vol. 1, pp. 528–29, vol. 5, pp. 844–45, vol. 22, p. 21; Smit in Hartkamp-Jonxis and Smit 2004, p. 147, n. 77.
8. Hall 1974, pp. 147–48, 209–10, 245–46, 278–79.
9. Ballon 1999. With thanks to Coert Peter Krabbe.
10. Smit in Hartkamp-Jonxis and Smit 2004, pp. 133–42, no. 38a–f.
11. Vlieghe 1959–60, p. 101, no. 22. With thanks to Koenraad Brosens.
12. Ibid., pp. 85–88.
13. A comparison can be made from the two pictures in Delmarcel 1999a, pp. 236–37.
14. Vlieghe 1959–60, p. 100, no. 19.
15. Thieme Becker 1907–50, vol. 4, p. 59, vol. 7, pp. 383–86; Grove 1996, vol. 7, pp. 832–33.
16. Rotterdam–Frankfurt 1999, p. 27.
17. Grove 1996, vol. 18, pp. 650–53; Rotterdam–Frankfurt 1999, pp. 29, 324–26; Brosens 2004a, pp. 101–2.
18. Timmers 1942, pp. 126–27, pls. 26–29.
19. Ibid., p. 126, pl. 26, no. 98.
20. A. G. Bennett 1992, no. 59; Brosens 2004a, pp. 90, 108, 370, 373.
21. Delmarcel 1999a, p. 339; Hartkamp-Jonxis and Smit 2004, pp. 425–26. In 1720, however, members of the Van der Goten family of Antwerp would succeed in founding a tapestry manufactory in Madrid. See Herrero Carretero 2000, pp. 9–26.
22. In the last decades of the 17th century, two tapestry weavers named Jacob van der Borcht were active in Brussels. One of these, the weaver of cat. no. 53, was granted privileges in 1676, the other in 1686. The latter, who died in 1693, also signed with the Latin version of his name, A Castro, and is mostly referred to as Jacob van der Borcht I. Brosens 2004a, pp. 39, 344–45.
23. Delmarcel 1999a, p. 363; Brosens 2004a, pp. 39, 104–5, 116, 210, 312–13, 344, 372.
24. Brosens 2004a, pp. 34, 49, 191, 250, 289–90, 323. In 1672 Leyniers was also granted permission to put the arms of the count of Monterey on the facade of his dye works.
25. Smit in Hartkamp-Jonxis and Smit 2004, p. 145. Closer inspection by Ebeltje Hartkamp-Jonxis, Thomas Campbell, and the author (April 2005) has established that the border and the main scene are woven on the same warps.
26. Tormo Monzó and Sánchez Cantón 1919, pp. 153–54, 167–69, pl. 50; Göbel 1928, p. 483 and figs. 503, 504; sale cat., Bernard Blondeel and Armand Deroyan collection, Christie's, London, April 2, 2003, no. 69.
27. Delmarcel 1999a, p. 250. The tapestry is in a private collection. With thanks to Guy Delmarcel.

54.
Caesar Crowned by Fame

From a set of the *Story of Caesar*
Design and cartoon by an artist tentatively identified
here as Charles Poerson, ca. 1650–67
Woven in the workshop of Jean or Hieronymus
Le Clerc, Brussels, ca. 1660–80
Wool and silk
374 x 407 cm (12 ft. 3¼ in. x 13 ft. 4¼ in.)
Kunstkammer, Kunsthistorisches Museum, Vienna
(T CV2 2)

PROVENANCE: 1861, transferred from the imperial
winter residence in Salzburg to Schloss Schönbrunn,
Vienna; 1921, the imperial tapestry collection became
part of the Kunsthistorisches Museum holdings.

REFERENCES: Birk 1883–84, pt. 2, pp. 211–12;
Delmarcel 1985b, p. 261; Delmarcel 1999a, p. 253.

Caesar Crowned by Fame depicts an episode from the life of the Roman general and statesman Julius Caesar (100–44 B.C.), as is revealed by the scroll in the upper border of the tapestry that reads FORTVNAM CAESARIS CVM CAESARI VEHIS (You carry Caesar's fortune together with Caesar). Caesar stands in a rowboat on a rough sea. He points at Fortuna, who floats on a cloud while sitting on the wheel of fortune; she crowns Caesar with a laurel wreath. Three of the rowers look in surprise at Caesar, but none of them seems to notice Fortuna. Personifications of the winds are shown in the upper left corner; they blow in different directions, thus stressing the dramatic turmoil of the scene. The tapestry is bordered with herm figures at the sides. They rest on a base composed of elegantly carved scrollwork. The herm figures hold a garland of laurel leaves that continues in the upper border. In the center of the upper border is a large shell with a scroll. Burning torches, chains, and a club are to the left of this arrangement; a crown, medallion, and scepter are to the right. The lower border features a globe flanked by cornucopias.

Iconography
Catalogue number 54 forms part of a series that has received virtually no attention until now.[1] No documents shed light on the composition, date, or designer of the series, and only fourteen tapestries pertaining to the series are known. Five pieces, including the present one, are at the Kunsthistorisches Museum, Vienna.[2] A set of four tapestries is in the Museum of Decorative Arts in Prague.[3] A set of five pieces with a French provenance surfaced on the art market in 1983.[4] These three sets reveal that the series was composed of at least seven episodes. Each episode has similar but not identical borders showing herm figures, scrollwork, objects related to strength and leadership, and Latin inscriptions.

These inscriptions allow us not only to arrange the scenes in chronological order but also to pinpoint the primary sources used by the designer to compile the series. The iconographic program was largely based on the *Parallel Lives* of Plutarch (ca. A.D. 45–125). The *Parallel Lives*, which must be considered a semifictional work rather than a genuine historical record, was a huge success in Plutarch's time as well as in the fifteenth, sixteenth, and seventeenth centuries, when it was popularized in most European languages. The designer also made use of the *Life of Julius Caesar* by Suetonius (ca. A.D. 70–ca. 135), written about 121. Numerous editions and French and English translations of this work were also readily available around the middle of the seventeenth century.

The first tapestry of the set bears the phrase IACTA EST ALEA (The die is cast) and shows Caesar crossing the Rubicon, a small river in northern Italy, in 49 B.C. Caesar had been elected senior consul of the Roman Republic in 60 B.C. He created an informal alliance with the leading general, Pompey the Great, and Rome's richest man, Licinius Crassus. This alliance is now known as the First Triumvirate (rule by three men). During Caesar's Gallic Wars (58–49 B.C.), however, the triumvirate disintegrated: Crassus was killed in a military campaign, and Pompey drifted toward Caesar's political enemies. When Caesar's term as consul came to an end in 50 B.C., Pompey ordered him to disband his army and return to Rome. Caesar, fearing he would be eliminated if he entered Rome without any political or military power, disobeyed Pompey's order. By leading his army across the Rubicon he started a civil war. Caesar reputedly said "The die is cast" before crossing the river to show that he understood the dramatic consequences of his action (Plutarch *Caesar* 32; Suetonius *Caesar* 32).

Pompey fled to Greece, and Caesar wanted to take money from the reserve funds of the state to secure his position and mount a military expedition against Pompey. One of Caesar's adversaries, however, claimed that Caesar had no right to despoil the treasury and hindered him, whereupon Caesar threatened to kill his opponent as "arms and laws have not the same season" (Plutarch *Caesar* 35).

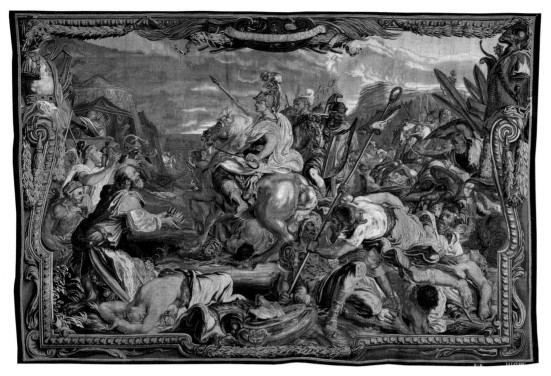

Fig. 212. *Victory at Pharsalus* from a set of the *Story of Caesar*. Tapestry design by an artist tentatively identified here as Charles Poerson, woven in the Le Clerc workshop, Brussels, ca. 1660–80. Wool and silk, 367 x 535 cm. Kunsthistorisches Museum, Vienna (KK T CV2 3)

This scene is the second episode of the set. The Latin phrase reads SI VIOLANDVM EST IVS REGNANDI GRATIA (If right must be wronged, do it for the sake of government), which was recorded by Suetonius (*Caesar* 30).

In 48 B.C. Caesar landed on the Greek coast in pursuit of Pompey. Yet as his auxiliary troops were delayed, Caesar feared that he would not be able to withstand a counterattack. He decided to return secretly to Italy to incite his generals and troops himself. Disguised as a slave, he boarded a boat to cross the Ionian Sea. A storm, however, forced the rowers to return to Greece, even after Caesar had disclosed himself and encouraged the men to persist by shouting, "You carry Caesar's fortune together with Caesar," as is recorded by Plutarch (*Caesar* 38). *Caesar Crowned by Fame* depicts this scene, which is also described by Suetonius (*Caesar* 58).

Still in 48 B.C. Caesar defeated Pompey's army on the plain of Pharsalus (Plutarch *Caesar* 45; Suetonius *Caesar* 35). The *Victory at Pharsalus*, entitled PHARSALIAM DOMANS, is the fourth episode of the set (fig. 212). After his defeat, Pompey fled to Egypt, where he asked Ptolemy XIII for asylum. The Egyptian king, however, who was fighting a civil war with his sister, wife, and coregnant queen,

Cleopatra, thought it would be wiser to kill Caesar's enemy rather than welcoming him, and he had Pompey murdered. Arriving shortly thereafter, Caesar became enraged when they presented him with Pompey's head, as is depicted in the fifth episode, which bears the title DVLCIOR VICTORIA SERVATI QVAM CAESI HOSTIS (Victory over a living enemy tastes sweeter than victory over a dead enemy) (Plutarch *Caesar* 58; Suetonius *Caesar* 35). Caesar deposed the Egyptian king and made Cleopatra queen, which caused a new civil war.

During a battle at Alexandria, Caesar was forced to throw himself into the sea. He escaped by swimming, while managing to safeguard some important documents (Plutarch *Caesar* 49; Suetonius *Caesar* 64). This episode is shown in the sixth scene. The designer depicted Caesar holding a sword as well as a sheaf of papers, which corresponds with the Latin inscription IN VTROQVE CAESAR (Emperor in both): this phrase alludes to the classical idea that in a well-governed state, law, symbolized by the documents, must be coupled with military strength, symbolized by the sword. The last episode, showing Caesar's triumphant entry into Rome in 45 B.C., bears the famous words VENI VIDI VICI (I came, I saw,

I conquered). According to Plutarch (*Caesar* 50) Caesar used these words to describe his swift and complete victory over the Pontic king in Turkey (47 B.C.), yet Suetonius (*Caesar* 37) stated that Caesar carried a banner with this phrase during his triumphant procession.

One of the famous Nine Worthies—historical figures who since the beginning of the fourteenth century embodied the ideal of chivalry—Caesar had been an icon throughout antiquity and the Middle Ages.[5] The success of Plutarch's and Suetonius's accounts inspired many dramatists of the sixteenth and seventeenth centuries. In France, Marc-Antoine de Muret published the neo-Latin tragedy *Julius Caesar* (1552–53), which was translated into French by Jacques Grévin (*César*, 1561).[6] In the beginning of the seventeenth century, Shakespeare's *Julius Caesar* was staged in London; the play was published in 1623.[7] *La mort de César*, written by Georges de Scudéry (1634), was translated into Dutch in 1650.[8] A Dutch translation of Muret's *Julius Caesar* had already been published in 1645.

Since Caesar was an integral part of seventeenth-century intellectual thought and culture and an appealing example for rulers and commanders, it is not surprising that he played a significant role in European Baroque tapestry.[9] No fewer than three series were produced in Brussels about 1650–80. One series was woven after a third-generation set of cartoons based on ones created by Pieter Coecke van Aelst (1502–1550).[10] This set might be related to a *Caesar* series recorded in a Brussels document in 1672 revealing that the lesser-known Brussels tapestry designer Daniel Leyniers II (1618–1688) transferred the cartoons of three sets, including a *Story of Caesar* series, to Hieronymus Pauwels, a Brussels tapissier whose life and production are even more obscure.[11]

The most famous seventeenth-century *Caesar* set was created by Justus van Egmont (1601–1674) before March 1659.[12] These cartoons were commissioned by a consortium of the Van Leefdael–Van der Strecken–Peemans workshops. The most complete edition is in Madrid (Diputación Provincial).[13] The set comprised eight episodes: *Clodius Disguised as a Woman, Caesar in the Gallic Wars, Caesar Crosses the Ionian Sea, Victory at Pharsalus* (fig. 213), *Caesar and Cleopatra Become Rulers of*

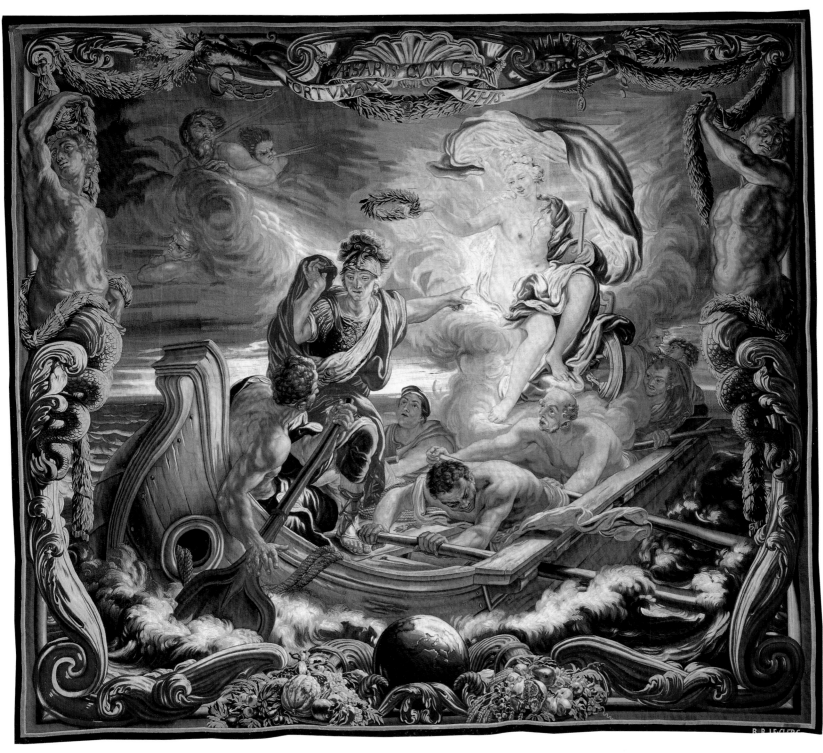

Detail of cat. no. 54

Egypt, *Discovery of the Plot to Kill Caesar and Cleopatra, Caesar Throws Himself into the Sea,* and the *Triumph of Caesar.*

Place of Manufacture

Catalogue number 54 belongs to the third series woven in Brussels about 1660–80. Many pieces of the latter series, including catalogue number 54, bear the Brussels city mark and the signature I.LE.CLERC or LE.CLERC. This signature can presumably be attributed to Jean Le Clerc (ca. 1600–1672), an entrepreneur workshop manager who had moved from the north of France to Brussels in 1634.[14] The same signature, however, might also have been

used by his son and successor, Hieronymus (1643–1722). One of the fourteen *Caesar* pieces is signed I.D.M.[15] This abbreviation can be read as standing for Jan de Melter (d. 1698). Biographical data pertaining to this entrepreneur is scarce, yet it is known that he was dean of the Brussels guild of tapissiers in 1679, when he was exempted from taxation on beer and wine by the Brussels city administration because of his status as an important workshop manager.[16] According to De Melter's request filed with the municipality, he had "made various sets commissioned by the French in the last four years."[17] It can be surmised that these commercial contacts inspired him to move

about 1688 to Lille in northern France, where he directed a tapestry workshop until his death in 1698.

Date and Designer

The designs for the Le Clerc *Caesar* series may be given an approximate date on the basis of their borders. The herm figures show the impact of Peter Paul Rubens's designs for the borders of the *Story of Achilles,* which has been dated 1630–35, and Jacob Jordaens's *Story of Odysseus,* which has been dated about 1635, suggesting a terminus post quem.[18] A terminus ante quem may be found in the rise of a different border type about 1660, when

462

Detail of cat. no. 54

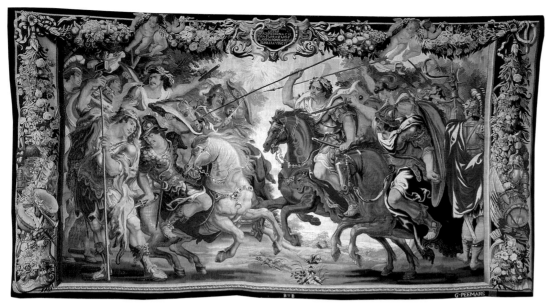

Fig. 213. *Victory at Pharsalus* from a set of the *Story of Caesar*. Tapestry design by Justus van Egmont, woven in the workshop of Jan van Leefdael or Gerard van der Strecken, Brussels, ca. 1680. Wool and silk, 673.5 x 370.2 cm. The Art Institute of Chicago, Gift of Mrs. Chauncey McCormick and Mrs. Richard Ely Danielson (1944.14)

painted by Jordaens and Van Egmont. In all, the *Caesar* cartoons used by Le Clerc present compositions that are far more spacious and refined than the contemporary counterparts by Van Egmont.

These stylistic features link the *Caesar* series to tapestry sets designed by the French painter Charles Poerson (1609–1667). It has been demonstrated that Poerson created at least four sets that were woven in Brussels: the *Story of Moses*, the *Story of Clovis*, the *Story of Titus and Vespasian*, and the *Story of Cleopatra*.[20] There are close similarities between the compositions, figures, gestures, and landscape settings of these sets and the *Caesar* series produced at the Le Clerc workshop. This strong affinity is exemplified by the battle scenes in the *Clovis* and *Moses* series (fig. 214) that recall the *Victory at Pharsalus* (fig. 212).

This tentative attribution of the *Caesar* set to Poerson is supported by historical data. It has recently been demonstrated that Charles de La Fontaine (ca. 1610/15–1678) and Adriaen Parent (ca. 1630–1705), both French or Walloon entrepreneurs based in Brussels, owned the cartoons and sketches of Poerson's

Brussels tapissiers and their customers favored borders featuring arrangements of flowers, fruits, birds, and putti. Consequently, the designs of the *Story of Caesar* could be dated about 1650. Equally, as Thomas Campbell suggested, the borders may be regarded as a sophisticated return to an earlier concept, implying that series may be dated in the 1660s or even later.[19]

The dramatic and dynamic compositions of the *Caesar* episodes support the thesis that the series was designed about 1660. There are, however, some important stylistic features that deserve attention, as they isolate the designs from contemporary sets created by Antwerp and Brussels painters like Jordaens, Anthonis Sallaert, and Van Egmont. A comparison between the *Victory at Pharsalus* produced by Le Clerc (fig. 212), on the one hand, and Van Egmont's depiction of the same episode, on the other, is most instructive (fig. 213). Van Egmont painted a direct confrontation between Caesar and his troops, represented by four riders, and Pompey's army, symbolized by six soldiers; the majestic, monumental figures and horses block a view of a landscape setting that is depicted in the simplest terms; in fact there is hardly any setting at all. The Le Clerc *Victory*, by contrast, offers a detailed view of Caesar's victory. To be sure, the expressive, theatrical faces and gestures are reminiscent of Flemish Baroque painting and tapestry design.

The scale of the figures, however leaves room for more actors and a careful rendering of the landscape setting. Moreover, the muscular male bodies are juxtaposed with elegant female figures that differ from the women

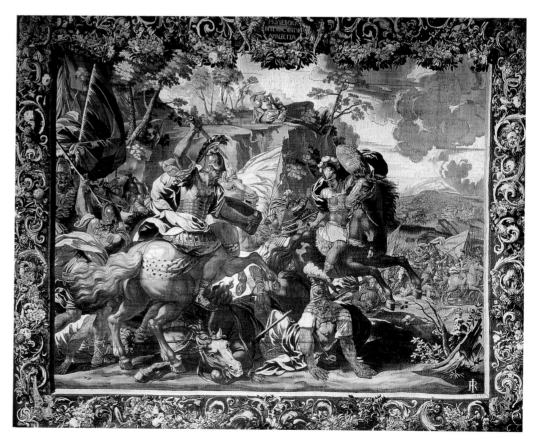

Fig. 214. *The Battle against the Amalekites* (detail) from a set of the *Story of Moses*. Tapestry design by Charles Poerson, woven in the workshop of Jan Leyniers II, Brussels, ca. 1675. Wool and silk, 390 x 485 cm. Palazzo Clerici, Milan

Moses, Clovis, Titus, and *Cleopatra* sets.[21] They leased and eventually sold the cartoons to a handful of Brussels workshop managers, including the Le Clercs. Interestingly, data pertaining to the cartoons owned by De La Fontaine, Parent's application for exemption from taxation on beer and wine, and the inventory recorded after Parent's death strongly suggest that French cartoons other than those depicting *Moses, Clovis, Titus,* and *Cleopatra* circulated in Brussels.[22]

Two unpublished documents recorded in Brussels in 1700 shed further light on this issue. In February 1700 Adriaen's son Nicolas Parent (d. 1714), who acted in his father's name, contracted with "Charles Comte de Walstein," who can be identified with either Charles Ferdinand, count of Waldstein (1634–1702), or Charles Ernest, count of Waldstein (1661–1713). Parent engaged himself to deliver four tapestries depicting "l'histoire de Jules César" and to start the production of two more more pieces, "la morte de pompée" (The Death of Pompey) and "la fortune de Caesar" (Caesar's Fortune), scenes that can be identified with the episodes entitled DVLCIOR VICTORIA SERVATI QVAM CAESI HOSTIS and FORTVNAM CAESARIS CVM CAESARI VEHIS.[23] The second document, recorded in March 1700, shows that the Brussels art dealer François van Coppenolle (d. 1701) was involved in this transaction and that the order for the additional pieces might have been dropped.[24]

Adriaen Parent can thus be linked to imported cartoons by Charles Poerson, to the Le Clerc workshop, and to a *Story of Caesar* set. These links obviously support the attribu-

tion of the *Caesar* cartoons used by the Le Clercs to Poerson.

The *Caesar* set is yet another example of the growing popularity of French classicist-decorative painting in Brussels tapestry in the second half of the seventeenth century, a vogue that is exemplified by the introduction of Charles Le Brun's *Meleager and Atalanta* cartoons in Brussels in 1672.[25] It should be noted that Van Egmont, former collaborator of Rubens and the last advocate of the Flemish Baroque in Brussels tapestry, must have been familiar with the fashionable, harmonious French manner, as he had collaborated with Simon Vouet (1590–1649), who designed several tapestry sets, and with Poerson during his stay in Paris in the 1630s and 1640s. When Van Egmont returned to the southern Netherlands about 1650, however, he refreshed and almost caricatured Rubens's and Jordaens's idiom in three sets that were commissioned by the Van Leefdael–Van der Strecken–Peemans association: the *Story of Caesar,* the *Story of Cleopatra,* and the *Story of Zenobia.* In the short term, this entrepreneurial strategy proved successful: the flamboyant Baroque style remained popular until about 1665; the business partners could market suites formed by an amalgamation of *Caesar, Cleopatra,* and *Zenobia* pieces;[26] and the plain Van Egmont compositions were relatively easy to weave, which lowered production costs. The French designs, however, became increasingly popular from about 1660 and shaped the development of Brussels tapestry design in the last quarter of the seventeenth century. Catalogue number 54 and the *Caesar* set can be regarded as key pieces in this evolution.

KOENRAAD BROSENS

I thank Dr. Katja Schmitz-von Ledebur (Kunsthistorisches Museum, Vienna), who made it possible for me to examine some pieces in Vienna; and Emeritus Professor Dr. Guy Delmarcel (K.U.Leuven) for the many discussions we had about this set.

1. Delmarcel 1985b, p. 261; Delmarcel 1999a, p. 253.
2. Birk 1883–84, pt. 2, pp. 211–12.
3. Blažková 1975, nos. 23–26.
4. Sale cat., Sotheby's, Monte Carlo, June 23–24, 1983, nos. 123a–c, 124a, b; subsequently sale cat., Christie's, Luttrellstown Castle, September 26–28, 1983, nos. 456–60.
5. Christ 1994.
6. Dutertre 1992; Bloemendal 2001.
7. Ayres 1910.
8. Worp 1904–8/1970, vol. 2, pp. 121, 126.
9. Delmarcel 1985b; E. Duverger 1996. See T. Campbell 1998 for Caesar in Renaissance tapestry.
10. T. Campbell 1998, pp. 18–21.
11. Algemeen Rijksarchief (hereafter ARAB), Brussels, Notariaat Generaal van Brabant (hereafter NGB), vol. 1701² (October 22, 1672); see also Brosens 2004a, p. 81, no. 337.
12. Donnet 1896, p. 291.
13. Arriola y de Javier 1976, pp. 46–64.
14. Brosens 2005b, p. 69.
15. Sale cat., Sotheby's, Monte Carlo, June 23–24, 1983, no. 124a; sale cat., Christie's, Luttrellstown Castle, September 26–28, 1973, no. 457.
16. Stadsarchief, Brussels (hereafter SAB), Register de Tresorije (hereafter RT), vol. 1303, fols. 34–35 (December 18, 1679). On De Melter, see Wauters 1878, pp. 346–47.
17. "[V]ier jaar lang in commissie van die van vranckrijck gemaakt diverse kamers"; SAB, RT, vol. 1303, fol. 34r.
18. On the *Achilles* and *Odysseus* series, see Haverkamp-Begemann 1975; Rotterdam–Madrid 2003; and Nelson 1998, pp. 24–28.
19. Thomas P. Campbell, email to the author.
20. De Reyniès in Metz 1997, pp. 107–37, 171–93.
21. Brosens 2005b; Brosens 2007b.
22. SAB, RT, vol. 1301, fols. 28r–29r (March 21, 1673); published in Brosens 2005b, pp. 75–76; ARAB, NGB, vol. 1995 (September 1, 1705).
23. ARAB, NGB, vol. 5982 (February 9, 1700).
24. ARAB, NGB, vol. 2415² (March 27, 1700).
25. Brosens 2003–4. See also "Flemish Production, 1660–1715" in this volume.
26. Cambini 2001.

55.
Temperance

This is one of a set of four armorial tapestries executed for John Churchill, first Duke of Marlborough, intended to be hung in the State Apartments at Blenheim Palace.

The Patron and the Historical Context

The set was commissioned in 1708–9 to celebrate Churchill's creation as a prince of the Holy Roman Empire, and it was executed in 1710–11. The design is unique and can probably be attributed to the Brussels artist Jan van Orley (1665–1735). Each panel features the new coat of arms prominently in the center, flanked by allegorical representations of one of the four Cardinal Virtues.

Churchill, who had an impressive but fluctuating diplomatic career, is chiefly remembered today as the greatest military commander of his time for the part he played in the War of the Spanish Succession (1701–14). This centered on the problem of the Spanish inheritance when the Spanish Habsburg King Charles II died childless in 1700. Diplomatic negotiations eventually failed, and when war was declared, Churchill was appointed captain general of Queen Anne's armies as well as those of her principal allies, the United Provinces (Holland) and the Holy Roman Empire (a confederation of states headed by the Austrian Habsburgs). Churchill was sent to the Spanish Netherlands (present-day Belgium), where King Louis XIV's French troops had attacked and occupied several fortresses and towns, threatening not just Dutch security but, more importantly, the balance of power in Europe. At the end of 1702, Churchill was created Duke of Marlborough. His new status was useful in wielding political influence and enhanced his authority in diplomatic dealings with the multinational alliance.

In the early eighteenth century, defensive conflict was conventional—tactical marches and sieges were employed to gain control of key towns and foraging areas. Although Marlborough was at the head of the combined armies of the alliance, every action needed the approval of two Dutch deputies, who were frustratingly reluctant to engage with the enemy. Three years into the war, a defining moment occurred. In 1704 Louis XIV was suspected of planning a strike on the Danube valley, which would have threatened Vienna, the capital of the Austrian Habsburgs. Their ambassador in London, Count Wratislaw von Mistrowitz, appealed to the duke for assistance. Marlborough responded, thus safeguarding the alliance. Strategy was decided, and by June 1704 Wratislaw recommended that the duke be named a prince of the Holy Roman Empire. This mark of distinction, granted by the emperor, was made greater by the conferment of a fiefdom that allowed the duke the coveted right to vote at the Imperial Diet.

That summer, Marlborough set in motion the plan for what would become his most legendary military action. His careful preparations; his cunning diversion of the troublesome Dutch deputies; his long march to the Danube, cleverly disguising his intentions from the French and their Bavarian allies; and his efficient system of getting supplies and provisions to his armies at every camp throughout the march were rewarded on August 13 with a remarkable victory over a numerically superior French force led by one of Louis XIV's most experienced and trusted marshals, Camile d'Hostun, comte de Tallard. Tallard's humiliating surrender at the Battle of Blenheim ended more than fifty years of French military supremacy in Europe.

The victory at Blenheim earned honors and rewards for Marlborough at home and abroad. After Emperor Joseph gained the imperial throne in 1705, he made Marlborough a prince of the Holy Roman Empire. This title, which from May 1706 included the lordship of the small territory of Mindelheim, was bestowed mainly to ensure Marlborough's future support of the alliance and the imperial cause.[1]

Commission

The duke did not commission his set of armorial tapestries immediately on receiving this distinction because the discussions regard-

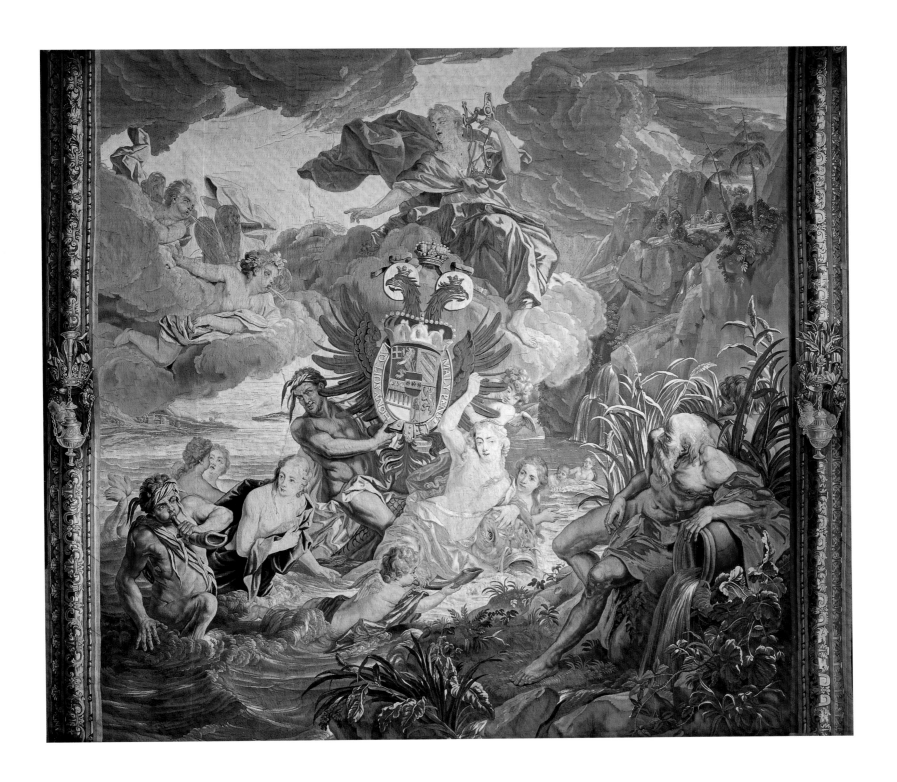

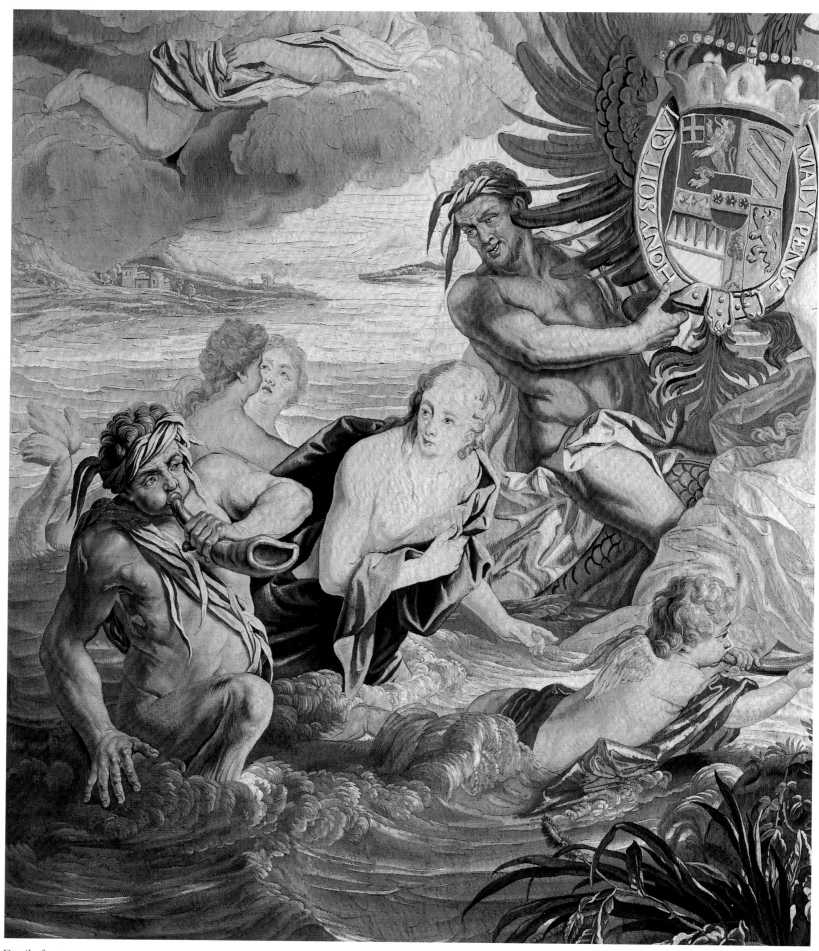

Detail of cat. no. 55

ing his rights and the succession of his new title and territory continued over several years. The order for this set is likely to have been placed in the winter of 1708–9, when two other sets were commissioned from the Brussels workshop of Judocus de Vos—a set of four panels from the *Pleasures of the Gods* series and a most important set of martial tapestries, now called the *Victories of the Duke of Marlborough* (see cat.no. 56).[2] These orders were placed through an intermediary, Philippe Louis Wenzel, Count Sinzendorf, who was at The Hague in 1709 as the imperial plenipotentiary.[3]

Count Sinzendorf was court chancellor in Vienna from 1702 to 1713 and also the protector of the Viennese Imperial Academy of Arts from 1705 on and was therefore well placed to advise Marlborough on his new tapestry commissions. Documentary evidence further shows that Count Sinzendorf recommended that the duke hang his armorial tapestries in the "grande salle" at Blenheim, a palatial house being built for him in Oxfordshire as a reward from Queen Anne after his victory at the Battle of Blenheim.[4] The decorative scheme planned for the Great Hall in this early stage of the project was not carried out, and by July 1709 a more conventional hanging proposal was considered: the tapestries were to be displayed in "the roome next to the sallon."[5]

Details of the tapestry commission are provided in a short memorandum written by the duke's quartermaster general, William Cadogan: "the area surrounding the arms will be decorated with figures representing the Virtues... who will hold up the arms and carry trophies which will correspond to the nature of the Virtue represented by the figure. The Border will be a simple square one on a blue background."[6]

While the identity of the designer of these tapestries is not known, the documentation indicates that the four panels were executed in the workshop of the Flemish master weaver Judocus de Vos in 1710–11.[7] As these were new commissions with complex symbolic and allegorical components within the designs, the cartoons had taken some time to prepare. There was also a problem with the drawing of the new coat of arms, as on February 19, 1710, De Vos wrote to his patron enclosing a revised version.[8] De Vos explained the delay in send-

Detail of cat. no. 55

ing this drawing to the duke: there was only one painter in Brussels able to execute armorial bearings and the man had been ill.

Archival documentation also confirms that two panels, *Temperance* and *Fortitude,* measured 6¼ ells each, while *Justice* and *Prudence* were slightly smaller, at 5¾ ells each.[9] The height of all the panels was 6⅜ ells. De Vos charged 45 florins per square ell for this specially com-

missioned set of tapestries and was paid 6,885 Flemish florins, plus 92 florins 6 stivers for the linings.[10]

As the duke was still actively engaged in the war, the delivery of the tapestries was organized through friends and officials based in Flanders. On November 21, 1711, Adam Cardonnel, the duke's field secretary, wrote to Henry Watkins, the deputy judge advocate

of the British forces based at The Hague: "my Lord Duke desires the three pieces with the arms may be sent immediately to Mrs. Cadogan at the Hague."[11] Mrs. Cadogan was Margaretta Munter, the wife of Marlborough's trusted quartermaster general, William Cadogan, whose home, Raaphorst Castle, located in parkland about ten miles from The Hague, was sometimes used as a depository for the works of art the duke collected while on campaign.

Iconography

The four tapestries in this set represent the Cardinal Virtues of Temperance, Fortitude, Justice, and Prudence. In each tapestry, a virtue is allegorically represented around a large, centrally placed coat of arms. Temperance is represented by the bridle, Justice by the scales, Fortitude by Hercules, and Prudence by the mirror. The Cardinal Virtues seemed to be of particular significance to Marlborough as we find the same four included once again in the medallions in the corners of the decorative border surrounding the *Victories* set, the other specially designed series of tapestries ordered at the same time.

The *Temperance* panel displays a cloud-borne allegorical figure of Temperance clothed in blue and gold flowing robes, holding up her principal attribute of a bridle, representing restraint. She points to two winged winds raising a storm in the sea below, which is populated with Neptune's attendants, Nereids and Tritons who sound their conch-shell horns to calm the waves. The coat of arms is held up by a Venus Pudica (modest Venus), another representation of Temperance derived from classical imagery. She is riding on the back of a dolphin, Neptune's steed, denoting swiftness of movement and also functioning as a symbol of fortune. A river god occupies the right foreground, where water pours from a vessel. This transferal of liquid, which is echoed in the background by the waterfall, is a further distinguishing feature of Temperance and alludes to the mixing of water with wine to moderate the vice of drunkenness.

The version of the coat of arms that proudly displays Marlborough's status (as duke, as a knight of the Order of the Garter,

and, most importantly, as a prince of the Holy Roman Empire) was used by him from 1706 on. The shield is divided into four quarters, the most significant of which is the first quarter—Sable a lion rampant argent, on a canton of the same a cross gules.[12] This originates from the arms of John Churchill's father, Sir Winston Churchill (1620–1685), who was awarded a rare mark of royal favor (for his service to King Charles I as Captain of the Horse and for his loyalty to King Charles II) in the form of an augmentation of honor, which allowed him to add the canton of Saint George to his arms.[13] The coronet over the shield indicates John Churchill's rank of duke. This coronet is normally a gold circlet with four of its eight strawberry leaves visible, but the inaccuracy in its representation here may be due to the Flemish cartoon maker misunderstanding its exact form. As Marlborough was a knight of the prestigious Order of the Garter, a blue Garter ribbon encircles the shield with the motto of the order, HONI SOIT QUI MAL Y PENSE, in gold letters. Finally, the double-headed eagle surmounted by the imperial coronet denotes that he was also a prince of the Holy Roman Empire.

Use

The location of this set of tapestries when the duke and duchess first occupied the east wing at Blenheim in mid-1719 is undocumented. It is possible that they were displayed as intended, in a state room next to the salon (present Green Writing Room), as their overall dimensions are very similar to those of the *Victories* panels, which were hung in the state apartments. It is also possible that when these tapestries were delivered at the end of 1711, they were taken to Marlborough House, a London residence newly completed by Sir Christopher Wren at that time.

When the first duke died in 1722, the tapestries, along with other heirlooms, were left in his will to his wife, Sarah, and then to subsequent holders of the title.[14] An inventory made of the furnishings in 1740 does not specifically mention the armorial set.[15]

These tapestries were definitely at Blenheim when the fourth Duke of Marlborough (1739–1817) made it his principal home. He employed Sir William Chambers (architect to

King George III) to supervise the renovations, working in conjunction with the London-based cabinetmakers and upholsterers Mayhew and Ince. John Mayhew removed the set for cleaning in early 1774, and they were returned to the Winter Drawing Room (also known as the Great Drawing Room and now the Red Drawing Room) on May 23.[16]

The tapestries were moved by the fifth Duke of Marlborough (1766–1840) in 1817, when the interiors were reorganized to accommodate the collection from Marlborough House in London when its lease reverted back to the crown.[17] About 1886–87 the tapestries were returned to the Great Drawing Room by the eighth duke (1844–1892), who used it as a billiards room. When the ninth Duke of Marlborough (1871–1934) redecorated the interiors once more, from 1895 to 1905, the tapestries were rearranged in a bedroom in the east wing.

Successive generations of the family owe their wealth and standing to the military achievements and honors of the first duke, and it is, therefore, not surprising that this significant set of tapestries still belongs to the Marlboroughs and survives in the house for which it was commissioned almost three hundred years ago.

JERI BAPASOLA

1. British Library, London, Add. MSS 61,144, fol. 72; Coxe 1818, vol. 1, pp. 529–38.
2. Bapasola 2005, pp. 52–57.
3. Blenheim Archives, Long Library Portfolios, vol. 2, fols. 30v, 31, 42.
4. Blenheim Archives, Long Library Portfolios, vol. 2, fol. 34.
5. Synder 1975, vol. 3, p. 1315.
6. Blenheim Archives, Long Library Portfolios, vol. 2, fol. 33v.
7. Blenheim Archives, Long Library Portfolios, vol. 2, fol. 40.
8. British Library, Add. MSS 61,367, fol. 121.
9. Blenheim Archives, Long Library Portfolios, vol. 2, fol. 30v.
10. Blenheim Archives, Long Library Portfolio, vol. 2, fols. 30v, 41–42.
11. British Library, Add. MSS 42,176, fol. 317.
12. Heraldic language denoting a white lion rampant on a black background with the cross of Saint George (a red cross on a white background) in a subdivision of the top left-hand corner.
13. Granted by a royal warrant of December 5, 1661, *Calendar of State Papers, Domestic Series* 1860–1938, [vol. 2], 1661–1662, p. 176.
14. British Library, Add. MSS 61,409, fols. 1–10.
15. British Library, Add. MSS 61,473.
16. Blenheim Archives, Steward's Daybook, 1772–1800, XXII/74/6.
17. Mavor 1817.

56.
The Siege of Bouchain III

From an eleven-piece set of the *Victories of the Duke of Marlborough*
Design and cartoon by Philippe de Hondt, ca. 1712–15
Woven in the workshop of Judocus de Vos, Brussels, ca. 1714–15
Wool and silk
440 x 807 cm (14 ft. 5¼ in. x 26 ft. 5¾ in.)
The Trustees of the Marlborough Chattels Settlement, Blenheim Palace, Woodstock

PROVENANCE: Ca. 1712–15, designed and woven on commission of John Churchill, first Duke of Marlborough, as part of a set intended for the State Rooms at Blenheim Palace; 1740, listed in the "Inventory of Furniture belonging to the Executors of the Late Duke of Marlborough at Blenheim House"; March 8, 1884, listed in the "Inventory of Heirloom Furniture and Effects made at Blenheim"; by descent in the Marlborough family and displayed continuously at Blenheim Palace in what is now called the second State Room.

REFERENCES: Wace 1968, pp. 60–62, 84–88; Hefford 1975, pp. 105–14; Brosens 2002, pp. 67, 72–73; Bapasola 2005, pp. 51–60, 71–81, 130–33.

CONDITION: Good, considering its size and the fact that it has been hanging for more than 250 years. There is fading in the landscape, particularly of the yellows and greens. The main scene was reduced at right and the side border reattached, possibly in the 1770s, when the fourth Duke of Marlborough renovated the State Drawing Room. Cleaning, spot repairs, and relining have been carried out over time, as in 1905, when the ninth duke refurbished the western state apartments, and most recently ca. 1960.

The military genius of John Churchill, first Duke of Marlborough, could not have been more convincingly demonstrated than in 1711 with the siege of Bouchain in Flanders. Marlborough impressively overpowered the enemy in what was to be his last campaign in the War of the Spanish Succession (1701–14) and a fitting end to his distinguished military career. A measure of the significance he accorded Bouchain is provided by the fact that three tapestries among the set of eleven celebrating his most important victories commemorate this specific action. This large panel is the last of the set, depicting the culmination of the siege with the surrender of the French. The set was designed and woven for the duke to form the centerpiece of an impressive display of artworks in the state apartments of his grand new Blenheim Palace,[1] where they still hang.

Patron
John Churchill (1650–1722) was appointed captain general of the allied forces in the War of the Spanish Succession, which was fought to preserve the balance of power in Europe against the expansionist ambitions of the French king Louis XIV. The partition of the vast Spanish possessions was at stake after the death of the childless King Charles II. The allies (England, Holland, and Austria, joined later by Portugal and Savoy) were pitched against the combined might of France, Spain, Bavaria, and Liège.

Assuming this high command late in his career, the Duke of Marlborough stunned the enemy with repeated and successive victories at Blenheim (1704), Ramillies (1706), Oudenaarde (1708), and Malplaquet (1709). At a time when conventional warfare consisted of complex tactical maneuvers rather than pitched battles, he also besieged and took thirty fortresses in the course of ten campaigns. His achievements in the early eighteenth century effectively broke the military supremacy of France and set the stage for two centuries of British dominance through the growth of trade routes and colonization,

which would redraw the map of the world.

Marlborough reached the height of his fame at the close of the campaign of 1708, a year in which the allies had been successful at Oudenaarde, Wynendael, and Lille. The duke, who had already actively embarked on amassing a vast collection of works of art, commissioned three sets of tapestries that winter, before the start of the 1709 campaign.[2] Two of these, an allegorical armorial set and one depicting his own victories, were important, newly designed works celebrating his status and achievements.

The purchase is documented through an order placed by Count Sinzendorf, the Austrian court chancellor, who had close diplomatic dealings with the duke throughout the war and was based in Flanders at this time. Sinzendorf reveals that tapestries of "the battles won by My Lord Duke" were ordered from Judocus de Vos "according to a contract signed by him at the Hague on 19th November."[3] Discussions regarding the design of the tapestries had taken place by February 1709, when the Naulaerts firm, which had previously supplied two sets of tapestries to the duke (a nine-piece set of the *Art of War* and eight panels of the *Story of Alexander*), was asked to send the border designs that had been specially painted by Jan van Orley for the *Art of War* tapestries to the weaver of the new set, Judocus de Vos.[4]

Within eight months the count had "finalized the design."[5] A few weeks later, the duke sent "compliments to Count Sinzendorff, and pray lett him know that I have receiv'd from England the measures for the Hangins[6] and if the designe be finish'd I shou'd be glad the man att Bruxelles [Judocus de Vos] might have orders to lett me see them."[7]

Commission
In the absence of a surviving formal contract, Sinzendorf's memorandum provides us with the only available information regarding the tapestries and their intended destination. Twelve panels of equal size were to be made to furnish three rooms at Blenheim. Each

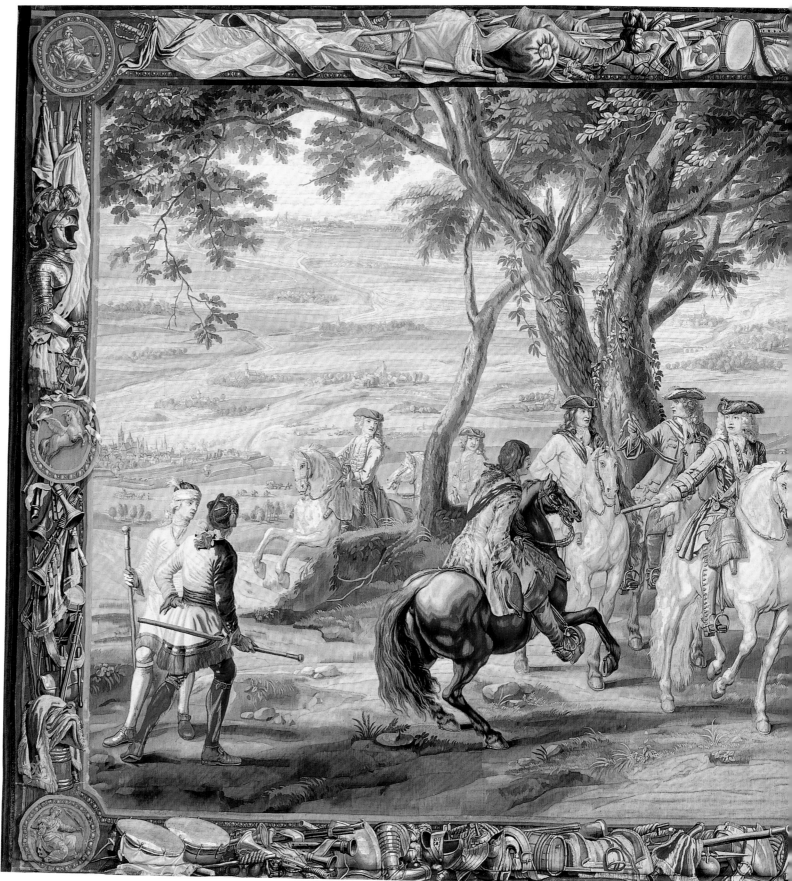

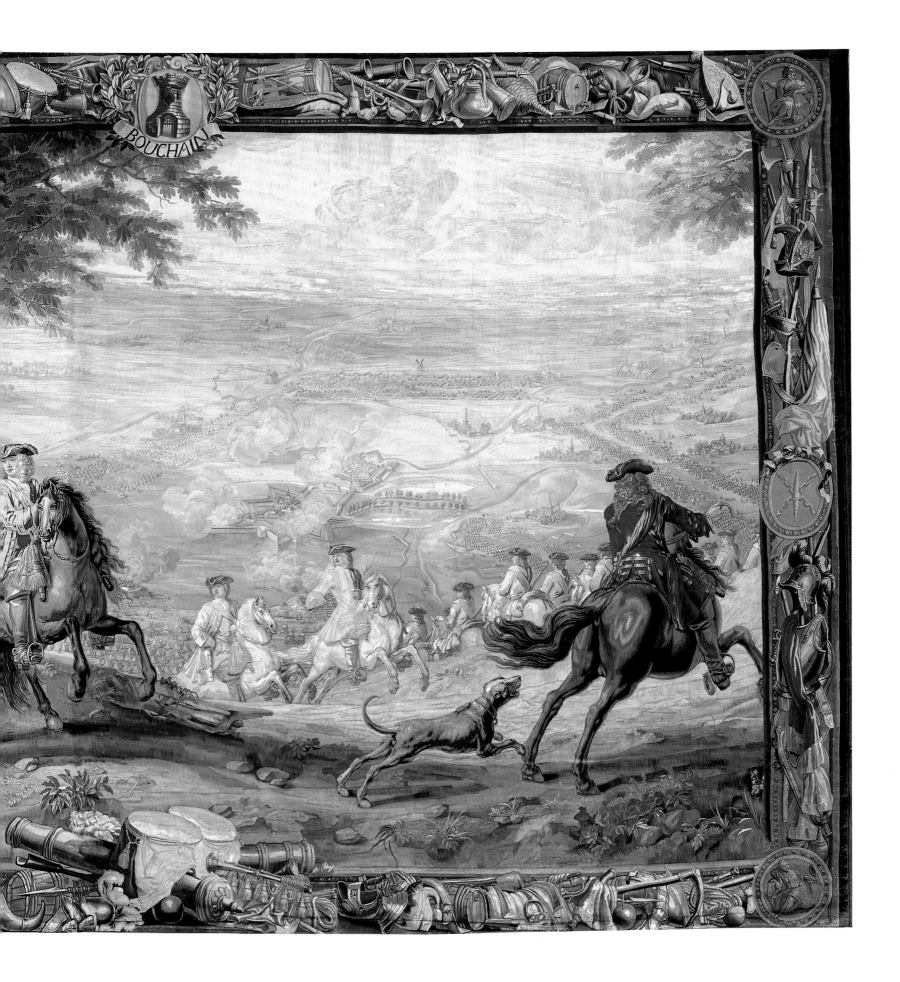

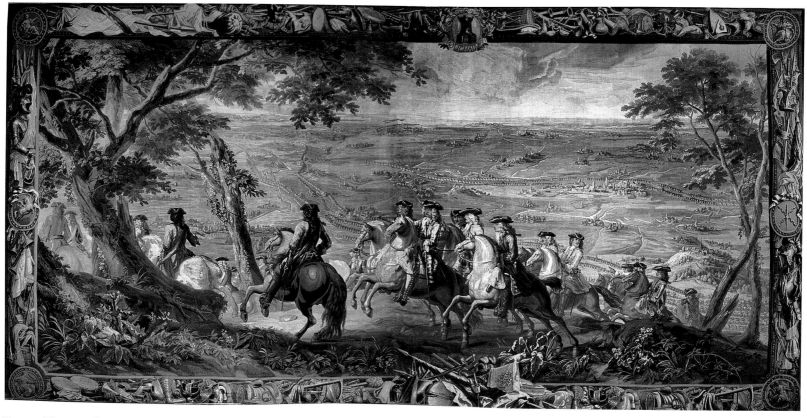

Fig. 215. *The Siege of Bouchain I* from a set of the *Victories of the Duke of Marlborough*. Tapestry design by Philippe de Hondt, woven in the workshop of Judocus de Vos, Brussels, ca. 1714–15. Wool and silk, 214.4 x 861 cm. Blenheim Palace, Woodstock

would describe a different battle in which the duke had been victorious over the French, with one depicting Peace. The twelve tapestries would measure 472 square ells and cost 21,240 florins. At the rate of 45 florins per square ell, this was the largest and most expensive set of tapestries made for John Churchill.

Early in 1710, work had begun on the first six panels—*Blenheim, Ramillies, Schellenburg, Lille, Oudenaarde, Wynendael*—and De Vos requested permission to enlarge two of these: "I cannot represent the Battle of Hooghstedt [Blenheim] or Ramillies on a piece of only 6½ ells with the borders, they need 8, 9 or 10 ells at least to execute them according to the design."[8]

The next three panels undertaken were *Crossing the Lines of Brabant, Malplaquet*, and the first of the *Bouchain* tapestries (now called *Bouchain II*). While the latter had been prepared by October 1711, almost immediately after the action took place in August–September, the design for the Battle of Malplaquet, fought in September 1709, was still incomplete.[9] It is likely that the *Malplaquet* panel was not ordered immediately, since it had been Marlborough's most controversial and bloody victory. The loss of almost 24,000 allied lives resulted in

much criticism and reproach in England, although Count Sinzendorf had, in a congratulatory letter sent two days after the battle, suggested, "Voila une bonne adjonction pour la tapisserie."[10]

After Malplaquet, there was a steady erosion of Marlborough's ascendancy. He became politically isolated when it became increasingly apparent that no single decisive military action could end the war. The conflict finally ended in 1713 with a treaty secretly negotiated between France and Marlborough's political enemies in England. That the peace was achieved without either his involvement or knowledge caused the duke considerable embarrassment and bitterness.

After the end of the war, eight tapestries[11] were delivered.[12] They measured 381 square ells because the *Blenheim* and *Ramillies* panels had to be resized.[13] This meant that of the twelve tapestries originally planned, totaling 472 square ells, only two more could be made within the terms of the contract, rather than four. While a ninth panel (*Crossing the Lines of Brabant*) was being executed, a further order was required to make up the contractual difference to the weaver: of the 472 square ells

commissioned only 426 (381 + 45) had been concluded.

Marlborough, understandably, now abandoned his original desire for a tapestry representing Peace. Two additional *Bouchain* panels were ordered instead, each measuring roughly 92 square ells. An undated memorandum from General William Cadogan specifies "two more tapestries representing the action of the campaign of 1711, these pieces will be 24 ells in length and of the same fine quality of those others which cost 45 florins per ell and the said de Vos will receive the same price for them."[14]

Through these tapestries, Marlborough assigned to Bouchain a prominence over all other great battles he won in the course of the war. The year 1711 was his last of successful command and arguably the finest campaign in proving his skill as a tactician and strategist as well as an administrator. At sixty-one years of age, despite his declining health and in the face of a superior French force, he baited and misled the enemy with an army of ninety thousand men before undertaking a sensational night march to cross the vaunted enemy lines of *Ne Plus Ultra* at Arleux and laid siege to Bouchain, a fortress town anchoring this

ninety-mile front to the east.[15] The siege lasted a mere thirty-six days, with a cost to the allies of just over four thousand casualties, which must have been gratifying after the lingering memories of Malplaquet.

In 1714, after his removal from the political and military spotlight and returning from a self-imposed exile on the Continent, Marlborough had only one major preoccupation, to complete the building and furnishing of his new home, Blenheim House. After his great victory at the Battle of Blenheim in 1704, Queen Anne had rewarded him generously with an ancient royal hunting estate outside the Oxfordshire village of Woodstock and with the monies to construct a new house there. The building progressed slowly for two main reasons: money for this project trickled through because of the significant demands made on the treasury by the long war and, more important, because the architect, John Vanbrugh, continually made changes to the original design, thereby substantially increasing the scale of the entire undertaking. The *Victories* were the most important works of art specifically commissioned for the house.

The last three tapestries were woven in 1714–15. On June 11, 1714, Judocus de Vos wrote, "I did not fail to look into when Your Highness will have the two tapestries, that is to say one of the large ones and the one representing the crossing of the lines above Louvain [Brabant]. This will take another five months. And for the last of the large ones eight [months]."[16] This last large panel referred to was *Bouchain III*, which was eventually finished in December 1715, when De Vos was able to report, "they have all been perfectly completed to the great astonishment and satisfaction of all those in the profession who have seen them. [It] is a figurative map from where the landscape and the towns can be viewed from all sides. As these are much more beautiful than those tapestries which I have had the Honour to deliver to Your Highness before, I am convinced that you will be very pleased with them. I have also enclosed my account and hope that your Grace will be good enough to pay me the balance."[17]

A document confirming payment for this last pair of tapestries shows that the *Bouchain I* panel (*Taking of the Lines above Bouchain*) cost 4,168 florins 3 stivers, while the *Bouchain III*

panel (*Figurative Map of All the Towns around Bouchain*) was just slightly larger and cost 4,200 florins 6 stivers. They were delivered to Mr. Leathes, the British resident at Brussels, in mid-January 1717, and the account was also settled through him. The eleven-piece set cost the Duke of Marlborough 27,625 florins.[18]

Designer and Iconography

Although the weaver is documented, the designer is not but has been presumed to be the Flemish artist Lambert de Hondt, who in 1696 had produced designs for the first version of the *Art of War* tapestries. His second son, Philippe, worked with him, and, as Koenraad Brosens has convincingly argued, stylistic parallels between the *Victories* and Philippe de Hondt's known work on the second version of the *Art of War* series allow us to conclude that it was actually he who designed the set.[19] Whether his father played a part in the design of the first panels is open to question because he may have died as early as 1708 and certainly before April 15, 1711, when Philippe was privileged, presumably when he took over the business.[20]

The iconographic and stylistic similarity of all the panels in the *Victories* set suggests that father and son worked together on most of the designs. However, since Lambert de Hondt had died before mid-April 1711, that is to say, before Marlborough's success at Bouchain (around which three panels are based), he could not have been responsible for any of the three *Bouchain* panels, so the design of these may be solely attributed to his son Philippe.

The question of the designer is further complicated by Horace Walpole's remark that "Van Hugtenburch of Harlem...had a share in the designs for the triumphal tapestry at Blenheim."[21] Jan van Hugtenburch was employed by Prince Eugene of Savoy, the distinguished imperial general who fought alongside the duke at Blenheim, Oudenaarde, and Malplaquet, to depict his own military triumphs. In Jean Dumont's 1725 engravings of Eugene's battles, Van Hugtenburch is described as "an artist of Battles and Tapestries" who worked as a designer at the Gobelins under Charles Le Brun and Adam Frans van der Meulen.[22] It is unclear what role Van Hugtenburch played in collaborating with Philippe de Hondt in the design of the *Victories*

tapestries, but it is possible that Prince Eugene's official artist was consulted for this important new commission in which his patron would also be depicted. Van Hugtenburch's involvement may have resulted from Count Sinzendorf's influence over the entire commission as, in his capacity of protector of the Viennese Imperial Academy of Arts, he would have known the artist.

The *Victories* designs were prepared from contemporary accounts of the battles, and the topography was rendered either from local knowledge or from plans and maps made available by the duke.[23] Portraits of the principal figures represented were similarly supplied.[24] No requirement was made of the designer to provide a narrative since the patron stipulated each event that was to be represented.

The three *Bouchain* panels, like the others in the set, contain multiple events. *Bouchain II*, the first panel woven (before the decision was made to order the larger pair), shows the fortress town being approached by Marlborough's army after the enemy's line was breached. The first of the larger panels, *Bouchain I*, illustrates the crossing of these lines on August 5 after a secret night march covering thirty-nine miles in eighteen hours, an astonishing feat at the time.[25]

The *Bouchain III* tapestry shows the successful conclusion of the siege. In the central foreground, the Duke of Marlborough (holding his commander's baton) is seen, along with his senior staff, at the very moment on September 14 when news of the French garrison's surrender was brought to him. Among the staff depicted are Colonel John Armstrong, a distinguished soldier-engineer whose skill and confidence in managing the construction of the lines of circumvallation were crucial to the success of the siege; and William Cadogan, quartermaster general, who led the night march and was also responsible for the investment of the town by cutting off a cowpath, the last line of communication and supply between the garrison in the fortress and the French army camped at Wavrechin.

This cowpath (lined with trees) is visible in the background to the right of the fortified town of Bouchain, located at the confluence of the Sensee and Selle (Scheldt) rivers. Lines of circumvallation and allied army camps at Neuville and Lieu St. Amand are seen in the

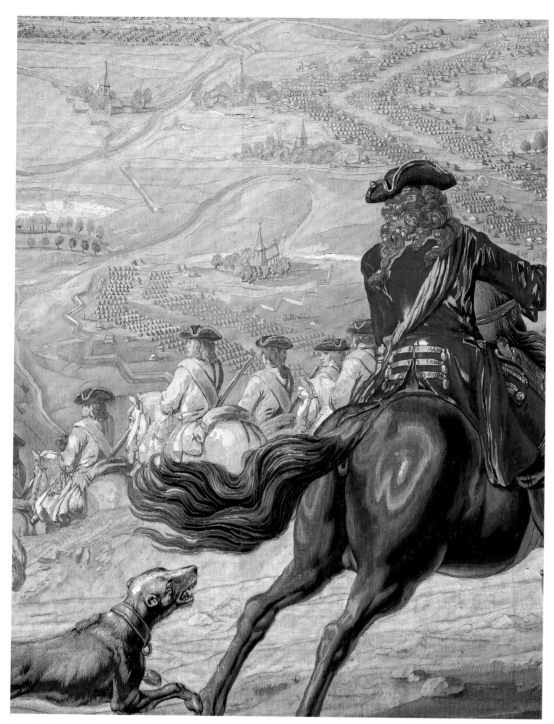

Detail of cat. no. 56

background to the right of the large central tree, while on the left, a startling degree of accurate detail in the topography shows the towns of Denain and Valenciennes.

The central group of figures is flanked by secondary subjects on both sides. On the left are two runners, who wear short, loose, fringed coats and carry gold- and silver-topped staffs of office denoting their rank. They were messengers who acted as Marlborough's eyes on the field, carrying information about what was happening elsewhere to him. By his judicious

use of these highly trained men, part of his network of spies, Marlborough was able to obtain a clearer picture of the action, allowing him almost always to retain the upper hand against the enemy. By being able to see, he was also able to be seen at critical places on the battlefield, appearing at the right moment to inspire his men forward. The inclusion of these runners in this vindicatory tapestry may have also been specifically made to underline the fact that their services were paid from secret funds that Marlborough was allowed as part of army

expenditure. This unaccounted money was unjustifiably but cunningly used against him. His enemies' accusations of peculation played a damaging part in his eventual dismissal.

On the right of the tapestry, a red-coated officer gallops away from the viewer, with a dog running alongside. These figures have been the subject of much speculation. Apart from the peculiarity of a dog with hooves instead of paws,[26] tradition maintains that this animal was General Cadogan's. While it was not unusual to have dogs accompany armies, it has been suggested that it symbolized Cadogan by playing on his name (Ca-dog-an) and because he was known to his troops as "the dog." Although unidentifiable, the officer on horseback is thought to be English because of his red coat. The allusion to Cadogan in this section of the tapestry underlines Marlborough's reliance on him during the entire operation.

Although the action illustrated in the panel took place in near-flat countryside, the foreground figures are placed on an imaginary hill and the viewer looks out over a vast panorama. This manner of representation, in keeping with the artistic tradition of the time, glorified the image of the commander to emphasize his power and authority.

The wide decorative borders are filled with the impedimenta of battle appropriately framing the central episode. At the top, a cartouche contains Bouchain's coat of arms. This device enables the viewer to identify the particular action represented in each tapestry.[27] Similarly, central elements overflow the lower borders and vary in each panel, referring specifically to the narrative in the main field. Here, emphasis is laid on the large guns employed in the siege action. In the corners, the four Cardinal Virtues of Fortitude, Prudence, Temperance, and Justice are depicted. Within the side borders, oval medallions carry two images from ancient mythology, the Greek winged horse Pegasus on the left and Jupiter's thunderbolt on the right. In Greek legend, Pegasus served the supreme god, Zeus, by fetching thunder and lightning. Zeus was the Greek counterpart of the Roman god Jupiter, whose attribute was the thunderbolt. The Romans worshiped Jupiter as the special protector of the state; his temple was the primary sanctuary and the

476

hub of political life. These allegorical elements along with the narrative in the panels convey their own iconographic story on the quality and greatness of Marlborough's leadership.

The cartoons for these tapestries were offered to the duke for a payment of 5,000 florins but were not purchased.[28] They were adapted and reused in the second version of the *Art of War* series,[29] which, ironically, was commissioned by one of Marlborough's enemies during the war, Maximilian Emanuel, elector of Bavaria.

JERI BAPASOLA

1. British Library, Add. MSS 61,473.
2. Bapasola 2005, pp. 51–57.
3. Blenheim Archives, Long Library Portfolios, vol. 2, fol. 34.
4. British Library, London, Add. MSS 61,348, fol. 83. The duke was charged 382 florins 10 stivers for the border design.
5. British Library, Add. MSS 61,216, fols. 39–40.
6. Exact measurements for these rooms were provided by the architect of Blenheim Palace, John Vanbrugh, after the duke wrote to his wife on July 11, 1709: "I also desire of you that you will gett me the exact measures for the great roome as well as all the others that are between the Sallon and the grande Cabinet and that I may have all these measures as soon as possible"; British Library, Add. MSS 61,430, fol. 156.
7. British Library, Add. MSS 41,178, fol. 39.
8. British Library, Add. MSS 61,367, fol. 104. A surviving statement of account reveals that he extended them to 11¾ ells (769 cm) and 9½ ells (620 cm) respectively. The *Ramillies* tapestry no longer exists at Blenheim Palace. Its fate is unknown.
9. British Library, Add. MSS 61,368, fols. 73v–74.
10. British Library, Add. MSS 61,216, fol. 46.
11. *Blenheim, Ramillies, Schellenburg, Lille, Oudenaarde, Wynendael, Bouchain II*, and *Malplaquet*.
12. British Library, Add. MSS 61,351, fols. 34–35v.
13. Blenheim Archives, Long Library Portfolios, vol. 2, fol. 30v.
14. Blenheim Archives, Long Library Portfolios, vol. 2, fol. 33v.
15. Bapasola 2005, pp. 124–33.
16. Blenheim Archives, Long Library Portfolios, vol. 2, fol. 35.
17. Blenheim Archives, Long Library Portfolios, vol. 2, fol. 37. None of the *Bouchain* tapestries is signed, although three other panels in the set carry both the Brussels mark and that of Judocus de Vos.
18. Blenheim Archives, Long Library Portfolios, vol. 2, fol. 40v. The rate of exchange at this time fluctuated between 10½ and 11 Flemish florins to the English pound. The total paid for the set was roughly 2,500–2,700 florins. A set of eight *Alexander* tapestries ordered by the duke a few years earlier, which had been woven to existing designs, had cost him just over 800 florins. This allows us to compare the enormous difference in cost between this newly commissioned work and sets ordered from existing designs.
19. Brosens 2002, pp. 72–73; Brosens 2004a, pp. 109–10.
20. Brosens 2002, p. 79.
21. Walpole 1763, p. 158.
22. Hefford 1975, p. 110.
23. British Library, Add. MSS 61,368, fols. 73v–74.
24. Blenheim Archives, Long Library Portfolios, vol. 2, fol. 35.
25. Chandler 1989, p. 289.
26. This is merely an irregularity in weaving, being the only dog in a set populated with horses and humans.
27. All except the *Lines of Brabant*, on which the central cartouche shows the ducal coat of arms.
28. Blenheim Archives, Long Library Portfolios, vol. 2, fol. 43.
29. In 1717 Sarah, Duchess of Marlborough (who carried on the duke's business in his final years after he suffered two incapacitating strokes), wrote, "I hope there was some bargain made with the Tapistry Man.... I know hee has sold the same Designs at very reasonable prices"; Wace 1968, p. 132.

57.
A Naval Battle

From a set of the *Art of War II*
Design and cartoon by Philippe de Hondt and workshop, ca. 1715–20
Woven in the workshop of Judocus de Vos, Brussels, ca. 1722–24
Wool and silk
400 x 792 cm (13 ft. 1½ in. x 25 ft. 11¾ in.)
Bayerische Verwaltung der Staatlichen Schlösser, Gärten und Seen, Neues Schloss Schleissheim, Munich

PROVENANCE: Ca. 1722–24, acquired by Maximilian Emanuel of Bavaria for the Neues Schloss, Munich.

REFERENCES: Wace 1968, pp. 90–97; Hefford 1975, pp. 109–13; Völker 1976, pp. 268–69; Brosens 2006–7, pp. 57–58.

CONDITION: The piece has been washed and conserved for this exhibition.

Catalogue number 57 depicts the dramatic turmoil of a naval battle. In the foreground sailors in a lifeboat rescue men from drowning while other seamen try to keep themselves afloat on barrels. A second rowboat picking up more sailors is on the right, in front of a large frigate that is capsizing. Seamen flee the sinking ship in despair. In the background other frigates are still engaged in the sea fight. The borders feature military trophies and paraphernalia such as gun barrels, powder kegs, kettles, casks, and boots. A cluster of military gear is in both the upper and lower border; curiously, these arrangements are on two different vertical axes, and neither coincides with the central axis of the tapestry.

Origin

A Naval Battle forms part of the *Art of War II* series produced by Judocus de Vos (1661–1734), who was by far the most important Brussels tapestry producer in the late seventeenth and early eighteenth century.[1] Wace published the standard work on this series and closely related military sets.[2] Basing his discussion on a body of *Art of War II* tapestries that are in public and private collections, Wace believed that the series was composed of eight scenes: *March of the Cavalry, Camp, Forage, Fascines, Looting, Ambush, A Naval Battle,* and *La Halte* (*A Pause*), although he recorded an *Art of War II* suite in a private collection that included a ninth episode, *Attacque*.

An unpublished document by Judocus de Vos allows us to fine-tune Wace's reconstruction of the series. In 1727 De Vos himself itemized all his tapestry cartoons.[3] De Vos's mother tongue was Flemish, yet he wrote the list in French, as it was intended for a customer—French being the lingua franca of the

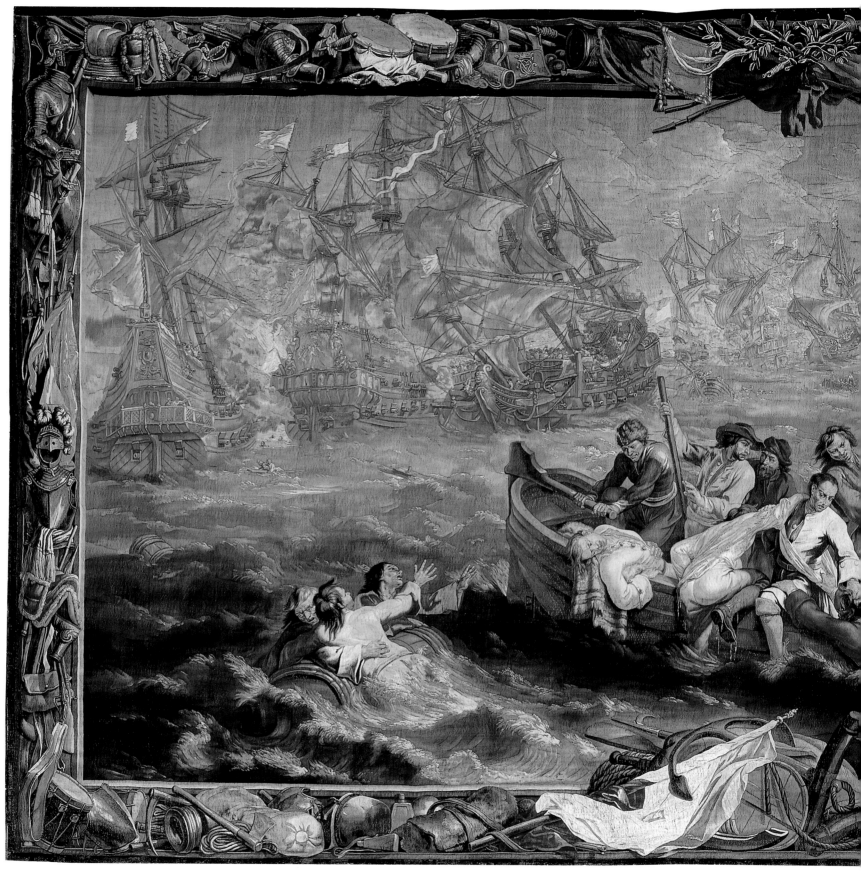

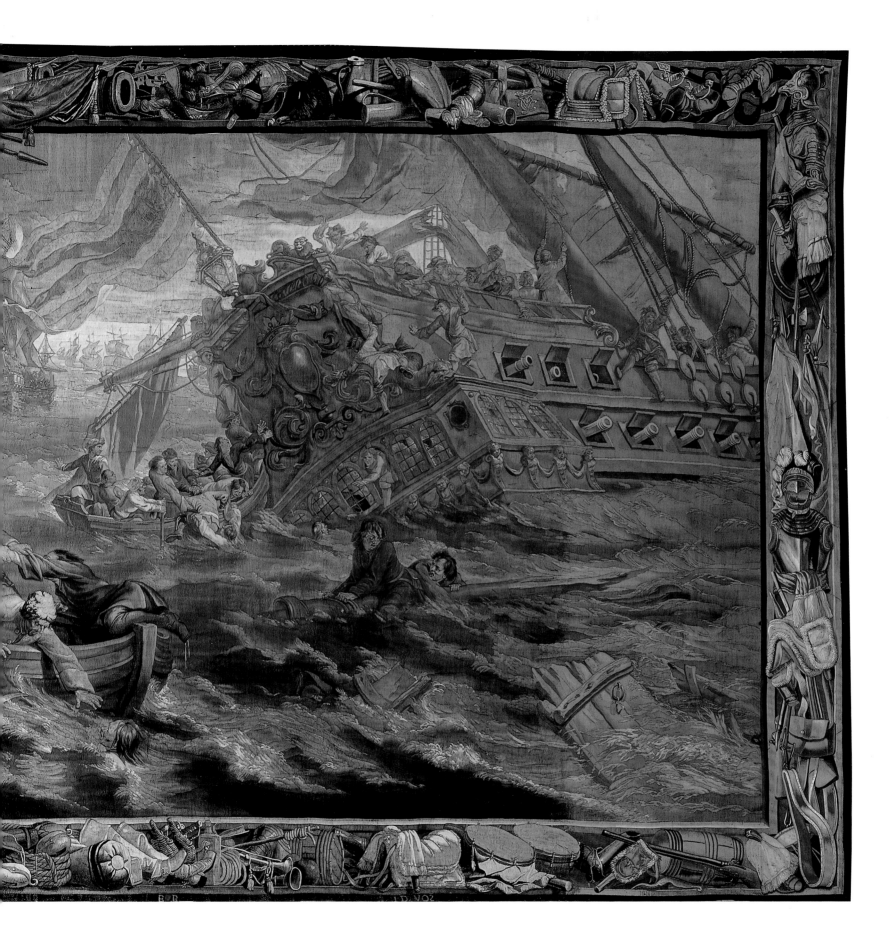

European aristocracy at that time. This explains the numerous spelling errors in the document. The inventory reveals that the *Art of War II,* entitled "les foinctions militaires" (*Exercises of War*), was made up of "le march d'armes" (*March of the Cavalry*), "le march d'artailleries" (*March of the Artillery*), "le campement" (*Camp*), "le fouragement" (*Forage*), "l'attaque d'un fort" (*Attack on a Fort*), "le pillage" (*Looting*), "le fachines" (*Fascines*), "l'ambuscade" (*Ambush*), and "une battaille navalle" (*A Naval Battle*).

Wace's *La Halte* (*A Pause*) is not on De Vos's 1727 list. Yet as this episode shows a train of carts and cannons en route rather than a period of rest, it can be identified with the *March of the Artillery.* The eighteenth-century document further firmly establishes that the *Art of War II* was composed of nine scenes. While Wace hesitantly mentioned an *Attacque* scene, De Vos unambiguously included the *Attack on a Fort* in his list.

The 1727 record further provides information on the dimensions of the cartoons, borders excluded. *A Naval Battle* was the widest cartoon of the series (10½ ells; about 731 cm) while *Attack on a Fort* was the smallest yet still sizable scene (6⅛ ells; about 424 cm). The height of the *Art of War* cartoons was about 365 centimeters, but De Vos noted that he could adjust the height to 345 or 380 centimeters. As catalogue number 57 measures 400 by 792 centimeters, borders included, it represents the complete composition of *A Naval Battle.*

Finally, De Vos specified that the production price of *Art of War II* pieces ranged from 26 guilders to 36 guilders per square ell, depending on the quality of the weaving. As *A Naval Battle* measures about 65 square ells and is of fine quality, the commissioner of the suite to which this tapestry belonged paid about 2,000 guilders for this single piece.

The titles of the scenes as recorded by De Vos in 1727 underline that the series is not a documentary report of a specific military campaign. There is, consequently, no reason to sustain the traditional assumption that *A Naval Battle* depicts the *Battle of La Hogue* (1692) or the *Sinking of the Spanish Silver Fleet at Vigo* (1702).[4] Still, the lively and accurate image of the prerequisites and execution of military campaigns about 1700 gives the *Art of War II* series a general documentary character. From about 1675 onward European rulers had been

enlarging their standing armies to a size unknown in their history.[5] They also had been investing heavily in new fortification works that had to secure militarily significant places, which had made it possible, according to a quote by the French general and engineer Sébastien de Vauban (1633–1707), "to communicate by means of cannon fire from one fortress to another."[6] As a result, battles in themselves no longer decided wars.[7] To be victorious, military leaders had to be capable of successfully staging a siege and positional war; they had to procure siege arms and transport them together with all necessary supplies, thereby making sure that the convoys, which often included five thousand or more wagons, were protected from enemy assault. In other words, war had turned into a primarily logistic problem, and entire campaigns degenerated into marching and camping. Therefore, scenes like the *March of the Cavalry,* the *March of the Artillery,* the *Camp, Forage,* and *Fascines,* the last showing soldiers making and carrying bundled sticks that were used to bridge ditches, do not represent idyllic-romantic snapshots of military life but were key aspects in successful siege and positional warfare.

By commissioning the cartoons of the *Art of War II,* De Vos followed fashion, for tapestries and paintings featuring warfare and military campaigns were extremely popular in the late seventeenth and eighteenth centuries. The *Art of War II* indeed is one of a group of military sets created about 1700. Ever since the fourteenth century, European rulers had commissioned tapestry sets to commemorate their heroic victories. About 1664 the French king Louis XIV revitalized the age-old practice by ordering the *History of the King,* a personalized series that was repeatedly woven in Paris (see cat. nos. 41–47). Following this example of overt self-glorification, William III of England commissioned three tapestries depicting the *Victories of William II and William III of England* from various Brussels tapestry producers, including Judocus de Vos, in 1698.[8] Between 1710 and 1714 De Vos produced the *Victories of the Duke of Marlborough* for John Churchill, Duke of Marlborough, who had commissioned both the cartoons and the suite to commemorate his victories in the War of the Spanish Succession (see

cat. no. 56). In 1712 Emperor Charles VI ordered a remake of the *Conquest of Tunis* from De Vos. This set was created and woven in 1546–54 for Emperor Charles V (Patrimonio Nacional, Madrid); Charles VI presumably considered a reedition an ideal vehicle for emphasizing the dynastic-political parallel and the continuity between him and his illustrious predecessor and namesake.[9]

The sets created for Louis XIV, William III, the Duke of Marlborough, and Charles VI can be linked not only to a rich tradition in Flemish and French tapestry but also to the immense popularity of the contemporary *genre militaire,* that is, cabinet-size paintings and engravings depicting (fictive) battle scenes and the everyday life of soldiers. This genre, epitomized by such Flemish artists as Philips Wouwerman (1619–1668)[10] and Adam Frans van der Meulen (1632–1690),[11] was especially popular on the European art market throughout the seventeenth and eighteenth centuries.[12]

Both the success of the personalized military tapestry sets and the impact of the *genre militaire* presumably inspired the associated Brussels tapissiers Hieronymus Le Clerc (1643–1722) and Jasper (Gaspar) van der Borcht "A Castro" (1675–1742) to commission a *genre militaire* tapestry series. About 1695 they engaged Lambert de Hondt (1650/60–1711), a painter who specialized in battle scenes, to design the "Exercitieën van den oorloghe" (*Art of War I*).[13] Le Clerc and Van der Borcht may also have been encouraged by the revival of the *Fructus belli* series.[14] This set, which takes a dim view of warfare and military campaigns, had been created about 1546, yet it was rejuvenated at the end of the seventeenth century: in 1685–86 the Gobelins workshop had executed an edition of the *Fructus belli,*[15] and in 1692 the original sixteenth-century cartoons, located in an unnamed Brussels tapestry workshop, had attracted the attention and praise of an agent surveying the tapestry market.[16] In contemporary documents the *Art of War I* series was sometimes referred to as the *Fructus belli* or the *Fruits of War.*[17]

Le Clerc and Van der Borcht's *Art of War I* series was composed of eight scenes: *March of the Cavalry, Camp, Forage, Attack, Looting, Fascines, Ambush,* and *Rencontre* (*A Skirmish*).[18] The set rapidly became one of the most

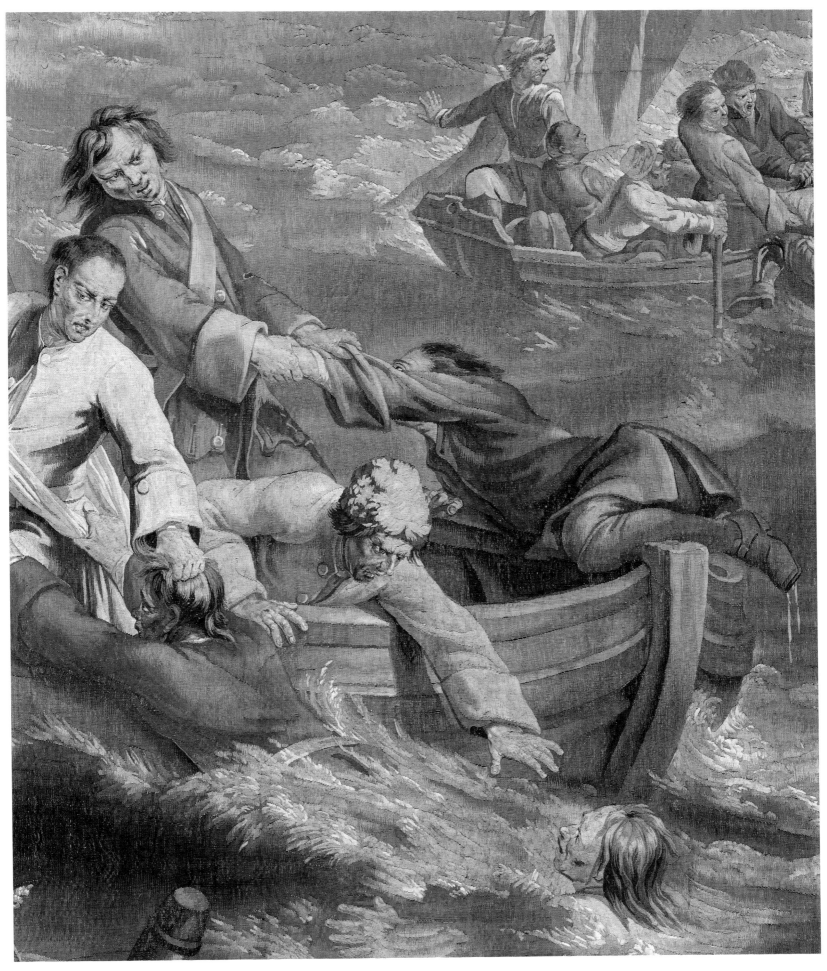

Detail of cat. no. 57

Fig. 216. *A Naval Battle*, by
Philippe de Hondt, ca. 1715–20.
Oil on canvas, approx. 80 x 150 cm.
Private collection

popular and influential tapestry series woven
about 1700.[19] In 1696 Le Clerc and Van der
Borcht delivered an edition to Maximilian
Emanuel von Wittelsbach, elector of Bavaria.[20]
William III of England, Ludwig Wilhelm of
Baden, the Duke of Marlborough, six English
generals who fought under Marlborough's
command in the War of the Spanish Succession,
and Jean-Philippe-Eugène, count de Merode
and marquis of Westerlo, all purchased an *Art
of War I* suite between about 1696 and 1715.

By commissioning the *Art of War II* car-
toons, Judocus de Vos thus capitalized on the
commercial success of the *genre militaire* and
the *Art of War I* set. The iconographic programs
of the *Art of War I* and the *Art of War II* are
almost identical. Only *A Naval Battle*, which
replaced *A Skirmish*, and the *March of the
Artillery*, an additional piece, provided fresh
subject matter in the *Art of War II*. The large
number of *Art of War II* tapestries that are
known today illustrate the popularity of the
series.[21] Three other versions of *A Naval Battle*
are known: one smaller piece, bearing identi-
cal borders as catalogue number 57, is in the
Rijksmuseum, Amsterdam; the other two
panels, which have no borders, have surfaced
on the art market.[22]

The impact of the *Art of War II* inspired
De Vos's rival Urbanus Leyniers (1674–1747)
to commission the cartoons of the *Art of War
III* series about 1735.[23] About the middle of
the eighteenth century the Brussels artist
Hyacinthe de La Pegna (1706–1772) created
the *Art of War IV* set that was produced in
both the Leyniers and Van der Borcht work-

shops.[24] These later series display a more
bucolic image of everyday military life.

Commissioner
Catalogue number 57 was commissioned
from Judocus de Vos by Maximilian Emanuel
of Bavaria, together with seven other *Art of
War II* tapestries and five related personalized
military tapestries.[25] Maximilian Emanuel was
a talented, ambitious ruler and commander.
At the age of twenty-one he was part of the
European alliance countering the expansionism
of the Ottoman Empire. He was involved in
the War of the League of Augsburg, also known
as the War of the Grand Alliance or the Nine
Years' War (1688–97). This war opposed Louis
XIV, king of France, on the one hand, and
Leopold I, Holy Roman Emperor, his son-
in-law Maximilian Emanuel, and numerous
other European leaders on the other. During
this war Leopold I installed Maximilian as
governor-general of the southern (Spanish)
Netherlands (1692). In 1701, however, when
the War of the Spanish Succession (1701–14)
broke out, Maximilian Emanuel allied himself
with the French *against* his father-in-law.
About 1706 he had to flee to Versailles, where
he stayed for about nine years before returning
to Germany in 1715.

Maximilian Emanuel was a patron of the
arts and an avid collector of Flemish tapestries;
after his return to Germany he established
and subsidized a tapestry workshop in Munich
in 1718.[26] Shortly after his installation as
governor-general of the Spanish Netherlands
in 1692, he bought and leased numerous

Brussels and Oudenaarde tapestry sets, includ-
ing a suite of the *Art of War I*. It can be
assumed that Maximilian Emanuel bought his
edition of the *Art of War II* shortly after his
return to Germany, about the time he com-
pleted his new palace at Schleissheim (Neues
Schloss) near Munich in 1722.[27] By then the
borders that were used for his *Art of War II*
suite were out of date, for from about 1690 to
1700 onward tapestries were framed by small
borders imitating picture frames or were
woven without borders. It is plausible, however,
that Maximilian Emanuel opted for old-
fashioned borders to harmonize his new *Art
of War II* series with his old *Art of War I* set.

Designer and Date
The designs of De Vos's *Art of War II* can be
attributed to the Brussels artist Philippe de
Hondt (1683–1741), who was a son of Lambert
de Hondt.[28] In the first half of the eighteenth
century Philippe de Hondt developed as an
important Brussels tapestry designer. Though
he specialized as a landscape and genre painter
rather than as a history painter, a document
recorded in 1735 states that De Hondt was
"well experienced, not only as a painter of
landscapes, but also as a painter of figures."[29]
The large canvases depicting dramatic events
from the lives of local saints that De Hondt
made in 1739 for the church of the Norbertine
abbey at Ninove near Brussels indeed show
his qualities as a history painter. In addition
to the *Art of War II* series, seven tapestry sets
have been attributed to De Hondt. Apart
from one, a *Teniers* series, these sets can be
dated approximately on the basis of archival
material and prints: the *Victories of the Duke
of Marlborough* (ca. 1709; cat. no. 56), the *Story
of Don Quixote* (ca. 1725), *Grotesques with
Ovid's Metamorphoses* (ca. 1730), the *Continents*
(ca. 1735), the *Elements* (ca. 1735), and the *Art
of War III* (ca. 1735).[30]

But when did De Hondt create the *Art of
War II* series? The compositions of this set are
reminiscent of those of the *Art of War I*, which
had been made by his father, and the *Victories
of the Duke of Marlborough*, which had been
created about 1709. From about 1725 onward
De Hondt increasingly developed a Regency
and Rococo vocabulary based on contempo-
rary French prints that differs from the dramatic

late Baroque style characterizing the *Art of War II*. Consequently, Philippe de Hondt's *Art of War II* designs and cartoons were presumably made about 1715–20. Wace surmised that Maximilian Emmanuel commissioned the editio princeps of the *Art of War II* series,[31] yet this claim cannot be substantiated.

Two unsigned paintings with similar measurements that have surfaced on the art market are directly connected to the *Art of War II*. The first painting is a representation of the *Camp* that is a mirror image of the tapestry by the same name.[32] The second painting is the mirror image of the composition of *A Naval Battle* (fig. 216).[33] Since these paintings are mirror images of the tapestries, they were presumably preparatory models used by the painter to create the lifesize oil paintings the tapestry weavers required.

KOENRAAD BROSENS

1. Brosens 2002; Brosens 2004a, pp. 117–18, 311–18.
2. Wace 1968, pp. 90–109, for a discussion of the *Art of War II* series.
3. The list was discovered by the late Margaret Swain in 1984 but remained unpublished. I am most grateful to Professor Emeritus Guy Delmarcel, who brought it to my attention. A study of this document is forthcoming.
4. Wace 1968, pp. 9, 97; Delmarcel 1999a, p. 345; Smit in Hartkamp-Jonxis and Smit 2004, p. 152.
5. Chandler 1976.
6. Cited in Luh 2000, p. 98.
7. Ostwald 2000.
8. See "Flemish Production, 1660–1715" in this volume.
9. Horn 1989; Bonn–Vienna 2000.
10. Duparc 1993; Bürger 2002.
11. Richefort 2004.
12. Chiarini 1998; Pfaffenbichler 1998.
13. Wace 1968, pp. 29–42.
14. Delmarcel 1989.
15. Fenaille 1903–23, vol. 2, pp. 279–89.
16. Viale Ferrero 1968, p. 813.
17. Bapasola 2005, p. 34.
18. Wace 1968, pp. 29–42.
19. Brosens 2005d, pp. 154–57.
20. Völker 1976, pp. 267–68.
21. Wace 1968, pp. 103–8.
22. Smit in Hartkamp-Jonxis and Smit 2004, p. 152.
23. Brosens 2006–7.
24. Wace 1968, pp. 27–28; Coekelberghs 1976, pp. 149–50; Brosens 2004a, pp. 112–13.
25. Wace 1968, pp. 90–102.
26. Völker 1976.
27. Wace 1968, p. 90; Völker 1976, p. 268.
28. Brosens 2002, pp. 72–73; Brosens 2004a, pp. 122–23; Brosens 2006–7. On the attribution issue prior to 2002, see Hefford 1975.
29. "Seer hervaren, niet alleenelijck in het schilderen van lantschappen, maar oock in figuren"; Stadsarchief, Brussels, Register der Tresorije, vol. 1309, fols. 54v–55v.
30. Brosens 2006–7.
31. Wace 1968, p. 90.
32. This painting (90 x 140 cm) was located in 1997 in the Galerie Jacques Ollier, Paris. I thank Wendy Hefford (Victoria and Albert Museum, London), who brought this work to my attention.
33. This painting (approx. 80 x 150 cm) was located in 2005 in the Netherlands. Thanks to Ebeltje Hartkamp-Jonxis (Rijksmuseum, Amsterdam), who brought this work to my attention.

58.
Diana Resting

From a set of the *Triumphs of the Gods*
Design by Jan van Orley and Augustin Coppens, ca. 1725
Woven in the southern Netherlands, Brussels, probably by Jan-Frans or Jacob van der Borcht II, ca. 1769–94
Wool and silk
335 x 610 cm (10 ft. 11⅞ in. x 20 ft. ⅛ in.)
8½ warps per cm
Rijksmuseum, Amsterdam (BK-1955-101)

PROVENANCE: Possibly Lord Waring (d. 1940), Foot's Cray Place, London; Perez, London; 1955, acquired by the Rijksmuseum as a gift of the Bank voor Handel en Scheepvaart, Rotterdam.

REFERENCES: *Rijksmuseum te Amsterdam* (The Hague, 1955), pp. 17–18; Standen 1985, p. 238; Delmarcel 1999a, p. 324; Smit in Hartkamp-Jonxis and Smit 2004, pp. 167–70, no. 46; Brosens 2005–6, pp. 123–25.

Diana Resting belongs to a series of six tapestries generally referred to as the *Triumphs of the Gods*, although the scenes represent Olympian gods and goddesses resting in arcadian landscapes rather than riding in triumphal processions. The set of three tapestries of which catalogue number 58 originally was a part also comprised scenes of Flora and Bacchus.[1] The complete series includes scenes of Apollo, Neptune, and Vulcan. With its elegant figures, deep landscape, delicate evening light, and elegiac mood, it typifies the mythological tapestries that were produced in large numbers by the Brussels workshops throughout the eighteenth century, and which continued to form an important decorative feature in the neo-Palladian mansions of Great Britain, and the châteaux and schlosses of northern and central Continental Europe.

In the first quarter of the eighteenth century, no fewer than three different series of the *Triumphs of the Gods*—all including a scene of Diana—were designed for workshops in Brussels. These three—woven many times in the course of the eighteenth century and sometimes difficult to distinguish from each other—have recently been convincingly disentangled.[2] The earliest series, designed by Victor Janssens (1658–1736) and Augustin Coppens (1668–1740) about 1705, and known only from separate tapestries on the art market, was executed by the workshops of Judocus de Vos and the Auwercx family.[3] The second, mostly referred to as *Triumphs of the Gods and Goddesses* (sometimes also as the *Pleasures of the Gods*), was designed about 1716 by Jan van Orley (1665–1735) and Augustin Coppens for the Reydams–Leyniers workshop;

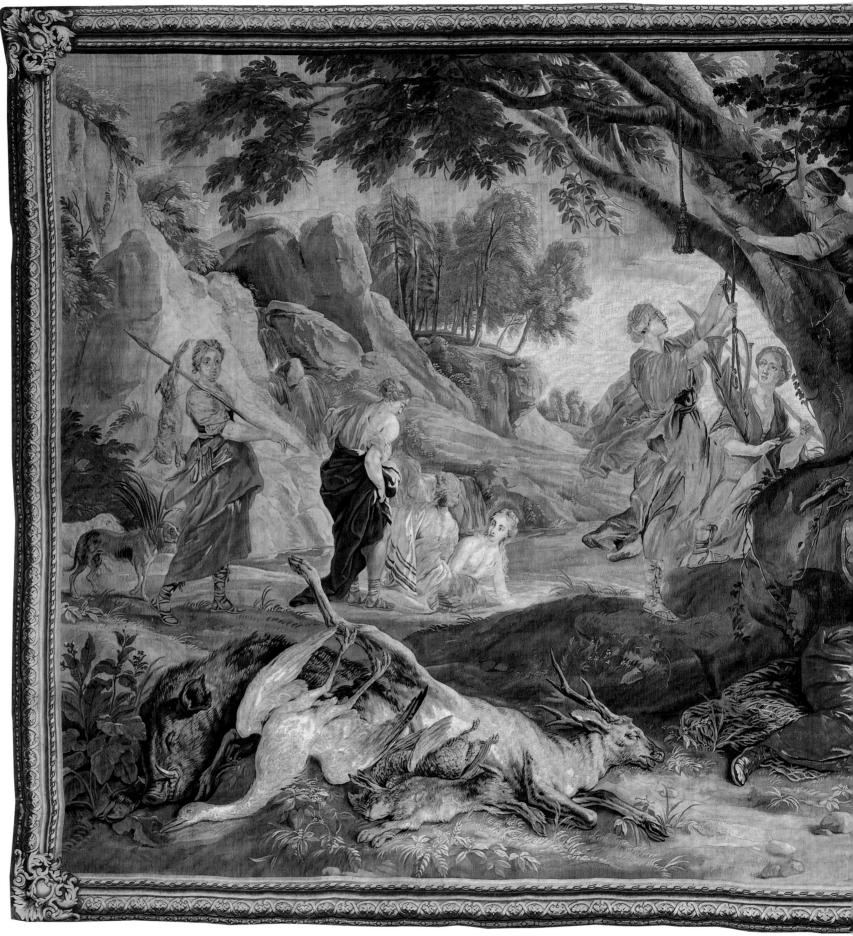

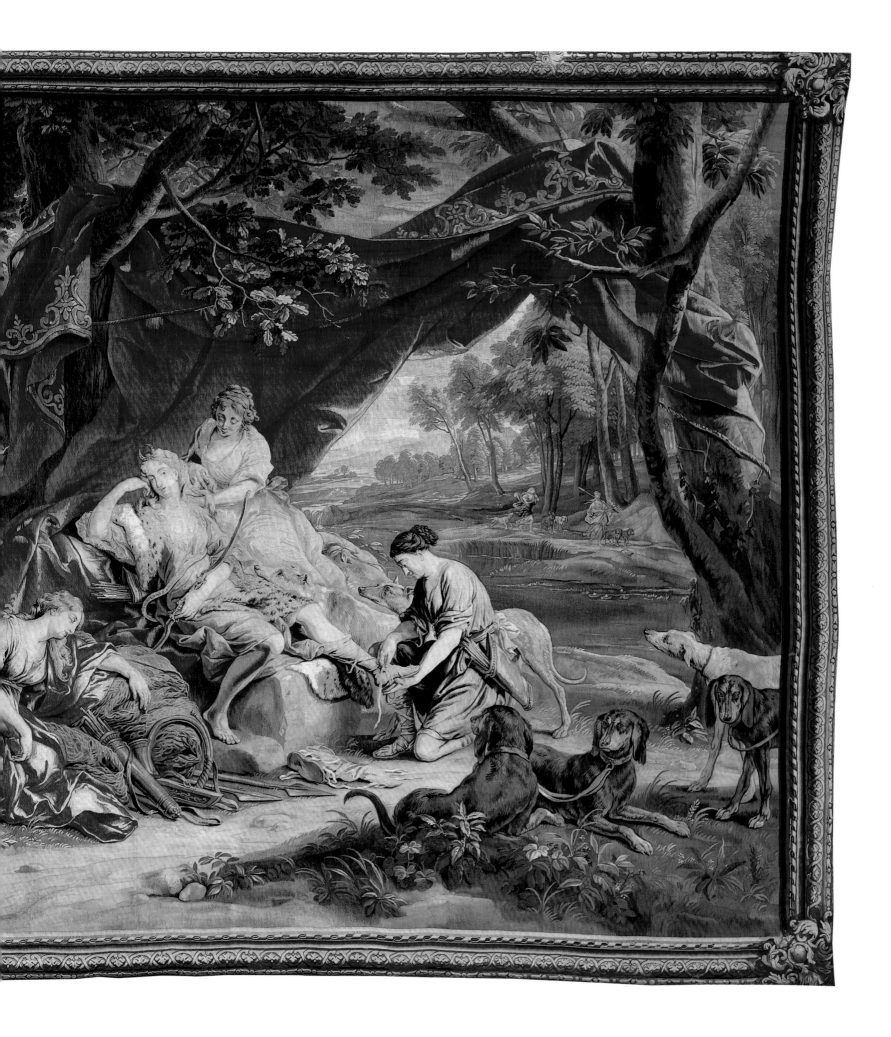

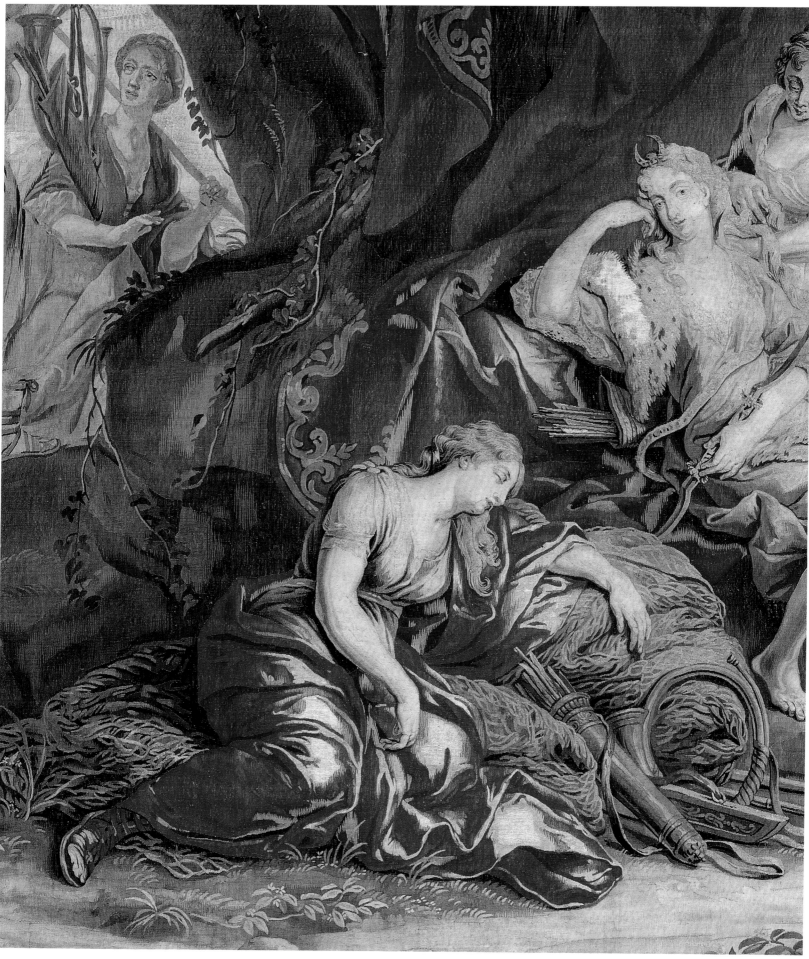

Detail of cat. no. 58

the earliest complete set, woven in 1717, is in the Museum voor Schone Kunsten, Ghent. Finally, the third series, to which the present piece belongs, was made after designs that can also be attributed to Van Orley and Coppens, from about 1725. The cartoons belonged to the Van der Borcht family workshop, and the most complete surviving set is in the Kunsthistorisches Museum in Vienna (series LV).

Description

Diana, goddess of the hunt, identified by the traditional attribute of a crescent moon on her forehead, rests beneath the spreading branches of a stately tree, as her maidservants tend to her needs and her dogs look on. One maiden removes Diana's sandals, while another tends her hair. A third nymph has fallen asleep on a pile of netting, exhausted by the rigors of the hunt. Diana's languid posture and dreamy gaze set the tone of this scene, which is complemented by the soft evening light that illuminates the foreground figures. The delicacy and softness of Diana's skin are set off by the luxurious red textile on which she reclines, the lower part of a drape that three of her maidservants are in the process of attaching to the branches above to form a canopy. In the left foreground are the spoils of the day's hunt—a wild boar, a heron, a hare, a duck, and a deer. Behind, three of Diana's maidens are bathing in a lake while a latecomer approaches from the left, bearing a dead hare on a stick over her shoulder. An idealized landscape extends into the distance, bathed in the evening light. The tapestry is surrounded by a border that imitates a carved and gilt picture frame, with stylized acanthus leaves in interlacing curved bands and corner ornaments consisting of acanthus leaves and volutes.

Place and Date of Manufacture

Catalogue number 58 has no town marks or workshop signatures. However, a tapestry depicting Diana after the hunt appears in an inventory of tapestries woven in the Van der Borcht family workshop in Brussels: "Diane au retour de la Chasse, se repose avec ses compagnes qui la déchaussent" (Diana returned from the hunt, rests together with her companions, who remove her shoes).[4] This tapestry is part of a set of "Les triomphes des Dieux,

en 6 pièces grandes figures a petite bordure," which also comprised scenes of Apollo and the Muses, Neptune and Amphitrite, Bacchus drinking wine, Flora in her garden, and Venus in Vulcan's forge.[5] The Van der Borcht inventory is undated, but it was drawn up in the time of Peter van der Borcht (1712–1763), who was in charge of the workshop between 1742 and 1763.[6]

Although catalogue number 58 is part of a series belonging to the Van der Borcht workshop, the border of this tapestry is of a type characteristic of the *Triumphs of the Gods and Goddesses* set signed by Urbanus Leyniers (1674–1747) and his son Daniel Leyniers IV (1705–1770).[7] Since each workshop as a rule used its own border types, it was suggested in the catalogue of the tapestries of the Rijksmuseum that the tapestry was in all probability woven in the workshop of Urbanus and Daniel Leyniers IV, about 1729–45.[8] However, in a review of the Rijksmuseum catalogue, Koenraad Brosens argued that the fierce competition between the Leyniers and Van der Borcht workshops made it unlikely that either had access to cartoons of the other.[9] Brosens considered it more probable that after the Leyniers workshop ceased to exist, at the end of 1768, the cartoon of the border of catalogue number 58 was bought by the Van der Borcht workshop, which continued to operate until the end of the eighteenth century. Surviving sets of tapestries of the *Triumphs of the Gods,* which combine Leyniers scenes with Van der Borcht scenes—as in the Kunsthistorisches Museum in Vienna—imply, according to Brosens, that the Van der Borcht workshop also purchased cartoons of main scenes from the property of the Leyniers workshop after it closed.[10] This line of reasoning does seem plausible. In this connection it should be noted that Jacob van der Borcht II (d. 1794) had worked with Daniel Leyniers IV before 1768.[11] Whether the collaboration actually led to the exchange of cartoons, however, has not been documented. The only known tapestry of *Diana Resting* that has a weaver's mark is signed by Jasper van der Borcht (d. 1742) and his son Peter.[12] This fact strengthens the case for arguing that catalogue number 58 was executed by the Van der Borcht workshop. That tapestry shows the right, half of catalogue number 58, with, to

the right, more of the original cartoon with a huntress holding the end of the rightmost dog's leash in her hand.[13] In addition, all the other known signed examples of the scenes mentioned in the Van der Borcht inventory bear the signatures of members of the Van der Borcht family exclusively.[14] Moreover, other tapestries bearing the Van der Borcht signature have the same borders as those of the Rijksmuseum tapestry.[15] When all of this evidence is taken into consideration, the most plausible conclusion is that catalogue number 58 was woven by the Van der Borcht workshop after 1768. In that period Jan-Frans van der Borcht, Peter's half brother, was in charge. After Jan-Frans's death in 1774, he was succeeded by his son Jacob van der Borcht II, who was in charge of the only surviving workshop in Brussels until his own death in 1794.

Design and Date

There is no documentation about who designed the Van der Borcht workshop's *Triumphs of the Gods.* However, the stylistic characteristics—elegant figures in delicate landscapes—make it possible to be unequivocal in attributing this series to Jan van Orley and Augustin Coppens, the two most prolific tapestry designers of about 1700.

Jan van Orley was born in Brussels in 1665, the son of the painter Peter van Orley (1638–1709). He was granted privileges in 1709 and in the following year was registered as a master in the Brussels painters' guild. He was active as a painter of portraits and religious subjects and as an engraver, tapestry designer, and cartoon painter.[16] He produced wall paintings and a series of engravings from the New Testament together with his brother Richard van Orley (1663–1732). However, his reputation rests on the large number of tapestry designs he produced, the earliest of which, the *Story of Psyche,* must have been made before 1688.[17] Most of the tapestry designs that he produced—in a monumental Baroque style— until his death in 1735 were the result of collaboration with Augustin Coppens.

The painter and engraver Augustin (Aurelius Augustinus) Coppens was born in Brussels in 1668, the youngest son of the landscape painter Frans Coppens (1625– 1685).[18] His most famous series of drawings and etchings depicts the ruins of Brussels after

it was bombarded by French mortars in 1695. He was registered in the Brussels painters' guild in 1698, but, by his own account, he had been active as a designer of tapestries and a cartoon painter since 1689.[19] He was highly productive and worked for various workshops in Brussels, Antwerp, and Oudenaarde.[20] Although independently producing designs for some series of landscape verdures with small figures, he mainly collaborated with various other tapestry designers. In this capacity, according to his own correspondence, Coppens executed the landscapes after his colleagues had completed the cartoons of the figures and animals.[21] In this way he designed a series after Ovid's *Metamorphoses* and a series of *Hunts* (ca. 1700) together with Lodewijk van Schoor (ca. 1650–1702). He worked on the *Story of Jupiter* (ca. 1700) with the little-known Johannes de Reyff,[22] and with Victor Janssens he produced the *Story of Rinaldo and Armida* (1701), the *Triumphs of the Gods* (ca. 1700), and *Plutarch's Illustrious Men* (1711–12). Coppens also designed a series of *Scenes of Country Life "after Teniers"* with Zeger-Jacob van Helmont (1683–1726).[23] However, Coppens's most fruitful partnership was with Jan van Orley, with whom he designed at least fifteen series of tapestries for various Brussels workshops, such as De Vos, Auwercx, Le Clerc, Van den Hecke, Reydams–Leyniers, and Van der Borcht.

From about 1713 to 1725 Van Orley and Coppens were the most important designers of the Reydams–Leyniers workshop in Brussels.[24] From 1712 to 1719 this workshop was run by Hendrik Reydams II (1650–1719) together with two second cousins of his wife, the brothers Urbanus and Daniel Leyniers III (1669–1728). Thereafter, until 1729, Urbanus Leyniers was in charge on his own.[25] Van Orley and Coppens designed seven important series for this workshop: the *Story of Don Quixote* (ca. 1713–14), the *Triumphs of the Gods and Goddesses* (before 1717), two series of *Country Scenes "after Teniers"* (between ca. 1717 and 1724), the *Story of Joseph* (1718), the *Story of Telemachus* (between 1719 and 1724), and the *Acts of the Apostles* after Raphael (before 1725). Van Orley was always responsible for the figures and Coppens painted the landscapes.

In the series *Triumphs of the Gods and Goddesses* by Van Orley and Coppens for the Reydams–Leyniers workshop, the classical gods are portrayed in real triumph situations or represented in glory in contrast with the series containing catalogue number 58.[26] This series, comprising thirteen different known scenes, was executed fourteen times (in varying numbers and combinations of tapestries) in the period 1717–47. In the tapestry with Diana from this series, the goddess of the hunt—likewise seated under a tree in which a cloth has been hung and surrounded by nymphs and the spoils of the hunt—is crowned with a laurel wreath. Thus, although the treatment of the subject is different, the style of catalogue number 58 is very similar to the style of that series and also to the aforementioned series by Van Orley and Coppens for the Reydams–Leyniers workshop. In all these cases Van Orley's elegant figures in brightly colored garments are featured in Coppens's delicate landscapes with their subtle nuances of color. Because of the striking stylistic similarities with the *Story of Telemachus* of the Reydams–Leyniers workshop—in which there are comparable compositions with a large spreading tree in the center with prospects of distant landscapes on both sides (such as in the tapestries of *Telemachus Hunting with Antiope* and the *Anger of Achilles*)—*Diana Resting* must have been designed around this time, about 1725.[27] When compared with the *Triumphs of the Gods and Goddesses* for Reydams–Leyniers, the *Triumphs of the Gods* of the Van der Borcht workshop (as is clearly the case in the *Diana Resting* of the Rijksmuseum) is conceived more classically, and the design is dramatically more refined.[28]

In the period about 1725–30 Van Orley and Coppens also designed at least four series of tapestries for the Van der Borcht workshop: the *Triumphs of the Gods* (including cat. no. 58, ca. 1725), the *Story of Achilles* (1726–30), the *Story of Moses,* and the *Life of Christ* (ca. 1730), of which sets were woven for, respectively, the Austrian court in Vienna; the king of Portugal; Archduchess Maria Elisabeth, governor of the Austrian Netherlands; and Bishop Hendrik van Susteren of Bruges.[29] However, compared with what is known about their work for the Reydams-Leyniers workshop, there is

regrettably almost no documentation about these designs for the Van der Borcht workshop.

As stated above, this edition of *Diana Resting* was in all probability woven after 1768. This means that the highly accomplished, refined design by Jan van Orley and Augustin Coppens was still considered worthy of execution roughly half a century after it was made.

HILLIE SMIT

1. These three tapestries, with identical borders, were with Perez in London in 1955. The present whereabouts of the *Flora* and *Bacchus* are unknown. A set with the same three subjects was in the collection of Lord Waring in London, according to the Marillier Tapestry Subject Index, Textile Department, Victoria and Albert Museum, London.
2. Brosens 2004a, pp. 117–24, 152–59. See also Smit in Hartkamp-Jonxis and Smit 2004, p. 170, n. 178.
3. Brosens 2002, p. 66, fig. 4.
4. Denucé 1936, pp. 395–96.
5. Ibid.
6. See Brosens 2004a, pp. 124, 152–59, and figs. 50–55.
7. For some examples, see Smit in Hartkamp-Jonxis and Smit 2004, p. 170, n. 177. In the literature, the numbering of the different generations of Leyniers sometimes varies. Here the numbering follows that in Brosens 2004a, p. 368, which includes the most recent data on the Brussels weavers' dynasties in the 17th and 18th centuries.
8. Smit in Hartkamp-Jonxis and Smit 2004, pp. 167–70, no. 46.
9. Brosens 2005–6, pp. 123–24.
10. Ibid., p. 125, n. 4. This set also contains a *Diana Resting* (Kunsthistorisches Museum, Vienna, LV/3). The only difference from cat. no. 58 (apart from the different type of borders) is that at the left-hand side a little less is shown of the scene.
11. Delmarcel 1999a, p. 364.
12. Sale cat., Cowper Collection from Panshanger, Christie's, London, October 22, 1953, no. 116.
13. This tapestry differs from cat. no. 58 in some details and also has a different type of border.
14. See Bauer in Halbturn 1991, p. 46; Brosens 2004a, p. 124, n. 547.
15. Tapestries of the *Elements*, sale cat., Earl of Iveagh Collection, Christie's, Elveden Hall, Thetford, Norfolk, May 21–24, 1984, nos. 1754, 1757. Mentioned in Brosens 2005–6, pp. 124–25, n. 4.
16. De Reyniès 1995a, pp. 171–72; Delmarcel 1999a, pp. 313–25; Brosens 2004a, pp. 14, 102–4, 106–9.
17. Brosens 2005c, pp. 401–3, 406.
18. Pierard-Gilbert 1964; Brosens 2004a, pp. 14, 98–99, 106–9, 125, 137, 220, 306–7.
19. Pierard-Gilbert 1964.
20. Ibid., pp. 19–20; De Meûter 1999, pp. 217, 224.
21. See De Meûter 1999, p. 224.
22. Delmarcel 1999a, p. 306.
23. Smit 2003.
24. Brosens 2004a, pp. 14, 106–9.
25. Delmarcel 1999a, pp. 367–69; Brosens 2004a, pp. 327–30, 334–37.
26. Brosens 2004a, pp. 152–59.
27. See Crick-Kuntziger 1927, pls. 1a, 3a, b.
28. See Brosens 2004a, p. 124.
29. Delmarcel 1999a, pp. 324–25, 334, 336; Brosens 2004a, pp. 123–24.

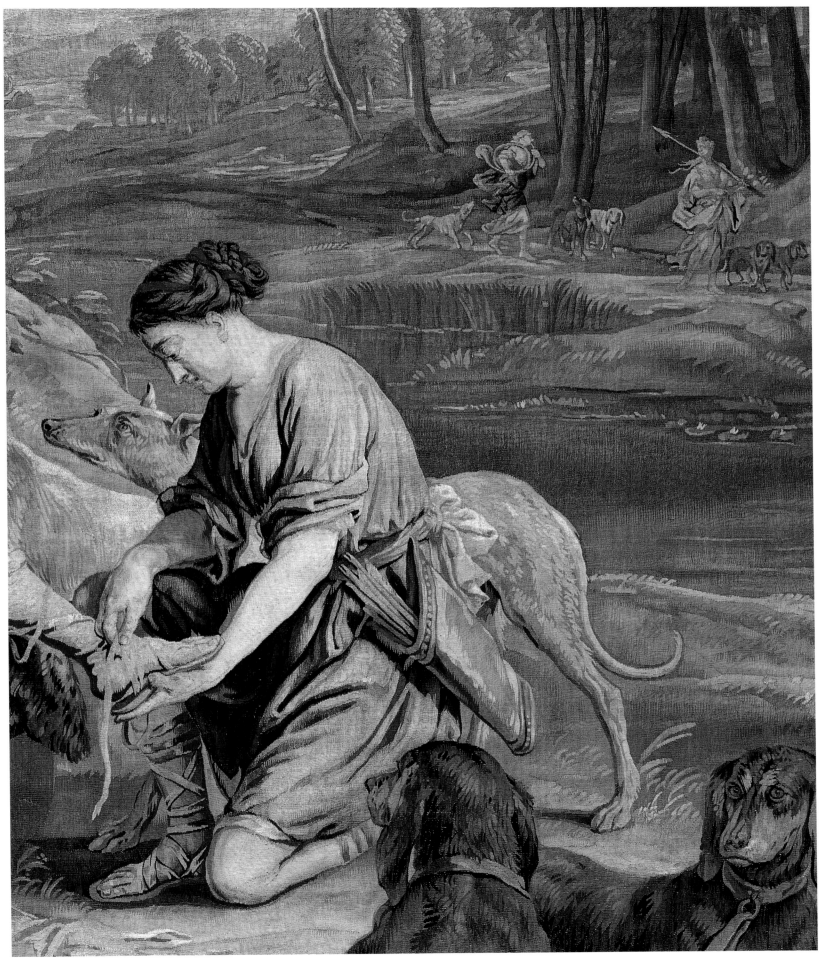

Detail of cat. no. 58

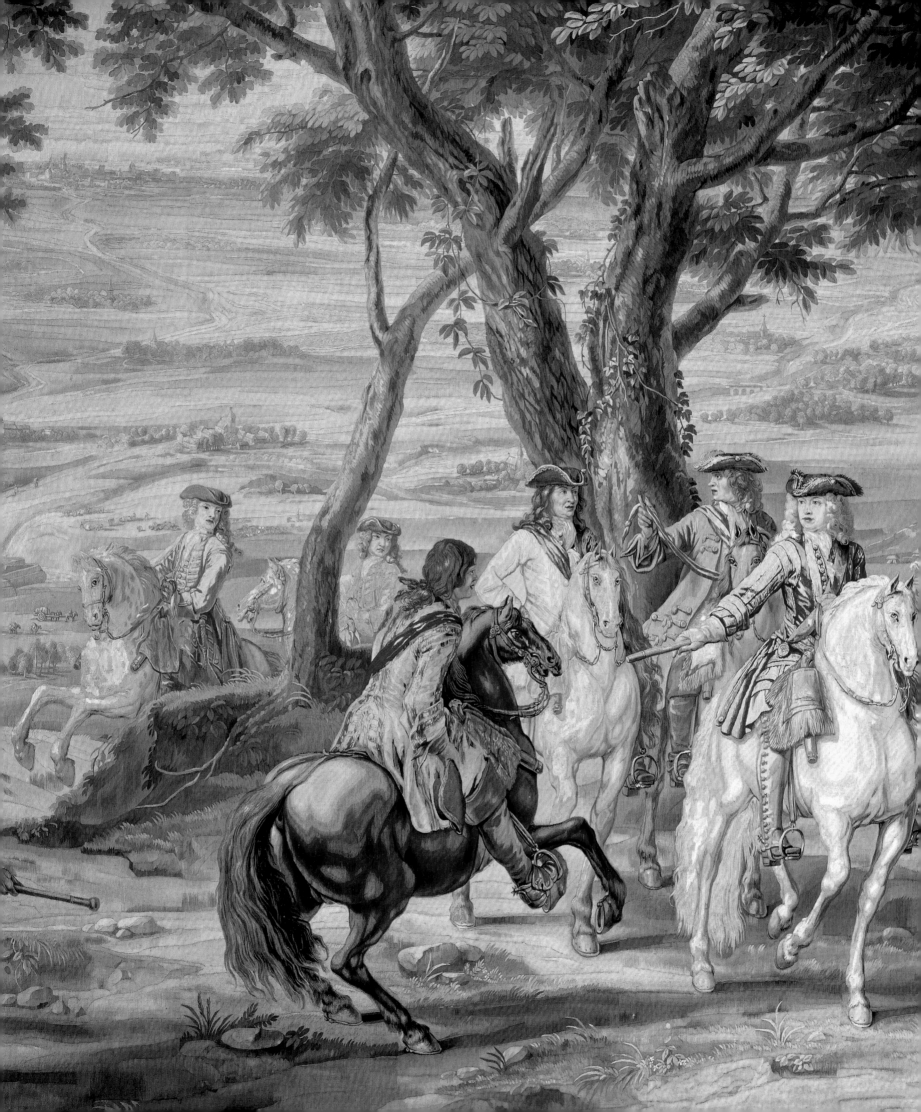

Continuity and Change in Tapestry Use and Design, 1680–1720

THOMAS P. CAMPBELL

The richness and status of the tapestry collection at the French court during the 1660s, 1670s, and 1680s has never been equaled, and the collection set an example that profoundly influenced tapestry usage and production throughout Europe for years to come. In the first place, while tapestry patronage had long been a manifestation of regal splendor, the scale of investment that Louis XIV made in the Gobelins tapestry works was unprecedented. Most of the series produced during those years resulted from directions and commissions made by Louis himself, and the close relationship between the king and his principal minister, Jean-Baptiste Colbert—who had been responsible for restructuring the Gobelins workshops in their aggrandized form—was pivotal in the ambitious projects undertaken at the manufactory (see Pascal-François Bertrand, "Tapestry Production at the Gobelins during the Reign of Louis XIV, 1661–1715"). Louis visited the Gobelins workshops regularly, as did other leading dignitaries and aristocratic tourists, both native and foreign (see fig. 218 and cat no. 47).[1]

Whereas royal funding and encouragement were central to the achievement of the Gobelins, so too was the artistic genius of Charles Le Brun. The style of design that he forged during the 1660s would reverberate in European tapestry design for the next four decades, as did the production practices he institutionalized at the Gobelins. Like the great designers of the sixteenth century, and more recently Simon Vouet, Le Brun devised beautifully structured, large-scale compositions and then delegated the elaboration of the detailing of his designs to teams of artists working under his supervision, ensuring the visual richness of the completed cartoons.[2] The highly skilled weavers that were attracted to the Gobelins and the quality of the materials used there paralleled the quality of the designs. Blending allegory, history, and heraldry to celebrate the monarch, the great Gobelins products of this period have a grandeur and artistry that rivaled and even exceeded those of

the finest Brussels products of the sixteenth century. In the ornately decorated interiors that Le Brun was devising at Versailles and elsewhere—replete with ceiling paintings, elaborate architectural fixtures, sumptuous furnishings that were being produced at the royal furniture manufactory at the Gobelins site, and rugs from the Savonnerie manufactory—the tapestries contributed to an iconographic and visual richness that set a new standard for European court magnificence. Much of this splendor has now been dispersed or destroyed, but the scenes depicted in the History of the King provide a glimpse of the combined effect of these diverse elements (see cat. no. 44 and figs. 164, 176).

Nor was the experience of this magnificence limited to those who visited the French royal palaces. Like his predecessors, Louis turned his new tapestry manufactory into a vehicle of national prestige, showering allies with great sets in a manner that echoed the largesse of Duke Philip of Burgundy three centuries earlier.[3] Engravings and descriptions eulogized and explained the iconography of the most significant series, thus furthering the dissemination of this royal propaganda and making an intellectual claim for the status and importance of the Gobelins tapestries in the overall scheme of Louis XIV's magnificence (see cat. nos. 39, 40).[4] It should also be noted that despite the numbers of new tapestries being made for the crown by the Gobelins manufactory, Louis acquired numerous sets of antique tapestry during the 1660s and 1670s through purchase, legacy, or appropriation. For example, in 1665, Louis acquired from Cardinal Mazarin's beneficiaries the Bernaert van Orley Hunts of Maximilian (fig. 9) and several of Charles I's finest sets of Mortlake tapestry, including the rich set of the Acts of the Apostles with the royal arms (cat. no. 16).[5] In this way, many of the suites acquired with such zeal by Nicolas Fouquet, Cardinal Mazarin and their contemporaries were absorbed into the crown possessions, where they joined the vintage sets that the king had inherited. By the end of Louis's reign, the royal

Fig. 217. Detail of cat. no. 56, *The Siege of Bouchain III* from a set of the *Victories of the Duke of Marlborough*

491

Fig. 218. *The King Visits the Gobelins* from a set of the *History of the King*. Tapestry design by Charles Le Brun, ca. 1672, woven at the Manufacture Royale des Gobelins, 1673–80. Wool, silk, and gilt-metal-wrapped thread, 480 x 688 cm. Mobilier National, Paris (GMTT 95/10)

collection included more than 230 tapestry sets, comprising more than 2,700 tapestries.[6]

Eager to keep up appearances with the court, the French aristocracy purchased hundreds of tapestry sets from a variety of sources during the last third of the century. Most came from the Beauvais manufactory established by Colbert in 1664 and from the workshops in the region of Aubusson and Felletin, which also received royal funding during the 1660s.[7] Others came from the Flemish workshops.[8] As discussed (see Charissa Bremer-David, "Manufacture Royale des Tapisseries, 1664–1715"), early Beauvais production was plagued by economic difficulties, but during the late 1670s, 1680s, and 1690s the workshops enjoyed considerable success with series depicting landscapes with children, genre, or hunting figures (fig. 186)—some of the last with scenes of the French royal châteaux in the background in imitation of Le Brun's *Royal Palaces* series. Other popular series featured exotic birds in landscape or marine settings (fig. 187). The quality of Aubusson and Felletin production was much coarser and, thus, cheaper. Here, too, the

example of the Gobelins was inescapable, and during the last quarter of the century the workshops produced innumerable bastardized copies of Le Brun's *Story of Alexander* series, along with other rather schematic narratives of Old Testament patriarchs and classical heroes such as Achilles and Ulysses.[9]

The French example ensured that tapestry remained at the forefront of fashionable decoration at the other courts of the day.[10] In England, the Mortlake workshop had been devastated by the civil war, and many weavers relocated to small independent ateliers in London during the late 1640s and 1650s. The restoration of the monarchy in 1660 promised new life to the former "King's Works", but despite efforts to revive the manufactory by various entrepreneurs during the 1660s, its products were of mediocre quality.[11] In 1674 the manufactory was taken over by Ralph Montagu, Charles II's friend and Master of the Great Wardrobe (the department of the household responsible for the textiles and furnishings of the British royal palaces). Montagu had acted as English ambassador to the French court in 1669, and he evidently harbored ambitions for

Fig. 219. *Banquet in the Thurn and Taxis Palace*, by Romeyn de Hooghe, 1685. Plate 5 of the *Divo et Inveclissimo Leopoldo I*. Etching, 38.9 x 54.6 cm. The Metropolitan Museum of Art, New York, The Elisha Whittelsey Collection, The Elisha Whittelsey Fund, 1949 (49.95.707)

English tapestry production that were inspired by contemporary activity at the Gobelins.[12] As Master of the Wardrobe, Montagu also had oversight of the "royal arras maker," the royal servant responsible for repairing the royal tapestries. Traditionally, a number of royal arras makers had operated their own workshops, and during the 1670s the present incumbent, a man named Francis Poyntz (d. 1684)—in conjunction with his brother Thomas—received royal encouragement to expand this workshop. In a petition of 1678, Poyntz listed the foreign weavers that he had attracted to his workshop and stated that 100,000 pounds' worth of tapestry was imported to England each year, and that this money could be kept at home by expanding native production.[13] This grand vision was never realized, but at least two tapestry schemes with propagandistic themes were initiated during these years. One of these was a genealogical series of Charles II's Stuart ancestors and their spouses, copied from older portraits by Paul van Somer and Anthony van Dyck (the one extant example, dated 1672, is now at Houghton Hall, Norfolk); the second series, first woven

about 1677–78, depicted the defeat of the Dutch fleet at the Battle of Solebay in 1672 (examples survive at Hampton Court and the Philadelphia Museum of Art).[14] But the scale and quality of these projects were mediocre in comparison to contemporary Gobelins production. In contrast to his father, Charles II lacked the financing to engender or sustain large-scale, high-quality production. The vast majority of tapestries woven in the last quarter of the century at Mortlake or other London workshops were coarse editions of designs conceived during the reign of Charles I or copies of the rather generic mythological subjects that were then being produced in the Antwerp workshops.[15]

Charles and Montagu were not alone in wishing to emulate the Gobelins model. In 1684 Christian V of Denmark (1646–1699), who had visited France in 1663 just as the Gobelins workshops were getting under way, established a new workshop at Copenhagen, which would remain in operation until 1698. Its main product was a twelve-piece set of tapestries (Rosenborg Castle) depicting the 1675–79 Scanian War against

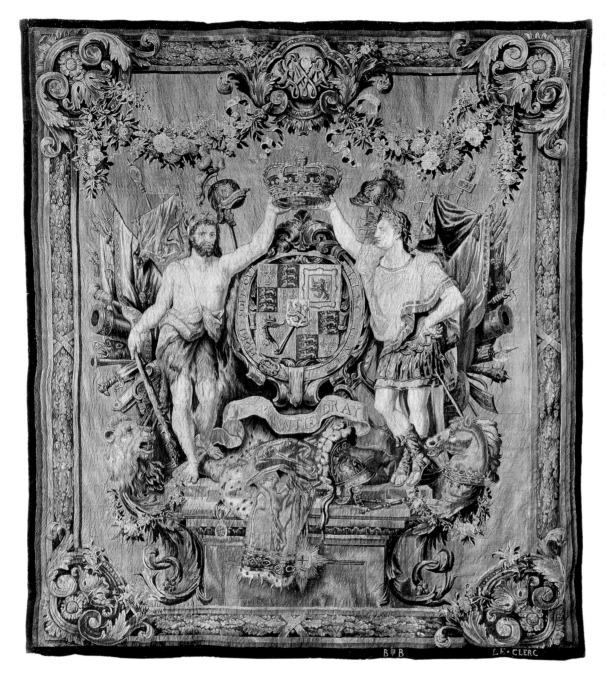

Fig. 220. *The Arms of William and Mary*. Tapestry design by Daniel Marot or Johannes Christoph Lotijn, woven by Hieronymus Le Clerc, Brussels, ca. 1695. Wool and silk, 297 x 231 cm. The Metropolitan Museum of Art, New York, Samuel D. Lee Fund, 1936 (36.57)

the Swedes. This was woven under the direction of the Flemish weaver Berent van der Eichen (fl. 1684–1700), from cartoons by Anton Steenwinckel and others. The style of the compositions is heavily indebted to Le Brun's *History of the King*, but the execution of both cartoons and weaving is coarse in comparison to contemporary Gobelins production.[16]

Those without such resources turned to the traditional centers of manufacture. As in previous eras, Brussels continued to dominate high-quality production in the Low Countries, marketing its wares widely all over Europe, from Spain to the capitals of eastern Europe. As such, it was to Brussels that ambitious patrons turned for custom-made designs, and a handful of new dynastic series were undertaken there during this period. One

of the most ambitious was a twenty-piece set depicting the *History of the House of Moncada* commissioned by the Spanish-Sicilian Moncada family after designs by David Teniers II, Willem van Herp, Jan van Kessel, and other artists. This was woven in the Auwercx workshop in Brussels in the mid-1660s (now Chamber of Commerce, Paris).[17] Another major commission was that of a *History of the House of Torriani* commissioned by the house of Taxis in celebration of the formal recognition of their dynastic claim to the Torriani (Thurn) title. The designs were by Erasmus Quellinus, and the tapestries were woven in Brussels in the 1670s (Schloss Thurn und Taxis, Regensburg).[18] A late seventeenth-century engraving shows the tapestries in situ in the family palace (fig. 219).

Such custom-made sets were, of course, exceptions because of their cost. Armorial portieres provided a cheaper form of dynastic display. Inspired by the large numbers of such hangings made at the Gobelins after designs by Le Brun, armorial portieres enjoyed considerable vogue during the last quarter of the seventeenth and first decade of the eighteenth centuries, providing a colorful and stately division between chambers in the *en filade* suites that were then being created in the more fashionable residences. The Spanish nobility, in particular, commissioned numerous slightly variant heraldic portieres from the Brussels workshops after designs by David Teniers and others (see, for examples, cat. no. 53, fig. 211).[19] One of the largest ensembles of this kind was the sixteen-piece set woven in Brussels during the early 1690s for William III, king of England (fig. 220).[20]

At the same time, numerous mythological and history sets were being produced in the Flemish workshops for the commercial market. As discussed in greater detail elsewhere in this catalogue, the large-figure histories and mythologies designed by Peter Paul Rubens, Jacob Jordaens, and Justus van Egmont fell out of fashion during the 1660s—partly as a result of the new style of design that Le Brun was pioneering in Gobelins production—displaced by a demand for more elegantly drawn figures in richer landscape settings. This demand was met with new designs by artists such as Charles Poerson and Lodewijk van Schoor (see Koenraad Brosens, "Flemish Production, 1660–1715," and cat. no. 54). The taste for the new French style was also catered to with literal copies of Le Brun designs, such as the *Story of Meleager* series (fig. 200), first conceived for Superintendent Fouquet, of which the cartoons remained in the hands of the French merchant, Jean Valdor. Valdor leased the cartoons to various Brussels workshops in the 1670s, and they were woven frequently in that and the following decade. The Brussels workshops also copied engravings of Le Brun's *Alexander* series, and these pirated designs were woven many times in the De Vos workshop in the 1690s and early 1700s.[21]

The militaristic character of the Gobelins *History of the King* series also stimulated a Flemish response of a related character. Louis XIV's aggressive foreign policy had ensured that warfare was a continuous preoccupation in the life of the European aristocracy—and their unfortunate subjects—for much of the last third of the seventeenth century. Several of the campaigns took the war into the Low Countries once again, with serious consequences for many of those involved with the local weaving industry. (Among the most traumatic of these events was the bombardment of Brussels in 1695, when four thousand buildings were destroyed, including much of the town center). Spurred no doubt by the reality of contemporary events, the Brussels workshops of Hieronymus Le Clerc and Jasper van der Borcht commissioned a series of tapestry cartoons from Lambert de Hondt depicting scenes of military life, which emulated the contemporary realism of the Gobelins *History of the King*, but with a less triumphalist content. The first set of this Brussels *Art of War* series (now Neues Schloss Schleissheim) was purchased in April 1696 by Duke Maximilian-Emanuel, governor of the Spanish Netherlands and elector of Bavaria. During the following years, this series was adapted and rewoven for several of the European rulers who had been involved in these drawn-out conflicts, including William III of England; Louis, margrave of Baden; and the Earl (later Duke) of Marlborough (this last set survives at Blenheim Palace).[22] While the Brussels designs of the *Art of War, Meleager,* and *Alexander* series catered to the continuing demand for tapestries with grandiose subject matter for formal audience chambers, the market for lighter subject matter was met with genre scenes based on paintings by David Teniers II (fig. 209). The popularity of such *Teniers* designs was to continue unabated for the next thirty years, as demonstrated by the different cartoon series that were developed by the competing Flemish workshops in the 1690s and early 1700s and by the substantial numbers of such tapestries that survive today.[23]

Although Brussels dominated the production of high-quality tapestries in the Low Countries, other centers such as Oudenaarde, Antwerp, and Lille (which came under French rule in 1668) continued to enjoy considerable success with cheaper, decorative tapestries, often of relatively modest dimensions, featuring woodlands and formal gardens, some populated with genre or mythological figures, others with scenes of bacchanalian children.[24] The enormous demand for such products in the late seventeenth century resulted from the growing size of the professional classes and lesser gentry who were building town and country houses across western Europe and who, in emulation of the style and manners of the grandees of the day, were equipping their residences with fashionable decorations (fig. 221). Increasingly, the trend was for such decorative hangings to be fixed with nails, often within paneling, rather than hanging freely as had been the traditional mode of display (fig. 222). Many tapestries woven in Antwerp were specifically produced with a reduced height that was considered to be appealing to the English market, where such tapestries were often set in paneling above a wood dado.[25] The sheer number of low- and medium-quality tapestries produced in this period, of

Fig. 221. *The Van Goyen Family,* by Jan Steen, ca. 1665–67. Oil on canvas, 84.5 x 101 cm. The Nelson-Atkins Museum of Art, Kansas City, Missouri, Purchase: Nelson Trust (67-8)

Fig. 222. *Bedroom Scene,* by an unidentified French artist, ca. 1690. Oil on canvas, 47.5 x 72 cm. Victoria and Albert Museum, London (P.25-1976)

which large numbers survive in European country houses, is one of the factors that have encouraged a rather dismissive opinion of the tapestry medium in modern times. It should be remembered that a large proportion of these hangings were created as decorative furnishings and were always perceived to be of a different character and caliber than the more expensive high-quality figurative tapestries that were being made for the richer patrons of the day.

The Continuing Role of Antique Tapestries

The role of antique tapestries in grand ceremonies continued undiminished throughout this period. When James II of England was crowned at Westminster Abbey in 1685, the ceremony took place against a backdrop of the *Story of Abraham* tapestries purchased by Henry VIII in the early 1540s (fig. 223). It was the richest set of tapestries in the English royal collection, but its selection also reflected a long-standing tradition. The subject had appealed to Henry because it provided a celebration, by proxy, of the succession of the Tudor dynasty from Henry to his son, Edward, just as God's covenant with Abraham was extended to his son Isaac. This analogy was equally resonant for subsequent monarchs at their accession, and as such, this set seems to have become associated with royal coronations. It was also displayed at Westminster Abbey for the coronation of William III in 1689, and subsequently for the coronations of Queen Anne in 1712 and King George I in 1727.[26]

Tapestries continued to play a similar role in the ephemeral decorations for major ceremonies at the other European courts. A contemporary pen and ink depiction of the coronation of Charles XII of Sweden in 1697 shows the facade of the royal palace entirely covered with tapestries (fig. 224).

From the 1690s antique tapestries also came to play a more permanent role in the decoration of the English royal palaces. Lacking funds to commission extensive new tapestries, William III expanded a practice that Charles II had initiated at Windsor Castle and Whitehall in the 1670s, by hanging many of the finest antique tapestries on a permanent basis in the formal audience rooms of his palaces. For example, at both Hampton Court and Kensington Palace, the new state apartments constructed for William and his wife Mary were hung with sets purchased by Henry VIII in the 1540s. These grand Romanist designs contrasted with the more decorative, contemporary tapestries that were utilized in more private spaces.[27] Although the use of the antique tapestries may have been dictated in part by expediency, this should not veil the fact that they continued

to be held in the highest regard at this time. For example, the design of the *Story of Abraham* tapestries was then attributed to Michelangelo. The selection of several pieces of this set for display in the King's state apartments at Hampton Court may in part reflect a desire to bring the work of this famous artist into proximity with that of Raphael, whose *Acts of the Apostles* cartoons were displayed in the adjacent Long Gallery.[28]

Certainly, antique tapestries were evidently still a matter of considerable note in their own right. As discussed above ("Collectors and Connoisseurs: The Status and Perception of Tapestry, 1600–1660") the relative status of tapestry and painting at this time requires more nuanced investigation, but it is readily evident from historical documentation that quite apart from continuing to invest large sums in new tapestries, contemporary patrons also continued to hold antique tapestries in the highest regard both for their physical value and for their artistry. For example, when, many years later, the third duke of Gramont recalled a visit to Madrid with his father in 1659—when his father was acting as French ambassador—he described the Spanish royal palace in the following terms:

> In all the apartments there is no ornament, excepting the hall where the king receives ambassadors. But what is admirable are the pictures that all the chambers are full of; and the superb tapestries, many more beautiful than those of the crown of France, of which His Catholic Majesty has eight hundred hangings in his furniture repository. Once this compelled me [i.e., the third duke of Gramont] to say to Philip V, when I was an ambassador extraordinary to him, that he ought to sell four hundred of them in order to pay his troops and fight the war, and that enough of them would still remain to him to furnish four palaces like his.[29]

The innate respect for antique hangings reflected by this comment is also demonstrated in the preparations that were made in the Grande Galerie at the Louvre in 1699, when Jules Hardouin Mansart persuaded Louis XIV to hold a salon, the first since 1683. The arrangements for what was essentially a display of paintings nonetheless incorporated two vintage tapestry sets from the royal collection, evidently chosen because they were considered to be by two great High Renaissance masters. The center of the Grande Galerie was occupied by a dais, on which portraits of the king and dauphin were hung. On either side, the walls were hung with Francis I's set of Raphael's *Acts of the Apostles*. The end of the gallery was hung with Francis's *Deeds and Triumphs of Scipio* designed by Giulio Romano and Giovanni Francesco Penni. The catalogue of the

Fig. 223. *The Coronation of James II* from Francis Sandford, *The History of the Coronation of the Most High, Most Mighty, and Most Excellent Monarch, James II . . .* (London, 1687). The Thomas J. Watson Library, The Metropolitan Museum of Art, New York (239 Sa5 Q)

Fig. 224. *The Coronation of Charles XII*, by Jacques Fouquet (attrib.) after Nicodemus Tessin, 1697. Ink and grey wash, 470 x 650 cm. Nationalmuseum, Stockholm (NM THC 5645)

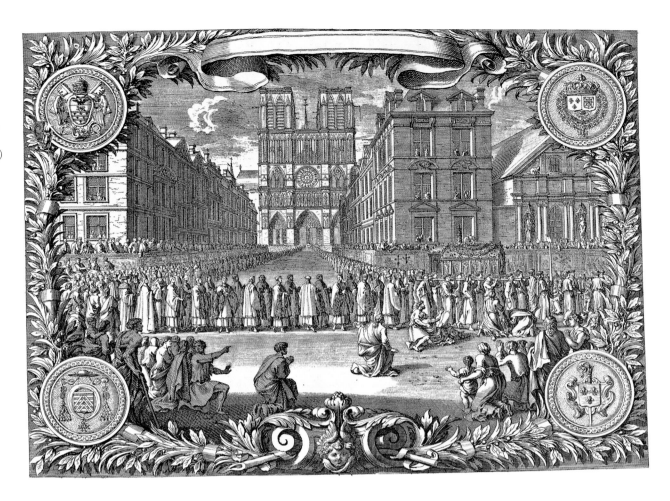

Fig. 225. *Procession of the Reliquary of Saint Geneviève in Paris from Notre-Dame to the Abbey of Saint-Geneviève*, by Jean Le Pautre, 1679. Engraving, 235 x 314 cm. Bibliothèque Nationale de France, Paris (ED-42a)

display states explicitly that paintings were not hung on top of either set because of their great artistic beauty.[30] Five years later, tapestries were also included in the salon of 1704.[31]

If antique hangings continued to play a major part in court ceremony and decoration, they also continued to feature in ecclesiastic and civic ceremony. The practice of displaying tapestries in the streets of many Catholic cities for the Feast of Corpus Christi and the feasts of other patron saints continued throughout the seventeenth and early eighteenth centuries. A print of 1679 records arrangements for the procession of the reliquary of Saint Geneviève in Paris from Notre-Dame to the Abbey of Saint-Geneviève with the streets lined with tapestries (fig. 225). Indeed, it was the continuation of this practice in Paris that resulted in what was, in effect, the first catalogue of a tapestry exhibition. This two-page pamphlet, printed in 1705, identified the tapestries that were displayed in the courtyards of the Gobelins and the Louvre on the Feast of Corpus Christi.[32] Not that such displays were purely a matter of aesthetics by this date. In 1717, Cardinal de Noailles, archbishop of Paris, felt it necessary to appeal against the display on such occasions of tapestries whose subject matter might offend sensibility, enjoining that only images of a pious nature should be shown.[33]

In Rome and other Italian cities, too, antique tapestries remained in high regard. The Vatican continued to incorporate its finest hangings in its liturgical ceremonies, displaying the famous Raphael tapestries in the Borgo for the Feast of Corpus Christi, setting an example that was followed by the Italian aristocracy in Rome and in other cities.[34] Many Italian noble families retained large collections of tapestries.[35] Those who had not inherited sizable collections sought to amass them. For example, following the death of Queen Christina of Denmark, Don Livio Odescalchi, adoptive nephew of Pope Innocent XI, purchased the main part of her collections. He was sufficiently proud of the tapestries to publish a short pamphlet describing them.[36] It continued to be common practice for the richer families to hang tapestries on the facades of their palaces on grand civic occasions well into the next century.

The Revocation of the Edict of Nantes and A New Diaspora of Weavers

Tapestry sets of a wide range of date and quality thus remained a central component of display and decoration in the palaces and residences of the wealthy in the latter part of the seventeenth century. This was the background against which the

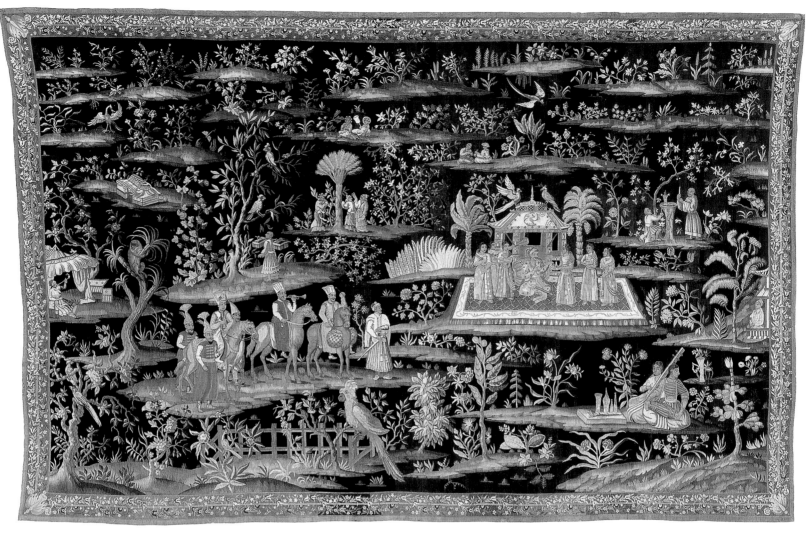

Fig. 226. *The Concert* from a set of *Indo-Chinese Scenes*. Tapestry design by John Vanderbank, woven in the London workshop of John Vanderbank, ca. 1700. Wool and silk, 305 x 457 cm. The Metropolitan Museum of Art, New York, Gift of Mrs. George F. Baker, 1953 (53.165.1)

character and circumstances of production were to undergo further development between 1685 and 1720.

One of the first engines of change was the revocation of the Edict of Nantes in 1685, which resulted in the exodus from France of large numbers of skilled Protestant artisans, including many tapestry weavers. Some settled in London, others in German towns like Berlin and Dresden.[37] As had happened a century earlier when the religious wars spurred the migration of weavers from the southern Netherlands, the workshops established by these migrant weavers provided a new stimulus to local patrons, who saw in them an opportunity to acquire customized tapestry products more economically than from the traditional centers in the Low Countries and France, and who may also have aspired to the prestige attached to having their own workshops. One of the most successful émigrés of the day was the weaver John Vanderbank (d. 1717), who moved from Paris to London in the mid 1680s and was appointed as

the "royal arras maker" to the new king, William III, in 1689.[38] Vanderbank evidently operated a sizable workshop in addition to his royal duties. During the late 1680s he produced copies of Gobelins tapestries such as the Le Brun *Elements* (fine examples survive at Boughton House and Burghley House).[39] From the early 1690s he began to enjoy great success producing rather schematic "chinoiserie" designs—in which the motifs were inspired as much by Indian sources as Chinese motifs—in response to the current craze for imported Asian ceramics. The first weaving of this design was made for Queen Mary's apartments at Kensington Palace where, along with sets of *Teniers* tapestries, it provided a decorative contrast to the grandiose sixteenth-century sets that were hung in the formal staterooms. Thereafter, Vanderbank produced numerous sets of this design for other English patrons (fig. 226).[40] The attraction of these chinoiserie designs for the weavers was akin to that of millefleurs patterns in earlier periods, because the small figurative motifs

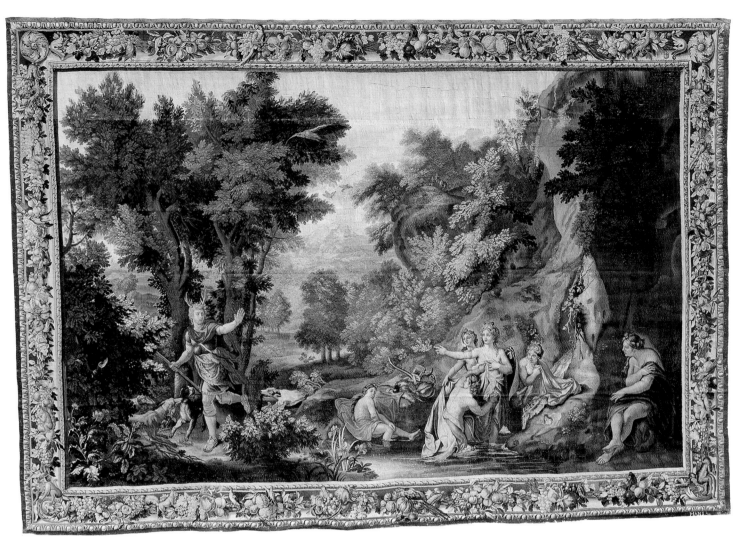

Fig. 227. *Diana and Acteon* from a set of *Metamorphoses*. Tapestry design by Charles de La Fosse, woven in the workshop of Jean Jans the Younger at the Gobelins manufactory, Paris, ca. 1695. Wool and silk, 330 x 462 cm. The Metropolitan Museum of Art, New York, Gift of Mrs. George S. Amory, in memory of her father and mother, Mr. and Mrs. Amory Sibley Carhart, 1964 (64.208)

were generally represented against a plain ground and could thus be produced quickly and cheaply.

Another notable Huguenot who left France at this time was an Aubusson weaver, Pierre Mercier (d. 1729), who relocated in 1686 to the Berlin court of Frederick, the elector of Brandenburg (and king of Prussia from 1701). Following the example of the Gobelins *History of the King*, Mercier wove a set of tapestries illustrating the reign of the elector that was completed in 1699 (now Schloss Charlottenburg). Subsequently, he also wove a set depicting the *Life of Queen Sophie-Charlotte* (woven 1699–1713).[41] In 1713 he relocated from Berlin to Dresden, where he established a workshop for Frederick Augustus I, elector of Saxony and king of Poland and for whom he wove a *History of Augustus the Strong* (Schloss Moritzburg), among other series.[42]

Of course, not all the new workshops of the day were established by Protestants. In 1698 Duke Leopold of Lorraine

reestablished a workshop in Nancy, in part staffed by weavers who had previously worked at the Gobelins. The principal works of this atelier were two sets depicting the *Victories of Charles V* (Leopold's father), which were woven from designs by Jean-Baptiste Martin—who had also previously worked for the Beauvais and Gobelins workshops—and which were completed in 1717 (Kunsthistorisches Museum, Vienna).[43]

Stylistic Changes in French Tapestry Production

The second significant change that took place in tapestry production in the closing years of the seventeenth century was a stylistic one, driven in part by changes at the Gobelins. After Colbert died in 1683, his erstwhile rival, the marquis de Louvois, succeeded him as superintendent of royal buildings. Seeking to find alternatives to Le Brun's designs, Louvois commissioned a number of cartoon series that were copied from sixteenth-century tapestry and fresco cycles (see Bertrand,

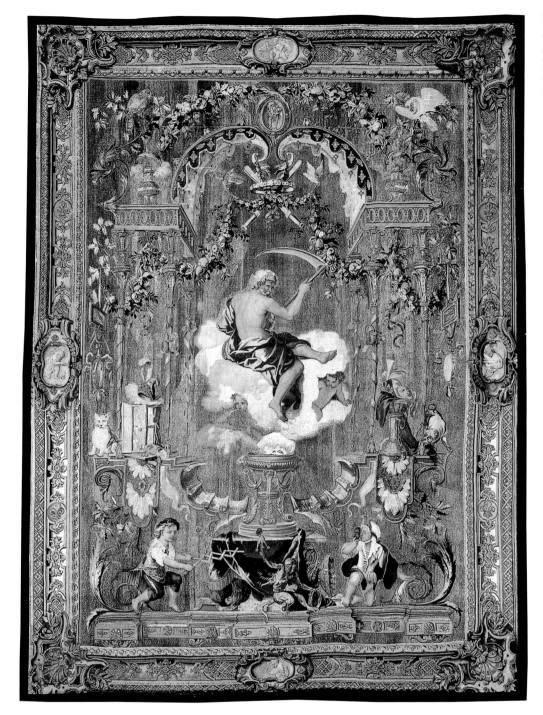

Fig. 228. *Saturn, or Winter*, from a set of the *Portières des dieux*. Tapestry design by Claude Audran III and others, woven in the workshop of Jean Jans, Paris, 1701. Wool, silk, and gilt-metal-wrapped thread, 352 x 236 cm. Mobilier National, Paris (GMTT 162-3)

"Tapestry Production at the Gobelins during the Reign of Louis XIV").[44] This practice, which reflects the continuing appreciation for old master designs among the most elevated members of the French court, was not entirely new. Colbert had already instigated the reweaving of the Van Orley *Hunts of Maximilian* some years before, including a very fine set for his own use.[45] But the number of replica series that Louvois initiated was remarkable. Focusing particularly on tapestry and fresco schemes by the Raphael and Giulio Romano workshops, these reweavings reflected the French court's aspiration to appropriate the grandeur of Renaissance Rome to Baroque Paris. A by-product of this policy was that the designs chosen for reproduction included a number of decorative series that were to have a profound influence on contemporary court style, particularly the Raphael workshop *Grotesques of Leo X*, also known as the *Triumphs of the Gods* (cat. no. 49) and another mid-sixteenth-century Brussels series known as the *Arabesque Months*.[46] These series revived a design model that was more delicate in spirit and appearance than the formal, grandiose style that Le Brun had promoted at the

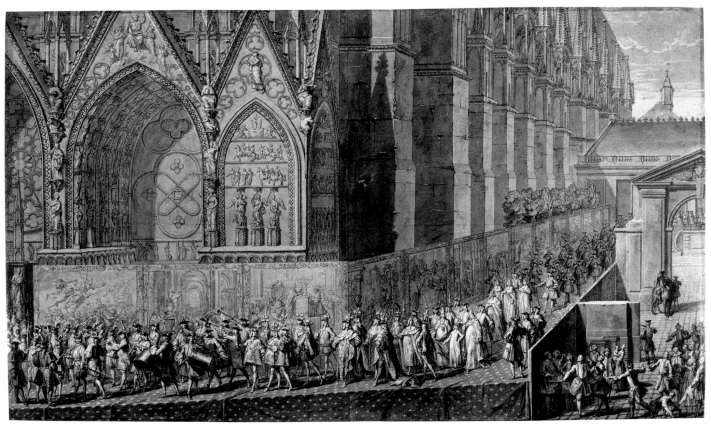

Fig. 229. *Louis XV Processing to Reims Cathedral, October 25, 1722*, from the *Album of the Coronation of Louis XV*, by Pierre Dulin, ca. 1722. Ink and wash with white heightening, 44 x 72 cm. Département des Arts Graphiques, Musée du Louvre, Paris (26303)

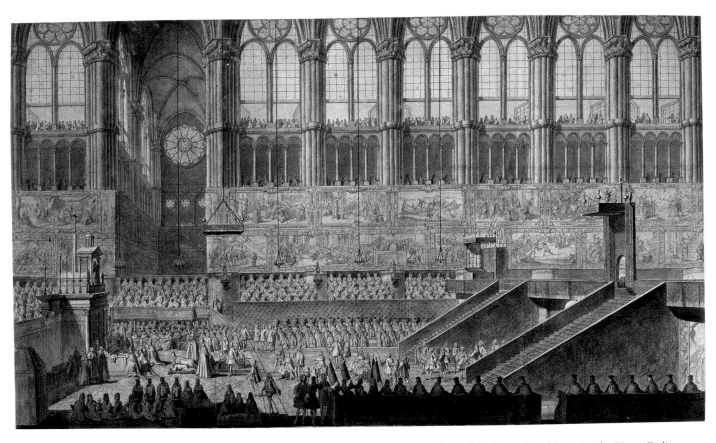

Fig. 230. *King Louis XV in Front of the Altar at Reims Cathedral, October 25, 1722*, from the *Album of the Coronation of Louis XV*, by Pierre Dulin, ca. 1722. Ink and wash with white heightening, 43.5 x 71.5 cm. Départment des Arts Graphiques, Musée du Louvre, Paris (26309)

French court. During the 1690s, designers like Jean Berain and Jean-Baptiste Monnoyer, were quick to copy and develop this model in their tapestry designs for the Beauvais manufactory and other independent Paris workshops. These essentially decorative designs found a ready market among the French aristocracy and also further afield, as for example among Swedish patrons, as discussed elsewhere in this catalogue (see Bremer-David, "Manufacture Royale de Tapisseries de Beauvais," and cat. nos. 50, 51).

While designers working for the Beauvais and Paris workshops were quick to pick up on and develop this stylistic tendency, its impact was not manifested so quickly in new designs produced for the French Crown at the Gobelins because of the temporary closure of these workshops between 1694 and 1699 as a result of the financial difficulties caused to Louis by the War of the Grand Alliance. During the interim, some of the Gobelins workshops turned to the production of mythological scenes with small figures and decorative borders for the open market, after designs by Charles de La Fosse and others (fig. 227).[47] But when the Gobelins reopened in 1699, the lighter decorative style was reflected in series like the *Portières des dieux* (fig. 228) conceived by Claude Audran III (1658–1734) and executed in conjunction with various artists such as Louis de Boullogne, Michel Corneille II, and Alexandre François Desportes.[48]

The new lighter style of tapestry design emerging from the Beauvais and Gobelins manufactories was quickly emulated at other European workshops. In some cases, the French designs were simply copied. For example, Jean Barraband (d. 1709), a Huguenot refugee from Aubusson who had settled in Berlin at some point after his brother-in-law, Pierre Mercier—and with whom he collaborated—enjoyed considerable success during the early years of the eighteenth century making copies of the Beauvais *Berain Grotesques* and the *Premier tenture chinois*.[49] In London, various workshops sought to develop new, more decorative series. Among the more successful were those of the workshop run by Joshua Morris (fl. 1700–28), which from the 1710s produced tapestries with decorative floral arrangements against a tobacco yellow ground, akin to that of the Beauvais *Berain Grotesques*, after designs attributed to the French artist Andien de Clermont (act. in London, 1716–56).[50] In Brussels too, a lighter spirit and tone were also manifested in the palette and character of the mythological, romance, and genre scenes created during the early years of the eighteenth century by artists such as Jan van Orley and Augustin Coppens (see Brosens, "Flemish Production").

From Baroque Splendor to Rococo Elegance

Tapestry thus remained a key component of European court ceremony and decoration during the early eighteenth century. One of the grandest manifestations of the traditional role of tapestry was provided by the preparations for Louis XV's coronation, which took place on October 25, 1722. In advance of this event, orders were given to the royal wardrobe to provide the finest hangings to Reims, and contemporary descriptions and depictions record the central role that tapestry played in the coronation proceedings. The streets outside the cathedral were lined with a continuous curtain of tapestries, while the nave and transepts of the cathedral were hung from floor to ceiling with the finest antique and modern products (figs. 229, 230).[51]

Although this display was extraordinary in size, it was by no means an isolated incident or limited to northern Europe. On the contrary, tapestry remained just as much a part of ceremonial display in Italy. For example, for the proxy marriage of Philip V and Elisabetta Farnese in Parma Cathedral in 1714, antique tapestries from the Farnese collection were hung on the facade and interior of the cathedral.[52] Rather than diminishing, the practice of displaying tapestries on the exterior of important buildings for important occasions seems to have become increasingly formalized in the course of the first quarter of the eighteenth century in Italy. Writing from Rome in March 1726, Nicolas Vleughels, the director of the Academy in Rome, asked the duc d'Antin to send Gobelins tapestries and portieres to him for the academy's new quarters in the Palazzo Mancini because it was the custom, which one could not ignore, to hang textiles from the windows on the occasion of feast days, and he thought that the portieres in particular would be a very impressive complement to the appearance of the palace.[53]

If tapestry continued to provide a primary component of court and civic ceremonial displays, it also remained a central component of more quotidian display in the grander residences of the day during the late 1710s and 1720s. Two distinct trends can be observed. On the one hand there continued to be a strong demand for antique tapestries or contemporary scenes of history and mythology for the grand audience chambers and parade rooms. At the same time, there was a strong demand for more decorative tapestries for more intimate spaces. This duality of function was to continue relatively unchallenged, at least in the grander households, for much of the second quarter of the eighteenth century.

Throughout this period, the French court continued to set the primary example, and the influence of French style is

Fig. 231. The State Dining Room at Stowe, decorated with a set of the *Triumphs of the Gods*, woven in Brussels for Lord Cobham, ca. 1720

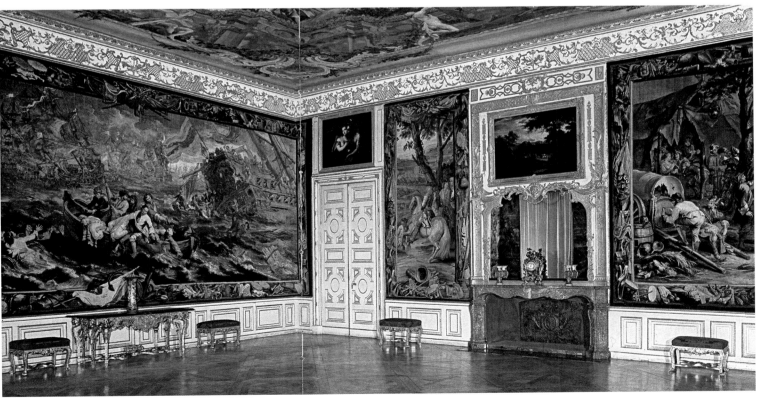

Fig. 232. The Elector's Antechamber at Neues Schloss Schleissheim, hung with pieces from a set of the *Art of War II*, woven in Brussels from cartoons by Philippe de Hondt, ca. 1722–24

readily apparent in the initiatives that were taken elsewhere in Europe in the 1710s and early 1720s. For example, in 1710, Pope Clement XI established a workshop in the hospice of San Michele a Ripa, under the direction of the Parisian Jean Simonet. Following the model of the Gobelins, its products were to be exclusively for the Vatican.[54] An even more overt emulation of the French example was provided by the tapestry workshop that Peter the Great established in 1717 in Saint Petersburg, immediately following his return from a trip to France. The founding weavers and dyers were French and traveled to Russia under the direction of Alexandre-Jean-Baptiste Le Blond of the Gobelins and Philippe Behagle II of Beauvais. Several of the earliest products were direct imitations of Gobelins tapestries, including the *Indes* series, a set of which had been presented to Peter when he visited the Gobelins workshops.[55] Similarly, when the Bavarian Prince-Elector Maximilian Emanuel reestablished a workshop in Munich in 1718, it was partly staffed by workers from the Gobelins.[56] In Spain Philip V sought to persuade French workers to establish a workshop in Madrid, but eventually settled for a team of Flemish weavers under the direction of the Antwerp master Jacob van der Goten (1659–1724), who established the Santa Barbara workshop in Madrid in 1720. In the first instance, this produced copies of Flemish *Teniers* designs before embarking on more ambitious designs by Spanish artists.[57]

More generally, the abiding influence of the grand style of the French court, as well as the role played therein by tapestry, were manifested throughout the late 1710s and 1720s among the European nobility by the continuing demand for sets of large figurative tapestries to decorate the formal rooms of their country seats and castles. The success of the first *Art of War* series after designs by Lambert de Hondt, and of the subsequent *Victories of the Duke of Marlborough* by his son Philippe, led to the development of a second, variant series of designs in the mid-1710s after designs by Philippe. At least six such sets were supplied to English generals who had fought with Marlborough in the campaigns, while others were provided to members of the German aristocracy such as the Bavarian Elector Maximilian Emanuel, who already owned the earlier version of this design series (see Brosens, "Flemish Production," and cat. no. 57). Indeed, along with Brussels tapestries depicting the *Triumphs of the Gods* (see cat. no. 58) and other mythological

and allegorical subjects after designs by Jan van Orley and Augustin Coppens, such sets provided the key decorative elements in many of the grandest European residences built or redecorated during the late 1710s and 1720s (figs. 231, 232).

At the same time that the leading tapestry workshops continued to enjoy demand for large figurative tapestry series for the more public spaces of the grand buildings of the day, they also benefited from the development of the decorative style—now known as Rococo—that was sweeping France in reaction to the ornate style of the previous era. The production of ambitious figurative designs at the main tapestry manufactories had always been supplemented and to some extent subsidized by the demand for cheaper decorative hangings: millefleurs tapestries during the medieval era, large-leaf verdures and grotesques during the sixteenth century, forest and garden scenes during the seventeenth century, and chinoiserie designs and decorative grotesques at the turn of the eighteenth century. In all, the common attraction for the workshops was the relative ease with which weavers could reproduce decorative floral designs or simple figurative motifs against relatively plain but richly colored grounds. Now such decorative tapestries provided a perfect complement to the new style of interior design, with its colorful ceramics and delicately carved wood paneling and furniture. And although paneling and silk hangings were certainly to provide competition to the ubiquitous presence of tapestry, it continued to be fashionable to have tapestry rooms, with en suite tapestry-covered furniture. Just at a time when the manufacture of figurative tapestry series with weighty subject matter was about to suffer increasing competition from the rival status and claims being made for history painting, the tapestry medium received a new lease of life from the growing demand throughout northern Europe for decorative, lighthearted tapestry hangings. Working from designs by artists like Jean-Baptiste Oudry and François Boucher, the Beauvais workshops in particular were to enjoy extraordinary success during the 1720s and 1730s, setting a model that was to be emulated by workshops throughout Europe. However, such reflections take us well beyond the present discussion of tapestry in the Baroque and may perhaps provide the material for a future exhibition dedicated to the final flowering of the European tapestry industry during the second third of the eighteenth century.[58]

1. See, for example, Lough 1984, pp. 58–60.
2. For Vouet's use of collaborators, see Lefébure 1995, pp. 182–86; for Le Brun's collaborators, pp. 186–90.
3. For full details of Louis's tapestry gifts during this period, see Fenaille 1903–23, vol. 2.
4. Fenaille 1903–23, vol. 2, contains extensive detail on the engraved reproductions. For the panegyrics, see Brassat 1992, pp. 138–55.
5. Vittet 2007.
6. For the complete inventory of Louis XV's tapestries, see Guiffrey 1885–86.
7. D. Chevalier, P. Chevalier, and Bertrand 1988, pp. 62–84.
8. Brosens 2004c.
9. D. Chevalier, P. Chevalier, and Bertrand 1988, pp. 67–80.
10. For a highly readable overview of European tapestry production in the late 17th century, see Lefébure 1995. See also D. Heinz 1995, 136–99.
11. Thomson 1930, pp. 294–303; Hefford 2002, esp. pp. 55–60. Hefford's forthcoming catalogue of English tapestries at the Victoria and Albert Museum will provide an authoritative review and updating of this material.
12. Hefford 1992, esp. p. 101.
13. Thomson 1930, pp. 355–60.
14. Ibid., pp. 356–59; Jourdain 1929; Marillier 1962, pp. 30–31.
15. Thomson 1930, pp. 359–61; Marillier 1930; Hefford 1983; Hefford 1992.
16. Boesen 1949; Woldbye 2002, p. 111.
17. Delmarcel 1999a, pp. 243, 250.
18. Piendl 1967; Piendl 1978.
19. For the various Göbelins portieres designed by Le Brun, see Fenaille 1903–23, vol. 2, pp. 2–21. For examples of Brussels portieres see Delmarcel 1999a, pp. 236–39, 249–50.
20. Standen 1985, pp. 224–27.
21. For a good visual survey of these developments, see Delmarcel 1999a, pp. 220–54.
22. Wace 1968, pp. 29–49. See also Koenraad Brosens, "Flemish Production, 1660–1715," in this volume.
23. Marillier 1932. See also Brosens, "Flemish Production."
24. Delmarcel 1999a, pp. 255–89; De Meûter 1999, pp. 202–63; Oudenaarde 1999, passim.
25. Delmarcel 1999a, p. 263.
26. T. Campbell 2007, pp. 281–97, 365–66.
27. Ibid., pp. 366–69. While these splendid hangings thus lent an air of grandeur and antique richness to the interiors, in the long term their permanent display had a detrimental effect on the tapestries, both in terms of the exposure to light and dirt and the respect in which they were held. Great objects that had been treated with the utmost veneration and hung only for special occasions now became, in effect, glorified wallpaper. A century later, these factors would contribute to the way tapestry fell out of fashion so quickly in England during the last third of the 18th century; ibid., pp. 369–76.
28. Ibid., pp. 367–68.
29. Petitot and Monmerque 1826–27, vol. 2, pp. 57–58; trans. in Orso 1986, p. 3.
30. *Liste des tableaux . . . exposez dans la Grande Gallerie du Louvre* 1699/1869, pp. 11–12, 25.
31. Brassat 1992, p. 154.
32. "Explication des tentures de tapisserie que l'on expose ordinairement dans la cour de la maison royale des Göbelins et du Louvre, le jour de la Fête-Dieu et de son octave"; Bibliothèque Nationale de France, Paris, Coll. Thoisy, 72, fol. 396f.; Brassat 1992, p. 154.
33. Standen 1981, p. 16.
34. Shearman 1972, pp. 141–43.
35. Bertini 1999; Forti Grazzini 1999; Bertrand 2005, pp. 85–89.
36. *Inventario e descrizzione di tutti gli arazzi posseduti dalla già fu Maestà della Regina Cristina di Svezia* n.d.; Nordenfalk 1966, esp. p. 270.
37. For London, see Hefford 1984. For Germanic centers, Göbel 1933–34, vol. 2, pp. 60–63, 80–85; D. Heinz 1995, pp. 194–96, 320–34.
38. Havinden 1966, pp. 515–16.
39. Hefford 1992, pp. 106–7.
40. Standen 1980; Standen 1985, pp. 717–25.
41. Göbel 1933–34, vol. 2, pp. 80–83; D. Heinz 1995, pp. 193–96.
42. Göbel 1933–34, vol. 2, pp. 60–63.
43. Antoine 1965, pp. 15–46.
44. Lefébure 1995, pp. 190–96.
45. Delmarcel 1999c.
46. Fenaille 1903–23, vol. 2, pp. 323–36.
47. Standen 1988a.
48. Fenaille 1903–23, vol. 3, pp. 1–60; Lefébure 1995, pp. 194–97.
49. Göbel 1933–34, vol. 2, pp. 83–85; D. Heinz 1995, p. 322.
50. Standen 1985, pp. 726–29.
51. Gastinel-Coural 1998a.
52. Forti Grazzini in Colorno 1998, pp. 122–29.
53. De. Montaiglon and Guiffrey 1887–1908, vol. 7, pp. 249–50.
54. De Strobel 1989, pp. 51–74.
55. Göbel 1933–34, vol. 2, pp. 238–39; Korshunova 1975, pp. 5–16, 34–35.
56. Göbel 1933–34, vol. 1, pp. 214–23; D. Heinz 1995, pp. 332–38.
57. Herrero Carretero 2000, pp. 9–39 and seq.
58. For an accessible overview of tapestry production in 18th-century Europe, see Bertrand 1995. For more detail, see Göbel 1923; Göbel 1928; and Göbel 1933–34.

Bibliography

Aarhus

1975 *Tegninger fra det statslige Eremitage-museum og det statslige russiske museum.* Exh. cat., Kunstmuseum. Aarhus.

Acanfora, Elisa

1994 *Alessandro Rosi.* Artisti toscani dal Trecento al Settecento. Florence.

1998a "Firenze (I)." In *Pittura murale in Italia: Il Seicento e il Settecento,* edited by Mina Gregori, pp. 34–41. Bergamo.

1998b "Pittura murale a Firenze dalla reggenza a Ferdinando II de' Medici." In *Pietro da Cortona* 1998, pp. 145–62.

Adelson, Candace J.

1993 "*Apollo and Daphne* from Charles de La Fosse's *Ovid's Fables*: A Series Designed for the Leyniers-Reydams Workshop in Brussels." In *Conservation Research: Studies of Fifteenth- to Nineteenth-Century Tapestry,* edited by Lotus Stack, pp. 35–55. Studies in the History of Art 42; Monograph Series 2. National Gallery of Art. Washington, D.C.

1994 *European Tapestry in the Minneapolis Institute of Arts.* Minneapolis.

Aix-en-Provence

1984 *La Tenture des Anciennes et Nouvelles Indes.* Exh. cat. edited by Marie-Henriette Krotoff. Musée des Tapisseries. Aix-en-Provence.

Albèri, Eugenio

1839–63 Ed. *Relazioni degli ambasciatori veneti al Senato.* 15 vols. Florence.

Aldovini, Laura

2004 "La Chambre de la duchesse d'Étampes, 1541–1544." In *Paris* 2004, pp. 226–30.

Alexander, Margaret A., and Mongi Ennaifer

1973– Eds. *Corpus des mosaïques de Tunisie.* Tunis.

Álvarez Lopera, José

1982 *La política de bienes culturales del gobierno republicano durante la guerra civil española.* 2 vols. Madrid.

L'ambasciata d'Italia a Londra

2003 *L'ambasciata d'Italia a Londra.* Rome.

Amberg

2003 *Der Winterkönig: Friedrich V., der letzte Kurfürst aus der Oberen Pfaltz—Amberg, Heidelberg, Prag, Den Haag.* Exh. cat. edited by Peter Wolf et al. Stadtmuseum Amberg. Augsburg.

Amsterdam

1955 *Le triomphe du Maniérisme européen, de Michel-Ange au Gréco.* Exh. cat., Rijksmuseum. Amsterdam.

1971 *Geweven boeket.* Exh. cat. by Caes A. Burgers and Vibeke Woldbye. Rijksmuseum. Amsterdam.

1993 *Dawn of the Golden Age: Northern Netherlandish Art, 1580–1620.* Exh. cat. edited by Ger Luijten and Ariane van Suchtelen, with contributions by Reinier Baarsen, Wouter Kloek, and Marijn Schapelhouman. Rijksmuseum. Amsterdam and Zwolle.

1998 *Schittering van Spanje, 1598–1648: Van Cervantes tot Velázquez.* Exh. cat. edited by Chris van der Heijden, Marina Alfonso Mola, and Carlos Martínez Shaw. Nieuwe Kerk, Amsterdam. Zwolle.

Anderson, John Eustace

1894 *A Short Account of the Tapestry Works, Mortlake.* Richmond.

Antal, F.

1951 "Italian Fifteenth and Sixteenth-Century Drawings at Windsor Castle." Review of *The Italian Drawings of the XV and XVI Centuries in the Collection of His Majesty the King at Windsor Castle,* by A. E. Popham and Johannes Wilde. *Burlington Magazine* 93 (January), pp. 28–35.

Antoine, Michel

1965 *Les manufactures de tapisserie des ducs de Lorraine au XVIIIe siècle (1698–1737).* Annales de l'Est (Faculté de Lettres et des Sciences Humaines de l'Université de Nancy), Mémoire 26. Nancy.

Antwerp

1977 *P. P. Rubens: Schilderijen, olieverfschetsen, tekeningen.* Exh. cat., Koninklijk Museum voor Schone Kunsten. Antwerp.

1991 *David Teniers de Jonge: Schilderijen, tekeningen.* Exh. cat. by Margret Klinge. Koninklijk Museum voor Schone Kunsten, Antwerp. Ghent.

1993a *Antwerp: Story of a Metropolis, 16th–17th Century.* Exh. cat. edited by Jan van der Stock. Hessenhuis, Antwerp. Ghent.

1993b *Jacob Jordaens (1593–1678).* 2 vols. Vol. 1, *Paintings and Tapestries.* Vol. 2, *Drawings and Prints.* Exh. cat. by Roger-Adolf d'Hulst, Nora De Poorter, and Marc Vandenven. Koninklijk Museum voor Schone Kunsten, Antwerp. Brussels.

1997 *Rubenstextiel / Rubens's Textiles.* Exh. cat. by Guy Delmarcel et al. Hessenhuis. Antwerp.

2004 *Een hart voor boeken: Rubens en zijn bibliotheek.* Exh. cat. edited by Marcus de Schepper. Museum Plantin-Moretus. Antwerp.

Arenfeldt, Pernille

2005 "The Female Consort as Intercessor in 16th-Century Saxony." In *Less Favored, More Favored: Proceedings of a Conference on Gender in European Legal History, 12th–19th Centuries, September 2004,* edited by Grethe Jacobsen, Helle Vogt, Inger Dübeck, and Heide Wunder, chap. 18, pp. 2–5. Copenhagen.

Argente Oliver, José Luis

1995 Ed. *Los tapices de Oncala (Soria).* Valladolid.

Arizzoli-Clémentel, Pierre

1985 "Les envois de la couronne à l'Académie de France à Rome aux XVIIIe siècle." *Revue de l'art,* no. 68, pp. 73–84.

Arras

1996 *La Vierge, le Roi et le ministre: Le décor de choeur de Notre-Dame de Paris au XVIIe siècle.* Exh. cat. edited by Nicolas Sainte-Fare-Garnot. Musée des Beaux-Arts. Arras.

Arriola y de Javier, María Pilar

1976 *Colección de tapices de la Diputación Provincial de Madrid.* Madrid.

"Artemesia Tapestries"

1948 "Artemisia Tapestries from Barberini-Ffoulke Collection Acquired by Art Institute." *Bulletin of the Minneapolis Institute of Arts* 37, no. 24 (October 2), pp. 117–32.

Aschengreen Piacenti, Kirsten

1986 "Le arti decorative alla corte granducale." In *Florence* 1986, vol. 1, pp. 77–78.

Fig. 223. Detail of cat. no. 8, *Night* from a set of the *Months, Seasons, and Times of the Day*

Asselberghs, Jean-Paul, Guy Delmarcel, and Margarita Garcia Calvo

1985 "Un tapissier bruxellois actif en Espagne: François Tons." *Bulletin des Musées Royaux d'Art et d'Histoire / Bulletin van de Koninklijke Musea voor Kunst en Geschiedenis* 56, no. 2, pp. 89–121.

Aumale, Henri d'Orléans, duc d'

1861 *Inventaire de tous les meubles du cardinal Mazarin, dressé en 1653, et publié d'après l'original, conservé dans les archives de Condé.* London.

Avignon

1979 *Mignard d'Avignon (1606–1668).* Exh. cat. by Antoine Schnapper. Palais des Popes, Avignon. [Marseille.]

Ayres, Harry Morgan

1910 "Shakespeare's *Julius Caesar* in the Light of Some Other Versions." *Publications of the Modern Language Association of America* 25, pp. 183–227.

Badin, Jules

1909 *La manufacture de tapisseries de Beauvais depuis ses origines jusqu'à nos jours.* Paris.

Bajou, Thierry

1998 *La peinture à Versailles: XVIIe siècle.* Paris.

Baldass, Ludwig

1920 *Die Wiener Gobelinssammlung.* 3 vols. Issued in 15 pts. Vienna.

Baldinucci, Filippo

1681–1728/ *Notizie dei professori del disegno da Cimabue in qua.* 6 vols. Florence,
1845–47 1681–1728. Rev. ed., edited by Ferdinando Rinalli. 5 vols. Florence, 1845–47. [Reprint of 1845–47 ed., with additional notices and an appendix edited by Paola Barocchi, and an index edited by Antonio Boschetto. 7 vols. Florence, 1974–75.]

Baldinucci, Francesco Saverio

ca. 1725–30/ *Vite di artisti dei secoli XVII–XVIII: Prima edizione integrale del*
1975 *Codice Palatino 565.* [ca. 1725–30.] Transcribed, annotated, and indexed by Anna Matteoli. Raccolta di fonti per la storia dell'arte, 2nd ser., 2. Rome, 1975.

Balis, Arnout, et al.

1993 Arnout Balis, Krista De Jonge, Guy Delmarcel, and Amaury Lefébure. *Les Chasses de Maximilien.* Paris.

Ballon, Hilary

1999 *Louis Le Vau: Mazarin's Collège, Colbert's Revenge.* Princeton.

Bandera, Luisa

1987a "Gillio Mechelaon di Malines: Una proposta per i cartoni delle Storie di Sansone." In Cremona 1987, pp. 75–93.

1987b "Qualche considerazione sulla serie della Vita di Cristo." In Cremona 1987, pp. 94–103.

Bapasola, Jeri

2005 *Threads of History: The Tapestries at Blenheim Palace.* Lydney, Gloucestershire.

Barbera, Gioacchino

1979 "Giovanni Camillo Sagrestani e Ranieri del Pace a Volterra." *Quaderni dell'Istituto di Storia dell'Arte Medievale e Moderna, Università di Messina* 3, pp. 27–31.

Barberini, Urbano

1950 "Pietro da Cortona e l'arazzeria Barberini." *Bollettino d'arte* 35 (January–March), pp. 43–51; (April–June), pp. 145–52.

1968 "Gli arazzi e i cartoni della serie 'Vita di Urbano VIII' della arazzeria Barberini." *Bollettino d'arte* 53 (April–September), pp. 92–100.

Barcelona–Paris

2003 *Dessins de la Renaissance: Collection de la Bibliothèque Nationale de France, Département des Estampes et de la Photographie.* Exh. cat., Fundació Caixa Catalunya, Barcelona; Bibliothèque Nationale de France, Paris. Paris and Barcelona.

Bardon, Françoise

1963 *Diane de Poitiers et le mythe de Diane.* Paris.

Barocchi, Paola, and Giovanna Gaeta Bertelà

2002 Eds. *Collezionismo mediceo e storia artistica.* Vol. 1, *Da Cosimo I a Cosimo II, 1540–1621.* 2 pts. Florence.

2005 Eds. *Collezionismo mediceo e storia artistica.* Vol. 2, *Il cardinale Carlo, Maria Maddalena, Don Lorenzo, Fernando II, Vittoria della Rovere, 1621–1666.* 3 pts. Florence.

Baroni Vannucci, Alessandra

1997 *Jan Van der Straet detto Giovanni Stradano: Flandrus Pictor et Inventor.* Archivi arte antica. Milan.

Barroero, Lilliana

1997 "Giovanni Francesco Romanelli." In Rome 1997, pp. 181–86.

Baschet, Armand

1861–62 "Négociation d'oeuvres de tapisseries de Flandre et de France par le nonce Guido Bentivoglio pour le cardinal Borghèse (1610–1621)." *Gazette des beaux-arts* 11 (November 1), pp. 406–15; 12 (January 1), pp. 32–45.

Basel–Tübingen

1990 *Frans Post, 1612–1680.* Exh. cat. edited by Thomas Kellein and Urs-Beat Frei. Kunsthalle Basel; Kunsthalle Tübingen. Basel and Tübingen.

Bassegoda, Bonaventura

2002 "Pictorial Decoration of the Escorial during the Reign of Philip IV." In Madrid 2002, pp. 107–40.

Batlle Huguet, Pedro

1946 *Los tapices de la catedral primada de Tarragona.* Tarragona.

Battelli, Guido

1922 *Ludovico Cardi, detto il Cigoli.* Florence.

Bauer, Rotraud

1980 "Veränderungen im Inventarbestand der Tapisseriensammlung des Kunsthistorischen Museums in Wien." *Jahrbuch der Kunsthistorischen Sammlungen in Wien* 76, pp. 133–71.

1999 "L'ancienne collection impériale de tapisseries du Kunsthistorisches Museum de Vienne." In *Tapisserie au XVIIe* 1999, pp. 113–26.

2002 "Flämische Teppichweber im deutschsprachigen Raum." In Delmarcel 2002b, pp. 63–89.

Baumstark, Reinhold

1988 *Peter Paul Rubens: Tod und Sieg des römischen Konsuls Decius Mus.* Vaduz.

Bean, Jacob

1986 With the assistance of Lawrence Turčić. *15th–18th Century French Drawings in The Metropolitan Museum of Art.* New York.

Beauvais

1991 *La route du nord: Van der Meulen. Dessins et soies peintes.* Exh. cat. by Laure C.-Starcky and Chantal Gastinel-Coural; foreword by Jean Coural. Galerie Nationale de la Tapisserie, Beauvais. Paris.

1998 *Tapisseries françaises à sujets religieux.* Exh. cat., Galerie Nationale de la Tapisserie, Beauvais. Paris.

2004 *Les amours des dieux: La mythologie dans la tapisserie du XVIIe au XXe siècle.* Exh. cat. by Jean Vittet. Galerie Nationale de la Tapisserie. Beauvais.

Beauvais, Lydia

2000 *Charles Le Brun, 1619–1690.* 2 vols. Inventaire général des dessins du Musée du Louvre. École française. Paris.

Beauvois-Faure, L.

1959 "Gehistorieerde en Groenwerktapijten uit de 17e eeuw in de verzameling van de kathedraal te Burgos." In *Het herfsttij van de Vlaamse tapijtkunst,* pp. 101–8. International Colloquium, October 8–10, 1959. Brussels.

Becatti, Giovanni
1968 "Raffaello e l'Antico." In *Raffaello: L'opera, le fonti, la fortuna*, edited by Mario Salmi, pp. 493–569. Novara.

Béchu, Philippe
1992 "L'hôtel de Sandreville, 26, rue des Francs-Bourgeois." In *La rue des Francs-Bourgeois au Marais*, pp. 234–43. Exh. cat. edited by Béatrice de Andia and Alexandre Gady. Mairie du IIIe arrondissement and Mairie du IVe arrondissement. Paris.

Beckett, Francis
1936 "The Painter Frantz Clein in Denmark." In *Mémoires de l'Académie Royale des Sciences et des Lettres de Danemark*, 7th ser., 5, no. 2, pp. 1–16.

Béguin, Sylvie
1960 *L'école de Fontainebleau: Le maniérisme à la cour de France.* Écoles de la peinture. Paris.
1967 "Guillaume Dumée: Disciple de Dubreuil." In *Studies in Renaissance and Baroque Art Presented to Anthony Blunt on His Sixtieth Birthday*, pp. 91–97. London.
1991 "À propos de Luca Penni." In *Disegno*, pp. 9–18. Actes du Colloque, Musée des Beaux-Arts, Rennes, November 9–10, 1990. Rennes.
1995 "Sixteenth-Century French Drawings." Review of the exhibition "Le dessin en France au XVIe siècle: Dessins et miniatures des collections de l'École des Beaux-Arts," held at the École Nationale Supérieure des Beaux-Arts, Paris; Sackler Gallery, Harvard University Art Museums, Cambridge, Massachusetts; and The Metropolitan Museum of Art, New York. *Burlington Magazine* 137 (March), pp. 192–95.

Belgrade–Ljubljana–Zagreb
1987 *Svetski majstori iz riznica Ermitaža od XV–XVIII veka / Hermitage Masterpieces: Paintings and Drawings, XV–XVIII Century.* Exh. cat., Narodni Muzej, Belgrade; Narodna Galerija, Ljubljana; Muzejski Prostor, Zagreb. Belgrade.

Bellesi, Sandro
2003 *Vincenzo Dandini e la pittura a Firenze alla metà del Seicento.* Pisa.

Bellori, Giovanni Pietro
1672 *Le vite de' pittori, scultori e architetti moderni.* Rome.

Benisovitch, Michael
1943 "The History of the *Tenture des Indes.*" *Burlington Magazine* 83 (September), pp. 216–25.

Bennett, Allis Eaton
1983 Ed. *J. B. Speed Museum Handbook.* Louisville.

Bennett, Anna Gray
1979 Ed. *Acts of the Tapestry Symposium.* Fine Arts Museums of San Francisco, November 20–21, 1976. San Francisco.
1992 *Five Centuries of Tapestry from the Fine Arts Museums of San Francisco.* Exh. cat. Rev. ed. Fine Arts Museums of San Francisco. San Francisco.

Benocci, Carla
1995–96 "Lo sviluppo seicentesco delle ville romane di età sistina: Il giardino della Villa Peretti Montalto e gli interventi nelle altre ville familiari del cardinale Alessandro Peretti Montalto." *L'urbe: Rivista romana*, 3rd ser., 55, no. 6 (November–December), pp. 261–81: pt. 1, "1606–1614"; 56, no. 3 (May–June), pp. 117–31: pt. 2, "1615–fine sec. XVII."

Benzi, Fabio, and Caroline Vincenti Montanaro
1997 *Palazzi di Roma.* I grandi libri. Venice.

Berger, Robert W.
1993 "Pierre Mignard at Saint-Cloud." *Gazette des beaux-arts*, 6th ser., 121 (January), pp. 1–58.

Bern
1948 *Dessins français du Musée du Louvre.* Exh. cat., Kunstmuseum. Bern.

Bernardi, Mariziano
1959 *Il Palazzo Reale di Torino.* Turin.

Bertelli, Sergio
2002 "Palazzo Pitti dai Medici ai Savoia." In *La corte di Toscana dai Medici ai Lorena*, edited by Anna Bellinazzi and Alessandra Contini, pp. 11–109. Atti delle Giornate di Studio Firenze, Archivio di Stato and Palazzo Pitti, December 15–16, 1997. Rome.

Bertini, Giuseppe
1999 "La collection Farnèse d'après les archives." In *Tapisserie au XVIIe siècle* 1999, pp. 127–42.

Bertrand, Pascal-François
1994 "Un grand décor tissé à Rome au XVIIe siècle: La *Vie du Pape Urbain VIII.*" *Mélanges de l'École Française de Rome: Italie et Méditerranée* [MEFRIM] 106, pp. 639–82.
1995 "Le XVIIIe siècle: Un art du décor et de l'ameublement." In Joubert, Lefébure, and Bertrand 1995, pp. 206–61.
1998a "La manifatture reale dei Gobelins e di Beauvais." In Colorno 1998, pp. 30–40.
1998b "Pietro da Cortona e l'arazzo." In Pietro da Cortona 1998, pp. 62–72.
1999 "Usages de la tapisserie à Toulouse au XVIIe siècle." In *Tapisserie au XVIIe siècle* 1999, pp. 89–98.
1999–2000 "*Hic Domus*: Le cardinal Francesco Barberini et le thème de ses premières tapisseries." *Bulletin* (Association des Historiens de l'Art Italien), no. 6, pp. 34–40.
2002 "Apollon, Déborah et les abeilles Barberini." *Filo forme: Quadrimestrale di storia, arte e restauro dei tessili* 3, no. 3, pp. 3–7.
2005 *Les tapisseries des Barberini et la décoration d'intérieur dans la Rome baroque.* Studies in Western Tapestry 2. Turnhout.
2006–7 "A New Method of Interpreting the Valois Tapestries, through a History of Catherine de Médicis." *Studies in the Decorative Arts* 14, no. 1 (Fall–Winter), pp. 27–47.
2007 "Le statut de la tapisserie sous l'Ancien Régime et en particulier aux Gobelins du temps de Louvois (1683–1691)." In *L'objet d'art en France du XVIe et XVIIIe siècles: De la création à l'imaginaire*, edited by Marc Favreau. Actes du Colloque International, Centre François-Georges Pariset, Université Michel de Montaigne, Bordeaux 3, January 12–14, 2006 (forthcoming in 2007). Bordeaux.

Beschreibung der Reiss
1613 *Beschreibung der Reiss, Empfahung dess ritterlichen Ordens, Volbringung des Heyraths und glücklicher Heimführung, wie auch der ansehnlichen Einführung, gehaltener Ritterspiel und Frewdenfests, des durchleuchtigsten, hochgebornen Herrn Friederichen dess Fünften, Pfaltzgraven bey Rhein. . . .* Heidelberg.

"Bibliografía"
1965 "Bibliografía." *Archivo español de arte* 38, pp. 333–74.

Bimbenet-Privat, Michèle
2002 *Les orfèvres et l'orfèvrerie de Paris au XVIIe siècle.* 2 vols. Paris.

Biriukova, Nina
1961 *Les tapisseries de Raphaël de La Planche. Inventaire des collections de l'Ermitage.* N.p.
1974 *Frantsuzskie shpalery kontsa XV–XX veka v sobranii Ermitazha / Les tapisseries françaises de la fin du XVe au XXe siècle dans les collections de l'Ermitage.* Leningrad.
1999 "Les tapisseries françaises du musée de l'Ermitage." In *Tapisserie au XVIIe siècle* 1999, pp. 191–200.

Birk, Ernst Ritter von
1883–84 "Inventar der im Besitze des Allerhöchsten Kaiserhauses befindlichen Niederländer Tapeten und Gobelins." *Jahrbuch der Kunsthistorischen Sammlungen des Allerhöchsten Kaiserhauses* 1 (1883), pp. 213–48; 2 (1884), pp. 167–220.

Birkenholz, Alescha Thomas

2002 *Die Alexander-Geschichte von Charles Le Brun: Historische und stilistische Untersuchungen der Werkentwicklung.* Ars Faciendi 11. Frankfurt am Main and New York. [Originally presented as the author's PhD diss., Universität München, 2000.]

Birmingham

1951 *Exhibition of English Tapestries.* Exh. cat., City of Birmingham Museum and Art Gallery. Birmingham.

Birrell, Francis

1914 "English Tapestries at Boughton House." *Burlington Magazine* 25 (June), pp. 183–89.

Blažková, Jarmila

1957 *Wandteppice aus tschechoslowakischen Sammlungen.* Prague.

1959 "Les tapisseries de Jacob Jordaens dans les châteaux tchécoslovaques." In *Het herfsttij van de Vlaamse tapijtkunst,* pp. 69–95. International Colloquium, October 8–10, 1959. Brussels.

1965 "Die Tapisserien des Erzherzogs Leopold Wilhelm und ihre Schicksale." *Alte und moderne Kunst,* no. 83 (November–December), pp. 13–19.

1975 *Tapiserie XVI.–XVIII. století v Uměleckoprůmyslovém Muzeu v Praze.* Prague.

1978 "Les tapisseries de Décius Mus en Bohême." *Artes textiles* 9, pp. 49–74.

1981 "Deux tentures des Mois à Prague." *Artes textiles* 10, pp. 203–20.

Blažková, Jarmila, and Erik Duverger

1970 *Les tapisseries d'Octavio Piccolomini et le marchand anversois Louis Malo.* Interuniversitair Centrum voor de Geschiedenis van de Vlaamse Tapijtkunst, Verhandelingen en bouwstoffen 2. Sint Amandsberg.

Blažková, Jarmila, and Olga Květoňová

1959–60 "Antoine et Cléopâtre: Histoire d'un achat de tapisseries à Bruxelles en 1666." *Artes textiles* 5, pp. 63–77.

Bloemendal, Jan

2001 "Tyrant or Stoic Hero? Marc-Antoine Muret's *Julius Caesar.*" In *Recreating Ancient History: Episodes from the Greek and Roman Past in the Arts and Literature of the Early Modern Period,* edited by Karl A. E. Enenkel, Jan L. de Jong, and Jeanine de Landtsheer, pp. 303–18. Intersections 1. Leiden.

Bluche, François

1986 *Louis XIV.* Paris.

Blunt, Anthony, and Hereward Lester Cooke

1960 *The Roman Drawings of the XVII and XVIII Centuries in the Collection of Her Majesty the Queen at Windsor Castle.* The Italian Drawings at Windsor Castle. London.

Bober, Phyllis Pray, and Ruth Rubinstein

1987 *Renaissance Artists and Antique Sculpture: A Handbook of Sources.* Rev. ed. London and Oxford.

Boccara, Dario

1971 *Les belles heures de la tapisserie.* Zoug (Switzerland).

Boccara, Jacqueline

1988 With Séverine Reyre and Monelle Hayot. *Âmes de laine et de soie.* Saint-Just-en-Chaussée.

Boccardo, Piero

1999 "Découvertes à propos de l'*Histoire de Diane* de Toussaint Dubreuil." In *Tapisserie au XVIIe siècle* 1999, pp. 51–60.

2006 "Prima qualità 'di seconda mano': Vicende dei *Mesi* di Mortlake e di altri arazzi e cartoni fra l'Inghilterra e Genova." In *Genova e l'Europa atlantica: Opere, artisti, committenti, collezionisti—Inghilterra, Fiandra, Portogallo,* edited by Piero Boccardo and Clario Di Fabio, pp. 182–85. Genova e l'Europa. Cinisello Balsamo (Milan).

Bochius, Joannes

1602 *Historica narratio profectionis et inaugurationis Serenissimorum Belgii Principum Alberti et Isabellae, Austriae Archiducum.* Antwerp.

Boesen, Gudmund

1949 With the assistance of Preben Holck and Elisabeth Schmedes. *Christian den Femtes Robenborgtapeter fra den Skaanske krig.* Copenhagen.

Bogota

1986 *Dibujos de maestros europeos de los siglos XV al XVIII: Colección del Museo Estatal Ermitage de Leningrado.* Exh. cat., Museo de Arte Moderno. Bogota.

Bonn

1997 *Zwei Gesichter der Eremitage: Von Caravaggio bis Poussin.* 2 vols. Exh. cat., Kunst- und Ausstellungshalle der Bundesrepublik Deutschland. Bonn.

Bonn–Vienna

2000 *Der Kriegszug Kaiser Karls V. gegen Tunis: Kartons und Tapisserien.* Exh. cat. by Wilfried Seipel. Kunst- und Ausstellungshalle der Bundesrepublik Deutschland, Bonn; Kunsthistorisches Museum, Vienna. Milan.

Bonnet-Laborderie, Philippe

1982 *Les tapisseries de la cathédrale de Beauvais.* Beauvais. Issue of *Bulletin* (Group d'Études des Monuments et Oeuvres d'Art de l'Oise et du Beauvais [G.E.M.O.B.]), nos. 14–15 (1982).

Van den Boogaart, E., Hendrik Richard Hoetink, and Peter James Palmer Whitehead

1979 Eds. *Johan Maurits van Nassau-Siegen, 1604–1679: A Humanist Prince in Europe and Brazil. Essays on the Occasion of the Tercentenary of His Death.* The Hague.

Borghini, Raffaello

1584/1967 *Il Riposo.* Florence, 1584. Reprint, with bio- and bibliographical essay and index by Mario Rosci. 2 vols. Gli storichi della letteratura artistica italiana 13, 14. Milan, 1967.

Böttiger, John

1895–98 *Svenska statens samling af väfda tapeter: Historisk och beskrifvande förteckning.* 4 vols. Vol. 4, *Résumé de l'édition suédoise,* translated by Gaston Lévy-Ullmann. Stockholm.

1928 *Tapisseries à figures des XVIe et XVIIe siècles appartenent à des collections privées de la Suède: Inventaire descriptif.* Stockholm.

Bottineau, Yves

1954 "La cour de Louis XIV à Fontainebleau." *XVIIe siècle,* no. 24, pp. 697–734.

Bourdon, Sébastien

1669/1996 "Sur la lumière (9 février 1669)." In *Les conférences de l'Académie Royale de Peinture et de Sculpture au XVIIe siècle,* edited by Alain Mérot, pp. 169–80. Collection Beaux-Arts histoire. Paris, 1996.

Bourg-en-Bresse–Montélimar–Roanne

1990 *Tapisseries anciennes en Rhône-Alpes.* Exh. cat. by François-Pascal Bertrand et al. Musée de Brou, Bourg-en-Bresse; Château des Adhémar, Montélimar; Musée Déchelette, Roanne. Bourg-en-Bresse.

Bournon, Fernard

1880–81 "Présent fait par la ville de Paris à la reine Marie de Médicis à cause de la naissance d'un Dauphin d'une tapisserie de l'histoire de Scipion." *Nouvelles archives de l'art français,* 2nd ser., 2, pp. 309–10.

Boyer, Ferdinand

1930 "Deux amateurs romains de tapisseries françaises: Le cardinal de Montalte et le cardinal Borghèse (1606–1609)." *Bulletin de la Société de l'Histoire de l'Art Français,* pp. 23–35.

Boyer, Jean-Claude

1996 "Louvois surintendant des Bâtiments: Quelques réflexions." *Histoire, économie et société* 15 (January–March), pp. 21–35.

Van den Branden, Franz Josef Peter

1883 *Geschiedenis der Antwerpsche schilderschool.* 2 vols. Antwerp.

Brassat, Wolfgang

1992 *Tapisserien und Politik: Funktionen, Kontexte und Rezeption eines repräsentativen Mediums.* Berlin.

1993 "Monumentaler Rapport des Zeremoniells: Charles Le Bruns 'Histoire du Roy.'" *Städel-Jahrbuch,* n.s., 14, pp. 251–88.

1997 "'Les exploits de Louis sans qu'en rien tu les changes': Charles Perrault, Charles Le Brun und das Historienbild der 'Modernes.'" In *Bilder der Macht—Macht der Bilder: Zeitgeschichte in Darstellungen des 19. Jahrhunderts,* edited by Stefan Germer and Michael F. Zimmermann, pp. 125–39. Veröffentlichungen des Zentralinstituts für Kunstgeschichte 12. Munich.

2002 *Die Raffael-Gobelins in der Kunstakademie München.* Schriftenreihe der Akademie der Bildenden Künste München. Munich.

Brejon de Lavergnée, Arnauld

2000 "L'inventaire après décès de Simon Vouet (3 juillet–21 août 1649)." In *Le Livre et l'art: Études offertes en hommage à Pierre Lelièvre,* edited by Thérèse Kleindienst, pp. 253–91. Paris and Villeurbanne.

Brejon de Lavergnée, Barbara

1984 "Contribution à la connaissance des décors peints à Paris et en Île-de-France au XVIIe siècle: Le cas de Michel Dorigny." *Bulletin de la Société de l'Histoire de l'Art Français* (1982; pub. 1984), pp. 69–84.

1987 *Dessins de Simon Vouet, 1590–1649.* Inventaire général des dessins, École française. Cabinet des Dessins, Musée du Louvre. Paris.

Bremer-David, Charissa

1984 "Set of Five Tapestries." In "Acquisitions Made by the Department of Decorative Arts in 1983." *J. Paul Getty Museum Journal* 12, pp. 173–81.

1994 "*Le Cheval Rayé:* A French Tapestry Portraying Dutch Brazil." *J. Paul Getty Museum Journal* 22, pp. 21–29.

1997 *French Tapestries and Textiles in the J. Paul Getty Museum.* Los Angeles.

2002 "Tapestries in the Wernher Collection." *Apollo* 155 (May), pp. 29–34.

Brenninkmeijer-de Rooij, Beatrijs

1996 *Roots of Seventeenth-Century Flower Painting: Miniatures, Plant Books, Paintings.* Edited by Rudolf E. O. Ekkart. Leiden.

Brière, Gaston

1951 With Marguerite Lamy. "Inventaires du logis de Simon Vouet dans la Grande Galerie du Louvre (1639 et 1640)." *Mémoires* (Fédération des Sociétés Historiques et Archéologiques de Paris et de l'Île-de-France) 3, pp. 117–72.

Briganti, Giuliano

1951 "Milleseicentotrenta, ossia il Barocco." *Paragone,* no. 13 (January), pp. 8–17.

1982 *Pietro da Cortona; o, Della pittura barocca.* 2nd ed., augmented. Florence.

Brive-la-Gaillard

1989 *Tapisseries françaises des XVIIe et XVIIIe siècles.* Exh. cat. by Dominique Chevalier and Nicole de Pazzis-Chevalier. Galeries du Théâtre Municipal, Brive-la-Gaillarde. Paris.

Brosens, Koenraad

2002 "Brussels Tapestry Producer Judocus de Vos (1661/62–1734): New Data and Design Attributions." *Studies in the Decorative Arts* 9, no. 2 (Spring–Summer), pp. 58–86.

2003 Ed. *Flemish Tapestry in European and American Collections: Studies in Honour of Guy Delmarcel.* Turnhout.

2003–4 "Charles Le Brun's *Meleager and Atalanta* and Brussels Tapestry, c. 1675." *Studies in the Decorative Arts* 11, no. 1 (Fall–Winter), pp. 5–37.

2004a *A Contextual Study of Brussels Tapestry, 1670–1770: The Dye Works and Tapestry Workshop of Urbanus Leyniers (1674–1747).* Verhandelingen van de Koninklijke Vlaamse Academie van België voor Wetenschappen en Kunsten, n.s., 13. Brussels.

2004b "La serie di Chinoiserie del Duca di Arenberg tessuta a Bruxelles dall'arazziere Judocus de Vos." *Filo forme: Quadrimestrale di storia, arte e restauro dei tessili* 4, no. 9, pp. 3–6.

2004c "The Organisation of Seventeenth-Century Tapestry Production in Brussels and Paris." *De zeventiende eeuw* 20, pp. 264–84.

2005a "The *Maîtres et Marchands Tapissiers* of the *Rue de la Verrerie:* Marketing Flemish and French Tapestry in Paris around 1725." *Studies in the Decorative Arts* 12, no. 2 (Spring–Summer), pp. 2–25.

2005b "Nouvelles données sur l'*Histoire de Cléopâtre* de Poerson: Le réseau parent et la tapisserie bruxelloise à la française." *Revue belge d'archéologie et d'histoire de l'art / Belgisch tijdschrift voor oudheidkunde en kunstgeschiedenis* 74, pp. 63–77.

2005c "The 'Story of Psyche' in Brussels Tapestry, c. 1700: New Information on Jan van Orley, Jan-Baptist Vermillion and Victor Janssens." *Burlington Magazine* 147 (June), pp. 401–6.

2005d "Don Quijote y Compañía: Los mercados europeos de tapices en el siglo XVIII / Don Quixote & Co.: European Markets for Eighteenth-Century Tapestry." In *Don Quijote: Tapices españoles del siglo XVIII / 18th Century Spanish Tapestries,* pp. 151–81. Exh. cat., Meadows Museum, Dallas; Museo de Santa Cruz, Toledo. Madrid.

2005–6 Review of Hartkamp-Jonxis and Smit 2004. *Studies in the Decorative Arts* 13, no. 1 (Fall–Winter), pp. 122–25.

2006–7 "Eighteenth-Century Brussels Tapestry and the *Goût Moderne:* Philippe de Hondt's Series Contextualized." *Studies in the Decorative Arts* 14, no. 1 (Fall–Winter), pp. 53–79.

2007a "Autour de la rue Saint-Martin: Nouvelles données sur les importations et la distribution des tapisseries flamandes à Paris, 1600–1650." In *L'objet d'art en France du XVIe au XVIIIe siècle: De la création à l'imaginaire,* edited by Marc Favreau. Actes du Colloque International, Centre François-Georges Pariset, Université Michel de Montaigne, Bordeaux 3, January 12–14, 2006 (forthcoming in 2007). Bordeaux.

2007b "Bruxelles / Paris / Bruxelles: Charles de La Fontaine et la diffusion des modèles des tapisseries de Charles Poerson, 1650–1675." *Revue belge d'archéologie et d'histoire de l'art / Belgisch tijdschrift voor oudheidkunde en kunstgeschiedenis* 76 (forthcoming).

2007c "'The Story of Theodosius the Younger': A Rediscovered Tapestry Set by Jordaens and His Studio." *Burlington Magazine* 149 (June), pp. 376–82.

Brosens, Koenraad, and Guy Delmarcel

1998 "Les aventures de Don Quichotte: Tapisseries bruxelloises de l'atelier Leyniers-Reydams." *Revue belge d'archéologie et d'histoire de l'art / Belgisch tijdschrift voor oudheidkunde en kunstgeschiedenis* 67, pp. 55–92.

Brotton, Jerry

2006 *The Sale of the Late King's Goods: Charles I and His Art Collection.* London.

Brown, Clifford M., and Guy Delmarcel

1996 With the collaboration of Anna Maria Lorenzoni. *Tapestries for the Courts of Federico II, Ercole, and Ferrante Gonzaga, 1522–63.* Seattle.

Brown, Jonathan

1991 *The Golden Age of Painting in Spain.* New Haven.

1995 *Kings & Connoisseurs: Collecting Art in Seventeenth-Century Europe.* Bollingen Series, 35, 43. Andrew Mellon Lectures in the Fine Arts, 1994. Princeton.

2002a "Artistic Relations between Spain and England, 1604–1655." In Madrid 2002, pp. 41–68.

2002b Ed. "Documents Relating to the Charles I Sale in the Archivo de la Casa de Alba [ACA]." Transcribed by Beatriz Mariño. In Madrid 2002, pp. 278–97.

Brown, Jonathan, and John Huxtable Elliott
1980 *A Palace for a King: The Buen Retiro and the Court of Philip IV.* New Haven.
2003 *A Palace for a King: The Buen Retiro and the Court of Philip IV.* Rev. ed. New Haven.

Bruges
1980 *Zilver & wandtapijten: Catalogus.* Exh. cat. by Valentin Vermeersch. Gruuthusemuseum. Bruges.
1987 *Bruges et la tapisserie.* Exh. cat. by Guy Delmarcel and Erik Duverger. Musée Gruuthuse and Musée Memling. Bruges.

Brussels
1882 *L'art ancien à l'exposition nationale belge.* Exh. cat. Brussels.
1977 *Tapisseries bruxelloises au siècle de Rubens du Kunsthistorisches Museum, Vienne, and des Musées Royaux d'Art et d'Histoire, Bruxelles.* Exh. cat. by Rotraud Bauer and Guy Delmarcel. Musées Royaux d'Art et d'Histoire. Brussels.
1985 *Splendeurs d'Espagne et les villes belges, 1500–1700.* 2 vols. Exh. cat. edited by Jean-Marie Duvosquel and Ignace Vandevivere. Palais des Beaux-Arts. Brussels.

Brussels–Rotterdam–Paris
1949 *Le dessin français de Fouquet à Cézanne.* Exh. cat., Palais des Beaux-Arts, Brussels; Museum Boymans, Rotterdam; Musée de l'Orangerie, Paris. Paris.

Buchanan, Iain
1994 "Michiel de Bos and the Tapestries of the 'Labours of Hercules' after Frans Floris (c. 1565): New Documentation on the Tapestry Maker and the Commission." *Revue belge d'archéologie et d'histoire de l'art / Belgisch tijdschrift voor oudheidkunde en kunstgeschiedenis* 63, pp. 37–61.
2006 "The Contract for King Philip II's Tapestries of the 'History of Noah.'" *Burlington Magazine* 148 (June), pp. 406–15.

Van Buchell, Arend
1907 *Diarium van Arend van Buchell.* Historisch Genootschap (Utrecht), Werken. Amsterdam.

Buckland, Frances
1983 "Gobelins Tapestries and Paintings as a Source of Information about the Silver Furniture of Louis XIV." *Burlington Magazine* 125 (May), pp. 271–83.

Buenos Aires
1986 *Dibujos de los maestros de Europa occidental de los siglos XV al XVIII: Colección del Ermitage de Leningrado.* Exh. cat., Museo Nacional de Arte Decorativo. Buenos Aires.

Buffa, Sebastian
1983 Ed. *Antonio Tempesta.* The Illustrated Bartsch 36 (formerly 17, pt. 3). New York.
1984 Ed. *Antonio Tempesta.* The Illustrated Bartsch 35 (formerly 17, pt. 2). New York.

Bull, Malcolm
2005 *The Mirror of the Gods.* New York.

Bulst, Wolfger A.
2003 "*Sic itur ad astra*: L'iconografia degli affreschi di Pietro da Cortona a Palazzo Pitti." In *Palazzo Pitti: La reggia rilevata*, pp. 240–65. Exh. cat. edited by Gabriella Capecchi. Palazzo Pitti. Florence.

Bürger, Kathrin
2002 "'. . . wo sich Pferde bäumen, wo der Kampf . . . wütet . . .': Philips Wouwerman als Schlachtenmaler." *Weltkunst* 72, no. 9 (September 15), suppl., pp. 1414–17.

Burke, Marcus B.
2002 "Luis de Haro as Minister, Patron and Collector of Art." In Madrid 2002, pp. 87–105.

Burke, Marcus B., and Peter Cherry
1997 *Collections of Paintings in Madrid, 1601–1755.* Edited by Maria L. Gilbert. 2 vols. Documents for the History of Collecting. Spanish Inventories. Los Angeles.

Burke, Peter
1992 *The Fabrication of Louis XIV.* New Haven. Also published as *Louis XIV: Les stratégies de la gloire.* Translated by Paul Chemla. Paris, 1995.

Burresi, Mariagiulia, and Giovanna Piancastelli Politi Nencini
1994 *Pieter de Witte: Un pittore fiammingo a Volterra nel Cinquecento.* Volterra.

Buschbeck, Ernst, and Erich Strohmer
1949 *Art Treasures from Vienna.* Edited by Alfred Stix. New York.

Busse, Kurt Heinrich
1911 "Manierismus und Barockstil: Ein Entwicklungsproblem der florentinischen Seicentomalerei, dargestellt an dem Werk des Lodovico Cardi da Cigoli." PhD diss., Philosophischen Fakultät der Universität, Leipzig.

Buvelot, Quentin
2004 Ed. *Albert Eckhout: Een Hollandse kunstenaar in Brazilië.* Exh. cat., Mauritshuis, The Hague. The Hague and Zwolle. Also published as *Albert Eckhout: A Dutch Artist in Brazil.* The Hague and Zwolle.

Calberg, Marguerite
1959 "Hommage au pape Urbain VIII: Tapisserie de la manufacture Barberini à Rome, XVIIe siècle (après 1663)." *Bulletin des Musées Royaux d'Art et d'Histoire / Bulletin van de Koninklijke Musea voor Kunst en Geschiedenis* 31, pp. 99–110.

Calendar of State Papers, Colonial Series
1860–1969 *Calendar of State Papers, Colonial Series . . . Preserved in the Public Record Office. . . .* Edited by William Noel Sainsbury et al. 44 vols. London.

Calendar of State Papers, Domestic Series
1860–1938 *Calendar of State Papers, Domestic Series, of the Reign of Charles II, 1660–1685, Preserved in the State Paper Department of Her Majesty's Public Record Office.* Edited by Mary Anne Everett Green. 28 vols. London.

Calvert, Albert Frederick
1921 *The Spanish Royal Tapestries.* The Spanish Series. London.

Cambini, Giacinta
2001 "Gli arazzi fiamminghi di Palazzo Mansi." In *Lucca, città d'arte e i suoi archivi: Opere d'arte e testimonianze documentarie dal Medioevo al Novecento*, edited by Max Seidel and Romano Silva, pp. 333–88. Collana del Kunsthistorisches Institut in Florenz 5. Venice.

Campbell, Ian
2004 *Ancient Roman Topography and Architecture.* 3 vols. Paper Museum of Cassiano del Pozzo, series A, Antiquities and Architecture, pt. 9. London.

Campbell, Malcolm
1977 *Pietro da Cortona at the Pitti Palace: A Study of the Planetary Rooms and Related Projects.* Princeton Monographs in Art and Archaeology 41. Princeton.

Campbell, Thomas P.
1987 "A Consideration of the Career and Work of Francis Clein (including a Survey of Tapestry Designs Used at Mortlake Whilst Clein Was Artistic Director)." Master's thesis, Courtauld Institute of Art, London.

1994 "William III and 'The Triumph of Lust': The Tapestries Hung in the King's State Apartments in 1699." *Apollo* 140 (August), pp. 22–31.

1996a "Henry VIII and the Château of Écouen History of David and Bathsheba Tapestries." *Gazette des beaux-arts*, 6th ser., 128 (October), pp. 121–40.

1996b "School of Raphael Tapestries in the Collection of Henry VIII." *Burlington Magazine* 138 (February), pp. 69–78.

1997 "The National Trust Tapestry Collection." In *Textiles in Trust*, edited by Ksynia Marko, pp. 147–55. Proceedings of the symposium at Blickling Hall, Norfolk, September 1995. London.

1998 "New Light on a Set of History of Julius Caesar Tapestries in Henry VIII's Collection." *Studies in the Decorative Arts* 5, no. 2 (Spring–Summer), pp. 2–39.

2003 "The *Story of Abraham* Tapestries at Hampton Court Palace." In Broesens 2003, pp. 59–85.

2004a "The Gathering of Manna, by Allesandro Allori." In "Recent Acquisitions: A Selection, 2003–2004." *The Metropolitan Museum of Art Bulletin* 62, no. 2 (Fall), p. 17.

2004b "New Evidence on 'Triumphs of Petrarch' Tapestries in the Early Sixteenth Century." *Burlington Magazine* 146 (June), pp. 376–85: pt. 1, "The French Court"; 146 (September), pp. 602–8: pt. 2, "The English Court."

2006 "Karel van Mander the Elder: *The Liberation of Oriane*." In "Recent Acquisitions: A Selection, 2005–2006." *The Metropolitan Museum of Art Bulletin* 64, no. 2 (Fall), pp. 32–33.

2007 *Henry VIII and the Art of Majesty: Tapestries at the Tudor Court.* New Haven.

Caneva, Caterina

2000 "Arazzi agli Uffizi." In *Meraviglie tessute della Galleria degli Uffizi: Il restauro di tre arazzi medicei*, pp. 13–25. Exh. cat. edited by Clarice Innocenti, with Gianna Bacci. Galleria degli Uffizi. Florence.

Cantarel-Besson, Yveline

1992 *Musée du Louvre (janvier 1797–juin 1798): Procès-verbaux du Conseil d'Administration du "Musée Central des Arts."* Notes et documents des musées de France 24. Paris.

Cardella, Lorenzo

1793 *Memorie storiche de' cardinali della Santa Romana Chiesa.* Vol. 5. Rome.

Cardi, Giovanni Battista

before 1628/ "Vita di Lodovico Cigoli." MS 2660, Gabinetto Disegni e
1974–75 Stampe degli Uffizi, Florence. [Before 1628.] In Filippo Baldinucci, *Notizie dei professori del disegno da Cimabue in qua*, vol. 7, app., edited by Paola Barocchi, pp. 40–64. 7 vols. Florence, 1974–75. [Vols. 1–5 reprinted from the 1845–47 edition edited by Ferdinando Rinalli.]

Carrillo, Juan

1616 *Relación histórica de la Real Fundación del Monasterio de las Descalças de S. Clara de la Villa de Madrid. Confesor de la dicha casa . . . dirigida al Rey don Felipe III, nuestro señor.* Madrid.

Casa Buonarroti

1993 *Casa Buonarroti: Il museo.* Casa Buonarroti, Florence. Milan.

Castelluccio, Stéphane

1998 "Les 'Conquestes du Roy' du château de Marly." In Dijon–Luxembourg 1998, pp. 220–31.

Cataldi Gallo, Marzia

2003 "The Sauli Collection: Two Unpublished Letters and a Portrait by Orazio Gentileschi." *Burlington Magazine* 145 (May), pp. 345–53.

Cavallo, Adolfo Salvatore

1957 "Notes on the Barberini Tapestry Manufactory at Rome." *Bulletin of the Museum of Fine Arts, Boston* 55, pp. 17–26.

1967 *Tapestries of Europe and Colonial Peru in the Museum of Fine Arts, Boston.* 2 vols. Boston.

1986 *Textiles: Isabella Stewart Gardner Museum.* Boston.

Cavazzini, Patrizia

1993 "New Documents for Cardinal Alessandro Peretti Montalto's Frescoes at Bagnaia." *Burlington Magazine* 135 (May), pp. 316–27.

Cecchi, Alessandro

1999 "La collezione di quadri di Villa Medici." In Rome 1999, pp. 58–65.

Cederlöf, Ulf, et al.

1986 *Kung Sol i Sverige.* Nationalmusei utställningskatalog 490. Stockholm.

Cetto, Anna Maria

1966 "Der Berner Traian- und Herkinbald-Teppich." *Jahrbuch des Bernischen Historischen Museums in Bern* 80 (1963–64; pub. 1966), pp. 9–230.

Cetto, Anna Maria, and Paul Hofer

1964 *Das Beatrice von Wattenwyl-Haus in Bern.* Bern.

Chambord

1996 *Lisses et délices: Chefs-d'oeuvre de la tapisserie de Henri IV à Louis XIV.* Exh. cat., Château de Chambord (Loir-et-Cher). Paris.

Chandler, David G.

1976 *The Art of Warfare in the Age of Marlborough.* London.

1989 *Marlborough as Military Commander.* 3rd ed. Speldhurst.

Chantelou, Paul Fréart de

1665/1985 *Diary of the Cavaliere Bernini's Visit to France.* [1665.] Edited by Anthony Blunt. Annotated by George C. Bauer. Translated by Margery Corbett. Princeton, 1985.

1665/2001 *Journal de voyage du cavalier Bernin en France.* [1665.] Edited by Milovan Stanić. Paris, 2001.

Chappell, Miles L.

1989 "On Some Drawings by Cigoli." *Master Drawings* 27 (Autumn), pp. 195–214.

1998 "Renascence of the Florentine Baroque." *Dialoghi di storia dell'arte* 7 (December), pp. 56–111.

Château de Coppet

1962 *Les Gobelins (1662–1962): Trois siècles de tapisserie française.* Exh. cat., Château de Coppet. Coppet.

Chevalier, Dominique, Pierre Chevalier, and Pascal-François Bertrand

1988 *Les tapisseries d'Aubusson et de Felletin, 1457–1791.* Paris.

Chiarelli, Caterina, and Giovanna Giusti

2006 "Gli arazzi dei Granduchi: Un patrimonio da non dimenticare." In *Gli arazzi dei Granduchi: Un patrimonio da non dimenticare*, pp. 5–13. Exh. cat. edited by Caterina Chiarelli, Giovanna Giusti, and Lucia Meoni. Galleria degli Uffizi, Florence. Livorno.

Chiarini, Marco

1998 "The Thirty Years' War and Its Influence on Battle Painting in the Seventeenth and Eighteenth Centuries." In *1648: War and Peace in Europe*, vol. 2, *Art and Culture*, pp. 485–91. Exh. cat. edited by Klaus Bussmann and Heinz Schilling. Westfälische Landesmuseum. Münster.

Chiarini, Marco, and Serena Padovani

2003 Eds. *La Galleria Palatina e gli appartamenti reali di Palazzo Pitti: Catalogo dei dipinti.* 2 vols. Florence.

Childs-Johnson, Elizabeth

1998 "The Metamorphic Image: A Predominant Theme in the Ritual Art of Shang China." *Bulletin* (Östasiatiska Museet, Stockholm), no. 70, pp. 5–171.

Christ, Karl

1994 *Caesar: Annäherungen an einen Diktator.* Munich.

"La chronique des arts"
1967 "La chronique des arts." *Gazette des beaux-arts*, 6th ser., 69 (February), suppl., pp. 1–148.

Ciatti, Marco, and Elisabetta Avanzati
1990 "Gli arazzi." In *Il palazzo della provincia a Siena*, edited by Fabio Bisogni, pp. 271–304. Rome.

Clark, Jane
1983 "A Set of Tapestries for Leicester House in the Strand: 1585." *Burlington Magazine* 125 (May), pp. 283–84.

Cleland, Elizabeth
2007 "An *Exemplum Iustitiae* and the Price of Treason: How the Legend of Herkinbald Reached Henry VIII's Collection." In *Late Gothic England: Art and Display*, edited by Richard Marks, pp. 48–56. Proceedings of the conference "Gothic: Art for England, 1400–1547," at the Victoria and Albert Museum, London, November 21–23, 2003. Donington, Lincolnshire, and London.

Clément, Pierre
1861–82 Jean-Baptiste Colbert. *Lettres, instructions et mémoires de Colbert.* Edited by Pierre Clément. 7 vols. in 9. Paris.

Clifford, Timothy
1976 "Polidoro and English Design." *Connoisseur* 192 (August), pp. 282–91.

Coekelberghs, Denis
1976 *Les peintres belges à Rome de 1700 à 1830.* Études d'histoire de l'art 3. Brussels and Rome.

Colbert, Jean-Baptiste
1861–82 *Lettres, instructions et mémoires de Colbert.* Edited by Pierre Clément. 7 vols. in 9. Paris.

Cologne
1977 *Peter Paul Rubens, 1577–1640.* Vol. 2, *Maler mit dem Grabstichel: Rubens und die Druckgraphik.* Exh. cat. edited by Wolfgang Vomm. Kunsthalle. Cologne.

Cologne–Antwerp–Vienna
1992 *Van Bruegel tot Rubens: De Antwerpse schilderschool, 1550–1650.* Exh. cat., Wallraf-Richartz-Museum, Cologne; Koninklijk Museum voor Schone Kunsten, Antwerp; Kunsthistorisches Museum, Vienna. Antwerp.

Colorno
1998 *Gli arazzi dei Farnese e dei Borbone: Le collezioni dei secoli XVI–XVIII.* Exh. cat. edited by Giuseppe Bertini and Nello Forti Grazzini. Palazzo Ducale, Colorno. Milan.

Compin, Isabelle, and Anne Roquebert
1986 *Catalogue sommaire illustré des peintures du Musée du Louvre et du Musée d'Orsay.* Vols. 3–5. Paris.

Complete Guides to Warwick
1826 *Complete Guides to Warwick and Its Castle, Kenilworth Castle, Stratford-upon-Avon, Coventry and Leamington Spa.* Warwick and Leamington.

de Conihout, Isabelle, and Patrick Michel
2006 Eds. *Mazarin: Les lettres et les arts.* Saint-Remy-en-l'Eau.

Connors, Joseph
1998 Review of the exhibitions "Pietro da Cortona, 1597–1669," Palazzo Venezia, Rome, and "Pietro da Cortona e il disegno," Istituto Nazionale per la Grafica and the Accademia Nazionale di San Luca, Rome. *Journal of the Society of Architectural Historians* 57 (September), pp. 318–21.

Conti, Cosimo
1875 *Ricerche storiche sull'arte degli arazzi in Firenze.* Florence. [Reprint, with a preface by Alberto Busignani. Sansoni antiquaria. Florence, 1985.]

Contini, Roberto
1986 "Agostino Melissi (Firenze 1616?–1683)." In Florence 1986, vol. 3, pp. 123–26.
1991 *Il Cigoli.* Mensili d'arte 6. Soncino.

Coolidge, John
1966 "Louis XIII and Rubens: The Story of the Constantine Tapestries." *Gazette des beaux-arts*, 6th ser., 67 (May–June), pp. 271–92.

Copenhagen
1969 *Hollandsk buket.* Exh. cat. Introduction by Vibeke Woldbye. Kunstindustrimuseet. Copenhagen.
1975 *Tegninger fra det statslige Eremitage-museum og det statslige russiske museum i Leningrad.* Exh. cat., Thorvaldsens Museum. Copenhagen.

Copenhagen and other cities
1988 *Christian IV and Europe: The 19th Art Exhibition of the Council of Europe, Denmark 1988.* Exh. cat. edited by Steffen Heiberg. Nationalmuseet, Copenhagen, and other locations in Denmark. Copenhagen.

Coquery, Emmanuel
1996 "Michel Corneille le père (vers 1603–1664) et la tapisserie." *Bulletin de la Société de l'Histoire de l'Art Français* (1995; pub. 1996), pp. 69–98.
2002 "La tapisserie et ses bordures." In Paris 2002, pp. 149–53.
2003 "*Les Attributs de la Marine,* d'après Jean Berain et Jean Lemoine: Une tenture d'exception entre dans les collections du Louvre." *Revue du Louvre / La revue des musées de France* 53 (December), pp. 56–67.

Cordellier, Dominique
1987 "Toussaint Dubreuil: 'Singulier en son art.'" *Bulletin de la Société de l'Histoire de l'Art Français* (1985; pub. 1987), pp. 7–33.

Cordey, Jean
1922 "La manufacture de tapisseries de Maincy." *Bulletin de la Société de l'Histoire de l'Art Français,* pp. 38–52.
1926 "Un manuscrit à miniatures du XVIIe siècle: 'Devises pour les tapisseries du Roy.'" *Bulletin de la Société de l'Histoire de l'Art Français,* pp. 84–90.

Cornette, Joël
1993 *Le roi de guerre: Essai sur la souveraineté dans la France du Grand Siècle.* Bibliothèque historique Payot. Paris.
1996 "La tente de Darius." In *L'état classique: Regards sur la pensée politique de la France dans le second XVIIe siècle,* edited by Henri Méchoulan and Joël Cornette, pp. 9–41. Histoire des idées et des doctrines. Paris.

Corrêa do Lago, Pedro, and Bia Corrêa do Lago
2007 *Frans Post, 1612–1680: Catalogue raisonné.* Milan.

Cortés Hernández, Susana
1996 "Una serie de tapices de 'La Apoteosis de la Eucaristía y los obispos toledanos' de la catedral de Toledo." *Reales sitios,* no. 130, pp. 54–64.

Cosnac, Gabriel-Jules, comte de
1884 *Les richesses du Palais Mazarin.* Paris.

Costa, V.
1981 "Les peintres cartonniers de tapisseries." *L'estampille,* no. 139 (November), pp. 38–49.

Costamagna, Alba
2001 "La cupola di Sant'Andrea della Valle." In *Giovanni Lanfranco: Un pittore barocco tra Parma, Roma e Napoli,* pp. 71–76. Exh. cat. edited by Erich Schleier. Reggio di Colorno, Parma; Castel Sant'Elmo, Naples; Palazzo Venezia, Rome. Milan.

Coural, Jean

1967 "Notes documentaires sur les ateliers parisiens de 1597 à 1662." In Versailles 1967, pp. 15–24; see also pp. 25–105.

1977 "La Manufacture Royale de Beauvais." *Les monuments historiques de la France* 6, pp. 65–82.

1982 Introduzione / Introduction. In Florence 1982, pp. 9–15.

Coural, Jean, and Chantal Gastinel-Coural

1992 *Beauvais: Manufacture nationale de tapisserie*. Paris.

Coural, Natalie

2001 *Les Patel—Pierre Patel (1605–1676) et ses fils: Le paysage de ruines à Paris au XVIIe siècle*. Paris.

Cox-Rearick, Janet

1984 *Dynasty and Destiny in Medici Art: Pontormo, Leo X, and the Two Cosimos*. Princeton.

Coxe, William

1818 *Memoirs of John, Duke of Marlborough*. 3 vols. London.

Coypel, Antoine

1708–21/ "Discours sur la peinture (1708–21): *Sur l'esthétique du peintre,*
1996 *Sur l'excellence de la peinture*." In *Les conférences de l'Académie Royale de Peinture et de Sculpture au XVIIe siècle*, edited by Alain Mérot, pp. 395–519. Collection Beaux-Arts histoire. Paris, 1996.

Cremona

1987 *Arazzi per la cattedrale di Cremona: Storie di Sansone; Storie della Vita di Cristo*. Exh. cat. edited by Loretta Dolcini. Santa Maria della Pietà. Milan.

Crick-Kuntziger, Marthe

1927 "The Tapestries in the Palace of Liège." *Burlington Magazine* 50 (April), pp. 172–83.

1935 "Contribution à l'histoire de la tapisserie anversoise: Les marques et les tentures des Wauters." *Revue belge d'archéologie et d'histoire de l'art* 5, pp. 35–44.

1936 "Marques et signatures de tapissiers bruxellois." *Annales de la Société Royale d'Archéologie de Bruxelles* 40, pp. 166–83.

1940 "Une tapisserie bruxelloise d'après Jordaens." *Bulletin des Musées Royaux d'Art et d'Histoire* 12 (September–October), pp. 117–20.

1944 *De tapijtwerken in het Stadhuis te Brussel*. Maerlantbibliotheek 14. Antwerp.

1955 "Tapisseries bruxelloises d'après Rubens et d'après Jordaens." *Revue belge d'archéologie et d'histoire de l'art / Belgisch tijdschrift voor oudheidkunde en kunstgeschiedenis* 24, pp. 17–28.

Croft-Murray, Edward, and Paul Hulton

1960 *Catalogue of British Drawings*. Vol. 1, *XVI & XVII Centuries*. 2 vols. British Museum. London.

Cruciani, Fabrizio

1983 *Teatro nel Rinascimento: Roma, 1450–1550*. Biblioteca del Cinquecento 22. Rome.

Cruzada Villaamil, Gregorio

1874 *Rubens, diplomático español: Sus viajes á España y noticia de sus cuadros, segun los inventarios de las cases reales de Austria y de Borbon*. Madrid.

C.-Starcky

See under Starcky

Dacos, Nicole

1969 *La découverte de la Domus Aurea et la formation des grotesques à la Renaissance*. Studies of the Warburg Institute 31. London and Leiden.

Dacos, Nicole, et al.

1987 Nicole Dacos, Caterina Furlan, Liliana Cargnelutti, and Elio Bartolini. *Giovanni da Udine*. 3 vols. Udine.

D'Afflitto, Chiara

2002 *Lorenzo Lippi*. Florence.

Darcel, Alfred

1881 *Rapport à son Excellence le Gouverneur de l'Île de Malte sur les tapisseries du Palais de Gouvernement*. Malta.

1882 *Excursion à Malte*. Rouen.

1902 "Manufacture Nationale des Gobelins." In *Inventaire général des richesses d'art de la France, Paris, Monuments civils*, vol. 3, pp. 79–167. Paris.

Daremberg, Charles, and Edmond Saglio

1877–1919 Eds. *Dictionnaire des antiquités grecques et romaines, d'après les textes et les monuments*. 5 vols in 10. Paris.

Darmstadt

1964 *Zeichnungen alter und neuer Meister aus dem Heissischen Landesmuseum in Darmstadt*. Exh. cat. by Gisela Bergsträsser. Heissisches Landesmuseum. Darmstadt.

Davidson, Bernice F.

1990 "The *Navigatione d'Enea* Tapestries Designed by Perino del Vaga for Andrea Doria." *Art Bulletin* 72 (March), pp. 35–50.

Davis, Bruce William

1986 *The Drawings of Ciro Ferri*. Outstanding Dissertations in the Fine Arts. New York.

De Benedictis, Cristina

1996 "Devozione-collezione: Sulla committenza fiorentina nell'età della Controriforma." In *Altari e committenza: Episodi a Firenze nell'età della Controriforma*, edited by Cristina De Benedictis, pp. 7–17. Florence.

Decavele, J.

1979–83 "De opkomst van het protestantisme te Brussel." *Noordgouw: Cultureel tijdschrift van de provincie Antwerpen* 19–20, pp. 25–44.

Delesalle, Hubert

1964 "Aunes de France et aunes de Flandre: Note sur le mesurage des anciennes tapisseries de Beauvais." *Revue de métrologie pratique et légale* 3 (March–April), pp. 95–98.

Delft

1962 *Meesterwerken uit Delft*. Exh. cat. Stedelijk Museum Het Prinsenhof. Delft.

Delmarcel, Guy

1979 "*The Triumph of the Seven Virtues* and Related Brussels Tapestries of the Early Renaissance." In A. G. Bennett 1979, pp. 155–69.

1980 *Tapisseries anciennes d'Enghien*. Mons.

1983 "The Rubens Tapestry Set in Valletta, Malta: Some New Facts and Documents." *Ringling Museum of Art Journal* 1, pp. 192–203. Papers presented at the International Rubens Symposium, John and Mable Ringling Museum of Art, Sarasota, Florida, April 14–16, 1982.

1985a "Nieuwe gegevens over de wandtapijten van het Nieuwe Testament door Judocus de Vos te Malta (1699–1700)." *Revue belge d'archéologie et d'histoire de l'art / Belgisch tijdschrift voor oudheidkude en kunstgeschiedenis* 54, pp. 29–44.

1985b "Présence de Jules César dans la tapisserie des Pays-Bas méridionaux." In *Présence de César: Hommage au doyen Michel Rambaud*, edited by Raymond Chevallier, pp. 257–61. Actes du Colloque, December 9–11, 1983. Collection Caesarodunum 20bis. Paris.

1987 "L'arazzeria antica a Bruxelles e la manifattura di Jan Raes." In Cremona 1987, pp. 44–53.

1989 "Fructus Belli: Brusselse wandtapijten en Italiaanse Renaissance bij de Gonzaga's." *Bulletin des Musées Royaux d'Art et d'Histoire / Bulletin van de Koninklijke Musea voor Kunst en Geschiedenis* 60, pp. 159–201.

1997a "La collection Toms: Musée de la tapisserie des temps modernes / Die Sammlung Toms: Ein Museum des neuzeitlichen Wandteppichs." In Payerne 1997, pp. 21–33.

1997b	"De Geschiedenis van Decius Mus / The History of Decius Mus." In Antwerp 1997, pp. 39–51.
1997c	"Rubens en de Wandtapijtkunst / Rubens and Tapestry." In Antwerp 1997, pp. 28–37.
1999a	*Het Vlaamse wandtapijt van de 15de tot de 18de eeuw.* Tielt. Also published as *Flemish Tapestry from the 15th to the 18th Century.* Translated by Alastair Weir. Tielt. And as *La tapisserie flamande du XVe au XVIII siècle.* Paris.
1999b	"Le roi Philippe II d'Espagne et la tapisserie: L'inventaire de Madrid de 1598." *Gazette des beaux-arts,* 6th ser., 134 (October), pp. 153–78.
1999c	"Une suite de tapisseries des *Chasses de Maximilien* et les collections de Jean-Baptiste Colbert." In *Tapisserie au XVIIe siècle* 1999, pp. 77–88.
2002a	"Flemish Tapestry Weavers Abroad: An Introduction." In Delmarcel 2002b, pp. 9–13.
2002b	Ed. *Flemish Tapestry Weavers Abroad: Emigration and the Founding of Manufactories in Europe.* Proceedings of the International Conference, Mechelen, October 2–3, 2000. Symbolae (Facultatis Litterarum Lovaniensis), ser. B, 27. Louvain.
2003	"The Cartoons and Tapestries of Rubens's *Life of Achilles.*" In Rotterdam–Madrid 2003, pp. 33–41.
2006	"De Antwerpse schilder Pieter van Lint (1609–1690) als ontwerper van wandtapijten: Een bijdrage." In *Munuscula Amicorum: Contributions on Rubens and His Colleagues in Honour of Hans Vlieghe,* edited by Katlijne van der Stighelen, vol. 2, pp. 577–91. Pictura nova 10. Turnhout.

Delmarcel, Guy, and Clifford M. Brown
| 1988 | "Les Jeux d'Enfants: Tapisseries italiennes et flamandes pour les Gonzague." *RACAR* 15, pp. 109–21. |

Denis, Isabelle
1992	"L'Histoire d'Artémise, commanditaires et ateliers: Quelques précisions apportées par l'étude des bordures." *Bulletin de la Société de l'Histoire de l'Art Français* (1991; pub. 1992), pp. 21–36.
1996a	"Le répertoire décoratif des bordures." *Dossier de l'art,* no. 32 (September), pp. 30–41.
1996b	"Tenture de l'Histoire de Daphné." In Guy Blazy, Isabelle Denis, Sophie Gaultier, Martine Mathias, and Nicole de Reyniès, *Catalogue des tapisseries,* pp. 38–41. Musée des Tissus, Musée des Arts Décoratifs. Lyon.
1998	"Vignon, Richelieu et la tapisserie." In *Claude Vignon en son temps,* edited by Claude Mignot and Paola Pacht Bassani, pp. 215–36. Actes du Colloque International de l'Université de Tours, January 28–29, 1994. Paris.
1999	"Henri Lerambert et l'*Histoire d'Artémise*: Des dessins d'Antoine Caron aux tapisseries." In *Tapisserie au XVIIe* 1999, pp. 33–50.

Denucé, Jean
1932	*The Antwerp Art-Galleries: Inventories of the Art-Collections in Antwerp in the 16th and 17th Centuries.* Historical Sources for the Study of Flemish Art 2. The Hague. Also published as *Les galeries d'art à Anvers aux 16e et 17e siècles: Inventaires.* Sources pour l'histoire de l'art flamand 2. Antwerp.
1934	*Italiaansche koopmansgeslachten te Antwerpen in de XVIe–XVIIIe eeuwen.* De wetenschappelijke bibliotheek. Amsterdam and Mechelen.
1936	*Antwerp Art-Tapestry and Trade.* Introductory text in English. Historical Sources for the Study of Flemish Art 4. Antwerp and The Hague. Also published as *Antwerpsche tapijtkunst en handel.* Bronnen voor de geschiedenis van de Vlaamsche kunst 4. Antwerp and The Hague.

Depauw, Carl
| 1993 | "De Eucharistie-cyclus / The Eucharist Series." In *Rubens Cantoor: Een verzameling tekeningen ontstaan in Rubens' atelier,* pp. 194–213. Exh. cat., Rubenshuis, Antwerp. Ghent. |

Depping, Georges-Bernard
| 1850–55 | *Correspondance administrative sous le règne de Louis XIV.* 4 vols. Paris. |

Descripción de los tapices de Rubens
| 1881 | *Descripción de los tapices de Rubens que se colocan en el claustro del monasterio de las señoras religiosas Descalzas Reales, en los días de Viernes Santo para la procesión del Santo Entierro, y en la octava del Santissimun Corpus Christi para la procesión de los altares.* Madrid. |

Desprechins de Gaesebeke, Anne
| 1996a | "À la gloire d'Amadis: Tapisseries de Delft d'après Karel van Mander." *Gazette des beaux-arts,* 6th ser., 128 (December), pp. 253–62. |
| 1996b | "Une tenture d'Amadis de Gaule tissée à Delft d'après les cartons de Karel van Mander." *Gentse bijdragen tot de kunstgeschiedenis en oudheidkunde* 31, pp. 81–96. |

Desroches, Jean-Paul
| 2004 | "Chronique de l'empereur au fil des jours." In Versailles 2004, pp. 43–49. |

Dessert, Daniel
| 1987 | *Fouquet.* Paris. |

De Strobel, Anna Maria
| 1989 | *Le arazzerie romane dal XVII al XIX secolo.* Quaderni di storia dell'arte 22. Rome. |
| 1998 | "L'arazzeria di San Michele tra il Settecento e l'Ottocento attraverso le opere delle collezioni vaticane." In *Arte e artigianato nella Roma di Belli,* edited by Laura Biancini and Franco Onorati, pp. 118–36. Papers from a conference at the Fondazione Marco Besso, Centro Studi Giuseppe Gioachino Belli, Rome, November 28, 1997. Memorie romane. Rome. |

Deville, Jules
| 1875 | *Recueil de documents et de statuts relatifs à la corporation des tapissiers, de 1258 à 1875.* Paris. |

Díaz Padrón, Matías
| 1975 | *Museo del Prado: Catálogo de Pinturas.* Vol. 1, *Escuela flamenco, siglo XVII.* 2 vols. Madrid. |

Dickinson, Gary, and Linda Wrigglesworth
| 2000 | *Imperial Wardrobe.* Rev. ed. Berkeley. |

Diemer, Dorothea
| 1980 | "Hans Krumper." In Munich 1980, vol. 1, pp. 279–311. |

Diemer, Dorothea, and Peter Diemer
| 1995 | "Das Antiquarium Herzog Albrechts V. von Bayern: Schicksale einer fürstlichen Antikensammlung der Spätrenaissance." *Zeitschrift für Kunstgeschichte* 58, pp. 55–104. |

Dijon–Luxembourg
| 1998 | *À la gloire du Roi: Van der Meulen, peintre des conquêtes de Louis XIV.* Exh. cat. by Emmanuel Starcky, Danièle Wagener, Jean Meyer, et al. Musée des Beaux-Arts de Dijon; Musée d'Histoire de la Ville de Luxembourg. Dijon, Luxembourg, and Paris. |

Van den Donk, Hesther
| 1994 | "Een Middelburgs tapijt aan de vergetelheid ontrukt: *The Last Fight of the Revenge,* 1598." *Oud Holland* 108, pp. 87–97. |

Donnet, Fernand
1894	"Les tapisseries de Bruxelles, Enghien et Audenarde pendant la Furie Espagnole (1576)." *Annales de la Société Royale d'Archéologie de Bruxelles* 8, pp. 442–76.
1896	"Documents pour servir à l'histoire des ateliers de tapisserie de Bruxelles, Audenarde, Anvers, etc., jusqu'à la fin du XVIIe siècle." *Annales de la Société d'Archéologie de Bruxelles* 10, pp. 269–336.
1908	"Les Reydams: Tapissiers bruxellois." *Annales de la Société d'Archéologie de Bruxelles* 22, pp. 79–156.

D'Onofrio, Cesare
1967 *Roma vista da Roma*. Rome.

Dreyss, Charles
1860 *Mémoires de Louis XIV pour l'instruction du Dauphin*. 2 vols. Paris.

Drossaers, Sophie Wilhelmina Albertine, and Theodoor Herman Lunsingh Scheurleer
1974–76 Eds. *Inventarissen van de inboedels in de verblijven van de Oranjes en daarmede gelijk te stellen stukken, 1567–1795*. 3 vols. Vol. 1, *Inventarissen Nassau-Oranje, 1567–1712*. Vol. 2, *Inventarissen Nassau-Dietz en Nassau-Dietz-Oranje, 1587–1763*. Vol. 3, *Inventarissen Nassau-Oranje, 1763–1795*. The Hague.

Drury, P. J.
1980 "'No other palace in the kingdom will compare with it': The Evolution of Audley End, 1605–1745." *Architectural History* 23, pp. 1–39, 145–71.

Dubon, David
1964 *Tapestries from the Samuel H. Kress Collection at the Philadelphia Museum of Art: The History of Constantine the Great, Designed by Peter Paul Rubens and Pietro da Cortona*. Complete Catalogue of the Samuel H. Kress Collection. London.

Dubos
1834 *Notice historique sur la Manufacture Royale de Tapisseries de Beauvais*. Beauvais.

Dumolin, Maurice
1933 "Nouveaux documents sur l'église Saint-Gervais." *Bulletin de la Société de l'Histoire de l'Art Français*, pp. 45–73.

Duparc, Fritz J.
1993 "Philips Wouwerman, 1619–1668." *Oud Holland* 107, pp. 257–86.

Duplessis, Georges
1892 *Les Audran*. Les artistes célèbres. Paris.

Durian-Ress, Saskia
1981 "Die Bordüre der Münchner Paulusserie." In *Documenta textilia: Festschrift für Sigrid Müller-Christensen*, edited by Mechthild Flury-Lemberg and Karen Stolleis, pp. 213–33. Forschungshefte (Bayerisches Nationalmuseum) 7. Munich.

Duro, Paul
1997 *The Academy and the Limits of Painting in Seventeenth-Century France*. Cambridge Studies in New Art History and Criticism. New York.

Dutertre, Eveline
1992 "A propos de quelques tragédies de la mort de César des XVIe et XVIIe siècles." *Littératures classiques*, no. 16 (Spring), pp. 199–227.

Duverger, Erik
1960 *Jan, Jacques en Frans de Moor: Tapitwevers en tapijthandelaars te Oudenaarde, Antwerpen en Gent (1560 tot ca. 1680)*. Interuniversitair Centrum voor de Geschiedenis van de Vlaamse Tapijtkunst, Verhandelingen en bouwstoffen 1. Ghent.
1969 "Tapijtwerk uit het atelier van Frans Geubels." In *De bloeitijd van de Vlaamse tapijtkunst / L'âge d'or de la tapisserie flamande*, pp. 91–204. International Colloquium, May 23–25, 1961. Brussels.
1971a "Tapijten naar Rubens en Jordaens in het bezit van het Antwerpse handelsvennootschap Fourment-Van Hecke." *Artes textiles* 7, pp. 119–73.
1971b "Une tenture de l'Histoire d'Ulysse livrée par Jacques Geubels le jeune au prince de Pologne." *Artes textiles* 7, pp. 74–98.
1972 "Aantekeningen betreffende de tapijthandel van Daniël Fourment en van diens zoon en schoonzoon Peter Fourment en Peter van Hecke de Jonge." *Bijdragen tot de geschiedenis* 55, pp. 48–76.
1981 "Patronen voor tapijtwerk in het sterfhuis van François van den Hecke." *Artes textiles* 10, pp. 221–34.
1981–84 "Enkele archivalische gegevens over Catharina van den Eynde en over haar zoon Jacques II Geubels, tapissiers te Brussel." *Gentse bijdragen tot de kunstgeschiedenis* 26, pp. 161–93.
1986 "Flämische Wandteppiche für den Wiener Hof anlässlich der Hochzeit des Kaisers Leopold I. im Jahre 1666." *Artes textiles* 11, pp. 176–77.
1995 *Antwerpse kunstinventarissen uit de zeventiende eeuw*. Vol. 8, *1658–1666*. Fontes historiae artis Neerlandicae 1. Brussels.
1996 "Zeventiende-eeuwse Brugse wandtapijten met de geschiedenis van Julius Caesar." *Gentse bijdragen tot de kunstgeschiedenis en oudheidkunde* 31, pp. 59–80.
1997 *Antwerpse kunstinventarissen uit de zeventiende eeuw*. Vol. 9, *1666–1674*. Fontes historiae artis Neerlandicae 1. Brussels.
1999 *Antwerpse kunstinventarissen uit de zeventiende eeuw*. Vol. 10, *1674–1680*. Fontes historiae artis Neerlandicae 1. Brussels.

Duverger, Erik, and Danielle Maufort
1996 "Giovanni Battista van Eycke en de patronen met de Historie van Decius Mus van Antoon van Dyck naar inventies van Peter Paul Rubens." *Gentse bijdragen tot de kunstgeschiedenis en oudheidkunde* 31, pp. 97–119.

Duverger, Jozef
1959 "De Rijschool of grote en kleine paarden in de XVIIe eeuwse tapijtkunst." In *Het herfsttij van de Vlaamse tapijtkunst*, pp. 121–76. International Colloquium, October 8–10, 1959. Brussels.
1959–60 "Aantekeningen betreffende tapijten naar cartons van Jacob Jordaens." *Artes textiles* 5, pp. 47–62.
1968a "Jan I Tons." In *Nationaal biografisch woordenboek*, vol. 3, cols. 869–71. Brussels.
1968b "Jan II Tons." In *Nationaal biografisch woordenboek*, vol. 3, cols. 871–72. Brussels.
1971 "De Brusselse tapijtwever Guilliam van de Vijvere en zijn atelier." *Artes textiles* 7, pp. 99–118.
1976–78 "Aantekeningen betreffende de patronen van P. P. Rubens en de tapijten met de geschiedenis van Decius Mus." *Gentse bijdragen tot de kunstgeschiedenis* 24, pp. 15–42.

Earp, Frank Russell
1902 *A Descriptive Catalogue of the Pictures in the Fitzwilliam Museum*. Cambridge.

Ehret, Lisa O.
1977 "*Château and Garden* Tapestries at Fenway Court." *Fenway Court*, pp. 25–33.

Ehrmann, Jean
1986 *Antoine Caron: Peintre des fêtes et des massacres*. Paris.

Eidelberg, Martin
1997 "'Dieu invenit, Watteau pinxit': Un nouvel éclairage sur une ancienne relation." *Revue de l'art*, no. 115, pp. 25–29.

Eisler, Max
1921 "Die Delfter Gobelinfabrik." *Oud Holland* 39, pp. 188–232.

Elbern, Victor H.
1955 "Die Rubensteppiche des Kölner Domes: Ihre Geschichte und ihre Stellung im Zyklus *Triumph der Eucharistie*." *Kölner Domblatt* 10, pp. 43–88.
1958 "Der eucharistische Triumph, ergänzende Studien zum Zyklus des P. P. Rubens." *Kölner Domblatt* 14–15, pp. 121–39.
1963 "Addenda zum Zyklus Triumph der Eucharistie von P. P. Rubens." *Kölner Domblatt* 21–22, pp. 77–80.

Ellul, Joseph
1996 *The Grandmaster's Palace & the Gobelin Tapestries*. Malta.

Engerand, Fernand
1901 *Inventaire des tableaux commandés et achetés par la direction des Bâtiments du Roi (1709–1792)*. Paris.

Equicola, Mario

1999 *La redazione manoscritta del Libro de Natura de Amore di Mario Equicola.* Edited by Laura Ricci. Biblioteca del Cinquecento 89. Rome.

Erkelens, A. M. Louise E.

1962a "Rafaëleske grotesken op enige Brusselse wandtapijtseries." *Bulletin van het Rijksmuseum* 10, pp. 115–38.

1962b *Wandtapijten 1 / Tapestries 1: Late Gotiek en vroege Renaissance.* Facetten der verzameling, 2nd ser., 4. Rijksmuseum. Amsterdam.

1962c "De wandtapijtkunst te Delft." In Louis Jacob Florus Wijsenbeek, *Delfts zilver*, pp. 53–102. Oud Delft: Een serie historische publicaties over Delft en Delvenaren 1. Rotterdam.

1981 "Een Hollands Scipio-tapijt 'De overgave van Carthago' anno 1609." In *Nederlandse kunstnijverheid en interieurkunst: Opgedragen aan professor Th. H. Lunsingh Scheurleer*, pp. 36–49. Haarlem. Issue of *Nederlands kunsthistorisch jaarboek* 31 (1980).

Essen

1954 *Peter Paul Rubens, Triumph der Eucharistie: Wandteppiche aus dem Kölner Dom.* Exh. cat. by Victor H. Elbern. Villa Hügel. Essen.

Evelyn, John

1955 *Diary.* Edited by E. S. de Beer. 6 vols. Oxford.

Fagiolo dell'Arco, Maurizio

2001 *Pietro da Cortona e i "cortoneschi": Gimignani, Romanelli, Baldi, il Borgognone, Ferri.* Biblioteca d'arte Skira 4. Milan.

Faldi, Italo

1967 Ed. *I cartoni per gli arazzi Barberini della serie di Urbano VIII.* Galleria Nazionale, Palazzo Barberini. Rome.

Fandrey, Carla, et al.

2002 Carla Fandrey, Ulrike Grimm, Hanns Hubach, Andrea Huber, Diane Lanz, Klaus Merten, Afroditi Papagialia, Rosemarie Stratmann-Döhler, and Wolfgang Wiese. *Tapisserien: Wandteppiche aus den staatlichen Schlössern Baden-Württembergs.* Schätze aus unseren Schlössern 6. Weinheim.

Farabulini, David

1884 *L'arte degli arazzi e la nuova Galleria dei Gobelins al Vaticano.* Rome.

Faranda, Franco

1986 *Ludovico Cardi, detto il Cigoli.* Collana "I professori del disegno" 2. Rome.

"Fastes romains"

1971 "Fastes romains." *L'oeil*, nos. 201–2 (September–October), pp. 36–44.

Félibien, André

1663 *Les Reines de Perse aux pieds d'Alexandre. Peinture au Cabinet du Roy.* Paris.

1665 *Les quatre élémens peints par M. Le Brun et mis en tapisseries pour Sa Maiesté.* Paris.

1666–88 *Entretiens sur les vies et sur les ouvrages des plus excellens peintres anciens et modernes.* 5 vols. Paris.

1666–88/ *Entretiens sur les vies et sur les ouvrages des plus excellens peintres
1972 anciens et modernes.* 5 vols. Paris, 1666–88. Reprint, 5 vols. in 3. Geneva, 1972.

1667a *Les quatre élémens peints par M. Le Brun et mis en tapisseries pour Sa Maiesté.* 2nd ed. Paris.

1667b *Les quatre saisons peintes par M. Le Brun et mises en tapisseries pour Sa Maiesté.* Paris.

1668 Ed. *Conférences de l'Académie Royale de Peinture et de Sculpture pendant l'année 1667.* Preface by André Félibien. Paris.

1670 *Tapisseries du Roy où sont représentés les quatre élémens et les quatre saisons avec les devises qui les accompagnent et leur explication.* Paris.

1671 *Description de divers ouvrages de peinture faits pour le Roy.* Paris.

1685–88 *Entretiens sur les vies et sur les ouvrages des plus excellens peintres anciens et modernes.* 2nd ed. 2 vols. Paris.

1689 *Recueil de descriptions de peintures et d'autres ouvrages faits pour le Roy.* Paris.

1689a/1973 *Les quatre élémens peints par M. Le Brun et mis en tapisseries pour Sa Maiesté.* [1665.] Reissued in André Felibien, *Recueil de descriptions de peintures et d'autres ouvrages faits pour le Roy*, pp. 95–141. Paris, 1689. Reprint, Geneva, 1973.

1689b/1973 *Les quatre saisons peintes par M. Le Brun et mises en tapisseries pour Sa Maiesté.* [1667.] Reissued in André Felibien, *Recueil de descriptions de peintures et d'autres ouvrages faits pour le Roy*, pp. 143–93. Paris, 1689. Reprint, Geneva, 1973.

1689c/1973 *Les Reines de Perse aux pieds d'Alexandre. Peinture au Cabinet du Roy.* [1663.] Reissued in André Felibien, *Recueil de descriptions de peintures et d'autres ouvrages faits pour le Roy*, pp. 23–67. Paris, 1689. Reprint, Geneva, 1973.

1696 *Description du château de Versailles, de ses peintures et d'autres ouvrages faits pour le Roy.* Paris.

1705 *Entretiens sur les vies et sur les ouvrages des plus excellents peintres anciens et modernes.* 4 vols. London.

1725 *Entretiens sur les vies et sur les ouvrages des plus excellens peintres anciens et modernes; avec la vie des architectes.* New ed. 6 vols. Trévoux.

Fenaille, Maurice

1903–23 *État général des tapisseries de la Manufacture des Gobelins depuis son origine jusqu'à nos jours, 1600–1900.* 6 vols in 5. Vol. 1, *Les ateliers parisiens au dix-septième siècle depuis l'installation de Marc de Comans et de François de La Planche au Faubourg Saint-Marcel en 1601 jusqu'à la fondation de la Manufacture Royale des Meubles de la Couronne en 1662* (1923). Vol. 2, *Période de la fondation de la Manufacture Royale des Meubles de la Couronne sous Louis XIV, en 1662, jusqu'en 1699, date de la réouverture des ateliers* (1903). Vol. 3, *Période du dix-huitième siècle*, pt. 1, *Depuis la réouverture des ateliers en 1699 jusqu'à la mort du duc d'Antin en 1736* (1904). Vol. 4, *Période du dix-huitième siècle*, pt. 2 [1737–93], (1907). Vol. 5, *Période du dix-neuvième siècle, 1794–1900* (1912). [Vol. 6], *Table* (1923). Paris.

Fernández Bayton, Gloria

1975 *Inventarios reales. Testamentaría del Rey Carlos II, 1701–1703.* Vol. 1. Museo del Prado. Madrid.

1981 *Inventarios reales. Testamentaría del Rey Carlos II, 1701–1703.* Vol. 2. Museo del Prado. Madrid.

Ferrari, Oreste

1968 *Arazzi italiani del Seicento e Settecento.* Le arti nella casa italiana. Milan.

Ffolliott, Sheila

1986 "Catherine de Medici as Artemisia: Figuring the Powerful Widow." In Margaret W. Ferguson, *Rewriting the Renaissance: Discourses of Sexual Difference in Early Modern Europe*, edited by Maureen Quilligan and Nancy J. Vickers, pp. 227–41, 370–76. Women in Culture and Society. Chicago.

1993 "Once upon a Tapestry: Inventing the Ideal Queen." In *Images of a Queen's Power: The Artemisia Tapestries*, pp. 13–19. Exh. cat., Minneapolis Institute of Arts. Minneapolis.

Ffoulke, Charles Mather

n.d. "Ffoulke Tapisseries." Typescript 86.K.2, National Art Library, Victoria and Albert Museum, London.

1913 *The Ffoulke Collection of Tapestries.* New York.

Filedt Kok, Jan Piet

1992 "Conservatie of restauratie: Het wapentapijt van Monterey." *Kunstschrift* 36, no. 4 (July–August), pp. 52–54.

Fitzwilliam Museum

1912 *The Principal Pictures in the Fitzwilliam Museum, Cambridge.* Prefatory note by S. C. Cockerell. London.

1929 *The Principal Pictures in the Fitzwilliam Museum, Cambridge.* Prefatory note by S. C. Cockerell. 2nd ed. London.

Florence

1880 *Cataloghi degli arazzi, dei disegni e degli altri oggetti di arte antica.* Exh. cat. edited by Cosimo Conti. Former convent of S. Croce and the Cappellone dei Pazzi. Florence.

1965 *70 pitture e sculture del '600 e '700 fiorentino.* Exh. cat. by Mina Gregori. Palazzo Strozzi. Florence.

1977 *Rubens e la pittura fiamminga del Seicento nelle collezioni pubbliche fiorentine / Rubens et la peinture flamande du XVIIème siècle dans les collections publiques florentines.* Exh. cat. edited by Didier Bodart. Palazzo Pitti. Florence.

1980 *Palazzo Vecchio: Committenza e collezionismo medicei. Firenze e la Toscana dei Medici nell'Europa del Cinquecento.* Exh. cat. edited by Claudia Beltramo Ceppi and Nicoletta Confuorto. Palazzo Vecchio, Florence. Milan.

1982 *Gli arazzi del Re Sole / Les tapisseries de l'Histoire du Roi.* Exh. cat. by Daniel Meyer; introduction by Jean Coural. Palazzo Vecchio. Florence.

1986 *Il seicento fiorentino: Arte a Firenze da Ferdinando I a Cosimo III.* 3 vols. [Vol. 1], *Pittura.* [Vol. 2], *Disegno / incisione / scultura / arti minori.* [Vol. 3], *Biografie.* Exh. cat., Palazzo Strozzi. Florence.

1992 *Disegni di Lodovico Cigoli (1559–1613).* Exh. cat. edited by Miles L. Chappell. Gabinetto Disegni e Stampe degli Uffizi. Florence.

1994 *Firenze e la sua immagine: Cinque secoli di vedutismo.* Exh. cat. edited by Marco Chiarini and Alessandro Marabottini. Forte di Belvedere, Florence. Venice.

2001 *Scienziati a corte: L'arte della sperimentazione nell'Accademia Galileiana del Cimento (1657–1667).* Exh. cat. edited by Paolo Galluzzi. Galleria degli Uffizi, Florence. Livorno.

2002 *Il mito di Europa: Da fanciulla rapita a continente.* Exh. cat., Galleria degli Uffizi. Florence.

2005 *Mythologica et erotica: Arte e cultura dall'antichità al XVIII secolo.* Exh. cat. edited by Ornella Casazza and Riccardo Gennaioli. Museo degli Argenti, Palazzo Pitti, Florence. Livorno.

Fock, C. Willemijn

1969 "Nieuws over de tapijten, bekend als de Nassause Genealogie." *Oud Holland* 84, pp. 1–28.

1975 "De voorgestelde personen op de tapijtenreeks 'De Nassause Genealogie.'" *Oud Holland* 89, pp. 73–78.

Fogelmarck, Stig

1988 "John Böttiger: Keeper of Textiles." In *Opera Textilia Variorum Temporum: To Honour Agnes Geijer on Her Ninetieth Birthday,* edited by Inger Estham and Margareta Nockert, pp. 171–79. Studies (Museum of National Antiquities) 8. Stockholm.

Fontainebleau

1993 *Tapisseries des Gobelins au château de Fontainebleau.* Exh. cat. edited by Danielle Denise and Yves Carlier. Musée National du Château de Fontainebleau. Paris.

Forti Grazzini, Nello

1986 *Arazzi del Cinquecento a Como.* Como.

1992 *Gli arazzi dei Mesi Trivulzio: Il committente, l'iconografia.* Rev. ed. Milan. [First ed., 1982.]

1994a "Il 'curioso itinerario' degli arazzi parmensi e i 'Teniers' di Lille al Palazzo del Quirinale." *Arte tessile: Rivista-annuario del Centro Italiano per lo Studio della Storia del Tessuto* 4.

1994b *Gli arazzi.* 2 vols. Il patrimonio artistico del Quirinale. Rome and Milan.

1997 "Gli arazzi." In *Le raccolte storiche dell'Accademia di Brera,* edited by Giacomo Agosti and Matteo Ceriana, pp. 137–46. Florence.

1998a "Un arazzo dell'*Inverno* da modello di Salviati." In *Itinerari d'arte in Lombardia dal XIII al XX secolo: Scritti offerti a Maria Teresa Binaghi Olivari,* edited by Matteo Ceriana and Fernando Mazzocca, pp. 181–94. Milan.

1998b "Le Indie tessili: Arazzi di Malta." *FMR* (Italian ed.), no. 128 (June–July), pp. 37–74. English ed., *FMR / International,* no. 92 (June–July 1998), pp. 37–74; French ed., *FMR / Édition française,* no. 74 (June–July 1998), pp. 37–74.

1999 "Les oeuvres retrouvées de la collection Farnèse." In *Tapisserie au XVIIe siècle* 1999, pp. 143–72.

2002 "Flemish Weavers in Italy in the Sixteenth Century." In Delmarcel 2002b, pp. 131–61.

2003 *Gli arazzi della Fondazione Giorgio Cini.* Venice.

2004 *Paesaggio con cervo / Paysage au cerf / Landscape with Deer.* Montecarlo and San Marino.

2005 "Gli arazzi delle *Storie di Amadigi di Gaula* nel Museo Poldi Pezzoli." In *Le imprese tessute di Amadigi di Gaula: Due arazzi del Museo Poldi Pezzoli,* pp. 17–50. Exh. cat. edited by Annalisa Zanni. Museo Poldi Pezzoli. Quaderni di studi e restauri del Museo Poldi Pezzoli 6. Milan.

2007 "Brussels Tapestries for Italian Customers: Cardinal Montalto's Landscapes with Animals Made by Jan II Raes and Catherine van den Eynde." In *Cultural Exchange between the Netherlands and Italy (1400–1600),* edited by Ingrid Alexander-Skipnes. In press.

Franke, Birgit

2000 "Herrscher über Himmel und Erde: Alexander der Grosse und die Herzöge von Burgund." *Marburger Jahrbuch für Kunstwissenschaft* 27, pp. 121–69.

Frankenburger, M.

1913 "Zur Geschichte des Wandteppiche des bayerischen Fürstenhauses unter Herzog Maximilians I Regierung." *Das Bayerland* 24, pp. 291–95.

Franses, Simon

1986 *European Tapestries, 1450–1750: A Catalogue of Recent Acquisitions.* S. Franses Ltd. London.

Frezza, Angelica

1982 "Documenti fiorentini per il parato di Clemente VIII." *Paragone,* no. 391 (September), pp. 57–75.

1983 "Influenze fiamminghe e originalità fiorentina nella storia dell'arazzeria medicea." In *Rubens e Firenze,* edited by Mina Gregori, pp. 229–48. Atti del Colloquio, Florence, October 1977. Florence.

Fuller, Thomas

1662 *The History of the Worthies of England.* London.

Fumaroli, Marc

1995 "Cross, Crown, and Tiara: The Constantine Myth between Paris and Rome (1590–1690)." In *Piero della Francesca and His Legacy,* edited by Marilyn Aronberg Lavin, pp. 89–102. Studies in the History of Art 48; Symposium Papers 28. National Gallery of Art. Washington, D.C.

1997 *Le poète et le Roi: Jean de La Fontaine en son siècle.* Paris.

Gachard, Louis-Prosper

1848–1936 *Correspondance de Philippe II sur les affaires des Pays-Bas.* 6 vols. Brussels.

Gady, Alexandre

2005 *Jacques Lemercier: Architecte et ingénieur du Roi.* Monographie (Centre Allemand d'Histoire de l'Art). Paris.

Gady, Bénédicte

2007 "Charles Le Brun et la manufacture des Gobelins." In *Charles Le Brun: Maître d'oeuvre.* Exh. cat. edited by Nicolas Milovanovic and Alexandre Maral. Musée National du Château de Versailles (forthcoming in 2007).

Gaeta Bertelà, Giovanna

1979 "Gli arazzi." In *Gli Uffizi: Catalogo generale,* pp. 1047–75. Florence.

1980 "Fortune e sfortune degli arazzi medicei." In *Le arti del principato mediceo,* pp. 117–40. Specimen 6. Florence.

García Sanz, Ana

1999 "Nuevas aproximaciones a la serie El Triunfo de la Eucaristía." In Madrid 1999, pp. 108–17.

Garnier, Nicole

1989 *Antoine Coypel (1661–1722)*. Paris.

Gastinel-Coural, Chantal

1996 "Beauvais: Centre of Tapesty Production." In Grove 1996, vol. 3, pp. 460–62.

1998 "Van der Meulen et la Manufacture Royale des Gobelins." In Dijon–Luxembourg 1998, pp. 110–20.

1998a "Les tapisseries du sacre." *L'estampille / L'objet d'art*, no. 320 (January), pp. 54–82.

Geffroy, Gustave

n.d. *Les modèles et les tapisseries de la Manufacture Nationale des Gobelins*. Vol. 5, *Ornements, animaux, figures*. Paris.

Geisenheimer, Hans

1907 Summary of a talk given by Hans Geisenheimer on the *Passion of Christ* tapestries in the Palazzo Pitti, Florence, at a meeting at the Kunsthistorisches Institut, Florence, December 18, 1906. [Signed H. B.] *Kunst-chronik*, n.s. 18 (March 15), cols. 299–300.

Gentili, Pietro

1874 Ed. *Sulla manifattura degli arazzi: Cenni storici sulle origini e dicende dell'arte degli arazzi in Roma*. Rome.

Germer, Stefan

1997 *Kunst, Macht, Diskurs: Die intellektuelle Karriere des André Félibien im Frankreich von Louis XIV*. Munich.

Gerson, Horst, and Jack Weatherburn Goodison

1960 *Catalogue of Paintings in the Fitzwilliam Museum, Cambridge*. Vol. 1, *Dutch and Flemish*. Cambridge.

Gerson, Horst, and Engelbert Hendrik ter Kuile

1960 *Art and Architecture in Belgium, 1600 to 1800*. The Pelican History of Art. Harmondsworth.

Gerszi, Teréz

1985 "Eine kürzlich entdeckte Zeichnung von Carel van Mander." In *Rubens and His World—Bijdragen, Études, Studies, Beiträge: Opgedragen aan R.-A. d'Hulst naar aanleiding van het vijfentwintigjarig bestaan van het Nationaal Centrum voor de Plastische Kunsten van de 16de en de 17de Eeuw*, pp. 71–76. Antwerp.

Geudens, E.

1911 "'Blijde Inkomst' der aartshertogen Albertus en Isabella te Antwerpen in 1599." *Bijdragen tot de geschiedenis, bijzonderlijk in 't aloude Hertogdom Brabant* 10 (January), pp. 120–39.

Giannini, Cristina

1993 "Un'alcova del primo Settecento a Firenze: La bottega di Giovanni Camillo Sagrestani in Palazzo Suarez de la Concha." *Antichità viva* 32, no. 1 (January–February), pp. 28–33.

Gibson-Wood, Carol

1988 *Studies in the Theory of Connoisseurship from Vasari to Morelli*. Outstanding Theses in the Fine Arts from British Universities. New York.

Gien

1994 *La chasse au vol au fil des temps*. Exh. cat. edited by Catherine Parpoli and Thierry Vincent. Musée International de la Chasse. Gien.

Gigli, Giacinto

1608–70/ *Diario di Roma*. [1608–70.] Edited by Manlio Barberito. 2 vols.
1994 Rome, 1994.

Göbel, Heinrich

1922 "Das Brüsseler Wirkergeschlecht der van der Hecke." *Der Cicerone* 14, pp. 17–31.

1923 *Wandteppiche*. Vol. 1, *Die Niederlande*. 2 vols. Leipzig.

1928 *Wandteppiche*. Vol. 2, *Die romanischen Länder: Die Wandteppiche und ihre Manufakturen in Frankreich, Italien, Spanien und Portugal*. 2 vols. Leipzig.

1933–34 *Wandteppiche*. Vol. 3, *Die germanischen und slawischen Länder*. 2 vols. Berlin.

Godefroy, Théodore

1649 *Le cérémonial françois*. Paris.

Goldberg, Gisela

1980 "Dürer-Renaissance am Münchner Hof." In Munich 1980, vol. 1, pp. 318–22.

Golvers, Noël

1993 *The Astronomia Europaea of Ferdinand Verbiest, S.J. (Dillingen 1687): Text, Translation, Notes and Commentaries*. Monumenta Serica Monograph Series 28. Nettetal.

Gómez Martinez, Amando, and Bartolomé Chillón Sampedro

1925 *Los tapices de la catedral de Zamora*. Zamora.

Gori, Pietro

1926/1987 *Le feste fiorentine attraverso i secoli*. [Vol. 1], *Le feste per San Giovanni*. Florence, 1926. Reprint, 1987.

Goris, Jan-Albert, and Julius S. Held

1947 *Rubens in America*. New York.

Gracián y Morales, Baltasar

1640/1967 *El político Don Fernando el Católico*. Saragossa, 1640. Reprinted in Baltasar Gracián y Morales, *Obras completas*, edited by Arturo del Hoyo, pp. 35–71. 3rd ed. Madrid, 1967.

Van der Graft, J.

1869 *De tapijtfabrieken van der XVIe en XVIIe eeuw: Gevolgd door een historische beschrijving der zeven tapijtbehangsels in de Groote Vergaderzaal der Provinciale Staten van Zeeland*. Middelburg.

Graves, James

1852–53 "Ancient Tapestry of Kilkenny Castle." *Transactions of the Kilkenny Archaeological Society* 2, pp. 3–9.

Graziani, René

1972 "The 'Rainbow Portrait' of Queen Elizabeth I and Its Religious Symbolism." *Journal of the Warburg and Courtauld Institutes* 35, pp. 247–59.

Greenwich–Ulster

1988 *Armada, 1588–1988*. Exh. cat. by Mía J. Rodríguez-Salgado et al. National Maritime Museum, Greenwich; Ulster Museum, Botanic Gardens, Belfast. Harmondsworth.

Gregori, Mina

1962 "Avant-propos sulla pittura fiorentina del Seicento." *Paragone*, no. 145 (January), pp. 21–40.

1974 "A Cross-Section of Florentine Seicento Painting: The Piero Bigongiari Collection." *Apollo* 100 (September), pp. 218–29.

1986 "Tradizione e novità nella genesi della pittura fiorentina del Seicento." In Florence 1986, vol. 1, pp. 21–25.

1988 "La pittura a Firenze nel Seicento." In *La pittura in Italia* 1988, vol. 1, pp. 279–324.

1990 "Barocco a Firenze." In Christina Acidini Luchinat et al., *Cappelle barocche a Firenze*, edited by Mina Gregori, pp. 9–16. Cinisello Balsamo (Milan).

2006 "Palazzo Pitti, piano nobile: Gli affreschi di Pietro da Cortona nella Stanza della Stufa e nelle Sale dei Pianeti." In *Fasto di corte: La decorazione murale nelle residenze dei Medici e dei Lorena*, vol. 2, *L'età di Ferdinando II de' Medici (1628–1670)*, edited by Mina Gregori, pp. 91–136. Florence.

Grell, Chantal, and Christian Michel

1988 *L'école des princes, ou, Alexandre disgracié: Essai sur la mythologie monarchique de la France absolutiste*. Collection Nouveaux confluents. Paris.

Grenoble–Rennes–Bordeaux

1989 *Laurent de La Hyre, 1606–1656: L'homme et l'oeuvre*. Exh. cat. by

Pierre Rosenberg and Jacques Thuillier. Musée de Grenoble; Musée de Rennes; Musée de Bordeaux. Geneva.

Grilli, Cecilia

2003 "Le cappelle gentilizie della chiesa di Sant'Andrea della Valle: I committenti, i documenti, le opere." In Alba Costamagna, Daniele Ferrara, and Cecilia Grilli, *Sant'Andrea della Valle*, pp. 69–193. Geneva and Milan.

Grisone, Federico

1550 *Gli ordini di cavalcare*. Naples.

Grivel, Marianne, and Marc Fumaroli

1988 *Devises pour les tapisseries du Roi*. Paris.

Grouchy, Emmanuel-Henri, vicomte de

1892 "Inventaire des tapisseries et tableaux trouvés après décès du chancelier Michel Le Tellier (5 novembre 1685)." *Nouvelles archives de l'art français*, 3rd ser., 8, pp. 112–14.

1894 "Inventaire des tapisseries, tableaux, bustes et armes de Louvois (1688)." *Mémoires de la Société de l'Histoire de Paris et de l'Île-de-France*, pp. 115–22, 140–47.

Grove

1996 *The Dictionary of Art*. Edited by Jane Turner. 34 vols. London: Grove's Dictionaries.

Gruber, Alain

1992 Ed. With the assistance of Bruno Pons et al. *L'art décoratif en Europe: Classique et baroque*. Paris.

Guicciardini, Lodovico

1567 *Descrittione de M. Lodovico Guicciardini, patritio fiorentino, di tutti i Paesi Bassi, altrimenti detti Germania Inferiore*. Antwerp.

Guichard, Édouard, and Alfred Darcel

1881 *Les tapisseries décoratives du Garde-Meuble (Mobilier National): Choix des plus beaux motifs*. 2 vols. Paris.

Guido, Laurence [de]

2002 "*Moïse sauvé des eaux*, ou le renouveau de la tapisserie française." *Dossier de l'art*, no. 86 (May), pp. 12–13. Issue titled *Les arts décoratifs sous Louis XIII*.

Guiffrey, Jean, and Pierre Marcel

1909 *Inventaire général des dessins du Musée du Louvre et du Musée de Versailles. École française*. Vol. 4, *Corot à Delacroix*. Paris.

1913 *Inventaire général des dessins du Musée du Louvre et du Musée de Versailles. École française*. Vol. 8, *Le Brun–Le Clerc*. Paris.

Guiffrey, Jules

1878–85 *Tapisseries françaises*. Pt. 1 of Jules Guiffrey, Eugène Müntz, and Alexandre Pinchart, *Histoire générale de la tapisserie*. Paris.

1879a "Documents inédits sur les tapisseries de haute lisse sous Henri IV et sous ses successeurs." *Nouvelles archives de l'art français*, 2nd ser., 1, pp. 233–46.

1879b "Van der Meulen: Mémoire de ses travaux pour le Roi depuis le 1er avril 1664. Inventaire des tableaux et dessins trouvés chez lui, aux Gobelins, le 6 mars 1691." *Nouvelles archives de l'art français*, 2nd ser., 1, pp. 119–45.

1881–1901 *Comptes des Bâtiments du Roi sous le règne de Louis XIV*. 5 vols. Comité des travaux historiques et scientifiques, Collection de documents inédits sur l'histoire de France, 3rd ser., Archéologie. Paris.

1882 *Les amours de Gombault et de Macée: Étude sur la tapisserie du Musée de Saint-Lô*. Paris.

1885–86 *Inventaire général du mobilier de la couronne sous Louis XIV (1663–1715)*. 2 vols. Paris.

1886 *Histoire de la tapisserie, depuis le Moyen Âge jusqu'à nos jours*. Tours.

1887 "Destruction des plus belles tentures du mobilier de la couronne en 1797." *Mémoires de la Société de l'Histoire de Paris et de l'Île-de-France* 14 (1887), pp. 265–98.

1892 "Les manufactures parisiennes de tapisseries au XVIIe siècle." *Mémoires de la Société d'Histoire de Paris et de l'Île-de-France* 19.

1897 "Les tapisseries de Malte aux Gobelins et les tentures de l'Académie de France à Rome." *Revue de l'art ancien et moderne* 1, pp. 64–66.

1898 "Nicolas Houel: Apothicaire parisien, fondateur de la maison de la Charité Chrétienne, premier auteur de la tenture d'Artémise." *Mémoires de la Société d'Histoire de Paris et de l'Île-de-France* 25, pp. 179–270.

1899 "Scellé et inventaire des joyaux, meubles, argenterie, tapisserie, peintures, etc., appartenant au duc de La Meilleraye ... décédé à l'Arsenal le 7 février 1664." *Nouvelles archives de l'art français*, 3rd ser., 15, pp. 12–43.

1904 "Les tapisseries de Malte: L'église St. Jean, le Palais du Gouvernement." *Gazette des beaux-arts*, 3rd ser., 32 (October and November), pp. 299–310, 406–22.

1913 "Inventaire descriptif et méthodique des tapisseries du Garde-Meuble." In *Inventaire général des richesses d'art de la France, Paris, Monuments civils*, vol. 4, pp. 1–204. Paris.

1923 "Notes et documents sur les origines de la Manufacture des Gobelins et sur les autres ateliers parisiens pendant la première moitié du dix-septième siècle." In Fenaille 1903–23, vol. 1, pp. 1–88.

Haberditzl, Franz Martin

1907–9 "Die Lehrer des Rubens." *Jahrbuch der Kunsthistorischen Sammlungen des Allerhöchsten Kaiserhauses* 27, pp. 161–235.

Habicht, V. Curt

1917 "Die Gobelins im Rittersaale des Doms zu Hildesheim." *Monatshefte für Kunstwissenshaft* 10, pp. 275–80.

Hager, Luisa

1959–60 "Kurzreferate: Die verschollene Herkulesfolge aus dem ehem. Herkulessaal der Residenz München." *Artes textiles* 5, pp. 44–45.

Hairs, Marie-Louise

1965 *Les peintres flamands de fleurs au XVIIe siècle*. 2nd ed. Art et savoir. Brussels.

Halbturn

1975 *Barocke Tapisserien aus dem Besitz des Kunsthistorischen Museums Wien*. Exh. cat. by Rotraud Bauer. Schloss Halbturn. Eisenstadt.

1976 *Historische Schlachten auf Tapisserien aus dem Besitz des Kunsthistorischen Museums Wien*. Exh. cat. by Rotraud Bauer. Schloss Halbturn. Eisenstadt.

1991 *Wohnen im Schloss: Tapisserien, Möbel, Porzellan und Kleider aus drei Jahrhunderten*. Exh. cat. edited by Rotraud Bauer. Schloss Halbturn. Eisenstadt.

Hall, James

1974 *Dictionary of Subjects and Symbols in Art*. London.

Hamann-MacLean, Richard

1976 *Grundlegung zu einer Geschichte der mittelalterlichen Monumentalmalerei in Serbien und Makedonien*. Vol. 2 of *Die Monumentalmalerei in Serbien und Makedonien vom 11. bis zum frühen 14. Jahrhundert*. Giessen.

Hammond, Frederick

1994 *Music and Spectacle in Baroque Rome: Barberini Patronage under Urban VIII*. New Haven.

Harper, James

1998 "The Barberini Tapestries of the Life of Pope Urban VIII: Program, Politics and 'Perfect History' for the Post-Exile Era." 2 vols. PhD diss., University of Pennsylvania, Philadelphia, 1998. Microfilm, Ann Arbor.

2001 "The High Baroque Tapestries of the *Life of Cosimo I*: The Man and His Myth in the Service of Ferdinando II." In *The Cultural Politics of Duke Cosimo I de' Medici*, edited by Konrad Eisenbichler, pp. 223–52. Aldershot.

2005 "Pietro Lucatelli, Pietro da Cortona, and the *Arazzeria Barberini*: Three New Attributions." *Studies in the Decorative Arts* 12, no. 2 (Spring–Summer), pp. 26–59.

Hartkamp-Jonxis, Ebeltje

1993 "Helden en heldendaden: Historietapijten in de Noordelijke Nederlanden omstreeks 1600." *Antiek* 28 (December), pp. 212–19.

2002a "Bloemen op tafel: Nederlandse tapisserietafelkleden in de zeventiende eeuw." In *IJdel stof: Interieurtextiel in West-Europa, 1600–1900*, pp. 17–24. Exh. cat. by Derek Balfour et al. Hessenhuis. Antwerp.

2002b "Flemish Tapestry Weavers and Designers in the Northern Netherlands: Questions of Identity." In Delmarcel 2002b, pp. 15–41.

2006 "De Scandinavische connectie: Nederlandse wandtapijten en hun Deense en Zweedse afnemers, 1615 tot 1660." *Textielhistorische bijdragen* 46, pp. 45–72.

Hartkamp-Jonxis, Ebeltje, and Hillie Smit

2004 *European Tapestries in the Rijksmuseum.* Catalogues of the Decorative Arts in the Rijksmuseum 5. Zwolle and Amsterdam.

Haskell, Francis

1963 *Patrons and Painters: A Study in the Relations between Italian Art and Society in the Age of the Baroque.* New York.

1989 "Charles I's Collection of Pictures." In MacGregor 1989, pp. 203–31.

Haskell, Francis, and Nicholas Penny

1981 *Taste and the Antique: The Lure of Classical Sculpture, 1500–1900.* New Haven.

von Haumeder, Ulrika

1976 "Antoine Caron: Studien zu seiner 'Histoire d'Arthémise.'" PhD diss., Ruprecht-Karls-Universität, Heidelberg.

Havard, Henry, and Marius Vachon

1889 *Les manufactures nationales: Les Gobelins, la Savonnerie, Sèvres, Beauvais.* Paris.

Haverkamp-Begemann, Egbert

1975 *The Achilles Series.* Corpus Rubenianum Ludwig Burchard 10. Brussels.

Havinden, M. A.

1966 "The Soho Tapestry Makers." In *Survey of London*, edited by F. H. W. Shephard, vol. 34, *The Parish of St. Anne Soho*, app. 1, pp. 515–20, 542–43. London.

Heeringa, Klaas

1910 *Bronnen tot de geschiedenis van den Levantschen handel.* 4 vols. Vols. 3 and 4 compiled by J. G. Nanninga. The Hague.

Hefford, Wendy

1975 "Some Problems Concerning the 'Art of War' Tapestries." *Bulletin de liaison du Centre International d'Étude des Textiles Anciens* [CIETA], nos. 41–42, pp. 101–18.

1977 "Cardinal Mazarin and the Earl of Pembroke's Tapestries." *Connoisseur* 195 (August), pp. 286–90.

1983 "The Chicago *Pygmalion* and the 'English Metamorphoses.'" In *The Art Institute of Chicago Centennial Lectures*, pp. 93–117. Issue of *Museum Studies* (Art Institute of Chicago) 10.

1984 "Soho and Spitalfields: Little-Known Huguenot Tapestry-Weavers in and around London." *Proceedings of the Huguenot Society of London* 24, no. 2, pp. 103–12.

1990 "Cleyn's Noble 'Horses.'" In *National Art Collections Fund Review*, pp. 97–102. London.

1992 "Ralph Montagu's Tapestries." In *Boughton House: The English Versailles*, edited by Tessa Murdoch, pp. 96–107. London.

1999 "The Duke of Buckingham's Mortlake Tapestries of 1623." *Bulletin du CIETA*, no. 76, pp. 90–103.

2002 "Flemish Tapestry Weavers in England, 1550–1775." In Delmarcel 2002b, pp. 43–61.

2003 "Brussels *Horsemanship* Tapestries Owned by Charles I and Frederick Prince of Wales." In Brosens 2003, pp. 117–31.

2006 "I *Mesi* di Mortlake: Una serie di arazzi inglesi a Genova." In *Genova e l'Europa atlantica: Opere, artisti, committenti, collezionisti—Inghilterra, Fiandre, Portogallo*, edited by Piero Boccardo and Clario Di Fabio, pp. 167–81. Genova e l'Europa. Cinisello Balsamo (Milan).

forthcoming *Study of English Tapestries in the Collection of the Victoria and Albert Museum.*

Heikamp, Detlef

1969 "Die Arazzeria medicea im 16. Jahrhundert: Neue Studien." *Münchner Jahrbuch der bildenden Kunst*, 3rd ser., 20, pp. 33–74.

Heinz, Dora

1963 *Europäische Wandteppiche: Ein Handbuch für Sammler und Liebhaber.* Vol. 1, *Von den Anfängen der Bildwirkerei bis zum Ende des 16. Jahrhunderts.* Bibliothek für Kunst- und Antiquitätenfreunde 37. Brunswick.

1995 *Europäische Tapisseriekunst des 17. und 18. Jahrhunderts: Die Geschichte ihrer Produktionsstätten und ihrer künstlerischen Zielsetzungen.* Vienna, Cologne, and Weimar.

Heinz, Günther

1967 "Studien über Jan van den Hoecke und die Malerei der Niederländer in Wien." *Jahrbuch der Kunsthistorischen Sammlungen in Wien* 63, pp. 109–64.

Held, Julius S.

1949 "Jordaens and the Equestrian Astrology." In *Miscellanea Leo van Puyvelde*, pp. 153–56. Brussels. [Reprinted as "Jordaens and the Equine Astrology," in *Rubens and His Circle: Studies by Julius S. Held*, edited by Anne W. Lowenthal, David Rosand, and John Walsh Jr., pp. 32–34. Princeton, 1981.]

1959 *Rubens: Selected Drawings.* 2 vols. London.

1968 "Rubens's Triumph of the Eucharist and the *Modello* in Louisville." *Bulletin of the J. B. Speed Art Museum* 26, no. 3 (February), pp. 2–22.

1980 *The Oil Sketches of Peter Paul Rubens: A Critical Catalogue.* 2 vols. Kress Foundation Studies in the History of European Art 7. Princeton.

Hennel-Bernasikowa, Maria

1972 "Verdures aux animaux." In *Les tapisseries flamandes au Château du Wawel à Cracovie: Trésors du foi Sigismond II Auguste Jagellon*, edited by Jerzy Szablowski, pp. 191–286. Antwerp.

1991 "Dwa Gebeliny według projektów Jacoba Jordaensa w zbiorach Wawelskich." *Studia do dziejów Wawelu* 5, pp. 468–79.

1994 *Gobeliny katedry Wawelskiej.* Biblioteka Wawelska 9. Kraków.

1998 *Arrasy Zygmunta Augusta / The Tapestries of Sigismund Augustus.* Kraków.

Herrero Carretero, Concha

1992–93 "La fábrica de tapices de Madrid. Los tapices del siglo XVIII. Colección de la Corona de España." 4 vols. PhD diss., Universidad Complutense, Madrid.

1994 "Las tapicerías ricas del Alcázar de Madrid." In *El Real Alcázar de Madrid: Dos siglos de arquitectura y coleccionismo en la corte de los reyes de España*, pp. 288–307. Exh. cat., Palacio Real, Museo del Prado, Real Academia de Bellas Artes de San Fernando, and other venues in Madrid. Madrid.

1999 "Tapisseries royales espagnoles de la maison des Habsbourg et acquisitions flamandes de la maison des Bourbons." In *Tapisserie au XVIIe siècle* 1999, pp. 103–12.

2000 *Catálogo de tapices del Patrimonio Nacional.* Vol. 3, *Siglo XVIII: Reinado de Felipe V.* Madrid.

2004 "Decio e Manlio vanno combattere i latini. Decio consulta l'oraculu." In *L'età di Rubens: Dimore, committenti e collezionisti genovesi*, pp. 110–11. Exh. cat. edited by Piero Boccardo. Palazzo Ducale, Galleria di Palazzo Rosso, and Galleria Nazionale di Palazzo Spinoa, Genoa. Milan.

Hessels, Jan Hendrik
1887–97 *Ecclesiae Londino-Bataviae Archivum*. 3 vols. in 4. London and Amsterdam.

Heyndrickx, Jeroom
2004 "Ferdinand Verbiest: Un jésuite et Kangxi." In Versailles 2004, pp. 85–91.

Heyning, Katie
2007 *The Zeeland Tapestries*. Forthcoming in 2007.

Hilaire, Michel
1995 *Le Musée Fabre, Montpellier*. Musées et monuments de France. Paris.

Hill, John Walter
1997 *Roman Monody, Cantata, and Opera from the Circles around Cardinal Montalto*. Oxford Monographs on Music. Oxford.

Historical Manuscripts Commission
1889 *The Manuscripts of His Grace the Duke of Rutland, K.G., Preserved at Belvoir Castle*. Vol. 2. Twelfth Report, app., pt. 5. London.

Hochmann, Michel
1999 "La collezione di Villa Medici: I primi esperimenti museografici del cardinale Ferdinando." In Rome 1999, pp. 14–21.

Hoefer, Jean-Chrétien-Ferdinand
1853–66 Ed. *Nouvelle biographie générale depuis les temps les plus reculés jusqu'à nos jours*. 46 vols. Paris. [Reprint, Copenhagen, 1969.]

Hoek, D.
1959 "Een onbekend huwelijk van François Spiering, tapijtwever te Delft." *Zuidhollandse studiën* 8, pp. 126–29.

Hong Kong
1997 *From Beijing to Versailles: Artistic Relations between China and France*. Exh. cat., Hong Kong Museum of Art. Co-organized by the Musée National des Arts Asiatiques-Guimet. Hong Kong.

Honnens de Lichtenberg, Hanne
1981 "Some Netherlandish Artists Employed by Frederik II." *Hafnia*, no. 8, pp. 51–71.
1984 "Frederik II's Frederiksborg." In *Art in Denmark, 1600–1650*, pp. 37–53. Delft. Issue of *Leids kunsthistorisch jaarboek* 2 (1983).

Hoogewerff, Godefridus Johannes
1919 *De twee reizen van Cosimo de' Medici, prins van Toscane door de Nederlanden (1667–1669): Journalen en documenten*. Amsterdam.
1921 "Prelaten en Brabantsche tapijtwevers, 1610." *Mededeelingen van het Nederlandsch Historisch Instituut te Rome* 1, pp. 141–53. 2nd ed., 1932, pp. 127–40.
1925 "Prelaten en Brusselsche tapijtwevers. III." *Mededeelingen van het Nederlandsch Historisch Instituut te Rome* 5, pp. 137–60.

Horn, Hendrik J.
1989 *Jan Cornelisz Vermeyen, Painter of Charles V and His Conquest of Tunis: Paintings, Etchings, Drawings, Cartoons and Tapestries*. 2 vols. Aetas Aurea, Monographs on Dutch and Flemish Painting 8. Doornspijk.

Houdoy, Jules
1871 *Les tapisseries de haute-lisse: Histoire de la fabrication lilloise du XIVe au XVIIIe siècle, et documents inédits concernant l'histoire des tapisseries de Flandre*. Lille and Paris.

Van Hout, Nico
2002 *Flemish Masters: Rubens, Van Dyck, Jordaens and Their Contemporaries*. Rijksmuseum Dossiers. Zwolle and Amsterdam.

Howarth, David
1994 "William Trumbull and Art Collecting in Jacobean England." *British Library Journal* 20, no. 2 (Autumn), pp. 140–62.

Huard, Georges
1939 "Les logements des artisans dans la Grande Galerie du Louvre sous Henri IV et Louis XIII." *Bulletin de la Société de l'Histoire de l'Art Français*, pp. 18–36.

d'Hulst, Roger-Adolf
1956 "Jordaens and His Early Activities in the Field of Tapestry." Translated by René Muller. *Art Quarterly* 19 (Autumn), pp. 237–54.
1960 *Vlaamse wandtapijten van de XIVde tot de XVIIIde eeuw*. Brussels. Also published as *Tapisseries flamandes du XVIe au XVIIIe siècle*. Brussels.
1967 *Flemish Tapestries, from the Fifteenth to the Eighteenth Century*. Translated by Frances J. Stillman. New York.
1974 *Jordaens Drawings*. Monographs of the Nationaal Centrum voor de Plastische Kunsten van de XVIde en XVIIde Eeuw 5. London.
1982 *Jacob Jordaens*. Translated by P. S. Falla. Ithaca, N.Y.
1993 "Jordaens Life and Work." In Antwerp 1993b, vol. 1, pp. 23–29.

Hunter, George Leland
1912 *Tapestries: Their Origin, History and Renaissance*. New York.

Huygens, Frank
1994 "Mozes in de Zuidnederlandse tapissierskunst: Traditie en vernieuwing in twee tapijten van Jasper van der Borcht." *Bulletin des Musées Royaux d'Art et d'Histoire / Bulletin van de Koninklijke Musea voor Kunst en Geschiedenis* 65, pp. 257–304.

Hyde, James H.
1924 "L'iconographie des quatre parties du monde dans les tapisseries." *Gazette des beaux-arts*, 5th ser., 10 (November), pp. 253–72.

Inventario e descrizzione di tutti gli arazzi posseduti dalla già fu Maestà della Regina Cristina di Svezia
n.d. *Inventario e descrizzione di tutti gli arazzi posseduti dalla già fu Maestà della Regina Cristina di Svezia . . . possedut presentemente de Sua Eccelenza il Signor Principe D. Livio Odescalchi, Duca di Bracciano*. Copy in the Vatican Library.

Jacquiot, Josèphe
1968 *Médailles et jetons de Louis XIV, d'après le manuscrit de Londres (ADD 31.908)*. 4 vols. Paris.

Jaffé, Michael
1977 *Rubens and Italy*. Oxford.
1989 *Rubens: Catalogo completo*. Translated by Germano Mulazzani. Milan.

Jarry, Madeleine
1958 "The 'Tenture des Indes' in the Palace of the Grand Master of the Order of Malta." *Burlington Magazine* 100 (September), pp. 306–11.
1959 "Les 'Indes': Série triomphale de l'exotisme." *Connaissance des arts*, no. 87 (May), pp. 62–69.
1969 "Esquisses et maquettes de tapisseries du XVIIIe siècle pour les manufactures royals (Gobelins et Beauvais)." *Gazette des beaux-arts*, 6th ser., 73 (February), pp. 111–18.
1975 "Chinoiseries à la mode de Beauvais." *Plaisir de France*, no. 429 (May), pp. 54–59.
1976 "L'exotisme au temps de Louis XIV: Tapisseries des Gobelins et de Beauvais." *Medizin historisches Journal* 11, pp. 52–71.
1980 "La vision de la Chine dans les tapisseries de la Manufacture Royale de Beauvais: Les premières tentures chinoises." In *Les rapports entre la Chine et l'Europe au temps des Lumières*, pp. 173–83. Actes du IIe Colloque International de Sinologie (Centre de Recherches Interdisciplinaire de Chantilly [CERIC]), September 16–18, 1977. Paris.

J. B. Speed Art Museum
1978 *A Checklist of Drawings, Paintings and Sculptures in the J. B. Speed Art Museum, 1927–1977*. Louisville.

Jestaz, Bertrand
1968 "La tapisserie française, 1597–1662." Review of Versailles 1967. *Revue de l'art*, nos. 1–2, pp. 133–34.
1979 "The Beauvais Manufactory in 1690." In A. G. Bennett 1979, pp. 187–207.

Jombert, Charles-Antoine
1774 *Catalogue raisonné de l'oeuvre de Sébastien Le Clerc, chevalier romain, dessinateur & graveur du Cabinet du Roi.* 2 vols. Paris.

Joppien, R.
1979 "The Dutch Vision of Brazil: Johan Mauritz and His Artists." In Van den Boogaart, Hoetink, and Whitehead 1979, pp. 297–376.

Joubert, Fabienne, Amaury Lefébure, and Pascal-François Bertrand
1995 *Histoire de la tapisserie en Europe, du Moyen Âge à nos jours.* Paris.

Jouin, Henry
1889 *Charles Le Brun et les arts sous Louis XIV.* Paris.

Jourdain, M.
1929 "Lord Iveagh's Solebay Tapestries." *Country Life* 65 (March 16), pp. 351–53.

Junquera de Vega, Paulina
1977 "Las aventuras de Telemaco: Tres series de tapices del Patrimonio Nacional." *Reales sitios*, no. 52, pp. 45–52.

Junquera de Vega, Paulina, and Carmen Díaz Gallegos
1986 *Catálogo de tapices del Patrimonio Nacional.* Vol. 2, *Siglo XVII.* Madrid.

Junquera de Vega, Paulina, and Concha Herrero Carretero
1986 *Catálogo de tapices del Patrimonio Nacional.* Vol. 1, *Siglo XVI.* Madrid.

Junquera de Vega, Paulina, and Juan José Junquera
1969 "Descalzas Reales. Serie de Tapices: La Apoteosis de la Eucaristía." *Reales sitios*, no. 22, pp. 18–31.

Kagan, Judith
1997 "'De grands et pieux tableaux qui retracent dans la chapelle le glorieux martyre de Sainte-Reine.'" In *Reine au Mont Auxois: Le culte et le pèlerinage de Sainte Reine des origines à nos jours*, edited by Philippe Boutry et Dominique Julia, pp. 147–68. Dijon.

Karlsruhe
2005 *David Teniers der Jüngere, 1610–1690: Alltag und Vergnügen in Flandern.* Exh. cat. by Margret Klinge and Dietmar Lüdke. Staatliche Kunsthalle Karlsruhe. Karlsruhe.

Kaufmann, Thomas DaCosta
1995 *Court, Cloister, and City: The Art and Culture of Central Europe, 1450–1800.* Chicago.

Kendrick, A. F.
1918 "An English Tapestry." *Burlington Magazine* 33 (November), pp. 158, 163.
1927 "A Tapestry at the Merchant Taylors' Hall—II." *Burlington Magazine* 51 (October), pp. 161–62.

Kervyn de Lettenhove, Henri M. Bruno, Baron
1909 *Albert et Isabelle (1595–1633): Notes sur le règne et le gouvernement de l'Archiduc et de l'Infante et sur la protection qu'ils accordèrent aux arts, aux lettres et aux sciences.* Brussels.

Kimball, Fiske
1941 "Sources and Evolution of the Arabesque of Berain." *Art Bulletin* 23 (December), pp. 307–16.
1943 *The Creation of the Rococo.* Philadelphia. Also published with additions as *Le style Louis XV: Origine et évolution du Rococo.* Translated by Jeanne Marie. Paris, 1949.

Kinds, Karel
1999 *Kroniek van de opstand in de Lage Llanden, 1559–1609: Actuele oorlogsverslaggeving uit de zestiende eeuw met 228 gravures van Frans Hogenberg.* 2 vols. [Netherlands.]

King, Donald
1989 "Tapestries and Other Hangings." In MacGregor 1989, pp. 308–14.

Kirchner, Thomas
2001 *Der epische Held: Historienmalerei und Kunstpolitik im Frankreich des 17. Jahrhunderts.* Munich.

Klaits, Joseph
1976 *Printed Propaganda under Louis XIV: Absolute Monarchy and Public Opinion.* Princeton.

Kleve
1979 *Soweit der Erdkreis Reicht: Johann Moritz von Nassau-Siegen, 1604–1679.* Exh. cat., Städtisches Museum Haus Koekkoek. Kleve.

Klingensmith, Samuel John
1993 *The Utility of Splendor: Ceremony, Social Life, and Architecture at the Court of Bavaria, 1600–1800.* Edited by Christian F. Otto and Mark Ashton. Chicago.

Knowlton, Edgar C.
1956 "The Scale of Man." *Studies in the Renaissance* 3, pp. 131–44.

Koch, Robert A.
1980 Ed. *Early German Masters.* The Illustrated Bartsch 16 (formerly 8, pt. 3), Jacob Bink, Georg Pencz, Henrich Aldegrever. New York.

Kolb, Arianne Faber
2005 *Jan Brueghel the Elder: The Entry of the Animals into Noah's Ark.* Getty Museum Studies on Art. Los Angeles.

Korshunova, Tamara Timofeevna
1975 *Russkie shpalery* (Russian Tapestry). Leningrad.

Krahl, Regina
2005 "The Kangxi Emperor: Horseman, Man of Letters, Man of Science." In London 2005, pp. 208–14.

Krarup, Rigmor, and Erik Lassen
1946–47 "Frederik den Andens bordhimmel paa Kronborg." *Kunstmuseets aarsskrift*, pp. 105–23.

Kraus, Johann Ulrich
1687 *Tapisseries du Roy, ou sont representez les quatre elemens et les quatre saisons avec les devises qui les accompagnent et leur explication / Königliche französische Tapezereijen, oder Überaus schöne Sinn-Bilder in welchen die vier Element samt den vier Jahr–Zeiten neben den Denksprüchen und ihren Auslegungen vorgestellet werden.* Augsburg.

Krause, Katharina
2005 "Die 'Histoire de Moïse' des Nicolas Poussin." *Münchner Jahrbuch der bildenden Kunst* 56, pp. 139–66.

Krüger, Peter
1989 *Studien zu Rubens' Konstantinszyklus.* Europäische Hochschulschriften, ser. 28, Kunstgeschichte 92. Frankfurt am Main and New York.

Kumsch, Emil
1913 *Wandteppiche im Hause Krupp von Bohlen und Halbach auf dem Hügel a. d. Ruhr.* Dresden.
1914 *Die Apostel-Geschichte: Eine Folge von Wandteppichen nach Entwürfen von Raffael Santi.* Dresden.

Kunsthistorisches Museum
1991 *Die Gemäldegalerie des Kunsthistorischen Museums in Wien: Verzeichnis der Gemälde.* Vienna.

Lablaude, Pierre-André
1998 *Les jardins de Versailles.* Paris.

Laborde, Léon, marquis de
1877–80 *Les comptes des Bâtiments du Roi (1528–1571), suivi de documents inédits sur les châteaux royaux et les beaux-arts au XVIe siècle.* Edited by Jules Guiffrey. 2 vols. Paris.

Lacordaire, Adrien-Léon
1853 *Notice historique sur les manufactures impériales de tapisseries des Gobelins et de tapis de la Savonnerie.* Paris.

de Lacroix-Vaubois, Jacqueline
2005 "Jean I Cotelle: Dessinateur et décorateur." In *Rinceaux et figures: L'ornement en France au XVIIe siècle,* edited by Emmanuel Coquery, pp. 45–59. Actes du Colloque du Musée du Louvre, 2002. Paris.

de La Fontaine, Jean de
1671 *Recueil des poesies chrestiennes et diverses.* Paris.

de La Gorce, Jérôme de
1986 *Berain: Dessinateur du Roi Soleil.* Paris.

Laking, Guy Francis
1905 *The Furniture of Windsor Castle.* London.

Langberg, Harald
1985 *Dansesalen på Kronborg.* Copenhagen.

Langedijk, Karla
1981–87 *The Portraits of the Medici, 15th–18th Centuries.* 3 vols. Florence.

Lara Arrebola, Francisco
1982 *Artes textiles en el Palacio de la Casa de Viana en Córdoba.* Córdoba.

Larsen, Erik
1952 *P. P. Rubens: With a Complete Catalogue of His Works in America.* Antwerp.
1962 *Frans Post: Interprète du Brésil.* Amsterdam.
1985 *Seventeenth Century Flemish Painting.* Düsseldorf.

Lassen, Erik
1973 "Kongens Himmel." In Erik Lassen et al., *Dansk kunsthistorie: Billedkunst og skulptur,* vol. 2, *Rigets maend lader sig male, 1500–1750,* pp. 84–88. Copenhagen.

Latham, Charles
1904 *In English Homes: The Internal Character, Furniture & Adornments of Some of the Most Notable Houses of England.* Vol. 1. London.

Laurain-Portemer, Madeleine
1973 "Le Palais Mazarin à Paris et l'offensive baroque de 1645–1650, d'après Romanelli, P. de Cortone et Grimaldi." *Gazette des beaux-arts,* 6th ser., 81 (March), pp. 151–68.

Lavalle, Denis
1990 "Simon Vouet et la tapisserie." In Paris 1990, pp. 489–503.

Lavin, Irving
1974 "Divine Inspiration in Caravaggio's Two *St. Matthews.*" *Art Bulletin* 56 (March), pp. 59–81.
1985 "Bernini's Bust of Cardinal Montalto." *Burlington Magazine* 127 (January), pp. 32, 34–38.

Lavin, Marilyn
1975 *Seventeenth-Century Barberini Documents and Inventories of Art.* New York.

Law, Ernest Philip Alphonse
1885–91 *The History of Hampton Court Palace in Tudor Times.* 3 vols. London.

Lawrence–Chapel Hill–Wellesley
1981 *The Engravings of Marcantonio Raimondi.* Exh. cat. by Innis H. Shoemaker and Elizabeth Broun. Spencer Museum of Art, University of Kansas, Lawrence; Ackland Art Museum, University of North Carolina, Chapel Hill; Wellesley College Art Museum, Wellesley, Mass. Lawrence.

Le Blant, Robert
1988 "Henri IV et les tapisseries." *Revue de Pau et du Béarn* 16, pp. 47–67.

Le Brun, Charles
1667/1668 "Sixième conférence tenuë dans l'Académie Royale. Le samedy 5. jour de novembre 1667." In *Conférences de l'Académie Royale de Peinture et de Sculpture pendant l'année 1667,* edited by André Félibien, pp. 76–106. Paris, 1668.
1668/1996 "Sur *L'Expression des passions* (7 avril et 5 mai 1668)." In *Les conférences de l'Académie Royale de Peinture et de Sculpture au XVIIe siècle,* edited by Alain Mérot, pp. 145–62. Collection Beaux-Arts histoire. Paris, 1996.

Lecchini Giovannoni, Simona
1991 *Alessandro Allori.* Turin.
1996 "Il Corpus Christi e la mensa d'altare in alcuni dipinti fiorentini del Cinquecento." In *Altari e committenza: Episodi a Firenze nell'età della Controriforma,* edited by Cristina De Benedictis, pp. 28–35. Florence.

Lee, Rensselaer W.
1991 *Ut Pictura Poesis: Humanisme et théorie de la peinture, XVe–XVIIIe siècles.* Translated and updated by Maurice Brock. Littérature artistique. Paris. [Originally published as *Ut Pictura Poesis: The Humanistic Theory of Painting.* Norton Library. New York, 1967.]

Lefébure, Amaury
1995 "Le XVIIe siècle: Des tapisseries pour la cour, la ville et la campagne." In Joubert, Lefébure, and Bertrand 1995, pp. 138–205.
1996 "Les tapisseries et leur usage, en France au XVIIe siècle." In Chambord 1996, pp. 17–29.

Lefèvre d'Ormesson, Olivier
1860–61 *Journal d'Olivier Lefèvre d'Ormesson et extraits des mémoires d'André Lefèvre d'Ormesson.* 2 vols. Paris.

Lefrançois, Thierry
1981 *Nicolas Bertin (1668–1736): Peintre d'histoire.* Neuilly-sur-Seine.

Lejeaux, Jeanne
1948 "La tenture de la *Vie de la Vierge* à la cathédrale de Strasbourg." *Gazette des beaux-arts,* 6th ser., 34 (December), pp. 405–18.

Lemaire, Louis
1924 "Le rachat de Dunkerque par Louis XIV (1662). Documents inédits." *Bulletin* (Union Faulconnier, Société Historique de Dunkerque), 21.

Lemmens, J. T. M.
1979 "Die Schenkung am Ludwig XIV, und die Auflösung der brasilianischen Sammlung des Johann Moritz, 1652–1679." In Kleve 1979, pp. 265–93.

Le Pas de Sécheval, Anne
1992 "La politique artistique sous Louis XIII." 3 vols. PhD thesis. Université de Paris IV.
2002 "Louis XIII (Fontainebleau, 1601–Saint-Germain-en-Laye, 1643)." In Paris 2002, pp. 30–31.

Leribault, Christophe
2002 *Jean-François de Troy (1679–1752).* Paris.

Le Rouge, Georges-Louis
1723 *Les curiositez de Paris: De Versailles, de Marly, de Vincennes, de S. Cloud, et des environs.* 2 vols. New ed. Paris.
1742 *Les curiositez de Paris: De Versailles, de Marly, de Vincennes, de S. Cloud, et des environs.* 2 vols. New ed., rev. Paris.

Leuchtmann, Horst
1980 "Die Maximilianeische Hofkapelle." In Munich 1980, vol. 1, pp. 364–75.

Levi, Honor
1985 "L'inventaire après le décès du cardinal de Richelieu." *Archives de l'art français* 27, pp. 9–83.

Liedtke, Walter A.
1989 *The Royal Horse and Rider: Painting, Sculpture, and Horsemanship, 1500–1800.* New York.

Lietzmann, Hilda

1998 *Valentin Drausch und Herzog Wilhelm V. von Bayern: Ein Edelstein-schneider der Spätrenaissance und sein Auftraggeber.* Kunstwissen-schaftliche Studien 75. Munich and Berlin.

Lille

2004 *Rubens.* Exh. cat., Palais des Beaux-Arts, Lille. Paris.

Lindblom, Jack

1979 *Vävda tapeter.* Stockholm.

Liste des tableaux . . . exposez dans la Grande Gallerie du Louvre

1699/1869 *Liste des tableaux et des ouvrages de sculpture exposez dans la Grande Gallerie du Louvre par messieurs les peintres et sculpteurs de l'Académie Royale, en la présente année 1699.* In *Collection des livrets des anciennes expositions depuis 1673 jusqu'en 1800,* [vol. 2], *Exposition de 1699.* Paris, 1869.

Lo Bianco, Anna

1987 "I dipinti sei-settecenteschi degli altari del Pantheon: Bonzi, Camassei, Maioli, Labruzzi." *Bollettino d'arte* 72, no. 42 (March–April), pp. 91–116.

Loire, Stéphane

1998 "La représentation des batailles dans la peinture française du XVIIe siècle." In Dijon–Luxembourg 1998, pp. 53–65.

London

1927 *Exhibition of Flemish and Belgian Art, 1300–1900.* Exh. cat., Royal Academy of Arts. London.

1947 *Masterpieces of French Tapestry.* Exh. cat., Victoria and Albert Museum and Arts Council of Great Britain. London.

1968 *France in the Eighteenth Century.* Exh. cat. compiled by Denys Sutton. Royal Academy of Arts. London.

1972 *The Age of Charles I: Painting in England, 1620–1649.* Exh. cat. by Oliver Millar. Tate Gallery. London.

1995 *Dynasties: Painting in Tudor and Jacobean England, 1530–1630.* Exh. cat. edited by Karen Hearn. Tate Gallery. London.

1998 *The Print in Stuart Britain, 1603–1689.* Exh. cat. by Antony Griffiths. British Museum. London.

2001 *French Drawings and Paintings from the Hermitage: Poussin to Picasso.* Exh. cat. by Timothy Clifford et al. Hermitage Rooms at Somerset House. London.

2005 *China: The Three Emperors, 1662–1795.* Exh. cat. edited by Evelyn S. Rawski and Jessica Rawson. Royal Academy of Arts. London.

2006 *At Home in Renaissance Italy.* Exh. cat. edited by Marta Ajmar-Wollheim, Flora Dennis, and Elizabeth Miller. Victoria and Albert Museum. London.

London–Bilbao–Madrid

1999 *Orazio Gentileschi at the Court of Charles I.* Exh. cat. edited by Gabriele Finaldi. National Gallery, London; Museo de Bellas Artes, Bilbao; Museo del Prado, Madrid. London.

London–Toronto–Los Angeles

1999 *Raphael and His Circle: Drawings from Windsor Castle.* Exh. cat. by Martin Clayton. The Queen's Gallery and National Gallery, London; Art Gallery of Ontario, Toronto; J. Paul Getty Museum, Los Angeles. London.

Longhi, Roberto

1951/1999 Introduction to *Mostra del Caravaggio e dei Caravaggeschi.* Exh. cat. by Roberto Longhi, Mina Gregori, Costantino Baroni, and Gian Alberto Dell'Acqua. Palazzo Reale, Milan. 2nd ed. Florence, 1951. Reprinted in *Studi Caravaggeschi,* vol. 1, *1943–1968,* pp. 59–69. Edizione delle opere complete di Roberto Longhi 11. Milan, 1999.

Longo-Endres, Lucia

2005 "Baldassare Pistorini und seine Beschreibung der Münchner Residenz." *Akademie Aktuell* (March), pp. 38–41.

2006 Ed. *Kurf gefasste Beschreibung des Palastes, Sitzes der erlauchtesten Fürsten von Bayern / Descrittione compendiosa del palagio sede de'*

Serenissime di Baviera, by Baldassare Pistorini. Quellen zur neueren Geschichte Bayerns 4; Reiseberichte 2. Munich.

Loomie, Albert J.

1987 *Ceremonies of Charles I: The Note Books of John Finet, 1628–1641.* New York.

1989 "New Light on the Spanish Ambassador's Purchases from Charles I's Collection, 1649–53." *Journal of the Warburg and Courtauld Institutes* 52, pp. 257–67.

Looström, Ludvig

1885 *Le dais du roi Frédéric II de Danemark au National-Museum.* Publications de l'Association Suédoise des Arts Industriels. Copenhagen.

Lough, John

1984 *France Observed in the Seventeenth Century by British Travellers.* Stocksfield, Northumberland, and Boston.

Ludmann, Jean-Daniel

1968 "Le mobilier de l'appartement royal au palais des Rohan à Strasbourg." *Cahiers alsaciens d'archéologie, d'art et d'histoire.*

1979–80 *Le palais Rohan de Strasbourg.* 2 vols. Strasbourg.

Lugt, Frits

1949 *Inventaire général des dessins des écoles du Nord, publié sous les auspices du Cabinet des Dessins. École flamande.* 2 vols. Musée du Louvre. Paris.

Luh, Jürgen

2000 *Ancien Régime Warfare and the Military Revolution: A Study.* Baltic Studies 6. Groningen.

Lunsingh Scheurleer, Theodoor Herman, Cornelia Willemijn Fock, and A. J. van Dissel

1992 *Het Rapenburg: Geschiedenis van een Leidse gracht.* Vol. 6a, *Het Rijck van Pallas.* Leiden.

Lüscher, Philippe

2001 "Verdures avec les oiseaux de la ménagerie." In *Tapisseries anciennes de la Maison de Mon-Repos et du Musée Historique de Lausanne.* Lausanne.

Mabille, Gérard

2004 "Le grand buffet d'argenterie de Louis XIV et la tenture des Maisons Royales." In *Objets d'art: Mélanges en l'honneur de Daniel Alcouffe,* pp. 180–91. Dijon.

MacGregor, Arthur

1989 Ed. *The Late King's Goods: Collections, Possessions and Patronage of Charles I in the Light of the Commonwealth Sale Inventories.* London and Oxford.

Machabey, Armand

1962 *La métrologie dans les musées de province et sa contribution à l'histoire des poids et mesures en France depuis le treizième siècle.* Paris.

Machault, Pierre-Yves

1996 "Les ateliers de Tours: L'Histoire de Coriolan." *Dossier de l'art,* no. 32 (September), pp. 56–57.

Mackeprang, Mouritz, and Sigrid Müller-Christensen

1950 *Kronborgtapeterne.* Copenhagen.

Macon, Gustave

1913 "Les tapisseries de Colbert." *Archives de l'art française,* n.s., 7, pp. 248–54.

Madrid

1999 *El arte en la corte de los archiduques Alberto de Austria e Isabel Clara Eugenia (1598–1633): Un reino imaginado (1598–1633).* Exh. cat., Palacio Real. Madrid.

2002 *The Sale of the Century: Artistic Relations between Spain and Great Britain, 1604–1655.* Exh. cat. edited by Jonathan Brown and John Huxtable Elliott. Museo Nacional del Prado, Madrid. New Haven.

De Maeyer, Marcel

1955a *Albrecht en Isabella en de schilderkunst: Bijdrage tot de geschiedenis van de XVIIe-eeuwse schilderkunst in de Zuidelijke Nederlanden.* Verhandelingen van de Koninklijke Vlaamse Academie van België voor Wetenschappen, Letteren en Schone Kunsten van België, Klasse der Schone Kunsten 9. Brussels.

1955b "Otto Venius en de tapijtenreeks 'De Veldslagen van Aartshertog Albrecht.'" *Artes textiles* 2, pp. 105–11.

Magalotti, Lorenzo

1668/1991 *Diario di Francia dell'anno 1668.* Edited by Maria Luisa Doglio. Palermo, 1991.

Magnanimi, Giuseppina

1983 *Palazzo Barberini.* Rome.

Magurn, Ruth Saunders

1955 Trans. and ed. *The Letters of Peter Paul Rubens.* Cambridge, Mass.

Mai, Ekkehard

1975 *"Le portrait du Roi": Staatsporträt und Kunsttheorie in der Epoche Ludwigs XIV. Zur Gestaltikonographie des spätbarocken Herrscherporträts in Frankreich.* PhD diss. Bonn.

Malan, Alfred Henry

1900 Ed. *Famous Homes of Great Britain and Their Stories.* New York.

Manchester

1974 *Drawings by West European and Russian Masters from the Collections of the State Hermitage and the Russian Museums in Leningrad.* Exh. cat., Whitworth Art Gallery. Manchester.

Mancinelli, Fabrizio

1983 "Mostra dei restauri in Vaticano." *Bollettino dei Monumenti, Musei e Gallerie Pontificie* 4, pp. 257–75.

Van Mander, Karel

1604 *Het Schilder-boeck.* Haarlem. [Reprint, 2 vols. Documents of Art and Architectural History, ser. 1, 2. New York, 1980.]

1604/ *Karel van Mander: The Lives of the Illustrious Netherlandish and*
1994–99 *German Painters, from the First Edition of the "Schilder-Boeck" (1603–1604).* Edited and translated, and with an introduction by Hessel Miedema. 6 vols. Doornspijk, 1994–99.

1618 *Het Schilder-boek.* Amsterdam.

1618/1943 *Het Schilder-boek van Carel van Mander: Het leven der doorluchtige Nederlandsche en Hoogduitsche schilders.* 2nd ed. Amsterdam, 1618. 1943 ed., edited by A. F. Mirande and G. S. Overdiep. Amsterdam.

Manners, Victoria, Lady

1899 *Descriptive Notes on the Tapestry in Haddon Hall.* London.

Mannini, Maria Pia

1994 "Decorazioni fiorentine del Seicento: Tra commedia dell'arte e melodramma." *Paragone*, nos. 529, 531, 533 (*Gli allievi per Mina Gregori*) (March–July), pp. 220–30.

Mantua–Vienna

1999 *Roma e lo stile classico di Raffaello, 1515–1527.* Exh. cat. by Konrad Oberhuber and Achim Gnann. Palazzo Te, Mantua; Graphische Sammlung Albertina, Vienna. Milan.

Marder, Tod A.

2004 "Bernini's *Neptune and Triton Fountain* for the Villa Montalto." In *Bernini dai Borghese ai Barberini: La cultura a Roma intorno agli anni venti*, edited by Olivia Bonfait and Anna Coliva, pp. 118–27. Atti del Convegno, Accademia di Francia, Rome, February 17–19, 1999. Rome.

Mareš, Franz

1887 "Beiträge zur Kenntnis der Kunstbestrebungen des Erzherzogs Leopold Wilhelm." *Jahrbuch der Kunsthistorischen Sammlungen des Allerhöchsten Kaiserhauses* 5, pp. 343–63.

Marillier, Henry Currie

1927 "The Mortlake *Horses*." *Burlington Magazine* 50 (January), pp. 12–14.

1930 *English Tapestries of the Eighteenth Century: A Handbook to the Post-Mortlake Productions of English Weavers.* London.

1932 *Handbook to the Teniers Tapestries.* Tapestry Monographs 2. London.

1962 *The Tapestries at Hampton Court.* [Rev. ed.] London.

Marin, Louis

1981 *Le portrait du Roi.* Paris.

Marlier, Georges

1966 *La Renaissance flamande: Pierre Coeck d'Alost.* Brussels.

Marmottan, Paul

1901 *Les arts en Toscane sous Napoléon: La princesse Élisa.* Paris.

Marnef, Guido

1996 *Antwerp in the Age of Reformation: Underground Protestantism in a Commercial Metropolis, 1550–1577.* Translated by J. C. Grayson. Johns Hopkins University Studies in Historical and Political Science, ser. 114, 1. Baltimore and London.

Martin, J. F.

1973 Ed. *J. B. Speed Art Museum Handbook.* Louisville.

Martin, Laurence

1981 "Sir Francis Crane: Director of the Mortlake Tapestry Manufactory and Chancellor of the Order of the Garter." *Apollo* 113 (February), pp. 90–96.

Martinena Ruiz, Juan José

1998 *Guía del palacio de Navarra.* Pamplona.

Marubbi, Mario

2003 Ed. *La Pinacoteca Ala Ponzone: Il Cinquecento.* Museo Civico di Cremona. Milan.

Matteoli, Anna

1974 "Studi intorno a Lodovico Cardi Cigoli." *Bollettino dell'Accademia degli Euteleti della città di San Miniato* 43, pp. 154–57.

1980 *Lodovico Cardi-Cigoli, pittore e architetto: Fonti biografiche, catalogo delle opere, documenti, bibliografia, indici analitici.* Pisa.

Maumené, Charles, and Louis d'Harcourt

1931 "Iconographie des rois de France." Pt. 2, "Louis XIV, Louis XV, Louis XVI." *Archives de l'art français*, n.s., 16 (1929–30; pub. 1931).

Mavor, William Fordyce

1817 *A New Description of Blenheim: The Seat of His Grace the Duke of Marlborough.* 10th ed. Oxford.

Mayer, Manfred

1892 *Geschichte der Wandteppichfabriken (Hautelisse-Manufacturen) des Wittelsbachischen Fürstenhauses in Bayern.* Munich.

Mayer Thurman, Christa C., and Koenraad Brosens

2006 "*Autumn* and *Winter:* Two Gobelins Tapestries after Charles Le Brun." In *Old Masters at the Art Institute of Chicago*, edited by Larry J. Feinberg, pp. 61–71, 94–95. New Haven. Issue of *Museum Studies* (Art Institute of Chicago) 32, no. 2.

Maxon, John

1970 *The Art Institute of Chicago.* London.

McGrath, Elizabeth

1997 *Rubens: Subjects from History.* Edited by Arnout Balis. 2 vols. Corpus Rubenianum Ludwig Burchard 13. London.

McKendrick, Scot

1991 "The *Great History of Troy*: A Reassessment of the Development of a Secular Theme in Late Medieval Art." *Journal of the Warburg and Courtauld Institutes* 54, pp. 43–82.

Meaux

1988 *De Nicolo dell'Abate à Nicolas Poussin: Aux sources du classicisme (1550–1650)*. Exh. cat., Musée Bossuet. Meaux.

Mechelen

2000 *Los Honores: Flemish Tapestries for the Emperor Charles V.* Exh. cat. by Guy Delmarcel. Cultureel Centrum Antoon Spinoy. Antwerp.

Melbourne–Sydney–Adelaide

1978 *Hermitage and Tretiakov: Master Drawings and Watercolours.* Exh. cat., National Gallery of Victoria, Melbourne; Art Gallery of New South Wales, Sydney; Art Gallery of South Australia, Adelaide. Sydney.

Mellbye-Hansen, Preben, and Johansen, Katia

1997 *Kongens himmel.* Copenhagen.

Meloni Trkulja, Silvia

1997 "Dipinti tradotti in arazzo a Firenze e Roma." In *Iskusstvo i kul'tura Italii epokhi Vozrozhdeniia i Prosveshcheniia* (Arte e cultura in Italia dal Rinascimento all'Illuminismo), edited by L. M. Bragina and V. E. Markova, pp. 210–20. Moscow.

Menčik, Ferdinand

1911–12 "Dokumente zur Geschichte der kaiserlichen Tapezerei-sammlung, aus dem gräfl. Harrachschen Archive." *Jahrbuch der Kunsthistorischen Sammlungen des Allerhöchsten Kaiserhauses* 30, pp. xxxiv–xlvi.

Meoni, Lucia

1994 "'I panni d'arazzo' con le cacce per la villa di Poggio a Caiano." *Paragone*, nos. 529, 531, 533 (*Gli allievi per Mina Gregori*) (March–July), pp. 94–100.

1998 *Gli arazzi nei musei fiorentini: La collezione medicea. Catalogo completo.* Vol. 1, *La manifattura da Cosimo I a Cosimo II (1545–1621).* Livorno.

2000 "L'arazzeria medicea." In *La grande storia dell'artigianato*, vol. 3, *Il Cinquecento*, edited by Franco Franceschi and Gloria Fossi, pp. 225–61. Florence.

2001a "L'arazzeria medicea." In *Il Seicento*, edited by Mina Gregori, pp. 107–16. Storia delle arti in Toscana. Florence.

2001b "Una soprapporta tessuta a Firenze con le armi del duca d'Alba de Tormes, Antonio Álvarez de Toledo Beaumont, e della moglie Mencía de Mendoza." *Filo forme: Quadrimestrale di storia, arte e restauro dei tessili* 1, pp. 5–7.

2002a "Europa nella rinascita (e congedo) dell'arazzeria medicea a Firenze." In *Il mito di Europa: Da fanciulla rapita a continente*, pp. 135–42. Exh. cat., Galleria degli Uffizi. Florence.

2002b "Flemish Tapestry Weavers in Italy in the Seventeenth and Eighteenth Centuries." In Delmarcel 2002b, pp. 163–83.

2003a "Gli arazzi fiamminghi nella collezione de' Medici." In Brosens 2003, pp. 37–47.

2003b "L'arazzo con la *Madonna della Gatta* e le copie tessute di Pietro Févère dai quadri della granduchessa Vittoria della Rovere." In *Federico Barocci: Il miracolo della Madonna della Gatta*, edited by Antonio Natali, pp. 123–37. Le stanze di Calliope 3. Cinisello Balsamo (Milan).

forth- *La manifattura all'epoca di Ferdinando II (1621–1670).* Vol. 2
coming a of *Gli arazzi nei musei fiorentini: La collezione medicea. Catalogo completo.* Livorno.

forth- "Il Ratto di Proserpina o Elemento del Fuoco di Giuseppe
coming b Grisoni per una serie degli Elementi: Da modello per l'arazzo di Leonardo Bernini a dipinto di galleria." In *La Sala della Niobe agli Uffizi*, edited by Antonio Natali.

Merle du Bourg, Alexis

2004a *Peter Paul Rubens et la France, 1600–1640.* Histoire de l'art. Villeneuve d'Ascq.

2004b *Rubens au Grand Siècle: Sa réception en France, 1640–1715.* Collection "Art & société." Rennes.

Merola, Alberto

1964 "Barberini, Francesco." In *Dizionario biografico degli Italiani*, vol. 6, pp. 172–76. Rome.

Mérot, Alain

1987 *Eustache Le Sueur (1616–1655).* Paris.

1992 "Simon Vouet et la grotesque: Un langage ornemental." In *Simon Vouet*, pp. 563–72. Rencontres de l'École du Louvre. Colloque International, Galeries Nationales du Grand Palais, Paris, February 5–7, 1991. Paris.

1995 *French Painting in the Seventeenth Century.* Translated by Caroline Beamish. New Haven.

Merz, Jörg M.

2005 *Pietro da Cortona und sein Kreis: Die Zeichnungen in Düsseldorf.* Munich.

forthcoming *Pietro da Cortona and Roman Baroque Architecture.* New Haven.

Metz

1997 *Charles Poerson, 1609–1667.* Exh. cat. by Barbara Brejon de Lavergnée, Nicole de Reyniès, and Nicolas Sainte-Fare-Garnot. Musées de la Cour d'Or, Metz. Paris.

De Meûter, Ingrid

1999 "Overzicht van de iconografische thema's." In Oudenaarde 1999, pp. 119–263.

Meyer, Daniel

1980 *L'histoire du Roy.* Paris.

1982 "La fabbricazione degli arazzi / La fabrication des tapisseries." In Florence 1982, pp. 18–24.

1988 *Versailles.* Paris.

1994 "Le mobilier dans l'iconographie royale aux XVIIe et XVIIIe siècles." *L'estampille / L'objet d'art*, nos. 285–86 (November–December), pp. 90–103.

Mezzalira, Francesco

2001 *Beasts and Bestiaries: The Representation of Animals from Prehistory to the Renaissance.* Archives of Art pre-1800. Turin.

Michel, Patrick

1999 *Mazarin, prince des collectionneurs: Les collections et l'ameublement du cardinal Mazarin (1602–1661). Histoire et analyse.* Notes et documents des musées de France 34. Paris.

Migeon, Gaston

1909 *Les arts du tissu.* Manuels d'histoire de l'art. Paris.

1920 "Tapisseries des ateliers de Paris avant les Gobelins (1550–1667)." *La renaissance de l'art français et des industries de luxe* 3, no. 1 (January), pp. 5–10.

1929 *Les arts du tissu.* New ed. Manuels d'histoire de l'art. Paris.

Millar, Oliver

1960 Ed. *Abraham van der Doort's Catalogue of the Collections of Charles I.* Walpole Society 37. London.

1972 Ed. *The Inventories and Valuations of the King's Goods, 1649–1651.* Walpole Society 43. London.

Milovanovic, Nicolas

2005 *Du Louvre à Versailles: Lecture des grands décors monarchiques.* Le cabinet des images. Paris.

Minneapolis

1955 "Fortieth Anniversary Exhibition: Forty Masterpieces." Exh. cat. in *Bulletin of the Minneapolis Institute of Arts* 44, no. 1 (January).

Mochi Onori, Lorenza

2003 "I cartoni di Gherardi per la serie degli arazzi con la vita di Urbano VIII Barberini." In *Antonio Gherardi, artista reatino (1638–1702): Un genio bizzarro nella Roma del Seicento*, pp. 89–94. Exh. cat. edited by Lydia Saraca Colonnelli. Palazzo Papale, Rieti. Rome.

Montagu, Jennifer

1962 "The Tapestries of Maincy and the Origin of the Gobelins." *Apollo* 77 (September), pp. 530–35.

1971 "Exhortatio ad Virtutem: A Series of Paintings in the Barberini Palace." *Journal of the Warburg and Courtauld Institutes* 34, pp. 366–72.

1994 *The Expression of the Passions: The Origin and Influence of Charles Le Brun's "Conférence sur l'expression générale et particulière."* New Haven.

de Montaiglon, Anatole, and Jules Guiffrey

1887–1908 Eds. *Correspondance des directeurs de l'Académie de France à Rome avec les surintendants des Bâtiments.* 17 vols. Paris.

Montevideo

1986 *Dibujos de los maestros de Europa occidental de los siglos XV al XVIII: Colección del Ermitage de Leningrado.* Exh. cat., Museo Nacional de Artes Visuales. Montevideo.

Montreal–Cologne

2002 *Richelieu: Art and Power.* Exh. cat. edited by Hilliard Todd Goldfarb. Montreal Museum of Fine Arts; Wallraf-Richartz-Museum, Cologne. Montreal, Cologne, and Ghent.

Morán Turina, Miguel

1994 "Importaciones y exportaciones de pinturas en el siglo XVII a través de los registros e de los libros de pasos." In *Madrid en el contexto de lo hispánico desde la época de los descubrimientos: Congreso nacional,* vol. 1, pp. 543–60, 2 vols. Madrid.

Morgan Zarucchi, Jeanne

1999 "Perrault's Titular Subversions: Tapestries, Tales and Medals." *Seventeenth-Century French Studies* 21, pp. 239–46.

Morini, Luigina

1996 Ed. *Bestiari medievali.* I millenni. Turin.

Moroni, Gaetano

1851 *Dizionario di erudizione storico-ecclesiastica da S. Pietro sino ai nostri giorni.* Vol. 52. Venice.

Mosco, Marilena

1982 "L'appartamento da inverno del granduca Ferdinando II (1610–1670)." In *La Galleria Palatina: Storia della quadreria granducale di Palazzo Pitti,* pp. 33–36. Exh. cat. edited by Marilena Mosco. Florence.

Moscow

1955 *Vystavka francuzskogo iskusstva XV–XX vv.* (Exhibition of French Art, 15th–20th Centuries). Exh. cat., State Pushkin Museum of Fine Arts. Moscow.

Moutié, Auguste, and Dion, Adolphe, comte de

1886 "Quelques documents sur le Duchépairie de Rambouillet." *Mémoires et documents* (Société Archéologique de Rambouillet) 7.

Mulder-Erkelens

See under Erkelens

Muller, Jeffrey M.

1975 "Oil-Sketches in Rubens's Collection." *Burlington Magazine* 117 (June), pp. 371–74, 377.

Munich

1978 *Peter Candid: Zeichnungen.* Exh. cat. compiled by Brigitte Volk-Knüttel. Staatliche Graphische Sammlung. Munich.

1980 *Um Glauben und Reich: Kurfürst Maximilian I.* Edited by Hubert Glaser. Vol. 1, *Beiträge zur Bayerischen Geschichte und Kunst, 1573–1657.* Vol. 2, exh. cat., Residenzmuseum München. Wittelsbach und Bayern 2. Munich.

1991 *Simon Vouet: 100 neuentdeckte Zeichnungen aus den Beständen der Bayerischen Staatsbibliothek.* Exh. cat. by Richard Harprath et al. Neue Pinakothek. Munich.

2005 *In Europa zu Hause: Niederländer in München um 1600 / Citizens of Europe: Dutch and Flemish Artists in Munich, c. 1600.* Exh. cat. by Thea Vignau-Wilberg. Staatliche Graphische Sammlung and Neue Pinakothek. Munich.

Müntz, Eugène

1875 "Documents sur la fabrication des tapisseries dans la première moitié du XVIIe siècle, en France, en Italie et dans les Flandres." *Revue des Sociétés Savantes des Départements* 8 (November–December), pp. 504–20.

1876 "L'atelier de tapisseries du cardinal François Barberini à Rome." *La chronique des arts,* July 15, pp. 229–30.

1878–85 *Histoire de la tapisserie en Italie, en Allemagne, en Angleterre, en Espagne, en Danemark, en Hongrie, en Pologne, en Russie et en Turquie.* Pt. 2 of Jules Guiffrey, Eugène Müntz, and Alexandre Pinchart, *Histoire générale de la tapisserie.* Paris.

1885 *A Short History of Tapestry: From the Earliest Times to the End of the Eighteenth Century.* Translated by Louisa J. Davis. The Fine-Art Library. London and New York.

1897 *Les tapisseries de Raphaël au Vatican et dans les principaux musées ou collections d'Europe: Étude historique et critique.* Paris.

Museo del Prado

1990 *Museo del Prado: Inventario general de pinturas.* Vol. 1, *La colección real.* Madrid.

1996 *Museo del Prado: Catálogo de las pinturas.* Madrid.

Nantes–Toulouse

1997 *Visages du Grand Siècle: Le portrait français sous le règne de Louis XIV, 1660–1715.* Exh. cat. edited by Emmanuel Coquery. Musée des Beaux-Arts, Nantes; Musée des Augustins, Toulouse. Paris.

Natale, Mauro

2000 *Le Isole Borromeo e la Rocca di Angera: Guida storico-artistica.* Cinisello Balsamo (Milan).

Natali, Antonio

2003 "Come per il figliol prodigo: Minimi cabotaggi sulla *Madonna della Gatta.*" In *Federico Barocci: Il miracolo della Madonna della Gatta,* edited by Antonio Natali, pp. 23–43. Le stanze di Calliope 3. Cinisello Balsamo (Milan).

Nees, Lawrence

1978 "Le 'Quos Ego' de Marc-Antoine Raimondi: L'adaptation d'une source antique par Raphaël." *Nouvelles de l'estampe,* nos. 40–41 (July–October), pp. 18–29.

Nelson, Kristi

1998 *Jacob Jordaens: Design for Tapestry.* Pictura nova 5. Turnhout.

Neumann, Erwin

1964 "Die Begebenheiten des Telemach: Bemerkungen zu den Tapisserien im sogenannten Gobelin-Zimmer des Stiftes Klosterneuburg." *Jahrbuch des Stiftes Klosterneuburg* 4, pp. 139–53.

1968 "Tamerlan und Bajazet: Eine Antwerpener Tapisserien-Serie des 17. Jahrhunderts." In *Miscellanea Jozef Duverger: Bijdragen tot de kunstgeschiedenis der Nederlanden,* vol. 2, pp. 819–35. Ghent.

New York

1985 *Liechtenstein, the Princely Collections: The Collections of the Prince of Liechtenstein.* Exh. cat., The Metropolitan Museum of Art. New York.

1998 *Master Drawings from the Hermitage and Pushkin Museums.* Exh. cat. by Marina Bessonova et al. Pierpont Morgan Library. New York.

2002 *Tapestry in the Renaissance: Art and Magnificence.* Exh. cat. by Thomas P. Campbell, with contributions by Maryan W. Ainsworth, Rotraud Bauer, Pascal-François Bertrand, Iain Buchanan, Elizabeth Cleland, Guy Delmarcel, Nello Forti Grazzini, Maria Hennel-Bernasikowa, Lorraine Karafel, Lucia Meoni, Cecilia Paredes, Hillie Smit, and Andrea Stockhammer. The Metropolitan Museum of Art. New York.

New York–Chicago–San Francisco

1982 *The Vatican Collections: The Papacy and Art*. Exh. cat., The Metropolitan Museum of Art, New York; Art Institute of Chicago; Fine Arts Museums of San Francisco. New York.

New York–Fort Worth

1991 *The Drawings of Anthony van Dyck*. Exh. cat. by Christopher Brown. Pierpont Morgan Library, New York; Kimbell Art Museum, Fort Worth. New York.

New York–Kansas City

1999 *Life and the Arts in the Baroque Palaces of Rome: Ambiente Barocco*. Exh. cat. edited by Stefanie Walker and Frederick Hammond. Bard Graduate Center for Studies in the Decorative Arts, New York; Nelson-Atkins Museum of Art, Kansas City. New Haven.

New York–London

2001 *Vermeer and the Delft School*. Exh. cat. by Walter Liedtke, with Michiel C. Plomp and Axel Rüger, and contributions by Reinier Baarsen et al. The Metropolitan Museum of Art, New York; National Gallery, London. New York.

Niclausse, Juliette

1938 *Le Musée des Gobelins, 1938: Notices critiques*. Foreword by Guillaume Janneau. Collection du Musée des Gobelins 1. Paris.

1971 "Notes sur quelques tapisseries de l'Histoire de Diane de Toussaint Dubreuil." In *João Couto: In Memoriam*, pp. 137–49. Lisbon.

Nivelon, Claude

1700/2004 *Vie de Charles Le Brun et description détaillée de ses ouvrages*. Paris, 1700. 2004 ed., edited and with an introduction by Lorenzo Pericolo. École pratique des hautes études, Sciences historiques et philologiques 5, Hautes études médiévales et modernes 86. Geneva.

Noldus, Badeloch

2005 *Trade in Good Taste: Relations in Architecture and Culture between the Dutch Republic and the Baltic World in the Seventeenth Century*. Architectura moderna 2. Turnhout.

Nordenfalk, Carl

1966 "Queen Christina's Roman Collection of Tapestries." In *Queen Christina of Sweden: Documents and Studies*, edited by Magnus von Platen, pp. 266–95. Analecta Reginensia 1. Nationalmusei skriftserie 12. Stockholm.

Norgate, Edward

1919 *Miniatura; or, The Art of Limning*. Edited by Martin Hardie. Oxford.

Novosselskaya, Irina

1970 "Risunok Sharlia Lebrena v Ermitazhe." *Zapadno-Evropeiskoe iskusstvo*, pp. 120–28.

Nussdorfer, Laurie

1992 *Civic Politics in the Rome of Urban VIII*. Princeton.

O'Connor, John Joseph

1970 *Amadis de Gaule and Its Influence on Elizabethan Literature*. New Brunswick, N.J.

Okayama, Yassu

1992 *The Ripa Index: Personifications and Their Attributes in Five Editions of the Iconologia*. Doornspijk.

Oldenbourg, Rudolf

1921 Ed. *P. P. Rubens: Des Meisters Gemälde*. 4th ed. Klassiker der Kunst in Gesamtausgaben 5. Stuttgart.

Orbaan, Johannes Albertus Franciscus

1920 *Documenti sul Barocco in Roma*. 2 vols. Miscellanea della R. Società Romana di Storia Patria. Rome.

Orléans

2006 *Michel Corneille (Orléans, v. 1603–Paris, 1664): Un peintre du Roi au temps de Mazarin*. Exh. cat. by Emmanuel Coquery. Musée des Beaux-Arts, Orléans. Paris and Orléans.

Orso, Steven N.

1986 *Philip IV and the Decoration of the Alcázar of Madrid*. Princeton.

Ortega, Isabel

1998 "La Junta de Iconografía Nacional y sus fotografías del Monasterio de las Descalzas Reales." *Reales sitios*, no. 138, pp. 63–70.

Ortega Vidal, Javier

1998 "La capilla sepulcral de Doña Juana en las Descalzas Reales. Una joya en la penumbra." *Reales sitios*, no. 138, pp. 40–54.

Ostwald, Jamel

2000 "The 'Decisive' Battle of Ramillies, 1706: Prerequisites for Decisiveness in Early Modern Warfare." *Journal of Military History* 64 (July), pp. 649–78.

Ottawa

1968 *Jacob Jordaens, 1593–1678*. Exh. cat. by Michael Jaffé. National Gallery of Canada. Ottawa.

Oudenaarde

1999 *Oudenaardse wandtapijten van de 16de tot de 18de eeuw*. Exh. cat. by Ingrid De Meûter, Martine Vanwelden, Luc Dhondt, Françoise Vandevijvere, and Jan Wouters. Lakenhalle and other locations. Tielt. Also published as *Tapisseries d'Audenarde du XVIe au XVIIIe siècle*. Translated by Charlotte Cauchie-De Keyster et al. Tielt.

Oxford Companion to Gardens

1986 *The Oxford Companion to Gardens*. Edited by Geoffrey Jellicoe et al. Oxford.

Padua and Rovigo

1999 *La miniatura a Padova dal Medioevo al Settecento*. Exh. cat. edited by Giovanna Baldissin Molli, Giordana Canova Mariani, and Federica Toniolo. Palazzo della Ragione—Palazzo del Monte, Padua, and Accademia dei Concordia, Rovigo. Modena.

Pallmert, Sigrid

1992 "La tenture des Indes: Eckhouts Echo auf französischen Bildteppichen." In *Brasilien: Entdeckung und Selbstentdeckung*, pp. 89–95. Exh. cat., Kunsthaus and other locations in Zürich. Zürich.

Palma, Juan

1636 *Vida de la sereníssima Infanta Sor Margarita de la Cruz, religiosa Descalça de S. Clara*. Madrid.

Papworth, John Woody

1874 *An Alphabetical Dictionary of Coats of Arms Belonging to Families in Great Britain and Ireland: Forming an Extensive Ordinary of British Armorials*. 2 vols. London.

Pardailhé-Galabrun, Annik

1991 *The Birth of Intimacy: Privacy and Domestic Life in Early Modern Paris*. Translated by Jocelyn Phelps. Oxford.

Paredes, Cecilia

2005 "Vertumne et Pomone: Une fable et son décor dans quatre tentures tissées d'or." 3 vols. PhD diss., Université Libre de Bruxelles.

Paris

year X (1802) *Notice des dessins originaux, esquisses peintes, cartons, gouaches, pastels, émaux, miniatures et vases étrusques, exposés au Musée Central des Arts, dans la Galerie d'Apollon, en messidor de l'an X de la République Française*. Pt. 2. Exh. cat., Musée Central des Arts. Paris.

1820 *Notice des dessins, peintures, émaux et terres cuites émaillées exposés au Musée Royal dans la Galerie d'Apollon*. Exh. cat., Musée du Louvre. Paris.

1841 *Notice des dessins, placés dans les galeries du Musée Royal au Louvre*. Exh. cat., Musée du Louvre. Paris.

1902 *Exposition de la Manufacture Nationale des Gobelins: Troisième centenaire, 1601–1901*. Exh. cat., Grand Palais. Paris.

1930 *Tapisseries des ateliers de Paris.* Exh. cat., Manufacture Nationale des Gobelins. Paris.

1931 *Antoine-François van der Meulen, 1634–1690.* Exh. cat., Manufacture Nationale des Gobelins. Paris.

1939 *Le Musée des Gobelins, 1939: De la tapisserie décor à la tapisserie peinture.* Exh. cat. edited by Juliette Niclausse. Foreword by Guillaume Janneau. Collection du Musée des Gobelins 2. Paris.

1950 *Dessins du Nationalmuseum de Stockholm: Collections Tessin & Cronstedt. I. Claude III Audran (1658–1734). II. Dessins du d'architecture et d'ornements.* Exh. cat., Bibliothèque Nationale. Paris.

1960 *Louis XIV: Faste et décors.* Exh. cat., Pavillon de Marson, Palais du Louvre. Paris.

1962 *Charles Le Brun: Premier directeur de la Manufacture Royale des Gobelins.* Exh. cat. by Michel Florisoone, Juliette Niclausse, Madeleine Jarry, and Bernadette Brot. Musée des Gobelins. Paris.

1965 *Le XVIe siècle européen: Tapisseries.* Exh. cat. by Germain Viatte. Mobilier National. Paris.

1966 *Les Gobelins: Trois siècles de tapisserie.* Exh. cat. edited by Jean Coural. Mobilier National. Paris.

1971 *Dessins du Musée de Darmstadt, Hessisches Landesmuseum: XLVIIe exposition du Cabinet des Dessins.* Exh. cat. by Gisela Bergsträsser. Musée du Louvre. Paris.

1982 *L'atelier de Desportes: Dessins et esquisses conservés par la Manufacture Nationale de Sèvres. LXXVIIe exposition du Cabinet des Dessins, Musée du Louvre.* Exh. cat., Musée du Louvre. Paris.

1983a *Colbert, 1619–1683.* Exh. cat. edited by Étienne Taillemite and Elisabeth Pauly. Hôtel de la Monnaie. Paris.

1983b *Raphaël dans les collections françaises.* Exh. cat. by Sylvie Béguin et al. Galeries Nationales du Grand Palais. Paris.

1985a *Le Brun à Versailles.* Exh. cat. by Lydia Beauvais and Jean-François Méjanès. Cabinet des Dessins, Musée du Louvre. Paris.

1985b *Versailles à Stockholm: Dessins du Nationalmuseum. Peintures, meubles, et arts décoratifs des collections suédoises et danoises.* Exh. cat., Hôtel de Marle. Nationalmuseums skriftserie, n.s., 5. Paris.

1990 *Vouet.* Exh. cat. by Jacques Thuillier, Barbara Brejon de Lavergnée, and Denis Lavalle. Galeries Nationales du Grand Palais. Paris.

1993 *13e arrondissement: Une ville dans Paris.* Exh. cat. by Gilles-Antoine Langlois. Délégation à l'Action Artistique de la Ville de Paris. Paris.

2001 *Pieter Boel, 1622–1674: Peintre des animaux de Louis XIV. Le fonds des études peintes des Gobelins.* Exh. cat. by Elisabeth Foucart-Walter. Musée du Louvre. Paris.

2002 *Un temps d'exubérance: Les arts décoratifs sous Louis XIII et Anne d'Autriche.* Exh. cat., Galeries Nationales du Grand Palais. Paris.

2004 *Primatice: Maître de Fontainebleau.* Exh. cat. by Laura Aldovini et al. Musée du Louvre. Paris.

2007 *La tenture d'Artémise: À l'origine des Gobelins—La redécouverte d'un tissage royal.* Exh. cat., Galerie des Gobelins. Paris.

Paris–Florence

2004 *Botticelli e Filippino: L'inquietudine e la grazia nella pittura fiorentina del Quattrocento.* Exh. cat., Musée du Luxembourg, Paris; Palazzo Strozzi, Florence. Milan.

Paris–Geneva–New York

2001 *Le dessin en France au XVIIe siècle dans les collections de l'École des Beaux-Arts.* Exh. cat., École Nationale Supérieure des Beaux-Arts, Paris; Musée d'Art et d'Histoire, Geneva; Frick Collection, New York. Paris. Also published as *Poussin, Claude and Their World: Seventeenth-Century French Drawings from the École des Beaux-Arts, Paris.* Paris, 2002.

Paris–London

1994 *Nicolas Poussin, 1594–1665.* Exh. cat. by Pierre Rosenberg and Louis-Antoine Prat. Galeries Nationales du Grand Palais, Paris; Royal Academy of Arts, London. Paris.

Parker, Geoffrey

1977 *The Dutch Revolt.* London.

Pascoli, Lione

1730–36/ *Vite di pittori, scultore ed architetti moderni.* 2 vols. Rome, 1730–36.
1992 1992 ed., with an introduction by Alessandro Marabottini. Perugia.

Passerini, Luigi

1874 *Storia e genealogia delle famiglie Passerini e De' Rilli.* Florence.

Pavière, Sydney H.

1966 *Jean Baptiste Monnoyer, 1634–1699.* Leigh-on-Sea, Essex.

Payerne

1997 *Collection Toms: De fils et de couleurs, tapisseries du XVIe au XVIIIe siècle / Sammlung Toms: Von Garnen und Farben, Wandteppiche vom 16. bis 18. Jahrhundert.* Exh. cat. by Guy Delmarcel et al. Abbatiale et Musée de Payerne. Payerne.

de Pazzis-Chevalier, Nicole, and Dominique Chevalier

1984 "Les tapisseries anglaises de Mortlake." *L'estampille* 166 (February), pp. 27–35.

de la Peña, Juan Antonio

1632 *Discurso en exaltación de los improperios que padeció la sagrada imagen de Christo N. S. à manos de la perfidia judaica: Con relación de la magnífica octava, sermones . . . que à estos Católicos intentos hizo en el Real Convento de las Descalças la Serenísssima y Religiosíssima Infanta Sor Margarita de la Cruz.* Madrid.

Pepys, Samuel

1921–24 *The Diary of Samuel Pepys: Transcribed from the Manuscript in the Pepysian Library, Magdelene College, Cambridge.* Edited with additions by Henry B. Wheatley. 10 vols. London.

Pericolo, Lorenzo

2001 "Le Roi et le favori: Essai d'interprétation sur *Les Reines de Perse* de Charles Le Brun." *Annali della Scuola Normale Superiore di Pisa,* 4th ser., 6, pp. 125–48.

Perrault, Charles

1668/1981 "La peinture." [1668.] In Charles Perrault, *Contes,* edited by Jean-Pierre Collinet, pp. 219–38. Collection Folio classique. Paris, 1981.
1668/1992 *La Peinture.* [1668.] Edited by Jean-Luc Gautier-Gentès. Geneva, 1992.
ca. 1703/ *Mémoires de ma vie.* [ca. 1703.] Introductory essay by Antoine
1993 Picon. Un moderne paradoxal. Paris, 1993.
1759 *Mémoires de Charles Perrault de l'Académie françoise, et premier commis des Bâtiments du Roi.* Avignon.

Petitfils, Jean-Christian

1998 *Fouquet.* Paris. [Reprint, 1999 and 2005.]

Petitot, Alexandre, and Louis-Jean-Nicolas Monmerque

1826–27 Eds. *Mémoires du maréchal de Gramont.* Collection des mémoires relatifs à l'histoire de France, depuis l'avènement de Henry IV, jusqu'à la paix de Paris, conclue en 1763, [2nd ser.], vols. 56, 57. Paris.

Pfaffenbichler, Matthias

1998 "The Early Baroque Battle Scene: From the Depiction of Historical Events to Military Genre Painting." In *1648: War and Peace in Europe,* vol. 2, *Art and Culture,* pp. 493–500. Exh. cat. edited by Klaus Bussmann and Heinz Schilling. Westfälische Landesmuseum. Münster.

Philipp, Michael

1996 *Das "Regentenbüch" des Mansfelder Kanzlers Georg Lauterbeck: Ein Beitrag zur politischen Ideengeschichte im konfessionellen Zeitalter.* Augsburg.

Phillips, Charles James

1930 *History of the Sackville Family (Earls and Dukes of Dorset) Together with a Description of Knole, Early Owners of Knole and a Catalogue Raisonné of the Pictures and Drawings at Knole.* 2 vols. London.

Piendl, Max

1967 *Wandteppiche des Hauses Thurn und Taxis*. Munich.

1978 "Die fürstlichen Wirkteppiche und ihre Geschichte." In *Beiträge zur Geschichte Kunst- und Kulturpflege im Hause Thurn und Taxis*, edited by Max Piendl, pp. 1–107. Thurn und Taxis-Studien 10. Kallmünz.

Pieraccini, Gaetano

1986 *La stirpe de' Medici di Cafaggiolo: Saggio di ricerche sulla trasmissione ereditaria dei caratteri biologici*. 3 vols. Florence. [Reprint of 1924–25 ed.]

Pierard-Gilbert, R.

1964 "Un bruxellois oublié: Augustin Coppens, peintre, dessinateur et graveur (1668–1740)." *Cahiers bruxellois* 9 (January–March), pp. 1–44.

Pierguidi, Stefano

2001 "Precisazioni documentarie sulla committenza Montalto: Brevi note a Guido Reni, Pasquale Ottino e Antiveduto della Gramatica." *Bollettino d'arte* 115, no. 86 (January–March), pp. 93–97.

Pietro da Cortona

1998 *Pietro da Cortona*. Atti del Convegno Internazionale, Rome and Florence, November 12–15, 1997, edited by Christoph Luitpold Frommel and Sebastian Schütze. Milan.

Piganiol de La Force, Jean-Aimar

1742 *Description de Paris, de Versailles, de Marly, de Meudon, de S. Cloud, de Fontainebleau, et de toutes les autres belles maisons & châteaux des environs de Paris*. 8 vols. New ed. Paris.

de Piles, Roger

1699 *Abrégé de la vie des peintres, avec des reflexions sur leurs ouvrages, et un traité du peintre parfait, de la connoissance des desseins, & de l'utilité des estampes*. Paris.

Pinchart, Alexandre

1868 "The Origin of the Tapestry Manufactory at Mortlake." *Chronicle*, February 1.

1878–85 *Tapisseries flamandes*. Pt. 3 of Jules Guiffrey, Eugène Müntz, and Alexandre Pinchart, *Histoire générale de la tapisserie*. Paris.

Pine, John

1739 *The Tapestry Hangings of the House of Lords: Representing the Several Engagements between the English and Spanish Fleets, in the Ever Memorable Year MDLXXXVII. . . .* London.

Piot, Charles

1885 "Le testament et les codicilles de l'Infante Isabelle." *Compte-rendu des séances de la Commission Royale d'Histoire; ou, Recueil de ses bulletins*, 4th ser., 12, pp. 108–22.

La pittura in Italia

1988 *La pittura in Italia: Il Seicento*. Edited by Mina Gregori and Erich Schleier. 2 vols. Milan.

Platter, Thomas

1937 *Thomas Platter's Travels in England, 1599*. Edited and translated by Clare Williams. London.

Plourin, Marie Louise

1955 *Historia del tapiz en Occidente*. Barcelona.

Pons, Bruno

1991 "Le décor de l'appartement du Grand Dauphin au château neuf de Meudon (1709)." *Gazette des beaux-arts*, 6th ser., 117 (February), pp. 59–76.

De Poorter, Nora

1978 *The Eucharist Series*. 2 vols. Corpus Rubenianum Ludwig Burchard 2. Brussels.

1979–80 "Over de weduwe Geubels en de datering van Jordaens' tapijtenreeks 'De taferelen uit het landleven.'" *Gentse bijdragen tot de kunstgeschiednis* 25, pp. 209–24.

1997 "De Triomf van de Eucharistie / The Triumph of the Eucharist." In Antwerp 1997, pp. 78–105.

Portús, Javier

1998 "Las Descalzas Reales en la cultura festiva del Barroco." *Reales sitios*, no. 138, pp. 3–12.

Posner, Donald

1959 "Charles Lebrun's *Triumphs of Alexander*." *Art Bulletin* 41 (September), pp. 237–48.

1993 "Concerning the 'Mechanical' Parts of Painting and the Artistic Culture of Seventeenth-Century France." *Art Bulletin* 75 (December), pp. 583–98.

Prague

1972 *Kresby evropských mistru, XV.–XX. století ze sbírek Státní Ermitáze v Leningrade*. Exh. cat., Národní Galerie. Prague.

Préaud, Maxime

1980 *Inventaire du fonds français: Graveurs du XVIIe siècle*. Vols. 8 and 9, *Sébastien Leclerc*. Département des Estampes, Bibliothèque Nationale. Paris.

1989 *Inventaire du fonds français: Graveurs du XVIIe siècle*. Vol. 10, *Leclercq–Lenfant*. Département des Estampes, Bibliothèque Nationale. Paris.

1993 *Inventaire du fonds français: Graveurs du XVIIe siècle*. Vol. 11, *Antoine Lepautre, Jacques Lepautre et Jean Lepautre*. Pt. 1. Département des Estampes et de la Photographie, Bibliothèque Nationale. Paris.

Princeton–Washington–Pittsburgh

1982 *Drawings from the Holy Roman Empire, 1540–1680: A Selection from North American Collections*. Exh. cat. compiled by Thomas DaCosta Kaufmann. Art Museum, Princeton University; National Gallery of Art, Washington, D.C.; Museum of Art, Carnegie Institute, Pittsburgh. Princeton.

Prosperi Valenti Rodinò, Simonetta

1990 "Canini en France." In *Seicento: La peinture italienne du XVIIe siècle et la France*, pp. 199–214. Rencontres de l'École du Louvre. Paris.

Puglisi, Catherine R.

1995 "Guido Reni's *Pallione del Voto* and the Plague of 1630." *Art Bulletin* 77 (September), pp. 403–12.

Purnell, Edward Kelly, and Allen Banks Hinds

1924–40 *Report on the Manuscripts of the Marquess of Downshire, Preserved at Easthampstead Park, Berks*. 4 vols. in 5. London.

Van Puyvelde, Leo

1951 *The Sketches of Rubens*. New York.

Quednau, Rolf

1979 *Die Sala di Costantino im Vatikanischen Palast: Zur Dekoration der beiden Medici-Päpste Leo X. und Clemens VII*. Studien zur Kunstgeschichte 13. Hildesheim.

Quignon, G. Hector

1914 "La Manufacture Royale de Tapisseries de Beauvais: Les ouvriers flamands et wallons, de 1664 à 1715." In G. Vanden Gheyn, *Annales du XXIIIe Congrès (Gand 1913)*, vol. 3, *Mémoires de la section d'archéologie et des sous-sections de l'histoire de l'art et de la musicologie*, pp. 139–56. Ghent.

De Raadt, Johan Theodoor

1894 *Mengelingen over heraldiek en kunst*. Antwerp.

Racine, Jean

1676/1829 *Oeuvres de Racine*. 2 vols. Paris, 1676. Reprint, *Oeuvres de Jean Racine*. 5 vols. in 3. Paris, 1829.

Raffaello

1993 *Raffaello nell'appartamento di Giulio II e Leone X: Monumenti, musei, gallerie pontificie*. Luce per l'arte. Milan.

Ragusa, Elena
1988 "Arazzi a Torino: La collezione della Galleria Sabauda." *Bollettino
 d'arte* 73, no. 52 (November–December), pp. 43–66.

Ranke, Leopold
1901 *History of the Popes: Their Church and State.* Translated by E. Fowler.
 3 vols. Rev. ed. The World's Great Classics. New York.

Rapp Buri, Anna, and Monica Stucky-Schürer
2001 *Burgundische Tapisserien.* Munich.

Rawski, Evelyn S.
2005 "The 'Prosperous Age': China in the Kangxi, Yongzheng and
 Qianlong Reigns." In London 2005, pp. 22–40.

Real Biblioteca
1999 *Manuscritos e impresos.* Vol. 1, *Del Monasterio de las Descalzas Reales
 de Madrid.* Catálogo de la Real Biblioteca 14. Catálogo de los
 Reales Patronatos 1. Madrid.

Réau, Louis
1955–59 *Iconographie de l'art chrétien.* 3 vols. in 8. Paris.

Recife and other cities
2002 *Albert Eckhout volta ao Brasil, 1644–2002 / Albert Eckhout Returns
 to Brazil, 1644–2002.* Exh. cat., Instituto Ricardo Brennand,
 Recife; Conjunto Cultural da Caixa, Brasília; Pinacoteca do
 Estado de São Paulo; Paço Imperial, Rio de Janeiro. Copenhagen.

Rée, Paul Johannes
1885 *Peter Candid: Sein Leben und seine Werke.* Beiträge zur Kunst-
 geschichte, n.s., 2. Leipzig.

Reindel, Ulrik
2006 "Bordhimlens dydsmønstre: Kongen som garant for kunst,
 videnskab og velstand." *Renaessanceforum* 2, pp. 2–28.

Reiset, Frédéric
1869 *Notice des dessins, cartons, pastels, miniatures et émaux exposés dans les
 salles du 1er et 2e étage au Musée Impérial du Louvre. Pt. 2, École
 française: Dessins indiens, émaux.* Paris.

Relations artistiques
1964 *Les relations artistiques entre la France et la Suède, 1693–1718:
 Nicodème Tessin le jeune et Daniel Cronström. Correspondance
 (extraits).* Stockholm.

de Reyniès, Nicole
1995a "Jean van Orley cartonnier: La tenture d'Achille au Musée
 Jacquemart-André." *Gazette des beaux-arts*, 6th ser., 125
 (February), pp. 155–76.
1995b "Jean van Orley: Une tenture de l'Histoire de Psyché." *Gazette
 des beaux-arts*, 6th ser., 125 (March), pp. 209–20.
1999 "*Le Pastor Fido* et la tapisserie française de la première moitié du
 XVIIe siècle." In *Tapisserie au XVIIe siècle* 1999, pp. 15–32.
2002 "Les lissiers flamands en France au XVIIe siècle, et considérations
 sur leurs marques." In Delmarcel 2002b, pp. 203–26.

de Ribou, Marie-Hélène
2004 "L'histoire de l'empereur de la Chine." In Versailles 2004,
 pp. 221–24.

Rice, Louise
1997 *The Altars and Altarpieces of New St. Peter's: Outfitting the Basilica,
 1621–1666.* Monuments of Papal Rome. Cambridge and
 New York.

Richefort, Isabelle
1988 "Nouvelles précisions sur la vie d'Adam François van der
 Meulen: Peintre historiographe de Louis XIV." *Bulletin de la
 Société de l'Histoire de l'Art Français* (1986; pub. 1988), pp. 57–80.
1998 *Peintre à Paris au XVIIe siècle.* Paris.
2004 *Adam-François van der Meulen (1632–1690): Peintre flamand au
 service de Louis XIV.* Collection "Art & société." Rennes.

Riegl, Alois
1890 "Die Gobelins-Ausstellung im Oesterr. Museum." *Mittheilungen
 des K. K. Oesterreich. Museums für Kunst und Industrie,* no. 51
 (March), pp. 49–58; no. 52 (April), pp. 81–85.

Righini, Alberto
2003 "Galileo e il progetto iconografico delle Sale dei Pianeti in
 Palazzo Pitti." In *Palazzo Pitti: La reggia rilevata,* pp. 266–77.
 Exh. cat. edited by Gabriella Capecchi. Palazzo Pitti. Florence.

Rigoni, Cesare
1884 *Catalogo della Reale Galleria degli Arazzi.* Florence and Rome.

Ripa, Cesare
1603/1970 *Iconologia.* Rome, 1603. Reprint, with an introduction by Erna
 Mandowsky. Hildesheim, 1970.
1618/1992 *Nova Iconologia.* Rome, 1618. Reprint, edited by Piero Buscaroli,
 and with a foreword by Mario Praz. Milan, 1992.

Robert-Dumesnil, A-P.-F.
1835–71/ *Le peintre-graveur français; ou, Catalogue raisonné des estampes gravées
1967 par les peintres et les dessinateurs de l'école française.* 11 vols. Paris,
 1835–71. Reprint, Paris, 1967.

Rochester–New Brunswick–Atlanta
1987 *La Grand Manière: Historical and Religious Painting in France, 1700–
 1800.* Exh. cat. by Donald A. Rosenthal. Memorial Art Gallery
 of the University of Rochester, Rochester, N.Y.; Jane Voorhees
 Zimmerli Art Museum, New Brunswick, N. J.; High Museum of
 Art, Atlanta. Rochester, N.Y.

Rodríguez G. de Ceballos, Alfonso
1998 "Arte y mentalidad religiosa en el Museo de Las Descalzas
 Reales." *Reales sitios,* no. 138, pp. 13–24.

Roethlisberger, Marcel
1967 "La Tenture de la Licorne dans la Collection Borromée." *Oud
 Holland* 82, pp. 85–115.

Rogers, Phillis
1988 "The Armada Tapestries in the House of Lords." *RSA Journal* 136
 (September), pp. 731–35.

Rome
1870 *L'esposizione romana delle opere di ogni arte eseguite pel culto cattolico.*
 Exh. cat. Rome.
1984 *Roma, 1300–1875: L'arte degli Anni Santi.* Exh. cat. edited by
 Marcello Fagiolo and Maria Luisa Madonna. Palazzo Venezia,
 Rome. Milan.
1997 *Pietro da Cortona, 1597–1669.* Exh. cat. edited by Anna Lo Bianco.
 Palazzo Venezia, Rome. Milan.
1999 *Villa Medici, il sogno di un cardinale: Collezioni e artisti di Ferdinando
 de' Medici.* Exh. cat. edited by Michel Hochmann. Accademia di
 Francia. Rome.

Ronot, Henry
1976 "Lettre de Michel I Corneille à la supérieure des Ursulines de
 Dijon (1649)." *Bulletin de la Société de l'Histoire de l'Art Français*
 (1975; pub. 1976), pp. 61–63.

Rooses, Max
1886–92 *L'oeuvre de P. P. Rubens: Histoire et description de ses tableaux et
 dessins.* 5 vols. Antwerp.
1906 *Jordaens' leven en werken.* Antwerp.

Rooses, Max, and Charles Ruelens
1887–1909 Eds. and trans. *Correspondance de Rubens et documents épistolaires
 concernant sa vie et ses oeuvres.* 6 vols. Antwerp.

Rosenberg, Pierre, Nicole Reynaud, and Isabelle Compin
1974 *Catalogue illustré des peintures: École française, XVIIe et XVIIIe
 siècles.* 2 vols. Musée du Louvre. Paris.

Rossi, Lovanio

1972 "Buonarroti, Michelangelo, il Giovane." In *Dizionario biografico degli italiani*, vol. 15, pp. 178–81. Rome.

Rotterdam–Frankfurt

1999 *Hollands classicisme in de zeventiende-eeuwse schilderkunst*. Exh. cat. by Albert Blankert et al. Museum Boijmans Van Beuningen, Rotterdam; Städelsches Kunstinstitut, Frankfurt am Main. Rotterdam. Also published as *Dutch Classicism in Seventeenth-Century Painting*. Rotterdam.

Rotterdam–Madrid

2003 *Peter Paul Rubens: The Life of Achilles*. Exh. cat. by Friso Lammertse and Alejandro Vergara, with contributions by Annetje Boersma, Guy Delmarcel, and Fiona Healy. Museum Boijmans Van Beuningen, Rotterdam; Museo Nacional del Prado, Madrid. Rotterdam.

Russell, Margarita

1983 *Visions of the Sea: Hendrick C. Vroom and the Origins of Dutch Marine Painting*. Publications of the Sir Thomas Browne Institute, n.s., 2. Leiden.

Sabatier, Gérard

1999 *Versailles; ou, La figure du Roi*. Bibliothèque Albin Michel de l'histoire. Paris.

2000 "La gloire du Roi: Iconographie de Louis XIV de 1661 à 1672." *Histoire, économie et société* 19 (October–December), pp. 527–60.

2004 "Allégories du pouvoir à la cour de Louis XIV." In *Arte barroco e ideal clásico: Aspectos del arte cortesano de la segunda mitad del siglo XVII*, edited by Fernando Checa Cremades, pp. 177–93. Papers from a series of conferences, Real Academia de España en Roma, May–June 2003. Madrid.

Saint Petersburg

1999 Frantsuzskii risunok XVII veka v sobranii Ermitazha / *Le dessin français du XVIIe siècle dans les collections du Musée de l'Ermitage*. Exh. cat. by Irina Novosselskaya. State Hermitage Museum. Saint Petersburg.

Saint-Simon, Louis de Rouvroy, duc de

1983–88 *Mémoires*. Edited by Yves Coirault. 8 vols. Paris.

Saint-Sulpice-le-Verdon

2000 *La Vendée au temps de la Renaissance*. Exh. cat. edited by R. Levesque. Saint-Sulpice-le-Verdon.

de Sainte-Marie, Anselme

1726 *Histoire genealogique et chronologique de la maison royale de France*. 3rd ed. Vol. 1. Paris.

Saintenoy, Paul

1932–35 *Les arts et les artistes à la cour de Bruxelles*. 3 vols. [Vol. 1], *Leur rôle dans la construction du château ducal de Brabant sur le Coudenberg de 1120 à 1400 et dans la formation du parc de Bruxelles*. [Vol. 2], *Le palais des ducs de Bourgogne sur le Coudenberg à Bruxelles du règne d'Antoine de Bourgogne à celui de Charles-Quint*. [Vol. 3], *Le Palais Royal du Coudenberg du règne d'Albert et Isabelle à celui d'Albert Ier, roi des Belges*. Académie Royale de Belgique, Classe des Beaux-Arts, Mémoires, 2nd ser., 2, fasc. 3; 5, fasc. 1; 6, fasc. 2. Brussels.

Salmon, Xavier

1998a "The Court's Reigning Flower Painter." In *Splendors of Versailles*, pp. 116–25. Exh. cat. edited by Claire Constans and Xavier Salmon. Mississippi Arts Pavilion, Jackson. New York.

1998b "The *King's Conquests* Tapestries." In *Splendors of Versailles*, pp. 136–45. Exh. cat. edited by Claire Constans and Xavier Salmon. Mississippi Arts Pavilion, Jackson. New York.

Sánchez Beltrán, María Jesús

1983 "Los tapices del Museo Arqueológico Nacional." *Boletín del Museo Arqueológico Nacional* 1, pp. 47–82.

San Giovanni Valdarno

2003 *Fortune di Arnolfo*. Exh. cat. edited by Alessandra Baroni. Casa Masaccio, San Giovanni Valdarno (Arezzo). Florence.

San Miniato (Pisa)

1959 *Mostra del Cigoli e del suo ambiente*. Exh. cat. edited by Mario Bucci, Anna Forlani, Luciano Berti, and Mina Gregori, with an introduction by Giulia Sinibaldi. Accademia degli Euteleti. San Miniato (Pisa).

Sarmant, Thierry

2003 "Clan Le Tellier et clan Colbert à l'aube des années 1680." In Sarmant, *Les demeures du soleil: Louis XIV, Louvois et la surintendance des Bâtiments du Roi*, pp. 33–50. Époques. Seyssel.

Saunders, Alison

1999 "Emblems to Tapestries and Tapestries to Emblems: Contrasting Practice in England and France." *Seventeenth-Century French Studies* 21, pp. 247–59.

Saur

1992– *Allgemeines Künstlerlexicon: Die bildenden Künstler aller Zeiten und Völker*. Munich: Saur, 1992 to date.

Sauval, Henri

1724 *Histoire et recherches des antiquités de la Ville de Paris*. 3 vols. Paris.

Schaeffer, Enrico

1965 "Albert Eckhout e a pintura colonial brasileira." *Dédalo: Revista de arte y arqueologia* 1 pp. 47–74.

Schleier, Erich

1968 "Domenichino, Lanfranco, Albani, and Cardinal Montalto's *Alexander* Cycle." *Art Bulletin* 50 (June), pp. 188–93.

1972 "Le 'Storie di Alessandro Magno' del cardinale Montalto." *Arte illustrata*, no. 50 (September), pp. 310–20.

1981 "Ancora su Antonio Carracci e il ciclo di Alessandro Magno per il cardinal Montalto." *Paragone*, no. 381 (November), pp. 10–25.

Schnapper, Antoine

1974 *Jean Jouvenet (1644–1717) et la peinture d'histoire à Paris*. Paris.

1986 "The King of France as Collector in the Seventeenth Century." *Journal of Interdisciplinary History* 17 (Summer), pp. 185–202.

1994 *Collections et collectionneurs dans la France du XVIIe siècle*. Vol. 2, *Oeuvres d'art. Curieux du Grand Siècle*. Série Art, histoire, société. Paris.

Schneebalg-Perelman, Sophie

1971 "Richesses du Garde-Meuble parisien de François Ier: Inventaires inédits de 1542 et 1551." *Gazette des beaux-arts*, 6th ser., 78 (November), pp. 253–304.

1972 "La tapisserie flamande et le grand témoignage du Wawel." In *Les tapisseries flamandes au Château du Wawel à Cracovie: Trésors du roi Sigismond II Auguste Jagellon*, edited by Jerzy Szablowski, pp. 375–437. Antwerp.

Schrickx, Willem

1974 "Denijs van Alsloot en Willem Tons in Londen in 1577." *Artes textiles* 8, pp. 47–64.

Schuckman, Christiaan

1991 Comp. *Claes Jansz Visscher to Claes Claesz Visscher II [Nicolaes Visscher II]*. Edited by D. de Hoop Scheffer. Vol. 38 of *Hollstein's Dutch and Flemish Etchings, Engravings and Woodcuts, ca. 1450–1700*. Edited by Dieukwe de Hoop Scheffer. Roosendaal.

1995–96 Comp. *Maarten de Vos*. Vols. 44 (text, 1996), 45 (plates, pt. 1, 1995), 46 (plates, pt. 2, 1995) of *Hollstein's Dutch and Flemish Etchings, Engravings and Woodcuts, 1450–1700*. Edited by Dieukwe de Hoop Scheffer. Rotterdam.

Schumacher, Birgit

2006 *Philips Wouwerman (1619–1668): The Horse Painter of the Golden Age*. Aetas Aurea 20. Doornspijk.

Scott, John Beldon

1991 *Images of Nepotism: The Painted Ceilings of Palazzo Barberini.* Princeton.

Scott, Katie

1995 *The Rococo Interior: Decoration and Social Spaces in Early Eighteenth-Century Paris.* New Haven.

Scribner, Charles, III

1975 "Sacred Architecture: Rubens's *Eucharist* Tapestries." *Art Bulletin* 57 (December), pp. 519–28.

1982 *The Triumph of the Eucharist: Tapestries Designed by Rubens.* Studies in Baroque Art History [1]. Ann Arbor.

1989 *Peter Paul Rubens.* New York.

Setterwall, Åke, Stig Fogelmarck, and Lennart af Petersens

1950 *Stockholms slot och dess konstskatter.* Stockholm.

Shearman, John

1972 *Raphael's Cartoons in the Collection of Her Majesty the Queen, and the Tapestries for the Sistine Chapel.* London.

Silva, Leonardo Dantas

2000 *Dutch Brazil.* Vol. 1, *Frans Post: The British Museum Drawings.* Petrópolis.

Siple, Ella S.

1938 "A Flemish Set of *Venus and Vulcan* Tapestries, I: Their Origin and Design." *Burlington Magazine* 73 (November), pp. 212–20.

1939 "A Flemish Set of *Venus and Vulcan* Tapestries, II: Their Influence on English Tapestry Design." *Burlington Magazine* 74 (June), pp. 268–78.

Smit, Hillie

2003 "New Data on the History of a *Set of Scenes of Country Life 'after Teniers'* in the Rijksmuseum Amsterdam." In Brosens 2003, pp. 153–59.

Smith, John

1829–42 *A Catalogue Raisonné of the Works of the Most Eminent Dutch, Flemish and French Painters.* 9 vols. London.

Smith, William, William Wayte, and George Eden Marindin

1890–91 Eds. *A Dictionary of Greek and Roman Antiquities.* 2 vols. London.

Snyder, Henry Leonard

1975 Ed. *The Marlborough-Godolphin Correspondence.* 3 vols. Oxford.

Sonntag, Stephanie

2006 *Ein "Schau-Spiel" der Malkunst: Das Fensterbild in der holländischen Malerei des 17. und 18. Jahrhunderts.* Kunstwissenschaftliche Studien 132. Munich and Berlin. [Originally presented as the author's PhD diss., Rheinische Friedrich Wilhelms-Universität, Bonn, 2003.]

de Sousa-Leão, Joaquim

1947 "Os célebres gobelins 'Tenture des Indes.'" *Anuário do Museu Imperial,* 1944 (pub. 1947), pp. 67–86.

1961 "Du nouveau sur les tableaux du Brésil offerts à Louis XIV." *Gazette des beaux-arts,* 6th ser., 57 (February), pp. 95–104.

1973 *Frans Post, 1612–1680.* Painters of the Past. Amsterdam.

Spagnesi, Alvaro

1996 "Affreschi del Butteri nell'oratorio di S. Elena e S. Croce alle Masse di Serpiolle." *Antichità viva* 34, nos. 5–6 (1995; pub. 1996), pp. 44–52.

Spagnesi, Gianfranco

1988 "Il Palazzo Madama di Roma." In Gian Paolo Romagnani et al., *Il Senato italiano nelle tre capitali,* pp. 227–68. Rome.

Spinosa, Nicola

1971 *L'arazzeria napoletana.* Naples.

Standen, Edith A.

1957 "Two Scottish Embroideries in the Metropolitan Museum." *Connoisseur* 139 (May), pp. 196–200.

1974 "Romans and Sabines: A Sixteenth-Century Set of Flemish Tapestries." *Metropolitan Museum Journal* 9, pp. 211–28.

1976 "The Story of the Emperor of China: A Beauvais Tapestry Series." *Metropolitan Museum Journal* 11, pp. 103–17.

1979a "Grotesques: Five Pieces from a Set of Tapestries. The Camel; Musicians and Dancers; the Elephant; the Offering to Bacchus; Violin and Lute Players." In The Metropolitan Museum of Art, *Notable Acquisitions, 1975–1979,* pp. 40–41. New York.

1979b "Some Beauvais Tapestries Related to Berain." In A. G. Bennett 1979, pp. 209–19.

1980 "English Tapestries 'After the Indian Manner.'" *Metropolitan Museum Journal* 15, pp. 119–42.

1981 "Studies in the History of Tapestry, 1520–1790." *Apollo* 114 (July), pp. 6–54.

1985 *European Post-Medieval Tapestries and Related Hangings in The Metropolitan Museum of Art.* 2 vols. New York.

1987 "Renaissance to Modern Tapestries in The Metropolitan Museum of Art." *Metropolitan Museum of Art Bulletin* 44, no. 4 (Spring), pp. 6–56.

1988 "Some Tapestries at Princeton." *Record of the Art Museum, Princeton University* 47, no. 2, pp. 3–18.

1988a "Ovid's *Metamorphoses:* A Gobelins Tapestry Series." *Metropolitan Museum Journal* 23, pp. 149–91.

1996 "The Comte de Toulouse's *Months of Lucas* Gobelins Tapestries: Sixteenth-Century Designs with Eighteenth-Century Additions." *Metropolitan Museum Journal* 31, pp. 59–73.

1998 "The Tapesty Weaver and the King: Philippe Behagle and Louis XIV." *Metropolitan Museum Journal* 33, pp. 183–204.

1999 "For Minister or for King: Two Seventeenth-Century Gobelins Tapestries after Charles Le Brun." *Metropolitan Museum Journal* 34, pp. 125–34.

[C.-]Starcky, Laure

1988[b] *Paris, Mobilier National: Dessins de Van der Meulen et de son atelier.* Inventaire des collections publiques françaises 33. Paris.

1998 "L'épopée d'une traversée." In Dijon–Luxembourg 1998, pp. 149–51.

Starkey, David

1998 Ed. *The Inventory of King Henry VIII: Society of Antiquaries MS 129 and British Library MS Harley 1419.* Reports of the Research Committee of the Society of the Antiquaries of London 56. London.

Stein, Fabian

1985 *Charles Le Brun: La tenture de l'Histoire du Roy.* Manuskripte zur Kunstwissenschaft in der Wernerschen Verlagsgesellschaft 4. Worms.

Steinbart, Kurt

1928 "Die niederländischen Hofmaler der bairischen Herzöge." *Marburger Jahrbuch für Kunstwissenschaft* 4, pp. 89–164.

1937 "Pieter Candid in Italien." *Jahrbuch der Preuszischen Kunstsammlungen* 58, pp. 63–80.

Steppe, Jan-Karel

1956 "Vlaamse wandtapijten in Spanje: Recente gebeurtenissen en publicaties." *Artes textiles* 3, pp. 27–66.

1981 "Enkele nieuwe gegevens betreffende tapijtwerk van de geschiedenis van Vertumnus en Pomona vervaardigd door Willem de Pannemaker voor Filips II van Spanje." *Artes textiles* 10, pp. 125–40.

Stierhof, Horst H.

1980 "Zur Baugeschichte der Maximilianischen Residenz." In Munich 1980, vol. 1, pp. 269–78.

Stockholm

1966 *Christina, Queen of Sweden: A Personality in European Civilisation.* Exh. cat. edited by Per Bjurström. Translated by Patrick Hort and Roger Tanner. Nationalmuseum. Stockholm.

2002 *Krig och Kärlek på tapeter: En unik samling vävda tapeter från 1500- och 1600-talet.* Exh. cat. by Ursula Sjöberg. Royal Palace. Stockholm.

Van der Straaten, Harald S.

1998 *Maurits de Braziliaan: Het levensverhaal van Johan Maurits van Nassau-Siegen, stichter van het Mauritshuis, gouverneur-generaal van Nederlands-Brazilië, stadhouder van Kleef, 1604–1679.* Amsterdam.

Suffolk Collection

1975 *The Suffolk Collection: Catalogue of Paintings.* Compiled by John Jacob and Jacob Simon. Ranger's House, Blackheath, London. London.

Swain, Margaret H.

1988 *Tapestries and Textiles at the Palace of Holyroodhouse in the Royal Collection.* London.

Van Swigchem, C. A., and G. Ploos van Amstel

1991 *Zes unieke wandtapijten: Strijd op de Zeeuwse stromen, 1572–1576.* Zwolle.

Szmydki, Ryszard

1987 "Vlaamse wandtapijten uit de verzameling van Jan Casimir Vasa (1609–1672) / Tapisseries flamandes dans la collection de Jean-Casimir Vasa (1609–1672)." In *Vlaamse wandtapijten uit de Wawelburcht te Krakau en uit andere Europese verzamelingen / Tapisseries flamandes du château du Wawel à Cracovie et d'autres collections européennes,* pp. 122–35. Exh. cat. by Maria Hennel-Bernasikowa, Erik Duverger, Ryszard Szmydki, and Guy Delmarcel. Centrum voor Kunst en Cultuur, Sint-Pietersabdij. Ghent.

Tagliaferro, Laura

1981 "Per venticinque arazzi 'genovesi.'" *Bollettino dei Musei Civici Genovesi* 3, nos. 7–9, (January–December), pp. 69–127.

Tamizey de Larroque, Philippe

1880–83 Ed. *Lettres de Jean Chapelain, de l'Académie Française.* 2 vols. Paris.

Tanner, Marie

1993 *The Last Descendant of Aeneas: The Hapsburgs and the Mythic Image of the Emperor.* New Haven.

Tapisserie au XVIIe siècle

1999 *La tapisserie au XVIIe siècle et les collections européennes.* Edited by Catherine Arminjon and Nicole de Reyniès. Actes du Colloque International de Chambord, October 18–19, 1996. Cahiers du patrimoine 57. Paris.

Tauss, Susanne

2000 *Dulce et decorum? Der Decius-Mus-Zyklus von Peter Paul Rubens.* Osnabrück. [Originally presented as the author's PhD thesis, Universität Tübingen, 1996.]

"Tentures de tapisseries"

1892 "Tentures de tapisseries." *Nouvelles archives de l'art français,* 3rd ser., 8, p. 128.

Terlinden, Charles, vicomte

1958 "Victor Janssens: Peintre bruxellois (1658–1736)." *Bulletin* (Musées Royaux des Beaux-Arts / Koninklijke Musea voor Schone Kunsten) 7 (March), pp. 33–48.

Terradura, Elisabetta

1996 "Due opere di Giovanni Maria Butteri nella chiesa di San Salvatore a Vaiano." *Prato* 36, no. 87 (1995; pub. 1996), pp. 53–63.

Tetius, Hieronymus

1642/2005 *Aedes Barberinae ad Quirinalem descriptae.* Rome, 1642. Reprint, *Aedes Barberinae ad Quirinalem descriptae / Descrizione di Palazzo Barberini al Quirinale: Il palazzo, gli affreschi, le collezioni, la corte.* Edited by Lucia Faedo and Thomas Frangenberg. Testi e commenti 2. Pisa, 2005.

Thessaloníki

1997 *Alexander the Great in European Art.* 2 vols. Exh. cat. edited by Nicos Hadjinicolaou. Organized by "Thessaloníki: Cultural Capital of Europe, 1997." [Thessaloníki.]

Théveniaud, Valérie

1984 "Michel Dorigny (1617–1665): Approches biographiques." *Bulletin de la Société de l'Histoire de l'Art Français* (1982; pub. 1984), pp. 63–67.

Thiem, Gunther

1958 "Studien zu Jan van der Straet, genannt Stradanus." *Mitteilungen des Kunsthistorischen Institutes in Florenz* 7, no. 2 (September), pp. 88–111.

Thieme, Ulrich, and Felix Becker

1907–50 *Allgemeines Lexikon der bildenden Künstler von der Antike bis zur Gegenwart.* 37 vols. Leipzig.

Thoenes, Christof

1986 "Galatea: Tentativi di avvicinamento." In *Raffaello a Roma: Il convegno del 1983,* pp. 59–73. Papers presented at a congress held in Rome, March 21–28, 1983. Rome.

Thøfner, Margit

1999 "Marrying the City, Mothering the Country: Gender and Visual Conventions in Johannes Bochius's Account of the Joyous Entry of the Archduke Albert and the Infanta Isabella into Antwerp." *Oxford Art Journal* 22, pp. 1–27.

Thoison, Eugène

1901 "Notes sur des artistes se rattachant au Gatinais: Les Vernansal." *Réunion des Sociétés des Beaux-arts des Départements* 25, pp. 108–35.

Thomsen, Thomas

1938 *Albert Eckhout, ein Niederländischer Maler, und sein Gönner Maurits der Brasilianer: Ein Kulturbild aus dem 17. Jahrhundert.* Copenhagen.

Thomson, William George

1906 *A History of Tapestry from the Earliest Times until the Present Day.* London.

1913 "The 'Diana Hunting' Tapestries, Belonging to Mr. Kennedy Jones." *Connoisseur* 35 (April), pp. 229–34.

1914 *Tapestry Weaving in England from the Earliest Times to the End of the XVIIIth Century.* London and New York.

1930 *A History of Tapestry from the Earliest Times until the Present Day.* 2nd ed. London.

Thornton, Peter

1978 *Seventeenth-Century Interior Decoration in England, France, and Holland.* Studies in British Art. New Haven.

Thornton, Peter, and Maurice Tomlin

1980 "The Furnishing and Decoration of Ham House." *Furniture History* 16, pp. 1–194.

Thuillier, Jacques

1984–85 "Simon Vouet: Documents positives sur l'oeuvre d'un peintre du XVIIe siècle. 3. La période parisienne." *Annuaire du Collège du France,* pp. 765–78.

Thurley, Simon

2003 *Hampton Court: A Social and Architectural History.* New Haven.

Van Tichelen, Isabelle

1987 "La manifattura di Martin Reymbouts." In Cremona 1987, pp. 54–55.

1990 "Diana en Endymion: Een 17de-eeuws wandtapijt uit de ateliers van Parijs. Eerste resultaten van een onderzoek." *Bulletin des Musées Royaux d'Art et d'Histoire / Bulletin van de Koninklijke Musea voor Kunst en Geschiedenis* 61, pp. 133–55.

1994 "De Geschiedenis van Kirke." In *Mobiele fresco's van het Noorden: Wandtapijten uit onze gewesten, 16de–20ste eeuw*, edited by Nora Chalmet and Guy Delmarcel, pp. 61–66. Exh. cat., Hessenhuis, Antwerp. Ghent.

1997 "De Geschiedenis van Constantijn / The History of Constantine." In Antwerp 1997, pp. 58–77.

Timmers, Jan Joseph Marie

1942 *Gérard Lairesse*. Amsterdam.

Tipping, H. Avray

1926 "Audley End, Essex. The Seat of Lord Braybrooke—II." *Country Life* 59 (June 26), pp. 916–24.

Titi, Fillipo

1763 *Descrizione delle pitture, sculture e architetture esposate al pubblico in Roma*. Rome.

Tormo Monzó, Elías

1927/1972 *Las iglesias del antiguo Madrid: Notas de studio*. Madrid, 1927. 1972 ed., *Las iglesias de Madrid*. Valencia.

1942 "La Apoteosis Eucarística de Rubens: Los tapices de las Descalzas Reales de Madrid." *Archivo español de arte* 15, pp. 1–26, 117–31 ("Estudio de la composiciones"), 291–315 ("La subserie segunda de los tapices Eucarísticos de la Descalzas").

1945 *Los tapices: La Apoteosis Eucarística de Rubens*. Vol. 2, pt. 2, of *En las Descalzas Reales de Madrid*. Madrid.

Tormo Monzó, Elías, and Francisco Javier Sánchez Cantón

1919 *Los tapices de la casa del Rey N.S.: Notas para el catálogo y para la historia de la colección y de la fábrica*. Madrid.

Torra de Arana, Eduardo, Antero Hombría Tortajada, and Tomás Domingo Pérez

1985 *Los tapices de la Seo de Zaragoza*. [Saragossa.]

Toulouse–Aix-en-Provence–Caen

2004 *Saints de choeurs: Tapisseries du Moyen Âge et de la Renaissance*. Exh. cat. by Catherine Arminjon et al. Ensemble Conventuel des Jacobins, Toulouse; Musée des Tapisseries, Aix-en-Provence; Musée de Normandie, Caen. Milan.

Tracy, James D.

2006 *Europe's Reformations, 1450–1650: Doctrine, Politics, and Community*. 2nd ed. Critical Issues in History. Lanham, Md.

Trautmann, Karl

1887 "Zwei unbekannte Beschreibungen Münchens aus dem siebenzehnten Jahrhundert." *Jahrbuch für Münchner Geschichte*, pp. 506–10.

Tuck, Steven L.

2005 "The Origins of Roman Imperial Hunting Imagery: Domitian and the Redefinition of *Virtus* under the Principate." *Greece & Rome*, 2nd ser., 52, no. 2, pp. 221–45.

Turin

1952 *Arazzi e tappeti antichi*. Exh. cat. by Mercedes Viale [Ferrero] and Vittorio Viale. Palazzo Madama. Turin.

1984 *La collezione di arazzi della Galleria Sabauda: Note sulla sua formazione*. Exh. cat. by Elena Ragusa and Vittorio Natale. Galleria Sabauda. Turin.

1989 *Diana trionfatrice: Arte di corte nel Piemonte del Seicento*. Exh. cat. edited by Michela Di Macco and Giovanni Romano. Promotrice delle Belle Arti. Turin.

Tuve, Rosemond

1966 *Allegorical Imagery: Some Mediaeval Books and Their Posterity*. Princeton.

Uhlmann-Faliu, Odile

1978 "Jean Valdor: Graveur et diplomate liégeois, marchand-bourgeois de Paris (1616–1675)." Master's thesis, Université de Paris—Sorbonne, Paris IV.

Urbani de Gheltof, Giuseppe Marino

1878 *Degli arazzi in Venezia, con note sui tessuti artistici veneziani*. Venice.

Vaillant, V.-J.

1884 "Plan des fortifications." In Vaillant, *Le Siège d'Ardres en 1657 d'après une relation contemporaine inédite; ou, Ardresiens et boulonnais*, pp. 68–69. Notes boulonnaises 3. Boulogne-sur-Mer.

Valentiner, W. R.

1946 "Rubens' Paintings in America." *Art Quarterly* 9, pp. 153–68.

Vanhoren, Raf

1999 "Tapisseries bruxelloises d'après les modèles de Charles Le Brun: L'*Histoire d'Alexandre le Grand*." In *Tapisserie au XVIIe siècle* 1999, pp. 61–68.

Vanuxem, Jacques

1955 "Emblèmes et devises, vers 1660–1680." *Bulletin de la Société de l'Histoire de l'Art Français* (1954; pub. 1955), pp. 60–70.

Vanwelden, Martine

1999 "Groei, bloei en teloorgang van de wandtapijtennijverheid in Oudenaarde." In Oudenaarde 1999, pp. 23–101.

Vasari, Giorgio

1568/ *Le vite de' più eccellenti pittori, scultori et architettori*. 2nd ed. 3 vols.
1912–14 Florence, 1568. 1912–14 ed., *Lives of the Most Eminent Painters, Sculptors and Architects*. Translated by Gaston du C. De Vere. 10 vols. London.

Il Vasari storiografo

1976 *Il Vasari storiografo e artista: Atti del Congresso Internazionale nel IV Centenario della Morte*. Arezzo and Florence, September 2–8, 1974. Florence.

Van der Velden, Hugo

1995a "Cambyses for Example: The Origins and Function of an *Exemplum Iustitiae* in Netherlandish Art of the Fifteenth, Sixteenth and Seventeenth Centuries." *Simiolus* 23, pp. 5–39.

1995b "Cambyses Reconsidered: Gerard David's *Exemplum Iustitiae* for Bruges Town Hall." *Simiolus* 23, pp. 40–62.

Veldman, Ilja M.

1993 Comp. *Maarten van Heemskerck [Old Testament, including Series with Old & New Testatment Subjects]*. Edited by Ger Luijten. [Vol. 1], pt. 1 of *The New Hollstein: Dutch and Flemish Etchings, Engravings and Woodcuts, 1450–1700*. Roosendaal.

Venturi, Adolfo

1901–40 *Storia dell'arte italiana*. 11 vols. in 25. Milan. [Reprint, Nendeln, Liechtenstein, 1967. Index, edited by Jacqueline D. Sisson, 2 vols., Nendeln, 1975.]

Verdier, Jeanine

1980 "Les Tentures des Indes." *L'oeil*, no. 297 (April), pp. 44–51.

Verdon, Timothy

1996 "Le origini dell'altare barocco e la Contro-Riforma a Firenze." In *Altari e committenza: Episodi a Firenze nell'età della Controriforma*, edited by Cristina De Benedictis, pp. 19–27. Florence.

Verlet, Pierre

1982 *The Savonnerie: Its History. The Waddesdon Collection*. London and Fribourg, 1982.

Verpoort, Erik

2005 "Lodewijk van Schoor (ca. 1650–1702) en de Brusselse wandtapijtreeks De Geschiedenis van Perseus: Een stilistisch en iconografisch onderzoek." Master's thesis, Katholieke Universiteit Leuven.

Versailles

1937 *Deux siècles de l'histoire de France (1589–1789)*. Exh. cat., Château de Versailles. Versailles.

1963 *Charles Le Brun, 1619–1690: Peintre et dessinateur.* Exh. cat. by Jacques Thuillier and Jennifer Montagu. Château de Versailles. Paris.

1967 *Chefs-d'oeuvre de la tapisserie parisienne (1597–1662).* Exh. cat., Orangerie du Versailles. Paris.

1990 *Charles Le Brun, 1619–1690: Le décor de l'escalier des Ambassadeurs à Versailles.* Exh. cat. by Lydia Beauvais. Musée National du Château de Versailles. Paris.

2004 *Kangxi, empereur de Chine, 1662–1722: La cité interdite à Versailles.* Exh. cat., Musée National du Château de Versailles. Paris.

Viale Ferrero, Mercedes

1961 *Arazzi italiani.* Milan.

1968 "Nouveaux documents sur les tapisseries de la maison de Savoie." In *Miscellanea Jozef Duverger: Bijdragen tot de kunstgeschiedenis der Nederlanden,* vol. 2, pp. 806–18. Ghent.

1973 "Quelques nouvelles données sur les tapisseries de l'Isola Bella." *Bulletin des Musées Royaux d'Art et d'Histoire / Bulletin van de Koninklijke Musea voor Kunst en Geschiedenis* 45, pp. 77–142. Actes du Colloque International "L'art brabançon au milieu du XVIe siècle et les tapisseries du château de Wawel à Cracovie," December 14–15, 1972.

1981 "Quatre tapisseries inédites de l'Histoire de Troie." *Artes textiles* 10, pp. 183–92.

1982 "Arazzo e pittura." In *Storia dell'arte italiana,* pt. 3, vol. 4, pp. 115–58. Storia dell'arte italiana 11. Turin.

1984 "Arazzi." In Museo Poldi Pezzoli, vol. 4, *Arazzi, tappeti, tessuti copti, pizzi, ricami, ventagli,* pp. 15–40. Musei e gallerie di Milano. Milan.

Vianden

1995 *Flemish Tapestries: Five Centuries of Tradition.* Exh. cat. by Guy Delmarcel and An Volckaert. Vianden Castle. Luxembourg.

Viatte, Françoise

1988 *Dessins toscans, XVIe–XVIIIe siècles.* Vol. 1, *1560–1640.* Musée du Louvre. Cabinet des Dessins. Inventaire général des dessins italiens 3. Paris.

Vienna

1920 *Katalog der Gobelinausstellung.* Exh. cat. by Ludwig Baldass. Belvedereschloss. Vienna.

1921 *Katalog der II Gobelin-Ausstellung.* Exh. cat. by Ludwig Baldass. Belvedereschloss. Vienna.

Villalobar, Ramiro de Saavedra y Cueto, marqués de

1925 *L'Archiduchesse-Infante Isabelle-Claire-Eugénie au Musée du Prado: L'Espagne et la Belgique dans l'histoire.* Proceedings of the conference Journées Hispano-Belges, March 16 and 17, 1924. Brussels.

Vittet, Jean

2004a "L'Histoire de Constantin." In Lille 2004, p. 278.

2004b "L'Histoire de Decius Mus." In Lille 2004, p. 270.

2004c "Les tapisseries de Michel Particelli d'Hémery et de son gendre Louis Phélypeaux de la Vrillière." In *Objets d'art: Mélanges en l'honneur de Daniel Alcouffe,* pp. 171–79. Dijon.

2007 "Les tapisseries de la Couronne à l'époque de Louis XIV: Du nouveau sur les achats effectués sous Colbert." *Versalia,* no. 10, pp. 182–201.

Vitzthum, Walter

1965 Review of Dubon 1964. *Burlington Magazine* 107 (May), pp. 262–63.

Vlieghe, Hans

1959–60 "David Teniers II en David Teniers III als patroonschilders voor de tapijtweverijen." *Artes textiles* 5, pp. 78–102.

Vocelka, Karl, and Lynne Heller

1997 *Die Lebenswelt der Habsburger: Kultur- und Mentalitätsgeschichte einer Familie.* Graz.

Volk-Knüttel, Brigitte

1967 "Zur Geschichte der Münchner Residenz, 1600–1616." *Münchner Jahrbuch der bildenden Kunst* 18, pp. 187–210.

1976a *Wandteppiche für den Münchener Hof: Nach Entwürfen von Peter Candid.* Forschungshefte (Bayerisches Nationalmuseum) 2. Munich.

1976b "Wandteppiche für den Münchener Hof: Nach Entwürfen von Peter Candid." *Weltkunst* 46 (June), pp. 1221–23.

1980 "Maximilian I. von Bayern als Sammler und Auftraggeber: Seine Korrespondenz mit Philipp Hainhofer, 1611–1615." In *Quellen und Studien zur Kunstpolitik der Wittelsbacher von 16. bis zum 18. Jahrhundert,* edited by Hubert Glaser, pp. 83–128. Mitteilungen des Hauses der bayerischen Geschichte 1. Munich and Zürich.

1981 "Jan de la Groze: Ein Brüsseler Tapissier am Hof Wilhelms V. von Bayern." In *Documenta textilia: Festschrift für Sigrid Müller-Christensen,* edited by Mechthild Flury-Lemberg and Karen Stolleis, pp. 234–50. Forschungshefte (Bayerisches Nationalmuseum) 7. Munich.

Völker, Angela

1976 "Die Tapisserieeinkäufe des Kurfürsten Max Emanuel und die Anfänge der Münchner Wandteppichmanufaktur." In *Kurfürst Max Emanuel: Bayern und Europa um 1700,* vol. 1, *Zur Geschichte und Kunstgeschichte der Max-Emanuel-Zeit,* edited by Hubert Glaser, pp. 265–73. Munich.

Voltini, Franco

1987 "Arazzi per la cattedrale: Elementi di storia e iconografia." In Cremona 1987, pp. 56–74.

de Vries, Elly

2002 Ed. *Albert Eckhout volta ao Brasil, 1644–2002: Simpósio internacional de especialistas / Albert Eckhout Returns to Brazil, 1644–2002: International Experts Symposium.* São Paulo.

De Waard, C.

1897 "De Middelburgsche tapijten." *Oud Holland* 15, pp. 65–93.

Wace, Alan John Bayard

1935 "The Hunters' Chase." *Burlington Magazine* 67 (July), pp. 28–30.

1968 *The Marlborough Tapestries at Blenheim Palace and Their Relation to Other Military Tapestries of the War of the Spanish Succession.* London.

Waddy, Patricia

1990 *Seventeenth-Century Roman Palaces: Use and the Art of the Plan.* New York and Cambridge.

Waldman, Louis A.

2004 Ed. *Baccio Bandinelli and Art at the Medici Court: A Corpus of Early Modern Sources.* Memoirs of the American Philosophical Society 251. Philadelphia.

Walpole, Horace

1763 *Anecdotes of Painting in England: With Some Account of the Principal Artists, and Incidental Notes on Other Arts; Collected by the Late Mr. George Vertue; and Now Digested and Published from His Original MSS.* Vol. 3. Strawberry Hill.

1927–28 "Horace Walpole's Journals of Visits to Country Seats, &c." [July 1751–September 1784.] In *The Sixteenth Volume of the Walpole Society,* pp. 9–80. Oxford.

Waquet, Françoise

1989 *Le modèle français et l'Italie savante: Conscience de soi et perception de l'autre République des lettres, 1660–1750.* Collection de l'École française de Rome 117. Rome.

Washington

1977 *Fons Sapientiae: Garden Fountains in Illustrated Books, Sixteenth–Eighteenth Centuries.* Exh. cat. by Elisabeth B. MacDougall and Naomi Miller. Dumbarton Oaks. Washington, D.C.

1990 *Anthony van Dyck*. Exh. cat. by Arthur Wheelock Jr. et al. National Gallery of Art. Washington, D.C.

Washington–Cleveland–Paris

1975 *The European Vision of America*. Exh. cat. by Hugh Honour. National Gallery of Art, Washington, D.C.; Cleveland Museum of Art; Galeries Nationales du Grand Palais, Paris. Cleveland. Also published as *L'Amérique vue par l'Europe*. Paris, 1976.

Wauters, Alphonse-Guillaume-Ghislain

1878 *Les tapisseries bruxelloises: Essai historique sur les tapisseries et les tapisseries de haute et de basse-lice de Bruxelles*. Brussels. [Reprint, 1973.]

Waźbiński, Zygmunt

1994 *Il cardinale Francesco Maria del Monte, 1549–1626.* 2 vols. Studi (Accademia Toscana di Scienze e Lettere "La Columbaria") 137. Florence.

Weddigen, Tristan

1999 "Tapisserie und Poesie: Gianfrancesco Romanellis Giochi di Putti für Urban VIII." In *Barocke Inszenierung*, edited by Joseph Imorde, Fritz Neumeyer, and Tristan Weddigen, pp. 72–103. Proceedings of a Colloquium, Technische Universität Berlin, June 20–22, 1996. Zürich.

Weigert, Laura

2004 *Weaving Sacred Stories: French Choir Tapestries and the Performance of Clerical Identity*. Conjunctions of Religion and Power in the Medieval Past. Ithaca, N.Y.

Weigert, Roger-Armand

1933 "Les grotesques de Beauvais et les tapisseries de Chevening (Kent)." *Bulletin de la Société de l'Histoire de l'Art Français*, pp. 7–21.

1937a *Jean I Berain: Dessinateur de la Chambre et du Cabinet du Roi (1640–1711).* 2 vols. Paris.

1937b "La tenture des Triomphes Marins d'après Jean I Bérain." *Gazette des beaux-arts*, 6th ser., 17 (May–June), pp. 329–34.

1939 *Inventaire du fonds français: Graveurs du XVIIe siècle.* Vol. 1, *Alix–Boudeau*. Département des Estampes, Bibliothèque Nationale. Paris.

1946a "The Beauvais Factory." In *French Tapestry*, edited by André Lejard, pp. 49–62. London.

1946b "Les grotesques de Beauvais." *Hyphé* 1, no. 2 (March–April), pp. 66–78.

1948 "Deux compositions gravées d'après Jean I Berain et leurs transcriptions textiles." *Gazette des beaux-arts*, 6th ser., 34 (September), pp. 153–72.

1949 "Une tenture tissée par l'atelier du Louvre pour Simon Vouet (1637)." *Gazette des beaux-arts*, 6th ser., 35 (January), pp. 11–20.

1950 "Two Tapestries in the Ashmolean Museum." *Burlington Magazine* 92 (July), pp. 193–94.

1956 *La tapisserie française*. Paris.

1962 *French Tapestry*. Translated by Donald King and Monique King. London.

1964 "Les commencements de la Manufacture Royale de Beauvais, 1664–1705." *Gazette des beaux-arts* 64 (December), pp. 331–46.

Weimar–New York–Paris

2005 *De Callot à Greuze: Dessins français des XVIIe et XVIIIe siècles des musées de Weimar*. Exh. cat. by David Mandrella, Hermann Mildenberger, Benjamin Peronnet, and Pierre Rosenberg. Stiftung Weimarer Klassik und Kunstsammlungen, Weimar; Frick Collection, New York; Musée Jacquemart-André, Paris. Berlin. Also published as *From Callot to Greuze: French Drawings from Weimar*. Berlin.

d'Welles, Jacques

1957 "Les tapisseries du château de Cadillac." *Revue historique de Bordeaux*, n.s., 6, pp. 5–23.

Wells-Cole, Anthony

1983 "Some Design Sources for the Earl of Leicester's Tapestries and Other Contemporary Pieces." *Burlington Magazine* 125 (May), pp. 284–85.

Whinney, Margaret, and Olivar Millar

1957 *English Art, 1625–1714.* The Oxford History of English Art 8. Oxford.

Whitehead, Peter James Palmer, and Marinus Boeseman

1989 *A Portrait of Dutch 17th Century Brazil: Animals, Plants, and People by the Artists of Johan Maurits of Nassau*. Amsterdam and New York.

Whiteley, Jon

2000 *Catalogue of the Collection of Drawings.* Vol. 7, *French School.* 2 vols. Ashmolean Museum. Oxford.

Willk-Brocard, Nicole

1995 *Une dynastie les Hallé: Daniel (1614–1675), Claude-Guy (1652–1736), Noël (1711–1781).* Paris.

Wilmers, Gertrude

1996 *Cornelis Schut (1597–1655): A Flemish Painter of the High Baroque*. Pictura nova 1. Turnhout. [Originally presented as the author's PhD diss., Columbia University, New York, 1991.]

Wilson, Gillian, and Catherine Hess

2001 *Summary Catalogue of European Decorative Arts in the J. Paul Getty Museum.* Los Angeles.

Wine, Humphrey

2001 *The Seventeenth Century French Paintings*. National Gallery Catalogues. London.

Wingfield Digby, George

1980 Assisted by Wendy Hefford. *The Tapestry Collection: Medieval and Renaissance.* Victoria and Albert Museum. London.

Wittkower, Rudolf

1958 *Art and Architecture in Italy, 1600 to 1750.* The Pelican History of Art. Harmondsworth.

1966 *Gian Lorenzo Bernini: The Sculptor of the Roman Baroque*. 2nd ed. London.

Woldbye, Vibeke

1965 "Tapestries from the Workshop of Michel Wauters in Antwerp at Rosenborg Castle in Copenhagen." *Artes textiles* 6, pp. 75–92.

1969 "Hollandske blomstertaepper i Danmark." In *Kunstindustrimuseets virkomhed* (Copenhagen) 4, pp. 51–78.

2002 "Flemish Tapestry Weavers in the Service of Nordic Kings." In Delmarcel 2002b, pp. 91–111.

Wolf, Gerhard

1990 *Salus Populi Romani: Die Geschichte römischer Kultbilder im Mittelalter.* Weinheim.

Wood, Frances

2005 "Imperial Architecture of the Qing: Palaces and Retreats." In London 2005, pp. 54–62.

Wood, Jeremy

1996 Review of *Kings and Connoisseurs: Collecting Art in Seventeenth-Century Europe*, by Jonathan Brown. *Burlington Magazine* 138 (August), p. 549.

Worcester

2005 *Hope and Healing: Painting in Italy in a Time of Plague (1500–1800).* Exh. cat. edited by Gauvin Alexander Bailey et al., with contributions by Sheila C. Barker et al. Worcester Art Museum. Worcester, Mass.

Worp, Jacob Adolf

1904–8/ *Geschiedenis van het drama en van het tooneel in Nederland.* 2 vols.
1970 Groningen, 1904–8. Reprint, Rotterdam, 1970.

Worsdale, Derrick
1977 "The State Apartments: From 1800 to the Present Day." *Apollo* 106 (September), pp. 232–39.

Van Ysselsteyn, Gerardina Tjaberta
1936 *Geschiedenis der tapijtweverijen in de noordelijke Nederlanden: Bijdrage tot de geschiedenis der kunstnijverheid.* 2 vols. Leiden.
1937 "Tapisserieën uit de weverij van François Spiering." *Oud Holland* 54, pp. 165–72.

Zerafa, M. J.
1975 "Tapestries of the Indies. Council Hall—Grandmaster's Palace." *Kalendarju ta' Malta 1975.* Malta.

Van Zijl, M. I. E.
1976 *De tapijten van François Spiering en het aandeel van Karel van Mander de Oude in hun vormgeving.* Leiden.

1981 "De Delftse wandtapijten." In *De stad Delft,* [vol. 2], *Cultuur en maatschappij van 1572 tot 1667,* pp. 202–9. 2 vols. Stedelijk Museum Het Prinsenhof. Delft.

Zöllner, Frank
1991 "Rubens Reworks Leonardo: 'The Fight for the Standard.'" *Achademia Leonardi Vinci* 4, pp. 177–90.

Zrebiec, Alice, and Scott Erbes
2000 *Conquest and Glory: Tapestries Devoted to Louis XIV in the Collection of the Speed Art Museum.* Louisville.

Zupko, Ronald Edward
1978 *French Weights and Measures before the Revolution: A Dictionary of Provincial and Local Units.* Bloomington, Ind.

Zurawski, Simone Alaida
1979 "Peter Paul Rubens and the Barberini, ca. 1625–1640." PhD diss., Brown University, Providence, R.I.

Index

Page numbers in italic type refer to illustrations; page numbers in **boldface** *type refer to the main catalogue entry for a work. The catalogue number (cat. no.) is provided for catalogue works and the figure number (fig.) for other illustrated works. Series and sets, which are often referred to in the text by a short form of the title (e.g., Caesar), are indexed under the full form (Story of Julius Caesar). The dates that are used to distinguish successive works, series, or sets of the same title are provided as aids to identification and may not reflect nuances of chronology.*

A

Abbatini, Guido Ubaldo, 294
Académie Royale de Peinture et de Sculpture, 347, 352, 353, 354, 358, 425, 428, 438
Academy of Sciences (painting by Henri Testelin), 383, *385*; fig. 177
Accolti, Benedetto, 263
Achtschellinck, Lucas, 445–46
Acts of the Apostles (ca. 1517–19, 10-piece set commissioned by Leo X) (designs by Raphael and workshop) (woven in workshop of Pieter van Aelst, Brussels) (at Vatican), 6, 8, 72, 74, 75, 111, 116, 184, 229, 280, 293, 404
 cartoons purchased by English Crown, 74, 75, 104, 171, 497
 Charge to Peter, 96
 Conversion of Saul, 6; fig. 6
 ecclesiastical use of, 264
 Healing of the Lame Man, 192, 267
 Rubens's *Story of Decius Mus* cartoons influenced by, 95, 96, 104
 Sacrifice at Lystra, 96, 104
Acts of the Apostles (Francis I's sets from Raphael's designs), 111, 497
Acts of the Apostles (ca. 1540–42, for Henry VIII) (cartoons by Raphael) (woven in Brussels): *Sacrifice at Lystra* (in Berlin), 176, 335, *336*; fig. 153
Acts of the Apostles (ca. 1605–6, among sample tapestries and designs for Robert Cecil, Earl of Salisbury, and Thomas Howard, Earl of Suffolk), 68
Acts of the Apostles (ca. 1614, for Antonio Bono) (designs from second-generation cartoons by unidentified Flemish artist based on originals by Raphael) (woven in workshop of Jan Raes II, Brussels), 72
Acts of the Apostles (ca. 1620, for Infanta Isabella) (designs from second-generation cartoons by unidentified Flemish artist based on originals by Raphael) (woven in workshops of Jan Raes II and Catherine van den Eynde, Brussels) (possibly in Madrid), 72, 87, 90
Acts of the Apostles (ca. 1620) (designs from second-generation cartoons by unidentified Flemish artist based on originals by Raphael) (woven in workshop of Jan Raes II, Brussels): *Conversion of Saul* (at Hampton Court Palace), *70*, 72; fig. 40
Acts of the Apostles (1628, for church of Saint Mederic) (woven in Louvre workshops, Paris), 135
Acts of the Apostles (ca. late 1620s to early 1640s, for Charles I) (from seven cartoons by Raphael, copied by Francis Clein with additions and new border designs) (woven at Mortlake), 75, 113, 118, 175–79, 182, **184–89**, *185*, *187*, *188*, 337, 491

Blinding of Elymas, 176, 176–77, 188, 189, 195; fig. 89
Christ's Charge to Peter, 188–89
Death of Ananias, 176–77, 188, 189
Death of Sapphira, 176–77, *177*, 184, 188
Miraculous Draft of Fishes, 75, 118, 176, 178, **184–89**, *185*, *187*, *188*, 491; cat. no. 16
related sets, 118, 176–78, *179*, 182, 187, 189
Saint Paul Preaching at Athens (Warsaw, presumed destroyed), 184
Acts of the Apostles (ca. 1636–37, with arms of Philip Herbert, Earl of Pembroke) (from designs by Raphael, border designs by Francis Clein) (woven at Mortlake), 177, *179*, 180, 182, 189
 Christ's Charge to Peter (at Boughton House), 179
 Death of Sapphira (design by Francis Clein) (at Boughton House), 176–77, *177*, 179, 335; fig. 90
 Miraculous Draft of Fishes (at Boughton House), 179
Acts of the Apostles (ca. 1637–39, with arms of Henry Rich, Earl of Holland) (designs by Raphael, borders by Francis Clein) (woven at Mortlake), 182, 189
 Death of Ananias (in Paris), 178, *179*; fig. 92
Acts of the Apostles (ca. 1638–39) (designs by Raphael, border by Francis Clein) (probably woven at Mortlake), 175–77, 330
 Sacrifice at Lystra (in Paris), *178*; fig. 91
Acts of the Apostles (1690s) (from Raphael's designs, cartoons by students at French Academy, Rome) (woven under Philippe Behagle at Beauvais), 414–16
Acts of the Apostles (17th-century reweaving shown in Stefano della Bella's depiction of Corpus Christi procession, 1648), 113, 116
Acts of the Apostles (mid-17th century) (designs after Abraham van Diepenbeeck) (woven in Antwerp), 214
Acts of the Apostles after Raphael (ca. 1725) (designs by Jan van Orley and Augustin Coppens) (woven in Leyniers workshop, Brussels) (in Essen), 452, 488
Adonis. *See Story of Venus and Adonis*
Aedes Barberinae, 293, 294, 316
Aelianus, 88
Aelst, Pieter van (called Pieter van Edingen [Enghien]), 6, 402
Aeneas. *See* entries at *Story of Dido and Aeneas*
Aerschot, duke of, 69, 331
Aerts, Nicasius, 73
Aertsen, Pieter, 234, 236
Alba, Fernando Álvarez de Toledo, duke of, 18, 20, 48
Alba Passion (ca. 1525–28) (designs by Bernaert van Orley) (probably woven in workshop of Pieter de Pannemaker, Brussels): *Crucifixion* (in Washington), 6, 7; fig. 7
Albani, Francesco, 92, 449, 452
Albanzani da Pratovecchio, Donato degli, 268
Alberti, Cherubino and Giovanni, 267
Albon de Saint-André, Jacques d', 206, 331, 333
Albrecht V, elector of Bavaria, 63
Alcaretto family, 454
Aldobrandini family, 281
Alexander the Great. See entries at *Story of Alexander*
Alexander and Ulysses (1630s) (designs by Jacob Jordaens), 208
Alexander I, czar, 161

Alexander VII, pope, 299, 309, 310, 321, 378
Allegorical Armorials of the Duke of Marlborough (1710–11, 4-piece set) (designs attrib. to Jan van Orley) (woven in the workshop of Judocus de Vos, Brussels) (at Blenheim Palace): *Temperance*, 451–52, **466–70**, *467–69*; cat. no. 55
allegorical meanings in Gobelins tapestries glorifying Louis XIV, 275, 345–49, 358–59
Allegory of the Life of Man (1638, for Philip IV) (designs by Anthonis Sallaert) (woven in Brussels), 203, 441
Allegory of Time (ca. 1650, 14-piece set, for Archduke Leopold Wilhelm) (designs by Jan van den Hoecke with Pieter Thijs and Adriaen van Utrecht) (woven in workshop of Everaert Leyniers III, Brussels) (in Vienna), 114, 203, 212, **246–52**, *247*, *249–51*, 288, 457
 January and February
 cartoon, *247*, 250; fig. 116
 modello, **246–52**, *247*, 457; cat. no. 27
 tapestry, **246–52**, *249–51*, 288, 457; cat. no. 28
 related sets, 252
 Teniers III's *Months* and, 444
Allori, Alessandro, 63, 64, 93, 115, 263–67, 276–77, 280, 282, 284, 286
altar furnishings. *See* vestments and altar furnishings
Altemps family, 314
Álvarez de Toledo, Don Pedro, 146, 151, 153
Amadis of Gaul. See entries at *Story of Amadis of Gaul*
Ambrose of Milan, 88
Aminta (Tasso), 130
Amling, Carl Gustav, 85
Amphitrite, 240, 241, 243, 402, 405n19, 420, 422, *425*, 487
Ampieri, Anna, 295
Ananias, Death of. See entries at *Acts of the Apostles*
Andromeda. *See* entries at *Story of Perseus*
Angeli, Filippo d', 297
angels supporting dead Christ, Counter-Reformation use of Byzantine tradition of, 264, 276–77
Anghiari, Battle of. See Battle of Anghiari
Anglois, Guillermo, 458
Anguier, Guillaume, 350, 382
Animal Combats (17th century) (woven in workshop of Henry van der Cammen, Enghien): *Lion Hunting* (in Philadelphia), 216, *217*; fig. 110
Animals in a Wood (drawing attrib. to Pieter Coecke van Aelst), 89, *92*; fig. 42
Anne of Austria, 144, 146, 332
Anne, queen of England, 47, 182, 469, 475, 497
Anne, infanta, betrothal of, 107
Anne-Marie-Louise d'Orléans, duchesse de Montpensier, 371
Anthonisz, Cornelis, 53
Antin, Louis Antoine de Pardaillan de Gondrin, duc d', 384, 425, 504
antique/inherited tapestries, 106, 107–12, *108*, *109*, 111, 491–92, 497–99, 504
Antwerp
 Joyous Entry of Albert of Austria and Infanta Isabella into, 27, 56–57
 sack of, 20, 20–21
 as tapestry marketing and distribution center, 4, 13–15, 18, 214, 441
 as tapestry weaving center, 214–16, 442, 446, 452, 493, 495

Apollo and Daphne (sculpture) (by Bernini), 316
Apollo and Diana Slaying the Children of Niobe (drawing by unknown 16th-century artist), 148, *150*; fig. 76
Apollo, tapestries depicting. *See* entries at *Mythological Scenes*; *Stories of Apollo*; *Story of Diana*
Apuleius, 402
Arabesque Months (16th-century Brussels series revived at Gobelins, late 17th–early 18th centuries), 502
Arch of Constantine, 104, 307
Archduke Leopold Wilhelm in His Gallery (painting by David Teniers II), 325, *326*; fig. 146
Archinto, Filippo, count, 445, 446
Arenberg, duke of, 445, 454
Ariana (tapestry designs after Claude Vignon engravings for Jean Desmarets de Saint-Sorlin romance), 131
Arigucci, Luigi, 295
Ariosto, Ludovico, 38, 119, 130. *See also* entries at *Story of Orlando Furioso*
Aristides. *See Plutarch's Illustrious Men*
Armida. *See* entries at *Story of Rinaldo and Armida*
armorial tapestries, popularity of, 444–45, 448, 454, 495
Armorial Tapestry of the Count of Monterey (ca. 1675) (design by unknown Netherlandish artist stylistically related to Gerard Lairesse) (woven by Jacob van der Borcht and Jan de Melter, Brussels) (in Amsterdam), 445, 454–58, *455*, 495; cat. no. 53
Armorial Tapestry of the Count of Monterey (ca. 1675) (design by unidentified artist) (woven in workshop of Jacob van der Borcht, Brussels), *457*, *458*, 495; fig. 211
Armorials of the Duke of Marlborough. See Allegorical Armorials of the Duke of Marlborough
Arms of William and Mary (ca. 1695, 16-piece set) (design by Daniel Marot or Johannes Christoph Lotijn) (woven by Hieronymus Le Clerc, Brussels) (in New York), *494*, 495; fig. 220
Armstrong, John, 475
Arpino, Cavaliere d', 92
Art of War I (ca. 1695) (designs by Lambert de Hondt) (woven in Brussels), 448, 451, 475, 480–82, 495, 506
Art of War II (ca. 1722–24) (designs and cartoons by Philippe de Hondt and workshop) (woven in workshop of Judocus de Vos, Brussels)
 elector's antechamber at Neues Schloss Schleissheim, hung with pieces from a set, *505*, 506; fig. 232
 Naval Battle, A
 painting, model for tapestry, *482*, 483, 506; fig. 216
 tapestry (in Munich), *440*, 452, 477–83, *478–79*, *481*; cat. no. 57, fig. 198
Art of War III (1735) (designs and cartoons by Philippe de Hondt) (woven by Urbanus Leyniers, Brussels), 482, 506
Art of War IV (mid-18th century) (designs by Hyacinthe de La Pegna) (woven by Urbanus Leyniers, Brussels), 482
Artagnan, comte d', 344
Artemisia. See entries at *Story of Artemisia*
Arthois, Jacques d', 212
artistic status of tapestries, 4–5, 325–39, 497–99
 change in perception of painting medium, 325–26
 Charles I's tapestries and paintings sold after his execution, 333–37
 development of connoisseurship and collecting, 325–27
 display of tapestries and paintings, 326–28
 divergence in evaluation of paintings and tapestries, 329–30
 duplication of oil paintings in tapestry, 272, 331
 growing demand for low- and medium-quality tapestries and diminution of, 495–97
 inherited/antique collections, *106*, 107–12, *108*, *109*, *111*, 491–92, 497–99, 504
 Le Brun's work, contemporary appreciation of, 370–71

Louis XIV's salons of 1699 and 1704, tapestries displayed at, 497–99
 stylistic influence of oil painting on tapestries, 330–31
 tapestries as collectible objects, 331–33
Artsdael, Joost van, I (Joost van Herzeele), 21, 25, 45, 47
Artsdael, Joost van, II, 21
Asselt, Bernardino van, 265–68, 270–72, 290
Asselt, Jacopo van, 265, 266, 267, 268, 270, 288
Asselt, Pietro van, 265, 266, 267, 268, 290
Assembly of the Gods (drawing by Toussaint Dubreuil), 150
Astrée, Story of, 62
Atalanta. *See* entries at *Story of Meleager*
Attributes of the Marine (1689–92, 12-piece set) (designs by Jean Berain I) (woven in Paris workshop of Jean-Baptiste Hinart), 420, *424*
Aubusson, 131, 139n31, 371, 492, 504
Audley, Margaret, 80
Audley End House, 80
Audran, Claude, 361
Audran, Claude, III, 354, 390, 393, 400, 502, 504
Audran, Girard, 354, 363, 371
Augsburg, League of, French war with (War of the Grand Alliance, 1688–97), 341, 352, 369, 371, 417, 482
aune, 419n11. *See also* ell
Autumn (drawing by Francesco Salviati), 267
Auwercx family, 494
Auwercx, Albert, 444, 448–52, 488
Auwercx, Philippe, 452
Avila, Sancho d', 51
Ayala family, 445

B

Babin, M., 396
Bacchiacca (Bachiacca), 13, 288
Baccio del Bianco, 268, 269–70
Backer, Jan de, 243–44
Baden, Louis, margrave of, 495
Baërt, Jean, 410, 411
Bailly, Jacques, 359, 360, 362
Bajazet. *See Story of Tamerlan and Bajazet*
Bajazet II, sultan, 186
baldachins
 Sistine Chapel baldachin and altarpiece ensemble (designs by Pietro da Cortona) (woven in Barberini workshop under Giacomo della Riviera, Rome) (at Vatican), 298–99, 310, 312
 throne baldachin (ca. 1560, commissioned by Charles III, duke of Lorraine) (design by Michiel Coxcie and Hans Vredeman de Vries) (woven in Brussels), 33–34
 throne baldachin (1585–86, commissioned by Frederick II of Denmark) (design by Hans Knieper) (woven in workshop of Knieper, Helsingør) (in Stockholm), 28–35, *29–33*; cat. no. 1
Baldi, Lazzaro, 302
Baldinucci, Filippo, 269, 272, 285, 290, 295
Ball (etching and engraving by Abraham Bosse), *117*, 328; fig. 56
Ballin, Michel, 361, 381
Baltasar Carlos, infante, 110
Bandinelli, Baccio, 276
Banquet in the Thurn and Taxis Palace (etching by Romeyn de Hooghe), *493*, 494; fig. 219
Barbadori, Camilla, 302
Barberini family, 92, 113, 117, 118–19, 267, 294, 322, 333
Barberini, Antonio, 47, 118, 142, 146, 302
Barberini, Carlo, 268, 318
Barberini, Francesco, cardinal, 111, 112, 118, 128, 137, 146, 155, 158, 160, *293*, 302–3, 306, 308–9, 316, 322. *See also* Barberini manufactory, Rome
Barberini, Maffeo. *See* Urban VIII

Barberini manufactory, Rome, 293–303
 death of Francesco Barberini and closing of, 302–3
 founding of, 293–95
 Maincy workshop compared, 341–42
 Medici manufactory products and, 270, 272
 tapestry projects of, 295–302. *See also* entries at *Giochi di putti*; *Life of Christ*; *Stories of Apollo*; *Story of Constantine*; vestments and altar furnishings
 weavers, workshops, and artists, 295
Barberini, Palazzo, Rome, tapestries in, *294*, 298, 300, 304, 307
Barcelona, Review of the Troops at. See Conquest of Tunis
Bargrave, Robert, 112
Barocci, Federico, 271, 272, 285
Barraband, Jean, I, 504
Barraband, Jean, II, 433
Bartholomeus Anglicus, 88
Bartolomeo, Fra, 269
Bas-Relief with Three Cupids (engraving by Marco Dente), *401*, 402; fig. 182
Baseler, Adam, 33
battle genre, 448, 452. *See also* at *Art of War*
Battle of Anghiari (cartoons and fresco by Leonardo da Vinci), 95, 96, 104
Battle of Arbela (painting by Charles Le Brun), *347*; fig. 163
Battle of the Granicus. See at *Story of Alexander*
Battle of the Milvian Bridge. See entries at *Story of Constantine*
Battle of Pavia (ca. 1527, for Charles V) (designs by Bernaert van Orley) (woven in Brussels), 6, 27, 56
 Surrender of King Francis I, modello, *6*, 7; fig. 8
Battle of Solebay. See Defeat of the Dutch at the Battle of Solebay
Battle of Zama. See at *Deeds of Scipio*
Battles of the Archduke Albert (1597–99, 7-piece set, for Albert of Austria) (designs by Otto van Veen, cartoons by Jan Snellinck the Elder) (woven in workshop of Maarten Reymbouts II, Brussels): *Surprise Attack on Calais* (in Madrid), 27, 54–56, 54–59, *58*, 73; cat. no. 6
Battles of Charles XI of Sweden (1699) (designs attrib. to Jean-Baptiste Martin following Johann Philipp Lemke, borders by Guy-Louis Vernansel and Jean Berain I) (woven at Beauvais under Philippe Behagle): *Battle of Landskrona* (in Stockholm), 416–17, *418*, 424, 425; fig. 192
Baudoin (Boudewyns), Adrian Frans, 350
Baudouin, Claude, 13
Bazzi, Giovanni Antonio (Sodoma), 369
Beauvais, Manufacture Royale de Tapisseries de (1664–1715), 354, 407–19, 492. *See also* entries at *Grotesques*; *Story of the Emperor of China*; *Triumphs of the Gods*
 advantages of location, 408
 under Behagle, Philippe, the Elder, 410–16
 under Behagle's son and widow, 417–18
 Dutch War (1672–78), effects of, 410
 as economic initiative, 407–9
 Flemish weavers, importation of, 408–9
 Hinart, Jean-Baptiste, and, 409, 410, 416–18
 under Hinart, Louis, 409–10
 lighter style introduced at, 504, 506
 under Oudry, 418, 506
 Paris, private workshops of Hinart and Behagle in, 416–17, 420–22, 425–26
Becerra, Gaspar, 230
bedcovers, 259. *See also* at *Story of Tobias*
Bedford, Duke of, 112
Bedroom Scene (painting by unidentified French artist), 495, *496*; fig. 222
Behagle, Jean-Joseph, 417
Behagle, Philippe, the Elder, 354, 384, 410–18, 420, 422, 425, 426, 427, 429–31, 433, 434, 438, 439
Behagle, Philippe, the Younger, 418, 427, 433, 506

Behagle, widow (Anne van Heuven), 417–18, 427, 433, 439
Beham, Hans Sebald, 35
Belgium. *See* Netherlandish tapestry industry
Belin de Fontenay, Jean-Baptiste, 390, 392, 393, 412, 414, 430, 434, 438, 439
Bella, Stefano della, 113, 116
Bellin, François, 134, 165
Belloni, Giuseppe, 300, 302
Bellori, Giovanni Pietro, 102, 180, 353
Belon, Pierre, 87
Benavides, Don Luis de, 205
Bening, Simon, 172
Bentivoglio, Guido, 71–72, 90, 127–28
Benvenuti, Matteo, 272
Bérain, Jean, I, 354, 420–24, 427–29, 504
Beringhen, Jacques-Louis, marquis de, 363
Berlin, tapestry production in, 501, 504
Bernaerts, Gerard, 73
Bernini, Gian Lorenzo, 92, 308, 313, 315, 316, 351, 370
Bernini, Leonardo, 273, 274
Berrettini, Pietro. *See* Cortona, Pietro da
Bertin, Nicholas, 384, 385
Berwick and Alba, dukes of, 72
Beuckelaer, Joachim, 234, 236
Beveren, Baudouin van, 204, 212
Bibbiena, cardinal, 401, 427
Bielke, Niels, 252
Biest, Hans van der, 63–64, 81–86, 216
Bieurde, Henrik van, 85
Bilivert, Giovanni, 270
Birds from the Royal Menagerie (1684–1705) (woven at Beauvais under Philippe Behagle): *Ostrich* (in Lausanne), 411–12, *413*, 492; fig. 187
Biset, Charles Emmanuel, 457
Bloin, Jérome, 378
Bloomaert, Adrian, 369, 411
Blyenberch, Abraham van, 172
Boating Party (drawing by Jacob Jordaens), 237
Bochius, Joannes, 56, 57
Bock, Hendrick de, 190
Boel, Pieter, 350, 412, 430, 438
Boeseman, Marinus, 396
Bombeck, Seger, 17
Bonechi, Matteo, 274
Bonnart, Nicolas, 430
Bonnemer, François, 365, 381, 390, 392, 415
Bono, Antonio, 72
Bor, Pieter, 50
Borcht family, 487, 488
Borcht, Jacob van der, I, 442, 445, 454, 457, 458
Borcht, Jacob van der, II, 483, 487
Borcht, Jan Frans van der, 371, 483, 487
Borcht "A Castro," Jasper (Gaspar) van der, 447, 448, 451, 452, 480, 482, 487, 495
Borcht, Peter van der, 487
Bordeaux, Antoine de, 335
Borghese, Scipione, cardinal, 71–72, 90, 92, 99, 118, 127, 147, 316, 329
Borghini, Raffaello, 265, 282
Borgia, Gaspare, 267
Borromini, Francesco, 308
Bosschen, Hans van den, 85, 86
Bosse, Abraham, 117, 324, 327–28
botanical designs on table carpet, 257–59; cat. no. 30
Botticelli, Sandro, 402
Bottineau, Yves, 379
Bouchain, Siege of. See Victories of the Duke of Marlborough
Boucher, François, 506
Boucherat, Louis, 414, 415, 431
Boudewyns (Baudouin), Adrian Frans, 350
Boullogne, Louis du, 504
Bourdon, Sébastien, 135
Bouret, Etienne-Michel, 393

Bourzeis, Amable de, 346, 359
Bouvet, Joachim, 438
Brahe, Tycho, 31
Brentel, Frédéric, 108
Breughel, Jan, the Elder, 89
Breughel, Jan, the Younger, 246, 248
Brienne, Henri-Auguste de Loménie, comte de, 168
Brienne, Louis-Henri de Loménie, comte de, 363
Bril, Paul, 92
Brinck, Jan, 452
Bronconi, Antonio, 273, 274
Bronzino, Agnolo, 13, 14, 263, 269, 280
Brook, Fulke Greville, first Baron, 47
Bruges as tapestry weaving center, 214
Bruggen, Conrad van der, 234, 238
Bruggen, Gaspard van der, 238
Brussels
 gardens of royal palace, 44
 stylistic change to lighter manner, late 17th–early 18th centuries, 504
 as tapestry marketing and distribution center, 213–14, 441
 as tapestry weaving center
 in 16th century, 3, 5, 12, 13–15, 24–27
 1600–20, 67–74
 1625–60, 212–14
 1660–75, 441–44
 1675–1700, 444–48
 late 17th and early 18th centuries, 448–52, 494–95
Brustom, van (Brussels weaver), 214
Bruzio, Giovanni Antonio, 318
Bry, Johann Theodor de, 258
Buchell, Arend van, 24, 38, 47
Bucher, Paul de, 21
Buckingham, George Villiers, Marquess (later Duke) of, 74–75, 172, 194, 325, 332, 333
Bullion, Claude de, 129
Buonarroti, Michelangelo, the Younger, 268
Butsel, Joost van, 212
Butteri, Giovanni Maria, 276, 280
Byzantine traditions, Counter-Reformation use of, 264, 276–77

C

Cadillac, Château de, tapestry workshop at, 118, 341
Cadogan, Margaretta Munter, 469–70
Cadogan, William, 469, 470, 475, 476
Caesar. See entries at *Story of Caesar; Story of Julius Caesar*
Calumny of Apelles (painting by Botticelli), 72
Camassei, Andrea, 293, 322
Camassei, Giacinto, 302, 319–23
Cammen, Filips van der, 45
Cammen, Henry van der, 216–17
Campbell, Sir Colin and Dame Juliana, 178
Campion, Adrien, 412
Camus de Pontcarré de Viarmes de la Guiborgère family, 396
Candid, Aemilia, 85
Candid, Peter (Pieter de Witte or Pietro Candido), 63–64, 81–85, 113, 248
Caravaggio, Michelangelo Merisi da, 237, 264, 286n11, 290, 309
Caravaggio, Polidoro da. *See* Polidoro da Caravaggio
Carcavy, Pierre de, 363
Cárdenas, Don Alonso de, 325, 332, 335
Cardi, Giovanni Battista, 286
Cardi, Ludovico (called il Cigoli), 264, 267, 282–86, 290
Cardinal Mazarin in His Palace (engraving by Robert Nanteuil and Pierre van Schuppen), 332, *333*; fig. 150
Cardonnel, Adam, 469
Carenna, Giacomo Antonio de, 204

Carew, George, 124
Carignan, Thomas de Savoie, prince de, 151
Carleton, Sir Dudley, 74, 95, 99, 329
Carlisle, James Hay, Earl of, 47
Carmes, Jacob de, *18*, 19
Carmoy, Charles, 148
Caron, Antoine, 25, 26, 124, 140, 142, 143, 146
Carracci, 309
Carracci, Annibale, 375
Carracci, Antonio, 92
Carrillo, Juan, 226
cartoons, generally, 3–4, 8, 26, 61–62, 86, 212–13
Cassanges, Jacques de, 346, 359, 375
Castellani, Lorenzo, 295, 319
Castillo, José del, 458
Castles (1627–30) (cartoons by Francesco Mingucci) (woven in Barberini workshop under direction of Giacomo della Riviera, Rome): *"Hic Domus" Portiere with the Barberini Arms and a View of Palestrina* (in Rome), 295–97, *296*; fig. 133
Castro, First War of, 300, 308, 312
cataloguing tapestries, 499
Catholic League, 82
Cattaneo, Franco, 73, 97, 99
Cavallerini, Giovanni Giacomo, 431
Cecco d'Ascoli, 88
Cecco Bravo, 269
Ceremony of the Contract of Marriage between Władysław IV, King of Poland, and Louise Marie Gonzaga, Princess of Mantua, at Fontainebleau (etching by Abraham Bosse), *324*, *327*; figs. 145, 147
Chambers of the Vatican (1683–89) (woven in Gobelins workshop of Jean Jans the Younger, Paris): *School of Athens* (at Fontainebleau), *350*, 353; fig. 166
Chambers, Sir William, 470
Champaigne, Philippe de, 115, 135, 345, 379
Chancellerie for Louis Boucherat (1685–86) (design by François Bonnemer and Jean Lemoyne) (woven at Beauvais under Philippe Behagle) (in Paris), 414, *415*; fig. 190
Chancellerie for Louis Phélypeaux, comte de Pontchartrain (design by Guy-Louis Vernansel) (woven in Gobelins workshops, Paris), 425
Chandos, Grey Brydges, fifth Baron, 69
Chantelou, Paul Fréart de, 351, 370, 378
Chapelain, Jean, 346, 348, 358, 359, 375
Chapman, George, 190, 192
Chariclea. *See Story of Theagenes and Chariclea*
Chariot of the Sun. See entries at *Seasons and Hours*
Charlemagne (1660s) (designs by Jacob Jordaens), 208
Charles the Bold, duke of Burgundy, 5
Charles I, king of England
 Acts of the Apostles woven for. *See* at *Acts of the Apostles*
 Churchill, Winston, and, 470
 as connoisseur and collector, 325, 327, 330, 331
 court life, tapestries in context of, 111, 112, 113, 118
 Mortlake and, 171–76, 178, 179–83, 196, 201, 330
 as Prince of Wales, 72, 74, 104, 110, 171, 172
 Rubens's *Achilles* tapestries and, 174
 tapestries sold after execution of, 107, 171, 184, 206, 244, 325, 330, 332, 333–37
Charles II, king of England, 80, 182, 376, 470, 492–93, 497
Charles IX, king of France, 62
Charles V, Holy Roman Emperor; also Charles I of Spain, 6, 11, 20, 27, 56, 107, 110, 203, 214, 221, 501
Charles VI, Holy Roman Emperor, 452, 480
Charles III, duke of Lorraine, 33–34, 108. *See also Funeral of Duke Charles III of Lorraine; Lying-in-State of Duke Charles III of Lorraine*
Charles IV, duke of Lorraine, 205
Charles II, king of Spain, 59, 104, 456, 466, 471
Charles III, king of Spain, 104, 458
Charles X, king of Sweden, 190, 194

Charles XI, king of Sweden, 416–17, 418, 424. *See also*
 Battles of Charles XI of Sweden
Charles XII, king of Sweden, 497, 498
Charles-Emmanuel, duc de Savoie, 146
Charles Joseph, archduke of Austria, 114
Charost, Louis de Béthune, comte de, 378
Charpentier, François, 346, 359
Chartres, duc de, 354
Chasserat, Marius, 409
Chaste Susannah (1579, 6-piece set for King Frederick II
 of Denmark) (woven in workshop of Hans Knieper,
 Helsingør), 32
Châteauneuf-sur-Cher, Charles de l'Aubespine, marquis
 de, 194, 195
Chevreuse, duc de, 332
Chiavistelli, Iacopo, 271, 272
Chifflet, Philippe, 221, 226, 229, 230
Chigi family, 299
Chigi, Flavio, cardinal, 295, 349, 374, 376, 378–79
Child Gardeners (*Enfants jardiniers*) (after 1685) (after
 painted decorations by Le Brun) (woven in Gobelins
 workshops, Paris), 355n21
Children's Games (ca. 1665–69) (designs by Florentin
 Damoiselet) (woven at Beauvais under Louis
 Hinart): *Spinning Top* (in Paris), 409–10, *410*; fig. 184
Children's Games (designs by Michel Corneille), 131, 133
China. *See Story of the Emperor of China*
Chinoiseries (1717–34) (woven in workshop of Judocus de
 Vos, Brussels): *Altar of the Three Buddhas* (in Seattle),
 449, 452; fig. 207
Choisy, Jean de, 167
Christian IV, king of Denmark, *21*, 33, 66, 75, 173
Christian V, king of Denmark, 493–94
Christina, queen of Sweden, 67, 109, 111, 114, 331, 497
Christine of Lorraine, 264, 265, 276, 277
Christine de Pisan, 196
Christoph, prince of Württemberg, 19
Christophe, Joseph, 384, 385
Christ's Charge to Peter. See entries at *Acts of the Apostles*
Church life. *See* ecclesiastical life; Vatican and papal court
Churchill, Winston (father of first Duke of
 Marlborough), 470
Cigoli (Ludovico Cardi), il, 264, 267, 282–86, 290
Cinganelli, Michelangelo, 93, 264–68, 270
civil war ("Dutch Revolt") in Netherlands, 20, 20–21,
 24, 48–53, 61
Cleef, Joos van, 181
Clein, Francis, 75
 Acts of the Apostles, 184–89
 Hero and Leander, 190–95
 Horses, 195–201, 242
 at Mortlake, 171–77, 179–82
Clement VII, pope, 111
Clement VIII, pope, *225*, 228, 264, 276, 277, 284, 312–13
Clement IX, pope, 109, 111
Clement XI, pope, 303, 506
Clermont, Andien de, 504
Clorinda. *See Story of Tancred and Clorinda*
Clovis. See entries at *Story of Clovis*
Cobham, Henry Brook, Lord, 47
Cobham, Lord, 47
Cobus, Jan, 454, 458
Coccapani, Sigismondo, 268
Cockx, Jeremias, 446–47
Cocquel, 78–79
Coecke van Aelst, Pieter, the Elder, 8–12, 71–74, 107,
 293, 332, 460
Coecke van Aelst, Pieter, the Younger, 87, 89, 92
Coeffier-Ruzé d'Effiat, Antoine, 130, 146, 151, 160
Coenot, Jan, 454, 458
Colasse, Pascal, 424
Colbert, Jean-Baptiste. *See also* Gobelins, Manufacture
 Royale des, Paris

Beauvais workshops and, 407–10, 492
collection and connoisseurship of tapestries, 333, 337,
 502
Gobelins workshops and, 341, 344–53, *345*, 356, 358,
 359, 361, 375, 379, 383, 392, 491, 501
Paris workshops before Gobelins and, 137, 138
son of, 420
Spanish Netherlands tapestries and, 206
Colbert de Villacerf, Édouard, 353, 363, 371, 372, 416
Coles, Elizabeth, 310–12
collectors of tapestries. *See* artistic status of tapestries
Coloma, Don Carlos, 194, 195
Colonna family, 295
Comans family, 410
Comans, Alexandre de, 128, 166, 168
Comans, Charles de, 128, 137, 150–51, 160
Comans, Hippolyte de, 128
Comans, Marc de, 61, 73, 75, 84, 124, 128, 137, 162, 168,
 293, 304
connoisseurship. *See* artistic status of tapestries
Conquest of Tunis (1548–54, tapestry set for Charles V)
 (cartoons by Jan Cornelisz Vermeyen and Pieter
 Coecke van Aelst) (woven in workshop of Willem
 de Pannemaker, Brussels), 20, 27, 56, 107, 110, 112
 related sets, 443–44, 452, 480
 Review of the Troops at Barcelona (in Madrid), *2*, 12, 20;
 figs. 2, 15
 used at Descalzas Reales, 226, 230
Conquest of Tunis (1550s, for Mary of Hungary) (from
 cartoons by Jan Cornelisz Vermeyen and Pieter
 Coecke van Aelst for Charles V set) (woven in
 Brussels), 107, 110
Conquests of King Louis XIV (1703) (designs attrib. to
 Jean-Baptiste Martin) (woven at Beauvais under
 Philippe Behagle), 416, 426
 Surrender of the Garrison at Dole (at Versailles), 416, *417*;
 fig. 191
Constantijn Huygens and His Clerk (painting by Thomas
 de Keyser), *118*; fig. 58
Constantine, Roman emperor. *See* entries at *Story of
 Constantine*
Contarini family, 25, 47
Continence of Scipio (painting by Karel van Mander the
 Elder), 40
Continents (ca. 1735) (designs by Philippe de Hondt)
 (woven in van der Borcht workshop, Brussels) (in
 Vienna), 452, 458, 482
Conversion of Saul. See entries at *Acts of the Apostles*; *Story
 of Saint Paul*
cope (1595, for Clement VIII) (design and cartoon by
 Alessandro Allori and collaborators [Giovanni Maria
 Butteri, attrib.]) (woven in Medici workshops under
 Guasparri Papini, Florence) (at Vatican), **276–81**,
 278–79, 284; cat. no. 32
Copenhagen, Christian V's workshop at, 493–94
Coppenolle, François van, 465
Coppens, Augustin, 448, 450, 452, 483, 487–88, 504, 506
Coppens, Frans, 487
Coques, Gonzales, 120, 457
Cordys, Jan, 212
Coriolanus. See entries at *Story of Coriolanus*
Corneille, Michel, I, 129, 131–33, 136–37, 161
Corneille, Michel, II, 504
Cornelisz, Lucas, 242, 244
Coronation of Charles XII (drawing attrib. to Jacques
 Fouquet after Nicodemus Tessin), 497, *498*; fig. 224
Coronation of James II (engraving by Francis Sandford),
 497, *498*; fig. 223
Coronation of Louis XIV at Reims, June 7, 1654 (etching by
 Jean Le Pautre), *106*, 109; fig. 46
Corpus Christi processions, 116, 226, 230, 232, 284, 499
Correggio, 285
Corsa, di, archbishop, 295

Corsini, Lorenzo, 274
Corte, Anthonius de (Anthonius de Goech), 28–31
Cortona, Pietro da. *See also* at *Story of Constantine*
 Barberini manufactory and, 293, 295, 297, 298, 300,
 301–2, 319, 320, 322, 323
 court life, tapestries in context of, 113, 118, 119
 Le Brun and, 350, 369
 Maioli and, 315, 318
 Medici workshops and, 265, 268–69, 270, 286, 288, 309
 Paris workshops and, 314
 Romanelli and, 313–14
Coryat, Thomas, 116
Cossa, Francesco del, 403
Costaguti family, 314
Cotelle, Jean, 130, 134, 164, 168
Cotte, Robert de, 354
Cottem, Frans van, 212
Coudenberg Palace, 112, 113
Council of Trent, 18, 114, 162, 276–77
Counter-Reformation
 Constantine as subject of tapestries and, 162
 Council of Trent, 18, 114, 162, 276–77
 ecclesiastical ceremony, use of tapestries in, 114, 115
 Maximilian I of Bavaria and Catholic League, 82
 Medici manufactory and, 264–65, 276–77, 280,
 282–85
 Netherlandish tapestry industry disrupted by, 15, 18–20
 transubstantiation
 altar frontal of Clement VIII and, 276–77
 Triumph of the Eucharist tapestries and, 203
country life. *See also Scenes of Country Life*
 peasant scenes (*genre Teniers*), *447*, 447–48, 450, 451,
 452, 482, 488, 506
Country Scenes after Teniers (1682–1726) (designs by
 Augustin Coppens and Zeger-Jacob van Helmont),
 488
Country Scenes after Teniers (1717–24, two series) (designs
 by Augustin Coppens and Jan van Orley) (woven in
 Reydams–Leyniers workshops, Brussels), 488
Couplet, Philippe, 434, 437
court life, tapestries in context of, 107–21
 Barberini in Rome. *See* Barberini manufactory, Rome
 in Denmark, 493–94
 ecclesiastical splendor and ceremony, use in, *113*, 114–
 17, *115*, 499
 in England, 107, 109, 111, 112, 113, 114, 492–93, 497
 in France, 109, 111, 112, 114, 491–92, 504–6
 inherited/antique collections, *106*, 107–12, *108*, *109*, *111*,
 491–92, 497–99, 504
 Italian nobles and princes of the Church, 118–19, 499
 Louis XIV of France. *See* Gobelins, Manufacture
 Royale des, Paris
 low- and medium-quality tapestries, effect of growing
 demand for, 495–97
 Medici in Florence. *See* Medici manufactory, Florence
 movement of tapestries among palaces and houses,
 110, 111, 118, 120
 new commissions as manifestation of princely
 magnificence, 112–14, 495
 nobles and princes of the Church as tapestry patrons,
 116–18, 117–20, 495–99, 504
 public display of tapestries, 263, *264*, 499, 504
 in Sweden, 114, 497
 Vatican and papal court, 111, 113, 116, 264, 499
Cousin, Jean, the Elder, 148
Coxcie, Michiel
 continuing popularity of works, 107, 332
 Le Brun and, 369
 Mortlake tapestry works and, 181
 in Netherlandish tapestry industry, 10–12, 19, 22, 24,
 34, 63, 69–73, 81, 93
 Paris workshops and, 132
 table carpet based on designs of, 257–58; cat. no. 30

Coypel, Antoine, 354, 423
Coypel, Noël, *351*, 353, 397–402
Cracht, Pieter de, 259
Crane, Richard, 171, 177–78, 179, 188–89, 196, 201
Crane, Sir Francis, 75, 112, 171, 172, *175*, 176–79, 182, 187–89, 194, 195, 200, 201
Crayer, Gaspar de, 214
Creation and Fall of Man. See Redemption of Man; Story of the Creation; Story of the First Parents
Creation of the Horse. See at Horsemanship
Créqui, duc and duchesse de, 378
Crispin and Crispinian, saints, 135
Cristofani, Fabio, 300, 302, 323
Cromwell, Oliver, 206, 335
Cronström, Daniel, 416, 417, 428, 431–33
Crotesco (Grotesque Senses) (ca. 1625–35) (designs by Francis Clein) (woven at Mortlake) (at Haddon Hall), 173–74, *175*, 194
 Sense of Smell, 173, *175*; fig. 87
Croullé, Sieur de, 325
Crow, Sir Sackville, 193, 200
Croy-Teppich (1554) (woven in workshop of Peter Heyman, Stettin) (in Greifswald, Germany), 17; fig. 19
Cungi, Camillo, 294
cushion covers, 258
Cyrus. See entries at Story of Cyrus

D

Dahlberghe, Erik, 109
Damoiselet, Florentin, 410, 413
Damour, Pierre, 115, 137
Dandini, Vincenzo, 270, 271
Daniel (1579, 2 pieces for Frederick II of Denmark) (woven in workshop of Hans Knieper, Helsingør), 32
Danish Wars Against the Swedes (1616–20, for Christian IV of Denmark) (designed and woven in workshop of Karel van Mander the Younger, Delft), 66
Daphne. See Stories of Apollo; Story of Daphne
Darcy, Lord, 69
David. See entries at Story of David
David, Gerard, 35
Dead Christ Supported by an Angel (painting by Baccio Bandinelli), 276
Death of Ananias. See entries at Acts of the Apostles
Death of Sapphira. See entries at Acts of the Apostles
Decius Mus. *See entries at Story of Decius Mus*
Deeds and Triumphs of Scipio (ca. 1530–35, 22-piece set for Francis I of France) (designs by Giovanni Francesco Penni and Giulio Romano) (woven in Brussels), 8–11, 76, 111, 143, 205, 229, 497
Deeds and Triumphs of Scipio (mid-16th century, for Jacques d'Albon de Saint-André) (based on designs by Giovanni Francesco Penni and Giulio Romano) (woven in Brussels): *Continence of Scipio* (in San Simeon, Calif.), 206–7, 213, 331, *333*; fig. 151
Deeds and Triumphs of Scipio (1619, 13-piece set for Gustav II Adolph of Sweden) (designs by Karel van Mander II) (woven in Spiering workshop, Delft), 78, 79–80, 254
Deeds and Triumphs of Scipio (1660–64) (cartoons based on designs by Giovanni Francesco Penni and Giulio Romano) (woven in workshop of Gerard van der Strecken, Brussels), 213
 Continence of Scipio (in Lausanne), *205*; fig. 100
Deeds of Hercules (1603, for Maximilian I of Bavaria) (woven in Antwerp), 82
Deeds of Scipio (ca. 1544) (designs by Giulio Romano) (probably woven in workshop of Balthazar van Vlierden, Brussels): *Battle of Zama* (in Madrid), *10*, 11; fig. 12

Deeds of Scipio (1609, set of eight tapestries for Thomas Howard, Earl of Suffolk) (designs attrib. to Karel van Mander the Younger) (woven in workshop of François Spiering, Delft), 47, 64, 66, **76–81**, *77–79*
 Clemency of Scipio (in Brussels), *79*
 Scipio and the Envoys from Carthage (in Amsterdam), **76–81**, *77–79*; cat. no. 7
Defeat of the Dutch at the Battle of Solebay, 1672 (ca. 1677–78) (woven in England) (at Hampton Court; in Philadelphia), 493
Defeat of the Spanish Armada (1592–95, for Lord Charles Howard of Effingham) (designs by Hendrick Cornelisz Vroom) (woven in Spiering workshop, Delft), 23–24, *24*, 27, 41, 47, 52, 111
Delfin, Pietro, 404
Delft, tapestry production in, 21–24, 26–27, 36–42, 64–67, 114, 253–57, 259–60
Delibet, Marx, 86
Demignot, Vittorio, 273
Denmark
 Christian V and workshop in Copenhagen, 493–94
 Clein, Francis, in, 173
 Flemish weavers emigrating to, 21, 21–22
 Helsingør workshop, 28–33
 Mander, Karel van, the Younger and Christian IV, 66
Dente, Marco, 402
Deposition from the Cross (painting by Peter Paul Rubens), 237
Dermoyen workshop, 8
Descalzas Reales, 221–26, 230. *See also entries at Triumph of the Eucharist*
Desgodetz, Antoine, 354
Desmarets de Saint-Sorlin, Jean, 131
Desportes, Alexandre François, 390, 393, 394, 396, 504
Devolution, War of (1667–68), 369, 376, 379, 380, 384
Devonshire, William Cavendish, second Earl of, 237
Diana and Acteon (fountain by Luigi Vanvitelli), 46
Diana and Calisto (before 1636) (designs after Titian) (woven at Mortlake), 195
Diana, tapestries depicting. *See entries at Mythological Scenes; Story of Diana; Triumphs of the Gods III*
Diderot, Denis, 135
Dido and Aeneas. See entries at Story of Dido and Aeneas
Diepenbeeck, Abraham van, 213, 214, 242, 244
Dieu, Antoine, 384, 385
Digby, Sir Kenelm, 180
Diodorus Siculus, 241
Divine Providence (fresco by Pietra da Cortona), 268, 298, 312, 313, 316, 322
Domenichino, 92, 295, 313
Domus Aurea, 398, 402, 427
Don Juan Domingo de Zúñiga y Fonseca, Count of Monterey (etching by Gerard Lairesse), *456*, *457*; fig. 210
Don Quixote. See entries at Story of Don Quixote
Doort, Abraham van der, 180, 181, 188, 189
Doria, Andrea, 11, 182, 336
Dorigny, Michel, 165, 273
Dosso Dossi, 13
Drayton House, Northamptonshire, 195
Dresden, tapestry production in, 501
dressage, 242
Dries, Andries van den, 213
Dromedaries (painting by Pieter Boel), 429–30, *430*; fig. 196
Dubois, Jean, 361
Dubout, Maurice, the Elder, 61, 92, 123, 124, 129, 134–35, 142, 150, 313
Dubout, Maurice, the Younger, 137
Dubreuil, Toussaint, 62, 92, 125, 138, 147, 148–50, 153
Dulin, Pierre, 384, 385, 503
Dumée, Guillaume, 126, 128, 135, 138, 142, 144
Dumesnil, Louis-Michel, 385
Dumont, Jean, 475
Dunkirk. *See under History of the King*

Duodo, Pietro, 114
Duras, comte de, 379
Duras, Jacques-Henri de Durfort, duc de, 431
Dürer, Albrecht, 6, 312, 335, 396
Dutch Revolt, 20, 20–21, 24, 48–53. *See also under Netherlandish tapestry industry*
Dutch Sea Battles. See Zeeland Tapestries
Dutch War (1672–78), 348, 369, 383, 384, 410, 416
Dyck, Anthony van, 74, 102–4, 175, 180, 190, 330, 331, 493
dyeing industry, 4, 128, 212, 214, 452
dynastic sets. *See entries at Genealogy; History of the House*

E

ecclesiastical life. *See also* Vatican and papal court; vestments and altar furnishings
 church ceremony, use of tapestries in, *113*, 114–17, *115*, *499*
 Corpus Christi processions, 116, 226, 230, 232, 284, 499
 Louvre tapestry workshops specializing in religious commissions (1625–60), 134–37
 princes of the Church as tapestry patrons, 117–20, 499
 public display of tapestries on feast days, 263, *264*, *499*, 504
 Sistine Chapel, tapestries in, 264, 276–80, 282, 284, *298*, 298–99, 310
 Triumph of the Eucharist tapestries at Descalzas Reales convent, 226, 230
 ecclesiastical use of copies of, 231–32
Eckhout, Albert, 352, 390–91, 396
Edelinck, Gérard, 371, 372
Edict of Nantes, revocation of (1685), 499–501
Edmonds, Sir Thomas, 68–69
Edward VI, king of England, 497
Eggermans, Daniël, 118, 207, 213
Egmont, Justus van, 165, 209, 213, 216, 441, 444, 460–62, 464, 465, 495
Egmont, Lamoral, count of, 18–19
Eichen, Berent van der, 494
Elements (1728–40) (designs by Giovanni Camillo Sagrestani, Lorenzo del Moro, Gian Domenico Ferretti, Giuseppi Grisoni, and Vincenzo Meucci) (woven in Medici workshops, Florence), 274
Elements (ca. 1735) (designs by Philippe de Hondt) (woven in Van der Borcht workshop, Brussels), 452, 482
Elements. See also Four Elements
Elephant, Order of the, 34
Elisabeth Renata of Lorraine, 81
Elizabeth I, queen of England, 19, 23, 61, 112, 171
Elizabeth Stuart, daughter of James I, 47, 66, 79, 80, 111, 254
Elizabeth of Valois, 38, 221
Elizabeth of York, 337
ell, 28, 53, 90, 99, 133, 135, 137–38, 166, 188, 194, 195, 196, 201, 212, 230, 265, 339n49, 382, 394, 409, 419n11, 433, 439n30
Elst, Claes van der, 17
Emperor of China. See Story of the Emperor of China
Enfants jardiniers (Child Gardeners) (after 1685) (after painted decorations by Le Brun) (woven in Gobelins workshops, Paris), 355n21
Enghien as tapestry weaving center, 216–17
Enghien, Henri Jules de Bourbon, duc d', 376
England. *See also* Mortlake tapestry works, England
 Brussels tapestries of early 17th century popular in, 68–69
 court life, tapestries in context of, 107, 109, 111, 112, 113, 114, 492–93, 497
 Flemish weavers emigrating to, 19–20, 21
 low- and medium-quality tapestries, growing demand for, 495–97
 revocation of Edict of Nantes (1685), diaspora of weavers resulting from, 500
 Spiering's success in, 47

stylistic change to lighter manner, late 17th–early 18th centuries, 504

entrepreneurial backing for tapestry production, 4, 66, 213

Épernon, Jean-Louis de Nogaret, duc d', 118, 341

equestrian portraits, tapestries depicting, 114, 118, 242. *See also* entries at horse

Erik IV, king of Sweden, 21

Erlanger, Baron d', 72

Eskilson, Nils, 21

Este family, 294, 295

Este, Ercole II d', 13

Estrades, Godefroy Louis, comte d', 376

Estrées, François-Annibal d', 146

Eugene, prince of Savoy, 475

Eusebius of Caesarea, 155, 306

Evelyn, John, 116

Eyck, Jan Baptista van, 102

Eynde, Catherine van den, 59, 68, 72, 73, 87, 88, 90, 92, 105, 230, 237–38

ℱ

Facade of the Palazzo Barberini alle Quattro Fontane (frontispiece of *Aedes Barberinae*, engraving by Camillo Cungi after Guido Ubaldo Abbatini), *294*; fig. 132

Fagon, Guy-Crescent, 363

Famous Women from Antiquity (ca. 1660) (designs by Jacob Jordaens), 209, 441

Farnese family, 119, 205

Farnese, Alessandro, 21, 24, 57, 119

Farnese, Elisabetta, 504

Farnese, Ranuccio II, 119

Faubourg Saint-Germain weaving workshops, Paris, 128, 132, 137

Faubourg Saint-Marcel weaving workshops, Paris, 124, 128, 137–38, 341

Félibien, André, 89, 129, 163, 165, 341, 347, 349, 353, 358, 359, 362, 363, 375

Ferdinand, cardinal infante and governor of the Netherlands, 229

Ferdinand II, Holy Roman Emperor, 220, 221

Ferrara as tapestry weaving center, 13, 294

Ferrara, dukes of. *See* entries at Este

Ferretti, Gian Domenico, 274

Ferri, Ciro, 268, 299, 302, 309, 319, 323

Ferro, Giovanni, 316

Févère, Pietro (Pierre Lefebvre), 134, 267, 268, 270, 271–72, 287–90

Ffoulke, Charles Mather, 140, 304, 310, 315

Filippo, Camillo, 242, 244

filoselle, 269, 287, 290

Finet, Sir John, 194

Fiorentino, Rosso, 12

First War of Castro, 300, 308, 312

Fishing (Summer) (1612, 4-piece set for Alessandro Montalto) (cartoons by Alessandro Allori, border designs by Michelangelo Cinganelli) (woven in Medici workshops, Florence), 93, 265

Flemish tapestry industry. *See* Netherlandish tapestry industry

floral designs on table carpet, 257–59; cat. no. 30

Florence as tapestry weaving center, 13, 63, 84, 93, 115. *See also* Medici manufactory, Florence

Floris, Frans, 35

Floris, Hans, 28, 35

Fobert, Jacob, 219, 229, 230

Fonseca, Don Manuel, 446

Fontainebleau as tapestry weaving center, 12, 123

Forchondt, Marcus, 102, 213, 215

Formigny, tapestry depicting French defeat of English at battle of, 112

Fouquet, François, archbishop of Narbonne, 337

Fouquet, Jacques, 498

Fouquet, Nicolas, 146, 337, 341–44, 442, 454

Fouquières, Jacques, 134

Four Ages of Man (1545–48) (designs by Francesco Salviati and Giovanni Stradano), 267, 288

Four Ages of Man (fresco by Pietro da Cortona), 266, 267, 268, 272

Four Continents (1720–23) (cartoons by Giovanni Camillo Sagrestani) (woven in workshop of Leonardo Bernini and Vittorio Demignot, Florence): *Europe* (in Florence), *273*, 273–74; fig. 126

Four Elements (1666, 4-piece set, plus 4 *entrefenetres*) (designs by Charles Le Brun after scheme devised by Petite Académie) (woven in Gobelins workshop of Jean Jans the Elder, Paris), 345, 346–48, *356–57*, **356–64**, *359–62*

 accompanying publications, 359, 360, 361, 362–63, 372

 Air, 356, 360, 361

 Earth, 356, 360, 361

 entrefenetres, 360–61

 Fire

 engraving (by Charles Perrault after gouache by Jacques Bailly), *361*; fig. 171

 tapestry, 356, 360, 361

 miniatures, 359, *360*, 362–63

 related sets, 358, 363, 416, 500

 Water (cartoon for main scene by Baudrin Yvart, cartoon for borders by Isaac Moillon) (in Florence), 345, 346–48, *356–57*, **356–64**, *359*, *362*, 491; cat. no. 39

Four Seasons (design scheme by Charles Perrault), 345, 346–47, 348

Fourcy, Henri de, 129–30, 160

Fourcy, Jean de, 124

Fourment, Daniël, 213

Fourment, Peter, 213

Fraisslich, Kaspar, 85

France

 court life, tapestries in context of, 109, 111, 112, 114, 491–92

 Dutch War (1672–78), 348, 369, 383, 384, 410, 416

 Flemish tapestry, taste for, 441

 League of Augsburg, war with (War of the Grand Alliance; 1688–97), 341, 352, 369, 371, 417, 482

 revocation of Edict of Nantes (1685), diaspora of weavers resulting from, 499–501

 Spanish siege of Calais, 57

 Spanish Succession, War of (1701–14), 418, 425, 466, 471, 480, 482

 stylistic change to lighter manner, late 17th–early 18th centuries, 501–4

 tapestry weaving centers. *See also* Beauvais, Manufacture Royale de Tapisseries de; Gobelins, Manufacture Royale des, Paris; Paris tapestry workshops

 in 16th century, 12–13, *13*

 in early 17th century, 61–62, 74

 Maincy workshop (1658–61), 341–44, 353, 442

 in late 17th and early 18th centuries, 495, 501

 War of Devolution (1667–68), 369, 376, 379, 380, 384

 Wars of Religion in, 61

France, Story of. See Story of France

Franchi family, 172

Franchi, Giovanni Andrea De, 174, 337

Franciabiagio, 272

Francis I, king of France, 7, 11, 12, *13*, 76, 109, 111, 143, 205, 337, 344, 497

Francis II, king of France, 62

Francis Stephen III, duke of Lorraine, grand duke of Tuscany (later Francis I, Holy Roman Emperor), 274, 371

Franco, Baptist, 252

Frederic Hendrick, Prince of Orange, 114

Frederick, elector of Brandenburg and king of Prussia, 501

Frederick II, king of Denmark, *21*, *22*, 28, 31–35

Frederick III, king of Denmark, 390

Frederick III, elector Palatine, 19

Frederick IV, elector Palatine, 42

Frederick V, elector Palatine, 66, 79, 111, 254

Frederick Augustus I, elector of Saxony and king of Poland, 501

Frederick William (Friedrich Wilhelm), elector of Brandenburg, 111, 114, 352, 390–91

Fronde, 331, 333

Fructus belli (Fruits of War), 206, 443, 480. *See also* entries at *Art of War*

Fuensaldaña, count of, 325

Fugger, Hans, 82

Füll, Franz, 86

Fuller, Thomas, 172, 173

Funeral of Duke Charles III of Lorraine, 1608 (engraving by Frédéric Brentel after Claude de la Ruette), *108*, 109, 111, 328; fig. 48

𝒢

Gabburri, Francesco Maria Niccolò, 274

Gagliardi, Filippo, 115, 117, 146

Galilei, Galileo, 265, 268, 308

Galle, Filips (Philip), 219, 282

Galleries and Flowers (ca. 1600–1610) (woven in Brussels): *Gallery with Figures* (in Boston), 66, 68; fig. 36

Galleries and Flowers (1605) (woven in workshop of Gerard Bernaerts), 68

Galleries and Flowers (1609) (woven in workshop of Gerard Bernaerts), 68

Galleries of Pomona (ca. 1609–15, 3-piece set for Albert of Austria) (woven in workshop of Maarten Reymbouts II, Brussels), 59

Galleries with Vertumnus and Pomona (1611) (woven in workshop of Maarten Reymbouts, Brussels), 73

Galleries with Vertumnus and Pomona (1614) (woven in workshop of Maarten Reymbouts, Brussels), 73

Gallery of François I (ca. 1539) (designs by Claude Baudouin and others after Rosso Fiorentino and Francesco Primaticcio) (woven at Fontainebleau): *Unity of the State* (in Vienna), 12, *13*; fig. 16

Garden Scenes with Mythological Fountains (1604, 5-piece set) (designs attrib. to Karel van Mander the Elder) (women in Spiering's Delft workshop): *Garden with Diana Fountain* (at Warwick Castle), 24, 26, **43–48**, *44–46*; cat. no. 4

Garter, Order of the, 111, 180, 470

Genealogy of the Danish Kings (1581–85, 40-piece set for Frederick II of Denmark) (designs by Hans Knieper) (woven in workshop of Knieper, Helsingør) (in Copenhagen), 22, 32, 33, 34

 King Frederick II with Prince Christian, 21, 22, 33; fig. 23

Genealogy of the Nassau Family (16th century), 451

Genealogy of the Stuarts and Their Spouses (1672) (after portraits by Paul van Somer and Anthony van Dyck) (woven in England) (at Houghton Hall, Norfolk), 493

Genealogy of the Swedish Kings (ca. 1553–65) (designs by workshop of Paul de Bucher and Nils Eskilson, Sweden) (woven in Sweden), 21

Genevieve, saint, 499

Genoels, Abraham, 350, 361

genre militaire, 448, 452. *See also* entries at *Art of War*

genre Teniers, 447, 447–48, 450, 451, 452, 482, 488, 506

Gentileschi, Orazio, 180, 290

George I, king of England, 497

George III, king of England), 47, 470

Germanic states

 tapestry production in later 16th century, 17–19, 21

 tapestry production in early 17th century, 62–64, 81–86

 tapestry production in late 17th and early 18th centuries, 501, 504, 506

Gerusalemme liberata (Tasso), 38

Gervasius, saint. *See Story of Saint Gervasius and Saint Protasius*
Gessner, Conrad, 87, 89
Gesualdi, Ascanio, 90
Geubels, Frans, 45, 47, 397, 400–402, 422
Geubels, Jacques, I, 68, 72, 87, 105, 230, 237
Geubels, Jacques, II, 95, 104–5, 224, 229, 230, 231, 237–38, 244, 267
Geubels, Jean, 244
Gherardi, Antonio, 302
Giambologna, 396
Gideon. See entries at *Story of Gideon*
Giles (Mechelen master), 71
Gimignani, Giacinto, 270–71
Giochi di putti (1637–39) (designs by Giovanni Francesco Romanelli) (woven in Barberini workshop under Giacomo della Riviera, Rome)
 Lion Stung by a Bee (in Rome), *299*, 314; fig. 136
 papal tapestries as source for, 314, 404
Giordano, Luca, 274, 309
Giovanni da Udine, 6, 397, 401–4, 422
Giovio, Paolo, bishop, 263
Giugni, Vincenzo, 285
Giulio Romano, 6, 8, 11, 13, 72, 76, 181, 205, 343, 382, 401, 404, 497, 502
Giustiniani, Vincenzo, 92, 93
Glorification of Christ (ca. 1500) (woven in Brussels) (in Washington), 335, *337*; fig. 154
Glorification of Louis XIV (ca. 1680) (designs attrib. to Adam Frans van der Meulen) (woven in Tournai under Philippe Behagle): *Louis XIV Crowned by Victory* (in Louisville, Ky.), 410–11, *411*; fig. 185
Gobelins, Manufacture Royale des, Paris. *See also* specific tapestries, esp. *Four Elements; History of the King; Old Indies; Story of Alexander; Triumphs of the Gods*
 Faubourg Saint-Marcel workshops preceding, 341
 Maincy workshop as catalyst for (1658–61), 341–44, 353
 under Colbert and Le Brun (1661–83), 344–51
 under Louvois (1683–95), 351–53, 501–3
 temporary shut down of (1694–99), 341, 352, 353–54, 416, 504
 under Hardouin-Mansart (1699–1715), 341, 352, 353–54
 connoisseurship and collecting, development of, 325
 Copenhagen workshops of Christian V inspired by, 493–94
 establishment and initial flourishing (1683–95), 344–51
 glorification of king as aim of, 345–49, 358–59, 375
 "Grand Manner" or "noble style" and, 346–47, 353, 502, 506
 Medici workshops and, 272
 Mortlake and, 337, 492–93
 Paris workshops 1590–1650 and, 123, 124, 128, 137, 138, 164
 religious subjects, introduction of, 354
 Saint Petersburg workshop patterned after, 506
 social and political significance of, 491
 stylistic change to lighter manner, late 17th–early 18th centuries, 501–4
 Vatican workshop at San Michele a Ripa patterned after, 506
Goddere, Peter de, 73
Godin, Christophe, 59
Goech, Anthonius de (Anthonius de Corte), 28–31
Golden Fleece, Order of the, 110, 220, 425
Goltzius, Hendrick, 23, 52
Gombaut and Macée. See entries at *Story of Gombaut and Macée*
Gómez de Mora, Juan, 230
Gonzaga family, 175, 181, 327
Gonzaga, Ercole, cardinal, 104, 181, 404
Gonzaga, Federigo, 13
Gonzaga, Ferrante, 11, 74
Gonzaga, Louise Marie, 324, 327
Goossenson studio, Gouda, 259

Goten, Jacob van der, 446, 447, 506
Gouda, tapestry weaving in, 259–60
goût moderne or *goût du temps* (Rococo), 452
Goyton, Jean, 363
Gracián, Baltasar, 220
Gramont, third duke of, 497
Grand Alliance, War of (French war with League of Augsburg, 1688–97), 341, 352, 369, 371, 417, 482
"Grand Manner" or "noble style," 346–47, 353, 502, 506
Grane, marquis de, 244
Granicus, Battle of the. See at *Story of Alexander*
Gregory XIII, pope, 284
Gregory XV, pope, 162
Grenier, Pasquier, 5, 334
Greuter, Johann Friedrich, 293
Greville, Francis, 47
Grimaldi, cardinal, 295
Grimani, Huybert Jacobsz, 66
Grimani, Marino, 265
Grisone, Federico, 242
Grisoni, Giuseppe, 274
Grotesque Senses. See Crotesco
Grotesques of Leo X (1519–21, 8-piece set) (cartoons by Giovanni da Udine probably with Giovanni Francesco Penni and Perino del Vaga) (woven by Pieter van Aelst, Brussels) (known only from later weavings), 353, 397, 400–404, 502
Grotesques (16th century, estate of Cardinal Richelieu), 332
Grotesques (1603) (designs by Denys van Alsloot) (woven in workshop of Jakob Tseraerts), 68
Grotesques (early 17th century, 12-piece set) (designs by Peter Candid) (woven in Munich), 84
Grotesques (ca. 1690–1711, 6-piece set) (designs by Jean-Baptiste Monnoyer in style of Jean Berain I; border designs by Monnoyer and Guy-Louis Vernansal) (woven at Beauvais under Philippe Behagle or his successors, widow Anne van Heuven or son Philippe Behagle), 407, 412–13, 416, 418, 424, 426, **427–33**, *429–32*, 504
 Camel (in New York), 407, 412–13, 416, 418, **427–33**, *429, 431, 432*; cat. no. 51, fig. 183
 Dromedaries (painting by Pieter Boel), 429–30, *430*; fig. 196
 Offering to Pan, 428, 429
 related sets, 430, 430–33
Grotesques (ca. 1700–1715) (designs by Jean-Baptiste Monnoyer in the style of Jean Berain I) (woven at Beauvais under Philippe Behagle): *Camel* (in London), *430*; fig. 197
Grotesques with Ovid's Metamorphoses (ca. 1730) (designs by Philippe de Hondt), 482
Grotto of Thetis, Versailles, 423
Grousseliers, Jean-François de, 213–14
Guarini, Giovanni Battista, 125
Gucht, Bartholomeus van der, 259
Gucht, Maximilaen van der, 114, 254, 259, 391, 392
Guénégaud du Plessis-Belleville, Henri de, 128
Guicciardini, Ludovico, 3
Guidi di Bagno, Gian Francesco, 224
guilds for tapestry industry, 3, 13, 42, 73, 81, 86, 462
Guise family, 206, 336
Guise, Charles de, cardinal of Lorraine, 88
Gunpowder Plot, 80
Gustav II Adolph, king of Sweden, 67, 78, 253, 254
Guyot, Laurent, 62, 97, 126, 127, 128, 138, 142, 144, 146, 150, 155, 158, 161, 308

H

Haarlem, Cornelisz van, 23
Habbeke, Gillis van, 212, 252
Haddon Hall, Derbyshire, 173–74
Hadrian, Roman emperor, 307

Hali Pasha, Turkish admiral, 66, 80
Hallé, Claude-Guy, 384, 385
Ham House, Surrey, 118, 120, 182
Hannibal. See entries at *Story of Hannibal; Story of Scipio and Hannibal*
Harcourt, Henri de Lorraine, comte d', 378, 379
Hardouin-Mansart, Jules, 353–55, 497
Hardwick Hall, 118, 120, 237, 238
Haro, Don Luis Méndez de, 206, 325, 332, 335
Harrach, Count Ferdinand Bonaventura I von, 441, 442, 443, 452
hatchings or hachures, 4
Head of a Woman (drawing by Karel van Mander the Elder), 40
Healing of the Lame Man. See entries at *Acts of the Apostles*
Hecke family, 441, 488
Hecke, François van den, 105, 203, 212, 213, 231, 441
Hecke, Jan-François van den, 213, 231, 371, 441
Hecke, Peter van den, the Younger, 213
Hecke, Pieter van den, 371, 452
Hedwig Eleonora, Swedish Queen Mother, 252
Heemskerck, Maarten van, 253, 254
Heimbach, Wolfgang, 116, 117
Helmont, Zeger-Jacob van, 452, 488
Henrietta Anne of England, duchesse d'Orléans, 146
Henry VII, king of England, 5, 334, 337
Henry VIII, king of England, 11, 12, 74, 107, 111, 112, 171, 172, 176, 331, 334, 335, 337, 404, 497
Henry, Prince of Wales (son of James I), 330
Henry II, king of France, 62, 71, 72, 123, 132, 147, 148
Henry III, king of France, 118, 341
Henry IV, king of France, 42, 57, 61–62, 75, 123–26, 138, 140–46, 147–50, 152, 162, 171, 263, 331, 332, 407
Henry II, duc de Lorraine, 74
Hero and Leander (ca. 1630–36, 6-piece set for Charles I) (designs by Francis Clein) (woven at Mortlake), 75, *170*, 173, **190–95**, *191–94*, 200
 dating, 194–95
 Death of the Lovers (in Stockholm), 190, *192*; fig. 95
 Meeting at the Temple of Venus (at Drottningholm Palace), 75, *170*, 173, **190–95**, *191, 193, 194*, 200; cat. no. 17, fig. 83
 related sets, 190–92, 194–95
Heroines from the Bible (after 1650) (designs by Justus van Egmont) (woven in Bruges), 209
Herp, Willem van, 494
Herzeele, Joost van (Joost van Artsdael I), 21, 25, 45, 47
Hesiod, 402
Hessen-Cassel, Wilhelm von, Landgraf, 20
Heuven, Anne van, 417–18, 427, 433, 439
Heyman, Peter, 17
Hickes, Richard, 19
high-warp vs. low-warp looms, 4, 124, 135–36, 138n11, 268, 274, 361
Hinart (Hinard), Christophe, 409
Hinart (Hinard), Jean-Baptiste, 409, 410, 416–18, 420–22, 424, 425, 426
Hinart (Hinard), Louis, the Elder, 342, 408–12
Hinart (Hinard), Louis, the Younger, 409
History of Augustus the Strong (after 1713) (designs by Pierre Mercier) (woven in workshop of Pierre Mercier, Berlin) (at Schloss Moritzburg), 501
History of Henry III (1636, 22-piece set for Jean Louis de Nogaret, duc d'Épernon) (woven in workshop at Château de Cadillac) (in Paris; at Château de Cadillac), 118
History of the House of Moncada (mid-1660s) (after designs by David Teniers II, Willem van Herp, Jan van Kessel, and others) (woven in Auwercx workshop, Brussels) (in Paris), 494
History of the House of Torriani (ca. 1670s) (designs by Erasmus Quellinus) (woven in Brussels) (in Regensburg), *493*, 494

History of the King (1665–80, 14-piece set) (designs by Charles Le Brun) (woven in Gobelins workshops, Paris), 341, 345, 348–52, 363, **374–88**, *376–87, 389,* 480; cat. nos. 41–47
 Academy of Sciences (painting for proposed but never-woven tapestry by Henri Testelin), 383, *385;* fig. 177
 accompanying publications, 363
 Audience with Cardinal Chigi
 preliminary drawing (Charles Le Brun), **374–88**, *380;* cat. no. 45
 tapestry (cartoon by Antoine Mathieu the Elder; cartoon for border attrib. to Jean Lemoyne le Lorrain) (woven in workshop of Jean Lefebvre) (in Paris), **374–88**, *381, 389,* 491; cat. no. 44
 Audience of the Conde de Fuentès (tapestry woven by Jeans Jans the Elder and Younger) (at Versailles), 375, 380, *384,* 491; fig. 176
 Beginning of the 1672 Campaign (drawing by Charles Le Brun and Adam Frans van der Meulen), 383, *387;* fig. 179
 Behagle's tapestries complementing, 410–11, *416, 417,* 425, 434
 drawings, modelli, and cartoons, 379–82
 iconography, 376–79
 initially planned but never woven subjects, 383–85
 King Visits the Gobelins
 preliminary drawing (Charles Le Brun), 370, **374–88**, *383,* 491; cat. no. 47
 tapestry (weaving of 1673–80) (in Paris), 370, 491, *492;* fig. 218
 King's Entry into Dunkirk
 preliminary drawing (Charles Le Brun), **374–88**, *376;* cat. no. 42
 study for, *View of the City of Dunkirk* (Adam Frans van der Meulen), 350, **374–88**, *378–79;* cat. no. 43
 tapestry (cartoon by Antoine Mathieu the Elder, completed by Pierre de Sève) (woven in workshop of Jean Lefebvre) (in Paris), **374–88**, *377;* cat. no. 41
 later proposed subjects, 384–85
 Meeting between Louis XIV and Philip IV (in Paris), *348, 349,* 375, 381, 491; fig. 164
 Queen's Entry into Douai (painting for proposed but never-woven tapestry by Adam Frans van der Meulen), 383, *386,* 404n13; fig. 178
 related sets and influences, 383, 491, *494, 495,* 501
 Siege of Douai (preliminary drawing by Charles Le Brun, with his workshop, and Adam Frans van der Meulen), **374–88**, *382;* cat. no. 46
 weaving of, 382–83
Hoecke, Jan van den, 114, 203, 246–52, 288, 444–45, 457
Hogenberg, Frans, 20, 52–53
Holbein, Hans, the Younger, 35
Holland. *See* Netherlandish tapestry industry
Holy Family with Saint Elizabeth and Saint John (painting by Raphael), 335
Holy Spirit, Order of the, 398, 422, 425
Hondt, Lambert de, 448, 452, 471, 474, 475, 480, 482, 495, 506
Hondt, Philippe de, 452, 475, 477, 482–83, 505, 506
Honors (ca. 1520s, for Charles V) (designs by Bernaert van Orley) (woven in Brussels), 107
Honthorst, Gerrit van, 75, 114
Hooghe, Romeyn de, 493
Hôpital de la Trinité, Paris, weaving workshop at, 123, 150
horse caparisons (1621, for Gustav II Adolph of Sweden) (woven in Spiering workshop, Delft) (in Stockholm), 254
horse, striped. *See* Old Indies
horseback, tapestries depicting portraits of rulers on, 114, 118, 242

Horsemanship (1665–66, 8-piece set) (designs by Jacob Jordaens) (woven by Everaert Leyniers III, Brussels), 204, 208, 213, 230, **240–46**, *241–43, 245*
 Creation of the Horse
 modello, 242–43, *243;* fig. 115
 tapestry (in Vienna), 204, 208, 213, 230, **240–46**, *241, 245;* cat. no. 26
 Pesade or Courbettes in the Presence of Mercury and Mars (in Vienna), *242;* fig. 114
 related sets, 243–44
Horses (ca. 1636–37, 6-piece set) (designs by Francis Clein) (woven at Mortlake), 75, 173, 174, **195–201**, *197–200,* 242
 Perseus on Pegasus Rescuing Andromeda (in London), 75, 173, 174, **195–201**, *197, 199, 200;* cat. no. 18
Horses (ca. 1660–80, for Henry Mordaunt, Earl of Peterborough) (designs by Francis Clein, ca. 1635–36) (woven at Mortlake or Lambeth)
 Destruction of the Children of Niobe (in New York), 196, *198;* fig. 96
 reuse of border, *198*
Houasse, René-Antoine, 365, 384, 385, 390, 392, 393, 413, 438
Houel, Nicolas, 52, 140, 142
Houte, Peeter van, 243
Howard, Lord Charles, of Effingham, 23, 41, 47, 52, 111
Hugo da San Vittore, 88
Hugtenburch, Jan van, 475
Huguenot exodus from France after revocation of Edict of Nantes (1685), 499–501
Hullenberch, Philip, 182
Hunters' Chase (ca. 1645–75) (designs by Francis Clein) (woven at Mortlake), 200
 Boar Hunt (in London), 182
 Evening Entertainment (in Brive-la-Gaillarde, France), *181,* 182, 200; fig. 94
Hunts of Francis I (ca. 1620) (designs by Laurent Guyot) (woven in Faubourg Saint-Marcel workshop, Paris) (at Château de Chambord): *Arrival in the Country-side,* 126, *127;* fig. 64
Hunts of Maximilian (ca. 1531–33) (designs by Bernaert van Orley) (woven in Dermoyen workshop, Brussels), 6, 182, 350, 426, 491, 502
 Departure for the Hunt (Month of March) (in Paris), 6, *8,* 336, 350, 491; fig. 9
Huntsman Resting with His Hounds, A (drawing by Jacob Jordaens), 237
Huygens, Constantijn, *118*

I

Iconologia (Ripa), 248, 320
Ignatius of Loyola, 162
Ijkens, Pieter, 446–47
Illustrious Men (woven in workshop of Catherine van den Eynde), 90
Indies. See New Indies; Old Indies
Indo-Chinese Scenes (ca. 1700) (designs by John Vanderbank) (woven in workshop of John Vanderbank, London): *Concert* (in New York), *500;* fig. 226
inherited/antique tapestries, *106,* 107–12, *108, 109, 111,* 491–92, 497–99, 504
Innocent III, pope, 186
Innocent X, pope, 300, 308, 316
Innocent XI, pope, 499
Inquisition, 18, 268
insulation, tapestries serving as, 112
Isabella Clara Eugenia, infanta and archduchess of Austria, 27, 54–59, 61, 67, 72, 105, 113, 114, 203, 219, 220, 221–26, *227,* 231. *See also* entries at *Triumph of the Eucharist*
Isabella of Bourbon, 110, 220, 221
Isabelle of Portugal, 107

Italy
 artistic influence on Netherlandish tapestry industry, 6–11
 nobles and princes of the Church as tapestry patrons, 118–19, 499
 public display of tapestries in, 263, *264, 499,* 504
 Spanish Netherlands, Italian merchants in, 204
 tapestry weaving centers in, 13, 63, 84, 93, 274. *See also* Barberini manufactory, Rome; Medici manufactory, Florence

J

Jabach, Everard, 182
Jacob. See entries at *Story of Jacob*
James I, king of England; as James VI, king of Scotland, 23, 47, 66, 74, 79, 111, 112, 117, 171
James II, king of England, 111, 497, 498
Jans, Jan (Jean), the Elder, 128, 342, 348, 351, 356, 358, 361, 365, 382
Jans, Jean, the Younger, 348, 351, 361, 363, 365, 368, 382, 383, 393, 397, 400, 501, 502
Janssens, Carolus, 210, 214
Janssens, Victor, 449, 450, 452
January and February. See Allegory of Time
Jeannin, Pierre, 64, 80
Jesuit missionaries in China, 434, 436, 437, 438
Jode, Gerard de, 254, 258
Johannes Casimirus Vasa, king of Poland, 401
Johansen, Marina, 33
John the Baptist. *See* entries at *Story of Saint John the Baptist*
John George IV, elector of Saxony, 431
Joosz, Adriaen Jacob, 51
Jordaens, Jacob, 114, 119, 203, 204, 208–9, 216, 234–37, 240, 242–43, 441, 444, 462, 464, 465, 495
Joseph. See entries at *Story of Joseph*
Joseph, Holy Roman Emperor, 466
Joshua. See Story of Joshua
Jouvenet, Jean, 354
Juana, infanta, 221, 226, 230
Judgment of Cambyses (painting by Gerard David), 35
Judgment of Trajan (painting by Rogier van der Weyden), 35
Judgment of Zaleucus (painting by Hans Holbein the Younger), 35
Julius Caesar. See entries at *Story of Caesar; Story of Julius Caesar*
Julius II, pope, 265
Julius III, pope, 404

K

Kaisersaal tapestries (commissioned by Maximilian I of Bavaria) (woven by Hans van der Biest and Hans van den Bosschen, Enghien), 86
Kangxi emperor of China, 434–39. *See also Story of the Emperor of China*
Karcher, Nicolas, 14, 181, 263, 288, 404
Karl Joseph, archduke of Austria, 203
Keluneicz, Christof, 32
Kempeneer, Peter de, 25
Kempeneer, Willem, 7, 334
Kerkove, Jacques de, 412
Kessel, Jan van, 494
Keyser, Thomas de, 118
King Louis XV in Front of the Altar at Reims Cathedral, October 25, 1722 (drawing by Pierre Dulin), *503,* 504; fig. 230
Kircher, Athanasius, 434, 437, 439
Kleyn, Frans. *See* Clein, Francis
Knevet, Catherine, 78, 80
Knibbere, Jean de, 28
Knieper, Hans, 22, 28–33, 35

Knights of Malta, 232, 390, 451
Korte, Jacob de, 32
Kraus, Johann Ulrich, 363
Krumper, Hans, 82

L

La Chapelle, Henri Bessé, Sieur de, 352, 353
La Croix, Dominique de, 351, 400
La Croix, Jean de, 344, 351, 365, 393
La Fontaine, Charles de, 464–65
La Fontaine, Jean de, 344
La Fosse, Charles de, 452, 501, 504
La Fraye, Jean de, 400
La Hyre, Laurent de, 132, 135–36, 414, 416
La Meilleraye family, 160
La Meilleraye, Charles de La Porte, duc de 160, 168
La Pegna, Hyacinthe de, 482
La Planche, François de (Frans van der Plancken), 61, 73,
 75, 84, 124, 125, 126, 127, 128, 137, 146, 155, 158, 162,
 168, 293, 304
La Planche, Raphaël de, 128, 132–33, 134, 136, 137, 151,
 161, 168
La Planche, Sébastien-François de, 129, 138, 161
Labbé, Hermann, 86
Labors of Hercules (ca. 1605–6, among sample tapestries
 and designs for Robert Cecil, Earl of Salisbury, and
 Thomas Howard, Earl of Suffolk), 68
Lairesse, Gerard, 454, 456, 457
Lame Man, Healing of the. See entries at *Acts of the Apostles*
Lamoral, count of Egmont, 18–19
Landscape with Castle and Animals (ca. 1560–65) (woven in
 workshop of Frans Geubels, Brussels) (in Detroit), 90
Landscape Verdure with Tiger, Panthers, and Hunting Scenes
 (ca. 1650) (woven by Erasmus Oorlofs, Brussels) (in
 Amsterdam), 211, 212; fig. 108
Landscapes (before 1589, for Contarini family) (woven in
 workshop of Joost van Herzeele): *A Woodland Park
 with Palace and Pavilions* (in London), 25, 26; fig. 27
Landscapes (ca. 1614, for Hali Pasha) (woven in Spiering
 workshop, Delft), 66
Landscapes (1649, for Ottavio Piccolomini) (designs by
 Lucas van Uden) (woven in workshop of Jan Raes
 II, Brussels), 204, 212
Landscapes (ca. 1675–1700) (woven in Brussels), 446
Landscapes with Animals (ca. 1550–60, more than 44-piece
 set, for Sigismund II Augustus) (woven in Brussels)
 (in Kraków), 87, 88, 89, 90
Landscapes with Animals (1611–14, for Alessandro
 Montalto) (cartoons by unidentified Flemish
 painter, possibly Pieter Coecke van Aelst the
 Younger or Jean Tons II, ca. 1550–60) (woven in
 workshops of Catherine van den Eynde and Jan
 Raes II, Brussels), 72, **87–94**, *89, 91–93*
 Leopard Biting a Lion, 88, 90
 Leopard over a Pond, **87–94**, *89, 91, 93*, 206; cat. no. 9
 Lion in a Pond, 88
 Ostriches, 87, 88, 90
 Rhinoceros, 90, *92*; fig. 43
 Stag, 90
 Unicorn Fighting Lions, 88
Landscapes with Animals (ca. 1620s–30s) (woven in Van
 den Eynde and Raes workshops, Brussels): *Stag* (in
 Córdoba), 90
Landscapes with Animals (ca. 1620s–30s) (woven in work-
 shop of Jan Raes II, Brussels)
 Leopard Biting a Lion, 90
 Lioness in a Pond, 90
 Unicorn Fighting with Leopards, 90
Landscapes with Animals (1638, for Philip IV), 203
Landscapes with Animals (early 17th century) (woven by
 Frans Tons, Pastrana), 88

Landscapes with Foliage and Hunting (1603, for Maximilian
 I) (woven in Antwerp), 82
Landscapes with the Hunts of Diana (ca. 1701, for Cosimo
 III de' Medici) (woven in Brussels), 446
Landscapes with Poetic Figures (1614) (woven by workshop
 of Gerard Bernaerts, Brussels), 73
Landscapes with Scenes from Ovid's Metamorphoses (ca. 1690–
 1700) (woven in Brussels), 446
Landscapes with Small Mythological Scenes (ca. 1675–1700)
 (woven in Brussels), 446
Laneron, Pierre, 135–36
Lanfranco, Giovanni, 92
Langlois, Nicolas, 372
Lapierre, Claude de, 118
large figure genre, 7, 11, 27, 64, 119, 506
Lascot, Pierre, 295, 299, 300
Last Fight of the Revenge (1598, for Thomas Howard, Earl
 of Suffolk) (woven in De Maeght workshop,
 Middelburg), 53
Lastman, Pieter, 254
Lateran Council, 404
laurel, as motif, 315–16
Laurent, Girard, the Elder, 124, 134–35
Laurent, Girard, the Younger, 129, 137, 166
Laurent, Henri, 351, 361, 363, 365, 382
Lauterbeck, Georg, 35
Lauwers, Nicolaas, 231
Le Blond, Alexandre-Jean-Baptiste, 506
Le Blond, Étienne Claude, 390, 393, 394
Le Brun, Charles. *See also* Gobelins, Manufacture Royale
 des, Paris; specific tapestries, esp. *Four Elements*;
 History of the King; *Royal Palaces*; *Story of Alexander*;
 Story of Constantine; *Story of Meleager*
 armorial tapestries of, 342, 448, 454
 art, tapestry as, 309
 Beauvais manufactory and, 411, 416, 424, 425,
 428, 492
 Flemish tapestries of late 17th and early 18th
 centuries and, 442, 465, 475
 Gobelins manufactory and, 341–54, 356, 358–63, 365,
 368–72, 374–77, 379–84, 387, 491
 "noble style" or "Grand Manner" and, 346–47, 353,
 502, 506
 Paris tapestry workshops and, 164
Le Clerc, Hieronymus, 447, 448, 451, 454, 458, 459, 460,
 463, 464, 465, 480, 482, 488, 494, 495
Le Clerc, Jean, 363, 442, 459, 460, 462, 464, 465
Le Nôtre, André, 363
Le Pautre, Jean, 106, 423, 429
Le Petit, Pierre, 362
Le Roy de Saint Lambert, Antoon, 244
Le Sueur, Antoine, 135
Le Sueur, Eustache, 129, 133, 135
Le Sueur, Hubert, 174
Le Tellier, Michel, 337, 410, 430
Le Vau, Louis, 342, 456
League of Augsburg, French war with (War of the Grand
 Alliance, 1688–97), 341, 352, 369, 371, 417, 482
Leander. *See Hero and Leander*
Leclerc, Jean, 127
Leclerc, Sébastien, 347, 360, 371, 372, 383, 416
Leclerq, Achille, 396
Leefdael, Jan van, 205, 213, 441, 462, 464, 465
Leefdael, Willem van, 213, 252, 441, 442
Lefebvre, Jean, 134, 270, 361, 365, 374, 382, 393, 400
Lefebvre, Pierre. *See* Févère, Pietro
Lemercier, Jacques, 164
Lemke, Johann Philipp, 418
Lemmens, Jan-Baptist, 244
Lemon, Margaret, 193
Lemoyne, Jean, 415
Lemoyne le Lorrain, Jean, 377, 382, 388n51
Lenaerts, Hendrik, 213

Leo X, pope (Giovanni de' Medici), 6, 104, 111, 184, 186,
 293, 353, 397, 401–4, 422. *See also* at *Acts of the
 Apostles*
Leo XI, pope (Alessandro de' Medici), 265
Leonardo da Vinci, 95, 96, 104, 206, 402
Leopold, duke of Lorraine, 501
Leopold I, Holy Roman Emperor, 102, 114, 206, 240,
 244, 482
Leopold Joseph, duke of Lorraine, 371
Leopold Wilhelm, archduke of Austria, 114, 203–4, 212,
 246, 248–52, 325, *326*, 327, 330, 457
Lepelaer family, 259
Lerambert, Henri, 62, 92, 123, 124–25, 138, 143, 147, 150,
 153, 172
Leymeyers, Heribrecht, 33
Leyniers family, 33, 172, 212, 452, 488
Leyniers, Daniel, I, 212
Leyniers, Daniel, II, 460
Leyniers, Daniel, III, 488
Leyniers, Daniel, IV, 444, 487
Leyniers, Everaert, III, 205, 212, 213, 240, 243–44, 246,
 252, 442
Leyniers, Gaspar, 458
Leyniers, Hubrecht, 48, 53
Leyniers, Jan, II, 442
Leyniers, Urbanus, 452, 482, 487, 488
Licherie, Louis, 365
Liechtenberg, Giovanni Battista Guidobon Calvachino,
 baron of, 82
Liechtenstein, Johann Adam, prince of, 102
Life of Christ (1513) (Canterbury Cathedral, now in Aix),
 337
Life of Christ (early 16th century) (Raphael school
 designs) (at Vatican), 116
Life of Christ (1584, for church of Saint Mederic) (designs
 by Henri Lerambert) (woven in Hôpital de la
 Trinité workshop, Paris), 123
Life of Christ (ca. 1590) (designs by unidentified artist)
 (woven in workshop of Maarten Reymbouts,
 Brussels), 25–26, 116
 Jesus and His Disciples on the Banks of Lake Genazareth
 (in Cremona), 27; fig. 28
Life of Christ (1633, 9-piece set commissioned by arch-
 bishop of Reims) (woven by Daniel Pepersack,
 Reims), 115
Life of Christ (1643–56, 12-piece set) (designs and car-
 toons by Giovanni Francesco Romanelli and others)
 (woven in Barberini workshop under Gaspare
 Rocci, Caterina della Riviera, and Maria Maddalena
 della Riviera, Rome), 299–300, 300, *300*, **310–14**,
 311, 313, 318, 322
 Adoration of the Shepherds (design by Romanelli, car-
 toon by Paolo Spagna) (in New York), *300*; fig. 137
 Crucifixion (cartoon by Gaspare Rocci based on paint-
 ing by Pietro da Cortona), 300
 Resurrection of Christ
 cartoon (by Romanelli), **310–14**, *311*; cat. no. 36
 tapestry (in New York), 300, 310–13, *313*; fig. 141
Life of Christ (ca. 1730) (designs by Jan van Orley and
 Augustin Coppens) (woven in Van der Borcht
 workshop, Brussels), 488
Life of Emperor Charles V (after 1635) (from paintings by
 Gaspar de Crayer) (woven in Bruges) (in Besançon),
 214
Life of François de Paule (1572, for Pierre Passart) (woven
 in Hôpital de la Trinité workshop, Paris), 123
Life of Frederick, Elector of Brandenburg and King of Prussia
 (1699) (designs by Pierre Mercier) (woven in work-
 shop of Pierre Mercier, Berlin) (at Schloss Charlot-
 tenburg), 501
Life of Pope Urban VIII (1663–79, 10-piece set) (woven in
 Barberini workshop under Maria Maddalena della
 Riviera, Rome), 301–2, 306, 309, 318, **319–23**, *320, 321*

Allegory of Maffeo Barberini's Florentine Birth, pilaster *termine* panel (design by Antonio Gherardi with collaboration of Lazzaro Baldi) (in Philadelphia), *302*; fig. 139

Double Portrait of Antonio Barberini and Camilla Barbadori, Parents of Pope Urban VIII, pilaster *termine* panel (design by Antonio Gherardi with collaboration of Lazzaro Baldi) (in Boston), *302*; fig. 140

Election of Pope Urban VIII (woven from cartoon by Fabio Cristofani) (at Vatican), *301*; fig. 138

Protection of Rome from Plague and Famine cartoon (by Giacinto Camassei), *320*; fig. 144

tapestry (design by Ciro Ferri and Giacinto Camassei) (at Vatican), 301, *319–23*, *321*; cat. no. 38

Life of Queen Sophie-Charlotte (1699–1713) (designs by Pierre Mercier) (woven in workshop of Pierre Mercier, Berlin), 501

Life of Saint Regina (ca. 1621, 7-piece set for church of Saint Eustache): *Martyrdom of Saint Regina* (cartoon for seventh panel), *134*, 135, 136; fig. 71

Life of Saint Roche (1575, for Michel le Sec) (woven in Hôpital de la Trinité workshop, Paris), 123

Life of Saint Ursula (ca. 1640, for Ursulines of Dijon) (designs by Michel Corneille I) (woven in Louvre workshops, Paris), 135–36

Life of the Virgin (1635, 14-piece set commissioned for Notre-Dame Cathedral) (designs by Philippe de Champaigne, Charles Poerson, and Jacques Stella) (probably woven in Louvre workshop and workshop of Pierre Damour, Paris): *Birth of the Virgin* (in Strasbourg), 115, *136*, 137; fig. 73

Lille as tapestry weaving center, 495

Limbo, Counter-Reformation use of descent into, 264, 276

Lint, Pieter van, 213, 214

Lionne, Hugues de, 378

Lippi, Lorenzo, 269, 287–90

Lipsius, Justus, 99

Lisle, Viscount, 69

Lives of Saint Crispin and Saint Crispinian (1634, 4-piece set commissioned by cobblers' fraternity for Notre-Dame Cathedral) (designs by Georges Lallemant) (woven in Louvre workshops, Paris), 135

Livy, 76, 95, 96, 99

Lodi da Cremona, Giovanni Battista, 205, 442

Long, William Evelyn, 200

Lorrain, Claude, 315

Lotijn, Johannes Christoph, 494

Louis XIII, king of France

Barberini manufactory and, 293, 297, 304, 308

connoisseurship and, 330

court life, tapestries in context of, 107, 113, 118

Paris workshops and, 127, 129, 142, 144, 146, 148, 155, 158, 160, 162, 163–66

portrait at Fontainebleau, 379

Spanish Netherlands tapestries and, 242, 244

Louis XIV, king of France

Beauvais workshops and, 404, 407–8, 410, *411*, 416, 417, 433

as connoisseur and collector, 12, 106, 111, 332–33, 337, 404, 433, 491, 497

Coronation of Louis XIV at Reims, June 7, 1654 (etching by Jean Le Pautre), *106*, 109; fig. 46

Gobelins manufactory visited by, 370, 375, 379, 380, *383*, 491, *492*. *See also* Gobelins, Manufacture Royale des, Paris

Medici and Barberini manufactories and, 272, 314, 316, 327

Mortlake tapestries and, 178, 182, 184, 193

Paris workshops before Gobelins and, 137, 164, 166

salons of 1699 and 1704, tapestries displayed at, 497–99

tapestries commemorating reign of. *See Conquests of King Louis XIV; History of the King*

Louis XV, king of France, 354, 433, *503*, 504

Louis XV Processing to Reims Cathedral, October 25, 1722 (drawing by Pierre Dulin), *503*, 504; fig. 229

Louis XVI, king of France, 393

Louise Henriette of Orange Nassau, 111, 114

Louvois, François Michel Le Tellier, marquis de, 337, 351–53, 363, 383, 410, 416, 442, 501–4

Louvre tapestry workshops, Paris, 124, 134–37

Loves of the Gods (designs by Simon Vouet), 130, 164

Loves of Jupiter (early 1530s, for Andrea Doria) (after designs by Perino del Vaga), 336

low- and medium-quality tapestries, growing demand for, 495–97

Low Countries. *See* Netherlandish tapestry industry

low-warp vs. high-warp looms, 4, 124, 135–36, 138n11, 268, 274, 361

Loyola, Ignatius, 162

Lucas, Months of. See Months of the Year

Lucatelli, Pietro, 302

Ludwig Wilhelm of Baden, 448, 482

Lully, Jean-Baptiste, 344, 425

Lying-in-State of Duke Charles III of Lorraine, 1608 (engraving by Frédéric Brentel after Claude de la Ruette), *108*, 109, 328; fig. 47

Lystra, Sacrifice at. See entries at *Acts of the Apostles*

M

Macartney, Lord George, 436

Macée. *See* entries at *Story of Gombaut and Macée*

Maderno, Carlo, 92

Madonna of the Cat (1663–64) (after painting by Federico Barocci) (woven in Medici workshop of Pietro Févère, Florence) (in Florence), 271, *272*; fig. 125

Madonna of the Rosary (painting by Caravaggio), 237

Madrid, tapestry workshops in, 506

Maeght, Hendrick de, 24, 48, 52, 53

Maeght, Jan de, 24, 42, 52, 53

Maeght, Laurens de, 42

Maeght, Philip de, 150, 160, 171–72, *173*, 175, 179, 195

Magalotti, Lorenzo, 363

Maidservant with a Basket of Fruit (tapestry). *See under Scenes of Country Life*

Maidservant with a Basket of Fruit and Two Lovers (painting by Jacob Jordaens), *237*; fig. 113

Maidservant with a Basket of Fruit in Front of an Open Door (drawing by Jacob Jordaens), *236*, 237; fig. 112

Maincy tapestry workshop (1658–61), 341–44, 353, 442

Maine, Louis-Augustus de Bourbon, duc du, 416, 425

Maintenon, Madame de, 354

Maioli, Clemente, 295, 300, 314, 315–18

Malherbe, François de, 144–46

Malo, Louis, 212

Malta, Knights of, 232, 390, 451

Mander, Karel van, the Elder, 23, 26–27, 36–42, 43, 47, 52, 58, 64, 78, 89

Mander, Karel van, the Younger, 40, 42, 47, 64–67, 76–79, 242, 254

Mannerist style

in Antwerp weavings of early 18th century, 447

Medici workshops' reaction against, 265, 285, 290

in Netherlandish tapestry industry, 23–24, 26–27, 43, 44, 78, 92

in Paris tapestry workshops, 124–28, 140, 142, 146, 147, 150, 162

Mantua

dukes of. *See* entries at Gonzaga

as tapestry weaving center, 13, 294

Marcgraf, Georg, 390

Margaret of Austria (Sor Margarita de la Cruz), 6, 17, 220, 221, 230, 267

Margaret Theresa (Margarita Teresa), infanta and empress, 114, 206

Marguerite Louise d'Orléans, 272

Maria of Austria, empress, 220, 221

Maria Eleonora of Brandenburg, 79, 254

Maria Elisabeth, archduchess of Austria, 488

Maria Magdalena of Austria, 265, 267

Maria Theresa, empress, 371

Maria Theresa, infanta and queen of France, 111, 362

Mariani, Giovanni, 267

Marine Triumphs (ca. 1697–98, 4-piece set for comte de Toulouse) (designs by Jean Berain I, cartoons by Guy-Louis Vernansal) (woven in Paris workshop of Philippe Behagle), 417, **420–27**, *421*, *423–26*

Triumph of Venus

preparatory sketch (Jean Berain I), 422, *423*; fig. 193

tapestry (in Paris), 417, **420–27**, *421*, *426*; cat. no. 50

Marlborough, John Churchill, first Duke of, 448, 451–52, 466, 471–75, 482. *See also Allegorical Armorials of the Duke of Marlborough; Victories of the Duke of Marlborough*

Marlborough, later Dukes of, 470

Marlowe, Christopher, 190, 192

Marot, Daniel, 454, 494

Marot, François, 384

Marriage of Friedrich Wilhelm, Prince Elector of Brandenburg, and the Princess Louise Henriette of Orange Nassau, December 7, 1646, at the Hague (painting by Jan Mytens), 109, *111*, 114, 328; fig. 52

Mars Ultor, statue of, 96

Martin, Jean-Baptiste, 416, 417, 418

Marvels of Brazil. See Old Indies

Mary I, queen of England, 19

Mary II, queen of England, 454, 494, 497, 500

Mary of Hungary, 107

Mathieu, Antoine, the Elder, 374, 381

Mathieu, Pierre, 354

Mati, Francesco, 264, 267, 286

Matilda of Canossa, 313

Mattens, Jan, 73

Matthias Corvinus, king of Hungary, 5

Mausolus, 140

Maximilian III, archduke of Austria, 146

Maximilian I, elector of Bavaria, 62–64, 81–86, 113, 248

Maximilian II, Holy Roman Emperor, 220, 221. *See also Hunts of Maximilian*

Maximilian I, emperor of Mexico, 250

Maximilian Emanuel von Wittelsbach, elector of Bavaria, 414, 448, 477, 482, 483, 495, 506

Mayenne, Henry of Lorraine, duc de, 107, 110

Mayhew, John, 470

Mazarin, Jules, cardinal

Barberini manufactory and, 308, 314

as collector and connoisseur, 325, 331, 332–33, *333*, 335–37

death of, 207, 344, 407, 491

Gobelins manufactory and, 341–45, 350

Mortlake tapestries and, 178, 179, 182, 184, 193

Spanish Netherlands tapestries, 1625–60, 206–7, 244

Medici family, 113

Medici, Alessandro de' (Pope Leo XI), 265

Medici, Catherine de', 25, 62, 140, 206

Medici, Cosimo il Vecchio (the Elder) de', 265, 402–3

Medici, Cosimo I de', 13, 17, 263, 264, 269, 277–80, 284. *See also Story of Cosimo I*

Medici, Cosimo II de', 13, 17, 176, 263, 264, 265, 267

Medici, Cosimo III de', 272–74, 287–88, 363, 441, 446

Medici, Ferdinando I de', 263–65, 276, 277, 280, 281, 282–84, 286

Medici, Ferdinando II de', 265–72, 285, 287–88, 309

Medici, Francesco I de', 263, 280, 284

Medici, Gian Gastone de', 274

Medici, Don Giovanni de' (legitimized bastard son of Cosimo I), 280, 284

Medici, Giovanni de' (Pope Leo X), 6, 104, 111, 184, 186,

293, 353, 397, 401–4, 422. *See also at Acts of the Apostles*

Medici, Leopoldo de', 265

Medici, Lorenzo il Magnifico (the Magnificent) de', 402

Medici, Marie (Maria) de', 42, 127, 142, 144, 146, 160, 162, 263, 331, 333, 348

Medici manufactory, Florence, 263–75
 under Cosimo I (1545–74), 263
 under Francesco I (1574–87), 263
 under Ferdinando I (1587–1609), 263–65
 under Cosimo II (1609–21), 265
 under Ferdinando II (1621–70), 265–72
 under Cosimo III (1670–1723), 272–74
 under Gian Gastone and Hapsburg-Lorraines (1723–47), 274
 Cortona's painting style, influence of, 268, 269
 Counter-Reformation culture and, 264–65, 276–77, 280, 282–85
 court life, tapestries in context of, 115
 French influence on, 268, 270, 273–74
 Maincy workshop compared, 341–42
 Netherlandish tapestry industry and, 63, 84, 93
 public display of tapestries on feast days in Florence, 263, 264
 realistic subject matter, desire for, 265, 285, 290

Medina Celi, duke of, 445

Meleager. See entries at Story of Meleager

Melissi, Agostino, 268–72

Melter, Jan de, 454, 457–58, 462

Melter, Katharina de, 458

Melun, Louis de, 381

Mercier, Pierre, 501, 504

Merian, Matthäus, the Elder, 258

Mérou, Noël-Antoine de, 433, 438

Mesmes, Jean Jacques de, 394

Metamorphoses (Ovid). *See also entries at Horsemanship; Horses; Stories of Apollo; Story of Diana*
 Barberini manufactory and, 315, 318
 Beauvais workshops and, 413–14, 438
 court life, tapestry in context of, 119
 Grotesques with Ovid's Metamorphoses, 482
 Landscapes with Scenes from Ovid's Metamorphoses, 446
 Mortlake tapestry works and, 148, 195–97, 200–201
 in Netherlandish tapestries
 1570–1600, 43, 44, 45, 47
 1625–60, 241, 254
 1660–1715, 446, 452, 482, 488
 Paris tapestry workshops and, 130, 138
 Scenes from Ovid's Metamorphoses (Story of Diana), 23, 41, 47

Metamorphoses (ca. 1690) (designs by René-Antoine Houasse) (woven at Beauvais under Philippe Behagle): *Abduction of Orithyia* (in San Francisco), 413–14, *415*, 416, 438; fig. 189

Metamorphoses (ca. 1695) (designs by Charles de La Fosse) (woven in Gobelins workshop of Jean Jans the Younger, Paris): *Diana and Acteon* (in New York), *501*, 504; fig. 227

Meteren, Emanuel van, 50

Meucci, Vincenzo, 274

Meulen, Adam Frans van der, 350, 361, 363, 374–77, 379–81, 383, 411, 416, 448, 475, 480

Michelangelo, 11, 268, 280, 312, 497

Miel, Jan, 115, 117, 146

Mignard, Nicolas, 363

Mignard, Pierre, 352, 420

military genre, 448, 452. *See also entries at Art of War*

Milvian Bridge, Battle of the. See entries at Story of Constantine

Minerva Embroidering a Portrait of Jean-Baptiste Colbert (engraving by Pierre-Louis van Schuppen after Philippe de Champaigne and Charles Le Brun), *345*; fig. 161

Mingucci, Francesco, 296, 297

Miraculous Draft of Fishes. See entries at Acts of the Apostles

Mistrowitz, Count Wratislaw von, 466

Moillon, Isaac, 356, 361

Molière, 344

Monaldi, Bernardino, 264, 286

Moncada family, 494

Mondragon, Cristobal de, 50, 52

Monnoyer, Jean-Baptiste, 350, 390, 392, 412, 414, 424, 427–30, 434, 438, 439, 504

Montagu, Ralph, 492

Montalto, Alessandro Damsceni Peretti, cardinal, 62, 72, 88, 89–93, 118, 124, 138, 142, 143, 265, 286, 313, 329

Montalto, duke of, 450

Monte, Francesco Maria del, 90

Montefeltro, Federigo da, duke of Urbino, 5

Monterey and Fuentes, Don Juan Domingo de Zúniga y Fonseca, count of, *456*, 457, 458. *See also Armorial Tapestry of the Count of Monterey*

Montespan, Françoise-Athénaïs de Rochechouart-Mortemart, marquise de, 416, 417, 420, 424–25, 439

Months (1550–53) (cartoons by Bachiacca) (woven by Jan Rost and Nicolas Karcher in Medici workshops, Florence), 288

Months (ca. 1740) (designs by David Teniers III) (woven in workshop of Daniel Leyniers IV, Brussels): *May and June* (in Vienna), *444*; fig. 201

Months (Royal Palaces or Royal Residences). See Royal Palaces

Months, Seasons, and Times of the Day (1612–14, 18-piece set, for Maximilian I) (designs by Peter Candid) (woven in workshop of Hans van der Biest, Munich) (in Munich), 60, 63, 63–64, **81–86**, *83–85*, 248
 cartoons, 84–85
 December, 60, 63, 81, 84; figs. 30, 32
 Night, **81–86**, *83–85*, 216; cat. no. 8

Months of the Year (known as the *Months of Lucas*) (ca. 1650) (woven in Bruges): *April* (in Vienna), *206*, 214, 288, 426; fig. 101

Montmorency, Philip de, 18–19

Moor, Frans de, 214

Moro, Lorenzo del, 274

Morra, archbishop of Otranto, 99

Morris, Joshua, 504

Mortemart, Gabriel de Rochechouart, duc de, 378

Mortlake tapestry works, England, 170–83
 Acts of the Apostles sets from Raphael designs, 175–77, 330
 after Civil War and Restoration, 492–93
 collectibility of, 330, 334, 335, 337
 court life, tapestries in context of, 112, 113, 114, 117, 118, 119
 duplication of oil paintings at, 272, 331
 establishment of, 171
 Gobelins manufactory and, 337, 492–93
 Netherlandish tapestry industry and, 69, 74–75
 new designs under Francis Clein, 171, 172, 173–75
 as royal works, 179–82
 weavers and designs, sources for, 171–72, 174–75, 182

Mortlet, Nicholas, 182

Moses. See entries at Story of Moses

movement of tapestries among palaces and houses, 110, 111, 118, 120

Mozin, Jean-Baptiste, 351, 365, 383, 393

Munich, tapestry production in, 62–64, 81–86, 506

Munter, Margaretta (later Cadogan), 469–70

Muret, Marc-Antoine de, 460

Mytens, Daniel, 174

Mytens, Jan, 111

Mythological Scenes (before 1622) (designs by Laurent de La Hyre) (probably woven in Faubourg Saint-Marcel workshop of Hippolyte de Comans, Paris) (in New York): *Diana and Her Nymphs*, *132*; fig. 68

Mythological Scenes (ca. 1700) (designs by Lodewijk van Schoor and Lucas Achtschellinck) (woven in workshop of Jacob van der Borcht, Brussels): *Four Seasons Make an Offer to Apollo* (in Vienna), *445*; fig. 202

N

Naked Boys (ca. 1650–70) (copied by Francis Clein from Brussels 1550s tapestry designs) (woven at Mortlake): *City* (in London), *180*, 180–81, *182*; fig. 93

Nancy, tapestry workshops in, 74, 501

Nantes, revocation of Edict of (1685), 499–501

Nanteuil, Robert, 333

Naples, tapestry weaving in, 274

Nassau-Siegen, Johan Maurits of, 352, 390–94

Nativity (1635–36, altarpiece dossal from Sistine Chapel baldachin project) (design by Pietro da Cortona) (woven in Barberini workshop under Giacomo della Riviera, Rome) (at Vatican), *298*, 298–99, 310, 312; fig. 135

Naulaerts, Nicolaas, 446, 451, 471

Nauwincx workshop, Gouda, 259

Naval Battle, A. See Art of War II

Nemean Lion, 306–7

Neostoicism, 99

Neptune, 405n19, 422, *425*. *See also Creation of the Horse, under Horsemanship*

Nero, Roman emperor, 398, 427

Netherlandish tapestry industry, 3–15. *See also* specific towns, e.g., Brussels
 golden age, 1530–70, 2–15
 France and Italy compared, 12–13
 Italian artistic influence on, 6–11
 main centers of, 3, 5, 12–15
 production and marketing, 3–4, *4*
 royal patronage, 11–12
 stylistic, iconographic, and compositional developments in, 4–11, *5–11*
 disruption and diaspora in late 16th century, 15, 17–27
 civil war ("Dutch Revolt"), 20, 20–21, 24, 48–53
 Counter-Reformation, Philip II's attempt to enforce, 15, 18–20
 Delft, Spiering manufactory in, 21, *22*, 22–24, *23*, 26–27
 England, emigration of weavers to, 19–20, 21
 Germany, emigration of weavers to, 17, *17–18*, 19, 21
 Reformation movement, 17–18
 survival of tapestry weaving in southern Netherlands, 24–27, *25–27*
 Sweden and Denmark, emigration of weavers to, 21, *21–22*
 revival in early 17th century
 Brussels workshops, 67–74
 civil war ("Dutch Revolt"), 61
 continuing emigrations despite, 74–75
 Delft manufactories, 64–67
 foreign competition, 74–75
 old master designs, market for, 69–73
 quality issues, 74
 Rubens's designs for *Decius Mus* series, 73–74
 in Spanish Netherlands, 1625–60, 203–17
 Antwerp workshops, 214–16
 Bruges workshops, 214
 Brussels workshops, 212–14
 Enghien workshops, 216–17
 Oudenaarde workshops, 214
 production and marketing, 213–14
 Renaissance models and tapestries, continuing market for, 204–7
 subject matter popular in, 209–12
 tapestry patrons in, 203–4
 weavers influential in, 207–9

Flemish production, 1660–1715, 440–53
 contemporary classical, verdure, and genre designs,
 444–47, 444–48
 foreign and Renaissance designs, reuse of, 441–44,
 442, *443*
 goût moderne or *goût du temps* (Rococo), 452
 neo-Baroque designs, *448–51*, 448–52
 production and marketing, 441
 production and marketing, 3–4, *4*, 213–14, 441
Neuburg, Wolfgang Wilhelm, duke of, 85
New Indies (1735–41) (cartoons by Alexandre François
 Desportes based on designs and cartoons for *Old
 Indies*) (1740–19th century, woven in Gobelins
 workshops, Paris), 393–94
Newcastle, William Cavendish, Duke of, 242
Niccolini, Giovanni, 280
Nicholas V, pope, 294
Nieuhof, Johannes, 434, 437, 439
Night. See Months, Seasons, and Times of the Day
Night (drawing by Peter Candid), 82
Night Banquet (painting by Wolfgang Heimbach), *116*, 117,
 328; fig. 55
Nine Worthies, 460
Nivelon, Claude, 365
Noah. See entries at Story of Noah
Noailles, Anne, duc de, 378
Noailles, de, cardinal, 499
Noailles, Monsieur le Bailly de, 394
"noble style" or "Grand Manner," 346–47, 353, 502, 506
nobles as tapestry patrons, *116–18*, 117–20, 495–99, 504.
 See also court life, tapestries in context of
Norgate, Edward, 188, 193
Normand, Jacques le, 337

O

Obberghen, Antonis van, 28
Occupations of the Months (ca. 1624–25, for John Williams,
 bishop of Lincoln) (based on 16th-century designs)
 (woven at Mortlake): *March–April* (in Genoa), 172,
 174, 337; fig. 86
Octavian. See Story of Octavian
Odescalchi, Don Livio, 499
*Odysseus. See entries at Alexander and Ulysses; Story of
 Odysseus; Story of Ulysses*
Ogilby, John, 200
Old Indies ("marvels of Brazil," 1667, 9-piece set for
 Frederick William of Brandenburg) (designs by Albert
 Eckhout and Frans Post) (woven by Maximilaen
 van der Gucht, Delft) (lost), 352, 390–91
Old Indies (1687–88, 1689–90) (cartoons by Albert
 Eckhout and Frans Post) (woven in Gobelins work-
 shops of Jean-Baptiste Mozin and Jean de La Croix,
 Paris), 352–53, 393
Old Indies (1692–1700) (woven in Gobelins workshops
 of Jean Jans the Younger and Jean Lefebvre, Paris)
 (destroyed; fragments in Saint Petersburg), 393
Old Indies (1708–10, 10-piece set for Ramón Perellos y
 Rocafull, Grand Master of the Knights of Malta)
 (cartoons by Albert Eckhout and Frans Post,
 retouched and probably adapted by Jean-Baptiste
 Monnoyer, Jean-Baptiste Belin de Fontenay, René-
 Antoine Houasse, and François Bonnemer;
 retouched and adapted again by Alexandre François
 Desportes; and restored by Claude Audran III)
 (woven in Gobelins workshop of Étienne Claude Le
 Blond, Paris) (in Valletta), **390–97**, *391–93*, *395*, 436
 Council Chamber of Presidential Palace, Valletta, hung
 with *Old Indies*, *393*, 394; fig. 180
 Striped Horse, **390–97**, *391*, *392*, *395*, 436, 451; cat. no. 48
Old Indies (1718–20) (woven in Gobelins workshops of
 Jean Jans the Younger and Jean Lefebvre, Paris), 393
Old Indies (1723–27) (woven in Gobelins workshops of

Jean Jans the Younger, Jean Lefebvre, and Louis de la
 Tour, Paris) (in Rome), 393
Old Indies (1725–32) (woven in Gobelins workshops of
 Jean Jans the Younger, Jean Lefebvre, and Louis de la
 Tour, Paris) (in Paris), 393–94
Old Indies (1726–30, known as the *Small Indies*) (woven
 in Gobelins workshops of Jean Jans the Younger,
 Jean Lefebvre, and Louis de la Tour, Paris) (in São
 Paulo), 393–94, 396
Old Indies (1735–41). *See New Indies*
old master designs, market for, 69–73, 502
Old Testament Prefigurations of the Eucharist (1596–1600,
 for Alessandro de' Medici and Como Cathedral)
 (designs by Alessandro Allori) (woven in Medici
 workshops under Guasparri Papini, Florence), 115,
 265, 280
Old Testament Series. See Story of the Old Testament
Oldebarnevelt, Johan van, 80
Olivares, Gaspare de Guzmán y Pimentel, conde-duque
 de, 104
Ontoneda, Francisco de, 20
Oorlofs, Erasmus, 211, 212
opera, influence of, 423–24
Order of the Elephant, 34
Order of the Garter, 111, 180, 470
Order of the Golden Fleece, 110, 220, 425
Order of the Holy Spirit, 398, 422, 425
Order of Saint Michael, 398, 422, 425
Orlando furioso (Ariosto), 38, 119, 130. *See also* entries at
 Story of Orlando Furioso
Orley, Bernaert van, 6–8, *7–8*, 11, 17, *18*, 19, 63, 81, 114,
 182, 242, 350, 502
Orley, Jan van, 449–50, 451, 452, 466, 471, 483, 487–88,
 504, 506
Orley, Nicolaas van, 19
Orley, Peter van, 449, 487
Orley, Richard van, 487
Ormesson, Henri d', 393
Ormonde, duke of, 196
Oscar II, king of Sweden, 190
Ostrich Hunt (1643–45) (after designs of Clemente
 Maioli) (woven by Lorenzo Castellani, Barbarini
 manufactory, Rome), 295
Otto von Wittelsbach. See Story of Otto von Wittelsbach
Oudenaarde as tapestry weaving center, 214, 408–9, 442,
 446, 447, 452, 495
Oudry, Jean-Baptiste, 418, 506
Ovid
 Amores, 190. *See also* entries at *Hero and Leander*
 Metamorphoses. See Metamorphoses
Oxenstierna, Axel, 194
Oxenstierna, Gabriel, 194
Oxenstierna, Count Johan, 190, 194

P

Paduano, Alessandro, 84
paintings and tapestries compared. *See under* artistic status
 of tapestries
Palazzo Barberini alle Quattro Fontane, Rome, tapestries
 in, *294*, 298, 300, 304, 307
Palazzo Pitti, Florence, tapestries hung in, 268–69
Pallavicini, Nicolò, 99
Pallavicino, Gian Battista, 204
Palmer, Sir James, 178–82, 187, 189, 201
paneling, tapestries in relationship to, 495, *496*
Panneels, Willem, 231
Pannemaker, Pieter de, *7*, 17
Pannemaker, Willem de, 9, 20, 181, 230
papal court. *See* Vatican and papal court
Pape, Simon de, III, 411, 433
Papi, Stefano, 273
Papini, Guasparri, 93, 263, 264, 265, 268, 276, 280–86, 288

Parent, Adriaen, 464–65
Parent, Nicholas, 465
Parigi, Giulio, 267
Paris tapestry workshops, 122–39
 of Beauvais weavers Hinart and Behagle, 416–17, 420–
 22, 425–26
 character and quality of works produced by, 127–28,
 137–38
 court and noble life, role of tapestry in, 114, 115, 117, 119
 Gobelins manufactory. *See* Gobelins, Manufacture
 Royale des, Paris
 under Henry IV, 123–24
 Medici workshops influenced by, 268, 270, 273–74
 Netherlandish tapestry industry and, 12–13, 61–62
 religious commissions at Louvre workshops (1625–
 60), 134–37
 scholarly study of, 123
 shift from royal to private patronage, 128–29, 134
 style developments
 Mannerist style legacy (1599–1623), 124–28
 Rubens and, 128, 129, 155–63
 Vouet to Corneille (1627–61), 129–34
 lighter style of late 17th–early 18th centuries, 504
 "Verdures et oiseaux" designs, 132–33
 workshop developments
 1623–60, 128–29
 after 1660, 137
Parklands with Birds (1705) (woven in Van Verren work-
 shop [?], Oudenaarde) (in Maastricht), *446*, 447;
 fig. 204
Parma, dukes of. *See* entries at Farnese
Particelli d'Hémery, Michel, 146, 168
Passart, Pierre, 123
Passe, Crispijn van de, the Younger, 242, 244
Passeri, Giovanni, 313
Passeri, Giuseppe, 302
Passerini, Bartolomeo, 267
Passignano, Domenico, 285
Passion. See Alba Passion; Scenes of the Passion
Passion of Christ (1592–1615, 10-piece set) (designs and
 cartoons by Alessandro Allori, Ludovico Cardi, called
 il Cigoli, and others) (woven in Medici workshops
 under direction of Guasparri Papini, Florence), 264,
 277, 280, **282–87**, *283–85*, 290
 Christ before Herod
 preparatory sketch by il Cigoli (*Christ before Herod*),
 284, 285; fig. 127
 preparatory study by il Cigoli (*Head of Christ*), *284*,
 285; fig. 128
 tapestry (in Florence), *262*, 264, 277, 280, **282–87**,
 283, *285*, 290; cat. no. 33, fig. 117
Pastor fido (Guarini), 125. *See also* entries at *Story of
 Pastor Fido*
Pastorales. See entries at *Landscapes*
Pastrana, Don Ruiz Gomez de Silva de Mendoza y de la
 Cerda, duque de, 93
Pastrana, Spain, tapestry workshop of Frans Tons in, 75, 88
Paul, saint and apostle. *See* entries at *Acts of the Apostles;
 Story of Saint Paul*
Paul V, pope, 71, 313, 316
Paule, François de, 123
Paulli, Franz, 32
Pausanias, 241
Pauwels, Hieronymus, 460
Pavia, Battle of. See Battle of Pavia
peasant scenes (genre Teniers), *447*, 447–48, 450, 451, 452,
 482, 488, 506
Peemans, Gerard, 213, 371, 441, 442, 444, 462, 465
Peiresc, Nicolas-Claude Fabri de, 155, 158, 159, 162, 330
Pembroke, Philip Herbert, Earl of, 177, 179, 180, 182
Peña, J. A. de la, 230
Penni, Giovanni Francesco, 6, 8, 76, 205, 397, 402, 422, 497
Penthièvre, duc de, 146

554

Pepersack, Daniel, 115
Perellos y Rocafull, Ramón, 232, 390, 393, 394, 451
Peretti, Prince Michele, 93
pergola tapestries, 204, *208*, 216
Perino del Vaga, 11, 182, 336, 397, 402
Perrault, Charles, 346, 347, 351, 359, 362, 363, 375–76
Perseus. See entries at *Story of Perseus*
Pesne, Jean, 422
Peter the Great, emperor of Russia, 393, 506
Peterborough, Henry Mordaunt, Earl of, 198
Petite Académie, 346, 347, 348, 352, 356, 358, 359, 363, 375, 377
Petrarch, 268. *See also* entries at *Triumphs of Petrarch*
Phaeton. See entries at *Story of Phaeton*
Philip the Good, duke of Burgundy, 110, 491
Philip II, king of Spain
 Barberini manufactory and, 297
 court life, tapestries in context of, 107
 Netherlandish tapestry industry and, 15, 18, 20, 27, 38, 56, 59, 61, 67, 70, 93, 203, 220, 221, 226, 230
 Triumph of the Eucharist and, 220, 221
Philip III, king of Spain, 110
Philip IV, king of Spain, 59, 95, 104, 110, 111, 112, 203, 220, 221, 325, 327, 332, 335, 348, 349
Philip V, king of Spain, 59, 104, 425, 497, 504, 506
Philippe I, duc d'Orléans, 371, 376, 442
Philips Willem (eldest son of William of Orange), 64
Piccolomini, Ottavio, 204, 212, 238
Piepers, Johannes, 48
Pieri, Giovan Francesco, 274
Pies (Piso), Willem, 390
Pignatelli, Giovanni, 242
Piles, Roger de, 96
Pillars and Vases (before 1661) (woven in workshop of Jacob Wauters, Antwerp)
 A Single Pergola of Four Pillars (in Edinburgh), *208*, 216; fig. 103
Pine, John, *23*
Piper, Carl, 412, 431–33
Piso (Pies), Willem, 390
Pitti, Palazzo, Florence, tapestries hung in, 268–69
Pius V, pope, 264, 280, 284
plague of 1629, Rome, 301, 319–23
Plancken, Frans van der. *See* La Planche, François de
Pleasures of the Gods. See Triumphs of the Gods II
Pliny the Elder, 88
Plutarch, 403, 459, 460
Plutarch's Illustrious Men (1735–45) (designs by Victor Janssens and Augustin Coppens) (woven in Leyniers workshop, Brussels): *Offer of Aristides* (at Schloss Bruchsal), *450*, 452, 488; fig. 208
Pluvinel, Antoine de, 242, 244
Poccetti, Bernardino, 264
Poerson, Charles, 115, 137, 442, 459, 460, 464–65, 495
Poitiers, Diane de, 13, 123, 147, 148
Polidore tapestries (woven at Mortlake), 182
Polidoro da Caravaggio, 137, 182
Poliziano, Angelo, 402
Pollastri, Giovanni, 271, 272
Pomona. *See* entries at *Galleries* and *Story of Vertumnus and Pomona*
Pomponne, marquis de, 352, 392
Poncet, Limousin Mathias, 168
Pontanus, 241
Pontchartrain, Louis Phélypeaux, comte de, 425
Pontormo, Jacopo da, 263
Ponzano, Antonio, 84
Pope Julius II della Rovere (painting by Raphael), *265*
Porter, Endymion, 175
portieres (1612, 2-piece set, for Alessandro Montalto) (woven in Medici workshops, Florence), 93
Portières des dieux (1701) (designs by Claude Audran III and others) (woven in workshop of Jean Jans, Paris):

Saturn, or Winter (in Paris), 354, *502*, 504; fig. 228
Portières des renommées (ca. 1660) (designs by Charles Le Brun) (woven at Gobelins manufactory, Paris)
 early 18th-century armorial tapestries derived from, 448
 preparatory drawing for *Portière des renommées* with arms of Fouquet, *342*; fig. 158
Portocarrero, Luis Manuel Fernández, cardinal, 232
Post, Frans, 390
Pour la valeur (*Water*) (painting by Jacques Bailly) (in illuminated manuscript by Jacques Bailly and Sébastien Leclerc, *Devises pour les tapisseries du Roy*, Paris, 1668), *360*, 362–63; fig. 170
Poussin, Nicolas, 308, 309, 315, 347, 353, 354, 422, 425, 429
Poyntz, Francis, 182, 493
Poyntz, Thomas, 493
Pozzo, Cassiano dal, 112, 309, 329
Pretti, Mattia, 232
Pride of Niobe (at Knole House), 42
Primaticcio, Francesco, 12, 142, 148
privileges granted tapestry makers, 18, 75, 87, 124, 128, 134, 343, 408, 411, 428, 467, 458, 475, 487
Procession of the Feast of Corpus Christi outside the Palais Royal, Paris, June 12, 1648 (etching by Stefano della Bella), *113*, 116; fig. 53
Procession of the Reliquary of Saint Geneviève in Paris from Notre-Dame to the Abbey of Saint-Geneviève (engraving by Jean Le Pautre), *499*; fig. 225
processions, use of tapestries in, *113*, 114–17, *115*, 226, 230, 232, 284, *499*
Prosopographia (Galle), 219
Protasius, saint. *See Story of Saint Gervasius and Saint Protasius*
Proverbs (1646–47) (designs by Jacob Jordaens) (woven by Baudouin van Beveren, Brussels), *208*, 212
 As the Old Sing, so Pipe the Young (at Hluboká Castle), 203, *204*; fig. 99
Psyche. See entries at *Story of Psyche*
public display of tapestries, 263, *264*, *499*, 504
Pugnae ferarum, 217
Pulzone, Scipione, 264
Puttini (ca. 1540–45, for Ercole Gonzaga) (designs by Giulio Romano) (woven by Nicolas Karcher, Mantua), 181, 404
 Barque of Venus (in Lisbon), 404
Puttini series (ca. 1550s, for Gonzaga family) (woven in workshop of Willem de Pannemaker, Brussels), 181
Pypelinckx, Hendick and Dionysus, 73

Q

Qing dynasty, 434–39. *See also Story of the Emperor of China*
Queen Christina Dining with Clement IX, December 9, 1668 (drawing by Pierre Paul Sevin), *109*, 111, 328; fig. 50
Queen Christina's Abdication, June 6, 1654 (engraving by Willem Swidde after Erik Dahlberghe), *109*, 328; fig. 49
Queen of Sheba tapestries (woven at Mortlake), 172
Queen's Entry into Douai (painting by Adam Frans van der Meulen, *383*, *386*, 404n13; fig. 178
Queens of Persia at the Feet of Alexander (painting by Charles Le Brun), *346*; fig. 162
Quellinus, Erasmus, 494
Quinault, Philippe, 346

R

Racine, Jean, 369
Raes, Frans, 204
Raes, Jan, I, 59, 212
Raes, Jan, II
 Medici workshop products and, 267
 in Netherlandish tapestry industry

1600–1620, 72, 73, 87, 88, 90, 92, 93, 95, 97, 104–5
 after 1625, 204, 212, 213, 229–30, 231
Raes, Jan, III, 105
Raet, Jan, 213
Raimondi, Marcantonio, 402
Raleigh, Walter, 23, 42, 47
Rambouillet, Madame de, 144
Raphael. *See also* at *Acts of the Apostles*
 Barberini manufactory and, 293, 299, 314
 Charles I's paintings, dispersal of, 335
 court life, tapestries in context of, 111, 113
 Gobelins manufactory and, 347, 350, 353, 382, 397–404
 Grotesques of Leo X, 353, 397, 400–404
 Maincy workshops and, 343
 Medici manufactory and, 264, 267, 271
 Mortlake tapestry works and, 171, 175, 176, 184, 192, 195, 331
 neo-Baroque references to, 449, 502
 Netherlandish tapestry industry and, 6, 8, 11, 70, 72–75, 95, 96, 104
 Pope Julius II della Rovere (painting), 265
 Rubens and, 70, 72–75, 208, 229
 Vatican Stanze and Loggia, 271, 347, 353, 401, 402, 427, 430
Redemption of Man (ca. 1500–1502, 10-piece gold-woven set purchased by Henry VII of England) (woven in southern Netherlands, probably Brussels): *Creation* (in Narbonne), 337, *338*; fig. 155
Reformation. *See also* Counter-Reformation
 disruption of Netherlandish tapestry industry by. *See under* Netherlandish tapestry industry
 Grotesques of Leo X and, 404
Regelbrugge, Abel, 212
Regina, saint. *See Life of Saint Regina*
religious symbolism attributed to animals, 88
Reni, Guido, 92
Return from the Christening (etching by Abraham Bosse), *117*; fig. 57
Revel, Gabriel, 365
Revenge. See Last Fight of the Revenge
Review of the Troops at Barcelona. See Conquest of Tunis
revocation of Edict of Nantes (1685), 499–501
Reydams, Hendrik, I, 205, 212, 213, 238, 243–44, 252
Reydams, Hendrik, II, 483, 488
Reyff, Johannes de, 488
Reymbouts (Reynbouts), Maarten, 25–27, 54, 57–59, 68, 69, 71, 73
Rich, Henry, Earl of Holland, 178, 179, 182
Richelieu, Armand Jean du Plessis, cardinal, 151, 160, 206, 308, 329, 331, 332, 341, 422, 429
Rijn, Rembrandt van, 254
Rinaldo and Armida. See entries at *Story of Rinaldo and Armida*
Rinceaux, 137
Rinieri, Christofano, 263
Ripa, Cesare, 248, 320
Riviera, Caterina della, 272, 295, 300, 319
Riviera, Giacomo della (Jacob van den Vliete), 295, 296, 297, 298, 299, 304, 309, 319, 323
Riviera, Maria Maddalena della, 295, 300–302, 315, 319, 323
Rocci, Gaspare, 295, 297, 299, 300, 309
Roche, saint, 123
Rococo, 274, 354, 402, 452, 482, 504–6
Rohan, Armand Gaston de, 160
Romanelli, Giovanni Francesco (il Viterbese), 113, 118, 215–16, 272, 299–300, 309, 310–14, 315, 318, 442
Romanelli, Urbano, 302
Rome, tapestry weaving in. *See* Barberini manufactory, Rome
Rondinelli, Francesco, 268
Rosi, Alessandro, 273, 274

Rosi, Giovanni, 269
Rosier, Hans, 85
Rosselli, Matteo, 290
Rossi, Alessandro, 273
Rost, Giovanni, 263
Rost, Jan, 17, 84, 263, 288
Rovere, Vittoria della, 265, 271, 288
royal life. *See* court life, tapestries in context of
Royal Palaces (also known as *Months*, or *Royal Residences*) (ca. 1670–80) (designs and cartoons by Charles Le Brun and associates) (woven at Gobelins manufactory, Paris), 341, 345, 350, 492
 cartoons, 350
 Month of December (Château de Monceau) (in Paris), *349*, 350; fig. 165
Rubens, Peter Paul
 artistic interest in tapestry design, 330
 Cortona and, 297
 court life, role of tapestries in, 113, 119
 on difference in evaluating tapestries and paintings, 329
 Le Brun and, 347
 Maincy workshops and, 343
 Mortlake tapestry works and, 174, 194
 Netherlandish tapestry industry, influence on
 in late 16th and early 17th centuries, 57, 64, 73–75, 92, 95–99, 102–4
 Spanish Netherlands, 1625–60, 203, 204, 207–8, 210, 213–15, 234, 236, 237, 244, 252
 in late 17th and early 18th centuries, 449, 465, 495
 Paris workshops and, 128, 129, 155–63
 Philip IV's collection of paintings of, 327
 Raphael and, 70, 72–75, 208, 229
 tapestry cartoons. *See* entries at *Story of Achilles; Story of Constantine; Story of Decius Mus; Triumph of the Eucharist*
Rudolf II (Holy Roman Emperor), 23
Ruette, Claude de la, 108
Russia, Saint Petersburg workshop established by Peter the Great in, 506
Rutland, countess of, 193, 200

S

Sabatini, Francisco, 230
Sacchi, Andrea, 115, 117, 146, 271
Sack of Antwerp from *Events in the History of the Netherlands, France, Germany, and England between 1535 and 1608* (engraving by Frans Hogenberg), *20*; fig. 22
Sacrifice at Lystra. See entries at *Acts of the Apostles*
Sagrestani, Giovanni Camillo, 273–74
Saint-Aignan, François de Beauvillier, duc de, 376, 378
Saint-André, Simon Renard de, 381
Saint-Évremond, Charles de, 333
Saint Genevieve, 499
Saint George, tapestry depicting, 111
Saint Gervasius. *See Story of Saint Gervasius and Saint Protasius*
Saint Jerome in His Study (painting by il Cigoli), 286
Saint John the Baptist Preaching in a Landscape (painting by Karel van Mander the Elder), 40
Saint John the Baptist, tapestries depicting. *See* entries at *Story of Saint John the Baptist*
Saint John of Jerusalem, Knights of (Knights of Malta), 232, 390, 451
Saint Michael, Order of, 398, 422, 425
Saint Paul. *See* entries at *Acts of the Apostles; Story of Saint Paul*
Saint Petersburg, workshop established by Peter the Great at, 506
Saint Protasius. *See Story of Saint Gervasius and Saint Protasius*
Saint Regina. *See Life of Saint Regina*

Saint Roche, 123
Saint-Simon, Louis de Rouvroy, duc de, 379
Saint Stephen. *See Stoning of Saint Stephen; Story of Saint Stephen*
Saint Ursula, 135–36
Saints Crispin and Crispinian, 135
Salazar, Luis de Velasco, count of, 57
Salisbury, Robert Cecil, Earl of, 68, 80
Sallaert, Anthonis, 203, 209–12, 441, 444, 464
Salomon, Bernard, 196, 201
Salviani, Ippolito, 88
Salviati, Francesco, 13, 263, 267, 269, 288, 290
Samson. See entries at *Story of Samson*
San Michele a Ripa workshops established by Clement XI, 506
Sandford, Francis, 498
Sandys, George, 196–97
Sapphira, Death of. See entries at *Acts of the Apostles*
Sarto, Andrea del, 269, 272
Sauval, Henri, 89, 123
Sauvoye, Benoît de, 168
Savonnerie manufactory, 491
Savoye, Benoît de, 168
Scanian War Against the Swedes (ca. 1663–98) (cartoons by Anton Steenwinckel and others) (woven in Copenhagen under Berent van der Eichen), 493–94
Scenes from Ovid's Metamorphoses. See at *Story of Diana*
Scenes of Country Life (ca. 1635, 8-piece set) (designs and cartoons by Jacob Jordaens and workshop) (woven in workshop of Conrad van der Bruggen, Brussels)
 Horsemanship tapestries and, 244
 A Huntsman Resting with His Hounds
 drawing (Jacob Jordaens), 237
 tapestry (in Vienna), 234
 Lute-Playing Cavalier with His Lady (in Vienna), 234, 238
 Maid Feeding Chickens (in Vienna), 234, 238
 Maidservant with a Basket of Fruit
 preparatory drawing, *236*, 237; fig. 112
 tapestry (in Vienna), 208, **234–40**, *235, 238, 239*; cat. no. 25
 related sets, 237, 238
 Return from the Hunt
 drawing (Jacob Jordaens), 237
 tapestry (in Vienna), 234
 Triumph of the Eucharist, influence of, 234, 236, 237
 Woman Carrying Fruit (in Vienna), 234, 238
Scenes of the Passion (1634–47) (woven by Tobias Schaep), 47
Schaep, Tobias, 47, 259
Schardt, Johann Gregor van der, 28
Schaumburg, Ernst von, Graf, 21
Schoonewal, Noël de Caron, seigneur of, 80
Schoonhoven, tapestry weaving in, 259–60
Schoor, Lodewijk van, 273, 445, 488, 495
Schriver, Peter, 178
Schuppen, Pierre-Louis van, 333, 345
Schut, Cornelis, 209, 210, 268
Schwarzenberg, Johann Adolf von, Count, 203, 441
Scipio Africanus (Publius Cornelius Scipio), 76. *See also* entries at *Deeds and Triumphs of Scipio; Deeds of Scipio; and Story of Scipio*
Scipio Africanus in Exile (1630, overdoor) (woven in Medici workshops, Florence), 268
Scipio Africanus in Exile in Liternum Receiving Homage from the Corsairs (cartoon by Cornelis Schut), 268
Scott, John Beldon, 312
Scudéry, Georges de, 460
Seaports (ca. 1690s) (designs by Jacques de Kerkove and Adrien Campion) (woven at Beauvais under Philippe Behagle), 412
Seasons (1545–48) (tapestry designs by Francesco Salviati and Giovanni Stradano), 267, 288
 sets woven (1603–35) in Medici workshops, Florence, 265, 267, 268, 288

sets woven (first half of 17th century) in workshops of Jan Raes II and Jacques Geubels II, Brussels, 267
Seasons and Hours (1640–44, 13-piece set with gold) (designs and cartoons by Lorenzo Lippi and Iacopo Vignali) (woven in Medici workshops, Florence): *Chariot of the Sun*, 268, 269, **287–91**, *288*; fig. 129
Seasons and Hours (1643–45, 13-piece set) (designs and cartoons by Lorenzo Lippi and Iacopo Vignali) (woven in Medici workshops, Florence): *Chariot of the Sun* (in Florence), 269, **287–91**, *289*; cat. no. 34
Sec, Michel le, 123
Segni, Fabbio, 82
Seignelay, Jean-Baptiste Colbert, marquis de, 420, 424
Seriacopi, Girolamo, 280, 284
Servien, Abel, 336–37
Sève, Pierre de, 374, 381, 383
Seven Deadly Sins (ca. 1533–34) (designs by Pieter Coecke van Aelst), 8
Seven Deadly Sins (ca. 1540s, gold-woven set) (designed and woven by Pieter Coecke van Aelst, Brussels), 107, 111
Seven Liberal Arts (ca. 1650 and later) (designs by Cornelis Schut after Peter Paul Rubens) (woven in workshop of Carolus Janssens, Bruges), 209, 214
 Consequences of War (in Lausanne), 209, *210*, 214; fig. 106
 Geometry (at Vatican), 209, *210*, 214; fig. 105
Seven Liberal Arts (etchings), 200
Sevin, Pierre Paul, 109
Shakespeare, William, 460
Sheldon, William, and Sheldon tapestries, 19, 21
Shen Fu-Tsung, Michael Alphonus, 434, 437
Shirley, James, 119
Siege of Bouchain. See Victories of the Duke of Marlborough
Sigismund II Augustus, king of Poland, 12, 88, 90
Signing of the Peace of Breda, 1667 (engraving by Romeyn de Hooghe), *328*; fig. 149
silk, as tapestry fiber, 4
Silvestre, Louis de, 384
Sinzendorf, Philippe Louis Wenzel, Count, 469, 471, 475
Sir Francis Drake Takes de Valdez's Galleon, and the Bear and Mary Rose Pursue the Enemy (engraving after a Delft tapestry from a set of the *Story of the Spanish Armada* by John Pine), 23–24, *24*; fig. 25
Sistine Chapel, use of tapestries in, 264, 276–80, 282, 284, *298*, 298–99, 310. *See also Acts of the Apostles* (ca. 1517–19, 10-piece set commissioned by Leo X)
Sixtus IV, pope, 186
Sixtus V, pope, 90, 92, 143
small Diana series, 254
small figure genre, 25–26, 43, 47, 48, 315, 500–501, 504
Small Hunts (1684–1705) (woven at Beauvais under Philippe Behagle): *Stag Hunt* (at Château d'Azay-le-Rideau), 411–12, *412*, 492; fig. 186
Small Indies. See at *Old Indies*
Smet, Frans de, 28
Snellinck, Jan, the Elder, 27, 54, 56, 58–59, 257, 258
Snouckaert van Schauburg, Nicolaas, 66
Sodoma (Giovanni Antonio Bazzi), 369
Soissons, Marie de Bourbon, comtesse de, 151, 152
Solebay, Battle of. See Defeat of the Dutch at the Battle of Solebay
Solinus, 88
Solomonic columns, 208, 216, 217, 219, 226, 229, 267
Somer, Paul van, 493
Somerset, Duke of, 117
Somerset House Conference, August 19, 1604 (painting by unknown artist), *110*, 111, *328*; fig. 51
Sophie of Mecklenburg-Schwerin, queen of Denmark, 33, 34
Sophie-Charlotte, queen of Prussia, 501
Souet, Jean, 400
Spagna, Arcangelo, 302, 303
Spagna, Paolo, 272, 300

Spain
court life, tapestries in context of, 107–9, 110–11, 112,
113
in Netherlands. *See* Netherlandish tapestry industry
tapestry workshops in, 75, 88, 506
Spanish Inquisition, 18
Spanish Succession, War of (1701–14), 418, 425, 466, 471,
480, 482
Speciano, Cesare, 26
Spiering, Aert, 67, 253, 254
Spiering, François (Frans Spierincx), 21–24, 26–27, 33,
36, 41–42, 43, 45, 47, 52, 53, 64–67, 76–79, 86, 114,
254
Spiering, Isaac, 254
Spiering (Spierincx), Pieter, 446–47
Spiering, Pieter (Pieter Spierinck-Silfvercrona), 67, 79,
253, 254
Spiljeurs, Nicolaes, 259
Spinola, Giovanni Stefano, 204
Spiringkh, Wilhelm, 86
Spranger, Bartholomeus, 23, 26
Squilli, Benedetto, 263
Stalrauber, Franciscus, 85
Steen, Jan, 496
Steen, Paul van den, 178
Steenwinckel, Anton, 494
Stella, Jacques, 115, 137
Stephen, saint. *See* Stoning of Saint Stephen; Story of Saint
Stephen
Stoning of Saint Stephen (painting by il Cigoli), 286
Stories of Apollo (1650–63) (designs by Clemente Maioli)
(woven in Barberini workshop under Maria
Maddalena della Riviera, Rome), 301, 314, **315–19**,
317, 318
Apollo and Daphne (in Lausanne), 301, **315–19**, *317*;
cat. no. 37
Latona Changing the Lycian Peasants into Frogs (in
Lausanne), *318*; fig. 143
Story of Abraham (ca. 1541–43, for Henry VIII) (designs
attrib. to Pieter Coecke van Aelst) (woven in work-
shop of Willem de Kempeneer, Brussels), 111, *334*,
335, 497, *498*
Circumcision of Isaac and the *Expulsion of Hagar and
Ishmael* (at Hampton Court), 111, *334*, 335; fig. 152
Story of Abraham (designs by Michel Corneille), 131
Story of Achilles (before 1642) (designs by Peter Paul
Rubens) (woven by Daniël Eggermans, Brussels),
174, 208, 462
cartoons and related sets, 213
Wrath of Achilles (in Rotterdam), *207*, 441; fig. 102
Story of Achilles (ca. 1656) (after designs by Rubens)
(woven in workshops of Jan or Frans Raes,
Brussels), 204, 213
Story of Achilles (ca. 1728) (designs by Jan van Orley and
Augustin Coppens) (woven in van der Borcht
workshop, Brussels) (in Paris), 452, 488
Story of Adonis (designs by Simon Vouet), 130
Story of Alexander (ca. 1560s) (designs by Michiel Coxcie)
(woven by Adrian Bloomaert, Brussels), 369
Story of Alexander (ca. 1610–20) (design based on cartoons
ca. 1550 from circle of Michiel Coxcie) (woven in
Geubels–Van den Eynde and Raes workshops,
Brussels), 73, 203
Story of Alexander (ca. 1617–19) (designs and cartoons by
Karel van Mander II) (woven in workshop of Karel
van Mander II, Delft): *Alexander and Jaddua* (in
Amsterdam), 65, 66, 78; fig. 35
Story of Alexander (ca. 1628–30) (designs by Jacob
Jordaens) (woven in workshop of Jacques Geubels
II, Brussels): *Alexander Wounded at the Battle of Issus*
(in Milan), 208, *209*; fig. 104
Story of Alexander (1651) (designs by Agostino Melissi)
(woven in Florence workshop of Pietro Févère), 270

Story of Alexander (ca. 1660–80) (designs by Francis
Clein) (woven at Mortlake) (border formerly used
for *Horses* tapestries): *Flight of Darius* (in Winnipeg),
198; fig. 97
Story of Alexander (1680–87, 5-piece set) (designs by
Charles Le Brun) (woven in Gobelins workshop of
Jean Jans the Younger, Paris), 345, 347–49, **365–72**,
366–71, 373
accompanying publications, 363, 371–72
Battle of Arbela (painting by Charles Le Brun), *347*;
fig. 163
Battle of the Granicus
engraving (Girard Audran), 371–72
Group of Warriors (study by Charles Le Brun), *368*;
fig. 173
painting (Charles Le Brun), *369, 370*; fig. 174
preparatory drawing (Charles Le Brun), *368*; fig. 172
tapestry (cartoon by Louis Licherie), *340, 347*, **365–
72**, *366–67, 370, 373*, 491; cat. no. 40, fig. 157
Defeat of Porus (or *Porus before Alexander*) (painting by
Charles Le Brun), 347
Queens of Persia at the Feet of Alexander (painting by
Charles Le Brun), *346*; fig. 162
related sets, 365, 371, 425, 442, 492, 495
Story of Alexander (14-piece set purchased by Alessandro
Montalto) (woven in Brussels), 92, 93
Story of Amadis of Gaul, popularity among nobility as
tapestry subject, 119
Story of Amadis of Gaul (ca. 1590–95, 6- or 7-piece set)
(designs attrib. to Karel van Mander the Elder)
(woven by François Spiering, Delft), 23, **36–43**
Liberation of Oriane (in New York), **36–43**, *37, 40, 41*, 47;
cat. no. 2
*Oriane Passing the Magical Love Tests in the Magician's
Enchanted Garden* (modello attrib. to Karel van
Mander the Elder), **36–43**, *39*, 47; cat. no. 3
Story of Amadis of Gaul (ca. 1590–1600) (designs by Karel
van Mander the Elder) (woven by François
Spiering, Delft)
Amadis Bidding Farewell to Oriane (in Milan), 38
Amadis Dueling with King Abies of Ireland and *Oriane
with the Magic Jewels of Macadon* (in Epinay), 38
Knights of Léonorette (in Rome), 38, 42
Liberation of Oriane (in Milan), 38
*Oriane Passing the Magical Love Tests in the Magician's
Enchanted Garden* (at Knole House), 38, 42
*Oriane Passing the Magical Love Tests in the Magician's
Enchanted Garden* (in Princeton, N.J.), 38, *39*; fig. 29
Presentation of the Enchanted Lance (in London), 38, 42
Story of Artemisia, popularity of, 138
Story of Artemisia (ca. 1601–7, for Alessandro Montalto)
(cartoons by Henri Lerambert and Toussaint
Dubreuil after Antoine Caron's drawings) (woven in
Louvre and Faubourg Saint-Marcel workshops,
Paris), 92, 124–26, 138
Story of Artemisia (ca. 1611–27) (woven in Faubourg
Saint-Marcel workshop, Paris), 118, *140–41*, **140–47**,
143–45, 150, 158
additional tapestries and sets based on, 144–46
Coronation Sacrifice, 146
Gifts, 146
Heralds on Horseback, 146
Riding Lesson
drawing (Antoine Caron), 52, *143*; fig. 74
tapestry (cartoon by Laurent Guyot after drawing by
Antoine Caron) (in Minneapolis), 118, *140–41*,
140–47, *145, 150*; cat. no. 12
Triumphal Scene (in Paris), *144*; fig. 75
Story of Artemisia (ca. 1627) (woven in Faubourg Saint-
Marcel workshop, Paris), 137
Story of Astrée, 62
Story of Caesar (ca. 1660–80) (designs and cartoons by
artist tentatively identified here as Charles Poerson)

(woven in workshop of Jean or Hieronymus Le
Clerc, Brussels), 442, **459–65**, *460–64*
Caesar Crowned by Fame (in Vienna), 442, **459–65**, *461–
63*, 495; cat. no. 54
related sets, 459, 460–62
Victory at Pharsalus (in Vienna), *460*; fig. 212
Story of Caesar (ca. 1680) (designs by Justus van Egmont)
(woven in workshop of Jan van Leefdael or
Gerard van der Strecken, Brussels), 460–62, *464*,
465
Victory at Pharsalus (in Chicago), *460, 464*; fig. 213
Story of Cleopatra (1601, for Henry Brook, Lord Cobham)
(woven by François Spiering, Delft), 47
Story of Cleopatra (1607) (tapestry sets woven in work-
shop of Catherine van den Eynde), 68
Story of Cleopatra (ca. 1623) (designs by Karel van Mander
the Younger), 67
Story of Cleopatra (ca. 1650) (designs by Justus van
Egmont) (woven in Brussels), 213, 441, 465
Story of Cleopatra (ca. 1650–60) (designs by Charles
Poerson) (woven in Le Clerc workshop, Brussels)
(in Lyon), 441, 442, 464–65
Story of Cleopatra (after 1668, 14-piece set) (woven by
Gerard Peemans, Brussels)
Cleopatra with Caesar and *Cleopatra with Anthony* (in
Chicago), 209, 213
Story of Clovis (cloth of state at Windsor Castle, part of
throne canopy looted from French royal collection
by Duke of Bedford in 1420s, sold as part of estate
of executed Charles I), 112, 334
Story of Clovis (ca. 1650–60) (designs by Charles Poerson)
(woven by Jacob van der Borcht, Brussels) (in
Brussels), 441, 442, 464–65
Story of Constantine (1607) (woven in workshop of
Willem Tons, Brussels), 68
Story of Constantine (1622–25, 7-piece set given by Louis
XIII to Francesco Barberini) (designs by Peter Paul
Rubens) (woven in the workshop of François de
La Planche and Marc de Comans, Paris) (in
Philadelphia), 118, 155, 293, 304, 308
Story of Constantine (ca. 1623–27, 6-piece set) (designs by
Peter Paul Rubens, border designs attrib. to Laurent
Guyot) (woven in Faubourg Saint-Marcel work-
shop, Paris) (in Vienna), 97, 113, 128, 137, **155–63**,
156–62, 207, 330, 343
Battle of the Milvian Bridge
modello, *158*, 158–59; fig. 79
tapestry, *122*, **155–63**, *156–57, 159, 161, 162*, 208, 304;
cat. no. 14, fig. 60
Constantine Defeating Licinius, 160
related sets, 160, 160–61
Rome Triumphant, 155, 158
Story of Constantine (1630–41, 5 pieces plus baldachin
with dossal to complement Francesco Barberini's
7-piece Paris set) (designs and cartoons by Pietro da
Cortona) (woven in Barberini workshop under
Giacomo della Riviera and Gaspare Rocci, Rome),
270, 293, 295–99, **304–10**, *305–7, 312*, 322
Constantine Fighting the Lion
cartoon, *306*, 309; fig. 141
tapestry (in Philadelphia), 118, 270, *292*, **304–10**, *305,
307, 312*; cat. no. 35, fig. 130
Sea Battle between the Fleets of Constantine and Licinius
(in Philadelphia), *297*; fig. 134
Story of Constantine (ca. 1650) (designs by Peter Paul
Rubens) (woven in Faubourg Saint-Germain work-
shop of Raphaël de La Planche, Paris): *Battle of the
Milvian Bridge* (in Paris), 160, *161*; fig. 80
Story of Constantine (1658–62) (designs by Charles Le Brun)
(first two pieces woven at Maincy, rest in Gobelins
workshop of Jean de La Croix, Paris): *Marriage of
Constantine* (before 1667), 343, *344*; fig. 160
Story of Coriolanus, 62

Story of Coriolanus (before 1606, for Alessandro Montalto) (designs by Henri Lerambert, after Maurice Dubout) (woven in the workshop of François de La Planche, Paris) (in Paris): *Coriolanus Ejects the Councillors*, 124–25, *125*; fig. 61

Story of Cosimo I (1655–56) (cartoons by Giacinto Gimignani, Vincenzo Dandini, Cosimo Ulivelli, and Agostino Melissi) (woven in workshop of Giovanni Pollastri and Bernardino van Asselt, Florence), 269, 270–71, *271*

 Coronation of Johanna of Austria (in Florence), *271*; fig. 123

Story of the Creation (after 1540) (designs by Pieter Coecke van Aelst), 8

Story of Cyrus (ca. 1560) (designs by Michiel Coxcie and collaborators) (woven in Brussels workshop of Jan van Tieghem)

 Creso Is Taken Prisoner (at Palacio Real de Aranjuez), *19*, 20; fig. 21

 related sets, 443

Story of Cyrus (1603, for Maximilian I of Bavaria) (woven in Antwerp), 82

Story of Cyrus (ca. 1630) (after designs by Michiel Coxcie) (woven in Brussels), 443

Story of Daphne (designs by Michel Corneille), 131, 133, 138

Story of David (ca. 1526–28, purchased by Henry VIII of England) (woven in Brussels): *Assembly of the Troops* (at Château d'Écouen), 337, *338*; fig. 156

Story of David (1571–73) (designs by Nicolaas van Orley) (woven in workshop of Jacob de Carmes, Stuttgart): *David with Goliath's Head* (in Vienna), 18

Story of David (1579, 12-piece set for King Frederick II of Denmark) (woven in Hans Knieper's Helsingør workshop), 32

Story of David (ca. 1610–20) (cartoon by David Vinckboons) (woven in workshop of François Spiering, Delft): *Triumph of David* (in London), 64–65, 67; fig. 34

Story of Decius Mus (1620–29, 8-piece set, "Decio de Oro") (designs by Peter Paul Rubens) (woven in workshops of Jan Raes II and Jacques Geubels II, Brussels), 73–74, **95–105**, *97–103*, 158, 160, 207, 208, 226, 230, 267, 330; cat. nos. 10, 11

 Battle of Veseris and the Death of Decius Mus

 cartoon, 96, 100, *102*; fig. 45

 modello, 96, 100, *102*; fig. 44

 preliminary drawing, 100

 tapestry (in Washington), **95–105**, *100–103*, 105, 226, 230; cat. no. 11

 borders, 96–97

 cartoons and modelli, 73–74, 95, 96, 100–104, *102*

 "Decio en Lana" set (in Madrid), 95, 104

 Decius Mus Consults the Oracle

 cartoon, 100, 104

 modello, 100

 tapestry (in Madrid), **95–105**, *97–99*, 104, 105, 226, 230; cat. no. 10

 Decius Mus Dismisses the Lictors, cartoon, 100, 104

 Decius Mus Relates His Dream to His Officers, cartoon, 100, 104

 Funeral Obsequies of Decius Mus, cartoon, 100, 104

 Marcus Valerius Consecrated Decius, cartoon, 100, 104

 panels in Liechtenstein collection, 99

 related sets, 105, 213, 214, 215

 Titus Manlius Presenting the Roman Senators with Plunder, 100, 104

 Virtus Romana and Honor, cartoon, 100

 War Trophy, cartoon, 100

Story of Decius Mus (bequeathed by Archduke Leopold Wilhelm to Archduke Karl Joseph) (after designs by Rubens), 203

Story of Diana (ca. 1550, for Diane de Poitiers) (designs attrib. to Jean Cousin the Elder) (woven in Paris) (in New York, Rouen, Écouen), 123, 147, 148, 153, 154n10

Apollo and Diana Slaying the Children of Niobe (drawing by unknown 16th-century artist), 148, *150*; fig. 76

Story of Diana (ca. 1595, commissioned by Walter Raleigh; also called *Scenes from Ovid's Metamorphoses*) (designs by Karel van Mander the Elder) (woven in the Spiering workshop, Delft) (in Amsterdam, at Knole House), 23, 41, 47

 Diana and Acteon, 42

 Story of Cephalus and Procris (in Amsterdam), *22*, 23, 41, 47; fig. 24

 Story of Meleager and Atalanta (ex-Coty Collection), 47

Story of Diana (ca. 1610s, for Philip IV) (woven in Paris), 203

Story of Diana (ca. 1613, 6-piece set, for Elizabeth, daughter of James I) (woven by François Spiering, Delft), 47, 66, 254

Story of Diana (1613) (woven by Catherine van den Eynde and Jan Raes II, Brussels), 73

Story of Diana (ca. 1619, 10-piece set for Gustav II Adolph of Sweden) (designs by David Vinckboons) (woven in Spiering workshops, Delft), 254

Story of Diana (1620–35, 8-piece set) (designs and cartoons attrib. to Toussaint Dubreuil and/or Henri Lerambert, 1600–1606) (woven in Faubourg Saint-Marcel workshop, Paris), 62, 117–18, 125, **147–54**, *149, 152–54*

 Assembly of the Gods, 148, *150*, 153

 Blasphemy of Niobe (in Vienna), 148, *151*, 152–53; fig. 78

 Diana and Apollo Slaying the Children of Niobe (in Vienna), 62, 117–18, **147–54**, *149, 152–54*; cat. no. 13

 Diana the Huntress with Her Hounds, 150, 153

 Drowning of Britomartis, 148, 153

 Latona Giving Birth, 150, 152, 153

 Latona Transforming the Lycian Peasants into Frogs, 148, *151–52*

 related sets, 150–53

Story of Diana (ca. 1625–30, for comtesse de Soissons) (designs by Toussaint Dubreuil) (woven in Faubourg Saint-Marcel workshop, Paris): *Blasphemy of Niobe* (in Turin), *151*, 152; fig. 77

Story of Diana (1631–33) (woven by Frans de Moor, Oudenaarde), 214

Story of Dido and Aeneas (1679) (designs by Giovanni Francesco Romanelli) (woven by Michiel Wauters, Antwerp), 215–16, *314*, 442, 446

 Dido Shows Aeneas the Plans for the Fortifications of Carthage (in Cleveland), *215*; fig. 109

Story of Dido and Aeneas (designs by Michel Corneille), 131, 133

Story of Dido and Aeneas (from cartoons purchased in Flanders) (woven at Mortlake), 182

Story of Don Quixote (ca. 1714) (designs by Jan van Orley and Augustin Coppens) (woven in Leyniers workshop, Brussels), 452, 488

 Tossing of Sancho Panza, *451*, 452; fig. 209

Story of Don Quixote (ca. 1725) (designs by Philippe de Hondt) (woven in van der Borcht workshop, Brussels) (in Vienna), 452, 482

Story of the Emperor of China (ca. 1697–1706, 10-piece set) (designs by Guy-Louis Vernansal, Jean-Baptiste Monnoyer, and Jean-Baptiste Belin de Fontenay) (woven at Beauvais under Philippe Behagle), 425, 426, 430, **434–39**, *435, 437, 438*

 Astronomers, 434, 436

 Audience of the Emperor (in Paris), *413*, *414*, 434, 436; fig. 188

 Collation (in Los Angeles), *412–13*, 416, 418, 424, **434–39**, *435, 437, 438*; cat. no. 52

 Emperor Sailing, 424, 434, 439

 Jesuit missionaries in China and, 434, 436, 437, 438

 Return from the Hunt, 434, 437, 438, 439

Story of the First Parents (ca. 1545–50) (designs by Michiel Coxcie and collaborators) (woven in Brussels): *Creation and Fall of Man* (in Kraków), *10*, 11; fig. 13

Story of France (ca. 1627) (woven in Faubourg Saint-Marcel workshop, Paris), 137

Story of Gideon (ca. 1440s, for Philip the Good) (woven in Brussels), 110

Story of Gideon (12-piece set of Netherlandish tapestries purchased from estate of Giovanni Battista Guidobon Calvachino, baron of Liechtenberg, by Maximilian I in 1603), 82

Story of Gombaut and Macée (before 1627) (designs by Laurent Guyot after 16th-century engravings) (woven in Faubourg Saint-Marcel workshop of François de La Planche, Paris) (in Paris), 62, 137

 Ball Game, *127*; fig. 63

Story of Hannibal (purchased by Maximilian I, elector of Bavaria), 82

Story of Hannibal (ca. 1605–6, among sample tapestries and designs for Robert Cecil, Earl of Salisbury, and Thomas Howard, Earl of Suffolk), 68

Story of Jacob (ca. 1532, for Willem de Kempeneer) (designs by Bernaert van Orley) (woven in Brussels), 7

Story of Jacob (ca. 1605–6, among sample tapestries and designs for Robert Cecil, Earl of Salisbury, and Thomas Howard, Earl of Suffolk), 68

Story of Jacob (mid-17th-century remake after designs by Bernaert van Orley) (woven by Jan Raes and Jacob van Zeunen, Brussels), 205

Story of Joseph (1548–49) (designs by Agnolo Bronzino and collaborators) (woven in workshop of Nicolas Karcher, Florence), 280

 Joseph Flees from Potiphar's Wife (in Florence), 13, *14*; fig. 17

Story of Joseph (1652, combined with floral design on table carpet, based partly on prints attrib. to Jan Snellinck the Elder and on a print after Michiel Coxcie) (woven in northern Netherlands) (in Amsterdam), 257–58; cat. no. 30

Story of Joseph (1718) (designs by Jan van Orley and Augustin Coppens) (woven in Leyniers–Reydams workshop, Brussels), 488

Story of Joshua (1605) (tapestry sets woven in workshop of Catherine van den Eynde), 68

Story of Julius Caesar (ca. 1605–6, among sample tapestries and designs for Robert Cecil, Earl of Salisbury, and Thomas Howard, Earl of Suffolk), 68

Story of Meleager (ca. 1659) (designs by Charles Le Brun) (woven in Paris by Jean Jans, and in Brussels workshops), 342–43, *343*

 Hunt of Meleager and Atalanta (cartoon), *343*; fig. 159

 related sets, 442, *443*

Story of Meleager and Atalanta (ca. 1680) (designs by Charles Le Brun) (woven in workshop of Jan Leyniers II, Brussels): *Death of Meleager* (in Saint Petersburg), 442, *443*, 465, 495; fig. 200

Story of Moses (designs, 1545–50, attrib. to Giovanni Battista Lodi da Cremona) (woven in Brussels), 442

Story of Moses (ca. 1650–75) (designs by Charles Poerson) (woven by Jan Leyniers II, Brussels), 441, 442, 464

 Battle Against the Amalekites (ca. 1675) (in Milan), *464*; fig. 214

 Moses Saved from Drowning (ca. 1660) (in Richmond, Va.), 441, *442*; fig. 199

Story of Moses (mid-17th-century Flemish reweavings of designs attrib. to Giovanni Battista Lodi da Cremona), 205

Story of Moses (1652–53) (cartoon by Agostino Melissi) (woven in Medici workshop of Pietro Févère, Florence): *Crossing of the Red Sea* (in Rome), 270; fig. 122

Story of Moses (ca. 1660) (designs by Charles Poerson) (woven by Jan Leyniers II, Brussels), 441, *442*

Story of Moses (before 1687, second set, with gold) (after painting by Nicolas Poussin) (woven in Gobelins workshop of Jean Jans the Younger, Paris): *Gathering of Manna* (in Paris), *352*, 354; fig. 168

Story of Moses (ca. 1730) (designs by Jan van Orley and Augustin Coppens) (woven in van der Borcht workshop, Brussels) (in Vienna), 452

Story of Noah (ca. 1545–50) (designs by Michiel Coxcie and collaborators) (woven in Brussels) (in Kraków): *Noah's Sacrifice*, 11, *11*; fig. 14

Story of Noah (ca. 1563–66, for Philip II) (after designs by Michiel Coxcie) (woven in Brussels), 70, 93, 107, 111

Story of Noah (ca. 1600) (from second-generation cartoons after Michiel Coxcie's designs) (woven in workshop of Maarten Reymbouts, Brussels): *Noah's Sacrifice* (in Palma de Mallorca), *68*, 69–70; fig. 38

Story of Noah (1609–10, for Alessandro Montalto) (cartoons copied from those painted for set woven ca. 1563–66 for Philip II) (woven by Jan Raes II, Brussels), 93

Story of Noah (1613) (woven in workshops of Catherine van den Eynde and Jan Raes II, Brussels), 73

Story of Octavian (designs by Joost van Artsdael II) (in Vienna), 21

Story of Odysseus (ca. 1620s–30s) (designs by Jacob Jordaens), 236, 441, 462

Story of Odysseus and Circe (ca. 1675–1700) (designs by Pieter Ijkens and Pieter Spierincx) (woven by Jeremias Cockx and Cornelis de Wael, Antwerp), 446–47

Story of the Old Testament (before 1643, proposed 6-piece set for Louis XIII) (cartoon by Simon Vouet, with several collaborators) (woven in Louvre workshop of Girard Laurent, Paris), 113, 130, 138, **163–69**, *165–68*

 Daughter of Jephthah, 164, 165–66, *166*, 208; fig. 81

 Moses Rescued from the Nile (in Paris), **163–69**, *165*, *167*, 208; cat. no. 15

 related sets, 166–68

 Study of a Woman for *Moses Rescued from the Nile* (drawing by Simon Vouet), 164, *168*; fig. 82

Story of Orlando Furioso (1605–15, 4-piece set for Gustav II Adolph of Sweden) (designs by Karel van Mander the Younger) (woven in Spiering workshop, Delft), 64–66, 78, 254

Story of Orlando Furioso (1620, for Sir James Hay, Earl of Carlisle) (woven in Spiering workshop, Delft), 47

Story of Orlando Furioso (ca. 1630) (designs by unknown artist after Simon Vouet): *Zerbino Expires in the Arms of Isabella* (cartoon), *130*, 208; fig. 66

Story of Otto von Wittelsbach (1612–14, 11-piece set for Maximilian I, elector of Bavaria) (designs and cartoons by Peter Candid) (woven in workshop of Hans van der Biest, Munich): *Reception of the Greek Embassy* (in Munich), *62*, 63–64, *64*, 84, 85; figs. 31, 33

Story of Pastor Fido (1610) (designs by Laurent Guyot and Guillaume Dumée) (woven in Faubourg Saint-Marcel workshop of François de La Planche, Paris), (at Château de Chambord), 125–26, 130, 138, 142

 Silvio and His Dog, *126*, 130; fig. 62

Story of Pastor Fido (ca. 1627) (woven in Faubourg Saint-Marcel workshop, Paris), 137

Story of Perseus (ca. 1700) (designs by Lodewijk van Schoor) (woven in Brussels) (in Vienna), 445

Story of Perseus and Andromeda (ca. 1700) (designs attrib. to Pieter Ijkens and Pieter Spierincx) (woven in workshop of Jacob van der Goten, Antwerp): *Fight between Perseus and Phineus* (in Magdeburg), *446*, 447; fig. 203

Story of Phaeton (1609–12, 6-piece set for Alessandro Montalto) (cartoons by Alessandro Allori) (woven in Medici workshops, Florence), 93

Story of Psyche (1650) (designs based on a 16th-century Brussels series) (woven in Faubourg Saint-Germain workshop of Sébastien-François de La Planche, Paris): *Psyche at the Temple of Ceres* (in Paris), *133*; fig. 69

Story of Psyche (ca. 1685) (designs by Jan van Orley) (woven in Regensburg), 449, 487

Story of Rinaldo and Armida (1635–50) (designs by Simon Vouet) (woven in Faubourg Saint-Marcel workshop of Alexandre de Comans, Paris) (at Château de Chateaudun), 129–30, 138, 164, 165

 Sleeping Rinaldo Carried off by Armida and Her Servant, *129*; fig. 65

Story of Rinaldo and Armida (ca. 1701) (designs by Victor Janssens and Augustin Coppens) (woven by Albert Auwercx, Brussels), 449, 488

Story of Saint Gervasius and Saint Protasius (ca. 1660, for church of Saint Gervasius) (designs by Philippe de Champaigne, Sébastien Bourdon, and Eustache Le Sueur) (woven in Louvre workshop of Girard Laurent, Paris): *Saint Gervasius and Saint Protasius Appearing to Saint Ambrose* (in Paris), *135*, 136; fig. 72

Story of Saint John the Baptist (1637–39 and 1651, 2 pieces to complement 8-piece 16th-century set) (cartoons by Sigismondo Coccapani and Agostino Melissi) (woven in Medici workshops, Florence), 268

Story of Saint John the Baptist (1665–70, cartoons by Agostino Melissi after frescoes by Andrea del Sarto and Franciabiagio) (woven by Giovanni Pollastri and Bernardino van Asselt, Florence), 272

Story of Saint Paul (ca. 1529–30) (designs by Pieter Coecke van Aelst): *Conversion of Saul* (modello), 8, *9*, 73, 74; fig. 10

Story of Saint Paul (ca. 1613–24) (copied from designs by Pieter Coecke van Aelst) (woven in Nancy), 74

Story of Saint Paul (1614, for comte de Vaudémont, prince of Lorraine) (based on designs by Pieter Coecke van Aelst) (woven in workshop of Frans Sweerts, Brussels), 72–73

Story of Saint Stephen (1646, for church of Saint-Étienne-du-Mont) (designs by Laurent de La Hyre) (woven by Antoine Le Sueur and Pierre Laneron, Paris), 135–36

Story of Samson (ca. 1625, for Scipione Borghese) (cartoons by unidentified 16th-century Flemish artist, with borders by unidentified 17th-century artist) (woven in workshop of Jan Raes, Brussels): *Samson Betrayed by Delilah* (in Philadelphia), *69*, 71–72; fig. 39

Story of Samson (1627–29) (designs by Michelangelo Cinganelli) (woven by Jacopo van Asselt, Florence): *Destruction of the Palace of the Philistines and the Death of Samson*

 preparatory sketch, *266*, 266–67; fig. 120

 tapestry (in Florence), *266*; fig. 119

Story of Samson (1629, for Cremona Cathedral) (woven in Brussels), 116

Story of Scipio (ca. 1589–1621) (designs by Joost van Artsdael II) (in Vienna), 21

Story of Scipio (1604–8) (designs by Cornelis Schut) (woven in Medici workshops, Florence), 267–68

Story of Scipio (ca. 1610–20) (based on designs by Giulio Romano) (woven in Mattens workshop, Brussels) (in Madrid), 73

Story of Scipio (ca. 1610–20) (based on designs by Giulio Romano) (woven in Reymbouts workshop, Brussels) (in Madrid), 73

Story of Scipio (1612, set purchased by Alessandro Montalto) (cartoons by Giulio Romano) (woven in Brussels), 92, 93

Story of Scipio (ca. 1613, 8- or 10-piece set for Elizabeth, daughter of James I) (woven by Spiering workshop, Delft), 47, 66, 79, 80

Story of Scipio (ca. 1616–21) (designed by and woven in workshop of Karel van Mander the Younger), 66

Story of Scipio (ca. 1650–55, for Farnese family) (second-generation cartoons based on designs by Giulio Romano) (in Rome), 119

Story of Scipio and Hannibal (1614, for comte de Vaudémont, prince of Lorraine) (after designs by Giulio Romano) (woven in workshop of Frans Sweerts, Brussels), 72–73

Story of Scipio and Hannibal (ca. 1660–75) (based on designs by Giulio Romano and Giovanni Francesco Penni) (woven in Brussels), 442

Story of Tamerlan and Bajazet (ca. 1675–1700) (designs by Johannes Hoebraken) (woven in Antwerp), 446

Story of Tancred and Clorinda (ca. 1645–60) (designs by Michel Corneille) (woven in Faubourg Saint-Germain workshop, Paris): *Meeting of Clorinda and Tancred* (at Château de Châteaudun), *131*, 133; fig. 67

Story of Telemachus I (ca. 1700) (designs by Jan van Orley) (woven in Auwercx workshop, Brussels) (in Madrid), 449

Story of Telemachus II (ca. 1723) (designs by Jan van Orley and Augustin Coppens) (woven in Leyniers workshop, Brussels) (in Klosterneuburg), 452, 488

Story of Theagenes and Chariclea (designs by Simon Vouet), 130–31, 164

Story of Theseus (1638, for Philip IV) (designs by Anthonis Sallaert) (woven in Brussels), 203

Story of Titus and Vespasian (ca. 1650–60) (designs by Charles Poerson) (woven by Gerard Peemans, Brussels) (in Lausanne), 441, 442, 464–65

Story of Tobias (1626, bedcover) (design partly based on prints by Maarten van Heemskerck and Maarten de Vos) (woven in workshop of Pieter and Aert Spiering, Delft) (in Stockholm), 67, **253–57**, *255–57*; cat. no. 29

Story of Tobias (1647–48) (cartoon by Agostino Melissi) (woven in Florence workshop of Pietro Févère): *Archangel Raphael Leaving the House of Tobias* (in Rome), *269*; fig. 121

Story of the Trojan War (ca. 1472, for Charles the Bold) (woven in southern Netherlands, probably Tournai), 5

Story of the Trojan War (ca. 1480–90) (woven in the southern Netherlands, probably Tournai): *Death of Troilus, Achilles, and Paris* (in Zamora), 5, 72; fig. 5

Story of the Trojan War (1488, purchased by Henry VII of England from Pasquier Grenier), 5, 334

Story of the Trojan War (1605) (woven in workshop of Catherine van den Eynde, Brussels), 68

Story of the Trojan War (ca. 1609–15, 8-piece set, for Albert of Austria) (woven in workshop of Maarten Reymbouts II, Brussels), 59

Story of the Trojan War (1610s) (reproduction of 15th-century design) (woven by Geubels and Raes workshops, Brussels), 72, 332

Story of the Trojan War (1615) (woven in workshop of Maarten Reymbouts, Brussels), 73

Story of Ulysses (designs by Simon Vouet), 129, 164

Story of Ulysses (for Hardwick Hall) (woven in Brussels), 120

Story of Venus and Adonis (after 1712) (designs by Jan Van Orley after Albani) (woven by Judocus de Vos, Brussels) (at Houghton Hall, Norfolk), 452

Story of Venus and Adonis. See also Marine Triumphs

Story of Vertumnus and Pomona (ca. 1545–50) (designs by Pieter Coecke van Aelst) (woven in workshop of Willem de Pannemaker, Brussels): *Vertumnus as a Haymaker* (in Madrid), 8, *9*, 107; fig. 11

Story of Vertumnus and Pomona (ca. 1610) (from second-generation cartoons based on originals by Pieter Coecke van Aelst) (possibly woven by Maarten Reymbouts, Brussels) (in Brussels, Boston):

Vertumnus Disguised as a Fisherman (in Boston), 71, 73; fig. 41

Story of the Virgin and the Infancy of Christ (ca. 1574–87) (designs by Alessandro Allori) (woven by Benedetto Squilli in Medici workshops, Florence), 263

Story of the Virgin and of the Infant Christ (ca. 1580s, 9-piece set for Santa Maria Maggiore, Bergamo) (designs by Alessandro Allori) (woven in Medici workshops, Florence), 115, 280

Story of the Virgin Mary (1639) (after Pieter van Lint) (woven in Bruges) (in Bruges), 214

Story of Vulcan and Venus (1540s, 5-piece set) (in Asheville, N.C.), 172

Story of Vulcan and Venus (ca. 1620–25, for Charles, Prince of Wales) (designs based on mid-16th-century Brussels tapestry, borders partly after Henri Lerambert) (woven at Mortlake): *Neptune and Cupid Plead for the Release of the Lovers* (in London), 172, 173; fig. 85

Story of Vulcan and Venus (1622–23, 9-piece set for George Villiers, Marquis of Buckingham) (designs based on mid-16th-century Brussels tapestry, borders after Henri Lerambert) (woven at Mortlake), 333, 335

Vulcan's Forge (in Stockholm), 171, 172; fig. 84

Story of Zenobia. See Zenobia and Aurelianus

Stradano, Giovanni (Jan van der Straet or Joannes Stradanus), 63, 263, 264, 282, 288

Strecken, Gerard van der, 105, 205, 213, 252, 441, 442, 462, 464, 465

Striped Horse. See entries at *Old Indies*

Suetonius, 459, 460

Sufferings of Cupid (1630) (woven by Jan Raes, Brussels): *Time and Temperance Detain Cupid* (in Madrid), 211, 212; fig. 107

Suffolk, Thomas Howard, Earl of, 47, 53, 66, 68, 76–80

Supper at Emmaus (painting by Titian), 175

Surrender of King Francis I (drawing by Bernaert Van Orley), 6, 7; fig. 8,

Susini, Antonio, 396

Susini, Giovanni Francesco, 396

Susteren, Hendrik van, 488

Sustris, Friedrich or Federigo, 82, 84

Sweden

Allegory of Time set in, 252

court life, tapestries in context of, 114, 497

Flemish weavers emigrating to, 21, 21–22

Spiering manufactory in Delft and, 67

Sweerts, Frans, the Younger, 72, 73, 97, 99

Swidde, Willem, 109

Swooning of Esther (painting by Antoine Coypel), 353, 354, 359; fig. 169

Sylvester, pope, 308

T

table carpet (1652) (designs based partly on prints attrib. to Jan Snellinck the Elder and on a print after Michiel Coxcie) (woven in northern Netherlands) (in Amsterdam), **257–60**, *259–61*; cat. no. 30

table carpet, *Story of Tobias* bedcover traditionally described as, 253. *See also* at *Story of Tobias*

Tallard, Camile d'Hostun, comte de, 466

Tallemant, Paul, 346

Talon, Jean, 430

Tamerlan and Bajazet. See Story of Tamerlan and Bajazet

Tancred and Clorinda. See Story of Tancred and Clorinda

tapestry-woven portrait of Sir Francis Crane (ca. 1626–36) (cartoon by Francis Clein after Anthony van Dyck) (woven at Mortlake) (at Ingatestone Hall), 175; fig. 88

Tarchiani, Filippo, 268

Tasso, Torquato, 38, 130

Taxis, house of, 118, *493*, 494

Taxis, Leonard de, 118

Tayer, Jean (Hans Taye), 150, 160

Tedeschi, Alberto Bruni, 393

Tedeschi, Fondaco dei, Venice, 82

Telemachus. See entries at *Story of Telemachus*

Temperance. See Allegorical Armorials of the Duke of Marlborough; Sufferings of Cupid

Tempesta, Antonio, 92, 127, 149, 200

Teniers (1701–6) (designs by David Teniers II) (woven in workshop of Hieronymus Le Clerc or Jasper van der Borcht, Brussels): *Village Fair* (at Schloss Mannheim), 447, 447–48; fig. 205

Teniers (ca. 1717) (designs by Jan van Orley and Augustin Coppens) (woven in Leyniers workshop, Brussels) (in Amsterdam), 452

Teniers, David, I, 446

Teniers, David, II, 114, 326, 330, 447–48, 494, 495

Teniers, David, III, 444–45, 449, 454, 457

Teniers genre, 447, 447–48, 450, 451, 452, 482, 488, 506

Tenniker, Thomas, 28

Tent of Darius (painting by Charles Le Brun), 365, 369, 370, 371

Termini, Giovan Battista, 272, 273, 274

Tessin, Nicodemus, the Younger, 416, 431, 498

Testelin, Henri, 365, 381, 383

Teti, Girolamo, 293, 316

Theagenes and Chariclea. See Story of Theagenes and Chariclea

Theodosius and the Apple (design by Jacob Jordaens), 209

Theseus. See Story of Theseus

Thijs, Pieter, 246–50, 457

Thoison, Eugène, 425

Thou, Jacques-Auguste de, 166–67

throne baldachin (ca. 1560, commissioned by Charles III, duke of Lorraine) (design by Michiel Coxcie and Hans Vredeman de Vries) (woven in Brussels), 33–34

throne baldachin (1585–86, commissioned by Frederick II of Denmark) (design by Hans Knieper) (woven in workshop of Knieper, Helsingør) (in Stockholm), **28–35**, *29–33*; cat. no. 1

Throne of Neptune (1st-century B.C. relief sculpture), *401*, 402

Thurn and Taxis family, *493*, 494

Tieghem, Jan van, 19, 20

Titian, 174–75, 206, 265, 286, 309, 331, 443

Tito, Santi di, 290

Titus and Vespasian. See Story of Titus and Vespasian

Titus Manlius Torquatus, 95, 99

Toledo, Don Pietro de, 90

Tonnet, Peeter, 243

Tons, Frans, 73, 75, 88

Tons, Jean, II, 72, 89

Tons, Willem, 59, 68, 72, 89

Torriani, house of. *See* Thurn and Taxis family

Tortebat, François, 164

Toulouse, Louis-Alexandre de Bourbon, comte de, 416, 417, 420, 425–26, 433, 434, 436, 438, 439

Tournes, Jean de, 201

Tour, Louis de la, 393

Tourves, Joseph-Anne de Valbelle, marquis de, 151

Trajan's Column, 104, 353

transubstantiation

altar frontal of Clement VIII and, 276–77

Triumph of the Eucharist tapestries and, 203

Treaty of London, signing of, *110*, 111

Trent, Council of, 18, 114, 162, 276–77

Triumph of Divine Providence (fresco by Pietro da Cortona), 268

Triumph of the Eucharist (ca. 1626–33, 20-piece set for Archduchess Isabella) (designs by Peter Paul Rubens) (woven in workshops of Jan Raes II, Jacques Geubels II, and others, Brussels), 105, 113, 158, 174, 203, 209, **218–33**, *220–25*, *227*, *228*, 231, 232, 267; cat. nos. 19–24

Abraham and Melchizedek (cartoon), *228*, 229, 231; fig. 111

Adoration of the Eucharist (bozzetto), **218–33**, *224*; cat. no. 22

bozzetti, 226–29

cartoons, 213, 226, 228–29, 231–32

commission, 221–26

Descalzas Reales and, 221–26, 230

design for, 226–29

Ecclesiastical Hierarchy in Adoration (modello), **218–33**, *225*; cat. no. 23

iconography, 219–21, 229

influence of, 232, 234, 236, 237, 248

modelli, 226–29

related sets, 231–32, 441

Secular Hierarchy in Adoration (at Descalzas Reales), **218–33**, *227*, 231, 232; cat. no. 24

Solomonic columns, 174, 208, 216, 217, 219, 226, 229, 267

Triumph of the Church over Ignorance and Blindness, **218–33**

bozzetto, *220*; cat. no. 19

modello, *221*; cat. no. 20

tapestry (at Descalzas Reales), *202*, 221–23; cat. no. 21

weaving of, 229–30

Triumph of the Eucharist (ca. 1650–75) (from copies of Rubens's cartoons) (woven by François and Jan-François van den Hecke, Brussels), 213, 231–32

Triumph of the Eucharist (1697, 29-piece set for Ramón Perellos y Rocafull, Grand Master of the Knights of Malta) (after designs by Rubens) (woven in workshop of Judocus de Vos, Brussels) (in Valletta), 232

Triumph of the Eucharist (1701, 6-piece set for Cardinal Portocarrero) (after designs by Rubens) (woven in Van den Hecke workshops, Brussels), 232

Triumph of Neptune and Amphitrite (painting by Nicolas Poussin), 405n19, 422, 425; fig. 195

Triumph of Pan (painting by Nicolas Poussin), 429

Triumphs of the Gods (ca. 1560–70) (designs after a series of ca. 1517–20 attrib. to Giovanni da Udine and other members of the Raphael workshop) (woven by Frans Geubels, Brussels): *Triumph of Venus* (in Paris), *400*, 400–401, 422–23; fig. 181

Triumphs of the Gods (1692–1703) (cartoons by Noël Coypel after Brussels tapestry by Frans Geubels, ca. 1560–70, from cartoons of the *Grotesques of Leo X*, painted by Giovanni da Udine and other members of Raphael's workshop) (woven in Gobelins workshop of Jean Jans the Younger, Paris), 351, 353, **397–405**, *398–401*, *403*, 422–23, 502

related sets, 398–400

sources for, 400–404

Triumph of Philosophy (preparatory drawing by Noël Coypel), 351, 353; fig. 167

Triumph of Venus (in Florence), 353, **397–405**, *398–99*, *403*, 502; cat. no. 49

Triumphs of the Gods I (designs, ca. 1705, by Jan van Orley and Augustin Coppens) (woven in workshops of Judocus de Vos and Auwercx family, Brussels), 451, 483

State Dining Room at Stowe, decorated with set woven in Brussels for Lord Cobham, ca. 1720, 483; fig. 231

Triumph of Bacchus (ca. 1715), *448*, 449; fig. 206

Triumphs of the Gods II (also known as *Triumphs of the Gods and Goddesses* or *Pleasures of the Gods*) (ca. 1717) (designs by Jan van Orley and Augustin Coppens) (woven in Reydams–Leyniers workshop, Brussels) (in Ghent), 452, 483, 488

Triumphs of the Gods III (ca. 1769–94) (designs by Jan van Orley and Augustin Coppens) (woven in Brussels, probably by Jan Frans or Jacob van der Borcht II): *Diana Resting* (in Amsterdam), 452, **483–88**, *484–86*, *489*, 506; cat. no. 58

Triumphs of Petrarch (ca. 1520, with portraits of Cardinal Wolsey and Henry VIII), 337

Triumphs of Petrarch (1525, purchased by Christina of Sweden from dispersal of Cardinal Mazarin's collection), 331

Triumphs of Petrarch (ca. 1605–6, among sample tapestries and designs for Robert Cecil, Earl of Salisbury, and Thomas Howard, Earl of Suffolk), 68

Triumphs of Petrarch (ca. 1609–1615, 6-piece set, for Albert of Austria) (woven in workshop of Maarten Reymbouts II, Brussels), 59

Triumphs of Petrarch (ca. 1610) (woven in workshop of Maarten Reymbouts, Brussels): *Triumph of Divinity* (ca. 1610), *67*, 68; fig. 37

trompe l'oeil, 252
 Candid's use of, 64
 development of architectural structures by Rubens and Jordaens, 119, 203, 234
 at Fontainebleau manufactory, 12
 in *Maidservant with a Basket of Fruit* from *Scenes of Country Life*, 234, 236
 in *Night* from *Months, Seasons, and Times of the Day*, 82
 placement of tapestries and, 119, 328
 in *Royal Palaces*, 350
 on throne baldachin of Frederick II of Denmark, 34
 in *Triumph of the Eucharist*, 203, 219, 229, 234
 in Vouet's tapestries, 130

Troy, Jean-François de, 384

Trumbull, William, 68–69, 117

Tserraerts, Cornelis, 73

tulipomania, 257

Turenne, Henri de La Tour d'Auvergne, vicomte de, 376, 379, 380–81

Tuscany, grand dukes of. *See* entries at Medici

Two Genii Crowning Fortitude (?) with Oak Leaves (1663–64) (cartoon by Iacopo Chiavistelli) (woven in workshop of Giovanni Pollastri, Florence) (in Florence), 269, 271, *272*; fig. 124

U

Ubeleski, Alexandre, 384

Uden, Lucas van, 212

Ulivelli, Cosimo, 271

Ulrika Eleonora of Denmark, queen of Sweden, 252, 442

Ulysses. See entries at *Alexander and Ulysses*; *Story of Odysseus*; *Story of Ulysses*

Unicorn (ca. 1550–60, set of nine tapestries, probably made for Charles de Guise, cardinal of Lorraine) (woven in Brussels) (at Palazzo Borromeo, Isola Bella), 87, 88, 89

United Provinces. *See* Netherlandish tapestry industry

Unity of the State. See Gallery of François I

upholstery, 259

Urban VIII, pope (Maffeo Barberini). *See also Life of Pope Urban VIII*
 Barberini manufactory and, *293*, 293–95, 299, 300
 Cortona and, 309
 court and ecclesiastical life, tapestry in context of, 115, 117, 118
 Life of Christ tapestries and, 312–13
 Montalto, Alessandro, and, 62, 92, 118, 124, 143, 313
 Paris workshops and, 124, 143, 146, 152
 Story of Constantine tapestries and, 304, 305, 307, 308, 309

Urban VIII Receiving from His Great-Nephews a Copy of the Aedes Barberinae by Girolamo Teti (engraving by Johann Friedrich Greuter after Andrea Camassei), *293*; fig. 131

Urfé, Honoré d', 214

Ursula, saint, 135–36

Utrecht, Adriaen van, 246–50

V

Vadder, Lodewijk de, 212

Vaenius, Octavius (Otto van Veen), 27, 54, 56–58, 212

Valaves, Palamède Fabri de, 162

Valcke, Jacob, 52

Valdor, Jean, 342, 442, 495

Valerius Maximus, 35

Valet, Pierre, 258

Valois Tapestries (ca. 1575, for Catherine de' Medici) (designs by Antoine Caron) (woven in Brussels): *Tournament of Breton and Irish Knights at Bayonne* (in Florence), 25–26, *26*; fig. 26

Van Goyen Family (painting by Jan Steen), 495, *496*; fig. 221

Vanbrugh, John, 475

Vanderbank, John, 500

Vanvitelli, Luigi, 46

Vasari, Giorgio, 63, 84, 96, 263, 264, 280, 326, 401

Vatican and papal court
 Barberini, Francesco, and, 316
 Raphael's Stanze and Logge, 271, 347, 353, 401, 402, 427, 430
 Roman noble families and, 294
 San Michele a Ripa workshops established by Clement XI, 506
 Sistine Chapel tapestries, 264, 276–80, 282, 284, *298*, 298–99, 310
 tapestries in context of life at, 111, 113, 116, 264, 499

Vauban, Sébastien de, 480

Vaudémont, comte de, prince of Lorraine, 72

Vaux-le-Vicomte, 342, 343–44

Veen, Otto van (Octavius Vaenius), 27, 54, 56–58, 212

Velázquez, Diego, 112, 327

Venus. See entries at *Hero and Leander*; *Marine Triumphs*; *Puttini*; *Story of Venus and Adonis*; *Story of Vulcan and Venus*; *Triumphs of the Gods*; *Vulcanus Mars and Venus*

Venus of Urbino (painting by Titian), 265

Verbiest, Ferdinand, 437

Verdure (1520, purchased by Henry VIII), 335

Verdure with Birds (ca. 1640) (design by Jacques Fouquières, borders by Jean Cotelle and workshop of Simon Vouet) (woven in Faubourg Saint-Germain workshop of Raphaël de La Planche) (in Paris), 133, *134*; fig. 70

verdures, popularity of, 132–33, 137–38, 411, 447

Verhulst, Franchoys, 26

Verlinden, Hans, 26

Vermeyen, Jan Cornelisz, 12, 107

Vernansal, Guy-Louis, 365, 384, 385, 412, 414, 420, 424, 425, 430, 434, 438, 439

Vernon-Wentworth, Muriel Hester, 200

Veronese, Paolo, 193

Verren, Jan van, 451

Versailles, Château de, 346, 349–50, 359, 371, 382, 423, 428, 430, 433, 434, 439

Vertumnus. See entries at *Galleries with Vertumnus and Pomona*; *Story of Vertumnus and Pomona*

Vervoet, Hans, 219, 229, 230

Verwilt, Domenicus, 21

Vespasian. See Story of Titus and Vespasian

vestments and altar furnishings
 Clement VIII set (1595) (designs and cartoons by Alessandro Allori and collaborators [Giovanni Maria Butteri, attrib.]) (woven in Medici workshops under Guasparri Papini, Florence) (at Vatican), 264, 284
 altar frontal and cope, **276–81**, *277–79*; cat. nos. 31, 32
 Sistine Chapel baldachin and altarpiece ensemble (designs by Pietro da Cortona, Giovanni Francesco Romanelli, and Ciro Ferri) (woven in Barberini workshop under Giacomo della Riviera, Rome) (at Vatican), *298*, 298–99, 310, 312; fig. 135

Vezzo, Virginia da, 164

Victories of Charles V (1717, for Leopold of Lorraine) (designs by Jean-Baptiste Martin) (woven in Nancy) (in Vienna), 501

Victories of the Duke of Marlborough (ca. 1714–15, 11-piece set) (designs and cartoons by Philippe de Hondt) (woven in workshop of Judocus de Vos, Brussels) (at Blenheim Palace), 451, 469, **471–77**, *472–74*, *476*, 480, 482, 495, 506
 Siege of Bouchain I, 471, *474*, 475; fig. 215
 Siege of Bouchain II, 475
 Siege of Bouchain III, 451, 469, **471–77**, *472–73*, *476*, 480, 482, *490*; cat. no. 56, fig. 217

Victories of William II and William III of England (1698) (woven by Judocus de Vos, Brussels), 451, 458, 480

View of the City of Dunkirk (drawing by Adam Frans van der Meulen), 374, 377; cat. no. 43

View of the Piazza della Signoria with a Procession (painting), *262*, 263; fig. 118

Vighi d'Argenta, Jacopo, 242, 244

Vignali, Iacopo, 269, 290

Vignon, Claude, 131

Villacerf, Édouard Colbert de, 353, 363, 371, 372, 416

Villanueva, Diego de, 230

Vincent de Beauvais, 88

Vincidor, Tommaso, 6, 8, 402

Vinckboons, David, 67, 254

Vinta, Belisario, 285

Virgil, 402

Virgin. *See* entries at *Life of the Virgin*; *Story of the Virgin*

Virtues. See Allegorical Armorials of the Duke of Marlborough

Virtues (1695–97) (designs by Alessandro Rossi) (woven in Medici workshops, Florence), 273

Visit (painting by Gonzales Coques), 120; fig. 59

Visit of Colbert de Villacerf to the Gobelins (etching by Sébastien Leclerc), *371*; fig. 175

Visit of Urban VIII to the Jesuit Church, 1639 (painting by Andrea Sacchi, Jan Miel, Filippo Gagliardi), 115, 117, 146; fig. 54

Visscher, Claes Jansz, 258

Viterbese, il. *See* Romanelli, Giovanni Francesco

Vittorio Amedeo (Victor Amadeus) II, duke of Savoy, 431, 441, 443, 446

Vleughels, Nicolas, 504

Vlierden, Balthazar van, *10*

Vliete, Jacob van den. *See* Riviera, Giacomo della

Vos, Judocus de, 232, 371, 444, 449, 451–52, 458, 466, 469, 471–77, 480–88

Vos, Maarten de, 253, 254, 266

Vos, Marcus de, 371, 451

Vouet, Simon, 113, 124, 129–33, 138, 146, 162, 163–68, 208, 270, 273, 274, 330, 350, 465

Vredeman de Vries, Hans, 34, 35, 46

Vroom, Hendrick Cornelisz, 23, 48, 52–53

Vulcan and Venus. See entries at *Story of Vulcan and Venus*

Vulcanus Mars and Venus (1548, for Henry VIII), 172

W

Wael, Cornelis de, 446–47

Wake, Thomas, 69

Waldstein, Charles Ferdinand or Charles Ernest, counts of, 465

Walpole, Horace, 180, 475

Wandandalle, Lucas, 144

warp, 3, *4*

Warwick, Ambrose Dudley, Earl of, 47

Watkins, Henry, 469–70

Watteau, Jean-Antoine, 385

Wauters, Filips, 215, 442

Wauters, Jacob, 208, 215

Wauters, Michiel, 215–16, 242, 314, 442

weft, 3, *4*

Werniers, Guillaume, 458

Westerlo, Jean-Philippe-Eugène, count of Mérode and marquis of, 448, 482

Weyden, Rogier van der, 35

Wierix, Anton, 266

Wilhelm V, elector of Bavaria, 63, 82, 84

Willeboirts Bosschaert, Thomas, 248

William I, Prince of Orange, 20–21, 24, 48, 50, 52, 64, 390

William II, Prince of Orange, 182, 451, 458, 480

William III of Orange, king of England, 80, 446, 448, 451, 454, 457, 458, 480, 482, *494*, 495, 497, 500

William the Silent, 38, 42

Williams, John, bishop of Lincoln, 172, 337

Witte, Pieter de, the Elder, 84

Witte, Pieter de, the Younger (Peter Candid or Pietro Candido), 63–64, 81–85, 113, 248

Wives at Table during the Absence of Their Husbands (engraving) (by Abraham Bosse), *328*; fig. 148

Władysław IV, king of Poland, 324, 327

Wolsey, Thomas, cardinal, 331, 337

Wonderyear 1566–67, 18

wood paneling, tapestries in relationship to, 495, *496*

wool, as tapestry fiber, 4

Wouwerman, Philips, 448, 480

Wren, Christopher, 470

x

Xenophon, 242

Ximénez del Río, Juan Francisco, 232

y

Yvart, Baudrin, 350, 356, 361, 381, 383

Yvart, Joseph, 361, 365, 381, 393

z

Zama, Battle of. See at *Deeds of Scipio*

Zamet, Sébastien, 331

Zee, Balthasar van der, 242

Zeeland Tapestries (1599–1600, 6-piece set) (designs by Hendrick Cornelisz Vroom, cartoons by Hubrecht Leyniers) (woven in workshop of Hendrick de Maeght, Middelburg) (in Middelburg)

Battle of Bergen op Zoom, 52

Battle of Lillo, 52, 53

Battle of Rammekens, 52, 53

Coats of Arms tapestry, 52

Siege of Veere, 52

Siege of Zierikzee, *16*, 24, 27, 42, **48–53**, *49–51*; cat. no. 5

Zenobia and Aurelianus (before 1660) (designs by Justus van Egmont) (woven in Brussels), 209, 441, 465

Zerbino Expires in the Arms of Isabella (painting by unknown artist after Simon Vouet), *130*, 208; fig. 66

Zeunen, Jacob van, 205

Zu Dohna family, 258

Zurbarán, Francisco, 327

Photograph Credits